THE LIBRARY OF LIVING PHILOSOPHERS

PAUL ARTHUR SCHILPP, FOUNDER AND EDITOR 1938–1981

LEWIS EDWIN HAHN, EDITOR 1981–

Paul Arthur Schilpp, Editor

THE PHILOSOPHY OF JOHN DEWEY (1939, 1971, 1989)
THE PHILOSOPHY OF GEORGE SANTAYANA (1940, 1951)
THE PHILOSOPHY OF ALFRED NORTH WHITEHEAD (1941, 1951)
THE PHILOSOPHY OF G. E. MOORE (1942, 1971)
THE PHILOSOPHY OF BERTRAND RUSSELL (1944, 1971)
THE PHILOSOPHY OF ERNST CASSIRER (1949)
ALBERT EINSTEIN: PHILOSOPHER-SCIENTIST (1949, 1970)
THE PHILOSOPHY OF SARVEPALLI RADHAKRISHNAN (1952)
THE PHILOSOPHY OF KARL JASPERS (1957; aug. ed., 1981)
THE PHILOSOPHY OF C. D. BROAD (1959)
THE PHILOSOPHY OF RUDOLF CARNAP (1963)
THE PHILOSOPHY OF C. I. LEWIS (1968)
THE PHILOSOPHY OF KARL POPPER (1974)
THE PHILOSOPHY OF BRAND BLANSHARD (1980)
THE PHILOSOPHY OF JEAN-PAUL SARTRE (1981)

Paul Arthur Schilpp and Maurice Friedman, Editors

THE PHILOSOPHY OF MARTIN BUBER (1967)

Paul Arthur Schilpp and Lewis Edwin Hahn, Editors

THE PHILOSOPHY OF GABRIEL MARCEL (1984)
THE PHILOSOPHY OF W. V. QUINE (1986)
THE PHILOSOPHY OF GEORG HENRIK VON WRIGHT (1989)

Lewis Edwin Hahn, Editor

THE PHILOSOPHY OF CHARLES HARTSHORNE (1991)

In Preparation:

Lewis Edwin Hahn, Editor

THE PHILOSOPHY OF A. J. AYER
THE PHILOSOPHY OF PAUL RICOEUR

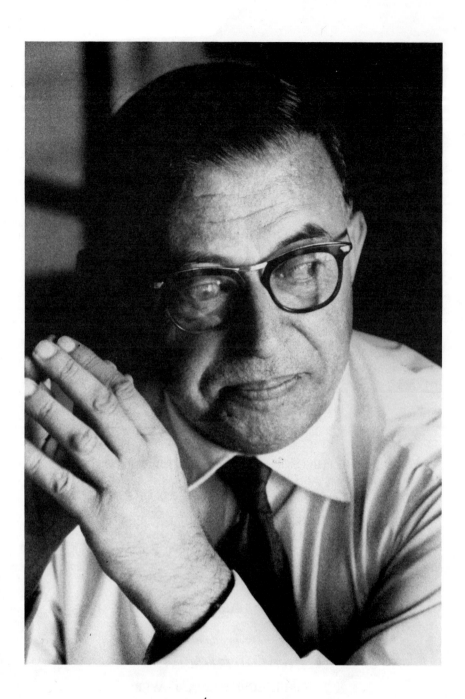

THE LIBRARY OF LIVING PHILOSOPHERS
VOLUME XVI

THE PHILOSOPHY OF
JEAN-PAUL SARTRE

EDITED BY
PAUL ARTHUR SCHILPP
SOUTHERN ILLINOIS UNIVERSITY—CARBONDALE

LA SALLE, ILLINOIS • OPEN COURT • ESTABLISHED 1887

 THE PHILOSOPHY OF JEAN-PAUL SARTRE

OPEN COURT and the above logo are registered in the U.S. Patent and Trademark Office.

First printing 1981
Second printing 1982
Third printing 1982
First paperback printing 1991

Printed and bound in the United States of America.

Library of Congress Cataloging in Publication Data

The Philosophy of Jean-Paul Sartre.

 (The Library of living philosophers; v. 16)
 Bibliography: p.
 Includes index.
 1. Sartre, Jean-Paul, 1905– . I. Schilpp,
Paul Arthur, 1897– . II. Series: Library of
living philosophers ; v. 16.
B2430.S34P47 194 81-38354
ISBN 0-87548-354-2
ISBN 0-8126-9150-4 (pbk.)

The Library of Living Philosophers is published under the sponsorship of Southern Illinois University at Carbondale.

GENERAL INTRODUCTION*
TO
"THE LIBRARY OF LIVING PHILOSOPHERS"

According to the late F. C. S. Schiller, the greatest obstacle to fruitful discussion in philosophy is "the curious etiquette which apparently taboos the asking of questions about a philosopher's meaning while he is alive." The "interminable controversies which fill the histories of philosophy," he goes on to say, "could have been ended at once by asking the living philosophers a few searching questions."

The confident optimism of this last remark undoubtedly goes too far. Living thinkers have often been asked "a few searching questions," but their answers have not stopped "interminable controversies" about their real meaning. It is nonetheless true that there would be far greater clarity of understanding than is now often the case if more such searching questions had been directed to great thinkers while they were still alive.

This, at any rate, is the basic thought behind the present undertaking. The volumes of *The Library of Living Philosophers* can in no sense take the place of the major writings of great and original thinkers. Students who would know the philosophies of such men as John Dewey, George Santayana, Alfred North Whitehead, G. E. Moore, Bertrand Russell, Ernst Cassirer, Karl Jaspers, Rudolf Carnap, Martin Buber, et al., will still need to read the writings of these men. There is no substitute for first-hand contact with the original thought of the philosopher himself. Least of all does this *Library* pretend to be such a substitute. The *Library* in fact will spare neither effort nor expense in offering to the student the best possible guide to the published writings of a given thinker. We shall attempt to meet this aim by providing at the end of each volume in our series as nearly complete a bibliography of the published work of the philosopher in question as possible. Nor should one overlook the fact that essays in each volume cannot but finally lead to this same goal. The interpretative and critical discussions of the various phases of a great thinker's work and, most of all, the reply of the thinker himself, are bound to lead the reader to the works of the philosopher himself.

* This General Introduction, setting forth the underlying conception of this *Library,* is purposely reprinted in each volume (with only very minor changes).

At the same time, there is no denying that different experts find different ideas in the writings of the same philosopher. This is as true of the appreciative interpreter and grateful disciple as it is of the critical opponent. Nor can it be denied that such differences of reading and of interpretation on the part of other experts often leave the neophyte aghast before the whole maze of widely varying and even opposing interpretations. Who is right and whose interpretation shall he accept? When the doctors disagree among themselves, what is the poor student to do? If, in desperation, he decides that all of the interpreters are probably wrong and that the only thing for him to do is to go back to the original writings of the philosopher himself and then make his own decision—uninfluenced (as if this were possible) by the interpretation of anyone else—the result is not that he has actually come to the meaning of the original philosopher himself, but rather that he has set up one more interpretation, which may differ to a greater or lesser degree from the interpretations already existing. It is clear that in this direction lies chaos, just the kind of chaos which Schiller has so graphically and inimitably described.[1]

It is curious that until now no way of escaping this difficulty has been seriously considered. It has not occurred to students of philosophy that one effective way of meeting the problem at least partially is to put these varying interpretations and critiques before the philosopher while he is still alive and to ask him to act at one and the same time as both defendant and judge. If the world's great living philosophers can be induced to cooperate in an enterprise whereby their own work can, at least to some extent, be saved from becoming merely "desiccated lecture-fodder," which on the one hand "provides innocuous sustenance for ruminant professors," and on the other hand gives an opportunity to such ruminants and their understudies to "speculate safely, endlessly, and fruitlessly, about what a philosopher must have meant" (Schiller), they will have taken a long step toward making their intentions more clearly comprehensible.

With this in mind, *The Library of Living Philosophers* expects to publish at more or less regular intervals a volume on each of the greater among the world's living philosophers. In each case it will be the purpose of the editor of the *Library* to bring together in the volume the interpretations and criticisms of a wide range of that particular thinker's scholarly contemporaries, each of whom will be given a free hand to discuss the specific phase of the thinker's work that has been assigned to him. All contributed essays will finally be submitted to the philosopher with whose work and thought they are concerned, for his careful perusal and reply. And, although it would be expecting too much to imagine that the philosopher's

1. In his essay "Must Philosophers Disagree?" in the volume of the same title (London: Macmillan, 1934), from which the above quotations were taken.

reply will be able to stop all differences of interpretation and of critique, this should at least serve the purpose of stopping certain of the grosser and more general kinds of misinterpretation. If no further gain than this were to come from the present and projected volumes of this *Library,* it would seem to be fully justified.

In carrying out this principal purpose of the *Library,* the editor announces that (as far as is humanly possible) each volume will contain the following elements:

First, an intellectual autobiography of the thinker whenever this can be secured; in any case an authoritative and authorized biography;

Second, a series of expository and critical articles written by the leading exponents and opponents of the philosopher's thought;

Third, the reply to the critics and commentators by the philosopher himself; and

Fourth, a bibliography of writings of the philosopher to provide a ready instrument to give access to his writings and thought.

The editor has deemed it desirable to secure the services of an Advisory Board of philosophers to aid him in the selection of the subjects of future volumes. The names of the seven prominent American philosophers who have consented to serve appear on the next page. To each of them the editor expresses his sincere gratitude.

Future volumes in this series will appear in as rapid succession as is feasible in view of the scholarly nature of this *Library.* The next volume in this series will probably be devoted to the philosophy of Georg Henrik von Wright.

Throughout its forty-three years, *The Library of Living Philosophers* has, because of its scholarly nature, never been self-supporting. The generosity of the Edward C. Hegeler Foundation has made possible the publication of many of the volumes, but for the support of future volumes additional funds are needed. On February 20, 1979, the Board of Trustees of Southern Illinois University contractually assumed all responsibility for the *Library,* which is therefore no longer separately incorporated. Gifts specifically designated for the *Library* may be made through the University, and inasmuch as the University is a tax-exempt institution, all such gifts are tax-deductible.

DEPARTMENT OF PHILOSOPHY
SOUTHERN ILLINOIS UNIVERSITY

P.A.S.
Editor

ADVISORY BOARD

ACKNOWLEDGMENTS

The editor hereby gratefully acknowledges his obligation and sincere gratitude to all the publishers of Jean-Paul Sartre's books and publications for their kind and uniform courtesy in permitting us to quote—sometimes at some length—from M. Sartre's writings.

PAUL A. SCHILPP

* Deceased.

TABLE OF CONTENTS

Frontispiece ... iv
General Introduction to *The Library of Living Philosophers* vii
Acknowledgments .. x
Preface .. xiii

PART ONE: AN INTERVIEW WITH JEAN-PAUL SARTRE
 Facsimile of Sartre's Handwriting 2
 Prefatory Note .. 3
 The Interview ... 5

PART TWO: DESCRIPTIVE AND CRITICAL ESSAYS ON THE
 PHILOSOPHY OF JEAN-PAUL SARTRE
 1. R. D. Cumming: To Understand a Man 55
 2. Robert Champigny: Sartre on Sartre 86
 3. Charles D. Tenney: Aesthetics in the Philosophy of
 Jean-Paul Sartre 112
 4. Edward S. Casey: Sartre on Imagination 139
 5. Paul Ricoeur: Sartre and Ryle on the Imagination 167
 6. Amedeo Giorgi: Sartre's Systematic Psychology 179
 7. Phyllis Berdt Kenevan: Self-Consciousness and the Ego
 in the Philosophy of Sartre 197
 8. Robert C. Solomon: Sartre on Emotions 211
 9. Hubert L. Dreyfus and Piotr Hoffman:
 Sartre's Changed Conception of Consciousness:
 From Lucidity to Opacity 229
 10. Robert V. Stone: Sartre on Bad Faith and Authenticity .. 246
 11. Joseph P. Fell: Battle of the Giants over Being 257
 12. Charles E. Scott: The Role of Ontology in Sartre and
 Heidegger 277
 13. Monika Langer: Sartre and Merleau-Ponty:
 A Reappraisal 300
 14. Maurice Natanson: The Problem of Others in *Being and
 Nothingness* 326
 15. Thomas R. Flynn: Mediated Reciprocity and the
 Genius of the Third 345

16. Risieri Frondizi: Sartre's Early Ethics: A Critique 371
17. Dagfinn Føllesdal: Sartre on Freedom 392
18. Donald Lazere: American Criticism of the Sartre-Camus
 Dispute: A Chapter in the Cultural Cold War 408
19. P. M. W. Thody: Sartre and the Concept of Moral Action:
 The Example of His Novels and Plays 422
20. Marie-Denise Boros Azzi: Representation of Character in
 Sartre's Drama, Fiction, and Biography 438
21. Bernd Jager: Sartre's Anthropology: A Philosophical
 Reflection on *La Nausée* 477
22. Oreste F. Pucciani: Sartre and Flaubert as Dialectic 495
23. Lee Brown and Alan Hausman: Mechanism,
 Intentionality, and the Unconscious:
 A Comparison of Sartre and Freud 539
24. Ivan Soll: Sartre's Rejection of the
 Freudian Unconscious 582
25. William Leon McBride: Sartre and Marxism 605
26. Klaus Hartmann: Sartre's Theory of *ensembles* 631
27. Hazel E. Barnes: Sartre as Materialist 661
28. Ronald Aronson: Sartre's Turning Point: The Abandoned
 Critique de la raison dialectique, Volume Two 685

PART THREE: JEAN-PAUL SARTRE: A SELECTED GENERAL
 BIBLIOGRAPHY
 Compiled by Michel Rybalka 709

INDEX
 By Pappu S. S. Rama Rao 731

PREFACE

This volume on the philosophy of Jean-Paul Sartre is unique in many ways. That there should be such a volume in our Library of Living Philosophers certainly needs no defense from me or from anyone else; its value should be obvious. The practical difficulties involved in preparing it in a format even approximating that of earlier works in this series, however, proved enormous and at times seemed all but insurmountable.

After M. Sartre had kindly agreed (in writing) to cooperate in this project, his eyesight began to fail so rapidly that at one point Mlle. Simone de Beauvoir found it necessary regretfully to inform me that it would be quite impossible for M. Sartre to fulfill his obligation to us: he could neither read the contributed articles nor write any of his expected responses.

Nevertheless, with the gracious and exceedingly helpful advice and assistance of Professor Michel Rybalka of Washington University, St. Louis, Missouri, we persisted in our efforts to bring the project to fruition. How this was achieved we have explained in some detail in our Prefatory Note to the interview with Sartre, which appears in Part I of this volume.

I must say that, without the continuous interest and assistance of Dr. Rybalka, this volume could not have seen the light of day. He could almost, therefore, have been named its co-editor. In addition to all his other help, he was one of the three scholars who interviewed M. Sartre, and it was he who edited the interview and prepared the Sartre bibliography that constitutes Part III of this volume. (Dr. Rybalka is also co-compiler [with Michel Contat] of the two-volume bibliography entitled *The Writings of Jean-Paul Sartre,* published by Northwestern University Press in 1974.)

I should also like to take this opportunity to thank the two other interviewers—Dr. Oreste F. Pucciani and Miss Susan Gruenheck—who devoted so much time and effort to securing these valuable remarks from M. Sartre. Miss Gruenheck also supplied the English translation of the interview and, together with Maya Rybalka, transcribed the original French version from tapes.

During a period when I was hospitalized, my colleague Professor Hans Rudnick of Southern Illinois University's Department of English, himself a philosophical scholar, stepped into the breach and helped with the task of editing some of the contributed essays.

PREFACE

The administration of Southern Illinois University at Carbondale has given its steady and unstinting support to the project of this Library and, by relieving me of any extra teaching and committee duties, has made the continuance of this series possible.

Indeed, since the completion of a contract between the Library of Living Philosophers and the University, dated February 20, 1979, Southern Illinois University at Carbondale has become the contractual owner of the Library, of which I am now merely the editor.

We had hoped, almost against hope, to be able to publish this volume during M. Sartre's lifetime. Unfortunately, albeit not entirely unexpectedly, M. Sartre died in Paris on April 15, 1980. In the intellectual life of the world, however, he will probably always live.

PAUL A. SCHILPP

JUNE 25, 1980

1991 PREFATORY NOTE

It is altogether fitting that Open Court should reissue in paperback in 1991 the Library of Living Philosophers volumes on the great French existentialists Gabriel Marcel (1889–1973) and Jean-Paul Sartre (1905–1980), the one devoutly religious and the other atheistic. Quite different in many ways, they shared an interest in and achieved distinction in literature and the arts, and their philosophies were richer because of this interest. Their plays illuminated and expressed vividly certain of their philosophical ideas. But there are sufficient misunderstandings of their views that it is good to have more readily available, for such light as they may afford, the Library of Living Philosophers volumes on their philosophies.

Concern with their philosophies also continues. Books and articles on their thought continue to appear, and such groups as the Gabriel Marcel Society and the Sartre Circle discuss their views at major professional meetings.

LEWIS E. HAHN

DEPARTMENT OF PHILOSOPHY
SOUTHERN ILLINOIS UNIVERSITY AT CARBONDALE
MARCH 1991

PART ONE

AN INTERVIEW WITH JEAN-PAUL SARTRE

même un peu vil"., C'était donc vil de pardonner? Et Jésus-Christ,
alors? Et la prière qu'on me faisait répéter chaque soir : "Pardonnez nous
nos offenses comme nous pardonnons à ceux qui nous ont offensés".?
Ce vieux mourait tout aussitôt : pourquoi? le docteur l'ouvrait. A quoi
bon, puisque tout était fini? Est-ce qu'on ouvrait tous les morts? Tant
être la pauvre Bovary avait-il avalé à montre, par mégarde, ou des
cascau? Je perdais la tête mais percevais tout : c'était écrit. En même
temps, les mots, les images agissaient sur mon humeur à la façon
d'une musique et me plongeaient dans des terreurs ou des
mélancolies dont je ne savais pas les causes. Je voyais un grand
barbu en loques se promener en pleurant dans son jardin, je
pressentais d'étranges déconvertis ; une vie brisée, la folie : j'avais
peur. J'adorais cela : je me sentais dominé par une force
étrangère. Connais je croire qu'on les eût forgés, ces histoires de fous
furieux? Elles ressemblaient si peu aux inventions raisonnable d'Hector
Malot, de Maurice Bouchor, des vieillards affable qui cautionnaient mon
enfance. aucune tête humaine n'eût pu les concevoir, il fallait qu'elles
s'affirment, inscrits toute seule dans le livre. Au soir tombant, oublié
dans le bureau, perdu dans cette forêt vierge, la parole, tressaillant
au moindre bruit, fasciné, je perçois surprendre le langage en l'absence
des hommes. Avec quelle lâche soulagement, avec quelle déception
je retrouvais la banalité familiale quand ma mère entrait,
donnait la lumière et s'écriait :" Mon pauvre chéri, mais tu t'arra-
ches les yeux. Elle se ~~~~ jusqu'au dîner. Je ~~~~ dans ~~~~
à mon grand père : qui écrivait les livres? pourquoi les écrivait on? Il
entreprit, au cours de longs entretiens flatteurs, de m'expliquer ce que
c'était qu'un poète - et fit si bien qu'il me marqua.
~~Faute en manqué, sûr de retrouver Dieu à l'heure de la mort, Charles~~
~~Schweitzer avait préféré d'étonner de sa vie ; mais il conservait~~

PREFATORY NOTE

THE interview with Jean-Paul Sartre that follows represents a major departure from the format which has heretofore characterized works in the Library of Living Philosophers. The departure was occasioned by an unfortunate circumstance. Shortly after Sartre agreed to participate in this Library project, his eyesight began to fail. The condition progressed so rapidly that it soon became clear that he would be unable either to read the papers contributed by others or to compose the responses and the autobiographical statement usually submitted by philosophers featured in this series. (Sartre was long accustomed to editing as he wrote, and therefore eschewed the use of a dictating machine.)

With the resourceful advice of Professor Michel Rybalka, we endeavored to complete the project despite these apparently insurmountable difficulties. We concluded that it would be possible only if one or more bilingual scholars would be willing first to read the contributed articles with some care and then to sit down with Sartre and summarize the authors' statements, pose the questions they raised, and invite his responses. By this interview procedure we hoped to obtain from Sartre not only some observations of an autobiographical nature, but also at least *some* answers to the more persistent questions raised by the contributed articles. To avoid abandoning the project altogether, Sartre agreed to participate in the interview designed to elicit some of this desired information.

However, it will become immediately obvious that, under these circumstances and with these handicaps, it was impossible to get either specific or detailed answers to each of the contributions. In brief, we had to do the best that could be done, which as it turned out, resulted in material which went beyond our fondest expectations. Any Sartre scholar who reads this interview will agree that it would have been most unfortunate if these frank and unhindered Sartrean remarks had been lost to posterity. The interview should be read as a document rather than a series of replies.

The interviewers were:

Dr. Michel Rybalka (hereafter designated as *R.*), Professor of French at Washington University

Dr. Oreste F. Pucciani (hereafter *P.*), Professor of French at the University of California at Los Angeles

Miss Susan Gruenheck (hereafter *G.*), an instructor of philosophy at
the American College, Paris, who at the time of the interview was
completing a dissertation on Merleau-Ponty at the Sorbonne

All three are philosophy scholars, all well versed in Sartre's writings, all
fluent in French as well as English. Their task was in part to represent the
contributors who had submitted articles for this volume, in part to draw
upon their own expertise in framing questions concerning Sartre's thoughts
about his life and work.

The interview spanned two sessions, which took place in late afternoon
on May 12 and May 19, 1975, in Sartre's small apartment in Montpar-
nasse. All told, it was one of the longest interviews Sartre ever accorded for
publication, and it should be read together with the Sartre interview con-
ducted shortly before by Michel Contat, "Self-Portrait at Seventy," which
is contained in *Life/Situations* (New York: Pantheon Books, 1977).

Both sessions were preceded by a thorough preparation, especially on
the part of Dr. Pucciani and Miss Gruenheck. Unfortunately, it proved
impractical to try to give Sartre complete summaries and systematically to
ask all the questions raised by close to thirty contributors. It will be found,
nevertheless, that in the course of the discussion Sartre actually answered
at least many of these questions in one way or another.

Sartre was in good physical condition (except, of course, for his prob-
lems with seeing), and he answered questions in a lively and easy manner.
He was particularly at ease when he talked autobiographically, but he was
less willing to get involved in theoretical problems. Sometimes he either
dropped or eluded lines of questioning; often he simply referred for
answers to his already published works. All these reactions are fairly well
shown in the interview transcript.

The document will doubtless be disappointing to the contributors from
a purely personal point of view. But under the existing circumstances, it
was impossible to find—or even to invent—any better procedures.

The interview sessions were taped while they were in progress. The
tapes were first transcribed in the original French, then arranged and
(where necessary) edited, and finally translated into colloquial English.
Sartre's spoken style has been preserved insofar as possible, but several
parts have been condensed to omit repetition and trivia.

We recommend that the transcript be read in its entirety both before
and after a reading of the essays.

P.A.S.

THE INTERVIEW

I

[At Sartre's request, the first interview session began with an overview of the subjects covered by the contributed essays. The transcript commences following that overview.]

R. *Now that we have introduced the essays, if you are willing, we will first attempt, by way of more general questions, to get something like an intellectual autobiography from you. After that we will go on to some of the specific questions raised in the essays.*

R. D. Cumming makes the following observation: You, M. Sartre, have left a kind of literary testament in the form of your Les Mots; *you have hinted at what might be your political testament with* On a raison de se revolter, *but until now you have not yet taken such a retrospective look at your own philosophy.*

Sartre This is precisely what I *have* undertaken with Simone de Beauvoir: a book that would be a sequel to *Les Mots* in which I take the position of someone drawing up a philosophical testament. This book will follow a topical procedure, not the chronological order of *Les Mots.*

R. *There is a period in your life concerning which we know relatively little, the one dating roughly from 1917 to 1930, in other words, from the end of what you have written about in* Les Mots *to the beginning of Simone de Beauvoir's memoirs. My first question may seem rather trite: Your initial intention was to write, that is, to do literary work; how did you come to do philosophy?*

Sartre I was not at all interested in philosophy in my last years at the lycée. I had a teacher named Chabrier, whom we nicknamed "Cucu-Philo." He did not arouse in me the slightest desire to do philosophy. Nor did I acquire that desire in *hypokhâgne;* * my teacher, by the name of Bernes, was inordinately difficult and I did not understand what he was talking about.

* *Editor's Note:* This is the name for the first year of preparation for the entrance examination to the Ecole Normale Supérieure. *Khâgne* is the second and final year of such preparation.

It was in *khâgne* that I made up my mind, under a new teacher, Colonna d'Istria. He was a cripple, a very small and wounded man. The story went around in class that he had been in a taxi accident and that the crowd had moved in around him saying, "How horrible!" Actually, he had always been like that.

The first essay topic that he assigned, advising us to read Bergson, was: "What Does Duration Mean?" [*Qu'est-ce que durer?*]. I therefore read Bergson's *Essay sur les données immédiates de la conscience,* and it was certainly that which abruptly made me want to do philosophy. In that book I found the description of what I believed to be my psychological life. I was struck by it, and it became a subject for me on which I reflected at great length. I decided that I would study philosophy, considering it at that point to be simply a methodical description of man's inner states, of his psychological life, all of which would serve as a method and instrument for my literary works. I still wanted to continue writing novels and, occasionally, essays; but I thought that taking the *agrégation* exam in philosophy and becoming a professor of philosophy would help me in treating my literary subjects.

R. *At that time you already saw philosophy as a foundation for your literary work. But didn't you also feel a need to invent a philosophy to account for your own experience?*

Sartre Both were involved. I wanted to interpret my experience, my "inner life" as I called it then, and that was to serve as a basis for other works that would have dealt with I don't quite know what, but assuredly purely literary things.

R. *Thus in 1924, when you entered the Ecole Normale, you had made your choice.*

Sartre I had made my choice: I was going to study philosophy as my *teaching* discipline. I conceived of philosophy as a means, and I did not see it as a field in which I might do work of my own. Undoubtedly, so I thought at the time, I would discover new truths in it, but I would not use it to communicate with others.

R. *Could your decision be described as a conversion?*

Sartre No, but it was something new which made me take philosophy as an object for serious study.

As the basis and foundation for what I was going to write, philosophy did not appear to me as something to be written by itself, for its own sake; rather, I would keep my notes, et cetera. Even before reading Bergson, I was interested in what I was reading and I wrote "thoughts" which seemed to me philosophical. I even had a physician's notebook, arranged in alphabetical order, that I had found in the subway, in which I wrote down those thoughts.

R. *Let's go back. Was there a philosophical tradition in your family?*

Sartre　Absolutely not. My grandfather, who taught German, knew nothing about philosophy; in fact, he made fun of it. For my stepfather, an engineer graduated from Ecole Polytechnique, philosophy was only, in some sense, philosophy of science.

R.　*Was your decision influenced by friends such as Nizan?*

Sartre　No, although Nizan (I don't know why) studied philosophy at the same time as I, and he too obtained the *agrégation* several years later. He made the change at the same time I did, and for him philosophy played more or less the same role as for me.

R.　*Didn't you discuss it with each other?*

Sartre　Obviously, we did.

P.　*What was it in your first reading of Bergson that awakened your interest in philosophy?*

Sartre　What struck me was the immediate data of consciousness. Already in my final year at the lycée, I had had a very good teacher who steered me a bit toward a study of myself. From then on, I was interested in the data of consciousness, in the study of what went on inside my head, in the way ideas are formed, how feelings appear, disappear, and so on. In Bergson, I found reflections on duration, consciousness, what a state of consciousness was, and the like, and that certainly influenced me a great deal. However, I broke away from Bergson very quickly, since I stopped reading him that same year in *khâgne*.

R.　*And you attack him rather harshly in* L'Imagination, *for which Merleau-Ponty reproached you.*

Sartre　I was never a Bergsonian, but my first encounter with Bergson opened up to me a way of studying consciousness that made me decide to do philosophy.

P.　*Even at that time you already thought that literature needed to be based on something.*

Sartre　That's right. What was new for me was the idea of literature having philosophical foundations, foundations concerning the world and the life of consciousness [*la vie intérieure*], concerning general topics which I thought were of interest only to philosophers.

R.　*In one of your early writings, "La Semence et le scaphandre," you describe yourself as determined to write only about your own experience. Did you have the same intention in philosophy?*

Sartre　Of course. I thought that my experience was the universal experience of man. That was my starting point, and then my studies naturally gave more importance to philosophy. At the Ecole Normale, I wrote works intended to be both literary and philosophical, which is very dangerous; one should never do that. But anyway, that is how I began, by writing novels of a sort, myths that in my eyes had a philosophical meaning.

R.　*You once told me that you considered "La Légende de la vérité" [un-*

published] to be a literary work. I read and re-read the manuscript with Michel Contat and we came to the conclusion that it is more philosophical than literary.

Sartre At that time I considered "La Légende" to be literary, and yet the content obviously tended to be philosophical.

R. *Nevertheless, we still have two philosophical texts from that period: your thesis on the image for the* diplôme d'études supérieures *and the essay on the theory of the State.*

Sartre Those are very small, unimportant things.

R. *And yet, your interest in the image . . .*

Sartre The thesis on the image had some importance, but I did not really expand my ideas on the question until later.

R. *But why* this *particular interest rather than some other?*

Sartre Because, in my mind, philosophy ultimately meant psychology. I got rid of that conception later. I was surprised a moment ago to learn that some of the contributors speak of my psychology. There is philosophy, but there is no psychology. Psychology does not exist; either it is idle talk or it is an effort to establish what man is, starting from philosophical notions.

R. *That, by the way, is the point of view of [Amedeo] Georgi. He sees only behaviorism in psychology today and he considers that you, on the contrary, have provided the groundwork for true psychology.*

When did you reject traditional psychology?

Sartre In *L'Esquisse d'une théorie des émotions*, which is still psychology, I try to explain that our conception of psychology does not correspond to true psychology, and in *L'Imaginaire* I go beyond what is ordinarily called psychology.

P. *For your* diplôme d'études supérieures *you worked with Professor Henri Delacroix . . .*

Sartre He was a professor of psychology, as a matter of fact.

P. *What sort of relationship did you have?*

Sartre We were on good terms, but I had little esteem for him. He was there to grant my diploma, that's all. He had written some works on language that were worthless. He was a professor at the Sorbonne like a hundred others every year. He was rather well known, I don't know why, but he had no influence on me.

R. *Since we are talking about influence, what philosophers interested you after Bergson?*

Sartre Well, they were classical philosophers: Kant, Plato very much, above all Descartes. I consider myself a Cartesian philosopher, at least in *L'Etre et le Néant*.

R. *Did you study these authors systematically?*

Sartre Quite systematically, since I had to take the required courses for

the *licence* and the *agrégation*. The development of my ideas on philosophy was related to what I was taught at the lycée and at the Sorbonne. I didn't come to philosophy independently of the courses I had: Colonna d'Istria assigned me that essay on Bergson, Delacroix directed my thesis . . . The philosophers I liked, Descartes and Plato, for example, were taught to me at the Sorbonne. In other words, the philosophical education I received all those years was an academic education. That is natural, since it leads up to the *agrégation*. Once one has passed the *agrégation*, one becomes a professor of philosophy and everything is settled.

R. *Were you influenced by Nietzsche?*

Sartre I remember giving a seminar paper on him in Brunschvicg's class, in my third year at the Ecole Normale. He interested me, like many others; but he never stood for anything particular in my eyes.

R. *That seems a bit contradictory. On the one hand, one senses that you were somewhat attracted, since in* Empédocle/Une *défaite you identified with Nietzsche, with the characterization "the lamentable Frederic." On the other hand, during the same period, you threw water bombs on the Nietzscheans of the Ecole Normale, yelling: "Thus pissed Zarathustra" [*Ainsi pissait Zarathustra*].*

Sartre I think they go together. In *Empédocle* I wanted to take up again, in the form of a novel, the Nietzsche–Wagner–Cosima Wagner story, giving it a far more pronounced character. It was not Nietzsche's philosophy that I wished to portray but simply his human life, which made him fall in love with Cosima in his friendship with Wagner. Frederic became a student at the Ecole Normale and ultimately I identified with him. I had other referents for the other characters. I never finished that little novel.

R. *And Marx?*

Sartre I read him, but he played no role at that time.

P. *Did you also read Hegel then?*

Sartre No. I knew of him through seminars and lectures, but I didn't study him until much later, around 1945.

R. *As a matter of fact, we were wondering at what date you discovered the dialectic?*

Sartre Late. After *L'Etre et le Néant*.

P. *[surprised] After* L'Etre et le Néant?

Sartre Yes. I had known what the dialectic was ever since the Ecole Normale, but I did not use it. There are passages that somewhat resemble the dialectic in *L'Etre et le Néant*, but the approach was not dialectical in name and I thought there was no dialectic in it. However, beginning in 1945 . . .

R. *There are one or two contributors who maintain that you were a dialectician from the start . . .*

Sartre That is their affair. I didn't see things that way.

P. *But isn't there, after all, a dialectic of* en-soi *and* pour-soi?

Sartre Yes. But then, in that case, there is a dialectic in every author's work; we find everywhere contradictions that oppose each other and are transformed into something else, et cetera.

R. *You have often been criticized for not being interested in scientific thought and epistemology. Did they have a place in your education?*

Sartre Yes. I had to study them at the lycée and at the Ecole Normale (where much attention was paid to the sciences), and afterward, for my own courses, I had to read particular works. But after all, I never found them terribly absorbing.

P. *And Kierkegaard, when did you discover him?*

Sartre Around 1939–1940. Before then I knew he existed, but he was only a name for me and, for some reason, I did not like the name. Because of the double *a,* I think . . . That kept me from reading him.

To continue this philosophical biography, I would like to say that what was very important to me was realism, in other words, the idea that the world existed as I saw it and that the objects I perceived were real. At that time this realism did not find its valid expression, since, in order to be a realist, one had to have both an idea of the world and an idea of consciousness—and that was exactly my problem.

I thought I had found a solution or something resembling a solution in Husserl, or rather in the little book published in French on the ideas of Husserl.

R. *Lévinas' book?*

Sartre Yes. I read Lévinas a year before going to Berlin. During the same period, Raymond Aron, who had just come back from Germany, told me, for his part, that it was a realist philosophy. That was far from accurate, but I was simply determined to learn about it and I went to Germany in 1933. There I read the *Ideas* in the original text and I really discovered phenomenology.

R. *Among the contributors, there are some who see a phenomenologist Sartre and some an existentialist Sartre. Do you think this distinction is justified?*

Sartre No, I don't see any difference. I think they were the same thing. Husserl made the "I" of the "ego" a datum within consciousness, whereas in 1934 I wrote an article called "La Transcendance de l'ego," in which I held that the ego was a sort of quasi-object of consciousness and, consequently, was excluded from consciousness. I maintained that point of view even in *L'Etre et le Néant;* I would still maintain it today; but at this stage it is no longer a subject of my reflections.

P. *This question concerning the ego presents a problem for many of your critics.*

Sartre Such critics are adhering to tradition. Why should the ego belong to an inner world? If it is an object of consciousness, it is outside; if it is within consciousness, then consciousness ceases to be extra-lucid, to be conscious of itself, in order to confront an object within itself. Consciousness is outside; there is no "within" of consciousness.

P. *The difficulty stems from the fact that it is not a thing . . .*

Sartre No, but you are not a thing either and yet you are an object of my consciousness. Subjectivity is not *in* consciousness; it *is* consciousness. Through this, we can restore one meaning of consciousness as objectified in the subject. The ego is an object that is close to subjectivity, but it is not within subjectivity. There can be nothing within subjectivity.

P. *Simone de Beauvoir wrote that this continues to be one of your firmest convictions. Is it a conviction or a fact?*

Sartre I consider it a fact. In non-reflexive thought, I never encounter the ego, my ego; I encounter that of others. Non-reflexive consciousness is absolutely rid of the ego, which appears only in reflexive consciousness—or rather in reflected consciousness, because reflected consciousness is already a quasi-object for reflexive consciousness. Behind reflected consciousness, like a sort of identity shared by all the states that have come after reflected consciousness, lies an object that we will call "ego."

R. *In your early philosophical writings, for example when you were writing* L'Imagination *or* L'Imaginaire, *did you have any stylistic ambitions?*

Sartre I *never* had any stylistic ambition for philosophy. Never, never. I tried to write clearly, that's all. People have told me there are passages that are well written. That is possible. Ultimately, when one tries to write clearly, in some sense one writes well. I am not even proud of those passages, if there are any. I wanted to write as simply as possible in French, and I did not always do this, as, for example, in the *Critique de la raison dialectique* (which was due to the amphetamines I was taking).

R. *How would you define "style"?*

Sartre I have already discussed style elsewhere, in other interviews. Style is, first of all, economy: it is a question of making sentences in which several meanings co-exist and in which the words are taken as allusions, as objects rather than as concepts. In philosophy, a word must signify a concept and that one only. Style is a certain relation of words among themselves which refers back to a meaning, a meaning that cannot be obtained by merely adding up the words.

P. *In this respect, then, if we employ the distinction set down in* Qu'est-ce-que la littérature? *style would come closer to poetry than to prose.*

Sartre Certainly.

R. *The question is often raised as to whether there is a continuity or a break in your thought.*

Sartre There is an evolution, but I don't think there is a break. The great change in my thinking was the war: 1939–1940, the Occupation, the Resistance, the liberation of Paris. All that made me move beyond traditional philosophical thinking to thinking in which philosophy and action are connected, in which theory and practice are joined: the thought of Marx, of Kierkegaard, of Nietzsche, of philosophers who could be taken as a point of departure for understanding twentieth-century thought.

P. *When did Freud enter in?*

Sartre I had known about Freud ever since my philosophy class and I read several of his books. I remember having read the *Psychopathology of Everyday Life* in my first year at the Ecole Normale and then, finally, *The Interpretation of Dreams* before leaving the Ecole. But he ran counter to my way of thinking, because the examples he gives in the *Psychopathology of Everyday Life* are too far removed from rational, Cartesian thinking. I talked about that in the interview I gave to the *New Left Review* in 1969.

Then, during my years of teaching, I went deeper into the doctrine of Freud, though always separated from him, by the way, because of his idea of the unconscious. Around 1958, John Huston sounded me out on doing a film about Freud. He picked the wrong person, because one shouldn't choose someone who doesn't believe in the unconscious to do a film to the glory of Freud.

I think you had a look at the manuscript, didn't you?

R. *Yes, I looked through it. It is a rather imposing manuscript, about 800 pages.*

Sartre I wrote a complete script. In order to do it, I not only re-read Freud's books but also consulted commentaries, criticism, and so forth. At that point, I had acquired an average, satisfactory knowledge of Freud. But the film was never shot according to my script, and I broke off with Huston.

R. *R. D. Cumming says you have a tendency to exaggerate the discontinuity in your thought: you announce every five or ten years that you are no longer going to do what you have been doing. If we take the example that you gave a moment ago—that of the little notebook you had when you were a student, which became the notebook of the Self-Taught Man in* La Nausée—*it is obvious that you were thinking in opposition to yourself.*

Sartre But it's not like that! I was thinking in opposition to myself in that very moment of writing, and the resulting thought was in opposition to the first thought, against what I would have thought spontaneously.

I never said that I changed every five years. On the contrary, I think that I underwent a continuous evolution beginning with *La Nausée* all the way up to the *Critique de la raison dialectique.* My great discovery was that of the sociality during the war, since to be a soldier at the front is really to be a victim of a society that keeps you where you do not want to be and

gives you laws you don't want. The sociality is not in *La Nausée,* but there are glimpses of it . . .

R. *However, in* Les Mots *you say: "I transformed a quiet evolutionism into a revolutionary, discontinuous catastrophism."*

Sartre [continuing what he was saying] At that time, having become aware of what a society is, I returned from being a prisoner of war to Paris. There I encountered a society occupied by the Germans, which gave a stronger and, I might say, more experimental character to my knowledge of the social phenomenon.

R. *And in terms of the social phenomenon,* L'Etre et le Néant *was the end of a period in your life?*

Sartre Yes, it was. What is particularly bad in *L'Etre et le Néant* is the specifically social chapters, on the "we," compared to the chapters on the "you" and "others."

R. *Then do you think you deserved to be reproached for idealism, as has rather frequently been charged?*

Sartre No, not idealism but rather, bad realism. That part of *L'Etre et le Néant* failed.

P. *One often has great difficulty with your analyses of love, of the "for-others." You yourself have said that in* L'Etre et le Néant *you depicted above all negative love.*

Sartre Yes, certainly. Beginning with *Saint Genet* I changed my position a bit, and I now see more positivity in love.

P. *Sadism and masochism are quite normal aspects of human love.*

Sartre Yes, that was what I wanted to say. I would still maintain the idea that many acts of human love are tainted with sadism and masochism, and what must be shown is what transcends them. I wrote *Saint Genet* to try to present a love that goes beyond the sadism in which Genet is steeped and the masochism that he suffered, as it were, in spite of himself.

R. *Natanson asks the question: "Does the 'for-itself' have a plural or a gender?"*

Sartre That relation is not in *L'Etre et le Néant,* as a matter of fact. It is in the *Critique de la raison dialectique.*

R. *In this connection, do you consider the notion of scarcity to be ontological?*

Sartre No, nor is it anthropological. If you like, it appears as soon as there is animal life.

R. *Natanson asks the question: "Does the 'for-itself' have a plural or a gender?"*

Sartre No, obviously not. There is always and only the "for-itself": yours, mine. But that does *not* make several "for-themselves."

P. *The strength of your system is that it is grounded in ontology. How did you arrive at your notion of ontology?*

Sartre I wanted my thought to make sense in relation to being. I think that I had the idea of ontology in mind because of my philosophical training, the courses I had taken. Philosophy is an inquiry concerning being and beings. Any thought that does not lead to an inquiry concerning being is not valid.

P. *I quite agree; but I would remind you that some scientific thought (the philosophers of the Vienna Circle, for example) completely denies any notion of being as a sort of daydream.*

Sartre I know that, and that is exactly what I mean: when one begins with being, one is doing philosophy. In other words, I do not believe that the thought of the Vienna philosophers (and that of people close to them) is valid; nor do I believe that it yielded valid results later on. One must either begin with being or go back to it, like Heidegger. Whatever the case, being must be called into question, and that leads to more detailed thinking on current philosophical problems.

R. *As Natanson asks, Must one have a retrospective point of view and can one discuss* L'Etre et le Néant *today without entering into dialectics?*

Sartre That raises a difficult problem, the problem of knowing how to interpret a dead philosopher who had several philosophies. How should one speak of Schelling, let's say: what value should be placed on his early philosophy and how should it be understood in relation to his later thought? To know exactly what are the sources of an early philosophy insofar as it is early and the sources of the later philosophy, to know to what extent the early one plays a part in the later one—that is a very difficult question, which I have not yet entirely answered.

P. *But without a fundamental ontology, I wonder if you could have raised the social problem in the way you did in the* Critique.

Sartre I think not. That is really where I differ from a Marxist. What in my eyes represents my superiority over the Marxists is that I raise the class question, the social question, starting from being, which is wider than class, since it is also a question that concerns animals and inanimate objects. It is from this starting point that one can pose the problems of class. I am convinced of that.

P. *That is how it always seemed to me.*

R. *To go back a little, I would like to ask you, with regard to the imagination, if you still maintain the analogon theory that has so often been contested.*

Sartre Yes, I still maintain it. It seems to me that if I had to write on the imaginary, I would write what I wrote previously.

P. *Philosophers have a great deal of trouble understanding the relation between the analogon and the mental image, when the mental image is the analogon of something else.*

Sartre Yes, but that is the definition of the mental image itself, to be always the analogon of something else.

P. *And this something else is found in the real world?*

Sartre Yes, I can have an image of Simone de Beauvoir, even though she is not here at this moment.

P. *Do you have both an analogon of Simone de Beauvoir and a mental image of her?*

Sartre No. The analogon is part of the intention that makes up the mental image. There is no separate mental image that would be the act of consciousness. There is an intention of Simone de Beauvoir through the analogon, and this intention is on the level of the image. That is what we call the image, but it is an intention, the intention by way of the analogon.

R. *You said that in the "Flaubert" you were in part taking up again* L'Imaginaire.

Sartre That is correct. I give it more . . . rather, I develop it somewhat differently. The "Flaubert" is *L'Imaginaire* at seventy years of age, while *L'Imaginaire* was at thirty.

R. *I read in an interview that it was Groethuysen who asked you to add the final chapter to* L'Imaginaire, *the one concerning the status of the aesthetic object.*

Sartre Originally, I did not plan to do such a broad "Imaginaire"; I wanted to do it only on the level of the analogon. In fact, I was not happy with that last chapter, because an entire book should have been done on it.

R. *There were rumors that you originally considered doing a thesis on Husserl.*

Sartre That is completely untrue. Moreover, I never thought that *L'Imaginaire* was going to be a thesis, even if I may have said so in conversation.

R. *One often asks what is the place of aesthetics in your philosophy. Do you have an aesthetics, a philosophy of art?*

Sartre If I have one—I have somewhat of a one—it is entirely in what I have written and can be found there. I judged that it was not worthwhile to do an aesthetics the way Hegel did.

R. *That was never your ambition?*

Sartre Never.

P. *Your aesthetics is implicit; it is everywhere and at times it becomes explicit.*

Sartre That's it, exactly. In *Saint Genet,* in the "Flaubert," one would find more specific things because I am dealing with an author, but in fact it is everywhere. I never wrote a book on aesthetics and I never wanted to write one.

P. *Was there a reason for that?*

Sartre No. I chose to talk about what interested me most.

R. *One of your commentators, [Charles] Tenney, writes: "Sartre could have produced a first-rate aesthetics; he could have become an art critic." Then he makes a distinction between aesthetic materials and non-aesthetic materials and he finds that the latter (Marxist interpretation, autobiography, sociology) have been gradually invading your work.*

Sartre But everything is aesthetic. It is incongruous to suppose that some material could be non-aesthetic.

R. *Tenney brings up a question that you have often been asked: "Sartre insists on the darker aspects of humanity. Shouldn't he have offset that by a study of light and joy?"*

Sartre And abundance, et cetera. Well, no, because they are not situated on the same plane. He seems to assume that men are made half-good and half-bad and that someone who speaks of the bad half without talking about the good half has only seen half of humanity. But that is his idea. Things are not at all like that!

It seems to me that this kind of question is no longer relevant, and it is brought up again by people who have not read anything after *L'Etre et le Néant.*

R. *Tenney raises a third question: "In recent years, Sartre has been especially interested in psychoanalysis and Marxism. Does he now consider poetry, painting, and music as insignificant or less important?"*

Sartre That's inept. Why? One can concern oneself with psychoanalysis and Marxism and still have other areas of interest.

R. *A final question from Tenney: "Does Sartre maintain the distinction between prose and poetry?"*

Sartre But that is a distinction that exists of itself. Prose and poetry have different aims and different methods. I still maintain what I wrote on this subject—more or less.

R. *However, you have slightly modified the distinction that you made . . .*

Sartre Yes, a little. In the "Flaubert," for example. But the distinction remains true. If we push it to its limits, I see prose and poetry as two poles within an overall idea of literature. Moreover, it is in *Qu'est-ce que la littérature?* that I made the distinction.

P. *But the writers of the Nouveau Roman brought the novel closer to poetry and were able to attack your conception of literature . . .*

Sartre They did not fail to do so, by the way. But the Nouveau Roman has disappeared; it attempted to take a position it could not maintain. Personally, I liked some of Robbe-Grillet's novels very much, as well as a few of Butor's.

P. *So, artistic prose would come closer to poetry, and purely signifying prose would be true prose . . .?*

Sartre That's right. But artistic prose is also removed from poetry so far as meaning and signification are concerned. There one would have to go much further.

R. *Given the difficulties raised by this distinction between prose and poetry, do you think it is operative?*

Sartre Yes, but one must know how to use it, and most literary critics do not.

G. *Have you ever thought of doing a philosophy of language?*

Sartre No. Language must be studied within a philosophy, but it cannot be the basis for a philosophy. I think that a philosophy of language could be drawn out of my philosophy, but there is no philosophy of language that could be imposed upon it.

G. *To continue on the literature/philosophy problem, do you still see literature as communication?*

Sartre Yes. I can't even imagine what else it might be. One never publishes anything that is not for others.

R. *And yet [in your own work] you have gradually reduced the role of literature, whereas originally philosophy was simply intended to serve as a foundation for literature.*

Sartre Philosophy has always served that purpose; there is no doubt about it—to the extent of becoming indistinguishable from it. *Les Mots*, for example, is a work which has philosophical underpinnings but which is purely literary. It is the story of a man who remembers what happened when he was a child.

R. *Couldn't* Les Mots *be considered part of a larger undertaking? Starting in 1953, you began to work out a threefold project: autobiographical with* Les Mots, *biographical with* L'Idiot de la famille, *theoretical with the* Critique—*and those three projects complemented each other.*

Sartre Yes, I had those three projects, but I did not see them through to the end and they will never be completed. I did not finish *Les Mots*. I am continuing it now with Simone de Beauvoir, but in a different way. I will never finish the *Critique,* which was supposed to have a second volume on history. I will not finish the "Flaubert"; it is too late now.

R. *And yet when I saw you some time ago, you were absolutely determined to finish it.*

Sartre There is my eyesight . . . and the "Flaubert" is very difficult. There are also those television programs I am preparing.

I cannot see what I write and therefore I cannot correct it. I can't re-read; someone must re-read it to me. Those are the worst possible conditions for writing. Other methods have been suggested to me: I have a tape recorder over there. If you press the button, it starts talking. Either I

am too old to learn that or it is not very ingenious—I don't know which. In any case, it does not replace the act of crossing out a word and putting in a new one above it.

R. *I suppose that those who are used to a tape recorder no longer know how to write.*

Sartre That's what I think. [Laughter]

R. *Robert Champigny points out that your early novels were already marked "to be continued" and he adds, without knowing about your eyesight: "If Sartre finishes the "Flaubert" we should have to offer him our condolences." [Laughter]*

Sartre He is right in saying that. There is something that goes beyond my eyesight. I took notes on the fourth volume of the "Flaubert" before my eyes became weak. They were read back to me; they were not first-rate . . . Something had stopped.

R. *In this regard, you have said that someone else, having read the first three volumes, could write the fourth. Then what is your role in your own written works? [Laughter]*

Sartre That someone could not write the first three volumes! The fourth book can be deduced or induced from the first three and, incidentally, people have already given me dissertations written after reading my "Flaubert."

R. *Do you think that the philosopher, like the writer, has an individual experience to transmit?*

Sartre No . . . well, perhaps. His role is to show a method whereby the world can be conceived starting at the ontological level.

G. *[R. D.] Cumming attempts to prove that this method, in your work, has always been dialectical. It is first a method for defining things; then it becomes a way of exploding the image in consciousness; and, finally, it appears as a dialectic of social classes. The truth always arises from such an explosion, from the displacement, the gap between opposing elements.*

Sartre You will find that in any philosopher, even in a non-dialectician. After all, the dialectic is more complicated than that. I tried to give an account of it in the *Critique*.

At first I was a non-dialectician, and it was around 1945 that I really began to concern myself with the problem. I delved deeper into the dialectic beginning with *Saint Genet* and I think that the *Critique* is a truly dialectical work. Now it is always possible to amuse oneself by showing that I was previously a dialectician without knowing it; one can show that Bergson was Bergsonian at age six when he ate jam and toast. [Laughter]

G. *Cumming uses as an example of a nascent dialectic your article "How a Good American Is Made," in which you describe a twofold process of disintegration and reintegration.*

Sartre It is a process that resembles the dialectic, but I do not think that

one becomes a dialectician just like that, by providing an example, a particular thought. One becomes a dialectician when one has posited what the dialectic is and tries to think dialectically.

P. *One is a dialectician when one thinks a totality.*

Sartre That's right, a totality with lots of contradictory relationships within the whole and an interconnection of the whole that comes from the shifting of all these particular contradictions. If one has a thought that contains an opposition between two terms and a third element that goes beyond them both, it is an ordinary thought of which the dialectic has indeed taken advantage but which is non-dialectical for most people who use it. People do this all the time.

G. *Cumming says that the synthesis must be the inert because, once synthesized, a thing becomes a product. His idea of the dialectic is, I believe, one of movement, of continual displacement without synthesis.*

Sartre That is one conception.

G. *Do you think that syntheses exist?*

Sartre Yes; partial syntheses, in any case. I demonstrated that in the *Critique de la raison dialectique.*

G. *You would reject an absolute synthesis, I suppose?*

Sartre Absolute, yes. But a synthesis of an historical period, for example, no. Our time is its own synthesis with itself. That is what I would have explained in the second volume of the *Critique*. Certainly one must go beyond the type of synthesis that was available to me in the first volume in order to arrive at syntheses touching oneself and others. We can, at every moment, each one of us, make syntheses. For example, I can make a synthesis of you three and, in some way, place myself in it, and you can do the same thing. But these syntheses are not at all on the same level as the synthesis of the whole, and one person alone can never accomplish that. If there were six of us, we could start over; but if there were a thousand of us, it would no longer have much meaning. Only individuals can take several individuals to make a group but not the totality, since they would have to place themselves within it. It is therefore necessary to look for another way of conceiving these latter syntheses. That is what I tried to do when I was working on the second volume of the *Critique*, but it was not finished.

P. *In L'Etre et le Néant, however, you say that consciousness is synthesis.*

Sartre Yes, of course. But it is the consciousness of everyone that is the synthesis of what he sees. I am synthesis in relation to everything I see, in relation to you three, but to you three in your relation to me. But I am not a synthesis of what happens in the street that I do not see. [At this moment, the wail of sirens sounds in the street.] Since I believe only in individual consciousness and not in a collective consciousness, it is impossible for me to provide, just like that, a collective consciousness as historical synthesis.

P. *That would be providing what one wished to find.*

Sartre Obviously.

R. *You have defined the* Critique de la raison dialectique *as a work opposed to the Communists and yet endeavoring to be Marxist.*

Sartre Opposed to the Communists, certainly. But Marxist is a word that I used a bit lightly then. At that time I considered the *Critique* to be Marxist; I was convinced of it. But I have changed my mind since then. Today I think that, in certain areas, the *Critique* is close to Marxism, but it is *not* a Marxist work.

R. *In* Question de méthode *you differentiate between ideology and philosophy, and that is a distinction which bothers people.*

Sartre That is because they all want to be philosophers! I would still maintain the distinction, but the problem is very complex. Ideology is not a constituted, meditated, and reflected philosophy. It is an ensemble of ideas which underlies alienated acts and reflects them, which is never completely expressed and articulated, but which appears in the ideas of a given historical time or society. Ideologies represent powers and are active. Philosophies are formed in opposition to ideologies, although they reflect them to a certain extent while at the same time criticizing them and going beyond them. Let us note that, at the present time, ideology exists even in those who declare that ideology must be brought to an end.

P. *I myself was bothered by your distinction. I saw the existentialism of the* Critique *as an attempt at synthesizing Marxism and going beyond it, whereas you said that existentialism was only an enclave of Marxism.*

Sartre Yes, but that was my mistake. It cannot be an enclave, because of my idea of freedom, and therefore it is ultimately a separate philosophy.

I do not at all think that ultimately this philosophy is Marxist. It cannot ignore Marxism; it is linked to it, just as some philosophies are linked to others without, however, being contained by them. But now I do not consider it at all a Marxist philosophy.

R. *Then what are the elements that you retain of Marxism?*

Sartre The notion of surplus value, the notion of class—all of that reworked, however, because the working class was never defined by Marx or the Marxists. It is necessary to re-examine these notions, but they remain valid in any case as elements of research.

R. *And today you no longer consider yourself a Marxist?*

Sartre No. I think, by the way, that we are witnessing the end of Marxism and that in the next hundred years Marxism will no longer take the form in which we know it.

R. *Theoretical Marxism, or Marxism as it has been applied?*

Sartre Marxism as it was applied, but it was also applied as theoretical Marxism. Since Marx, Marxism has existed, living a certain life and at the same time growing old. We are now in the period in which old age moves toward death. Which does not mean that the main notions of Marxism will

disappear; on the contrary, they will be taken up again . . . but there are too many difficulties in preserving the Marxism of today.

R. *And what are those difficulties?*

Sartre I would simply say that the analysis of national and international capitalism in 1848 has little to do with the capitalism of today. A multinational company cannot be explained in the Marxist terms of 1848. A new notion has to be introduced here, one which Marx did not foresee and which therefore is not Marxist in the simple sense of the word.

P. *And the* Critique *therefore already goes beyond Marxism?*

Sartre In any case, it is not on the level where it was placed, that of a simple interpretation of Marxism with a few alterations here and there. It is not opposed to Marxism; it is really *non*-Marxist.

P. *You go beyond Marxism with the idea of seriality, of the practico-inert, through new ideas that have never been used.*

Sartre Those are notions that seem to me to have come out of Marxism, but which are different from it.

R. *And what would be this philosophy of freedom that is being born today?*

Sartre It is a philosophy that would be on the same level, a mixture of theory and practice, as Marxism—a philosophy in which theory serves practice, but which takes as its starting point the freedom that seems to me to be missing in Marxist thought.

R. *In recent interviews, you seem to have accepted the term "libertarian socialism."*

Sartre It is an anarchist term, and I keep it because I like to recall the somewhat anarchist origins of my thought.

R. *You once said to me: "I have always been an anarchist," and you declared to Contat: "Through philosophy I discovered the anarchist in me."*

Sartre That is a bit hasty; but I have always been in agreement with the anarchists, who are the only ones to have conceived of a whole man to be developed through social action and whose chief characteristic is freedom. On the other hand, obviously, as political figures the anarchists are somewhat simple.

R. *On the theoretical level as well, perhaps?*

Sartre Yes, provided that one considers only the theory and deliberately leaves aside some of their intuitions which are very good, specifically those on freedom and the whole man. Sometimes those intuitions have been realized: they lived in common, they formed communal societies, for example, in Corsica around 1910.

R. *Have you been interested recently in those communities?*

Sartre Yes, I read that in the book on the anarchists by Maitron.

R. *In your television programs are you planning to adopt an anarchist view of history?*

Sartre Anarchist, no; but we will talk about anarchism.

R. *You have not said much about what socialism could be, and I surmise you have reproached yourself for having insufficiently outlined socialist society.*

Sartre That is correct, but I do not reproach myself severely, because it is not up to people now to do so. We can indicate the basis and the principles, but we cannot think through such an alteration of society. We know in what direction we are going, the direction of the freedom that must be given to men . . .

R. *If you had to choose today between two labels, that of Marxist or that of existentialist, which would you prefer?*

Sartre That of existentialist. That is what I just told you.

R. *Wouldn't you prefer another term that would better render your position?*

Sartre No, because I didn't look for it. I was called an existentialist and I took on the name, but I didn't give it to myself.

R. *The notion of lived experience [vécu] that you use in the "Flaubert" remains rather vague and you have not yet theorized it . . .*

Sartre I think that would have come, little by little, in the volume on *Madame Bovary*. But it is difficult to go very far in this area, because it means really "breaking into" the other. I can talk about *my* lived experience [*mon vécu*], but only at risk can I reconstitute yours.

P. *Wouldn't a theory of lived experience require you to reconsider the notion of consciousness? Because lived experience seems at times to be a reply to the Freudian unconscious.*

Sartre It is to some degree a reply to the Freudian unconscious, a way of showing that a host of complex intentions that Freud placed in the unconscious can be found in lived experience. That is certainly part of it. It is also the fact that we constantly have in ourselves states that we can understand if we take time, but that we do not understand. These states are full of richness, but they do not yield it. They come and go, there is nothing mysterious about them, nothing unconscious. Simply, they retain and contain in themselves a richness that is undeveloped, that one understands but does not develop.

P. *That is "understanding without understanding," as you say in the "Flaubert"?*

Sartre Exactly. Lived experience [*le vécu*] is just that.

P. *It is thus a question of a reflection that is pushed to genuine understanding and even farther, to become knowledge.*

Sartre Yes, *if* that happens.

P. *If that happens?*

Sartre Because with most people that does not happen. And then there are those who try to do it and fail, and those who sometimes succeed.

P. *Would this change the theory of consciousness as it is formulated in* L'Etre et le Néant? *For example, wouldn't lived experience call into question the perfect translucidity of consciousness?*

Sartre I don't think so. In theory, it would not have any effect on it. In practice, obviously, the states that are understood without being understood are not . . .

P. *Wouldn't lived experience introduce opacity into consciousness?*

Sartre No, for to be understood without being understood assumes that the object is not a pathos, is not something thick and opaque, but is grasped. Only we do not have the words, the divisions that would enable us to describe all the richness that this object has. If you like, it is a compression of consciousness. What would remain to be done would be to create centers, subdivisions and so forth, that would make the object a whole that is completely clear to the other. In the end, to be understood without being understood is to be understood by me without being able to make it understood by the other.

P. *Wouldn't that be that switching of the position of consciousness that goes from perception to imagination? There are two different theses and we retain in us the product of these two theses.*

Sartre Exactly. Frequently even the understanding will be achieved in a different language from that of "understanding without understanding."

P. *Thus, in some sense, lived experience would be a kind of imaginary within us.*

Sartre Exactly.

P. *Then a theory of forgetting would also be necessary . . .*

Sartre That has often tormented me, but I did not do it. Why? Because I did not know *how* to do it. There are plenty of problems pestering me that I have not resolved.

P. *Isn't forgetting an annihilation?*

Sartre No, because one can recall things that one has forgotten. There is perhaps a movement toward annihilation, but with many degrees before annihilation.

R. *Are there other problems, like the one of forgetting, that you have not treated?*

Sartre Social problems . . .

R. *Do you consider that your work [oeuvre] is done?*

Sartre Yes. You've come at the right time! You have found a dead man who isn't dead!

R. *That's going too far . . .*

Sartre Listen, I can no longer write and there are things that one cannot do at age seventy. But I can do television programs, for example.

R. *By the way, how are those programs working out?*

Sartre I don't know. As you know, the programs are an attempt to outline the history of France from my birth to my seventy years of age. Originally, they were to be placed under the category of "Documentaries"; but I find the word very unsatisfactory, because a life within seventy years of history is not a document. Now the name "Drama" has been proposed to me, and the directors of the program and I have accepted it, for that will make it possible to get things moving. Television has more money for dramatic programs and, moreover, the name allows for the imaginary side involved in reconstructing seventy years of history.*

R. *Many people who write about you say that your thought is essential but that you have not always pursued your intuitions and you have left obscurities and difficulties.*

Sartre That is true; but I think it is an extremely severe and even very partial view of things to imagine that a man is obliged to pursue the idea he launched down to its smallest details. That was not my work; that was not my role. What I wanted to do was to discuss as many problems as possible starting from ontology.

R. *That is what makes your work open-ended . . .*

Sartre Yes, open-ended, absolutely open-ended. That is one of the reasons why I said that anyone could continue it on any level, that anyone could, for example, finish the "Flaubert."

R. *On the other hand, in many people, especially the young, there is an adherence to your thought that leads to doing exactly what you have done, in the same context and in your own language . . .*

P. *There is a spell cast by your thought. It takes a long time to free oneself from it. If one wishes this thought to be an instrument, one must get perspective on it at a distance.*

Sartre You are right.

P. *But before getting to that point, one is under its spell.*

Sartre Yes. That is what I wanted. [Laughter]

G. *Listening to you talk, I have the impression that you continue to reflect as a phenomenologist. Have you ever left phenomenology?*

Sartre Never. I continue to think in those terms. I have never thought as a Marxist, not even in the *Critique de la raison dialectique.*

P. *Would it be fair to say that Marx provided you with ideas that you have treated in your own way?*

Sartre If you like, yes. At one time I even thought that one could not do without some of Marx's ideas, that it was absolutely necessary to go through Marxism in order to go farther. But now I no longer think that altogether.

* *Editor's Note:* Having concluded that the working conditions proposed to him were unacceptable, Sartre finally abandoned this television project at the end of September 1975.

P. *You have not by-passed Marx; you have gone right through.*

Sartre Yes, that's right.

P. *I see many people today trying to go beyond Sartre without going through Sartre's thought.*

Sartre Ha-ha!

R. *What is interesting is to grasp to what extent your thought is the thought of an historical time, how you are contemporaneous. In other words, how have you "programmed" yourself in relation to the philosophical thought of the time?*

Sartre That is a difficult question. *L'Etre et le Néant* was the phenomenology and existentialism . . . (existentialism is the wrong word) . . . let us say the philosophy of Heidegger and Husserl. I took from them what appeared to me to be true and I tried to develop my own ideas from there. For example, I took Husserl for a realist, which he is not; that is a philosophical error. He is much closer to Kant.

R. *In short, you took a pseudo-Husserl as Merleau-Ponty took from you a pseudo-Sartre?*

Sartre That's right.

R. *At the present time, Marxism is being contested by some. Are you in sympathy with them?*

Sartre That depends. I am in sympathy with the ones called "les Maos," the militants of the Gauche Prolétarienne with whom I directed *La Cause du Peuple*. They were Marxists in the beginning, but they have done what I did: they are not Marxists any longer, or they are much less so than before. Pierre Victor, for example, with whom I am working on these television programs, is no longer a Marxist, or at least he envisions the end of Marxism.

R. *Some critics attempt to find in you a Maoist philosopher.*

Sartre That is absurd. I am not a Maoist. That is meaningless, by the way. When I was writing *L'Etre et le Néant*, Mao was seldom talked about.

For some groups it had a meaning, though very vague: they imagined certain forms of socialist life such as had been seen or believed to have been seen in China, and they wanted to apply them here. These groups were Maoist when Mao's face had not yet appeared on the front page of *La Cause du Peuple*; they ceased to be when Mao's face did appear.

R. *It always seemed to me that in French Maoists there was 10 percent Mao and 90 percent something else that is not very easy to define.*

Sartre Difficult to define but interesting. That is what we tried to do in *On a raison de se révolter*.

[The conversation now continues in a rambling fashion, covering various subjects: Oreste Pucciani underlines the difficulty of fully representing the viewpoint of the various contributors and of playing the role of inter-

mediary. Sartre says that intermediaries are necessary, then wonders why, among the articles for the book, there is only one on literature, that of Marie-Denise Boros Azzi. Pucciani points out that he is directing a thesis on "Sartre in Rumania." Sartre observes that there would be more to discuss concerning his role in Czechoslovakia and Poland. Finally, we come to the situation in Portugal.]

R. *Some people who recently returned from Portugal told me that your work is widely read there, that it is being read in buses and even sold in dairy shops.*
Sartre Sartre next to jars of cream—that's very good. I just spent Easter vacation in Portugal, and a translation of *On a raison de se révolter* has recently been published there.
P. *And what do you think of the revolution that has taken place there?*
Sartre What is interesting is not so much the military that has taken power or the political parties, but rather the people, that is, the creativity of the masses. They have self-management there; groups create entire hospitals by occupying buildings and even palaces and mobilizing the whole district. They are taking action with the support of the population and are forming a people's power.
P. *Were you surprised by the relative defeat of the [French] Communist Party in the April elections?*
Sartre No, it was expected. The Communist Party is powerful because it works in connection with the military and controls the press and the television. It is opposed to the socialists and it is not well liked among the people.
R. *Is the socialist party really playing into the hands of the right wing?*
Sartre It is the old Social-Democrat party. One cannot have sympathy with it.
R. *Do you think this third power, the people's power, that you spoke of in your interview in* Libération, *is truly important?*
Sartre It exists and it is very interesting. It is not a party but rather people who are reacting to their own difficulties and problems in a socialist manner.
R. *Do you foresee this sort of people's power in France?*
Sartre Yes, but for the moment we have suffered a setback. It is such a people's power that we would like to encourage through the television programs.

[End of First Session]

R. *Before going on to the summaries of the articles, I would like to ask you two or three questions that were previously left aside.*

One of the contributors was struck by the status you give to the historical neurosis of the nineteenth century in Volume III of the "Flaubert." He considers it a discovery and would like to know what is the status of this inventive power. At what moment does a discovery take place? For example, when did the idea of programmation or that of historical neurosis occur to you?

Sartre I don't know. It comes in the course of my reflections, but I cannot say at what moment it appears.

R. *Some of us wonder how you invent hypotheses.*

Sartre That we do not know. It comes, we cannot say how.

R. *Is it the text that gives you a thesis of interpretation and leads you to be ideologically creative? Another idea is that today we can keep philosophy from being closed by the use of texts.*

Sartre That is correct. I agree on that score.

R. *Is that the reason you chose to make the "Flaubert" an example of concrete philosophy?*

Sartre Yes. But we do not know how ideas arise. How a specific idea came to me, I no longer know.

R. *Many critics raise the problem concerning the works that you did not complete. What is your position now concerning those works?*

Sartre I did finish some works. But there are many that I will not finish: *L'Etre et le Néant*, which was to include an ethical sequel that will never be done, at least not in that form; the novel *Les Chemins de la liberté*; the *Critique de la raison dialectique*; the "Flaubert" . . .

The novel, for example, has been completely forgotten. I do not attach great importance to it now; I don't think it was good.

R. *Didn't you take the project for the novel up again in other forms in the "Flaubert," insofar as you wanted to make it a true novel [roman vrai]? Wasn't there some sort of transfer there?*

Sartre Not at all. Volume IV of *Chemins* was not a true novel; it was a false novel that contained many imaginary or false circumstances unrelated to the "Flaubert." When I thought of the true novel it was rather in the sense that it was impossible to write an untrue novel and that it was necessary to raise questions about characters that had existed.

R. *As regards the incomplete works, do you have a feeling of regret or of necessity?*

Sartre Necessity. It stopped there. I feel perhaps some regret about the *Critique de la raison dialectique*, which I could have finished. But it did not happen. Well, that's too bad.

R. *In many cases, the manuscripts still remain . . .*

Sartre . . . which convey what might have been a continuation

R. *. . . and that you are not particularly anxious to see published for the moment, I believe?*

Sartre It is not worth the trouble. If it amuses people after my death . . . [Laughter]

R. *And yet, Michel Contat and I plan to publish in the* Pleiade *the manuscripts dealing with the novels.*

Sartre I don't care. Or rather, it no longer interests me.

R. *Publishing the philosophical manuscripts seems to me to be somewhat urgent: those concerning the "Ethics," the second volume of the* Critique, *Volume IV of the "Flaubert," and so on. In general, they are highly valuable. Why not consider that they, too, are part of the domain of the Other?*

Sartre They can be published later.

R. *There is a question that comes up several times and is perhaps best put by Robert Champigny, who accuses you of human racism, of anthropomania. What bothers him about your famous statement in* Les Communistes et la paix, *"An anti-communist is a dog," is not the political idea expressed . . .*

Sartre It's the dog?

R. *It's the dog. [Laughter]*

Sartre Really, I don't think one can conclude from that statement that I have something against dogs. I used a quite ordinary expression there.

R. *Champigny wrote a whole book to reproach you for that.*

Sartre A whole book! That's a lot.

R. *He is not the only one who raises the problem.*

Sartre This is the first time I have heard about it.

R. *Alluding to the passage in* L'Idiot de la famille, *where you describe the dog, he notices a certain evolution. From a general standpoint, it raises the problem of consciousness.*

Sartre I think animals have consciousness. In fact, I have always thought so. There is no evolution in that.

R. *What status would their consciousness have in relation to man?*

Sartre That is an extremely difficult problem, and I would not know how to answer. I know that animals have consciousness, because I can understand their attitude only if I admit a consciousness. What is their consciousness? What is a consciousness that has no language? I have no idea. Perhaps we will be able to determine that later on, but more will have to be known about consciousness.

P. *All the same, animals do have a kind of language, not an articulated language, but the possibility of communicating in another way.*

Sartre Certainly, but that still poses problems.

P. *This question amuses me because my students are always asking me: Where are the animals in* L'Etre et le Néant?

Sartre They are not in it, because I consider that what is said about ani-

mals in animal psychology is generally stupid or, in any case, absolutely unconnected to the conscious experiences that we have. Animal psychology has to be redone, but it is difficult to say on what foundations.

P. *At the present time, very interesting research is being done in the United States on monkeys. They are being taught to type on a machine. They can think symbolically even though they cannot speak.*

R. *Do plants have consciousness?*

Sartre I have absolutely no idea. I don't think so. I don't think that life and consciousness are synonymous. No, for me, consciousness exists where we notice it; and there are animals that do not have it, protozoa, for example. Consciousness appears in the animal kingdom at a certain moment: in men; surely also in monkeys. But how does it appear and what is it?

R. *There is a problem that is very bothersome to the Americans (who have a solid naturalist tradition), namely, ecology. Have you reflected on it?*

Sartre No.

P. *Some Americans have developed the idea that today the question of classes is completely secondary in relation to the question of the species: we live in Nature, which is the source of production and where the relations of production are less important.*

R. *One even uses the phrase "Capitalism mystifies biology."*

Sartre That does not appear to me to be serious thinking. The development of the human species has placed it in conditions that are no longer natural; but it nevertheless retains relations to Nature. The real problems of the human species today, the problems of class, capital, and so on, are problems that have no relation to Nature. They are posed by the human species in its historical movement, and that leaves Nature outside of them.

P. *I would agree, but what concerns these ecologists is that we are now in a situation in which we risk exhausting the resources of Nature, or of spoiling them completely. In several years there will be no more air for us to breathe. . .*

Sartre That is rather likely. In that case, there are two alternatives: the first is that as resources have been exhausted, we will have invented something else, which could happen; the other is that we will disappear, which could also happen. I never thought that the human species was infinite.

R. *To the Americans, you are often the philosopher of anti-Nature.*

Sartre I am an anti-Nature philosopher, but only in certain respects. I know that in the beginning there was Nature, which directly influenced man. It is certain that primitive men had real relations with Nature, like orang-utans or ants. This relation still exists, even today; but it is surmounted by other relations that are no longer material ones, or at least by relations in which Nature no longer plays the same role.

P. *The ecologists think that everything in Nature has been politicized and that a possible repercussion of this might affect the essential vitality of the human species.*

Sartre I think so too. It could end in the death of the species.

R. *It seems to me, however, that ecology, as it is often advocated, is mystifying thought insofar as it does not bring in the class struggle and claims to be universal.*

Sartre Yes. It is in the domain of class struggle, in the domain of contemporary societies that one can see the real problems. The problems of Nature come in below these domains.

P. *Some who begin with ecology go on to assert that today everyone is proletarized, that there is only one universal class, which is the working class . . .*

Sartre That seems to me an exaggeration. For example, I do not consider us here to be proletarians. I have many relations with the proletariat and much sympathy for it, but I do not think the work we are doing here can be defined as the work of proletarians.

R. *. . . The contention is nevertheless interesting, because it shows a whole new orientation of the former American New Left toward the ecology movement.*

Let us go on to another question. Frequently your critics allege that you give too much importance to the notion of scarcity, that you accord it an overemphasized status compared with other elements of Marxist thought.

Sartre It is not Marxist thought. Marx did not think that primitive man or feudal man lived under the rule of scarcity. He believed that they did not know how to use resources, but not that they were living in scarcity. This notion has been introduced into philosophy by others besides me, and I do not owe it to Marx. I consider that scarcity is the phenomenon in which we live. It is impossible to suppress it without changing the conditions of existence, of what is real, of intelligence . . . Even here, among ourselves, there is scarcity in our conversation: scarcity of ideas, scarcity of understanding. I may not understand your questions or may answer them badly—that, too, is scarcity.

P. *How is that? I don't understand.*

Sartre Well, a moment ago we were talking about ecology, about which I know practically nothing. There is therefore a certain scarcity in relation to ecological theory, scarcity in relation to me. The answers I gave, although I consider them to be true as regards the relation between Nature and capitalist man today—those answers are still scarce compared to the specific questions that an ecologist would ask me. There is scarcity on every level and from every point of view. You asked me a while ago how I came upon an idea. An idea is also a scarcity. Then how can such a scarcity

appear in the midst of perceptions and imaginings . . .? That question . . .

R. *Is scarcity linked to desire, or to need?*

Sartre Sometimes to need, sometimes to desire. Inasmuch as a cause, any cause whatsoever, makes us need a certain substance or a certain object, that object is not given in the proportion that we need it: that is scarcity.

R. *Doesn't scarcity thus tend to become an ontological category rather than an historical one? Oscar Wilde said, for example: "Wherever there is a demand, there is no supply."*

Sartre It is not an ontological notion, but neither is it simply a human notion or an empirical observation. It is drawn from the ontological side, but it is not ontological, because the human beings we are considering in the world are not to be studied only ontologically or on the level of particular abstract ideas, as some philosophies or particular ontologies do. They must be studied empirically as they are. And, on this level, one observes that a man is surrounded by scarcity, whether it be the toy that is not available to the child when he wants it or the food supplies that a human group demands and of which there is only a portion. In any case, there is a difference between supply and demand that arises from the way man is made, from the fact that man demands more, whereas the supply is limited.

R. *We are clearly seeing today that the idea of abundance that was once current in the United States is a mystifier.*

Sartre Absolutely. Totally. We live in a world of scarcity, and from time to time we may imagine that we have found abundance by changing the nature of our desires. Not having what is necessary in one domain, we shift our desire to another. But it is all the same scarcity that lies at the origin of this conception.

P. *However, I always understood scarcity in the* Critique de la raison dialectique *as a fact of social oppression.*

Sartre It is always a fact of social oppression. But there are other scarcities that arise solely from the relation of man's demand—a free demand, in no way imposed by someone else—to the quantity of what is given.

P. *But if there is an objective lack, is this also scarcity?*

Sartre Of course. In fact originally that is what scarcity was. Desire, will, the necessity to use such and such an object as a means, create a demand that may sometimes be unlimited, whereas the object in demand is limited in quantity in a territory or on the globe. Thus, for me, scarcity is a phenomenon of existence, a human phenomenon, and naturally the greatest scarcity is always the one based on social oppression. But scarcity is at the bottom of it. We create a field of scarcity around us.

P. *In the* Critique, *I thought need was the basic condition which afterward gave rise to scarcity.*

Sartre Indeed, but need is not an oppression; it is a normal biological

characteristic of the living creature, and he creates scarcity. In any case, the need of an animal or of primitive man for a certain object—for example, for food—does not make the object appear where he is. Thus, we must consider that the need is greater than the way in which the space surrounding us is constituted, which forces us to seek the object we lack elsewhere. As soon as this begins, there is struggle, the building of roads and a new construction of the field that surrounds us.

P. *Could one generalize and say that need is natural whereas scarcity is social?*

Sartre Need is natural, but that does not mean that the object of our desires is there. Scarcity is social to the extent that the desired object is scarce for a given society. But strictly speaking, scarcity is not social. Society comes after scarcity. The latter is an original phenomenon of the relation between man and Nature. Nature does not sufficiently contain the objects that man demands in order that man's life should not include either work, which is struggle against scarcity, or combat.

R. *Do you see a possible end to scarcity?*

Sartre Not at the moment.

R. *And what of the socialism we were talking about last time?*

Sartre It would not lead to the disappearance of scarcity. However, it is obvious that at that point ways of dealing with scarcity could be sought and found.

G. *When I study Heidegger with my students, they are often wary of him because of the position he took at one point in favor of Nazism in Germany, and they wonder if one can take a philosopher seriously who acts in such a way in the political sphere.*

Sartre In the case of Heidegger, I would not take him seriously; but I don't know if it is because of his character or because of his social action. And I don't know if one is the result of the other. I do not think that Heidegger's character, his way of entering into social action, trying not to compromise himself while at the same time giving certain assurances to the Nazis, justifies great confidence. It is not for his Nazism that I would reproach him, but rather for a lack of seriousness. His attitude showed a compliance with the regime in power in order to continue teaching his courses more than an awareness of any value that Nazism claimed to have.

P. *But why wouldn't you reproach him for his Nazism?*

Sartre I'm quite willing to reproach him for that; it wouldn't bother me in the least. [Laughter] You know I am not that fond of Heidegger. What I have said is simply the impression I had when I saw him. Heidegger's political ideas were of no importance, and he was doing philosophy almost in opposition to politics. But perhaps I am mistaken. In any case he was

wrong, very wrong to adhere to Nazism, even discreetly as he did. It is possible that Nazism was a philosophy or political theory in which he really believed. But I think not; and this neither brings me closer to nor separates me farther from his philosophy.

G. *Do you think that one can do philosophy without taking politics into account?*

Sartre In Descartes' time, perhaps, but today it is impossible to do philosophy without having a political attitude. Of course, this attitude will vary according to the philosophy; but it is impossible to avoid having one. Every philosopher is also a man and every man is political.

For a long time, philosophy was a kind of thought by which one tried to escape from the conditions of life, especially from those that created the obligation to be political. There was the man who was alive, who slept, who ate, who clothed himself, and this man was not taken into account by the philosopher. He studied other areas, from which politics was excluded. Today the concern of philosophers is the man who sleeps, eats, clothes himself, and so on. There is no other subject matter, and the philosopher is forced to have a political position, since politics develops at this level.

II

[We now proceed to the essays themselves. Oreste Pucciani points out to Sartre that there are essays on ontology, ethics, Freudianism and psychoanalysis, Marxism and politics, and aesthetics. He then sums up the essay of Ivan Soll (on Freud) and asks several questions raised by Soll.]

P. *Here is Soll's first point: Sartre uses above all Freud's first topology and fails to take into account the second. In so doing, he distorts the Freudian model into an ego, a censor, and an id.*

Sartre I didn't know that that was called a topology, but I think I tried to take everything into account.

P. *Soll's second point: Sartre's thought is a kind of strategy—the word is mine, not Soll's—designed to save the theory of consciousness in opposition to the Freudian theory of the unconscious. Sartre maintains that consciousness is equivalent to psychic reality. He puts forth a theory of consciousness that requires a theory of mind.*

Sartre I never maintained that consciousness was equivalent to psychic reality. Indeed, I consider that consciousness is a psychic reality; but I do not consider that all psychic reality can be defined by consciousness. One has only to look at what I have written on the subject. There are plenty of facts that appear to consciousness that are not themselves consciousness.

Consciousness is only consciousness *of* and the objects are outside consciousness and transcendent. Thus it is impossible to say that consciousness is the only reality.

P. *Third point: Sartre develops the theory of the pre-reflexive cogito in order to explain unconscious psychic processes. Thus consciousness becomes, according to Sartre, "the generic category of various psychic processes."*

Sartre To me that is meaningless. Consciousness is not a generic category.

P. *Fourth point: By consciousness, Sartre means any intentional psychic process. Judgment, desire, intention, emotion, and so forth are all conscious a priori; therefore there is no unconscious. That leaves the empirically known mental processes. How can they be explained? That would be the role of pre-reflexive consciousness or bad faith.*

Sartre It is certain that I explain a number of so-called unconscious states in that way.

P. *But, according to Soll, bad faith fails as a criterion for criticism of Freud, because Freud himself had abandoned the unconscious system in his second topology. And even in the first topology, the censor was not a lie to oneself, bad faith, conscious in order not to be conscious, the duper-duped, but simply duper or a duped pre-conscious. The Sartrean conditions for lying were fulfilled: it was a question of an interpersonal lie on an intrapsychic level.*

Sartre This comparison between Freud and me in this area seems to me absurd. I did not create the theory of bad faith in order to argue against Freud, nor in connection with the works of Freud, but because it appeared to me to be true. Moreover, to talk about the lie told by the conscious to the unconscious is simply to reduce the nature of the lie to someone who knows the truth and conceals it and someone who does not know the truth and from whom it is concealed. This ordinary, commonplace conception of the lie is only partly true. There are persons who know the truth and from whom one conceals it nevertheless, and there are persons who conceal a truth they know. At this point, there is no longer liar and lied-to, but each is liar and lied-to at the same time. This conception is much more complex but also much more true.

Soll abolishes consciousness as I tried to define it, that is, precisely the liar/lied-to at the same time, which is to say, consciousness as relation to self. He turns this relation into a relation to others, and it is consequently impossible to keep it within consciousness.

P. *I noticed that none of the articles here seems to take into account the circuit of selfness, although this characterizes the consciousness that needs to be a consciousness in order to be consciousness, and which can then constitute itself as an ego. It is starting from the circuit of fundamental selfness that consciousness becomes a structure of being.*

Sartre Of course.

P. *Soll next attacks the pre-reflexive cogito: Sartre's chief argument is a true reductio ad absurdum. The notion that an unconscious consciousness would be absurd fails in face of the fact that such a consciousness exists. I am conscious of this table, but I am simultaneously unconscious of other objects that are not in my visual field. Here is a consciousness that is both conscious and unconscious, unless we specify that it concerns the same object. There are therefore unconscious intentional processes, and the thesis of the unconscious is not absurd. It is not contradictory to say that one desires something without being conscious of desiring.*

Sartre But the example he provides is absurd. I am indeed unconscious at this moment of the St. Lazare Station, which is not in my perceptual field. But if I am unconscious of it, it is not because of consciousness, it is because of my position in the perceptual field and in the existential field. I may be conscious of it tomorrow, which does not mean that it is unconscious and acting at this moment. I am not in relation to the St. Lazare Station. If I am, I am in some way conscious of it. If I am waiting for the moment when a taxi will drive me there, I am conscious of the St. Lazare Station. But in the meantime, there is no relation to it and therefore I am not conscious of the St. Lazare Station.

P. *Soll continues. Sartre demonstrates his theory of the pre-reflexive cogito by an example, that of counting cigarettes. But this example is valid only in certain cases, whereas it must be shown to hold in all cases. Moreover, the example is badly formulated: Sartre gives it in the present tense, whereas it should have been done in the past tense, since it involves a memory. Therefore, there is no need here either for the pre-reflexive cogito or for a positional self-consciousness.*

Sartre I don't remember the example of the cigarettes . . .

P. *It is in L'Etre et le Néant where, taking twelve cigarettes, you explain how you have arrived at that number. Soll claims that you should have said, "I was counting cigarettes" and not "I am counting cigarettes," which falsifies the whole example.*

Sartre Indeed. It is now that I count them. Obviously, I should not have said, "I have arrived at twelve" but instead, "For the moment, I have counted four and there remains a group to be counted." [Laughter]

P. *Next, Soll wonders if there are certain cases in which a non-positional self-consciousness would be required. In La Transcendance de l'ego, the object of reflexive consciousness contains the "I." The "I" appears in every memory and is the universal possibility of reflecting in memory. Can one truly say that the object of reflexive consciousness contains the "I"?*

Sartre Not necessarily. Reflexive consciousness contains the "I" but outside itself; it manifests the "I."

P. *Then where does the "I" come from?*

Sartre That's just the point: it is not there. There must be some confusion here between reflected consciousness and reflexive consciousness.

P. *Soll goes on: Why must the memory depend on previous self-consciousness? Cannot a simple awareness of an object leave memory traces? A non-thetic consciousness of self is not necessary to explain a non-thetic memory; if the "I" that is attached to the memory is not present in original consciousness, one cannot explain how the "I" enters the memory. The pre-reflexive cogito does not shed any light on the mechanism of memory.*

 How can a non-reflexive consciousness explain the fact of counting cigarettes—I would add, in the past—whereas I was counting them without reflecting and my reply was a kind of memory? Haven't we an unconscious, unrepressed process here, as Freud would call it, a pre-conscious or latent process which can easily be brought to consciousness? This would avoid the Sartrean paradox of a conscious memory before the act of remembering. According to Freud, one can become conscious of something for the first time in memory. His terminology is more natural.

Sartre I am astonished. That is not what I said. One can criticize what I said, but that is not what I said. For example, there is no ego in consciousness any more than there is an "I." In *L'Etre et le Néant* I firmly insisted on the fact that the "I" and the ego were part of the system of objects, the system of things that are outside consciousness.

 [Oreste Pucciani next summarizes the article "Mechanism, Intentionality, and Unconscious" by Lee Brown and Alan Hausman, an article that attempts a synthesis of the theories of Sartre and of Freud, by sometimes forcing Freud's thought in a Sartrean direction. The discussion concerns especially the following points.]

P. *The two positions are in agreement in that the patient comes to know what he did not know, and one could even make Freud admit, although in a weak sense, that the patient knew it from the beginning.*

Sartre It is Freud who must decide on that, but I don't think that for him the patient knew from the start; he knew it in some way, but he did not know it consciously. Whereas, indeed, in my study of bad faith one could say that he knew it from the beginning. The comparison is forced.

P. *For the authors of the article, where Sartre speaks of a distinction between knowledge and consciousness, Freud speaks of a distinction between conscious and unconscious. It is a question of terminology.*

Sartre That is rather simple and facile. Yet it is true that, for me, the idea of knowledge is given at the start, that it is a work performed on data

already existing for consciousness. There is a kind of original vision of things that can be made known by working upon this content. However, I do not see what could be said similarly for Freud.

P. *The authors conclude, after a four-point argument, that Freud and Sartre leave us with the dilemma of a psyche that both knows and does not know its symptoms.*

Sartre Yes, but that is because in this case knowledge does not have the same meaning at the beginning as at the end. The psyche knowing its symptoms means one thing and the psyche not knowing its symptoms means something else. At the beginning, we have a kind of non-thetic, undeveloped, non-affirmative knowledge and we can, by certain methods, arrive at an affirmative, definite knowledge with distinctions, judgments, and so forth. These two kinds of knowledge have almost no relation to each other. It is going from the former to the latter that requires the greatest effort, both for the analyst and, very simply, for the individual who thinks.

You were asking me a moment ago how an idea comes to me. Well, it comes in the same way: at first one has a vague, completely unasserted idea and then one attempts to determine it, to create functions. At this point one attains an awareness that is already beyond the pure consciousness-feeling that one had in the beginning. At first one has something that I would call not knowledge but intuition, and in a sense knowledge is radically different from what is given by this original intuition. It clarifies things that were not clarified; it amplifies others; it tones down some that were more apparent in the beginning. It retains a certain relation to the original intuition, but it is something else. This is what has been misunderstood in this article, I believe.

G. *Professor Giorgi attempts to show that there exists in your work a systematic psychology, a metapsychology that radicalizes our understanding of psychology because it objectifies the psychic without transforming it into a thing. He wonders if the psychic could be characterized as "being-in-tension" and if it would thus form a third category situated between the for-itself and the in-itself.*

Sartre That is more or less what I did, but I did not consider it of major importance. It is true that, on the whole, one can compare a feeling to the in-itself, but obviously it is something other than the in-itself of a table or of a chair.

G. *Going on to the problem of method, Giorgi distinguishes three approaches: first, the phenomenology of Husserl that would be a complete reduction (progressive method); then an empirical psychology in which there would be no reduction at all (regressive method); finally, your phenomenological psychology that would be partly a reduction and partly empirical, thus constituting a progressive-regressive method.*

Sartre That is a bit oversimplified, but I accept the idea of a progressive-regressive method.

G. *For a phenomenological psychology?*

Sartre Yes, and for all human endeavors. I talked about the progressive-regressive method in *Question de méthode*, but perhaps that has nothing in common with this except the terms. I do not think my psychology is partly empirical in the sense he gives the word.

G. *Is your existential psychoanalysis a psychology?*

Sartre No. Quite frankly, I do not believe in the existence of psychology. I have not done it and I do not believe it exists. Even the little book that I wrote on the emotions is not psychology, because in it I am forced to return to the nature of consciousness to explain the simplest emotion. I consider that psychology does not exist except in the sense of the empirical psychology that one does in novels, for example, when we see a future assassin thinking about killing his victim an hour before he puts him to death.

P. *To go on to another problem, Professor [Risieri] Frondizi considers your ethical work to be above all negative, and feels that one ends up falling into moral indifference. It is a fact that freedom is a necessary but not sufficient condition for a moral human life of significance and creativity; the Sartrean man goes drifting off on the stream of freedom. How, asks Frondizi, can one avoid this moral indifference?*

Sartre I have never had an ethics of indifference. That is not what makes ethics difficult, but rather the concrete, political problems that have to be solved. As I already said in *Saint Genet*, I think that at present we are not in a position . . . society and knowledge are not such that we can rebuild an ethics that would have the same kind of validity as the one we have gone beyond. For example, we are unable to formulate an ethics on the Kantian level that would have the same validity as Kantian ethics. It cannot be done because the moral categories depend essentially on the structures of the society in which we live, and these structures are neither simple enough nor complex enough for us to create moral concepts. We are in a period without ethics, or, if you like, there are ethical theories but they are obsolete or they depend on each other.

R. *Isn't it impossible to live morally today?*

Sartre Yes. It has not always been impossible, will not always be, but it is today. Whereas a "morale" is necessary for man and such is still possible, there are periods in which it is unrealizable, because too many contradictions exist and ideas are too confused. We are in one of those periods.

R. *What I would reproach Frondizi for is that, insofar as your writings are concerned, he stopped in 1949.*

Sartre But they all stop too soon. I think that a study of my philosophical thought should follow its evolution. But no, they don't do it. It's odd.

[Next, Oreste Pucciani gives a rather lengthy summary of Hazel Barnes' article on Sartrean materialism.]

P. *For Hazel Barnes, your materialism, the materialism of the* Critique, *implicitly is or assumes a metaphysics of Nature. You were stopped by that question, but you yourself have said that it was not your affair. However, you have to explain the problem of man in his relation to Nature or risk exposing yourself to the same criticisms that you level against the Marxists. Barnes concludes with the following conjecture: If the expression "dialectical materialism" had not been adopted by a purely Marxist context, shouldn't we have to qualify Sartrean materialism precisely as "dialectical materialism"?*

Sartre To attempt to do so leaves me a little cold.

P. *Barnes considers that you assume a materialism without providing the metaphysical grounds for it. She also cites a passage of the* Critique *where you say: "We shall accept the idea that man is one material being among others and that as such he does not enjoy any privileged status. We shall not refuse a priori that a concrete dialectic of Nature may one day disclose itself."*

Sartre Yes, but by that I mean, if it were disclosed, the dialectic of Nature would go from the strictly physical object to the animal and to man, thereby indicating the material sources of what has thus far been irreducible in man: for example, consciousness. A dialectic of Nature would have to account for that; but since this dialectic does not exist and since I do not intend to do it, the problem remains unchanged. If it exists, we will have accounted for the material aspect of the conscious phenomenon, the material aspect that is behind consciousness.

P. *Barnes takes four statements from your philosophy:*

"Man loses himself as man in order that God may be born."

"Man loses himself so that the human thing may exist."

"The for-itself is the in-itself losing itself as in-itself in order to find itself as consciousness."

"All this happens as if the for-itself has a passion to lose itself so that the affirmation 'world' might come to the in-itself."

Does not the in-itself seem to have produced something, and do not these statements, especially the third and the fourth, have metaphysical implications? Does not the analysis of motion in L'Etre et le Néant *as "pure disorder of Being," "the malady of Being," "the clue to the alteration of the for-itself," reflect a metaphysics?*

Sartre In all of those cases, yes. But it is not up to me to deal with it. I don't wish to deal with it. I do not have the necessary knowledge; I am not competent to do it. I can simply point out the various elements and the questions that would be raised.

P. *To conclude, Barnes raises four questions. Here is the first: What is the nature of the in-itself or of matter?*

Sartre Matter is not exclusively the in-itself precisely because, if one is a materialist, one considers that consciousness itself is part of matter. Therefore it is not the in-itself. Both the for-itself and the in-itself must be included in materialism.

P. *In the* Critique, *consciousness belongs to matter . . .*

Sartre Exactly, but in the question that was asked it does not.

P. *What must be the being of matter if this being is capable of giving rise to a being that nihilates it, that is free of it, but without ceasing to be matter?*

Sartre That is true in a sense, but not quite in those terms.

P. *Sartre admits that Nature could conceal a kind of dialectic. Then how can the in-itself be simple plenitude?*

Sartre But Nature is not exclusively the in-itself. A plant that is growing is no longer altogether in-itself. It is more complex. It is alive.

P. *To what extent is it necessary to identify in-itself and matter?*

Sartre The in-itself is one kind of matter. But a man cannot be reduced to the in-itself precisely because he is conscious, and consciousness has been defined as a for-itself. That seems clear to me.

R. *Barnes also asks what the relations are between consciousness and the brain and reasoning.*

Sartre That is a problem I studied for several years at the time of *L'Etre et le Néant* and afterward. I tried to deal with it, but I did not finish it. I was not interested in doing a study on the relations of consciousness and the brain, because I first wanted to define consciousness. That is enough for one man's lifetime. I wished to define it as it presents itself to us, for you, for me. In so doing, I wanted to posit a definite object which others would then have to try to explain within a materialist system, that is, to study its relation to the brain.

More generally, what I have noticed in the articles you are summarizing is that there is one thing the authors do not recognize: one chooses a kind of work and one does it. One can do certain things somewhat alongside, but one will not go into domains that are not among those chosen at the outset. One can try to show how they are related to the domain one is studying, but one does not study them in themselves.

R. *Indeed, there are quite a few articles that lose sight of the overall view of your work, and they represent the work of specialists. Someone who does psychology, for example, would like to draw you into his domain and will find inadequacies that concern him rather than you.*

P. *In my own contribution I emphasize that, in your philosophy, it has always been a question of the priority of problems.*

Sartre Absolutely.

P. *Very often in reading these critical essays, I have the impression that they are telling you it would have been better had you begun with the "Flaubert."*

Sartre That's childish. One does not begin by what one wishes.

G. *In his essay on aesthetics, Professor Tenney raises a question that I find interesting: for Sartre, the ontology of freedom seems to have been replaced by a philosophy of* engagement *that places heavy sociopolitical obligations on the artist. Does the artist thereby lose his privilege of free creation?*

Sartre I do not consider that there has been such a shift from freedom to *engagement*. I still speak of freedom, and the *engagement*, if there is one, is the result of freedom. On this issue I have not changed since *L'Etre et le Néant*. Consequently, I do not understand the question.

G. *Tenney is speaking of socialist art or revolutionary art as it is practiced in socialist countries.*

Sartre I never believed in that kind of art. For example, I do not at all believe in literature as it is viewed by the writers in Moscow. I hope the author does not see anything like that in my aesthetics, for he would be very much mistaken.

G. *Tenney would like to know if, in general, sociopolitical responsibilities do not infringe upon the freedom of the artist.*

Sartre No. According to my view, responsibility necessarily arises from freedom. I can conceive of a responsibility only in someone who is free. If he is not, if he is constrained or forced to accept a responsibility, that responsibility is worthless. The only responsibility that counts is the one that is freely assumed. Therefore, I do not see what is interesting in his question. He begins by thinking that I have changed—and that is his point of view, not mine—and he asks me if, starting from this change, I can say whether *engagement* infringes on freedom. He is the one who is making this distinction, not I. Therefore, I cannot answer. I maintain my principles, and in any case my aesthetics, if there is one, stems from the idea of freedom and not from the idea of *engagement*, which is a by-product of freedom, a necessary by-product . . .

P. *In his article, Tenney says, by the way, that the ontology of Sartre has changed.*

Sartre No, it has not changed. *L'Etre et le Néant* deals with ontology, not the *Critique de la raison dialectique*.

P. *He speaks of an ontology that has been sapped, thinned out, and is no longer holding together because its back has been broken.*

Sartre That must be my second ontology. I don't believe that I broke the back of the first. [Laughter]

P. *And then he discusses Sartrean aesthetics without mentioning either the analogon or the real center of irrealization.*

Sartre Then what does he talk about?

G. *He lists six elements that compose your aesthetics. [A brief summary of the article follows.]*

Sartre's aesthetics must be measured against philosophies that are productive and comprehensive, not reductive and niggling.

The Sartrean aesthetic tends to repudiate the traditional aesthetics of representative objects, that is, the imitation of Nature in classical, romantic, and realistic works of art. It also rejects most official or "museum" art.

The Sartrean aesthetic tends to embrace an art that is open, not closed; dynamic, not static; suggestive, not fixed.

But presumably the Sartrean aesthetic has never been formalized. It must be inferred from statements scattered throughout his works, as well as from certain features of his total philosophy.

The chief components of an aesthetics drawn from Sartre's total philosophy would appear to be:

1. The situation, *that is, the place, historical time, environmental instrumentalities, fellow humans, and ultimate debility that must be expected and surpassed if I am to create art.*

2. The project, *that is, my choice of being and my leap ahead into the realm of possibles. Art always begins as a project or in a project.*

3. The use of bracketing, *the Husserlian abstention. This is especially relevant to aesthetics, because in order to enter the realm of art I must eliminate the natural view of things. Phenomenological brackets make possible the detachment and autonomy of imagined objects.*

4. The imagined object, *which derives from both the plenum of being and the nothingness of images. It is in these terms that I must define and create a work of art.*

5. The freedom *to transcend situations and to activate projects that makes possible all my creative work—notably my work in the arts.*

6. The beautiful, *which is the chief value of art. As the* in-itself-for-itself, *beauty is a golden impossibility, but art can come close to realizing it in* imagined objects, *because these extend elements of the real into the imaginary. The "correspondences" between the objective and the subjective provide* symbols, *by means of which I can place the beauty of a work of art in a bracketed totality.*

Sartre Those ideas are not mine. I think that I would write my aesthetics better than he. [Laughter]

G. *I think that is exactly what he would like to provoke.*

P. *Tenney goes on to say: It is sad that Sartre seems to be losing interest in aesthetics.*

Sartre But I am not losing interest in it. That is the third thing he has decided on his own.

R. *However, this article, like many others, is helpful inasmuch as it is characteristic of the things that are said about you and it functions as a catalogue of commonly accepted ideas. Since we are going on to Merleau-Ponty, I might interject that perhaps many of these authors are doing pseudo-Sartrism.*

Sartre That's right.

P. *Monika Langer's article on Sartre and Merleau-Ponty develops the following thesis: Merleau-Ponty, in attacking the philosophy of Sartre, actually turned it into a pseudo-Sartrism, as Simone de Beauvoir has shown. Yet, had he examined Sartre's philosophy in the light of his own and especially of the notion of "interworld" (which he calls "flesh" and which is situated between pure transcendence and inert matter), Merleau-Ponty would have discovered a genuine Sartrism, in perfect conformity with his own philosophy, for, at least from Langer's point of view, there is a fundamental agreement between the two positions. The positive significance of the flesh for Sartre appears in his analyses of sexuality. There would thus be an in-itself, an interworld (that is, an intersubjectivity), and a for-itself. Can one consider that there is an interworld in your philosophy?*

Sartre I admit neither that I have the same philosophy as Merleau-Ponty nor that there is this element of interworld.

G. *Is it a question of a mere misunderstanding, or is there a fundamental incompatibility between your philosophy and that of Merleau-Ponty?*

Sartre I believe that there is a fundamental incompatibility, because behind his analyses Merleau-Ponty is always referring to a kind of being for which he invokes Heidegger and which I consider to be absolutely invalid. The entire ontology that emerges from the philosophy of Merleau-Ponty is distinct from mine. It is much more a continuum than mine. I am not much of a continuist; the in-itself, the for-itself, and the intermediary forms that we talked about a moment ago—that is enough for me. For Merleau-Ponty, there is a relation to being that is very different, a relation in the very depths of oneself. I spoke about that in my article "Merleau-Ponty vivant."

R. *There are two versions of that article. Why did you abandon the first?*

Sartre Because it was neither well thought out nor well written. Simone de Beauvoir urged me to abandon it. So I said the same thing again, but a little better.

R. *Was this difference between you and Merleau-Ponty obvious from the beginning of your relationship?*

Sartre I think we always felt it. We were starting from the same philosophy, namely, Husserl and Heidegger; but he did not draw the same

conclusions from it that I did. It is impossible for me to get my bearings in the philosophy of perception. That is something completely different.

P. *Is not the major difference between the two of you that concern for ontology which we talked about last time?*

Sartre Yes. Merleau-Ponty does not do ontology, but his reflections lead to an obscure ontology, a little like that of Heidegger.

P. *I would like to come back to a question that has already been asked. How did you come to decide that the problem of ontology was fundamental, since that is rather unusual among twentieth-century thinkers?*

Sartre In spite of everything, I think it grew out of the few ideas on realism that I had in mind, although not very clearly, when I went to Berlin and read Husserl. I spent a year reading Husserl and wrote that article on the transcendence of the ego in which I indicated rather emphatically the necessity of an ontology. Yes, it started from the distinction between some vague, personal ideas—to which I have always remained faithful, as a matter of fact—and the thought of Husserl.

R. *To come back to Monika Langer, she says that for you, "consciousness is engulfed in a body which is itself engulfed in a world."*

Sartre That is beautiful; but consciousness is not engulfed in a body nor is the body engulfed in the world.

R. *She also says: "human being in the world and of the world . . ."*

Sartre Human being is of the world for the other but not for himself. He is in the world, yes, and he can also withdraw at a certain moment from his place, from his situation, although his only true thoughts are his thoughts in situation. That is baroque!

R. *Langer specifically says that the separation of consciousness does not necessarily imply hostility.*

Sartre In any case, the separation exists, and I do not see any reason to speak of intersubjectivity once subjectivities are separated. Intersubjectivity assumes a communion that almost reaches a kind of identification, in any case a unity. It designates a subjectivity that is made up of all subjectivities and it thus assumes each subjectivity in relation to the others—at once separated in the same way and united in another. I see the separation but I do not see the union.

[Here Susan Gruenheck summarizes Charles Scott's article comparing Sartre and Heidegger. Sartre, who seems to have had difficulty following, comments simply.]

Sartre Obviously one can compare anyone to anyone. One can compare me to Heidegger, although I think that we are too far apart for a comparison to be made.

G. *Would you accept the definition of ontology proposed by Scott: Ontology is a descriptive interpretation of things that enables us to see at a distance the conditions necessary for human fulfillment.*

Sartre No, I would dissociate myself from all that. Ontology is the study of the various forms of being—nothing else.

G. *Is it done for a particular purpose?*

Sartre It is for the purpose of defining, of knowing what being is. It is obviously for the purpose of reconstituting the edifice of knowledge by basing it on the knowledge of being.

R. *The word* fulfillment *is not exactly part of your vocabulary.*

P. *This author sees ontology as a kind of moral edification; ontology should give us a rule of life and help us to live better . . .*

R. *To overcome scarcity through ontology, that wouldn't be bad!*

Sartre That is incredible. If ontology were able to show that man would be better off committing suicide, that would not be giving us a moral viewpoint: we would have to take a revolver and shoot ourselves in the head. Ontology is not done so that we can use it for a time and then move on to something else.

R. *Inasmuch as time is running out, we should ask Oreste Pucciani to tell us about his own essay.*

Sartre I was just about to ask him.

P. *I have concentrated so much on these articles that I have not re-read mine and I have forgotten much of it. However, my thesis is that, from an early age, Flaubert represented for you the problem of art.*

> *Oreste Pucciani attempts to demonstrate the interaction of the enterprise of Sartre and that of Flaubert, an interaction that in 1947 took the form of a fundamental dilemma in Sartre of art, thought, and action. This dilemma is resolved in Sartre's work on Flaubert,* L'Idiot de la famille. *The "engagement" of the artist, which was at issue in 1947, becomes the assumption of total risk of one's self as a "universal singular" in order to create "permanent, real, stable centers of irrealization," material objects (such as* Madame Bovary) *which are analoga of reality itself. These works are grounded in an engagement that is ethico-aesthetic. "Eternal Art" is a myth and an ideology, the truth of which is not the essence but the making of a work of art. Thus the method of ontological inquiry once more permits Sartre to state a human reality: in the sick society of nineteenth-century France, the making of art became the enterprise of "Neurosis Art" by a "worker" persuaded that he must be either ill or mad to create in bourgeois capitalist society. It is not difficult to see that Sartre is explaining his work to himself as well as his own evolution from literature to philosophy.*

> *I myself floundered in the unreal for years and I was struck by the fact that, at a very young age and despite your neurosis, you grasped the problem*

of the real. From then on, there was a kind of inoculation by Flaubert that had a decided effect on your own acculturation . . .

Sartre It was not Flaubert that provided my acculturation, because at the time I read many things—Corneille, et cetera. Culture was not especially Flaubert, who, on the contrary, was an aborted attempt at reading, since ultimately I did not read him all the way through to the end. I stumbled onto a book that was too adult for me and I didn't understand it very well.

R. *In this connection, to what extent do the references to Flaubert you make in* Les Mots *derive from your preoccupation with Flaubert during the fifties and sixties?*

Sartre Certainly I was writing the "Flaubert" at that time, but on the other hand, everything I said on the subject in *Les Mots* is true. I had those memories for a long time, but perhaps I might not have talked about them if I had not written the "Flaubert." They were certainly connected. There certainly was a link between the two.

P. *I talked about your grandfather in relation to Flaubert. You yourself have said that he had "socialized your pen" and that that pen had fallen from your hand. I saw in him a kind of bearer of the nineteenth-century culture that had affected you.*

Sartre It was certainly my grandfather who gave me my idea of culture. Not the idea that I have now, but the one I had for a long time, from the age of six onward.

R. *You seem also to have reacted against the culture that he gave you, against visits to museums, speeches at awards ceremonies, and so on. Yet didn't he influence you regarding the image and the relation between the image and the word? He himself was one of the pioneers of the audiovisual method.*

Sartre No, that was over my head.

P. *In the course of your studies, there were two options: literary positivism and idealism. I took your former professor, Henri Delacroix, as an example of idealist immanentism and Gustave Lanson as an example of positivism.*

Sartre But Lanson was only the director of the Ecole Normale. I didn't take any courses from him.

P. *But hadn't everyone read his history of literature?*

Sartre Of course.

[The interview is interrupted here by the arrival of Simone de Beauvoir, who, however, leaves in a few moments.]

P. *In the* Critique de la raison dialectique *you define totalities and you say that, all the same, they require an imaginary status. Then you go on to practical totalities. Do these practical totalities also require an imaginary status?*

Sartre Not necessarily. For example, an object, a machine that represents a totalization of the product it makes or the action it performs, is not imaginary. It is a rational totalization.

P. *My understanding was that they both had the same status, required the same status in the social world. There are objects such as coffee mills that, with the passage of time, become aesthetic objects, analoga of themselves. How can they do this if there is no imaginary status?*

Sartre They become imaginary at that moment, but they are then no longer practical totalities. If they have an aesthetic quality from the start—for example, eighteenth-century ships had this quality—there may be a relation to the imaginary, but it exists above all for us.

P. *Is there not in your philosophy a constant crossfire between the realizing thesis and the irrealizing thesis?*

Sartre Yes, always. Our perception includes the imaginary.

P. *In L'Imaginaire, however, these two theses are mutually exclusive.*

Sartre Yes, but that was too radical. In the "Flaubert" I have tried to point out that they are often combined, and I have there outlined another theory of the imaginary. In this sense, it is possible that certain practical totalities include imaginary elements. I have not reflected on that, but it is possible.

G. *One problem that is raised several times in the articles is that of self-knowledge. Do you have the impression that you know yourself?*

Sartre Yes and no. Yes, in the sense that, through consciousness, I can grasp a certain type of psyche or elements of the psyche that are in direct relation with myself. For example, I know my feelings. If I love or detest a person, I know it. If I love or detest many, I can draw a line: those I love, those I detest; I have such and such a type of affection, such and such a type of animosity. I can therefore describe myself from this point of view. I can truly know myself in my desires; I feel them immediately.

There is a whole psychology which is the relation to the Other. One's feelings and actions, the number of recurrences of an action or a feeling—it is the Other who knows them. I cannot grasp this psychology myself. Someone tells me "You are like that," enabling me to realize that it may be true. But it is the Other who tells me. One can only have complete self-knowledge starting from that. If the Other does not tell you what you are for him, you cannot attain self-knowledge.

On the other hand, each person is made aware by others of such and such a relation to oneself or with others. He can thus learn from the world what he is, not in his consciousness or at least not through his consciousness, but through what others think. Thus there is a whole psychology pertaining to oneself that comes from the Other. I feel quite clearly what I feel myself and what I feel according to what others tell me, according to those

who I thought were right. One would not know oneself without the Other. For example, anger, irascibility—these are things I can know only if someone describes them to me.

Through myself, I know that a number of times I have been angry at those who contradicted me, but that signifies nothing. I don't know if I am irascible or not. But someone says: "You were really angry under certain circumstances, although the person's objections were facile and not malicious, and you were angry at other times under similar circumstances. Therefore you are irascible." I discover that, I learn that through the Other. Perhaps I will be sorry about it. It is clearly part of myself, but part of myself in relation to others. Thus there are: (1) an easy psychology of oneself that one possesses as soon as one reflects a little on oneself; (2) another, deeper psychology possessed by people who think to the depths of themselves, because they are in circumstances such that the depths are revealed or because they think about themselves that far; and then (3) the psychology of relations to others, relations that one cannot define without what is given by the Other. As a matter of fact, these three kinds of self-knowledge are not completely in accordance with each other. One always remains a little ignorant of oneself concerning the knowledge that others give us. If someone says: "You have an inquiring mind, you are ambitious, et cetera," one accepts that if the examples are specific, but often one does not unravel it. This is the kind of knowledge that one would find if one were to read a book about oneself once one is dead. It is knowledge that one does not control and it does not correspond to the other two categories, the ordinary self-knowledge that everyone has and the deeper self-knowledge that some have.

R. *These "others" whom you allude to, are these not the critics, the people who write about you?*

Sartre No, they are not. [Laughter]

R. *I think that in general—and today's example proves it—you learn rather little from others about your work.*

Sartre Thus far, rather little. When I was seventeen or eighteen I was always told that one learned a great deal from critics. So I approached them with positive ideas about criticism, with disciplined, sensible ideas. I read the critics, saying to myself, "What are they going to teach me?" But they taught me nothing.

R. *Even from the standpoint of you as "Other"?*

Sartre Yes, because most of the time the critical articles about one's work in the course of a lifetime are not very carefully done.

R. *Aren't there any critical works on you that you found notable?*

Sartre There are many that I have not read. From the ones I know, I never learned very much. However, sometimes, let us say in one one-hundredth of what I read, the critics contribute an idea.

R. *And in those cases, what is it?*

Sartre It is a relation between two passages in a work, a comparison between two works that shows me something they have in common, and so on. It strikes me and I say, "Well, that's true." But that doesn't go very far.

R. *Aren't there confrontations, other ideas that lead you to revise some of your own ideas?*

Sartre I have never been obliged to revise my ideas. I am perhaps an obstinate philosopher, but it has never happened. I read, I saw that indeed there were things to be said, and then I continued to do what I was doing.

R. *Has your thought therefore developed relatively autonomously?*

Sartre In relation to the thought of critical writers, yes. If friends point out something to me, it may have more importance. Among the critics, the best I encountered were those who said what I meant.

R. *Are you irritated at seeing your thought often simplified?*

Sartre No. Some people write those things, that's all.

R. *You have said yourself that "mediators" would be necessary for the "Flaubert." What do you foresee as a possible criticism of your work?*

Sartre To begin with, my work would have to be read. [Laughter] Many critics stop along the way.

R. *Read the whole of your work?*

Sartre Indeed, yes. I do not ask that of the ordinary reader, but only of specialized critics: Let them take the time. Then, the work has to be presented in order to see if a single point of view extends over a whole lifetime or changes midway, to try to explain the developments, the breaks, to attempt to find my original choice, which is the most difficult part: What did I choose to be by writing such and such a work? Why did I choose to write?

R. *The critic may not put himself in your place as much as you would like and thus would not completely do justice to you.*

Sartre In spite of all that, let him do something of what I did on Flaubert. I do not claim to have done justice to him entirely, but I hope to have found some directions, some themes.

R. *You would like a work to be done on you like the one you did on Flaubert?*

Sartre Yes, that's right. That seems to me to be the meaning of criticism. Here are books; a man wrote them. What does that mean? What is that man? What are these books? I find the aesthetic point of view so variable that it is this aspect that seems interesting to me.

R. *Do you attach great importance to documentation?*

Sartre Yes. I can positively affirm that because I know what had to be done for the "Flaubert."

P. *However, there is relatively little documentation on you. If one compares what you have put in* Les Mots *with what is known about the childhood of Flaubert, there is a huge difference.*

Sartre That is due to the time in which we live. Today fewer details are given about people, much less is known about them than in the preceding century, precisely because the problems of sexuality, the problems of life, become individual and disappear. For example, what is known about Solzhenitsyn are things that ultimately concern all of Russia. We know that he was exiled in a camp. Immediately when we reflect on the camps, we recall what they were, and so on. But, as for knowing whether he likes coffee or what is the nature of his sexuality—mystery. Perhaps certain elements can be defined on the basis of his books, but someone will have to do it.

Indeed, none of those things really is hidden. I think that my taste for coffee and my sexuality are in my books. They have only to be rediscovered and it is up to the critics to find them. In other words, the critics should, on the basis of the books and nothing but the books, together with the correspondence, establish what was the person who wrote these books, reestablish the trends, see the doctrines to which the author subscribed . . .

R. *Will there be much correspondence in your case?*

Sartre There won't be any, or very little.

R. *What you want, then, is a biography?*

Sartre Yes, a kind of biography that can be done only with documents. A literary biography, that is, the man with his tastes, his principles, his literary aesthetics . . . rediscover all those things in him, from his books and in him. That, I believe, is the work criticism should do.

R. *Curiously enough, none of the articles we have before us mentions the teaching of philosophy, the way your philosophy could be taught. How did you teach philosophy?*

Sartre That was a long time ago . . .

R. *The problem is especially acute today. What would you advise?*

Sartre That is a different question.

R. *But what was your method?*

Sartre I had to cover the philosophers included in the program and I did not teach strictly contemporary philosophers. And if I had ideas of my own . . .

R. *According to the French system, you were the only philosopher in your lycée?*

Sartre Yes.

R. *Therefore, there was no possibility for discussion with other philosophers?*

Sartre No. I gave professorial lectures, lectures *ex cathedra*, as they say; but I interrupted myself all the time to ask questions or to answer the questions I was asked. I thought that teaching consisted not in making an adult speak in front of young people but in having discussions with them starting from concrete problems. When they said, "This guy is an idiot: he

says this, but I have experienced something else," I had to explain to them that one could conceive of the matter differently.

R. *Did you succeed in establishing the beginnings of reciprocity, since it is never completely reciprocal?*

Sartre The reciprocity was rather strong. I should add that I was involved in other activities with my pupils, even boxing, and that helped. I also spent a lot of time drawing out the ideas they had in their heads.

R. *Wasn't that method of teaching considered a little scandalous at the time?*

Sartre Yes. I got reactions from colleagues, from the censor, from all those people. Moreover, I allowed my pupils to smoke in class, which met with great disapproval.

R. *What do you think of the teaching of philosophy today?*

Sartre As you know, in the proposed reform bill, philosophy is no longer required on the secondary school level.

R. *Did you know that in the United States philosophy is not taught in secondary school but only in college?*

Sartre In my opinion, it should be the other way around. I think, as someone has suggested, that a little philosophy could be taught up to the junior year of high school, enough to allow an understanding of the authors: for example, three hours a week.

To me, philosophy is everything. It is the way one lives. One lives as a philosopher. I live as a philosopher. That does not mean that I live as a good philosopher, but that my perceptions are philosophical perceptions, even when I look at that lamp or when I look at you. Consequently, it is a way of living and I think it should be taught as soon as possible, in simple language.

R. *That is the conclusion we needed. Thank you for giving us this interview.*

PART TWO

DESCRIPTIVE AND CRITICAL ESSAYS ON THE PHILOSOPHY OF JEAN-PAUL SARTRE

1

R. D. Cumming
TO UNDERSTAND A MAN

A true philosopher whose philosophy develops feels no need to disavow his preceding writings.

Jean-Paul Sartre

THE LAST PHILOSOPHER

SARTRE is often rebuked for making himself difficult to understand. The usual complaints are that he is cumbersome and diffuse. But there is a much more fundamental way in which he has made understanding his philosophy difficult, without his ever explaining why. It is not that he is deliberately evasive. It is rather as if the difficulty were something of which he himself is unaware. This difficulty is that Sartre has never made very clear what his conception of philosophy is which would account for what he has actually written.

Now one may well prefer to have a philosopher write philosophy than risk his virility by engaging in masturbatory expositions of his conception of philosophy. Yet Sartre is a special case. An explicit conception seems needed if he is to measure up to his existentialist norm of lucid and total responsibility, whereby "a man exists only to the extent he realizes himself; he is nothing other than the whole of his acts," which means, if he is a writer, "the totality of his writings." [1]

Furthermore many of these writings in Sartre's case are taken up with why various writers write what they write—Baudelaire, Genet, Mallarmé. Indeed by far the longest and most ambitious of Sartre's undertakings is his study of Flaubert in the three-volume *L'Idiot de la famille.* This study has begun with the question of how one is to go about understanding a man, has so far focused on the development of Flaubert's conception of litera- ture, and has come to a conclusion—after 2,783 pages—with Flaubert's assertion "Je suis écrivain," and with the question, "How is this to be un- derstood?" The question, Sartre explains, is to be answered with reference both to Flaubert's conception of literature, which Sartre has already ex-

pounded, and to Flaubert's actual writings. Sartre promises that in a fourth volume he will complete this answer by "re-reading *Madame Bovary*."[2]

When, however, one tries to understand Sartre as a philosopher by reading his actual writings, it is without the assistance of any comparable exposition of his conception of philosophy. In Sartre's autobiographical *The Words,* he has done much more briefly for himself what he has done for other writers; he has explained why he became a writer and how his conception of literature developed. But he has supplied no parallel explanation of why he became a philosopher and of how his conception of philosophy developed. Even "parallel" is a risky suggestion, for Sartre has had remarkably little to say about the relation between the two genres, considering that the profligacy with which he has resorted to both is without significant precedent in the history of philosophy. Even if we postpone this question of the relation between his philosophy and his literary works and linger with his conception of philosophy itself, we still need assistance, since Sartre's conception is obviously not traditional: to switch the use to which we can put the evidence already cited, Sartre's preoccupation with why writers write what they write has not been so prominent a theme in the case of any previous philosopher.

Sartre has had more to say about the relation between philosophy and the social sciences. An interviewer once challenged Sartre, "You are sometimes identified as the last philosopher, which is one way of saying that philosophy is dead." In his reply Sartre handed us the corpse: "In a technocratic civilization there is no longer any place for philosophy, unless it is transformed into a set of techniques, . . . as in the United States, where the social sciences have taken the place of philosophy." (He did allow us a half-life: "What survives in the United States under the name of philosophy is only a sort of vague reverie. . . .") Sartre's own counterclaim is that "no science can take philosophy's place," on the ground that any science applies to some already delimited subject matter, whereas philosophy is a process of "totalization."[3] In continuing our reverie we should not overlook this counterclaim, for there is some temptation to identify the recent Sartre as engaged, not in philosophy, but in roughly the kind of social science that is sometimes generated in the United States out of the Marxist heritage. After all, Sartre's most ambitious undertaking (aside from his study of Flaubert) is an analysis of social structures in the *Critique of Dialectical Reasoning.* And Marxism does unquestionably provide much of the setting for Sartre's handling of the problems of political action, though Marx could hardly endorse Sartre's conviction that "everything is political."[4]

One apparent result of this conviction is that when Sartre composed an autobiographical work that treated his adult career (as *The Words* treated

the earlier development of his conception of literature), he visualized it as a "political testament."[5] Yet the least one might ask of Sartre, before adding his name to the long list of those who qualify as "the last philosopher," is a philosophical testament. One can hope that this volume will tease something of the sort out of Sartre, inasmuch as such dealings as he has had with his conception of philosophy up to now have resulted mainly from his being pressed for comment—in interviews, and in *The Question of Method,* the original version of which was written at the request of a Polish periodical. And his "political testament" does take the form of a dialogue.

COFFINS, HERNIAS, BRAND-NAMES

Philosophers are most likely to be provoked into answering questions about their philosophy when the interpreter insinuates why they cannot answer them, or—worse—parades his own answers on their behalf. I shall try to be provocative in the first way in the present section, then more provocative in the second way for the rest of my interpretation.

So far I have regarded the difficulty of understanding Sartre's conception of philosophy as a result of the lack of explicit statements on his part that would account for the "totality" of his actual philosophical writings as the outcome of the process of "totalization," which is what philosophy is for Sartre. But according to Sartre, reliable understanding can be achieved only if this progressive and synthetic process has been preceded by a regressive analysis. And when we in fact begin by analyzing his philosophical writings separately, our difficulty has to be reassessed as an embarrassment of riches. Sartre's writings before World War II are conceived as "phenomenological psychology," but Sartre promptly accepted the designation "existentialism" for *Being and Nothingness* (1943).[6] The *Critique* (1960), however, is at once Kantian in format and Marxist in content, and most of Sartre's interpreters assume he is no longer an "existentialist." Thus a reasonably accurate rendering of the prevailing interpretation of Sartre would sort him out with those monstrous Roman numerals that have been inflicted on Heidegger: Sartre I (phenomenologist); Sartre II (existentialist); Sartre III (Marxist).

We cannot, however, finally accept these discontinuities, for "totalization" implies that we are dealing with a process of development. Indeed we have already seen that when Sartre deals with Flaubert's conception of literature, or with his own conception, he deals with its development. In fact, he conceives a "conception" itself as the grasping of what something is in terms of its development.[7] He is fond of citing Hegel's conception of "truth as having developed."[8] And he once proclaimed: "A true philosopher who develops feels no need to disavow his preceding works."[9]

In the case of some other philosopher one might examine his conception of philosophy without any attention to the development of his philosophy. But to do so in Sartre's case would be incongruent with his philosophy itself which, we shall see, seems to be conceived as a process of development that is pitted against the inert.

Yet here is the rub. I shall go on using the term "development," but, strictly speaking, it implies that some measure of continuity can be traced, and so we come up against the apparent discontinuities of Sartre I, Sartre II, and Sartre III. Here too Sartre himself is not entirely helpful. His later references to his earlier philosophical writings are rarely to specific passages and more often than not they sound like disavowals, for they allude to some drastic conversion he has undergone.

Another serious difficulty with respect to determining Sartre's conception of philosophy is how to decide which of his writings are to count as his philosophy. *Being and Nothingness* is usually interpreted as reaching its climax as a doctrine of freedom. Sartre in 1970 singled out *Saint Genet* as "perhaps the work where I have given the best explanation of what I mean by freedom." [10] Yet Sartre apparently would not classify this as a philosophical work any more than he would so classify his study of Flaubert, even though the latter is the work of Sartre's in which the terminology is the most rampantly philosophical. These are apparently the two works Sartre had in mind when he commented in 1960 that the "non-philosophical works," which he was then composing while "ruminating philosophy," suffered "hernias"—that is, bulging philosophical "digressions" which accumulated "as if I were chasing all the while after my philosophy." His ideas were "proliferating . . . like a cancer" to such an extent that he did not "yet know what to do with them," so he simply put them in the books he happened to be writing. [11]

Sartre finally moved to the *Critique* long passages that were originally written for the study on Flaubert; thus we cannot say that "hernias" are the final form taken by his philosophy. Nevertheless, Sartre is whimsical, perhaps even contemptuous, regarding the results of this surgery: "My philosophy will have been deposited in little coffins." [12] Now we begin to see how our difficulties arise from Sartre's own philosophical commitment to development and his aversion to the inert. The crucial difficulty in nailing down Sartre's conception or conceptions of philosophy is that we are then seeing the last of the last philosopher's philosophy; we are nailing down the lids of these coffins. The conceptions are inert nails, which keep the lids inertly in place as the coffins keep the corpses. [13] Sartre is disconcerted by the inertness of finality, not by proliferating bulges. How exactly the process of development is structured for Sartre cannot be settled until later. But it is already clear that we should not be misled into assuming an

Hegelian conception of development that would allow us to interpret the "totalization" involved as an *Aufhebung*. Sartre rejects the "retrospective illusion" that the interpreter is indulging whenever he follows up a development with a conception of its outcome toward which he presumes it was destined to proceed.[14] In order to dispose of the continuity—which the interpreter is thus prone to supply in retrospect, and which we ourselves have been looking for in Sartre's development—as illusory, Sartre tells an anecdote:

> A certain Sanzio was terribly anxious to see the Pope; he made such a fuss that they took him to the public square the day the Holy Father would pass. The child turned pale; his eyes opened wide. Afterwards they asked, "You must be satisfied now, Raphael? Did you get a good look at our Holy Father?" . . . "What Holy Father? All I saw were colors."[15]

Sartre's commitment to development entails instead what might be called a prospective illusion: "What comes first is always what I have not yet written, what I plan writing—not tomorrow, but the day after tomorrow—and perhaps will never write."[16] He would be correspondingly disdainful of the conceptions with which we are about to nail him down to what he has written. Thus when requested by a Polish periodical to discuss existentialism, he was reluctant:

> I don't like to discuss existentialism. An investigation should remain undefined. When it is given a name and definition . . . , what survives? A finite and already superseded feature of a culture, something like the brand-name of a piece of soap.[17]

The hope we entertained initially that Sartre could be persuaded to adopt a retrospective point of view, to survey his development as a philosopher, and to offer us a philosophical testament, now appears unwarranted. Even if the interpreter now goes ahead on his own, Sartre would seem to have already discredited the attempt.

THE INERT DEMAND

Recently, however, the problem of tracing some continuity in Sartre's development has come to seem a little less discouraging. I have mentioned the lack of specific cross-references from one of Sartre's works to another. But when the study of Flaubert finally began to come out, there seemed some textual justification for raising the question Sartre was then asked:

> How do you envisage the relationship between your early philosophical writings, above all *Being and Nothingness,* and your present theoretical work, from the *Critique* on? In the *Critique* the typical concepts of *Being and Nothingness* have disappeared, and a completely new vocabulary has taken their place. Yet when reading passages of your forthcoming study of Flaubert pub-

lished in *Les Temps modernes* one is struck by the sudden reemergence of the characteristic idiom of the early work. . . . These notions are now juxtaposed in the text with the distinct set of concepts which derive from the *Critique*. What is the exact relation between the two in your current thought?[18]

Unfortunately for us, Sartre in his reply dodged the textual and terminological aspects of the question: "The fundamental question here is, of course, my relation to Marxism. I shall try to explain autobiographically certain aspects of my early work."[19] When this interview was republished, only the first sentence of the interviewer's question was retained.[20] Although the excision may have been prompted partly by the fact that two volumes of the study of Flaubert had in the meantime been published, it has the effect of concealing Sartre's refusal to be cornered by the textual and terminological evidence for his philosophical development. Nevertheless, we can take advantage of the fact that Sartre has doubled back on his tracks in the study of Flaubert in a fashion that one would not have anticipated from any earlier work; for Sartre himself emphasizes that this study is "a sequel" to *Psychology of the Imagination* (1940),[21] the most important of his early phenomenological works. Moreover, in the "political testament" of 1974 Sartre explains how "very important" it is for him "to rediscover what I was thinking twenty-five years before."[22] Of course, this retrospect may merely betray the flagging that might be expected to take place in his development when a philosopher reaches an age at which he is eligible to be embalmed as a living philosopher. For Sartre further explains:

When one is 67, it is difficult not to live on what one has already acquired. . . . One has one's writings behind one, . . . pages with signs on them that set up the inert demand that they be defended.
I no longer have a future.[23]

Sartre's earlier commitment to development represented his refusal to succumb to the inert. Even now he does not in fact undertake the defense his writings demand. But, since to have only a past means in Sartre's own terms to pass into the hands of "the other,"[24] I can take over.

I shall undertake the defense of Sartre against Sartre—that is, the defense of the continuity of his development against what I shall claim is (or was) the prospective illusion with which he exaggerated its discontinuity. Ordinarily an interpreter concentrates on the "results" a philosopher has reached; the philosopher's development is his own private affair, which he is better qualified to interpret than anyone else. Nonetheless, I venture to raise questions about Sartre's development, since this is the only line of questioning that can get at what is essential to his philosophy, granted its commitment to development.[25]

Simone de Beauvoir has identified the major discontinuity in Sartre's development as his "conversion to dialectic."[26] She refers, of course, to the

conversion to the Marxist dialectic of Sartre III. I shall argue that it is appropriate to describe Sartre's philosophy as "dialectical" before this conversion, while it was still "existential," and that important "existential" traits survived his conversion and continue to distinguish his dialectic from a Marxist dialectic. Later I shall carry the argument for continuity yet another step backward to Sartre I, and claim that even before Sartre acknowledged his philosophy to be "existential," when he still regarded it simply as "phenomenological," it was already dialectical, in spite of the fact that Husserl repudiated dialectical method as well as existentialism. In this way I shall try to trace a certain methodological continuity that survives the apparent discontinuities we have noted. Otherwise, we would have to remain startled by his sudden and unexplained doubling back on his tracks when he presents his recent study of Flaubert as a "sequel" to the early phenomenological analysis of the imagination.

Needless to say, since my concern is with Sartre's development and with his conception of it, I can undertake only swift, inadequate forays into its three successive phases. Thus the example I shall use of the "existential" dialectic of Sartre II is not taken from *Being and Nothingness,* which is too sustained an application of this dialectic to be easily sampled. My example is instead relatively uncomplicated and trivial, but it has to do with a social phenomenon and so will lend itself to eventual comparison with the "Marxist" dialectic of Sartre III.

THE EXISTENTIAL DIALECTIC

This present volume by no means represents Sartre's first American venture. In 1945 he arrived here on a journalistic assignment arranged by Albert Camus. Sartre characterizes his American journey as an attempt to determine "what America is." The trait of his dialectic, thus exemplified, is that it is a method of definition. This is, of course, a fairly general trait of a dialectical method: Plato's *Republic* defines justice; Marx's *Das Kapital* defines capital. *Being and Nothingness* Sartre has characterized as an "eidetic analysis of self-deception,"[27] and eidetic analysis is Husserl's definitory procedure. The *Critique* defines several social structures, though we have to be satisfied here with Sartre's earlier and simpler definition of the structure of American society.

How is something defined dialectically? "Yesterday," Sartre recalls, "it was Baltimore, today it is Knoxville, the day after tomorrow it will be New Orleans, and after admiring the biggest factory or the biggest bridge or the biggest dam in the world, we fly away with our heads full of figures and statistics." But a dialectical method does not proceed by sorting out objective facts or statistics; this when tightened up is the scientific proce-

dure, which Sartre will identify in the *Critique* as "analytic reasoning" as opposed to his own "dialectical reasoning," which we have anticipated is caught up in a process of "totalization." The objective facts he has listed are random and unrelated; their range of implication is indeterminate. The biggest dam? So what. The biggest bridge? So what. Analytic reasoning has ultimately to be controlled by dialectical reasoning, which operates not on inert, isolated facts but on their relations. This is a general trait of any dialectical method, and specific dialectical methods can be differentiated by specifying what relations are traced as significant. In Sartre's existential dialectic, as in a Marxist dialectic, one most significant relation is the relation between opposites, or contradiction, such as that delineated by Sartre's title *Being and Nothingness*. We have already seen that this is Sartre's procedure at the higher level, where dialectical method itself is defined by its opposition to analytic reasoning. But to return to the lower level for a more concrete illustration, we find Sartre defining America by juxtaposing opposite positions: "the two contradictory slogans that are current in Paris—'Americans are conformists' and 'Americans are individualists.'"

For present purposes it will be sufficient if we consider Sartre's method of handling the first slogan. Conformism is something static, inert. Sartre's opposing commitment to development is methodological. His dialectic takes hold of whatever is to be defined and puts its relational structure into motion.[28] Thus Sartre's definition of America as conformist is a report of "How a Good American Is Made," which follows out the process of transformation by which conformity is secured: "Like everybody else, I had heard of the famous American 'melting pot' that transforms, at different temperatures, Poles, Italians, and Finns into American citizens. But I did not know what the term 'melting pot' really meant." Sartre then reports how he gained this knowledge:

> The day after my arrival I met a European who was in the process of being melted down. I was introduced, in the big lobby of the Plaza Hotel, to a dark man of rather medium height, who, like everyone else here, talked with a somewhat nasal twang, without seeming to move his lips or cheeks, who laughed with his mouth but not with his eyes, and whose laughter came in sudden bursts, and who expressed himself in good French, with a heavy accent, though his speech was sprinkled with vulgar errors and Americanisms.
>
> When I congratulated him on his knowledge of our language, he replied with astonishment, "But I'm a Frenchman." He had been born in Paris, had been living in America for only fifteen years, and before the war, had returned to France every six months. Nevertheless America possessed him half way. . . . He felt obliged every now and then to throw me a roguish wink and exclaimed: "Ah. New Orleans, pretty girls." But what he was really doing was conforming to the American image of the Frenchman rather than trying to be congenial to a fellow countryman. "Pretty girls," he said with a laugh that was forced: I felt Puritanism just around the corner, and a chill ran through me.

I had the impression I was witnessing an Ovidian metamorphosis. The man's face was still too expressive. It had retained the rather irritating mimicry of intelligence which makes a French face recognizable anywhere. But he will soon be a tree or a rock. I speculated curiously as to the powerful forces that had to be brought into play in order to actualize these disintegrations and reintegrations so reliably and rapidly.[29]

We saw that Sartre started out with opposed definitions of America: "Americans are conformists" and "Americans are individualists." We now see that the process of transformation by which conformity is secured is itself composed of opposing movements—the disintegration of a Frenchman and the reintegration of an American as an inert product of the process. I label this dialectic "existential" in that etymological sense of the term existentialists have more or less inherited from Heidegger (*ekstasis*: "dislocation," "removal from one's proper place"), whereby the individual (in the present instance the French expatriate) "ex-sists"—finds himself dislocated "outside" himself as the result of some process of transformation, granted that in Sartre we get a dialectical version of this dislocation as involving contradictions.

The two opposed movements are carefully poised, the Franco-American having reached the "half-way" point in the process of transformation.[30] The climatic opposition between French and American culture in 1945 was in the attitude toward sex. (The only area where Sartre could have found Frenchmen and Americans so diametrically opposed today would have been in their attitudes toward philosophy.) The American attitude toward sex is in turn contradictory—at once prurient and puritanical. Observe too how even Sartre's detailed touches are dislocating contradictions: the Franco-American talked "without seeming to move his lips or cheeks"; he "laughed with his mouth but not with his eyes," and "in sudden bursts."

THE MARXIST DIALECTIC

Let us pause to make an initial rough comparison with Marx's analysis of the contradictions operating in the process of transformation whereby a capitalistic society must disintegrate in order to be reintegrated eventually into its opposite—a communist society. The obvious difference which Sartre III will stress between Marxism and his earlier existential writings is that the earlier works lack an historical dimension. But what Sartre III does not acknowledge is that when this historical dimension is added, it largely retains the dialectical pattern that had already been established in these earlier writings. To this extent Sartre's later dialectic is neither distinctively historical nor Marxist. In fact, the dislocations and discontinuities that are distinctive of his own existential dialectic Sartre III attributes to Marx him-

self: "When Marx reproaches Hegel for having put the dialectic on its head
. . . , he wants to reintroduce . . . the delay, discrepancy, distortion, that are
constant characteristics of our undertakings."[31] "Reintroduce" is a strange
way of referring to what had not previously been a feature of the dialectic,
but it can perhaps be explained by recognizing that "delay, discrepancy,
distortion" had previously been "constant characteristics of our undertak-
ings" in Sartre's existentialism, granted that its dialectic was unhistorical, as
indeed "constant" suggests. In other words, Sartre is trying to existentialize
the official Marxist dialectic, which he views as having become temporarily
inert—"paralyzed" and "halted."[32] The "ex-sistentialist" accentuation of
dislocating contradictions lends an impulse to motion that is to transform
official Marxism, so that it will again develop an analysis able to catch up
with the transformations of social history.

 If this adjustment were confined to Sartre's interpretation of Marx it
might be discounted as not integral to Sartre's own philosophy. But the
same accent on dislocation and discontinuity is attributed by Sartre to the
history of the philosophical movement to which he himself originally be-
longed. When he refers to "the very complicated dialectic proceeding from
Brentano to Husserl and from Husserl to Heidegger," the complications he
lists are predominantly disruptions in the continuity of this development:
"influences, oppositions, agreements, new oppositions, misapprehensions,
misunderstandings, repudiations, goings beyond."[33] Sartre himself admits
to a tendency to exaggerate discontinuity, though not as a factor in his
interpretation of Marxism or of his predecessors, but rather in his own
psychoanalysis:

> I'm often informed that the past pushes us along, but . . . I hate feeling gentle
> forces at work in me, the slow unfolding of my dispositions. I have shoved the
> continuous progress of the bourgeoisie into my soul, making out of it an inter-
> nal combustion engine [moteur à explosion]; . . . I transform a tranquil
> evolutionism into a revolutionary and discontinuous catastrophism.

We have already watched him transform the evolutionary process of the
melting pot into a discontinuous and accelerated process of transformation.
Sartre himself offers a different illustration:

> The characters in my plays and novels reach their decision suddenly and in a
> moment of crisis. A moment, for example, is long enough for Orestes to carry
> through his conversion. You bet! For these characters are fashioned in my
> image, not as I am, of course, but as I would like to be.[34]

 Sartre's shoving of this dialectic with its accent on discontinuity down
into his own soul (and the souls of his characters) puts it out of normal
philosophical reach, depriving it of any philosophical significance compa-
rable to that of a Marxist dialectic.[35] Yet he also seems to have fashioned in

the image of his own performance (as he would like to have had it transpire dialectically) his interpretation of the way Marxism originally transformed the Hegelian dialectic, of the way official Marxism itself is to be transformed in response to existentialism, and of the way the philosophical movement to which he originally belonged underwent recurrent transformation. More crucial for our purposes is the way his interpretation exaggerates the discontinuity of the development of his own philosophy.[36] Consider the explosive moment of "ex-sistential" transformation that was his conversion to Marxism:

> I had reached the breaking off point. . . . In ecclesiastical terms it was a conversion.
> I wrote at top speed, rage in my heart, gaily, without tact: even with the best prepared conversions, why they explode, there is joy in the storm, and the night is black, except where the lightning strikes.[37]

The process of transformation involved in this conversion to Marxism is clearly not a Marxist performance but one of the many illustrations one finds in existentialism (though not in Marx) of how fundamentally Christian our behavior remains even (or especially) in explosive moments.[38]

The same acceleration, focusing finally on the apocalyptic moment, was characteristic of the "metamorphosis" of the Franco-American, and it will remain characteristic not only of Genet's and of Flaubert's transformations in Sartre's psychoanalyses but also of his Marxist social history:

> History goes forward wearing a masque: When it is uncovered, it brands its agents and witnesses forever. We have never recovered from the two *"moments of truth"* which France knew in the nineteenth century [when] the bourgeoisie . . . saw its real face in 1848 and in 1871.[39]

Observe that the truth can be given in a moment because its revelation is a matter of dislocation instead of synthesis. When Sartre attributes to Marx as opposed to Hegel (in the passage already cited) a more dislocating emphasis on contradictions, he is refusing to anticipate with Hegel the prospect of an *Aufhebung* that would transcend these contradictions in some "preserving" synthesis.

That Sartre's "totalization" is not *Aufhebung* comes out in a recent dialogue with another Marxist who was advocating what we call "coalition politics"—that is, a program that would be the "fusion," as in a "melting pot," of the demands of workers, peasants, women, etc. Sartre demurred:

> I'm not comfortable with your term "melting pot." A melting pot is something you put an assortment of things into, each of which has a quite definite form, and it all melts, taking another unitary form.
> I don't believe in the melting pot. . . . It's a too Hegelian idea that a thought is partial, . . . and that it must come into contact with a complementary thought, and that the two of them together will form a third thought.[40]

Thus Sartre's dialectic (to re-employ my earlier distinction) is not "retro-spective" in the sense that its validation is what some eventual synthesis *"preserves";* rather it is "prospective" in that the juncture where it can be compared with the Hegelian dialectic is the *destructive* moment when some initial synthesis is discredited as indeterminate in its form, as an "inter-penetration of opposites"—for example, the Franco-American's confusion as to what he was, or Flaubert's "habitual syncretism," which Sartre ana-lyzes by starting out with Flaubert's feeling of disgust, or at least malaise, that betrayed his distrust of certain experiences that had become blurred for him.[41] Sartre's discrediting dialectic, then, is an attempt to gain defini-tion and clarity by separating out as contradictions the opposites that have been con-fused.

THE REFLEXIVE REACTION

We now recognize that Sartre's disgust with the Frenchman being melted down was no ordinary emotion but rather a dialectical emotion—a reaction that is not restricted to this particular case but is a reaction to the confusion that is conformity. This reaction initiates a dialectical movement from the confusion to an opposing clarification, but the dialectic cannot be dealt with solely by reference to the *definiendum.* The dialectic is bilateral: the *definiendum* is only its objective pole, and the process of definition also involves the reflexive transformation of the subject. Why, in the present instance, did Sartre select a Frenchman instead of an Italian, or a Pole? As a matter of objective statistics, the number of Frenchmen who have been melted down into Americans is comparatively insignificant. The reason for the selection was, of course, that Sartre himself is a Frenchman, or rather a stand-in for his French readers. We have already observed that the op-posed movements of disintegration and reintegration that Sartre traced are not historical; rather than proceeding at what would be the actual historical pace of the melting pot, they were accelerated as if they were taking place right there in front of Sartre in the lobby of the Plaza. This acceleration was designed not only to heighten the "ex-sistential" sense of the ex-French-man's dislocation but also to portray Sartre's own reflexive involvement— that is, the dislocating rapidity of the process of transformation he himself underwent from supposing that the man confronting him was an American to recognizing that he was an ex-Frenchman.

One form this reflexive process of transformation takes might be termed "critical." Where did Sartre find that slogan "Americans are con-formists"? He brought it with him from Paris; for one sense in which an existential dialectic is reflexive is that it exposes the presuppositions a sub-ject brings with him to an experience so that they may undergo revision and

he will discover what is "really meant" by them. Sartre's analysis retains this reflexive character even when it becomes Marxist and historical. Sartre's *Critique* is a critique in that it analyzes and revises the presuppositions of contemporary Marxism; and although in the second volume the analysis was to have become historical, I would guess that one stretch of it at least was also to remain reflexive—perhaps, for example, as an analysis of the conditions of social history under which a Marxist analysis of those conditions (1) becomes possible, (2) becomes transformed into official Stalinist Marxism, and (3) becomes retransformable into the critique being offered of this Stalinist Marxism.

But the reflexive character of Sartre's dialectic is more easily brought out in the episode with the Franco-American, where the process of definition was obviously designed less to delineate objectively the way the melting pot operates than to elicit a reflexive, affective reaction to its operation: Sartre was dislocated too—disoriented, disconcerted, disgusted—by the discovery that the apparent American he was talking with was once a real Frenchman like himself, but was now being melted down. Disgust is the dislocating feeling which Sartre frequently elicits, disgust even to the point of nausea. We should not conclude that this is without philosophical significance. Sartre knew "what the term 'melting pot' really meant" only when he had this disgusted reaction. The obvious philosophical significance of his reaction is that his confidence in appearances, or rather in the distinction between appearance and reality, was itself dislocated: Sartre initially became conscious of someone who appeared to be an American; this appearance had to be dismissed as subjective when he was confronted with the claim "But I'm a Frenchman"; that was not, however, what the Franco-American really was, only what he appeared to himself to be; and Sartre's own feeling of disgust reached its climax when he recognized that the Frenchman not only was no longer a Frenchman and not yet an American but also conformed to the subjective requirements of "the American's image of a Frenchman." Finally, since the dialectic turned on the reflexive involvement of Sartre (and his reader) as being French, it could not remain unilaterally anti-American but had to be complicated by the reflection: "The man's face was still too expressive. It had retained the rather irritating mimicry of intelligence which makes a French face recognizable anywhere." To belabor the point, if the Frenchman was discounted reflexively as only a subjective appearance (as not a real Frenchman, but only "the American's image of a Frenchman"), a real Frenchman retains no real superiority since he is only apparently intelligent.

Although Sartre in his earlier writings usually retches at the lower levels of the dialectic (for example, where consciousness feels nausea as it becomes conscious that its movement is confused and compromised by the

flabby inertia of the flesh), we have seen how his disgust can extend to other syntheses. At the highest level it discredits philosophical idealism, which Sartre's dialectic disgorges by proceeding in the opposite direction, for idealism is envisaged as an "alimentary," or digestive, dialectic in which synthesis is the mind's confusion of things with itself and of itself with other minds: "The mind was a spider which drew things into its web, covered them with white spittle and slowly swallowed them. . . . Assimilation . . . of things to ideas, of ideas by ideas, of minds by minds."[42] Sartre wrote the essay I am citing in Berlin in 1933–1934—at the very beginning of his philosophical career. Thus Sartre's distrust of *Auflösung* and *Aufhebung* antedates his introduction to America in 1945, and it still survives when he expresses his discomfort with the fusions of a "melting pot" in the political dialogue of 1974. In spite of this continuity, Sartre III gives us the impression that his struggle against idealism coincides almost entirely with his belated transformation into a Marxist.

THE PHENOMENOLOGICAL DIALECTIC

The crucial function of the reflexive reaction in Sartre's existentialism is partly an inheritance from phenomenology. In view of Brentano's and Husserl's contempt for dialectic, it is sometimes assumed that there must be some essential discontinuity separating the phenomenological writings of Sartre I from the existential writings of Sartre II, just as it is often assumed that there must be some essential discontinuity separating these existential writings from the Marxist writings of Sartre III. Having argued that Sartre's method was dialectical before it became Marxist, I now want to argue that it was dialectical—and in important respects manifested the same dialectical pattern—before he explicitly adopted the existentialist label. I take an example of Sartre's phenomenological analysis from *The Psychology of the Imagination* (1940) because Sartre has indicated that *L'Idiot* (1972) is a "sequel" to this early work.

The example concerns a movement, a process of development or transformation, that is opposed to a threat of inertness, as illustrated in the following generalization: "Always ready to bog down in the materiality of an image, thought escapes by flowing into another image." In tracing this process Sartre is not dealing with the operations of purely reflective thought (which Husserl can segregate for a strictly phenomenological analysis), but with the way thought loses its reflective purity by becoming imaginative, and this development is dialectical in that pure thought would operate simply with ideas, whereas images exhibit "materiality." Furthermore, Sartre is concerned with the way thought develops in relation not to a single image but to two opposed images, flowing from one into the

other. This is the confusion to be exposed by an analysis that will become dialectical. The point of entry for Sartre's analysis is the appearance to the consciousness of the subject of a certain "distrust which is like a memory of reflection." A strictly phenomenological analysis is an analysis of the evidence presented by what appears to consciousness, but when what appears is "distrust," its appearance is the discrediting of the evidence yielded by some other appearance. At this juncture a phenomenological analysis almost has to become dialectical in order to get at the contradiction between the evidence yielded by the one image and the evidence yielded by the other.

Here is the initial episode in this process of development:

> I wanted to convince myself of the idea that every oppressed individual or group derives from its oppression the strength needed to shake off its oppressors. But I had the definite impression that such a theory was arbitrary and I felt a certain discomfort. I made a new effort of thought: now there emerged the image of a compressed spring. At the same time I felt in my muscles the latent force of the spring. It would expand the more violently the more it had been compressed. For a moment I felt with complete evidence the necessity of the idea which I could not convince myself of before.[43]

The dialectical character of this cognitive episode is obvious. The "idea" entertained (1) has to do with relations; (2) the *relata* are opposed; but (3) their bilateral opposition is not evenly balanced, for the oppressed are deriving from their oppression the strength to throw it off, so that what is accentuated is their reflexive reaction to their oppression. Another reflexive twist induces us to turn to the opposite pole of the dialectic, for what is finally at issue is less what the subject is thinking about than of what he would "want to convince himself" regarding what he is thinking about. In other words, we are being presented with another example of that contradiction in terms, "affective logic." But this reflexive effort in turn induces a reflexive reaction to it ("I felt a certain discomfort"), prompting a further reflexive effort to convince himself—Sartre's resort to the "image of a compressed spring." At this stage of the development he is thinking about the oppressed in relation to this image of a compressed spring. But once again what is crucial is not the object this image represents, but his reflexive reaction to the image: his feeling in his muscles, the latent force of the spring, constitutes the imaginative evidence for the idea.

Phenomenology can of course accept imaginative evidence, but here the evidence gives way under analysis:

> A compressed force clearly represents potential energy, and this potential energy is that of the oppressed since the oppressed is the spring. . . . But the image of the spring would not be sufficient to carry conviction. No doubt the spring accumulates force. But never enough to throw off the weight, since the force accumulated in the spring is always less than that compressing the

spring. The conclusion that then would be drawn from the image would be that the oppressed . . . will never succeed in throwing off its yoke.[44]

Conviction was obtained, the "affective logic" was effective because "the laws of development that are native to the image" (of the spring with its potential energy) were confused by the subject with the laws of development of what he appraised with this image (the strength of the oppressed), as soon as he felt reflexively in his own muscles the latent force of the spring: "The image of the spring is no longer a simple image of a spring. It is also . . . an image of a living spring. Here there is no doubt a contradiction, but there is no image without inherent contradiction."[45] This general conclusion suggests why this particular example is sufficient for our present purposes, for it indicates why Sartre was tempted methodologically to single out the image (as Husserl never had) for treatment; its phenomenological analysis becomes the dialectical exposure of a contradiction.

But the character of this example illustrates a larger difference between Husserl's phenomenology and Sartre's dialectized version. Husserl attempted to describe any act of consciousness by reflecting on what one is conscious of in performing such an act. His attempt presupposes a distinction between the subject matter of phenomenology—the sphere of consciousness which is immediately accessible to reflective description—and the mechanical relations that are relegated to the natural sciences as a subject matter for explanatory inferences from effects to causes. In Husserl this distinction excludes all reference to what lies beyond the immediate scope of consciousness. But in Sartre (as his analysis of "the living spring" suggests) the distinction can become dialectical—that is, the opposition between being conscious of oppression and the mechanical relation of compression is itself drawn within the scope of what one is conscious of. This dialectized phenomenological distinction will again be implicit in the "ex-sistential" dislocation the Frenchman undergoes as a human being when he is so mechanically transformed into an American by the metallurgical process of the melting pot.[46]

This dialectized phenomenological distinction will survive when Sartre III later criticizes Marxism for reducing the relations between conscious agents to mechanical relations. This reduction Sartre labels "objectivism."[47] Thus where the starting-point of a Marxist analysis of a stretch of social history is some technological change (for example, the invention of a tool—the lever, the wheel, the steam engine), Sartre starts out phenomenologically with a reflective experience—such as the movement whereby the individual "is continually making himself his own tool."[48] When the individual leans on a lever or pushes a wheelbarrow or pulls a rope over a pulley, he is using his own body as a tool for using the tool. Since his immediate experience is the reflexive experience of his own in-

strumentality, a bilateral analysis is required of the interplay between the subjective tool and the objective tool. Thus Sartre describes girls working in a factory as "ruminating a vague dream" but "at the same time traversed by a rhythm external to them," so that "it can be said that it is the semi-automatic machine which is dreaming through them." The rhythm of the machine was originally "so alien to a girl's vital personal rhythm that during the first few days it seemed more than she could endure." But "she wanted to adapt herself to it, she made an effort." Thus "she gave herself to the machine," which "takes possession of her work" until finally "she discovers herself as the object of the machine"—that is, "ex-sistentially" outside of herself.[49] This reflexive discovery could have no significance in an objectivist analysis, where in principle no distinction would be available to describe the factory worker as somehow no longer the subject of her own experience. The distinction can be reapplied, at a higher level of the dialectic, to the objectivist analysis itself, which can then be seen to reflect a social state of affairs in which the relations between men have in fact become a matter of mechanically exercised pressure (as under a Stalinist regime)[50] and no longer respect the reciprocity that should be the norm for the rhythm of human relations.

In short, although "the question of method" is posed only by Sartre III and as primarily a question of the relation between "existentialism and Marxism," I would claim on behalf of the continuity of Sartre's development that this relation between Sartre II and Sartre III cannot be understood unless we understand the relation between the existentialism of Sartre II and the phenomenology of Sartre I.[51]

MOMENTS OF TRUTH

Take another already encountered peculiarity which distinguishes Sartre's Marxist social history from Marxist social history: the dramatizing of "moments of truth." I have suggested that in Sartre truth can be given in a moment because its revelation is associated with an "ex-sistential" dislocation, rather than with an Hegelian-style synthesis. Reconsider the disgust that is dignified as the nauseous experience of existence itself. Much of the terminology of Sartre's treatment of nausea derives from Heidegger's analysis of the "affective" dimension of *Befindlichkeit*—not surprisingly, since we have found that Sartre's own existential dialectic is primarily an "affective logic." In other words, the immediate experiences which Sartre finds "ex-sistentially" dislocating (as opposed to the objective dislocations that are crucial in Marx) are the distinctively e-motional experiences of being "moved outside" oneself (for example, by disgust). In analyzing the affective dimension, Heidegger gained scope by bringing within the reach of his

analysis the apparent opposite of being affected—"the pallid (*fahl*), evenly
balanced lack of affectivity (*Ungestimmtheit*), which is often persistent and
wherein existence becomes satiated (*überdrüssig*) with itself."[52] Now Sartre
apparently identifies Heidegger's "lack of affectivity" as nausea, which he
describes as the way one feels when "no specific satisfaction or dissatisfac-
tion is 'existed' by consciousness," as "an insipid [*fade*] taste . . . which
stays with me in my effort to get away from it."[53] The first phrase reporting
this reflexive experience seems to reproduce Heidegger's *Ungestimmtheit;*
fade, to reproduce *fahl*, and the last phrase to spell out Heidegger's "persis-
tent" (*anhaltendes*). Finally, the disclosure by nausea that one's existence is
contingent takes the concrete form of one's consciousness that one is
"superfluous" (*de trop*)—a term which seems to reproduce Heidegger's
überdrüssig.[54]

 This is early Sartre. But as late as *The Idiot*, Sartre would seem to be
still drawing on Heidegger's conception of *Befindlichkeit* when he charac-
terizes the subject matter of his psychoanalysis as our "fundamental and
hidden affectivity, which is the way in which we live our anchorage," even
though he goes on to insert this subject matter within the broader Marxist
context where we are anchored "in a particular milieu which is defined
within our class by the antagonisms fomented by the division of labor."[55]

 Sartre has demonstrated his own doctrine of the "practico-inert" by
having succumbed more than is ordinarily realized to the inert demands of
Heidegger's "words." But there is no justification in Heidegger for Sartre's
curious usage "existed by consciousness" in *Being and Nothingness*, or for
his similar transitive use of "live" in the citation from *The Idiot*. Although
Sartre borrows the technical term "existence" from Heidegger (in addition
to the traits of nausea which we have just examined as consciousness of
existence), nothing could be more un-Heideggerian (except in its defiance
of grammar) than having nausea "existed by consciousness." This usage
seems to illustrate the conflation in *Being and Nothingness* of an existential
and a phenomenological analysis. In identifying the reflexive dimension of
consciousness Husserl had used the transitive verb *erleben*. An *Erlebnis* for
Husserl is "experience as lived from within," and the "lived" brings out the
immediacy with which one is reflexively conscious of the experience, as
well as intentionally conscious of whatever it is an experience of. The ac-
cessibility to consciousness of this translucent reflexive dimension renders
phenomenological reflection feasible in Sartre as a method of analysis.

 Thus the consciousness of existence that Sartre ascribes to his pro-
tagonist in *Nausea* is not entirely a spin-off from Heidegger's existential
analytic. Heidegger never claims, as does Sartre's protagonist with regard
to his nauseous vision: "All at once, in a single moment, the veil is torn

aside. I have understood, I have seen. . . . Suddenly, clear as day, existence has unveiled itself."[56] There is no moment of truth in Heidegger when so sudden a revelation occurs and existence becomes as clear as day. In fact, we reach the end of *Being and Time* only to find that "the fundamental problem . . . still remains veiled," and that whether or not Heidegger has even approached it in "the right way . . . can be decided only after one has gone along the way."[57] The problem cannot be dealt with by appealing to the immediate phenomenological evidence of an *Erlebnis*. Indeed, Heidegger junks Husserl's term, preferring *Erfahrung*, which can be construed as indicating that experience "stretches out" in time as a "journey" along a way. [58] The continuity of this "journey" Heidegger respects when he concedes a "turn" (*Kehre*) in his philosophical development, but vehemently denies that it is a "conversion" (*Bekehrung*).[59] Yet it is precisely a conversion which introduces discontinuity in Sartre, when "the lightning strikes" and a "moment of truth" is confronted—"those extraordinary and marvelous moments when the prior project collapses into the past in the light of a new project which emerges from its ruins . . . , when we let go in order to grasp and grasp in order to let go."[60]

Moments of truth, whether they occur as a conversion that transforms an individual or (as we have also seen) as occasions in social history, obviously obtain their cogency for Sartre phenomenologically, even though he substitutes "ex-sistential" dislocations for the preparatory procedure of Husserl's phenomenological reduction. Thus Sartre's method is not just the dialectical method of tracking down mediations; it also implements a criterion of immediacy, which is not the negative abstraction that im-mediacy is in an Hegelian dialectic, but a positive and concrete phenomenological experience. Or perhaps one should say that Sartre's own dialectical method operates at a higher level, where its distinctive dialectical feature is the discrepancy it incorporates between the immediate givenness, on the one hand, of experience (as phenomenologically conceived) and, on the other hand, the articulation of experience (when its implications are conceived as emerging through a process of mediation).[61]

Some of the intellectual power of Sartre's dialectic stems from its combining these two ways of conceiving experience that would ordinarily be regarded as contradictory. Retaining the contradiction seems indispensable to Sartre, perhaps especially in *Being and Nothingness,* where much of his philosophy is constructed out of references to Husserl and Heidegger and would have become a "melting pot" if he had "melted down" the differences between them. In that case the resulting "interpenetration of opposites" would incur Sartre's own rebuke of "syncretism" rather than the usual complaint of ill-sorted eclecticism.[62]

LE VÉCU

Having already considered several illustrations of the discontinuity of Sartre's dialectical method, we now see it is accentuated by the discrepancy between his phenomenological and dialectical conceptions of experience. If the discontinuity were peculiar to the philosophy of Sartre II, this philosophy might be construed simply as a manifestation of the movement of his consciousness, which in *Being and Nothingness* violates the principle of non-contradiction by being what it is not and not being what it is. But the discontinuity that has concerned us most is the discontinuity which Sartre reads into his own overall development as a philosopher; he seems to have been drawn, by the reflexive application to which his dialectical method lends itself, into exaggerating the discontinuity of this development. Thus the philosophy of Sartre III is distinguished by Sartre III from his previous philosophy of consciousness: "I have replaced my old conception of consciousness—although I still often use this term—with what I call *le vécu*."[63] Sartre in fact still sometimes uses in *L'Idiot* the term *Erlebnis* as well, and if his old conception of consciousness in *Being and Nothingness* translated this term, one would swear that its replacement does too, in spite of Sartre's own assertion: "This conception of *le vécu* marks my development since *Being and Nothingness*. In my first writings I was trying to construct a rationalist philosophy of consciousness." Both the first statement regarding what is new and the second statement regarding the old exaggerate the discontinuity of Sartre's development.

Le vécu itself still involves the reflexive dimension of consciousness: "The introduction [in *L'Idiot*] of the concept of *le vécu* represents an attempt to preserve that 'presence to itself' which seems to me indispensable to the existence of any psychological fact."[64] But Sartre adds that this "presence to itself" is "at the same time so opaque, so blind to itself that it is also absence from itself," so that "*le vécu* is always, at one and the same time, present to itself, and absent from itself."[65] In other words, the phenomenological moment when consciousness is immediately present to itself is still a moment of truth, but no longer in quite the old sense that consciousness is translucent to itself. Consciousness seems in the meantime to have flipflopped dialectically and to have acquired the opposite trait of opacity. Accordingly we find a doubling of Sartre's criteria for understanding: "*Le vécu* is always susceptible of *compréhension* [that is, of immediate subjective phenomenological understanding], but never of *connaissance* [dialectically articulated knowledge]." But we have seen that *Being and Nothingness* already delineated a transition from a phenomenological moment of truth to its dialectical articulation. And if *Being and Nothingness* is,

as Sartre has said, "an eidetic of bad faith," then its central phenomenon is the process of "distraction" whereby consciousness confuses and obscures from itself what is "present to itself" by rendering it "absent from itself."[66] When we reach Sartre III, the dialectical process of articulation is certainly much more complex, for the protohistorical dimension of childhood is now added; but the addition does not seem to alter the pattern of Sartre's dialectic any more drastically than does the addition of the historical dimension, aside from the fact that the confusion is now initially foisted on the child by its family and society as well as compounded by the child himself. In Sartre I we watched the subject himself concoct the confusion ("living spring") and eventually clarify it himself by a dialectical analysis. In Sartre III the intervention of an independent analyst now seems needed (for example, Sartre in relation to Flaubert), or at any rate the intervention of the dislocating effects of the course of history, which seem to provide in Sartre a dialectical equivalent for Husserl's phenomenological reduction.[67]

In acknowledging the opacity of immediate consciousness, Sartre III may to some extent be sacrificing the phenomenological conception of immediacy to the dialectical. He is in any case setting up a contrast with the "rationalist philosophy of consciousness," which he states he was "trying to construct" in his "first writings." But rationalism was Sartre's complaint in his first writings against Husserl's philosophy of consciousness; whereas Sartre's own continuous effort from his first writings on was to take the irrational into account—not merely "distraction," but the imagination and the emotions which Husserl had never singled out for treatment.[68] Nothing could be farther removed from Husserl's rationalism than Sartre's preoccupation in his first writings with affective meaning (as in his disgusted discovery of "what 'melting pot' really meant," or in his nauseous discovery of existence) or with "affective logic," whereby the subject *wants* to convince himself of this or that (as in the episode of the "living spring") or *wants* to imagine this or that.

Even Husserl's procedure of intentional analysis, which Sartre adopts in his first writings, is altered when the examples of "consciousness of something" that are taken to be characteristic are no longer, as in Husserl, the subject's consciousness of a physical or mathematical object, but the subject's consciousness of another subject as object, for the unilateral relation of intentionality in Husserl now can become bilateral and suffer a reversal that requires a dialectical method to trace.[69] This initial difference between Sartre and Husserl is more fundamental than the difference Sartre avows with his criticism of Husserl's rationalism. Sartre himself is attempting to understand "man," who is (he explains) "a sorcerer for other men,"[70] and we are much more likely to behave irrationally (imaginatively, emotionally,

and to employ sorcery) when we have to deal with other subjects instead of with physical objects, unless the latter happen to embody our dealings with the former (as in the case of property relations).

Once Husserl's phenomenology becomes dialectical in Sartre, a dialectical reversal can take place, so that Sartre's distinction between the inert and the developing can be applied as a distinction between the "sciences of man" and Sartre's own phenomenological and "totalizing" attempt to understand man: scientifically treated, "man is not total man" but an "object," assignable to the region of "the practico-inert," where he is "engaged in human activities but only insofar as they are mediated by strictly objective materials"; philosophically understood, man is an "object-subject"—that is, "a subject who is engaged in a process of development" in which by his mediation other men "become objects," including the objects which they become in the sciences.[71]

PHILOSOPHY AND LITERATURE

The discrepancy between Sartre's phenomenological and dialectical conceptions of experience yields some insight into other adjustments he undertakes besides the use he makes of Husserl and Heidegger respectively, the distinction he draws between Husserl's rationalism and his own phenomenology or between a science of man and his own philosophical understanding of man. Having just found that Sartre's philosophy is not scientific, we may be tempted next to regard it as literary, and thus face the problem, which we dodged at the outset, of what the distinction is between Sartre's philosophy and his literary works. After all, an obvious difference between Marx's analysis of a social process and Sartre's analysis is that Marx regarded his dialectical procedure as scientific, whereas Sartre II exploited a metaphor, the "melting pot."[72]

Sartre explicitly, if rather casually, assigns to literature the domain of "the immediate," whereas philosophy is the "reflection as such" which renders conceptually explicit the meanings of literature.[73] This distinction would not have seemed to add up to much had I reported it at the outset. For without prior recognition of the phenomenological cogency which immediate experience retains in Sartre, we might infer that the domain accorded to literature hardly enjoys any independence at all from philosophy, and indeed that it suffers the kind of subordination that is imposed on literature by philosophy in Hegel's dialectic, where immediacy is the negative movement waiting to be superseded by reflection.

The more difficult distinction to handle is between Sartre's philosophy and those works which would ordinarily be classified as literary criticism. Here I would suggest that Sartre's own conception of philosophy is too restrictive when he discriminates between the *Critique* as a philosophical

work and his studies of Genet and Flaubert as "non-philosophical works" on the grounds that "philosophy does not deal with the individual as such."[74] In insisting that his philosophy is Marxist, Sartre seems to want to deny a distinctive trait of his own philosophy—its reflexive character. In the episode of the melting pot the focus of the existential dialectic of Sartre II is not on the social process of transformation itself (as it would have been in Marx), but on the experience of an individual man who is involved in this process. The immediate experience of the individual retains its phenomenological validity even after Sartre's dialectic becomes Marxist. Thus we find Sartre III protesting that the Marxist "distinction between substructure and superstructure does not hold in that profound meanings are already given from the start."[75] Since these meanings can be given only to an individual consciousness, the individual is retrieved whom Engels eliminated when he wrote, "That such a man, precisely that particular individual, emerges at this particular epoque . . . is naturally a matter of pure chance."[76] Now Sartre by his own account does not deal merely with the particular individual as such in his study, for example, of Flaubert. The social scope of an individual's experience is assured by the way it recapitulates some larger social process of transformation. If the experience of the Franco-American recapitulates the operation of the "melting pot," Flaubert's experience provides "an excellent résumé" of "a century of vicissitudes in French society."[77] An individual can play this recapitulatory role because he is never simply a "particular individual" (as in Engels) but a dialectical composite—"a singularized universal."[78] The contradictions of Flaubert's century cannot simply be surrendered to a Marxist social history, for they retain a reflexive dimension as "a struggle . . . in which Flaubert is opposed to himself"[79] (as was the Franco-American), and is thereby dialectically qualified for his recapitulatory role.

At the same time, since the dialectic is bilateral, a reflexive criterion is also applied when Sartre the writer selects Flaubert to recapitulate the social contradictions of his century as they have been exhibited in the development of the modern novel, just as Sartre the Frenchman selected an ex-Frenchman to recapitulate the contradictions in the development of an American. The crucial contradiction from Sartre's reflexive point of view is that Flaubert "represents, for me, the exact opposite of my own conception of literature—total disengagement [from the problems posed by social contradictions] and the pursuit of a formal ideal."[80] With reference to this more specific contradiction, Sartre asks himself the "critical" question, "How was such a man possible?"[81]

Engels' example of the individual man who could be eliminated from an objective social history is Napoleon; the individual man whom Sartre retrieves is a writer. A difference between Marxist social history and Sartre's social history is that the most significant social relationship, in

Sartre's actual presentation, is what he calls "the interconnected relation between writing and reading."[82] Here the requirement of a bilateral dialectic is satisfied, for the attempt on the part of the reader to understand a man interacts with the man's own reflexive attempt "to make himself understood." In Flaubert's writings "something has turned on itself, ceaselessly, piling up; an experience has sought a hundred times its expression."[83]

READING

The attempt to make himself understood takes a singular form with any writer, but the attempt is not confined to writers. When reading introduces another man into the process of understanding, the process becomes bilaterally reflexive as well as bilaterally interactive: not only is the writer trying to make himself understood, but also "reading is to some extent rewriting."[84] Reading is a reproductive process that is not entirely at the mercy of "the inert demand" of the signs read,[85] but is also a development of its own.

My reading of Sartre can finally shift from the procedure he describes as "analytic" to the "progressive synthesis" that reproduces the development of his writings and tries to bring out the continuity which survives the discontinuities that analysis has sometimes disclosed. Man in Sartre III still retains his initial *phenomenological* role in Sartre I: "Man is for himself and for others a meaning-endowing being."[86] This phenomenological role became *human* when Sartre in his first philosophical work (1936) rejected Husserl's assignment of it to a Transcendental Ego. [87] This human role became *literary* when Sartre at one and the same time took over both Corbin's mistranslation of *Dasein* as *la réalité humaine* (which encouraged reversion to the traditional concept of existence as *actualitas*—for example, when Sartre argues "a man exists only to the extent he realizes himself"[88]) and Heidegger's conception of "ex-sistence" as *Dasein*'s being "outside" itself; for then a dialectically appropriate palliative was to realize oneself by bringing into being the work of art which has its own intrinsic *raison d'être*. Thus it is not a philosophical accident that we have been able to pick out the detailed influence of Heidegger's philosophy on Sartre in a novel, *Nausea* (1938), which traces, as the reason it came to be written, the development of the nauseous consciousness that there is no intrinsic philosophical reason for a human being to exist. But this literary role of the writer also became *questionable,* since man's phenomenological role as "a meaning-endowing being," which Sartre derived from Husserl, was combined with the "ex-sistential" role of "a being whose being is in question,"[89] which Sartre derived from Heidegger. Thus Sartre had to pose with respect to literature the *critical* question, "How is such a man as a writer possible?"—be that man Baudelaire, Genet, Flaubert, or Sartre himself.

Nausea was followed up with a further explanation, in *Psychology of the Imagination* (1940), of man's effort to realize the imaginary and how this effort is doomed dialectically to frustration (*échec*). When Sartre published *Being and Nothingness* (1943), he presented it as preparatory to *Man,* for which it provided "the principles of existential psychoanalysis,"[90] but the only candidates actually mentioned were individual writers. *Man* has never been published. We need no longer wait for it, now that we have recognized man's "meaning-endowing" role (in the setting of Sartre's phenomenology), why man writes (in the setting of Sartre's existentialism), and why the prospect of writing about man could become instead a preoccupation with individual writers (given the reflexive character of Sartre's phenomenological existentialism as opposed to his Marxism).

Baudelaire (1947) was Sartre's first analysis of why a writer writes, and in the same year he posed the question *What Is Literature?*[91] In 1953 he began his own analysis of why he himself wrote. He outlines an analysis of why Flaubert wrote in *Question de méthode* (1957), which thus becomes a kind of "preface" not only to the *Critique* (1960), but also to the later study of Flaubert. Sartre has agreed that he had to write about Marxist dialectic in the *Critique* before he could write about Flaubert.[92] In *The Words* (1963), Sartre finally published his analysis of why he himself writes, and in 1966 portions began appearing of what was to become the study of Flaubert—the three volumes which begin with the question of how one is to go about understanding a man, and end with the question of how Flaubert's assertion "Je suis écrivain" is to be understood, on the basis of his conception of literature and a reading of his crucial work.[93]

If the length and complexity of Sartre's study of Flaubert justifies reading it as his crucial work (in spite of the fact that it has been almost entirely ignored by philosophers), this reader may have succeeded in tracing what might not otherwise be discernible—the continuity of the development illustrated by Sartre's preceding writings. Sartre does not need to disavow these earlier writings; his philosophy need no longer suffer analytic dissection and end up deposited in three coffins—Sartre I, Sartre II, and Sartre III. How is such a philosopher possible? Whether as a phenomenologist, an existentialist, or a Marxist, Sartre writes philosophy in order to understand why writers write and in writing are being human. But if my "reading" is necessarily a reflexive *manoeuvre* to the extent (according to Sartre) that it is also a "rewriting," there should be another answer to the question—Sartre's.

ROBERT DeNOON CUMMING

DEPARTMENT OF PHILOSOPHY
COLUMBIA UNIVERSITY

NOTES

1. *L'Existentialisme est un humanisme* (Paris: Nagel, 1946), pp. 55, 57. "Existence" as self-realization I shall distinguish as the weak meaning of existence in Sartre; for the stronger meaning, "ex-sistence," see above, p. 63.

2. *L'Idiot de la famille* (Paris: Gallimard, 1972), 3: 665. Sartre has abandoned the project of the fourth volume on Flaubert.

3. "Jean-Paul Sartre répond," *L'Arc*, no. 30 (1966), pp. 94–95.

4. Ph. Gavi, J.-P. Sartre, P. Victor, *On a raison de se révolter* (Paris: Gallimard, 1972), p. 27.

5. *Situations*, IX (Paris: Gallimard, 1972), p. 134.

6. In order to exhibit the chronology of Sartre's development, the dates supplied after his titles are for the original French publication, even when the titles themselves are in English.

7. *L'Arc*, p. 94. I am translating as "conception" Sartre's term *notion*, which presumably translates Hegel's *Begriff*.

8. For an early example, see "Conscience de soi et connaissance de soi," in *Bulletin de la Société Française de Philosophie*, no. 3 (1948), p. 51. An example from 1970 is *Situations*, IX, p. 231. References to *la vérité devenue* are recurrent in *L'Idiot*. In short, whatever may be the discontinuities in Sartre's development as a philosopher, he continues to adhere to a philosophical conception of truth as involved in a process of development, if only because this is its involvement in the larger development of the "objective spirit."

9. Michel Contat and Michel Rybalka, *Les Ecrits de Sartre* (Paris: Gallimard, 1970), p. 209. This criticism of Lukács for his disavowals was made in 1949. It is ambiguous, but I believe that Sartre holds that a true philosopher must develop.

10. *Situations*, IX, p. 102.

11. Ibid., pp. 9–11.

12. Ibid., pp. 10, 12.

13. The young Flaubert's experience of the inert rigidity of the corpses dissected by his father, as a practitioner of "analytic reasoning" (see above, p. 62), provides Sartre with so many clues as to the constitution of Flaubert's sensibility (e.g., *L'Idiot*, 1: 473–474, 481, 489, 500) that I believe it also provides us with some clue as to the sensibility Sartre is exercising when he opposes his own dialectical procedure of pitting the developing against the inert.

14. *Les Mots* (Paris: Gallimard, 1964), p. 210.

15. Ibid., p. 169.

16. *Situations*, IX, p. 10; cf. *Les Mots*, p. 200. Before trying to nail down any conception as to what Sartre's philosophy is, or was, we should recognize that the discontinuities in his development are the more striking, in that works which he planned to write and which would have been culminating for some phase of his development, he never wrote, or at any rate failed to complete and publish. The "phenomenological psychology" of Sartre I was to have culminated with the appearance of the comprehensive work *Psyche*. Sartre anticipated in 1938 that it "will soon be published" (*Les Ecrits*, p. 65). But the only portion that was actually published was the short (60 pages) *Esquisse d'une théorie des émotions* (1939). *L'Etre et le Néant*, the major existentialist work of Sartre II, was to have prepared the way for *L'Homme*, which still has not been published. The second volume of the *Critique* was to have added an historical dimension to the analysis of social structures which Sartre III had undertaken in the first volume and was to have appeared a year after the first volume, but Sartre has apparently called it off (*Situations*, IX, p. 10). Sartre no longer plans to write the fourth and concluding volume of the study of Flaubert.

17. *Critique de la raison dialectique* (Paris: Gallimard, 1960), p. 9.

18. "Itinerary of a Thought," *New Left Review*, no. 58 (November–December, 1969), p. 43.

19. Ibid., pp. 43–44.

20. *Situations*, IX, p. 99.

21. Ibid., p. 118.

22. *On a raison*, p. 17.

23. Ibid., p. 68. For Sartre III, "Matter alone . . . retains meanings," rendering them at once "effective" and "inert" (*Critique*, p. 244).

24. *L'Etre et le Néant* (Paris: Gallimard, 1943), p. 628. With respect to the influence of his own writings on "the Other," Sartre maintains his commitment to development and his aversion to the inert. Accordingly, he repudiates the too-faithful disciple who instead of developing would "begin all over again what I have done" (*Situations*, IX, p. 26).

25. Further encouragement for adopting a developmental approach was my reading in typescript the sympathetic and incisive study of *Jean-Paul Sartre* (New York: Viking, 1975), in which Arthur Danto rejects this approach in structuralist language Sartre himself could hardly endorse: "My approach is structural and synchronic, treating Sartre's system timelessly, disregarding in favor of logical reconstruction such interesting questions as the development of the system in Sartre's thought."

26. Simone de Beauvoir, *La Force des choses* (Paris: Gallimard, 1963), p. 369. Sartre's political conversion was signalized by his publication of the first two installments of *Les Communistes et la paix* in 1952, but as Mme. de Beauvoir implies, it involved a philosophical conversion to Marxism that was sketched in his 1957 article in Polish on "Marxism and Existentialism." This article appeared in revised form the same year as *Question de méthode*, which was in turn republished as a preface to the *Critique* in 1960.

27. *Situations*, IV (1961), p. 196.

28. This dialectical procedure is of course traditional; cf., e.g., Plato, *Euthyphro*, 11E.

29. *Situations*, III (1949), pp. 75–77. The article appeared originally in *Le Figaro* with the title, "Comment on fait un bon Américain."

30. The "internal disequilibrium" of the family of which Flaubert was the idiot is partly explained by its being similarly poised dialectically at a half-way point in a process of social transformation: it is "half bourgeois, half rural" (*L'Idiot*, 3:34).

31. *Situations*, VII (1965), p. 58. I do not pretend to come to grips with Sartre's Marxism or with the way his Marxism may be presumed to be involved with the development of the "objective spirit." I am merely concerned with traits of his philosophy that survive his conversion to Marxism.

32. *Critique*, p. 25.

33. Ibid., p. 35.

34. *Les Mots*, pp. 197–98.

35. Consider Sartre's own appraisal: "Psychoanalysis has no principles, no theoretical basis; in Jung and in certain works by Freud it is merely accompanied by a mythology which is completely innocuous" (*Critique*, p. 47). This appraisal may clear the decks for Marxism to take over and provide "principles" and a "theoretical basis" that might encompass psychoanalysis as well, in a fashion compatible with Sartre's viewing himself as having "shoved" a "bourgeois" doctrine "into his own soul." Yet the appraisal seems too brusque a denial, not only of the theoretical significance which Sartre attributed to psychoanalysis when he found it worthwhile to attack Freud's resort to an unconscious (*L'Etre et le Néant*, pp. 88–93), but also of the theoretical significance Sartre still attaches to the differences between his own concept of *le vécu* (see above, p. 74) and Freud's unconscious. Moreover it seems rather inconsistent for Sartre to attack Freudian analysis as a reductive explanation that undermines the "autonomy" of higher-level "configurations" (for example, Sartre complains that Freud treats the relation of one adult to another as not merely "conditioned by" but also reducible to his childhood relation to a "primitive object" [*Situations*, IX, pp. 107–8]), for a reductive explanation can hardly be carried through without some theoretical justification.

36. I am not concerned to compare Sartre's analysis with Freud's but rather to use Sartre's upholding the "autonomy" of higher level "configurations" (i.e., experiences and performances) against Freudian reductionism (as well as against Marxist reductionism—see above, p. 77), in order to justify my rehabilitating the distinctively philosophical configurations which are handled reductively by Sartre himself. Indeed, sometimes Sartre's explanations of such philosophical issues as the development of his own philosophy seem obviously psychoanalytic. (What other explanation is available for the discontinuity of this development besides the humorous reference to his soul's operating like a *moteur à explosion* in the matter of his moral and intellectual performances?) Consider the explanation already cited: "The fundamental question here is, of course, my relation to Marxism. I shall try to explain *au-*

tobiographically certain aspects of my early work" (above, p. 60; my italics now added). Consider too the frequently psychoanalytic explanation of the political and philosophical issues in dispute between him and Merleau-Ponty (*Situations*, IV, esp. p. 258), which sometimes gives one the impression that, politically and philosophically speaking, both may have been irrelevant.

37. *Situations*, IV, p. 249. Sartre is referring to his writing of the first part of *Les Communistes et la paix* (see above, note 26).

38. This is Sartre's own claim: "We are all Christians, even today; the most radical disbelief is still a Christian atheism" (*L'Idiot*, 2: 2124). Sartre seems not to have worked out the differences between Marx and himself that would explain why, in his own philosophy, false consciousness fostered so drastic a cultural lag.

39. *Situations*, VI (1964), p. 274; my italics.

40. *On a raison*, p. 114.

41. In translating Hegel's *aufbewahren* as "preserve" one always laments one's failure to bring out the fact that "truth" is at stake. It is equally at stake in Sartre's dialectic, though no corresponding pun can be achieved in French. The destructive moment is usually identified in Sartre as an *échec*. For the frustration of the experience of the viscous (or slimy) as "halfway" between the fluid (the developing in its freest form) and the inert, see *L'Etre et le Néant*, pp. 668–670. There must be at least a hundred instances in *L'Idiot* where some feeling of disgust or malaise is analyzed to disclose the opposites that have interpenetrated. I cite one definition of syncretism itself—"a synthesis which remains a matter for dreaming, and because it has not been preceded by an analysis or a phenomenological description, is in fact merely an unstructured multiplicity of interpenetration" (2: 1703). Employing his analysis, which is at once phenomenological and dialectical, Sartre is able to take a single paragraph from Flaubert and "discover in this paragraph the simultaneous exposition of two points of view which are confused by Flaubert's habitual syncretism" (3: 453).

42. *Situations*, I (1947), p. 31. Hegel defines "assimilation" as "the enveloping of the externality within the unity of the subject" (*Philosophy of Nature*, sec. 363). To the example of the Frenchman being assimilated in America can be added another example of the process of assimilation where it is also a matter of individuals becoming fused together and thus confused. The anti-Semite is a conformist too. He "is nostalgic for those periods of crisis when the primitive community reemerges suddenly and reaches the temperature for fusion. His longing is to have his personality melt suddenly into the group" (*Réflexions sur la question juive* [Paris: Gallimard, 1954], p. 35). There is perhaps a difficulty in reconciling Sartre's epistemological and sociological misgivings over melting pots—whether synthetic truths, or Franco-Amercians, or anti-Semites are being manufactured—with what is usually interpreted as his enthusiasm for the *groupe en fusion* (*Critique*, pp. 384–434), but his enthusiasm lasts only so long as the fusion is developing and overcoming the serial relation between inert individuals. He cannot be interpreted as enthusing over political efforts to consolidate the group, any more than he does over the "rock" that the Franco-American will become. In any case, there seems to be some analogy between Sartre's commitment in his epistemology to the moment of truth (which is also the moment of conversion, inasmuch as "to understand is to transform oneself, to transcend oneself" [*Critique*, p. 23, where Sartre contrasts his failure as a student to understand Marx with his later conversion]) and his commitment in his sociology to the *groupe en fusion*. (The group's fusion is the lightning striking [*Critique*, p. 384], just as in the description of his conversion [cited above, p. 65].) Thus if there is a difficulty in reconciling Sartre's enthusiasm for sociological fusion and his misgivings over sociological fusion, it may perhaps be correlated with the difficulty of reconciling his epistemological commitment to phenomenological immediacy with his epistemological commitment to dialectical mediations.

43. *L'Imaginaire* (Paris: Gallimard, 1940), pp. 229–30.

44. Ibid., p. 230.

45. Ibid., p. 231.

46. Sartre is similarly self-denigrating when he characterizes his own soul as a *moteur à explosion*. A ferociously grotesque specimen of such mechanization is his interpretation of Madame Bovary's seduction in terms of the behavior of the moving cab in which it is being transacted (*L'Idiot*, 2: 1277–83.).

47. *Situations*, VI, pp. 26–27; cf. *Critique*, pp. 30–31.

48. *Critique*, p. 167.

49. Ibid., p. 364.

50. *Situations*, VI, pp. 38–39, 43; *Situations*, IX, pp. 240, 242, 251.

51. The reflexive twist that the phenomenological approach reinforces in Sartre's existential dialectic survived even when Sartre was most faithfully a fellow-traveler in *Les Communistes et la paix*: "One cannot struggle against the working class without becoming the enemy of mankind and of oneself" (*Situations*, VI, pp. 86–87). When Sartre repudiates Stalinism, this subjective reference becomes "an endemic weakness [from the Stalinist viewpoint] whose other name is treason" (*Situations*, VI, p. 46), and he then demands that "class-consciousness . . . become again a consciousness" (ibid., p. 68)—i.e., regain (I would interpret) a phenomenological grip on itself.

52. Martin Heidegger, *Sein und Zeit* (Tübingen: Max Niemeyer, 1927), p. 134.

53. *L'Etre et le Néant*, pp. 338, 404.

54. *La Nausée* (Paris: Gallimard, 1938), p. 168. There are differences which I am not taking into account between Sartre's treatment of nausea in the novel and in *L'Etre et le Néant*.

55. *L'Idiot*, 3: 18. The metaphor of "anchorage" need not concern us, for although it is probably borrowed from Merleau-Ponty, it is by and large the latter's version of Heidegger's *Befindlichkeit*.

56. *La Nausée*, pp. 165–66. There are other features of this vision which do not derive from Heidegger. Though Sartre's conception of *existence* as *de trop* does, his conception of existence as *être-là* is closer to Hegel's *Dasein* than to Heidegger's.

57. *Sein und Zeit*, p. 487.

58. Ibid., p. 375.

59. William J. Richardson, *Through Phenomenology to Thought* (The Hague: Nijhoff, 1963), p. xvi.

60. The collapse itself, as in the vision of *La Nausée*, may betray some debt to the way, in Heidegger, in which "the totality of involvements . . . collapses" (*Sein und Zeit*, p. 186). But in Heidegger no new project emerges in which one becomes reinvolved (even though Sartre's concept of *projet* derives from Heidegger's *Entwurf*), and our behavior in Heidegger is not dialectical (a letting go in order to grasp and a grasping in order to let go). We just let go, or rather things slip away from us.

61. One hopes that Sartre and the Hegelian scholar Jean Hyppolite got matters straightened out on some other unpublished occasion. But their all too brief interchange in 1947 illustrates how Sartre combines a phenomenological concept of immediacy with its dialectical development. Hyppolite challenged, "What I have difficulty in understanding is . . . this stage which is neither the immediate nor mediation." In reply Sartre explained, "Isn't this due to your tendency to adopt the point of view of categories (which moreover *are true*) like those of Hegel, and not the point of view of a *pure* and *simple* discovery (which will *later undergo interpretation*) of the non-thetic consciousness." Sartre went on to adopt the point of view of Husserl as "the first philosopher to have discussed [this] dimension which is distinctive of consciousness . . . and is not a kind of indefinite progress of the mind . . . but a consciousness of itself" that is "given *without movement*" (*Bulletin de la Société Française de Philosophie*, no. 3 [1948], pp. 88–89; my italics added to point up the apparent discrepancy between Sartre's phenomenological conception of immediacy and his dialectical conception of mediations).

62. "It is necessary," Sartre II explains, "to carry through a synthesis of Husserl's consciousness, which is contemplative and undialectical, and only leads us to the contemplation of essences, with the activity of the dialectical project, which lacks consciousness and thus remains without foundation, which we find in Heidegger" (*Bulletin*, p. 76). In my interpretation of *L'Etre et le Néant*, this synthesis is not carried through to an Hegelian *Aufhebung*, any more than is the synthesis between being and nothingness itself.

63. *Situations*, IX, p. 108.

64. Ibid., p. 112. The concept itself appears as early as *Théorie des émotions*, p. 53.

65. Ibid.

66. *L'Etre et le Néant*, p. 93.

67. Blindness, as well as its sudden dislocation in "moments of truth" not only are features of individual experience but also can be generalized to a social class, as in the following dialectic: "They saw nothing, they understood nothing, they thought they were acting but they did nothing, or rather they let loose forces they could not control and achieved the opposite of what they wanted. . . . Their hopes of '48 were 'dreams'; the reality is their double setback [*échec*], which suddenly reveals the truth of history, of societies, of man" (*L'Idiot*, 3: 255).

68. With regard to the irrationality of the emotions, see Sartre's comment that "all emotions have this in common . . . that the relation of things to consciousness [which they involve] is always and exclusively magical" (*Théorie des émotions*, p. 56).

69. The climactic reversal is, of course, the moment when I become conscious of myself as someone whom the other is conscious of (*L'Etre et le Néant*, pp. 275–364).

70. *Théorie des émotions*, p. 58.

71. *Situations*, IX, pp. 84–85. In this context Sartre is thinking primarily of the science of economics and the anthropological sciences, as contrasted with phenomenology. "Husserl's conception of philosophy as a *strict science* seems to me," Sartre admits, "an inane conception" (ibid., p. 70).

72. Recall that the metaphorical character of the melting pot was played up dialectically by Sartre's taking it literally: "I had heard of the famous American 'melting pot' that transforms, *at different temperatures,* Poles, Italians, and Finns into American citizens" (above, p. 62; italics now added). Recall too how Marxist technology gained a reflexive metaphorical dimension in Sartre, inasmuch as the individual uses his own body as a tool for using the tool (above, p. 70).

73. *Situations*, IX, pp. 67–69.

74. Ibid., p. 13.

75. Ibid., p. 93.

76. *Critique*, p. 44.

77. *L'Idiot*, 2: 1199.

78. Ibid., 1: 7; 2: 1503–4.

79. Ibid., 2:1199.

80. *Situations*, IX, p. 116. In Sartre's bilateral dialectic, his reflexive criterion applies not only to the way "Flaubert is opposed to himself," but also the way Sartre attempts to understand: "The only way of making progress in understanding is to put oneself at a juncture where one is oneself involved and the investigation challenges the investigator" (*L'Idiot*, 2: 1204).

81. *Situations*, IX, p. 117.

82. *L'Idiot*, 3: 179. The history of literature Sartre offered in answering the question *"Qu'est-ce que la littérature?"* (*Situations*, II [1948]) was his first important venture into social history. Similarly, the place that was to have been accorded social history in the second unpublished volume of the *Critique* has been taken by the social history of literature in the third volume of *L'Idiot*. The dialectical relation between writing and reading was also first examined in *"Qu'est-ce que la littérature?"* *Les Mots* is divided into two parts, "Reading" and "Writing."

83. *L'Idiot*, 1: 182.

84. *Situations*, IX, p. 37. *"Qu'est-ce que la littérature?"* had already stressed the creative role of the reader as compared with that of the writer (*Situations*, II, pp. 98–103). The theme is renewed in *L'Idiot*, 3: 324–26. It ties in, of course, with the notion of the precedence the other gains over me, inasmuch as I can never become an object for myself, nor can the book I write.

85. See p. 60.

86. *Critique*, p. 96. Sartre has transferred to man as *l'être signifiant* the intentional function reserved for consciousness in Husserl. See also his pronouncement that man "has the structure of a sign" (*L'Idiot*, 1: 151), and his assertion of "the homogeneity of the word with all the objective and subjective determinations of man" (ibid., p. 23). Sartre's reduction of the problems of interpreting Flaubert to a "level where every language is a man and every man is language" (*L'Idiot*, 1: 21) is presupposed by his conclusion that Flaubert became *l'idiot de la*

famille largely from the frustration of learning to read a language he felt to be alien. Will Sartre similarly come to a conclusion that American contributors to this volume are *idiots* as readers struggling with an alien language? Probably not, since *L'Idiot* is well sprinkled with anglicisms.

87. *La Transcendance de l'ego* was written while Sartre was a student in Berlin in 1934; it was republished in 1965 (Paris: J. Vrin).

88. See above, p. 55. Heidegger has accused Sartre of this reversion (*Brief über den 'Humanismus'* [Bern: A. Francke, 1947], p. 7), but Heidegger's knowledge of Sartre seems largely restricted to *L'Existentialisme est un humanisme,* a work Sartre discounts.

89. *L'Etre et le Néant,* p. 29. Sartre's combination of Husserl's analysis of consciousness with Heidegger's analysis of existence (*Dasein*) is illustrated by this formula (*L'Etre et le Néant,* p. 29), which conflates Heidegger's reflexive formulation of the question of *Sein* by reference to *Dasein* (*Sein und Zeit,* pp. 5–7) with the reflexive sense in which *Dasein* in the French translation is a being whose being is "in question" (ibid., pp. 42, 44). In the German original *umgeht* refers not to a consciously entertained question but rather to what is "going on" with *Dasein* (or what it is "going about"), which would exceed the scope of consciousness, as is indicated by Heidegger's ensuing analysis of its *Umgang* (ibid., pp. 66–76). Sartre's formula survives in his last work where he refers to "the being in question of man" and to "the question as the ontological structure of human reality" (*L'Idiot,* 3: 223).

90. *L'Etre et le Néant,* p. 663.

91. Baudelaire and Flaubert are linked for Sartre as "the two men . . . who forged modern literature" (*L'Idiot,* 2: 1621–22).

92. *Situations,* IX, p. 11.

93. See above, p. 55.

2

Robert Champigny
SARTRE ON SARTRE

IN *The Words,* in his reminiscences of Nizan and Merleau-Ponty, and in scattered passages elsewhere, Sartre has given some biographical details and made psychological remarks about himself. In published interviews he has discussed his writings. In his essays are passages in which the first person plural stands primarily for the first person singular; and readers who do not endorse the hypothetical examples he proposes will interpret them as bearing on Sartre whether the first person singular is used or not. Some characters in the novels and dramas may also be viewed as self-portraits. Finally, if the writings of Sartre were examined in the perspective he adopts toward those of Genet or Flaubert, all his publications should be given an equal status as self-definitions.

My attention will focus on *The Words,* but there will be many allusions to other texts as well. In itself and in its connections with other publications, *The Words* will be considered a sort of turntable.

I

In *Saint Genet* (p. 132)* Sartre declares that understanding men is his passion. The bulk of his writings testify to this orientation. In his literary and artistic criticism, he has endeavored to view the products as more or less veiled expressions of existential projects. *Being and Nothingness* (1943) is solely preoccupied with "human reality" and it sketches a method of comprehension called "existential psychoanalysis." In this essay, the term "existence" is reserved to the human condition, which was not the case in *Nausea* (1938). *Critique of Dialectical Reason* (1960) modifies the perspective, stressing need rather than desire, animal fear rather than the *angoisse* that pervades the experience of responsibility, the ruses of History rather than those of bad faith, I-we rather than I-thou relationships. But in both cases, intersubjectivity is strictly human and understanding is aimed at

* A bibliography of Sartre's works, in French, is given at the end of this article.

what is specifically human. The most extensive applications of the theory are to be found in the lengthy introduction to *Genet* (1952) and the huge philosophical biography of Flaubert. The following quotations are taken from the preface to the "Flaubert" (I, p. 7):

> What can be known of a man, today? . . . What do we know, for instance, of Gustave Flaubert? This amounts to *totalizing* the information at our disposal. There is no proof, at the start, that this totalization is *possible* and that the truth of a person is not plural; the pieces of information are quite different in nature. . . . Do we not run the risk of being left with heterogeneous and irreducible strata of meaning? This book attempts to prove that irreducibility is only apparent, and that each piece of information put in its place becomes a portion of a whole which does not cease to make itself. Thus each part reveals its deep homogeneity with all other parts.
>
> For a man is never an individual; it would be better to call him a *singular universal:* totalized, hence universalized, by his time, he retotalizes it by reproducing himself in it as a singularity.

According to these extracts, Sartre's "passion" would involve the following claims, or postulates: the comprehension of a person is not falsified by words; a discourse that arranges and interprets the data so as to express a unifying comprehension of a man as a whole can be true (hence of two discourses that express different comprehensions, one at least must be false); since the method is not scientific (we are not dealing with what a brain model could yield), the possibility of this kind of "truth" is the possibility of a correspondence between the organization of the discourse and the way the person chosen as a topic tried to com-prehend himself. The postulate that an ever-renewed attempt to totalize oneself is a characteristic of human existence is spelled out in a passage of the "Flaubert" (I, p. 653):

> Perpetual totalization appears as a defense against our permanent detotalization, which is a ruined unity rather than a pure diversity. For, in human reality, multiplicity is always haunted by a dream or memory of synthetic unity; thus it is detotalization itself which demands to be retotalized, and totalization is not a mere inventory followed by a statement of totality, but an intentional and oriented enterprise of reunification.

Since synthetic unity is only a dream, the inaccessible goal of repeated efforts à la Sisyphus, it cannot constitute the unity of a man through synchronic and diachronic diversity, unless there is something peculiar and constant in the ways a particular man is supposed to keep striving after this Hegelian carrot. Is this what is meant by the distinction between "person" and "individual" in the preface to the book on Flaubert?

I assume that "individual" alludes to the postulate of a spatio-temporal continuity that allows an inanimate body, or a living organism, to be considered as *one* process. Normally, we are content to rely on this principle of

individuation in order to think of a human being as one person; the logical question becomes bothersome only in cases of split personality, possession, mediumistic behavior. When a sharply schizophrenic individual gives two names to his two *personae,* he raises the question of a sui generis principle of identity regarding *personae* (spirits, souls, wills), a principle that would enable *personae* to be clearly distinct from individuals as well as from universals (nonpersonified properties) and from poetic atmospheres.

The claim that a man is never an individual is hard to swallow: "never just an individual" would be more palatable. After all, Sartre must depend on material individuation to isolate his topic as a man named Gustave Flaubert, or to write "I" when, in *The Words,* he refers to a child named Jean-Paul Sartre. But something else is involved when he writes: *"I was* Roquentin" (*Les Mots,* Folio ed., p. 211). This statement appeals to a principle of identification which is not that of material individuation.

The Words was published in 1964. Publication of the "Flaubert" started in 1971; but its preface links it to the procedure sketched in *Question of Method,* which first appeared in 1957. One might expect *The Words* to be another application of the same procedure.

Writing about someone who is still alive should present no insuperable obstacle: the purpose of a totalizing discourse is not to present a man as a constituted whole; it is rather to show self-totalization as a perpetually renewed goal. Nor should the fact that, in *The Words,* Sartre is concerned mostly with his childhood present any obstacle. Many sentences in *The Words* refer to the present. Besides, what is written about the child is not written by the child. According to Sartre's principles, the way he pictures his childhood should reveal the way he tries to totalize himself at the moment he is writing.

One may even conclude that writing about oneself disposes of certain objections. Although what we remember about ourselves is very small in comparison to what we have lived second after second, that memory still offers more data from which to draw a representative sampling than any source can tell us about others. Furthermore, when Sartre tries to totalize Flaubert explicitly, he must be trying to totalize himself implicitly. Thus the question "What do we know of Flaubert?" would become "How is Sartre going to totalize himself at this stage of his life through writing about Flaubert?" In the case of *The Words,* we should be dealing with a straightforward self-totalization, conducted by the man responsible for the doctrine.

On the other hand, this reflexive tightening bids fair to lead to a relativization. If *The Words* is to pass for an application of the method, it should totalize Sartre as, among other things, the deviser of the method. It should bear, for instance, on the preface to the "Flaubert" which, although

published seven years later, belongs to a major Sartrean tendency.[1] What if *The Words* totalized Sartre as a totalizing maniac? The application would short-circuit the method.

The relativization that is to be found in *The Words* is not as simple as that. Besides, I do not want to suggest that *The Words* stands on one side and the rest of Sartre's writings on the other. It may be noted, for instance, that the Roquentin side of Sartre (*Nausea*, 1938), which seemed to have been stifled in *Existentialism Is a Humanism* (1946) and in *Critique of Dialectical Reason*, emerges again in *The Words*.

II

What I have just written is false. True. Neither true nor false, like everything that is written about madmen, about men. I have reported the facts as accurately as my memory allowed. But to what extent did I believe in my delirium? This is the fundamental question and yet I do not settle it. Later on, I realized that everything can be known about our affects, except for their strength, that is to say, their sincerity. Even actions will not be decisive unless it is proved that they are not gestures, which is not always easy.

This extract from *The Words* (p. 61) appears to be in opposition to the claim about "truth" in the preface to the "Flaubert." But the assimilation of men to madmen suggests a possibility that turns the contrast into a qualification. Another passage in *The Words* concerns a psychopath who insists that he is a prince and confesses, almost in the same breath, that he is a shoe-mender. Writes Sartre: "We are all like this man, I presume; at any rate, at the age of nine I was like him: I was a prince and a shoe-mender" (p. 175). According to another passage, wherever the child Sartre was physically, he remained in the family library *"in person"* (p. 53).

A totalizing discourse would be about a man to the unverifiable extent that he is "mad," that he confuses himself with the *persona* he performs, internally or externally. To understand a man is to understand the logic of his madness. Attempts at self-totalization are attempts to mythicize, or fictionalize, oneself. If there is a personal identity, as distinct from an individual identity, it must be found in the role that is played, or in the way in which roles are played—a difficult, perhaps idle, distinction, since in this case the roles are not written out beforehand.

Different interpretations have been proposed for Hamlet, according to different patterns of explanation, different quotations, different emphases, different ways of understanding the same sentences. Which interpretation is true? At least they all deal with one complete text. The reduction of the data alluded to in the preface to the "Flaubert" means, first of all, that an interpretation of Flaubert as a whole must proceed as if it were dealing with a pre-established dramatic script.

A biography might be conceived as an extended *curriculum vitae* designed to adhere to a fairly pure narrative style. In that case, the prevalent logic would be that of material individuation. This is not the stylistic strategy adopted in *Saint Genet*, in the work on Flaubert, or in *The Words*. There, in accord with a stress on *persona* rather than on individual, the narrative parts are reduced to stage directions. The rest appears as an inner monologue, or as an analysis of an assumed monologue.

Drama thrives on a reduction of diversity to simple contradictions and conflicts, and on a dialectic that differs both from the logic of concepts (analysis) and from that of individuals (narration). In a way, as suggested by the phrase "singular universal," self-totalization would be an attempt to bridge the gap between universals and individuals. The entities that Plato used to span the *khorismos* were spirits, *daimons;* "myth" was the type of discourse that set them up.

At least since *Being and Nothingness* (bad faith is self-hypocrisy), Sartre's conception of the human has been predominantly meta-dramatic.[2] The book on Genet provides the most brilliant application of this kind of understanding. The meta-dramatic framework equates two dichotomies: being-nothingness and good-evil. The impossibility of making conceptual sense out of this assimilation impels the dramatic dialectic of the Sartrean Genet. Genet is pictured as someone who, through situation and decision, lives in critical fashion the mock-Platonism (or Manicheism) of a society. He turns this mock-Platonism against itself by identifying non-being and evil with beauty. In the book on Flaubert, the framework of interpretation becomes somewhat syncretic; it tries to absorb Freudian and Marxist terminologies in particular. Details, characters, digressions accumulate to such an extent that the meticulous attempt to comprehend a man results in a book that defies my limited ability to comprehend.

The Words is fairly short. It is not cluttered with characters. In the foreground are two protagonists, child and grandfather; in the background, fleeting apparitions; in the middle ground, a mother and a grandmother. There are many narrative bits, but they do not coalesce into one narrative. Sometimes they are used to set up scenes; always they are a springboard for reflections: special judgments or quick generalizations, as in the passage about men and madmen. These reflections are the major stylistic component of *The Words*. But there is no strong theoretical framework, and there are no long explanations and digressions. In spite of dramatic devices (oxymoron, synecdoche, hyperbole, in particular), the books on Genet and Flaubert remain essays, while *The Words* is more conspicuously a monologue. The basic character is neither the child nor the grandfather after all, but the speaker, the reminiscing "I".

This monologue is assiduously ironical and full of verve. The objective often appears to be a piquant formula in the *moraliste* tradition. We are treated to a number of antithetic aphorisms, such as: "The more absurd is life, the less tolerable is death" (p. 84); "Since I lost my chances of dying unknown [*inconnu*], I sometimes hope to live misunderstood [*méconnu*]" (p. 213). The game even turns to parodies of classical Alexandrines: "Il adorait en moi sa générosité" (p. 23); "Je feins d'être en péril pour accroître ma gloire" (p. 26); "L'inceste me plaisait s'il restait platonique" (p. 49).

Primed by various anecdotes, the short reflections are apt to fly in various directions. Sometimes this diversity produces a minor inconsistency. On page 16, the father "tried to take refuge in death"; on page 19, "he wanted to live, he saw himself die." On page 140, Sartre detests his childhood; on page 130, he is sorry he lost the tales he wrote as a child, for they would give him back all his childhood. On page 25, the child is spared "this harsh apprenticeship, jealousy"; on page 43, he is jealous of his mother.

Sartre's insistence on his "levity" (p. 20) invites his readers not to absorb his writings, in particular *The Words*, docilely. His taste for counterfactuals may be cited as an example of stylistic levity, or playfulness. For instance: "If Charles had exclaimed from afar: 'Here comes the new Hugo, the future Shakespeare!' I would now be an industrial draftsman or a professor of letters" (p. 134). Why not a hobo or a president of the Republic? Not to be gratuitous, such counterfactuals would have to be construed as applications of some general law: "If an entity belonging to the Jean-Paul Sartre class is told: 'Here comes the new Hugo,' then this entity, as proved by experiments, becomes an industrial draftsman or a professor of letters." The speaker partly attributes his levity to the fact that he was an infant when his father died. On page 19, this assumption is presented in counterfactual form: "Had my father lived. . . ." The choice of a cause of levity may itself be viewed as an example of levity.

Other passages directly tie singular event to singular event (destiny), instead of appearing to apply some law (causality). From scattered assumptions of such ties, the speaker jumps to this global assertion: "Thus my destiny was forged" (p. 138). But the child is also presented as someone who felt a lack of justification and who, in compensation, tried to imagine his future as a destiny similar to that of heroes of adventure stories. Hence a merry-go-round (in Sartrean terminology, a *tourniquet*): the destiny of Sartre was to believe in destiny. Another passage (pp. 168–69) criticizes the interpretation of a man at a certain stage of his life in the light of what is known about later stages. A "retrospective illusion" post-destines anterior events so that they appear to pre-destine posterior events. This can be done

with words; to some extent, this is done in *The Words*. The retrospective illusion is now supposed to be "in pieces" (p. 212). "Thus my destiny was forged" is a pretty big piece.

And then there is the declaration that what is written about madmen, about men, is neither true nor false. It invites the reader to consider as fiction much of what is said not only about Sartre the child, but about Sartre the adult. For instance, the emphasis that accompanies the disclosure of what the author was covertly seeking when he wrote *Nausea* ("quite sincerely, believe me," p. 211) is directly undermined, since it is precisely the possibility to ascertain sincerity which has been questioned. "In the last ten years or so, I have been a man in the process of waking up, a man who has recovered from a long, bittersweet madness" (p. 212). Since a man is a madman, one is led to wonder within which other dream, or madness, this "waking up" is taking place. One might venture to say that instant Parisian glory forced Jean-Paul Sartre to be a madman who thought he was Jean-Paul Sartre, at least when he wrote.

Some passages even undermine the assurance that the facts are reported as accurately as memory allowed. Take the report of a talk with the grandfather, which is supposed to have catalyzed a literary vocation (p. 133). "He sat me on his knees and spoke with gravity. I would write, that was agreed; I knew him well enough not to fear that he would stand in the way of what I wanted. But I had to face reality lucidly: literature did not pay." So far so good. We are given a summary that sounds faithful; a verbatim report would be more suspicious. But what follows capitalizes on *discours indirect libre* in order to leave the launching pad. Both teaching and writing are called a *sacerdoce*. It is doubtful that the grandfather used this word; it fits too conspicuously with the way the grandfather, on the one hand, and the child's literary vocation, on the other, are pictured. And here is how the report ends:

> I would cheer my provincial solitude with the composition of poems, a translation of Horace in blank verse, I would contribute short literary notes to the local newspapers, a brilliant essay on the teaching of Greek to the *Revue Pédagogique,* another on the psychology of adolescents; after my death, unpublished material would be found in my desk, a meditation on the sea, a one-act comedy, a few learned and sensitive pages on the monuments of Aurillac, enough to make up a plaquette which my former students would publish.

Elsewhere (p. 75) it is said that, through his theatrical behavior, the grandfather taught that "Truth and Fable are the same thing." The way his speech is rendered thus would indicate an ironical faithfulness to his teaching. But what about this claim that the grandfather taught the identity of

Truth and Fable? Is it a true claim, or is it false? Rather, it is neither true nor false.

The Words can thus be made to yield paradoxes in a philosophical sense: variants of the Liar. This paradox depends on the postulate that Epimenides, who talks about all Cretans, is himself a Cretan. Similarly, The Words would not yield paradoxes if the text were entirely interpreted as fancy, and the "I" as a pseudo-character in the manner of Beckett (The Unnamable), Des Forêts (Le Bavard), or even Camus (The Fall). One might then be content with a fictional voice, or voices, dreaming up a fictional past. But for me at least, and for the purpose of this essay, the "I" also refers to a real individual who wrote The Words, the same individual as the child who is talked about and as the author of other books I read.

Instead of extracting paradoxes, one might, I suppose, prefer to view The Words as setting up inner conflicts that could serve to launch a dramatic dialectic. Was this the way the sequel of Sartre's autobiography, announced on page 211, was planned? In The Words he notes some inner discrepancies, but he avoids stylizing them as sharp conflicts, thus: "The abstract postulation of my necessity and the immediate intuition of my existence subsist side by side without antagonism or fusion" (p. 206). Alluding to heroes of adventure stories, he says he depends on them. But "they depend on God and I do not believe in God. Try to make sense out of this; I can't" (p. 213). He also wonders whether he has not always written in order to please his grandfather (p. 139). But he does not decide; he is content to offer this comic bait to others, this possibility of unifying his writing personae.

The comparisons I am going to draw between The Words and other writings of Sartre will not be ordered so as to give the impression of a spiritual itinerary. Such a stylization would involve either considering The Words as one stage or lumping it with Critique of Dialectical Reason or else with the book on Flaubert. This is not the way I see it. I shall be content to comment on some traits which I find striking. I have to resist the temptation to make my essay cohere by making its topic coherent at any cost, either dramatically or analytically.

If we try to construct a writer as one persona, it is because we assume he is one individual. It would be more fun to play the game of analogy and contrast (inner conflicts) so as to "demonstrate" that the author of The Words is, for instance, the author of Man's Hope. Apart from factual information, what prompts me to assume that two texts are by the same author? A certain feel or taste, whose explicitation would result in heterogeneous remarks on style and content. But I do not think that I should thus be able to recognize the same author in The Communists and Peace, for instance,

and in *Nausea* or *The Words*. Besides, even professional winetasters have
been known to blunder.

III

In several passages of *The Words,* Sartre speaks of his "idealism."
Originally, this idealism is supposed to have been Platonic: "I ascribed
more reality to the idea than to the thing" (p. 46). It is a naive kind of
Platonism, a Platonism of linguistic labels and dictionary definitions. In
Nausea, the opposition between "being" and "existence" may be related to
this Platonism. Being is associated with words: in the crucial revelation of
existence, things reject their classificatory labels. But this revelation is not
the exalting intuition of a Bergsonian *élan vital:* it produces only nausea,
replaced, at the end, by a vague poetic impression. Value remains on the
side of being. However, it is no longer truth, it is only beauty. This mod-
ification of Platonism is accompanied by a Romantic shift: what fascinates
Roquentin is neither the dictionary nor the "little sense" that may float
over things, but a song, or the stylization of a human life as an adventure.
The Words dwells on the child's love of adventure stories and on his private
performances of heroic roles. Furthermore, "the crazy blunder of mistak-
ing life for an epic" (p. 101) is said to have bedeviled Sartre for a long time.
In *Nausea,* Roquentin formally rejects it: "Adventure is in books." But he
effects a compromise reminiscent of Symbolism, more particularly of
Proust. The singer and the songwriter are not the song; they are not in the
aesthetic world of the song; yet, somehow, they are supposed to be "saved"
through the song. On the last page, Roquentin accordingly proposes to
write a book which, "in the past, only in the past," will transmute his unjus-
tified existence into a "steely" adventure. Unable to fictionalize himself in
the present, he will fictionalize his past. A similar shift is mentioned in *The
Words:* "I slipped to the writer the sacred powers of the hero" (p. 142).
However, Roquentin is not allowed to write his redemptive book: an
"editor's note" conveniently kills him and all that is left is his diary. From
Roquentin's standpoint, this diary, *Nausea,* cannot pass for the projected
book. What about Sartre's standpoint? *The Words* proposes an answer: "*I
was* Roquentin, through him I showed the web of my life without compla-
cency; at the same time I was *I*, the chosen one, the annalist of Hell, a
photomicroscope of glass and steel focused on my own protoplasmic
syrups" (p. 211).

IV

In *The Words* Sartre labels himself a "convinced materialist" as well as
an "epic idealist" (p. 101). Some commentators of *Being and Nothingness*

were struck by its "materialism": was not consciousness more or less iden-
tified with emptiness, with a lack of being? Was not being-in-itself best
revealed by material things? But consciousness is empty like a conjurer's
hat: meaning, temporality, freedom, responsibility spring out of it like
doves (compare Descartes' *tabula rasa*). However, consciousness does not
provide a personal identity. A mystic presence to itself and the world, it is
supposed to justify the pseudo-definition of human reality as being what it
is not and not being what it is. It is subjectivity without a subject: the ego,
or egos, are objects.[3] Consciousness embodies itself, but material individu-
ation does not define a man: I ex-sist my body.

The quarrel with Freudianism stems from a lack of correspondence
between consciousness versus ego on the one hand, conscious ego versus
unconscious on the other. Besides, the Sartrean schema provides no room
for a superego. In *The Words* one can read: "I have no superego" (p. 19).
This time, however, "I" means "Sartre" rather than "human reality." As
consciousness, I experience choosing; as ego, I am chosen. Decisions may
thus be lived as visitations of the spirit of freedom summoning an ego.
Compare, in *The Words,* the theme of the mandate: "I could not draw from
myself the imperative mandate which would have justified my presence on
earth, nor grant to anyone the right to deliver it to me" (p. 114).

In *The Flies,* Orestes exclaims that freedom "has swooped down" on
him. He assumes the mandate: he kills (in the wings, so that killing may not
look like play-acting). But that is not all: in order to ensure, in words, a
synthesis between what summons and what is summoned, he mythicizes
himself as a Romantic Prometheus–Jesus–Lucifer, in convenient opposi-
tion to a Jupiter who, unfortunately, cannot be taken very seriously as a
rejected superego. If we superimpose *The Words* on the last act of *The
Flies,* Orestes will appear as a madman who insists on mistaking Sartre's
grandfather for the Zeus of Aeschylus or the Biblical Jehovah.

At the time of my first reading of *The Flies* I wondered why an atheistic
thinker should make Jupiter a character whom Orestes needs as an obliging
compère, should make him indeed *the* main character in his play, since he is
the only one who communicates with everyone: he is the objective spirit;
without him, the drama would fly to pieces. I could understand the device
as a bait to Christian critics who, as a matter of fact, kept dutifully busy in
the forties building the fame of a Luciferian Sartre. I could also understand
a desire to reach spectators still caught in a theological conception of ethics.
But why does not Orestes simply dismiss Jupiter as a phantasm, as an em-
peror with no clothes? This was to happen in *Lucifer and the Good Lord*
(1951), but there Goetz, the fearless adventurer, was to take a compla-
cently long time stripping the emperor. I know, the play is set in the six-
teenth century; but why? *The Words* offers an answer. Atheism is not taken

for granted. It is "a long and cruel enterprise: I think I have pursued it to the end" (p. 212).[4]

There is something quite traditional in the relation between ontology and ethics sketched in the last pages of *Being and Nothingness*. But the precept "according to nature" would become: "according to the lack of nature." Authenticity would consist in taking the origin of value (freedom) as the value *par excellence*. This precept implies the assumption of one's moral responsibility, the recognition that one has to decide what is good. But it also seems to involve an exaltation of choosing for the sake of choosing, of experiencing one's coincidence with freedom. "Good" and "evil" are left to the language of a theological kind of ethics; at least this is the case in *The Flies, Lucifer and the Good Lord,* and *Saint Genet.*[5] Yet, instead of dispelling mythical smoke screens, the conversion to authenticity is announced as a morality of "salvation" (*L'Etre et le Néant,* p. 484).[6]

In *The Words,* Sartre intimates that he quickly got rid of God as judge, but kept the Holy Ghost. Would he now interpret the ideal of authenticity as a coincidence with the Holy Ghost? As for the judging function, it is taken up by the others, that is to say, by other human manifestations of freedom. In the perspective of *Being and Nothingness,* the others are not animals, human or nonhuman, exposed to suffering. Human only, they are essentially one's own judges, and authenticity would have to take them into account as such. After *Reflections on the Jewish Question* (1946), the theme of authenticity will disappear but the mystique of the human condition will remain. And the theme of judgment, in essays and dramas, will be stressed in such a way as to suggest not only the impossibility of not being judged but also a need to be judged. Appraisal of each other's behavior is the basic interhuman bond.

The Words ends as follows: "My only business was to save myself—with nothing in my hands, nothing in my pockets—through work and faith. . . . If I discard the impossible Salvation, what is left? A whole man, made of all men, who is worth neither more nor less than anybody else." The phrase "nothing in my hands, nothing in my pockets" is a conventional utterance to introduce conjuring tricks. In the case of Sartre, one might add: "Nothing but words." Once salvation is shelved, there remains the human condition. Failing authenticity, playing roles can pass for a human privilege: other animals are poor actors. Besides, they are not permitted to stand as our judges: Vigny's wolf does not belong to Sartre's world.

The distaste expressed in *Being and Nothingness* for the phrase "human nature," the fact that not fear nor pain nor biological need, but nausea and shame, are chosen as the original disclosures of incarnation, finds echoes in *The Words.* I note in particular the passage in which the child makes faces in front of a mirror so as to avoid "shame": he denies he is an animal by

playing his animality. "To no avail. The mirror had taught me what I had always known: I was horribly natural. I never recovered from this" (p. 95). The passage about *Nausea,* quoted above, may be given a similar interpretation: the revelation of raw existence is played, veiled, with words. Man is the animal who masks his animality with language.

<p style="text-align:center">V</p>

The theme of levity, or lightheartedness, in *The Words* may be opposed to the *angoisse* which, according to *Being and Nothingness,* accompanies the realization of one's "total" responsibility. But this anxious concern fits the experience of having to choose rather than the experience of choosing, the coincidence with freedom in the act. In *What Is Literature?* Sartre dwells on the responsibility of writers. In *The Words,* writing appears not as the experience of having to choose what should be written and published, but as the inebriating experience of verbal creation: "I no longer feel anything except for a rhythm, an irresistible momentum, I start, I have started, I am moving, the engine is humming. I experience the speed of my soul" (p. 208).

On page 77, the child "had no soul." Apparently, writing gave him one. The passage refers to the child dreaming his writing role, but it is in the present tense; and the impression which the writings of Sartre most often give me is one of verbal enjoyment, of writing for the sake of writing, of playing a game with no pre-established rules—especially in *The Words,* where this enjoyment parodies itself.[7] Does any ingrained writer experience his responsibility while he is writing?

Consider also these other excerpts from *The Words*:

> In 1948, in Utrecht, Professor van Lennep showed me projective tests. One attracted my attention: a galloping horse, a walking man, an eagle in flight, a bouncing speedboat. The subject was supposed to choose the drawing which gave him the strongest feeling of speed. I chose the boat. . . . In my eyes, speed is not defined so much by the distance covered in a given time as by the power to wrench oneself away (pp. 194–95).

> Born of a future expectation, I leaped, luminous, total, and each moment repeated the ceremony of my birth. . . . I was often told that the past impels us, but I was convinced that the future was pulling me; I should have hated to feel gentle forces at work inside me, the slow blossoming of my dispositions. I had stuffed the continuous progress dear to the bourgeois into my soul and I turned it into a combustion engine; I raised the present above the past and the future above the present, I transformed a quiet evolutionism into a revolutionary and discontinuous catastrophism. A few years ago, I was told that characters in my plays and novels make their decisions abruptly, in a crisis, that, for instance, in *The Flies,* Orestes effects his conversion in a jiffy. No wonder: I make them in my image; not as I am, of course, but as I wanted to be (p. 199).

Arrachement (tearing oneself off) and *dépassement* (moving beyond) are favorite words of Sartre ("totalization" would complete the trinity). Through Orestes in *The Flies,* Mathieu in *The Roads of Freedom,* tearing oneself off appears as an exhilarating experience, not a painful one. Of the two passages about "speed," one stresses the engine, the other what the thrust does to the chassis. The image of the boat fits the theory of temporality in *Being and Nothingness:* temporality is to freedom what the chassis is to the engine.

The treatment of temporality provides Sartre an opportunity to shuffle the spiritualist/materialist cards: time has not usually been associated with transcendence. Sartrean temporality does not grant a "vertical" transcendence to human reality (the boat is preferred to the eagle); but on the other hand, it is not reduced to becoming (which is the time of "things"). Temporality consists of the three *ek-stases* of past, present, and future, which *Being and Nothingness* endeavors to define without having recourse to succession. Causality and destiny rely on an objective, undifferentiated time (before and after). The stress on differentiated time fits the concept of freedom: we are sentenced to freedom because we are not simply temporal objects (processes); we temporalize ourselves and cannot choose not to do so. The moment of "birth" is not a first moment, but the present as zero moment. Yet, before and after should still be needed to give a temporal meaning to "past," "present," and "future." Instead of that, *Being and Nothingness* presentifies the future as project, the past as situation or "facticity" (that is, what one has to wrench oneself away from). To avoid "before" and "after," *Being and Nothingness* uses the "back" and "front" image. The boat suggests "aft" and "fore." The stern is caught in facticity, but the propeller uses it as a springboard. The stem emerges out of the water, and points, if not toward the heavens, at least away from the water. What is enjoyed in the goal is that it is not a result. The future is not on the plane of events; only the past is objectified, reduced to inertia (identification of past and passive participles).[8]

According to *The Words,* Sartre would be quite willing to criticize himself in the past: "To acknowledge my failings with such good grace is to prove to myself that I am now immune to them" (p. 201). He would adopt the tactics of the Publican, but flippantly (in any case, "how wrong I was" implies "how right I am"). The child is said to have preferred "the adventurer to the intellectual" (p. 147). The adult will fashion intellectually tight situations from which to escape (to wrench himself away). In *The Words* Sartre says he likes to think against himself. His awakening from what he calls a "neurosis" could serve as an example. The comment on *Nausea* may also be recalled: the subjectivity that animates *The Words* triumphs over the subjectivity that created *Nausea,* now reduced to an objectified ego.

However, in *The Words* the signified egos catch up with the signifying subjectivity, since Sartre does not simply decide what he used to be like; he also determines what he remains like. Thus, is not thinking against oneself a trait of the self against which he thinks? One of the translations which the book suggests for the ontological principle that existence precedes essence would be that youth precedes old age, as well as death.

If *arrachement* is felt to be effected for its own sake, it must project its own shadow into the future; it must project itself as that which will have to be rejected: "Try as I may to throw myself into what I undertake, into work, anger, friendship, I am about to deny myself, I know it, I want it, I am already betraying myself, in the midst of passion, through the jubilant foreboding of my future treason" (p. 200). This passage from *The Words* calls to mind a remarkable series. Roquentin was not allowed to write his redemptive book. The author of *Being and Nothingness* was not allowed to develop his morals of salvation.[9] Except for a fragment, the last volume of *The Roads of Freedom* has not been published. *The Communists and Peace* and the book on Tintoretto were left unfinished. The second, forthcoming volume of *Critique of Dialectical Reason* has yet to come forth. In *The Words* itself, a sequel was announced, but it has not appeared.

When the first volume of the "Flaubert" was published, Sartre promised that this time he would keep his promise. If he does, condolences may be in order. According to *The Words,* the child wrote suspense stories patterned after the serials he read, but with a difference.[10] He placed his hero or heroine in a desperate situation and concluded with a mysterious ray of hope ("to be continued"), only to start another story the next day that would be similarly incompleted: "I felt that I would not survive my victory and I was too happy to put it off" (p. 100).

Being and Nothingness leaves the heroine (Human Reality) in an apparently inextricable maze of bad faith but announces salvation in the next episode. Instead of that, *Saint Genet* locks her up in the dungeon of alienation, then rekindles our hope: "What last resort is left to us? I see one, which I shall expound elsewhere" (p. 549). And instead of that, in the first volume of *Critique of Dialectical Reason,* the heroine is given a choice between "the hell of seriality" and "fraternity by terror"; in the absence of the second volume, this is where the epic of Human Reality has stopped.

In *The Words,* Sartre says he drew his "most intimate phantasm: optimism" from the happy endings of the stories he read as a child (p. 66). He seems to have renounced saving his heroine, which, in any case, would be the business of a hero rather than of a writer. Note also that a happy (or unhappy) ending would turn the goal into result, impose a final "nature" on the heroine, which, unlike a desperate situation, would rob her of her mysticity. With regard to the writer, *The Words* suggests two levels of op-

timism. First, it expresses the fancy that a verbal conjurer is a real *demiurgos:* "For a long time, I mistook language for the world" (p. 154); second, it conveys the certainty that each new wedding with language will produce a better specimen: "My best book is the one I am writing; immediately below, the latest one" (p. 202). In this perspective, it hardly matters whether the heroine is liberated or not; stronger ties and bolts, tighter and more complex contradictions may be just as satisfying.

To which I would add a remark of my own. In *Being and Nothingness* the prison is constituted by bad faith and the judgment of others (bad faith may be construed as a bad internalization of the Other). The Platonic cave thus becomes a theatrical *no exit:* "Hell is the others" (external and internalized).[11] *Critique of Dialectical Reason* shifts the emphasis to biological needs (hunger), animal fear. The others are not simply spiritual judges; violence, which Sartre says in *The Words* he had to learn, is not simply the violence of glance and word. Yet notice how it is delimited: "The only conceivable violence is that which freedom exerts on freedom through the mediation of inorganic matter" (*Critique,* p. 689). What seems to be of import is not the raw pain to which an animal, human or not, may be subjected. In *What Is Literature?* torture had already been interpreted as an "enterprise of debasement," a "Mass where two freedoms commune in the destruction of the human" (*Situations,* II, pp. 247–48). If the victim manages to dramatize (de-realize) his pain as the humiliation of the human, good for him. But it seems to me optimistic to consider such humiliation the basic horror.

In *The Words* the child is said to have felt the need to justify his existence. Cannot *arrachement* for the sake of *arrachement* serve as a self-justification of ex-sistence? Apparently this is not enough. Most of Sartre's dramatic characters are intent on judging and being judged: to a great extent, the theatrical cave is a tribunal. I shall mention two extreme cases, both versions of the Last Judgment (death turns *arrachements* into a shapely or unshapely destiny). In *No Exit,* Garcin tries to justify himself in the eyes of another "dead" character. At one point the door of the locked room opens by itself, but he prefers to stay inside to pursue his hopeless task. In *The Condemned of Altona,* Frantz, cooped up in his room, pretends to present the case of humankind before the "Crabs," the successors of humankind on earth.

In *The Words,* Sartre judges himself and toys with the idea of destiny as a possible justification: "Most of the time I assuaged my heart by taking care neither to exclude freedom which exalts, nor necessity which justifies" (p. 146). The idea of the mandate combines freedom and necessity: outside the play, freedom as dramatist determines the hero's fate, which is also the destiny of the actor. The appearance of a character named Cervantes in an

adventure story read by the child (p. 147) prefigures the modification of the schema that is summed up in the sentence "Thus my destiny was forged." There is no outside author; but the various actors (in *The Words,* the family milieu) quite closely determine each other's roles (for instance, Sartre's writing role). The impression of destiny is either mythical or aesthetic. For me at least, perhaps not for Sartre, it is quite distinct from cognitive necessity (the limit of probability).

The belief in automatic progress is an attractive way to combine choice and destiny. By some miracle, the rudderless boat will keep bouncing in one direction. In *The Words* the passage on progress ends as follows: "Of course, I am not blind: I do see that we repeat ourselves. But this more recent realization erodes my older certainties without dispelling them entirely" (p. 202). Comparing a page of his earlier writing with one he has just written, Sartre discovers that they are almost identical. However, he decides that there is "some undefinable superiority" in the new version.

The recognition of recurrence raises the ghost of an "inert" causality. Consider also this reflection: "One can get rid of a neurosis; one does not recover from oneself. . . . All the traits of the child remain in the quinquagenarian" (p. 213). *Being and Nothingness* spoke of an "original choice," opened the possibility of a "radical conversion," interpreted a *caractère* as an oath, a destining choice. *The Words* conscientiously depicts Sartre's literary vocation as a global response to the family milieu. But his *caractère* as a whole is permitted to appear as a contingent collection of natural traits.

The very project of an autobiography ill agrees with an injunction implicit in *Being and Nothingness:* Do not look back; if you define and judge your past you will get mired in bad faith; let the dead bury the dead. But this incongruity should not be overestimated. At the time of *Being and Nothingness* as at the time of *The Words,* Sartre was engaged in other projects with different directions, different emphases. Besides, *The Words* reminds us that even in the case of Sartre the published *personae* are only part of the man. On the whole, *The Words* invites us to distrust the tendency, abetted by Sartre among others, to stress diachronic change at the expense of synchronic diversity, conveniently reduced to neat contradictions.

VI

What strikes me as an anthropomania manifests itself in *The Words* as well as in other writings of Sartre. But there are also passages that could prime a questioning of his official humanism. If he should really be through

with the atheistic chore, if he is still intent on *arrachements* and treasons, this might be his next project.

In *Nausea,* Roquentin was allowed to make fun of various humanisms. In *Existentialism Is a Humanism,* at a time when he had suddenly become a public figure, a commonplace as it were, Sartre adopted the humanistic label in a sense that is supposed to differ from those enumerated in *Nausea.* In *The Words* the grandfather is a humanist, but his humanism is apparently one of the wrong kinds: "I got rid of Karl's humanism, the humanism of a prelate, on the day I understood that each man is the whole man" (p. 60).

In accord with a distaste for "individual" and "nature" as applied to the human, Sartre has shown some reluctance to speak of humankind as a species. Thus, in 1945: "No longer is there a *human species.* The community which has made itself the guardian of the atomic bomb is above the natural kingdom, since it is responsible for its life and for its death" (*Situations,* III, p. 69). [12] The word "man" is liberated from its physiological duties so that it may name a goal, or ideal: "Man is to be made" (*Situations,* VI, p. 22). Our mission is to pave the way for "the kingdom of man." As a species, we are like rats that would be obsessed by this mission: "This absence is Man, our tyrant. We are unmasked: rats preyed upon by man" (*Situations,* IV, p. 60). Sartre appears to allude to his uses of the word "man" to name an inaccessible ideal in this passage of *The Words:* "I showed cheerfully that man is impossible; I was impossible myself, but I differed from others simply through the mandate to manifest this impossibility, which was thus transfigured, became my most intimate possibility, the objective of my mission, the springboard of my glory" (p. 211).

In some texts, especially in *Critique of Dialectical Reason,* he agrees to base his notion of man on animal needs, on material individuation, on a physiology. Yet the word "man" is kept to name a value, the proper ethical goal: man is to be made by man; man is the future (the project) of man. I have noted the attempt to consider freedom both as the origin of value and as the value *par excellence.* A similar maneuver occurs with "man." Christian mystics tried to reconcile their negative theology with a positive theology (otherwise, why call "God" the ideal, rather than something else, or simply "nothing"?). Sartre tries to reconcile his negative anthropology (man as lack of nature) with a positive anthropology.

If each man is the whole man, and if this is the only value, then we shift from the recognition of the privilege, and burden, of moral responsibility to a human racism which *The Words* manifests in this version of the mandate: "Protect the species" (p. 144). Another version, "Tear the entire species away from animality" (p. 151), tries to combine mystic man and natural man. But if humankind escaped from animality, it would not be a species

any more; why call this non-species "man"? In order for humankind to prove it is no longer a species because it has the atomic bomb, would it not have to kill itself with that bomb? The phrase I have just quoted from *The Words* appears in a context that makes fun of the grandfather's humanism. But the criticism bears on the means (cultural ceremonies), not on the phrasing of the goal.

Unlike his grandfather, Sartre has realized that each man is the whole man. Yet this does not prevent him from saying that an anti-Communist, for instance, is "a dog" (*Situations,* IV, p. 248)—like Heidegger perhaps, the German Shepherd of Being. According to *Critique of Dialectical Reason,* under the reign of scarcity each man is an anti-man for any other man. A *We* produces, and is produced by, a *They* ("inhuman humans"). With words, we may behave as if we had the power to turn those who do not share our goals into dogs, possibly crabs. Practically, to be "for man" is to be with, and for, some human beings against some others. On a theoretical level, what does this do to the unity of the value called "Man," to the One *epekeina tes ousias?*

Sartre rejects the postulate of a hyperconsciousness. But "praxis," as the dialectical unity of interhuman conflicts, is supposed to bestow an originality and a coherence on "the human adventure." According to Roquentin, adventures are in books. I should say myself that the human adventure is on a hypothetical stage. The child fancies that a human life is an epic; failing this, one may try to conceive human history as a drama. History is "an adventure of nature" (*Critique,* p. 158). Nature is the field of the performance; History is the play to be performed.

Practical conflicts involve animal organisms as such: real work, real pain, real death. But if it is human, a work that fails acquires the meaning of a gesture; and as such, it can participate in the aesthetic success of a drama. In order to make History cohere and stand against the natural base, praxis requires the failures of the divergent and ephemeral efforts. In order to allow a dramatic kind of comprehension, it must feed on conflicts, contradictions, misunderstandings, ignorance. The ruses of History are comic and tragic ironies which allow a play to affirm its cogency, through an *Aufhebung* of the intentions and interpretations of the various characters which, by themselves, would break the play into pieces. If we want our existence to have a properly human meaning and value, we must consider ourselves not as agents but as improvising actors, and the rest of the landscape, the "practico-inert," as props.[13]

Outside the world of the play a traditional Christian would place not only that which is not equipped with a soul, but also God, as the author and the only competent critic: He is presumed to congratulate Himself and to reward some actors for their performance, punish some others: Genet, for

instance, might be rewarded for playing the role of the Villain very well. Sartre dispenses with outside author and critic. Each actor has to improvise, but the other actors and the props narrowly limit his possibilities. Since "the human adventure" is not recognized as an aesthetic fancy, the coherence of praxis as the dream of a dramatic rationalism, we are still in a myth that confuses moral and aesthetic values.

If Sartre easily gets rid of the outside author, he seems to experience some trouble with the absence of an outside critic. It is only after the denouement that a drama can be pronounced coherent. How can the human adventure be insured as one totalization without anyone in a position to comprehend it as a whole? This was the problem set for the second volume of *Critique of Dialectical Reason,* which has been postponed indefinitely. In *The Condemned of Altona,* what we have instead is Frantz addressing the Crabs, the inhuman judges of the human adventure. The end of the human race is the constitution of History, but the end of History, whatever else it may be, is the end of the human race.[14] In *The Words* I pick up this echo (p. 209):

> To assure me that the human species would perpetuate me, it was agreed in my head that it would not end. To die in it would be to be born and become infinite, but, if someone put forward the hypothesis that a cataclysm might one day destroy the planet, even in fifty thousand years, I was horrified. Even now that I am disenchanted, I cannot think without dread of the sun cooling off: it does not matter if my fellow men forget me the day after my burial; as long as they live, I shall haunt them, elusive, nameless, present in each of them like the billions of dead men whom I do not know, yet preserve from annihilation. But, if humankind disappears, it will kill its dead for good.

VII

In *What Is Literature?* (1947), Sartre quotes the answer of Jean Prévost, a writer of the thirties who took himself for neither devil nor prophet, to an inquiry about why he was a writer: "To earn a living." This answer, says Sartre, "shocked me. For the great literary myths of the nineteenth century still lingered in my head. All the same, he was wrong: one does not write to earn a living" (*Situations,* II, pp. 229–30). The major theme of *The Words* is the birth of a literary vocation. To replace Christianity, the Third Republic instituted an eclectic cult of writers, mostly French, all "great," which involved a one-hundred-year delay pending beatification and canonization proceedings (Sartre still uses the adjective "great," a mark of mythical value, when he speaks of some writers). The motley Gospel was dispensed to the happy few who went through high school. It appeared strange to me in comparison to the pagan Catholicism prevalent in my milieu, a cult of functional saints, most of whom the Pope had never heard of, with precise

powers to be captured under definite circumstances (which writer should be invoked when one had lost a five-franc note?). What is still stranger to me is that, according to *The Words,* a child of nine had fallen prey to the idol of the Writer.

Why is Sartre still writing literary-philosophical texts? In *The Words,* he endorses Prévost's answer: "It is my job" (p. 212). Then he adds: "For a long time I took my pen for a sword; now I know our impotence." This differs from *some* passages of *What Is Literature?*[15] But what follows is in full accord with his postwar manifesto: "Culture saves nothing and nobody, it does not justify. But it is a product of man: he projects himself in it; this critical mirror alone offers him his image." Finally, there is even a reluctant agreement with the child: "Besides, this old crumbling building, my imposture, is also my *caractère:* one can get rid of a neurosis; one does not recover from oneself."

As Sartre formulates it, his early literary vocation manifests his taste for totalizations. Like some religious conversions, it is meant to involve the whole person, to collect the *personae;* and the changing literary Gospel concerns humankind as a whole: "For a long time, I held the work of art to be a metaphysical event whose birth concerned the universe" (p. 151). In *What Is Literature?* he assigned limited tasks to himself and his fellow writers; and he correlatively limited the prospective audience. On the other hand, the last lines of the manifesto identified literature with what is human (value) in man (species):

> If the art of writing turned into pure propaganda or mere entertainment, society would fall back into the pigsty of immediacy, into the life without memory of hymenoptera and gastropods. Of course, it is not so important: the world can do very well without literature. But it can do without man even better. (*Situations,* II, p. 316)

Man is the animal with literature.

An echo of this conception can still be heard in a 1960 interview:

> I have lost many literary illusions: that literature has an absolute value, that it can save a man or simply change men (except under special circumstances), all this appears obsolete to me. The writer continues to write once these illusions are lost because, as psychoanalysts say, he has invested everything in writing. . . . But I still hold one conviction, which I shall never relinquish: to write is a need for everyone. It is the highest form of communication. (*Situations,* IX, p. 38)

But if everyone could and would find the time to write, the amount of publication would not increase, and the amount of reading would sharply decrease.[16] I am already in this position: to find the time to write about Sartre I have to ignore the Tower of Babel that has used his texts as a pretext.

Note also that, in the same interview, Sartre still considers that, even when some Romantic illusions are lost, to write may remain (should remain?) a global choice, if not for everyone, at least for some. In another passage of the interview, he appears to link this choice to the critical representation, if not of humankind (no human "nature"), at least of one's "time" as a whole: "If literature is not *everything, it is not worth one hour of trouble" (*Situations, IX, p. 15). Each man is the whole man, but writers, more than others, express the critical consciousness of a society.

Except for the unfinished *Tintoretto, Sartre, to illustrate at length his conception of the human, has chosen individuals who did not simply write novels, poems, or essays, but may be assumed to have invested "everything" in writing: Genet, Mallarmé, Flaubert, himself.[17] Flaubert would represent "the exact opposite" of Sartre's conception of literature (*Situations, IX, p. 116). But this is a family quarrel: "If I wrote *The Words, it was to answer the same question as in my studies of Genet and Flaubert: how does a man become someone who writes, someone who wants to speak of the imaginary?" (*Situations, IX, pp. 133–34).

In *The Words, the literary vocation of the child is attributed to a demiurgic conception of language: "Each thing humbly requested a name; to name it was both to create and to capture it" (pp. 53–54). Apparently forgetting the postulate of a universal need to write, Sartre adds: "Without this fundamental illusion, I never would have written." Does this mean that he considers his original relation to language to have been that of a poet rather than of a proper "writer" (prose writer), according to the distinction drawn in *Saint Genet and *What Is Literature?

I don't think so. His theory of poetry, which is derived from that of Mallarmé and Valéry, and which I would adopt, is that, in a poetic perspective, words are things, but not the things they name. A word is a special kind of thing: a set of phonetic and semantic *qualities. In a sonnet, Mallarmé superimposes evocations of Cygnus and a swan. The homophony between *Cygne and *cygne (also *signe) contrasts with the disparity of the significata, a contrast that does not favor a confusion of things with their names. An engineer, on the other hand, will not confuse the word "locomotive," a blueprint for a locomotive, and a real locomotive. The risk of word idolatry lies neither with poetry proper nor with verifiable prose, but with unverifiable prose.[18]

In *What Is Literature? prose and poetry are sharply distinguished; but the main objective of this move is to avoid a distinction between literary and philosophical proses on the one hand and cognitive-practical uses of language on the other. Philosophical concepts are implicitly lumped with scientific variables and genera, the fictional worlds of dramas and novels

with the real world. All prose is supposed to be "utilitarian." And yet novels and dramas are also considered ends in themselves, which puts them on the side of poetry. Literature may no longer save; but *What Is Literature?* tries to save literature (essays, dramas, novels) by claiming it is cognitive-practical on the one hand, autotelic on the other.

The Words relates an experience that is said to have threatened the child's vocation. "I had so often been told about the truth of novels that I thought I was telling the truth in my fables" (p. 180). At the beginning of World War I, the child wrote a story in which the Kaiser promptly surrendered. But the real war went on. Twenty-four years later, this experience did not prevent a fictional character named Roquentin, in a fictional town named Bouville, from boarding a train bound for the capital of France. Some pseudo-Platonic engineer must have built the track. Though it is supposed to "demystify," Sartre views a drama as "essentially a myth" (*Situations,* IX, p. 123). To me, a mythic perspective involves a confusion between the cognitive-practical and the playful-aesthetic functions of language.

Sartre has published no narrative fiction since 1949 and, except for an adaptation of *Euripides,* no play since 1959. Apart from political interventions, he has continued to write about real individuals. The preface to the "Flaubert" stresses "truth" and "knowledge." But according to *The Words,* what is said about men is neither true nor false; and according to a 1970 interview, "a writer is always a man who has more or less chosen the imaginary: he always needs a dose of fiction. For my part, I find it in my book on Flaubert, which may be considered a novel. . . . My hypotheses lead me partly to invent my character" (*Situations,* IX, p. 123). In my own essay, the name "Sartre" labels a collection of propositions extracted from several literary and philosophical texts; but it also refers to an individual, whom I take to be real, and so many kilometers away from me. Are the two uses kept quite distinct? No, since my only reason for assembling these propositions under one label is that it is the name of one individual. And what goes for "Sartre" also goes for "I".

Cannot myth-making be justified as sugar on a pill, as a seductive mask that allows practical effects to be smuggled? In 1960, asked whether certain changes had taken place because of what he had written, Sartre answered: "None. On the contrary, from my youth until now, I have experienced my total impotence. . . . It is not in this way that one acts on people" (*Situations,* IX, p. 25). He observed instead the deformations, or transformations, of what he wrote through what others write, especially about him. His publications started a mountain of comments incapable of giving birth to one practical mouse. Yet he cannot be sure: "Does it make any

sense to write this 'Flaubert' (I am not talking about its quality), is it a book necessarily marked for burial, or can it be useful in the long run? Nobody knows" (*Situations,* VIII, p. 470).

There is at present no experimental method that can show what effects reading a novel or essay may have on the behavior of various readers under various circumstances. I can imagine how I have been influenced by my readings of Sartre. But I cannot be certain of it, since I cannot apply the method of variations to my past. Can it not be asserted at least that, if Sartre's writings have encouraged us to torment words (his with mine, for instance), they have not, to this very extent, encouraged us to torture humans or even, in spite of his official humanism, animals without souls, without "praxis"? Could it not also be said that while he was rewriting the death of God, he contributed to the death, or entropy, of the literary institution, by turning the "critical mirror" into a maze of mirrors critical of one another? Or should it simply be stated that he and we who write about him have contributed to book pollution and the depletion of paper resources?

In a 1970 interview, Sartre declared: "I wrote exactly the contrary of what I wanted to write" (*Situations,* IX, p. 134). This judgment has something to do with his impression of powerlessness. The sentence is also an example of his taste for hyperbole. Since it is printed as part of his works, one is tempted to apply what it says to itself; hence another version of the Liar. Perhaps my essay should have been entitled: "Epimenides on His Fellow Sartres."

<div align="right">

ROBERT CHAMPIGNY
</div>

INDIANA UNIVERSITY

NOTES

1. *The Words* is the final version of an autobiography that seems to have been started in 1953, whereas Sartre began writing the "Flaubert" in 1957 or 1958.

2. Compare these fragments of a 1960 interview: "Today, I think that philosophy is dramatic. . . . The topic is man, who is both an *agent* and an *actor,* who creates and plays his drama, who lives the contradictions of his situation until his person breaks up or his conflicts are solved. . . . This is why the theatre is philosophical and philosophy is dramatic" (*Situations,* IX, pp. 12–13). Note that agency itself is defined in dramatic terms. In my opinion, a dramatically oriented temperament is the only reason why, "today," philosophy should be dramatic, or rather, meta-dramatic.

3. In "Of Rats and Men," inner egos are evoked as a synchronic plurality: "I should say that I am *others* and I should speak of myself in the third person plural" (*Situations,* IV, p. 48).

4. *Existentialism Is a Humanism* includes two conflicting passages about God. "It is quite bothersome that God does not exist, for the possibility of finding values in an intelligible heaven disappears with him: there is no a priori good any more" (p. 55). But a believer still

has to decide what God wants him to do; so, "Even if God existed, it would not make any difference: this is our point of view" (p. 95).

5. Yet Sartre does not always use "evil" and "good" as names of consecrated idols. Thus, in a 1972 interview, "evil" expresses his own moral judgment: "It is enough for me to know the reasons I have for refusing this society. It is possible to demonstrate that it is . . . an evil, that it is not made for man, but for profit" (quoted in Francis Jeanson, *Sartre dans sa vie,* p. 278). Also to be noted: the mystic, or mythic, use of "man" in the singular.

6. Compare what is said about Nizan and Sartre as young men: "For a long time, we kept the Christian vocabulary: though atheists, we were certain we had been brought into the world to earn our salvation and, with a little luck, that of others" (*Situations,* IV, p. 156).

7. In a 1965 interview, Sartre made this comment about his style:

> If I let myself write a literary sentence in a philosophical work, I always have the slight impression that I am going to fool the reader somewhat: it is a breach of trust. Once I wrote this sentence, which was remembered because it was literary: "Man is a useless passion." This is a confidence trick. I should have said it in strictly philosophical language. I do not think that there is any breach of trust in *Critique of Dialectical Reason. (Situations,* IX, p. 56.)

According to what is said in *The Words, Critique of Dialectical Reason* should be superior to *Being and Nothingness* in the eyes of Sartre, simply because it was written later. I shall note one stylistic detail. At the start of *Critique of Dialectical Reason,* a distinction is made between "philosophers," whose thinking is supposed to fit a historical period, and "ideologists," who are minor thinkers. Is this move, which allows Sartre to simplify history and to treat philosophy as if it could be empirically true, a legitimate application of the right to define, or is it a confidence trick? A few pages later, forgetting that he has just crowned Marx as the philosophical monarch of "our" time, Sartre calls Unamuno a "philosopher." Likewise, in the "Flaubert," the decree that a man "is never an individual" does not prevent the application of the term "individual" to Flaubert and others in the course of the development.

8. In *The Words* the grandfather likes to pose. The faces the child makes in front of a mirror may also be interpreted as attempts to mask one's animality. But a quick succession of various masks prevents any one from setting.

9. The shift from an essay on morals to an autobiography is given an explanation in a 1960 interview:

> I questioned everything, except for my profession. So that, one day, while writing about morals, I realized that I was writing the ethics of a writer for writers, though I addressed people who did not write! This forced me to go back to the origins of this odd attitude and look for the presuppositions or, if you like, the fixations, of my childhood. (*Situations,* IX, p. 33.)

10. In *The Words,* Sartre says he prefers reading the *Série noire* (a collection that specialized in translations of private detective fiction) to reading Wittgenstein. I do not know whether Wittgenstein ever read Sartre; but he too liked detective stories. Was he mostly interested in the solution to a mock-cognitive problem (a problem of individuation)? Would Sartre be more attracted by the suspense and adventure aspect?

11. I should take it as an axiom that the theatre can properly represent life to the extent that life is theatrical. It can capture and stylize only the gestural aura of action. Sartre prefers to view the dramatic representation of practical actions as an unsolved problem (*Un Théâtre de situations,* p. 133). What bothers Sartre sometimes also bothers those of his characters who are allowed to become conscious of their theatrical status: how can a dramatic character escape the theatrical cave?

12. Outside of human reality, there are only "things." In *Critique of Dialectical Reason* (p. 55), a special mention is granted, in passing, to animals, but it is "for Merleau-Ponty's sake." Sartre's Romanticism of Man contrasts with Romanticisms of Nature or Life, such as that of Bergson, for instance, or of less rosy kinds (Schopenhauer, von Hartmann). The Freudian *libido* owes something to von Hartmann's unconscious Will.

13. Sartre's favorite adjective, "total," does not fail to appear in a passage from a 1966 interview about truth:

Against positivism which wants to parcel out knowledge, the real problem is that there is no partial truth. . . . The whole must always be considered in the perspective of the part and the part in the perspective of the whole. This implies that human truth is total, that is to say, that there is a possibility, through constant detotalizations, to understand History as a totalization in the making. (*Situations,* IX, p. 92.)

For my part, I should say that, while the need to comprehend involves a need to unify, the satisfaction of this need involves a fictionalization: what can be totalized is either a candid fiction or a reflection of our ignorance. I should agree that if one is eager to stylize interhuman relations, bring out their originality, picture them as autonomous, the dramatic kind of logic which Sartre has pursued with exceptional flair and tenacity is the most appropriate. But I do not see it as a super-logic, as the logic of logics. It is one logic among others, one mode of meaning and understanding, to which certain temperaments and certain experiences are more attuned than others. The plurality of modes of meaning is a check against the idealistic aspiration to absorb and redeem experiences wholesale through logos (which logos?).

14. About crabdom: "At the age of thirty-two, I had some very unpleasant hallucinations in which there were crabs. Since then, I have always considered them a symbol of the inhuman" (*Un Théâtre de situations,* p. 155). Unlike Frantz, Sartre would not picture crabs as judges. Yet he does seem to be concerned over the judgment of posterity: "The important thing is to know that we shall be judged, and according to criteria which are not our own. This is what is horrible" (ibid.). Why should our successors, human, humanoid, or non-human, be interested in judging us? If they are, what practical difference will it make to them or to us? Apparently, failing an outside critic, the unity of Sartrean history needs the link of inside judgments. In this respect an unfavorable judgment, or a judgment lacking in empathy, would be better than no judgment at all. Sometimes hatred is a stronger bond than love: witness Sartre's "hatred of the bourgeoisie" (*Situations,* IV, p. 249).

15. Actually, *What Is Literature?* does not view the situation of French writers in 1947 with much hope regarding efficacy. And in 1948, Sartre declared: "I do not think that my writings have much importance, nor that they will change anything" (*Un Théâtre de situations,* p. 244). The function of prose, even literary prose, is utilitarian; but "utilitarian" does not automatically imply "useful." In *Being and Nothingness,* Sartre even went so far as to say that "success does not matter to freedom" (p. 563). It is not necessary to hope in order to undertake; it is better to fail than to abstain; a failure has a meaning as gesture. Hence the risk of an aesthetic shift: the dramatic value is apt to become the goal, with a mythical shadow. In *The Words* (p. 213), Sartre wonders whether he has not been playing a game of winning through losing, whether he has not trampled his youthful hopes in order for "everything" to be given back to him "a hundredfold" (Kierkegaardian repetition).

16. Sartre views without disfavor a disappearance of professionalism in literature. But he considers that even if writing became a normal exercise, a popular sport, it would still have the significance it has for him. People would write in order "to be their own witnesses in front of everyone" (*Situations,* IX, p. 39). It seems to me that, instead of that, the very notion of an audience would disappear.

17. Only a preface has so far come out of the book which Sartre was composing in the fifties on Mallarmé. The two authors write very differently, with different goals. Yet Sartre's conceptions of prose, poetry, the theatre, the imaginary, are reminiscent of Mallarmé. And the way he uses the words "being" and "non-being" may be derived from Mallarmé as well as from Hegel and Heidegger.

18. In a 1965 interview, Sartre associated the demiurgic illusion with literary prose: philosophical prose would not foster this illusion (*Situations,* IX, p. 45). Judging from my experience, it would seem that constructing definitions should make the enjoyment of philosophy more consciously playful than that of realistic literature. But some of Sartre's essays, or certain passages in some essays, give me an impression of word idolatry: they read as if philosophical definitions and illustrations were mathematical demonstrations and scientific proofs.

BIBLIOGRAPHY

Jeanson, Francis. 1974. *Sartre dans sa vie*. Paris: Le Seuil.

Sartre, Jean-Paul. 1938. *La Nausée*. Paris: Gallimard.

———. 1943. *L'Etre et le Néant*. Paris: Gallimard.

———. 1945–49. *Les Chemins de la liberté*. 3 vols. Paris: Gallimard.

———. 1946a. *L'Existentialisme est un humanisme*. Paris: Nagel.

———. 1946b. *Réflexions sur la question juive*. Paris: Morihien.

———. 1947. *Théâtre*. Paris: Gallimard.

———. 1948–72. *Situations*, II–IX. Paris: Gallimard.

———. 1951. *Le Diable et le bon Dieu*. Paris: Gallimard.

———. 1952. *Saint Genet, comédien et martyr*. Paris: Gallimard.

———. 1959. *Les Séquestrés d'Altona*. Paris: Gallimard.

———. 1960. *Critique de la raison dialectique*. Paris: Gallimard.

———. 1964. *Les Mots*. Paris: Gallimard.

———. 1971–72. *L'Idiot de la famille*. 3 vols. Paris: Gallimard.

———. 1973. *Un Théâtre de situations*. Paris: Gallimard.

3

Charles D. Tenney
AESTHETICS IN THE PHILOSOPHY
OF JEAN-PAUL SARTRE

A N adequate aesthetics should undergird the artist as he creates a work of art, the viewer or listener as he experiences it, and the large culture which the artist and his audience thereby support. This support cannot be established by reducing aesthetic processes to mere factual data, to physical or psychical determinants, to raw feelings and emotions, to crude sensations, to remembered images, to conceptual schemes, to verbal constructs, to political slogans, to anthropological reports, or to psychological case histories. Methods of analysis contribute little to aesthetic apprehension, which is an apprehension òf richnesses, complexities, and totalities. To break up these totalities, to simplify these complexities, to water down these abundances is to misrepresent the very thing presented. Richness itself is the distinction of aesthetics.

Unfortunately, richness is difficult to assess, and this is why aesthetics plays such a negligible part in many philosophies—in fact, in all philosophies that are reductive rather than productive in character. In their efforts to devise manageable schemes of description, such philosophies tend to fix upon discrete elements and to deal only with combinations derivable from ready-made formulas. In the process, they drop the subtleties, surprises, and distinctive qualities of experience. Presumably they intend to reinstate them later, but somehow they seldom do. This kind of reductionism—whether deliberate or inadvertent—may have a certain healthy utility in the physical sciences or in abstract metaphysics, but it wounds the biological and social sciences and it is usually fatal to the humane arts. Materialisms, positivisms, and absolute idealisms are simply too coarse to screen the fine substance of aesthetics.

Because of its subtlety and complexity, aesthetics cannot be based on a narrow philosophy. It is noteworthy that the problems of art have achieved their most adequate treatment in the systems of two great comprehensive thinkers, Aristotle and Kant. These men had the time and patience to pur-

sue the complex as well as the simple, the nuances as well as the obtrusions. Such thinkers establish firm connections between art and the rest of life. They find the aesthetic important to their systems precisely because it is a way of surpassing the regularities of science and the schemata of logic.

Conversely, a philosopher's view of art provides an excellent test of the adequacy of his system, for the very reason that experience of art is perhaps the most inclusive and most complex of human experiences. Unlike reason, which is essentially abstract and reductive, art is concrete and enriching. Unlike analysis, which is by definition divisive and sequential, art is unifying and immediate. Attempts to reduce the philosophy of art to a specific type of philosophy usually fail, or at the very least produce monstrous theories that maim and hinder the practice of both the art and the philosophy.

Art theory, therefore, needs a base as broad as the broadest of philosophies. The objects of art are shaped materials subject to the most subtle ontological and cosmological considerations. They provide kinds of knowledge—perceptual, illuminating, revelatory—that stretch our epistemological theories to the breaking point. They create not only aesthetic values but also utilitarian, emotional, material, and intellectual values in complicated relationships that fully test theories of axiology.

A philosopher's view of art (like his view of science) puts the historical relevance of his theories to the ultimate test. For art (as well as science) is accumulative: it changes, grows, develops, enlarges, and never ends. These constant alterations demand of the philosopher a certain prescience; his theories must have predictive value and a dynamism of their own. Otherwise his aesthetics (and his science) are condemned to perpetual inadequacy.

Some schemes of thought better support an aesthetics than others. For example, Aristotle's ontology clashes less with his aesthetics than does Plato's with his. Bergson's view of existence is more congenial to theorizing about art than, say, Ernst Mach's.

Jean-Paul Sartre is unusual in that his ontology is already an aesthetics and his aesthetics is already an ontology. He emphasizes a kind of existence that seeks to create being; and in general he is more interested in the process of creation than in its end product. He sees man's imagination as forever at work on projects, each unique to him in his situation.

Some of these projects result in objects of art, and some do not. At all events, the creative process is broadly the same whether it results in an imagined object (that is, a work of art), or a technological discovery (say a new instrument or machine), or a social invention (say a unique life-style), or a political device (say a novel method of balloting), or a new morality, or a new metaphysics. The creative process is inherently an aesthetic process,

for it enriches the world with new qualities and values; at the very least it achieves a basic aesthesis that is lacking in more abstruse intellectual processes. The union in Sartre of the imaginative and the rational is of great advantage to his aesthetic thinking.

It must first be noted, however, that the Sartrean aesthetic tends either to repudiate or to ignore traditional aesthetics—the classicisms, the romanticisms, the realisms of the past. The ancient theory of art as the imitation or representation of nature has never appealed to Sartre, who seldom if ever speaks of nature in the same terms as the stolid realist, the romantic enthusiast, or the restrained classicist. For the very word "nature" he tends to substitute such terms as "world," "objectivity," "situation," "being." Being, as the extreme of nature, is distasteful to him; it is either marmoreal, stonelike, inert, and cold, or viscous, gummy, doughy, and slimy—in a word, nauseating.

Even nature as modified by scientific thinking is too abstract, too rigid, too fragmented by analysis to be aesthetically appealing. The physiologist, for example, does not show us the life in nature, but the death. In fact, physiology reveals life itself as a modality of death; it attempts to reconstitute living persons into corpses.

Realistic art, based as it is on the scientific attitude, attempts to reconstitute nature by representing it in faithful artifacts or simulacra. But it succeeds only in yielding anatomies, skeletons, which lack the wholeness of particular lives.

Classical or neo-classical art, seeking as it does a conceptualization or idealization of nature, runs into a similar difficulty. By attempting to discover essences, it reduces art to fixity, to its pastness or history, thereby removing it from the sphere of living existence. Forms become formulas, meanings are regulated under hierarchal classifications, objects become frozen into signs, and lives sink beneath their appurtenances. In general, classical art is subsumed into ideas or at the very least into allegories.

Romantic art is closer to the aesthetic in its attempts at emotional syncretization and concrete mythologies; but in its idealizing tendency it often runs awash in undifferentiated feelings and blurred sensations. It is in a sense a return to primal viscosity; and it constantly verges on the bad faith of the sentimentalist.

By attempting to adhere to the outlines and details of being, all kinds of representative art limit and deaden the artist's program of expression. To imitate is simply to yield up one's freedom of expression.

It is for these reasons, among others, that Sartre is inclined to repudiate traditional and official art, however prestigious. Among the works he spurns are the vast majority of "masterpieces," which err chiefly by exalting political and economic power. For example, Sartre protests against

the Venetian establishment of the sixteenth century, which approved slick paintings that supported the religious, mythological, and monarchical hierarchies of the day. He thinks Titian too smooth and too bland, a painter who allowed a suave technique to gloss over the pain of cruelty and struggle. He is suspicious of the alliance between painting and money that has produced not only ornate mythological pieces celebrating heroines and heroes, goddesses and gods, but also numerous portraits of kings, queens, popes, presidents, and merchant princes. Such works, commissioned by the rich and powerful, are full of the trappings of position and wealth—velvets and brocades, gold chains and jewels, splendid furniture and ornate accessories, the luxury of Arcadian countrysides. They attempt to immortalize the sitters, immobolize the living flesh, deny the human, and in general emphasize being rather than becoming.

Sartre also despises the museums that enshrine official art. In his first novel, *La Nausée,* he includes a number of famous set pieces that presumably reflect stages of his own intellectual development. Among these is a fictional museum in the fictional town of Bouville, as viewed by the novel's protagonist Antoine Roquentin, who is presumed to be a thin disguise of Sartre himself. In the portrait gallery of the museum are ensconced the worthies of Bouville, or rather depictions of these worthies by the fictional painters Bordurin and Renaudas.

The complexions in the portraits tend to dark brown; lively colors would seem indecent. The backgrounds of the portraits tend to deep black, but against them white hair and white whiskers show up well and collars shine "like white marble." The accessories and appointments in the portraits are consistent with the positions of leadership held by the sitters: top hat and gloves, pearl-gray trousers, books with handsome bindings, a great leather armchair, a table loaded with papers. Roquentin starts out by noting these perquisites in a mildly satirical fashion, but the set piece ends with his explosion of rage and contempt ("Salauds!") in what can only be a glamor of loathing, an inspired nausea.

In *La Mort dans l'âme* (volume 3 of *Les Chemins de la liberté*), Sartre gives a fictional rendering of the Museum of Modern Art in New York— highly organized, systematized, approved, enclosed, sanitary, and sterile. Although this museum contains much of the kind of art Sartre finds congenial, he treats it too in a somewhat satirical fashion, as a place more dead than alive. In fact, he tends to wax sardonic about recognized art of any sort, but the height of his animus is directed against official portraits that glorify the power structure of a community.

This leaves for Sartre's approval a comparatively small number of works that, in his judgment, express the complexity, the mobility, the vitality, and the anguish of human existence by showing it in passage or process.

These works are open, not closed; dynamic, not static; suggestive and expressive, not fixed and definitive.

For example, Sartre has admired the Avignon *Pietà* and the Grünewald *Crucifixion* because they disclose, not only in their subject matter but also in their technical means, what it is to exist in anguished humanity. He has admired Tintoretto for the violence and expressiveness he was able to achieve in his paintings in spite of all the blandishments of the Venetian art establishment. In modern art, as against the fixity of Mondrian, he approves the disintegrative power of Picasso. He dislikes most sculptures because they are frozen, inert, but he enjoys Giacometti's emaciated and isolated forms because they are placed in an open field: they exist in never completely defined relationships with each other and with the ambient spaces, thereby discovering the solitude that enwraps individuals. He enjoys African poetry because of its emphasis on dynamics, which seems to relate it to dancing, and its expression of negritude, in which an image of blackness becomes an image of openness, of freedom. Obviously Sartre's resentment of closure has had a marked effect on his aesthetic preferences.

Among poets he finds little to admire in Mallarmé, whose work is hermetically sealed, but a great deal to admire in Francis Ponge, whose work flickers between interiority and exteriority. Sartre sees in the poems of Ponge, which constitute miniature existential psychoanalyses of specific physical objects, a refusal to comply with human society. He argues that the poet, in his attempt to penetrate physical objects and to allow them to speak in their own styles and voices, has gone a long way toward achieving an intuitive grasp of nature, an understanding of things not as human representations but as reposing in their own uniqueness. Ponge's poems appear to Sartre like the solids seen in the paintings of Braque and Juan Gris: discontinuities that force the eye to create continuities. Ponge's lines constantly flicker between objective and subjective elements, an effect emphasized by the poet's elimination of verbal connectives and his technique of gradual agglutination into an expressive synthesis. Owing to this achievement, in Sartre's view, Ponge's poems are truly creations rather than imitations of nature. Perhaps because Ponge deals with solid objects, however, Sartre feels a certain petrifaction, not so much in the poems as in the poet, whose project transforms him into statue and stone, into being rather than becoming. Sartre argues that Ponge is unable actually to assimilate consciousness into external objects; hence, his work tends to be retractile instead of expansive, as perfect poetry should be. It lacks the dynamism Sartre finds in African poetry.

As I have said, Sartre is disinclined to admire sculpture because of its customary massiveness and stolidity, which remind him of the immobility

of a plenum. He makes an exception, however, in the case of the mobiles of Alexander Calder, which he claims cannot really be compared to the sculptor's art. For a mobile is an object defined by its movement; the imagination revels in its continually changing forms. It moves, it hesitates, it gropes, it decides upon new courses as if correcting former errors of choice. Its motions can be violent or indolent, tremorous or sweeping, abrupt or gradual. When it is responding to movements of the air, it enjoys the holiday spirit of a festival; it is animated, alive. Aside from these movements, it is dead: in effect, non-existent.

Sartre enjoys Calder's creations because they are lively; because their motion is pure motion, signifying nothing save their own animation; and because, like living creatures, they are full of unpredictable variations, even though they work within general patterns.

Since Sartre himself is a fine literary artist, a word should be said about his own work in fiction and drama, which provides an interesting perspective on his aesthetics.

All aesthetic objects contain impurities—materials not perfectly assimilated while the artist is carrying out his aesthetic project. It is possible for a novel or a play, as a work of art, to contain a great deal of factual, moral, and philosophic matter, but it may then run the risk of being taken for an exposition or a tract. It is possible for a poem to incorporate a metaphysics without ceasing to be a poem, but only if its readers are able to subordinate the metaphysics to its total poetic intention. It is possible for a painting to represent historic events, costumes, faces, landscapes, and architecture, but it can surpass photography only by subduing the descriptive details to the painterly elements. It is possible for a musical composition to embody a program, but only at some risk to its character as music.

On the other hand, without some kind of solid content, the object of art may seem frivolous or inane. The problem in hand is for the artist to interpenetrate his aesthetic structure with non-aesthetic data, which by virtue of this interpenetration become thoroughly assimilated into the structure. There should be sufficient data to pack the structure densely, but not so much as to overstrain and destroy it. Furthermore, there should be no overage of unassimilated data.

As an artist, Sartre is fully aware of this principle, and in his best novels and plays (for example, in *La Nausée, Huis clos, Les Mains sales*) he adheres to it quite closely. These works are packed with images and ideas that nevertheless are successfully integrated into the projects that carry them forward: balance and tension are admirably sustained.

But Sartre, like most writers, is an uneven artist and he often violates the principle. At heart, perhaps, he is a moralist who has *used* fiction and drama to convey his ethical and political concepts.

Hence it is that when he comes close to assimilating his concepts into the basic imagery and structure, his fictional and dramatic works are superbly effective, but when he fails to do so his audience may end with the feeling that it is hearing lectures or exhortations. No work of art can successfully carry an intractable burden of factual data and intellectual material.

In sum, Sartre is responsive to two schemes of art, one of which he regards with satirical contempt and the other of which he applauds generously. Traditional and official art belongs to the past; it is over and done with, finished. Open art carries us into the future and can continue indefinitely. Traditional art is oppressive: it weighs us down with its unnecessary detail and its emphasis on a larger than life scale, on heroics and flourishes. Open art frees us: it is conceived on the human scale, it is close to our emotions, we live in it as an ongoing process. Traditional art limits itself to the death of essences; open art reveals the liveliness of existence. The two schemes are dialectical opposites that in a sense define each other.

Although Sartre well knows where his sympathies lie, he must recognize the strength and the persistence of tradition. This he must regard as part of what he has called the "practico-inert," the active resistance of the material environment and of all other finalities that limit the ends toward which we aspire. Official art cannot be ignored: it has the massiveness and the plenitude of endlessly accumulated data. But it is dead or ever dying and must be opposed by living art. Although traditional and official art cannot be ignored, it must somehow be surpassed. To surpass it should be the aim of all artists to come.

Sartre's declared preferences in art reveal his aesthetic predispositions, but they by no means add up to a systematic aesthetics. As far as I know, he has never brought all his artistic interests together into a statement that reveals an organizing philosophy of the fine arts. If anything resembling a complete aesthetics is to be found in his work, it must be inferred from the components of his total philosophy, and certain of these components must be inferred from other components.

Moreover, although Sartre's view of art is wide-ranging and ingenious, it is not held together by dominating principles. Instead it seems to emerge out of his disquisitions in the form of *aperçus*. It tends to anticipate or to follow from the several stages of his developing thoughts on other topics, phenomenological, ontological, political, sociological, anthropological, psychological, biographical. In other words, Sartre's aesthetics is a reflux from his other interests; it appears to be not central to his thinking and perhaps is not even a major interest. This in no way diminishes its value, but it does reduce the possibility of making accurate judgments and statements about it.

Nevertheless, we must now assume that from his basic views we can adumbrate an aesthetic that is both sound and attractive. I shall attempt to disclose the components of his thinking upon which his aesthetic responses and his art criticisms appear to be based. My purpose in doing this is not only to understand Sartre but also to understand new possibilities in aesthetics.

The first component of a Sartrean aesthetics is undoubtedly his philosophy of the *situation*. Sartre assumes that all human activity takes place in—and has developed from—specific circumstances and contingencies. My situation includes my place (the space in which I and all my projects are located), my past (which provides me with both a backdrop and a point of view), my environment (the instrumentalities that surround me, each with its coefficients of adversity and utility), my fellows (who constitute the Other and provide the words and techniques whereby I can both appropriate the world and belong to such of its collectivities as the human race, one of its nationalities, certain professional and family groups), and my approaching death (which I must choose as the certain limitation of all my choices, as one term of a series in effect present in all my other terms, as the phenomenon that makes my life unique because I can never recover from it).

In situation, I am an existent among other existents; but I can know only my own situation, not others. I cannot exist without my situation, for it is that part of externality upon which I must draw in my quest to surpass it. My growth takes place in a specific but changing context. All other externality is to me irrelevant. My situation is my place, an environment presented to my consciousness.

But I must not rely only upon my situation: I must also surpass it. In order to justify my existence, to objectify myself, I must imagine myself as ahead of my immediate circumstances. I must take hold of my freedom to foresee, to imply, to transcend. As a material being who is able to go beyond the condition in which he has been placed, I must work, act, and dramatize my situation. The situation is that which I must surpass to create my existence.

From the standpoint of Sartre's philosophy, it would appear that both artists and their art spring from situations. There is something vacuous about the work of artists who dwell in the ivory tower (although that, too, is a situation). Only in the hurly-burly of time and circumstance can they develop their art effectively and in strength.

The artist, like everyone else, is to some extent the slave of his situation. He must work against certain resistances and overcome certain obstacles. An important element in his situation is the medium in which he works. A sculptor confronts the intolerance of stone or metal. A painter

finds limits to the possible uses of canvas and pigments. A poet is rebuffed by the intractability of words, particularly when he tries to match them against the pattern of a sonnet or a five-act play. A musician may be baffled by the contingencies of instrumentation. Any artist may find himself crushed by the establishment, by the burden of history and tradition it forces him to bear. Any artist may find his opportunities for creation reduced by illness or privation.

The artist's situation usually includes the audience that is lying in wait for his work—an audience that may accept it, reject it, or ignore it. The terrible presence of the Other may ruin him or sustain him.

The artist's situation provides him with materials, subjects, themes, and models which must, however, be adapted to the need of his artistic projects and may exhibit considerable resistance to the adaptation. It also provides him with the setting or scenes of his story, poem, play, picture, or composition, but not with its intentions and freedom of action.

In aesthetic terms, therefore, the situation is everything that directly infringes upon the artist's freedom but that may also, in certain circumstances, assist him in carrying out his projects.

From the situation and the need for transcending it, we must turn to the second component of a possible Sartrean aesthetics: namely, his philosophy of the *project*. My character as a human being is that I can go beyond a situation and make of myself more than what I have already made. My behavior must grow out of both present and future factors: first, those that condition it and, secondly, those related to an object still to emerge that I am trying to bring into being. Those factors already given constitute the *situation;* those still to come (in the form of a surpassing of the given) constitute the *project*.

In a sense, however, situation and project are inextricably intertwined. For my situation consists of those coefficients of adversity and utility which will oppose or support my project; and my project retains much of the situation it surpasses. I must think of this surpassing as a leap ahead, as a relation of the existent to its possibles. By projecting the situation toward a field of possibles and by realizing one specific possible, I objectify both the possible and myself. The possible intervenes between two poles of objectivity: the given object and the surpassing object. In effect, the possible thereby accounts for my creative powers.

A chief distinction with respect to projects is that some are self-renewing and some are not. A completed project is a mere thing: the process of totalization is over, the imagination is stilled. We then have a museum object, a machine operating routinely, a stratified social system, a repressive tradition or institution, or what William James called a "block universe."

But some projects are open-ended; they involve perpetual activity. The formation and carrying out of such a project involves (or rather *is*) the total man; it is never really finished. Sartre's own activities as a writer illustrate this point. The last page of *L'Etre et le Néant* announces a sequel on morals, which was never written; the tetralogy *Les Chemins de la liberté* was suspended during its fourth book; half the *Critique de la raison dialectique* may never come forth. Sartre's apparent reluctance to finish a complex work perhaps stems from a feeling that this freezes it, consigns it to the past, and closes off its future. His personal project must remain open at any cost; and so these incomplete works stand as reminders of his theory of existence, always free and extensible.

Each artist (or, for that matter, any person who lives creatively) is defined by an original choice of being, which constitutes his total individual project. Each man aims at producing himself as an objective totality. Baudelaire's fundamental project differs from Flaubert's fundamental project; that is why Baudelaire is Baudelaire and Flaubert is Flaubert. Consciousness is initially projective, for it is always consciousness of something. Its project is not a mere bundle of separate drives or desires, but a totality, an irreducible and radical decision or choice. In effect, the original project I have as an artist can be discerned in my personal unity. The project itself constitutes me; it is my total impulse and upsurge toward being. My problem at any moment is to recover the impulse of the preceding moment in a totalizing process of enrichment. Each of my actions as an artist takes on the coloration of my fundamental project.

As an artist, therefore, I always do something more than nature demands, whether with my life or with my work. My project organizes my work so that, in my execution of an object of art, each partial structure can assimilate the details of my situation into a total structure as indicated by partial structures that indicate each other as well. In the process of composition, the data not only coalesce but achieve a totality much greater than the sum of their parts. And because my project not only discloses my situation but also transcends it, I gain a control over circumstances, not in any predeterministic sense, but in that I myself have become the chief cause of my development.

Considered in these terms, the making of a work of art is a project, or part of a project, growing out of a situation the artist must surpass. By responding actively to those coefficients of adversity and utility which oppose or support his project (thereby making it both difficult and possible) and by mastering the art of assimilating his data into complex structures, the artist achieves his totality and his creation.

The possible consummation of an artistic process through an aesthetic project entails examination of a third possible component of aesthetics:

Sartre's philosophy of *bracketing,* based (with alterations) upon Husserl's idea of abstention (the phenomenological *epoché*).

In order to free myself from the coils of brute reality (that is, in order to enter the realm of art), I must eliminate the natural view of things as an active force in consciousness. This I can do, said Husserl, by placing in "brackets" whatever the spatio-temporal world includes as objects, environmental laws, and natural facts generally. I simply abstain from any recognition of the world as an active force by disconnecting it (in my ego) from phenomena of which I may be otherwise conscious. The world may still remain in my consciousness, and its being cannot be denied; but by putting it in brackets, setting it off to one side, and abstaining from any consideration of it except as it appears in disconnection (that is, in judgments modified by bracketing), I rid myself of its rules and its objects.

On the positive side, consciousness must be consciousness of something, and hence it is always intentional. From Sartre's standpoint, the intention that underlies all my reflections is a project. At best it is an intention of beauty, the value that can emerge only with great difficulty from a blending of being and consciousness. In my project is embedded both my knowledge of phenomena and a volitional thrust or upsurge. My intention is to seize upon the phenomena and assimilate them into the project, to select and emphasize, through voluntary reflection, the values I reflect on. My project isolates the phenomena from the stream of irrelevant causes that would otherwise clog my consciousness. It insures that the important in my reflection survives.

My project, therefore, proceeds by a kind of bracketing that places the objects of my reflective consciousness in suspension, as in a cell cut off from the remainder of being. It insulates those objects with a layer of nothingness (nothingness in this sense is unacceptability to consciousness), and it makes them believable or valuable in their own terms, not in those of other volitions.

In terms of Sartre's views on bracketing, a work of art must be regarded not so much as nature extending itself, but as a free, separate, and autonomous project. Consisting as it does of imagined realities, it is separate from the ponderousness of the large world of common sense and science and refuses to obey its laws. It disconnects itself from the rest of nature by a kind of nihilation. Although it does not exist for its own sake it does not exist for nature's sake either, but for the responsive human consciousness. An aesthetic artifact is bracketed off from the rest of being by its man-made form, which delimits it in space-time, cuts it off from an overweening plenum, surrounds it with a nothingness in which it can live and move, and frees it from most of the contingencies that condition natural objects.

Artists often emphasize this separateness by devising frames that bracket off their work from the externalities of brute being. The painter puts a frame around his painting; the dramatist separates his action from its audience by a proscenium arch and a curtain on an elevated stage, the writer and the musician invent distancing devices to place their works in their own times and spaces.

The use of bracketing is of major consequence in the arts, because objects of art usually stand not on the world, but on pedestals. Their space-frames and time-frames separate them from the remainder of reality: when the viewer or listener is attending to them, he is not attending to anything else. They exist in a shell of nothingness, the effect of which is not to evaporate or eviscerate them, but to disclose the perfection of their being free from the distractions of the imperfect.

All this applies only when the viewer or the listener can concentrate upon an object of art without let or hindrance. If he allows his attention to wander or permits it to encompass objects irrelevant to the aesthetic object proper, the autonomy of the work is violated, and the resulting experience is scarcely art at all. It is a mush, a viscosity, a misplaced intention, an example of bad faith. The autonomy of art is its chief preservative.

This does not mean that art must be closed or hermetic. In its shell of nothingness it has freedom to extend itself, to reach out, to reveal its value. But this it does in its own terms, not by external references or confusing juxtapositions.

Unfortunately, the autonomy of a work of art is sometimes undercut by the artist himself. In so far as he feels bound to follow nature by imitating given objects, he constricts his own freedom to choose, to arrange, to express; he denies free consciousness and becomes enslaved by the thing itself. In so far as he follows other artists and draws upon existing conventions, he likewise surrenders his freedom cheaply in the name of moribund classicisms or romanticisms.

This is an error that Sartre would avoid at all costs. As we have seen, he is impatient with the slavishness of naturalistic art and the timid conformity of neo-classic art. Detailed likenesses, whether on glossy canvas or in polished marble, offend his sensibilities. He prefers the expressiveness of a free consciousness.

I doubt that we should infer from this preference that he entirely rejects the art of the past or even the art of the schools and academies. Surely he would grant to each artist a period of apprenticeship in which to study and learn from both nature and his fellow artists: an artist is first of all a craftsman, a workman. Surely he would concede that even the most self-expressive artist must accept something of what has been learned about the limitations of his medium and his forms. But the important thing is that the

artist must be free to move out on his own and to renounce the fruits of his apprenticeship, which after all only affords a basis for his creative extrapolations and distortions and by no means defines his true work as an artist. He must honor the brackets that maintain his work as integral.

A fourth basis for a Sartrean aesthetics is Sartre's philosophy of the *imagined object*. In order to imagine, I must be able to hypothecate an unreality. As a consciousness, I must somehow elude the massive body of the world and seek to withdraw from the impermeability of being. The world taken as a whole is a plenum; the world for the imagination is . . . nothing. For my imagination dwells in its own realm, which is a negation of the plenum. It directs my attention away from the practico-inert and toward the responsive and free.

To be sure, each of my images is limned across the wholeness of reality, but it achieves its status as image only by negating that wholeness, that reality. What is real and what is imaginary are two distinct things. They can come close to each other only in analogies or symbols, which are sources of correspondence between being and nothingness.

Art creates images and therefore must in part deal with the unreal. The work of art exists as partly real and partly imagined—partly as an object immersed in the plenum of being and partly as a dislocation of that object from the plenum by a negating consciousness. Although the object as object is subsumed in an undifferentiated plenitude, the object as a work of art is isolated (and hence defined) within that plenitude by an intentional consciousness that locates and identifies and brackets it off. The aesthetic consciousness makes a hole, a gap, a breach in being. It is like a cookie-cutter that surrounds a portion of dough within a boundary of nothingness, thereby shaping it into something distinct and perhaps tasteful.

For itself, the work of art is an imagined object; it exists not in actual time or space but in its own imagined atmosphere. To be sure, a painting as a physical object may occupy geographical space and endure in historical time—but only as a physical object. A painting as an imagined object, however, is not concerned with the motives and agencies of the geographical and historical world. What goes before it, or comes after it, or is external to it, is also irrelevant to it; and in a sense it is irrelevant to them. It is a negation of the world, and therefore free of the world. The negation as a sanctuary of freedom is in itself more real than the world; for art relies upon the nothingness that *is* rather than the nothingness that is *not*. By its disconnection with the world, the imagined object gains its autonomy, its freedom.

The physical object of art can, however, provide analogues to that pleasant state of consciousness which entertains imagery. The real is never beautiful; only states of mind supervening upon the real across nothingness

are beautiful. The beauty of an imagined object may in a sense be due to physical presences, but only in the form of analogous states in consciousness.

Each of the artist's images takes on the coloration of his fundamental project. He therefore reveals himself totally in an imagined object, because it is symbolic of his project and hence of him. Truly to interpret his art is to locate in his symbols the totalizing effort, the human thrust, which distinguishes him as an individual.

The intention of art is expressed in terms of the numberless concrete desires that weave themselves into the artist's life. In a totalizing movement of enrichment, each desire comes to stand for the artist himself; it enters into his project, his total vision. By virtue of his artist's skill in symbol-making, that vision may become generalized in an imagined object that embodies a desire for total being. What is significant for the individual thereby becomes significant for mankind (or at least for those men who understand and accept symbols).

The creation of imagined objects or symbols is not, of course, confined to the professional artist, who has no monopoly on artistry. Everyone senses some of the analogies between images and the feelings they seem to enshrine; almost everyone is an artist at moments.

Sartre delimits art by making a distinction between imagined objects and useful signs. A painting or a sculpture is an imagined object; a fire alarm or a red light is a useful sign. Painting and music consist of imagined objects, the materials and forms of which embody qualities that are directly felt. Poetry likewise consists of imagined objects—collections of words recognized not so much as signs but as objects with their own qualities of tonality and structure.

Prose, however, is not so much an art as a craft: it uses words as signs or cues to action. To the extent that we concentrate on the direct meanings of the words and neglect their tonal values or structures, we are dealing with them as practical objects and not as aesthetic objects. In literature, only poetry is art, and poetry is only art. Prose is utilitarian—in other words, non-art.

Drawing this distinction enables Sartre to cope with the problem of pure literature (art for art's sake) versus engaged or committed literature (explanation and persuasion). The poet deals with the qualities of life; the prose writer with the exigencies and urgencies. The poet regards writing as an end in itself; the prose writer, as a means to social activism. In Sartre's terms, social action should not be an aesthetic issue at all; it is simply the prose of experience. Unfortunately, however, poetry at times encloses prose, and prose at times encloses poetry; the two are not strictly separable. The distinction beween artistic and utilitarian writing is always being muddled.

Therefore Sartre sometimes has appeared to waver between a literature of *exis* and a literature of *praxis*. He started out by separating prose from the arts of poetry, painting, and sculpture: that is, prose is not an art but a praxis. He then began to urge a literature of commitment to the social causes in which he believed, but argued that it should fall short of outright propaganda. This literature of commitment must have at its command all the devices of art, but it must not use them for art's sake only—it must use them to encourage and abet the survival of man. In other words, prose literature must bring artistic means to bear on moral and political situations, but it must avoid the extreme of becoming an art, because that would argue its disengagement.

Ideally, of course, there could be a pure poetry without utility or moral reference, and a pure prose without aesthetic value. In practice, however, there is usually an admixture of the two, for life is seldom simple. And so art and utility are not single self-sustaining threads, but strands woven together in different combinations. We must constantly cope with totalities that yoke together both aesthetic (or disjunct) and non-aesthetic (or engaged) elements, but the distinction sometimes disappears in the work of art itself. The plain fact of the matter is that there is no hard and fast boundary between poetry and prose. They are simply two poles, between which extends an indivisible continuum.

The effect of all this is to blur the line between being and nothingness. In the most perfect art, the line may be clear; but many imagined objects are far from perfect.

A fifth Sartrean principle of aesthetics has been his philosophy of *freedom*. Creation and innovation are confined to artists and inventors, the freest of men. Starting from a still undefined situation, the free man comes to exist as a project— precognition of his own future. He carries out this project through actions that are basically free, that is, bracketed off from brute being; and as a result he is perhaps able to create imagined objects of surpassing worth. In carrying out his work, he both uses up and expresses his freedom by objectifying it.

The processes by which imagined objects come into being do not differ essentially from the processes that produce other kinds of creations. Provided that they result from the activities of free men, they achieve the uniqueness of freely created art.

Sartre's early and insistent regard for freedom is no doubt allied to his distaste for representative art, which inhibits the artist's freedom. To imitate is to conform to the outline and details of what is imitated. Only minor adjustments and deletions are allowable; basically, the object imitated controls the work.

Furthermore, realism stultifies nature itself: the medium in which nature is imitated never reproduces the truth of nature. Whereas in a non-representative work of art the value lies chiefly in the medium itself (which thereby becomes the very existent expressed), in a realistic work the value lies chiefly in the object simulated by the medium, even though this object is always falsified. Words or pigments become pseudo-objects; broad prospects are constrained to the limits of a page or a canvas; three dimensions are collapsed into two. Devices of illusionism—perspective and onomatopoeia, for example—may improve the simulation somewhat; but illusionism, being false to nature, always fails in the end to achieve a true representation. In free artistry, however, this problem does not arise; a non-representative artist has no obligation to try to match up one thing with another.

To the early Sartre, therefore, the achievement and practice of freedom was an aesthetic principle. For example, he rejected (in theory, at least) the familiar omniscient point of view that governs the course of the narration in many an old-fashioned novel, for the simple reason that it belies the notion of a free and open future. If everything is known to the narrator, all appears to be determined in advance. Only if the successive events are handled as if each were slipping into place as something fresh and unpredictable can the novelist convey feelings of life and freedom in his characters. Similarly, a painting should suggest not the rigidity of a plan but a feeling of spontaneity, as if no brush stroke is precontrolled but instead has been elected at the moment of its making.

In fact, all good art is made up of details that are not rigidly locked into place but that have emerged from a free selection.

There is no need to dwell further on Sartre's philosophy of freedom because, in his early writing, it held an eminent place. It must be said, however, that as he grew older Sartre quietly de-emphasized freedom as an aesthetic principle and moved in the direction of an increasing engagement to non-aesthetic principles. The exigencies of politics and of a bourgeois society predictably controlled the sequence of details in his later treatises; and in effect he ceased to regard the writer as a free spirit, an artist.

The sixth basis for a Sartrean aesthetics is most important of all: Sartre's philosophy of *beauty*. If essence and existence could combine, the result would be beauty. In the fusion of essence and existence, the abstract would become concrete and the concrete would become universal. Action and stasis would become one. The form would be its own matter, and matter would be completely realized form.

In any total sense, however, the fusion of essence and existence is impossible. Such a fusion would require a being at one and the same time

universal and concrete, completely in-itself and completely for-itself, object and subject as one, a combination of being and nothingness, a past that is simultaneously present and future, a reality that is also a myth, like a ghost that haunts consciousness. It would require as a basis for meditation the assumption of an absolute value and an unrealizable ideal.

What consciousness lacks but is constantly seeking is a totality of being—beautiful, ideal, and god-like—which is not only *for* itself as consciousness but also *in* itself as dense, comprehensive, and impermeable objective being.

Beauty is a value at the locus of which the in-itself and the for-itself unite. This combination Sartre usually designates by the hyphenated term "in-itself-for-itself." Outside art and beauty, there is no such thing as an in-itself-for-itself (unless it be God, which Sartre doubts). The in-itself-for-itself is the fusion we are seeking of essence and existence. This unattainable aim of becoming in-itself-for-itself is the basic human project. In other words, humans aim at a contradiction.

Nevertheless, the hope of a possible totality is a condition of consciousness and perhaps has such ontological status as pertains to indications of ideal states and transcendent values. Although total beauty may be impossible, local and temporary beauties can be realized in imagination. A beautiful object is always an imagined object—or an imaginary object. In effect, it is a perpetual possibility for apprehending imaginatively both an essence in a thing and a totalization of consciousness in ourselves.

This fusion of being and nothingness takes place in art as symbolism, which is the real extended by the imaginary. To be in-itself-for-itself is possible only if one of each pair of terms is real and the other concurrently imaginary.

An aesthetic symbol is simultaneously there and not there. Its being as a bare object—that is, as a relic or an artifact—is its being in-itself. But its being as a value, a significance, a tenor, a meaning, an expression, is a being for-itself, or rather is a being conferred by its compresence with a for-itself, a consciousness.

The God-seeker also aims at the complete in-itself-for-itself, but in Sartre's view he cannot achieve it (that is, there is no God). But the artist can have a kind of success that is impossible for the God-seeker. Because he deals with imaginary objects, the artist can embody in them—symbolically—the beauty he lacks and seeks. On the small scale of an object of art, he can realize the perfection of being—the full in-itself-for-itself—provided that he is willing to accept as well the fact that part of the object of art—the imaginary part—is a nothingness, an unreality.

The God-seeker, on the other hand, is perpetually disappointed; for a god without plenitude—an imagined God—is scarcely satisfactory. Only a

God-seeker who is willing to accept God as a work of art, an imaginary object, a creation of man, could in fact capture him. But this is usually not enough for the God-seeker, who in spite of the imperfections and incompatibilities within being itself, desires God as a manifestation of total Being.

One cannot arrive at being God—or at the being of God—all at once. Instead, he must work at realizing particular desires in particular concrete situations; and he must accept what he imagines as well as what he senses. As Bernard Shaw put it: "Only on paper has humanity yet achieved glory, beauty, truth, knowledge, virtue, and abiding love." The project of being God always fails, whereas the project of being an artist may have its small successes.

A Sartrean aesthetics must find a place for the ugly as well as the beautiful. Ugliness is the reversal of beauty, a special kind of value. Whereas beauty is the impossible ideal of the in-itself-for-itself, ugliness is the only too active possibility that the in-itself will compromise or destroy the for-itself. Most of Sartre's own fiction embodies the harsh, the hateful, the graceless; but such works as *La Nausée* and *Huit clos* cannot be called unaesthetic. Instead, they involve the imagination of the ugly, and thereby may become objects of art.

There are some embodiments of ugliness, however, which in Sartre's scheme must be viewed as anti-aesthetic. Two chief perils lie in wait for the in-itself-for-itself as that stage of being that encompasses art. The first peril is that it may succumb to the state of viscosity. The second is that it may end in a state of petrifaction.

Viscosity compromises freedom; in it, the in-itself entangles the for-itself. Viscosity is the quality of all sticky, gummy, gluey, adhesive, absorptive, clinging, miry, sucking, sugary, molasses-like, honey-like, pitch-like, leech-like things—things that are fluid, soft, yielding, docile, compressible, collapsing, deflating, foundationless, baseless, creeping, squashy, and slimy. In spite of its liquidity, the viscous may also be solidifying, crystallizing, resistant, thick, and slow. Morally, the viscous is ambiguous, vague, compromising, destructive, ensnaring, entrapping, appropriative, parasitical, possessive, fascinating, resistant, and stubborn.

In viscosity, the child and the artist come to recognize existence as an anti-value—the attempt of plenitude to overwhelm nothingness, of being in-itself to take over existence for-itself, of substance to invade and ultimately to obliterate consciousness. The child is both curious about the viscous and fearful of its entrapments. He seeks to re-establish plenitude by eliminating all the holes in it—he sticks his fingers and arms into every opening; he tries to fill up his mouth with all of the world he can take in. The artist seeks to re-establish the plenitude by filling vacancies with forms,

by creating beautiful or even ugly objects; by crowding the void with images and symbols; by eliminating from his art whatever is sentimental, mawkish, murky, syrupy, foggy, or nasty; by purifying his intentions; and by refusing to lapse into a bad conscience.

Petrifaction goes beyond viscosity by altogether eliminating freedom: in it, the in-itself destroys the for-itself and becomes marmoreal. Like the being of Parmenides, the plenum is solid and stolid, excluding the possibility of movement, life, and creativity. Because it fills to repletion, it excludes the nothingness that makes change possible. Fullness of being destroys all aspirations, even all anxieties. In the end, it destroys art—or at least it results in an unimaginative art, marmoreal and cold.

I have already indicated that Sartre scorns the formal portraits and statuesque postures of official art. Art that aims at "being," at Platonic ideas or essences, is petrified even apart from its stony materials. The art of museums and galleries, which is out of the living world, likewise is the victim of petrifaction. Art that attempts to present divinities in a hierarchy murders itself by sheer immutability.

In order to avoid the perils of petrifaction, the artist not only must repudiate the classical tradition, reject Parmenides' plenum and Plato's essences, destroy the hierarchy of officialdom, and burn down the museums and galleries, but also must devise new forms (like Giacometti's solitary figures and Calder's mobiles) that are bracketed by nothingness and have room to move in. He must emphasize the unique and ephemeral rather than the kind of finality that derives from depictions of a retractile immobility. Although, as Sartre has said, a chief aspect of the beautiful is the appropriateness of act to essence, act must leave its traces in the object of art if petrifaction is not to ensue.

In sum, an aesthetics that is firmly based in the actuality of situations, that sees the artist projecting himself beyond situations into a creative surpassing, that assures the autonomy of imagined objects by suspending them between phenomenological brackets and properly defining their imaginative contents, that stresses the freedom the artist requires in order to remain creative, and that defines the beautiful (and the ugly) in terms appropriate to the arts—this would appear to be a sound and attractive aesthetics. All these concepts are firmly in place in Sartre's ontology; and even though he has not attempted to bind them together into a coherent system, or even to apply them consistently throughout his own art criticism, they are no doubt responsible for his most dazzling insights into the arts.

Sartre's aesthetics, as far as he has completed it, stands up well against the general requirements for a philosophy of art. It is by no means reductive or limiting. It testifies to the adequacy of his total philosophy, at least in those parts of it that abut on the rationale of the arts. It has the further

value that it fully supports the artist and his audience in their respective roles, thereby enriching the culture to which they contribute. It accepts current practices in the fine arts and has by no means been outmoded by present-day developments.

Works that Sartre selected for admiration many years ago have also stood up very well; in fact, the reputations of the artists he early acclaimed —men like Hemingway, Faulkner, Calder, and Giacometti—have been steadily growing. Conversely, the trends he has opposed look worse now than when he first criticized them. His sardonic comments on traditional aesthetics and on the museum mentality that enshrines the tradition have lost none of their bite, simply because they have lost none of their truth.

For all these reasons, it is a bit sad that Sartre appears to have lost a great deal of his interest in aesthetics (although not necessarily his interest in the fine arts). For a while his concern for aesthetics grew in concord with his ontological interests and gave promise of his developing a powerful and effective instrument for the elucidation of the fine arts. In particular, his theory of situations and projects initially held great promise for aesthetics by providing a structure in which the artist can germinate, develop, organize, and totalize an aesthetic creation.

At some point along the way, however, Sartre's ontology changed into a scheme that no longer supported his aesthetic interests. This is not to say that Sartre was no longer capable of making aesthetic judgments, but rather that he increasingly came to see the situation and the project as psychological and political constructs. They became subdued to the needs of praxis; they were entangled by ideas of engagement, involvement, and commitment; instead of developing fully and freely they vanished in dialectical sleight of hand. The aesthetic components of his judgments were overshadowed by sociological and biographical components, which tended to dwarf his earlier concern for the fine arts as such. Although he never lost his interest in artists, particularly in literary artists like Genet and Flaubert, he came to regard them not so much as artists but as phenomena constituting case materials for existential psychoanalysis or anthropological investigations. Perhaps it was their stature as literary artists that initially drew him to them; but as he later viewed them he seemed much more concerned with their prose as psychologically or politically significant than as artistically rewarding.

What is responsible for Sartre's change in emphasis and for his increasing use of art and artists for other than aesthetic purposes?

First, it is evident that from the very start Sartre's own artistic production carried a heavy burden of non-aesthetic materials: philosophical concepts, autobiographical and biographical data, implied and overt moralizing. At his best, his command of form, imagery, and feeling was powerful

enough to maintain an aesthetic totality (for example, in *La Nausée* and *Huis clos*) even when he was handling an admixture of factual, conceptual, and didactic materials. But as certain of his social and political interests became more and more obsessive, his artistic production became more and more burdened with non-aesthetic materials. Sometimes it degenerated into allegories whose characters were little more than crude cartoons, whose speeches were coarsened into harangues, and whose drama fell away to melodrama (as, for example, in *La Putain respectueuse*). At the very least, internal strains began to show up and weakened the effect of totality.

This evolution was spasmodic and gradual, but the fact remains that the Sartre of the seventies is not so much concerned with literature as an art as is the Sartre of the forties.

Secondly, Sartre came down hard on the distinction between writing as instrumental or engaged and writing as artistic or poetic. In engaged writing, words are indicators, signs pointing beyond themselves. By virtue of their reference, they implicate us in our intentions. In the art of poetry, however, words are not signs but the stuff of symbols. They interest us because of their inherent qualities and the subtle analogies they can suggest. Their forms are more important than their meanings; they point largely to themselves. As Sartre has said, poets are those who refuse to *utilize* language.

It may be dangerous to draw parallels between the arts, but as far as utility and engagement are concerned poetry behaves like music and painting—it refuses to traffic with practicality; it lacks signification; it simply *is*. It lacks truth, but that is not a fault because it subsists in a world extraneous to truth: a world of imagined objects, a world in which the nothingness that denies its claims is more important than the kind of being it feigns.

In the writing of engagement, on the other hand, rhetoric replaces poetry, which gives way to the persuasiveness of actions and things. To be engaged is to intend with passion what one says and to say it in order to make things happen. The commitment to a non-aesthetic aim, as in a political directive, connects rhetoric ineluctably to being.

In his early thinking, it would appear, Sartre recognized the value of poetry as *aesthesis;* but over the years, as he became more and more committed to social and political aims, he tended to neglect, if not to deprecate, the poetic point of view. His first interest in the techniques and forms of poetry and fiction did not altogether disappear; for he recognized that those techniques can be applied to the rhetoric of engagement. Unfortunately for the arts, any such application deprives these techniques and forms of their

aesthetic bases and may even reduce them to the gimmicks of the special pleader and the propagandist.

Thirdly, Sartre's philosophy of art came to depend for its support upon an ontology with a broken back. Initially, his strength lay in his undivided concern for the free individual. Then he shifted to an equally strong emphasis on collective responsibility. Since individualism and collectivism are opposed terms (at least as exploited by Sartre), the growing strength of the latter sapped the vitality of the former. Nor was this shift merely a move in the dialectic, for it failed to yield a synthesis of the two terms. Sartre had simply broken the spine of his ontology.

To understand Sartre's aesthetic, therefore, we must largely confine our study to his work of the 1940s and early 1950s. We can trace its afterhistory only by its early history. To take it up in terms of his later years is scarcely to find much that is useful for the arts.

I say this not to be critical, but merely to report the facts of the situation. Perhaps Sartre's early concern with aesthetics simply cooled off as he moved away to other interests. Perhaps he came to regard the arts as mere flotsam in the massive currents of Marxist thought. Perhaps he became more interested in men themselves than in their paintings and stories. Perhaps his grief over the continual suffering of humankind led him to denigrate the arts as trivial decoration. After all, one may not be privileged to enjoy the playfulness of the imagination in the midst of overwhelming vicissitudes and heartbreaking catastrophes.

Another question that may call for consideration is whether or not certain of Sartre's personal preferences hindered the development of his aesthetics. Obviously, Sartre's responsiveness to the multiplicities of being is highly individual. Certain of the qualities of being obsess him and hence become his chief signs for other qualities. He stresses in particular those qualities which nauseate him, and he tends to neglect those qualities which fail to engender strong negative responses. What disturbs him most in being is its coldness and inertness on the one hand, and its adhesiveness and sliminess on the other. These qualities have provoked in him a bias toward freedom of movement and action, but they have also produced an aesthetic devoted to darkness, disgust, and hatred—an aesthetic of extreme situations committed to intolerance and violence.

The question arises, however, whether it would not be equally possible and satisfactory to construct a theory of being based upon quite another group of qualities and their sources. Take, for example, colors and colorfulness, light and luminosity, touch and tactility—sensations that typically yield pleasure. Take enjoyment, happiness, gratification, comfort, ease, refreshment, good health, and other states of euphoria. Take softness,

warmth, gentleness, which can palliate even a world grown hard, cold, and violent. Take the firm (as contrasted with the hard), the stable (as contrasted with the stolid), the resolute (as contrasted with the stubborn), the sympathetic (as contrasted with the absorptive), the integral (as contrasted with the sticky). One can derive aesthetic satisfaction from combinations of these qualities without thereby becoming an escapist, a sentimentalist, a voluptuary, or a grasping bourgeois. If Sartre had somehow been able to view the world in larger terms and to grant more attention to its aspects of light and joy, would he not have emerged with a different and perhaps more comprehensive aesthetics?

Sartre's advocacy of extreme positions also appears to limit his aesthetics; for in a sense it is a kind of bad faith. To attack one hierarchy of values in the name of what is really only another hierarchy of values, or to honor freedom in order to practice the violent repression of political views other than one's own is, to say the least, inconsistent.

Full freedom would extend to the republican as well as to the socialist or anarchist, to the deserving well-to-do as well as to the deserving poor, to the middle classes as well as to the proletariat (in America workers in all categories seek and often achieve middle-class status), to the lover of life as well as to the political assassin. Sartre's sympathies generally do him credit, but his revulsions are sometimes inconsistent with the arguments he uses to support his sympathies. How can one argue without drawing a second breath for both a radical freedom and a radical commitment? And is not his aesthetics to some extent falsified by his attempts to have it both ways? Why must he resort to the expedient of calling what is not committed "poetry," and what is committed "prose"? Even on his own terms this split does not work, for in the very essays[1] in which he lays down the distinction, he repeatedly devotes attention to aesthetic qualities in committed literature.

A part of the difficulty appears to lie in a conflict between Sartre's all-or-nothing methods of argument and the genuine reasonableness of many of his positions. On page x he may go all out for one point of view, on page y for another. Taken together (and stripped of their extremism), the points on pages x and y might make excellent sense. Possibly Sartre is actually committed to a view somewhat between total freedom and total engagement, but his reader has to figure this out for himself: it does not emerge from the extremes of the argument. And so aesthetic as well as other issues are beclouded.

The oddity of some of Sartre's responses toward the beautiful and the ugly is, of course, a matter of degree. Every strong philosophy is to some extent odd, individual, obsessed. But the unique attitudes from which it

springs perhaps disqualify it from including an impartial survey of general aesthetic qualities.

And perhaps, too, Sartre's use of overstatement is a deliberate strategy. What renders his philosophy exceptional is the vigorous, concrete terms in which he expresses it. He never fears to use analogies, metaphors, and expressive language generally. The result is a powerful individual style that exposes a powerful individual outlook.

Finally, we must raise the question, What happened to Sartre as a critic of the arts? Sartre's early criticism was illuminated by flashes of insight; it was sometimes playful and often witty; it ran off in unexpected but promising directions. In his criticisms of Ponge, Calder, Faulkner, Dos Passos, and the like, he developed a genuine feeling for aesthetic effects and values.

The aesthetic motive as such, however, seldom if ever appears in Sartre's more ponderous later works. Existential psychoanalysis, social commitment, political engagement, and Marxist exegesis are his chief concerns and felt obligations over the later decades. A philosophy of all or nothing, of extreme situations, of revolutionary intent propels him in new directions. Although he retains the skills he developed as an art critic, he increasingly devotes them to tenets or doctrines, to analyses and explications, to campaigns and vendettas. It is as if Sartre had come to regard the arts as too playful, too decorative, too disinterested, too distracting (in a word, too autonomous) to displace the serious mechanisms of his life. His intellectual intensity and his fiercely controversial attitudes simply could not accept the sensuality of an aesthesis, but had to burn through to the intellectual and moral core of things. In the process, what is aesthetic is either consumed or radically transformed.

As a result, Sartre is not a critic of art and literature in any strict sense of the phrase. That he has been a powerful and effective critical force in the arts cannot be denied; but that he might still be considered an art critic as such is open to question. Other commitments took him off on other critical tangents.

It is the business of an art critic or a literary critic to disengage from the artistic performance those qualities, actions, passions, and images which reinforce its aesthetic effect. This is the analytical part of his work. Having done this, he must turn his attention to the aesthetic effect itself—to the totality that should emerge from the particulars and, in the end, should define the aesthetic value of the performance. This is the synthetic, integrative, and totalizing part of his work.

It is *not* his business as art critic to produce a history, a biography, a memoir, a psychological case study, a political tract, or an anthropological treatise. True, each of these may contain elements that support an aesthetic

judgment; but when those elements are heaped too high on the aesthetic scale they destroy the balance and throw off the judgment. Art criticism is a delicate business: the fine discriminations it requires can only be blunted by confusing them with unassimilated alien elements that distract from the experience proper to art.

This is not to deny that there are many kinds of criticism other than art criticism, and that the practice of any one of these is a perfectly honorable profession. The analysis and evaluation of historical epochs, individual lives, political dynasties, or social trends must not be scorned, even by literary critics. But in the end, critics dealing with the arts must keep their heads clear and know what they are doing, never tangling up the strands so that, say, art criticism becomes hopelessly confused with, say, social criticism.

Nor is this to say that Sartre himself became confused; he always knew full well what he was doing. Near the end of *Saint Genet, comédien et martyr,* he states explicitly:

> I have tried to do the following: to indicate the limit of psychoanalytical interpretation and Marxist explanation and to demonstrate that freedom alone can account for a person in his totality; to show this freedom at grips with destiny, crushed at first by its mischances, then turning upon them and digesting them little by little; to prove that genius is not a gift but the way out that one invents in desperate cases; to learn the choice that a writer makes of himself, of his life and of the meaning of the universe, including even the formal characteristics of his style and composition, even the structure of his images and of the particularity of his tastes, to review in detail the history of his liberation.[2]

This statement admirably places Sartre's late works about literary artists, not as literary criticisms, but as extended biographical studies. The thrust of the statement is that he has written a complex study touching upon psychology, the nature of genius, the writer's philosophy and tastes, and politics. To be sure, Sartre includes in his statement a reference to matters frequently allied to aesthetics—style, composition, imagery—but this is thrown in almost as an afterthought, where it is subordinated to his other intentions. What he is presenting is not an aesthetics or even a mode of art criticism, but a combination of phenomenological psychoanalysis, Marxist social interpretation, and libertarianism.

In his massive studies of Flaubert, even more than in *Saint Genet,* Sartre creates a new kind of criticism that cannot properly be called art criticism. The "Flaubert" has in fact been styled a total biography, and it surpasses *Saint Genet* by devoting thousands of pages to psychological interpretations and Marxist explanations of Flaubert's individual and family history. One could hardly treat a self-conscious artist like Flaubert without side glances at his aesthetic beliefs, but the commanding thrust of the work comes from its elaborate analyses of his life and circumstances.

Sartre was always able to draw out his works to enormous lengths; in fact, he found it difficult if not impossible not to carry them to extremes. At his intense and brilliant best, his use of details for purposes of diagnosis was highly effective. But sometimes, particularly in his long later works, the result was a kind of imbrication—analysis upon analysis upon analysis—that had little to do with aesthetic totalization. In Sartre's treatments of Genet and Flaubert there is a kind of obscene giantism. He appears to know everything about them; and the smallest clues take on enormous meanings: a single phrase, precept, or symbol may be blown up, deflated, and blown up again. In these works Sartre is no longer viewing the artist as an artist but as a kind of elaborate case history, twisting and tearing away at his perceptions in the interest of a pre-emptive understanding. The machinery of analysis disrupts any feeling for the quality of his fictions.

To be sure, Sartre exhibits the details for purposes of diagnosis, as symptomatic of larger issues. But I cannot help thinking his concentration on clinical symptoms that particularly interest him gives false impressions of works of art, by putting these works under rigid constraints. Sartre virtually ignores Baudelaire's genius as a poet while dwelling at length on his childish adoration of his mother. He shows greater appreciation for Genet's response to being called a thief and his ability to violate the canons of bourgeois respectability than for any aesthetic quality he displays. He defines Flaubert also mainly in terms of his relationships to the complexities of bourgeois society (although he occasionally analyzes some of his artistic maxims as well).

Now all this is in no way discreditable to Sartre. His intensity, his scruples, his intellectual bent, his moral concern, and his profound sympathies and anxieties are all to be respected, if not admired; and his phenomenological analyses and Marxist excursions are of course perfectly justifiable. What is wrong is to call such occultations literary criticisms. Instead, they are fascinatingly detailed treatments of Sartre's preoccupation with bourgeois antics, revolutionary violence, psychological obsessions, moral doctrines, and partisan nuances. They do at times throw a somewhat lurid light on the literary works of Baudelaire, Flaubert, and Genet, but more as biographical artifacts than as works of art.

From the standpoint of art criticism, however, Sartre's emphasis on these matters is something of a tragedy, because Sartre had it in him to become a top-level art critic. Some of the essays collected in the several volumes of *Situations* demonstrate this only too well. In these essays, Sartre does not ride a thesis or pursue a project to its ultimate demise. In them he shows the finest critical abilities and sensitivities, together with a determination to respond to a body of work not in doctrinaire fashion but in terms of sympathy with its unique qualities. I think that a great critic of art and

literature was lost in Sartre, even though a powerful theorist and polemicist emerged.

CHARLES D. TENNEY

SOUTHERN ILLINOIS UNIVERSITY,
CARBONDALE

NOTES

1. *Qu'est-ce la littérature?* (1948).
2. Translator: Bernard Frechtman (in *Saint Genet, Actor and Martyr* [New York: George Braziller, 1963], p. 584).

Edward S. Casey
SARTRE ON IMAGINATION

I

IMAGINATION has been a preoccupying theme of Sartre's entire adult life—indeed, if we are to believe *The Words,* of his childhood as well. The seven-year-old Jean-Paul's fascination with film, with "seeing the un-seeable"—"in the equilitarian discomfort of the local theaters, I learned that this new art belonged to me, as to everyone"[1]—is continuous with the septuagenarian's obsessive concern with the significance of Flaubert's flight into fiction. Film and fiction both exemplify a transcendence of perceptual and social givens and a movement toward the imaginary; each involves a conjoint action of "derealizing" (*irréalisation*) and "imaginifying" (*imag-inarisation*). This action is not restricted to the experience of movies and novels but characterizes consciousness as such. Throughout Sartre's writing career, the imaginary toward which consciousness transcends has been identified with the realm of the unreal (*l'irréel*), which may be embraced or rejected but never allowed to merge with the opposite realm of the real.

It is true that Sartre's postwar writings, and in particular those follow-ing the publication in 1947 of "What Is Literature?," have borne witness to the considerable complexity of the manifold relationships between the real and the unreal, perception and imagination, prose and poetry—all of which were kept aseptically separate in Sartre's earlier works. But even in *Saint Genet* (1952), where Sartre is forced to recognize the "corrosive power" of Genet's basic project of *realizing* the imaginary, the ultimate distinctness of the imaginary and the real is maintained: "to realize the imaginary means to include the imaginary in reality *while preserving its imaginary nature*."* And, if Sartre has since 1954 allied himself increasingly with the real in certain of its concrete historical and political embodiments, this very act of allegiance has forced him to keep a wary eye on the imaginary as an

* Jean-Paul Sartre, *Saint Genet: Actor and Martyr,* tr. by B. Frechtman (New York: Mentor, 1963), p. 452; the italics are Sartre's. Hereinafter cited as *Saint Genet.*

excluded but still seductive counterpoise to the rigors of reality. Just as evil rises ineluctably but inefficaciously from the ruins of the good in Sartre's Genet-inspired moral vision, so the imaginary continues to emerge unsullied and uncompromised by the demands implicit in social *praxis*. Whether in the form of Giacometti's sculptural space, the lyrical poetry of *Orphée Noir*, or the fiction of Flaubert (who is termed "the master of the unreal"),[2] the imaginary remains for Sartre an uneliminable dimension or region of all human experience: "man is like a leak of gas, escaping into the imaginary."[3] The imaginary itself is at once a manifestation and a symbol of that free spontaneity of mind which Sartre has never ceased to cherish. Thus we should not be astonished at his declaration that *L'Idiot de la famille*, the monumental study of Flaubert, "represents a sequel to *L'Imaginaire*."[4]

Nevertheless, imagination as an explicit object of inquiry engaged Sartre most compellingly in the fifteen years that preceded the publication in 1940 of *L'Imaginaire* (hereinafter referred to as *The Psychology of Imagination*). During this decade and a half, Sartre devoted a considerable portion of his writing efforts to delineating "the role and nature of the image in psychological life," the title of his *diplôme* thesis of 1927. The thesis itself, written when Sartre was twenty-two years old, treats the following five topics: "image and perception," "image and thought," "attitudes toward the image" (that is, the attitudes of the mystic, the scholar, the artist, and the schizophrenic), "language and personality," and "the nature of the image."[5] This surprisingly scholarly work, which cites more than one hundred different sources, forms the basis for the two works in which Sartre's most exhaustive treatment of imagination occurs: *Imagination* (1936) and *The Psychology of Imagination*.[6]

II

Viewed in broader perspective, Sartre's theory of imagination as set forth definitively in these two books may be regarded as part of a widespread twentieth-century reaction to the enthusiastic claims of Romanticism. Where Baudelaire claimed that imagination "created the world," Sartre sees imagining as involving only an "anti-world." And where imagination is in Baudelaire's eyes "the Queen of the faculties," it is in Sartre's opinion only one of several possible modes of mentation.[7] The productive powers that were attributed to imagination by Kant and Schelling, Novalis and Blake, are repudiated in Sartre's acerbic assessment. In place of these powers, Sartre discerns a species of mental activity which promises more than it can produce—or rather, which can produce only in accordance with drastically lowered expectations. Imagining, in brief, is charged with an impoverishment of form and content from which it cannot recover. All the

extravagant encomia that had been lavished upon imagination by its admirers and adherents in the Romantic movement are forsworn in Sartre's terse testimony. Intentionally avoiding panegyrics, this testimony purports to bear on the phenomenon alone.

Phenomenological method is expressly designed to provide an unbiased and unextravagant account of the phenomena to which it directs itself. Of these phenomena, it gives a sober, cautious, and direct description. It is a significant fact that Husserl, in the opening years of this century and just at the moment of his discovery of the phenomenological reduction, investigated imagination with his usual scrupulous care. What Husserl found, in his seminal lectures of 1904–1905 on "Imagination and Image-Consciousness," is that the basic operation of imagining is one of "presentifying" (*vergegenwärtigen*)—that is, of placing intuitive, quasi-sensory psychic content before the mind. Precisely as a form of presentification, imagination is incapable of attaining the plenitude (*Fülle*) of perceived presence and is relegated to the position of a second-level mental power, limited to presentifying what only sensory perception can present *in propria persona*.[8] It was in vain that Eugen Fink, Husserl's aspiring assistant, struggled to show that imagination's considerable intuitive capacity gives it access to a unique "image world" (*Bildwelt*). Fink's prizewinning essay of 1927, "Vergegenwärtigung und Bild," lacking the incisiveness and rigor of Husserl's earlier analyses, falters and finally breaks off at the end of Part I. Overstressing the intuitiveness of what we imagine, Fink does not do justice to the factor of absence—and hence does not recognize the process of nihilation that is entailed by absence of a specifically imaginal sort.[9]

Sartre chooses to ignore Fink's essay entirely and to return to Husserl as his primary inspiration.[10] "Husserl blazed the trail," writes Sartre at the end of *Imagination,* "and no subsequent study of images can afford to ignore the wealth of insights he provides."[1] This *Rückkehr* to Husserl is only fitting, inasmuch as Sartre and Husserl share a common goal in their phenomenologies of imagination: namely, to avoid Romantic *Schwärmerei* by stressing the sanity of structure. Moreover, their respective attempts to demythologize previous accounts of imagination are initiated by the same resolute step, which consists in distinguishing imagining *in kind* from other mental acts, and especially from perceiving. In this effort to isolate the phenomenon, they rejoin philosophers of quite different persuasions who similarly wish to assign to imagining a distinctive role in the life of the mind. Thus, Ryle says flatly that "to see is one thing; to picture or visualize is another. . . . When a person says that he 'sees' something which he is not seeing, he knows that what he is doing is something which is *totally different in kind* from seeing."[12] Wittgenstein adds that "images tell us nothing, either right or wrong, about the external world."[13] In concert with Ryle and

Wittgenstein, Sartre (following Husserl's lead) tries to establish decisive, eidetic differences between imagining and other types of psychical experience. It is in view of just such differences, together with the differentiation of imaginative activity from what Sartre calls generically "realization," that the anti-Romantic program of a phenomenology of imagination is to be carried out.[14] Reflecting a pervasive twentieth-century malaise with the notion of imagination as an originary or productive power—and in this regard showing himself to be "profoundly and self-consciously contemporary," in Iris Murdoch's apt phrase[15]—Sartre aims at demolishing once and for all the Romantic myth of imagination's omnipotence: the puritan of prose calls into question the poetizing productivity of imagination and seeks to present a rigorous portrait of the phenomenon.

III

Before providing such a portrait, however, there must be a decontamination and deconstruction of previous philosophical and psychological theories of imagining. In *Imagination*, Sartre's criticism centers on the recurrent tendency of these theories to view images as discrete and dissociable inhabitants of the imagining consciousness, as its "inert psychic contents."* The result is a "naive metaphysics of the image" that considers images as mini-things, trapped within the mind: "the image is a lesser thing, possessed of its own existence, given to consciousness like any other thing, and maintaining external relations with the thing of which it is the image" (*I*, 5). Such reification of the image is found in Descartes, Spinoza, Leibniz, and Hume; but it is also present in Bergson and Bergsonians, as well as in associationist and introspectionist psychologists. All of these otherwise so disparate figures are intrinsically linked: "beneath this diversity can be found a single theory" (*I*, 6). According to this theory, images exist strictly atomistically and thus as incapable of becoming parts of genuine synthetic wholes. Yet consciousness is synthetic by its very nature: "every psychic fact is a synthesis" (*I*, 145). The atomistic view of images, by regarding them as isolated units, disrupts the continuity of consciousness and spoils its spontaneity.

Sartre's critique of atomizing and hypostatizing interpretations of imagination is threefold. First, if the naive metaphysics of the image were correct, we could not distinguish with any certainty between imagined and perceived objects. They would differ from one another only in degree, with the result that we would be continually mistaking one sort of object for the other. But in fact we distinguish between the two sorts of object with

* *Imagination*, tr. by Forrest Williams (Ann Arbor: University of Michigan Press, 1962), p. 146. This excellent translation will be hereinafter cited as *I*.

ease and for the most part accurately. Even when they share a similar description—exhibiting an "identity of essence"—they are experienced as different in their being (they do not possess an "identity of existence"). (Cf. *I*, 2–4.) Hence, we cannot say that they are the same kind of thing. Second, to posit images as mini-things is to duplicate needlessly the universe of entities. Like Aristotle criticizing Plato's theory of Forms, Sartre suggests that images *qua* internal objects are superfluous mental excrescences, to which Ockham's razor should ruthlessly apply. Third, an overvaluation of perceptual experience leads to a misconstruing of imaginative experience. When the dominant ontology holds that the only things that count as ultimately real are perceived objects and events, everything else in the universe of experience, including images, becomes derivative from what we perceive and even essentially *like* what we perceive. In this way images come to be regarded as renascent percepts, and we fall prey to what Sartre calls the "illusion of immanence," the mistaken belief that images possess the same basic properties as externally perceived objects. More than any other single factor, it is the illusion of immanence which has bedeviled theories of imagination in the West.

It is Husserl's considerable achievement to have suggested a specific remedy for the illusion of immanence. The remedy consists in conceiving the imagined object as strictly *transcendent* to our consciousness of it. Citing Husserl's analysis of the flute-playing centaur in *Ideen I*, Sartre claims that Husserl "restored to the centaur . . . its transcendence" and thereby "freed the psychic world of a weighty burden" (*I*, 134–35). The imagined object is an intentional object, and as such is stationed outside or beyond any particular consciousness *of* it. And what about the image? Here Sartre goes beyond anything Husserl has explicitly said to assert that the image *is* the consciousness of its object. It is a self-translucent act which intends this object as transcendent. The last vestige of reification is removed from the image when we consider it to be a mode of consciousness, and the Conclusion to *Imagination* affirms that "there is not, and never could be, images in consciousness. Rather, an image is a certain type of consciousness . . . a consciousness *of* something" (*I*, 146).

IV

The French version of *The Psychology of Imagination* is significantly subtitled "Phenomenological Psychology of Imagination."* As originally conceived by Husserl, phenomenological psychology has for its task the

* This subtitle was omitted by Bernard Frechtman from the English translation, *The Psychology of Imagination* (New York: Washington Square Press, 1966). Hereinafter cited as *PI*, this translation will be emended where necessary.

investigation of eidetic structures, that is, those structures which are indispensable to a given phenomenon. An "eidetics of the image," therefore, attempts to uncover "the set of conditions which a psychic state must fulfill in order to be an image" (*I*, 131). But we must notice that Sartre's conception of phenomenological psychology differs from Husserl's in two ways. First, Sartre does not require that a prior phenomenological reduction be performed; only the transcendental phenomenologist, not the phenomenological psychologist, is said to need this reduction. A phenomenological psychology remains "intramundane" for Sartre. This heterodox claim leads to a second significant departure from Husserl. Instead of holding that phenomenological method is a matter of *intuiting* essences (*Wesensschau*, in Husserl's term), Sartre appeals to "reflection," which is a second-order act that scrutinizes ordinary first-order acts. To understand what it is to imagine it is not enough merely to imagine; we must direct our reflective attention onto the original act of imagining so as to discern its eidetic structure:

> The act of reflection therefore has an immediately certain content which we shall call the essence of the image. This essence is the same for every person; the first task of psychology is to make it explicit, to describe it and fix it. . . . The method is simple: produce images in ourselves, reflect on these images, describe them; that is to say, attempt to determine and to classify their distinctive characteristics. (*PI*, 4)

The aim of Sartre's reflective method is accordingly twofold: first to describe and then to classify essential structures. In this way we come to grasp "the certain," which is the title of Part I of *The Psychology of Imagination*. When we abandon reflection and turn to strictly empirical considerations, we have to do with "the probable," the title of Part II of the book.

Let us concentrate upon what Sartre considers to be the certain, or indubitable, findings of his study. The most general of these is that imagination is one of the four or five major modes or "attitudes" of consciousness, along with perception, thinking, and emotionality.[16] Theoretically, each basic attitude of consciousness is of equal importance, but Sartre considers imagination and perception to be of special interest because they are "the two great *irreducible* attitudes of consciousness" (*PI*, 153; my italics). Not only are they irreducible to other attitudes, they are strictly irreducible to *each other*. Perceiving is a matter of observing physical objects and external events by allowing specific sensory contents to inhabit consciousness. Imagining has no such basis in observation; at most, it can be said to be "quasi-observational," that is, to induce in the imaginer a sense of observing when he is in fact not observing at all. Furthermore, images are incapable of containing immanent sensory data. Being themselves acts and not contents of consciousness, they are sheerly spontaneous—spontaneous through and

through. Of course, *all* conscious acts are spontaneous insofar as consciousness *per se* is considered by Sartre to be an impersonal or pre-personal spontaneous flow.[17] But other types of spontaneity are initiated or precipitated by objects or events existing externally to consciousness: a perceived tree or an eternally true mathematical theorem. In imagining, the spontaneity is wholly unmotivated: it is an instantaneous, self-generated upsurge. Nothing external initiates it, and it does not cease because of external factors. This is why there is a "magical" quality in imagining, which produces its objects spontaneously and, as it were, *ex nihilo*. Even more than emotion, imagination involves an "incantation" of its objects, which never fail to appear just as we intend them. (Cf. *PI*, 159.) These objects are never more—and also never less—than what we imagine them to be: "the object of the image is never anything more than one's consciousness of it, and is limited by this consciousness" (*PI*, 11). From this it follows that we cannot be deceived or disappointed by what we imagine: "no risk, no anticipation: only a certainty" (*PI*, 12).

In spite of imagination's independence from perception and other acts, and in spite of Sartre's resolutely anti-Romantic stance, he maintains that imagining is necessary to consciousness itself. Imagining is not merely a facetious or flippant mental posture that we may adopt gratuitously; on the contrary, it is "an essential and transcendental condition of consciousness" (*PI*, 246). In other words, one cannot be a conscious being without being able to imagine, and this is so for two reasons. To begin with, imagining is essential to the freedom of consciousness. Or rather, imagination *is* this freedom: imagining "is consciousness as a whole insofar as it realizes its freedom" (*PI*, 243). Freedom is conceived by Sartre as an "unmotivated upsurge," and imagination in its mercurial mobility provides a paradigm for such *jaillissement*. Yet the freedom of consciousness that is realized in imagining does not take place in a void; it is a free movement in relation to the *world*. And this indicates another and even more basic way in which imagination is crucial to consciousness: in its basically *nihilating* character. When we imagine, we nihilate the world—the domain of the perceptually given, the empirically real—in order to enter a realm in which an unhindered spontaneity becomes possible.

Acts of imagining are nihilative not only in relation to the world but in another sense as well. They project their objects in image-form (*en image*), that is to say, as *not being*. To exist in the form of an image is precisely not to be; it is to lack the thetic character of empirical reality that is possessed by perceived objects. Consequently, images are characterized by a distinctive *nothingness*—a "nothingness of being" (*néant d'être*). In imagining, we are immediately and pre-reflectively aware of this nothingness, which assumes four different forms:

1. non-existence
2. absence
3. existence elsewhere
4. strict neutrality: neither existing nor not existing

Of these four thetic characters, Sartre considers the first two the most essential. This priority of absence and non-existence is not accidental, for they serve most strikingly to distinguish imagined objects from perceived objects. The latter are never experienced as non-existent or as entirely absent; they give themselves as unequivocally existent and as bodily present to the perceiver.

When I posit an imagined object as non-existent, the object is either an originally perceivable object that has ceased to exist (for example, a friend who has died), a strictly non-perceivable object that has never existed (such as a centaur), or a perceivable object that does not yet exist (for example, my future book). When I posit an object as absent, the object may be, in itself, existent and perceivable; but it is not within the present purview of my perceptual apparatus: I have an image of it, but *it* is not present in such a way as to be perceived. It is to be noticed that in all these cases I enter into a relation with the imagined object which is "intuitive" in nature. The imagined object, whatever its exact thetic character, is given as present to my mental gaze. In this regard, Sartre stresses as much as does Fink the intuitiveness of images: "An image is nothing other than a relation [to an imagined object]. The imaging consciousness which I have of Pierre is not a consciousness of the image of Pierre: *Pierre is directly reached*" (*PI*, 7–8; my italics). Yet, despite this intuitive or direct relation to the imagined object, imaginative experience remains mediated. This inescapable mediation is a function of nihilation in the first sense discussed above. Such nihilation, as we have seen, involves transcending the world as an empirical base. Insofar as imagining is always nihilative in this respect, its activity is mediated by at least an indirect reference to the world as the transcended term. Thus if the imagined object as unreal is in fact directly given to intuition, it is given as infected with nothingness in two ways: by virtue of its transcendence of the empirically real world, and by virtue of its thetic character as absent or non-existent.

V

Having now briefly surveyed Sartre's basic view of imagination, I shall turn to a critical consideration of three areas of weakness in his account: the analogon, the relation between the real and the unreal, and the relation of imagining to knowing or reflective thinking. Each of these problematic topics represents a different point of breakdown in Sartre's analysis. Yet all

stem ultimately from a common fault: an inadequate description of the phenomenon of imagining itself. A more cautious and detailed description might have helped to avert the misconceptions into which Sartre is led by his all too rapid delineation of imagination's essential characteristics.[18]

The analogon is at once a key to Sartre's entire analysis of imagining and an Achilles heel. The analogon is that *on the basis of which* we imagine, the substrate with which all imagining must begin but which is also always transcended. When I intend my absent friend Pierre by looking at his photograph, my intention is "directed onto a content [that is, the physical photograph] which is not just anything, but which in itself must present some analogy with the object in question" (*PI*, 24). The photograph serves as a material substrate for imagining Pierre because of its structural similarity to Pierre-as-imagined; it serves as an analogon of the latter. Analoga need not be exact physical representations, however. I can imagine Pierre by means of a caricature or a memory image as well as by means of a photograph. In each instance, the object (Pierre) is the same, and so is the mode of imaginative activity (that is, visualization). Only the analogon differs from case to case.

The various members of the "image family" are to be distinguished from one another in terms of their distinctive analoga, physical or psychical:

1. physical analoga: photographs (portraits), caricatures, gestures of mimicry, schematic drawings, faces in the fire, etc.

2. psychical analoga: mental images

Even if psychical in status, an analogon functions as a "perceptual equivalent" of the imagined object. (Cf. *PI*, 22.) It is a material or quasi-material factor which I animate and yet also nihilate: a transcendence that is itself transcended in and through the act of imagining.

The primary role of the analogon is to convey an imagined object to the mind of the imaginer by being this object's "substitute" or "proxy" (*PI*, 112, 117). Accordingly, it is conceived as an "analogical representative" (*PI*, 25) of what is imagined. Precisely as a representative, the analogon *stands for* an imagined object; it has the status of a sign, albeit not an indexical sign. An indexical sign represents or stands for what it indicates without having to share anything with it by way of contiguity or resemblance; consequently, the relationship between sign and signatum is arbitrary: indexical designation can occur between *any* two terms. Representation by analogy, in contrast, requires that the analogon and that of which it is the analogon (the "analogate") resemble each other. This resemblance can take the form of functional or qualitative similarity; either way, the relationship between the representing and the represented terms is *iconic* rather than indexical. In a two-termed iconic relationship, each of

the terms resembles the other in some essential way, typically pictographically. The intrinsic similarity between sign and signatum means that they cannot be related to each other in a wholly arbitrary fashion. In Sartre's theory of imagining, then, the physical or psychical analogon enters into a non-arbitrary iconic relation with the imagined object.

Sartre contends that there are two components of the analogon which make its iconic relationship with the imagined object possible. These components are, respectively, affective and kinesthetic in nature. The affective component relays the depth dimension of the imagined object: "that which is most full and inexpressible in it" (*PI*, 105). The kinesthetic component conveys the imagined object's sense of directionality and movement. The analogon's affective and kinesthetic components are animated by a form of knowing unique to imagining and pre-conceptual in character. Such knowing fills in the gaps in the kinesthetic-cum-affective analogon. The more specific and determinate the analogon, the less such *savoir* is needed: the photograph-as-analogon demands little of it, the mental image considerably more.

The analogon as thus described raises a number of serious difficulties, which may be considered under two main headings.

1. *Psychical Analogon* The notion of the psychical analogon—the analogon inhering in the mental image proper—is problematic because it threatens to land Sartre in the illusion of immanence, the very illusion whose presence he decries in earlier theories of imagination. This illusion consists in "transferring to the transcendent psychical content the externality, spatiality, and above all the sensible qualities of the [external] thing" (*PI*, 69). Such reification of mental content turns what is purely psychical into something thing-like, that is, into something which can be objectively described and observed and which is therefore perceivable on its own account. The psychical analogon as conceived by Sartre is *not* perceivable, for it does not possess sensible qualities of its own: "rather than having these qualities it *represents* them, though in its own manner" (*PI*, 64). In making such an assertion, Sartre avoids falling into the classical form of the illusion of immanence whereby the perceptual properties of external objects are superimposed upon objects of a strictly psychical nature.

The question remains, however, as to whether Sartre does not fall prey to the illusion in a more subtle form when he ascribes to the psychical analogon a transcendent status in imaginative experience. The term "transcendent" is introduced into Sartre's account in an evident effort to forestall any suspicion that this account might itself be subject to the illusion of immanence. Yet this defensive move ends only in paradox. That becomes clear when we realize that to conceive of the psychical analogon as transcendent is to make of it a specific *object* of consciousness:

[I]n being conscious of an image, we apprehend an object as the "analogon" of another object. . . . The purely psychical "content" of the mental image cannot escape this law. . . . This necessity for the matter of the mental image to be already constituted as an object for consciousness is what we shall call the *transcendence* of the representative element. (*PI*, 69; Sartre's italics)

As an intentional object, the psychical analogon is transcendent to the act of imagining, but it has no such transcendent standing *outside* the domain of conscious acts. In fact, *qua* psychical, an analogon is located wholly *within* this domain; as Sartre says explicitly, "transcendence does not mean externality: it is the represented thing that is external, not its 'analogon'" (*PI*, 69). Not being located externally to consciousness, the psychical analogon must be internal to the mental realm; there is simply no other alternative within Sartre's latter-day Cartesian dualisms of mind/matter, psychical/physical, inner/outer, internal/external. The paradox, then, is that the psychical analogon is both immanent and transcendent—immanent to mind and yet transcendent to particular acts of mind.

As if to reinforce this paradox, Sartre stresses that the analogon of a mental image is a "psychical given," proffering itself directly to consciousness. It has "presence" in the mind, and it is a "real" factor there. (Cf. *PI*, 118, 161.) Unlike the imagined object *per se*, it is not posited as nonexistent or as absent: on the contrary, it is experienced as both present and existent. Indeed, the absent or non-existent imagined object appears precisely *through* the analogon, which thus possesses a presentational function. But the analogon is not purely functional in its being; it remains an object that exists in its own right:

What does one mean when one says that one "has an image"? One means that one has before his consciousness an *interposed object* which functions as a substitute for the [absent or non-existent] thing. This belief, if restricted to just this claim, would be justified: *this object exists*, it is the analogon. (*PI*, 112; my italics)

This is a most revealing passage. The analogon is said expressly not only to exist, but to be "interposed" between the act of imagining and the ultimate (that is, absent or non-existent) object of this act. Yet only of something *thing-like* can one claim that it exists or is interposed in human experience. Thus it appears that the psychical analogon is after all a mini-thing, and that Sartre has fallen into the illusion of immanence.

In defense of Sartre, it might be protested that the psychical analogon is at least not thing-like with regard to the possession of sensible qualities. We have seen that Sartre denies that this kind of analogon *has* any such qualities. Yet this matter is more complicated than it appears to be at first glance. Sartre says of the psychical analogon that "we apprehend on it [*sur lui*] the qualities of the thing aimed at" (*PI,* 70). This is a highly ambiguous

statement: do we actually apprehend the imagined object's sensible qualities *on*—that is, as directly qualifying—the analogon, or do we apprehend these qualities only *by means of* the latter? Even if the second, weaker interpretation is correct, it does not resolve the dilemma. For we can still ask, Precisely as *analogous* to the imagined object, must not the psychical analogon possess at least quasi-sensible qualities? If it does not exhibit qualities that are either sensible or quasi-sensible, how could it function as an *analogon* of an object that displays genuine sensible qualities?

By its very nature, an analogon is related to its analogate, the object which it represents, by means of resemblance, and a relation of resemblance involves an iconic likeness between representing and represented terms. Moreover, as Peirce has shown, iconicity is qualitative in character.[19] For the psychical analogon to fulfill its function, the same quality, or at least a similar quality, must be present both in it and in the imagined object of which it is the analogon. This quality need not have precisely equivalent epistemological standing in the two terms in question. What is actually perceivable in the object, for example, need only be quasi-perceivable in the analogon. The important point is that as a truly "analogical representative," the mental image *qua* analogon must be capable of presenting or sustaining qualities that resemble (though they need not replicate) sensible qualities. Indeed, without such resembling qualities, how could a mental image be experienced as a "transcendent psychical content" in the first place? The mental image must, then, serve to support these qualities. And yet to admit this is once more to fall prey to the illusion of immanence. To support qualities that resemble sensible qualities is to be to this extent thing-like. In order to play its role as an iconic representative of the imagined object, the psychical analogon must possess the status of a thing or quasi-thing. Hence the very hypostatization that Sartre had scorned in previous theories of the mental image reappears as a consequence of his own position.

2. *Physical Analogon* If the notion of the analogon thus leads to perplexity in the case of mental images, it is equally problematic in the case of external images. (By "external image" is meant any image whose analogon is entirely or predominantly physical in character.) According to Sartre, whenever we imagine, we must pass beyond particular analoga, whether physical or psychical, toward imagined objects. But the act of transcending physical analoga involves a special complication. In this case, we surpass a perceptual presence toward a nonperceptual, psychical object—instead of merely passing from one psychical entity to another. When I imagine Pierre on the basis of his photograph, my attention somehow shifts from the photograph as perceived toward an absent, unperceived Pierre. Despite the seeming simplicity of this operation, one wonders whether I

actually *take* the photograph as an analogon of Pierre. A highly reflective analysis such as Sartre's might claim this, but it does not fit one's usual experience of the situation. Normally, the photograph is not apprehended expressly as the analogon of the absent object. It is merely used as a point of departure for attaining this object in imagination. The photograph's inherent resemblance to the real Pierre (after all, it is a photograph of this very person) facilitates its usefulness as a cue or reminder. But such resemblance does not appear to be essential. I can also imagine Pierre on the basis of a photograph of a person who does *not* resemble Pierre—or, indeed, on the basis of something that is not photographic or pictorial at all. And if there need be no relation of resemblance between what Sartre calls the "representative element" (*le représentant*) and the imagined object it represents, then the very notion of analogon, which *eo ipso* involves resemblance or iconicity, must come into question.

Of relevance here is the fact that in such diverse experiential domains as dreams, language, and politics, representativity is not necessarily iconic. If relations of resemblance are not required in these modes of representation, why should they be demanded in the case of imagination? It would be question-begging to define or describe the image in such a way that it *must* involve an iconic relation between its immediately presented surface and the imagined object which appears on or through this surface. Nothing needs to function as an analogon in order to serve as a basis for attaining imagined objects. These objects can be intended and reached starting from a strictly non-analogical initial experience.

Another line of questioning casts further doubt upon the physical analogon. Sartre argues that if I imagine Pierre first by means of a photograph and then by means of a caricature, what distinguishes the resulting experiences from each other is their *matter*—that is, the specific material character of the photograph vs. the quite different material character of the caricature. In fact, the physical analogon *is* this distinctive material factor insofar as it plays a representative role, and as such it is a means of distinguishing between various kinds of imaginative experience. Yet it is doubtful that materiality *per se* is as crucial in experiences of imagining as Sartre claims it to be. The imagined object, precisely as something unreal, is unaffected by the nature of the specific matter on the basis of which we imagine it. It makes no essential difference whether we use a photograph or a caricature of Pierre as a material base; in neither case will the sheer materiality of this base affect or alter the non-material imagined object, "Pierre." Moreover, the material factor does not account for all of the experiential differences between the two cases of imagining. It is true that the apprehension and transcendence of one sort of perceived matter may be experienced differently from the apprehension and transcendence of another

sort of perceived matter. But the felt differences between imagining Pierre on the basis of a photograph and on the basis of a caricature cannot be reduced to differences in the perception of the two sorts of matter alone. There is also a difference in the *intentional* character of the two experiences. In one case, I intend "Pierre-through-a-photograph" and in the other I intend "Pierre-through-his-caricature." The "Pierre" that I attain in these varying manners will differ subtly in the two instances and in ways that cannot be attributed to perceived discrepancies between the physical surface of a photograph and of a caricature. Sartre himself acknowledges the role of the intentional factor in imagining when he claims that "knowledge" (*savoir*) constitutes "the active structure of the image" (*PI*, 73) and when he makes certain "attitudes of consciousness" responsible for interpreting objects as either real or imaginary (*PI*, 25). Hence the importance of the physical analogon, and of materiality as such, appears to be considerably exaggerated even within the formal framework of Sartre's own analysis.

There is still another problematic aspect of the physical analogon, and this concerns its role in the apprehension and appreciation of works of art. In Sartre's view, the work of art belongs to the same series of phenomena as do photographs, caricatures, faces in the flame, or objects seen in crystal balls. In all of these latter, we surpass a presented surface toward an imagined object that is perceivable in fact or at least in principle. In the case of works of art, however, the imagined object may be so radically unreal as to be strictly unperceivable. This situation arises most particularly in the case of abstract painting, where it is difficult to say *what* it is that we transcend toward. In such a case, says Sartre, we aim at "new things" which lack empirical reality altogether and which are not even perceivable in principle. (Cf. *PI,* 248–49). But no matter how abstract and unperceivable these novel things may be, we still must approach them *through* physical, perceivable phenomena. In other words, the imagined objects at which we aim in aesthetic experience must be *presented* by means of such material factors as physical paint, printed words, or a public performance. The work of art as a whole, however, cannot be identified with these sensible constituents, which act only as analogical representatives of imagined objects. For Sartre, these objects are always and only unreal: "outside the real, outside existence" (*PI*, 252).

This analysis of aesthetic experience is mistaken at several critical points. First of all, it is nonsensical to claim that "the work of art is an unreality" (*PI*, 246). If the work of art were inherently unreal, then the analogon *qua* physical could be related to it only extrinsically, contrary to Sartre's own thesis that a physical analogon is intrinsic to aesthetic experience. Called for here is a distinction between two fundamental factors

within the experience of art: the work of art proper, which is perceivable and capable of serving as an analogon, and the aesthetic object, which is strictly unperceivable. To say that the work of art is perceivable is not to reduce it to its material components; rather, it is to attribute to it the potential being of what Ingarden terms a "schematic formation." The work as schematic formation is capable, on the one hand, of being perceived on specific occasions and, on the other, of adumbrating imagined objects (that is, aesthetic objects proper). In such a conception, the various components of the complete work are not related to each other in an external and merely contingent manner.[20]

Secondly, it is not descriptively true that in aesthetic experience we take the physical presence of the work explicitly as an analogon of an unreal object. Despite Sartre's claims, we do not apprehend the actor's actual tears as the analogues of Hamlet's unreal tears, nor the perceived sounds of Beethoven's Seventh Symphony as analogues of an unreal Seventh Symphony. (Cf. *PI*, 249–52). To do so would be to interrupt and spoil these aesthetic experiences by introducing into them a reflective, second-order as-structure. In short, we do not take the work of art to be anything other than what it presents itself as being. The only as-structure normally present in the experience of art is that of identity: we interpret a given work of art as being a certain sort of art (such as painting, or poetry) and sometimes as belonging to a certain genre (for example, lyric, or epic); and we may also identify certain figures or forms within it as figures or forms borrowed from other works. But we do not transcend the work's physical presence—as embodied in its immediately sensed surface—toward something else of which this presence would be the mere analogon. Insofar as the work is successful, our aesthetic attention remains riveted to its perceived surface, on which or within which the entire content of aesthetic experience plays itself out. This does not preclude the ingrediency of other kinds of components (affective and conceptual components, for example) in the total presentation of the work; but we do not experience such components in isolation from the perceived surface. In Berenson's term, aesthetic experience is radically "intransitive." Indeed, of all human experiences it is perhaps the least receptive to an analysis that is based on the notion of the physical analogon. Yet *The Psychology of Imagination* concludes with just such an analysis: the work of art's perceptual presence is not of intrinsic, but only of analogical, significance.

It is to Sartre's credit that he has had some second thoughts about this theory of art. In *Saint Genet* (1952) he explores the alterntive possibility that the artist seeks to bring the unreal aesthetic object directly into the real world of perception and action. Instead of derealizing the physical analogon by nihilating it and transcending it toward the imaginary: "why not

attempt the inverse operation, why not *realize the imaginary*? . . . To realize the imaginary means to include the imaginary in reality while preserving its imaginary nature; it means unifying, within the same project, [the artist's] realizing intention and his derealizing intention" (*Saint Genet*, 452). If this is a genuine possibility—indeed, already an actuality in the case of Genet's theatrical works—the need for a physical analogon in art becomes questionable. Such an analogon would have no part to play in the project of realizing the imaginary. Since this project *begins with* the imaginary, it would have no use for the physical analogon as a point of departure: it would only stand in the way. But whether we begin with the imaginary or not, it is doubtful that an accurate analysis of art *ever* needs to include reference to the art work as analogon. The presence of a physical analogon in aesthetic experience—that is, the apprehension of the work of art *as* such an analogon—would only bog down or clutter this experience. If it is indeed true that Husserl, in his descriptions of imagination, "freed the psychic world of a weighty burden" (*I*, 135), why should we burden the imagined worlds of art with the highly problematic notion of the physical analogon?[21]

VI

A second major area of weakness in Sartre's account of imagination concerns his general conception of the relation between the real (the province of perception) and the unreal (the realm of the imaginary). To imagine, in Sartre's view, is to nihilate the real as it presents itself in perception, transcending it toward what it is not. But if what we imagine is unreal only in this sheerly negative sense, there would be no way to distinguish it from the merely *non*-real. The non-real is the simple negation of the real, and it represents a mere change of index: it has no being of its own. And yet Sartre regards the imaginary as unreal in such a way as to have its own kind of presence and ontic status. This richer sense of unreality constitutes the imaginary as a discrete and semi-autonomous realm. Unreducible to the non-real, it would be more than merely (in Merleau-Ponty's words) "a positivity [posited] only in order to make up for its own emptiness."[22] But Sartre does not want to go to the other extreme either. The imaginary *qua* unreal is not a strong positivity; it is essentially impoverished and contains nothing comparable to a world. (Cf. *PI*, 170, 190 ff.) What, then, is this strange realm, and in what respect is it unreal?

The imaginary is not sheer nothingness. For one thing, we *intuit* it and its contents, and intuition is never of nothing: "there can be no intuition of nothingness, precisely because nothingness [*le néant*] is nothing [*rien*] and because all consciousness—intuitive or not—is consciousness of some-

thing" (*PI*, 244). Another reason for being assured that the imaginary is indeed something, and not nothing, is that we transcend *toward it*. It is only in comparison with *what it transcends*—that is, perceived things—that the imaginary seems to be nothing. Regarded in itself, it is a genuine phenomenon: "the imaginary is in each case the concrete 'something' toward which the [perceived] existent is surpassed" (*PI*, 244). But what kind of something is it? Is it an unutterable "I know not what"? Sartre wants to claim much more for the imaginary than this. Not only is it not a mere lack or void, it is also more than a mutely subsisting substrate: the imaginary *exists*. Or more exactly, it exists insofar as its unreal contents can be said to exist: "the unreal object exists; no doubt it exists as unreal, as inactive; but its existence is undeniable" (*PI*, 179). At precisely this point, however, problems begin to arise. Sartre had earlier asserted that some imagined objects are expressly posited as *non*-existent. Still others are posited as absent, existing elsewhere, or "neutralized" (that is, not posited as existent *or* as non-existent). But how can such claims concerning the thetic activity of imagining be reconciled with the statement just quoted: "the unreal object *exists*"?

All imagined and thus unreal objects must, by Sartre's own admission, possess some sort of existence, however tenuous it may be; they cannot exemplify, much less *be*, nothingness *simpliciter*. Imagined objects that are posited as non-existent are posited as not empirically (spatio-temporally) existent; but they may still be existent in some *non-empirical* way. Those imagined objects posited as "absent" may exist either empirically (like Pierre, presently in Berlin) or non-empirically (like Pegasus on Mt. Olympus). Similarly, an object posited as existing elsewhere may be empirical or non-empirical, and a neutralized object continues to exist in imagination even though we have abstained from positing it either as empirically existent or as not empirically existent. Conspicuously lacking in this analysis is any account of what non-empirical existence consists in. All we are told is that such existence differs from the empirical existence enjoyed by perceptual objects. (Cf. *PI*, 235.) Yet we must know precisely *how* the two types of existence differ if the claim that the unreal objects of imagining somehow exist is to be borne out.

A related difficulty concerns the relationship between imagined and perceived, unreal and real, objects themselves. Here Sartre seems to contradict himself twice over. (1) The respective objects of imagination and perception are said to be both the same and different. On the one hand, Sartre says that "the imaginary and the real are constituted by the same objects" (*PI*, 25). On the other hand, he asserts that "the objects of the world of images cannot in any fashion exist in the world of perception; they do not meet the necessary conditions" (*PI*, 11). The first thesis might lead

us to think that the only difference between imagined and perceived objects lies in how they are posited, that is, in their thetic character. But the second thesis affirms a more radical difference; if this thesis is true, we can no longer assume that it is merely a question of the same objects being posited in two different ways. Sartre provides no clue as to how these conflicting theses might be made compatible with each other. (2) Early in *The Psychology of Imagination* Sartre claims that we are capable of making direct contact with imagined objects: "the imaging consciousness which I have of Pierre is not a consciousness of the image of Pierre: Pierre is directly reached; my attention is not directed onto an image, but onto an object" (*PI*, 7–8). But it soon develops, as we have seen, that an analogon mediates between the imaginer's consciousness and the imagined object: how, then, is this object to be reached *directly*? Further, the early claim contravenes descriptions of the imagined object which come later in the book and which hold this object to be "outside of reach" (*PI*, 239), "outside the real" (*PI*, 251), and "outside of our grasp" (*PI*, 253). These phrases deny the directness with which imagined objects are given, that is, their presence to consciousness in any unmediated form.

In view of such difficulties, it is perhaps not surprising that Sartre is driven to a position which dictates that the imaginary is incompatible with the real and that the two realms cannot co-exist or mix. This position is formulated by Sartre in two ways. On the one hand, he says that "the real is always accompanied by the collapse of the imaginary" (*PI*, 188); on the other, the imaginary is said to appear only with the collapse of the real: it emerges only on the basis of the perceived world as a "nihilated ground" (*PI*, 244). To support such formulations, Sartre is forced to modify his characterization of the basic action of imagining. This action is no longer held to be nihilative alone; it is now said to be "constitutive" and "isolating" as well. (Cf. *PI*, 236.) The consequence is that imagining is seen not only as nihilating the real but as creating the imaginary as a *separate* realm rigorously isolated from the real. No longer merely "on the margin" of the real (*PI*, 238), the imaginary is situated wholly *beyond* it. In advancing this claim, Sartre overlooks the fact that it leaves no place for his own notion of the physical analogon, which serves precisely to *relate* the real and the unreal. Moreover, Sartre here seems to be confusing unreality not so much with non-reality as with *surreality*. To be surreal is, by definition, to be excluded from the real altogether: this is the message of the surrealists themselves, especially of André Breton. To be unreal, however, does not imply complete exclusion from the real, and it is appropriate to call what we imagine "unreal" when by this term we allow for the borrowing of specific details from perception or memory. A less literary sur-realist thesis than Sartre's would allow for the undeniable fact of such borrowing.

Sartre has separated the imaginary from the real so sharply that he has no way of reintegrating them. A corollary of this separation is that Genet's (and Sartre's own) desperate efforts to make the imaginary efficacious in and through art are foredoomed within the perspective provided by *The Psychology of Imagination*: how could the imaginary ever affect that from which it is so totally alienated? Just as I have to derealize myself in order to enter the imaginary—"the imaginary world is entirely isolated, and I can enter it only in derealizing myself" (*PI*, 169)—so I would have to *re*-realize myself to re-enter and act upon the real as conceived by Sartre! Combination or compromise is ruled out: you must choose either the real or the imaginary, never both. Yet no such strictly exclusive choice operates in ongoing human experience, which is often composed of a subtle mixture of real and imaginal elements. Consider, for example, the way in which imaginative daydreams weave their way into ordinary perceptual experience without there being any sense of mutual exclusion between domains. The continuity that we then feel may also arise in aesthetic experience, where the imaginal and the perceptual frequently form alliances.[23]

In reaction to Sartre's divisive dichotomization of the real and the imaginary, however, we should not swing to the opposite extreme and maintain that the two realms are fully continuous with each other. This is a move that is made by Merleau-Ponty and Dufrenne, both of whom attempt to incorporate the imaginary wholly within perceptual reality—to the point of making it a mere aspect of the latter. Merleau-Ponty speaks of "the imaginary texture of the real" as if the imaginal were mere embroidery upon the perceptual.[24] In Dufrenne's view, imagination in its transcendental function is responsible for the schematization of space and time; in its empirical role, it fills spatial and temporal schemata with concrete images.[25] This is to make imagination a part—albeit an important part—of perception, since the space and time schematized by imagination are ultimately parameters of perceptual reality. Moreover, in his analysis of aesthetic experience, Dufrenne subordinates the imaginal to the "sensuous" (*le sensible*), which is basically perceptual in character.[26] Thus Merleau-Ponty and Dufrenne both propound a type of perceptual absolutism in which all mental acts, including imagination, are regarded as subsumable under perception. The alienation between the imaginary and the real is overcome at the price of a systematic subordination of imagining to perceiving.

Are we confined to the alternatives espoused by Sartre on the one hand and by Merleau-Ponty and Dufrenne on the other? I do not think so. We can avoid the Scylla of a schismatic dualism of the real and the imaginary while also escaping the Charybdis of a perceptual monism. There is a valid third viewpoint that considers imagination to be essentially indepen-

dent of perception—yet not as constituting a separate realm of being wholly severed from the real. The imaginary has its own traits and qualities, but it remains capable of allying itself on occasion with perceptual realities. In certain privileged cases it may even provide a unique inroad into the real that is not available in any other form. This occurs, for instance, when the real is regarded by poets from the viewpoint of the four ancient elements.[27] As imaginatively projected in the guise of fire, air, earth, or water, the real reveals itself in a way that is distinctively different from, and yet no less valid than, the way in which it exhibits itself in ordinary perception. Such poetizing of the real is only one among many possible forms in which the imaginary and the real can communicate and connect with each other. As a consequence, to dissever the two realms as Sartre has done is erroneous and misleading. It would be more accurate and more adequate to say that both imagination and perception retain their respective autonomy while remaining open to creative conjunctions with each other. Neither mutually exclusive nor always at one, the two activities are capable of joining forces in novel and significant ways.

VII

A third and final area in which Sartre's account of imagining is particularly problematic is found in his conception of the relation between imagination and knowledge. It is doubly ironic that Sartre, preoccupied with separating imagination and perception so as to avoid the illusion of immanence, not only makes himself subject to this illusion by proposing the idea of an analogon but in the process falls prey to yet another illusion. In striving to save imagination from contamination by perception (which is to reverse the traditional effort to salvage perception from contamination by imagination), Sartre falls into the embrace of an intellectualist illusion. This illusion consists in the belief that imagination is an inferior form of intellection, and that intellection itself is the apogee or paradigm of all mental activity. The classical expressions of intellectualism are provided by Descartes, Spinoza, and Leibniz, for whom imagination is a degenerate and low-level mode of knowledge. In the view of such intellectualists, the aim of philosophical reflection is to rise above the dangerously distorting influence of imagination to an exalted intellectual intuition of God or some other suitably elevated object.

Sartre is not in any obvious sense an intellectualist of the classical rationalist mold: he offers no salvation through intellection, and "God" becomes merely the name for the goal of an impossible project of combining the *en-soi* with the *pour-soi*. Nonetheless, very much in the manner of

the classical rationalists, Sartre believes in a "pure knowing" (*savoir pur*) which is reflective in character and which contrasts with the "degraded knowing" (*savoir dégradé*) located at the level of non-reflective thought. Degraded knowing is knowing or thinking *in terms of images alone*. Such knowing thinks within the image and not beyond it, and does not distinguish between the content of thought and the *prima facie* character of the image. Thus, in degraded knowing we "always go from image to image" (*PI*, 148), not from image to thought or vice versa; such knowing is a properly "imagistic knowing" (*savoir imageant*). Pure knowing, in contrast, aims at formal objects or relations that are not pictured or imaged in the mind. Such knowing involves gaining conceptual insights without clothing these insights in images: it is "naked thought" (*PI*, 148). Only as degraded does this kind of knowing have recourse to imagery, in which it seeks an intuitive presence lacking in sheerly formal content. An image, then, is "like an incarnation of non-reflective thought" (*PI*, 143), an embodiment of this thought in semi-sensuous form.

Sartre provides three reasons for the debasement that occurs whenever there is a transition from pure to imagistic knowing. First, in knowing by images the object determines thinking rather than the other way around, and thinking thus loses the autonomy it enjoys in pure knowing. Second, an image "restricts and deviates" intellection (*PI*, 133); it constricts the scope of thinking to what can be put into the form of an image; and an imaged thought is necessarily a debased thought. Third, the image itself "teaches nothing" (*PI*, 131). It does not aid or expand our powers of comprehension in any important way. At most, it may make certain sorts of knowing more explicit; but to make knowledge more explicit is not to *increase* this knowledge. Hence nothing new is to be learned from thinking imagistically: "comprehension is realized *in* the image but not *by* the image" (*PI*, 133). It is on the basis of this claim that Sartre considers most imagining to be poverty-stricken and threadbare. For we never gain from an experience of imagining anything more than we put into it in the first place. Precisely in the case of imagistic thinking, consciousness seeks an image to embody or exhibit what it *already knows*. Such an image is "nothing heterogeneous to thought" (*PI*, 123); indeed, it *is* thought in its lowest, non-reflective form.

The image stands indicted, and this is so even though Sartre struggles to distinguish his view of the image from that of the classical rationalists. For them, he asserts, the image is "superficial and very deceptive" (*PI*, 163). But much the same denigration of the image is found in Sartre's own theory. By the very act of differentiating "pure" from "degraded" knowing, and by then ranging the image under the latter heading alone, he severely downgrades the cognitive status of imagining. The same sense of

hierarchy controls Sartre's conception of philosophical methodology in *The Psychology of Imagination*, for only a genuinely "reflective" method can achieve the "certainty" demanded in a definitive analysis of imagining. The paradox is that Sartre's attempt to attain this certainty by means of a method of reflection ends in an invidious comparison of imagination with pure reflection itself. In this way Sartre further reinforces the rationalist tradition's penchant for deprecating imagination as a lowly species of thinking. For this tradition, only thinking that is unclouded by images is capable of entertaining clear and distinct ideas; only it achieves genuine intellectual intuitions and knowledge of the highest order.

For Sartre as for the rationalists, imagining therefore represents a lesser form, a lower limit, of pure reflective knowing. Of course, to be an inferior form of something is still to be a form *of* that something: to imagine is to know, albeit in a drastically delimited fashion. But to hold that imagining is knowing—"knowing through and through" (*PI*, 92)—is to cling to the intellectualist belief that knowing is the most encompassing of human activities. It is to subscribe to a monism of pure thought that is no less monolithic than Merleau-Ponty's or Dufrenne's perceptual monism. The effect of endorsing any such monism, be it intellectualist or perceptualist, is the same so far as the fate of imagination is concerned: imagining is deprived of any independent status as a mental act in its own right. To be regarded merely as a mode of perceiving or thinking (which one does not matter) is perforce to be seen as derivative, second-rate, and finally dispensable.

It is only to be expected that those who make perceiving the paradigmatic act of posit an ideal, plenitudinous perception that dispenses with images, as in Husserl's description of perception as a "simple act" capable of complete sensuous fulfillment. In a parallel manner, intellectualists dream of an act of pure cognition unalloyed by imagery; indeed, rationalist philosophers since Plato have been entranced with the notion of a high-level noetic state that, in Heidegger's mordant phrase, is "image-poor and charmless."[28] Though spurning perception as a paradigm, Sartre shows himself in *The Psychology of Imagination* to be quite susceptible to the austerely seductive model of pure thought—a thought that thinks its own content without having to rely on imagery for support. Consequently, although Sartre sets out to restore the autonomy of imagining, he manages only to heteronomize it, thereby reaffirming the traditional view of imagination as a subordinate faculty. It was just this traditional view which he had criticized so convincingly in the first of his two books on imagination; and yet the classical rationalists, who are taken to task in *Imagination*, are the progenitors of the intellectualist bias that informs so much of *The Psychology of Imagination*.[29]

VIII

Sartre, often considered to be an arch irrationalist or at least an anti-rationalist, has shown himself to be on very close terms with rationalists themselves. I shall conclude by citing five specific instances in which Sartre's intellectualist proclivities distort his analysis of imagination. At the same time, I shall hint at what I take to be a more adequate approach in each case.

1. One of the primary difficulties with the notion of the analogon, it will be recalled, is that it is not as deeply or expressly ingredient in imaginative experience as Sartre has claimed. To maintain that it is an explicit constituent in all human imagining is to substitute intellectualist reconstruction (which tries to determine what *should* or *must* be the case) for phenomenological description (which seeks only to determine what *is* the case). In Heideggerian language, it is to replace the "existential-hermeneutical as-structure" with the "apophantical as-structure."[30] Perhaps it is true that a psychical or physical analogon helps to *explain* how the imagining mind can effect a transition from an initially given content to objects imagined on the basis of this content, for such a transition would be considerably facilitated if a structural analogy were to exist between the two terms. But the explanatory power of the analogon, however valuable it may be from the standpoint of a highly reflective assessment of imagination, should not be confused with the *descriptive merit* of the same notion. Descriptively speaking, the analogon is at best an implicit factor in imaginative experience, and often it is not consciously present in such experience at all. Only from an intellectualist perspective, which is more concerned with explanation than with description, is one tempted to give the analogon the prominence bestowed upon it by Sartre. To abandon this perspective would mean abandoning one's insistence upon the analogon.

2. We have seen that the four forms of thetic character imputed to imagined objects are all conceived in a decidedly dualistic fashion: such objects are posited as non-existent (vs. existent), as absent (vs. present), as existing elsewhere (instead of here), or as neither existent nor non-existent (vs. posited as existent or as non-existent). This series of disjunctive pairs reflects Sartre's intellectualist preference for a clear choice between alternatives that are strictly incompatible with each other: absent/present, existent/non-existent, here/there, etc. Indeed, Sartre even suggests that a similarly exclusive choice is to be made between the imaginary and the real themselves. Just as a more open attitude is called for in the latter case (so as to accommodate possibilities of combination between the two realms), so a corresponding openness is needed in considering the thetic character of what we imagine. This character is not confined to choices between dyadi-

cally opposed features but includes a generic trait inherent in *all* imagined objects: pure possibility. What we imagine is posited not merely as absent, non-existent, or existing elsewhere (these are sheerly negative features in any case) but as purely possible—as having a positive thetic character that allows imagined content to escape certain empirical limitations.[31] Intellectualists are uneasy with any such notion as pure possibility, which resists exact definition and conceptual straitjacketing in dualistic terms. Posited as purely possible, imagined objects are more multifarious than such terms allow. Consequently, it is not imaginative experience as such that is "poor and meticulous" (*PI*, 190), but rather Sartre's own intellectualistic reduction of the rich thetic quality of this experience.

3. At the time of writing *Imagination* and *The Psychology of Imagination*, Sartre's ontology allowed for only two options. Whatever we experience must be of the nature of a thing or of consciousness; it must be either inert or spontaneous, in-itself or for-itself. Images too, then, must be either thing-like or consciousness-like. Having rejected the interpretation of the image as a mini-thing, Sartre can only conclude that it is of the character of consciousness; "an image is an *act*, not some thing" (*I*, 146; my italics). Yet to de-reify the image—in itself a correct critical move—is not to have to conceive of it as a form of consciousness. To think that we *must* conceive it thus, without there being any alternative to the disjunctive pair "thing/consciousness," is once again to display an intellectualist bias that dichotomizes and polarizes wherever possible. Here we ought to ask ourselves, Are there not objects of experience that are neither inert nor spontaneous? Is not the image precisely such an object, being neither thing nor act? Does it not exhibit a mode of being that is much more ambiguous and indeterminate than Sartre's concern for Cartesian clarity will permit? Much as pure possibility represents an alternative to the dyadic pairs absence/presence, non-existence/existence, etc., so the image may represent a *tertium quid* in respect to the dyad thing/consciousness. To put the point somewhat differently: perhaps imagination exists between perception and intellection as an independent mode of mentation whose importance as a *third* form of consciousness can be recognized only in a more dialectical conception of mind and of being than Sartre adopts in his early writings.[32]

4. A closely related difficulty arises from Sartre's assumption that all acts of imagining are to be described as varieties of "imaging consciousness" (*conscience imageante*), a term that recurs frequently in *The Psychology of Imagination*. An affiliated assumption is that, whenever consciousness is not explicitly entertaining images, it must be either purely reflective or purely perceptual in character: thinking and perceiving are taken to be the only two imageless psychical functions. In making such assumptions Sartre overlooks the fact that another option is available: we may imagine

in a *non-imagistic* manner. For example, in imagining *that something is the case*, we need not clothe the projected state of affairs in any specific imagery of a visual, aural, or kinesthetic sort. We just imagine *that* such a *Sachverhalt* obtains without recourse to sensuous imagery of any kind. Now, if we can in fact imagine without having to utilize images, it is simply mistaken to hold that all imagining is a form of imaging; any such claim fails to do justice to the full range of imaginative experience and hence of human experience *überhaupt*. At the same time, the recognition of cases of imagining-that (not to mention instances of still other forms of imagining such as imagining-how) serves to undermine the premiss that imagining is a type of knowing—that it is *savoir imageant*. For imagining-that, being an act of sheer *supposal*, cannot be considered a species of knowledge, not even of hypothetical knowledge.

5. Finally, and to come full cycle, Sartre's methodological commitments may also be viewed in the light of his intellectualist propensities. When Sartre calls for a method of "reflection," he is presupposing—like Descartes, Leibniz, and Husserl before him—that there are two and only two distinct levels of philosophical analysis. One of these, held to be inferior from the standpoint of reflection, contains matters of fact alone; hence all truths relating to this level are merely contingent and probabilistic, always being subject to disconfirmation by the discovery of new factual material. The other level, variously designated as "a priori," "reflective," or "transcendental," gives rise to apodictically certain truths, which are not subject to falsification by facts. Within such a model as this, there are no intermediate levels; nor are the two posited levels allowed to combine with each other in any meaningful way. The result is that philosophical analysis must be *either* eidetic *or* empirical. To use Sartre's own language, genuine eidetic investigation will yield "the certain," while factual research can furnish only "the probable." This bivalent conception of philosophical method closes off the possibility of a third type of procedure, one that stops short of the certain yet is not confined to mere observation of fact. Many of Sartre's own best analyses in *The Psychology of Imagination* tacitly employ such a middle-range procedure, mingling eidetic and empirical elements that in theory cannot be combined. In this way, Sartre's actual *use* of method belies his *theory* of method.

The basis of his theory lies in the presumption that empiricism and rationalism respectively offer the only viable models for philosophical methodology. Yet *this presumption is itself an expression of intellectualism*, which permits itself to think only in such strictly dichotomous terms as fact/essence, empirical/rational, perceptual/reflective. Like Merleau-Ponty, who came to question intellectualism during the very years in which Sartre was publishing his portrayal of imagination, we must wonder whether such

dichotomies are ultimate, and in particular whether the intellectualism that posits them is a valid philosophical stance. Much as Merleau-Ponty found perception to be inadequately accounted for by empiricists and rationalists alike, so we must question whether imagination fares any better when it is conceived in terms that reflect the either/or thinking of these same philosophers. Is imagination not a psychical phenomenon that obstinately resists being subsumed under perception or thought? If this is so, we should seek for a descriptive terminology that is appropriate to the activity of imagining itself and not merely derivative from descriptions of perceiving or conceptual thinking. Imagination must be described *in its own terms;* it calls for a renewed phenomenological description that possesses its own nomenclature and rules of evidence.

To conclude. We may say of Sartre what he said of Husserl: he blazed the trail. Nevertheless, it is one thing to blaze a trail and quite another to establish a definitive route. Sartre scintillates in his pioneering attempt and takes the phenomenology of imagination a number of steps farther than Husserl ventured to go. This is especially evident in his lucid descriptions of the nihilative and spontaneous aspects of imagining. Yet much work remains to be done if we are to overcome Sartre's inherent intellectualism and to provide a probing and unprejudiced assessment of imagination. Despite Sartre's earnest efforts, we still do not know for sure and in detail what it means to imagine.

EDWARD S. CASEY

DEPARTMENT OF PHILOSOPHY
STATE UNIVERSITY OF NEW YORK, STONY BROOK

NOTES

 1. Jean-Paul Sartre, *The Words*, tr. by B. Frechtman (New York: Braziller, 1964), pp. 122–23. I have altered the translation slightly.
 2. Cf. Jean-Paul Sartre, "The Quest for the Absolute" in *Essays in Aesthetics*, tr. by W. Baskin (New York: Washington Square Press, 1966); "Orphée noir" in *Situations III* (Paris: Gallimard, 1949); *L'Idiot de la famille: Gustave Flaubert de 1821 à 1857* (Paris: Gallimard, 1971), vol. I, pp. 653–773.
 3. "Itinerary of a Thought," *New Left Review* (1969), no. 58, p. 53.
 4. Ibid. Cf. also Sartre's statement on p. 52: Flaubert "*is* the imaginary." More than 100 pages of *L'Idiot de la famille* are devoted expressly to Flaubert as "l'enfant imaginaire."
 5. These five topics are in fact the titles of the five chapters of the thesis. I am indebted to Professors Herbert Spiegelberg and Michel Rybalka of Washington University for this information. I also wish to express my appreciation to Joseph Halpern, Monika Langer, and Robert Stone for having commented critically on an earlier version of the present essay.
 6. *L'Imagination* appeared in a series entitled "Nouvelle Encyclopédie Philosophique," edited by Henri Delacroix, the director of Sartre's 1927 *diplôme d'études supérieures*. Interrupting his writing of *La Nausée*, Sartre developed his earlier *diplôme* thesis

into a tract tentatively entitled "L'Image" or "Les Mondes imaginaires." His publisher accepted only the first, largely critical and historical, part of the expanded thesis. A further revision of "L'Image" resulted in *L'Imaginaire*. Cf. M. Contat and M. Rybalka, *The Writings of Jean-Paul Sartre* (Evanston, Ill.: Northwestern University Press, 1974), pp. 9–10, 45–76.

7. Both of the Baudelaire quotes are from Charles Baudelaire, *Curiosités esthétiques [et] l'art romantique*, ed. by H. Lemaître (Paris: Garnier, 1962), p. 321. The notion of "anti-world" is treated in Jean-Paul Sartre, *L'Imaginaire* (Paris: Gallimard, 1940), p. 175.

8. This view of imagination is hinted at in Husserl, *Zur Phänomenologie des inneren Zeitbewusstseins*, secs. 17–19 and in *Ideen I*, sec. 111. But its complete presentation occurs in the Göttingen lectures of 1904–1905, "Phantasie und Bildbewusstsein," an edited version of which appears in Husserl, *Phantasie, Bildbewusstsein, Erinnerung*, ed. by E. Marbach (The Hague: Nijhoff, 1980).

9. Cf. Eugen Fink, "Vergegenwärtigung und Bild" in *Studien zur Phänomenologie* (The Hague: Nijhoff, 1966), esp. pp. 46–78.

10. I say "chooses to ignore" because it is very unlikely that Sartre did not know of Fink's essay. He acknowledges and discusses Fink's article "Die phänomenologische Philosophie Edmund Husserls in der gegenwärtigen Kritik" in *The Transcendence of the Ego*, and during his stay in Berlin in 1933–1934 he must have read issues of Husserl's *Jahrbuch*, in which Fink's essay on imagination was published in 1930.

11. *L'Imagination* (Paris: Presses Universitaires de France, 1936), p. 158. This is not to deny that Sartre is also critical of Husserl, especially in regard to the latter's notion of *hylē*. Cf. ibid., pp. 147ff.

12. Gilbert Ryle, *The Concept of Mind* (New York: Barnes & Noble, 1949), p. 246; my italics.

13. Ludwig Wittgenstein, *Zettel*, ed. by G. E. M. Anscombe and G. H. von Wright (Berkeley: University of California Press, 1967), sec. 621. Cf. also Wittgenstein's statement in the *Philosophical Investigations*: "'But what is this queer experience?' Of course it is not queerer than any other; it simply differs in kind from those experiences which we regard as the most fundamental ones, our sense impressions for instance" (*Philosophical Investigations*, tr. by G. E. M. Anscombe [Oxford: Blackwell, 1967], p. 215).

14. Sartre's critics have not failed to perceive this dimension of the Sartrean project. Thus Gilbert Durand condemns *L'Imaginaire* for its constrictive scope in his remarkable Introduction to *Les Structures anthropologiques de l'imaginaire* (Paris: Presses Universitaires de France, 1969), pp. 11–15.

15. Iris Murdoch, *Sartre* (New Haven: Yale University Press, 1960), p. vii.

16. Sartre also refers to these attitudes as "functions" of consciousness, e.g., at *PI*, p. 26. Presumably the abandoned treatise "La Psyché" would have dealt with all of these major kinds of consciousness in a comprehensive and systematic fashion.

17. Sartre's first formulation of the intrinsic spontaneity of consciousness occurs in *The Transcendence of the Ego*, tr. by F. Williams and R. Kirkpatrick (New York: Noonday Press, 1957), p. 98: "transcendental consciousness is an impersonal spontaneity." In *Imagination*, Sartre says simply that "consciousness appears to itself as a pure spontaneity" (*I*, p. 2).

18. It is to be noted that Sartre's definitive eidetic analysis of imagination is confined to the first twenty pages of *The Psychology of Imagination*.

19. Cf. C. S. Peirce, *Collected Papers*, ed. by C. Hartshorne and P. Weiss (Cambridge: Harvard University Press, 1960), 2.275–77.

20. On the distinction between the work of art and the aesthetic object, see Mikel Dufrenne, *The Phenomenology of Aesthetic Experience*, tr. by E. S. Casey et al. (Evanston, Ill.: Northwestern University Press, 1973), chs. 1–2. On the work of art as a schematic formation, see Roman Ingarden, *The Cognition of the Literary Work of Art*, tr. by R. A. Crowley and K. R. Olson (Evanston, Ill.: Northwestern University Press, 1973), pp. 13, 50, 77, 253, 360, 391.

21. Nevertheless, in *L'Idiot de la famille* Sartre explicitly re-endorses his earlier theory of the analogon, especially as it forms part of aesthetic experience. Cf. *L'Idiot*, pp. 662–65, where many of Sartre's remarks read like paraphrases of the original explication of the analogon in *The Psychology of Imagination*. Moreover, in contrast with the stress in *Saint Genet* on

realizing the imaginary, there is again an emphasis on "derealizing matter by the function that is assigned to it"—a function which is precisely that of an analogon (*L'Idiot*, p. 662; cf. also p. 663 n.1).

22. Maurice Merleau-Ponty, "Eye and Mind," tr. by C. Dallery in *The Primacy of Perception*, ed. by J. M. Edie (Evanston, Ill.: Northwestern University Press, 1964), p. 190. I have slightly altered the translation.

23. For further discussion of this point, see my *Imagining: A Phenomenological Study* (Bloomington: Indiana University Press, 1976), ch. 6.

24. Cf. Merleau-Ponty, "Eye and Mind," p. 165.

25. Cf. Dufrenne, *The Phenomenology of Aesthetic Experience*, ch. 12.

26. Cf. ibid., pp. 223, 353–69.

27. Cf. the series of books by Gaston Bachelard that begins with *La Psychanalyse du feu* (Paris: Gallimard, 1938) and ends with *La Terre et les rêveries du repos* (Paris: Corti, 1948). See also Sartre's discussion of Bachelard in *Being and Nothingness*, tr. by Hazel Barnes (New York: Washington Square Press, 1966), pp. 735ff.

28. Martin Heidegger, *Vorträge und Aufsätze* (Pfullingen: Neske, 1954), p. 229: "bildarm und ohne Reiz."

29. A similar bias is evident in much of *Being and Nothingness*, which may be said to mirror Spinoza's *Ethics* by employing the term "freedom" where Spinoza would have written "determination." Sartre has owned up to his early intellectualist and idealist tendencies in *The Words*; and even more recently he has described himself as "a Frenchman with a good Cartesian tradition behind me, imbued with a certain rationalism. . . . In my early work I was a rationalist philosopher of consciousness" ("Itinerary of a Thought," pp. 46, 50). Sartre is here speaking of himself as the author of *Being and Nothingness*, but the self-description would be just as apt if applied to *The Psychology of Imagination*.

30. Cf. Martin Heidegger, *Being and Time*, tr. by J. Macquarrie and C. Robinson (New York: Harper and Row, 1962), esp. pp. 32–34. Cf. also Wittgenstein, *Philosophical Investigations*, pp. 193ff., on the phenomenon of seeing-as.

31. For further treatment of pure possibility, see *Imagining*, ch. 5.

32. It is significant that Sartre has now espoused a more dialectical viewpoint: "In my present book on Flaubert, I have replaced my earlier notion of consciousness . . . with what I call *le vécu*—lived experience . . . [this] is precisely the ensemble of the dialectical process of psychic life. . . . Lived experience is always simultaneously present to itself and absent from itself" ("Itinerary of a Thought," pp. 48–50).

5

Paul Ricoeur
SARTRE AND RYLE ON THE IMAGINATION
R. Bradley DeFord, Translator

I T is not easy to draw out all the consequences of the decisive distinction introduced by Kant between *productive* and *reproductive* imagination. Philosophy of the imagination has a preference for images that can be regarded as mental or physical replicas (photographs, pictures, drawings, diagrams) of an absent thing. Thus it tends to neglect heuristic fictions in a logic of invention, fictional narratives (such as tales, dramas, novels), and political fictions (ideologies and utopias). In a general way, philosophy of the imagination—ancient as well as classical and modern—fails to account for "productive" imagination in terms that do not reduce it to "reproductive" imagination. The claim of the fiction-image, over against the picture-image, is difficult to maintain throughout.

Sartre and Ryle are taken here as representatives of certain tentative modern philosophers who recognize the irreducibility of the image of the art of imagining, but who nevertheless fail to liberate the image from its bondage to the model or original of which it would be the picture or replica. The choice of these two men is, however, motivated more particularly by another reason. They represent two different trends in modern philosophy: phenomenology and linguistic analysis. They seem to be opposed not only in terms of method but in terms of theory as well. In fact there are between them more similarities than differences, and among their similarities the most striking is their common unwillingness to deviate from the paradigm of reproductive imagination. In that sense, I see them as two modern thinkers who reinforce the primacy of the original in spite of their efforts to acknowledge the specificity of the imagination. But because the specificity they acknowledge is defined *by difference* from straight seeing or

Editor's Note: An earlier version of this essay was delivered as the second of three James Henry Morgan Lectures for 1974 at Dickinson College, Carlisle, Pennsylvania. The essay is published in this volume with the permission of Dickinson College and has not previously been published.

observing, another difference cannot be produced—the difference between fiction and picture.

I shall not spend much time on the difference of method between these two writers. On the one hand, I assume that a linguistic analysis, which claims to inquire only into our statements about experience, cannot start amending our language about facts without putting what we say under the control of what we see. This critique of language under the pressure of experience is well supported by the remarkable strategy of examples and counter-examples which play a role similar to that of Husserl's "imaginative variations." On the other hand, I assume that a phenomenology, which claims to start with lived experience, never seeks merely to reduplicate experience, but inquires into its structures on the basis of an intellectual insight that directly links essences to examples in a way that differs from the inductive linkage between laws and facts. Furthermore, the "reduction" of the pseudo-evidence of the given as already there and already constituted compels us to articulate the complex meanings which appear to us as an object. The conjunction between the theory of essential intuition and that of the genetic constitution of meaning leads us to say that phenomenology addresses itself to the fundamental speakability of lived experience. Ultimately, this assumption is the factor common to both linguistic analysis and phenomenology. This is why I do not want to emphasize a difference that is unessential for our purpose.

SARTRE

Let me say at the outset that in focusing on the two volumes that Sartre devotes specifically to the subject of the imagination—*Imagination: A Psychological Critique* and *The Psychology of Imagination*—I am not claiming that these two works express his complete thought on the subject. In order to make such a claim we should have to take into account his novels and plays, his contributions to literary criticism, his monographs on Baudelaire and Genet, and his *L'Idiot de la famille*. But the two first-named volumes contain his explicit theory in psychological and philosophical terms; therefore, the arguments they contain merit special attention within the framework of this context.

A principal decision is made at the beginning of *Imagination: A Psychological Critique*. That decision concerns a paradigmatic example that will never be dislodged from its prominent position. The example: I produce an image of my friend Peter, who dwells in Berlin. This choice of examples, as we shall see, is not without consequences. It imposes from the very outset the paradigm of absence. Later on, the case of non-existent entities will introduce no dramatic change in this description.

The choice of the initial example can be explained in light of the polemical purpose of this first volume. What Sartre seeks to rebut is the notion that the image is a kind of thing in the mind. The best way to dissolve the fallacy of immanence is to address oneself to the kind of image whose referent exists elsewhere. Furthermore, by becoming aware that the *same* Peter may be either perceived or imagined, we are directed toward a difference which concerns the *mode of givenness* and a difference which is a relation. The *same object* is given one time in flesh and blood, another time "in image" (*en image*). This critique by Sartre of image as mental entity indeed goes very far, but without affecting the privilege of the original in the theory of the image. On the contrary, this privilege is paradoxically reinforced by all the arguments that underscore the difference between a mental image and a perceived object. Let us recall the arguments: The image, it is said, is not a copy, in the sense of a *simulacrum* endowed with an existence similar to that of its original. It is not a "lesser thing, possessed of its own existence, given to consciousness like any other thing, and maintaining external relations to the thing of which it is the image" (5).* Sartre demonstrates very forcefully that the principal metaphysical systems (Descartes, Leibniz, and Hume) all share the prejudice of "metaphysical identification" between image and perception. Even more modern psychologies, such as those influenced by Bergson and the Würtzburg school of interpretive psychology, only make the image more fluid but no less a thing. "The image remains in the guise of an inert element" (77). Philosophers and psychologists, equally deceived by the fallacy of immanence and its corollary, the substantial identity of image and thing, are condemned to rely on extrinsic criteria in order to distinguish between essentially identical phenomena. But "the differentiating judgment will never be anything but probable" (95); and this awareness stands against the immediate certitude of an essential gap between the two experiences of having an image and of perceiving: "No image ever mixes in with real things" (101). This first book on imagination draws the more positive conclusion that it is *spontaneity-consciousness*, pertaining to the experience of having an image, which supports and grounds the difference between image and thing. The self-transparency accompanying this spontaneity-consciousness excludes the possibility that an image is a thing in the mind and therefore a kind of sensory content. "That there are only two types of existence, as thing-in-the-world and as consciousness, is an ontological law" (116).

* The parenthetically placed numbers in this section refer to pages in Sartre's *Imagination: A Psychological Critique,* tr. by Forrest Williams (Ann Arbor: University of Michigan Press, 1962).

The paradox is that this polemic does not shake the privilege of the original in the slightest. On the contrary, it reasserts that privilege. As Husserl tells us, to have an image is to be intentionally directed toward something. In the example of the flute-playing centaur discussed by Husserl in *Ideas I*, the centaur as such (that is, as represented) is not a psychic state: it exists nowhere; nevertheless, it is not the invention itself. This example from fiction compels us to consider the problem of fiction in terms of a transcendent nothing. But what about the object of the image of Sartre's friend Peter? Here is a real object that is the same for perception as for imagination. Image and perception aim in two different ways at the existing Peter. Shall we say that the image nevertheless has an object (Peter "in image"), in the same way that the invention of the centaur has the represented centaur as its object? Then there are two objects, and we unwittingly re-establish the inert content which we have denounced and at the same time deny our initial statement that the image was only a relation, a mode of givenness. It seems, therefore, that the referent of the fiction and the referent of the picture cannot be treated within the same framework. Husserl's centaur is not an image of an existing object, as Sartre's image of Peter is.[1] But in *Imagination* it is uncritically assumed that the theory of the picture may be extended to that of the fiction, and vice versa. That is why Sartre's concluding statement remains ambiguous: "An image can enter into consciousness only if it is a synthesis, not an element. There are not, and never could be, images *in* consciousness. Rather, image is *a certain type of consciousness*. An image is an act, not some thing. An image is a consciousness *of* some thing" (146). But which some thing? The real Peter, or a mental appearance as the object of the act?

*The Psychology of Imagination** provides partial answers to this paradox of the object of the picture-image and, in the process, further reinforces the strategic position of the original of the picture. The reinforcement begins with the assertion that the first characteristic of the image is that the image is a "consciousness." It is for reflective consciousness that the image appears as an object. For direct intentional consciousness, the object is Peter-out-there. It is that Peter who appears in the form of an image. It is only when I reflect and try to describe the image as an image (that is, by an act of the second degree) that I form the judgment: I have an image.

This having been acknowledged, we must reassert that the same chair, at one time perceived and at another time imagined, exists out there: "Whether I see or imagine that chair, the object of my perception and that

* The parenthetically placed numbers in this section refer to pages in Sartre, *The Psychology of Imagination,* tr. by Bernard Frechtman (New York: Washington Square Press, 1966).

of my image are identical: it is that chair of straw on which I am seated. Only consciousness is *related* in two different ways to the same chair" (7). The only correct way of speaking of the absent friend Peter would be to speak of "the imaginal consciousness of Peter" (7). Thus it is the object of perception which gives an object to the picture.

The key position of the original is again reinforced by the second characteristic of the image, that of its being not observed, but quasi-observed. To observe is to learn endlessly from the inexhaustible richness of the perceived thing. By contrast, "nothing can be learned from an image that is not already known" (11). Quasi-observation "is an observation which teaches nothing" (12). We move in "a world in which nothing happens" (13).[2]

But is not this *poverty* of the image a feature of the image of the *absent*, which is not applicable to fiction? Is not this poverty the counterpart of the richness of the original? We shall see that fiction does not share this poverty of the image of an absent object, but rather produces new meaning capable of generating a metamorphosis of reality.

The denial of the specificity of fiction is made complete with the third characteristic of the image: its character of nothingness. This character, which is proper to the positional act of imagining as it appears for a reflective, non-thetic consciousness, blurs all the important contrasts between fiction and picture. Sartre asserts that "this [imaginal] act can assume four forms and no more: it can posit the object as non-existent, or as absent, or as existing elsewhere; it can also neutralize itself, that is, not posit its object as existing" (15). This list allows Sartre to generalize the negative character of the positional act of absence to the point of non-existence. But the four forms of the list are not homogeneous. Absence and presence are subclasses of reality, as the example of Peter shows: the same Peter is the object of both the perception and the image. However, non-existence as unreality is opposed both to absence and to presence as reality. Therefore, a theory of absence cannot be extended to a theory of unreality. This logical error excludes from the discussion the case of fiction on its own terms.

Consequently, the fourth characteristic, that of spontaneity, is applied indiscriminately to both picture and fiction, since it becomes merely the counterpart to the fact that the object occurs as a nothingness. Can we say, however, that when consciousness invents it is creative in the same way as when it produces the image of an absent thing or person? In the one case it creates its object, the unreal; in the other, it seems to me, it creates only the mode of givenness, and this creation is only for the non-thetic reflective consciousness.

Does the next chapter of this work open the description to the specific traits of fiction? Apparently not. Its inquiry into the image-family is di-

rected toward a problem that concerns only the relation between two kinds of pictures, the physical picture and the mental picture—not the relation between picture and fiction. Both kinds of pictures make an object present to myself, and in both cases the problem that absorbs all the attention is that of the role of the *analogue*. This problem, once again, refers the image to an original, whose analogue is a likeness. In the case of a purely mental image, the search for the analogical representative of the aimed-at object is exactly what closes the problematics of the image on that of the picture. The image-family is the picture-family.

This is true to such an extent that, whereas the preceding analysis started directly from the mental picture, the present analysis starts from the physical picture, because the analogue can be shown independently of the intention directed toward the absent object. But this analysis moves between the two extremes of a unique range, that of the picture. This limitation does not prevent the analysis from being brilliant, and to my mind very convincing. From the portrait to the mental image, through caricatures, impersonifications, schematic drawings, to interpretation of spots, shapes, etc., and hypnagogic images, the material analogue disappears step by step, down to the point where it seems legitimate to form the "probable" hypothesis that now ocular movements and feelings exert the same *hyletic* function (as regards the *morphic* function of the intentional attitude) as the physical support of the portrait.

But as genial as this description may be, it reinforces the privilege of the *original* by its very attempt—which is, to my mind, successful—to generalize on the concept of the *analogue* from the physical picture to the mental picture. The picture-family has found its homogeneity, perhaps, at the expense of fiction.

The extension of this description to "imaginary life" certainly overcomes the narrowness of the statics of the image, but not that of the initial paradigm. This is true for a fundamental reason. The problem which haunts this remarkable chapter is that of the apparent inversion of the spontaneity of consciousness into the magic of fascination. But the explanation of this paradox requires that the relation of consciousness to the object, left unsolved at the end of the descriptive section, be reconsidered. It now appears that the "intention" of "making the absent person appear" is suffocated by the desire magically to possess the absent. This desire turns into "an incantation destined to produce the object of one's thought, the thing one desires, in a manner that one can take possession of it" (159). Desire wants to "obtain" things, even to "reproduce their integral existence" (159): "The object is reproduced for no other purpose than to arouse feeling" (182). (One will have noticed the insistence on reproduction in this context of self-deception.)

This magical attempt is obviously parasitic on the role of absence. It even seems to be one of the reactions to absence. (Ryle will evoke a more playful relation to absence under the title of "pretending.")

It is true that Sartre leaves room for other, less compulsive reactions when he directly connects the "unreality" of imaginary objects to the act of "self-unrealizing" (169). But inasmuch as the relation between absence and unreality still is not clarified, it is difficult to ascribe to two different classes of phenomena the magic of the quasi-presence and the spontaneity of fiction. Further, Sartre's discussion of fascinated consciousness requires that the spontaneity of consciousness and the experience of fascination be ascribed to the same phenomenon, masterfully described as spellbound spontaneity or fatality (238). That explains why the most general and fundamental assertions concerning the identity between consciousness and "the possibility of positing an hypothesis of unreality" (238) do not give rise to a theory of fiction. And yet, is it not to fiction rather than to the magic of quasi-presence that the famous formula applies best? "There is then a twofold requisite if consciousness is to imagine: it must be able to posit the world in its synthetic totality, that is, the totality of the real as the situation for that consciousness, and it must be able to posit the imagined objects as being out of reach of this synthetic totality, that is, posit the world as a nothingness in relation to the image" (239–40). But this phenomenology of fiction would have to turn its back on the problematic of magical possessing for the sake of a new kind of relation between fiction and reality—a relation stemming from the non-existence of fiction's object.

RYLE

As I said earlier, I am not interested in the obvious epistemological differences between Ryle and Sartre. Declarations such as those of Sartre concerning the capacity of consciousness to negate the world of reality and the correlation between freedom and the nothingness of our images are quite unthinkable on the part of Ryle. Even the idea that the philosopher has the task of grasping an essential structure of imagination is foreign to him. Instead of an "eidetics," Ryle, in *Concept of Mind*, prefers to start from the loose enumeration of the sorts of *behavior* that we should "ordinarily and correctly" describe as imaginative (256).* Divergence is the rule here. At first sight, Ryle is more liberal than Sartre concerning the consistency of the field covered by the word "image." Among the "host of widely divergent sorts" of behavior, Ryle lists these: "the mendacious witness in the witness-box, the inventor thinking out a new machine, the constructor

* The parenthetically placed numbers in this section refer to pages in Gilbert Ryle, *Concept of Mind* (New York: Barnes & Noble, 1949).

of a romance, the child playing at bears, and Henry Irving are all exercising their imaginations; but so, too, are the judge listening to the lies of the witness, the colleague giving his opinion on the new invention, the novel reader, the nurse who refrains from admonishing the 'bears' for their sub-human noises, the drama critic and the theatre-goers" (256). This literal approach—which would appear both nominalistic and behavioristic from a Husserlian point of view—seems to promise a clearer recognition of the specificity of fictions among the "divergent sorts of behavior." Does not an important fraction of the quoted examples obviously belong to this sub-class?

But paradoxically enough, the initial discrepancy between Ryle and Sartre is offset by a convergence in their polemical concerns, which leads Ryle to pick as a paradigmatic case for his plea the same kind of example as Sartre emphasized, that is, the mental image of something. Furthermore, the concept of "pretending" which provides Ryle's key for solving—or dissolving—the apparent paradox displayed by the mental image rein-forces the primacy of the original as much as does Sartre's concept of "quasi-observation" of the absent friend.

First, it is the polemical concern of *Concept of Mind* to impose on description "a special case of imagining, namely imagining that we see" (256). It is this imagining—"what people commonly describe as 'having a mental picture of Helvellyn' or 'having Helvellyn before the mind's eye'"—which suggests most strongly "the notion that a mind is a 'place,' where mental pictures are seen and reproductions of voices and tunes are heard" (256). As the reader will readily observe, this special case of imag-ining does not represent the whole list of "widely divergent sorts," but it does shift the emphasis from productive imagination to reproductive imag-ination. At this point the kinship between Ryle and Sartre begins. "Having Helvellyn before the mind's eye" is like reproducing an image of our friend Peter from Berlin. In fact, this startling convergence in the choice of exam-ples proceeds from a common polemical concern. Both writers fight against misconstructions, misdescriptions, and misconceptions, and both claim to provide a new, more accurate account of what is actually experienced. This project similarity legitimates my contention that, beyond their theoretical divergences, linguistic analysts and phenomenologists have a great deal in common in their practice of description. Both would amend fallacious de-scription by looking more closely at experience on the basis of well-chosen examples.

The fallacious description that Ryle and Sartre want to dismantle is much the same, namely, the description of images as entities existing in the mind, which is itself conceived as the asylum or theatre where these images occur. While Sartre invokes the transparency and the spontaneity of con-

sciousness, Ryle would list among meaningless statements about the mind all of Sartre's assertions about *consciousness*. But this radical divergence at the level of fundamental assumptions concerning the mind or consciousness does not prevent them from attacking the same descriptions as fallacious and from drawing the same conclusion: "To see is one thing; to picture or visualize is another" (246).

Secondly, the analysis of "pretending," which Ryle elaborates for itself before applying it to the apparent paradox of the image as something seen in the mind's eye, has the same consequence as Sartre's theory of quasi-observation with respect to the privilege of the original in the theory of the image as picture. The analysis of "pretending" is introduced by arguments quite alien to Sartre's phenomenology. Sartre would not say that to see in one's mind's eye is to seem to see, because for him to deny that images exist *in* the mind does not imply that they appear before us. Quasi-observation is a kind of observation. Here phenomenology would help us in distinguishing between existing and appearing. Neither would Sartre say that the wrong description is induced by the existence of physical pictures bearing an observable likeness to their original. For him, visible pictures are not posited as real but as analogues, which are the neutralized bearers of an intention that sees through and beyond the physical thing. Therefore Sartre could assume without absurdity that a mental image is a "paperless picture" (Ryle, p. 247), since for him (according to an only "probable" analysis) the analogue of the mental picture is actually "paperless," in the sense of not being an external thing but a kinesthetic and emotional analogue of the thing. Sartre would, therefore, provide two alternatives to the mere denial of any substantive element in the image: he would say that something *appears* as the correlate of an intention, and that the intention goes through a *hyletic analogue* of the thing. But neither the appearance nor the hyletic analogue has to be a thing in the mind to be what it is and where it is. I would say that this account is more faithful to experience than Ryle's awkward reformulation of seeing in the mind's eye as "seeming to see" (248). (This reformulation introduces the central description of "pretending," which in turn will introduce a second reformulation of seeing in the mind's eye according to the model of pretending.) But, as was said, it is not their strategies but the fact that both of their analyses (of quasi-observation and of pretending) impose *the reference of the picture to an original* as the main structure of the mental image.

Within Ryle's frame of reference the analysis of pretending is, of course, a logical analysis. It is a transposition into the sphere of *doing* of a similar structure from the sphere of *talking*. When we quote a statement, assume an assertion, and in all similar cases of *oratio obliqua*, we are doing something more complex than merely asserting. We must first understand

what it is to assert, then we must qualify it in two ways, namely as not asserting and as *quasi*-asserting. In the same way, such acts as cheating, playing a part, forging a signature, and playing bears, whether or not they constitute deliberate simulation or dissimulation, represent "performances with a certain sort of complex description" (260). We must be able to describe some action directly in order to make sense of the complex description implying a main clause (such as "X fights") plus a subordinate clause ("seemingly"). This subordinate clause may be analyzed as a nonperformance and the likeness of a performance.

The main advantage of this account of pretending is that it sets up the logic of pretending for a treatment similar to that applied in intentional logic to expressions such as I think that . . . I believe that . . . , and this logic of pretending can be readily extended to the description of the mental image as "seeming to see." Between playing at . . . and fancying that . . . , between a mock action and a fancied perception, the transition is easy. And it is all the easier to reason that fancied perception is itself a kind of action by which we listen and follow and do something that can be trained and learned. As Ryle insists, the real difference is not between mock action and mock perception, but between performance and as-if performance. Picturing Helvellyn is realizing how Helvellyn would look. And this is "doing something which stands in the same relation to seeing Helvellyn as sophisticated performances stand to those more naive performances, whose mention is obliquely contained in the description of the higher order performances" (266).

I have no objection to this analysis of the logic of "pretending" as such. I take it for granted. My only reservations would be these: On the one hand, I doubt that "seeing in the mind's eye" can be construed, without loss of meaning, as "fancying that . . ." or in the mold of "playing at . . . ," for the above-stated reasons pertaining to the specific mode of appearance of the image. On the other hand, I wonder whether the logic of the hypothetical does not imply the phenomenology of nothingness and of likeness as partially developed by Sartre. The grammar of *oratio obliqua* shows us only the trace in language of an operation that implies our capacity to *deny* reality and to invent something other than the real, either in the form of a picture or in the form of fiction.

At this point, we could make many objections to Ryle from the perspective of Sartre and phenomenology. These reservations, however, are not my main concern, which is the import of this analysis of "pretending" for our discussion about pictures and fictions.

The parallel between Sartre's analysis of quasi-observation and Ryle's analysis of "pretending" resides in their common trait of indirect *reference* to an original situation, which is in one case quasi-observed and in the

other case quasi-performed. In other words, Ryle's oblique mention of a naive performance in a mock-performance posits the same kind of dependence on an original as does Sartre's presentation of the friend Peter "in image." In both cases an original precedes—either an original performance or an original presence. My contention is that oblique mention of an original (to apply Ryle's lexicon to both him and Sartre) cannot cover both subclasses of images, both pictures and fictions, because it is suitable only to pictures.

I know that Ryle, like Sartre, hints at a generalized theory of "pretending" in which the performance obliquely mentioned would not be already given as an acquired member of our repertoire. His analysis of hearing a tune in one's head as "following the tune in a hypothetical manner" (266) does not imply that one has actually listened to it as it is "heard" in one's mind. The hypothetical manner also applies, it seems to me, to the original performance. "A person with a tune running in his head . . . is in a certain way realizing what he would be hearing, if he were listening to the tune being played" (266). A bit earlier in the same chapter Ryle writes: "A person engaged in a planning or theorizing task may find it useful or amusing to go through the motions of thinking thoughts which are not, or are not yet, what he is disposed ingenuously to think. Assuming, supposing, entertaining, toying with ideas and considering suggestions are all ways of pretending to adopt schemes or theories" (262).

But does not the uniformity of grammatical expression conceal some important phenomenological differences? Ryle is right in saying that "the sentences in which the propositions entertained are expressed are not being ingenuously used; they are being mock-used" (263). But the notion of a proposition being ingenuously used conceals the difference between two situations. In the first, we *know how* to perform the action mentioned *before* the mention of the action, in the way we *know how* Helvellyn would look if we were there. In the other instance, we do not know how to deal with a situation—by doing something or by observing something—before thinking of it in a "hypothetical manner." The grammar of the conditional does not say the whole truth. It is the role of *knowing how* which is crucial. No knowing how precedes fiction. Fiction creates it as a "new idea."

This is why it seems awkward to me to say that in a fiction something is obliquely mentioned. The *oratio obliqua*, it seems to me, requires a knowing how relative to the performance obliquely mentioned. This argument seems compelling enough to justify the conclusion that Ryle, like Sartre, although for quite different reasons, has given a theory of "pretending" which perhaps does not give a complete account of what a "picture" is and certainly does not give a sufficient account of what a "fiction" is.

The shortcomings of both Sartre's and Ryle's theories of imagination,

with respect to productive imagination at the very least, attest to the difficulty of the enterprise so industriously begun by Kant.

Paul Ricoeur

University of Chicago

NOTES

1. The other example discussed by Husserl, in *Ideas I*, sec. iii, raises the same problem with an additional difficulty. Dürer's engraving *Knight, Death, and the Devil* depicts some entities which exist elsewhere and some entities which enjoy the status of the chimera and the centaur. Furthermore, the image is supported by a physical thing which is perceived but whose thesis as existing is neutralized. We shall return to this distinction between two kinds of pictures, physical and mental.

2. All along, this discussion of the object seems to be the correlate of the synthetic act: "In the image a certain consciousness does indeed present itself with a certain object" (*Psychology of Imagination*, 12). This object is entirely determined by intention; nevertheless, it is quasi-observed. (Ryle will fight with this insidious return of a something which keeps appearing as quasi-object in the mind's eye.) In fact, Sartre is not entirely at ease with this notion of the object of the image. From the spontaneity of consciousness, "it follows necessarily that the object as an image is never anything more than the consciousness one has of it" (18). Yet, we quasi-observe something. The first chapter ends without solving the paradox of the "object" of the image (20). We shall see whether a "functional analysis" may solve this paradox which a statics of the image does not.

6

Amedeo Giorgi
SARTRE'S SYSTEMATIC PSYCHOLOGY

INTRODUCTION

O N reading Sartre one quickly gets the impression that where man is concerned, psychology is indispensable yet insufficient. Phenomena that are spontaneously recognized by him to be psychological in nature, such as anguish, pride, joy, shame, perceiving, sensing, imagining, and jealousy, are referred to constantly and then continually surpassed as Sartre attempts to deepen his description of the totality that is man. Thus all of Sartre's psychological analyses, no matter how lengthy or faithful, are ultimately in the service of his philosophy. Nevertheless, Sartre himself has claimed that the arrival of phenomenology radicalizes psychology no less than it does philosophy (1962a, p. 127).* The purpose of this paper is to clarify precisely how Sartre's phenomenological approach would radicalize our understanding of psychology.

Before proceeding with this task, we shall have to delimit our inquiry. Even so specialized a topic as "Sartre's Psychology" has to be narrowed further because of Sartre's own voluminous writings as well as the many books and articles written by others about the various implications of his thought. Of all his writings on psychology, Sartre's existential psychoanalysis seems to have received the most attention; yet his other works hold many implications for systematic psychology as well, and it is on these that we shall concentrate. We are interested primarily in discovering what psychology means to Sartre, and how an authentic scientific psychology ought to be conducted within the framework of that meaning. First, however, we shall see how traditional psychology understands itself.

* For a full listing of sources cited, please see References at the end of this article.

Traditional Systematic Psychology

Modern psychology began as the scientific study of consciousness. The major theoretical difficulties of early psychology centered around the meaning of consciousness. Psyche was identified with consciousness, consciousness was equated with awareness, and awareness was presumably a container filled with certain kinds of contents (sensations, images, feelings, etc.). To be scientific meant to be empirical and/or positivistic in approach, and experimental in method. Consciousness was understood as a sector of reality that kept resisting the psychologists' attempt to bring it under sensory scrutiny. Introspective descriptions were obtained, but they were interpreted as the noting of facts that existed in consciousness as contents.

Thus, on the basis of premature metaphysical speculation, consciousness was conceived as the analogue of a thing; and for want of an alternative clear understanding of consciousness psychological progress was impeded. Nevertheless, many experiments were conducted using all kinds of surrogate processes as indices of consciousness. Theoretical psychologists felt they could not turn to the cogito for investigation, because to do so would be to venture into the realm of philosophy, and psychology was as interested in its independence from philosophy as it was in solving the problem of consciousness.

The problem of consciousness in psychology was ultimately solved by a denial. Today the subject matter of psychology is no longer consciousness but rather behavior and, more implicitly in some contexts, the unconscious. Both of these substitutions lend themselves better to the prejudices of empiricism than did consciousness. Behavior serves well insofar as it can be interpreted as a body (thing) that moves, and the unconscious holds promise insofar as it can be posited as that hidden substance (thing) in which inferred processes, of which consciousness is merely the indicator, can be located. Nevertheless the same problem that surrounded consciousness surrounds both behavior and the unconscious: ultimately, no one has a clear understanding of what they mean. The term "psychology" is merely a remnant of an earlier, more naive time in history when the scientific world accepted the notion of the psyche (the soul or the mind functioning at the center of thought and feeling); today, if psychology were just being invented, it would be called "behaviorology." Psyche has disappeared and behavior has taken its place not because phenomena demanded it, but because a certain conception of science did. Why consciousness could ever have been confused with behavior is never explained, and the relationship of the unconscious to the psyche is not raised. Still, the studies continue, and in a concrete sense much has been learned about psychological man, even though what "psychological man" means again is not clearly under-

stood. It is at this level that Sartre's systematic psychology makes its greatest contribution. But first we shall describe Sartre's attitude toward traditional psychology.

Sartre's Critique
of Traditional Psychologies

Sartre's psychology obviously belongs within a phenomenological frame of reference and ultimately must be evaluated in that context. Nevertheless, Sartre seems to be respectful of traditional psychology (that is, of existing non-phenomenologically influenced psychology) although hardly uncritical of it. It may be instructive to look at some of the criticisms he has scattered through his works concerning traditional psychology.

In *Being and Nothingness* Sartre writes that psychological determinism is simply an attitude of excuse (1956, p. 40). He further charges psychology with being abstract (1956, p. 559), with stopping its analyses arbitrarily (1956, p. 200), with trying to analyze psychological phenomena within a scientific perspective and thereby attempting to establish only external relations (1956, p. 200). Elsewhere, he asserts that psychology mistakenly tries to confront its subject matter in the same manner as physics does (1962b, p. 14), and that because all psychologists agree their inquiries should begin from the facts, psychology is condemned "to wait upon the isolated, . . . to prefer, positively, the accident to the essential, the contingent to the necessary, disorder to order" (1962b, pp. 15, 17). Furthermore, empirical psychologists, says Sartre, remain victims of the illusion of substance (1956, p. 557). And finally, Sartre opposes all mechanistic interpretations of the psyche (1956, p. 169). These samplings are sufficient to indicate that, in common with many other phenomenological critics of psychology, Sartre faults traditional psychology not so much for its facts as for its underlying presuppositions, its guiding concepts, and its interpretation of the facts. In brief, if one accepts a phenomenological philosophical perspective, the chief difficulty with psychology is its metapsychology, or its guiding philosophy, rather than anything within itself because, strictly speaking, the method or approach ultimately determines the content (1962a, p. 77).

Secondly, since Sartre's approach to psychology is phenomenological (albeit in a specifically Sartrean sense), we can see that all of his critiques of traditional psychology assert or imply that traditional psychology treats the psyche too much like a thing. Sartre's own bias is entirely in the opposite direction, and it will be interesting to see how a consistent interpretation of the psyche in terms of consciousness fares. Thus we now turn to Sartre's conception of psychology.

Sartre's Phenomenological Philosophical Approach to Psychology

The Meaning of Psyche

Sartre has worked out more precisely even than Husserl the implications of the intentionality of consciousness for psychology. Nevertheless, Sartre's discoveries concerning consciousness follow general phenomenological dictates. Rather than continue with the metaphysical interpretations of his day, he confronted the phenomenon of consciousness, intuited its essence, and then described it. The first important distinction we can note is that between consciousness and the psychical. Simone de Beauvoir has written of the significance of this distinction in the following manner (cited by Jeanson, 1974, p. 101):

> He [Sartre] had described, in a Husserlian perspective but in opposition to some of Husserl's more recent theories, the relationship of the Me with consciousness; between consciousness and the psychical he established a distinction which he must always maintain; while consciousness is immediate and evidently present to the self, the psychical is an ensemble of objects which are grasped only by a reflexive operation and which, as objects of perception, give themselves only in profile: hatred, for example, is a transcendent object which one apprehends across *Erlebnissen* and of which the existence is only probable. My ego is itself a being in the world, as is the ego of the other.

Thus, Sartre's distinction between the psychical and consciousness enables us to arrive at a more precise understanding of the psychical. The psyche is consciousness that has become the object of another consciousness; it is consistently on the side of the object. Moreover, Sartre makes a number of other key distinctions that enable us to come to grips with the psychical in a more comprehensive way: (1) Sartre distinguishes between reflective consciousness and unreflective consciousness. Unreflective consciousness is a totality and it is autonomous (1957, p. 58). In unreflective consciousness there is no knowledge, but rather an implicit consciousness of being conscious of an object (Barnes, 1956). Reflective consciousness has positional character, and it affirms the consciousness reflected on (1956, p. 155). (2) The ego is an object of consciousness and not its subject, for consciousness is defined by intentionality and needs no subject, and the ego is constituted by reflective consciousness. In Sartre's words, "The psychic is the transcendent object of reflective consciousness" (1957, p. 71). (3) The ego comprises both the I and the me; "The *I* is the ego as the unity of actions. The *me* is the unity of states and qualities" (1957, pp. 60–61). The important point here is that if the ego is transcendent, then both the I and the me, as aspects of the ego, are equally transcendent. (4) Sartre also distinguishes among states, actions, and qualities, and they

are all transcendent. "The state appears to reflective consciousness" (1957, p. 61), and by it Sartre intends to express the character of passivity of such phenomena, for they are always relative to reflective consciousness. The state transcends the specific experience, which is related to it as a profile is related to a thing. Action likewise is transcendent, because "the reflection which is directed on the consciousnesses apprehends the total action in an intuition which exhibits it as the transcendent unity of the active consciousnesses" (1957, p. 69). Quality, too, is a transcendent object that "represents the substratum of the states. . . . The relation of the quality to the state (or to the action) is a relation of actualizations. . . . Its actuality is precisely the state (or the action)" (1957, p. 70). Now, for Sartre, the ego is nothing other than "the concrete totality of states and actions it supports . . . it is the infinite totality of states and of actions which is never reducible to *an* action or *a* state" (1957, p. 74). Farther on in the same discussion Sartre states that "the ego is to psychical objects what the World is to things," except that, unlike world, "the ego . . . always appears at the horizon of states" (1957, p. 75). (5) Sartre also distinguishes between pure reflection and impure reflection. He writes:

> We see here two reflections: the one, impure and conniving, which effects then and there a passage to the infinite, and which through the *Erlebnis* abruptly constitutes hatred as its transcendent object; the other, pure, merely descriptive, which disarms the unreflected consciousness by granting its instantaneousness. These two reflections apprehend the same certain data, but the one affirms *more* than it knows, directing itself through the reflected consciousness upon an object situated outside consciousness. (1957, pp. 64–65)

Now, for Sartre it is impure reflection which constitutes the succession of psychic facts, or the psyche (1956, p. 159). (6) Thus Sartre has distinguished the psychic object from consciousness and described how it can be reached. However, he also asserts that the psychic object "can also be aimed at and reached through the perception of behavior" (1957, p. 117). (7) Lastly, Sartre has distinguished consciousness from knowledge. "Consciousness is not a mode of particular knowledge . . . it is the dimension of transphenomenal being in the subject" (1956, p. li); knowledge "is the very being of the for-itself insofar as this is presence to—that is, insofar as the for-itself has to be its being by making itself not to be a certain being to which it is present" (1956, p. 174). In other words, "consciousness is the knowing being in its capacity as being and not as being known" (1956, p. li). This distinction is important to an understanding of Sartre's conception of existential psychoanalysis.

Thus, for Sartre, the psychical emerges as the consequence of "the consciousness of something that is not consciousness." There are therefore two peculiar characteristics of the psyche that differentiate it from the in-

itself: on the one hand, it is *posited* by reflective consciousness, and from the for-itself; on the other, it is a consciousness objectified, which Sartre calls a "quasi-object." The distinctions among levels of reflectiveness that Sartre introduces also serve to set the limits of the psychical. Unreflective consciousness, as such, cannot be psychical because one needs a reflective consciousness to posit the psyche; that is, the psychic is actually the unreflected–reflected on. Pure reflection, on the other hand, surpasses the psychical because it dwells on non-thetic consciousness, not the objectified consciousness, and it allows the reflected-on consciousness to be instantaneous rather than reified.

Thus the necessary correlation for the psychical has been set up: impure reflection and quasi-object. All further differentiations of the psychical take place within this correlation but represent different levels of analysis or different contextualizations. For example, we have seen that the ego supports both the "I" and the "me," but in different contexts; the state, the quality, and the action all are transcendent unities exceeding specific experiences but in different contexts: the state is a noematic unity of spontaneous consciousnesses (1957, p. 71), the quality, a potentiality, is the unity of objective passivities (1957, p. 71), and actions refer to "the whole synthetic activity of the person" (1956, p. 162). Behavior poses no special difficulty for the Sartrean approach because, as a psychic object, it is constituted and posited no differently than a state, an action, or an ego. Lastly, "the non-thetic consciousness of self, which is the being of consciousness" (1967, p. 123) is not knowledge because knowledge is the object of reflection. Thus while we *are* the being that non-thetic consciousness is, we do not necessarily *know* this; and what psychological investigation yields is *knowledge* concerning the psyche, but this knowledge does not exhaust consciousness. Thus neither knowledge nor the psychical exhausts the consciousness that is. This reasoning seems to parallel the distinction generally made by phenomenologists between the fact of living through something as opposed to knowing what it is one has lived through.

Certain other aspects of Sartre's philosophy afford equally important clarification in approaching the psychic. (1) Owing to the way in which he overcomes the purported subjectivity of the psyche, as emphasized by Simone de Beauvoir in the quote above, the psyche is now the object of reflective consciousness rather than the subject of its acts, and therefore the psychical is no longer an inaccessible interiority. Thus Sartre is able to meet the requirement of objectivity that all scientific investigations demand. Sartre illustrates this point most succinctly in the following passage:

> If Paul and Peter both speak of Peter's love, for example, it is no longer true that the one speaks blindly and by analogy of that which the other apprehends in full. They speak of the same thing. Doubtless they apprehend it by different

procedures, but these procedures may be equally intuitional. . . . In a word, Peter's *me* is accessible to my intuition as well as to Peter's intuition, and in both cases it is the object of inadequate evidence. (1957, pp. 95–96)

(2) Sartre writes: "The existent is a phenomenon; this means that it designates itself (and only itself) as an organized totality of qualities" (1956, p. xlix). The important point here is that phenomena—including the phenomenon of man—refer only to themselves. If I interpret him correctly, Sartre by this means avoids all reference to unseen causes (for example, the unconscious) or hidden substances (for example, the soul). And finally (3) Sartre's concept of the intentionality of consciousness or the transcendence of man yields important insights. By interpreting man substantially, or merely as the product of external relations, the possibility of considering man as "transcendence-transcended" is ruled out. Yet the latter interpretation is necessary if man's relation to the world or to others is to make sense. By "transcendence," Sartre alludes to the fact that man or consciousness must "transcend itself in order to make known to itself by means of other realities what it is." Thus man is defined for himself by his relations to others and to the world.

Explicit Statements on Psychology

Thus far we have been dealing with Sartre's philosophy insofar as it relates to our understanding of his psychology. In this section we shall consider some of Sartre's explicit statements concerning psychology and examine their relevance for our systematic concerns. Some of the more important Sartrean statements in this vein follow.

1. Sartre writes:

We will not quarrel with psychology for not bringing man into question or putting the world in brackets. . . . In a general way, what interests psychology is *man in situation*. In itself it is, as we have seen, subordinate to phenomenology since a truly positive study of man in situation would have first to have elucidated the notions of man, of the world, of being-in-the-world, and of situation. (1962b, pp. 28–29)

Man in situation, then, is the fundamental unit of psychology. The phrasing seems to be a way of expressing in a psychological way the more philosophical "being-in-the-world." Moreover, Sartre says that psychology can profit from phenomenology because the latter can help clarify the concepts that the former implicitly uses in a less clarified way. That much is clear and certainly unobjectionable, except that Sartre fails to note that the concepts psychology employs must also be partially right, and perhaps even fruitful for phenomenology. Interestingly, Sartre goes on to note that phenomenology is hardly born yet. Does psychology have to wait until

phenomenology matures? Sartre does not think so; but he merely serves warning that where this does in fact happen, psychology will have to draw upon the resources of phenomenology.

2. Sartre also says, "Psychology should endeavor not so much to collect the facts as to interrogate the phenomena—that is, the actual psychic events insofar as these are significations, not insofar as they are pure facts" (1962b, p. 29). Farther on (1962b, pp. 29–30), Sartre says,

> But since this meaning is precisely not a quality superimposed from without upon the joy or the sadness, since it exists only to the degree that it appears— namely, to which it is *assumed* by the human-reality—it is the consciousness itself that is to be interrogated, for joy is joy only insofar as it appears as such . . . psychology too will then offer itself as an eidetic science.

Thus psychology should seek the meaning of psychic phenomena based on how these psychic events are actually lived. In and of itself, psychology does not possess the means to arrive at what is ultimately signified, which is indeed the totality of man (1962b, p. 30); hence it is limited to the study of "the phenomenon *inasmuch as it signifies*" (1962b, p. 30). For Sartre, insofar as psychology is interested in the phenomenon as meaning, it is wholly different from empirical psychology, which is interested merely in facts. Thus, the pivotal terms are "fact" and "meaning," for it is upon their distinction that the difference between empirical and eidetic psychology turns.

3. In another brief passage (1962a, p. 85) Sartre writes: "One could ask how the psychic structure known as an 'image' presents itself to reflection *as an image*, and the structure of 'perception' *as a perception*. The problem is thus limited to its strictly psychological aspect without recourse to the *objects* of perceptions and images." Implied in this statement is the notion that the strictly psychological is the mode of givenness of objects, with objects known in some other way. Thus, to reflect on an image is to reflect on an *imagined object* and to discover its correlate, imaginative consciousness; to reflect on perception is to be present to a *perceived object* and to discover its correlate, perceptual consciousness, and attempt to describe it.

4. It would not be far wrong to say that phenomenology was founded in opposition to psychology or, more precisely, to psychologism; and yet a phenomenological psychology is supposed to be possible. Thus Sartre (1962a, pp. 67–68) writes: "Opposing psychologism's attempt to reconstitute the life of thought by means of 'contents of consciousness,' Husserl set forth a new conception of a transcendent sphere of meanings . . . none of which can in any way be constituted by contents." Farther on, Sartre characterizes phenomenology as follows:

The study of meaning as such belongs to logic. The study of the consciousness of signification belongs, after a special "conversion" or "reduction," to a new discipline, phenomenology. We encounter here once again what we saw in Descartes: essences, intuitions of essences, acts of judgment, and deductions completely escape psychology, conceived as a genetic and explanatory subject passing from fact to law. (1962a, p. 68)

It should be clear that phenomenological psychology is not conceived as a factual discipline and hence it is not on the same project as psychologism; it is not trying to "explain" consciousness. On the other hand, if pure phenomenology is interested in the "consciousness of signification," what is phenomenological psychology's interest? Once again Sartre would probably make a distinction between levels of consciousness and say that phenomenological psychology would investigate how "consciousness of signification" is lived and related to various situations in the world.

5. Sartre, following Husserlian reasoning, declares his own ambition for phenomenological psychology:

Perhaps, however, error does not creep into the reflective act itself. Perhaps error appears at the inductive level, when, on the basis of facts, one establishes laws. If so, would it be possible to create a psychology which would remain a psychology of experience yet would not be an inductive science? Is there a kind of privileged experience which would put us directly in contact with the law? (1962a, p. 126)

Sartre says that that was precisely Husserl's aim, and Sartre himself affirms the possibility.

Sartre then continues: " . . . of course the psychologist does not perform this *epochē,* but remains on the terrain of the natural attitude. Nevertheless, there are methods available to the phenomenologist after the reduction that could be of use to the psychologist" (1962a, p. 128). One of these methods, apparently, is reflection. Sartre says, "There is another type of reflection, utilized by the phenomenologist, which aims at the discovery of essences. That is to say, it begins by taking its stand from the outset on the terrain of the universal" (1962a, p. 128). Precisely because this task has not been systematically carried out, Sartre has written: "In a word, psychology is an empirical discipline that is still looking for its eidetic principles" (1962a, p. 130). Such a psychology would borrow its methods "from the phenomenological sciences, which are descriptive. It would be a 'phenomenological psychology,' investigating and specifying essences on the intramundane level, as phenomenology does on the transcendental level" (1962a, p. 130). Sartre continues further: "And indeed we must continue to speak here of experience, since every intrinsic seeing of an essence remains experiential. But it is an experience that altogether precedes experimentation" (1962a, p. 230).

Fundamentally, then, the differences among pure phenomenology, phenomenological psychology, and empirical psychology relate to levels of consciousness. Pure phenomenology investigates transcendental consciousness, phenomenological psychology ascertains the *eide* of psychological phenomena, and empirical psychology discovers facts; yet all findings are within the context of experience, but raised to different levels.

6. Overall, the most succinct expression of Sartre's understanding of phenomenological psychology is as follows:

> One must try to set out the eidetic of the image, that is to say, fix upon and describe the essence of this psychological structure as it appears to reflective intention. Then, only after having established the set of conditions which a psychic state must fulfill in order to be an image, one should pass from the certain to the probable in order to learn what experience can teach us concerning images as presented in a contemporary human consciousness. (1962a, pp. 130–31)

The most complete achievement of this aim by Sartre is his effort as it appears in *The Psychology of Imagination* (1966). In this work Sartre simply produces images, describes them and reflects on them, and then determines and clarifies their distinctive characteristics. He then goes on to relate different types or levels of images that description produces. Sartre calls this a clarification of the "image family." Only after completing these descriptions does Sartre turn to what he calls "the probable"—that is, only then does he begin to speak to the nature of the image. Before this, Sartre interprets himself as being in the domain of the certain, because he is merely describing what appears to reflective consciousness and at that level he cannot be wrong. Sartre then moves on to describe the role of the image in mental life and decides that the imaginary function is one of the great functions of consciousness. He then speaks to the imagining function of consciousness as it reveals itself in imaginary life and further clarifies the role of the unreal. That is where the psychology stops. The last section philosophizes about the nature of consciousness, granted that consciousness is capable of imagining. Sartre concludes that it is an essential feature of consciousness to be able to imagine. The task of psychology, then, is first to describe from a reflective attitude whatever phenomenon is present to consciousness, then to trace out the relationship of that phenomenon with allied phenomena so that a "family" is constituted, and finally to extend these "certain" insights into the order of the probable and see how they intertwine there.

Thus most of Sartre's explicit statements concerning psychology have to do with explicating a phenomenological psychology that is neither pure phenomenology nor empirical psychology. Phenomenological psychology differs from pure phenomenology in that it does not view the stream of

consciousness from the perspective of the reduction or consider it merely an example of consciousness as such; rather, it regards the stream as real, an actual process taking place in the world, although the object to which the stream is oriented is usually taken as meant and intended and not as it actually is. The last step is necessary in order to arrive at the essence of the object. Phenomenological psychology differs from empirical psychology in that it seeks the essence or meaning of phenomena rather than merely noting or describing their factual presence.

Let us examine an example from Sartre. I am imagining the Pantheon. To describe this from the viewpoint of pure phenomenology I take not only the imagined object, the Pantheon, precisely as it is meant and intended, but also the conscious act in which it appears precisely as it is meant and intended. The entire structure, "imaginary act–imagined object," is taken merely as it presents itself and no statement concerning its actual existence is made. From the viewpoint of phenomenological psychology, the imaginary act is considered to be real and actual; but since one wants to clarify the sense of the imagined object, the imagined object is taken precisely as it presents itself to a real act of imaginary consciousness. For empirical psychology, the imagined object and the imaginary act are taken to be real, actual events and are described insofar as they happen to take place in the individual who is experiencing them. Thus they are considered to be facts that happened to a certain individual in the world at a certain moment in time.

Method

Sartre's method, like all phenomenological methods, rests on descriptions and intuiting essences. Certainly this is the method employed in his studies on emotion and imagination. However, when Sartre turns to social phenomena or individual biographies, he uses what he calls the "progressive-regressive" method. However, the progressive-regressive method is simply a more specified description that dialectically relates goals and ends (progressive movement) to origins (regressive movement); generalities to concrete, unique events; and social-cultural factors to biographical ones. What is of particular interest in this context is the fact that as early as 1939, when he wrote *Sketch for a Theory of Emotions,* Sartre was interpreting the relationship between the phenomenological disciplines and the empirical disciplines in terms of the progressive-regressive method. Sartre then wrote: "The various disciplines of phenomenological psychology are regressive . . . ; those of pure phenomenology . . . are progressive" (1962b, pp. 93–94). He went on to explain. The reason for this, he said, is that:

... if phenomenology can prove that emotion is realization of the essence of the human-reality insofar as the latter is affectivity, it will be impossible for it to show that the human-reality must necessarily manifest itself in *such* emotions as it does. That there are such and such emotions and not others—this is, beyond all doubt, evidence of the factitious character of human existence. It is this factitiousness that necessitates a regular recourse to the empirical. (1962b, p. 94)

Sartre adds that it is his opinion the two movements will never completely converge. Thus, even when Sartre seems to be describing in a more "static" manner, a deeper analysis reveals that it is, in fact, merely a moment of a dialectical process. The study on imagination reveals this explicitly when Sartre compares the results of the "certain" with those of the "probable."

RELATION OF SARTREAN METAPSYCHOLOGY AND METHODOLOGICAL CONCEPTIONS TO TRADITIONAL PSYCHOLOGY

At the beginning of this article we noted that a major problem confronting scientific psychology has been how to submit the phenomenon of consciousness to the requirements of science—to wit, observability, objectivity, experimentation, and finally subsumption under law. Over the history of psychology consciousness has been understood by various theorists to be an interiority, a thing, a mere fact; it has been interpreted functionally, biologically, epiphenomenally; it has been regarded as real but scientifically useless; and it has even been explicitly denied. All these interpretations have contributed to a sustained tension between the requirements of science and the mode of appearance of consciousness. Until the application of phenomenological philosophy to psychology, no attempt was made to formulate a simple descriptive inventory of consciousness in order to see precisely what type of being it was and how it presented itself in the world. It is here that phenomenology in general, and Sartre in particular, have made a great contribution to psychology.

If Sartre's delineation of the psychical could be understood correctly, it would be readily seen as a genuine contribution. His analysis of the psychical as an object for consciousness rather than the subject of consciousness, ensures that it receives objective treatment. He solves the problem of an inaccessible interiority because there is no such thing, and his concept permits consciousness to be rigorously described even in experimental situations. Moreover, his acceptance of the phenomenological interpretation of the intuition into essences avoids the problem of going from fact to law, for the insight is already at a general level. Thus his analysis meets the demands of science if the understanding of science can be slightly enlarged.

Sartre's approach also enhances our understanding of the relationship among consciousness, behavior, and the psychical. The psyche, for Sartre, is the "organized totality of the virtual and transcendent existents" (1956, p. 163) that are posited by impure reflection. But the motive for positing these objects is given in experience, and the experience can be a consciousness or a behavior. In other words, the "psychic object" is constituted by the same means whether one is impurely reflecting on certain unreflective consciousnesses belonging to oneself, or one is impurely reflecting on perceptually given behaviors of another. In both cases the psychical object is apprehended and constituted by the reflective act, and the object transcends the specific experiences on which it is based. The individual to whom the experience or the behavior belongs is not privileged with respect to the object of the psyche. For example, to describe the psychological act of imagining I must first produce an act with its imagined object. I identify the process as psychological when I call the entire structure the "act of imagination," implying by this that I am not limiting my imagining to the object given to me presently, but I am referring to the permanent possibility I have of imagining objects. Similarly, when I see an angry parent spanking a misbehaving child, I am already on the psychological level because anger is posited as a type of action that humans are capable of performing which transcends the specific behaviors I see; otherwise there would simply be awareness of "this child being spanked by this parent," which would quickly be succeeded by other perceptions. Thus the psychic is an object that is constituted across consciousnesses or behaviors by reflective consciousness. It should be clear, however, that the psychic as object of consciousness is not the same as a thing as object of consciousness. Impure reflective consciousness can use either unreflective consciousness or behavior to posit the psyche because they both belong to human reality and partake of the same fundamental structure—that is, both participate in the structure of an act, both are intentional and directed toward the nonconscious, and both partake of the structure of temporality. The difference between them is that behavior takes place in the world of things (1957, p. 69).

Sartre's explicit statements on psychology for the most part boil down to theoretical classifications of various psychological phenomena and interpretations. We can contrast these, along with Sartre's other critiques of psychology, with the three major movements in psychology: Gestalt psychology, behaviorism, and psychoanalysis. Sartre's relationship to Gestalt psychology is mostly affirmative. He utilizes its idea of organization, figure-ground, part-whole, and totality. He cites its literature as support for a number of his arguments. His chief criticism is lodged at the metapsychological level and concerns the extent to which Gestalt theory still relies

on isomorphic or causal (genetic, etc.) interpretations. For Sartre, consciousness has to intervene somewhere along the way in the process of organization.

In general, Sartre affirms the intention of behaviorism to remove the "inner man" and to place man in the world, but he disagrees with the movement's specific manner of implementation and interpretation. He considers behaviorism's attempt to be strictly objective and exact to be a form of "solipsism as a working hypothesis" that practices a sort of *epochē* "with respect to systems of representations organized by a subject and located outside my experience" (1956, p. 229). The other difficulty with behaviorism, for Sartre, has both negative and positive consequences. On the one hand, behaviorism does not interpret man in terms of his characteristic principle, "transcendence-transcended," and thus it conceives of behavior as a thing closed in on itself that must relate to its situation as though it were another thing. On the other hand, behaviorism positively interprets the temporal unfolding of behavior instant by instant and in terms of external relations. For Sartre, "The Other's body [behavior] is perceived wholly differently than other bodies: for in order to perceive it we always move to it from what is outside of it, in space and time; we apprehend its gesture 'against the current' by a sort of inversion of time and space" (1956, p. 346).

Sartre has made fairly explicit his differences with traditional psychoanalysis (see 1956, pp. 568–75), so we do not have to repeat them here. As usual, the differences flow from different presuppositions concerning man, and, in parallel with the other two systems of psychology, Sartre wants to introduce a more active role for consciousness. Hence, in existential psychoanalysis the tension is between consciousness and knowledge, as opposed to consciousness and the unconscious; and Sartre wants to work back to a fundamental choice of project, rather than to a state. Sartre introduces these changes at the same time as he affirms numerous psychoanalytic themes—for example, the symbolic interpretation of behavior, the comparative method, and pre- or para-logical interpretations of behavior.

Overall, then, Sartrean metapsychology is a corrective to traditional psychology because it provides a sharper understanding of what man is. The resulting clarification of "the human reality" does not so much cancel out traditional psychology as complement it; for in many ways Sartrean metapsychology understands what traditional psychology wants to do better than does traditional psychology itself. What is more, the fleshing out of the implications of this clarified understanding might well result in a transformation of the praxis of traditional psychology.

Sartrean metapsychology, then, radicalizes our understanding of psychology primarily because it makes the psyche objective without transform-

ing it into a thing, and at the same time it accounts for all traditional psychological phenomena. Each psychological phenomenon is some variation of the ego and its states, actions, and qualities, and all such phenomena are equally objective. Psychological phenomena are now differentiated according to how we are aware of them, how they present themselves to consciousness—that is, according to their mode of organization and the type of intentional object posited.

Moreover, precisely because of its comprehensiveness, Sartrean metapsychology could serve to unify the Gestalt, behaviorist, and psychoanalytic movements by highlighting their complementarity, an achievement none of the three movements themselves could provide owing to their too narrow viewpoints and their failure to clarify the image of man that their systems imply. Thus, the complementarity that Sartre described between the phenomenological progressive movement and the empirical regressive movement is visible here, too.

EVALUATION OF SARTRE'S SYSTEMATIC PSYCHOLOGY

The whole aim of the phenomenological effort with respect to psychology is to clarify concepts which psychologists constantly employ without adequate understanding. The above analyses show that in many ways Sartre's metapsychology can help clarify our understanding of traditional psychology because he elucidates the meaning of key terms such as "psyche," "consciousness," and "behavior" and presents implications for method as well. Thus, if the problems of communications with traditional psychologists could be overcome, there is no doubt that acquaintance with Sartrean systematic psychology could only help traditional psychology.

The evaluation of Sartre's systematic psychology from within the general phenomenological viewpoint is more difficult because no fully developed phenomenological psychological system as yet exists. Husserl's comments remained programmatic, Merleau-Ponty dealt with the subject at length but his "system" remained implicit, and even Sartre's formulations cannot be considered complete because, apart from *The Psychology of Imagination*, all of his psychological writings take the form of "sketches" or "outlines" or examples introduced for the purpose of philosophical clarification.

Thus, although Sartre's systematic psychology is clearly adequately grounded in a philosophical phenomenology, it does pose some questions for a psychologist. These questions we shall now enumerate:

1. Sartre clearly is committed to the all-encompassing but mutually exclusive categories of for-itself and in-itself. As we have seen, Sartre's bias

is in the direction of consciousness, or for-itself. In one sense, that is why his system is complementary to traditional psychology. One consequence of these commitments, however, is Sartre's characterization of the psychical as non-originary and "degraded"; that is, from the viewpoint of pure reflection of full-fledged consciousness, the psychic is degraded.

First of all, we should note that the very reflection which constitutes the psychical is "impure." Nowhere is the psychical originary; it is always "made-to-be," constituted. Psychic duration, for example, is the opposite of historicity since it is constituted by the concrete flow of autonomous organizations which are the equivalent of psychic facts. Sartre also says that to be present to the psychic one must apprehend it "across a consciousness reflected on, of which they (states, acts, etc.) are the objectivation, the shadow cast on to the in-itself" (1956, p. 164). The psychical object, according to Sartre, "appears as an unachieved and probable totality, there where the for-itself makes itself exist in the diasporate unity of a detotalized totality" (1956, p. 165). On the other hand, the psychic is not on the same plane of being as the existents of the world, but its inertia enables it to be apprehended as related to those existents (1956, p. 167). Over and over again, we see the psychic as in-between: psychic temporality is the hypostasis of original temporality (1956, p. 167); the psychic object is the objectivation of the for-itself (1956, p. 168); its spontaneity is degraded; psychic duration must perpetually be made-to-be (1956, p. 170); the psychic world is a virtual presence, a shadow (1956, p. 170); the psychic body is not yet cognitive (1956, p. 336); a sort of *implicit* space supports the duration of the psychic (1956, p. 338); the body is called the psychic *quasi-body* and the psychic body is understood as a *quasi-object* (1956, p. 354); and lastly, even the degraded, magical cohesion of the psychic has to combat its tendency toward a division in indifference (1956, p. 338).

Thus, even as Sartre maintains two primary ontological categories, the for-itself and the in-itself, somehow the psychical shares characteristics of both, yet this sharing of both characteristics does not motivate a third category. Nor is the psychical ever seen as an upgraded in-itself. It is always seen as a low-grade for-itself because of the priority given to consciousness. In a certain sense, the psychical is a "for-itself-in-itself"—that is, the ultimate desire of the for-itself—but it has not attained the ultimate perfection that Sartre claims the for-itself seeks. Using more recent Sartrean terminology, could one not say that the psyche is the contradiction of both the for-itself and the in-itself, and precisely the contradiction that could motivate the overcoming of the very categories that create the contradiction?

Thus perhaps one could conceive of the psychical as a category in its own right that would not necessarily demand the specific interpretations given by Sartre. It almost seems as though the essence of the psychical is

to-be-in-tension—between ontological categories, between self and world, between self and others, and among the temporal ek-stases. To conceive of the psychical in this manner could give a different slant to the descriptions because it would imply a third category and not just the negation of the other two.

2. Sartre's formulation of the relationship between eidetic psychology and empirical psychology certainly cannot be the last word on that problem. Merleau-Ponty (1964) pointed out long ago that in Sartre's study of imagination he exceeded his own formulations in that some of the findings from the empirical side (the probable) cast doubt on some of the earlier eidetic analyses, which purported to define "The Certain." Moreover, Sartre (1962b, p. 29) himself has indicated that psychology need not wait until phenomenology is completed in order to embark on its project, only that it will have to be modified when phenomenology does arrive. Does this not, then, make the relationship between eidetic and empirical psychology not one of simple succession but one of simultaneity? And if the empirical can inform the eidetic, is it not also a dialectical relationship? Would not the progressive-regressive method actually provide a more workable model for the relationship?

This point can be demonstrated in another way. Earlier we exemplified the distinctions among pure phenomenology, phenomenological psychology, and empirical psychology in terms of complete reduction, partial reduction, and lack of reduction, respectively (see pp. 185–89). However, if pure phenomenology is progressive and empirical psychology is regressive (1962b, pp. 93–94), would not phenomenological psychology, which is partially empirical and partially eidetic (because it only performs a partial reduction) be precisely progressive-regressive? Such a conception of the relationship between phenomenological philosophy and phenomenological psychology would be more in line with Sartre's later writings (1968). Further, it would give the psychologist a more active role rather than reducing him to the position of a mere bystander who must wait upon the philosopher to "purify" his results.

3. Lastly, if the psyche is an object *for* consciousness, and if the consciousness to which the psyche is present transcends the psychical, and if the fundamental choice of the project is made by the same consciousness that transcends the psychical, to what extent is existential psychoanalysis psychological? Perhaps Sartre would be better off simply calling it existential analysis, despite the fact that aspects of his method have come from Freudian psychoanalysis, and even if it is necessary to go *through* the psychological to arrive at consciousness. This would bring Sartre's terminology in line with his position that, for human reality, the psychological is necessary but insufficient. However, this position also renders ambiguous the

ultimate meaning of a genuinely psychological analysis, for the psyche presents itself as merely something to be overcome, something with no intrinsic value of its own.

AMEDEO GIORGI

DEPARTMENT OF PSYCHOLOGY
DUQUESNE UNIVERSITY

REFERENCES

Barnes, H. 1956. Key to special terminology. In Sartre, Jean-Paul. *Being and Nothingness*. Tr. by H. Barnes. New York: Philosophical Library.

Jeanson, F. 1924. *Sartre dans sa vie*. Paris: Le Seuil.

Merleau-Ponty, M. 1964. Phenomenology and the sciences of man. In Edie, J., ed. *The Primacy of Perception*. Evanston, Illinois: Northwestern University Press.

Sartre, J.-P. 1956. *Being and Nothingness*. Tr. by H. Barnes. New York: Philosophical Library.

———. 1957. *The Transcendence of the Ego*. Tr. by F. Williams and R. Kirkpatrick. New York: Farrar, Straus & Giroux.

———. 1962a. *Imagination*. Tr. by F. Williams. Ann Arbor, Mich.: University of Michigan Press.

———. 1962b. *Sketch for a Theory of Emotions*. Tr. by P. Mairet. London: Methuen and Co., Ltd.

———. 1966. *The Psychology of Imagination*. New York: Citadel Press.

———. 1967. Consciousness of self and knowledge of self. In Laurever, N., and O'Connor, D., eds. *Readings in Existential Phenomenology*. Englewood Cliffs, N.J.: Prentice-Hall.

———. 1968. *Search for a Method*. Tr. by H. Barnes. New York: Vintage Books.

7

Phyllis Berdt Kenevan
SELF-CONSCIOUSNESS AND THE EGO
IN THE PHILOSOPHY OF SARTRE

THE problem of self-knowledge is one of the most difficult for a philosopher to handle because it involves not only a definition of the self but also the validation of a knowing consciousness. Even Descartes, who affirmed as the most certain of all knowledge the knowledge of the self as thinking thing, foundered on the question of the unity of that self as both thinking and extended substance. Hume also had his problems for, although asserting that the self is only a disconnected bundle of fleeting perceptions that are linked through imagination, he was unable on analysis to account for the principles of association which provided the imaginative link between those perceptions. Nor was Kant immune from difficulty here, for according to his epistemology we have knowledge of the empirical self only, whereas our moral experience makes it necessary for us to postulate a noumenal self which, however, can never be known by us.

Sartre faces similar difficulties in his account of self-consciousness and the ego. Specifically, he attempts to account for a self which, though lacking self-identity, is yet self-conscious; and he attempts to provide some validation of that consciousness in terms other than its knowing that it knows.

In coming to grips with these problems Sartre manages to avoid one of the pitfalls, namely, an infinite regress of self-as-subject knowing self-as-object, by affirming that it is not knowledge which grounds knowledge, but being. Our own existence is the foundation of our self-consciousness, as the brute existence of the world is the foundation of our knowledge of the world. This awareness of existence which is the foundation for any knowledge, is itself non-cognitive awareness. Thus, in the case of the self, our self-consciousness is non-thetic or non-conceptual.

Sartre introduces here an extremely important distinction between consciousness and knowledge. Not all consciousness, he makes clear, is cognitive; for only that consciousness which posits an object fulfills the

requirement for knowledge. Non-cognitive consciousness is by no means depreciated, however, for this awareness provides the ground and conditions for knowledge. I ground my self-consciousness (and indirectly my consciousness of objects) not on knowing that I know I exist; I ground it on my non-cognitive awareness of my existence, which is a pre-reflective apprehension of myself, a "taste."

It is here that Sartre departs from Husserl's position with its bracketing of existence. For whereas Husserl equates the being of the phenomenon with its essence or meaning, Sartre argues that the being of the phenomenon is its existence. That is, existence always precedes essence, whether our own or that of the external world, and this brute existence is always something we are conscious of non-thetically. This non-thetic consciousness of existence, then, founds the knowledge posited by consciousness as, for instance, in our knowledge of objects in the external world, where our non-conceptual awareness of being overflows any meaning or knowledge given through aspects or profiles.

The situation is not parallel in regard to the self, however; for while here, too, existence precedes essence—for we make ourselves be what we are by our choices—we can never really know what we have made ourselves be. Yet non-positional self-consciousness accompanies every positional act of consciousness.

Sartre thus avoids the problem of an infinite regress of self-as-subject-knower and self-as-object-known; but how are we to understand this self-consciousness which can never be called self-knowledge? Does the non-thetic self-consciousness which Sartre describes indeed successfully account for what seems to us to be self-knowledge, specifically in the case of authenticity and purified reflection?

In pursuing this question we will examine both Sartre's account of the self as an entity and his account of the self-consciousness that replaces what is ordinarily thought of as self-knowledge. In the course of this analysis, it will be argued that Sartre's account of self-consciousness as non-positional is not adequate to account for the revelation of purified reflection. Finally, a modification in the notion of intentionality will be suggested as one means of solving the apparent inconsistencies, although, admittedly, new problems may be generated by this adaptation.

I

To begin, then, how does Sartre explain self-consciousness and the ego? In *The Transcendence of the Ego* as well as in *Being and Nothingness,* Sartre presents a radical view of consciousness. The transcendental field, he tells us, is purified of all egological structure. Consciousness is an absolute

impersonal spontaneity, bubbling up in temporal dispersion and providing the foundation for a psychological ego as object. But this ego as object, being the product of impure reflection, is pure passivity:

> This absolute consciousness, when it is purified of the I, no longer has anything of the *subject*.[1]

> ... the spontaneity *goes toward* the I, rejoins the I, lets the I be glimpsed beneath its limpid density, but is itself given above all as *individuated* and *impersonal* spontaneity.[2]

A brief explication of Sartre's notion of consciousness may be useful at this point. Two things primarily characterize consciousness: it is *ekstatic,* and it is intentional.

To say that consciousness is ekstatic is to say that it is shattered in its very being by temporal ekstases; that is, it is a split process of present intention, past retentions, and future protentions, in a dispersed totality. Moreover, it is ekstatic in ways other than temporal. It is split into pre-reflective and reflective consciousness; and it is a non-positional *self-*consciousness of a positional consciousness of something *other* than itself.

The last condition expresses the structure of consciousness as *intentional.* That is, consciousness posits an object other than itself. It is also, as consciousness, *self-*consciousness. But this self-consciousness is always a *non-positional* consciousness; that is, it cannot posit itself as object.

Given the above, Sartre claims that consciousness is characterized as "nothingness," the point being that it is *no thing.* It is "not what it is," meaning it is not identical with what it was in the past, though it still *is* that self it was; and it "is what it is not," meaning it is not *yet* what it will be in the future. Every act of consciousness is the bubbling up of pre-reflective consciousness in this temporal dispersion. He calls this spontaneous absolute consciousness an *impersonal consciousness.* The character of impersonality appears to be used by Sartre in two ways. First, he uses it to mean "subject-less"—consciousness is devoid of any ego, I, me, as subject. Second, he refers to its intentionality—consciousness is impersonal in that it always posits something *other* than itself.

But an impersonal consciousness in the first sense is still a non-positional self-consciousness, and there is something odd about describing an impersonal subject-less consciousness as a self-consciousness. This leads me to the supposition that, in his zeal to deny the presence of a transcendental ego, Sartre has overstated his case. This contention is supported by the account he gives of consciousness as a temporal ecstasis with protentions and retentions, a "unity in dispersion," a "detotalized totality." Even granting that this is not an egological structure, it is nevertheless a structure with some sort of unity. Thus it seems that Sartre's intention, in emphasiz-

ing primary consciousness as impersonal with "nothing of the subject" in it, is designed primarily to separate his account of consciousness from any notion of consciousness as thing or substance (compare Descartes' substantial ego, or Husserl's transcendental ego).

But to describe consciousness as Sartre does is misleading; for it seems to deny the possibility of *any* kind of structural *self* while at the same time describing consciousness as a self-consciousness. Hence we get the peculiarity of an impersonal consciousness which is at the same time a self-consciousness. Therefore, I think, one ought to interpret Sartre as meaning by this radical description that, although the self is no *thing* standing behind consciousness, there is nevertheless a self-as-temporal-process of which we are non-positionally conscious with every act of positional consciousness. There is support for this view in his description of consciousness as spontaneously emerging in a temporal framework.

In the upsurge of the for-itself as presence to being, he says, there is an original dispersion; the for-itself is lost outside, next to the in-itself, and in the temporal ekstases. And this process, he says, has the "structure of selfness."[3] Given this description, it may be asked, Does Sartre mean any more by "primary consciousness" than that consciousness is unfinished, in process, contingent? It is impersonal in that it never takes itself as object, but in regard to the other sense of impersonal—that is, in lacking a subject—does he mean to imply any more than the notion that a *total,* completed self as a structure in consciousness is impossible? If he does not, then to say this is not to deny that there is a self-in-process, but only to deny a substantial self. "Count no man happy until he dies" expresses precisely this contingency of the self without ruling out a personal consciousness as "subject" of some sort.

To sum up this point, in describing consciousness as impersonal Sartre is insisting that, although consciousness always posits an object other than itself, self-consciousness must be non-positional (the second meaning of impersonal); but this does not preclude our describing consciousness as a process in temporal dispersion with some sort of unity, even if it is only a "de-totalized" unity. Hence primary absolute consciousness is not "impersonal" in the first sense (subject-less). I claim this, even though Sartre contends an "I" is not necessary in the transcendental field because there is never a *direct* unity of consciousness. For the point is that, however much he describes spontaneous consciousness as "non-personal" and "non-egological," there is a structure of self as temporal process in the bubbling up of unreflective consciousness.

The case is otherwise in his description of the psychological ego, which is clearly a pseudo-object made up by impure reflection.

... the ego is an object apprehended, but also an object *constituted,* by reflective consciousness. The ego is a virtual locus of unity, and consciousness constitutes it in a *direction contrary to* that actually taken by the production; *really* consciousnesses are first; through these are constituted states; and then, through the latter, the ego is constituted.[4]

Sartre suggests that the essential role of the ego is to hide from consciousness its own spontaneity. It is as if consciousness constituted the ego as a false representation of itself, and although it gives itself as object, it is nothing but the ideal totality of states and actions. Psychologically, it appears to be a reality, but ontologically, it is an impure and unreal product of consciousness. For its origin one must turn to the spontaneous upsurge of the unreflective consciousness, as the foundation for the reflective consciousness' projection of this false "in-itself." According to Sartre, it is reflection which personalizes the impersonal.

II

Although the production of the "ego" by reflection is a result of the ordinary mode of reflective consciousness, it is nevertheless an impure production. The ego is a personalized account of the primary upsurge viewed as "object"; thus the object of psychology is a product of the ecstatic nature of primary consciousness, a construct out of primary flux, invested with a mythical permanence. It is an "impure growth" in a pure field of consciousness. Why impure? Because it is ego as *thing,* as object of reflection; hence it can only be pseudo-object.

By what means is the false ego exposed as such? Three mechanisms in consciousness expose the ego as pseudo-object: authenticity, purified reflection, and phenomenological reduction. It is in examining these mechanisms that one encounters difficulties with Sartre's account of consciousness as impersonal and non-positional.

In a state of authenticity I experience the anguish of myself as freedom. I apprehend that choice is inescapable, and that my freedom is the freedom of a contingent, unfinished self. It is my ontological contingency which forces me to choose myself. But if we try to locate this active agent of choice and anguish and insight, we are faced with a problem. It cannot be the ego which acts, since the psychological ego is a posited ideal object, passive, not active. It can only be the impersonal consciousness. Yet Sartre tells us that this self-consciousness is not only subject-less but also only non-positional. Authenticity thus poses a dual problem. It implies an active agent of consciousness, and it implies the possibility of self-knowledge, whereas impersonal consciousness can provide neither of these. Sartre,

however, does locate anguish in impersonal consciousness. "Consciousness," he says, "is frightened by its own spontaneity."

If, however, we understand impersonal consciousness as being the structure of a de-totalized self-in-temporal-process (as Sartre also describes it), then authenticity is possible; that is, there is some unity of consciousness, some personal self as active agent of choice and the self of which we are non-positionally conscious. It is not an *act* of consciousness which is frightened by its own spontaneity, but an historical self. If this were not the case, neither historicity nor authenticity would be possible.

But does not this interpretation constitute an inadmissable departure from Sartre's assertions in *The Transcendence of the Ego?* Not if, indeed, his position was an overstatement of his intentions. Some comments made by Sartre in a lecture to the Société Française de Philosophie defending the thesis of *Being and Nothingness* seem to bear out this supposition.

> In the first place, we ascertain that there is no distinction of subject-object in this consciousness. The fact of saying that it is not inhabited by an ego has essentially the following significance: an ego as an inhabitant of consciousness is an opacity in consciousness; in reality, if consciousness does not have an ego at the level of immediacy and non-reflexivity, it is nonetheless personal because it is a return in spite of everything to itself.[5]

This comment certainly supports the contention that consciousness is in some sense a personal unity. One might also point to Sartre's quite frank use of the terms "subject" and "object" in *Being and Nothingness* in the section "The Existence of Others." In that context, consciousness can be subject positing another as object, or it can be objectified by another's subjectivity. The stricture against subjectivity seems to apply only when it is a case of subject-object within the *same* consciousness. In other words, my subjectivity is revealed to me when I objectify another. But this is, again, an instance of a psychological description of consciousness that seems unfounded by his ontological description of the transcendental field unless one admits the unity of an historical self as belonging to that field.

The same point could be made in regard to his use of the term "subjectivity" when he is opposing it to the notion of "personality." By "subjectivity" he clearly means here "historicity," whereas "personality" refers to the psychological ego with its traits and characteristics. But unless one understands this historicity as a description of the transcendental field, there is no ontological ground for the distinction he makes.

To return to the question of authenticity, the question was posed as to how authenticity is possible. It is possible only because the reflective consciousness, whose ordinary state is one of *impure* reflection, can purify itself. Because it can purify itself, consciousness apprehends its true ontological structure; it sees itself as an incomplete unity in dispersion, with no

completed self-identity. Here, too, Sartre claims that this self-revelation occurs to an impersonal consciousness.

> One might ask why the *I* appears on the occasion of the *Cogito,* since the *Cogito,* correctly performed, is an apprehension of a pure consciousness, without any constitution of states or actions. To tell the truth, the *I* is not necessary here, since it is never a direct unity of consciousness. One can even suppose a consciousness performing a pure reflective act which delivers consciousness to itself as a non-personal spontaneity. Only we must realize that phenomenological reduction is never perfect.[6]

No "honest cogito" is therefore possible. Sartre also claims that, if it were, the consciousness reflecting upon the cogito would be a different consciousness from the cogito reflected upon. But this assertion rests on an unwarranted assumption. If we look at the self of self-consciousness as the indirect unity of consciousness *in temporal dispersion,* then the cogito appears as that "process self" and the problem of two different consciousnesses ought *not* to arise, since the consciousness which is reflecting *on* its past *is* that past in the mode of "having to be it." This is how Sartre describes the relation of our present consciousness to our past consciousness. To deny this is to de-temporalize consciousness, to view it as made up of discrete instants. In other words, his description of the temporalizing of consciousness provides an adequate basis for the possibility of the self-recognition of a temporalizing consciousness which is *one* dispersed consciousness and not two isolated consciousnesses.

It is this historical self, then, which is revealed in purified reflection, whether one calls this revelation a cogito or not.

The next question that arises is, What occasions the event of purified reflection? Sartre says very little about this possibility of reflective consciousness, but he describes it as a sort of *katharsis.*

> Pure reflection, the simple presence of the reflective for-itself to the for-itself reflected-on, is at once the original form of reflection and its ideal form; it is that also which is never first given; and it is that which must be won by a sort of *katharsis.*[7]

> Pure reflection can be attained only as the result of a modification which it effects on itself and which is in the form of a *katharsis.*[8]

What is revealed to impersonal consciousness through purified reflection is its temporal structure, its existence as a unity in disperson—in other words, its existence as a "self-in-process."

> But pure reflection still discovers temporality only in its own original nonsubstantiality, in its refusal to be in-itself. It discovers possibles *qua* possibles, lightened by the freedom of the for-itself. . . . Finally reflection discovers the for-itself in its detotalized totality as the incomparable individuality which reflection *itself is* in the mode of having to be it. . . . Reflection therefore ap-

prehends temporality and reveals it as the unique and incomparable mode of being of a selfness—that is, as historicity.[9]

What is one to conclude from these comments? In regard to the question of the ontological possibility of a unity of consciousness, Sartre is ambiguous. He has disposed of the self as psychological object, but he is not equally convincing in his assertion that a purified consciousness reveals the absence of all egological structure. Can the temporal structure of consciousness be described as self-in-progress? Obviously, it can; and we can allow *this* self even though we grant the absence of any egological structure. The point is that the revelation of purified consciousness is that of the temporalizing self. To call that self simply an impersonal consciousness (a subject-less intention of something other than itself) is misleading because, although it *is* as pre-reflective consciousness an impersonal consciousness, it is also *as reflective consciousness* a revelation of *itself* as a contingency positing something other than itself. The reflective and pre-reflective consciousnesses are an indirect unity of consciousness, and only *because* they are is purified reflection possible.

Sartre refuses to label that unity a "cogito" because he does not want to imply a substantial ego. So let us call that unity simply the "self" of which we have non-positional consciousness. Sartre's comments, cited earlier, regarding consciousness as "personal" seem to indicate a willingness to grant the existence of "self" in this sense.

But at the same time that he grants a personal self, Sartre makes a distinction which proves that self unknowable; and this raises another problem. If the self of consciousness is unknowable, then how are we to comprehend authenticity and the *katharsis* of purified reflection? Both imply knowledge, or at least suggest an alteration in the non-positional consciousness of self so that a genuine revelation of the ontological nature of consciousness is made possible. But Sartre argues that self-consciousness must not be confused with self-knowledge. Consciousness of self occurs only as non-positional self-consciousness; therefore, knowledge of self is impossible.

III

Either authenticity and purified reflection are non-cognitive states of non-positional self-consciousness; or they are cognitive states, in which case some explanation is required to support this claim.

As I have indicated earlier, I believe the first alternative (non-cognitive) is inadequate to account for the phenomenon of purified reflection, and therefore some solution must be sought on grounds of the second alternative.

Why does Sartre deny the possibility of self-knowledge? At first glance it seems reasonable to suppose that the incomplete status of the self is the cause. It is not in-itself, thing. In other words, how can we know that whose totality is only a projected ideal? Admittedly there is a problem, but it is not insurmountable. For even though not in-itself, the self, if it has the structure of some sort of unity, can be known as that unity—that is, as a contingent, unfinished self, given to itself as historicity. This problem of the incompleteness of the self has already been discussed and the possibility of self-revelation admitted. The cognitive problem here rests in a more crucial way upon Sartre's adherence to his theory of intentionality, upon the assertion that consciousness can posit only something other than itself. If this is the case, reflective consciousness *cannot* posit itself as object, and will necessarily "slide through" the prior act of self-consciousness, resting only on the object posited in the unreflective consciousness. Knowledge can occur only where there is an object posited that is other than consciousness itself. In fact, with this notion of intentionality it is logically impossible for there to be a consciousness of self that could be cognitive. Therefore Sartre is committed to the thesis that no self-knowledge is possible. The case is quite clear: the object of knowledge is a posited object; but consciousness cannot posit itself as object. That is why Sartre calls the revelation of purified reflection "pseudo-knowledge," "quasi-knowledge," or being "luminous" for oneself.

> The non-thetic consciousness arrives at itself without recourse to discursive thought or implications, for actually, it is consciousness, but one must not confuse it with knowledge. To arrive at one's self is to be luminous for oneself, but this is in no way a thing that can be named, or expressed to oneself . . . the problem will be to understand how we are able to pass from non-thetic consciousness of self, which is the being of consciousness, to reflexive knowledge, which is based on itself.[10]

Since it is his theory of intentionality which limits the possibility of self-knowledge, any theory opposing such limitation must confront that theory.

I am here suggesting as a possible solution a modification in the operation of intentionality that would be simultaneous with the *katharsis* of purified reflection. In other words, if we are to understand the possibility of authenticity and purified reflection, then the same pattern of intentionality cannot operate during these moments as operates under ordinary conditions. Or, if purified reflection is possible, then some alteration must occur in non-positional self-consciousness to make that revelation possible. What kind of modification might that be?

My proposal is yet another ekstasis, whereby a double arrow of intention is activated. That is, in this state of consciousness there would be not only a positional intention of objects other than consciousness, but also,

simultaneously, an *at*tending arrow, an *at*tention to the self as it *in*tends objects. To put it simply, the modification would be an intention of an object *accompanied by* an attention to self. In this double arrow of attention-intention, a self revelation would occur, not as the object of a posited consciousness (a revealed object) but as a "lighting up" of that self in its intention (a revealed self). This would suffice to account for the sudden revelation of one's historicity in purified reflection and the anguish of one's freedom in authenticity. Not being the kind of condition that could be easily sustained—for obviously it would demand a powerful concentration of consciousness—it would correspond very well with the kind of momentary apprehension that is suggested by both authenticity and purified reflection.

In this way, Sartre's account of the ordinary operation of consciousness is not jeopardized; yet there is an epistemological explanation for what is really to be understood as an extraordinary operation of consciousness. One can even explain, on this hypothesis, the radical conversion in relation to one's project that Sartre describes; for a sudden revelation as a result of attending to self in this way, illuminates one's choice of himself.

But is this illumination *knowledge?* Why not? Of course this means multiplying criteria so that knowing involves two categories; that is, not only intentionality in regard to posited objects, but also the attending to itself of that positing consciousness. But should not *self*-knowledge, by its very nature, operate through different categories than knowledge of what is other than the self? This is surely a question that must be answered by phenomenological inquiry. At any rate, it ought not to be ruled out on grounds of dogma.

To repeat, then, Sartre insists that only the in-itself can be known by positional consciousness, and therefore denies knowledge of the for-itself. But the suggestion here is that the for-itself can be known to itself in special instances whereby the intentional mode of knowing is modified by a self-attention which does not *replace* normal intentionality, but accompanies it.

An interesting subject for further inquiry might involve the question of memory. The intensive moments of consciousness which persist as ineradicable memories could be viewed as precisely those moments when ordinary consciousness with its non-positional self-consciousness suddenly transforms itself into an attending self-consciousness. If this is the case, then such moments will recur in memory as a heightened awareness of self perceiving a world.

But regardless of the status of such memories, the spontaneous attention-intention split I am describing is consistent with the little that Sartre does say about purified reflection.

But it can happen that consciousness suddenly produces itself on the pure reflective level. Perhaps not without the ego, yet as escaping from the ego on all sides, as dominating the ego and maintaining the ego outside the consciousness by a continual creation . . . there are no more barriers, no more limits, nothing to hide consciousness from itself.[11]

The troubling question, Why does consciousness purify itself spontaneously, what motivates it? is one that Sartre cannot answer. He suggests that it is a rare phenomenon. Looked at from this point of view, ordinary consciousness appears to be rather mechanical or dream-like. One can even conceive of a sort of Platonic soul tending as motivation toward some conversion or "awakening." In fact, in *The Transcendence of the Ego,* Sartre himself suggests a parallel with phenomenological reduction and Plato's "philosophical conversion." In this passage he suggests that the "natural attitude" appears wholly as an effort made by consciousness to escape from itself into the false ego, and since that effort is never completely rewarded, we experience an anxiety which *becomes* a motive for consciousness to purify itself. He describes it here as "both a pure event of transcendental origin and an ever possible accident of our daily life."

But, in his lecture to the Société Française de Philosophie (as well as in *Being and Nothingness*), he is less optimistic. In the lecture he says:

Is it possible to pass from immediate consciousness to pure reflection? I know nothing about it. Perhaps one can achieve it after the exercise of pure reflection, but I could not say *a priori* that a being living on the level of pure immediacy is capable of pure reflection. What is most frequently encountered is, I believe, people who pass calmly from the immediate to impure reflection. The type who is thirsty, who hasn't enough money, who has difficulties with his wife, is plunged into all of this and one fine day exclaims: "How miserable I am!" It is a reflection welling up from an impure psyche. But I can't imagine the individual going on from this to see the ontological reality of his being, which is perhaps leading him to leave his wife and change his job; and we would be on the level of morality. I don't think there would be a transition from one to the other.[12]

In this example the moral problem, the problem of authenticity, is clearly related to the question of consciousness "purifying itself." Perhaps that is why authenticity poses such a problem, and why Sartre never wrote his promised book on ethics.

IV

In conclusion, whether one agrees that the revelation of one's ontological reality constitutes a cognitive state or not, some modification in Sartre's theory is necessary to provide the epistemological grounding for what he

describes as purified reflection. Sartre himself acknowledges as much when he makes the following statement:

> Here, there is a phenomenon of being which we can no longer describe with our ordinary categories, which are the categories applied to being-in-itself. We shall say, on the contrary, that when we arrive at what we are, we must utilize a more supple vocabulary, since we establish that consciousness is at the same time that which it is not. . . . Actually, the notion of self is a notion which in itself is evanescent.[13]

In fact, one might want to argue that Sartre has already provided grounds for a modification in his epistemology. For, although he insists that all consciousness is intentional—that is, it takes an object other than itself—he does argue that it is also non-positing self-consciousness. Similarly, there is a non-positing awareness, through nausea or boredom, of the brute existence of an external world, and there is the non-positing awareness of the Other as subject, upon experiencing oneself as object. Taken all together, this is an impressive source of awareness, for what is given to us is our own existence, the external world, and the Other. None of these as such is an object of a positing consciousness, and so none can be an object of knowledge. One is tempted to argue that there is more significance in non-conceptual awareness of existence than in knowledge, which concerns only the meanings we give to ourselves, the world, the Other. In fact, one might even ask whether such a division between positing and non-positing consciousness implies an appearance-reality dualism. That is, does it imply two worlds, one concerning knowledge as a structuring of essences and meaning, and the other an affective apprehension of self, brute existence, and the Other? It does not, according to Sartre, because the same reality is in question; but Sartre insists upon separating existence (the being of phenomenon) as given through pre-reflective awareness from meaning (the phenomenon of being) as given through positional consciousness. Hence existence which precedes essence is what we are aware of without, however, its being posited knowledge. Although this may seem perverse, it is precisely what Sartre intended in his attempt to provide a foundation for knowledge that would not itself be a case of knowledge. Yet it is perhaps this very fundamental distinction between existence and meaning that lies at the root of the problem with purified reflection. For the illumination of the self in purified reflection must be, also, an affective apprehension of the authentic existence of the self as contingent, ekstatic, in process. The problem of self-consciousness, then, may be part of a larger problem of non-cognitive or non-positional awareness of existence that is more basic than what is given through intentional objects. What makes the problem acute here is the fact that the possibility of authentic choice rests upon this non-positional self-awareness. In all these cases, however, of self, external

world, and the Other, there is a "gut-level knowing," a non-conceptual consciousness which Sartre is committed to calling simply "awareness" of existence. On the whole, this may work very well; but whereas the affective apprehension of the existence of the external world reveals the "it is, is what it is, and is in-itself," the purification of reflection seems to go beyond ordinary pre-reflective apprehension of one's own existence or "taste"; for here is a revelation of the structure of a for-itself, with its ekstases and temporal openness, its contingency and responsibility. In this case, "awareness" of one's own existence seems to be unmistakably cognitive.

In view of this dual role of consciousness, one wonders whether it might not be justifiable to grant cognitive status to both positional and non-positional consciousness; for at least in the case of purified reflection, one seems to be knowing more through non-conceptual consciousness of existence than through a positional consciousness of the meanings of objects.

One might ask, then, as a speculative possibility, whether there is not an affective or "subjective" cognition that precedes, and grounds the knowledge of, the intentional consciousness. Sartre certainly does not present the case as such; but in view of the extent and significance of this awareness-that-is-not-knowledge, one may have grounds for arguing the case. In any event it might resolve the paradox that purified reflection which is not knowledge reveals an authentic self, whereas impure reflection which is knowledge reveals a false self.

Let us briefly recapitulate the possibility for self-knowledge. Pre-reflective self-consciousness is an affective consciousness of our existence, our "taste," but it is not knowledge.

Impure reflection, since it posits an ego as in-itself, is doomed to give us a false object, inasmuch as the ego is only an ideal unity of states and actions. In fact, by a positing consciousness, self-knowledge is impossible, since one would need a substantial self that could be posited as an object. But the self is not substantial and furthermore cannot posit itself as object. As Sartre has made clear, the desire to be in-itself-for-itself is an impossible ideal.

By what magic, then, can purified reflection authentically illuminate for us the true structure of the self as process? This can occur, it seems, only if there is possible an affective cognition of existence on the part of the reflective consciousness, just as the pre-reflective self-consciousness apprehends its existence as its "taste."

A modification of this magnitude is perhaps too large a demand in view of the distinction that Sartre makes between consciousness and knowledge; but if such possibility of affective cognition is to be ruled out, then one is left with the problem of somehow modifying intentionality as suggested

earlier, in order to account for that revelation of the reality of the self which occurs when reflection purifies itself and makes authentic choice possible.

PHYLLIS BERDT KENEVAN

DEPARTMENT OF PHILOSOPHY
UNIVERSITY OF COLORADO

NOTES

1. Jean-Paul Sartre, *The Transcendence of the Ego* (New York: Noonday Press, 1957), p. 106; original French version in *Recherches Philosophiques,* VI (1963–37).

2. Ibid., p. 98.

3. Jean-Paul Sartre, *Being and Nothingness* (New York: Philosophical Library, 1956), p. 91.

4. *Transcendence of the Ego,* pp. 80–81.

5. Nathaniel Lawrence and Daniel O'Conner, eds., *Readings in Existential Phenomenology* (Englewood Cliffs, New Jersey: Prentice-Hall, 1967), p. 123.

6. *Transcendence of the Ego,* p. 91.

7. *Being and Nothingness,* p. 155.

8. Ibid., pp. 159–60.

9. Ibid., p. 158.

10. *Readings in Existential Phenomenology,* p. 123.

11. *Transcendence of the Ego,* pp. 101–2.

12. *Readings in Existential Phenomenology,* p. 142.

13. Ibid., pp. 127–28.

8

Robert C. Solomon
SARTRE ON EMOTIONS

W HAT are the emotions? Ancient poets described them in terms of
madness and brute forces. ("Anger is like riding a wild horse,"
wrote Horace.) Medieval and modern poets alike have talked of the emo-
tions in terms of physiological disruptions—the breaking of hearts, the out-
pouring of bile, spleen, and gall. Our present-day language of the emotions
is riddled with metaphors of passivity: "falling in" love, "struck by" jeal-
ousy, "overwhelmed by" grief, "paralyzed by" fear, "haunted by" guilt,
"plagued by" remorse. Not surprisingly, the first full-blown psychological
theory of the emotions, the so-called James–Lange theory (simultaneously
formulated by William James in America and C. G. Lange in Denmark),
was nothing other than a scientific canonization of these metaphors; the
emotions are physiological disturbances with certain epiphenomenal "af-
fects" in consciousness. Similarly, Sigmund Freud describes the "affects" as
we might speak of hydraulics, in terms of various pressures and their out-
lets: filling up ("cathexis") and discharge ("catharsis"), channeling ("subli-
mation") and bottling up ("repression"). Like James and Lange, Freud
links this "hydraulic model" to scientifically acknowledged operations of
the central nervous system.[1] In each case, the emotions are viewed as un-
toward and disruptive forces or pressures, erupting in "outbursts" or man-
ifesting themselves in behavior that is aimless and "irrational," degrading
and often embarrassing, inimical to our best interests and beyond our con-
trol. They are not our responsibility (except, that is, in their *expression*,
which we are told we *ought* to control).

Jean-Paul Sartre was among the first writers on the subject to break
with this tradition. He did so incompletely, but I shall argue that he must
nonetheless be credited with the initiation of a persuasive alternative to the
ancient model of invasion by alien physiological and animal forces assailing
our normal patterns of behavior and thought. In his "Esquisse d'une

théorie des émotions,"* Sartre defends a view of the emotions as conscious *acts*, as purposive and "meaningful" ways of "constituting" our world, for which we must accept responsibility. The essay is the only published portion of a projected 400-page manuscript that was to be called "The Psyche."² It is worth noting that it was written in 1939, about the same time as *Nausea*, Sartre's first "existentialist" novel, and only a short time after "La Transcendance de l'ego,"³ his best-known phenomenological essay. The "Sketch" on the emotions not only anticipates but actually argues many of the familiar themes of *Being and Nothingness*,** mapping out its phenomenological presuppositions with a simplicity that is lacking in the larger work. (In fact, I have suggested to my students that they read the "Sketch" as an introduction to *Being and Nothingness* in place of the opaque so-called Introduction to that work, in which the paradoxes of phenomenological ontology often obscure the existential themes that occupy Sartre for the next several hundred pages.⁴

Since the "Sketch," Sartre has not attempted to develop his "theory" of the emotions as such. Its basic structures, however, are prominent throughout *Being and Nothingness* and his later "psychoanalytic" studies. In his brilliant analysis of the career of Jean Genet,⁵ for example, the conception of an emotional "transformation of the world," the key to the theory of his early "Sketch," is also the key to Genet's "word magic" and his "poetic use of language." And the evidence of the first volumes of his gargantuan study of Flaubert⁶ demonstrates that no matter how his interests over the years have shifted (in scope if not in direction), Sartre has continued to hold and to use the theory he sketched for us four decades ago.

SARTRE'S METHOD: PHENOMENOLOGY (INTRODUCTION)

The Introduction to Sartre's "Sketch" tells us that the key to his approach to the emotions lies in an appreciation of the fact that "the consciousness which must be interrogated and what gives value to its responses is precisely that *it is mine*" (8;11, my italics). He contrasts this precept with what he characterizes as "the methods of the psychologist," in which "our

* "Esquisse d'une théorie des émotions" ("Sketch of a Theory of the Emotions") in *Actualities scientifiques et industrielles* ser. no. 838 (Paris: Hermann, 1939, copyright February 23, 1940). This work, translated by B. Frechtman, first appeared in English in 1948 as *The Emotions: Outline of a Theory* (New York: Philosophical Library). All references here are to the 1949 (second) Hermann edition with translations based on the Frechtman 1971 Citadel Press edition. The page numbers that appear in parentheses in the text refer first to the French, then to the English.

** All quotes from *Being and Nothingness* are from the 1972 printing of the Washington Square paperback edition, translated by Hazel Barnes (New York: Philosophical Library, 1956). This work is hereinafter cited in parentheses as *B&N*.

knowledge of the emotion will be added *from without* to other knowledge about the physical being" (6;7). What difference will appreciation of this fact make? It will allow us, according to Sartre, to investigate "the very structure of human reality," the possible conditions of emotion (ibid.), arrived at by the same Kantian style of inquiry that will be central to *Being and Nothingness.*[7] The psychologist reports the "objective" and "empirical" physiological facts of human behavior and, if he allows himself, examines certain "states of consciousness" through introspection (which Sartre insists is equally "objective" and "empirical"). What is missing in the psychologist's method, Sartre complains, is a consideration of consciousness as a *meaningful activity* in and for itself, a consideration that "cannot come to human reality *from the outside*" (11;17).

From the outset Sartre rejects the notion of the emotions as sporadic and inessential disruptions of behavior with conscious "affects"; rather, he says, the emotions are "essential" and "indispensable structures of consciousness" (10;15). Moreover, emotion must not be considered as a set of empirical facts gained through introspection or as a "corporeal phenomenon" (12;19), but rather as "an organized form of human existence" (11;18). This approach Sartre appropriately couches in the now familiar but then novel and exciting language of *phenomenology.* The idea of a form of investigation that goes "beyond the psychic, beyond man's situation in the world, to the very source of man, the world, and the psychic," is essential to Husserl's "transcendental phenomenology," which Sartre endorsed enthusiastically during this period. (See as well his essay "Intentionality" and his *La Transcendance de l'ego,* both written a few years earlier, and his essay "L'Imaginaire" a year later.) The phenomenologist, according to Sartre, attempts "to describe and fix by concepts precisely the essences which preside as the transcendental field unrolls" (8;11). Again anticipating the central theme of *Being and Nothingness,* Sartre argues that it is "just as impossible to get to essence by accumulating accidents as to reach 1 by adding figures to the right of 0.99" (5;5). Sartre's "phenomenology of emotion" would, following Husserl, "put the world in parentheses" in order to study "emotion as a pure transcendental phenomenon," "to attain and elucidate the transcendental essence of emotion as an organized type of consciousness" (8;12).

It is worth noting to what extent Sartre then accepted what he was soon to reject in Husserl—not only the idea of the *epochē,* or "putting in parentheses," but also the very idea of a "transcendental phenomenology" as Husserl conceived it. What is more, it is interesting to note that in these same passages of the Introduction Sartre expounds and endorses views of Heidegger, "another phenomenologist" (8;12), who adds to Husserl's transcendental method the need to "assume" human reality, "to be re-

sponsible for it instead of receiving it from the outside like a stone," "to 'choose' itself in its being" (8–9;12, quoting Heidegger from *Sein und Zeit*). Sartre does not seem to see the radical disagreements between these two, as if he felt that Husserl's transcendental phenomenology and Heidegger's existential phenomenology could embrace each other without conflict. (For example, he mentions Heidegger's *Dasein,* or "being-in-the-world," along with Husserl's *epochē* apparently without noticing that the one is a radical rejection of the other.)

Sartre's analysis is peppered with phenomenological jargon, not always accurately employed but virtually always superfluously, more by way of fetish than conceptual need. Throughout, we find mentions of "neomatic correlate" (33,37;58,65), "noesis" (43;79), "hylē"(34,40;60,73) "thetic consciousness" and "non-thetic consciousness" (29,32,42–43;51,57,77), but it is clear that then, as later, Sartre adopted the language of other theorists only insofar as it suited his own creative intentions. It does not surprise us that all that would remain of this Husserlian enthusiasm in *Being and Nothingness* was its basic Cartesianism, its emphasis on the "first-person standpoint" and its stress on "subjectivity." The substantial doctrines, on the other hand, would be drawn more from Heidegger than from Husserl, the idea that "man makes himself" (27,28;46,49), that he has no "essence" (2ff.;2ff.), that one "lives his body" (*le vécu*) (41;75), that one "assumes" or "chooses" himself and takes responsibility for even his feelings: "it is senseless to think of complaining since nothing foreign has decided what we feel, what we live, or what we are" *(B&N,* 708).

The emotions in particular are to be viewed as "essentially" acts of consciousness, and therefore as intentional and as purposive. An emotion is a mode of consciousness that "by its synthetic activity, can break and reconstitute forms," "transforming an aspect of the world" (24;40). "One can understand emotion only if he looks for *signification*" (24;41). And this means, within the phenomenological framework Sartre is presupposing, that we must ask what its "intentions" are, in a double sense: what it has to do with the world (its *"intentionality"*), and what *purposes* it serves (its "finality" [*finalité*]). As opposed to merely reporting "the facts" of our emotions—their manifestations in behavior, physiology, and "states of consciousness"—Sartre intends to tell us what we are *doing*.

SARTRE'S CRITIQUE OF TRADITIONAL THEORIES (CHAPTERS 1 AND 2)

Given his phenomenological approach, the thrust of Sartre's criticism of traditional psychological theories of emotion should be evident. Such theories pay attention only to "the facts," not to the essence of emotion; they regard an emotion as passive, that which afflicts us or, in Freud, "in-

vades us" (29;49); they regard an emotion as disruptive, purposeless, and meaningless. And most importantly, they do not see an emotion as a structure *of* consciousness, as a conscious *act,* but rather as a state or occurrence with manifestations *in* consciousness (as "affect"), as well as in behavior and physiology. Such "peripheric theories" of emotion have in common the thesis that consciousness "is a secondary phenomenon," that what is primary is the bodily response, what William James calls the "expression" of emotion (thus his famous observation, "A mother is sad because she weeps"[8]).

Sartre singles out for attack two theories—that of James, which holds that the conscious "affects" of emotion are mere "epiphenomena" of certain physiological (particularly visceral) disturbances, and that of Janet, whose theory places far greater stress on behavior and "organization" than on physiology. Yet the true target of Sartre's attack is far larger, including all the variations on physiological theory (for example, those of Cannon and Sherrington: 16;24–25:25;41–42); all versions of "behaviorism" that attempt to do away with "consciousness" and conscious purposiveness; and all the numerous varieties of "philosophical behaviorism" that have sprung up in the wake of the later Wittgenstein and of Gilbert Ryle's *Concept of Mind,*[9] in which emotion is reduced to "agitation," a breakdown in normal, "rational" behavior patterns. These theories may, as in Janet (and subsequently in Freud), involve a "hydraulic" model of accumulated tension and nervous energy, or they may confine themselves to the operational definitions and pure behavioral descriptions of latter-day behaviorism. What they all have in common is a radically de-emphasized conception of consciousness as an "epiphenomenon" (James) or "secondary phenomenon" (Janet), or as no phenomenon at all (as in behaviorism). Against them all, Sartre argues, as anticipated in his Introduction, that there can be no accounting for emotions in a model that is not purposive and that does not explain their *significance.* He draws from the German Gestalt psychologists Köhler, Lewin, and Dembo, but he quotes only the Frenchman P. Guillaume at considerable length (20–23;33–36) in order to show, by way of a single example, that our emotions *must* be interpreted "functionally," as purposeful and meaningful yet neither explicit nor deliberate. Anger, for example, "is neither an instinct nor a habit nor a reasoned calculation. It is an abrupt solution of a conflict, a way of cutting the Gordian knot" (22;36–37). It is "an escape" (ibid.). Thus, against Janet in particular (but against all such theories in general), Sartre insists that reference to "finality" is unavoidable and that we "return to consciousness, with which we should have begun" (24;40).

Of particular interest is Sartre's interpretation and critique of Freud's psychoanalytic theory of the emotions (ch. 2:24–29;41–49). He credits this theory with being "the first to put the emphasis on the signification of

psychic facts, that is, the fact that every state of consciousness is the equiva-
lent of something other than itself" (25;43). (Freud, who had studied with
Brentano, also referred to this equivalence as the "meaning" of a psychic
act.) According to psychoanalysis, an emotion is "a symbolic realization
of a desire repressed by censorship" (26;44). As in *Being and Nothingness*
(pt. I, ch. 2; pt. IV, chs. 1, 2) Sartre's interpretation of Freud's complex
and evolving theories in the "Sketch" is oversimplified and highly critical,
aiming doubly at (1) the problem of self-deception (anticipating his analy-
sis of "bad faith" in *Being and Nothingness* as not dishonesty as such, yet as
needing both "to know and not to know"), and (2) causal determinism. On
the one hand, Sartre acknowledges that the psychoanalytic theory recog-
nizes the emotion as meaningful and purposive, but as *symbolically* so. On
the other hand, "one *undergoes* it; it takes one by surprise; it develops in
accordance with its own laws and without our conscious spontaneity's being
able to modify its course appreciably" (25;42). Thus it "invades us in spite
of ourselves" (24;49). But this is "a flagrant contradiction" (27;46), Sartre
complains, and in support of this assertion he cites reasons similar to those
he will marshal to attack the Freudian notion of "the Unconscious" in
Being and Nothingness: "It cuts off consciousness from itself"; in Saussu-
rian language, "The thing signified is entirely cut off from the thing signify-
ing" (Le *signifie* est entièrement coupe du *signifiant*) (26;45). One must be
conscious of his own symbolism, but at the same time he cannot be (the
same paradox that constitutes the "lie to oneself" of "bad faith" in *Being
and Nothingness*). The argument, again as in *Being and Nothingness,* turns
on the Cartesian conception of the *cogito* and its Kantian conditions of
possibility: "If the cogito is to be possible, consciousness is itself the *fact,*
the *signification* and the *thing signified*" (27;46).

Sartre distinguishes sharply, as he will in *Being and Nothingness,* be-
tween the intentional model of emotions as meaningful and the mechanical
model of emotions as caused. These are, he assumes, mutually exclusive
antitheses. "The profound contradiction of all psychoanalysis is to intro-
duce *both* a bond of causality and a bond of comprehension between the
phenomena it studies" (28;48). (Similarly, he accuses Janet [from whom
Freud borrowed heavily in his early years] of wavering between "a spon-
taneous finalism and a fundamental mechanism" [20;32–33].)

Thus the Sartrean position emerges from the rubble of tradition: the
fundamental emphasis must be on consciousness, its purposiveness and its
signification, only secondarily on the "expression" of emotion in behavior
and its physiological correlations. There can be no "unconscious purposes"
and therefore no "unconscious emotions," although we may well find our-
selves in a position of *refusing* to recognize our own emotions and their
purposes. But the very idea of refusal leads us to suspect that it is itself
motivated, as a way of "saving face." Accordingly, the phenomenological

sketch that follows is of paramount importance in unmasking the various deceptions about ourselves that Sartre will lay bare four years later in *Being and Nothingness*.

Sartre's "Sketch" of a Theory of the Emotions (Chapter 3)

We have already anticipated that Sartre's theory will be based on the idea that an emotion has meaning ("signification") and purpose ("finality"). It is not merely a "state of consciousness" but an *intentional act,* something we *do,* a mode of behavior (*conduite*[10]) that has distinctive purposes and characteristics. The act is inseparable from its object ("the affective subject [*le sujet ému*] and the affective object [*l'objet émouvant*] are bound in an indissoluble synthesis" [30;52]). The emotion is "not absorbed in itself" but "returns to the object at every moment" (30;51). Nor is an emotion an isolated disturbance of consciousness; an emotion is "a certain way of apprehending the world" (30;52), a "transformation of the world" (33;58), a "mode of existence of consciousness" (49;91), an "existential [*existentielle*] structure of the world" (45;83). "There is," Sartre tells us, "a world of emotion" (44;80) (as there is a world of dreams and there are worlds of madness).

Although this is only a "sketch" (*esquisse*) or a theory that has yet to be filled in, the phenomenological structures of Sartre's theory are here spelled out with a clarity that is sometimes missing from *Being and Nothingness*. For example, a defining characteristic of the emotions in this theory is that they are "unreflective" (*irréflechie*), and Sartre here gives us (30ff.;52ff.) the explication of that conception which is so painfully opaque in the Introduction (sec. III) of *Being and Nothingness* (although he had also provided such an explication in his "Transcendence of the Ego" two years earlier). He defines "unreflective behavior" (*conduite irréflechie*) as behavior without consciousness of self, and insists that "in order to act it is not necessary to be conscious of the self as acting" (32;56–57). (In the next section, we shall raise objections against both this shift from "unreflective consciousness" to "unreflective behavior," and this characterization of "unreflective.") The point is that emotion involves purposive and meaningful acts which are not themselves objects of consciousness. This is not to say that they are "unconscious," Sartre insists, but only that they are "nonthetic" (32;57) or "non-positional" (29;51), thus anticipating a long familiar phenomenological paradox that emerges in the opening pages of *Being and Nothingness* (esp. pp. 9–17).

An emotion is "significant"? But wherein lies its significance? Certainly not in pure "intentionality" (which Sartre, like Husserl, takes to be primarily a *cognitive* conception). Sartre follows Merleau-Ponty in avoid-

ing the term (just as Merleau-Ponty replaces Husserl's term with his own conception of "motility"[11]). He rather borrows from the German Gestaltists the concept of the *Umwelt*—the world of our desires, our needs, and our acts (32;57). The objects of our emotions are not merely "things to be known," but objects of personal concern. Thus the meaning of an emotion must be referred to its *purpose*. And what is this purpose? It is not one we would readily acknowledge. The purpose of our emotions is to allow us to cope with a world that we find *difficult*, frustrating and, in Camus' quasi-paranoid terms, "indifferent" if not "hostile":

> When the paths traced out become too difficult, or when we see no path, we can no longer live in so urgent and difficult a world. All the ways are barred. However, we must act. So we try to change the world, that is, to live as if the connection between things and their potentialities were not ruled by deterministic processes, but by magic. (33;58–59)

We cannot change the world itself, but we can change "the direction of consciousness" (33;59), our "intentions and behavior" (34;60). It is thus that our emotions "transform the world." An act is impossible and so we seek "magical" compensation. Choosing a familiar example from Aesop, Sartre analyzes the emotional structure of the "sour grapes" attitude. He sees a bunch of grapes as "having to be picked," but he cannot reach them. By way of compensation, he then sees them as "too green." This is not a change in the chemistry of the grapes, but a change of attitude. So it is with all emotions. In order to cope with frustration, they change our view of a world we cannot change.

Such behavior is not "effective" (34;60), if what we mean by that term is "effective in changing the world." It surely is effective in another way, however, in allowing us to cope with our own impotence. But neither is it merely "symbolic"; we cannot believe our behavior to be a wholly satisfactory substitute. Every emotion has the purpose of allowing us to live with our own "unbearable" conflicts and tensions without explicitly recognizing them. Sartre calls such behavior "magical" because of this ineffective yet effective change, not in *the* world, but in *our* world. Every emotion "sets up a magical world by using the body as a means of incantation" (39;70). In a sense, we fail to *do* anything, that is, anything effective; but in another sense, we are very decidedly "doing something," namely, transforming the world to suit ourselves, through our "magical comedy of impotence" (*comédie magique d'impuissance*) (37;67).

Thus we can understand how it is that an emotion is not to be taken as a mere "disruption," as "a trivial episode of everyday life" (*un banal épisode de notre vie quotidienne*) (48;89). It is a "total alteration of the world" (47;87), even "an intuition of the absolute" (*l'absolu*) (44;81). It is not a disorder, but a response to an emergency. We must not allow our-

selves to be stunned by this Hegelian terminology; what Sartre means is something quite ordinary: an emotion is not a distraction in our lives, like an itch on the calf or an arthritic shoulder. It is not an isolated interruption of consciousness but a "mode" of consciousness, an "existential structure of the world" (45;83), even a world unto itself (44;80). (This ambiguity seems not to have bothered Sartre.) It is a structure in which we *live,* often an obsessive structure, which extends forward into the indefinite future (44;81) and may well establish a durable if not permanent view of the world. In some emotions, notably spite and resentment, envy and hatred (the "poisonous emotions," perhaps the "deadly sins" as well), this premonition is evidently self-fulfilling. (On a happier note, however, we could argue that the same may be true of love.)

Borrowing from Heidegger, Sartre analyzes the difference between the "magical," ineffective behavior of our emotions and our effectively doing something in terms of "instrumentality" (cf. *Sein und Zeit,* pt. I, div. 1, sec. 3: "die Weltlichkeit der Welt"). In action, the world appears as a "complex of instruments," in which "each instrument refers to other instruments and to the totality of instruments; there is no absolute action or radical change that one can immediately introduce into this world" (48;89). In other words, we do something *in order to* do something else (for example, we pull a trigger to shoot a rifle to propel a bullet to kill a dictator to open up the way for democracy so that we can . . .). In the "magical" world of emotion, however, this "world of instruments abruptly vanishes" (49;90) and we act as if to "transform" the world (in fact, however, transforming only our view of the world) in one "magical act." It is as if one wanted to produce a house not brick by brick and board by board, but by a simple magical incantation, a wish pronounced to a thankful genie or one of those wish-giving witches we find in fairy tales. The "magic" is this extraordinary and ineffectively effortless attempt to transform the world without effectively doing anything. But, Sartre reminds us, this is "not a game" (33;59) or a joke (34;61); quite to the contrary, our emotions are typified by their "seriousness" (41;74), by the fact that they require *belief* (40ff.; 73), even to the point where we "cannot abandon it at will" (ibid.).

It is worth noting that Sartre distinguishes two forms of emotion, one in which "we constitute the magic of the world," the other in which "it is the world which abruptly reveals itself as being magical" (for example, a face appears at the window) (45;85). Thus he introduces a distinction *within* the emotions between active and passive. This distinction betrays a weakness in Sartre's theory which we shall presently examine.

What is an emotion, according to Sartre? It is a "magical transformation" of an "unbearable" world, a compensating and necessarily unreflective (and thus easily—but not necessarily—self-deceptive) way of changing

our intentions and behavior toward the world when the world itself will not satisfy us.

A Critique of Sartre's Theory

Traditionalists will respond, of course, that Sartre has too glibly neglected the physiological correlates of emotion and attributed too much to consciousness and too little to simple behavior; that he has made sound too voluntary what is demonstrably involuntary[12]; and that he has obscured a fairly simple set of "primitive" reactions by his use of phenomenological, Hegelian and occultist terminology. Our complaint, however, is the very opposite. Although Sartre's "sketch" of a theory needs to be supplemented with more detailed arguments against traditional physiological, behaviorist, and "emotions-are-simply-feelings" theorists, the theory itself is a major step in the right direction—that is, away from the view of emotions as passive disruptions, invasions from a Freudian "id," or disorders in our physiology which are registered as "states of consciousness" that are no more our doing than are headaches, itches, and pains in the shoulder. From our point of view, the problem is that Sartre has not gone *far enough* in this early work, that he has retained *too much* of the traditional view of emotions as patterns of behavior and reaction, as irrational, disruptive, passive, and degrading. Using the radically voluntarist philosophy in *Being and Nothingness* as our basis (though our arguments can be duplicated in a broader framework), I want to argue that Sartre's early theory of emotion must be further radicalized, according to the very principles he himself has been so instrumental in formulating.

Our first objection is a familiar one, and it points up an error that is often repeated or uncritically accepted by a great many phenomenologists. It concerns the confusion of *reflection* with *self-consciousness*. These must be distinguished, although the reason they often are not is that the usual contrasts between pre-reflective chores or mechanical skills and the clearly reflective self-consciousness of philosophy gives us no reason to suspect *two* sets of distinctions. But we can be reflective without being self-conscious (for example, in thinking about a problem, even a problem concerning ourselves); and we can be self-conscious without being reflective (as in experiencing embarrassment or pride). Sartre long struggled with these two distinctions, between reflective and pre-reflective and self-conscious and unself-conscious, and developed a convoluted but demonstrably unsatisfactory conception of the *pre-reflective cogito* in response. In any theory of the emotions this is a serious error, for it does not follow that because the emotions are pre-reflective they are therefore without self-consciousness. In fact, I would argue that every emotion, as part of its

essential structure, involves consciousness of oneself.[13] This is not to dis-
agree with Sartre's contention that emotions are pre-reflective (although I
would disagree that they are essentially so); it is rather to say that his oft-
cited example of "my writing but not being aware of *my* writing" (see, for
instance, 31;54; cf. "Transcendence of the Ego," ch. 2) has confused many
readers because he claims too much. It would be sufficient for him to say,
simply, that such acts are unreflective. It does not follow that they are not
self-conscious.

Our second objection also turns on a problematic distinction, though
one that has long been central to most theories concerning the emotions.
The distinction between an emotion and its *expression* has often been con-
sidered absolute, with the emotion as some mental occurrence or state, and
its expression the behavioral manifestation of that occurrence. This con-
cept of "expression" has been expanded by some theorists (by James, for
example) to include various physiological manifestations as well. Thus the
emotion becomes "the emotion felt," while expression includes "vigorous
action" as well as ineffective gestures, physiological flushing and grimaces,
and "faces" and facial "expressions."[14] Sartre, anxious to reject these
Cartesian distinctions between "mind" and "body," "inner" and "outer"
(even as he firmly retains a related dualism at the very core of his
phenomenological ontology), denies these distinctions and characterizes
the emotions in terms of behavior, in terms of "our body *lived*." Sartre's
characterization also obscures our understanding of the emotions, how-
ever. He has criticized Janet for asserting that emotions are *just* behavior;
"Behavior pure and simple," says Sartre, "*is not emotion*" (39;71). In pre-
tense, for example, we feign emotional behavior without having the emo-
tion; such behavior "is not sustained by anything," he tells us (40;72). The
definitive element here is our belief and the "seriousness" of the emotion
(40,41;73,74). Yet the emotion, according to Sartre, is a mode of behavior,
an employment of the body as a way of changing one's relations with the
world (34;61), as "a means of incantation" in "setting up a magical world"
(39;70). Thus he moves immediately from his discussion of unreflective
consciousness to a discussion of "unreflective behavior" (30;52). In his
examples it is always behavior that attracts his emphasis although it is
"change of intention" that is his thesis. (For example, he singles out "acting
disgusted" in his description of the "sour grapes" phenomenon, when it is
the "magical conferring of a quality" ["too green"] that is the point of the
example.) He concludes, "an emotion is not a matter of pure demeanor
[*comportement*]. It is the demeanor of a body which is in a certain state"
(41;74).

It is noteworthy that Sartre sees that the need for a second "form of
emotion," in which "the world reveals itself as magical," arises because in

certain instances (a face appearing at the window) "there is no behavior [*conduite*] to take hold of" (45;82–83), and so "the emotion has no finality at all" (45; 83). This second "form of emotion" threatens to betray Sartre's entire thesis, for it presupposes that emotion is a way of behaving, rather than a mode of *consciousness*. And, even without bringing into question the important Sartrean (and later Merleau-Pontean) doctrine of the "lived body," we must protest that this conception of emotions is too nearly a return to Janet and the behaviorists (a return evidently welcomed by Merleau-Ponty). Sartre, of course, insists that such behavior is purposive and "meaningful," that it requires consciousness in order to be so, but nevertheless, it is in terms of behavior that our emotions must be understood.

Sartre has not taken seriously enough the phenomenological viewpoint which he introduced with such fanfare but evidently with too little devotion. In particular, he has not taken seriously enough the Husserlian conception of "constitution" with its Kantian overtones, the concept of an "act of consciousness" that need not be viewed in terms of any resultant behavior. Our "setting up of a world that is magical" need have no such manifestations. Sartre is surely right that, through our emotions, we "constitute" and "transform the world." But the notion of "ineffective" which he adds to this idea of transformation only betrays his thinking that an emotion *ought* to be effective, that its behavior is ineffective and therefore "inferior." But not all emotions involve behavior, effective or otherwise. It is the very essence of certain emotions—for example, guilt, resentment, or envy—that they refrain from any expression no matter how "ineffective," even from facial expression, for they find it much more to their interest either to hide from view entirely or to show the world a bland and superficial smile, a pretense of hearty handclasps, and an "expression" of self-confidence. One can feel even love or fear and yet express nothing in word or stance, in gesture or grimace. We want to say that expression and emotion *must* be distinguished, even if it is true, as it probably is, that the phenomenological view must deny any such absolute distinction *when there is expression*. We want to say that it is not essential to an emotion that it be expressed. We do not need to act disgusted in our "sour grapes" attitude, nor do we need to break down in tears in our sadness or shout insults in our anger. In resentment, we may well mutter silent curses, but we need not thereby *behave* in any distinctive way. This point is crucial to our understanding of the emotions: they are transformations of our world through "acts" of consciousness, but they need not involve our behavior and they need not entail expression of any kind whatever.

Our most serious objection follows from the idea that emotions represent ineffective behavior or, to use the term Sartre borrowed directly from

Janet, "inferior behavior." Despite his persuasive rejection of the tradi-
tional theories in which the emotions are viewed as disruptions, as irra-
tional and degrading, Sartre has retained many of these attitudes in his own
theory. He says, for example, that "in order to believe in magical behavior,
it is necessary to be highly disturbed" (42;75). An emotion is "an irrational
synthesis of spontaneity and passivity" (46;84), a "collapse of the
superstructures laboriously built by reason" (ibid.). Emotions "obscure"
consciousness (43;76)[15] and fail to see "the event in its proper propor-
tions" (47;87). In language more reminiscent of Freud than of his own
theories, Sartre tells us that *"captivity"* (43;79) is typical of the emotions,
that they are "undergone" (ibid.), and that they are a "trap" in which we
are "caught" (43;78). We "cannot abandon [an emotion] at will," and "we
cannot stop it" (40f;73). When he tells us that there is "a world of emo-
tion" (44;80), he adds "as of dreams of madness" (ibid.) as he had earlier
compared emotions to "dreaming and hysteria" (43;78). And he tells us
that "when, with all paths blocked, consciousness precipitates itself into the
magical world of emotion, it does so by *degrading* itself (42;75–76, my
italics), and again, "the origin of emotion is a spontaneous and lived degra-
dation of consciousness in the face of the world" (42;77); and again, "con-
sciousness is degraded" (45;83).

In short, Sartre has fallen prey to the very attitudes he seeks to refute.
Despite his contributions to our thinking, he evidently believes that our
emotions are "inferior," "irrational," and "degrading." They are meaning-
ful, but their meanings are *de*-meaning; they have purposes, but their pur-
poses serve to compensate for impotence. They may be our own conscious
"acts," but they are nevertheless beyond our control, "traps" in which we
are "caught," "a consciousness rendered passive" (46;84). What he had yet
to realize is the revolutionary vigor of our emotions,[16] the fact that they are
as important in sustaining our *effective* behavior as in rationalizing our fail-
ures and our impotence.

THE EMOTIONS: IDEOLOGY AND MAGIC

If emotions are "transformations of the world," those transformations
are not always "magical." For Sartre, the concept of magic serves to under-
score the *ineffectiveness* of emotional behavior, the fact that our emotions
merely change the direction of consciousness without really changing *the*
world at all. Like Janet, and like the Gestaltist from whom he borrows his
most extensive example, Sartre treats the emotions in general as isolated
modes of frustration behavior, as ways of *coping* or "escaping" from a
world that is "too difficult." But our emotions are much more than this.
Using the doctrines of *Being and Nothingness* and the examples of his more

recent works, we can offer a far more vital and existentially inspiring account of the emotions.

Sartre insists that our emotions are "meaningful." In his "Sketch," however, this meaningfulness is minimal, capturing the rudiments of Husserl's thesis of "intentionality" but surely giving us much less than the "meaningfulness" which Sartre (and so many other philosophers) have sought and demanded in other contexts (for example, in the sense of "the meaning of life" or the concept of "meaningful action"). The problem is that Sartre continues, in the fashion of those psychologists whom he castigates, to treat the emotions as "isolated" and the "world of emotions" as a world that is distinct from the "real" world of effective action and commitment. But it is our emotions which motivate our actions and sustain our commitments. The "fundamental project" that dominates so much of Sartre's writings is by its very nature an emotional project, one in which we heavily invest ourselves, even to the extent of reorganizing ("transforming") our entire world around its demands. Thus Nietzsche, following both Kant and Hegel, proclaimed that "nothing ever succeeds which exuberant spirits have not helped to produce."[17] It is through our emotions that we constitute not only the magical world of frustration and escape, but the living and often radical ideologies of action and commitment. In *Being and Nothingness*, Sartre himself tells us: "A Jew is not a Jew *first* in order to be subsequently ashamed or proud. It is his pride of being a Jew, his shame, or his indifference which will reveal to him his being-a-Jew; and this being-a-Jew is nothing outside the free manner of adopting it" (p. 677). On the same page, Sartre speaks of "my own choice of inferiority or pride," which appear "only with the meaning that my freedom confers upon them." In other words, an emotion, such as pride, is not an isolated conscious transformation, restricted to those cases of reaction and frustration to which Sartre limits himself in his early "Sketch." The emotions are the constitutive structures of our world. It is through them that we give our lives meaning. Thus the emotions are, in Sartre's own philosophy, elevated from their traditional status as "degradations" and "disruptions" to those very "existential structures" of our existence with which Sartre has been concerned throughout his career.

In view of Sartre's more recent emphasis on "the power of circumstances"[18] and the demands of politics, it is necessary to go beyond the view of emotions as frustration reactions and to stress the idea that every emotion has as part of its essential structure an *ideology*, a set of demands regarding how the world *ought* to be changed. Some of these—for example, moral indignation and anger, love of mankind and Rousseauian "Sympathy"—may have straightforward political ramifications. Others—notably guilt, envy, and resentment—may betray precisely that a-political

and self-indulgent "sour-grapes" attitude that Sartre discusses in his "Sketch." But the point is to recognize *both* kinds of ideology, radical as well as ineffective and reactionary frustration, and to appreciate the power of the former as well as to reject the latter as "degradations of consciousness."

Regarding the *expression* of emotion, it is similarly an error to restrict our attention to "emotional outbursts" and frustration and emergency reactions. Our emotions may also be solid and durable structures of our lives—dedicated love to a spouse, a friend, or a child; "whole-hearted commitment" to a cause or a project; or passionate involvement in a movement, a faith, or a relationship. Such emotions are not even plausible candidates for "irrationality" and, though *some* emotions surely are irrational, it is obvious that *not all* are. Nor can such emotions—which may not only last for, but give meaning to, a lifetime—be plausibly classified as "disruptions" or as "degradations of consciousness." Quite to the contrary, they are precisely those constitutive structures with which we prove ourselves to be most human, of which we are rightly most proud, and in which we justifiably feel ourselves to be the most "uplifted" rather than "degraded."

This conception of emotional ideologies merits a brief examination, though this is not the place to work it out in detail.[19] In anger and indignation, we demand rectification, vindication, the righting of a wrong, whether it be a minor personal affront or a social injustice embedded in the political structures of the contemporary world. In sadness and grief we desire the redress or return of a loss; in shame and remorse we seek to redeem ourselves; in love and hate we work toward the welfare or the ill-fare of our lover or our enemy. This conception of ideology allows us to clarify that most abused notion of emotional "expression." The expression of an emotion (the "natural expression," if you like) is precisely that action or set of actions which will most effectively and directly satisfy its ideological demands. This is, of course, not what is usually implied by that term. The "expression" of an emotion is often taken to be the least effective, the least voluntary, and the least "meaningful" of gestures and movements, the grimace of the face and the gnashing of teeth. Many psychologists (James, for example) have even included one's physiological responses as part of the "expression" of emotion. But focusing on these expressions (which are indeed typically frustration reactions and "outbursts") only underscores the fallacious view of the emotions as "disruptions" and as "ineffective," a view which is all too evident even in Sartre's "Sketch." Turning rather to the concept of the "fundamental project" of *Being and Nothingness* and the ideological language of his later writings, we can revise Sartre's thesis and take direct and effective expression as our paradigm: Mathieu's grab-

bing the machine gun or Hugo's finally resolute (if ambiguous) assassination of Hoerderer, Inez's double suicide or Sartre's own lifetime of "engaged" literature. The expression of an emotion is, first of all, *the realization of an ideological demand*. What is so often called the "expression" of emotion is only that by way of derivation, a suppressed or inhibited action that might otherwise be effective, a gesture instead of an act, a grimace instead of a battle, the gnashing of teeth in place of an articulated threat, the knotted fists held rigid at one's side rather than a well-thrown and much-deserved punch to the jaw.

But if expression is the realization of an ideological demand, we must now turn back to Sartre's conception of the "magic" of emotions in order to understand the nature of ineffective expression. Sartre is correct, of course, when he suggests that often such ineffective expressions are a means of coping or escaping. They are not so much the expression of the emotion as expressions of frustration, namely, the frustration of the emotion—as, for example, when I beat my cane against a tree in anger whose true target is a person (not the tree). Even if this answer is correct, however, it is not illuminating. Why this mode of frustration behavior rather than another? And why any behavior at all, given its evident ineffectiveness? The traditional idea that we thereby "vent"[20] our emotion is not only metaphorical—a return to the "hydraulic model" of the psyche as an ethereal pressure cooker. It is also false. Such ineffective modes of expression have precisely the opposite result; they do not satisfy the emotion but rather *intensify* it. Consider yourself reviewing a minor offense—perhaps a slighting comment by a friend—and grimacing, gesturing, cursing, perhaps even stamping and kicking and literally "working yourself into a rage." It is often suggested that such behavior is "symbolic," that you are acting *as if* the curses you mutter would be "magically" effective (like the "incantations" Sartre mentions), as if your stamping and kicking register some mysterious pain to the shins of your malefactor (as if by voodoo). The "symbolic" analysis only underscores the question, Why should we indulge in such useless practices, knowing all the while that they will be without effect and consequently will only increase our demands for satisfaction?

The very idea that such so-called expressions intensify rather than satisfy our emotions provides us with our answer. It is an answer that has so long been overlooked precisely because of a general uncritical acceptance of the "hydraulic model" of the emotions, which posits a need to "get them out" and "discharge" them, a need that seems evident even in the etymology of the word "ex-press"—to "force out." But though we demand satisfaction of our emotions, we demand something more as well. The emotions, we have already argued, sustain the "fundamental projects" of our lives, "give our lives meaning" and provide the constitutive structures

within which we live. If this is so, we can see that we have good reason for *not* satisfying them—in order to keep them alive and, in a great many cases, to intentionally intensify them and their demands. Thus some lovers take delight in hystrionic responses to small infidelities, "expressions" of love in a sense but, more literally, *im*pressions which intensify (and surely do not "relieve") that same emotion. Dostoevsky's man of spite acts—or does not act—merely in order to intensify the bitterness and resentment through which he constitutes his dubious conception of "freedom."[21] And Sartre himself, to take our most important example, has engaged his life in the pursuit of an ever-intensified sense of injustice and indignation, sometimes even at the cost of excruciating self-imposed guilt and despair, simply, in his own words, "to move history forward by recommending it, as well as by prefiguring within himself new beginnings yet to come."[22] If there is "magic" in the emotions, surely that magic is here, in these *chosen* ideologies through which we dramatize our lives in struggle against an unsatisfactory if not indifferent world, *against* the "power of circumstances," making that world, if not better, at least less "indifferent" through these very choices. And these choices are—our emotions.

Thus we must insist, taking our cues from Sartre's "Sketch" but our substance from his later works, that our emotions are nothing other than our own *choices,* views of our world for which we alone are responsible. The development of this Sartrean thesis might be a fitting tribute to the philosopher whom I would not hesitate to call the Socrates of our century.

Robert C. Solomon

Department of Philosophy
University of Texas, Austin

NOTES

1. See, for example, his early "Project for a Scientific Psychology" in James Strachey, ed., *The Standard Edition of the Complete Psychological Works of Sigmund Freud,* vol. III (London: Hogarth, 1953—).

2. According to Simone de Beauvoir, *Coming of Age* (New York: Putnam, 1973), p. 253, and M. Contat and M. Rybalka, *The Writings of Jean-Paul Sartre,* an extensive bibliography translated from the French by Richard C. McCleary (Evanston, Ill.: Northwestern University Press, 1974, p. 65).

3. *Recherches Philosophiques,* VI (1936–1937): 85–123. Translated by Forrest Williams and Robert Kirkpatrick as *The Transcendence of the Ego* (New York: Noonday, 1957).

4. See also Contat and Rybalka, op. cit., p. 83.

5. *St. Genet, comédien et martyr* (Paris: Gallimard, 1952); tr. by B. Frechtman as *St. Genet, Actor and Martyr* (New York: Braziller, 1963).

6. *L'Idiot de la famille* (Paris: Gallimard, 1972).

7. See, e.g., his formulation of the question of "Bad Faith" (*B&N,* 85, 87, 96).

8. W. James, "What Is an Emotion?" *Mind* (London), 1884.

9. (New York: Barnes & Noble, 1949), esp. ch. 6.

10. Sartre uses this term except where I have otherwise noted.

11. In *Phénoménologie de la perception* (Paris: Gallimard, 1945).

12. Thus Paul Ricoeur, to take but one prominent example, retains the traditional view of the emotions, placing them on the "involuntary" side in his most important work, *Le Volontaire et l'involontaire* (Paris: Aubier, 1950); see *Freedom and Nature*, vol. I, tr. by E. Kohak, (Evanston, Ill.: Northwestern University Press, 1966).

13. See my *The Myth of the Passions* (New York: Doubleday, 1976), esp. pt. II.

14. In this light, it is worth rereading Sartre's early essay "Faces," in Maurice Natanson, ed., *Essays in Phenomenology* (The Hague: Nijhoff, 1966). See also D. Rapaport's *Emotions and Memory* (New York: International University Press, 1971).

15. Leibniz once argued that emotions were "confused intelligence."

16. Gilles Deleuze and Felix Guattari have argued this position in their *Capitalisme et schizophrene: l'anti-oedipe* (Paris: Editions de Minnit, 1972).

17. *Twilight of the Idols,* in Walter Kaufmann, *The Portable Nietzsche* (New York: Viking, 1954).

18. See *Between Existentialism and Marxism,* tr. by John Mathews (New York: Pantheon, 1975).

19. I have done so in op. cit. above.

20. See, e.g., Wittgenstein's discussion of Fraser's *The Golden Bough* in *Synthese* (1957).

21. *Notes from Underground,* tr. by R. Matlaw (New York: Dutton, 1960).

22. *Between Existentialism and Marxism.*

Hubert L. Dreyfus and Piotr Hoffman
SARTRE'S CHANGED CONCEPTION
OF CONSCIOUSNESS:
FROM LUCIDITY TO OPACITY

S ARTRE'S *Being and Nothingness,* with its exploration of the total spontaneity of consciousness, might well be considered the final achievement of a tradition which began with the pure activity of the Aristotelian *nous* and reached perfection in Husserl's proclamation of transcendental subjectivity as the absolute source of significance. Sartre's surpassing of this tradition—at a time when deconstruction is more popular than reconstruction—may offer us a way to see the limitations of the tradition and yet preserve its insights. This is clearly Sartre's aim. His final word on the existentialism of *Being and Nothingness* is anything but a repudiation:

> Absorbed, surpassed and conserved . . . it will cease to be a particular inquiry and will become the foundation of all inquiry.[1]

To understand this claim we must understand what has changed and what has been conserved in Sartre's earlier picture of consciousness as a pure, empty, objectifying activity.

Merleau-Ponty, who was one of the first to appreciate the importance of *Being and Nothingness,* was also one of the first to point out its essential inadequacies.

> In our opinion the book remains too exclusively antithetical: the antithesis of my view of myself and the other's view of me, the antithesis of the *for-itself* and the *in-itself* often seem to be alternatives instead of being described as the living bond and communication between one term and the other.[2]

At numerous points in his own work Merleau-Ponty situates his own position with respect to what he takes to be Sartre's paradigmatic inadequacies. Most fundamentally, he shows that although Sartre devotes ingenious analyses to embodiment he does not offer an account of the body

that makes it more than a pure hole in the center of the field of instruments, and that lacking any account of the body Sartre's account of a spontaneity "beyond freedom" ends up making freedom impossible.

> The question is to know what part freedom plays and whether we can allow it something without giving it everything. We said earlier that *l'Etre et le Néant* seems to require further development on this point and that one would expect the author to elaborate a theory of passivity.[3]

Furthermore, Merleau-Ponty argues that in spite of his original and illuminating analysis of the being of and for others, Sartre's consistent development of the nothingness of consciousness makes it impossible to understand how consciousness can be colored by its social involvement.

> If indeed I made myself into a worker or a bourgeois by an absolute initiative, and if in general terms nothing even courted our freedom, history would display no structure, no event would be seen to take shape in it, and anything might emerge from anything else.[4]

Thus Sartre's account has no place for history.

In a later work, *Critique de la raison dialectique* (1960) Sartre acknowledges that his existentialist account of freedom is a "bourgeois ideology" and moves to incorporate what was valuable in his early work into a new and deeper theory. He proposes to accomplish this transformation by approaching human consciousness not as a desire for being but as concrete need.

> There is no question of denying the fundamental priority of need . . . it sums up in itself all the existential structures. In its full development, need is a transcendence and a negativity . . . hence a surpassing-toward (a rudimentary pro-ject).[5]

A reading of the *Critique* shows that the untenable dualisms of *Being and Nothingness* are toned down, and an effort is made to work out a philosophical position in which various mediations between the for-itself and the in-itself become possible. We must now examine these changes in detail to measure the distance Sartre has come from his previous position. We must ask: To what extent has Sartre answered Merleau-Ponty's objections, and to what extent, if any, does his new insistence on need allow him to go beyond even the philosophy of the lived body proposed by Merleau-Ponty?

In chapter 1, part II of *Being and Nothingness,* Sartre attempts to deduce the in-itself-for-itself structure of transcendence, projection, and surpassing (at least in the present context, all of these terms designate the same aspect of consciousness) from the most basic feature of the for-itself: that it is "a being, such that in its being, its being is in question."

This deduction can be summarized as follows:

1. *Presence-to-Itself.* Human consciousness is always an "issue," a "task," a "problem" to itself. It follows that there is an internal "decompression," a "fissure" in the heart of consciousness. In fact, since *any* relation of consciousness to its object has to be supported by a negation—otherwise, the very difference between consciousness and that *of* which one is conscious would collapse—we have to conclude that "Presence to self . . . supposes that an impalpable fissure has slipped into being. If being is present to itself, it is because it is not wholly itself."[6] In other words, I could not be a self-questioning, self-concerned being if I fully coincided with what I am, if there were no internal distance between me and myself.

Hence, none of the characterizations applicable to me ever defines who I am. For instance, any belief which I hold involves consciousness (of) belief and, because of that, cannot be lived in the undisturbed self-identity of immediacy. As I am always *witness* to my belief, as I always question myself about it, I can only live it as a "troubled" belief, as a belief which lacks something[7] and with which I do not fully identify myself.

2. *Facticity.* But what is the content of this "me" which I am concerned about in my presence-to-myself? Clearly, it cannot be merely a product of my wishes—I am not concerned about myself as a king of England. The being which is in question for me is my *given* being: something which I didn't choose and which is already there as brute boundary condition of my self-questioning. This is why the cogito—the presence-to-itself—always refers me back to the contingency of my existence: "Being apprehends itself as not being its own foundation, and this apprehension is at the basis of every cogito."[8] More precisely, the for-itself is the foundation of its own nothingness, that is, of the way it takes up and questions its own being, but it is not the foundation of that being itself, which "remains at the heart of the for-itself as its original contingency."[9]

3. *The In-Itself-for-Itself.* Presence-to-itself and facticity have not led us beyond the limits of the instantaneous Cartesian cogito. But our task is now to show how facticity and presence-to-itself imply the *temporal* structures of projection, desire, etc. To be sure, in order to see the temporal structure of the for-itself, one can start with the "human fact of desire."[10] But this "fact" is not a contingent feature of the for-itself; Sartre's argument here is clearly progressive for it shows how, given the structures of facticity and presence-to-itself, consciousness *must* exist as projection and transcendence. This conclusion is justified by the following reasoning:[11]

 a. Human consciousness does not have a fixed and stable identity, and hence it appears to itself as a "lack of being." This, in turn, implies

some understanding of what it would be like for me to *have* an identity. Thus I am always related to an ideal or normative standard of myself in the light of which I evaluate, and interpret my *actual* self as lacking.[12] And since the very status of that standard as norm and value introduces an element of *obligation,* it has to be revealed as the goal of my attempt to bring it about—that is, as the goal of my transcendence and projection.

b. But what would happen if I *could* actually achieve the ideal and self-imposed standard which I project? I would then have become a self-caused consciousness (in-itself-for-itself), producing its whole content by its own activity and in conformity with what is, for me, the highest norm of existence. This would mean that my *facticity* would disappear, giving place to the peace of self-achieved perfection. Thus, we can characterize human projection as an attempt to surpass the contingency of our existence toward the ideal of a self-caused in-itself-for-itself.

c. Finally—and this is the last point we must make here—to the extent to which consciousness is defined through its *world,* my projection toward the norm of the in-itself-for-itself appears, first and foremost, as a projected image of a *world* which I want to bring about. Thus, through the transformation of the world, "human reality" attempts to realize its own perfection and completeness.

This, then, is Sartre's existentialist deduction of the *project* as one of the fundamental structures of the for-itself. And it is easy to see far-reaching similarities between Sartre's way of bridging the gap between the cognitive and practical capacities of man and, for example, the way this very problem is dealt with in Hegel's *Phenomenology of Mind.* Both philosophers start with consciousness as a self-questioning and self-examining being; in both *Being and Nothingness* and *Phenomenology of Mind,* practical activity is implied by the overall structure of consciousness as a self-questioning entity. For Hegel, desire (*Begierde*) appears as the most primitive and immediate way in which self-consciousness tries to confirm its infinity; far from being simply a natural function of man, it expresses the whole symbolism of spirit.

Thus, for both Hegel and Sartre, practical activity is deduced from and integrated into the total structure of what Marx called, in the *Manuscripts,* "mental labor." In other words, the gap between cognition and practice is closed only because practical activity has lost its *material* character and has become dissolved into mental activity.

Naturally, Sartre's consciousness has nothing to do with the universality of the Hegelian subject, and we can find many places in *Being and Nothingness* where the author of the *Phenomenology* is criticized for having ignored the fact that consciousness is always *mine.* Thus, for instance, when I demand recognition from the other, I claim it for me *as me,* this

unique, irreplaceable person—and not as a simple *case* of the essence "free and independent I." To this extent Sartre is justified in continually criticizing Hegel for his dissolution of being into knowledge and for the substitution of a universal subjectivity for the concrete reality of being-for-itself. But this simply means that the "mental labor" is generated not by the pursuit of a universal essence, but by the search for *my* essence; it does not mean that the labor itself ceases to be *mental*. The world may very well appear within the *circuit de l'ipseité,* but it still sends us back to the constituting powers of *consciousness.* The idealism of *my* consciousness simply replaces the idealism of *universal* consciousness, and in both cases desire is not a material, organic activity, but a way in which consciousness expresses itself. And it does not help at all to talk about *thirst* as "transcendence," when the only account given of thirst involves the language of consciousness: "The meaning of the subtle confusion," concludes Sartre, "by which thirst escapes and is not thirst (*in so far as it is consciousness of thirst*) is a thirst which would be thirst and which haunts it."[13] Thus thirst *as thirst,* the concrete organic need, does not by itself exhibit the structures of transcendence and projection. That means that both my anticipation and my bringing about of a certain status of that glass of water "over there" (intended as "to-be-drunk") would be dispersed into an in-itself-like, inarticulate and externalized sequence if it weren't for the fact that my thirst is from the very beginning "consciousness of thirst." In other words, thirst appears as transcendence and projection only because it is *subsumed* under the general symbolism of consciousness. This is why my suffering is always a "drama of suffering."[14] Given that my suffering could not be lived without receiving its form from my consciousness,[15] it must express the overall symbolism of consciousness, that is, its search for the in-itself-for-itself.

If there is a privileged point where we can grasp the full scope of the shift that has occurred between *Being and Nothingness* and *Critique de la raison dialectique,* it is here, in the reinterpretation of the status of need, desire, or affectivity. From the very beginning of the *Critique,* man is defined as "l'homme du besoin,"[16] and the immediate goal of human activity—praxis—is the satisfaction of organic, material needs in an environment of scarcity. The dialectical categories of negation, negation of negation, project, temporality, etc., turn out to be the categories of material praxis, not the structures of consciousness. My "mental labor," my "putting my own being in question" are now determinations of my real labor (praxis) and of my concern about myself as a particular organism.[17] Thus, in Marx's terms again, what appeared before as subject appears now as predicate, and the alleged essence turns out to be an appearance of a deeper and more concrete reality or, as Sartre puts it: "the end as the signification of the lived project of a man or of a group of men remains real

to the extent that, as Hegel said, the appearance possesses a reality as appearance."[18] Can one even imagine the Sartre of *Being and Nothingness* referring to the ends of projection as mere "appearances"? Of course, even now the appearance is to have certain reality "as appearance"; for instance, we still need existential psychoanalysis and concrete sociological research in order to grasp reality in all its mediations and details. But this does not alter the fact that the symbolism of consciousness is reintegrated into the movement of material praxis as one of its determinations.

We can grasp the trend of this evolution in Sartre's philosophy by analyzing three important problems in which the shift in Sartre's position comes out with particular strength and clarity. These are the problems of the body, freedom, and the existence of the other.

THE BODY

Sartre's theory of the body, construed as a reply to Cartesian dualism and its difficulties, attempts to recover the unity of body and consciousness by means of a close phenomenological description of the for-itself. This description gives us two important results which justify a new conception of the subject as an *embodied* consciousness. Let us review briefly Sartre's reasoning.

1. The world is that which, by its very essence, exhibits a certain *order*—and this in two senses, having both (a) *an* order (certain structures of figure-background, and instrument-instrumental complex) and (b) *this particular order* rather than a different one (the book on my table is grasped as the background of the cup, not vice versa, etc.). Now, the condition of the presence of order—in the sense of both (a) and (b)—in my perceptual and instrumental field is my having a "point of view," a "perspective" from which the distribution figure-background, and instrument-instrumental complex structures are established. Furthermore, I could not be such a center of reference of my perceptual and instrumental field unless *I myself* was a *part* of it (the condition of my having a point of view is, Sartre argues, my being visible, etc.). To be sure, my own experience of my body (the body as being-for-itself) does not and cannot reveal it to me as an element of my perceptual and instrumental field; for insofar as my body provides me with a point of view, it is impossible for me to be able to take a view *on* it. Nonetheless, my consciousness of the world *refers* me to and demands, in me, the presence of my body as that which is responsible for the organization of my world and which, as such, has to *belong* to it. "Thus my being in the world by the sole fact that it *realizes* the world, causes itself to be indicated to itself as a being-in-the-midst-of-the-world by the world, which it realizes."[19]

This description shows the necessity for my consciousness (as subject of both perception and action) to have a "point of view" *within* the world; but the problem remains—as Sartre fully realizes—that it still does not give a sufficient condition for the identification of this "point of view" as *my body,* because "the *point of view* can approach the body to the point of almost being dissolved in it, as we see, for example, in the case of glasses, pince-nez, monocles, etc., which become, so to speak, a supplementary sense organ."[20]

The solution which Sartre now proposes is this:

2. Since my body is revealed to me as that which must already be *given* if the world is to exhibit an order, my body merges with facticity. Now, facticity expresses, in the for-itself, its belonging to the in-itself—that is, the presence of passivity in the heart of my spontaneous meaning-giving activity. Passivity consists, for me, in being *affected.* And as I am always non-positionally conscious (of) myself, there has to be a way in which my body as affectivity reveals itself to my consciousness.[21] In effect, if there is a difference between my glasses and my eyes—which are indistinguishable by the "point-of-view" criterion alone—it appears in phenomena of *coenesthesia.* By this, Sartre understands moods and tonalities of "pure" affectivity, stripped of their intentional meanings.

These phenomena always accompany our meaning-giving activities, as that which is already given and which consciousness tries to surpass towards its goals. Thus, for instance, when I am reading a book and my eyes hurt, pain is experienced as a diffuse atmosphere, which I always try to leave behind in my project of reading the text but which always catches up with me.[22]

A. de Waelhens[23] has correctly pointed out that this account of my experience of the body is unreconcilable with the framework of Sartre's ontology—that is, in the last analysis, with his definition of consciousness as pure negativity. For if the for-itself is pure negativity and if moods and tonalities of coenesthesia simply reveal the presence of facticity in my consciousness, then why is it that my body occupies such a privileged and unique place in the general domain of facticity; why is the facticity of my body lived as particularly *mine,* instead of merging with the general facticity and past of the world?[24] If we answer that my body is distinguishable and different from the facticity of the world because it fulfills, for me, the function of my "point of view," then the situation becomes clearly circular: in order to distinguish the status of my glasses (a "point of view," too) from the status of my body, we are appealing to moods and tonalities as manifestations of *my* bodily facticity, but in order to account for the "mineness" of this facticity, we have to introduce the "point of view" criterion. What remains is a trivial observation of a perfectly incomprehensible state of

affairs: I experience my pain as a revelation of my body. No satisfying account of this can be offered in the language of *Being and Nothingness*.

But what kind of account could be satisfying here? For one thing, we would have to show how the body as a point of view (a structure of the for-itself as project and transcendence) connects, by its very essence, with affectivity and mood. An argument to that effect is totally impossible within the dualistic philosophy of *Being and Nothingness,* but it becomes perfectly intelligible in terms of the theoretical framework laid down in the *Critique de la raison dialectique.*

Let us recall the facts. My body as a "point of view" was discovered as an implicit condition of a world which is constituted by my "mental labor" and which reflects the image of my possibilities—goals, that is, of my projection. Thus, the world—such as it is already described in the chapter in *Being and Nothingness* on "Transcendence"—refers back to the activity of consciousness. "Body" means simply the finite and perspectival character of that activity. Now, the kind of world presented by *Critique de la raison dialectique* in order to construct its regressive arguments differs sensibly from the conception of the world defended in *Being and Nothingness.* For the *Critique,* the world has to be seen as an organized field within which I can satisfy my *needs*—a material environment that "resists" me and "lacks something" not because it does not conform to the ideal standards projected by my "mental labor," but because, in the condition of scarcity, it represents a threat to my survival as an individual organism. This world, too, appears as a synthetic totality of instruments and always "calls" me to action—but the instrumentality does not result from my projection toward a set of freely chosen possibilities; its fundamental and immediately given function is the satisfaction of my needs. Hence, the subject which is referred to by such a world ceases to be pure consciousness and becomes a kind of subject which is always defined and burdened by its material needs. Need, passivity, etc., can now be discovered in the subject—as the center of motoric and perceptual activities—not by an incomprehensible experience of coenesthesia, but because the original status of the world demands, as its point of reference, the kind of subject that would have to be understood, from the very beginning, as constantly experiencing the pressure of its organic needs and acting for the sake of their satisfaction. Thus, need and passivity are connected with (finite and perspectival) transcendence, not externally, but because the fundamental goal of transcendence (praxis) is the satisfaction of basic needs.

FREEDOM

The theory of freedom argued for in *Being and Nothingness* needs no introduction. Let us only recall, for the purposes of our analysis, that ac-

cording to Sartre's position in *Being and Nothingness,* the *meaning* of my situation (this rock as an "obstacle," my place as an "exile," etc.) depends strictly on the choice I make of myself and which—at least within the limits prescribed by the boundary-conditions of the given—could have been totally different. Thus all evaluations and actions of an individual refer us back to his total original choice of his being-in-the-world.

However, to say that we are always already our fundamental project, amounts to saying that our life is already made, that its development is nothing but a pale repetition of the primordial choice ". . . and it is therefore impossible . . . to name a single gesture which is absolutely new in regard to that way of being in the world which, from the very beginning, is myself. There is no difference between saying that our life is completely constructed and that it is completely given."[25]

This description is corrected by the *Critique de la raison dialectique.* To begin with, my situation does not appear as a synthesis of meanings that could be changed by a radical transformation of my system of values (following a "conversion" in my fundamental project), but as a *demand (exigence)* of the practico-inert field which surrounds me. Moreover, this demand is imposed upon me in the form of a *categorical imperative.*[26] And this should not surprise us! For since man is now defined as "l'homme du besoin," he cannot possibly abstract from the demands through which the environment of the practico-inert appeals to his needs. To put it in different terms,[27] once we grant that "human reality" is not a purely symbolic activity, but an organism striving toward satisfaction of its needs through the movement of praxis, we should not be surprised at the *categorical* form in which the field of practico-inert imposes itself upon man. As to the possibility of questioning the sense of my survival itself—a possibility which is paradigmatic to all idealist conceptions of freedom and which is, in that capacity, taken up by Sartre in his own analysis in *Being and Nothingness* (I am on the edge of a precipice feeling anxiety and vertigo, for I know that *nothing* prevents me from choosing the mortal leap)—this is now an abstraction, which can only be understood as a way of responding to the pressure of needs within a specific context of the practico-inert.[28]

What, then, becomes of human freedom? Certainly, it is not eliminated from Sartre's new philosophy. Sartre emphasizes it again and again. However, we now have to put it in the general context of the statement we quoted at the beginning of this paper: all existential structures are the structures (specifically human, to be sure) of Need. Thus, freedom is simply a way (specifically human) of acting for the sake of and being defined by organic needs. "Cela revient à dire que sa [the reified individual's] liberté est le moyen choisi par la Chose et par L'Autre pour l'écraser et le transformer en Chose Ouvrée."[29] The worker has *no choice*[30]; he *has* to sell his labor-power; he has to obey the categorical imperative coming to him from

the practico-inert. But his commitment to the job is a *personal* act involving a certain choice of values and means, a certain effort at adaptation, etc. "En d'autres terms, liberté, ici, ne veut pas dire possibilité d'option mais nécessité de vivre la contrainte sous forme d'exigence à remplir par une praxis."[31] Sartre can no longer respond that, however inarticulate, incomplete, and underdetermined the meaning of my position in the practico-inert may be, it is nonetheless the result of *my* free meaning-giving activity; this meaning is already there, in that diffuse mass of social machinery; it proposes itself to my own praxis, which can only articulate and sharpen it but never deny it.

This last conclusion—of crucial importance—follows directly from our new interpretation of the relation: man—environment. For if the demands of the latter are lived as *categorical imperatives,* then what defines a man as a *real* being is not his "fundamental project," but the "material conditions [which] characterize the man and color the project."[32] This talk about a "coloration" of the project is a completely new development with respect to *Being and Nothingness.* To say that man's project is *colored* is to say that human choice cannot be described as free nihilation and negativity—it is always "burdened" by its material conditions, which "tint" it from within as a more or less diffuse and underdetermined atmosphere. Thus, my being a proletarian or a Jew is not an external label; it fits my own understanding of my life as already endowed with a certain social "style" of meeting my needs which colors my actions and permeates all my personal decisions. Similarly, since the universal conditions of the practico-inert influence a child's life through the mediation of the *family,* the family background itself will become part of those material factors forming the project. This is why, speaking of Flaubert, Sartre can write of his "overwhelming Father ... set up *inside him.*"[33] Of course, without free, personal decisions the coloration would remain forever in the state of generality and vagueness— it is *my* freedom which brings it to articulation. But my freedom can only articulate the meaning, never *create* it—or rather, its meaning-giving activities are themselves led by a certain latent sense which it didn't create. It is clear, then, that we are moving, with Sartre, toward a certain version of the philosophy of ambiguity, where the meaning can never be said to exist *through* my freedom and where it still needs my freedom in order to bring itself to articulation.

THE EXISTENCE OF THE OTHER

Very similar remarks can be made about Sartre's new approach to the problem of intersubjectivity. *Critique de la raison dialectique* is not vulnerable to the objections urged by Merleau-Ponty[34] against *Being and*

Nothingness. In fact, if my project draws its coloration from the *material* conditions of my life, then *my* view of myself and the *Other's* view of me converge; the Look of the Other brings to clarity what I myself already feel as the atmosphere of my life.

Naturally, in order to demonstrate that in Sartre's new philosophy the for-itself and the for-another converge, we have to show this in the theory of intersubjectivity itself. Are the changes introduced there sufficient to overcome the old dualisms? The issue is crucial, for if the for-itself and for-another remain separated, if I simply *make* myself a "bourgeois" or a "Jew" by my own free choice of image or role, then as Merleau-Ponty pointed out[35], history is transformed into a sequence of miraculous events and attributing any *meaning* to our historical past becomes a contradiction in terms.

We can answer our question by contrasting Sartre's new theory with the view defended in *Being and Nothingness.* Sartre's old point of departure was clear enough: by a sheer necessity of fact I happen to have a pre-ontological comprehension of myself as an object of the pre-numerical and absent Look of the Other. On the ground of this comprehension I can apprehend myself, all of a sudden, as a pure facticity, a being-in-the-midst-of-the-world. To be sure, my facticity (my body, my past, my class, etc.) appears at once as endowed with a meaning; but this meaning does not arise from *my* meaning-giving activity. Thus, insofar as I exist for the Other, I am not the "master of the situation"; I discover myself as possessing labels, meanings and functions, which qualify my life in spite of and against my freedom.

Sartre's second move is this:

1. Since consciousness of anything has to be supported by a negative relation—without which the difference between consciousness and its object would collapse—it follows that if the Other as Look is to exist for me, his presence has to be established through my *refusal* to be identified with him. This refusal is the necessary condition of the Other existing as *different* from me: "Thus the internal negation, here as in the case of presence to the world, is a unitary bound of being. It is necessary that the Other be present to consciousness in every part and even that it penetrate consciousness completely in order that consciousness precisely by *being nothing* may escape that Other who threatens to ensnare it. If consciousness were abruptly to *be* something, the distinction between itself and the Other would disappear at the heart of a total undifferentiation."[36]

2. My refusal to identify myself with the Other cannot refer directly to the Other's subjectivity, for this latter is an *absence.* Hence,

3. I can only sustain the difference from the Other by my refusal to be identified with what the Other identifies *me* with, i.e., with my self-for-

the-other.[37] This is why my self-for-the-other appears to me as an alien-ated, degraded self which I have to refuse. When we say this, we do not mean that the for-itself has to reject its very *existence* for the Other—which could only be done in bad faith—but that it is obliged, by an ontological necessity, to establish itself as a refusal to be identified with what the Other takes it to be.

4. I can fulfill such a demand only by shaking off the alienating power of the Other's look; I can then disarm and enslave his look and affirm myself as free subjectivity. Furthermore, granted that the Other is another *me,* his intentions toward me are similar to my intentions toward him; and as neither of us can be both a free Look and a Look enslaved, our relation turns out to be one of conflict.[38]

We are not going to comment here on the Hegelian origins of this conception, which are only too clear. Let us concentrate instead upon the profound re-interpretations of this theory introduced in the *Critique de la raison dialectique.*

First of all, the Other is not lived as alienating and degrading because of his mere presence and the necessity that I establish my non-identity with the Other through the refusal of my self-for-the-other as alien. In the *Critique,* the vocabulary of consciousness and "mental labor" is aban-doned: the Other is alienating and threatening because, given the condi-tions of scarcity, his presence threatens my individual survival and consti-tutes me as "non-human":

> Il s'agit d'*une lutte pour vivre;* ainsi le scandale est non seulement saisi dans son apparence de scandale mais profondément compris comme impossibilité pour tous deux de coexister. Le scandale n'est donc pas, comme l'a cru Hegel, dans la simple existence de l'Autre, ce qui nous renverrait à un statut d'inintelligibi-lité. Il est dans la violence subie (ou menaçante) c'est-à-dire dans la rareté intériorisée.[39]

Thus, I have to refuse my self-for-the-other for the simple reason that the Other threatens my life. Of course, the way in which I take up this threat, the symbolic and free expressions it receives from me, can vary. But again, it is not up to my *consciousness* to constitute the meaning of the Other as threat—for however varied and unique the above expressions may be, the real meaning they express is already there, before any activity of consciousness.[40] Thus, underneath the "mental" fight for prestige or recognition, there exists a deeper sphere of intersubjective life which pro-vides my symbolic encounters with the Other with a foundation in *reality.*

A conclusion which can at once be drawn from these remarks is this: If the presence of the Other is alienating because the Other is perceived as a threat to my life—and he is perceived as such because of the context of material scarcity we are thrown into—it follows that the threat reaches me

through a threat to *matter*. The Other threatens the *objects* I need, or my position—secured by objects—in the field of the practico-inert; this explains why, for instance, the formation of a group has to be centered around an object.[41] Of course, the threat to the object does not have to be *explicit* in every case in which I encounter the Other. Nonetheless, it constitutes the hidden background within which the Other is lived as a threat, so that the human struggle occurs within the context of the struggle for objects.

Here again, Sartre's old position is reversed. *Being and Nothingness* argued extensively for the following thesis: When I grasp the objects as looked-upon by the Other, they slip from under my power; they are "stolen" from me. This is so because I have a pre-ontological comprehension of *myself* as being looked-upon by the Other, and the way I grasp the *objects* the Other looks upon is mediated by the way I understand myself as looked-upon by the Other. The *Critique* now takes the opposite course. Human relations are mediated through our relations with objects: if the Other is lived as a threat, it is because he threatens my access to a certain material environment. And this is not an accident of a psychological or sociological nature: once man is defined as a "material being"[42] his relations with the world and with others have to be mediated by matter.

We can now return to our point of departure: we can see the reason why the for-itself and the for-another converge. This is the result of the transformation of the fundamental relation with the Other from an ideal into a real one. I am no longer a pure and unqualified nihilation; my project is an "appearance" of my material praxis, and the determinations of that praxis (my position in the field of the practico-inert, etc.) color my projects and permeate them with a style or atmosphere that is always present in my life. At the same time, what I am *for the Other* has to be determined—once we agree about the *material* character of my relation with the Other—by the very factors which color *my own* projects. This means that my appearing as a "proletarian" in the eyes of the Other meets with what is already present in the for-itself dimension of my own life as its general rhythm and direction. Needless to say, this correction is absolutely necessary if we want to be able to talk about history having a *meaning*.

Sartre has now shown that by defining human reality in terms of concrete organic need, he is able to answer Merleau-Ponty's objections to *Being and Nothingness*—by providing a convincing account of the material body, of freedom as grounded in a situation, and of history arising from non-arbitrary social action. The question now arises: How *can* man be identified as need? In becoming conscious of his needs, does he not separate himself from them? How has Sartre avoided the rigorous deduction of the nothingness of consciousness which he introduced in *The Transcen-*

dence of the Ego and developed in *Being and Nothingness?* In attempting to answer this last question we will be able not only to focus more precisely on Sartre's changed conception of consciousness, but also to see how his way of avoiding the traditional trap of lucidity goes deeper than the simple dogmatic assertion of opacity characteristic of Merleau-Ponty.

The distance Sartre has come is clearest in his account of freedom. According to *Being and Nothingness,* consciousness is free of anything it can objectify, and because it can objectify every aspect of human life, it is totally free. The *Critique,* however, digs beneath this objectifying power to seek out its source. Objectification and interpretation are viewed as responses to need. Thus, if we *could* objectify need itself we would indeed be free of it, but then there would also be no motivation for consciousness and objectification. In order for there to be consciousness at all, our needs must remain beneath the level of lucid representation, as their unobjectifiable ground.

Merleau-Ponty, on the other hand, has no *theory* of passivity. He simply asserts that "there is no freedom without a field"[43] and that "choice presupposes a prior commitment"[44] without being able to tell us more about this field than that "there is an autochthonous significance of the world which is constituted in the dealings which our incarnate existence has with it and which provides the ground of every deliberate *Sinngebung.*"[45] Why consciousness by its very nature has to presuppose this background remains a total mystery. For Sartre, however, consciousness *is* the attempt to deal with the background of need.

The same holds for history. For Merleau-Ponty it is simply a fact that my life style expresses my class. "What makes me a proletarian is not the economic system or society considered as a system of impersonal forces, but these institutions as I carry them within me."[46] But there is no account of why I *must* identify myself in terms of my economic situation. "I am a psychological and historical structure, and have received, with existence, a manner of existing, a style."[47] That is all.

Sartre's view goes farther and explains why I must have an economic identity. To begin with, I am not free to give any meaning I choose to the existence of the Other. His threat to my life is more basic than any meaning I might choose to give it. Furthermore, since our mutual survival depends upon our common praxis as creatures of need in a world of scarcity, we *must* work together as a class in opposition to other classes, and we *must* define ourselves in terms of the economic class to which we belong.

In the end it is Sartre, rather than Merleau-Ponty, who gives the more concrete account of embodiment. For Merleau-Ponty our body simply *is* our primitive receptivity and our oriented striving to gain a maximum *prise* on the world.

Although our body does not impose definite instincts upon us from birth, as it does upon animals, it does at least give to our life the form of generality, and develops our personal acts into stable dispositional tendencies. In this sense our nature is not long-established custom, since custom presupposes the form of passivity derived from nature.[48]

For Sartre, this unanalyzed passivity is explained as organic need, and at the same time its connection with the *je peux* as teleology of perception becomes intelligible, since that teleology *is* the way I must cope with the environment in order to survive.

Merleau-Ponty comes close to embracing this view himself in the passage cited above. After characterizing the lived body as the "form of passivity" he continues:

> The body is our general medium for having a world. Sometimes it is restricted to the actions necessary for the conservation of life, and accordingly it posits around us a biological world; at other times, elaborating upon these primary actions and moving from their literal to a figurative meaning, it manifests through them a core of new significance; this is true of motor habits such as dancing. Sometimes, finally, the meaning aimed at cannot be achieved by the body's natural means; it must then build itself an instrument and it projects thereby around itself a cultural world.[49]

Merleau-Ponty in this atypical passage seems on the verge of identifying man as a biological being, but the fact that this idea is never developed further shows that he did not see its importance. Perhaps he could not see it because even the notion of conservation of life is too vague; or perhaps, because, as the passage shows, he did not see the cultural as motivated by the need to cope with the biological but merely as another function of the body superimposed upon nature. In any case, it remained for Sartre to see the fundamental importance of need and to trace in detail its pervasive work in structuring all cultural, social, familial, and individual life.

HUBERT L. DREYFUS

UNIVERSITY OF CALIFORNIA, BERKELEY

PIOTR HOFFMAN

UNIVERSITY OF NEVADA, RENO

NOTES

1. J.-P. Sartre, *Search for a Method,* tr. by H. Barnes (New York: Knopf, 1963), p. 181.

2. Maurice Merleau-Ponty, *Sense and Non-Sense,* tr. by H. and P. Dreyfus (Evanston, Ill.: Northwestern University Press, 1964), p. 73.

3. Ibid., p. 77.

4. Maurice Merleau-Ponty, *Phenomenology of Perception* (London: Routledge and Kegan Paul, 1962), p. 449.

5. *Search for a Method*, p. 171.

6. J.-P. Sartre, *Being and Nothingness*, tr. by H. Barnes (New York: Washington Square Press, 1969 [4th printing]), p. 124.

7. Ibid., p. 122.

8. Ibid., p. 127.

9. Ibid., p. 130.

10. Ibid., p. 136.

11. Ibid., pp. 138–39.

12. "Since human reality in its primitive relation to itself is not what it is, its relation to itself is not primitive and can derive its meaning only from an original relation which is the *null relation* or identity. It is the self which would be what it is which allows the for-itself to be apprehended as not being what it is; the relation denied in the definition of the for-itself—which as such should be first posited—is a relation (given as perpetually absent) between the for-itself and itself in the mode of identity. The meaning of the subtle confusion by which thirst escapes and is not thirst (in so far as it is consciousness of thirst) is a thirst which would be thirst and which haunts it. What the for-itself lacks is the self—or itself as in-itself." Ibid., p. 138.

13. Ibid., p. 138 (our italics).

14. Ibid., p. 142.

15. "If I must suffer, I should prefer that my suffering would seize me and flow over me like a storm, but instead I must raise it into existence in my free spontaneity. I should like simultaneously to be it and to conquer it, but this enormous, opaque suffering, which should transport me out of myself, continues instead to touch me lightly with its wing, and I cannot grasp it. I find only *myself* who moans, myself who wails, myself who in order to realize this suffering which I am, must play without respite the drama of suffering." Ibid., p. 142.

16. *Critique de la raison dialectique* (Paris: Gallimard, 1960), p. 167.

17. *Search for a Method*, p. 168.

18. Ibid., p. 158.

19. *Being and Nothingness*, p. 419.

20. Ibid., p. 433.

21. Ibid., pp. 434–35.

22. Ibid., p. 436.

23. A. de Waelhens, *Une Philosophie de l'ambiguïté. L'Existentialisme de Maurice Merleau-Ponty* (Louvain: Publications Universitaires de Louvain, 1951), pp. 6–7.

24. Ibid.

25. *Sense and Non-Sense*, p. 21.

26. *Critique de la raison dialectique*, p. 255.

27. Ibid., p. 288.

28. Ibid., p. 255.

29. Ibid., p. 364.

30. Ibid.

31. Ibid., p. 365.

32. *Search for a Method*, p. 110.

33. Ibid., p. 59 (Sartre's italics).

34. Cf. *Phenomenology of Perception*, pp. 448–49.

35. See Ibid.

36. *Being and Nothingness*, p. 378.

37. For the (crucial) points 2 and 3, see the following passage: ". . . originally the Other is the not-me-not-object. Whatever may be the further steps in the dialectic of the Other, if the Other is to be at the start the Other, then on principle he cannot be revealed in the same upsurge by which I deny being him. In this sense my fundamental negation cannot be direct, for there is nothing on which it can be brought to bear. What I refuse to be can be nothing but this refusal to be the Me by means of which the Other is making me an object. Or, if you

prefer, I refuse my refused Me; I determine myself as Myself by means of the refusal of the Me-refused; I posit this refused Me as an alienated-Me in the same upsurge in which I wrench myself away from the Other." Ibid., p. 379.

38. Ibid., p. 474–75.

39. *Critique* . . . , p. 752.

40. "En n'allons pas imaginer que cette impossibilité interiorisée caractérise les individus *subjectivement:* tout au contraire, elle rend chacun *objectivement dangereux* pour l'Autre et elle met l'existence concrete de chacun en danger dans celle de l'Autre. Ainsi l'homme est *objectivement* constitué comme inhumain et cette inhumanité se traduit dans la *praxis* par la saisie du mal comme structure de l'Autre." Ibid., p. 208.

41. Ibid., p. 384.

42. *Search for a Method,* p. 150.

43. *Phenomenology of Perception,* p. 439.

44. Ibid., p. 438.

45. Ibid., p. 441.

46. Ibid., p. 443.

47. Ibid., p. 455.

48. Ibid., p. 146.

49. Ibid.

Robert V. Stone

SARTRE ON BAD FAITH
AND AUTHENTICITY

I shall argue that Sartre's account of bad faith in *Being and Nothingness* is ambiguous. He draws a sharp line between the lie to another and the lie to oneself: in the latter case alone is consciousness inveigled by its own activity. But since the lie to another is the only overtly other-directed act of the two, it is easy to infer that the lie to oneself is purely inward and free of interpersonal references. This impression—reinforced by Sartre's own treatments—is false. We shall see that bad faith need not be an act in which one operates only upon oneself. But even when it is, its aim is to circum-navigate a real problem encountered in the interpersonal world. Sartre, by reducing this social context to a mere occasion for an antecedent project of bad faith, and by concentrating on the inner-life movements involved, over-looks the inherently social aspect of bad faith. This aspect is sufficiently present both in Sartre's introduction of the topic and in his examples for us to call the results ambiguous. But his theoretical account of bad faith cuts the phenomenon off from the context to which it constitutes a meaningful if deficient response, causing it to appear as a self-limitation moved only by one's inner experience of one's own ineradicable freedom. One conse-quence, as I shall try to show, is foreclosure of escape from bad faith. And if we make explicit the interpersonal origin and reference immanent in bad faith and implicit in Sartre's examples, we shall find ourselves running afoul of his general account of consciousness as empty, ego-less, and transparent to itself. Although our analysis will take sides with one aspect of the ac-count in *Being and Nothingness,* we shall thereby rejoin the deeper theme of the possibility of liberation, which runs the length of Sartre's thinking.

Sartre's aim in the sections on bad faith is to determine the nature of consciousness. Perhaps for this reason it is not often remarked that the topic opens with a discussion of social repression. The existence of slave-masters, caretakers, jailers, and others "whose social reality is uniquely

that of the Not"[1] establishes the possibility of "negative attitudes" *between* individual consciousnesses. But Sartre seems to hold that *this same* interpersonal repression also grounds the possibility of assuming negative attitudes with respect to *oneself* through internalization of other-initiated repression, even though the interpersonal origin of this internalized negation may be forgotten. Initially, the consciousness of the jailer "constitutes itself in its own flesh as the nihilation of a possibility which another human reality projects as *its* possibility."[2] Those who suffer this intersubjective negation may either resist or conform. Infrasubjective negation occurs in the latter case, for such persons "make the Not a part of their very subjectivity; establish their human personality as a perpetual negation. This is the meaning and function of what Scheler calls 'the man of resentment'—in reality, the Not."[3] Bad faith is here introduced as one such attitude of self-negation. Sartre pictures it as "more subtle" than resentment and more "inward" than other negative attitudes such as cynicism, but not different in kind. The essential point is that in *all* such attitudes *"consciousness, instead of directing its negation outwards, turns it toward itself."*[4]

This account of bad faith seems to me true and important. Up to this point Sartre has represented it as a free choice of a freedom-limiting alternative over a freedom-enhancing one. I *could* direct my "negation" at the source of nihilation of my possibility, thereby presumably either regaining that possibility or provoking further repression (to which I would have to respond anew). Instead, choosing bad faith, I turn the negation against myself, that is, against my very ability to choose.

But, having suggested this outline, Sartre does not fill it in. What form does this other-initiated self-negation take? Does it perhaps involve re-instituting within myself the repressor-repressed duality that originated in my dealings with the other, such that I attempt to unilaterally deny my own possibility "in advance"? And what would it be like to resist such other-initiated negation? Sartre does not say. Indeed, he virtually drops the whole thematic of bad-faith-as-internalized-negation at this point and concentrates on its infraconscious machinations. Sincerity, whose essential structure is the same as that of bad faith, is found not in interpersonal relations, he tells us, "but rather where it is pure—in the relations of a person with himself."[5] It is not clear whether he believes the same of bad faith proper. Sartre admits there is an articulation of my consciousness into "capacities" of deceiver and deceived, but denies that bad faith retains the liar's "transcendence" of his lie. Does this mean he would reject interpreting bad faith as an internalization of the repressor-repressed duality? I do not know. He remarks that Freud's id-ego distinction "introduces into my subjectivity the deepest intersubjective structure of the *Mitsein*."[6] But whereas for us bad faith is just such an "introducing," for Sartre it is a

category mistake. Thus, having set in motion the interpretation we are extracting, Sartre aborts its development.

Sartre willingly admits bad faith can be "conditioned" by our being-with-others. But this domain can only "call forth" bad faith and cannot enter into its immanent structure, being transcendent to consciousness. Thus:

> ... the *Mitsein* can call forth bad faith only by presenting itself as a *situation* which bad faith permits surpassing; bad faith does not come from outside to human reality. One does not undergo his bad faith; one is not infected with it; it is not a *state*. But consciousness affects itself with bad faith. There must be an original intention and a project of bad faith. . . .[7]

But let us unravel the two ideas operating here. Clearly Sartre wishes to represent bad faith as self-imposed, never a mere mechanical response. Well and good. But this does not require us to deny that bad faith is an internalization of a negation initiated in the social world, retaining the *Gestalt* of that negation and tacitly referring back to it as its source. Bad faith may *originate in* the social world without being *imposed by* that world; its internalization need not be conceived as an imprinting in an inert consciousness, as in Descartes' sealing wax. Yet Sartre posits an infraconscious origin, an "original project" of bad faith motivated and structured not by the world but by itself, in order to distinguish it from such a mechanical imprinting. This represents a confusion. The self-imposed character of bad faith is assured, without disengaging it from its social source and reference, by distinguishing internalization from imprinting and also from introjection. Bad faith is a response to a situation, not a reception or introjection of a force; it is not as if the "force" of an aggression, for example, has its own vector and motion apart from the spontaneity of the consciousnesses that initiate or suffer it. Such distinctions allow us to affirm the Other is always the origin of the negation I internalize in bad faith but never the cause of that internalization.

Sartre's "examples" of bad faith are not examples in the usual sense of illustrations of a phenomenon whose possibility has been established in principle. Instead, he launches into analyses of plausibly real cases as a means of extracting the main structures of the phenomenon itself, grounding the possibility of the latter in the reality of the case. It is an argument by performance, and Sartre uses it to establish the possibility of methods as well as lived structures. The Flaubert work, for example, is presented as having established the possibility of coordinating Marxian analysis with Freudian analysis by *carrying out* that coordination in the case of Flaubert.[8] This strategy is consistent with phenomenology's unwillingness to purify essences of all existence. But it contains the risk that, since such examples

are richer than the concepts extracted from them, the same examples may be analyzed by persons other than their creators and shown to have essential features that differ from those their creators extracted from them. And this is what I shall attempt. If we re-examine some of Sartre's examples we shall find a blurry line between the lie to oneself and the lie to another, an interpersonal origin of bad faith, and an immanent interpersonal reference. These are essential rather than incidental features. Perhaps Sartre deliberately implanted these meanings in his examples. Why, then, did he leave them out of his theoretical account?

Stekel's analyses of "women whom marital infidelity has made frigid" (Sartre's words) led him to place the origins of pathology in the conscious mind, which Sartre notes approvingly in bringing out the peculiar self-consciousness in bad faith. Freud's postulation of an unconscious is held to be unable to account for it. These women, patients of Stekel's, exhibited "frigidity" to their husbands. Yet they simultaneously manifested sexual pleasure to their husbands through "acts of conduct which are objectively discoverable, which they cannot fail to record at the moment when they perform them."[9] Stekel learned this through independent interviews with the husbands. How, then, do these women prove to themselves that they are nonetheless frigid? By way of inward self-distraction away from their felt pleasure, Sartre holds, evidently considering it enough to note that "the frigid woman" evades her pleasure by reviewing her household accounts, etc.—a "proof" that is not cynical but "rife with inner conflict." But Sartre's answer is inadequate. If the "frigidity" comes down to this inner conflict over pleasure, then where is the bad faith? Why aren't these women content with a good-faith awakening to their "frigidity" (a dubious labeling in the first place since, as Sartre lays it out, it may mean only that these husbands are puzzled rather than satisfied by these wives)? Why do they go to the length of displaying elaborately contradictory behavior that gives evidence of being a performance? And why is the frigidity of these women manifested to their *husbands,* whose reports ground Stekel's imputation of conscious pathogenesis?

It seems to me that the bad faith (if any) of these wives consists in seeking to prove their "frigidity" to themselves *by means of* establishing it in their husband's minds. Whether authentic or not, "frigidity" is clearly a "relational property": I cannot be frigid alone, but only for-another. Approached warmly by a partner, I am willing, but find myself unresponsive to him; I conclude that I am frigid. Sartre's account does not deny this of frigidity *simpliciter.* But if there is a higher-order project of *proving* that I am frigid when I am not, the relational character of frigidity requires that the consciousness I directly manipulate be not my own but that of a part-

ner. Since there must be another in order for "frigidity" to be brought into the world in the first place, the proof must, and here appears to, start with a performance of frigidity that covers its own tracks *qua* performance.

As described, the women in question are trying to harmonize incompatible relationships, one licit but unwanted, the other illicit but deeply desired. Frigidity with their husbands means faithfulness to their lovers despite its external violation. Now this triangular and, if you will, repressive social array seems not to be the occasion for living out a prior project of bad faith but that project's living substance. If the women that Stekel examined sought to prove *to themselves* that they are frigid with their husbands, their chances of success are improved if they "appoint" their unwitting husbands as judges of the genuineness of the performed frigidity. If their husbands come to believe they are frigid, then they must really be so (and a hard decision based on truth is avoided); if not, then not. The example does not rule out, indeed it invites this interpretation of the "proof." But such a proof is not completed within "the unity of one [*une*] consciousness," as Sartre says of bad faith.[10] Instead, the proof is *routed through* the consciousness of another in order to return as a fact. If the self-distractions Sartre notes are thus part of a performance, then the self-deception consists of an other-deception whose structure is considerably richer than Sartre's theory of bad faith allows. What is dissembled is not merely my felt pleasure but (1) my efforts at communicating "frigidity," (2) my transferring of authorship of my own acts onto another, (3) my substitution of another's judgment for my own in the case of my first-person experiences, and (4) my suborning of all three of the freedoms involved. This cannot be captured by describing the infraconscious movements of a single consciousness. Indeed the sense of these very movements is lost if they are disengaged from their immanent references to others in a situation evidently experienced as repressive.

Now if other-initiated repression is thus internalized by a feigned replacement of my agency and judgment with that of another, then there seems to be an immanent presence of another's ego in my consciousness that is incompatible with Sartre's general picture of consciousness as egoless, refractory to the consciousness of another, and possessed only of a nonpersonal "ipseity" that haunts the anonymous act of reflection.[11] If consciousness were such a non-egological transparency, it would catch itself in the very *attempt* to internalize (what would be for it) the opacity of another's freedom. It would be "transcendent" not only with respect to the lie to another but also with respect to the lie to oneself, and, as a result, the lie to oneself could never be brought off.

This problem is clearer if placed in the context of what Sartre and Freud call "resistance"—the obvious discomfort, the lacunae in associa-

tions, the severing from therapy altogether—manifested by the psychoanalytic patient as he senses the coming unmasking. Sartre argues that these data become inexplicable if, as Freud holds, the patient is related to his own unconscious as he is to the opaque consciousness of another.[12] He cannot be troubled by unconscious desires simply because, like the consciousness of another, *he could not know* what they are. But it seems equally difficult to make sense of resistance on Sartre's model of ego-less consciousness. Sartre correctly insists the frigidity of Stekel's patients is not constructed of unconscious acts. But neither could it be realized within a consciousness whose "parts" apprehend each other with complete adequacy, like confluences of clear air. In fact consciousness is always already beyond itself owing to its bodily insertion in the world, and is consequently to some degree always "social," differentiated, muddied. Sartre tells us such a woman "is not in full agreement with herself," but he does not go the next step and grant that in bad faith she is for herself her own other. Consciousness may harbor no structural differentiations of parts, as in Freud's mythology of the id, ego, and superego. But it does not follow that internal roles cannot be sustained solely by the spontaneity of consciousness. Indeed these patients' efforts to internalize incompatible roles seems precisely to make up the discomfort and resistance in their bad faith. A consciousness defined by its negativity, characterized as a wind blowing toward the world, could only contemplate such roles as its objects, with an equanimity quite alien to bad faith.

Sartre's example of "the" waiter invites a similar analysis.[13] Observing a waiter's solicitousness, his tray-balancing, his too-quick movements, Sartre concludes that this person is *playing at* being a waiter. He is not someone else masquerading as a waiter. Rather, being-a-waiter is realized only by someone's undertaking to play an established ceremonial role which, in principle, he could never coincide with. So described, however, any bad faith involved would seem to depend on the degree to which some persons who are waiters internalize their socially defined role. A waiter may be very little "taken in" by his performance of the role of waiter, in which case his bad faith is minimal. On the other hand, he will increasingly coincide with his role (up to a point) in proportion as he is successful in alienating his consciousness of the indignity constitutive of being a waiter in a stratified society. Sartre recognizes no such variation in degree: he calls being-a-waiter an "in-itself," and implies by speaking of "the" waiter that anyone who is a waiter is *eo ipso* and absolutely in bad faith. But being-a-waiter is first a *social* reality. It presents itself as an "unrealizable" that one can only strive to be but can never be. We grant Sartre that in practice in an alienated society this means being-a-waiter is realized only through *some* degree of bad faith. But this allows variability within an essentially inau-

thentic project. The solicitousness Sartre observed may have originated, for example, in a particular waiter's project of overly scrupulous performance, designed both to manifest resentment and to forestall any charge of inefficiency. Like the solitary drunkard whom Sartre prefers to the leader of the people (owing to the former's greater "degree of consciousness" within a common inauthentic project, namely, "to sacrifice man in order that the self-cause may arise"[14]), a resentful waiter must be distinguished from and preferred over one who finds the role a pleasant second nature.

Sartre remarks that the waiter's "dance"—like that of the tailor or the grocer—issues from his encounter with the public, in whose eyes he imagines a daydreaming waiter is not wholly a waiter. But Sartre oversimplifies in asserting that the waiter's bad faith consists in pretending to realize his being-a-waiter as if it were an imposed in-itself. It *is* to some extent an imposed in-itself, *and also* the waiter does to some extent freely constitute it; both are matters of degree. Sartre has elsewhere held that because the petit bourgeoisie make their living by dealing with an amorphous public, whereas workers are in constant contact with things, the petit bourgeois is partial to conspiracy theories of history such as anti-Semitism.[15] This may account for Sartre's unredeemed portrait of the waiter. More likely, the absence of nuance in the phenomena here described is due to the equalizing effects of the Olympian perspective of their observer. Lurking behind the pages about the waiter is that "elect" author of *Nausea* whom Sartre himself denounced in 1964 for presuming to "write about . . . the bitter unjustified existence of my fellow man while exonerating my own."[16]

The waiter example also points to the problem of the *possibility* of authenticity. Sartre tells us little of a positive character about authenticity. He abandoned the "First Morality" that would clarify this notion.[17] "Authenticity" has here the minimal sense of escape from bad faith. Sartre's waiter anxiously flees his freedom. This is bad faith simply because human reality is freedom. One cannot *not* be free; such attempts are foredoomed because themselves free. Now anxiety, or, more precisely, "anguish" is the direct apprehension of my freedom. "Fear is fear of beings in the world, whereas anguish," Sartre explains, "is anguish before myself. Vertigo is anguish to the extent that I am afraid not of falling over the precipice, but of throwing myself over."[18] This means bad faith is only indirectly motivated by interpersonal repression, being already directly motivated by anguish before my freedom "in absolute immanence." My "original project" of escaping anguish into bad faith itself confers significance on worldly events, which merely occasion the realization of my project. But this entails the unwelcome consequence that my anguished flight in the face of interpersonal repression is an endless journey. For if this repression merely occasions a prior undertaking, how can we envision a "recovery of being which

was previously corrupted"?[19] Once enmired in bad faith from inward motivations, I cannot break out, since my anguish endures and my "corrupted" consciousness remains the only possible source of conversion. And if all interpersonal negation originates thus in self-negation, rather than the reverse, then interpersonal negation, far from appearing eradicable, appears inevitable—a social institution phenomenologically grounded in the permanent structures of consciousness.

Yet if authenticity is possible for Sartre's waiter, it is precisely because the perspective of observers like Sartre is itself something contained in the *waiter's* world. Waiters sometimes encounter people who observe them— and in relation to whom they can sense their imprisonment. One's being-a-waiter now appears as one possibility ranged alongside others in a field of possibilities. Without abandoning the theory of consciousness, the *Critique of Dialectical Reason* proposes this perpetually self-totalizing field of reciprocally interacting consciousnesses as both the source of my alienation and the arena for my emancipation from my past and my class.[20] As a waiter I might live this internalization of an observer in two ways: I may (1) quash my freedom at the source, magically draining the repressiveness from my situation by constituting it as an unchosen destiny (a self-defeating "transcendence" of my situation since I must perpetually re-constitute this transcendence freely in immanence). Or (2) under certain conditions I may attempt along with others to change my objective situation.[21] In either case we will understand "the" waiter only on the premise that his situation is *objectively* repressive.[22]

Despite Sartre's bow to the social genesis of bad faith in his introduction of the topic, this is precisely what he omitted to do in *Being and Nothingness*. His analysis leads into the infinite interiority of consciousness from which a return to authenticity is impossible, despite suggestions of hope. But if individual bad faith is grounded in objective structures which we experience together as oppressive, it can in principle be collectively thrown off. Of course this requires a movement beyond the perspective of solitary conversion to a more ample philosophical dimension that also includes social interaction.

Sartre's works after *Being and Nothingness* make up for many of the lacks we have noted here. Moreover, the aborted theme I have here extended is consistent with the theme of individual and social liberation underlying even Sartre's earliest works. For Sartre such liberation is always rooted in unwavering readiness to comprehend what is real and true. Our interpretation of bad faith resembles Sartre's phenomenological analysis of emotions, published four years before *Being and Nothingness*.[23] Emotion, Sartre held, is an active "intending" of a world and does not come to consciousness from without. It consists in a free entanglement of my freedom

as a way of "solving" a problematic situation. Thus, for example, upon seeing a bear, a camper faints in terror. Does not consciousness "affect itself" with bad faith in a similar way and for similar reasons? If so, neglecting to examine it within the problematic situation to which it responds (badly) is like examining the camper's fainting as if it were a purely psychophysical phenomenon instead of a way of living that particular situation. In *Being and Nothingness* itself, Sartre speaks of "interiorization" but it is in connection with authenticity, not bad faith.[24] Certain "unrealizables" arise from my original upsurge in relation to others—for example, my being a Jew or a worker. These are due to me only in an attenuated sense and constitute part of my situation. I am free to flee them since, in any case, I can never *be* these things that I am for another. I am equally free to consciously assume or "interiorize" them; but if I do, it can only be in an act of passing beyond them as limits. Thus, whereas what we have called internalization is an acceptance of a repressive situation, interiorization is the first step in liberation.

As Sartre's thought develops, and the analysis of *praxis* complements and includes the earlier analysis of consciousness, this distinction between internalization and liberation becomes central. In *Saint Genet: Actor and Martyr*, Sartre shows how Genet's resolve to *be* a thief is an initial if flawed liberation from a "respectable" society that "defines being by having," stigmatizing even an orphaned ten-year-old in order to project its own repressed greed onto others.[25] In *Search for a Method* Sartre contends, in opposition to Communist intellectuals of the era, that one's class-being doesn't spring into existence with one's first job, but is mediated by childhood "internalization" of one's family structure. This deforms one's freedom, reducing it to the margin of innovation present in the re-exteriorization of these limits in acts.[26] In *L'Idiot de la famille* Sartre analyzes in detail the dialectical interplay between negation at the level of class struggle and denial of freedom within a particular aesthetic act.[27] Thus the theme of the internalization of a negation originating in others is precisely the aspect of bad faith retained from *Being and Nothingness*.

In the *Critique* Sartre sees internalized negation giving rise in turn to interpersonal negation in a dialectical *circle,* and no longer its phenomenological *ground.*[28] It is perhaps in part because this wider circle of bad faith cannot be broken solely by individual "radical conversion" *ad seriatim* that Sartre abandoned his "First Morality" in 1950.[29] Such radical conversion must be incorporated in revolutionary praxis for there to be a chance of halting the "practico-inert" momentum of *both* the infrasubjective and the intersubjective negations. Thus, by defending one aspect of Sartre's early ambiguous account of bad faith against its contrasting aspect, we re-join the main theme of his own evolution: human liberation.

Nevertheless, not all of the problems we have noted are laid to rest by Sartre's later development. While the social genesis of the pathology of bad faith and its (necessarily) social cure are later acknowledged, the original theory of consciousness as ego-less and refractory to the consciousness of others remains unaltered. The later developments outrun their basis in this theory and this is expressed in the *Critique*'s rather weak account of the revolutionary act as a "fusion" of inherently dispersed subjectivities.[30] How, in principle, is this fusion possible? Without abandoning Sartre's insight into the essentially ambiguous character of human reality, the theory of consciousness must be retrospectively revised in light of Sartre's later discoveries.

ROBERT V. STONE

DEPARTMENT OF PHILOSOPHY
C. W. POST COLLEGE
LONG ISLAND UNIVERSITY

NOTES

1. *Being and Nothingness: An Essay in Phenomenological Ontology,* tr. by Hazel E. Barnes (New York: Philosophical Library, 1956), p. 47.
2. Ibid.
3. Ibid.
4. Ibid., p. 48. Emphasis added.
5. Ibid., p. 65.
6. Ibid., p. 51.
7. Ibid., p. 49.
8. Preface to *L'Idiot de la famille: Gustave Flaubert de 1821 à 1857,* vol. I (Paris: Gallimard, 1971), pp. 7–8.
9. *Being and Nothingness,* p. 54.
10. Ibid., p. 89. Sartre's emphasis. The entire sentence is: "Bad faith on the contrary [i.e., as opposed to the lie] implies in essence the unity of *one* consciousness." In this case the translation is mine. Barnes, with equal correctness, renders *"une"* as *"a single."*
11. Ibid., p. 239. See also *The Transcendence of the Ego: An Existentialist Theory of Consciousness,* tr. by Forrest Williams and Robert Kirkpatrick (New York: Noonday, 1957).
12. See *New Introductory Lectures,* tr. by W. Sprott (New York: Norton, 1933), p. 100.
13. *Being and Nothingness,* p. 59.
14. Ibid., p. 627.
15. *Anti-Semite and Jew,* tr. by George J. Becker (New York: Schocken Books, 1965), pp. 36–37.
16. *The Words,* tr. by Bernard Frechtman (New York: George Braziller, 1964), p. 251.
17. Simone de Beauvoir, *Force of Circumstance,* tr. by Richard Howard (New York: G.P. Putnam's, 1964), p. 199.
18. *Being and Nothingness,* pp. 29 et seq.
19. Ibid., p. 70n.
20. *Critique of Dialectical Reason,* vol. 1: *Theory of Practical Ensembles,* tr. by Alan Sheridan-Smith and ed. by Jonathan Rée (London: New Left Books, 1976). See, for an example, pps. 100–9.
21. As in the cases mentioned in George Orwell's description of Barcelona in 1936

when, for a time, the city was in the anarchists' hands: "Waiters and shop-walkers looked you in the face and treated you as an equal. Servile and even ceremonial forms of speech had temporarily disappeared. Nobody said 'Señor' or 'Don' or even 'Usted'; everyone called everyone else 'Comrade' and 'Thou,' and said 'Salud!' instead of 'Buenos días.' Tipping had been forbidden by law since the time of Primo de Rivera; almost my first experience was receiving a lecture from an hotel manager for trying to tip a lift-boy." *Homage to Catalonia* (New York: Harcourt, Brace and World, 1952), p. 5.

22. The same might be said for the examples of the young woman and the homosexual, and even for Francis Jeanson's example (in a commentary on Sartre's works that Sartre recommended strongly) of the young bourgeois who will grow into a position of power. *Le Problème moral et la pensée de Sartre* (Paris: Editions du Seuil, 1965), p. 175. This work is soon to appear in translation.

23. *The Emotions: Outline of a Theory,* tr. by Bernard Frechtman (New York: Philosophical Library, 1948). See especially pp. 62–64.

24. *Being and Nothingness,* p. 529.

25. "Castoff of a society that defines being by having, the child Genet wants to have in order to be." *Saint Genet: Actor and Martyr,* tr. by Bernard Frechtman (New York: George Braziller, 1963), p. 10. See also p. 29.

26. *Search for a Method,* tr. by Hazel E. Barnes (New York: Knopf, 1963), pp. 57–63, esp. p. 63. See also "Itinerary of a Thought," an interview with the editors of New Left Review, in *Between Existentialism and Marxism,* tr. by John Mathews (New York: Pantheon, 1974), p. 35.

27. *L'Idiot de la famille,* vol. 3, pp. 50–107.

28. *Critique of Dialectical Reason,* vol. 1, pp. 148–52.

29. Sartre remarked, after Merleau-Ponty's death, that his "good faith" had to be questioned "not as I did, in 1942, by the eidetic of bad faith, but by the empirical study of our historical commitments, and of the inhuman forces which pervert them." "Merleau-Ponty," in *Situations,* tr. by Benita Eisler (New York: George Braziller, 1965), p. 234n. The translation in this case is mine. See also, in this regard, *Search for a Method,* p. 14.

30. *Critique of Dialectical Reason,* vol. 1, pp. 345–404.

11

Joseph P. Fell
BATTLE OF THE GIANTS OVER BEING

S ARTRE and Heidegger have long been identified in textbooks as
fellow existentialists, phenomenologists, or existential phenomenolo-
gists. Many grounds for associating the two thinkers can be adduced,
among the most important being their mutual debts to Kierkegaard and
Husserl; their common preoccupation with the themes of existence and
essence, being and nothingness, anxiety, projection, temporality, and au-
thenticity; and the many references, direct and indirect, to Heidegger's
Sein und Zeit in Sartre's *L'Etre et le Néant*. In the lecture *L'Existential-
isme est un humanisme* (1946), Sartre went so far as to situate himself and
Heidegger within the same philosophical movement, atheistic existential-
ism. If Sartre criticized Heidegger rather severely in *L'Etre et le Néant*, and
if Heidegger criticized Sartre rather severely in the *Brief über den Hu-
manismus*, it nonetheless seemed that their differences revolved chiefly
around the issue of the proper means of accomplishing a program, phenom-
enological ontology, to which both were committed.

Given the foregoing grounds for identifying the two with a common
cause, the subsequent silence of each concerning the other must be seen as
remarkable. It is probably fair to say that their later positions diverged
more sharply than their earlier philosophies had led us to anticipate. We
might expect that increasing divergence would elicit more frequent and
more vehement criticism of each by the other. But this did not happen.
Indeed, in the later years neither vouchsafed more than passing reference
to the other, and then neither demonstrated great familiarity with the cur-
rent thought of the other. Perhaps most remarkable of all, Heidegger and
Sartre appear to have conversed personally just once, in December 1952,
although Paris and Freiburg are separated by only 250 miles. Simone de
Beauvoir records that Sartre went to Freiburg to give a lecture. While
there, he "paid a visit to Heidegger, perched on his eyrie, and told him how
sorry he was about the play Gabriel Marcel had just written about him.
That was all they talked about, and Sartre left after half an hour."[1]

Whatever the reason for this failure of communication between two significant minds—the vehemence of their earlier exchange of criticisms, perhaps, or their allegiance to opposing sides during World War II—it is a philosophical misfortune. The imaginary face-to-face confrontation which follows was written as an effort to ameliorate, insofar as it can be ameliorated, this missed opportunity. It goes beyond their earlier recorded disagreements to speculate about how they might have judged each other from the sharply divergent orientations of their later thought. I imagine them wasting little time over obvious or superficial similarities and differences and coming quickly to grips with the fundamental locus of disagreement between them. It must be left to the reader to judge whether I have hit upon the crux of their disagreement, whether this philosophical divergence might already have been implicit in their early philosophies, and whether this fictive dialogue is a fair reflection of the thought of either or both. I do not regard it as entirely naturalistic, for it is unlikely that either Sartre or Heidegger would have spoken in quite the manner I have contrived to have them speak.

We suppose that Heidegger and Sartre have met in their later years at some unspecified place and, at the urging of a mutual friend, have sat down for a serious interchange. What follows is the imaginary record of their conversation.

Sartre: Our friend suggests we keep off the subject of politics.

Heidegger: I don't discuss politics, M. Sartre.

Sartre: That's a serious admission.

Heidegger: Of course it's serious. If we think back to the root meaning of the Greek word *polis* . . .

Sartre: Do we have to, Professor Heidegger? We might better talk about where we are now. We find ourselves together again and again in books on existentialism and on phenomenology, yet we've been together very seldom.

Heidegger: A thinker must go his own way.

Sartre: Of course. But we do have a certain philosophical ancestry in common. And my position owes a great deal to *Sein und Zeit*.

Heidegger: Yes and no. I don't recognize myself in your writings—not even in *L'Etre et le Néant*. There are French equivalents of some of my terminology. There are summaries of some aspects of *Sein und Zeit*, which you present in the form of contextless arguments and as "better" or "worse" than Hegel's or Berkeley's arguments. But *Sein und Zeit* wasn't a collection of arguments and it wasn't written as a stage in the "progressive" development of modern philosophy. It's on another path, though almost no

one saw that. What you called *l'ontologie phénoménologique* has next to nothing in common with what I was trying to express.

Sartre: Well, we did have "nothing" in common, and that's something. In fact a great deal. Your notion of *das Nichts* was decisive for me.

Heidegger: But in your hands it's no longer "my" notion, if it was ever "mine" at all. It comes out Cartesian and Hegelian, not "Heideggerian."

Sartre: The intervention of Husserl, to whom we both owe something, makes it a different notion than it could have been for either Descartes or Hegel. Thanks to Husserl, "nothing" belongs permanently out there, in the world. Not as an alternative to what is but as its very texture, what makes the world a *human* world.

Heidegger: But you haven't radicalized Husserl as he must be radicalized. You stay too close to the Descartes and Kant who remain in Husserl. This means that the existentialist "world" is *too* human. It's more human than it is world. You speak of nothing as belonging "out there, in the world," but you really trace it back to man, to the *pour-soi*. As soon as you do that, "nothing" and all other "intentional" traits of the world become subjective all over again. The fact that you have man place "nothing" in the world doesn't establish that nothing *belongs* there. Its origin is what decides where it belongs, and you locate its origin in the subject's intentions, in consciousness.

Sartre: The *pour-soi* isn't a subject. In fact I've "radicalized" Husserl on just that point. You're right to want to radicalize Husserl, as you put it, but you push this radicalization too far. It's one thing to discard the ego and quite another to discard consciousness. If you discard consciousness, then the occurrence of any intentional traits of the world is unintelligible, purely magical. Consciousness as non-egological spontaneous intentionality is precisely what explains that "nothing," the lovable, the revolting, etc., are really out there and not "in" some "subject."

Heidegger: I don't "discard consciousness," as you put it. There is *Verstehen*, understanding, which is a being conscious or aware. But it can't be spontaneous. "Spontaneous" says "self-generating"—created *ex nihilo*—and that means once again to locate the "nothing," the *nihil*, in an act of consciousness, something subjective. If you're serious about intentionality, about the referent of the "of" in the expression "consciousness of the world," then you have to start with what consciousness is of, not with consciousness *per se*. But if you do, then consciousness is no longer a spontaneous or self-generating act. Whenever there is consciousness, it's already dependent on the world.

Sartre: You misunderstand me. I agree with what you've just said:

consciousness is necessarily and totally dependent on the world. But it makes sense to say this only if consciousness is conscious of itself precisely as nothing, as empty, hence as always referred beyond itself—to the world—for meaning, for real content, for anything substantive at all.

Heidegger: Yet you hold consciousness to be self-generating. If consciousness gets all its content from the world, it's not *self*-generating and it's a mistake to think of it as free and independent. Why not then call consciousness *pour-monde* rather than *pour-soi*? The real "given," or the real "experience," is always an essential togetherness of world and understanding; it's not a matter of an essentially "empty" consciousness spontaneously jumping into an essentially "full" environment. You relate consciousness and world by a "from-to" movement that has the effect of making the consciousness-world unity only a derived and inessential unity; what's essential and irreducible for you are the end-points of the "from-to" movement—*pour-soi* and *en-soi*—rather than what lies in the middle, in the real center. It's Cartesian, and you can't really relate the antithetical any more than Descartes could.

Sartre: You use Descartes like a bludgeon.

Heidegger: So do you, but for the opposite purpose. It's a mark of our destiny that we still have to wrestle with him.

Sartre: It's a *rational* destiny. Hegel was right about the permanent significance of Descartes and right about the rational necessity of *preserving* his thought as well as surpassing it. You know that I think your references to "destiny" reek of alienation. Cartesian freedom represents a permanent safeguard against non-rational destinies. If you swamp man in what you call the "center," then you take away his ability to surpass his fate, to change the world. Man's ends cease to be his own. It's you, after all, who put intentionality explicitly into the context of human ends in *Sein und Zeit*. I remain indebted to that teleological radicalization of Husserl, while you yourself seem to have left it behind. When you wrote about *Dasein* as projecting toward ends, and about tracing the significance of the world of instruments back to *Dasein* as the ultimate "for the sake of which" and the "baseless basis" of the significance of that world, you were talking about a *human* world; and you could do that because you were tracing the significance of things back to human reality, to human ends, to the human project. So I naturally associated you with what I called "existentialist humanism." In taking *Dasein* as the baseless basis, you were freeing man from God as basis and so establishing the world as a region whose possibilities were man's and nobody else's.

Heidegger: So it appeared.

Sartre: Well, aren't you responsible for the way *Sein und Zeit* appeared? My reading of it wasn't idiosyncratic—everybody was interpreting

it in roughly the same way I was. Let me be quite blunt, in fact, and tell you that in my opinion what *Sein und Zeit* appeared to say is really more valuable than what you've subsequently claimed it meant to say.

Heidegger: You might as well add, with equal bluntness, that my later thinking has been a degeneration. What I would have to invoke in order to explain why *Sein und Zeit* didn't mean what it appeared to many to mean is the very destiny you've already rejected. You've written that I have "no character," and it's not difficult to see that you regard my later interpretation of what *Sein und Zeit* was about as a covert effort to make that book mean now what it didn't mean when I wrote it. And it *does* now mean more, or less, than what it meant to me when I wrote it. But what of your own work? I've read *Les Mots*. There you allow that *L'Etre et le Néant* has a hidden significance which you didn't recognize when you wrote it. In fact you see that hidden and deeper forces were at work in you which weren't exactly a *rational* destiny. I'm not offering this as an *ad hominem* judgment; I'm suggesting that when we speak we express more than we know. Time is needed for what speaks through us to express itself.

Sartre: It's one thing to be the mouthpiece of a class, as I was, and quite another to be the mouthpiece of Being. If a class is a destiny, which in a real sense it is, it's a destiny which is amenable to change; if it's inhuman, it's nevertheless a product of the human, hence in the sphere of things alterable by man. That's what time is needed for—to establish the conditions in which each man is a "mouthpiece" for all and all a "mouthpiece" for each. But what you call "Being" is a kind of inertia which isn't even in principle practical. If it's beginnings that count, then from the beginning and by definition you condemn man to permanent alienation. For you, man is used by Being and has no recourse.

Heidegger: Class-being is itself a way of being. But Being is more than practical and so is class-being. If you regard beings and ways of being primarily as things to be changed, or improved, or brought under human control, then I think it's you who are condemning man to a permanent alienation, because you encourage him to attempt to control what is prior to all control and to all design. If, so to speak, Being controls, that is the condition of everything human. What makes "humanity" possible is and can be nothing human or humanizable.

To go back to *Sein und Zeit*: it didn't make its intentions clear because it couldn't. But even at that time I warned repeatedly that it wasn't an anthropology, a doctrine of man, and I also warned that it was only a first step, though a necessary one, toward a reappropriation of the ancient question of Being. I even warned, and hence already saw, that the next step would require a turn in which the first step would have to be seen in a different way. It's true that the turn proved to be both more protracted and

more radical than I had anticipated. But it's also true that even in 1926 *Dasein* was not *la réalité humaine,* nor was it a *conscience* which refused to acknowledge itself as such. *Dasein* was a way in which *Sein* "is" *da.* Not a way picked by me at random, but the way the interpreter who makes an approach to Being can't help but walk, the way he has always already walked. Hence what you call the "teleology" of the book. The teleology was there because I already saw that whatever in any way "is" for any investigator is so in time, and not in the alleged pure present with which the ancient ontology associates what really "is" or "Being." Though for the most part beings show themselves as if they were pure presences, hence not as they are in themselves. What especially impressed itself upon me, and what continues to do so, is the way in which beings dissemble their own Being, so that they appear as if they were wholly independent and self-contained. Later on the law of identity, $A = A$, concerned me because I came to see that the law of identity perfectly expressed this semblance of things as self-contained and independent, as complete in a so-called pure present time. It was only later that I saw clearly how our language conspires to make beings seem that way. This alleged pure present is the *privation* of true time, and the being which seems self-contained in itself is a privation of the phenomenon—what I now call *das Ding*. What I meant by "Being" was the conditions beyond those apparently self-contained beings relative to which they are what they are. Human Being is one of those conditions, even a necessary one. Because metaphysics recognizes only beings in the aforesaid manner, as self-contained, it fails to recognize Being. What *ekstasis* meant to me was that beings are what they are "in" themselves only in being *beyond* themselves . . .

 Sartre: That's just why I spoke of both man and things as diasporatic unities, as ideal wholes not realizable in any pure present!

 Heidegger: But at the same time you regarded pure presentness or self-identity as an ideal. So behind man you found the instant, and behind the thing timeless plenitude. I was concerned to exhibit the allegedly self-identical present being as a privation of its *temporal* being, while you were arguing that the temporal being was a privation of its actuality, its a-temporal Being. This indicates how far your ontology was from mine. You modeled your conception of *l'être* on the ancient ontology—on Being conceived as internal self-completeness, self-identity independent of time. And, so far as I can see, you still do. You stand wholly within the metaphysical tradition. It seems to me that you regard what Nietzsche calls "time and its 'it was'" as something to be overcome. Even your latest writings treat what has been as a moral outrage, as a loss of control to be remedied in a future which will abolish the need for historical becoming by making the present self-sufficient.

Sartre: That sounds more like your position than mine. Your "destruction" of the history of ontology is hardly an expression of satisfaction with man's past—your mystical *Sein* and your references to "the eternal" and to "rest" seem to be precisely an appeal to a timeless transcendence. I don't wish to resort to what the Americans call "one-upmanship," but if I understand you at all it's my position, not yours, which is absolutely committed to history. It wasn't, before the late forties, I grant you; but you'll notice that I no longer appeal to *l'être-en-soi* as an undifferentiated pretemporal plenitude, and I speak of no human transcendence of temporal conditions, not even a symbolic one.

Heidegger: But you *confirm* my placing you in the metaphysical tradition when you think, as you're obviously doing, of my references to "the eternal" and "rest" in the usual metaphysical way—as a timeless presence over and above temporal conditions. It's just because that's *not* what I mean that the "destruction" of the history of ontology isn't the "transcending" or "surpassing" of that ontology and its "replacement" by something else. You refer to what I've written as "your position"—as if I were adding one more position to the history of positions, the history of metaphysics . . .

Sartre: The question is whether you can do otherwise. You have a right to criticize "positions" and "metaphysics" only if you can show that you really stand outside of any metaphysics—that you can escape taking a position, a *particular* and partial stand. Taking a particular and partial stand seems to me the human condition—even the "mortal" condition, to use your term. Your manner of writing and the content of your writing suggest to me a claim to a more-than-mortal vantage point. You write about *Dasein* as *having* to make particular and limiting decisions, then you turn around and exempt yourself from this requirement by playing the role of seer presaging a restful wisdom of the ages. Whether you intend it or not, this ageless wisdom has a profoundly conservative function. In effect, you ally yourself with the religious sages who counsel resigned contemplation *of* the mortal condition. Whether intended or not, that says: Let things be; don't try to interfere with the working of Nature; don't try to improve mortal conditions. But that view is itself an option, a metaphysical choice. It affirms but it also denies, and what it most fundamentally denies is the possibility of any essential revolution in human affairs. It has the effect of a politics of conservatism wearing the benign mask of the ineffectual sage or the cleric who's clear of the fray . . .

Heidegger: We were going to stay clear of politics. Politics is at another level, grounded in ontology . . .

Sartre: Why isn't that a dodge? Every philosophy has political implications. I've even entertained the possibility that your later thought may have the function of suppressing the sort of resolute decisiveness that can

as easily lead to Belsen as to the Bastille. It's only if you're essentially delivered from a world of Belsens and Bastilles that you can afford to look down on this violent revel with serenity and contemplate it as a "play" or a "round-dance." I made a similar mistake, but I think I've got over it. Given what you've been through in your lifetime, how can you justify this aesthetic attitude? Even your references to "strife" in the thirties sounded aesthetic, abstract; it wasn't a matter of *men* struggling with each other, but instead an interplay of archaic mystic beings—"earth" and "world." You argue that you're not replacing the "destroyed" history of ontology with something else, but I fail to see why that's not the effect of your thought; it's precisely the history of ontology that has *freed* us of mythic beings and of confidence in poetic and aesthetic constructions. If there's any wisdom of the ages, it's a wisdom that has *become*, that has developed, and it has developed in part by criticizing and revising mythopoetic cosmologies that cede properly human powers and determinations to immortals. . . . In short, there's bad metaphysics and good metaphysics; the latter takes into account that its dreams and constructions are of human origin and acts accordingly.

Heidegger: The general opinion is that I've not "succeeded" in overcoming metaphysics. That opinion of course supposes that I was trying to. My critics remind me that I wrote in *Was ist Metaphysik?* that "as long as there is man there will be philosophizing of some sort" and, in the same place, that "Metaphysics . . . is *Dasein* itself." As if I had forgotten this, or subsequently denied it. The most fundamental misinterpretation of my work—it is near universal—persists in maintaining that the so-called later Heidegger shifts to a "new" ground and proselytizes his readers to forsake the "old" ground. I haven't jumped out of my own skin and I don't count on anyone else doing so. What's necessary is care in reading and thinking through my works as one work. The "turn"—a turn of phrase I've had ample occasion to regret—is, so to speak, a deepening or rooting, and not a turnabout or an overthrow or an establishing of anything novel or different or unprecedented. Pöggeler says the turn really occurs between Divisions I and II of *Sein und Zeit*, and this is truer than the assertion that it occurs "after" *Sein und Zeit*. But the real "turn" is happening from the beginning to the end of my thought and is not a "turnabout" or a turn "from" or "away" or "toward" but only "into" or "in." For the careful reader, this is already signified by the title of an essay that "deepens"—not overturns—*Was ist Metaphysik?* That title is *The Way Back into the Ground of Metaphysics*. This signifies the way farther *into*, and *not* above or against or beyond, the ground *of* metaphysics *itself*. It means into where we already are—not somewhere else, not somewhere where we might be or ought to be. Of course every philosopher wants to claim that he's teach-

ing man where he "really is." Why am I any different? Why is my "philosophy" anything more than one more "theory of reality" in a long succession of alternative competing theories or "visions of the whole"? What could count toward showing that it's anything more or less than my own epoch-relative temperamental option? What would go to show that it's anything more than one more effort to "fill the vacuum of nothing" with one more allegedly Absolute Ground? Isn't the difference between us in fact just the difference between two metaphysical options: *pour-soi* as Ground versus *Sein* as Ground? In the face of the history of metaphysics, wouldn't it be the worst sort of hubris to claim anything else? A special, even unique, status for Heidegger!

Sartre: Surely you do make precisely that claim.

Heidegger: I don't. Of course if I say something like "Being claims my thought," you'll nod skeptically, having heard such "claims" all too often before, and you will on the very best of grounds—the passing parade of such claims—find your skepticism justified. I'm in an admittedly difficult spot. I claim to be claimed only as you're claimed, as we're all claimed—but you'll reply with all apparent justice that the world is full of individuals who can tell others where they "really" stand. You'll reserve your inherent right to "decide for yourself" on what grounds you stand. To be sure. You may even go further and situate *my* thought within the "unsurpassable" Marxist philosophy. But what does this indicate? We shall be repeating, in our own way, what Plato in the *Sophist* called "the battle of the giants over Being." We shall war over the correctness of our respective metaphysical options. But we may reach the difficult and perhaps desperate point at which we shall ask each other: On what mutual ground, in what single place, do we stand when we war with each other over Being? We're arguing, we say, "with" each other. What is this "with"? How is it that we understand each other at all? We claim to disagree at the most fundamental level—that of the very ground itself—yet we still have enough ground *in common* to be able to argue and to criticize each other, to assert and to deny as if we understood each other in so doing.

Sartre: You want to claim there is a *Mitsein* between us.

Heidegger: So to speak, yes, but more around us and through us than between us.

Sartre: In your *Sein und Zeit* what *Daseins* seemed chiefly to have in common was nothing, since each is a groundless ground. Inauthentic *Dasein* participates in a kind of faceless community, *das Man*, by suppressing its individuation. But in anxiety *Dasein* discovers that it makes its *own* ground by temporalizing itself. From then on, the warrant for its actions isn't the crowd but instead its own choices made over the abyss, out of nothing. But if *Dasein* invents its own grounds, then what reason is there to

think that one authentic *Dasein* and another authentic *Dasein* will commit themselves to the same grounds? In a sense, there's more *Mitsein* in the crowd than among authentic *Daseins*. One could interpret you as having subsequently turned "into" *Sein*, as you put it, in order to exorcise this specter of nihilism conjured up by anxiety and authenticity.

Heidegger: So on your reading *Sein und Zeit* comes out sounding like a mixture of Kierkegaard and Nietzsche. It's possible that Kierkegaardian formulations played too large a role in *Sein und Zeit*. Kierkegaard was interested neither in time nor in his environment; he conceived Being as lying elsewhere, as the correlate of a subjective act of faith. *Sein und Zeit* is already headed in another direction. Nothing is the veil of a Being of which Divisions 1 and 2 could not yet speak. The way is prepared for the remembering of Being by *Dasein*'s experience of its own groundlessness. This means that *Dasein* can locate no other *entities* or beings on which to ground itself. That is to say, *Dasein*'s quest for some-thing on which to ground itself—some other entity such as the highest entity or *summum ens*—turns up no-thing. That says in turn that among entities that can ground, there is no appeal beyond the entity *Dasein*. But *Sein und Zeit* already refers to the "ontological difference" between entities and Being. Ontologically, "world" already manifests a way of Being beyond that of pure entities.

Sartre: But in anxiety the world goes dark, so to speak, and it lights up again only when *Dasein* illumines it.

Heidegger: *Sein und Zeit* has been misinterpreted on that point, as on many others. The world doesn't "go dark" in anxiety, hence *Dasein* isn't in a position to "re-illumine" it. In anxiety *Dasein* can't *account for* the world's illumination, which thus appears "uncanny." *Dasein* can trace the illumination, the intelligibility of things, to no source other than itself—that's true—but that only means that *Dasein* doesn't *know* any other source. Not knowing any other ground but itself, *Dasein* has to take over being a ground—but *Dasein* after all doesn't *create* either itself or other beings. *Dasein*'s anxiety is akin to wonder or awe, with which I subsequently related it. Under this condition of anxious awe, entities can show themselves as what they are in *themselves* and from *themselves* because they can no longer be explained by tracing them to other entities. At such a moment there can be no recourse to metaphysical beings which will "explain" the entities as essentially divine creations, essentially Democritean atoms, essentially Cartesian corpuscles, and so forth. All the alleged "metaphysical essences" vanish, freeing the entity to show itself in its Being, not as essentialized existentia. Phenomena are freed of *reasons*.

Sartre: Yet you wrote that *Dasein* is itself the clearing or lighting. What can this mean except that phenomena show themselves in light of *Dasein*'s own teleology, relative to its own project? It's in terms of human

praxis that there are phenomena such as hammers or windmills or jugs. Or a peasant's work-boots.

Heidegger: That's quite correct, though my formulation of the situation was inadequate. First, it must be recognized that *Dasein* as clearing is not Cartesian "natural light"; it's not the projection of and by a subject upon objects. It's a happening that's prior to any alleged "subjects" and "objects" which are somehow supposed to "join up" or "interact" in order to produce "experiences." To say that *Dasein* is the happening of intelligibility is not to say that consciousness or a project of consciousness is the source of intelligibility. Second, to say that there is intelligibility—that there are phenomena—for a being who projects is to say that phenomena appear in time or, as I later wrote, along a way. That way is, to be sure, a laborious way along which things are both practical and impractical, useful and useless. Third, *Dasein* is a *cleared* clearing insofar as the intelligibility of phenomena, their Being, is not simply owing to a human Being or his "praxis" but to other contemporaneous conditions as well. In *Sein und Zeit* I expressed this—inadequately, as it turned out—by saying that the ready-to-hand being is also present-at-hand. A being must be "present" in order to be "ready." But its readiness, its practicality, doesn't exhaust its presentness.

Sartre: I recognize that. Otherwise one falls into idealism. There must be a Being-in-itself.

Heidegger: But that says: an existentia prior to essentia.

Sartre: I'd rather say: a material ground of praxis. But a *workable* matter, not a transcendent Being.

Heidegger: Then you define matter relative to praxis and work.

Sartre: But it remains matter, with an inertia of its own. It has a coefficient of adversity. It's neither simply ideal nor simply actual.

Heidegger: But you nevertheless define its inertia or "adversity" relative to praxis and praxis alone.

Sartre: Is that a crime? What counts is matter's relation to human ends. If matter gets defined apart from human ends, then the world is in principle unhumanizable and matter is in principle unintelligible.

Heidegger: Assuming that praxis is the sufficient condition of intelligibility, or of presence.

Sartre: It's not a sufficient condition—there must be matter—but it is a necessary condition.

Heidegger: What's left of phenomenology if the talk is of "matter" and of "necessary" and "sufficient" conditions? And if beings are simply objects of praxis, instruments of human will, utilities?

Sartre: Husserl could speak of *hylē,* and of transcendental conditions. But, as I maintained earlier, he put insufficient stress on praxis.

Heidegger: But one doesn't reach phenomena by a judicious combination of transcendental conditions, practical conditions, and material conditions. You can't start with discrete elements and then glue them together; that's a fabrication.

Sartre: Naturally. We start with phenomena. But we understand what they are in part by regressively fixing their conditions. Otherwise one appeals to an empty or mystical notion like "the Event of Being," which seems to me to explain nothing.

Heidegger: You still want to explain, and to do so by referring to beings.

Sartre: To abandon explaining just at the critical point is to resign yourself to unintelligibility.

Heidegger: No, it's to resign yourself to the *limits* of intelligibility as an essential "condition" of intelligibility itself. If you have to know everything about a being in order to say you know it, then knowledge recedes into the future, infinitely.

Sartre: With all this talk of mortals resigning themselves to limits, you preserve a religious and numinous presence in the world, but at the price of human passivity.

Heidegger: There *is* essential limitation. Descartes and Hegel, to mention only two, recognize no limit. Your *projet fondamental* recognizes no limit. It's will to will, to which there is no end. That's the real alienation. For us even the sky is no limit. Total knowledge of conditions and total control of conditions are infinitely receding ends and therefore eternally alienating ends.

Sartre: Man makes his own limits, so there are and will be limits. I'm only committed to what's probably a historically realizable end: the cooperative surpassing of those limits which now alienate one man from another man, one group from another group. Your critique of will and willing encourages a passivity in the face of real material alienation. What counts is to encourage and facilitate a rational aspiration—not to suppress it! If man is to have hope, the price is going to be the risk of failure. It may be that the lack of food and the hope of sharing even a fraction of a factory owner's leisure don't appear in their full material density from the slopes of Todtnauberg.

Heidegger: You perceive my approval of Marx as a mere formality.

Sartre: I frankly perceive it as too verbal, in fact as entirely abstract, aside from the fact that it has the effect of approving of the very "materialist" brand of Marxism that takes man to be a mouthpiece of material Being.

Heidegger: You rightly judge yourself to be an ideologist—an ideologist, as you've written, in the service of a "philosophy." But phi-

losophies encourage ideology. A plurality of contesting philosophies, each claiming to ground and orient praxis and none able to demonstrate its rightness—this is the condition for the unresolved and unresolvable struggle of "ideas" and "programs." The rage to ground continues even past the time when the essential poverty of this quest has appeared in philosophy itself—the time when the metaphysical quest has reached its inevitable terminus, which is not its fulfillment.

Sartre: You regard dialectic as the perpetuation of the rule of logic in philosophy, and you see logic fundamentally as a verbal reduction or manipulation of reality at the level of assertion. So for you it follows that dialectical struggle doesn't touch the heart of reality. That view of course takes the sting out of dialectic and out of any philosophy that practices dialectic. Hence it's easy to think of dialectical philosophy as a symptom of philosophy's poverty since Hegel. But if dialectic is the logic of praxis itself, and not just of theory or statement, then everything appears differently.

Heidegger: It does indeed. I'm not in a position to "take the sting out of dialectic," as you put it; Marx and Marxism provide sufficient testimony to the force of this idea. It's not just an epiphenomenon of our culture; it *has* made and *is* making a difference in the organization of the planet. And for the best of reasons: There is real alienation of one will by another; mastery and power are gained by the enslavement of others. Hegel's analysis of the dialectic of master and slave is trenchant. But part of the force of Hegel's dialectic—and of Marx's—is premised on the claim that this dialectic is *fundamental*, the law of the development of Being itself, the profound mover of man and his history. Hegel and Marx think dialectic determines and defines a global becoming which is the coming of individual and social man into his own, the actualization in practice of his potential and ideal and rational "nature." It's just at this point that dialectical philosophy blocks the way to the truth of origins and the origin of truth.

Sartre: It's here that I think we reach the point of essential divergence between us.

Heidegger: The original divergence, which is not simply between *us* but in the directive of Being that determines our relation with each other.

Sartre: It's at this point that I don't understand you. One can question whether your references to "origins" and "beginnings" meet the conditions for understanding or intelligible discourse at all. Assertions that are rooted in the practical pursuit of ends, as expressions of and instruments for those ends, have an intelligible reference. But discourse that's rooted in what you call *Ursprung* or *Ereignis* seems to me essentially disconnected from its alleged roots because you hold these roots to be pre-dialectical, pre-practical, pre-human. What can human assertions have to do with what's of another nature altogether? For you, the transition from discourse

or dialectic to Being or origin is a slide from a familiar world to an ineffable one. The region of truth and falsity, the region of intelligible discourse or conversation, has to be the region of human action, human projects, a *human* world.

Heidegger: We've both been concerned with the conditions for the possibility of intelligibility, with the puzzling question of how and when intelligibility happens. Your consideration of this problem in *Question de méthode*, where you challenge allegedly non-temporal and impartial conceptions of understanding and the object of understanding, is more important than anything in *L'Etre et le Néant*. But it still forgets the heart of the question of method, which is not reached by any dialectical rectification of methods. As a last resort, let me try to depart from my accustomed way of speaking and writing in an effort to point to the common ground between what you're saying and what I'm saying. There is a "relation" between origin and discourse, between intelligibility and its roots. But this relation is not a slide from one region to another. The region of origin is *itself* the region of discourse and of intelligibility and of assertion. It's the place of intelligibility itself, where discourse and assertion belong, and where assertion and its referent first belong to each other. Your nominalism is incapable of reaching this place; in fact it blocks all access to this elemental place. Nominalism in fact expresses the utmost forgetting of the original happening of truth. This original happening is of lasting importance because it's not a one-time event but rather what remains throughout all changes and rules our way of being even in its forgottenness . . .

Sartre: You don't seem to be departing significantly from your accustomed way of speaking. If you're claiming that language can block the way to truth, I can agree with you. But since you hold that language is the "house of Being," I suspect you're really arguing for a kind of linguistic realism, though you don't call it that. How do you relate language to this original and lasting happening of truth?

Heidegger: You can't relate them if "relating" means linking two distinct things!

Sartre: But if they aren't distinguishable from each other then there's nothing to relate! Look—I think you can agree that all of our experience and praxis moves amid and thrives on distinctions. We say that we "make distinctions." One of the most elementary among these distinctions is that between word and thing: word and thing are distinct, even different in kind. Words are for the most part "universals"; things are "particulars." Words pertain to speech; things pertain to reality or materiality or substance or actuality. Words refer to things; things refer only to themselves. Words are therefore secondary, *post hoc*. The real *hoc*, or the real *hic et nunc*, is the thing. Even common sense knows that words are and must be

independent of things: if word and thing weren't different in kind, words couldn't refer *to* things, and things wouldn't be more than words. All this is elementary.

Heidegger: Indeed. And right, in a sense.

Sartre: Furthermore, the same is true of the relation between *thought* and thing. They are and must be distinct, different in kind. The thing is and has to be independent of and prior to the thoughts we entertain about it. If I advanced the thesis that thought and thing aren't distinct, I'd rightly be accused of succumbing to a poetic or primitive confusion, or a lapse into mystical indistinction or inarticulateness, or a relapse into the crassest idealism.

Furthermore, to these distinctions a third must be added. Despite the affinity between word and thought—both of which are distinguished from the material thing as secondary to it and by comparison with it merely mental or ideal or ideational—word and thought are different in kind. A thought, a concept, is essentially pre-linguistic, though the word may refer to the thought and even express it.

So we have three distinct kinds of beings—words, thoughts, things. But both word and thought have only a borrowed being: they're meaningful only if they refer to a thing. Word and thought need the thing, but the thing doesn't need them. This ontological poverty or dependence of word and thought upon the thing is reinforced by the commonsensical fact that man depends on things—food, timber, etc.—more essentially than on either word or idea. To take any other position is to ignore or suppress man's real needs and his real and fundamental dependence on materiality.

Heidegger: You're oversimplifying your own position—for dramatic effect, I suppose—as you often do.

Sartre: There's more to it; there can't be any real *syntheses* of thought and thing in praxis—but synthesis presupposes that the things to be related are distinct.

Heidegger: These distinctions, then, aren't accidental and they aren't erasable. I agree with you. And if any of these distinctions come under attack, invocation of elementary logic can easily dispel the attack: a thing is a thing; a word is a word; a thought is a thought; therefore a word is not a thing, nor is a thought a thing, nor is a word a thought. The law of identity maintains beings as what they are, in their distinctness. The price of being able to relate beings to each other is that they first be maintained in their difference from each other, that their distinct identities be maintained and preserved against any thoughtless attempt to confuse them with each other. British philosophers, I'm told, now warn against "category mistakes." By the reflective exercise of one's analytic powers, one preserves philosophy and culture against the collapse of distinctions, isolating differences in kind.

Having done so, one is in a position to relate these distinct beings to each other by an exercise of one's powers of synthesis: to point out which words properly correspond to which concepts, and which concepts properly correspond to which things, to spot discrepancies between matter and our ideals and to use ideas to transform resisting matter. The exercise of these analytic and synthetic powers goes under the name of "dialectic." Dialectic works with, or uses, distinctions.

Now if I come along and say that dialectic isn't fundamental or that the rule of logic isn't absolute, it's a scandal. And when I say that distinct kinds of being are "the same" even though "different," the scandal is confirmed. Heidegger succumbs to the nihilistic loss of all distinctions foretold by Nietzsche! Logic and common sense are undermined! It is difficult to make people understand that I'm not in a position to undermine these distinctions, and that I wouldn't if I could. The "absoluteness" or "fundamentality" of these distinctions has in fact *never existed*; yet this has prevented neither these distinctions nor the logic that "supports" them from being preserved. There is in fact always already a community between "dialectical polarities," between distinct opposites. I expressed this in *Einführung in die Metaphysik* by saying that there's "an initial inner union between thinking and being itself," a union that I spoke of as a "harmonia." Harmony is a tension in which opposites are together in their apartness. The original and originary unity is a togetherness in apartness and an apartness in togetherness. Earth and thought are, to be sure, distinct, yet they belong together and from the beginning play into each other as intelligible Earth.

Sartre: I hear echoes of both Heraclitus and Hegel. You seem to be espousing precisely a dialectic, an interplay of opposites. These polar opposites are dualities, yet you claim to have escaped both dialectic and dualism.

Heidegger: It isn't a question of *escaping* either dialectic or dualities but rather of recollecting their origin in the same. Let me take an ordinary philosophical case—the case of universals and particulars.[2] We say that universals and particulars are "opposites," opposed in their natures, yet we invoke them together. The particular, we say, is just the individual itself. The universal goes far beyond that particular or indeed beyond *any* particular. The universal does violence to the particular, in the sense that it departs from the particular, seems perhaps to ignore the uniqueness of the particular, seems to subsume the particular by force under a generality. The particular, for its part, resists this universalization by remaining a mere particular, an irreducible particular, in some ways a unique particular. There is tension, *polemos*, as Heraclitus says, between them. But each requires the other in order to be what it is. The particular tree is what it is—a tree—with reference to the universal, treeness. It owes its very appearing *as* a particular, even unique, tree to the violence done it by the universal; it

is as it is *in* itself only in light of what is *beyond* itself; its showing itself as what it is—a tree—thus depends on its place or situatedness within the universal. On the other hand, the universal is what it is only by reference to particular trees—it is the treeness *of* trees.

Sartre: But all this is painfully obvious.

Heidegger: The problem is to *rethink* the obvious, and not just *assume* it. Universal and particular are what they are—are distinct—only by playing into each other and out of each other. They are the same *and* different, unity and disunity. The harmony or equilibrium in which there appears tree as tree is extremely delicate, precarious; it requires what I've called "restraint." Particular and universal must each defer and yield to the other while at the same time preserving their difference or independence. In our thinking the precarious balance is generally upset: particulars go their own way and universals are reached only by sloppy generalization from particulars or habitual association of particulars. Or so empiricists maintain. Or universals go their own way and dictate to particulars, regardless of how they first appear, their real natures or essences. Or so rationalists maintain. In either case there seems no mutual deference, no restraint, no harmony. And logic requires that one choose between sameness and difference; things that are distinct can't enter into each other and yet remain distinct! What I call the original "gathering" seems dispersed—beings are only beings, thought is only thought.

Sartre: Why is this any different from Hegel's "concrete universal"?

Heidegger: In part because Hegel regards the concrete universal as an *achievement*, a final result of dialectical becoming, of logical negation and affirmation.

Sartre: You want it all to happen immediately, at the beginning, without work, as if by magic.

Heidegger: It's not a question of what I want. If by "magic" you mean what's not adequately explicable by means of ordinary logical assertion, then yes, the original happening of intelligibility or meaning is "magical"—or wondrous, or awesome. What happens at the very beginning and ever since is that meaning and the meant are simultaneously the same and different. There's an unmediated difference of the same. If there were no original togetherness of meaning and the meant, a sameness of natures, then it would never be possible subsequently to relate them. It's just because there has occurred a forgetting of this original union that we're now confronted with an *essentia* and an *existentia* that seem to have nothing to do with each other, that seem unrelatable, or relatable only by man's arbitrary and conflicting imposition of essences upon existences. There *seem* to be only particular existences, surrounded by nothingness—a free field for the imposition of essences at will, the situation known as nihilism.

What needs to be recollected is that this free field has always already been filled and that if it hadn't been, the allegedly pure particulars wouldn't and couldn't be intelligible as the particulars they are.

Sartre: Then man just passively suffers or experiences a pre-existing intelligibility.

Heidegger: You can interpret my later thought that way only if you've failed to see its relation to my early thought—how the later grows out of the earlier as well as how the earlier grows out of the later. You seem to interpret the development of my thought as an unaccountable shift from pure activity to pure passivity. And that accords with your baleful onto-logical habit of thinking in clear-cut either/or's. In *Sein und Zeit* the stress falls on those aspects of human being which show human being to be ac-tively open, so to speak, for the time of the Being that I wished to treat. My later essays don't abrogate this active openness but rather show its mem-bership in the happening of Being itself. Even the notion of the circle in *Sein und Zeit*, insufficient as it is, already points to a thinking that's beyond having to choose between activity and passivity. The activity-passivity po-larity isn't ultimate.

Sartre: Yet in your recent work man seems to be conceived as a pas-sive parrot of language. You give language a life of its own, such that man gets used by language for its own purposes. Language gets substantialized and hypostatized. My impression, though it's not based on extensive read-ing of your recent publications, is that you envision language as a sort of Universal Medium which in some furtive and mysterious and mystifying manner binds human ideas and their objects together as two expressions of language itself. You're then in danger of losing sight of the fact that the power of language is given it by man, and not the other way around.

Heidegger: *Language* is the tool, not *man*. In so saying you again assume—metaphysically—that the nature of beings can be traced to *a being* as ground or cause: in this case, to man. And it's just in metaphysical thought that language itself can get substantialized, or characterized as an agent.

Sartre: Your denials are clearer than your affirmations. You say what language—and Being for that matter—is not, but then at the critical point, when one needs to know what language or Being is, you invoke a mysteri-ous hiddenness. If some of your critics are reminded of the *via negativa* of the mystics, that's no accident. You claim to be interested in the conditions of intelligibility or articulation, yet at the critical moment your thought abruptly defers to the unarticulable—you nod your head cryptically toward the East and invoke the Tao. If you're going to invoke the irrational, you're asking man to forgo the rational formulation and solution of his problems. The problems man inherits grow out of the praxis of prior generations, and

not out of his failure to defer to the mystery of Being. The man who invokes sacred mysteries is likely to be the man who'd yoke you to an authority to whom man has no access, to whom man can address no appeal and of whom he can demand no explanation or restitution or justice—like Kafka's authorities. That kind of authority, especially when it goes by the gentle name of "the gift" or "grace" or "the holy," is the age-old mask of totalitarianism. The last thing man needs at the present historical juncture is for philosophy to become a willing accomplice of hidden powers. No real material problems are solved when man decides to sit around listening for silent voices or for the harmony of the spheres. If the East has done so, it's now waking up and rightly looks to Western revolutionary philosophy for amelioration of its real problems. I have to speak quite bluntly on this point.

Heidegger: Without frankness our discussion wouldn't be useful. But it also can't be terribly useful without careful study of each other's writings. You manifestly speak now, as you've also written of me, without careful reading or long reflection on my publications on language. I'm afraid it's unlikely that our friend's hopes for this discussion are fulfillable.

Sartre: It appears not. I suspect that what's at issue between us isn't resolvable by the simple expedient of further reading. It's a matter of two radically divergent interpretations of the history of philosophy, of culture, and of society. If you and I are able to generate such radically divergent positions, I take that fact itself as evidence for the human ability to posit and to choose between alternative metaphysical options.

Heidegger: I think there's even more at stake between us than that: what expresses itself in our discussion is an ambiguity in Being itself—its own two faces, so to speak. If I'm right, that means, curiously enough, that the same voice speaks through both of us. We're far nearer to each other than the distance between us would suggest. We've been destined to that distance by a single and singular happening in ancient times. If that distance now begins to appear explicitly, it's perhaps possible that further meditation might indicate in what way the distance dissembles a nearness, even a togetherness.

Sartre: Meditation isn't mediation. What you say seems to confirm your own position rather than indicating a way to any real reconciliation. It's dialectic that provides the medium for resolving differences.

Heidegger: M. Sartre, I'm going to give you in life what you think ultimately, in death, none of us can have: the last word.

JOSEPH P. FELL

DEPARTMENT OF PHILOSOPHY
BUCKNELL UNIVERSITY

NOTES

1. The detailed chronology of Sartre's career in Michel Contat and Michel Rybalka's *Les Écrits de Sartre* (Paris: Gallimard, 1970), p. 34, lists only one meeting of Sartre and Heidegger, which occurred at Sartre's initiative. It is this brief encounter in December 1952 which is described by Simone de Beauvoir in *Force of Circumstance* (New York: G. P. Putnam's Sons, 1965), pp. 288–98. In the winter semester of 1933–34 Sartre had attended Heidegger's lectures in Freiberg, but personal contact between the two men was so slight that Heidegger later had difficulty remembering Sartre. See Herbert Spiegelberg, *The Phenomenological Movement* (The Hague: Nijhoff, 1960), II, p. 463.

2. While the analysis of the interrelation of universal and particular that appears here might seem uncharacteristic of Heidegger's manner of thinking, the reader should consult *An Introduction to Metaphysics* (New Haven: Yale University Press, 1959), pp. 80–81, where Heidegger provides considerable precedent for the way in which I have made him speak.

12

Charles E. Scott
THE ROLE OF ONTOLOGY
IN SARTRE AND HEIDEGGER

ONTOLOGICAL SEPARATION

S ARTRE is correct in saying that the question of being with others is at the center of modern metaphysics and ontology. How we understand the issue of ontological separation both expresses and gives further direction to our deepest expectations for individual and social relations. Our existence consists in how we are in the presence of others, and people have long been aware that we and the presence of others are violatable, that there are limits and possibilities which are given and which can be ignored only at considerable personal and community expense. Within the existential/phenomenological orientation we find the cultivated suspicion that violation of human being or being-in-the-world, however it be specifically understood, is part of our own tradition. We need a reconsideration of what is thought to be known about human beings in order to find ways to repair the perpetuated damage to ourselves in our cultural inheritance, and such a reconsideration involves questioning the assumptions on which "normal" certainties are based. One of those assumptions is the idea of substance, with its accruing ideas of causation, form and matter, time and eternity, perfection and plenitude. Another is the modern primacy of the ego for subjectivity. And a third asserts the primacy of knowledge for consciousness.

Both Sartre and Heidegger have played major roles in this questioning process, and their ontologies offer alternatives not only to the traditional notions noted above but to the general philosophical orientation out of which such ideas come. Each forecasts in his understanding of being appropriate ways of existing that violate traditional expectations and styles of life which are harmonious with the metaphysical ideas in question. The question of how we are foundationally present with ourselves, with other humans, and with non-human things lies at the heart of their revolutioniz-

ing inquiries. Their thinking serves to reorient our expectations about ourselves and how we live, and to teach us to think and see in ways that are appropriate for how we and the world are together.

How things are present with consciousness is the subject of *Being and Nothingness*. How human beings stand in relation to things is to be understood through a descriptive account of consciousness, and our access to consciousness is to be found in how things are manifest. This is not to say that consciousness is merely a complex set of meaning relations—that would imply that consciousness knows only itself, which Sartre finds to be a clear denial of my awareness of, say, my shoes or of you as being quite distinct from my awareness.[1] Both my shoes and the other person are apparent in their difference from my consciousness of them. That of which I am aware happens as distinct to my consciousness. I am always related to what I, as conscious of something, am not. That concreteness of difference is ineluctable; moreover it allows us to see that when we deal with consciousness we are not dealing with mere abstract relations, any more than we are dealing with purely psychological relations, only intentional awareness, or an empty self-relation of identity. In short, this point of departure allows Sartre to emphasize that when we describe consciousness we are describing how things must occur for human beings (that is, we are doing ontology) without engaging in either a Fichtean or Hegelian logic that makes consciousness primarily an abstract principle of identity.

But why, then, is Sartre so concerned with the issue of solipsism? That issue runs through *Being and Nothingness* and is one of *the* positions he seeks to refute. Sartre bases his conception of the concrete otherness of things on the principle that consciousness differs from everything other than itself. Consciousness is a position or posture. That means that in being aware of my shoes I am also immediately aware in being that awareness. Or, consciousness is absolute in the sense that the appearance of what I am not is also my own appearance. In my consciousness of what I am not, there is no non-conscious aspect. Consciousness *is* a manifestation that manifests itself, a self-disclosing disclosure of something other than itself. So consciousness is, after all, isolated. There is a fundamental ontological difference between consciousness and what appears for it. And as self-aware, as absolute, consciousness is a realm (Sartre says *field*) that cannot be anything but itself. It cannot know itself or be known by anyone else without negation of its being (i.e., its conscious immediacy). It cannot express itself "in" anything publicly available without loss of its own being. It is not egological; that is, it is no one conscious historical and social identity, but is the immediate non-objective, non-personal foundation of all that appears and can be named and referred to.

So the *world* is what human consciousness is *not*. And consciousness as an object for itself is also what human consciousness is not. The elucidating power of this description can be seen as Sartre names aspects of conscious occurrence and shows that they cannot be dissolved into a primordial unity of identity. He says:

> The task which ontology can lay down for itself, is to describe this scandal [of the plurality of consciousnesses] and to found it in the very nature of being, but ontology is powerless to overcome it. It is possible . . . that we may be able to refute solipsism and show that the Other's existence is both evident and certain for us. But even if we could succeed in making the Other's existence share in the apodictic certainty of the cogito, i.e., of my own existence, we should not thereby "surpass" the Other toward any inter-monadic totality. So long as consciousnesses exist, the separation and conflict of consciousnesses will remain; we shall simply have discovered their foundation and their true terrain.[2]

Consciousness never happens as an uninterrupted unity, and plurality gives us no basis to claim that behind the occurrence is an identity that gives an essential sameness to appearances.

We may now bring together two principles: being is manifestation, and determination is negation. The distinctiveness of consciousness is found in its immediacy. It is manifest as negation in relation to particular things that are distinct from consciousness. We have access to human consciousness by means of negation; that is, by describing how things are manifest we are in the field of what they are not. In accounting for how they are not what they are, we give an account of consciousness. This claim raises many issues, but inasmuch as our interests presently are not methodological we shall observe only that the separation or utter distinctness of human consciousness is to be found in its non-objectivity, which appears in negation. To approximate Sartre's language more closely: negation is founded in being. That means that we may give an account of the foundation of what appears by describing the occurrences of negation.

That of which we are aware is always an object which, on the one hand, consciousness does not create and which, on the other hand, happens for consciousness. The object does not happen *in* consciousness as a structure of awareness. It happens *for* consciousness, as a way of being that is defined by how it is related with consciousness. *World* thus means how non-conscious things appear with consciousness and are organized by it. Even with so short a reflection on Sartre, we may be certain that he has avoided the claims of solipsism, and for the purposes of this essay we may assume that he makes good on his refutations by his extensive phenomenological account of such situations as "The Look."

We have seen that consciousness is a sui generis way of being that is immediately and pre-egologically or pre-thetically self-aware and is at the

same time aware of things that it itself is not. Awareness of a thing occurs in its transformation from being-in-itself to being an object for consciousness. This transformation is negation, and we must investigate this idea more closely in order to understand the separateness of human consciousness.

Let us look at several statements by Sartre which, although they deal with both conscious and non-conscious beings, are complementary: "Presence is an immediate deterioration of coincidences, for it supposes separation."[3] "I cannot know myself in the other if the other is first an object for me; neither can I apprehend the other in his true being—that is, in his subjectivity. No universal knowledge can be derived from the relation of consciousness. This is what we shall call their ontological separation."[4] "[T]here is a truth of consciousness which does not depend on the Other."[5] "[T]he sole point of departure is the interiority of the cogito."[6] And finally, the Other occurs as a transcendence of my being "which conditions the very being of that interiority."[7] This conditioned interiority, which is not reducible to any other way of being and which is *the* point of departure, is a state of need, a lack, an impersonal desire for what it itself is not. It aims for self-sufficiency, to be the cause of itself,[8] to be unconditioned. It seeks to restore "the totality which has been broken by the lacking," "a synthesis of the lacking and the existing." And "what the for-itself lacks is the self—or itself as in-itself."[9] These statements mean that consciousness seeks its own dissolution—it seeks to dissolve itself as an internally split for-itself and to become being-in-and-for-itself—and in its quest for completion it always devours what it is not. But in this search for self-fulfillment by means of consuming or taking in (objectification), everything it encounters lacks exactly what it needs—namely, an undivided plenitude of freedom from the rift of nothingness. Everything that consciousness encounters in fact conditions it in the encounter and has its objectivity in being as it is *only* in relation to the very consciousness that seeks to overcome the rift that defines the objects' objectivity. Nothingness—in this case the ontological difference between consciousness and that of which one is conscious—is the difference between a fundamental state of desire for unconditioned wholeness and a non-desiring object that cannot fulfill that desire. We may say that the ontological principle of separation means for Sartre that human beings are related to things not by steady, knowable categories, but by desiring, and that "things" always *are,* or occur, as differentiated in relation to this desiring state. The desiring nature of the cogito is the meaning of our fundamental separation in relation to others.[10]

In *Being and Nothingness* Sartre interprets Heidegger as falling into the same problems that Sartre seeks to avoid. Although since Sartre wrote *Being and Nothingness* Heidegger has written a great deal that has clarified his intent, we should at least take note of the way Sartre understood

Heidegger in 1943. In so doing, we shall see how this highly influential interpretation of Heidegger cast into clearer relief Sartre's own position in relation to ontological separation and at the same time constituted a fundamental misreading of Heidegger's thought.

Although Heidegger and Sartre commonly reject both the primacy of knowing for being and the primacy of ego for human being, Heidegger rejects entirely the significance of the idea of the cogito in interpreting human being.[11] Consequently, for Heidegger the ideas of negation and nothingness have neither the methodological nor the ontological significance that they have for Sartre. In Sartre's view, this fundamental difference means that Heidegger makes human being into a transcendence that "surpasses" the world, and in this context *surpasses* means *withdraws from* the world.[12] Whereas Sartre sees human consciousness as a dialectical relation with what it is not, he finds Heidegger making *Dasein* a "transcendental relation to the Other." The "structures" of *Dasein*, Sartre says, are transcendental (that is, constitutive of isolated human being), but not egological, in nature. As a result, he sees Heidegger turning away from concrete relations with Others and attending to *Dasein*'s relation to its own internal self-transcendence. This means that whereas Sartre finds transcendence always in the concrete presence of the Other, he interprets Heidegger as ignoring specific particularity and as looking for a fundamental but abstract category for Others within *Dasein*'s own being. According to Sartre, "The ontological point of view" found in Heidegger "joins with the abstract view of the Kantian subject."[13] It does not go beyond "an essential and universal capacity."[14]

Desire in Heidegger, in this reading, becomes a project of self-development in which a person aims at an appropriate relation with his own transcendence. One attempts to "make" himself in conformity with his own being and, ideally, as we all hear the inward command of fundamental possibilities we become alike in our authenticity—like a well-trained crew that follows the basic rhythm of the oars and the calls of the coxswain.[15] Authenticity is a "mute" existence in common with others who are attuned to the inwardness of their being. This "fall back into solipsism"[16] means that we are faced with the basic alternatives of choosing either a life governed by norms external to our being or a "resolute decision" to attend to one's own being.[17] In both cases, *Dasein* is thought of as transcendental subjectivity which is not immediately aware of itself and is not constituted by concrete relations to what it is not. In short, Heidegger does not offer an adequate basis for showing how we are in fact concretely related because he has only "affirmed" being with others and has not explained how our co-existence is possible.[18] In Sartre's reading of Heidegger, *Dasein* is understood as isolated because human being is posited as

fundamentally out of context with Others. We are all mountaintops which form an attractive and picturesque scene from a distance, but which lack constitutive interrelatedness apart from the synthesis provided by the on-looker.

For Sartre, the immediate self-awareness of being aware of other be-ings names the separate inwardness of consciousness; and as Sartre sees him, Heidegger simply ignores or overlooks this state in his effort toward a new ontology. The Heideggerian account does indeed have a center of focus that is basically different from Sartre's account of the cogito. Heideg-ger's concept of disclosure, or unhiddenness, forms the interpretive center of his description of human being. Sartre is right in saying that when one begins with consciousness, conceived as a cogito, the immediacy of the con-scious state means a fundamental separation from the world. Heidegger, on the other hand, finds no adequate basis for the conviction that the cogito is adequate as an interpretive principle for human being. *Dasein* is being-in-the-world, which means that *all* events are characterized by the ontological structure described in *Being and Time*. This book is a descriptive account of how things come forth, and that means that for Heidegger there is no trans-worldly realm of human being, no a priori subject. Being-towards-death, for example, names one aspect of how *beings* are disclosed, not how a person is always by himself. The greatest difficulty in understanding this central concept in Heidegger's work arises when one believes him to be dealing from the outset with a transcendental self. Then his statements do indeed sound as though he were dealing with an a priori state of isolation. But when one understands that his ontology in *Being and Time* is a descrip-tive account of how things are disclosed, one sees that the entire discussion deals with the concreteness of human being or being-in-the-world and that disclosiveness, occurring as human being, not consciousness, is the subject of the entire discussion.

Entschlossenheit, to take a further example, is frequently translated as "resoluteness" and was taken by Sartre to mean a decisive resolve, a fun-damental choice. Within *Being and Time*, however, it has the meaning of unlocking (*ent-schliessen*), or uncovering, and carries for Heidegger *no* vo-litional overtones. An opening up to how things come forth is simply an allowance of things in their truth or disclosure. The term indicates no desire at all. It is to be elucidated rather by the idea of allowing things to be as they are (see, for example, Heidegger's discussion of truth in *Vom Wesen der Wahrheit*) or of release to disclosure (as in *Gelassenheit*). The insight developed in *Being and Time* is that *Dasein* is a realm of openness which is fundamentally non-volitional and non-subjective, and which finds its fulfillment in a release to the disclosiveness of things, a release that is the opposite of denying the concreteness of beings. *Dasein*, as a realm of dis-closure, is always in the disclosed presence of beings. There is no *legitimate*

question about the reality of beings (that is, solipsism is a problem generated by certain substantival ways of thinking). There is rather the problem of finding a language that allows us to interpret human being in a way that takes account of the primordial manifestations of things in the openness of *Dasein*, a language which does not assume from the start a trans-worldly dimension of human being. All separateness is founded *in* the manifest presence of things. There is no primordial subject/object distance in being-in-the-world.

In his discussion of *Verstehen*, or understanding, Heidegger is describing one fundamental way in which human being is worldly.[19] In his conception, the word names a way in which all beings are disclosed in the world-openness of human being; it does not name a subjective state of being. The word names the givenness of the meaning and significance of beings. This given meaningfulness makes possible interpretations and misinterpretations. Meaning is not to be found in a transcendental structure or by virtue of a constituting activity. All projecting *activity* is founded in the enabling possibilities given with the manifestness of things, a manifestness that is not "done" or "made," but is the non-reducible apparentness of possibilities and relations. *Human being is the disclosive occurrence of beings.* It is not something behind and extrinsically related to the way things come forth. "Understanding," as the given possibilities of beings, means that human being *is* an understanding by virtue of the disclosure of things. This is a view of immediate, pre-thematic comprehension without subjective or cogito-oriented assumptions. The ways in which beings are, unintended and uncalled for, make up a particular being and constitute a complex of possibilities, directions, and histories, i.e., constitute a highly complex understanding on the basis of which one is able to set other specific directions in the bestowed directions of the particular occurrence.

Whereas Sartre speaks of the immediate pre-thetic consciousness of being conscious, Heidegger says that *Dasein* is its *there* in understanding. The differences between those two claims is immense. Sartre is articulating a principle for the world-separateness of a cogito. Heidegger is speaking of the non-subjective, non-objective immediacy of beings. Beings are at once constitutive of a human event and make up an understanding, a non-volitional state of comprehending things non-thematically in their coming forth in *particular ways with specific, given, and historical relations.* This immediacy, for Heidegger, indicates both the specificity of things and their apparentness without the principle of ontological isolation or the idea of a transcendental subjectivity: his comprehension of immediacy establishes a claim quite the opposite of Sartre's claim.

Instead of being an a priori structure, the ontological aspects described in *Being and Time* are ways in which human being seems perpetually to be addressed or claimed. To be addressed means to be positioned or poised in

a certain way by virtue of how beings are manifest. Human existence, then, is to be understood as a realm of address, and *world* is to be taken as a hearing realm of openness where addresses occur. Heidegger's ontology is an account of how address occurs in hearing openness.

Thinking, for Heidegger, is thus a way of letting beings be apparent in how they come forth rather than a re-cognizing of something at first synthesized into a sense datum or into an intentional matrix. Rather than a re-presentation of something, thinking is a release to how beings are already manifest. One way of interpreting this claim of Heidegger's is to say that thinking allows our given understanding. It is a question of not dictating how what is already there must be. The basis of this claim is his understanding of openness or *Dasein*, which replaces a transcendental subjectivity as the clearing for beings. Beings are not the result of a synthesis on the part of a conscious subject, but are already given when synthesizing acts of any sort on the part of individuals take place. I shall close this reflection on the ontological status of separation by noting Heidegger's understanding of release and nearness vis-à-vis beings. We shall then be in a position to consider the purposes and limits of ontology in relation to Heidegger's concept of Being and Sartre's understanding of creative activity. Our aim presently is to see more clearly what Heidegger means when he says that thinking is a matter of releasing oneself in the disclosiveness of beings.

Heidegger's attempt to develop his language with respect to Being has involved a thorough rethinking of our presence with beings. When we deal with beings we are telling only the preliminary part of the story, given the primacy of Being for his thought. The context of Heidegger's account is the encrusted state of our ways of seeing and the consequent difficulty of using language without implying immediately an ontological separation of man and beings: we cover over things with expectations, interests, and ideas in which we recast how beings are disclosed. We then re-present them, make them over according to what we want or think to be right according to our expectations, and we have always as a result an object of interest. That means that from Heidegger's way of thinking, Sartre's ontology is an account of how we relate to beings in desiring, or how we impose projects on what is *already* present as something. The inevitability of separation for Sartre arises out of the primacy he gives to *a* way of being, namely desiring.

When a person is open to what comes forth without imposing desires, he is appropriated by the disclosive event. The word "appropriated" in this context, should be understood as "given a place"; that is, the *a* is taken as privative, and we see the word as meaning "giving place for something," "moving out of the way so that something can take its own stand." To be appropriated by a disclosure of something means that one steps back to allow something to be as it is, and that one finds himself then "hearing" the

cleared disclosure. One then, for example, speaks out of the disclosure rather than at it; one then is attentive in the presence of something rather than over against it. One allows something to be as it *is* and bespeaks rather than objectifies the occurrence. It is like the difference between living in a friendship rather than talking sympathetically about a friendship. What is there is no longer hidden by the veil of my demands or concerns. I am free to be concerned with the being as it occurs, and I am not bound by my dictates as to how it must be in order for me to be concerned with it. Beings then are found to be near on their own account and not because of my looking at them or focusing on them. They are already available for looking or focusing when I make such a move. Heidegger's account allows us to see an option to claiming that human existence is in some sense trans-worldly and separated from what is present with it. The opposite of "separateness," we now see, is not "union," but non-objective apparentness. *Concealment* and *hiddenness* do not mean primordial bifurcation. They mean present, but veiled, disclosed but refused, covered over. Ontology consequently involves the development of a language that allows description of how things are veiled and unveiled, a language free of the assumption of ontological separation by transcendence or by the mechanics of conscious synthesis.

We have only skimmed the claims of the founding work done by Sartre and Heidegger. But we can see that ontology for each man is a descriptive account of how beings are to be. For Heidegger, ontology is a preparatory process. By coming to see that human being is a disclosive event and that beings are non-objective disclosures, we are poised to wonder what disclosiveness or openness itself is like. Description has taken us to the question of the basis for disclosures. With Sartre, one is left wondering how, on his terms, one is to go beyond a destructive process of continuous alienation. Is bad faith, or self-deception by one's identification with objects, the final word for human existence? Do we live only by lying to ourselves?

Both ontologies have led us to the edge of descriptive thought. Both suggest implicitly, by the questions they raise, that ontology cannot be a way of solving the issues of our existence. Both suggest that thinking correctly about how things are is a beginning that leads beyond ontology. Both ontologies show that ontology should lead one beyond the limits of careful, accurate descriptive reflection.

BEYOND ONTOLOGY

Descriptive accounts of how human beings and other beings occur issue in knowledge. When we reflect on the uses of ontology in Sartre and Heidegger, we reflect on a type of study that cannot itself fulfill the aims

that it has discovered to be fundamental for human beings. We are already clear that knowledge, in the sense of discursive, reflective interpretation, is not a *culminating* type of awareness: our study of how beings happen has led us away from the reflective connections of intelligence to non-thematic ways of being aware, and our discussion of negation in Sartre and disclosure in Heidegger has made apparent that pre-thematic ways of being are not completed or fulfilled in thematic consciousness or knowledge. The central use of ontology for both philosophers is to lead us beyond ontology, and that is the case because the center of their thought is to be found in what is generally called authenticity, or ways of being appropriate for the way being is. For Sartre, ontology rightfully leads to undeceived activity, which I believe may be taken to be a type of enlightenment. For Heidegger, it leads to "thinking Being," a topic we shall explore later in this paper. And in both cases, the specific knowledge of an adequate ontology is not necessary for the achievement of the projected goal, although in many cases it may be most helpful as a preliminary way of seeing. Ontology for both men is an interpretation of how things occur that may allow us to see at a distance how human being is to be fulfilled.

Not only does reflective description have limits that prohibit it from becoming an adequate way to be conscious of things. An ontology, once conceived or written, is accomplished. It may be remembered or learned or followed. But its moment is then lost—it *is* as an act of envisagement. Once it is institutionalized—published, noted, quoted—it is an object, a finished product. Sartre turned down both the French Legion d'Honneur and the Nobel Prize for Literature in affirmation of his own non-objectivity as well as for political reasons. He refused to identify himself with any established cultural point of reference. And similarly he would assert that a conceptualized scheme is to be thought, but not kept. If we think with Sartre, we shall be motivated to find our own way to give individuality to the space around us. We shall have learned from him not how to be ourselves, but how to see our own negation and that of those around us. We shall have come to accept what we can think only at a distance. That acceptance happens as we carve out relations and perspectives either free of illusions or alert to their illusoriness, and ontology has its concrete limits insofar as one man's illusion may be another's honesty. Sartre's emphasis always falls on the concrete, and ontology has its use in helping us to see what is specifically the case in the particular situation. This "help," I believe, is limited to ridding us of general expectations and aims that overlook the negation of immediacy by conscious action. When we are helped in this way, there is no necessity to remain academically with the ontology. We are then free to be as we are.

A central part of Sartre's passion has always been to see. In *The Words*, he records his illusions and tells of his release from many of those illusions through irony and perspective. We may be sure that seeing for him means being free of illusions—and part of that freedom consists in expecting to be captured by illusions, to be duped, to find oneself not superior to others by even a whit because we all are subject to deceptions. *Being and Nothingness* is thus to be understood as one path on the way to a clearing in which Sartre can see with fewer lies. It was written over thirty years ago, which is a long time for a man who says in *The Words* that it is only the book that he is writing that really counts,[20] and he has written much since he wrote that first installment of his autobiography. His project of acting with unclouded honesty means that we are misled if we center our interpretation of his ontology on his particular use of a transcendental method, or if we develop his claims as a theoretical superstructure that makes sense historically as a departure from Idealism and a founding contribution to Existentialism. Those are secondary issues. What counts, in his terms, is whether we come to see ourselves and our world with fewer deceptions as we read the essay. The emphasis must fall on how we see and what we see, and neither the *how* nor the *what* is primarily a theoretical structure. It is misleading to say simply that Sartre is seeking a kind of salvation—that is true to an extent, but the term "salvation" muddles the point because of its history. Perhaps we should say that he has sought an appropriateness of attitude vis-à-vis his being, a lessening of contradiction between intention and the foundation of intention. This appropriateness is a way of being conscious, a way of living, a way of informing oneself and relating to others.

As we move beyond ontology we find the meaning of ontology in a way of living that can make a place for reflective thought, but is always more than reflection, a broad circumference of consciousness which thinking rightfully serves. We must leave ontology in order to understand its plan and use.

Fundamental separation means the inevitability of objectification. The other is always either objectified or the objectifier. Non-objective immediacy occurs only as one's own being conscious. As one produces or makes objects he is immediately himself in his activity. He may adopt the other's view of him, may sell out to a self-image, or may identify himself with his own past out of which he lives. But he is a fundamental project, be it to escape something frightful, to waste time lavishly, or to make something because it pleases him. In the uncritical immediacy of that project, even when his aim is to dissolve all reality into a criticism, he is no other. In being no other, the individual "distances, isolates, and separates" himself.[21]

The recognition and acceptance of this separation is the aspect of being appropriate to one's own being on which we shall concentrate.

The turning point for a person, found by Sartre most specifically in an artist, is when he "becomes conscious of his solitude."[22] The impotence of being only my own act, the fragility that "becomes the sole plenitude,"[23] is the center of one's awareness. This center is the opposite of illusions which fill one with images that are taken to be unions of self and world or an unbifurcated fullness of reality. "The Absolute is absence. . . ."[24]

Genius is born as "a conflict between . . . a finite presence and infinite absence."[25] Sartre used the word "genius" in the context of the artist, but it may be taken to pertain to a lived, appropriate insight on the part of any person. It fosters an undeceived effort to project out of the absence, to overcome the absence with one's own project, to fill the emptiness, "the imbecile passion of a part for the whole, an icy tenebrous wind blowing through perforated hearts."[26] It is a project that is aware of its own absurdity in its passion to find a moment of completeness or awareness of the rest of reality.

Calder's mobiles give expression to this state of being. "His mobiles signify nothing; he captures and embellishes true, living moments." They "refer to nothing other than themselves."[27] These creatures are made of slivers, bits and pieces, threads, wires, plumes, and stems. They come into motion as a wind chances to pass through the ensemble or as heat provides mobility. Then they go into unpredictable agitation. They fly or beat the air, rotate, spiral out or upward, flutter, and make sounds, only to collapse in upon themselves as the breeze dies away. They "imitate nothing." They "create chords and cadences of unknown movements."[28] They fill a space with a motion that is defined by its chance beginning and its inevitable end. Add undeceived awareness to such an ensemble and you have an authentic man.

Calder's mobiles have their expressive power because they are structures that bespeak their isolation and superfluity in their movement. *How* they move reveals rather than hides the gapped and non-material nature of their own being. "Their hesitations, revivals, gropings, fumblings, abrupt decisions, and especially their swan-like nobility make Calder's mobiles strange creatures, halfway between matter and life."[29] Their way of being particular expresses also their non-necessity and their remarkable independence of how they are viewed. They are simply as they are, without justification. Their movement is defined as much by the absence of completion and fullness of being as by their specificity and uniqueness.

The inventiveness of Calder and Giacometti indicate to us the task to which ontology is subservient. Speaking of the latter, Sartre says: "His substance is a rock, a lump of space. From mere space Giacometti therefore

had to fashion a man, to inscribe movement in total immobility, unity in infinite multiplicity, the absolute in pure relativity, the future in the eternal present, the loquacity of signs in the tenacious silence of things." [30] Our reflective thinking is to be an interpretation that sees things in a space that cannot be overcome, an awareness that the project to see things is at once an effort to overcome the distance that we find inevitable. Giacometti's figures have a direction of centripetal force, "giving the impression that in five minutes [the face] will be the size of your fist, like a shrunken head." [31] Giacometti was consistent with his work. He destroyed most of his sculptures. He lived simply to carve. He "is forever beginning anew . . . there is . . . a unique problem to be resolved: how to make a man out of stone without petrifying him." [32] Or how to describe things without reification, how to see without falling prey to what *has been* seen, how to be appropriate to the immediate separateness of being aware, a distance that no completed work and no recognition can overcome.

This appropriateness means continual leaving, the opposite of a search for final truth or for certainty on which we can rely. An ontology articulates how one sees things to occur; but one falls into profound contradiction if one agrees with Sartre and yet holds on to the descriptions he has made. Giacometti teaches us that it is the seeing and the making that count, not the seen or the made. One can be appropriate to the immediacy of consciousness only by letting its products die, by continuing to see anew. Or, we read *Being and Nothingness* with sympathy as we look with the essay, see through its words, and let it go as we see. This is the opposite of bad faith, found in the act of making, unconcerned for what has been made, undeceived by objectifications of oneself, releasing the made to be a provocation for those who want to look through it. Authenticity is found in the rubble of broken masterpieces in the corner of Giacometti's studio.

We may also see the meaning of authenticity in the distance that is "part and parcel" of his paintings and sculptures. His figures are "united by their solitude." They are "hopelessly alone and yet together." [33] Things are *there*, certainly. The world is not an idea or an abstraction. Aloneness is the way we are together. We are united by a distance that pares us away, dissolves the solidity of certainty, and allows us to collapse in unshareable immediacy in our very act of relating. The immediacy of what we share means that human being must fall away from what it makes in order to be itself. We are beyond ontology, and to be appropriate to our own being we must see our ontology as a deception once we have seen with it. [34]

Heidegger's thought too may be understood as one accepts it and leaves it behind. One's insight into the validity of his ontology involves the recognition that correct ontological description is insufficient for the topic of Being precisely because of its correctness. We have known since *Being*

and Time was published that it was to be taken as a preparatory discussion, that Heidegger's intention was to develop an approach to human being that freed his thinking from the Cartesian legacy and showed at the same time that human being cannot be interpreted adequately without an account of Being as such. Being emerges through *Being and Time* as not susceptible to objective grasp. Objectively we may see that Being is disclosing. We may see the limits of our ways of knowing, etc., but thinking is not limited to objectification or to descriptive, speculative, or analytical kinds of activity. Thinking may be a transparent awareness of beings *in* their disclosure, not necessarily objectively over against this disclosure. Sartre and Heidegger both see that Being has dominance over discoursive understanding in human awareness, that how something comes forth occurs as its own truth in its disclosure, and that the *coming forth* of beings is the deepest human language. This "speaking" of things is how they occur. It is the basis, the "foundation," for referential or descriptive ways of speaking, and the aim is to find that language, those ways of being, that articulate what ontology can speak of only at a distance. But we have found Sartre and Heidegger to disagree profoundly on the watershed issue, the question of ontological separation. And we find this difference spelled out in their divergent ways of using ontology to go beyond ontology.

The philosophical basis for going beyond ontology is the recognition that the faculty of comprehension articulated in ontology is limited with regard to both human awareness in general and the way things occur in particular. Ontology can be both thoroughly accurate and insufficient for its subject matter. Describing is a re-presenting or tracing out of something. When we allow our words to be molded by the contours of our subject, as distinct from bringing a canon of skilled clarity with us as the criterion of what the subject can be like, we are already countenancing the concreteness of what is at hand. Our descriptive language, out of respect for the concreteness of relation among ideas, feelings, and things, will strain the boundaries of meaning and always go beyond the often insensitive borders of day-to-day comprehension. Yet when we have finished, even if our work is blessed with descriptive genius, we have a representation, an abstraction, that violates the immediacy and concreteness of our awareness. We inevitably see more than we can say in objective descriptions, and our description has helped us toward this understanding. Both Sartre's and Heidegger's ontologies have the purpose of creating dissatisfaction with the limits of what they have done. For Heidegger this means that *Being and Time* leads to a developed dissatisfaction with the language and conceptuality of that essay, a *relinquishing*, as he says in *Gelassenheit*, of satisfaction with the reach of his own way of thinking. In the ontological, descriptive aspect of Heidegger's thought, that is, in *Being and Time,* we must speak

of *awareness,* in the sense of mood and understanding. But in the move out of his approach to human existence the central words are *language* and *thought,* and he has not used the language of *awareness* in relation to these words. His sense for Being indicates an Openness that may not be approached adequately on the basis of awareness. His reason for this approach is his perception that anything that leads in the direction of a language of inwardness or subjective apprehension distorts our understanding of Openness. But in my opinion he is developing, in fact, a new understanding of awareness, arising out of his perception that human being is a non-subjective, perceptive event that is aware in the non-objective disclosure of things. Perhaps H.-G. Gadamer has carried this insight the farthest, in his understanding of language and tradition.[35] But in any case we should see Heidegger's reflections on thinking and language as meditations that free us from the idea that awareness is an inward state of mind that is fundamentally private and outside of the world. Heidegger has laid an initial foundation for seeing that awareness happens as the coming forth of things in disclosive openness, not in a conceptual or desire-oriented framework.

The aim is to release oneself from the desire to describe, so that one is free for the disclosiveness of his own existence. The thereness of our existence, we have noted, is not the upsurge of desire, but the open situation for the disclosure of beings.[36] When we allow this region of openness without mandate, we find that our existence is not fundamentally a drive or hunger, but a non-controlling, hearing openness where things come forth in particular ways. We are in the truth of things. As we relinquish our grasp on things we find that we are already "appropriated" in Openness; we are already situated in dis-closure or uncoveredness. We allow the non-volitional Openness that appears with all appearing things as we cease to make demands on how things can be.[37]

Thinking, in this context, is an undemanding awareness that happens as release to how things come forth and waiting for the appropriate language. *Waiting* is not like smashing the last statue or grasping for a figure that consumes itself as it becomes apparent. It is an absence of demand and expectation, an allowance in an unclouded dimension of Openness where things strike their own accord.

In our effort to achieve a working order of things and to give our world a rational viability, this language has an absurd ring, although certainly no more absurd than a Calder mobile. Within any perspective that is completely governed by singular drives, it *is* absurd. Heidegger waits for language to come. His struggle is to reach the released place of waiting. And after that, anything. His claim is that Openness—the region of disclosure—is man's "home," and that we misplace ourselves when we

identify our being with any particular state that is disclosed. That is because our being occurs as open immediacy with the immediate forthcoming of whatever is there. Our being is uncovered to us only by our release from defining structures—which is the same as being free for ourselves as we are. But this release is "an opening of *Dasein* for the coming forth of Truth's nature."[38] It is not a negation and it does not manifest a primordial separation. It reveals an Openness that accommodates relations of distance or closeness. But above all, it reveals the disclosiveness of Being which is independent of volition. Volition, rather, is one *way* of disclosing which has no privilege for the whole of human being.

Heidegger's effort is to go beyond ontology to non-representational thinking in which the name of what happens comes with the happening.[39] That impresses me as a cultivated state of awareness in which one gives up his demands and finds where he is prior to his demanding—a state of being that can be put so simply, but which is remarkably difficult to achieve. Heidegger's ontology has prepared us to allow Being's openness, which is no part of a project, and in which we find ourselves released as we are with beings which we have not created and which are not separated from us by a gulf of self-conscious immediacy. Through Heidegger we have found the world to be a region of openness whose inheritance we receive as we allow our openness in it.[40] This allowance leaves ontology behind, not simply as something finished, but as a way that takes us only so far in our effort to answer appropriately the claims that move us to be.

ONTOLOGY AND HUMAN WELL-BEING

The character of Sartre's and Heidegger's ontologies that is frequently overlooked is that they both internally demand that they be interpreted by reference to how one leaves behind the ontology. One "uses" each ontology appropriately by going through it and beyond it in ways such as those specified above. But there is a tension between that central character of their thought and the use of the ontological claims themselves. We are faithful to the ontology in going beyond it appropriately, and we preserve it in our ways of making place for the claims of Being in how we live through our various relationships. The difference between ontology and living out the claims of Being does not mean that interpretations of Being do not teach. We shall look at a productive aspect of this tension—this strain among discoursive thinking, its products, and the immediacy of awareness—by noting the relevance of ontology for understanding the fulfillment of human existence. In this case we find that ontology guides our expectations and our work with responsible, descriptive reflection. In describing how human being is, the philosopher opens our thinking to how

human existence may reject or fulfill itself. Ontology, as Sartre and Heidegger have carried it out, provides bases for understanding the meaning of human well-being and being ill and also shows one way in which we may both preserve and go beyond the insights of this particular philosophical discipline.

Ontology, Sartre says, teaches us about desire, "since desire is the being of human reality."[41] We have already seen that *desire* is the name for the immediacy of human being, that it means separation by negation from everything with which it has contact, that it is a state of emptiness or need, and that it occurs as a consuming effort to fill itself—to be in-and-for-itself. Human being is a finite, fundamental aim to be God, an imperfection for which perfection means the elimination of need and negation. Whether such "fulfillment" be interpreted as death or as divinity, it would be the annihilation of human being: human being *always* means the destruction of itself in its aim to overcome its own, definitive contingency. Sartre's ontology teaches us that human well-being involves perpetual incompleteness, a wish for self-destruction by perfection, and the impossibility of the "ideal" of the desire to be.

Sartre's account brings with it a huge segment of Western culture: the primacy of will, the priority of the individual, the significance of self-denial and self-expression, the infinite otherness of absolute being. His characteristic mark is his rejection of the idea of substance, his expansion of consciousness far beyond the limits of knowledge, and his separation of human being from all resources other than its own power of desire and its contingent relations with other finite beings. His passion has been to live without God. He consequently is able to develop a remarkable critique of dominant values and ideals that have as their basis belief in either some type of providential power or a fundamental community of human beings which makes negation and separation unnecessary. Our overcoming such values and ideals is necessary for a living self-acceptance that is appropriate for how we are.

His ontology is addressed to our theoretical heritage which cultivates our ways of living. It has the destructive task of showing us that much of our thinking and the aims consequent to it misapprehend the way we are. Its constructive task is to point out the fundamental elements of human being which can be violated only at the cost of unnecessary self-alienation and conflict between ourselves and our values.

And that means that our ideal of ontological union, our belief in a providential God as the ground of our being, or our uncritical and living acceptance of values as objective realities are ways of being alienated from ourselves. They are ways in which we violate the negation and separation of our own being. For Sartre, the aim to be on the part of human existence

294 CHARLES E. SCOTT

finds its fulfillment in a living acceptance of how it has to be. The ontology which we leave haunts us in the inevitabilities of our being, which we experience in the destruction or confusion of the desire to be ourselves when we live deep deceptions, deceptions that deny a world we already understand non-discoursively. The inevitabilities of human being, inadequately grasped in a correct ontology, are concretely found as we refuse them in our deceptions and consequently cut ourselves off from aspects of the world, and as we discover our own appropriateness when we accept being with others and ourselves in negation and separation.

Human being is the desire to be. Sartre's criticism of Freud and Adler, for example, is that each took one way to be—sexuality and the will to power—and made these relative projects into the essence of human existence.[42] Sexuality and love of power are real for us all, but they may be means among other means by which we carry out quite different fundamental projects, like that of justifying ourselves to the universe, being an artist, or avoiding all danger. Our being means that we have a fundamental direction. But what the direction is is not adjudicated by our being. Our being is an issue only for how we live the direction we choose. The primacy of the desire to be for Sartre means that we are profoundly deceived so long as we treat the realities of our world as though their meanings were founded in anything other than our own particular, fundamental project. Such deception is at the heart of all "psychological" pathology.

We have already seen that desire happens as lack, in Sartre's account. I can be both a saint and appropriate for my being only if I accept the desiring process of my saintliness—only if I am free to accept my choice of consuming the world by making it an object of love. I can sacrifice myself for a cause appropriately only if I accept my absurd and impossible desire to be absolute in my sacrifice. In such cases of appropriateness I choose my fundamental project as *my* choice and gain sincerity as I lose that seriousness born of identifying myself with the object I propose to become. Even the behaviorist can be "authentic," I suppose, if he accepts his desire for consolation in the rigid world that he constructs for the purpose of prediction and control and thereby refuses to identify himself with the necessary, causal entities he uses in his explanations of "human" action.[43] Human existence is the desire to be. It is an immediate self-referential state that has no other justification and can be appropriate to itself only by accepting its own origin of the ways through which it lives itself. In this meaning of the word *responsible*, human existence fulfills itself in its responsibility, in its responding to how it is with appeal to nothing but itself. Healing occurs as we become free from illusions born of rejecting the primacy of our own fundamental choices for the meaning of what is otherwise absurdly present in the world.

Of the function of ontology, Sartre says:

> Ontology teaches us that desire is originally a desire of *being* and that it is characterized as a free lack of being. But it teaches us also that desire is a relation with a concrete existent in the midst of the world in that this existent is conceived as a type of in-itself; it teaches us that the relation of the for-itself to the desired in-itself is appropriation.[44]

We find that ontology "teaches" what a human being already "understands" pre-thematically, and we now see that the aim is not thematic understanding for its own sake but for the sake of that most fearful human possibility of accepting how we are. That acceptance constitutes a lived appropriateness with one's own being that is free of the illusions of justification, non-finiteness, worldless freedom, and non-possessing consciousness. Ontology teaches us the "meaning" of being who we are, and as such it is a basis for understanding the goals of being human.

In relation to psychotherapy, Heidegger's ontology has a function similar to Sartre's. And like Sartre's, Heidegger's interpretation culminates in ways of living only one possible aspect of which is correct description and interpretation. But the disagreement between Sartre and Heidegger concerning the interpretation of human being leads them to project very different ways of being in the name of fulfillment. For each, the content of the other's ideal must be taken as a deception. This profound difference should not be taken as indication of the inadequacy of ontology for the purpose of self-understanding. Rather, it points to the overriding importance of fundamental insights, to the embarrassing difficulty of understanding our own being, and to the necessity for critical, ontological thought if we are to understand reflectively how we are to be. A descriptive ontology cannot be proved or disproved by argument. It leads to sight and hearing, an opening to what is there so that it can be accepted on its own terms. Deception is usually a problem of not seeing or hearing something present, hence of living as though it were not there.[45] Arguments may help along the way to clarify a set of ideas or to find the limits of what can be said within certain forms of thinking. But the purpose of ontology is to allow us to see how things happen, to become attuned to how we are with things. It culminates in sight, not in closed conviction or conceptually self-referential certainty. The final question of ontology is, rightfully, Do you see how Being happens? We are driven over and over again to Being, which means that we are driven away from ontology by ontology. Such is the case with Sartre and Heidegger. The enormity of the difference between them, when cast in the context of human well-being, allows us to see clearly that *destiny* means how we live interpretations of Being. When there is such striking disagreement on the question of ontological separation between two men who are so remarkably aware of Western culture, we can be sure that our destiny as

a people presently is conflict and a miserable absence of self-understanding. Sartre and Heidegger reflect a deep split within our heritage that can be lived only as deep uncertainty regarding our destiny.

We have noted that the immediacy of Being for Heidegger is to be interpreted as disclosure, not desire. "To be" means openness for the coming forth of beings. We have seen that *release* rather than *possession* is central in Heidegger's interpretation. While for Sartre a therapeutic aim is release for one's possessive separation with beings, congruence with Heidegger's thought dictates emphasis on release to the releasement of Being. Heidegger has deciphered the non-volitional openness of the world which is already given in a desiring state. Sartre and Heidegger look in fundamentally different places when they interpret the meaning of being. When Sartre interprets Tintoretto's work, for example,[46] he ferrets out the basic aims and purposes of this man. When Heidegger interprets Van Gogh's painting,[47] he deals with how painting is a disclosive event. Sartre deals first and last with the way fundamental, pre-thematic desiring happens. He shows how such a state is not solipsistic, and how desiring is a way of being in the world, how we are with each other in separation as we desire. But he also finds in this state of desiring with the other the full reach of Being. Being-in-itself and being-for-itself and their relations constitute the perimeters of ontology. Heidegger rightly finds a dimension of occurrence that does not happen at all as desiring happens. His recognition of this dimension enables us to see that human well-being does not culminate in an acceptance of being separated with others, but in allowance of the openness of Being in which there is disclosive immediacy.[48] Consequently, whereas for Sartre fear of separation and negation is fundamental to pathology, for Heidegger fear of disclosive immediacy will form a center for interpreting our being ill.

The crucial phrase—allowance of the openness of Being—means, as we have seen, that a person is released not simply to how particular beings come forth, but to disclosiveness as such. Sartre's aim is the acceptance of desiring without illusion. Freud's aim was the acceptance of the unconscious and the dynamics between it and consciousness. Heidegger has pointed out that disclosiveness or primordial Openness is rejected only at the expense of closing oneself off from the region of the appearance of all beings, that is, from oneself as *Dasein*. By analogy, people sometimes find that opening themselves to the region of dreaming, with its absence of agent control and its disregard for self-image, discursive judgment, and specific moral sensibilities, is far more difficult than paying attention to the content of a specific dream that by chance comes to mind. Within a Heideggerian context, human well-being, which involves freedom from the *limits* of craving, desire, and judgment (although by no means the absence

of craving, etc.), means an unbounded welcoming of the non-measurable dimension world-openness. It is free allowance of an alert world-openness, to use a phrase of Medard Boss.[49] The existential impact of this release to the Openness of Being involves cultivating our immediacy with beings, an immediacy which is free of measurable relations and of demand engendered by desire. It is the freedom to be in the world with beings without the separations of desire, imposed justification, or illusion born of the fear of disclosive immediacy.

The circle we have found is that of ontology's inability to provide fundamental, human self-fulfillment and of our being driven back to descriptive accounts of Being out of the inadequacy of the fulfillments we have sought. A basic view of how things are and the goal of well-being assume each other. The issue of ontological separation and the differences between Sartre and Heidegger on the issue show that a consideration of how we are to be cannot ignore the question of Being, a question that needs ontology, but never finds its answer in any way of thought.

We have discovered a circular movement of people attempting to understand how they are with things, with this attempt raising the question of Being, leading to the discovery that that question takes one beyond the inquiry to ways of living, and those ways of living, in their *partial* fulfillment, leading again to the effort at self-understanding which promises a greater openness to Being, a better way of leaving ontology. Sartre's ontology allows us to see how desiring occurs and to see something of what the life of desire is like. We find Sartre's description, when thought out in relation to Heidegger, limited to the being of desire, and we find Heidegger directing us to non-desiring Being. To see Sartre and Heidegger in relation to each other is to find roots among the deepest in our tradition coming to incompatible claims that have to do with the fulfillment and denial of ourselves as human beings. In this context, the role of ontology is to discover and reflect a destiny that it cannot fulfill and that we, in either a privative or a fulfilling way, cannot avoid.

CHARLES E. SCOTT

DEPARTMENT OF PHILOSOPHY
VANDERBILT UNIVERSITY

NOTES

1. This means that Sartre rejects the place Ricoeur gives to symbol in interpretation. For Ricoeur a symbol is a meaning relationship (cf. *Freud and Philosophy,* tr. by Dennis Savage [New Haven: Yale University Press, 1970], pp. 28ff.), and the subject of interpretation is a dialectical and reflective relation of meanings. Both things themselves and the immediacy of consciousness resist symbolic relations and meaning, according to Sartre. His in-

terpretation of this resistance forms the core of his rejection of idealism and solipsism and forms the basis of his understanding of negation.

2. *Being and Nothingness* (New York: Citadel Press, 1966), p. 220.

3. Ibid., p. 53.

4. Ibid., p. 219.

5. Ibid., p. 215.

6. Ibid., p. 220.

7. Ibid.

8. Ibid., p. 57.

9. Ibid., p. 65.

10. Nothingness fundamentally characterizes desire as such. We shall deal with this central issue later. Presently I wish to show that for Sartre separation is a necessary aspect of all conscious relationships.

11. The following statement from *Being and Nothingness* (pp. 49–50) is particularly helpful for understanding how Sartre sees Heidegger departing from his own fundamental perception: "Heidegger, wishing to avoid that descriptive phenomenalism which leads to the Megarian, antidialectic isolation of essences, begins with the existential analytic without going through the cogito. But since the *Dasein* has from the start been deprived of the dimension of consciousness, it never regains this dimension. Heidegger endows human reality with a self-understanding which he defines as an "ekstatic pro-ject" of its own possibilities. It is certainly not my intention to deny the existence of this project. But how could there be an understanding which would not in itself be the consciousness (of) being understanding? This ekstatic character of human reality will lapse into a thing-like, blind in-itself unless it arises from the consciousness of ekstasis. In truth the cogito must be our point of departure, but we can say of it, parodying a famous saying, that it leads us only on condition that we get out of it."

12. Ibid., p. 18.

13. Ibid., p. 223.

14. Ibid., p. 224.

15. Ibid., pp. 222–23.

16. Ibid., p. 224.

17. Ibid., p. 222.

18. Ibid., p. 223.

19. Heidegger's entire discussion of how human being is *in* the world is particularly relevant to an understanding of how he avoids the alternatives of either separation or union in dealing with the presence of other beings. I shall discuss only *understanding*, but we note that Heidegger's interpretation of mood as being *in* the presence of others is quite a different way of understanding our non-cognitive apprehension of how we are in the world than that embodied in Sartre's discussion, for example, of nausea. For Sartre we discover the evacuation of our own selfness in our fundamental feeling. For Heidegger we find an enabling, given involvement that makes autonomy possible.

20. (Greenwich, Conn.: Fawcett, 1964), p. 151.

21. *Essays in Aesthetics* (New York: Washington Square Press, 1963), p. 57.

22. Ibid., p. 59.

23. Ibid., p. 60.

24. Ibid.

25. Ibid.

26. Ibid., p. 61.

27. Ibid., p. 124.

28. Ibid., p. 127.

29. Ibid., p. 126.

30. Ibid., p. 129.

31. Ibid., p. 87.

32. Ibid., p. 131.

33. Ibid., p. 80.

34. Ricoeur states: "No doubt I have an apperception of myself and my acts, and this apperception is a type of evidence. Descartes cannot be dislodged from this incontestable

proposition: I cannot doubt myself without perceiving that I doubt. But what does this apperception signify? A certitude, certainly, but a certitude devoid of truth. So Malebranche well understood, in opposition to Descartes, this immediate grasp is only a feeling and not an idea. If ideas are light and vision, there is no vision of the Ego, nor light in apperception. I only sense that I exist and that I think; I sense that I am awake; such is apperception." *Freud and Philosophy*, p. 44. In Sartre's understanding, consciousness, if consciousness be Ricoeur's meaning for *light* in the above statement, is never completed in an idea or in a philosophic truth. That means further that consciousness is not fulfilled in a symbol, but in the making and leaving of symbols or in the making and leaving of any other form of relationship. That consciousness is beyond "truth" is the meaning of the incompleteness and destructiveness of all truth that is taken as establishing a reliable and steady point for continuing and defining reference. For Sartre "interpretation" is always to be made by reference to non-symbolic, dominant desires or fundamental projects that are never justifiable by anything else and that are neither true nor false. Truth is founded in meaninglessness for him, and belief and faith are found as the pursuit of a desire that is never completed in a symbol or myth. Desire is *completed* only in bad faith. The opposite of bad faith is found in leaving the creations of desire.

35. Cf. *Wahrheit und Methode* (Tübingen: J. C. B. Mores, 1960).

36. *Being and Time* (New York: Harper and Row, 1962), p. 132.

37. Cf. *Vom Wesen der Wahrheit* (Frankfurt A.M.: Klostermann, 1954), p. 14.

38. *Discourse on Thinking* (New York: Harper, 1966), p. 81.

39. This claim is to be understood most clearly by reference to Heidegger's understanding of language, to which we must for the present make only this passing allusion.

40. By contrast, Sartre says: "Thus being-in-the-world is a project of possessing the world. . . ." *Existential Psychoanalysis* (Chicago: Gateway, 1953), p. 113.

41. Ibid., p. 61.

42. Ibid., pp. 51ff.

43. Cf. ibid., p. 54, for Sartre's critique of the behaviorist assumption of "mechanical causation."

44. Ibid., p. 84.

45. As an example we note Ludwig Binswanger's case of Lola Voss (see Binswanger, *Being-in-the-World*, tr. by Needleman [New York: Harper, 1963]), who tried to live as though her existence could be freed of all fundamental insecurity and who became insane in the process.

46. *Essays in Aesthetics*, pp. 13–76.

47. *Poetry, Language, and Thought* (New York: Harper, 1971), pp. 15–89.

48. Because of limited space I have not dealt with hiddenness as an aspect of disclosure. It is well to recall, however, that hiddenness for Heidegger does not mean the objective separation central to Sartre's ontology. Hiddenness for Heidegger names an aspect of how disclosure occurs non-volitionally.

49. "*Vernehmende Weltoffenheit.*" See Boss, *Grundriss der Medizin* (Bern: Hans Huber, 1971), pt. II, ch. 3. Under the restrictions of the present essay, I have not been able to develop Boss's appropriation of Heidegger for psychoanalytic theory, an appropriation that was developed in close association with Heidegger and is particularly germane to this last section. Boss develops the meaning of Heidegger's ontology for psychotherapeutic interpretation with remarkable penetration and poses a radical and innovative understanding of human being in relation to the classical theories of man within the psychoanalytic tradition. Cf. also Boss's *Psychoanalysis and Daseinanalysis* (New York: Basic Books, 1963), and *A Psychiatrist Discovers India* (London: Oswald Wolff, 1965), as well as his "Anxiety, Guilt and Psychotherapeutic Liberation," *Review of Existential Psychology and Psychiatry*, IV, no. 3 (September 1962): 173–96.

13

Monika Langer
SARTRE AND MERLEAU-PONTY:
A REAPPRAISAL

O NE of Sartre's finest articles is that written on the occasion of Merleau-Ponty's death in 1961. Reminiscing about their long and sometimes rather painful friendship, Sartre acknowledged that it was Merleau who had "converted" him to a genuine appreciation of history as the universal setting of human action. Although three years Sartre's junior, Merleau was nevertheless Sartre's guide, and the profound respect the elder accorded the younger never waned. During the turbulent postwar years the two collaborated in the editing of *Les Temps Modernes*. "Merleau had no other boss but himself," observed Sartre. "He was much better oriented than I in the ambiguous world of politics. I knew this. And it would be an understatement to say that I had faith in him. It seemed to me, reading him, that he revealed my own thoughts to me."[1]

Simone de Beauvoir, Sartre's lifelong associate, nevertheless has argued that Merleau failed to understand Sartre.[2] Such failure to comprehend need not rest on fundamental philosophical differences: de Beauvoir in fact suggests that the ideas the two men shared led Merleau, in the interests of proclaiming his own originality, to invent a "pseudo-Sartrisme" that served as a "contre-Merleau-Pontysme."[3] Although I would question the ascription of such motives to Merleau, it seems to me that there is indeed a fundamental accord between his position and that of Sartre. Further, I am in agreement with de Beauvoir's contention that the Sartrism which Merleau submitted to such scathing criticism in the *Adventures of the Dialectic* is a "pseudo-Sartrism."

I would maintain that, aside from any inherent interest their long association might hold for us, there is a very real philosophical gain to be made from reappraising the relationship between Sartre and Merleau. Of Sartre's innumerable critics, Merleau was without question the one best versed in both phenomenological ontology and Marxism. Sartre observed that they were not only friends, but equals.[4] Merleau's "pseudo-Sartrism"

is by no means unique. Other critics have adopted a very similar interpretation of Sartre's position. In fact, it seems to me that such a reading constitutes the most widespread interpretation.[5] Moreover, de Beauvoir points out that the public, aware both of Merleau's philosophical prestige and his long acquaintance with Sartre, has largely assumed that he knew Sartre's thought.[6] It is of no little importance, therefore, to establish whether this was in fact the case. An investigation of Merleau's "pseudo-Sartrism" will, I think, bring "genuine Sartrism" into focus and help to discredit prevalent misinterpretations.

It is impossible within the confines of an article to examine all aspects of the relationship between Sartre and Merleau. I shall therefore confine my discussion to some of the most important features. Further, I shall argue that the leitmotif of Merleau's whole philosophy provides the key to an understanding of Sartre's own position. In order to appreciate the full significance of Merleau's criticisms, the context of the immediate object of his attack, *The Communists and Peace,* must be indicated. It is therefore essential to begin with a brief sketch of the sociopolitical environment shared by the two philosophers.[7]

Like many French intellectuals, Sartre and Merleau experienced an awakening of political consciousness during World War II. Although initially "to the right of Merleau," Sartre gradually aligned himself more closely with the P.C.F. (Parti Communiste Français. It should be noted, however, that neither Sartre nor Merleau ever became a party member.) Merleau, on the other hand, became increasingly disillusioned not only with communism as practised in the Soviet Union but also with Marxism itself. As early as 1945 he was sharply critical of some aspects of Marx's thought, although at that time he still considered Marxism to be "the only universal and human politics."[8] He was growing increasingly pessimistic about the possibility of a proletarian revolution, but he continued to advise his readers to follow the policy of the Communist Party. Information about the Stalinist camps led him to conclude that both communism and Marxism were in need of re-evaluation. And when the Korean War broke out he decided that sympathy without adhesion was no longer warranted because, in his eyes, the U.S.S.R. had shown itself to be imperialistic; it therefore no longer deserved any privileged status. Merleau now opted for silence, gave up his post as political director of *Les Temps Modernes,* and eventually resigned altogether.

Sartre, on the other hand, thought that the alliance of the bourgeoisie and the French socialist leaders left "no other alternative but to stay as close to the Communist Party as possible." Although the chances of a leftist regrouping seemed remote, he felt it imperative "to keep its possibility alive from day to day by concluding alliances with the Party on a

local basis."[9] Thus while Sartre was convinced he was being faithful to Merleau's thought of 1945, Merleau was abandoning his former emphasis on a united Left and at the same time thinking that he was remaining true to himself and Sartre was betraying him.[10] Sartre's contempt for the bourgeoisie, which had long been accumulating, finally burst out in *The Communists and Peace:* "I had to write or suffocate."[11] Although he did not mention the Korean conflict, he was to realize in retrospect that he wrote "heedlessly" and "tactlessly," and that, contrary to his own intentions, it seemed as though he had planned a systematic refutation of Merleau.[12] Understandably, therefore, Merleau was stung, and he replied sharply, albeit a few years later. If the exchange between the two had been merely a matter of "verbal warfare" it would hardly merit investigation. There was, however, considerably more at stake. Merleau thought that beneath the immediate political differences he detected a profound *philosophical* incompatibility between his own position and that of Sartre. *The Communists and Peace* aroused him to elaborate these supposed differences. In order to evaluate Merleau's interpretation of Sartre's philosophy, it is therefore necessary to examine, if only briefly, the stand taken by Sartre in *The Communists and Peace.* After suggesting and developing an interpretation of Sartre that runs directly contrary to that adopted by Merleau, I shall, toward the end of this paper, outline a reinterpretation of *The Communists and Peace.* Since, as Merleau himself claimed, Sartre's political stance is directly related to his philosophical position, a re-interpretation of the latter must involve a concomitant re-evaluation of the former. It is with this in mind that I propose now to undertake a short investigation of *The Communists and Peace.*

This work first appeared in *Les Temps Modernes,* in several installments beginning in July 1952. It was devoted mainly to a criticism of the moderate Left, an analysis of the significance of the May 28th demonstration and the June 4th strike, and a discussion of the advantages of an alliance between the proletariat and the Communist Party. Sartre outlined the "four inevitable stages" through which many on the Left were passing from disillusionment with the Communist Party to alignment with the United States. Opposing the construction of "the true socialism, international, democratic, and reformist" which these people sought, Sartre attempted to demonstrate "to what extent the C.P. is the *necessary* expression of the working class, and to what extent it is the *exact* expression."[13] In the course of his discussion, Sartre drew attention to the essential ambiguity of democratic centralization and tried to explain that "the revolutionary who lives in our epoch, and whose task is to prepare for the Revolution with the means at hand and in his historical situation, . . . must indissolubly associate the Soviet cause with that of the proletariat."[14] Unlike the United

States, whose "show of force" served to break the will of the colonized peoples by terror, the Soviet Union, according to Sartre, proved daily that it wanted peace. Along these lines, Sartre declared that the May 28th demonstration "was a supreme effort toward peace" and "was acting out the deep-seated pacifism of the masses." He asked that the recourse to violence during that demonstration be understood in the perspective of the "climate of pessimism."[15] Sartre took pains to point out that reformism, in confining itself to elementary demands, necessarily involves a de facto rejection of the Revolution and the betrayal of the working class. He also drew attention to the impotence of the Communists in the Assembly and to the hidden violence in bourgeois legality. Sartre went on to discuss the relationship between "interiorized" and "exteriorized" violence, and stressed that the violence exercised by the worker was in fact humanism: "From the point of view of a future society which will be born thanks to his efforts, his violence is a positive humanism. . . . Not a means of achieving humanism. Not even a necessary condition. But the humanism itself, insofar as it asserts itself against 'reification.'"[16]

According to Sartre, "on June 4th . . . there *wasn't* any working class."[17] He maintained that the proletariat was not synonymous with a great number of individuals, or even with "the great majority of the workers." The proletarian, Sartre contended, no longer saw the relationship between his immediate struggles and "the destiny of the proletariat." He recalled Marx's claim that "the proletariat can act as a class only by shaping itself into a distinct political party," and concluded that "if the working class wants to detach itself from the Party, it has only one means at its disposal: to crumble into dust."[18] In his view, an opposition between the working class and the Party was "not even conceivable." The *unity* of the workers characterized the class, and in the absence of the Party this unity was not possible. Sartre argued that "the class makes and remakes itself continuously": "The proletariat forms itself by its day-to-day action. It exists only by acting. It is action. If it ceases to act, it decomposes."[19] He depicted class as "a system in motion" that prevents the individual from reverting to inertia and isolation.[20] In keeping with this view, he declared the proletariat to be utterly impotent unless unified by the Party, and emphasized the need for obedience to party authority.

Merleau was particularly disturbed by this view of the relationship between the proletariat and the Party. In *Adventures of the Dialectic* (1955), he bitterly accused Sartre of "ultra-bolshevism." Merleau himself was by this time questioning the very idea of revolution and coming to the conclusion that revolutions inevitably fail. Ultimately, he felt, they could not tolerate opposition, and therefore they invariably substituted equivocation for dialectic. To concentrate all negativity and all sense of history in the pro-

letariat constituted, in Merleau's view, a grave error and involved a failure to appreciate both the ambiguity of power and the inertia of history. Convinced that revolutions could accomplish only relative progress, Merleau finally found himself incapable of believing any longer in the revolution of the proletariat. The Korean War, by reminding him of the identity of theory and practice, brought him to the realization that Marxism could not be considered both true as critique or negation and false as positive action. Merleau now advocated a re-examination of Marxism, in the belief that the failures of its action must be foreshadowed within its critique. Although he remained convinced that a politics based on anti-communism was a politics of aggression, he now contended that there were many fruitful ways of being non-communist. Merleau therefore felt compelled to replace the idea of revolution with that of responsible reform, and to support a parliamentary democracy insofar as it alone guaranteed at least a minimum of opposition and truth.[21]

These views, of course, were diametrically opposed to those expounded by Sartre in *The Communists and Peace.* As already indicated, Merleau was convinced that the differences between Sartre and himself went far beyond an immediate political divergence—that, indeed, their differences were ultimately philosophical.[22] Merleau's entire philosophical thought is based on the notion of an "interworld." It seems to me that all his criticisms of Sartre resolve themselves ultimately into the question of the presence or absence of this "interworld" in the latter's philosophy. I shall argue that there is indeed such a "third term" for Sartre, and that it is, moreover, *the* key to "genuine Sartrism."

According to Merleau, the "interworld" is incarnation, carnality, the "flesh of the world." Its vehicle is the living human body—not as physiological system but as embodied, situated subjectivity. The "interworld" is there where "subjective" and "objective" intersect (*inter secare*), merge, and are transformed. In this realm, natural facts become cultural acquisitions, temporal ekstases flow into one another, and history is born. This is the world of lived ambiguity, of expression, of dialogue. Here, the centrifugal is also centripetal[23]: meanings are not imposed, but elicited; events do not coerce, but solicit response. This is the sphere "in between" inertia and pure spontaneity; between contingency and necessity, transparency and opacity. It is the locus of praxis, of dialectic. In such an "interworld," the living, expressing, human body is the "third term" mediating between the self and others. Embodied subjects open onto a common world, a world "in between" them—in short, an *inter-subjectivity* where subjects *inter-act,* perspectives merge, and truth comes-to-be.

The "interworld," then, is neither lifeless matter nor abstract *Geist.* It is truly *flesh.* As I have already pointed out, Merleau's entire "pseudo-

Sartrism" is ultimately reducible to the charge that such "flesh" is nonexistent in Sartre's philosophy. In *Adventures of the Dialectic*, Merleau argued that Sartre's whole theory of the Communist Party and the proletariat was derived from his philosophy of fact, of consciousness, and of time. He claimed that Sartre's subject is a translucent consciousness coextensive with the world. In his criticism of idealism in *Phenomenology of Perception* (1945), Merleau had already explained at length that it is impossible to be simultaneously coextensive with, and situated in, the world. The Sartrean subject, therefore, is a "spectator consciousness" possessing absolute knowledge. Merleau contended that, for Sartre, meaning does not come from the world but is imposed on it by the constituting consciousness. There are, thus, no meanings that are operative before being known. Subject and world, meaning and being, are irreconcilably opposed.

In short, Sartrean philosophy is, in Merleau's eyes, a Cartesian dualism which confronts absolute lucidity, pure consciousness (*pour-soi*) with impenetrably opaque matter (*en-soi*), and categorically denies any "in-between." Because consciousness is solely centrifugal, there is a fundamental closure of meaning. In his chapter "Other People and the Human World" in *Phenomenology of Perception*, Merleau had already argued that a philosophy in which the subject enjoys absolute lucidity is necessarily solipsistic. If consciousness is coextensive with, and wholly constitutive of the world, then other consciousnesses are inevitably incorporated into that world as objects:

> In so far as I constitute the world, I cannot conceive another consciousness, for it too would have to constitute the world and, at least as regards this other view of the world, I should not be the constituting agent. Even if I succeeded in thinking of it as constituting the world, it would be I who would be constituting the consciousness as such, and once more I should be the sole constituting agent.[24]

Merleau therefore replaced idealism with a philosophy of incarnate subjectivity. In place of an absolute consciousness, he put a subjectivity that "draws its body in its wake." Such a body "forms between the pure subject and the object a third genus of being."[25] In Merleau's philosophy, "the subject loses its purity and its transparency," and an "internal relation" is established not only "between my consciousness and my body as I experience it," but also "between this phenomenal body of mine and that of another as I see it from the outside." The Other, here, appears as "the completion of the system."[26]

On the other hand, if subjectivity is "transcendence through and through," if all meaning proceeds from the individual, then there is no "in-between," no room for meaning which arises elsewhere, whether from others or from the natural world. The only alternative such idealism offers

is plurality—a plurality of worlds, each constituted entirely by its own single sovereign consciousness. Intersubjectivity, however, is completely ruled out, precisely because there is no "interworld," no realm in which subjects can participate in something which "lies between" them, which is *shared.* There is a radical separation between the self and the Other. Each lives exclusively in his own world. If such plurality is rejected, rivalry and "false fraternity" are all that remain. In short, if a universe of monads is replaced by a single world, consciousnesses will fight for sovereignty, for the satisfaction of constituting meaning rather than the degradation of being constituted as an element of another's world.

The paradigm of possible relations between consciousnesses in "pseudo-Sartrism" is that of the Look, in which subjectivity can remain subjectivity, pure transcendence, only on condition that it objectify the Other. Thus, the subject either objectifies the Other or is himself objectified. There is no "in-between." I am either subject or object, either sovereign or slave. There is no "interworld." The Other, therefore, is a rival, an intruder in *my* world. He alone threatens my sovereign subjectivity, my absolute transcendence. He alone can, by his gaze, de-center my freedom. The Sartrean subject lacks any "hinge," any anchorage in the world. Consequently, his action must be impingement, imposition, intervention in being. Since there is no "hold" on being, there can be no acquisition, no continuity. Action is not "true" or "substantial," but utterly "pure": it is continual rupture, continual creation *ex nihilo.* The subject is pure spontaneity confronting opaque, inert "matter." Antidialectic has replaced dialectic. There is no revolutionary "ebb and flow." Action is reduced to absolute, rootless initiative, to pure trickery which confronts the force of being. There is no *praxis,* no adjustment of action to the situation, no deciphering of events, no "historical matter." Instead, there are merely continual creations *ex nihilo* on the part of a non-situated, or "spectator," consciousness. In the absence of a shared "field" of experience there can be no mutual projects, but only individual encounters, traps, and tasks. Mere "cinders of consciousness" lie "between men and things."[27] Time is atomized—there is no "temporal thickness" separating volition from action. To will is to do; action is the immediate result of volition. The Sartrean subject is, therefore, radically free. Anything and everything is equally possible at any instant. The subject makes himself to be whatever he wishes. In the absence of any "common ground," any "interworld" between consciousness and being, the law of "all or nothing" takes over. There is no sphere of becoming, no genesis of meaning, no evolution of truth, no process, no dialectic, no *social* realm, no history.[28]

The nature of Sartre's political thought is easily understood, argued Merleau, when viewed against this background. Since "facts" belong to the

impenetrable realm of the *en-soi,* they are absolutely equivocal. Their meaning is external to them; it is imposed by the *pour-soi.* Political life is thus reduced to the level of judgment. Since, in the absence of an "interworld," intersubjectivity is ruled out, the relation between the Party and the proletariat can be no other than that of subject to object, sovereign to slave. There can be no participation, no *inter*-action, no discussion, no deliberation. The Party, therefore, wields absolute authority and demands unquestioning obedience. Revolution becomes the exclusive concern of Party leaders; history is reduced to personal volitions, to "a pact of wills." In its role as subject, the Party enjoys complete lucidity, absolute knowledge. There is no possibility of error. The facts themselves are utterly devoid of significance. Since they bear no meaning of their own, they can be interpreted at will. The Party consequently is not subjected to any controls but is entirely free to impose any meaning on the facts, to make history in whatever way it deems fit. It is the sole agent of history. The Party thus has a "blank check" for terrorism. In keeping with the law of "all or nothing," whoever is not for the Party is against it. Since there is no mixture of fact and meaning, no "interworld," truth is a *willed* truth, a dogmatism that authorizes one to go ahead against all appearances. Truth is imposed on the world by the political judgments of the Communist Party. Sartre's political philosophy, therefore, lacks a humanist perspective. It is an "ultrabolshevism," a communism that no longer justifies itself by truth, by a philosophy of history, or by the dialectic. Merleau conceded that Sartre perhaps intended to follow his essays in *The Communists and Peace* with a critical exposé of the Party. However, he contended that any such appraisal had already been ruled out by Sartre's desperate justification of a communism that did not admit of restriction.[29]

In her article "Merleau-Ponty et le Pseudo-Sartrisme," Simone de Beauvoir declared that Merleau had falsified Sartre's ontology and made a travesty of his political thought.[30] Through a systematic juxtaposition of Merleau's criticisms with carefully selected passages from Sartre's own works, she sought to counter Merleau's attack point by point. For example, she accused Merleau of having neglected Sartre's theory of facticity and of having overlooked his description of the Other as presented in *Saint Genet.* She reminded him of the "Reply to Albert Camus," in which Sartre had insisted on the insertion of consciousness and action in history. She called Merleau's attention to Sartre's stress on the "weight" and ambiguity of history, as presented, for example, in his criticisms of the Trotskyites and Lefort. In the course of her counterattack, de Beauvoir acknowledged that Sartre's philosophy presented difficulties. She hastened to add, however, that these would be remedied in a book which Sartre was then in the process of writing. Since Merleau, however, had no access to this new work

(*Critique de la raison dialectique*), I shall try to meet his objections without reference to it.

According to de Beauvoir, Merleau not only had fallen victim to traditional idealism, but also had demonstrated bad faith in deliberately misreading Sartre, in using phrases out of context, in constructing artificial antinomies, paradoxes, equivocations, and so on.[31] It seems to me, however, that there *are* genuine grounds for Merleau's (mis-)interpretation of Sartre. As already pointed out, the notion of "interworld" is central to Merleau's own work. His whole emphasis is on intersubjectivity, on community, on dialogue, on participation. Yet Sartre's philosophy indeed seems to deny these outright. The very title *Being and Nothingness,* for example, smacks of dualism and seems to indicate that *becoming* is at best unimportant, and at worst, nonexistent. In *Being and Nothingness,* Sartre *does* say quite clearly that "the essence of relations between consciousnesses is not *Mitsein*: it is "conflict"; "conflict is the original meaning of being-for-others."[32] Dialectic and intersubjectivity seem to be denied in Sartre's analysis of concrete relations with others, for he insists that such relations constitute a circle in which we are "ceaselessly tossed from being-a-look to being-looked-at."[33] According to Sartre,

> We are indefinitely referred from the Other-as-object to the Other-as-subject and vice versa. The movement is never arrested, and this movement with its abrupt reversals of direction constitutes our relation with the Other. At whatever moment a person is considered, he is in one or the other of these attitudes. . . . we shall never place ourselves concretely on the plane of equality: that is, on the plane where the recognition of the Other's freedom would involve the Other's recognition of our freedom.[34]

Sartre concludes that "respect for the Other's freedom is an empty word."[35] "There is no dialectic for my relations toward the Other but rather a circle"; and this circle is unbreakable because, "at the very root of my being," I am "the project of assimilating and making an object of the Other."[36]

One could find many additional passages like the above in Sartre's works. These will suffice, however, to show that Sartre's own work would seem to support the tenor of Merleau's interpretation as presented in *Adventures of the Dialectic.* I shall now attempt to show why, despite the apparent viability of such an interpretation, I nevertheless feel compelled to reject it in favor of another.

There are several approaches one could adopt regarding Sartre's philosophy. One might argue, for example, as Merleau does, that Sartre presents a thoroughly negative view of human relationships, that he succumbs to a Cartesian dualism and that his phenomenological ontology, therefore, discounts any "third term," or "interworld." Instead, one might

contend that Sartre's philosophy as presented in *Being and Nothingness* is not really a phenomenological ontology at all, but rather a descriptive analysis of human experience within a certain historical framework— namely, the framework of alienation, or "pre-history," in the Marxian sense. In this view, human relationships are negative, are relationships of conflict, and will continue to be so until a proletarian revolution ushers in a genuinely human society. When this occurs, conflict will be replaced by dialogue, bourgeois individualism by genuine intersubjectivity, and the circle by a dialectical spiral.

Neither of the foregoing approaches strikes me as acceptable. Against the second, I contend that *Being and Nothingness does* present a genuine phenomenological ontology depicting human experience as such and is, therefore, a trans-historical description rather than a depiction of human relationships within the confines of capitalist society. Against the first, I would maintain that Sartre's philosophy does indeed leave room for an "interworld"—that, in fact, the notion of "interworld" lies at the very heart of "authentic Sartrism." Further, I would argue that Sartre's view of human relationships is *not* necessarily negative, although both his terminology and his choice of examples easily lead one to believe that this is the case. I shall not present in this article my reasons for thinking that *Being and Nothingness* is indeed, as its subtitle indicates, an essay in phenomenological ontology. Rather, I propose to address myself to the claim shared by the positions outlined above: that in Sartre's philosophy (at least, in *Being and Nothingness* and in other "early" works) the "interworld" is absent and human relationships are presented as negative. To counter such interpretations, it is not sufficient that one simply present various quotations from Sartre's works. I propose, therefore, to pick up the thread of Simone de Beauvoir's defense and to pursue it a little further.

In her attack on *Adventures of the Dialectic,* de Beauvoir accuses Merleau of confounding the notion of consciousness with that of the subject in Sartre's philosophy.[37] It seems to me not only that this criticism is valid, but also that it strikes at the very root of Merleau's "pseudo-Sartrism." I shall therefore pursue it beyond the few quotations offered in its defense by de Beauvoir.

In *The Transcendence of the Ego,* Sartre takes great care to insist on the distinction between consciousness and subject. Following Husserl, he declares that all consciousness is intentional. In its primary mode (that is, as pre-reflective consciousness), consciousness is absolute, non-personal spontaneity; it is non-positional self-consciousness, immediate presence, *lived* interiority. The subject, or ego, on the contrary, is an object constituted and apprehended by reflective, or secondary, consciousness. The ego is *opaque;* it gives itself to reflection as an interiority closed upon itself. As

the ideal unity of states and actions, the ego tends to mask from consciousness its very spontaneity—a spontaneity which is beyond freedom. Since consciousness is pure spontaneity, "all lightness, all translucence," pure power to nihilate, it possesses no "inner life," no contents of its own.[38] It is not inhabited by a self, as is commonly supposed. The ego is not a structure of consciousness. It "is neither formally nor materially in consciousness: it is outside, *in the world*," and it "participates in all the vicissitudes of the world."[39] As there is nothing "in" consciousness, the philosopher must turn his attention to the world if he wishes to describe the being of the human reality. Thus any attempt to study consciousness while "bracketing" the world is doomed to failure. Sartre declares that, contrary to idealism, his phenomenology "plunges" the human being back into the world.[40] The "me;" as the ideal unity of qualities and states, draws its entire content from the world. The ego neither creates nor is created by the world. Rather, consciousness, as the "absolute source of existence," constitutes not only being "as a world," but also its own activities as an ego, and establishes their interdependence.[41]

In *The Transcendence of the Ego,* Sartre states that "consciousness is defined by intentionality," and that, "by intentionality, consciousness transcends itself."[42] Consequently, there is always a "gap" between the clarity and lucidity of consciousness and the characteristic opacity of its objects.[43] Although involvement in the world is inevitable, coincidence with that world is impossible. It is ridiculous, however, to deplore this permanent *écart,* since its disappearance would necessarily spell the death of consciousness. It is equally senseless to suppose that the constituting of the ego as an object by, and for, consciousness, connotes rivalry, hostility, or hatred on the part of consciousness. Nor does *écart* indicate dualism. Since consciousness *is* "pure ekstatic presence to the world," its link with that which it transcends is inextricable. Although the ego, as an opaque object of consciousness, belongs to the order of *en–soi,* "the relation between the for-itself and the in-itself is not one of juxtaposition or indifferent exteriority. Its relation with the in-itself, which is the foundation of all relations, is the internal negation."[44] In fact, "*the for-itself is relation.*"[45]

While it is always already beyond itself, the for-itself is "a unitary structure of being." Consequently, reflection involves a "separating nothingness" but not "an addition of being." Instead of a completely new consciousness directed on the unreflective for-itself, there is here

> an intrastructural modification which the for-itself realizes in itself; in a word, it is the for-itself which makes itself exist in the mode reflective-reflected-on, . . . The one who is reflecting on me is not some sort of non-temporal regard but myself, myself who am enduring engaged in the circuit of my selfness, in danger in the world, with my historicity. This historicity and this

being-in-the-world, and this circuit of selfness—these the for-itself which I am lives in the mode of reflective dissociation [*dédoublement*].[46]

Inasmuch as for-itself and world are *internally* related, they cannot be two closed entities standing in opposition. The for-itself is not some sort of "free-floating" consciousness hovering over the world, but rather human reality engaged "at the heart of the world."[47] As Sartre points out, "for human reality, to be is to-be-there," and "to-be-there" is to *exist* its body. Consciousness is always incarnate: "The body is nothing other than the for-itself," inasmuch as the for-itself necessarily exists "as an engaged, contingent being among other contingent beings."[48] Sartre points out:

As such, the body is not distinct from the *situation* of the for-itself, since for the for-itself, to exist and to be situated are one and the same; on the other hand the body is identified with the whole world inasmuch as the world is the total situation of the for-itself and the measure of its existence.[49]

The for-itself is at one and the same time wholly body and wholly consciousness; it is neither a consciousness *united with* a body, nor a psyche *behind* a body. There is no question here of a "contingent bringing together of two substances radically distinct." Sartre points out that "on the contrary, the very nature of the for-itself demands that it be a body; that is, that its nihilating escape from being should be made in the form of an engagement in the world."[50]

Since consciousness is not an *entity* located *within* the body, "the body is not a screen between things and ourselves."[51] Rather, "the body is the totality of meaningful relations to the world."[52] As pure power of transcendence, consciousness is always already beyond the situation which, as body, it lives. Consequently, "in one sense the body is what I immediately am. In another sense I am separated from it by the infinite density of the world."[53] It is only in virtue of being a body that consciousness can exist at all; yet its existence *as* body spells an inevitable and eradicable alienation insofar as it engages consciousness in a world which it continually surpasses, and confers on it an eternally elusive "being-for-others."

The relationship between one consciousness and another, like that between consciousness and the ego, involves negation and, correlatively, objectification. Consciousness *of* its *self*, implies that consciousness is already *beyond* that self and, consequently, is *not* that self. Therefore, as already explained, there is an internal negation here on the part of consciousness. Similarly, consciousness of an Other involves a consciousness of *not* being that Other. This "withdrawal" on the part of consciousness institutes a "gap" between it and the Other. Although a nothingness is thus interposed between consciousness and the Other, it is no more (and no less) a "barrier" than that which surges up between non-personal spontaneity and the

ego. As Sartre maintains, the ego "is a being of the world, like the ego of another."[54] Contrary to common belief, my emotions and states, my ego itself, are not my exclusive property. I have no privileged access to my own states; far from being absolute, the "I," though more intimate, is no more certain for consciousness than the "I" of others.[55] Another's "I" is accessible to my intuition as well as to his own; consequently, there is nothing "impenetrable" about the Other except his very consciousness. Refractory to both intuition and thought, "his consciousness is *radically* impenetrable"; but then, as Sartre points out, Rimbaud was correct in stating that even "I is *an other*."[56] Since the ego is object, rather than owner, of consciousness, "we never have a direct intuition of the spontaneity of an instantaneous consciousness as produced by the ego."[57] The reason for this is simply that transcendental consciousness does not emanate from the "I," but is an impersonal spontaneity which ceaselessly creates itself *ex nihilo* and surpasses the "me."[58]

Both ego and Other, then, are objects for consciousness. However, the Other is not originally given to me as an object but as a "presence in person," as a subject who reveals to me my "being-for-others." In virtue of its body, consciousness has an "exterior," and can experience the Other's Look. This look simultaneously reveals the Other as subject and makes me aware of a facet of my own being which, on principle, will always elude me.

Simone de Beauvoir criticized Merleau for attempting to reduce all Sartre's relationships between the self and the Other to the Look.[59] Yet Sartre *does* say clearly that the Look is the "fundamental connection which must form the basis of any theory concerning the Other"; and that "being-in-the-act-of-looking and . . . being-looked-at . . . constitute the fundamental relations of the for-itself with the Other."[60] The problem, therefore, it would seem to me, lies not in reducing relationships to the Look, but rather in deciding how to interpret it.

By looking at me, the Other invariably freezes my freedom, circumscribes my possibilities, confers an "exterior" on me. I shall never know how the Other sees me; yet, I *am* this being which he apprehends. The Other therefore simultaneously "steals" my being from me and "causes 'there to be' a being which is my being."[61] In distinguishing himself from me, the Other "nihilates" me, objectifies me, surpasses my ends toward his own. On the other hand, insofar as I apprehend the Other as *not* being me, I in turn distance myself from him and constitute his "otherness." Nevertheless, in objectifying the Other, I cannot wrench from him the "secret" of my being—that is, my own being-for-others. It should be noted that the Other's body is not synonymous with his objectivity. The latter "is his transcendence as transcended. The body is the facticity of this

transcendence. But the Other's corporeality and objectivity are strictly inseparable."[62]

My body is at one and the same time the body which I live and the body which is an object for the Other. "The Other's look fashions my body . . . , causes it to be born, sculptures it, produces it as it *is*, sees it as I shall never see it."[63] Since my being-for-others is a fundamental structure of my being, "I *need* the Other in order to realize fully all the structures of my being."[64] My original relation to the Other is an internal negation, such that the being of each is distinguished from, and determined through, that of the Other.[65]

The permanent "gap" created by this surpassing of each by the Other, rules out any *coinciding* of incarnate consciousnesses. "Distance," or lack of coincidence, however, need not indicate hostility. Instead of a *stare,* the look may be a *caress.* In both cases, of course, consciousness draws a distinction between itself and the Other whom it encounters by virtue of its body. Nonetheless, such an *écart* can be the source of mutual enrichment. Internal negation is a mediation effected in and through the body. Just as consciousness requires the body-in-situation in order to *be* a subject, so consciousness requires the Other in order to appreciate its own facticity, to become aware of its anchorage in the world. Consciousness exists its body sexually; consequently, it is fundamentally characterized by affective intentionality. As incarnate, consciousness experiences desire—indeed, it *exists* that desire. Sexuality is the "skeleton" upon which all human relationships are constructed. Sartre insists that sexuality is not "a contingent accident bound to our physiological nature," but rather, that "the for-itself is sexual in its very upsurge in the fact of the Other."[66]

In desire, I "call" to the Other.[67] As object *of* desire, the Other never *coincides* with the desiring consciousness. Yet, I reach the Other in his body and cause him to be born as *flesh,* as "unutilizable facticity," not only for him, but also for me. In the caress, a "double reciprocal incarnation" occurs, such that we both experience our fundamental anchorage in the world and in each other. Flesh is neither pure spontaneity nor inert "matter." Rather, it is the "pure contingency of presence."[68] As presence, the for-itself is not at rest in itself but is intentionally directed outside itself upon that being to which it is present. "And it must adhere to being as closely as is possible without identification."[69]

I would argue that the key to genuine, or "authentic," Sartrism, lies in this notion of *flesh.* In *desire,* the for-itself exists its body in a particular way, thereby placing itself "on a particular level of existence." Consciousness becomes "clogged" by facticity; it "is engulfed in a body which is engulfed in the world."[70] Daily activities break down, normal involvement

in the world is suspended. At such times, the for-itself ceases to *live* its situation, to be actively engaged in the pursuit of its projects. Lived space becomes transformed, denying it that distance required for the maintenance of perspective. Desire compromises the human being to such an extent that he may "'suffocate' with desire, and experience the world as suffocating," while discovering his body "as the fascinating revelation of facticity—that is, as flesh."[71]

Desire expresses itself in the *caress,* which seeks to transform the Other's body from a body-in-situation into "the pure contingency of presence"; that is, into flesh. While the Other transcends his body toward his goals, and while I grasp his body-in-situation, that body does not exist explicitly as flesh for either of us. The birth of flesh occurs through the caress, which "strips" the body of its action and severs it from its surrounding possibilities. In "shaping" the Other's body, my caress reveals his flesh by uncovering "the web of inertia" which lies beneath, and sustains, his actions.[72] However, the revelation of the Other's flesh can be made only through my own flesh:

> In desire and in the caress which expresses desire, I incarnate myself in order to realize the incarnation of the Other. The caress, by *realizing* the Other's incarnation, reveals to me my own incarnation . . . my caresses cause my flesh to be born for me in so far as it is for the Other flesh causing her to be born as flesh.[73]

Incarnation, in short, can only be *reciprocal.* Desire cannot be held at a distance; in desire, the for-itself "experiences the vertigo of its own body."[74] The desiring consciousness "chooses to exist its facticity on another plane"; it becomes opaque to itself, "heavy." In making itself flesh, the for-itself "tastes" its own contingency, which is "the very texture of consciousness."[75]

Sexual desire brings about a radical transformation of both for-itself and world. As soon as the body begins to be lived as flesh, the world comes into being for the for-itself "in a new way." The world "ensnares" my body.[76] In a world of desire, objects cease to be apprehended as instrumental complexes, and become instead "the transcendent ensemble which reveals my incarnation to me." I become sensitive to their *matter.* To the extent that I make myself passive, I experience their contact as a *caress.* Sartre points out that "in my desiring perception I discover something like a *flesh* of objects."[77] In a world constituted by desire, objects are present to me "without distance"; they "reveal my flesh by means of their flesh." Desire, thus, is a "lived project" which "destructures" the world.[78]

In choosing to live my body as flesh, I renounce being the one who establishes references and unfolds distances. Desire aims, fundamentally, at the appropriation of the Other's freedom. However, since the Other can be grasped only in his objective facticity, desire attempts "to ensnare his

freedom within this facticity."[79] To this end, the situation lived by the Other must be dissolved. However, "I can neither wish nor even conceive of the incarnation of the Other except in and by means of my own incarnation."[80] Consequently, to the extent that I make the Other's facticity emerge by "corroding" his relations in the world, I bring about the disintegration of my own situation. Nonetheless, this suspension of my own situation is not to be understood negatively. My flesh, in finding the way to that of the Other, achieves a mutually *enriching* "communion of desire." As Sartre says: "Each consciousness, by incarnating itself, has realized the incarnation of the other; . . . and is thereby so much enriched."[81]

Sexual relationships, as already noted, form the basis of our concrete relations with others. However, they usually "remain implicit inside more complex conduct," "just as a skeleton is veiled by the flesh which surrounds it."[82] Although "there are thousands of other ways . . . to exist our contingency,"[83] sexual desire constitutes a very special experience for the for-itself. In the experience of fear, for example, I do not relinquish my hold on the environment. Rather, my project of flight induces instrumental-object configurations to emerge into the foreground. I surpass my body in "nihilating" noxious elements of the situation: a vase becomes not an ornament but a weapon for shielding myself from the Other's wrath; my legs become vehicles of flight; a nothingness surges up between my present frightening situation and that haven toward which I flee. I apprehend the Other as a center of reference, as one who blocks my possibilities in transcending them toward his own ends. I experience my contingency in this precarious position insofar as the Other threatens me and I am vulnerable. Nevertheless, since I am intent on transcending this frightening situation, I do not really *taste* my anchorage in being, my *texture* as flesh, my basic *reciprocity* with the Other. In the case of pain—especially that experienced at the hands of the sadist—I may indeed consent to become passive, to submerge consciousness in my body; but again, that fundamental reciprocity is missing.

In the language of the caress, on the other hand, the environment is made to retreat, my body and that of the Other are stripped of their customary actions and are reduced to flesh. In the (double) reciprocity of incarnation, each of us *tastes* his pure *presence,* the weight of facticity, the interdependence of incarnate consciousnesses. Since daily projects are temporarily arrested, the full weight of consciousness's inherence in the body can be genuinely appreciated. The pre-reflective, *bodily* cogito, usually overlooked, is here experienced. The body alone "knows" how to reach the Other in his flesh. The world reveals itself as flesh to my flesh, and through my flesh I become aware of the world's texture. Objects, stripped of their form and function, reveal their matter, their inertia, to our flesh.

Through the destructuring of the everyday environment, we come to grasp the textural harmony of world and incarnate consciousness. We apprehend that we are not only *in* the world but *of* the world in the truest sense.

Consciousness cannot remain indefinitely fascinated by flesh. The vertigo of its own body gradually gives way to the natural momentum of spontaneity and the concomitant resumption of arrested projects. Desire carries the seeds of its failure within itself, insofar as it reaches out for an impossible goal—namely, "to possess the Other's transcendence as pure transcendence and at the same time as body"[84]; to apprehend simultaneously the Other's freedom and his objectivity.[85] As long as he is alive, the Other's consciousness continues to hover on the horizon of his body; consequently, I can never reduce him entirely to an object. Moreover, satiation breaks the spell of reciprocal incarnation. One of the incarnate consciousnesses may become so submerged in its bodily being that it ceases to aim at the Other's incarnation through its own, and seeks instead to strip itself of all transcendence—that is, to become a mere object in the Other's world. The permanent danger of such degeneration into masochism is accompanied by the constant threat of sadism. In the latter case, consciousness begins to focus exclusively on appropriation as *taking,* or grasping. Thereby, it transforms the Other from flesh into mere instrument, hence destroying the reciprocity of incarnation. Thus, despite the fact that sexuality, for Sartre, constitutes the cornerstone of human relationships in general, its radical modification of for-itself and world cannot be permanent. Nevertheless, I would argue that the transience, the inherent instability of (sexual) desire, does not detract from the importance of this experience. Caught up in our daily projects, we are seldom explicitly aware of our fundamental facticity, our basic inherence in the world and in one another. We require that relationship which is initiated by desire to remind us of our "moorings," and to exhibit the fallacies of taking ourselves to be non-situated, abstract consciousnesses. It should be noted that the reciprocity of incarnation, though central, is not primary. As Sartre says:

> . . . the body is not that which first manifests the Other to me. In fact if the fundamental relation of my being to that of the Other were reduced to the relation of my body to the Other's body, it would be a purely external relation. But my connection with the Other is inconceivable if it is not an internal negation. I must apprehend the Other first as the one for whom I exist as an object.[86]

Again:

> The appearance of the Other's body is not therefore the primary encounter; on the contrary, . . . the Other exists for me first and I apprehend him in his body *subsequently*. The Other's body is for me a secondary structure.[87]

In desire, incarnate consciousness projects itself toward a concrete *human individual,* rather than toward a lifeless thing. Thus, reciprocal incarnation presupposes an awareness of the "humanness" and the "otherness" of the object of desire. The Other, in sum, must be given to me originally not as *object,* but as inapprehensible *subjectivity.* The prereflective cogito reveals the Other to me in this way through the Look: "In my own inmost depths I find the Other himself as not being me."[88] Therefore, the awareness of textural accord between my flesh and that of the Other, as well as that of the world, is based on a primary comprehension of our similarity insofar as the Other and I are both freedoms, or subjects. We are linked through our bodies with one another and the world; yet there always remains a "gap," an "ontological separation,"[89] insofar as each of us is *distinct,* or *unique.* Ontological separation, however, need not imply hostility. It simply means that the Other's subjectivity is ultimately inapprehensible and that he and I can never coincide. Any striving for such coincidence is inevitably thwarted. There can be no *unity,* if by unity we mean *identity.* It is in this sense that "the separation and conflict of consciousnesses" will remain "so long as consciousnesses exist."[90] What we have here is no raging battle, but an assertion of the fact that consciousness necessarily *individualizes* itself.

I have argued that the notion of flesh, as the vehicle of an "interworld," is the key to genuine Sartrism. It is with a view to the existence of such an "interworld" in Sartre's philosophy, that one must approach his discussion of action, freedom, knowledge, meaning, truth, history, the social world, and dialectic. "Flesh" has been shown to be neither lifeless object nor translucent consciousness, but a "third term" lying "in between." Furthermore, sexuality has emerged as a fundamental structure of the very being of human reality. Consciousness, in realizing itself as desire, has proven its own carnality as well as its need for, and its reciprocity with, other embodied consciousnesses. In making itself flesh, consciousness has revealed its fundamental inherence in the world, thereby bringing to light the "interworld." Any charge of dualism has thus been dispelled.

If human reality is *situated* in the world, and if there is "something like a flesh of objects," then *meaning* cannot be the sole creation of a consciousness; neither can it be imposed on facts which are themselves devoid of significance. On the contrary, the existence of an "interworld" rules out a radical separation of facts from meanings. Insofar as the human being is not only *in* the world, but truly *of* the world—that is, insofar as there is a common *texture*—there is not only a *creation* but also a *sedimentation* of significances. The human being finds himself in an already meaningful world, in a world already possessing a cultural heritage. Since conscious-

nesses are anchored in the world and are mediated through the body, there is a genuine intersubjectivity. If consciousness is incarnate, action ceases to be intervention, imposition from without. Instead of a "spectator" consciousness surveying a world of inert objects, we now have a *pour-soi* actively engaged within the world. Desire, in revealing both *pour-soi* and world as flesh, has shown these to have "weight," and to be "of a piece." The "web of inertia" subtending not only the *pour-soi* but also the things of the world, ensures that freedom both encounters obstacles and leaves acquisitions. It prevents the immediate coincidence of volition and action, by interposing the "thickness" of facticity. As a result, action ceases to be "pure"; freedom ceases to be "rootless"; knowledge ceases to be absolute; truth ceases to be arbitrary. The social world replaces the isolated individual; history stops being absolute creation.

At the beginning of this article I stated that Sartre's thought was in fundamental accord with that of Merleau, and that the latter's criticisms constituted a "pseudo-Sartrism." Having established the existence of flesh as vehicle of an "interworld" in Sartre's philosophy, I now propose to return briefly to Merleau's accusations in order to explicate the basic harmony between the two philosophies.

Merleau, it will be recalled, had accused Sartre of having "a plurality of subjects but no intersubjectivity."[91] It has emerged that Sartre does indeed have a plurality, in the sense that there *is* a "gap," an ontological separation between the for-itself and the Other. However, plurality in *this* sense is, in fact, intersubjectivity. It has been shown that Sartrean subjects are fundamentally interdependent while retaining their individuality and that, for Sartre, intersubjectivity is a carnal reciprocity which rules out equally a unity of identity or coincidence on the one hand, and an external negation on the other. It will be recalled that incarnation *does* make for an inevitable alienation. Sartre states that alienation "is an essential characteristic of all situations in general . . . [and we] cannot escape this alienation since it would be absurd even to think of existing otherwise than in situation."[92] Merleau's *own* philosophy, however, also admits an eradicable aspect of alienation in all human relationships. Like Sartre, Merleau holds that the primordial encounter of incarnate consciousnesses occurs at the level of the pre-reflective cogito, and is an experience involving a permanent *écart:* I am necessarily destined never to experience the presence of another person to himself. And yet each person does exist for me as an unchallengeable style or setting of co-existence, and my life has a social atmosphere.[93] For Merleau, there is a violence which is an inevitable element of the human situation. I have argued at length elsewhere[94] that, according to Merleau, human beings, as incarnate subjects, inevitably encroach upon one another; that there is already at the level of perception an

unavoidable type of "invasion." I have shown there that, although Merleau stresses the "internal relationship," the lived presence of incarnate beings to each other, nevertheless his description of incarnate subjectivity as "the junction of the *for-itself* and the in-itself" provides an ontological basis for his contention that the very fact of intersubjectivity makes encroachment inevitable. For Merleau, then, there is already an element of alienation at the most fundamental level of human coexistence.[95]

In his attack on Sartre, Merleau further accused him of reducing knowledge to an abstraction and attaching human beings mentally to history.[96] Merleau's *own* philosophy emphasized that the incarnate subject is characterized by "historical density." It ruled out any abstract knowledge or absolute standpoint, and stated that knowledge is always perspectival, incomplete, "situated."[97] However, I would contend that for Sartre, *just as* for Merleau, the realm of "interworld" prohibits idealism and ensures the fundamental inseparability of knowledge and action. Like Merleau, Sartre was aware that if, through abstract thought, "I place myself in a state of simple surveying" and "escape from the senses which I am," then "I cut my bonds with the world"[98] and adopt a contradictory position:

> The point of view of pure knowledge is contradictory; there is only the point of view of engaged knowledge. This amounts to saying that knowledge and action are only two abstract aspects of an original, concrete relation. . . . A pure knowledge in fact would be a knowledge without a point of view; therefore a knowledge of the world but on principle located outside the world. But this makes no sense; . . . thus knowledge can be only an engaged upsurge in a determined point of view which one *is*.[99]

Another of Merleau's criticisms concerned the status of freedom in Sartre's philosophy. I noted earlier that Merleau dismissed Sartre's conception of freedom as an abstraction. In its place, he wished to put a freedom which "gears itself" to the situation, which is not a matter of instantaneous transformations or intellectual projects.[100] In line with this, Merleau declared that, "in reality, the intellectual project and the positing of ends are merely the bringing to completion of an existential project."[101] Merleau's subject finds himself already situated within a social world and a pre-personal tradition. His existence therefore bears "an atmosphere of ambiguity," which endows his choices and actions with a certain opacity and inertia. Already in his *Phenomenology of Perception* Merleau had warned against placing the for-itself and in-itself in opposition without mediation. He argued that there is "never determinism and never absolute choice, . . . I am never a thing and never bare consciousness"; that the choice which I make of my life is always based on a certain givenness.[102] Despite Merleau's statements to the contrary, his philosophy is in fact in agreement with "genuine Sartrism." Sartre, too, insists that freedom is not a matter of

caprice; that it does not denote the ability to do "anything whatsoever," that it involves a fundamental "lived" project. "Genuine Sartrism" insists on "the coefficient of adversity of things" and the dialectical relationship between intention and action.[103] Like Merleau, Sartre emphasizes that there is a continual *inter*change between the human reality and the situation within which it finds itself:

> [T]here is freedom only in a *situation,* and there is a situation only through freedom. Human-reality everywhere encounters resistances and obstacles which it has not created, but these resistances and obstacles have meaning only in and through the free choice which human-reality *is.*[104]

Sartre, like Merleau, recognizes that freedom does not mean incessant rupture, that even "the most radical decisions" are made in reference to the past, and that that past is immensely "important as a backdrop and a point of view."[105] Sartre even cautions his readers lest they forget that "action requires time to be accomplished"; that "it has articulations," "moments."[106] The past which gives birth to a particular action does not act deterministically; yet it definitely has "weight." As Sartre says, "We choose our past in the light of a certain end, but from then on it imposes itself upon us and devours us."[107]

In *Adventures of the Dialectic,* Merleau attacked Sartre's conception of meaning and truth, arguing, in supposed opposition to Sartre's position, that meaning is neither imposed nor undergone, but "taken up and carried forward" by the incarnate subject.[108] Merleau insisted that the subject's life has a significance which he himself does not constitute; and that history likewise has "at least a fragmentary meaning" of its own which it "puts forward"; that, briefly, meaning comes into being through the complex interplay of the subjective and the objective.[109] Merleau argued that, because consciousness is incarnate, its historical inherence is "the point of origin of all truth."[110] Consequently, truth always retains "its coefficient of facticity" and is never final or completed.[111] For Merleau, truth is always truth in genesis, and demands a continual effort of creative expression on the part of the human being. The human being is already in primordial contact with truth by the mere fact of existing as incarnate subjectivity.[112] It is now evident that, contrary to Merleau's contention, Sartre's conception of truth and meaning is in harmony with this view.[113] More generally, it can now be seen that the fundamentals of "authentic Sartrism" harmonize with those of Merleau-Ponty. The latter, notwithstanding, failed to appreciate that the notion of *flesh,* which lies at the core of his own philosophy, is central also to Sartre's thought. It will be easier to understand why Merleau overlooked the positive significance of flesh in Sartre's philosophy if it is kept in mind that Sartre did not focus *explicitly* on the socio-historical world in *Being and Nothingness.* Nevertheless, in establishing the "inter-

world" in that important treatise, Sartre *did* create the necessary condition for action and intersubjectivity. In so doing, he laid the foundation for the intensive social-political study later undertaken in *Critique de la raison dialectique*. Already in *Being and Nothingness,* Sartre indicated the direction which such a treatment would take[114]; and it is within this framework that a re-interpretation of *The Communists and Peace* must be sought.

It was, as I noted earlier, *The Communists and Peace* which sparked Merleau's anger and caused him to elaborate what he considered to be basic philosophical differences between Sartre and himself. Consequently, it is necessary to provide, if only in outline, a re-interpretation of this work in light of the approach to Sartre suggested in this article; unfortunately, space limitations for the present prevent a more exhaustive treatment. It will be recalled that Merleau accused Sartre of reducing political life to the level of judgment. I would argue, however, that Sartre, in analyzing the failure of the Communist-led demonstrations of 1952, makes it amply clear that, for the proletariat at least, political life is not an intellectual, but rather an existential project. Given the "interworld," it is clear that the relation of Party to proletariat cannot be that of sovereign to slave. In view of the "thickness" of the world, history can never be reduced to "a pact of wills," to "personal decisions." Meanings are visible in history. Even if the relationship of Party to proletariat were reducible to a subject-object relationship, this would not imply absolute knowledge on the part of the Party. The reason for this is that the subject as such has been shown to be *embodied.* Insofar as consciousness is incarnate, it cannot, on principle, take a "spectator's" view. Consequently, the Party cannot be omniscient. Facts bear a significance of their own and therefore will not allow of purely arbitrary interpretations. Since the subject is incarnate, it cannot enjoy complete lucidity. In keeping with this, the Party is not free to make history simply in any way whatsoever, to impose any meaning on the facts. If there is an "interworld," then there can be genuine dialogue between proletariat and Party; revolution ceases to be reduced to personal volitions. The Party, therefore, is not the sole historical agent. I have shown earlier that the relationship between two subjects is inherently unstable, and therefore calls for controls. Since absolute knowledge, utter lucidity, is ruled out, truth ceases to be a dogmatism that is imposed. Therefore, the Party cannot become dictatorial or terroristic. It follows from this that Sartre's philosophy does not lack a humanist perspective, despite Merleau's claims to the contrary.

The above reappraisal is admittedly sketchy; however, it serves to indicate the sort of reappraisal of Sartrism that can emerge once the "interworld" is reclaimed for Sartre. In this article I have made it my task to establish the existence of an "interworld" in Sartre's philosophy, to show

that the notion of *flesh,* which is central to Merleau's thought, also provides the key to "authentic Sartrism." To this end, I submitted Merleau's criticism of Sartre to a re-examination. It should be noted that Merleau's comments regarding Sartre's philosophy did not end with his *Adventures of the Dialectic.* At the time of his death in 1961, Merleau was in fact working on a book that was to provide the ontological foundation for his previous works. In this book Merleau intended to develop theories of intersubjectivity and truth, and more generally, to take up again, deepen, and rectify his earlier philosophizing.[115] Unfortunately, this work never progressed beyond some working notes and a manuscript containing the first part of the projected book. In this material, Merleau returned again to the consideration of Sartre's philosophy. Although his treatment here was concerned directly with the philosophical bases of Sartre's thought, it reaffirmed that interpretation which had already emerged in his earlier *Adventures of the Dialectic.*[116] Merleau, in this unfinished manuscript, returned to the very core of his own philosophy in stressing

> . . . that every being presents itself at a distance, which does not prevent us from knowing it, which is on the contrary the guarantee for knowing it . . . [that] the presence of the world is precisely the presence of its flesh to my flesh, that I "am of the world" and that I am not it . . . [that] there is this thickness of flesh between us and the "hard core" of Being . . .[117]

Is not this precisely what "*genuine* Sartrism" itself claims?

MONIKA LANGER

DEPARTMENT OF PHILOSOPHY
YALE UNIVERSITY

NOTES

 1. Jean-Paul Sartre, *Situations,* tr. by Benita Eisler (New York: Fawcett World Library, 1966), p. 174; hereinafter *Sits.*
 2. "Merleau-Ponty et le Pseudo-Sartrisme," *Les Temps Modernes,* 10, 2 (1955): 2121; hereinafter *T. M.*
 3. *T. M.,* 10, 2, p. 2122.
 4. *Sits.,* p. 156.
 5. See, e.g., Ronald Aronson, "Interpreting Husserl and Heidegger: The Root of Sartre's Thought," *Telos,* no. 13 (Fall 1972): 47–67; Ronald Aronson, "Sartre's Individualist Social Theory," *Telos,* no. 16 (Summer 1973): 68–91; Colin Smith, "Sartre and Merleau-Ponty: The Case for a Modified Essentialism," *Journal of the British Society for Phenomenology,* I (May 1970): 73–79; M. de Tollenaere, Jr., "Intersubjectivity in Jean-Paul Sartre," *International Philosophical Quarterly,* 5 (May 1965): 203–20; and Mary Warnock, *The Philosophy of Sartre* (New York: Barnes & Noble, 1965). On the other hand, James F. Sheridan, *Sartre: The Radical Conversion* (Athens: Ohio University Press, 1969) presents a very different interpretation.
 6. *T. M.,* 10, 2, p. 2072.

7. For a more detailed account of the social and political events that took place during the years of their friendship, I refer the reader to such works as David Caute's *Communism and the French Intellectuals 1914–1960,* George Lichtheim's *Marxism in Modern France,* Michel-Antoine Burnier's *Choice of Action: The French Existentialists on the Political Front Line,* and Sartre's essay entitled "Merleau-Ponty" in *Sits.* See also Monika Langer, "Violence in the Philosophy of Merleau-Ponty" (thesis, 1973); hereinafter *V. M.-P.*

8. Maurice Merleau-Ponty, *Sense and Non-Sense,* tr. by Hubert Dreyfus and Patricia Dreyfus (Evanston, Ill.: Northwestern University Press, 1964), p. 122; hereinafter *S. N.*

9. *Sits.,* p. 203.

10. *Sits.,* p. 202.

11. *Sits.,* p. 198.

12. *Sits.,* p. 199.

13. Sartre, *The Communists and Peace,* tr. by Martha H. Fletcher (New York: G. Braziller, 1968), pp. 4, 9; hereinafter *C. P.*

14. *C. P.,* pp. 10, 12.

15. *C. P.,* pp. 15, 23, 24.

16. *C. P.,* p. 55.

17. *C. P.,* p. 67.

18. *C. P.,* pp. 76, 87, 88.

19. *C. P.,* pp. 89, 97.

20. *C. P.,* p. 98.

21. Merleau-Ponty, *Adventures of the Dialectic,* tr. by. Joseph Bien (Evanston, Ill.: Northwestern University Press, 1973), pp. 207–32; hereinafter *A. D.*

22. *A. D.,* p. 188; in my thesis, "Violence in the Philosophy of Merleau-Ponty," I have argued that Merleau's position regarding political issues occupies a crucial place in the framework of his philosophy.

23. Merleau-Ponty, *Phénoménologie de la perception* (Paris: Gallimard, 1945; Bibliothèque des Idées). *Phenomenology of Perception,* tr. by Colin Smith (New York: The Humanities Press, 1962), pp. 439, 450; hereinafter *P. P.*

24. *P. P.,* p. 350.

25. *P. P.,* pp. 352, 350.

26. *P. P.,* p. 352.

27. *A. D.,* pp. 99ff., 124ff., 138ff., 165.

28. *A. D.,* pp. 111ff., 124ff., 132, 162, 199ff.

29. *A. D.,* pp. 99ff.

30. *T. M.,* 10, 2, pp. 2074ff.

31. *T. M.,* p. 2077.

32. Sartre, *L'Etre et le Néant; essai d'ontologie phénoménologique* (Paris: Gallimard, 1943; Bibliothèque des Idées). *Being and Nothingness,* tr. by Hazel E. Barnes (New York: Washington Square Press, Inc., 1966), pp. 525, 445; hereinafter *B. N.*

33. *B. N.,* p. 499.

34. *B. N.,* p. 499.

35. *B. N.,* p. 501.

36. *B. N.,* p. 444.

37. *T. M.,* 10, 2, p. 2074.

38. Sartre, *La Transcendance de l'ego: Esquisse d'une description phénoménologique* (Paris: Boivin, 1936; Recherches Philosophiques, VI). *The Transcendence of the Ego,* tr. by Forrest Williams and Robert Kirkpatrick (New York: The Noonday Press, Inc., 1957), pp. 80ff., 100, 42; hereinafter *T. E.*

39. *T. E.,* pp. 31, 104.

40. *T. E.,* p. 105.

41. *T. E.,* p. 106; *B. N.,* p. xiv (I am indebted to Hazel Barnes).

42. *T. E.,* p. 38.

43. *T. E.,* p. 40.

44. *B. N.*, pp. 193, 225.
45. *B. N.*, p. 442.
46. *B. N.*, p. 185.
47. *B. N.*, p. 377.
48. *B. N.*, pp. 377, 379.
49. *B. N.*, pp. 378–79.
50. *B. N.*, p. 379.
51. *B. N.*, p. 399.
52. *B. N.*, p. 422.
53. *B. N.*, p. 399.
54. *T. E.*, p. 31.
55. *T. E.*, pp. 94, 104.
56. *T. E.*, p. 97.
57. *T. E.*, p. 97.
58. *T. E.*, pp. 97ff.
59. *T. M.*, 10, 2, p. 2109.
60. *B. N.*, pp. 315, 507.
61. *B. N.*, p. 445.
62. *B. N.*, p. 430.
63. *B. N.*, p. 445.
64. *B. N.*, p. 273.
65. *B. N.*, p. 285.
66. *B. N.*, pp. 469, 497.
67. *B. N.*, p. 480.
68. *B. N.*, pp. 494, 476.
69. *B. N.*, pp. 146, 148.
70. *B. N.*, pp. 473ff., 479ff.
71. *B. N.*, pp. 480, 176.
72. *B. N.*, p. 477.
73. *B. N.*, p. 478.
74. *B. N.*, p. 475.
75. *B. N.*, pp. 474ff., 406.
76. *B. N.*, p. 479.
77. *B. N.*, p. 479.
78. *B. N.*, pp. 479, 483.
79. *B. N.*, pp. 484, 481.
80. *B. N.*, p. 483.
81. *B. N.*, p. 484.
82. *B. N.*, p. 497.
83. *B. N.*, p. 414.
84. *B. N.*, p. 482.
85. *B. N.*, p. 499.
86. *B. N.*, p. 415.
87. *B. N.*, p. 416.
88. *B. N.*, p. 308.
89. *B. N.*, p. 298.
90. *B. N.*, p. 299.
91. *A. D.*, p. 205.
92. *B. N.*, p. 643.
93. *P. P.*, pp. 364–65.
94. *V. M. P.*, pp. 112ff.
95. *V. M. P.*, pp. 113, 114.
96. *A. D.*, p. 158.
97. *P. P.*, pp. viii, 61.
98. *B. N.*, p. 391.

99. *B. N.,* p. 377.
100. *P. P.,* p. 442.
101. *P. P.,* p. 447.
102. *P. P.,* pp. 453, 455.
103. *B. N.,* pp. 554, 587, 589, 592.
104. *B. N.,* p. 599.
105. *B. N.,* p. 607.
106. *T. E.,* p. 69.
107. *B. N.,* p. 615.
108. *A. D.,* pp. 144, 159, 200; *P. P.,* p. 450.
109. *P. P.,* pp. xix, xxi, 448–49.
110. Merleau-Ponty, *Signs,* tr. by Richard C. McCleary (Evanston, Ill.: Northwestern University Press, 1964), p. 109.
111. *P. P.,* pp. 394, 395.
112. *V. M. P.,* p. 80.
113. *B. N.,* pp. 617, 625.
114. See, e.g., *B. N.,* pp. 617, 625.
115. Merleau-Ponty, *Le Visible et l'invisible; suivi de notes de travail* (Paris: Gallimard, 1964; Bibliothèque des Idées). *The Visible and the Invisible,* tr. by Alphonso Lingis (Evanston, Ill.: Northwestern University Press, 1968), p. 183; hereinafter *V. I.*
116. See, e.g., *V. I.,* pp. 50, 258, 272; see also Rabil, *Merleau-Ponty: Existentialist of the Social World* (New York: Columbia University Press, 1967).
117. *V. I.,* p. 127.

14

Maurice Natanson
THE PROBLEM OF OTHERS IN
BEING AND NOTHINGNESS

THE following considerations of the problem of Others in the thought of Jean-Paul Sartre are restricted largely to the analyses offered in *Being and Nothingness*. Although occasional reference will be made to Sartre's earlier and later works, the emphasis of this essay is purposely focused on his ontology. Such a limitation is clearly possible, but is it advisable? Do we risk making a torso of the problem of Others by shielding our critical glance not only from other important philosophical works in the Sartrean corpus but from his fiction and drama as well? Besides, is it not the case that Sartre's thought has undergone a development which compels his reader to attend to the historicity of an intellectual career rather than the confines of the covers of a particular book? Still further, has not Sartre himself served as his own critic and presented us with serious qualifications if not retractions of central features of his ontology? Has not the *Critique of Dialectical Reason* been read as a repudiation of much that gave *Being and Nothingness* its philosophical life? Finally, if a critic restricts himself to one book, should he not at least take into account the counter-arguments of another book: can one really discuss Sartrean ontology today without engaging in Marxian dialectics? The conviction which underlies these pages is that by turning to *Being and Nothingness* we are not so much accepting a chapter in the book of Sartre's entire thought as demanding that attention be paid to the interior sovereignty of his essay on phenomenological ontology. *Being and Nothingness* has a coherence of its own and merits attention on its own. Readers should not be badgered or bullied by their authors. If Sartre has indeed abandoned or repudiated positions he held as the author of an ontology, his reader is not automatically liberated from the task of deciding whether Sartre is correct in his later position and in his judgments of his previous work. Because Sartre has refused Sartre is no proper ground for our accepting his refusal. Our thesis shall be that, for all of its problems, *Being and Nothingness* is preferable to the *Critique of Dialectical Reason*.

That thesis, however, will not be argued here. Instead, I shall develop one side of the coin, and even then the issue will not be ontology in general but the status of the *alter ego* in particular.

I

The problem of Others, or other selves as it is more commonly called, is a function of the traditional impasse of solipsism. Sartre refers to the "reef of solipsism," and against that reef have foundered the philosophical expeditions of all thinkers, both idealist and realist, who have sought to generate the Other out of the self or who have commenced philosophical analysis by assuming the existence of the alter ego. As Sartre's discussion of Husserl, Heidegger, and Hegel shows, either one tries to build an epistemological bridge from consciousness to consciousness or else one repudiates the necessity for such bridge-building and asserts that one consciousness is already in touch with another within the sociality of human existence.[1] Either way, however, leads to a fresh impasse, for both ways are determined by the assumption that *knowledge* is the clue to the discovery of the Other. Against that assumption, Sartre offers a radically different view: that being, not knowledge, is the ground for our relationship to others. Accordingly, ontology rather than epistemology is the appropriate level of discourse. Later, we shall examine this claim more closely; for the moment let us reconnoiter the lay of Sartre's land.

The prime example, for Sartre, of a philosopher caught up in the trammels of solipsism is Husserl. That is not to say that Husserl is a solipsist; to the contrary, his thought represents the strongest effort in recent philosophy to overcome solipsism. Yet that effort, according to Sartre, fails. He writes:

> When Husserl in his *Cartesian Meditations* and in *Formal and Transcendental Logic* attempts to refute solipsism, he believes that he can succeed by showing that a referral to the Other is the indispensable condition for the constitution of a world. . . . For Husserl the world as it is revealed to consciousness is intermonadic. The Other is present in it not only as a particular concrete and empirical appearance but as a permanent condition of its unity and of its richness. Whether I consider this table or this tree or this bare wall in solitude or with companions, the Other is always there as a layer of constitutive meanings which belong to the very object which I consider; in short, he is the veritable guarantee of the object's objectivity. And since our psycho-physical self is contemporary with the world, forms a part of the world, and falls with the world under the impact of the phenomenological reduction, the Other appears as necessary to the very constitution of this self.[2]

This is an odd exposition of Husserl's argument. What falls with phenomenological reduction is the immanent thesis that this world is indeed *ours*. The genius of the natural attitude has solved the problem of Others by

never raising it, by tacitly taking it for granted that my perception of the world is true not only for me but for you as well. It is not to a referral to the Other that Husserl owes his phenomenological debt but to the appresentative accomplishment of intentional consciousness which makes such referral possible. To be sure, Sartre is correct in saying that Husserl's world is inter-monadic, but the source of that community of consciousness is transcendental subjectivity itself. What I locate within that subjectivity is the recognition that this world is for-Others as well as for-me. Husserl writes:

> In any case, then, within myself, within the limits of my transcendentally reduced pure conscious life, I *experience* the world (including others)—and, according to its experiential sense, *not* as (so to speak) my *private* synthetic formation but as other than mine alone . . . , as an *intersubjective* world, actually there for everyone, accessible in respect of its Objects to everyone.[3]

It is also true, as Sartre points out, that "the Other is always there as a layer of constitutive meanings which belong to the very object which I consider," but the constitutive source for those meanings is the intentional activity which generates "the world" out of the essential materials of "my world." The necessary referral to the Other is an unavoidable and powerful residue of the natural attitude. Phenomenological reduction, for Husserl, discloses the fateful anatomy of the constitution of authentic solitude. Husserl tells us:

> If I "abstract" (in the usual sense) from others, I "*alone*" remain. But such abstraction is not radical; such aloneness in no respect alters the natural world-sense, "experienceable by everyone," which attaches to the naturally understood Ego and would not be lost, even if a universal plague had left only me. Taken however in the transcendental attitude and at the same time with the constitutional abstraction that we have just characterized, my (the meditator's) ego in his transcendental ownness is not the usual I, this man, reduced to a mere correlate phenomenon and having his status within the total world-phenomenon. What concerns us is, on the contrary, *an essential structure, which is part of the all-embracing constitution* in which the transcendental ego, as constituting an Objective world, lives his life.[4]

So far in his commentary on Husserl's theory of the Other, Sartre has been biding his time. Now it is possible to see that the source of his dissatisfaction with the Fifth Cartesian Meditation is not really the referral to the Other or the layer of constitutive meanings which belong to the object, but rather Husserl's doctrine of the transcendental ego. Sartre writes:

> Formerly I believed that I could escape solipsism by refuting Husserl's concept of the existence of the Transcendental "Ego." At that time I thought that since I had emptied my consciousness of its subject, nothing remained there which was privileged as compared to the Other. But actually, although I am still per-

suaded that the hypothesis of a transcendental subject is useless and disastrous, abandoning it does not help one bit to solve the question of the existence of Others. Even if outside the empirical Ego there is *nothing other* than the consciousness *of* that Ego—that is, a transcendental field without a subject—the fact remains that my affirmation of the Other demands and requires the existence beyond the world of a similar transcendental field. Consequently the only way to escape solipsism would be here again to prove that my transcendental consciousness is, in its very being, affected by the extra-mundane existence of other consciousnesses of the same type. Because Husserl has reduced being to a series of meanings, the only connection which he has been able to establish between my being and that of the Other is a connection of *knowledge*. Therefore Husserl can not escape solipsism any more than Kant could.[5]

The earlier position referred to is that expressed in *The Transcendence of the Ego*, where intentionality is translated into a pure and lucid force. But the recognition that emptying consciousness of a subject is not sufficient to resolve the problem of a transcendental field has not stopped Sartre from pursuing the full ontological implications of the flushing out of transcendental identity. He is still reacting against the damage of a transcendental idealism which engorges both self and world in the "digestive philosophy" of empirico-criticism, neo-Kantianism, and all psychologism.[6] Alas, the sticking point of such intentional liberation is the transcendental ego. Husserl has betrayed his own intuition: intentionality frees us from introspection; it is not a return to the web of concepts, constructs, categories, and pure thought returning upon itself. "Back to Husserl" would mean, for Sartre, a return to the integrity of intentionality and world—an integrity unmediated by an ego *a priori* to the autonomy of consciousness. Thus, "we are delivered from Proust. We are likewise delivered from the 'internal life': in vain would we seek the caresses and fondlings of our intimate selves, like Amiel or like a child who kisses his own shoulder. . . ."[7]

Sartre's refusal of the transcendental ego amounts to a way of reconstructing Husserl. The more nearly technical problem of a non-egological theory of consciousness is not before us.[8] Rather, what we confront in Sartre's interpretation of intentionality is the preview of his doctrine of nihilation and nothingness; we are already in the presence of the *pour-soi*. It does not follow that those who, like Aron Gurwitsch, agree with Sartre's critique of the ego necessarily follow his ontology of consciousness. Gurwitsch certainly did not. The larger claim being made regarding intentionality is that consciousness is a void which throws us into the world, which vomits us into reality. Sartre's repudiation of Husserl's theory of Others is consistent with the fundamental philosophical insight of *Being and Nothingness*: that knowledge can never lead to a proof of the Other. A further examination of that thesis is necessary.

II

By turning Husserl against himself, Sartre manages to rid the ego not only of its transcendental subject but of its idealistic *a priorism*. Consciousness can never reach beyond itself; for that reason, something more fundamental than consciousness is required to locate the Other. The problem has at least two sides: the ego and the Other's impinging on the ego. We shall examine both. From the side of the ego, we come at once to the notion of the pre-reflective cogito (non-thetic or non-positional consciousness). Every intentional act not only has a subject intending some object but also bears an immanent consciousness of the arc of intending. "The first condition of all reflection is a pre-reflective cogito. This cogito, to be sure, does not posit an object; it remains within consciousness. But it is nonetheless homologous with the reflective cogito since it appears as the first necessity for non-reflective consciousness to be seen by itself."[9] Pre-reflective consciousness is, in Sartre's formulation, "consciousness (of)." Much of the subsequent argument of *Being and Nothingness* rests on the character and activity of this pre-reflection. In fact, ontology proper, for Sartre, is generated from the pre-reflective cogito. How is this possible? The answer, it appears, is that "consciousness (of)" is both a reflecting and a reflected within absolute immanence. We are left with an enigmatic duality:

> Thus consciousness (of) belief and belief are one and the same being, the characteristic of which is absolute immanence. But as soon as we wish to grasp this being, it slips between our fingers, and we find ourselves faced with a pattern of duality, with a game of reflections. For consciousness is a reflection [*reflet*], but *qua* reflection it is exactly the one reflecting [*réfléchissant*], and if we attempt to grasp it as reflecting, it vanishes and we fall back on the reflection.[10]

The reflected lives through the reflecting while the reflecting intends the reflected. Neither moment of the movement of consciousness yields being, but the interior passage between the two constitutes the character of nothingness, a prime mode of being. The pre-reflective cogito *is* the passage between the reflecting and the reflected. To say that this passage is characterized by absolute immanence is to say that pre-reflective consciousness is presence to itself. Such immanence marks the locus of the self.

For Sartre, the self is paradoxically present to itself in the mode of negation. The self *is* not itself yet is itself in so far as it is tantalized by its possibilities. As Sartre suggests: "The *self* therefore represents an ideal distance within the immanence of the subject in relation to himself, a way of *not being his own coincidence*, of escaping identity while positing it as unity—in short, of being in a perpetually unstable equilibrium between identity as absolute cohesion without a trace of diversity and unity as a

synthesis of a multiplicity. This is what we shall call presence to itself."[11] And he concludes with this ontological principle: "The law of being of the *for-itself*, as the ontological foundation of consciousness, is to be itself in the form of presence to itself."[12] Presence to self is the revelation of nothingness: it is the nothing which separates the subject from himself. The road from the pre-reflective cogito to the discovery of nothingness as presence to self is a long one but a direct and continuous one as well. But the "discovery" at issue is not the location of a something which happens to be nothingness. Rather, discovery arises in the upsurge of the *for-itself*, in which nothingness is not a content but a relocation. Sartre writes:

> One does not *find*, one does not *disclose* nothingness in the manner in which one can find, disclose a being. Nothingness is always an *elsewhere*. It is the obligation of the for-itself never to exist except in the form of an elsewhere in relation to itself, to exist as a being which perpetually effects in itself a break in being. This break does not refer us elsewhere to another being; it is only a perpetual reference of self to self, of the reflection to the reflecting, of the reflecting to the reflection.[13]

And now it is possible to understand why Sartre believes that his conception of the pre-reflective cogito is a qualitative advance over Husserl's doctrine of reflective consciousness: Husserlian doubt and Husserlian method are restricted methodologically, Sartre thinks, to reflective consciousness; *epochē* is an instrument of reflection alone. Yet it is the consciousness reflected-on which is the ground of the genuinely ontological. Since the pre-reflective cogito gives us the reflecting-reflected, it transcends the circuit of consciousness and locates being. We have moved from knowledge to the ontological, from epistemology to ontology.

There are several critical implications to be noted in this advance. First, Sartre assumes that Husserl's conception of "knowledge" is restricted to a formal concern for the structure of the *a prioris* of intentional consciousness. Husserl's interest is far wider: phenomenology is an inquiry into the experiential order in which reflection is of decisive but not isolated importance. Sartre is quick to invite Husserl into his home and just as quick to bid him goodbye. Phenomenology becomes a fair-weather friend. A closer examination of Husserl's work shows that he too has his "pre-reflective" domain: pre-predicative experience. Indeed, much of Sartre's discussion of non-thetic consciousness is a translation of Husserl's discussion of the passive and active syntheses which underlie the rudimentary strata of pre-predicative as well as predicative experience. *Erfahrung und Urteil* can be read in conjunction with *L'Etre et le Néant* on the subject of pre-reflective consciousness. The message of such a reading would be, in my judgment, that Husserlian "reflection" has a noetic-noematic duality internal to it in a way that is not all that distant from Sartre's "reflecting-

reflected." That is not to read ontology back into Husserl, but rather to qualify Sartre's instauration of being as an autonomous realm. Second, the self which is present to himself must be an instantiated self, an individual actualized in the world. How is such instantiation achieved? The pre-reflective cogito underlies the being of the individual as self, but whereas the way in which that being is structured is meticulously examined by Sartre, the fact of there being the individual in the world is left innocent of any fundamental analysis. It must be remembered that pre-reflective consciousness is generalized consciousness. With the ego emptied of its transcendental subject, the identity of the individuated self has been expelled from the phenomenological Eden. His return is permitted by way of the entrance of the empirical ego in and through reflective acts, memory, and related agencies of recoupment. The difficulties that attend such a back-door return are emphasized in the paradoxical status of the *pour-soi*, for the latter is a universal structure apparently already dispersed in the manifold reality of intersubjectivity. Does the *pour-soi* have a plural or is it a *singulare tantum* (to follow the usage of Alfred Schutz)? Does the *pour-soi* have gender? Does each self participate in the *pour-soi* or is *the pour-soi* a construction out of a plurality of concretized *pour-sois*? And is it chance which leads us to raise the same questions regarding the *pour-soi* which Husserl's followers and critics have asked about the transcendental ego? Is the *pour-soi* a disguised replication of a repudiated transcendental doctrine?

III

If the status of the *pour-soi* as one or many remains unresolved in Sartre's ontology, the plurality of selves within social reality emerges as indubitable. Others are a fact of sociation. Pursuing the kind of Kantian formulation frequently to be found in *Being and Nothingness*, we may ask, How is such a plurality possible? What must consciousness be in its infrastructure if its ultimate empirical expression is a social world? Such questions lead us to a central position which Sartre propounds regarding the relationship between selves: The "We" of sociality is not a genuine ontological structure. The reasons for Sartre's repudiation of the *Mitsein* are clear enough: if the self posits the Other, the latter is an object for the subjectivity of the former; if the self experiences itself as part of the field of the Other's awareness, it is as object-for-the-Other that the self emerges. Either the self has ontological mastery over the Other or it is mastered by the Other. In these terms, genuine being-with-Others in the full communion of social life proves to be an illusion. It is at this point that a rather standard criticism of Sartrean ontology is made: the treatment of relations

with Others in *Being and Nothingness* is not true to experience. I am interested in a different level of the entire problem of other selves. The question I propose to examine is, What is the structural relationship between Sartre's ontology of Others and the existence of fellow men within mundane experience? Or more broadly stated, What is the connection between ontology and sociology?

Within the natural attitude, in Husserl's terms, *we* is a taken-for-granted ground of experience. As a common-sense person operating naively in daily life, I assume that the Other is there twenty paces away from me, that the Other is walking toward me, that he is greetable, interruptible, pregnable. Furthermore, I assume that the Other is going about his business, taking a constitutional, or off to a rendezvous. If I stop him and engage him in conversation, I assume that, all things being equal to the occasion, I will receive a response to my remarks. Even if I am ignored or rebuffed, I am still in some sort of social relationship with him. Scorned, I may choose to play the injured party and complain about my treatment; shoved aside, I may plot my revenge, like the Underground Man. In fine, I remain within the realm of social action, a man among men related to them in sometimes tenuous but nevertheless binding ways. The fundamental predicate attaching to my response to Others is that of sociality. In turn, sociality is grounded in the typifications of mundane existence.[14] Mundanity is through and through we-structured. More important, it is the hallmark of the natural attitude that such communality is the tacit basis for all modes of sociation I have with my fellow men. Not only do I assume that their actions are grounded in *our* concretely shared world, but I also assume that they make the same assumption. *We*, my fellow men and I, are able to enjoy the same concert, play soccer together, build bridges together, fight together, revolt together. By the same token, the reality of everyday existence presupposes the possibility of mutual interaction for all human beings of whatever epoch or culture.

In other terms, it might be suggested that being-with Others is a cardinal feature of the orientation of mundane man in the life-world—an orientation which expresses itself in the character of social action. For the way in which *ego* is related to his *alter* involves an order of interpretation through which we make sense of what the Other is doing, why he does it, and why he does it at this particular moment. Max Weber's notion of the "subjective interpretation of meaning" may serve as the foundation on which social action is built. Within mundane life, I assume that the Other means something by his action. *Verstehen*, as Alfred Schutz has pointed out, is at bottom more than a methodological instrument of the social scientist; it is the medium through which common-sense men comprehend each other's actions.[15] In these terms, sociality is we-structured because the originary form

of understanding for mundane men is based on an interpretive procedure through which I endeavor to give meaning to the Other's action as I comprehend what his act means to him, the actor. Here, then, in the midst of mundanity is a naive hermeneutics which provides the substance of the life-world. It should be noted that at this point there is no distance between myself and the Other, no epistemological gap which separates the knower and the known. I am in the presence of my fellow men just as I am present to myself. But if it be objected that such presence is an epistemological construction rather than an ontological relationship, then it is necessary to turn once more to the large issue of the nexus between epistemology and ontology. Would a fully formed ontology of mundane existence demonstrate Sartre's claim that the we-relationship is an abortive phenomenon?

Whether or not one follows Husserl into the realm of phenomenological reduction, there are certain "transcendental clues" which offer the inquirer—even the ontologist—an insight into the order of sociality to which all fundamental philosophical analysis must ultimately return and with whose structure it must reckon. For Husserl, there is what I would term a methodological isomorphism between all determinations made at the phenomenologically reduced level and the character of the mundane sphere. For every item found upon transcendental examination, there is an analogue in the natural attitude. The isomorphism holds as a phenomenological principle because the qualitative distance between the phenomenologist's world and that of mundane man is a matter of levels of analysis of what is ultimately the same world, rather than a movement from one insulated domain to another. If, for the sake of our discussion, we accept Husserl's principle, we find that everything which holds true for common-sense reality offers a truth whose interior meaning is illuminated by an uncovering of the sedimentation constituted through the history of its becoming. Mundane existence is already historicized in virtue of its intentional ordering. And a cardinal feature of such historicization is the intersubjective force which the natural attitude naively expresses and symbolizes. The Others with whom I share mundane life are not objects which happen to swarm together; they are themselves interrelated in the manifold of *their* sociality. Thus, my connection with Others presupposes that apart from my relationship with them, they are already associated with each other. Husserl's claim that the perceptual world carries with it the intending of Others needs to be augmented: in my intending of world-as-pointing-to-Others, those Others are we-related on their own. If a responsible ontology is to join forces eventually with the social world, it must attend to the phenomena which comprise that world and look to their essential structure. If there is nothing abortive in the we-relationship in mundane experience, then ontology must account for such integrity.

In trying to avoid the reef of solipsism, Sartre has charted his course in the sea of being rather than the waters of knowledge. The result is that he cannot reach the shores of sociality. Yet it is the denizens of those shores which provide him with the means for avoiding the classical nautical disasters whose wreckage he so carefully examines. The Other is introduced as the herald of a new approach to the philosophical problem that haunts Husserl: instead of proving the existence of the Other, he appears on the scene; instead of arguing for his reality, I find myself disclosed by his glance; instead of being damned to the circuit of my own consciousness, I find myself suddenly as an object within his field. I have suggested that the first price Sartre has had to pay for such a victory is the distancing of authentic sociality from an ontology which, despite all its legitimate claims to the force of human reality, cannot transcend its own categories. Sartre has overcome solipsism only to find himself locked in its castle.

IV

In place of an elaborate argument for the existence of the Other, Sartre presents an apparently simple thesis: the Other is he who looks at me. My being seen by the Other is the egological point of access to the alter ego. Sartre writes:

> ... [T]his relation which I call "being-seen-by-another," far from being merely one of the relations signified by the word *man*, represents an irreducible fact which can not be deduced either from the essence of the Other-as-object, or from my being-as-subject. On the contrary, if the concept of the Other-as-object is to have any meaning, this can be only as the result of the conversion and the degradation of that original relation. In a word, my apprehension of the Other in the world as *probably being* a man refers to my permanent possibility of *being-seen-by-him*; that is, to the permanent possibility that a subject who sees me may be substituted for the object seen by me. "Being-seen-by-the-Other" is the *truth* of "seeing-the-Other." Thus the notion of the Other can not under any circumstances aim at a solitary, extra-mundane consciousness which I can not even think. The man is defined by his relation to the world and by his relation to myself. He is that object in the world which determines an internal flow of the universe, an internal hemorrhage. He is the subject who is revealed to me in that flight of myself toward objectivation. But the original relation of myself to the Other is not only an absent truth aimed at across the concrete presence of an object in my universe; it is also a concrete, daily relation which at each instant I experience. At each instant the Other *is looking at me*.[16]

There appear to be two aspects of the Other present in Sartre's account of the Look. The Other who looks at me is a mundane creature who has concrete being in the world; yet he is also a hypothetical construct of sorts built up as the necessary source of my egological disestablishment as subject of experience. Thus Sartre is able to write that "it is in the reality of

everyday life that the Other appears to us . . ."[17] but also that "the Other
. . . belongs to the category of 'as if.'"[18] Two ways seem equally blocked: I
recognize the Other as a fellow being in the midst of mundane existence,
yet ontological examination of that "fellow being" returns me to my
being-for-the-Other, returns me to myself; in the other direction, the "as
if" being of the Other would seem to be rooted in the construction the self
makes of his alter ego, a construction which also returns me to myself. Yet
the prime character of "the reality of everyday life" is that the Other is *with*
me in the thick of things, *there* at the end of the footpath, crowding me in
the subway train, cheering with me at the stadium, being examined with me
at the university, huddled together with me in the trenches. What I have
called the prime character of everydayness is neither a construct nor a sub-
jective posit of some kind; it is the world itself which is given in immediacy
to the self which intends it. It is clear that Sartre honors the force of the
mundane and opposes any effort to translate it into any version of idealism,
phenomenological or otherwise. Indeed, it would appear that against Hus-
serl, Sartre seeks to join ranks with common sense in denying to conscious-
ness the capacity to build a world. He writes:

> We know enough at present to attempt to explain that unshakable resistance
> which common sense has always opposed to the solipsistic argument. This re-
> sistance indeed is based on the fact that the Other is given to me as a concrete
> evident presence which I can in no way derive from myself and which can in no
> way be placed in doubt nor made the object of a phenomenological reduction
> or of any other *epochē*.[19]

Very well. But what, then, are we to make of that concrete Other who
looks at me over his newspaper from his chair on the sidewalk cafe as I pass
by? Is his glance casual, deliberate, purposeful, hostile, sexual, conniving?
We are told that it is not possible to enter another consciousness, and that
we must begin with what we have: finding myself at the end of another's
stare, a fragment within *his* world. There are reasons why such a response
is unsatisfactory; first among them is the fact that in searching for an ac-
count of myself-for-the-Other, I take for granted precisely the question at
issue in this entire discussion: How is the concrete Other constituted as a
fellow man?

 Not only has Sartre failed to answer the question concerning the con-
crete Other, he is incapable of answering it as long as he remains on the
terrain of his ontology. Nor should it be thought that existential psycho-
analysis will provide a resolution of the problem. The actualized human
being who is taken as the subject for existential psychoanalysis has already
been accepted as a self in the world; it is that concrete selfhood which is at
issue here. "That unshakable resistance which common sense has always
opposed to the solipsistic argument" is the implicit aspect of the General

Thesis of the natural attitude which Husserl has uncovered and explored. Without *epochē* the character of that thesis cannot be thematized. One result of Sartre's rejection of phenomenological reduction is that he relinquishes the instrumentality through which "unshakability" can be explicated. In place of reduction we are given a doctrine of being which purports to return experience to itself. "If we are to refute solipsism," Sartre writes, "then my relation to the Other is first and fundamentally a relation of being to being, not of knowledge to knowledge."[20] The trouble with that sentiment is that in the relation of being to being we have failed to account for that concreteness and individuation of the Other which is at the center of daily life. In effect, Sartre's ontology of the Other puts the alter ego in retreat, for it is not the actualized, specific fellow man I meet on ontological ground but the Other's world with respect to which I am a peripheral moment. In my being-for-the-Other, I discover him as the origin of interpretive organization of a reality in which I am an object of some order; in coming to recognize the Other as a master, I lose him as a brother; I discover myself as a character in the Other's drama; my own sovereignty is overthrown. Sartre writes:

> I grasp the Other's look at the very center of my act as the solidification and alienation of my own possibilities. In fear or in anxious or prudent anticipation, I perceive that these possibilities which I *am* and which are the condition of my transcendence are given also to another, given as about to be transcended in turn by his own possibilities. The Other as a look is only that—my transcendence transcended.[21]

It should be emphasized that our criticism of Sartre at this point is not a piece of the broader, more familiar argument which maintains that he has failed to acknowledge the I-Thou relationship or give its due to the solidarity of men in the career of society. Rather, I am interested in the failure of ontological analysis to confront concrete existence in its mundane expression. In turning to the relation of "being to being" instead of "knowledge to knowledge," Sartre has lost the specificity of the very experience he sought to engage as concrete and *lived*. To be sure, we were warned early in *Being and Nothingness* that "knowledge can not by itself give an account of being,"[22] but the assumption that being could account for itself has not proved any more acceptable. Inevitably, tradition reminds us that if every epistemology presupposes an ontology, so each ontology demands an epistemology. One is embarrassed by such historical chants, yet they serve as a grim reminder that it is of little consequence to avoid the reef of solipsism only to discover that the ship is sinking from internal leakage. It is my conviction that much of Sartre's trouble in *Being and Nothingness* could have been alleviated had he been more open to the later turn of Husserl's thought. In his haste to avoid the suspicion of transcendental idealism,

Sartre fails to recognize the existential implications and possibilities of phenomenological reduction. I shall return to that point shortly, but for the moment I might point out merely that Sartre has reversed a common criticism of phenomenology: that its method betrays an incapacity to appreciate concrete existence, that a doctrine of essence cannot accommodate the factic quality of the world. Curiously enough, Sartre's cautious reliance on phenomenology does not liberate him from much the same complaint: instead of plunging "man back into the world,"[23] ontology has removed him from his presence to concrete fellow men and substituted for that presence the immanence of being.

If *Being and Nothingness* loses touch with mundane reality, the numerous examples it employs remain very much rooted in the life-world. What have now become characters in the private novel each reader of Sartre is privileged to construct for himself remain flesh and bone protagonists, immobilized forever at their exemplary stations: the waiter in the cafe, the woman holding hands in Bad Faith, the soldier fixing his stare at so many paces, as prescribed by the manual, the friend still looking for the absent Pierre at their prearranged meeting place. What status do these figures have? Are they mediators between the realms of being and knowing, ontology and mundanity? Do they permit us to construct a kind of schematism of the categories of being? Or are they reminders that Sartre leaves with us to tell us that the world of ordinary human beings is still going on as the *pour-soi* spins its dialectic of negation, reminders that with all of the downward power of analysis created in *Being and Nothingness*, a movement upward which might rejoin the world of naive being in which concrete men are haunted by their *possibles* is still being sought and remains out of reach?

V

If Sartre's effort to rejoin the world of concrete mundanity has not succeeded, we may return to the question of whether his ontological descent to pre-reflective consciousness has fared any better. Earlier, we charged Sartre with failing to take the full measure of Husserl's transcendental phenomenology. Although that discussion helped to launch our inquiry, it will not serve as an adequate response to Sartre's criticism of Husserl. It is not enough for us to demand that Sartre return to transcendental subjectivity as the authentic ground for the constitution of intersubjectivity when that ground is the target of a detailed critique in *Being and Nothingness*. For Sartre, Husserl has failed to demonstrate how the transcendental subjectivity of the ego can constitute the transcendental subjectivity of the alter ego. There is considerable force to that argument; but it comes to grief not because it is false but because Husserl's doctrine of

transcendental subjectivity proves to be a much more fluid notion than has hitherto been recognized. Of course, we have long known that there was great ambiguity in the status of the transcendental. What we have perhaps not appreciated is the nature of "proof" when we examine the Fifth Cartesian Meditation. If we are compelled to answer the question, Strictly speaking, does Husserl prove his case regarding Others?, the narrow answer is "no." However, if we ask, Does Husserl provide the resources for a transcendental proof for the alter ego?, then we may say that his "proof" of Others as constituted in transcendental subjectivity offers a matrix through which both the problem of other selves and a philosophical reconstruction of Others may be comprehended. In a way, Husserl's argument in the Fifth Cartesian Meditation is analogous to Anselm's ontological argument. As a logical demonstration, the proof fails; but as an instrumentality through which the problem of the existence of God may be grasped and illuminated, the argument deserves its reputation as the most subtle of all such efforts. There is a methodological affinity between Husserl and Anselm. In both cases, the meaning of primordial terms is reconstructed.

It might appear that we have given Husserl a consolation prize. To the contrary, my point is that he has won the only prize available to phenomenology: the tracing out of the career of intentional consciousness in its transcendental unfolding. We have returned to Sartre's position. If phenomenology is a discipline concerned solely with meaning, then at best it can display the structure of knowledge; beyond that lies the quicksand of transcendental creation. Once again, however, Sartre complains that phenomenology understood as a discipline of meaning is correctly understood, yet cannot move beyond itself. Meaning cannot arrive at being. I do not constitute the Other; I encounter him. But if knowledge will not yield the social, neither will being. We are driven to the consideration of two alternative evaluations of Sartre's procedure. First, by rejecting Husserl's theory of transcendental subjectivity, Sartre has placed sociality on the far side of any epistemological effort. Meaning simply will not reach to being. If that is true, not only does phenomenology fail to provide access to being but its method must also be inappropriate to the description and analysis of being. How does it happen, then, that *Being and Nothingness* carries the subtitle it does? What use, we are at last driven to ask, can Sartre have for a method which, on his own terms, must remain indentured to epistemology and forever under the influence of idealism? In sum, by refusing the later Husserl, Sartre sought to vindicate Husserl's earlier, descriptive enterprise. As it turns out, phenomenology as a philosophy of meaning remains alienated from the tasks of ontology.

We must not fail to attend to a second feature of Sartre's procedure. That being which phenomenology cannot reach has its roots in the pre-

reflective cogito. Indeed, much of the early discussion in *Being and Nothingness* is an attempt to clarify the implications as well as the structure of non-thetic consciousness. Sartre is convinced that all reflection has as its essential condition a non-reflective, non-positional or pre-reflective cogito. He writes:

> . . .The reflecting consciousness posits the consciousness reflected-on, as its object. In the act of reflecting I pass judgment on the consciousness reflected-on; I am ashamed of it, I am proud of it, I will it, I deny it, etc. The immediate consciousness which I have of perceiving does not permit me either to judge or to will or to be ashamed. It does not *know* my perception, does not *posit* it; all that there is of intention in my actual consciousness is directed toward the outside, toward the world. In turn, this spontaneous consciousness of my perception is *constitutive*, of my perceptive consciousness. In other words, every positional consciousness of an object is at the same time a non-positional consciousness of itself.[24]

Since Sartre takes phenomenology to be a reflective procedure, its method cannot gain access to the activity of the pre-reflective cogito. Yet the medium of the cogito is intentionality, and intentionality for Husserl puts us in the presence of the world. Despite the promise that intentionality has a transcendence which places us in the immediacy of the real, Sartre maintains that Husserlian consciousness, in its reflective posture, can yield only absence, not presence. Rather than delivering the world, intentionality points to the adumbrative character of slivers of intended being. Sartre asks:

> But how can non-being be the foundation of being? How can the absent, *expected* subjective become thereby the objective? A great joy which I hope for, a grief which I dread, acquire from that fact a certain transcendence. This I admit. But that transcendence in immanence does not bring us out of the subjective. It is true that things give themselves in profile; that is, simply by appearances. And it is true that each appearance refers to other appearances. But each of them is already in itself alone a *transcendent being,* not a subjective material of impressions—a *plenitude of being,* not a lack—a *presence,* not an absence. It is futile by a sleight of hand to attempt to found the *reality* of the object on the subjective plenitude of impressions and its *objectivity* on non-being; the objective will never come out of the subjective nor the transcendent from immanence, nor being from non-being. But, we are told, Husserl defines consciousness precisely as a transcendence. In truth he does. This is what he posits. This is his essential discovery. But from the moment that he makes of the *noema* an *unreal*, a correlate of the *noesis*, a noema whose *esse* is *percipi*, he is totally unfaithful to his principle.[25]

It appears that Sartre deems it perfectly all right to utilize phenomenological method to anatomize the pre-reflective cogito, but balks at Husserl's constitutive history of irreality. Somehow, the former yields being, whereas the latter secretes absence. It is time to make explicit the

quarrel that has been muttering under its text in these pages: the fact is that much of the detailed analysis of the *pour-soi*, negation, nihilation, and the entire dialectic of non-being is rooted in a phenomenology of pre-reflective consciousness which selected what it pleased from Husserl's bounty. If the pre-reflective cogito is in the presence of the world, it is because intentional consciousness is at work in its immanent being. Being becomes meaning when the instantiated *pour-soi* locates the Other *as being* his apoplectic face, his clenched jaw, his tightened fist. But the Gestalt of wrath does not achieve its signification from an examination of skin color or muscle tension. The threatening presence of the Other's face understood as a noematic unity *is* the reality of the threat as intended by the one being threatened. Why is the noema here any less "real" or present to consciousness because it is grasped as a correlate of the acts which intend it? Somehow Sartre believes that Husserl's realm of meaning is cordoned off from the real world, but he remains at ease with a conception of the pre-reflective cogito whose geography is the pure landscape of immanence. In short, Sartre is a good borrower but a poor returner. If Husserl is guilty of transcendental isolation, Sartre remains an accomplice to the crime, despite all his protestations to the contrary. We have, in fact, returned to the problem of solipsism.

Within the natural attitude, the Other presents himself as someone with whom I can act. If my gauging of Sartre's position in *Being and Nothingness* is accurate, his ontology of Others accounts for the actuality of interaction but does not explain how such interaction is possible. The alter ego becomes an ontological construct built up out of the very concretion which has escaped him. In a way, the argument presented in *Being and Nothingness* is an ontological version of Husserl's transcendental subjectivity. For all of Sartre's explicit and vociferous renunciation of noetic-noematic phenomenology, his own account of intersubjectivity has not escaped the failings of its transcendental analogue. Such a formulation is of course completely unacceptable to Sartre; I merely suggest that in repudiating Husserl, Sartre has bitten his own tongue. Much of what gives *Being and Nothingness* its life and its genius remains rooted in the possibility of phenomenology to seize the world in an originary way—to radicalize even Hegel's inverted world by pursuing the farthest reaches of phenomenological reduction. Even if epistemological solipsism is overcome, the means for overcoming are the unavoidable responsibility of a methodological solipsism. The difference between Husserl and Sartre at this point is that the phenomenologist of Freiburg has elected to struggle with the transcendental implications of solipsism, whereas the phenomenologist of Paris has embraced sociality without ever having fought his way to that concrete Other *already there* in the heart of sociality.[26]

The unspoken motto for the preceding pages is: Let Husserl do unto Sartre what Sartre has done unto Husserl. Although that recommendation seems to have an element of retaliation in it, I intend it in quite a neutral sense. In *The Transcendence of the Ego* as well as in *Being and Nothingness*, Sartre has endeavored to defend the "good" Husserl against the "bad" Husserl, the descriptivist against the transcendentalist. In the present essay I have attempted to recall Sartre to himself by setting the Sartre who has been nourished by phenomenology against the Sartre who flees from contact with transcendental subjectivity. Thus, I pit Sartre against himself. It appears to me that the true existential force of phenomenological reduction has been missed, for different reasons, by both Husserl and Sartre. The former is fearful that a primarily methodological instrument will be psychologized by Heideggerian-like hermeneutics; the latter worries that the undertow of the old idealistic current will drag human reality under. We remain dominated on both sides by anxieties that the legitimate center of a doctrine will be eroded by allies as well as by opponents. The position with which I have associated myself in this essay is rooted in the later Husserl, the Husserl whose phenomenology has returned to the life-world and to that historicity which was always, if only tacitly, the theme of transcendental philosophy. In the years of his post-ontological labors, we have heard little from Sartre about the new developments in Husserl's later writings. Instead of a critique of *The Crisis of European Sciences and Transcendental Phenomenology*, we have had the *Critique of Dialectical Reason*. The themes of the *pour-soi* and of the pre-reflective cogito have given way to other concerns. It is as if the remarkable barricades constructed in *Being and Nothingness* had finally been breached in a massive assault of history, as if ontology had been wiped out. Yet Sartre remains his past in the mode of negation. The itinerary that led him through *Being and Nothingness* is inevitably continuous with the path he has chosen in the publications of the last fifteen years. To understand Sartre, the reader must traverse Sartre. Nor does our placing of Sartre *contra* Sartre liberate the reader from the task of following where ontology leaves off. That granted, an additional truth manifests itself: If Husserl's thought was precious to the early Sartre, it must remain virtually present in his later work. Accordingly, the transcendental paradoxes and aporias involved in Husserl struggling to overcome Husserl find their mundane analogue in the history of Sartre seeking to define Sartre.

MAURICE NATANSON

DEPARTMENT OF PHILOSOPHY
YALE UNIVERSITY

NOTES

1. Jean-Paul Sartre, *Being and Nothingness: An Essay on Phenomenological Ontology*, tr. by Hazel E. Barnes (New York: Philosophical Library, 1956), pt. III, ch. 1, sec. III. Original: *L'Etre et le Néant: Essai d'ontologie phénoménologique* (Paris: Gallimard, 1943).

2. Ibid., p. 233; original: pp. 288–89.

3. Edmund Husserl, *Cartesian Meditations: An Introduction to Phenomenology*, tr. by Dorion Cairns (The Hague: Martinus Nijhoff, 1960), p. 91. For German version, see *Cartesianische Meditationen und Pariser Vorträge*, ed. by S. Strasser (The Hague: Martinus Nijhoff, 1950), p. 123.

4. Ibid., p. 93; original: p. 125.

5. *Being and Nothingness*, p. 235; original: pp. 290–91.

6. See Jean-Paul Sartre, "Intentionality: A Fundamental Idea of Husserl's Phenomenology," tr. by Joseph P. Fell, *Journal of the British Society for Phenomenology*, 1 (1970): 4–5. For French version, see "Une Idée fondamentale de la phénoménologie de Husserl: l'intentionalité," *Situations* I (Paris: Gallimard, 1947), pp. 31–35.

7. Ibid., p. 5; original: p. 34.

8. See Aron Gurwitsch, *Studies in Phenomenology and Psychology* (Evanston, Ill.: Northwestern University Press, 1966), ch. 11: "A Non-egological Conception of Consciousness." Cf. Alfred Schutz, *Collected Papers*, vol. I: *The Problem of Social Reality*, ed. by Maurice Natanson (The Hague: Martinus Nijhoff, 1962), pp. 169–70.

9. *Being and Nothingness*, p. 74; original: pp. 116–17.

10. Ibid., pp. 75–76; original: p. 118.

11. Ibid., p. 77; original: p. 119.

12. Ibid.

13. Ibid., p. 78 (translation slightly modified); original: p. 121.

14. See Alfred Schutz, *Collected Papers*, vol. I, especially pt. I.

15. Ibid., pp. 56–57.

16. *Being and Nothingness*, p. 257; original: pp. 314–15.

17. Ibid., p. 253; original: p. 311.

18. Ibid., p. 227; original: p. 282.

19. Ibid., p. 271 (*note*: I have transliterated the Greek word for "epochē"); original: p. 330.

20. Ibid., p. 244; original: pp. 300–1.

21. Ibid., p. 263; original: p. 321.

22. Ibid., p. li; original: p. 16.

23. Jean-Paul Sartre, *The Transcendence of the Ego: An Existentialist Theory of Consciousness*, tr. by Forrest Williams and Robert Kirkpatrick (New York: Noonday Press, 1957), p. 105. For French version, see *La Transcendance de l'ego: Esquisse d'une description phénoménologique*, ed. by Sylvie Le Bon (Paris: Vrin, 1965), p. 86.

24. *Being and Nothingness*, p. lv; original: p. 19.

25. Ibid., p. lxiii; original: p. 20.

26. Alfred Schutz writes (*Collected Papers*, vol. I, pp. 198–99): "As a starting point of his analysis he [Sartre] takes it tacitly for granted that my experiencing the Other and the Other's experiencing me are simply interchangeable. For instance, instead of analyzing the meaning of my body for the Other, as he promised to do, he offers merely an analysis of the meaning the Other's body has for me. He says, moreover, that by objectifying the Other, the Other is an object to me merely to the extent to which I am an object to him. It will not be denied that the demonstration of such an interchangeability might be the *outcome* of any analysis of intersubjective relationship. Yet it cannot be taken for granted as its '*starting point*' without committing a *petitio principii*. The whole problem of constituting the Other consists in answering the question: How is such an interchangeability possible? Sartre's criticism of the solipsistic argument can be applied to his own theory. For even if we were prepared to admit with him that our belief in the Other's *existence* needs no proof since it is

rooted in a pre-ontological understanding, we should have to show how we can arrive at an understanding of the *concrete* Other's *concrete behavior* without falling back upon the solipsistic argument." Cf. Edmund Husserl, *Formal and Transcendental Logic*, tr. by Dorion Cairns (The Hague: Martinus Nijhoff, 1969), pp. 236–37. Original: *Formale und transzendentale Logik: Versuch einer Kritik der logischen Vernunft* (Halle: Niemeyer, 1929), pp. 208–10.

15

Thomas R. Flynn
MEDIATED RECIPROCITY AND THE
GENIUS OF THE THIRD

For today there are only two ways of speaking about the self: the third person singular and the first person plural. We must know how to say "we" in order to say "I"—that is beyond question. But the opposite is also true. If some tyranny, in order to establish the "we" first, deprives individuals of the subjective image, all "interiority" disappears and all reciprocal relations with it.

Sartre's Foreword to Andre Gorz's *The Traitor*[1]

W HAT follows may be considered an extended gloss on the above remarks. For this article offers a critical examination of Sartre's defense of interiority and reciprocity in the midst of collective action by distinguishing two uses of the concept of the third person, or simply the "Third" (*le tiers*), which occur in his systematic writings. After a brief review of this concept in *Being and Nothingness*, where it is introduced, our attention will focus on *Critique of Dialectical Reason* and on that apocalyptic moment when the group emerges. It is only then that Sartre distinguishes between what we shall term the "alienating" Third and the mediating Third.

The dismal conclusion of *No Exit*, "Hell is other people," has long been taken to be a fitting epitaph for Sartre's social philosophy. At the time *Being and Nothingness* was published, in 1943, critics tended to read its description of intersubjective relations as normal, indeed as inevitable, and for that reason to conclude that Sartrean social theory was bankrupt. Yet by the end of the next decade Sartre had produced the *Critique* which, if scarcely a logical outgrowth of *Being and Nothingness*, yet preserved its "existentialist" values and at the same time suggested new and significant alternatives to standard dilemmas in contemporary social philosophy.

Besides answering the "normative" challenge of *Being and Nothingness*—namely, that any existentialist social theory must respect the primacy of individual freedom/responsibility at the very peak of collective

life—the *Critique* responds to the common ontological question concerning the nature of the individual-group relation and the status of its terms, as well as to the current debate between methodological holists and individualists regarding sociological and psychological explanations in the social sciences.

After closely examining Sartre's treatment of the Third in the apocalyptic genesis of the group (section II, below), we shall evaluate the success of the mediating Third in resolving those questions which must be faced by any adequate social philosophy (section III). But first let us observe Sartre's initial use of the term in *Being and Nothingness*.

I

Sartre's systematic introduction of the Third occurs in part III of *Being and Nothingness* as a development of the category "for-others" (*pour-autrui*). The Other, he writes, "has established me in a new type of being which can support new qualifications."[2] This new type of being is my "self-as-object"; the qualifications are the well-known relations of fear, pride, shame, alienation of possibilities, and the like, which the Look (*le regard*) of the Other-as-subject now brings into play. But the Other's look at best constitutes a duality of mutually objectifying consciousnesses, each transcending the other, each the internal negation of the other. The barrier is insuperable: though I experience the Other as subject (indirectly, by experiencing myself objectified), I can only know him as object. Deliverance from objectification requires a reverse objectification. Hence the fundamental projects of the *pour-soi* regarding others are the antisocial attitudes of sadism, masochism, and hatred. Sartre insists that *all* men's complex patterns of conduct toward one another are merely enrichments of these attitudes.[3] In an apparent effort to salvage a semblance of social forms, Sartre at this point introduces the Third.

We first discover the Third as the alienating presence who objectifies two lovers by his look, fixing their mutual relationship into a set of dead possibilities. Whatever they do, he is always there to qualify their plans, to give them a meaning which they cannot control. In Sartre's metaphor, he "robs" them of their freedom. We shall designate this use of the term the "alienating" Third, for its major features are shared with the Other, the chief agent of alienation in *Being and Nothingness*. The Third merely establishes a "more complex modality of being-for-others."[4]

We must insist on Sartre's claim that the Third constitutes only a "more complex mode" of being-for-others. For we wish to argue that it is precisely this similarity between Other and Third in Sartre's "existentialist" analysis which accounts for the concept's poverty in social theory. It

will be supplemented, though not supplanted, in the *Critique* by a richer (in terms of explanatory force) and qualitatively different use. So let us summarize the features common to the Other and the alienating Third.

Like the Other, the Third is essentially *extrinsic* to the dual.[5] It transcends and totalizes the dual into an object-like unity (*unité-objet*), the *Us-object*. This object-unity effected by the Third *ab extra* is a *unity of equivalence* wherein each loses his identity and individuality in a common equation with every Other. The result is what Sartre calls a "community of equivalence" between me and the Other.[6] He will ascribe this characteristic to serial unity in the *Critique*. In fact, the entire discussion of the series in the later work falls heir to the description of the Us-object in *Being and Nothingness*.

But chiefly, the Third *alienates* the dual in a twofold sense which summarizes the preceding features. It does this first by objectifying it, deadening its possibilities, and constituting it a transcended transcendence in the same way the Other alienates the for-itself. Secondly, by establishing an equivalence between the for-itself and the Other, the Third forces the former to assume responsibility for a totality "which it is not, although it forms an integral part of it."[7] Being an Us-object is thus felt to be a still more radical alienation for the for-itself than simple being-for-others.

Significantly, the Third figures only obliquely in Sartre's discussion of the We-subject. (It will form the very center of his analysis of the "We" in the *Critique*.) He dismisses the We-subject as a mere "subjective *Erlebnis*," a purely psychological phenomenon, lacking the ontological ground in being-for-others which supported the Us-object.[8] But the same relationship, *looking/looked-at*, which accounts for the reality of the Third and the Us-object, precludes any non-objectifying, non-alienating exchange such as a real, intrinsic unity of subjectivities would require. Although the Look may succeed in obviating solipsism in Sartre's ontology, the net gain for social philosophy is practically nil. For the others whose existence is apodictically evident in shame consciousness are radically out of reach from me and from each other.[9]

Conflict, not reciprocity, is the essence of relations between consciousnesses in *Being and Nothingness*.[10] The alienating Third merely raises to another power Sartre's famous dyadic and non-dialectical opposition looking/looked-at. And the social ideal of *Being and Nothingness*, if we may even speak of one, is an extrapolation of this dyad to the "humanistic Us"—the limit concept of humanity as the totality of the Us-object before God, the impossible Third—and the "We" of collective subjectivity, as "simple symbol of the longed-for unity of transcendences."[11] But the former is merely alienation writ large while the latter remains a psychological symptom.

The challenge, therefore, which *Being and Nothingness* raises in the name of individual consciousness (freedom/responsibility) springs from "the impossible ideal of the simultaneous apprehension of [the Other's] freedom and of his objectivity. . . . We shall never place ourselves concretely on a level of equality; that is, on the level where the recognition of the Other's freedom would involve the Other's recognition of our freedom."[12] It is as if to disprove this claim that Sartre introduces the mediating Third in the *Critique*. Its presence marks a major advance in his social theory ontologically, methodologically, and normatively.

II

If a preponderance of dyadic relationships (including the covert dyad, Dual/Third) severely limits the social scope of *Being and Nothingness,* the abundance of triads in the *Critique* signals a new phase in Sartre's social philosophy. Paradigmatic of dyadic opposition in *Being and Nothingness* is the sadomasochistic circle that revolves incessantly and without advance in that work like the alternating negations of the characters in *No Exit*. But in the *Critique* the analytic law of Double Negation (that is, $-(-p) = p$) has been suspended; the circle is exchanged for a spiral; the concept of *mediation* comes to the fore.[13]

"The capital discovery of dialectical experience," Sartre claims, "is that man is 'mediated' by things to the same degree that things are 'mediated' by man."[14] "Man" now signifies primarily *praxis* for Sartre, and "things" signifies the practico-inert. The chief dialectical agent is individual praxis, and the "mediators" are the practico-inert and the Thirds. We must explain this dialectical repertoire as we prepare to analyze the genesis of the group from a multiplicity of separated individuals.

Admittedly, a dualistic opposition continues to pervade the *Critique*. But the *pour-soi/en-soi* dichotomy of *Being and Nothingness* gives way to praxis and the practico-inert. Praxis, a technical term essential to Marxist socioeconomic theory, for Sartre denotes human activity in its material environment.[15] As human, this activity is originative and purposive. As activity, it is dialectical in that it constantly totalizes its past and present in relation to an objective to be realized in the future.[16] And as dialectical, it is the negation of its negation, the practico-inert, to which it is internally related.

But the principal characteristic of individual praxis from the viewpoint of Sartre's overall strategy in the *Critique* is doubtless its self-luminosity. As constitut*ing* dialectic, individual praxis is totally evident to itself, like the *pour-soi* in *Being and Nothingness*. Thus it serves as the ultimate source of evidence in Sartre's present system, establishing that link between being

and knowing which he wishes to restore with Hegel, while denying the "ideality" of matter, that is, without turning Hegel once more on end.

The other term in Sartre's duality, the practico-inert, functions as anti-praxis or anti-dialectic, making history possible and rendering any overarching master dialectic impossible. The practico-inert is the locus of scarcity (*la rareté*), that simple but transcendental fact that there are not enough material goods to go around,[17] of material objectivity, and of the permanence of human endeavors in their "solid" state as institutions, traditions, artifacts, and the like (what Sartre terms "worked matter").[18]

Yet the same practico-inert by its sheer material recalcitrance blocks the success of any superdialectic. It is never fully subsumable into a non-inertial form. Hence in the *Critique* it dissipates practical unities, hardens spontaneity into habit, reverses or deflects projects with its counter-finality, and functions generally as the antithesis of freedom. It moderates as a kind of "reality principle" any utopian expectations with which one might be tempted to clothe Sartre's talk of a classless society and, as we shall see, leaves the question of "disalienation" at best problematic.

All social objects, Sartre insists, "are beings of the practico-inert field, at least in their fundamental structures."[19] By construing the practico-inert as anti-dialectic and by further qualifying it with the fact of scarcity, Sartre has grounded the Marxist historical dialectic and offered an explanation for the scandal of continued alienation in socialist societies.

What Sartre calls the social field, that is, the proper domain of sociology, consists of structured ensembles formed from praxis and the practico-inert in dynamic tension. At either extreme of this polar opposition stands a social ensemble, namely, the collective (*le collectif*) and the group. Sartre defines the collective as "that two-way relationship between a material, organic, worked object and a multiplicity which finds its 'external unity' [*unité d'exteriorité*] in it."[20] The group, in contrast, is defined by its common enterprise, which provides a practical unity and a specific intelligibility for its praxis. Whereas group is conceived as project, praxis, internal unity, and dissolution of inertia, the collective as described as passivity, exis, multiplicity, and discrete quantity. At the limits of the social field Sartre speaks of "collectives which have almost entirely absorbed their groups and groups where passivity tends to disappear completely."[21] Although his regressive analysis moves from series to group to "concrete" class struggle, no attempt is made to assign a temporal precedence to one form over another. Conceptually, however, collectives are simultaneously "the matrix of groups and their grave."[22]

As we complete this dialectical lexicon, it should be noted that these social ensembles are *relational*. Sartre writes: "When I wish to find my location in the social world, I discover ternary and binary formations

around me. The former are in constant dissolution, and the latter appear on the ground of a revolving totalization and can be integrated into a trinity at any moment."[23] Throughout the *Critique* Sartre is tireless in affirming that these relations are ever *en cours*, that the totalities which praxis effects are really "totalizings," and that the ensembles which social science studies are *practical* unities, not metaphysical hypostases. As our final prelude to the question of mediated reciprocity, let us turn to the dual in the *Critique*, the better to understand Sartre's claim that "the *real* relation of men among themselves is necessarily ternary."[24]

In *L'Idiot de la famille* Sartre insists that "the fundamental relation among men—masked, deviated, alienated, reified as you will—is reciprocity."[25] In the *Critique* he lists four conditions necessary for reciprocity: (1) that the Other be a means to the exact degree that I am a means myself, that is, that he be the means toward a *transcending* goal and not *my* means; (2) that I recognize the Other as *praxis*, that is, as totalization *en cours*, at the same time that I integrate him into my totalizing project; (3) that I recognize his movement toward his own ends in the very movement by which I project myself toward mine; and (4) that I discover myself to be the object and instrument of his ends by the same act which makes him the object and instrument of mine.[26] Although Sartre offers such examples of reciprocity as the boxing match and the exchange of goods and services, it is clear from his statements in the *Critique* and elsewhere that he takes reciprocity among laborers to be the most significant instance of this relationship, for it generates class consciousness and thereby furthers history.[27]

Before considering these conditions singly, we must understand what reciprocity is not. Sartre denies that it is an abstract, universal bond such as he believes Christian charity to be. But neither is it the Kantian ideal of treating each man as an end and never as a means alone. His opposition to the Kantian kingdom of ends is revealing of his own anthropology, for it assumes that only *ideas* can be ends in the unconditional sense which he ascribes to Kant. Against what Sartre rather loosely terms "absolute idealism" he maintains that "man is a material being in the midst of a material world."[28] In other words, man *is* his relationship to matter and he cannot establish new relations except *via* the dissolution of the present ones. Thus he himself becomes the instrument or *means* in his present state toward achieving that future condition which he will be. And this in turn clarifies Sartre's opposition to the Kantian imperative as he reads it: since I must treat even myself as a means, I cannot be expected to consider another as an end. "Cannot" negates "ought."

So the first condition for reciprocity recognizes the fact that every man is a means. But it requires that the goal of this instrumentality be non-

exclusive. To the extent that reciprocity obtains, mutually exclusive aims must be suspended.

The second and third conditions entail that I recognize the Other as praxis (Sartre would have said "as freedom" in *Being and Nothingness*), and that I thus acknowledge the purposive character of his action as I am determining my own. (Consider the example of the boxing match.)

Finally, this recognition must be practical and mutual. It must be achieved in the very act that expresses it as, for example, in the feinting and jabbing of the boxer. This excludes the alternating "reciprocity" described in *Being and Nothingness*.

These conditions clearly avoid the built-in conflict which marks the dyads of *Being and Nothingness*. In effect, Sartre is arguing that *unmediated* reciprocity is an abstraction; and that the *quality* of the reciprocity, that is, its antagonism or supportiveness, depends on those *mediating* factors of which the dialectical experience made him aware, namely, the practico-inert and the Thirds.

Not only is unmediated duality abstract, it lacks *unity* as well. Pushed to the limit, binary integration still remains plural. This very reciprocity is "the negation of unity."[29] But the principles of mediation which we have analyzed thus far—the practico-inert and the alienating Third—merely confirm the inner dividedness of the dual, imposing an external unity on a multiplicity which continues to resemble the Us-object of *Being and Nothingness*.

The fundamental reason why unmediated reciprocity implies separation, a reason that continues to this day to deprive Sartre of a dialogical model, is his insistence that "mutual integration implies the being-object of each one for the Other."[30] Sartre has long considered objectification a major form of alienation. Hence, whatever mutuality a binary relationship achieves will always be a compromise between agents who recognize that the Other's project exists *outside* their own. They cannot totalize without objectifying. The result is what Sartre calls "disunion in solidarity" as he goes on to argue that internal unity can be effected only by the mediation of the Third.

Another form of Third, however, is demanded by the deficiencies of the dual which Sartre portrays. Unmediated reciprocity is not unifying because it is objectifying. Non-objectifying or "free" reciprocity, as Sartre calls it, must be mediated. But the alienating Third suffers from the same defect. Like the collective object which confers an external unity on a plurality of individuals, the alienating Third "serializes" the relations between the terms which it totalizes. What is required is a Third which *totalizes without objectifying*; that is, a Third which elicits union *from within* rather

than imposing it from without.[31] This Third must render every other "the same" (le même) in practice without resorting to an abstract idea (the sameness of a universal) on the one hand, or to a mere nominalistic stipulation on the other. The Third, in effect, must be a *mediating* Third, and its mediation must be dialectical. Sartre labels this position "dialectical nominalism."[32] It turns on the notion of the mediating Third.

The collective with its serial relations forms the first degree of sociality for Sartre, a level which seems to extend the "sociality" of *Being and Nothingness* to the realm of praxis. The second degree of sociality is the group, which is by definition the suppression of seriality in a constitut*ed* praxis, a constitut*ed* dialectic. Sartre's problem at this juncture is to explain the appearance of constituted praxis (group praxis) out of the serial relations of the collective while respecting the existentialist requirement that only individual praxis be constitut*ing*. This is the *experimentum crucis* for his dialectical nominalism. In undertaking it, he appeals to three interrelated concepts: free individual action, free reciprocity, and the mediating Third.

We may speak of "the primacy of individual praxis" as a basic principle of Sartre's social thought, indeed as part of his existentialist legacy. Individual human work, even if "enriched" by group membership or absorbed and deflected by the practico-inert (and note the implicit reference to praxis in the latter term), is the ultimate active source of change in the social sphere.[33] Throughout his popular polemical writings and in the *Critique* as well, he is intent on underscoring the oppressive praxis (and hence the personal responsibility) which underlies the "impersonal" processes of exploitation throughout the world.[34] There is no collective subject acting independently of the organic individual. And yet group action is necessary: "I do not believe," Sartre has recently stated, "that an individual can accomplish anything alone."[35] But the collective object and the alienating Third impose an external unity which keeps serial impotence intact. "Unity in fact can appear as the omnipresent reality of a seriality undergoing total liquidation only if it affects each one in his relations as Third with Others, relations which form one of the structures of his existence *in freedom*."[36]

To appreciate what Sartre means by "free reciprocity" we must first consider his distinction between free and serial alterity. The latter denotes that object-being and otherness which accrue to the terms of binary relations in virtue of reference to a collective object or an alienating Third. Such mediated relations may be called "serial reciprocity" to distinguish them from free reciprocity, where "free alterity" obtains. Free alterity is precisely that non-alienated otherness which characterizes each individual in a group as being distinct though "the same" (in a sense soon to be explained) as every other member. Sartre must account for the fact that the

individual is never totally integrated into the group. By insisting that there is a form of alterity which is not inimical to group praxis as is serial alterity, he can defend the primacy of individual praxis while emphasizing that group unity is never completed but is ever under way. The reciprocity which is operative within the group is free because the alterity which, according to Sartre, qualifies *all* reciprocity is in this case free. But the elixir of this freedom is the mediating Third.

It is in relation to dyadic separation and serial impotency that the mediating Third must be understood, for it exists in dialectical opposition to them. Structurally, the Third is "the human mediation by which the multiplicity of epicenters and ends (identical and separated) directly allows itself to be organized as determined by a synthetic objective."[37] The pure but abstract dyadic relationship in which agents suspend mutually incompatible actions toward individual goals becomes actualized as free reciprocity only through the mediating Third. It is by the organic agent *as Third* that multiplicity is interiorized and alterity rendered harmless in view of a common objective.

Because Sartre's powerful imagination adds flesh to the bare bones of an admittedly technical analysis, let us view his dialectical nominalism in practice as he describes the origin of the revolutionary group from the serialized mob of the Quartier St.-Antoine on the 14th of July, 1789. We can then appeal to this extended example as we pursue our examination of the mediating Third.

Sartre begins with the serial status of the crowd. Totalized negatively and from without by the army that surrounds Paris, the immediate reaction of the people is panic—that is, serial dispersion. Each is Other, fleeing for his life at the expense, if need be, of the others. The alienating Third, as the basic structure of any Third, is functioning here as well. The army assumes this status in regard to the inhabitants of the quarter. Yet Sartre adds a new aspect to his description when he treats of the resident of the quarter who would withdraw himself from the fray. Though this resident views the panic from his window, or in some other way may attempt to maintain the position of Other toward the situation as a whole, socioeconomic conditions and historical circumstances conspire to preclude this possibility. This is a striking instance of the praxis/practico-inert relationship which is Sartre's understanding of Engel's dictum: men make their history themselves, but they make it within a given milieu which conditions them.[38] Like it or not, the individual finds himself totalized by the menacing Other. His material membership in the series, as well as its passive activity (its flight), confers on him a status that precludes detachment. For example, he lives in the quarter, he is "standing around" when the crowd starts to move, his dress or accent betrays him. To realize the plausibility of Sartre's descriptive

analysis one need only recall the experience of the "onlookers" in the Kent State affair who, by virtue of their curiosity, their attire, their very presence in an area "where the trouble was starting," suddenly found themselves totalized with activist war protesters by nervous guardsmen.

Every Third must start as an alienating Third, for each at first grasps the situation as a whole without integrating himself into it. As he starts to move, for example, he notices that the crowd is running through the narrow street. But in that same moment he realizes that his absence from "the crowd" is *risk of death*. The resultant fear is surmounted by his "joining in." But one does not "join in" a serial flight; such flight is contagious, yes, but not unifying. By one and the same act, he constitutes the crowd as more than serial unity and allies himself with it. As Sartre puts it, "There are neither Others nor individuals who flee in his eyes; but flight, conceived as common praxis responding to a common danger, becomes flight as active totality."[39]

In effect, a transformation is taking place. As the awareness grows on the part of each that together they are numerous or that death awaits them in total rout, the Third in each is actualized and flight is converted into a free common act. This is no mere change in the individual's way of perceiving the situation or regarding himself, although both elements are doubtless involved. Rather, at this crucial moment, each becomes *sovereign*; he becomes the organizer of a common praxis.[40] Now men turn to countercharge, or they withdraw only to obtain a better position from which to do battle. This is true of each one, for each is the same as far as the resistance is concerned. In the white heat of mortal combat, the individual has shed his serial alienation and powerlessness: the group is born.

The relationship among individual members which arises with the emergent group is at once *transcendent* in that each as sovereign synthetically unifies the group, and *immanent,* in that seriality dissolves only to the degree that unity of objective is interiorized by the practical comprehension of each member. The practical relationship which constitutes the group is in effect a totalizing action on the part of each Third of all the actions ascribable to the group as being "the same" as his own. In uniting and coordinating similar or reciprocal actions, each discovers "*our* flight."

But the very act of totalizing cannot include itself as a totalized element. Here we encounter a gap in the action of the mediating Third, a certain lack of coincidence between members and group reminiscent of the *pour-soi* in *Being and Nothingness,* a lingering (albeit "free") alterity, parallel to the necessary being-object which we saw vitiate every attempt at full mutual integration on the level of abstract reciprocity. This marks the limit of integration of any individual into the group (a point we shall develop when our analysis reaches the phenomenon of *décalage*); it accounts for

the tension that obtains at the heart of the group; and it leaves room for the group's reflexive self-possession via the self-made inertia of the oath.[41] Members are related to each other and to the group as quasi-object and quasi-subject.[42] Sartre believes that it is the error of analytic, as distinct from dialectical, sociologists to stop at this point, considering the group as a binary relationship (individual/community), when in reality it is a set of ternary relations ordered dialectically. In effect, Sartre contends that analytic sociologists have overlooked the mediating function of the Third.

We now reach the high point in Sartre's analysis. He distinguishes two moments in the mediated reciprocity which constitutes the inner life of the group. The first is the mediation of the Third by the group itself. His example is that of a man joining ninety-nine others in a common struggle. Via their numerical presence he renders *each* the hundredth. So the group mediates reciprocity among its members; but it does so as praxis, unlike the practico-inert which mediates the collective. What was lacking to the collective is available through the mediation of the group, namely, a bond of *interiority* established between the Thirds. Thus interiorized number, to continue Sartre's example, is converted from discrete to intensive quantity, conferring the same degree of power upon all the Thirds in opposition to the enemy. The result of this interiorized quantity is the "objective reality" of the group, as Sartre calls it: not sheer number, but number in the service of a specific goal. It is to this that the prospective member approaches as he "joins in." And at this apocalyptic stage (the group-in-fusion), the very decision to join is itself effective of membership since the latter consists in acting on the assumption that multiplicity is a *means* toward a common objective.

Sartre's dialectical nominalism comes to the fore as he attempts to account for the specific unity which the group achieves. For he is hard pressed to avoid the claim that the group is a whole with characteristics independent of the sum of its individual parts.[43] To this end he introduces the category of "the same" (*le même*): the unity of the group is one of sameness, not identity, and this sameness is the contrary of serial otherness. Thus he writes: "The Third is no longer Other nor is he my identical: but he comes to the group as I do; he is the same as I."[44] Throughout the *Critique* Sartre distinguishes seriality from group unity in terms of otherness and sameness, respectively.

"Sameness" can be analyzed into "singularity" and "ubiquity." "Singularity" denotes the organic agent as a unique, totalizing praxis which precludes the group's becoming a hyperorganism (complete integration is impossible) and which accounts for persistent alterity even in the group-in-fusion. The group is an *instrument* for the praxis of each individual, freely chosen as such. But the converse is not true; that is, the individual is

not an instrument of the group as subject, though he is a quasi-means in reciprocity with other free praxes, as we have seen.

"Ubiquity" is Sartre's term for the common character conferred on a multiplicity of individual actions by virtue of their being *interiorized* as means to a common end. Because we are acting together, each action is "here" in the sense of "within the range of my concern and responsibility." To be a group member means to be wherever the group acts—that is, wherever each member acts *qua* member—for that is "here" for me. The spatial term calls attention to the *practical* nature of group unity, based as it is on the transformation of numerical power which occurs when multiplicity is interiorized.

By resolving sameness into singularity and ubiquity, Sartre hopes to arrive at a practical, non-substantial "We." In so arguing, he imitates those nominalists who opt for resemblance theories of universals without realizing that "resemblance" is itself a universal in the sense they wish to reject. Not that Sartre has created a substantial "We" *malgré lui;* but his zealous opposition to what he takes to be substantialism in social theory has blinded him to the fact that he, too, has assigned an ontological status to the group, namely, that of a relational entity (though the relations are practical),[45] and that it is in virtue of this status that the group itself operates at this first moment of mediation. Perhaps the chief deficiency in Sartre's theory from the ontological viewpoint is precisely this failure to offer a thoroughgoing ontology of relations. He has never undertaken a systematic analysis of relations themselves, though their distinction from substances and events has been crucial to Sartrean philosophy since *Being and Nothingness*.

The second moment of mediated reciprocity which Sartre distinguishes within the group obtains between the group and other Thirds on the one hand and the "regulating Third" (*le tiers régulateur*) on the other. Each Third in a sense assumes responsibility for the praxis of the others by designating his own action regulative of the common action, and this prior to any formal organization of the group. "From this perspective I am a free human agent in the eyes of each Third," Sartre writes, "but one *committed* (with the other Thirds and in the group) to a constellation of mediated reciprocities."[46] Each Third moves from totalizing sovereign to totalized sovereign in relation to the directions of the other Third. This occurs not theoretically but in practice by each Third's accommodating his action to the action of the other Third as normative. Sartre explains: "Practically, this means that I am integrated into the common action when the common praxis of the Third is posited as *regulative*."[47] Again, I recognize the action of the other Thirds as "the same," this time through the mediation of the regulating Third. The *mot d'ordre* which the Third emits is really the articu-

lation of my own desires at that moment. In following it, I am actually pursuing my own designs. Unlike the worked matter of the collective, the *mot d'ordre* becomes the "vehicle of sovereignty"[48] as it passes from man to man. For in expressing the same direction that I give myself, it realizes my freedom.

In his conception of the mediated reciprocity of the regulating Third, and especially in his analysis of the *mot d'ordre* as vehicle of sovereignty, Sartre is doubtless inspired by Rousseau's notion of the general will which confers freedom on the individual precisely because it involves obedience to a command he has given to himself.[49] And at this stage of the analysis Sartre is probably right. The group member is not coerced from without; neither is he the passive victim of propaganda or other forms of serial conditioning (limitations on freedom which recur at subsequent stages, namely, the organized group and the institution). For that brief moment when the group is born, unalloyed freedom and sovereignty appear, only to fade before the harsh exigencies of the practico-inert.

Every agent of integration in Sartre's social thought meets a limit. The limit to group mediation is "singularity"; that of the regulating Third is *décalage*: an infinitesimal but insuperable distance between totality and totalization, between identity and difference. The Third is able to direct (*régler*) because he is neither Other, like the head of an institution, nor identical, as some part in an organic whole. Thus evasion and tyranny remain possible even in the spontaneous unity of the group-in-fusion.

With the revolving *décalage* of the regulating Third we witness Sartre's closest approximation to a Hegelian *Aufhebung* of subject and object in the social sphere, as well as its necessary failure. If commentators have remarked on the new concept of freedom which Sartre develops in the *Critique*, namely, that the individual is free only in the group, they are probably impressed with his description of the group-in-fusion. But if they speak of the later Sartre as repudiating the existentialist theory of the primacy of the individual, they have neglected to note the limitations to group integration which Sartre invokes at every turn.

Our study of Sartre's answer to the challenge of *Being and Nothingness* by a new use of the "Third" has reached its term with the two moments of mediated reciprocity in the group-in-fusion. It has revealed that common praxis is *dialectical* at its most elementary stage, and that this social dialectic is constituted by a plurality of individual praxes which alone are constitut*ing*. The qualitative leap from plurality to interiorized multiplicity which marks the genesis of the social subject in Sartre,[50] therefore, can be accounted for without appeal to collective consciousness or hyperorganisms on the condition that the *individual* functions in a new and different way, namely, as mediating Third. And this is what Sartre's dialectical

nominalism set out to establish. His contractual social theory develops this insight in the remainder of the *Critique*.

In his preface to Gorz's *The Traitor*, Sartre observes that today there are only two ways of speaking about the self: the third person singular and the first person plural. The thrust of this central portion of our essay has been to demonstrate that for Sartre the secret of the latter is the former: multiplicity is interiorized (that is, obtains its subjective dimension) and free reciprocity is achieved only through the mediation of the Third.

III

The genius of the Third consists in its function as a *via media* (1) between atomism and organicism in ontology, and (2) between simple psychologism and unmitigated sociologism in methodology. Moreover, (3) it serves this function in a manner which respects the existentialist values of individual freedom and responsibility, a crucial concern of Sartrean social philosophy. In order to assess the last point, therefore, we must evaluate each of these claims for the Third.

1. Ontologically, we have noted, Sartre is loath to allow anything like a collective consciousness. Thus only individual praxis is constitut*ing*; group praxis is constitut*ed* and, one might add, always being constituted and reconstituted, totalized and detotalized by individuals in dialectical relation with each other, with other groups, and with the practico-inert. It is the individual *qua* member of the group who is the subject of ascriptions which organicists would attribute to the group *simpliciter*. But conversely, such group attributes as "structure, being-in-the-group, function, power and, basically, oath"[51] cannot be predicated of the organic individual *qua* individual; neither are they "translatable" into descriptions from individual psychology. While allowing a "synthetic enrichment" of individual praxis in the group, Sartre nevertheless insists that each Third is individual and sovereign though "the same" as every other with regard to praxis.

The concept of sameness, we saw, could be resolved into "singularity" and "ubiquity." Now the latter is equivalent to the conditional: "If under attack, my fellows will do what I would do if I were there." This is a dispositional use compatible with an atomistic ontology. So far, then, we cannot claim, as some have, that the *Critique* marks the disappearance of the individual from Sartre's philosophic concern. On the contrary, he seems particularly concerned to see that the individual does *not* disappear into some organic totality like the state, the party, or even the group. In this he sees a parallel between his existentialist mission to combat a Marxist "scholasticism of the totality" and Kierkegaard's attack upon Hegelianism in the name of the individual.[52]

When Sartre begins his account of that "synthetic enrichment" which characterizes the mediating Third as group member, however, he becomes increasingly paradoxical and vague. The plausibility of his argument suffers accordingly. This is particularly true of his explanation of mediated reciprocity between the Thirds and the group. For he is unclear as to how *the group* can mediate between Thirds, even allowing that both come into existence simultaneously. True, not all group attributes are reducible to dispositionals; but what is the status of the *subject* to which they are ascribed? To speak of the Third, the "common individual," or, as we have, the individual *qua* group member, leaves the crucial notion of relationality or "qua-ness" unanalyzed. For agents in relation differ from agents alone (if there could be such), and the difference is precisely *the relation*. Without a theory of relations, Sartre fluctuates between denials that the group is a hypostasis and assertions that group praxis is distinct from and irreducible to individual praxis—both correct but insufficient claims. His analysis calls for a real, though relational, *group subject* which his ontology does not seem able to accommodate.

W. V. O. Quine argues in his discussion of ontological commitment that it is reasonable for any philosopher to accept the "existence" of abstract entities if to do so is in accord with "the simplest conceptual scheme into which the ordered fragments of raw experience can be fitted and arranged."[53] And he posits "objects of a special and abstract kind, viz., classes," in order to do higher logic.[54] The example of Quine, who is certainly not noted for a needless multiplication of entities, constitutes a challenge to Sartre in the present problem. Either Sartre accepts the existence of groups, that is, admits them as values for bound variables (in the language of contemporary logic), or he is left with his present paradox of a group which is not a subject and a subject which cannot be a group. Dialectic is called for, no doubt; but dialectical nominalism turns out to be self-defeating, since it destroys as nominalism what it aims at establishing as dialectic, namely, a real synthesis of individual actions into group praxis.

We have previously alluded to an important sense in which Sartre has never overcome the atomism of *Being and Nothingness*. This is fundamentally expressed by the inability of the mediating Third to include itself as part of its totalization. Not only does this render the enrichment of individual praxes somewhat less than "synthetic," but the resultant *décalage* harbors the individualistic freedom of *Being and Nothingness* at the very heart of the group-in-fusion (the agent can still betray or refuse to join). It is as if Sartre were unwilling to leave all the idols of his bourgeois forebears behind as he enters the promised land of collective freedom.

2. Methodologically, the *Critique* is a justification of that marriage of psychoanalysis and historical materialism which finds its most extended

exemplification in Sartre's massive study of Flaubert.[55] On the one hand, the sociological dimension is secure. With the group-in-fusion a new reality (however ambiguous its status) has entered the social scene. To the extent that it is constituted by the translucid praxis of individuals, it shares in their intelligibility (and in their responsibility—this moral concern continues to be paramount for Sartre). But as a "synthetic enrichment" of individual praxis, the group requires an intelligibility of its own.[56] Sartre discovers this in dialectical sociology with its conflict models, double negations, totalizations, historical vectors, and the rest. His regressive analysis, for example, explains how classes and class warfare are possible, why groups are less stable than collectives, and why man always seems to see the work of his hands turn against him in counterfinality.

In terms of Sartre's philosophical evolution, this move to historical materialism represents the discovery of what Max Weber called "objective possibility,"[57] a category conspicuously absent from *Being and Nothingness*, though one that could have evolved from the concept of "situation" in that earlier work. It constitutes the acknowledgement of objective limits to one's freedom-possibility which cannot be circumvented by a Gestalt-shift of any kind, as Sartre seems to imply in *Being and Nothingness*. This is, of course, a concomitant of that basic dialectical experience mentioned earlier whereby the mediation of matter came to Sartre's attention.

Yet if man is the victim of history, he is primarily its agent. (This is the enduring tenet of Sartrean humanism.) To learn the "inside" of history one has available the mediating Third's grasp of the group objective. We defined the mediating Third in terms of its ability to organize a multiplicity of agents and ends under a synthetic objective. It is such objectives which legitimate what we might call the dialectical teleology of Sartre's social thought. To understand the movement of history (and this is the ultimate purpose of the *Critique* as a whole), one must focus on these objectives *as they are conceived by the mediating Thirds*.[58]

With this objective/Third relationship we reach the term of Sartre's quest for dialectical intelligibility, at least as far as the group-in-fusion is concerned. He argues that the *structure* of certain objectives (flight before an organized foe, for example) is understood by the praxis of individuals to require the common unity of *one* praxis for all. It is the historian's task to weigh the urgency, what Sartre calls the "totalizing force," of a group's objective. He must do this by considering primarily the praxis of the Third in so far as it freely arises in relation to this objective; that is, to the extent that it defines itself in terms of the objective as its common future to be accepted or refused. "It is the tension of this future to the present practice and the progressive and regressive deciphering of this fundamental relation which provide the first elements of intelligibility."[59]

The "deciphering" Sartre speaks of is the *hermeneutic* which his existential psychoanalysis employs.[60] Psychoanalysis promises the historian the means of achieving that "comprehension" (Sartre's peculiar employment of the *Verstehen* of German historians and social philosophers) of the unique group-defining project which explains the historical event to a degree that mere structural analysis cannot attain. Such an understanding eludes even the Marxists, who must rest content with "situating" a certain event in its socioeconomic context.[61] The rest, for them, is pure chance. But the rationalist in Sartre has always balked at brute facts.[62] So he seeks to discover "the mediations which allow the individual concrete [reality]—the particular life, the real and dated conflict, the person—to emerge from the *general* contradictions of productive forces and relations of production."[63] At the forefront of these mediations stand worked matter and the Third. By introducing the latter, Sartre has made room for subjectivity in the materialistic dialectic and has thereby retained a place for existential psychoanalysis in the social sphere.

Despite his method's promise and the unquestionable brilliance of his descriptions, however, the crucial question remains: How does the psychoanalysis of a *particular* individual elucidate the specific meaning of a "real and dated conflict"? In other words, How does the Third mediate biography and history? Clearly, Sartre believes that it should. His Flaubert study is predicated on the thesis that "a man, whoever he may be, totalizes his era to the exact degree that he is totalized by it."[64] This is no doubt true of history's "great men," with whom psychohistory is most at home. But the test case for Sartre would be the individual whose status as Third contributes to the group-in-fusion and thence to the subject of history.[65] To speak of an objective's "totalizing force" is important, for it moves us into social psychology and out of pure sociologism. But Sartre must complete the move by explaining why this objective "weighs upon" this particular individual the way it does. Only then will his account be complete. Significantly, Sartre has thus far avoided psychoanalyses of revolutionaries, limiting his studies to artists and men of letters, solitary and "symbolic" totalizers like himself.

Notwithstanding its laudable aim of humanizing the abstractions of Marxist socioeconomic theory, Sartre's methodological enterprise suffers from the limitations of its component parts. A brief examination of its two leading elements, existential psychoanalysis and dialectical sociology, will make this clear.

We have just observed the difficulty existential psychoanalysis encounters in accounting psychologically for the agent's move from individual to group member. But the theory of existential psychoanalysis itself has been a matter of dispute since Sartre first adopted the term in *Being and Noth-*

ingness. A species of the phenomenological psychiatry inspired by Husserl and Heidegger, Sartre's version profits from his rich imagination and his descriptive powers. But it labors under a burden peculiarly its own. For its rejection of any notion of the unconscious deprives it of the panoply of instincts and complexes usually associated with psychoanalytic theory, while its disregard of experimental psychology bars access to a wealth of scientific research.[66] Moreover, the theory hangs perilously by the thread of an initial choice which is neither unconscious nor reflectively conscious. In fact the revolving totalizations of mediating Thirds take place at this pre-reflective level. But one can reasonably question the existence of such a fundamental choice in the life of every man as well as its methodological significance in social philosophy. And one should likewise demand evidence justifying Sartre's extensive use of the pre-reflective level itself, a use which suspiciously resembles that which the Freudians make of the unconscious. Suspicion is heightened when so much emphasis is now placed on infant experiences, for example, in *L'Idiot,* and when one has to be "told" what he has "consciously" done, a common occurrence in Sartre's analyses and descriptions.

Sartre's dialectical sociology is open to criticism in at least two respects, namely, in respect to his own understanding of the dialectic and in respect to the entire dialectical undertaking itself. The most telling criticism in the first instance comes from the late Georges Gurvitch, eminent dialectical sociologist at the Sorbonne, who concluded his study of the *Critique* with the remark that "Sartre shows himself to be incomparably more dogmatic than Marx both in his general conception of dialectic and in his application of it to sociology."[67] For Sartre begins the *Critique* with a critical survey of the "dogmatic dialectic" of Marxist philosophers,[68] and from there goes on to affirm a "dialectic within the dialectic" which will afford him a methodological flexibility unavailable to his Marxist counterparts.[69] But in practice he has retained the single, "classic" form of antinomies and syntheses in which the Third is paramount, ignoring the rich variety of dialectical relationships employed by other dialecticians, including Gurvitch himself.[70] On the whole, Gurvitch's point is well taken. The primacy of the Third does seem to blind Sartre to the "dialectic within the dialectic" he had promised, and he does stress the "classic" form of the dialectic. But Gurvitch disregards the crucial absence of an *Aufhebung* to a collective subject, as well as the revolving *décalage* of the regulating Third which constitutes its surrogate. This is surely a major contribution of the Sartrean dialectic, problematic as it remains.

But the dialectic itself comes under fire from Anglo-American philosophers who are committed to a form of the hypothetico-deductive model of explanation in the social sciences, as well as from those who admit

that *Verstehen* is the proper method of what Mill called the "moral sciences" but are wary of denials of the principle of Double Negation and of talk about "objective contradictions" which clearly are not logical contradictions at all. Sartre would correctly see in these criticisms a refusal by thinkers given to analytical reason to consider the possibility of another criterion of the rational. Yet when the crisis is one of the criteria themselves, it is difficult if not impossible to adjudicate the matter.

3. Having critically assessed the function of the Third as a middle way between ontological and methodological extremes in current social philosophy, we consider finally its role in answering Sartre's own challenge to any existential social theory. This normative function of the Third centers on its fostering of existentialist humanist values in the social sphere.

Sartrean humanism can be epitomized as the conviction that "a man can always make something out of what has been made of him."[71] This confidence in individual freedom/responsibility is the legacy of *Being and Nothingness* to the *Critique*. We shall briefly observe the Third as it mediates this humanistic commitment in three major areas of Sartre's social concern: (a) the end of alienation, (b) ethical realism, and (c) libertarian socialism or anarchism.

a. Sartre's humanism, like its Marxian cousin, is a struggle against alienation. The dialectical experience figures here as well: "It is in the concrete and synthetic relation of agent to other by the mediation of [material] thing and to thing by the mediation of other that we shall be able to find the bases of all possible alienation."[72] To the extent that alienation is the product of agents, we have observed Sartre's resolution of the problem via the mediating Third.

Dialectical experience, however, has revealed the alienating function of the practico-inert as well, and it is this which causes Sartre his greatest difficulties. No doubt the most pressing alienation, that which stems from the fact of scarcity, can be conquered in a "socialism of abundance."[73] Yet even here there are limits; consider, for example, the sheer temporal and spatial scarcity called "human finitude." Moreover, Sartre seems to be making a covert appeal to technology for the removal of scarcity, and this raises additional forms of alienation, as Weber, Habermas, and others have pointed out.

But what of that alienation (read "objectification") which seems to be a feature of the practico-inert as such? Can the inevitable object-being of worked matter be neutralized as totally as can the alterity of multiple agents in the group? This question which has separated Marx from Hegel returns to haunt their common heir. His answer is ambiguous. On the one hand, he speaks of a non-alienating objectification in the product of group praxis, for example, the captured Bastille. In this case the objective being

of the agents would be "homogeneous with the practice of objectification."[74] But on the other hand, he admits that man "discovers himself as Other in the world of objectivity" and that "totalized matter, as inert objectification and as perpetuated by inertia, is in effect a *non-man* and even, if you will, a *counter-man*."[75] And if this synchronic alienation can be overcome by the agent as Third, diachronic alienation (for example, the "bloody past" of a class or even the "generation gap") remains. Sartre's humanism has not offered us a means of totally ransoming the past. Furthermore, the practico-inert faces us with the insuperable fact of contingency. In terms of alienation, therefore, and despite the service of the Third, his humanism is at best a muted optimism.

b. An inveterate moralist, Sartre refuses to relegate "living morality" to the status of an ideological superstructure with dead "moral systems," arguing rather that the former belongs to the productive base. Echoing a thesis he had defended in "Materialism and Revolution," Sartre points out that the worker perceives his world and his values *via* his productive activity; for the worker, the ethical "in act" is one with his praxis. The living ethic which Sartre discovers here is one of justice and solidarity where, again, man as Third would figure centrally. This link between one's living ethic and his productive activity is what Sartre means by "material and ethical realism" as distinct from the ethical idealism of his youth and the "amoral" Marxist realism with which he flirted in his middle years.[76] Conjoined with Sartre's overtly moral understanding of "alienation," this confers an explicit ethical significance upon the mediating action of the Third.

Moreover, Sartre's moral predicates, even when attributed to collectives and groups, are ascribed *distributively* across each and every member. This seems to be the only type of collective responsibility he is willing to allow.[77] But the *vehicle for this distribution* of collective ascriptions to individuals is precisely the mediating Third. As we have seen, he insists on the oppressive praxes at the base of "impersonal" processes of exploitation.[78] We have called this his principle of the primacy of individual praxis. But it is upon individual praxis/freedom/responsibility that he aims his moral canons, and he can do so because *each as Third* is responsible for collective undertakings.

c. Recently, Sartre has noted that the concept of direct democracy is his essential bond with *les maos*.[79] Let us conclude this brief survey of his humanism by considering his sociopolitical ideal, for it is the very model of an existentialist society, namely, the participatory democracy of libertarian socialism, and it turns upon the mediating Third.

The *Critique* is clearly anti-hierarchical and libertarian in its conception of the ideal state of interpersonal relations.[80] Authority and represen-

tative government are considered revivals of serial alienation. Consensus and face-to-face groups remain the sole guarantors of co-sovereignty, another name for freedom limited only by another freedom or by itself (oath). The Third is the keeper (*le détenteur*) of sovereignty.[81] As alienating, he is the master of a multiplicity of alienated freedoms; but as mediating, he is co-sovereign freedom, "the same" as every other Third.

Translated into common political language, this amounts to an endorsement of libertarian socialism (anarchism). Sartre claims that in a "true" socialism, for example, there will be no political experts, since "each man will become the mediator of the ensemble."[82] Then domination will give way to persuasion, delegation to consensus: "There will be free men who will make decisions of which each could be considered the author."[83] He awaits the advent of "socialist man." Considering the limitations of our historical and economic situation, however, Sartre avows that we cannot conceive what this man will be like. Yet we do know that he will be *free*—freedom being "one of those rare but important notions which exist in all classes and which, though not completely the same from one class to another, contain common elements."[84] He will be free because no longer alienated. And with this we have completed the circle of these humanistic concepts, each hinging on the reciprocity between agents made possible by the mediation of the Third.

It is difficult to ascertain whether Sartre sees this direct democracy in a socialism of abundance as the conclusion of a viable project or as a utopian *als ob*, that is, as more of a goad than a goal. The fact that he has always linked freedom/possibility with the *imagination,* and that he has praised even unsuccessful revolutionaries for their willingness to bring *l'imagination au pouvoir*,[85] while inconclusive, does suggest the latter. So does his pessimism about total victory over the alienating practico-inert. But his active involvement with the New Left movement and his unfeigned struggle against oppression and exploitation of any form indicate a belief that the roots of social evil, as he understands them, can be extracted and that a new, socialist man will one day emerge. Still, the matter is not clear. One can work assiduously for the eradication of alienation without believing that it will ever be entirely removed. After all, the Sartre who now speaks of the coming of socialist man is the one who in 1946 answered his own question, "Will collectivization [the social ideal] as such ever become a reality?" by "I don't know. I only know that I shall do all in my power to bring it about. Aside from that, I can't count on anything."[86]

The ontological and methodological difficulties raised against Sartre's theory are not insuperable. Neither are they appreciably worse than those which face alternative speculative approaches to the social sphere. And the overall thrust of the *Critique* displays a healthy respect for individual

freedom/responsibility even as it affirms the need for group action in a less than perfect world. That he has met the challenge of *Being and Nothingness* and has succeeded in constructing an "existential" social philosophy in which true, mediated reciprocity is not only exhibited as an ideal but is accounted for theoretically as well, is due in large measure to the genius of the Third. For if hell is other people, Sartre would now have us believe that salvation is the mediating Third.

THOMAS R. FLYNN

DEPARTMENT OF PHILOSOPHY
EMORY UNIVERSITY

NOTES

1. Andre Gorz, *The Traitor*, with Foreword by Jean-Paul Sartre, tr. by Richard Howard (New York: Simon and Schuster, 1959), p. 35.

2. *L'Etre et le Néant* (Paris: Gallimard, 1943), p. 276; hereinafter *EN*. English translation by Hazel Barnes, *Being and Nothingness* (New York: Philosophical Library, 1956), p. 222; hereinafter *BN*. Although all translations are my own, the corresponding page in *Being and Nothingness* is listed for the convenience of those using the Barnes translation. What follows is a revision and expansion of material first developed in my "The Alienating and the Mediating Third in the Social Philosophy of Jean-Paul Sartre," in *Heirs and Ancestors*, ed. by John K. Ryan (Washington, D. C.: Catholic University Press, 1973), pp. 3–38.

3. See *EN* 477, *BN* 407.

4. *EN* 493, *BN* 421. Throughout the essay we shall use "Third" to refer both to the concept and to the concrete agent in this role. The distinction, unimportant for our argument, will be clear from the context, especially from the corresponding pronouns.

5. We use "dual" here, as Sartre does occasionally, to refer to the relationship for-itself/Other. It forms one of the terms of the subsequent relationship, dual/Third. The dual need not be limited to two consciousnesses. Indeed, in one of Sartre's favorite examples of the dual/Third, class consciousness, it is not.

6. *EN* 489, *BN* 418.

7. *EN* 490, *BN* 419.

8. See *EN* 502, *BN* 429.

9. See *EN* 498, *BN* 425.

10. See *EN* 502, *BN* 429.

11. *EN* 498, *BN* 425.

12. *EN* 479, *BN* 408.

13. The law of Double Negation continues to characterize what Sartre calls Analytical Reason. Although dialectical thinking is evident in his early writings on the imagination in the 1930s, the *Critique* constitutes his first *ex professo* treatment of the topic which henceforth dominates his formal discourse.

14. *Critique de la raison dialectique, précédé de Question de méthode* tome I, *Théorie des ensembles pratiques* (Paris: Gallimard, 1960), p. 165; hereinafter *CRD*.

15. Nevertheless, praxis signifies primarily "work" in Sartre's vocabulary, and in this meaning evokes more clearly its counter-concept, the practico-inert. He writes admiringly: "The essential discovery of Marxism is that work as a historical reality and as the utilization of determinate tools in an already determined social and material milieu is the real foundation for the organization of social relations. This discovery can no longer be questioned" (*CRD* 224–25, n. 1); see also *CRD* 154, 671, and 683.

In a valuable note to the *Critique* (*CRD* 286, n. 1), Sartre offers a rough "translation" of the two dichotomies of *Being and Nothingness* and the *Critique* in terms of each other. Thus

he likens praxis in its self-luminosity to "consciousness (of) self"—a technical term in *Being and Nothingness* (see *EN* 20, *BN* liv).

16. Late in the *Critique* Sartre provides a descriptive definition of praxis: "organizing project moving beyond material conditions toward an end, and imprinting itself by work upon inorganic matter as a reworking of the practical field and a reunification of the means in view of attaining the end" (*CRD* 687).

17. It is this fact which gives human history its particular poignancy, rendering men competitors rather than cooperators despite their best intentions. This too explains why class struggle is a fact, indeed why it is the moving force of history (see *CRD* 730–31).

18. The Hegelian term "objective spirit," purportedly bereft of its *résonances spiritualistes*, is a form of the practico-inert which figures importantly in the *Critique* (see 721–34) and dominates the third volume of *L'Idiot de la famille* (Paris: Gallimard, 1971—), hereinafter cited as *IF* with volume in roman numerals.

19. *CRD* 306.

20. *CRD* 319. The multiplicity so united is what Sartre calls the "series," and the relations between individuals in a series or collective are designated "serial." Sartre tends to use the terms "collective" and "series" without respecting his distinction. Though this may lead to a certain amount of confusion, it leaves the general argument intact.

21. *CRD* 307.

22. *CRD* 608.

23. *CRD* 189.

24. *CRD* 189, italics in original.

25. *IF*, I, 816.

26. *CRD* 192.

27. Already in *Being and Nothingness* he had emphasized communal work as an "objective situation-form" which by its "internal reciprocity" was more likely to arouse the experience of the *Nous* than were other situations (*EN* 489–91, *BN* 418–19). But it is in his 1946 essay, "Materialism and Revolution," that he explicitly characterizes the revolutionary as one who "sees human relationships from the viewpoint of work" and who hopes that "the relationships of solidarity which he maintains with other workers will become the very model of human relationships"; *Situations*, III (Paris: Gallimard, 1949), p. 180.

28. *CRD* 191. In fact he criticizes Hegel for having "suppressed matter as a mediation between individuals" (*CRD* 192).

29. *CRD* 193.

30. *CRD* 193.

31. Sartre conceives of the mediating Third's totalization as a revealing or "unveiling" of a practical unity already under way. He writes: "I find myself in the midst of the Thirds without privileged status. But this operation [my totalization by the other mediating Third] does not transform me into an object, since totalization by the Third merely reveals a free praxis as a common unity already there and qualifying it" (*CRD* 408). Whenever Sartre speaks of "objectification" (*l'objectivation*) of the group in its early stages or of the mediating Third, he is referring to its attainment of its material objectives which form a totality external to it (see, e.g., *CRD* 412) but not necessarily heterogeneous to it (see above, pp. 363–64).

32. "The dialectic, if it exists, can only be the totalization of concrete totalizations effected by a multiplicity of totalizing individuals (*singularités*). This is what I call 'dialectical nominalism'" (*CRD* 132).

33. "If the mode of production in human history is the sub-structure of all society, it is because work . . . is the substructure of the practico-inert (and of the mode of production)" (*CRD* 671).

34. The antidialectic of colonial exploitation, for example, is "the product of a human undertaking [*travail*] which has forged it and which does not cease controlling it" (*CRD* 683).

35. Ph. Gavi, J.-P. Sartre, and P. Victor, *On a raison de se revolter: Discussions* (Paris: Gallimard, 1974), p. 171; hereinafter *ORR*.

36. *CRD* 398, italics in original.

37. *CRD* 398.

38. Quoted by Sartre from a letter of Engels to Marx (*CRD* 30 and 60).

39. *CRD* 401.

40. "By 'sovereignty' . . . I mean the absolute practical power of the dialectical organism, that is, its pure and simple praxis as synthesis *en cours* of every given multiplicity in its practical field whether inanimate objects, living beings or men" (*CRD* 563). Whereas sovereignty was lacking to the collective, in the group-in-fusion every man is sovereign. The only limit to his sovereignty is that of the other Third. Thus each is co- or quasi-sovereign, just as each is quasi-transcendence, quasi-subject, and quasi-object. Sartre hopes to see this sovereignty resurrected in the classless society.

41. See *CRD* 439ff., where the oath is discussed as mediated reciprocity.

42. See *CRD* 404.

43. In fact, he does speak of "specific modalities of the group"—power, structure, oath, for example—which require a new, constitu*ted* dialectic for their intelligibility. They are incomprehensible to a solitary praxis, if such could exist. See *CRD* 540.

44. *CRD* 405. "I see myself coming to the group in him [the Third], and what I see is only lived objectivity." In the group-in-fusion the Third is "my interiorized objectivity. I grasp it in him not as Other but as mine" (*CRD* 406).

45. Sartre explains: "In effect, the group is not a metaphysical reality but [is] a certain practical relationship of men to an objective and among themselves" (*CRD* 427 n.). Before relegating our difficulty to a mere *lis de verbis*, however, we should note that Sartre never analyzes what real relations are. Doubtless his lifelong bout with idealism has made him wary of relational "entities." But the force of his argument depends upon the *existence* of groups distinct from and irreducible to their members but not independent of them.

46. *CRD* 408.

47. *CRD* 408, italics mine.

48. *CRD* 409.

49. See *The Social Contract*, book II, ch. 6, "On Law."

50. Once reflectively aware of its status and made permanent by the oath (two sides of the same event), the group becomes in Sartre's eyes "the subject of history" with its proper intelligibility, namely, "constituted dialectical Reason" (see *CRD* 548).

51. *CRD* 540.

52. See *CRD* 28 and 108.

53. Willard Van Orman Quine, *From a Logical Point of View*, 2d ed., rev., Harper Torchbooks (New York: Harper & Row, 1961), p. 16.

54. Willard Van Orman Quine, *Methods of Logic*, rev. ed. (New York: Holt, Rinehart and Winston, 1959), p. 228.

55. "Let us say that the 'Flaubert' [work] is a concrete application of the abstract principles which I presented in the *Critique of Dialectical Reason* for grounding the intelligibility of History" (*ORR* 77).

56. See *CRD* 407. Sartre distinguishes two dialectics: those of individual and those of group praxis (*CRD* 359). Although he insists that the intelligibility of the group "as praxis" depends on the intelligibility of individual praxis (as the constituted depends on the constituting), he explains this position as would any methodological holist: "This dialectic of the group is most certainly *irreducible* to the dialectic of individual work, but it cannot exist by itself" (*CRD* 432, italics in original).

57. See his essay "Critical Studies in the Logic of the Cultural Sciences," Part II: "Objective Possibility and Adequate Causation in Historical Explanation," tr. and ed. by Edward A. Shils and Henry A. Finch, in Max Weber, *The Methodology of the Social Sciences* (New York: The Free Press, 1949), pp. 164ff.

58. "So the first necessity for the situated investigator . . . is to understand (*comprendre*) the comprehension of the regulating Third" (*CRD* 657). This may, of course, be different from the "real" significance of the objective as discovered by the historian after the fact (see *CRD* 414). The anatomy of the objective/Third relationship is essentially as we have described it in the threshold instance of the group-in-fusion. The actual content of such objectives, that is, what gives rise to *this* group here and now, cannot be determined a priori, but remains a matter for empirical study. The general content of such objectives, however, *can* be determined in advance: it is scarcity interiorized (see *CRD* 752).

59. *CRD* 414.

60. See *EN* 656, *BN* 569.

61. See *CRD* 43ff. Sartre agrees with this method as far as it goes but criticizes it for hovering at a certain level of abstraction, leaving the comprehension of the concrete individual to other disciplines or to chance. Thus in the case of Valéry, the Marxists offer us the "general particularities" of a class, an era, an ideology, etc., but the concrete Valéry eludes them. The latter can be discovered only a posteriori, and can be understood only in terms of an existential psychoanalysis of his childhood, focusing on that "point of insertion of the man into his class, i.e., the particular family as mediation between the universal class and the individual" (*CRD* 47). "Valéry is a petit-bourgeois intellectual, of that there is no doubt. But every petit-bourgeois intellectual is not Valéry. The heuristic insufficiency of contemporary Marxism is contained in those two sentences" (*CRD* 44). In effect, what Marxism lacks is a "hierarchy of mediations by which to grasp the process which produces the person and his product within a given class and society at a given moment in history" (*CRD* 44).

62. His voluntarist strain, on the contrary, has always thrived on chance and contingency. Iris Murdoch has captured this conflict in Sartre's philosophic character with the title of her study, *Sartre: Romantic Rationalist* (New Haven: Yale University Press, 1959).

63. *CRD* 45, italics in original.

64. *IF*, III, 426.

65. To the extent that personal peculiarities of individual agents contribute to the intelligibility of the leap from series to group, Sartre argues that these circumstances are relevant only as "general particularities," that is, as attributes which modify the individual precisely in his function *as Third*. As he had insisted in *Being and Nothingness* that no one *is* cowardly, that each man "does" his cowardice by individual cowardly choices, so he is now claiming that no one *is* a leader of men, for example, except when men (that is, the group) in specific circumstances confer this function upon him; see *CRD* 414–15. This stance is consistent with the mediating role Sartre reserves for the group in regard to the Thirds, but it favors the sociological over the psychological in historical explanation. It errs by default, as did the Marxists criticized above (see n. 61). If Sartre will balance these two approaches to the meaning of history (a fortiori, if he will synthesize them), he must apply the fruits of existential psychoanalysis at the moment when the Third mediates the group and other Thirds. At that juncture an appeal to "general particularities" will not suffice.

66. Sartre's attitude toward Freud is much more nuanced now than it was formerly, although he continues to reject the term "unconscious"; see an interview recorded in *New Left Review*, no. 58 (November–December 1969), pp. 45ff. His work on Flaubert is clearly Freudian in inspiration.

67. Georges Gurvitch, *Dialectique et sociologie* (Paris: Flammarion, 1962), p. 176.

68. See *CRD* 115ff.

69. *CRD* 281.

70. For a detailed typology of such dialectics, see Gurvitch, *Dialectique,* pp. 189ff.

71. *New Left Review*, no. 58, p. 45.

72. *CRD* 154, n.1. As the antithesis of freedom, "alienation" retains a basically moral connotation throughout Sartre's writings.

73. *IF*, III, 189.

74. *CRD* 360.

75. *CRD* 285.

76. See *ORR* 45, 79, and 118–19.

77. We can deduce this from his principle of the primacy of individual praxis plus the fact that praxis, freedom, and responsibility are correlative for him. He would be opposed to any form of collective responsibility which *excused* the individual member from responsibility. This is no doubt the reason why he rarely uses the term, even though the concept permeates his political writings of the 1950s and 1960s as well as the *Critique* (see *CRD* 707, 709, 729).

78. See, for example, *CRD* 696. His humanist conviction leads to a deliberate reversal of Marx's words from the Preface to *Capital*, for Sartre concludes: "In short, it is men whom we judge and not physical forces" (*CRD* 39).

79. *ORR* 75.

80. A position he maintains in *L'Idiot* as well: "The true relationship between men is reciprocity, which excludes commands properly speaking" (*IF*, III, 48).

81. *CRD* 253.

82. *ORR* 288.

83. *ORR* 350.

84. *ORR* 341–42.

85. See *Situations,* VIII (Paris: Gallimard, 1972), p. 273; see also *ORR* 347.

86. *L'Existentialisme est un humanisme* (Paris: Nagel, 1970), p. 54.

16

Risieri Frondizi
SARTRE'S EARLY ETHICS:
A CRITIQUE

A T the very end of *Being and Nothingness,* Sartre promised to write a book on ethics. After raising several questions, he wrote: "All these questions, which refer us to a pure and not an accessory reflection, can find their reply only on the ethical plane. We shall devote to them a future work."[1]

There has been much speculation about the reasons that kept Sartre from writing such a work. Some critics believe that the *Critique of Dialectical Reason* (1960) constitutes his statement of ethics. Others, taking for granted that his ethics was never written, try to puzzle out the theoretical or practical reasons why it was not. His commitment to political matters, from both the theoretical and the practical point of view, seems to have been an important factor that prevented him from fulfilling his desire.

As is well known, after publishing *Being and Nothingness,* Sartre got more and more involved in political activities, which take a lot of a man's time and energy. But the basic reasons for his not publishing a book on ethics seem to reside on the theoretical level. He thought that the conditions of the world were not suited for a universal ethics. In an interview published in the 1960s by *Le Monde,*[2] he said: "First, all men must be able to become men by the improvement of their conditions of existence, so that a universal morality can be created."

One may well feel that it is not worthwhile to try to create a universal morality when at least one third of the world's population is living under inhuman conditions. But this is a personal feeling, not a theoretical rationalization. As a matter of fact, the most important universal moralities appear to have been motivated by the injustice of human misery; Christ's doctrine affords an excellent illustration. In any case, as the gap widens between the "is" and the "ought to be," the force of the "ought to be" becomes greater—and defining the "ought to be" is precisely the function of ethics.

On the other hand, it may be argued that the desire to improve the conditions of existence of others is morally rooted, and when we try to improve such conditions we are advancing a moral ideal that may serve as guidance for action. In this regard, may we point out, incidentally, that Sartre's phrase, "the improvement of the conditions of existence," quoted above, is very vague. No matter how much we do, we shall always be confronted by conditions that could be improved. Where might we find that satisfying point at which we may rest from our labors long enough to create a universal morality?

Sartre's dissatisfaction with the present seems to be his prevailing attitude. Dubreuilh, the character who represents Sartre in Simone de Beauvoir's novel *Les Mandarins*, says: "In a curved space, it is impossible to draw a straight line. You cannot lead a correct life in a society that is not itself correct."[3] Admitting that the present political, social, and economic situation is unfair, and I have no doubt that it is, one may reasonably ask, Why should we wait until society changes to lead a proper life? Is not the analogy of the straight line in a curved space misleading, inasmuch as society is neither curved nor straight? Wherever we are and whatever the conditions that surround us, we have moral duties to fulfill. One of these duties is to try to change conditions if they are bad. We do not need a satisfactory reality to be able to develop an ideal model for society; and we must live morally, whatever the reality is. It seems strange that a philosopher like Sartre, who has so emphasized the situational conditions of man, should profess to need a particular type of situation before he can develop a universal morality.

The problem is different if what he means to say is that it is not worth while to devote one's time to moral speculation when the situation is so bad; it is morally better to devote time and energy to changing conditions rather than to speculate about them. But such a judgment would be more appropriate to Sartre the human being than to Sartre the philosopher. For the philosopher, no matter how bad reality is, one can analyze it and develop an ideal model; and the worse reality is, the stronger the need to develop proper models for change.

In my opinion, the principal reason for Sartre's failure to write an ethics lies in his awareness of the fundamental conflict between his individualistic approach, as presented in *Being and Nothingness* (1943), and his later concerns about man's sociopolitical conditions, as advanced in the *Critique of Dialectical Reason* (1960). It would be very difficult for anyone to reconcile these two doctrines, and I believe if Sartre had ever written an ethics, it would have been in line with the *Critique*. In what follows, however, I shall concentrate on the first period of his thought, which seems to

have ended around 1949 and is presented in his major work *Being and Nothingness*.

Although, for whatever reason, Sartre has not written an ethics, an ethical theory is implicit in his doctrine of man, as he admits in the final section of *Being and Nothingness*. In this section, entitled "Ethical Implications," he rightly points out that "ontology itself cannot formulate ethical precepts. It is concerned solely with what is, and we cannot possibly derive imperatives from ontology's indicatives." But he adds: "It does, however, allow us to catch a glimpse of what sort of ethics will assume its responsibilities when confronted with a *human reality in situation*."[4]

Sartre's theory of man succeeds in breaking through traditional concepts. The influences of Nietzsche, Husserl, and Heidegger are discernible, but the theory is Sartre's own. Indeed, his originality and boldness has incited bitter criticism from traditional quarters.

Other reasons for the flood of criticism directed against Sartre derive from a related but different source. The moral theory developed by the great majority of philosophers is essentially supportive of the status quo and relates to a society which is not torn to pieces by moral problems, a society which is relatively satisfied and in which moral problems are conceived of in terms of paying one's bills and keeping one's promises. Sartre's concerns have nothing to do with conventional morality; hence his ethics is not for these kinds of thinkers. Neither is it for those who believe in the existence of fixed, objective values and moral principles, nor for those who try to read truth in the heavens, nor for those who lack the imagination and courage to push ahead and invent on their own, daring in their inventions to discover new principles and values.

Sartre's concerns for morality are far removed from tradition. He has no situation to defend, and clearly he is not looking for arguments in favor of the status quo. One of his more important affinities with Nietzsche is to be found here, in a concern for breaking through established morality and developing each person's morality by the full exercise of imagination and courage.

We are all familiar with Sartre's conception of man as presented in *Being and Nothingness*, and it is therefore unnecessary to detail that conception before inferring its implicit moral doctrine. Suffice it to say that if man makes himself by his choice and actions, and if he is condemned to be free, he cannot abide by ready-made norms, values, and principles. He has to create them himself by his free choices.

So far, so good. The road looks exciting, but it is also cluttered with difficulties. "We are on our own" without justification and without excuses, Sartre tells us, and we have to assume full responsibility for our choices and

actions. Though this position about values and norms is also well known, let us examine a few of Sartre's relevant quotations. In *Being and Nothingness* he writes: "... *nothing*, absolutely nothing, justifies me in adopting this or that particular value, this or that particular scale of values."[5] And he adds:

> I do not have nor can I have recourse to any value against the fact that it is I who sustain values in being. Nothing can ensure me against myself, cut off from the world and from my essence by this nothingness which I *am*. I have to realize the meaning of the world and of my essence; I make my decision concerning them—without justification and without excuse.[6]

This attitude, found throughout his basic work, is reiterated in his lecture entitled *L'Existentialisme est un humanisme* (1946):

> Man makes himself; he is not already made; he makes himself by choosing his morality. . . . We define man in relation to his commitments; it is therefore absurd to reproach us for irresponsibility [*gratuité*] of choice. . . . Every time a man chooses his commitment and project in all sincerity and lucidity, whatever his project may be, it is impossible to prefer another to it.[7]

One finds the same attitude in several of his literary writings as well. For example, in *Les Mouches*, Orestes says: "I am condemned to have no law other than my own. . . . For I am a man and each man has to invent his own way."[8] And in *L'Age de raison* Sartre says of Mathieu, the professor of philosophy:

> There would be neither right nor wrong unless he invented them. . . . He . . . was free and alone, without help, without an excuse, condemned to decide without any possible recourse, condemned forever to be free.[9]

I quite agree with Sartre that man cannot accept a set of norms and moral principles when he does not know where they come from. Usually, principles that are urged upon us are those of a predominant group pretending to make them universal. This is true of an ethics purportedly based on "the will of God" and on a priori values, as well as of the more empirical, socially rooted type of ethics. But if one denies the possibility of finding some kind of rules or values, one risks getting into a chaotic moral situation. This is the basic dilemma of subjectivists of every sort, and Sartre is no exception.

In other words, if one believes there are objective moral norms deriving from God, reason, or society, one can decide whether or not one is behaving morally, since there are criteria for such decisions. The difficulty there is to define and *justify* the foundation of such objective moral norms or values, to confirm or refute their validity. But if, on the other hand, one altogether rejects the notion of objective norms and bases moral behaviors and values solely on subjective choice without any possibility of confirmation, one runs into tremendous difficulties.

Are these the only possibilities? Must one either accept the existence of objective value imperatives or "invent" one's own values without any guidance or criteria? Must we choose between this Scylla and this Charybdis? Sartre seems to think we must. And as he rejects the former extreme, he falls into the latter. I think he is trapped by a false alternative.

It is true in the present age that man seems to be constrained by fixed and strict rules of the type of the Ten Commandments, not only with respect to morality but also with respect to politics and many other human activities. In view of such constraints, the natural reaction of a person with imagination and a critical mind is to look into himself for the norms he should follow. But to say that the subject freely chooses in moral matters, is not to say that he can decide arbitrarily, that his free choice is the only foundation of morality and he can ignore facts and circumstances that bear upon moral decisions.

The extreme position taken by Sartre is similar in this respect—though completely different in its foundations, meaning, and context—to Ralph B. Perry's doctrine of value as "any object of any interest."[10] In both cases, we are denied the possibility of making a mistake. The mere fact of my choice or my interest makes a thing valuable. I may be mistaken in my belief that I have freely chosen or that I am genuinely interested, but then, in either case, my mistake would be psychological, not moral. If I have freely chosen "in all sincerity and lucidity," there is no possibility of an axiological or moral mistake. Yet if I can never be wrong, I can never be right, since these notions are interrelated.

This position creates a cluster of difficulties. If I can be neither right nor wrong, how can I be praised or blamed, and how can I be responsible? Education as it relates to moral questions loses all meaning, and we cannot accuse anyone of acting in a perverted, sadistic, or unfair manner. The whole moral world seems to collapse, and with it all our political, social, and educational concepts related to morality.

I am not defending any particular interpretation of right or wrong. I am only maintaining that if I can make anything right by the mere act of freely choosing it, I am destroying the very notion of "right" and "wrong." Logical positivists, and some members of the analytical school who pursue the same logic on a different level, can at least excuse themselves by saying that theirs is a metalanguage, and that they are not affecting normative ethics or morality at all. But in the case of Sartre, there is not even room for this excuse.

Let us take a simple moral case and see how Sartre's theory helps us to solve it. We know his answer before presenting the case to him: "You are free; choose, that is, invent."

But this is exactly the problem: I do not know what to do, and that is why I come to him for advice. If I knew how to decide or how to "invent" a

solution, I would not need any advice, since I would have no problem. But in my hypothetical case I perceive several alternatives, and I do not know which one to take. More than that, I do not know what criteria to follow, how to weight the various facts related to the decision, etc. That is why I do have a problem and I come to a moral philosopher for advice. On many other occasions, I have no problem when confronted with a moral situation because the solution seems to be clear. If I see a big man beating a child to take the little food he has away, I immediately see what I should do. Perhaps I feel afraid of the man and therefore abstain from interfering, but I am quite clear about what *should* be done. My lack of physical and/or moral strength is a factual matter. Unfortunately, in many other cases I do not know what I should do. In this I am not an exception: the great majority of adults have at one time or another been confronted with a moral problem without knowing what to do.

SARTRE'S ILLUSTRATION OF MORAL CHOICE

Let us now consider one of Sartre's own illustrations of a moral dilemma.

> One of my students came to see me under the following circumstances: his father had quarrelled with his mother, and moreover, was inclined to be a collaborationist; his older brother had been killed in the German offensive of 1940, and the young man, with somewhat immature but generous feelings, wanted to avenge him. His mother lived alone with him, very much upset by the half-treason of her husband and the death of her older son; the boy was her only consolation.
>
> The young man was faced with the choice of leaving for England and joining the Free French Forces—that is, leaving his mother—or remaining with his mother and helping her to carry on. He was fully aware that the woman lived only for him and that his going-off—and perhaps his death—would plunge her into despair. He was also aware that every act that he did for his mother's sake was a sure thing, in the sense that it was helping her to carry on, whereas every effort he made toward going off and fighting was an uncertain move which might run aground and prove completely useless; for example, on his way to England he might, while passing through Spain, be detained indefinitely in a Spanish camp; he might reach England or Algiers and be stuck in an office at a desk job. Consequently, he was faced with two very different kinds of action: one [was] concrete, immediate, but concern[ed] only one individual; the other concerned an incomparably vaster group, a national community, but for that very reason was dubious, and it might be frustrated on the way. And, at the same time, he was hesitating between two kinds of morality: on the one hand, a morality of sympathy, of personal devotion; on the other, a broader morality, but one whose efficacy was more dubious. He had to choose between the two.
>
> Who could help him choose? Christian doctrine? No. Christian doctrine says: "Be charitable, love your neighbour, sacrifice yourself for the others, take the roughest road, etc., etc." But which is the roughest road? Whom

should he love as a brother? The fighting man or his mother? Which does the greater good, the vague act of fighting in a group, or the concrete one of helping a particular human being to go on living? Who can decide a priori? No one. No book on ethics can tell him. The Kantian ethics says: "Never treat any person as a means, but as an end." Very well, if I stay with my mother, I'll treat her as an end and not as a means; but by virtue of this very fact, I'm running the risk of treating the people around me who are fighting, as means; and conversely, if I go to join those who are fighting, I'll be treating them as an end, and, by doing that, I run the risk of treating my mother as a means. . . . I had only one answer to give: You're free; choose, that is to say, invent.[11]

If this young man must invent a course of action, it means there is no right or wrong course; for had there been one, his problem would be to discover it, find it, not to "invent" it.

This seems to be very poor advice, from both the theoretical and the practical point of view. From the practical side, it is bad advice because the student apparently has not been able to "invent" a value, which is why he asks for advice. From the theoretical point of view it is bad because the student wants to make the "right" decision and Sartre's ethical doctrine gives him no help. The advice he receives does not mean "take a chance and find out later if you have hit upon the right decision," but rather: "no matter what you do, you are going to be right."[12]

Nevertheless, the student wants to have some guidance to help him arrive at the right "invention," to choose properly. Should he be judged according to the consequences, since there are no ready-made norms?

Even though there are no criteria acceptable to Sartre, he analyzes some possible criteria in order to reject them: Christian doctrine, Kantian ethics, and the trust we give to our feelings. The first two he finds unequal to the student's problem, and I agree with Sartre on this point. As far as trusting our feelings is concerned, he says: "But how is the value of a feeling determined? What gives the feeling for his mother value? Precisely the fact that he remained with her."[13] With this, we come back to Sartre's theory that the mere choice makes it valuable and that we cannot be wrong, no matter what.

There are some facts in the case, however, that make a lot of difference. Sartre refers to them in his description. But mere facts are blind; one has to evaluate them. One must first consider only relevant facts, but when one decides that a fact is relevant, he is already evaluating it. Furthermore, one must evaluate each of the relevant facts to determine which ones are the weightiest. How can he evaluate if there are no criteria of evaluation? Again, he has to invent.

But Sartre himself seems to have some criteria for evaluating the relevance and weight of facts, since he points out some and neglects others. He refers to the relation between father and mother, the fact that the brother

was killed, that the petitioner is the only son left, that the mother feels alone and needs him, that he might have difficulties in reaching England, etc. But these facts are not enough to prompt a decision. One should know more. For example, what is the potential of this young man for becoming a good soldier and being a help rather than a nuisance to the Free French Forces? And is there any possibility that some other relative might care for the mother?

Apart from these facts and possibilities, there are relevant intentions and motives to be considered. If the young man were to decide to stay with his mother out of a fear of being killed, the morality of his choice would be very doubtful. We would have a similar situation if he were to leave France because he hated his father or feared death at the hands of the German forces. As the description suggests, possible consequences also must be considered before he reaches his decision. It is not a question of deciding blindly, but of supporting his decisions by valid reasons and being able to foresee consequences with due regard to relevant facts, intentions, and motives. Sartre, by contrast, avoids assigning relevance to facts and validity to reasons.

I am not concerned, of course, with the advice given to the young man, but rather with the moral theory implicit in that advice. If one is going to take into consideration neither facts nor values, I do not see how one can avoid arriving at a purely arbitrary decision determined by whim or the toss of a coin.

Sartre's free decision sounds rather mysterious. It is not rational, since it entails no previous deliberation: "When I deliberate," says Sartre, "the chips are down."[14] That may be true in some cases, but not in all. The case in point affords a good illustration of Sartre's tendency, already pointed out, to exaggerate and go far beyond the evidence. There are many cases where rational deliberation is clearly required prior to a moral decision. We pay attention to the facts, the norms, the rules of the game, the consequences, motives, and intentions, and we render our decision upon drawing a total balance in that particular case and in that specific situation. The facts do count; we know this because if we discover a new relevant fact, we may change our decision. The same applies to reasons.

I think that, as a matter of fact, Sartre's general description of the psychological decision is wrong. But it is even worse if we take it not as a description of what happens, but as an indication of what one *should* do.

Sartre gives the impression that values come to us out of the blue. In contrast to Scheler's and Hartmann's interpretations, which consider values as essences that exist up there in the ether like some kind of Platonic "Ideas," Sartre jumps to the other extreme and contends that we can make anything valuable by the mere fact that we freely choose it. If we have a

good look at things which are valuable, we can discover that they have such a quality, not by the mere fact that they have been chosen by some people but rather because they embody certain specific qualities. Water is valuable because it can satisfy physiological needs of living organisms; food in general is valuable for the same reason, and so on in hundreds of other cases. It is true that these things are not valuable in themselves, but in relation to an individual. The value of food depends on the need of living beings for it; but the opinion or the choice of the individual does not affect the value of the food, not even for him.

SARTRE'S FIRST DIFFICULTIES

Let us now analyze some psychological states and see how they can be explained according to Sartre's theory. Take repentance, for instance. If whatever I freely choose "with all sincerity and lucidity" is right, how can I repent of such a choice? In Sartre's theory, there is no possibility of repentance, because I was right in the first instance and it would seem rather odd to repent of right choices.

Actually, one repents because one concludes that he has made a wrong choice. And how does he discover that he was wrong? We may make such a discovery in many ways, most commonly by becoming aware of relevant facts that we have ignored or neglected, sometimes by realizing, belatedly, that we have applied a wrong criterion or principle or have failed to take motives, consequences, aims, etc., into consideration. We may also realize that we have made a logical mistake. Logic is not incompatible with moral choice; as a matter of fact, it is one of its prerequisites.

Millions of people throughout the ages have endured the experience of repentance after a wrong moral decision. Many such decisions were freely chosen, but this fact did not change the situation. They were wrong decisions, nevertheless, and were acknowledged as such by repentance.

Repentance, then, provides us with material for criticism. Suppose I have to choose between two diametrically opposite actions and I freely choose one. According to Sartre, I am right in my choice. But then suppose I reconsider and change my mind. I repent of my previous action and I freely choose the alternative. Again I am right, according to Sartre. But, if all the facts and circumstances remain exactly the same, the only difference being that I have changed my mind, how can the two contradictory alternatives both be right?

In the case of conversion, the situation is even more troublesome. A "radical conversion" means a change of our fundamental project. But for Sartre our project is not based on previous values, reasons, or motives; instead, it is itself the foundation of values and reasons. He says that our

"original choice which originally creates all causes [*motifs*] and all motives [*mobiles*] . . . arranges [*dispose*] the world with its meaning."[15] The project, by its very nature, is "fragile" and "unjustifiable,"[16] in the sense that no values or reasons exist outside the free choice that sustains them.

Thus when one changes his project he cannot base the change on anything outside his free choice, any value, norm, or reason, since the new project creates new values, norms, and reasons. But when the logical bases of the two projects, the old and the new, are incompatible, they cannot both be right. If one chooses to be Catholic and behaves accordingly, and then becomes an atheist, he cannot be right in both cases. In the first, his faith was based on a belief in the existence of God, whereas now he believes God does not exist. The basis of this change, namely, the proposition "God exists," is either true or false. Of course there are many cases in which the old and the new projects are not logically incompatible, and they can both be successively right—or wrong, I may add.

Incidentally, I would like to point out that Sartre's presentation of the choice of the fundamental project is most unsatisfactory. He tells us that in many cases (that of Baudelaire, for example) the fundamental project which gives sense to one's life is freely chosen while one is yet a child. Can a child freely choose something so fundamental as the meaning of a total life? I doubt it. As Sartre does not want to make the choice of fundamental project or any other choice a rational activity, he keeps it in the shadows of some mysterious process. But the contradiction emerges: the basis of our values and reasons is the result of a choice that cannot be completely free, since it has been the choice of a child. Of course, one can change his project later on, but Sartre admits that most of us remain in our original projects.

What is more, a simple consideration of obviously immoral cases shows that our free choice or decision cannot turn a bad action into a good one. A man who beats his young children to make them work hard from sunrise to sunset so he can lend their earnings to the poor at high rates of interest, presents a clear case of immorality. Could the man's behavior be seen as good if we could irrefutably prove that he has freely chosen such a course of action? An immoral action might be freely chosen and still be immoral. I am sure Sartre would not deny the immorality of a case such as this; it is the weakness of his moral theory that I am criticizing, not his moral conscience. In other words, if it is sheer choice and not its content that counts, then all possibilities are equivalent and we end up in an ethics of mere chance.

I would go so far as to concede that Sartre may be correct in saying there is no "right" or "wrong" way to choose or act, but he should at least grant that there may be "better" and "worse" choices. I do not think he

would allow this possibility either. But, if there are no "better" and "worse" ways of behaving, one falls into an ethics of indifference: anything will do.[17]

On the other hand, if there is a better-worse dimension with regard to choosing, deciding, or acting, there must be some criteria to determine in a particular case that one alternative is better than another. Sartre does not provide such criteria, not even general guidance.

Why not? Because to suggest any criterion, guidance, or rule of behavior would be to imply a limitation to freedom, which for Sartre is the foundation of all moral values: "My freedom is the only [unique] foundation of values."[18] There is nothing above it. Any posited value, rule, etc., would belie this assertion.

Of course, there is the well-known Kantian case whereby freedom becomes the basis of ethics and at the same time implies a moral law, albeit an autonomous one. Sartre, however, seems to believe that freedom and law are incompatible—or perhaps he reasons that if freedom is the foundation of values, it cannot at the same time be founded on values without leading into a vicious circle. Either way, the problem remains: how can freedom escape becoming void if it ignores values? I shall return to this point later.

But if there is no moral value or law, it will be difficult to avoid falling into an arbitrary "free" choice or decision. In Sartre's view, as we have seen, moral values and norms have no other foundation for their existence than the fact that they have been freely chosen. Free choice becomes, therefore, the key notion in Sartre's ethics; it is also the basic category in his ontology of man. We have also pointed out that, for Sartre, we are made by our decisions and actions, since we have no essence or nature. But in order for our actions to be able to constitute our personality, they have to be free. Otherwise, we will be made from the outside and will not make ourselves.

SARTRE'S NOTION OF FREEDOM

Let us now have a closer look at Sartre's notion of freedom. The first thing one should point out is his tendency to use the word "freedom" in an ambiguous and even vague sense. He writes: "If man is not originally free, but determined once for all, it is impossible even to conceive what his liberation would be."[19] And Francis Jeanson[20] quotes Sartre as saying: "If man is not free, then his liberation would not make sense." These sentences might be interpreted in various ways, but if one takes them at their face value, one can argue that if man is free there is no need to liberate him, particularly in view of Sartre's contention that freedom does not admit of degrees but is absolute.

The word "freedom" has in Sartre's writings at least three different meanings. It means (1) a fact: man is condemned to be free; (2) a goal: one should liberate himself and the rest of humanity; (3) a criterion: choice must be free if it is to engender moral values and to imply moral responsibility. Sometimes context clearly indicates which of these meanings he has in mind; but at other times the reader becomes thoroughly confused about the meaning of this key word. And as Sartre is further inclined to shock the reader with apparently contradictory statements (man "is a being which is not what it is and which is what it is not"[21]), frequently a fog pervades his texts.

The confusion is compounded where Sartre gives the impression of reifying freedom. Though he stresses that there are only free choices and decisions, he sometimes speaks about freedom as if it were an entity. Even from the fundamental statement "Freedom has no essence,"[22] the reader can get the impression that freedom is a thing, an entity which happens not to have an essence. Actually, freedom has neither essence nor existence. It is only a label used for the purpose of describing free choices, decisions, acts, persons, etc.

Perhaps it is more than just a way of expressing himself, particularly when he defends the existence of "absolute freedom." "Absolute" has more force and meaning when attached to an entity, like freedom, than to an adjective like "free." Most adjectives admit degrees, as is clearly the case with "fat" or similar qualities which are incompatible with the notion of any kind of absolute.

What I have said about Sartre's use of the noun "freedom" also applies to his use of the verb "to be" (être). "To be" has at least a dozen meanings in idiomatic French: for example, it can refer to a quality, inclusion in a class, existence, equivalence to, etc. The context usually helps us to understand in which sense it is being used, but not in Sartre's case. When "to be" should be used as a quality, he uses it as meaning "equivalent to." For instance, instead of saying "man is free," he says "man is freedom." This use might be justified on the ground that he wants to avoid the misunderstanding that freedom is just a quality of man, but it nonetheless invites confusion in the mind of the reader.

It is easy to understand why man should be free in Sartre's ontology. Man has no essence or nature, as we have seen; he is made by his own choices, decisions, and actions. If such choices were not free, he would not be making himself but would instead be made from the outside. Stated in this general way, the position carries a strong force of conviction; but closer examination reveals some flaws.

To begin with, Sartre is either begging the question or indulging in circular logic when he assumes that man has no essence because he can

freely change the course of his life at any time; and that because man makes himself by his own choices, he has to be free. He offers no proof whatsoever of man's freedom. One finds in his works only flat assertions that man is free, absolutely free, condemned to be free, and so on. Such statements sound all right in his plays, but they do not hold up so well in a philosophical treatise, where one is obliged to support statements with relevant facts and valid reasons. As we shall soon see, Sartre starts from some sound psychological analyses, but very soon tends to go beyond the evidence, or at least so it seems to me.

For Sartre, man is free. But he is not free in the same sense in which he is tall, blond, or French, nor even in the sense that he has two hands, two eyes, or any other quality or property. He writes: "[M]y freedom . . . is not a quality added on or a *property* of my nature. It is very exactly the stuff of my being."[23] The same concept is articulated in his first presentation of the problem of freedom, and in practically the same words.[24]

Not only is man free but he is "condemned to be free."[25] There is no escape from freedom. Any rejection of freedom is a free act: not to choose is a way of choosing. Trying to get away from our freedom is like trying to get away from our selves or trying to jump out of our skin. Man is free not in a particular situation or circumstance, but in all situations and circumstances. Man is absolutely free; his freedom is unlimited.[26]

(As far as I know, Sartre's extreme doctrine of absolute freedom is unique in the annals of philosophy. All other doctrines in favor of freedom at least acknowledge some limitation or other. It is only fair to point out, however, that there are some indications that Sartre himself modified his views after publishing *Being and Nothingness*. In an interview in 1970, he said he had recently read again his preface to *The Flies, No Exit* and other plays, and was "scandalized" (*scandalisé*) at the statement, "Whichever the circumstances, no matter the place, a man is always free to choose if he will be a traitor or not." And he added: "When I read that, I said to myself: It is incredible: I have really thought so!"[27] I do not know what limitations, if any, he was prepared to admit in 1970 or thereafter; I am here analyzing his notion of freedom as it is presented in his major earlier work.)

At the same time, freedom is a lack, rooted in "nothingness," derived from our finitude and limitation. There is freedom because man, the "for-itself," is incomplete. A physical object, an "in-itself," does not need freedom. It is what it is. It is not in the making as we are, and it does not have to make up its "mind" as to what kind of being it would like to be.

Finally, one should keep in mind that when Sartre is discussing freedom he is not concerned with free actions, in the sense of "the ability to obtain the end chosen"; freedom, for him, "means only the autonomy of choice."[28] In other words, "the formula 'to be free' does not mean 'to ob-

tain what one has wished' but rather 'by oneself to determine oneself to wish' (in the broad sense of choosing)."[29] With this distinction he moves out of the reach of criticisms against freedom based on our patent inability to *do* certain things. For example, a prisoner is not free to get out of prison, or I am not free to get into my own house if it is locked and I have no key. Sartre examines similar situations to show that our limitations or obstacles spring from our own choice or decision to do something. I am not free to get into my home only if I previously have chosen to enter it; the limitation derives from my previous choice. Sartre's illustration specifically refers to climbing a crag: all the difficulties in climbing disappear as soon as I decide not to climb.

One should not think, however, that Sartre completely separates choice from action.

> The choice, being identical with acting, supposes a commencement of realization in order that the choice may be distinguished from the dream and the wish. Thus we shall not say that a prisoner is always free to go out of prison, which would be absurd, nor that he is always free to long for release, which would be an irrelevant truism, but that he is always free to try to escape (or get himself liberated).[30]

A Critical Analysis of Sartre's Theory of Freedom

Sartre has insisted on many occasions that "freedom is the freedom of choosing."[31] It is true that he has compared moral freedom to artistic creation, in the sense that in neither case is there a set of rules to be adjusted to; but in many passages he makes freedom almost equivalent to freedom of choice.

Is this in fact the fundamental meaning of freedom? I do not think so. When choosing, we are already restricted to the alternatives imposed by the situation. Freedom should go beyond the mere choice and become creative. Kant, after reading Hume, could have chosen to remain a rationalist or to become an empiricist. Those seem to have been the historical alternatives at that time. But he exercised his freedom on a higher level by overcoming the two possibilities.

Science and philosophy do not develop by the exercise of free choice. The dialectical process implies, among other things, that man does not choose between two opposites—thesis and antithesis—but supersedes them both. Creative freedom is best illustrated in the arts. One cannot reduce the creative process involved in painting, writing poetry, or composing music to a series of choices between alternatives without distorting it completely. The process in ethics is similar. Far beyond and above freedom of choice, there is creative freedom. I am sure Sartre would not reject this notion, but he has paid little attention to it because he has put all his em-

phasis on freedom of choice. (As Sartre wrote in *L'Etre et le Néant* [p. 561] "La liberté est liberté de choisir.")

Is man really free in the way Sartre claims? If he is not, Sartre's whole foundation of morality collapses. Thus a critical analysis of his notion of freedom has fundamental moral consequences.

Even if one grants that man is condemned to be free, experience readily proves that different men, in different situations, exercise their freedom in different ways and at different degrees. I do not mean freedom in the sense of actions or success, but on the level of choice. It is clear that physical, intellectual, and cultural factors, among others, limit the exercise of our potential freedom. One has to attain a certain level of nutrition, health, and intellectual development in order to be free and to become aware of the actual limitations of his freedom. Marx recognized this requirement when he said he did not expect any revolution from the *Lumpenproletariat*. Consciousness of social injustice is the first step toward revolution. If one is not aware of the limitations on his freedom, he will not try to liberate himself from them. The slave starts his liberation when he becomes aware he is a slave. But millions of slaves throughout the centuries have lived out their slavery as if it were a "natural" state.

It is not reasonable to expect that a poor, sick, ignorant Indian in the Bolivian mountains, for instance, can have "freedom of choice." Inadequate nutrition, sickness, ignorance, and adverse socioeconomic conditions have made him a victim of, and not a responsible agent for, his lack of freedom. He cannot "determine himself to wish"; he is sunk so low, physically and mentally, that he cannot envision a release from his chains. He attributes his condition to the will of God or "the nature of things." If one wants to liberate him, one must set about altering these oppressive conditions instead of preaching about a freedom he is unable to perceive, much less to exercise. Urging him to pull himself out of his miserable condition is like exhorting someone mired in quicksand to pull himself up by his own hair. It is not the case that the poor Indian does not want to choose; he literally cannot choose. Lack of awareness in some cases, resignation in others—these ultimately are the factors that prevent people from exercising their freedom or seeking their way out of slavery.

But Sartre does not seem to be ready to allow for such limitations of freedom. He writes: "Even torture does not dispossess us of our freedom; when we give in, we do so *freely* . . . prohibition can have meaning only on and through the foundation of my free choice."[32] In this respect, Sartre's doctrine of freedom wholly disregards the true condition of millions of people who are victims of starvation, sickness, ignorance, and socioeconomic oppression. In the interests of these millions, a careful delineation of the factors that limit freedom would be vastly more important

than any metaphysical speculation. Indeed, it is difficult to see how even Sartre can reconcile the individualistic approach to freedom expounded in *Being and Nothingness* with the sociopolitical commitment advanced in his *Critique of Dialectical Reason*.

His doctrine of freedom disregards other millions as well. I leave aside the extreme cases of very small children, mentally retarded persons, and others who obviously have no actual "autonomy of choice." At what age and in what circumstances is a person able to choose? Sartre's doctrine seems to have been worked out with the middle-class European adult in mind. It certainly does not apply to millions of children and "primitive" peoples. What shall we do with them? Exclude them from an ontology of man because they do not fit into the picture?

One may reasonably have some doubts about so specialized an ethics, but for the sake of the argument let us now assume that Sartre is right about freedom and concentrate on his moral doctrine, which rests upon his notion of freedom.

In the first place, an absolute, unrestricted freedom destroys the very meaning of moral values and norms, just as an absolute truth destroys freedom. If there is an absolute truth and man knows it, he has only one way to go, namely, to follow the truth. In the same way, if there is an absolute, unrestricted freedom, there can be no moral value, law, or norm, not even an autonomous and self-imposed one, because any such law would be a limitation to man's freedom.

But man happens to be in the middle of these two absolutes. He is submerged in a world of truths in the making that evolve and supersede one another, and within a limited, flexible freedom that changes from individual to individual and according to circumstance. Be that as it may, man needs some criteria, both in knowledge and in morality, to decide when he is right or wrong. Sartre provides some criteria in the case of knowledge, but no criteria whatsoever for morality because, I take it, he does not want to put any limit on freedom, which is limited only by itself.[33] Thus, freedom becomes an end in itself and the source of all moral values and principles. What happens when man uses his freedom—as man sometimes will—to do mischievous, selfish, and cruel acts? If one drains the notion of freedom of all content, one is heading toward an ethics of indifference, where only empty freedom counts. To have meaning, freedom needs a content which can be provided by moral values which one freely chooses because of what they are, and not the other way around, namely, that they are what they are because one has chosen them. Sartre is right in trying to develop a dynamic morality, but he is wrong when he makes it virtually equivalent to moving at random or for the sake of moving.

Freedom, Commitment, Responsibility, and Obligation

Ethics has always involved the notions of moral responsibility and obligation. Obligation is not incompatible with freedom. As a matter of fact, the one notion seems to imply the other. Kantian ethics affords the most outstanding illustration of the profound interrelation between these two key philosophical concepts.

Sartre frequently refers to commitment and responsibility, but in no place does he make clear how one can measure such responsibility and commitment, nor does he tell us what criteria he has in mind for deciding whether one has fulfilled his responsibility. As a matter of fact, I am convinced that his notion of unrestricted freedom as the foundation of morality rules out the very notions of moral commitment, responsibility, and obligation. Let us analyze this problem carefully.

Since there are no pre-established moral rules or principles, Sartre maintains that man has neither obligation nor commitment until he freely chooses them. Let us accept that. Only when a man decides to get married or to be in love, for instance, is he committed to being faithful to his spouse or beloved. If he does not want to be faithful, he is free to break his bond and thus resume his complete freedom. This seems to be quite reasonable and in agreement with Sartre's theory. But if one delves down into his doctrine of freedom as the only foundation of morality, one realizes that the matter is not so simple as that.

Why should either love or marriage entail a commitment to be faithful, particularly when, like Sartre, one does not recognize any pre-existing moral rules which might imply such a commitment? To be committed to be faithful in marriage, one actually needs to make two separate choices: (1) to get married, and (2) to be faithful. Neither one implies the other; I can change my mind about one without changing my mind about the other. Indeed, one can choose to keep his marriage tie and change his mind about being faithful only at the very moment of being unfaithful, since "the choice, being identical with acting, supposes a commencement of realization."[34] But if this is so, the very meaning of commitment and obligation evaporates, because commitment and obligation usually derive by implication from a more basic free choice, such as deciding to get married. According to Sartre's theory, we are committed to what we are particularly committed, since in each case our obligation is rooted in a free choice and for as long as we keep that choice. There are no pre-established moral rules that can justify any sort of implications.

The illustration concerning marriage and commitment is not, of course, an isolated case. If one chooses to join a revolutionary party, to

support an underground movement, to become a monk, etc., he is not committed to anything further. If in the course of his membership in such a group he is asked to do a particular type of job, he is not committed to do it by the fact that he has joined the group. All moral obligations are effectively wiped out, since one has to support them at each moment with a new free choice. Sartre's theory reminds one of Descartes' continuous creation of the world by God.

Notions like "traitor" and other similar moral evaluations lose their meaning. To be a traitor means to be committed to a "cause" and actually do something different. But if each commitment rests on a free choice, one cannot be considered a traitor if he gives up his choice. To be a traitor, one should keep his free commitment to do something and yet do the opposite, which would be a rare case, particularly from the perspective of Sartre's theory, whereby choice and action cannot be separated.

Sartre has either to admit that there are moral duties and commitments by implication or else follow my reasoning to its destructive consequences. I do not see how he can take the first alternative without contradicting himself, since any implication presupposes the existence of moral rules, which he has denied on many occasions.

In all the cases presented, at least one other person is involved. By changing my mind, I am affecting the other person's freedom. The effect is potentially even worse when the theory is applied on a broader social scale. How can a society avoid chaos if each of its members can change his mind at any time on any matter without feeling any moral obligation to live up to his or her commitments? Thus the freedom of each of the members becomes a constraint on the freedom of all other members, and none is morally justified in expecting anything from any other.

This chaotic situation seems incompatible with Sartre's principle concerning the universality of our choices, which resembles Kant's principle although its foundation is wholly different. Because Sartre never bothers to justify this principle, the reader never knows what types of actions and choices are included in this possible universalization. Still, all the criticisms that have been raised against Kant's principle can be raised in Sartre's case, and many others can be added. For instance, Sartre says that if I lie, I choose the liar as a model for every human being. But I say I can choose to lie to save the life of another person, and then I do not choose the liar as a model, but a lie to save a life. Besides, there are many things I may choose that depend on my unique situation. Just to avoid becoming entangled in an argument about levels of choosing, let us take the case of the fundamental project, which is the most important choice, to illustrate this point. If I have chosen to be a philosopher or a professor of philosophy, I cannot really want everybody to do the same and to have a world made up only of

philosophers. Indeed, most types of choices and professions imply the existence of people making different or even opposite types of choices: teacher implies student, policeman implies lawbreaker, etc.

When everyone is exercising his autonomy of choice, it is only natural that many choices collide and *conflicts* are unavoidable. How one can solve conflicts between incompatible choices within Sartre's theory? On the legal level, conflicts are solved by the application of a formalized law, but there is no such law in morality. I do not see any way in Sartre's theory to solve such conflicts but, unfortunately, the conflicts are there. A theory that does nothing to solve them can hardly be satisfactory.

There are other internal contradictions to be pointed out. If man creates values by a free choice and "my freedom is the only [*unique*] foundation of values and . . . nothing, absolutely nothing justifies me in adopting this or that particular value, this or that particular scale of values,"[35] the meaning of choice disappears, since all possibilities become equivalent.

To choose is to decide in favor of an alternative for some reason, not to act out of caprice or chance. Usually, the reason is that we consider one alternative to be "better" than the others, no matter how one defines "good" and "better." But when no better or worse is indicated, because there is no justification for adopting a particular value, "free choice" loses its meaning. One may have a motive for choosing, adopting or preferring a particular alternative, but not a *valid reason*, even within his own subjectivity, to do so. Choice, therefore, can be psychologically explained but never morally justified. In other words, if all the moral alternatives are equivalent, chance and arbitrariness are the "foundations" of our choice. Actually, there is no choice but chance, and "free choice," meant to be the foundation of value, becomes meaningless. So, after a long ontological journey, man ends up in an ethics of indifference.

For those, like myself, who do not believe there are a priori, absolute, objective moral principles and values, Sartre's contribution is important as a severe criticism of an already declining doctrine. But once the destructive critique is accomplished, one must be prepared to climb the risky road toward a reconstruction. Which way to go? This is the problem. I do not mean "where" should one go, or which are the goals, but rather, In what direction should one move? Concerning this question, Sartre is very disappointing. It is true that we make choices without excuse, that we are on our own and should blame no one else. I want to be solely responsible for what I decide and what I do; but still I need to have some guidelines in my moral life. I want to decide freely, but not by chance. I cannot be trapped in an ethics of indifference where the exercise of freedom is equivalent to tossing

a coin. Chance is no foundation for moral action. I must base my decisions on facts and reasons. Sartre provides no clues as to what are the relevant facts and valid reasons to be considered in making a moral decision. Instead, he projects a jaded pessimism. This pessimism in turn seems to be the result of a naive optimism. It is as if, having triumphantly assailed the traditional moral edifice, he discovers there is no place left to look for guidance and he must drift on the stream of freedom.

One can admit that freedom is the foundation of moral norms, but at the same time one should realize that values give meaning to freedom. Otherwise, freedom becomes empty. Freedom for what? one may ask reasonably. In other words, freedom is a necessary but not a sufficient condition for a meaningful, moral, creative human life.

RISIERI FRONDIZI

PHILOSOPHY DEPARTMENT
SOUTHERN ILLINOIS UNIVERSITY, CARBONDALE

NOTES

1. *Being and Nothingness*, trans. by Hazel E. Barnes (New York: Washington Square Press, 1969; 4th printing), p. 798. French original: *L'Etre et le Néant* (Paris: Gallimard, 1957), p. 722. Future references pertain to these two editions, with the English translation *BN*, followed by the French original *EN*. For the Barnes translation, page numbers vary with the different printings of the Washington Square Press edition.

2. Published in English in *Encounter* (London), June 1964, p. 62.

3. *Les Mandarins* (Paris: Gallimard, 1954), pp. 489–90.

4. *BN*, 795; *EN*, 720.

5. *BN*, 76; *EN*, 76.

6. *BN*, 77–78; *EN*, 77.

7. *Existentialism and Humanism*, trans. by P. Mairet (London: Methuen, 1965), p. 50. There are many mistakes in this translation. For instance, in the passage quoted above, the word *project*, which is a key word in Sartre's ontology, is twice translated as "purpose." See *L'Existentialisme est un humanisme* (Paris: Editions Nagel, 1970), pp. 78, 79.

8. *Les Mouches* (Paris: Gallimard, 1945), pp. 100–1.

9. *L'Age de raison* (Paris: Gallimard, 1945), p. 249.

10. R. B. Perry, *General Theory of Value*, 2d ed. (Cambridge, Mass.: Harvard University Press, 1950), pp. 115, 116, and ch. 5.

11. *Existentialism*, 35–38; *L'Existentialisme*, 39–47.

12. Cf. fn. 5: "*nothing*, absolutely nothing, justifies me in adopting this or that particular value . . ." and other passages cited above.

13. *Existentialism*, 37; *L'Existentialisme*, 44.

14. *BN*, 581; *EN*, 527.

15. *BN*, 598; *EN*, 543.

16. *BN*, 598; *EN*, 542.

17. I think this is the logical conclusion of my argument. I am not supporting it with the common misinterpretation of a passage usually taken out of context, namely, that "all human activities are equivalent. . . . Thus it amounts to the same thing whether one gets drunk alone or is a leader of nations [*peuples*]." *BN*, 797; *EN*, 721.

18. *BN*, 76; *EN*, 76. Barnes translates the French word *unique* as "unique." I think it means "only" in this case.

19. *Situations*, III (Paris: Gallimard, 1949), p. 207.

20. Francis Jeanson, *Le Problème moral et la pensée de Sartre* (Paris: Editions du Myrte, 1947), 309–10.

21. *BN*, 28, 127; *EN*, 33, 121.

22. *BN*, 565. "La liberté n'a pas d'essence," *EN*, 513. In pt. IV, ch. 1, the whole discussion is about "freedom" and not about "free choice"; see esp. *BN*, 623; *EN*, 565.

23. *BN*, 566; *EN*, 514.

24. *BN*, 60; *EN*, 61.

25. *BN*, 567; *EN*, 515, et passim.

26. "Je suis condamné à être libre. Cela signifie qu'on ne saurait trouver à ma liberté d'autres limites qu'elle-même ou, si l'on préfère, que nous ne sommes pas libres de cesser d'être libres." *EN*, 515. See also *EN*, pt. IV, ch. 1, passim.

27. Reproduced in *Situations*, IX (Paris: Gallimard, 1972), p. 100. In the same interview Sartre acknowledges the influence of the war and the German occupation on what he wrote in that preface, and he calls the statement "théâtre de la liberté." In *Being and Nothingness* we find the same expressions he later uses in the preface to *The Flies*. Cf. *BN*, 646, 672; *EN*, 607.

28. *BN*, 622; *EN*, 563.

29. *BN*, 621. His idea is much clearer in the French original: "se déterminer à vouloir (au sens large de choisir) par soi-même." *EN*, 563.

30. Ibid.

31. *BN*, 618; *EN*, 561. See also *BN*, 621; *EN*, 563, and pt. II, ch. 1, passim.

32. *BN*, 672; *EN*, 607. Sartre's italics.

33. *EN*, 673, 680; *EN*, 608, 614–15.

34. *BN*, 622; *EN*, 563.

35. *BN*, 76; *EN*, 76. In the next page he adds: "I do not have nor can I have recourse to any value against the fact that it is I who sustain the values in being." *BN*, 77; *EN*, 77.

17

Dagfinn Føllesdal
SARTRE ON FREEDOM

A philosophy whose sole dogma is the affirmation of human freedom."[1] Thus Sartre characterizes his philosophy. But Sartre is never satisfied with commonplace observations. Not only is man "completely free,"[2] free "regardless of circumstances, regardless of time or place,"[3] but as a consequence of his freedom, man has unlimited responsibility: "I am as profoundly responsible for the war as if I had myself declared it," he says, and "I must be without remorse or regret as I am without excuse." To Jules Romains' statement that "in war there are no innocent victims," Sartre adds: "We have the war we deserve." As if this were not enough, Sartre continues: "Someone will say, 'I did not ask to be born.' This is a naive way of throwing greater emphasis on our facticity. I am responsible for everything, in fact, except for my very responsibility . . . everything happens as if I were compelled to be responsible . . . in a certain sense I *choose* being born."[4]

Especially this last sentence ought to give pause to those interpreters of Sartre who attempt to "save" Sartre by distinguishing two senses of the word "choice." A choice may be something that implies action; to choose to do *A* is to do *A,* it is said. But a choice may also be an internal psychological event; one may choose to do *A* but do something quite different, perhaps because one discovers that one is not able to do *A.* According to this interpretation Sartre does not mean that we are free to do whatever we might choose to do; he means only that our choice, as a psychological event, is free.

This commonly posited distinction between two notions of choice is of little help in trying to understand Sartre. For when did I choose to be born? Does it make sense at all to speak of choice, freedom, and responsibility here? What shall we then do? Shall we write off Sartre as unclear and confused, more interested in causing a stir than in imparting insight, or should his moments of inscrutability make us regard with even greater respect those parts of his philosophy which we think we understand? Neither

of these alternatives appeals to me, the latter least of all. When considerable parts of a philosopher's thought seem incomprehensible or obviously unreasonable, there is a strong possibility that we have misunderstood that which we think we understand, and that we have also missed the interconnections between the different views which are part of their justification. If we nevertheless enthusiastically profess what we think we understand, we are either dogmatic—that is, we do not pay much attention to justification—or we have missed much of what the philosopher in question wants to tell us.

In the case of Sartre, I think we easily miss something if we fail to look beyond the few utterances on freedom cited above. In this paper I shall argue that there is more coherence in his philosophy than one might think, that his apparently extreme assertions concerning freedom and responsibility make good sense when his philosophy is interpreted in a certain way, and that his apparently more ordinary and traditional statements concerning freedom must be reinterpreted when he is interpreted in the manner which I propose.

The starting point of my interpretation is that Sartre is a phenomenologist. He studied Husserl's phenomenology in Berlin in 1933–1934, prompted by Raymond Aron[5]; and *Being and Nothingness,* from which most of the quotations I have given are drawn, has the subtitle "An Essay on Phenomenological Ontology." However, the connection between Sartre's theory of freedom and Husserl's phenomenology is not obvious. Husserl writes little on freedom, and Sartre makes no direct reference to Husserl in developing his theory of freedom. Furthermore, the phenomenological interpretation of Sartre's theory of freedom which I am going to present in this paper, leads to serious difficulties for Sartre's ethics, which I shall consider toward the end of the paper.

First, let us briefly review the ideas which we need to consider from Husserl's phenomenology.

A basic idea in Husserl is that what is peculiar to man and distinguishes him from anorganic nature, from plants, and from most animals, is *consciousness.* What characterizes consciousness is a special kind of *directedness:* all consciousness seems to have an object toward which it is directed. When I am thinking, there is something I am thinking of; when I am seeing, there is something I see; when I hear, there is something I hear, and so forth. Let us consider seeing as a more detailed example. When I see, I see physical objects; I do not see sense data, as some philosophers have held. That is, I see something which goes far beyond that which is exhausted by my immediate experience. What I see, say a tree for example, has a far side, which I do not see from where I stand but which I expect to find if I walk around the tree and look at it from the other side. I do not see the far

side from where I am, but I see something, a tree, which has a far side. If I walk around it and do not find the other side which I expected to find, I give up the belief that I see a tree. I restructure my experience and think, perhaps, that what I have before me is a stage prop. To be a tree is to have properties and aspects like those which I attributed to it when I originally thought I saw a tree. Not all properties are equally firmly determined; I have perhaps no definite explanations concerning the color and detailed shape of the far side. But to have a back side rather like its front side is part of what it is to be a tree.

To *be* for the tree is simply to correspond to the expectations I have concerning it. The tree is *constituted* by my consciousness, Husserl said. To perceive is not to receive something passively from one's surroundings; if this were the case, how should we explain that we experience something that has far more to it than what meets the eye—a far side, for example? Perception is an activity that structures our surroundings. The different components of consciousness are connected with one another in such a way that we have an experience as of one complete thing, with a far side, etc. All there is to be for the thing thus corresponds to components of consciousness.

In this way our consciousness constitutes not only the different properties of the thing, but also the relation of the thing to other objects. The tree is conceived of as something which is in front of me, as perhaps situated among other trees, as seen by people other than myself, etc. It is also conceived of as something which has a history: it was there before I came, it will remain after I have left, perhaps it will eventually be cut and transported to some other place. However, like all material things, it does not simply disappear.

My consciousness of the tree is in this way also a consciousness of the world in time and space in which the tree is located. My consciousness constitutes the tree, but at the same time it constitutes the world in which the tree and I are living. If my further experience makes me give up the belief that I have a tree ahead of me because, for example, I do not find a tree-like far side or because others of my expectations prove false, this affects not merely my conception of what there is, but also my conception of what has been and will be. Thus in this case, not just the present, but also the past and the future are reconstituted by me.

So far I have mentioned only the factual properties of things. But their *value* properties are constituted in corresponding manner, Husserl says. The world in which we live is experienced as a world in which certain things and actions have a positive value, others a negative. Our norms and values, too, are subject to change. Changes in our views on matters of fact are often accompanied by changes in our evaluations.

This tendency of mine to change my conception of what I see or in other ways experience, illustrates another important point in Husserl: that such a change is always possible shows that the purely physical features of what I have in front of me, the light rays that reach my eye, etc., are never sufficient uniquely to determine what I see; another factor is decisive. This factor Husserl calls consciousness. Usually, I am not aware of the influence of this factor. I see the tree ahead of me and normally I have difficulties imagining that there should not be a tree there. However, once my further experience makes me understand that I was wrong, that what I see before me is not a tree, then at the same time I see the thing before me in a different way. Only in very few situations are we able to pass back and forth without much resistance between two different ways of seeing what is ahead of us. An example is the well-known figure (from Jastrow) which may be construed as a duck or as a rabbit.

After J. Jastrow

Or, as another example, in the figure on page 396 (from Hill) we may see either a young woman or an old woman.

(Incidentally, these two figures should be considered parallels, rather than examples, of Husserl's idea. Husserl is not concerned with physical objects, such as lines, which may be "taken" by us in different ways. In his view what limits us, and what has to be accommodated by our constitution, is certain kinds of experiences, the *hylē,* and not objects that are experienced.)

Returning now to Sartre, I believe that this is what Sartre means when he says that man is always free: Regardless of the physical situation, the external influences we are subjected to, we are always free to constitute reality in several different ways. This may seem an uncommon use of the word "freedom," but it fits in well with what Sartre says about freedom, and when we look at Sartre's writings from this perspective things seem to

After W. E. Hill

fall into place. Sentences that previously seemed mysterious become in-
telligible, and sentences that previously seemed fairly trivial acquire
another, more provocative, sense and at the same time help to amplify
Sartre's theory of freedom.

I shall now present this interpretation more precisely and at the same
time support it by quoting Sartre's writings. Like Husserl, Sartre holds that
there is a fundamental difference between consciousness, which he calls
"the for-itself" (*le pour-soi*), which constitutes the world, and the world
that is constituted, "the in-itself" (*l'en-soi*). The world which is constituted
is conceived of by us as structured in some specific manner: it consists of
things which affect one another and ourselves according to laws that have
been disclosed by and can be studied in the natural sciences. These things
have sides that are hidden from us, and these things are conceived of as
something external, something foreign, which through its influence wholly
or in part determines our movements and our experience. But that there
are such things is due to our consciousness. As Sartre expresses it, some-
what cryptically: " 'There is' being because the for-itself is such that there
is being."[6]

Consciousness is always free to constitute the world in a different way,
but it is not free to constitute it in any way whatsoever. If that were the
case, there would be no difference between fantasy and reality: "If conceiv-
ing were sufficient to make real, then I have been put into a world which is
like a dream, where what is merely possible is not in any way different from

what is real."[7] Consequently, the domain of physical objects is experienced as something which is recalcitrant and limiting to our freedom. However, this "coefficient of adversity" in things (to use Sartre's phrase) cannot be used as an argument against our freedom. Sartre says, "[I]t is our freedom itself which first must constitute the setting, the technique and the goals of which they (the things) appear as limitations."[8] This recalcitrant rest is therefore not a limitation of our freedom, Sartre says: "But this *rest* is far from being an original limitation of our freedom; it is thanks to this rest— that is, the raw in-itself as such—that freedom arises as freedom."[9] This framework, within which things appear as recalcitrant, Sartre calls "the situation," and we now understand what he means by what he calls "the paradox of freedom": "There is freedom only in a *situation* and there is a situation only through freedom."[10]

The situation which I experience as mine is hence constituted by me, it has been *chosen* by me, Sartre says. Here he uses the verb "to choose" in an uncommon way. I choose to constitute the world in a specific manner, he continues. I choose my *project,* the whole meaningful web of which all I encounter is a part: things, values, means, and ends. Since everything is part of my project, I choose everything. It might seem that I cannot however choose my past, that my past is finished and irrevocable. However, if the freedom which Sartre is talking about is freedom to constitute the world, and our constitution of the world concerns not only what is but also what will be and what has been, we should expect Sartre to hold that by our choice of a project we are also choosing our past. And that in fact is what he says: "In order that we shall 'have' a past, it is necessary that we maintain its existence through our very project for the future: we do not receive our past, but the necessity in our facticity makes it impossible for us not to choose it."[11] Thus this sentence, which might at first glance seem somewhat enigmatic, makes sense when interpreted in a Husserlian manner. The same holds for the following: "[T]he meaning of the past is strictly dependent upon my present project."[12] Moreover, we now see what Sartre means by one of the puzzlers I mentioned in the introduction: "I choose to be born." He does not mean that before my birth I made a choice and decided that then, at a certain moment, I wanted to be born. He means that now, at every instant of my life, I constitute a world in which the event of my birth is included as a part. This interpretation also fits in with Sartre's use of the present tense of the verb: I *choose* to be born, not I *chose* to be born.

Likewise, when Sartre says that the justification of our actions lies in the future, he is not expressing a utilitarian outlook. He does not simply mean that the justification of our actions depends on their consequences and, since these largely belong to the future, it is only the future that can

show whether our actions are justified. What Sartre means is far more orig-
inal: that the value of my actions depends on the place they have within the
world which I am constituting, with its different facts and values. If now or
in the future I reconstitute this world, the actions I have performed may
come to change their character and their value: "[T]hrough its choice of a
future the for-itself bestows a value on its earlier facticity."[13]

Sartre also says that we have responsibility for what we are choosing.
Concerning this he says: "We use the word 'responsibility' in its ordinary
sense, for 'consciousness of being the uncontested author of an event or a
thing.' In this sense the responsibility of the for-itself is overwhelming,
since it is thanks to the for-itself that it happens that there is a world."[14]
Therefore man carries the weight of the whole world on his shoulders.
"Hence it is senseless to think of complaining, for nothing alien has deter-
mined what we feel, what we live or what we are."[15] On the basis of the
interpretation of Sartre which I have been presenting, we may see what he
means by this assertion. We also see that when Sartre says that we have
responsibility for the war, he does not mean simply that we have a certain
co-responsibility by dint of our having complied and having failed to do
everything in our power to prevent the war. He means that we have the
full responsibility because we constitute the world in which this war occurs.
This perspective emerges even more clearly in the following passage, which
would seem so unreasonable as to approach absurdity if we were to inter-
pret it along the lines of ordinary moral philosophy:

> . . . [I]t depended on me that for me and by me this war should not exist, and I
> have decided that it does exist. There was no compulsion here, for the compul-
> sion could have got no hold on a freedom. I did not have any excuse, for . . . the
> peculiar character of human reality is that it is without excuse.[16]

In view of what I have said so far concerning constitution, existence, and
choice, we understand what Sartre means by "I have decided that the war
exists": I have decided to constitute the world in such a way that there is a
war in it.

Ordinarily we do not conceive of our situation in this manner, Sartre
says. This is however due to the fact that to constitute the world is to consti-
tute it as something alien, something *other,* something that is independent
of us. We conceive of ourselves and others as things in the world; we are
links in causal processes which to a considerable extent limit our freedom
and thereby our responsibility. By holding that our material surroundings,
our inherited dispositions, our childhood experiences, and the like limit
our possibilities and determine wholly or in part what we are and what we
do, we attempt to flee from our freedom. This concealment of man's com-
plete freedom Sartre calls "bad faith" (*mauvaise foi*), and he regards it as

one of his most important tasks to help liberate us from it.

Having examined some of the main features of Sartre's theory of freedom, one is likely to be struck immediately by at least two difficulties. First, if man himself constitutes his values, then cannot every action be deemed right so long as one constitutes one's values in such a manner as to justify that action? And, secondly, even if we constitute the world, as Husserl claims, is it not highly misleading for Sartre to say that "we decide whether there is a war"? Does he not then give too little weight to the material limitations on our constitution? Admittedly, I am always free to constitute the world in different ways, but I am not thereby free to constitute it in any way I want.

The first question apparently troubles Sartre himself. After all, he has repeatedly spoken out against oppression and acts of tyranny—for example, against French torture in Algeria. Might not all this which he has been denouncing be all right if only one were to constitute one's values differently? Over and over again he returns to this problem in his literary writings. In an interview published in *Comoedia* in 1943, the year in which *Being and Nothingness* appeared, Sartre says with regard to his play *The Flies:*

> I wanted to treat the tragedy of freedom as opposed to the tragedy of destiny. In other words, the theme of my play could be summarized as follows: "How does a man react when he has committed an action for which he fully accepts the consequences and responsibility, but which nevertheless appalls him?"[17]

In 1946, Sartre is quoted in *Le Figaro* in connection with the opening of *The Respectful Prostitute:* "Torture raises problems concerning man's freedom."[18] And he takes up the problem more fully in *The Condemned of Altona* (1959), of which he says in a 1961 interview in *Tulane Drama Review:*

> The play is really about torture. . . . But it is not the play I wanted to write. I wanted to write a play about French torture in Algeria. In particular, I wanted to write about the kind of person who tortures and who is no worse for that. He lives perfectly well with what he has done.[19]

However, Sartre does not seem to think it is truly possible to live perfectly well regardless of what one has done. Frantz, the leading character of *The Condemned of Altona,* has been a torturer and has now closed himself up in a room where the only impressions that reach him are those he gets through his sister, who sifts them carefully in order that he may continue to live in his falsified world. When the truth finally dawns on him, he commits suicide. Sartre says in the interview just cited: "Frantz comes to see what he has done, and so does his father. They have to commit suicide."[20] Sartre

further points out that the title of the play, which translates literally as "The Sequestered of Altona," is significant: "[T]he whole theme of the play is sequestration. Léni is *sequestré* because she is incestuous. Old Gerlach is the powerful industrialist—*un grand bourgeois*—who is sequestered from the beginning."[21] In connection with this same play, Sartre tells a meeting of lawyers in 1966: "Torture is a radical action which can be eradicated only by the agent's committing suicide."[22]

On the basis of these statements it seems reasonable to conclude that Sartre would acknowledge certain limitations on how we may constitute the world: certain actions are such that if we have committed them, we must either falsify the world by enclosing ourselves behind a barricade of "bad faith," or else face what we have done and commit suicide.

Hence, just as Kant held that there are certain limitations on how we may constitute factual reality—it has to be such that cause-effect relations hold in it, that arithmetic and Euclidean geometry hold in it, etc.—Sartre apparently holds that there are certain ethical limitations on how we may constitute reality and still go on living. His view is also related to the Socratic view that one may act wrongly only when one lacks insight.[23] It is possible that Sartre planned to work out such an ethics in the book on ethics which he promised in the last sentence of *Being and Nothingness;* unfortunately, however, that book never got written.

The second difficulty we have pointed out in Sartre's theory of freedom is that he seems to give far too little weight to material limitations which prevent us from constituting the world as we wish. Admittedly, as we have noted, Sartre does speak of a "coefficient of adversity" in things, but then he immediately observes that what is adverse for us depends on how we constitute the world. In this assertion, by the way, he is in full accord with Husserl's view. To constitute the world is not to impose order on a collection of things given beforehand; the things, too, are a product of our constituting. But according to Husserl, we are nevertheless not free to constitute the world whichever way we want. The light rays that reach our eye and the impulses that register upon our other sense organs function as boundary conditions which restrict our possibilities for constitution. What we see is not the pattern of light rays on our retina; we see things which are constituted by us. But these things and their relation to us must be constituted in such a way that they fit in with the pattern of light rays on our retina and the impulses reaching our other sensory organs. Which things we see, and how they are experienced as "recalcitrant," depend on how we constitute the world; however, how we constitute the world must fit in with, and is thereby limited by, what takes place on our retina and on our other sensory organs. Sartre says very little about this inherent limitation. He describes our constitution of the world as if it were an act of creation. This

notion is made particularly explicit in "Cartesian Freedom," an introduction to a selection from Descartes which Sartre wrote in 1946. There he says, among other things:

> . . . [I]t is [Descartes'] own freedom, as he would have conceived it without the fetters of Catholicism and dogmatism, that he speaks of when he describes the freedom of God. We have here an obvious phenomenon of sublimation and transposition. The God of Descartes is the freest of the gods that have been forged by human thought. He is subject neither to principles—not even to that of identity—nor to a sovereign Good of which He is only the executor.[24]

A little farther on in this introduction Sartre says: "Descartes realized perfectly that the concept of freedom necessarily involved an absolute autonomy, that a free act was an absolutely new production, the germ of which could not be contained in an earlier state of the world, and that consequently *freedom and creation were one and the same*" (emphasis added). Further:

> For Descartes, the divine prerogative is in the last analysis an absolute freedom which invents Reason and Good and which has no limits other than itself and its fidelity to itself. But, on the other hand, there is nothing more in this freedom than in human freedom, and he is aware in describing his God's free will that he has merely developed the implicit content of the idea of freedom.[25]

And finally:

> It took two centuries of crisis—a crisis of Faith and a crisis of Science— for man to regain the creative freedom that Descartes placed in God, and for anyone finally to suspect the following truth, which is an essential basis of humanism: man is the being as a result of whose appearance a world exists.[26]

Given this conception of man as creator of the world, it does not seem strange that Sartre says what he says about man's unlimited freedom. If to constitute is to create, then one can accept the idea that we have unlimited freedom and responsibility for everything. The parallel which Sartre draws between man and God also makes it easier to address the question, Can one who creates his own values do anything at all that is morally wrong? Similar questions arise in the philosophy of religion when one applies ethical notions to God.

However, Sartre's turning man into god is difficult to accept. What is more, Sartre frequently contradicts himself, and he is silent on many points that give rise to difficulties. For example, what in Descartes' theory of freedom corresponds to the "coefficient of adversity" in Sartre's theory of freedom? Without such a "coefficient of adversity" Sartre's theory of course loses all plausibility. Even Sartre says that without it there is no distinction between sense experience and fantasy.

If one concedes that constitution is something other than creation and instead uses the word "constitution" as Husserl uses it, then it becomes in-

appropriate to use ethical terms such as "choice" and "responsibility" in connection with constitution. In criticism of Sartre, let us now consider some of the reasons why this is so. First, when one constitutes the world, one does not usually choose between alternatives; only in special cases, such as the duck-rabbit example, may one go back and forth between different ways of constituting something. It is possible that with some training we might be able to do this in many more cases, but Sartre has not shown that we can always set forth such choice alternatives. Constitution has much in common with induction; that is why, in developing phenomenology, Husserl often refers to Hume. The idea of a choice among various alternatives seems to be as out of place in connection with constitution as it is in connection with induction. When one has seen 100 ravens which are all black, does one then *choose* to believe that the next raven will be black?

A second difficulty: If I constitute my world in such a way that there is no war in it, does this reduce anybody's suffering—except perhaps my own? Only a metaphysical idealist could hold such a view, and as Sartre says in an interview in 1969, he has attempted all his life to "provide a philosophical foundation for realism. . . . In other words, how can one give man both his autonomy and his reality among real objects, avoid idealism. . . ."[27]

A third argument against Sartre is that, in order to be able to speak of a choice in the moral sense of the word, one must usually have in mind a motive, an aim, an intention; but apparently this is not a requirement when one constitutes reality in Sartre's scheme. Admittedly, Husserl has much to say about "intentionality" in connection with constitution; for him, intentionality consists in just those features of consciousness which make it always behave as if it were directed toward an object. But Husserl makes a sharp distinction between this usage and the more conventional, practical sense in which it is used in ethics, whereby one says that one's intentions in doing something are such and such. Sartre does not distinguish between these two senses. For example, in the beginning of part IV of *Being and Nothingness,* Sartre uses the word "intentional" in its ethical, practical sense. He says:

> We should first note that an action is in principle *intentional.* The careless smoker who inadvertently causes a powder magazine to explode has not *acted.* On the other hand, a worker who has the task of dynamiting a quarry and who obeys the orders he has received, has acted when he has brought about the expected explosion; he knew what he did, or, if you will, he intentionally carried out a conscious project.[28]

As Sartre goes on, however, one notes a gradual change in his use of the words "intentionality," "project," and related clearly ethical terms such as "choice" and "responsibility" in connection with Husserl's theory of con-

stitution, until he finally arrives at the remarkable statements concerning freedom that introduced this paper.

Probably one of the reasons Sartre's theory of freedom seems so intriguing is that it ties together concrete ethical situations, such as the example of the careless smoker, with an imposing theoretical structure adapted from Husserl's theory of consciousness and intentionality. But the connection is brought about by means of a translation of Husserl's theory into an ethical vocabulary, a translation which is of highly dubious validity. For, as I have argued, Sartre has not shown that our constituting of reality is a kind of activity that falls under ethical judgment.

Furthermore, Sartre himself seems to have great difficulty setting a steady course with respect to human freedom. We have seen how, on the one hand, he compares man to a god who creates freely and, on the other hand, talks about a "coefficient of adversity" in things. He also states, in a letter written in 1943 concerning *The Flies,* that "freedom is not an abstract power to fly high above the human condition,"[29] and in the same year he writes in *Being and Nothingness* that "the formula 'to be free' does not mean 'to get what one has wanted,' but 'to decide oneself to will' (in the broad sense of decide). In other words, to succeed is of no importance to freedom."[30] This latter passage, considered in isolation, seems to be the inspiration for the interpretation of Sartre which I mentioned briefly in the beginning of this paper: that for Sartre "freedom" means freedom to will, not freedom to act. Be that as it may, both of these cited passages from 1943 fit in poorly with Sartre's identification of human freedom with God's freedom.

In his later writings, Sartre's assertions concerning freedom become more modest. For example, in *Critique of Dialectical Reason* (1960), he says:

> Neither do I see . . . necessity in this increasing constriction of action which finally reduces the possibilities to a *single one*. . . . If there had been only one possible way . . . if this way exists and if it offers itself, if it opens itself, *praxis* conceives of itself as if it invents this way—and for a good reason, for without *praxis* neither the possibilities nor the means would exist as such.[31]

A play Sartre once planned was to have as its main theme the notion that one has freedom even if the road one must travel is fully determined. Colette Audri, with whom Sartre once discussed this play, tells us that the play was to be called *The Wager* (after Pascal's wager), and would concern a child who is not wanted by his father. The mother, however, does not let herself be pressed into abortion, although a horrible life has been prophesied for the child: severe trials and reverses, poverty, and finally death at the stake. The child is born, grows up, and everything takes place as prophesied. "In fact he changes nothing material in his existence,"

Sartre says, "and his life ends, as foretold, at the stake. But thanks to his personal contribution, his choice and his understanding of freedom, he transforms this horrible life into a magnificent life."[32] Elements from this play design ultimately appear in other of Sartre's plays, in *Bariona* (1940), and *The Flies* (1943), and in the movie script *The Chips Are Down* (1947).

The quote concerning this planned play probably expresses as well as any of Sartre's recorded remarks just what it is that he is after in his discussion of freedom: he wishes to show that there is room for freedom even in a world where everything is physically determined (the same theme is very central in Kant). Especially in his later years, Sartre leans increasingly toward such a moderated view. In an interview in 1969, for example, he says:

> For the idea that I have never ceased developing is that, when all is said and done, one is always responsible for what becomes of one, even if one can do nothing more than accept this responsibility. For I believe man can always do something out of that which he has become. This is the only limit I will draw for freedom today: the small movement which makes of a totally conditioned social being someone who does not give back completely that which his conditioning has given him.[33]

Quite a change from the conception of man as a god!

However, there are also in Sartre indications to the effect that freedom consists in unpredictability (as, for example, in the early Wittgenstein: "The freedom of the will consists in this, that future actions cannot be known now" [*Tractatus* 5:362]). Thus Sartre says in an article entitled "François Mauriac and Freedom" (1939): "Neither you nor I know what Rogogine is going to do. I know that he is going to see his guilty mistress again, but I cannot tell whether he will control himself or whether his anger will drive him to murder; he is free."[34]

In his later writings, especially in the *Critique of Dialectical Reason,* Sartre becomes ever more concerned with political freedom, but he distinguishes sharply between this and what he calls "metaphysical freedom." In a discussion in connection with a performance of *The Flies* in Berlin in 1948, Sartre says:

> Our concrete goal, which is highly actual and modern, is to liberate man. This has three aspects. First, metaphysical liberation: to make him conscious that he is completely free and that he must fight against everything which contributes to limiting this freedom. Secondly, artistic liberation: to further the free man's communication with other men through art and, aided by this, to place them [the communicants] in one and the same atmosphere of freedom. Thirdly, political and social freedom: liberation of the oppressed and other men. . . .[35]

Man's metaphysical liberation is in Sartre's view a necessary condition for his political liberation. In an interview in 1946 Sartre says: "But what would it mean to liberate a man whose actions were determined? If

man were not free, it would not be worth moving a finger for him."[36]

Although in *Critique of Dialectical Reason* Sartre is primarily concerned with political freedom, he retains much of his original phenomenological existentialism. He now combines Husserl and Marx in order to explain how the constitution of the world takes place: it is constituted through our praxis. The state of being by which we are not aware that we constitute the world, in which we rather conceive of ourselves and others as things in a world which is independent of us and influences us, Sartre calls "alienation." Like Marx, Sartre holds that this situation is to a large extent due to economic and social conditions. He does not, however, agree with Marx's contention that alienation begins with exploitation, but rather accords more closely with Hegel's view that "alienation is a constant feature of objectivization of whatever kind it may be."[37] Sartre's continued reliance on the phenomenology he outlined in *Being and Nothingness* also comes out in his big study of Flaubert (1971),[38] where he repeatedly talks of "consciousness," "ego," "being and nothingness," while at the same time bringing in themes and terminology from *Critique of Dialectical Reason:* "totalization," "practico-inert," "collectives," etc. In a letter from 1959 Sartre says:

> I have always considered the methods which phenomenology provides to enable one to grasp existential projects as excellent tools for approaching the fundamental question of praxis. . . . When existentialist thought (at least mine) joins Marxism and wants to integrate itself with it, this is thanks to its own inner powers and not because of the inner excellence of Marxist thought.[39]

Sartre, therefore, obviously has not cut himself loose from his phenomenological-existentialist moorings. But he clearly has some qualms concerning his earlier extreme theory of freedom. In the interview from 1969 from which I have already quoted, he says, among other things:

> The other day I read again an introductory note I wrote for a collection of . . . plays—*The Flies, No Exit,* and others[40]—and I was scandalized. I had written: "Regardless of circumstances, regardless of place, a man is always free to choose whether he will be a traitor or not. . . ." As I read this, I said to myself: It is unbelievable, I really believed this! . . . I had concluded that regardless of circumstances a choice is always possible. This is false.[41]

Sartre apparently still hopes for a philosophy of freedom, but he has come to regard it as something that belongs to the future. In *Search for a Method,* he says:

> As soon as there exists *for everyone* a margin of *real* freedom beyond the production of life, Marxism will have lived out its span [and] a philosophy of freedom will take its place. But we now have no means, no intellectual instrument, no concrete experience that allows us to conceive of this freedom or this philosophy.[42]

We have seen that the phenomenological-existentialist philosophy of freedom which Sartre propounded in *Being and Nothingness* and in some of his plays and novels of the 1940s is full of inconsistencies and difficulties. Indeed, it does not seem unreasonable to suppose that these problems prevented Sartre from working out the ethics which he promised more than thirty years ago. The difficulties become immediately apparent when one tries to apply the ethical vocabulary into which Sartre translated Husserl, to a systematic discussion of ethical problems; for then one sees that unless man is to be considered a god, one who creates the world and not merely constitutes it, Sartre's basic terms "freedom," "choice," and "responsibility" lack the ethical character which Sartre once imputed to them. It seems that Sartre never gave up his belief that his translation of Husserl into an ethical terminology could constitute a suitable starting point for an ethics and a theory of freedom. It is a pity he did not.

DAGFINN FØLLESDAL

DEPARTMENTS OF PHILOSOPHY
UNIVERSITY OF OSLO, NORWAY,
AND STANFORD UNIVERSITY

NOTES

1. "Le Processus historique," *La Gazette de Lausanne*, February 8, 1947.
2. *L'Etre et le Néant* (Paris: Gallimard, 1943), p. 641.
3. Sartre's presentation of *Théâtre* in *Bulletin de la N.R.F.*, July 1947.
4. *L'Etre et le Néant*, p. 641.
5. Simone de Beauvoir, *La Force de l'âge* (Paris: Gallimard, 1960), p. 141.
6. *L'Etre et le Néant*, p. 713; cf. p. 639.
7. Ibid., p. 562.
8. Ibid.
9. Ibid.
10. Ibid., p. 569.
11. Ibid., p 578.
12. Ibid., p. 579.
13. Ibid., p. 585.
14. Ibid., p. 639.
15. Ibid.
16. Ibid., p. 640.
17. *Comoedia*, April 24, 1943.
18. *Le Figaro*, November 1, 1946.
19. *Tulane Drama Review*, 5, no. 3 (1961): 13.
20. Ibid., pp. 14–15.
21. Ibid., p. 14; Sartre's italics.
22. Jean-Paul Lacroix, "Le 'Séquestré d'Altona' condamné à un deuxième suicide," *Paris-Presse*, April 29, 1966.
23. This has also been pointed out by Harald Ofstad in "Ondska och ofrihet: Sartres Fångarna i Altona i belysning av hans filosofi," *Bonniers Litterära Magasin*, 32 (1963): 468–76. See also Bernt Vestre, "Er kjærlighet og tortur moralsk likeverdige for Sartre?" in ibid., pp. 659–62, and Harald Ofstad, "Sartre" in ibid., pp. 743–44.

24. "La Liberté cartésienne," Introduction to Sartre, ed., *Descartes, 1596–1650* (Genève–Paris: Traits, Trois Collines, 1946). Here quoted from Sartre, *Situations,* I (Paris: Gallimard, 1947), p. 331.

25. *Situations,* I, p. 333.

26. Ibid., p. 334.

27. "Itinerary of a Thought," Sartre interview, *New Left Review,* no. 58 (November–December 1969): 46.

28. *L'Etre et le Néant,* p. 508.

29. Sartre, in a letter proposing to print an excerpt from *The Flies* in *Confluences,* 1943.

30. *L'Etre et le Néant,* p. 563.

31. *Critique de la raison dialectique* (Paris: Gallimard, 1960), p. 282.

32. In "Connaissance de Sartre," an issue of *Cahiers de la Compagnie Madeleine Renaud–Jean-Louis Barrault,* cahier XIII, October 1955, pp. 54–55.

33. "Itinerary of a Thought," p. 45.

34. "M. François Mauriac et la liberté," *La Nouvelle Revue Française,* no. 305 (February 1939): 212–32. Here quoted from *Situations,* I, p. 37.

35. "Jean-Paul Sartre à Berlin. Discussion autour des *Mouches,*" *Verger* (Baden-Baden/Paris) 1, no. 5 (1948): 109–23.

36. "A la recherche de l'existentialisme: M. Jean-Paul Sartre s'explique," interview by Jean Duché, *Le Littéraire,* April 13, 1946.

37. *Critique de la raison dialectique,* p. 285; see also *Question de méthode* in the same volume, pp. 63–64.

38. *L'Idiot de la famille: Gustav Flaubert de 1821 à 1857* (Paris: Gallimard, 1971).

39. "Marxisme et philosophie de l'existence," letter, in Roger Garaudy, *Perspectives de l'homme: Existentialisme, pensée catholique, marxisme* (Paris: P.U.F., 1959), pp. 111–14.

40. Here Sartre refers to his note to the collection entitled *Théâtre* in *Bulletin de la N.R.F.,* July 1947.

41. "Itinerary of a Thought," p. 44.

42. *Question de méthode,* p. 32, in *Critique de la raison dialectique.*

18

Donald Lazere
AMERICAN CRITICISM OF THE SARTRE-CAMUS DISPUTE:
A CHAPTER IN THE CULTURAL COLD WAR

THE comparative evaluation of the political thought of Jean-Paul Sartre and Albert Camus by American philosophical, literary, and political critics forms a significant chapter in the history of what Christopher Lasch has termed the cultural Cold War.[1] In this body of criticism, especially during the 1950s concerning the two authors' disagreement over Camus's *L'Homme révolté,* the positions of both were uniformly distorted in the tacit interests of anticommunist ideology. Sartre's scrupulously qualified justifications of communism and colonial revolution were hostilely oversimplified to the point of travesty. Camus's nonviolent, anarchosyndicalist socialism and his disapproval of bourgeois society in America and Western Europe were played down, making him appear to be an enthusiastic supporter of the West in the Cold War. It is instructive today to review the history of this controversy, both because of what it reveals about the American intellectual climate in the era of McCarthyism and because of the new light which subsequent events have cast on the issues involved.

"Violent attacks against *L'Homme révolté* from all political directions" greeted the French publication in 1951 of Camus's study in the history of rebellion and revolution, as Germaine Brée,[2] Camus's most tireless defender in the United States, conceded in 1959. Francis Jeanson reviewed the book unfavorably in *Les Temps Modernes* in May 1952. Camus responded with an angry letter addressed to "Monsieur le directeur"—his former close friend Sartre. Camus's letter was published, together with Sartre's equally angry reply, the following September. This public break between France's two leading men of letters became a *cause célèbre* among European intellectuals, who divided about equally in support of Sartre's and Camus's positions.

Oddly, however, when Camus's book appeared here in translation as *The Rebel* in Spring 1954, many reviewers failed to mention the controversy that had taken place in Europe. A front-page review in *The New York Times Book Review* by Manes Sperber, a close friend and ideological ally of Camus, praised the book lavishly and gave the impression that its reception in France was wholly favorable. Similarly, Irwin Edman, in *The New York Herald Tribune*, flatly declared that *The Rebel* had "had an enormous vogue in intellectual circles in France."[3] Kermit Lansner, writing in Fall 1952 for *Kenyon Review,* referred to "the acclaim with which the publication of this book was greeted in France," and added: "There was no great criticism of the thesis or analysis of the contents."[4] In *The New Yorker* the dispute with Sartre is not mentioned either in Janet Flanner's "Letter from Paris" of May 1953 discussing the forthcoming American publication or in a one-paragraph anonymous review of January 1954.

It may be that these reviewers suppressed mention of the Sartre controversy because they thought it would detract from the unqualifiedly favorable image they wished to project for a book that lent itself to an affirmation of American liberal anticommunism. This interpretation is borne out by the failure of the critics to emphasize Camus's denunciation of the U.S. role in the nuclear arms race, or of the alienation of labor that he saw continuing under American-style industrial capitalism even after the "managerial revolution" then being lauded by American liberal intellectuals.

The critics' impulse to twist *The Rebel* into pro-West propaganda was most blatantly evident in *Newsweek,* which portrayed Camus as an unabashed admirer of the United States and a man who "daily does battle against the Communists ('the rational terror') by his writings and his example." In contrast to "the drab and destructive philosophy of 'existentialists' like Jean-Paul Sartre," Camus "has made his way back, through the sad philosophies of his contemporaries, to hope in the justice and moderation of Europe's Christian, Western past—he calls it the Mediterranean tradition."[5] In reality, Camus had attributed the excesses of fascism and communism to the absolutist strain in modern Europe's Christian and bourgeois past, in contrast to the ancient Greek concepts of limited justice and moderation, which he identified as "the Mediterranean tradition."

Throughout the decade following the U.S. publication of *The Rebel,* virtually all of the American critics who did mention the Sartre-Camus debate failed to give anything close to a full or fair account of Sartre and Jeanson's side, and readers were left with the impression that Camus had indisputably carried the day in France. Robert Gorham Davis, for example,

in a 1957 review of *The Fall* in *The New York Times Book Review,* wrote: "In 1952, after he became an uneasy apologist for Stalinism, Sartre attacked Camus for criticizing Russia and for trying to stay above the battle and outside history. Camus made an eloquent reply that seemed to most of his countrymen to give him clear moral victory."[6]

The most influential report of the dispute here was that of Nicola Chiaromonte, who was like Manes Sperber a personal friend of Camus and whose highly partisan interpretation set the pattern for subsequent distortions of Sartre's position. Chiaromonte's report, which first appeared in the Italian journal he edited, *Tempo Presente,* was translated in the November–December 1952 *Partisan Review* and was reprinted in 1962 in Germaine Brée's *Camus: A Collection of Critical Essays.* (Aside from the substantive issues, what are we to conclude about the degree of ideological fair play in America during the 1950s when two of the most influential journals of opinion, *The New York Times Book Review* and *Partisan Review,* assign coverage of a major dispute to close friends of one of the disputants, with no editorial indication of the reviewers' partisanship and no space allowed for rebuttal by the opponent's allies?)

Following Camus's line of attack, Chiaromonte found several weaknesses in Sartre and Jeanson's position; later critics following the same line find the same flaws—or *claim* to have found them, for their accounts are rarely based on the actual texts and frequently bear little resemblance to them. First, they attribute to Jeanson and Sartre "the cult of History," as Chiaromonte puts it. Brée similarly claims that Jeanson and Sartre "accept the theory of the infallible development of history."[7] Compare these accounts with Sartre's text:

> Does History have a meaning, you ask? Has it an objective? For me, these are questions which have no meaning. Because History, apart from the man who makes it, is only an abstract and static concept, of which it can neither be said that it has an objective nor that it has not. And the problem is not to *know* its objective, but to *give* it one. . . . And Marx never said that History would have an objective. How could he? One might as well say that one day man would be without goals. He spoke only of an objective to prehistory, that is, of an objective which would be reached in the womb of History itself, and then surpassed, like all objectives. It is not a question of knowing whether History has a meaning and whether we should deign to participate in it, but to try, from the moment we are in it up to the eyebrows [an allusion to a similar phrase in Camus's *Neither Victims nor Executioners*], to give History that meaning which seems best to us, by not refusing our participation, however weak, to any concrete action which may require it.[8]

Emmett Parker, in 1965, was the first of Camus's American defenders even to quote this passage, and Parker then followed it with the comment, "This semantic somersault is typical of Sartre's whole reply."[9] Parker does

not explain, however, why he thinks this is a semantic somersault. Sartre's attackers constantly accuse him of rhetorical sleight-of-hand, yet they themselves frequently fall back on the debater's trick of denigrating the opponent's argument out of hand while offering no substantive rebuttal. Meanwhile, they praise the sterling logic of their ally's argument with equal disregard for substantiating its validity. Thus Chiaromonte gives an over-simplified summary of Jeanson's argument, then, with no attempt to refute it, simply comments, "This was bad enough. Much worse, and much sadder, is the fact that . . . Sartre himself did little more than restate his disciple's arguments." Chiaromonte then quotes extensively from that part of Camus's reply to Jeanson which Sartre claimed mistakenly attributed a deterministic notion of history to Sartre and Marx; for Chiaromonte, "This is a stringent argument. Sartre did not answer it, except by insisting that 'our freedom today is nothing but the free choice to struggle in order to become free.'"[10] This, together with Sartre's passage quoted above, seems to me quite an adequate answer.

Summarizing Jeanson's and Sartre's arguments to this point, in accusing Camus of rejecting history they are not speaking of history as a transcendental current toward a predestined goal, but as the present flux of historical conflict in which we are all obliged to serve one camp or another, intentionally or unintentionally, by active involvement or passive acquiescence. They are disputing Camus's belief that one can effectively take an active part in present struggles as a nonviolent, nonpartisan "free lance" (Jeanson supplies an apt analogy to the Red Cross). They do misrepresent Camus as advocating unconditional nonviolence rather than carefully circumscribed limits on violence. This misrepresentation, however, involves only an incidental issue in their main line of argument. They would probably agree with Camus's limits, all other things being equal, but his principle, they say, is formulated in a vacuum insofar as historical actualities are concerned; it is meaningless in the situation of people caught involuntarily in a particular struggle—a struggle for colonial liberation, for example—who might not have the option of abstaining from uncircumscribed violence when the defense of their own lives or freedom is at stake. (This disagreement has commonly been twisted around by critics to make Camus the champion of moral principles and individual lives, Sartre the unscrupulous advocate of ideological abstractions and *Realpolitik,* whereas in fact Sartre's position is couched as much in moral and individualistic terms as is Camus's.) Camus's defenders to this day frequently are quite obtuse on this point. Parker, for instance, approvingly paraphrases Camus as saying, "No matter how desperate the plight of oppressed peoples may be, it is fatal to surrender to impatience and to commit oneself unreservedly to any despotic force. Far better to fight oppression on a day-to-day basis, always

redefining values in the light of the single recognizable absolute value, inviolable human life."[11] Who is "oneself"? The bourgeois intellectual or the Indochinese peasant? "Fatal" and "far better" for whom?

The second major distortion of Sartre's position by Camus's defenders is exemplified in this statement by Charles Rolo: "While insisting that he differed from the Communists, Sartre had for some time been taking a parallel stand to them on most issues, including the criminality of criticizing Russia.[12] What Sartre actually said in his reply to Camus (or imagined a member of the Communist Party saying) was this: "I am sick of seeing bourgeois like you furiously going about destroying the Party, which is my sole hope, when you are incapable of putting anything in its place. I am not saying that the Party should be above all criticism. I am saying that one has to earn the right to criticize."[13]

Robert Greer Cohn's 1962 article, "Sartre-Camus Resartus," was one of the first American attempts to turn the balance to Sartre's favor. Concerning Chiaromonte's account, Cohn comments:

> After citing exactly five and one half lines of Sartre's nineteen-page "Letter to Camus," as against whole pages of Camus's "Letter," Chiaromonte dramatically proclaimed: "It remains that Jean-Paul Sartre has not answered Albert Camus." From here on it was easy coasting to persuade an American public that "Sartre is ready to swallow a totalitarian ideology plus a totalitarian organization" or that "the amateur communist" [Sartre] considers it obvious that the Soviet Union is a fundamentally just state. This is, to put it mildly, an oversimplification of Sartre's position.[14]

Cohn goes on to quote several passages from Sartre's writings over the years that contradict Chiaromonte's allegations.

Sartre's expressed views on the Soviet Union certainly underwent several twists, turns, modifications, and possible contradictions and have occasioned endless differences in interpretation, but his exact position on that subject does not directly concern us here. What does concern us is the way in which Chiaromonte and most American critics have evaded one of Sartre's most substantial arguments: that it is overly facile for bourgeois intellectuals, who for the most part have led comfortable lives sheltered from oppression, to pass self-righteous and categorical judgments on communism, especially when they themselves have done nothing effective to combat the capitalist and colonialist injustices that give rise to communism. Sartre's opponents accuse him of a Manichean attribution of all historical virtue to the communist camp, yet they have been equally Manichean in rejecting out of hand any suggestion of Western fault in the Cold War and in denying the slightest justifiability to any communist position. For example, even as late as 1965 Parker stated, without further evidence, "Since Soviet totalitarianism was incompatible with true revolutionary aims, Sartre was forced to rationalize its existence in terms of American aggres-

sion and to accept, against the weight of evidence, the possibility of an eventual liberalization of Communist rule."[15]

Even when Sartre's conclusions were disputable or equivocal, it appears obvious from today's perspective that he, like Merleau-Ponty, Jeanson, and others of their circle, showed a more subtle political consciousness than Camus and, *a fortiori,* his American supporters who oversimplified not only Sartre's position but Camus's to make them fit the received ideas of Cold War anticommunism. Sartre took far greater account of the ambiguities in the history of the Cold War: the reciprocity of aggression (for example, American "covert operations" and support of right-wing dictatorships throughout the world); the persistent reality of injustices in capitalist countries; the problem of distinguishing between support for unjust Russian communism and for just colonial revolution or for widely varying Communist parties in countries other than the U.S.S.R.; the possible susceptibility of the communist system to internal and external pressures for reform or simply to historical flux; and the subjective restrictions inherent in the bourgeois political analyst's viewpoint.

A frequent line of attack on Sartre involves his attempts to critically delineate the limitations in the sociopolitical situation of bourgeois intellectuals vis-à-vis the working class and the Third World. These attempts obliged him personally to sustain a precarious balance in remaining independent organizationally and ideologically from the Communist party while generally supporting communism against the West, and in condemning capitalist society while continuing to live in a relatively privileged position within it. Sartre's position here provoked no end of invective from Camus and his supporters in America, much of it couched in the vocabulary of "guilt complex," "self-hatred," "judge-penitent," and "moral smugness."

Chiaromonte's scornful assessment of Sartre's motivation is certainly a travesty of the way Sartre and Jeanson expressed the problem:

> Far from being uncertain, [the amateur Communist] feels very certain. . . . He enjoys both the prestige of the Communist uniform, which he shuns, and the advantages of the civilian clothes, which he ostensibly wears. . . . The last, and most refined, touch of such a character is the conviction he often expresses that, in case of a Communist victory, he will be among the first to be "liquidated." His heretical orthodoxy will thus receive even the crown of the martyrs. In what substantial way these refinements can further the cause of the oppressed is, on the other hand, a question that should not be asked. The important thing here is that the unhappy consciousness of this believer without faith should continue to feed on contradictions, since contradictions are to him *the* sign that he has a firm grip on real life.[16]

Brée praised Camus because "he was never hampered by the grinding obsessive sense of limitation and guilt that Sartre seems to feel as a 'petit-

bourgeois' in the era of 'the Masses.'"[17] Leslie Fiedler took the same tone
in "The Pope [Sartre] and the Prophet [Camus]," a 1955 review for *Commentary* of *The Myth* and Sartre's *Literary and Philosophical Essays*. Fiedler largely ignored the two texts in question and instead constructed a
political polemic extolling the integrity of Camus's moral and lyrical
affirmations in contrast to the abject bourgeois bad conscience of Sartre
and other intellectual fellow travelers—the same line Fiedler was then pursuing in *An End to Innocence*.

With the hindsight gained by observing the discomfort of many American liberal intellectuals who found themselves placed in limbo during the
1960s by the pressures of the militant minority, antiwar, student, and
feminist movements, one is inclined to conclude that Sartre's analysis had
more basis in "real life" than his critics gave him credit for. Although this is
not to assert that Sartre was free from inconsistencies, or that his conclusions by any means resolved the dilemma, it must be acknowledged that he
took greater pains than any other thinker of our time to diagnose and cope
with the very real contradictions implicit in the role of the intellectual who
is ineradicably of the bourgeoisie yet sympathizes with its victims and opponents. Certainly his self-questioning explorations revealed less moral
smugness than the accusations of his critics who assumed themselves to be
above such contradictions.

Explanations of the anti-bourgeois attitudes of Sartre and other leftist
intellectuals in terms of guilt complexes, self-hatred, the quest for a missing
father in communist authoritarianism or for the blind certitude of the True
Believer, undoubtedly had some element of truth in them; but they tended
to be used as an excuse for a priori dismissal of leftist charges against
capitalist society that happened to have some basis in objective reality.
Thus H. Stuart Hughes claimed as late as 1968, "Like Lenin before him,
Sartre discovered the underdeveloped world when he needed it most to
buttress a faith that seemed increasingly inapplicable to European conditions." Hughes conceded, however, that "Here his 'ultra-Bolshevism' expressed a bitter reality: the anguished look of the poor was patent for all
to see. Moreover, the neo-colonial wars waged by the Western powers
provided ample reason for indignation."[18] Victor Brombert's *The Intellectual Hero* in 1961 presented more sympathetically and informatively
than most previous accounts in America the historical background of
the difficult position of French leftist intellectuals caught between the
upper bourgeoisie which they detested and the working class which distrusted them. But Brombert, too, eventually gave in to a psychologizing
dismissal of Sartre's political activities and his efforts to cope with the intellectual's dilemma. Although Brombert did not deal extensively or critically enough with Camus's responses to the same problems, he did side

more with Camus, approvingly reading "The Renegade" as a tacit commentary on the Sartrean left: "The missionary-intellectual becomes a grave-digger who prepares his own burial. No problem of our time has preoccupied Camus more than this disastrous temptation of the absolute and the death-wish of the modern intellectual."[19]

Among all these attempts to discredit Sartre's arguments by attributing them to subjective, self-deluding psychological needs, none of Sartre's American critics so much as raised the possibility that they themselves were anything but objective, impartial commentators on these issues. None seemed to see that their own arguments too might be subject to coloration by the need for self-justification. One cannot help wondering whether the shrillness of their attacks did not in some cases indicate an element of defensiveness if not bad conscience. After all, they were for the most part intellectuals with a background of liberal to far-left sympathies who had opted for middle-class careers in universities, publishing houses, or established journals during a period, after World War II, of unprecedented affluence, prestige, and security in these professions. Sartre's position was doubly inimical to them because, first, it challenged the intellectual authority of the disengaged scholar and, second, it implied that their chosen career was not necessarily conducive to the most socially efficacious of lives.

Obviously, Camus's position in favor of ideological autonomy and limited engagement for intellectuals was more congenial even to those who understood its refinements; for others it lent itself to being distorted into an excuse for evading political involvement in the name of art for art's sake, as did the New Criticism then in fashion. Little attention has been given by Camus's American commentators to his provisos, such as "The freedom of art is not worth much when its only purpose is to assure the artist's comfort," or "Wisdom has never declined so much as when it involved no risks and belonged exclusively to a few humanists buried in libraries."[20] It is of course impossible either to confirm or refute such *ad hominem* speculations, but one fact is verifiable: the very question of whether critics might be interested parties in the dispute was never raised by Sartre's American detractors. On this score again, by at least addressing himself to the important issue of the intellectual's subjective viewpoint, Sartre demonstrated a more sophisticated ideological and methodological consciousness than either Camus or his supporters.

An additional perspective on the Chiaromonte article came to light nearly twenty years after its appearance, when Conor Cruise O'Brien wrote:

> Wherever there was a public capable of interesting itself in the Sartre-Camus controversy, that public was encouraged to see in Camus, not in Sartre, the

exemplar of the truly independent intellectual. These efforts continue to be influential in our own day. The account of the controversy best known in America, for example, is that contained in the widely read collection of critical essays edited by Germaine Brée under the title *Camus*. In this collection the essay "Sartre versus Camus, a Political Quarrel" by Nicola Chiaromonte allows no merit whatever to Sartre's side in the controversy and accuses Sartre of being an amateur Communist, intellectually dominated by the Marxist–Leninist–Stalinist mentality, guilty of moral smugness and intellectual arrogance, and spreading "the intellectual confusion by which the Communist Party benefits." What Mr. Chiaromonte was spreading, on the other hand, was that by which the United States government considered itself to benefit. He was at the time in question director of *Tempo Presente,* the Italian magazine supported by the Congress for Cultural Freedom and—as we now know—then covertly subsidized by the Central Intelligence Agency.

Cruise O'Brien added in a footnote:

> To those who will certainly consider it in bad taste to bring this up, I offer a question: If it could have been established that Sartre's *Les Temps Modernes* stood in the same relation to the government of the Soviet Union as it has been shown that Chiaromonte's *Tempo Presente* stood to that of the United States, would they consider that also irrelevant to a discussion of the controversy?[21]

By the same token, Cruise O'Brien could have added that the revelation in 1967 of similar CIA subsidies to *Encounter* in England, which had printed several articles by or sympathetic to Camus (along with one letter criticizing his Algerian policy), would very likely have proved an embarrassment to Camus had he still been living.

Brée's extensive writings on Camus and Sartre have been even more influential than Chiaromonte's article, and even more biased. In the 1962 passage quoted earlier about Sartre's guilt complex, Brée continued:

> This is perhaps why Sartre, who speaks so often of "commitment," has never been able decisively to make the practical choices involved in action—forever postponing that crucial moment where action limits thought and challenges its conclusion. Sartre settles with his conscience through speech and writing, whereas Camus took positions and acted directly in the political issues of concern to him, whether with or against the point of view prevalent in his entourage. The football player and lightweight boxing champion of Algiers that he had once been never mistook a battle of words for a real battle with all the physical risks, violence, and dangers it involved.[22]

And Sartre, one feels obliged to reply, never mistook a football match for political action.

In Brée's 250-page book *Camus,* published in 1959, she devoted less than a page to the substantive issues in the controversy, siding completely with Camus. She justified the fact that Camus

> obviously did not stop to re-read the complete works of Hegel and Marx. What was important to him for his essay was the bearing that certain conclusions or

assumptions of these men had upon his own analysis. To misunderstand this, as did his existentialist opponent, M. Jeanson, and reproach Camus for a lack of scholarly thoroughness, seems rather pedantic.[23]

It would not, however, seem so pedantic if Camus's account of these men's conclusions or assumptions was indeed inaccurate, which is exactly what Jeanson and Sartre charged. Brée's own misgivings about Camus's political stance seemed to be directed from a position to the right of him. She criticized "his complete inheritance of certain attitudes of the French political left, which accepts the decadence and social guilt of the bourgeois capitalist society as an axiom,"[24] and she found that his "pre-Marxian revolutionary syndicalism . . . passed over the really fundamental problem which confronts the Western world and France more particularly, and that is not so much how to maintain the basic rights and liberties of the individual as how to reconcile them with the necessities of twentieth-century existence."[25]

Over the course of the 1960s, and continuing into the 1980s, the general tendency in American criticism has been toward a rise in Sartre's reputation and a decline in Camus's. From the outbreak of the Algerian War in 1954 until his death in January 1960, Camus's continuing support of the French colonial presence in his homeland lessened his prestige on the political left in Europe. Meanwhile, the active support by Sartre, Jeanson, and others in their circle of Algerian independence, which was eventually to be almost universally acknowledged as a just cause, to a large extent vindicated their position in the earlier dispute with Camus. Frantz Fanon's *The Wretched of the Earth,* published in 1961 with a preface by Sartre denouncing the opposition of bourgeois intellectual pacifists like Camus to colonial revolutionary violence, further influenced leftist opinion against Camus, first in Europe and later in the United States.

Sartre's position on communism, which looked extremely tenuous from the American perspective in the fifties, began to appear more defensible in the sixties as the world communist bloc split up and the focus of international concern moved from the Cold War to Third World liberation struggles. The disfavor into which Camus had fallen among French leftists in the mid fifties was repeated here a decade later, first in consequence of the relative stability achieved by Algeria in its independence, against his predictions, and later with the American fiasco in Vietnam.

American critiques favoring Sartre over Camus began to appear in about 1962. In "Camus-Sartre Resartus," which appeared in *Yale French Studies* for Fall–Winter 1962–63, Robert Greer Cohn concluded,

> We are in trouble if we allow an intellectual McCarran Act to be enacted, shutting out all but a remote echo of European voices like Sartre's. . . . Sartre has received far less than his due, particularly from Americans. He was hand-

icapped here by not being a football player, nor handsome, as well as for other obvious reasons. But if we can look past these things, to not a few of us he is still the Frenchman to watch.[26]

Susan Sontag, reviewing Camus's notebooks in September 1963, said of Camus's indecisiveness on the issue of the Algerian War,

> It is a harsh irony that both Merleau-Ponty, whose general political and moral outlook was so close to that of Camus, and Sartre, whose political integrity Camus had seemed to demolish a decade before, were in a position to lead French intellectuals of conscience to the inevitable stand, the only stand, the one everyone hoped Camus would take.[27]

Sontag's review was the lead article in one of the first issues of *The New York Review of Books,* which had been founded partly to advance a political perspective to the left of the blandly liberal *New York Times Book Review,* and *The New Yorker Review* has continued to treat Sartre more sympathetically than Camus; in 1969, for example, it printed a long section from Conor Cruise O'Brien's book *Albert Camus of Europe and Africa,* the harshest criticism of Camus and the strongest defense of Sartre to be published by an established critic in English up to that date.

The older political conventions of the Brée-Chiaromonte persuasion, however, continued to be adhered to unquestioningly by several critics, as was demonstrated in such works as Emmett Parker's *Albert Camus: The Artist in the Arena* (1965), Harry T. Moore's *Twentieth-Century Literature Since World War II* (1966), Fred H. Willhoite, Jr.'s *Beyond Nihilism: Albert Camus's Contribution to Political Thought* (1968), Phillip H. Rhein's *Albert Camus* (1969), and Rima Drell Reck's *Literature and Responsibility: The French Novelist in the Twentieth Century* (1969). (At the risk of falling prey to regionalist stereotyping, one might—upon observing that Willhoite and Reck both taught at Louisiana State, Parker at the University of Alabama, and Rhein at Vanderbilt, and that their political perspectives are virtually indistinguishable—speculate that a Southern school of Camus criticism had emerged, recruiting Camus for a reaffirmation of moderate liberalism in tacit opposition to New Left radicalism.) When a French book favorable to Sartre, Michel Burnier's *Choice of Action: The French Existentialists on the Political Front Line,* was published here by Random House in 1968, the translator, Bernard Murchland, C.S.C., a Holy Cross father (and the author of an article called "Albert Camus: The Dark Night Before the Coming of Grace?" in Brée's collection of critical essays), felt compelled to add a chapter on "Sartre and Camus: The Anatomy of a Quarrel" to exorcise Burnier's heresies with anti-Sartre orthodoxies.

In Brée's *Camus and Sartre: Crisis and Commitment,* published in 1972, it is obvious that her anti-left and pro-French Algerian biases were

exacerbated by Algerian independence; the rising stock of Sartre, Jeanson, Beauvoir, and Fanon among followers of the New Left; and the growing number of negative critical reassessments of Camus, especially Conor Cruise O'Brien's. It is an extremely uneven book, evidently written in a defensive mood and edited in haste, with an excess of typographical errors and with material in footnotes—several inserted in subnumerals at the last minute—that should be in the text, including most of her responses to Cruise O'Brien's book, which was published nearly two years earlier. (A revised edition in 1973 corrected most of the mechanical errors but left the awkward footnotes.)

Brée has surprisingly little to add to her previous sketchy account of the dispute over *The Rebel.* She does, however, provide more thorough coverage of the issues involved, in the course of tracing the two men's separate political activities and ideas. The book is most valuable in marshaling Camus's lesser-known texts to elucidate fine points of his positions on communism, violence, and Algeria, points that at least partially answer the accusations of his leftist critics. However, she does not respond to Cruise O'Brien's contention that certain passages in *The Stranger* and *The Plague* indicate Camus's unconscious racist and colonialist conditioning.

In reviewing Sartre's career, Brée accords greater recognition to his active political commitments, which certainly equaled those of Camus, than she did in her 1962 essay. She misses no opportunity, though, to vent her grudge against Sartre in assertions that are disputable at best and purely peevish at worst. She speaks of "his obdurate refusal to recapitulate to common sense, his quixotic stance and unsparing labor." While granting "the affectionate respect his person generally elicits," she concludes: "His intellectual authority is nonetheless a thing of the past."[28] She speaks of "the buzz of comment that personal notoriety assures and which accompanies Sartre's presence wherever he goes, perhaps in spite of Sartre himself, perhaps because he wants it that way."[29] And elsewhere:

> In the tiresome Marxian jargon they later adopted to describe their simplest moods, Simone de Beauvoir sums up Sartre's concern. . . .[30] His view of the functioning of society, like his view of the masses, was to remain abstract to the very end, scholastically acquired in intensive reading, strait-jacketed in obsolete language, and immobilized.[31]
>
> Sartre was still for himself the center of reference of a universe he posited abstractly in Hegelian-Marxist terms; and furthermore, he still spoke as if he were in solitary charge of the fate of "mankind" embodied in a singular passive and gullible "proletariat."[32]
>
> He detests the here and now. . . .[33]

All this invective is supported by remarkably few extensive direct quotes or summaries of Sartre's specific works. *The Critique of Dialectical Reason,* which one would expect to be the central topic in an account of

Sartre's political development since the fifties, is not quoted at all, receiving only a one-sentence summary in a footnote to Brée's concluding chapter. Some of Brée's charges against Sartre are undoubtedly just, but the general animus of her book makes one wary of accepting any of them at face value without pursuing the issues further in the numerous bibliographical references that are the most useful part of this book.

After nearly thirty years, the capacity of the Sartre-Camus dispute still to spark heated polemics in the United States provides proof of the enduring relevance of the ideological issues articulated by these two masterful minds. In the meantime, works like Daniel Bell's *The End of Ideology*, which in 1960 dismissed their debate as a manifestation of the backwardness of French intellectuals who had not heard that the age of ideology was ended, now appear themselves to be outdated manifestations of American illusions of self-righteousness that characterized the Cold War mentality.

DONALD LAZERE

DEPARTMENT OF ENGLISH
CALIFORNIA POLYTECHNIC STATE UNIVERSITY,
SAN LUIS OBISPO

NOTES

1. The main emphasis in this article is on American critics' interpretation of the Sartre-Camus dispute rather than on the substance of the dispute itself. For a fuller account of the points of disagreement between Sartre and Camus, see my book *The Unique Creation of Albert Camus* (New Haven, Conn.: Yale University Press, 1973). A further restriction in this essay is that it deals only with those American critical works directly concerned with the dispute. My sense of American Sartre criticism as a whole, however, is that a similar bias pervades it, and that his political thought was a source of embarrassment to his interpreters here through the 1950s and early 1960s; few of them did justice to the Marxist dimension of his philosophy and aesthetics, in comparison to more recent critics like Fredric Jameson, whose *Marxism and Form* (Princeton University Press, 1971) contains a thorough and highly sophisticated analysis in a long, sympathetic chapter on Sartre.

2. Germaine Brée, *Camus* (New Brunswick, N.J.: Rutgers University Press, 1959), p. 54.

3. Irwin Edman, "The Rebel," *New York Herald Tribune Book Review*, 10 January 1954, p. 6.

4. Kermit Lansner, "Albert Camus," *Kenyon Review*, 14, no. 4 (Fall 1952): 577.

5. "A Hopeful Frenchman," *Newsweek*, 20 September 1954, p. 105.

6. 17 February 1957, p. 1.

7. Brée, *Camus*, p. 225.

8. "Reply to Albert Camus," in *Situations* (New York: Fawcett World Library, 1966), p. 77.

9. Emmett Parker, *Albert Camus: The Artist in the Arena* (Madison: University of Wisconsin Press, 1965), p. 138.

10. Nicola Chiaromonte, in *Camus: A Collection of Critical Essays*, ed. by Germaine Brée, pp. 34–35.

11. Parker, *Albert Camus*, p. 136.

12. Charles Rolo, "Albert Camus: A Good Man," *Atlantic*, May 1958, p. 31.

13. Sartre, *Situations*, p. 58.

14. Robert Greer Cohn, "Sartre-Camus Resartus," *Yale French Studies,* 30 (Fall–Winter 1962–63), p. 75–76.

15. Parker, *Albert Camus,* p. 141.

16. Chiaromonte, *Camus: A Collection of Critical Essays,* p. 36.

17. Brée, "Introduction," in Chiaromonte, *Camus: A Collection of Critical Essays,* p. 36.

18. H. Stuart Hughes, *The Obstructed Path: French Social Thought in the Years of Desperation, 1930–1960* (New York: Harper and Row, 1968), p. 213.

19. Victor Brombert, *The Intellectual Hero: Studies in the French Novel, 1880–1955* (Philadelphia: Lippincott, 1961; Chicago: Phoenix Books, 1964), p. 231 (Phoenix edition).

20. Camus, "Create Dangerously," in *Resistance, Rebellion, and Death* (New York: Modern Library, 1963), pp. 207–8.

21. Conor Cruise O'Brien, *Albert Camus of Europe and Africa* (New York: Viking, 1970), pp. 73–74.

22. Brée, in *Camus: A Collection of Critical Essays,* pp. 7–8.

23. Brée, *Camus,* p. 218.

24. Ibid., p. 221.

25. Ibid., pp. 224–25.

26. Cohn, "Sartre-Camus Resartus," pp. 76–77.

27. Susan Sontag, "Camus's Notebooks," *New York Review of Books,* 26 September 1963, p. 3; reprinted in Sontag, *Against Interpretation* (New York: Dell, 1969), pp. 65–66.

28. Brée, *Camus and Sartre: Crisis and Commitment* (New York: Delta Books, 1972), p. 2.

29. Ibid., p. 43.

30. Ibid., p. 159.

31. Ibid., p. 175.

32. Ibid., p. 180.

33. Ibid., p. 189.

19

P. M. W. Thody
SARTRE AND THE CONCEPT
OF MORAL ACTION:
THE EXAMPLE OF HIS NOVELS AND PLAYS

I

I F, as could well be argued, the aim of criticism is to compel the reader
to see an author's work from a new, unexpected but revealing angle,
the question "Is there a concept of moral action in the work of Jean-Paul
Sartre?" is excellently designed to investigate how a basically philosophical
inquiry can cast new light on predominantly literary matters. What such an
inquiry in fact unfolds is a new taxonomy for Sartre's plays, novels, and
essays as well as for his more formal, philosophical works, and it thereby
creates a more useful way of categorizing them. Thus there are, first and
foremost, the books for which Sartre is perhaps best known, and which
seem to deny all possibility of right action: *L'Etre et le Néant* (1943), *Saint
Genet, comédien et martyr* (1952), *Les Séquestrés d'Altona* (1959), *Les
Mots* (1963), *Huis clos* (1963), and, in many of its arguments, *Critique de la
raison dialectique* (1960). These works stand out in sharp contrast to the
books which suggest that man can in fact formulate a meaningful program
of personal or political behavior, and which—like the first category—
transcend any division of Sartre's work into conventional literary or
philosophical genres. Thus *Esquisse d'une théorie des émotions* (1939),
L'Existentialisme est un humanisme (1945), *Baudelaire* (1946), *Réflexions
sur la question juive* (1947), *Kean* (1954), and *Nekrassov* (1955) all imply
that an ethic of personal honesty is both desirable and possible, while
Bariona (1941), *Les Mouches* (1943), *Qu'est-ce que la littérature?* (1947),
Le Diable et le bon Dieu (1951), and *Les Communistes et la paix* (1952) all
go a long way to suggest that political and literary commitment can be
justified on both philosophical and pragmatic grounds. These works again
differ from what is perhaps the most interesting group, those in which the
hope of meaningful action in society is held out only to be destroyed, either

by historical accident or because of a more fundamental, ontological defect in the human condition: *Les Mains sales* (1948), the uncompleted novel sequence *Les Chemins de la liberté* (1945–49), or the introduction to *Critique de la raison dialectique* to which Sartre gave the title, in 1957, of *Question de méthode*.

There are, of course, works which remain unaffected and unilluminated by the attempt to discover whether or not Sartre can be considered an author who seriously entertains the possibility of actions that are ethically significant. The early studies of the imagination, like the first three volumes of the monumental *L'Idiot de la famille* or the essays on artists as different as Faulkner, Tintoretto, and John Calder—or even the aesthetic solution put forward by the ending of *La Nausée*—seem to lie quite outside the realm of ethical discussion. But such works are, in the overall context of Sartre's enormous achievement, relatively rare.

Because so many of Sartre's books do seem to fall into one of the three categories of total despair, definite hope, or ambiguous defeat, the initial question about moral values inevitably raises a series of even more interesting queries: Why does Sartre sometimes present morality as totally impossible only to contradict his own pessimism by the implications of books written either at the same time or immediately after his gloomiest volumes? On what does he base his hopes when ethics do seem possible, either in a personal or in a political context? Why, above all, does he sometimes raise hopes only to declare them totally invalid?

The pessimism of *L'Etre et le Néant* is still perhaps the best-known feature of Sartre's work, and it has been so frequently described and discussed that there is really little new that can be said about it. Right action, for the early Sartre, is impossible because human beings are caught up in a contradictory enterprise. They are trying to achieve a coincidence between what they are and what they know themselves to be, and this is something that simply is not within human reach. We can be conscious of what we are only because we never, in an absolute sense, are ourselves. Self-awareness inevitably postulates the capacity for change, and only death can put an end both to our freedom and to our knowledge that we might be other than what we now are. In our relationships with others, we are similarly prevented by our own fundamental drives from achieving anything deserving the name of right action. Where the specific example of *Huis clos* supports and illustrates the more abstract analyses of *L'Etre et le Néant* is in respect to the view that I am always trying to make you worship my ideal image of myself, while you are constantly trying to do the same to me. Our relationship thus can never be anything but one of a conflict from which all notions of right and wrong are totally absent, and no human relationship can ever be either stable or satisfying. For even if I were to win, I should still be

unsatisfied. What I want is the worship of free minds, and it is a defining characteristic of free minds that they do not worship in the unquestioning, consecrating manner that I require. Neither, if the concluding passage of *Saint Genet, comédien et martyr* is to be believed, does the middle-period Sartre ever really change his views. As human beings move from the timeless world of ontological absolutes described in *L'Etre et le Néant* to the less rarefied world of criminal or political activity in the middle years of the twentieth century, they still find the same problems of frustration and defeat. It is precisely because Genet is the poet of fruitless betrayal and impotent evil that, in Sartre's view, he speaks to us so clearly of what it is to be alive in the 1950s; and it is precisely because his work is a monument erected to the impossibility of rational communication that it reveals our present situation to us. If, as has been suggested,[1] *Saint Genet, comédien et martyr* is the discussion of ethical perspectives presented to us at the end of *L'Etre et le Néant,* then Sartre would appear to have achieved very little in the years between 1943 and 1952 except a multiplication of reasons for despair. For even if the "just man" (*le juste*) is compelled, by reading *Notre-Dame-des-Fleurs,* to discover how evil he really is, there is nothing that either he or anyone else can do to improve himself. Genet himself may have invented his literary genius as a way out of an impossible situation, and it may be true of him personally that "optimism does not consist of saying that man is happy or that he may be, but merely that he does not suffer for nothing."[2] But all that Genet seems to achieve in his reader's mind, apart from a more acute sense of bourgeois guilt, is the realization that "the event which occurs changes our best intentions into criminal desires not only in history but also in family life," and it is extremely difficult to see how the world view implied in *Saint Genet, comédien et martyr* can be assimilated into any meaningful philosophy of social or even personal action. Like the more extreme theologians among his Protestant forebears, Sartre seems so anxious to inculcate a sense of sin that he denies any possibility that human beings could improve matters by actually doing something either about their own salvation or about their relationship with their fellows.

What one might call the ontological reasons for despair thus never disappear entirely from Sartre's work, and *Critique de la raison dialectique,* the only book which comes near to rivaling *L'Etre et le Néant* in size, ambition, or complexity of argument, presents only a different set of reasons for disbelieving in what earlier philosophers have regarded as right action: the conscious performance of acts destined to achieve ethical, spiritual, or social values regarded as applicable to all mankind. Admittedly, the object which Sartre had in mind when writing the book does presuppose at least the possibility of meaningful political action. There is no point in trying to

reconcile Marxism and existentialism for purely intellectual reasons and without the belief that human society can and should be changed. Marxism has always had a strongly moral content in addition to its scientific pretensions, and nothing is more central to its teachings than the remark that "philosophers in the past have tried to understand the world; our task is to change it." But as the argument in *Critique de la raison dialectique* develops and the phenomenon of scarcity confirms its ontological status as the aspect of the human condition which makes conflict an integral part of all human relationships, so the possibility of political action that is justifiable on moral as distinct from purely practical terms totally disappears. For if, as Sartre argues, men are driven on by the perpetual need to compete with their fellows for the always inadequate goods and markets available, then the relationship between man and man can never be anything but one of conflict and rivalry. And if human groups come together in violence and maintain their own existence only by terror, there is never any chance of a social contract that moves beyond the Hobbesian cult of tyrannical order as the only possible antidote to unacceptable chaos. The Sartrean vision of man as the creature that perpetually and inevitably preys upon his fellows precludes the notion of good and evil as meaningful concepts in the organization of society, and consequently strikes at the very root of any coherent philosophy of moral action. A curious feature of Sartre's work has always been the uneasy cohabitation of an intense, virtually metaphysical pessimism and a consistent cult of progressive political attitudes. This apparent contradiction reaches its height in *Critique de la raison dialectique,* and is all the more interesting, in the context of the argument being advanced in this essay, because of the date (1960) at which the work was published.

II

If one looks at the books in which Sartre apparently contradicts the immense pessimism of *L'Etre et le Néant* or *Saint Genet, comédien et martyr,* they seem to fall into two main periods: those written during and immediately after his wartime experiences and his activity in the Resistance movement; and those composed and published during the four years immediately following his acceptance, in May 1952, of the need for at least a tactical alliance with the French Communist Party. Thus his first play, *Bariona* (1941), written and performed while he was still in a German prison camp, presents the struggle against a foreign invader and usurper as an eminently desirable and justifiable form of personal and political activity. It has also the much more unusual feature of an eventually enthusiastic attitude toward the forthcoming birth of a child, and the final impression left by the play is certainly that of a world in which men can, both as private

individuals and members of a political group, perform actions that are morally worthwhile. Admittedly, Sartre's immediate intentions when writing *Bariona* were rather more limited. It should never be forgotten that he composed it as a "nativity play for prisoners of war." But it certainly resembles the play which immediately followed it, *Les Mouches,* in presenting a hero who derives some kind of personal authenticity from his readiness to defy a tyrant. The note of moral triumph on which it ends is also at the farthest possible remove from the sinister *"Eh bien, continuons"* which concludes *Huis clos,* and it does seem, to the present-day reader of the play, that Bariona cannot avoid carrying out an action that is, when compared to anything that lies within the reach of Roquentin or the heroes of the short stories in *Le Mur,* both morally and politically admirable.

Both the moral and political meanings of *Les Mouches* have, of course, been rendered much more ambiguous by Sartre's later reservations about the play, and it is certainly no longer possible to regard Orestes as being, in Sartrean terms at any rate, anything like an authentic existentialist hero. It is nevertheless fairly obvious that he is on a higher moral plane than his sister Electra. His readiness to assume responsibility for his crime inevitably presupposes that resistance and self-assertion are morally preferable to self-abasement and remorse, while the immediate consequences of his act must surely be regarded as more desirable, on moral as well as political grounds, than the continuation of Aegisthus' dictatorship. The inhabitants of Argos will at least be freer to decide how best to organize their own lives; and however much Sartre's own later political development may have led him to reject the concept of liberty to be found not only in Periclean Athens and the works of John Stuart Mill but also in the *Déclaration des Droits de l'Homme et du Citoyen,* the readiness of Orestes to encourage his new-found fellow citizens to make their own use of their own liberty can only seem admirable to non-Marxist or to Anglo-Saxon eyes.[3] The literary essays which Sartre wrote during this period—*Baudelaire, Qu'est-ce que la littérature?*—nevertheless constitute the strongest argument for regarding Orestes as being, except for Bariona, the first character in Sartre's fictional universe to exemplify a concept of what might be called "moral action."

It is indeed edifying to look particularly closely at the essay on Baudelaire in order to see what the Sartre of the resistance and the immediate postwar period regarded as desirable moral behavior in the context of a man's private as well as political life. Baudelaire, it seems, was both wrong and dishonest to look upon himself as a hapless victim of fate, and equally unjustified to regard the writing of poetry as an adequate substitute for the "invention of the good which he denied himself."[4] Instead of sniveling about his undeserved bad fortune or kowtowing to the reactionary authorities who condemned *Les Fleurs du mal* as an immoral book,

Baudelaire should—for the Sartre of 1946—have behaved like Rimbaud, Van Gogh, or André Gide: he should have chosen to be himself, whatever may have been the imperfections of his personality and his world view in the eyes of others. He should have told his persecutors, as Barry Mackenzie would certainly do nowadays, precisely what they could do with their moral disapproval. He should, in terms of the old Revivalist hymn, have "dared to be a Daniel/dared to stand alone/dared to have a purpose clear/ dared to make it known," choosing freedom and responsibility rather than determinism and *mauvaise foi,* while at the same time making a choice which would, in the long run, have helped other men to realize their freedom as well. The argument in *Qu'est-ce que la littérature?* that writers should take sides on the political issues of their day reinforces the political implications that are never far below the surface in the essay on Baudelaire; for it is clear from both books that Sartre cannot envision the possibility of any writer worth his salt adopting anything but a left-wing attitude. Only by consistently espousing the cause of political freedom, argues Sartre, will the writer fulfill his duty of helping to create a society in which his own freedom to write and his readers' freedom to read will be protected and encouraged. There can thus be no question, for the Sartre of the Resistance and the immediate postwar period, of accepting as valid the statement which concludes *L'Etre et le Néant:* "Ainsi en revient-il au même de s'enivrer solitairement ou de conduire les peuples."[5] In so far as Orestes' action in killing Aegisthus and Clytemnestra helps to create a freer society in Argos, it is an example of how men should act when they find their country occupied and oppressed by reactionary forces; while the whole argument of *Baudelaire* and *Qu'est-ce que la littérature?* is based on the presupposition that one course of personal or political action is preferable to another.

The ethic of cultural and racial self-assertion which runs through the second part of the *Réflexions sur la question juive*—and which was later to inspire Sartre's active support for the Algerian Front de Libération Nationale—also constitutes a strand in his first formulation of a guide to his contemporaries on how they should act in the context of such specific problems as racial intolerance or the writer's attitude toward his public. Indeed, it is fairly clear, both from these texts and from the policies adopted by *Les Temps Modernes,* that the Sartre of the immediate postwar period was elaborating, in a piecemeal and not always systematic manner, a series of concepts of what moral action might be. Yet not only did he refrain— rather disappointingly, perhaps—from making any coherent attempt to reconcile these recommendations with the total nihilism of *L'Etre et le Néant* or *Huis clos;* in the late 1940s he wrote two works which seem to cast doubt on whether moral action is a practical possibility in social and politi-

cal matters. Both the play *Les Mains sales* and the prose work *Drôle d'amitié*—the two extracts which he published in 1949 of what was to be the fourth volume of *Les Chemins de la liberté, La Dernière chance*— present heroes who try to act in accord with a set of moral and political values, but fail. The implications of their failure do much to explain the reservations which Sartre was later to express both about *Les Mouches* and about the best-known statement of his relative optimism during the immediate postwar period, the lecture entitled *L'Existentialisme est un humanisme;* while the circumstances surrounding the composition of both works show how closely Sartre's attitude toward the possibility of moral action is bound up with his reaction to the immediate political events of his time.

It is of course true that Hoederer, the hero and central character of *Les Mains sales,* goes out of his way on a number of occasions to denounce formal morality. It is, he argues, merely the expression of class interests, a form of mystification that will disappear when the classless society eventually comes into being. It is nevertheless quite clear from his behavior that Hoederer has a very definite idea of what constitutes right action: political behavior likely to bring about the triumph of socialism. The means employed to achieve this end may lack formal virtue, but there is no doubt that the end itself is good; and it is again inconsistent with the arguments in *L'Etre et le Néant* that Hoederer should also behave, on an individual basis, in such a way as to show that his own personal concept of moral action involves treating people as individuals as well as risking his own skin to save them from humiliation. It is nevertheless precisely because of these private virtues that he is killed: for a less generous man would never have tried to help Hugo after discovering that his pose as a secretary disguised a hired assassin. What is even more significant, however, is that the plot of *Les Mains sales* emphatically underlines how both Hugo and Hoederer fail to achieve in the real world of political action any of the moral qualities which either of them regards as desirable. That Hugo should fail is not wholly unexpected. He represents for Sartre an abstract bourgeois virtue that is at the farthest possible remove from the genuine human concerns of Hoederer. But not only is Hoederer killed just as he is about to put his policy successfully into practice; his memory is betrayed by the Party he tried so hard to serve, and the final tableau of *Les Mains sales* constitutes a complete denial that men can, in their lifetime, pursue policies which realize ethical values in and through history. Admittedly, Hoederer's policy is adopted; and in this respect it could be argued, on purely Marxist grounds, that both his life and his death have contributed toward a meaningful pattern of desirable historical change. But Hoederer's successor as leader of the Proletarian Party in Illyria is Louis, a man who makes the late

Walter Ulbricht stand out by comparison as a model of political intelligence and moral integrity, and it is difficult to see how Hoederer's death and betrayal can be read as anything but the denial of all reasonable possibility that ethics and politics can be brought together. Like the Brunet of *La Dernière chance,* Hoederer is that most typical and tragic of mid twentieth-century political figures: the Communist betrayed by the very Party in which he places his faith. The decision of the French Communist Party to observe both the spirit and the letter of the Nazi-Soviet pact of 1939 likewise puts an end to Brunet's wholly admirable attempt to save his fellow prisoners from despair. It also leads directly to the murder of his friend Vicarios, and almost every book which Sartre published in the late 1940s seems to constitute a denial that the kind of political ethics implied by the example of Bariona or Orestes is possible on practical grounds in the modern world. It could be argued that there are only two ways in which actions can continue to have moral significance in a history that has lost all rationality: through the conviction that the spiritual gain of asserting one's beliefs becomes all the more intense because one knows they will be defeated; and through the readiness to give pride of place to an ethic of personal relationships which regards the political field as a meaningless realm of telegrams and anger. Sartre's cult of efficacity is so marked a feature of his general world vision that it dominates the whole section of *Saint Genet, comédien et martyr* that is devoted to attacking the idea of sainthood; and the whole of his analysis of human behavior in *Les Chemins de la liberté* presupposes that private life lived privately can never offer anything but frustration, disappointment, and anguish. The political option is therefore the only one that remains open to him.

Like Baudelaire's many imperfections, though in a very different way, Hoederer's defeat is nevertheless a clear enough indication of what the Sartre of the mid to late 1940s would regard as moral action. He is an exemplary hero in his readiness to take risks, his lack of personal pride, his consistency in pursuing long-term political aims, his ability to exercise authority, his physical courage, his generosity, his realism, his skill in action and debate, his modesty, clear-sightedness, and readiness to accept responsibility. His refusal to believe that one can exercise leadership simply by committing one magnificent act reinforces Sartre's own later reservations about the character of Orestes; and he is again superior to the hero of *Les Mouches* in his down-to-earth approach to ideas and his lack of interest in the figure he cuts in other people's eyes. Many writers, like most societies, create an ideal human type in whose actual or potential behavior they incarnate their concept of what moral action should be. In this respect, Sartre's portrait of Hoederer is comparable to Camus's Rieux, Corneille's Auguste, or the visions of the Christian saint in the hagiographical litera-

ture of the Middle Ages. Yet it is unusual for a writer to present such a hero as being at one and the same time morally admirable and defeated in practice—defeated moreover by a rival who incarnates what is most disliked by an important part of the hero's personality. The victory of Louis at the end of *Les Mains sales* is, in the context of Sartre's concept of moral action, fully as important as the sympathetic presentation of Hoederer during the rest of the play. For it is this unimaginative, narrow-minded, Stalinist hatchetman who actually wins power in the Illyria of 1944. It is, in other words, the wrong man; and although the echoes of Homais's triumph on the last page of *Madame Bovary* are doubtless accidental, they are clearly there. The implications of this ending for Sartre's concept of moral action are highly significant because, in spite of the analyses of *L'Etre et le Néant,* the Sartre of the mid 1940s seems to have believed that moral action was possible, and to have placed it very firmly in the political field. Yet *Les Mains sales* ends in Hoederer's defeat. The reasons for this ending are not difficult to find in the political history of postwar France. The hopes of the Resistance movement rested on the idea that the wartime alliance between Communists and democratic socialists would continue and grow stronger after the war. When, on the contrary, the Cold War grew more intense, all hope for a triumph of the left in France evaporated, and with it, at least temporarily, went Sartre's belief that some actions might be not only morally preferable to others but more efficacious in improving the human lot.

It is unlikely that the insults which the Communist Party heaped upon Sartre in 1947 and 1948 were a precipitating factor in turning him away from the hopes implicit on a personal level in *Baudelaire* and within a more avowedly political context in *Qu'est-ce que la littérature?* and back to the pessimism of *L'Etre et le Néant.* Undoubtedly a far more important influence was the general political situation in postwar France, in which the rigidly Stalinist policy of the French Communist Party effectively prevented all unity with the democratic left. *Les Mains sales* is an excellent, if possibly unintentional, comment on the impotence of the French left during this period. Similarly, a revival of optimism in Sartre's work which began in 1952 is closely linked to the general movement of world and national politics, particularly to the beginning of the Korean war in July 1950. For although, as Simone de Beauvoir has remarked, Sartre was initially a little worried by the fact that it was the North Korean troops who actually began that war by attacking in force across the 38th Parallel, he lost little time in adopting a more thoroughly left-wing version of events. In December 1950, *Les Temps Modernes* published an article highly critical of American intervention; in 1952 Sartre's own *L'Affaire Henri Martin* added to its denunciation of French policy in Indo-China a remark about the

Americans "beginning to massacre Asiatics on their own account"; and in January 1957 he finally wrote: "The aggression came from North Korea, the provocation from Syngman Rhee, the ultimate responsibility falls upon MacArthur."[6] The last statement marked the culminating phase in a conversion process that had initially showed itself in a primarily literary context: the production in Paris in June 1951 of *Le Diable et le bon Dieu,* Sartre's longest and technically most ambitious play. However complicated the plot of this play, two conclusions emerge with overwhelming clarity from its overall structure: all attempts to attain absolutes, in either good or evil, are forms of alienation that do nothing but reinforce the existing power structure of society; right action therefore consists of allying oneself with the revolutionary forces which are trying to overthrow this structure. When Goetz, the protagonist, decides to throw in his lot with the peasants' army and shows his readiness to assume the responsibilities of leadership by stabbing to death the first soldier who threatens mutiny, he is presenting the image of a new type of Sartrean hero, a new version of what Sartre clearly intended his public to see as right action. Not for him the aristocratic abandonment of the day-to-day struggle for liberty which characterized Orestes. He will be like Hoederer in his rejection of noble attitudes and traditional morality, though more avid of self-protection in his attitude to dissidents. His concept of moral action will indeed be simple: act at all times in such a way as to destroy oppressive power structures as quickly as possible; shun like the plague any temptation to pursue absolutes, whether in social, ethical, or metaphysical terms; and show equally scant mercy to the cowards who flinch and the traitors who sneer.

It says much for Sartre's sense of restraint as a literary man that *Le Diable et le bon Dieu* was not followed by a whole series of plays glorifying Marxist bully-boys of the Goetz type. The cult of violence which became so marked a feature of his political thinking in the 1960s did not, however, begin to emerge until the more rational hopes expressed through the character of Goetz proved illusory, and the pattern of his work between 1952 and 1956 had a far milder tone than the end of *Le Diable et le bon Dieu* might have led one to expect. For the first time in his career, Sartre was not only writing works in which the hero solved his personal dilemmas by an act of defiance aimed at reactionary power structures; he also was writing and producing plays actually intended to make people laugh, and at the same time publishing a number of political articles in favor of a definite policy in French internal affairs. Thus both *Kean* (1954) and *Nekrassov* (1955) present heroes who successfully come to terms with their relationship with society and with themselves, while *Les Communistes et la paix* puts forward the case, on practical as well as theoretical grounds, for an alliance with the Communist Party. Right action, for Sartre's Kean, lies in

exchanging his attempt to gain acceptance by the aristocratic society of
Regency England for a freer, more independent life in the democratic soci-
ety of early nineteenth-century America. His decision to continue to earn
his living as an actor is also more than an accidental parallel to the recom-
mendation, in the *Réflexions sur la question juive,* that Jews can best attain
their authenticity by consciously and deliberately being Jewish. If it is
Kean's nature to be histrionic, then a career devoted to the stage will be a
better way of becoming an authentic individual than a series of attempts to
act either like an aristocrat or like an ordinary individual. The ending of
Nekrassov, the play that immediately followed *Kean,* also shows a hero
who comes to terms with himself and is, on a political level, much more
significant. Indeed, it comes close to echoing in more light-hearted terms
the ending which Sartre at one time intended to give to *Les Chemins de la
liberté,* where Mathieu dies as a hero of the Resistance and Brunet solves
the problem of his relationship to the Communist Party. Georges de Valera
(Sartre's lack of awareness of the associations which certain proper names
still have for an English ear is quite extraordinary) is a professional confi-
dence trickster who hits upon the bright idea of pretending to be a Rus-
sian politician called Nekrassov who has "chosen freedom." However, he
comes to see the error of his ways and replaces the irresponsible concept
of freedom which led him to lend his services to the right-wing, bourgeois
press with a much more serious and committed attitude toward life. He
becomes the ally—and, we hope, the lover—of a rather earnest left-wing
woman journalist called Véronique, and this decision is again an echo of
the choice which Goetz makes at the end of *Le Diable et le bon Dieu.*
Alliance with the cause of progress was expressed in Sartre's own life by his
attack on Camus's criticism of Marxist historicism in *L'Homme révolté,* by
the enthusiastic interviews he gave on his return from Russia and China,
and his articles on *Les Communistes et la paix* and his campaign for the
liberation of Henri Martin. As far as his literary career is concerned, this
alliance led to a revival of heroes in whom, as in *Bariona* or the Orestes of
Les Mouches, thought and actions coincide. The concept of right action is,
in these later works at any rate, quite disconcertingly unambiguous. The
subtle analyses of *L'Etre et le Néant* or *Saint Genet, comédien et martyr* are
replaced by the much blunter instrument of class war, and the question of
right or wrong seems to depend, for the Sartre of the 1950s, exclusively on
whether or not one is on the side of the proletariat. *Question de méthode,*
inspired by a visit to Poland in 1957, argues that the validity of a philo-
sophical system depends upon the extent to which it reflects the world view
of the rising class. Between 1952 and 1956, Sartre seems to have held not
only the general Marxist belief that this class is the industrial proletariat,

but the more specific belief that its interests and attitudes were validly expressed by the French Communist Party.

III

This sketch of how Sartre presented his heroes in the forties and fifties is naturally inadequate in one important respect: it offers no links whatsoever with the more systematic philosophical view advanced elsewhere in his work. This is not, however, a defect which can be easily remedied, since the Sartre of the 1950s continued to resemble the Sartre of the 1940s in offering the curious spectacle of a man who argued that all human activities were, ethically speaking, equally unjustifiable, but who nevertheless continued to give active support to a number of well-intentioned political causes. To the French reader, of course, this dichotomy may appear less pronounced. Even at his most apolitical, Sartre never ceased to be a hater of the bourgeoisie, and most of the commentators who have written sympathetically about him in France seem to agree implicitly with a remark he made in 1947 in the essay *Matérialisme et révolution:* "I know there is no salvation for man except through the liberation of the working class: I know it *before* being a materialist, simply by looking at the facts."[7] While it is perhaps inevitable, given such presuppositions, that he should have refrained from providing reasoned justification for his political choices in the language of traditional ethics, his failure to do so in no way precludes an attempt on the part of his commentators to build up a fairly coherent philosophical system by extrapolating from the various statements he has made. Thus if it is true, as he argues in *L'Etre et le Néant,* that all choices are chock-full of ethical values which "rise like partridges from under my feet," then the plot of *L'Age de raison* is, implicitly, full of ammunition for implied value judgments. For if I react to the news of my mistress's pregnancy by an immediate decision to look for an abortionist, my act does indeed involve a whole set of value judgments: the world is overpopulated, and people can live in human terms only if there are fewer births; children should be born only if their parents went to bed with the conscious intention of procreating; the right of two adults to continue their own "lifestyle" is more important than the "right to life" of an embryo who may, if allowed to live, have "une paire d'yeux verts comme ceux de Mathieu ou noirs comme ceux de Marcelle, qui ne verraient jamais les ciels glauques de l'hiver, ni la mer, ni jamais aucun visage";[8] and certain women can better achieve self-realization (as Simone de Beauvoir actually argues) through books than through babies. The choice by Sartre himself of the working class as the group currently richest in human promise equally implies that

cooperation ought to replace competition as the driving force in economic conduct, that inherited wealth should disappear, that certain of what have been previously considered economic rights should be abolished, and that there is no justification for an institution which, like the stock exchange, offers possible financial rewards to those ready to take considerable risks with the money they have earned. Sartre himself, of course, would be unlikely to extrapolate either his own or his characters' choices in quite these terms. The choices are nevertheless present both in what he says and in what the characters do, and so long as one recognizes that such choices cannot find ultimate justification "dans des valeurs inscrites au ciel clair," there is nothing to prevent each individual from elaborating his own perfectly rational code of values. And so long as the political climate seems to offer a reasonable chance that certain social values can pass from the potential to the actual, then Sartre's own preference for the working class can be seen as a valid source of moral actions. It is, however, a fundamental tenet of Marxism that ethics should never be separated from action. Moral and political judgments which cannot be translated into a meaningful attempt to change society and which are nothing but manifestations of abstract idealism and unrealizable values, are not values at all. It is consequently not surprising that when Sartre is compelled, under the shock of the Russian invasion of Hungary in 1956, to give up his dream of an alliance with the Communists, he also begins to revert to the pessimism of his earlier work.

In this respect, the similarity between *Les Séquestrés d'Altona* and *Critique de la raison dialectique* introduces a new and crucial element into Sartre's thinking on political and philosophical questions. In his earlier career, in *Les Mouches* or *Réflexions sur la question juive,* Sartre expressed progressive political views in some of his plays, novels, and literary essays without ever trying to bring his philosophical thinking into line with this implicit optimism. In 1959 and 1960, however, the coincidence between the conclusions of *Les Séquestrés d'Altona* and the argument in the *Critique* is absolute. It is not only because he belongs to a social class doomed by history and damned by its participation in the monstrous experiences of Nazi Germany that Frantz von Gerlach fails to achieve any of the moral values he had sought to realize during his idealistic youth. It is because no one can hope to escape from the conflict which characterizes all human relationships, and there is nothing accidental in the fact that Frantz's insistence, throughout his "closing speech for the defense" on "la bête maligne et sans poil," should be a word-for-word transposition of the central passage in the *Critique.*[9] Simplistic though explanations in terms of social events might appear when applied to complex phenomena such as highly structured literary and philosophical works, it is certainly difficult—

especially in the light of Sartre's own adherence to the Marxist cult of ethics in action—not to be struck by the strong link between the political events of 1956 and the books he wrote in the late fifties and early sixties. It is not that Khrushchev's decision to send the tanks into Budapest produced a pessimistic reaction in Sartre in the same way that an electric shock can produce a muscular movement in the arm. It is rather that, as the whole of Sartre's own thinking on psychological matters implies, it presented him with a situation which he had to make sense of in his own way. On a conscious level, he explained it by the eminently rational considerations set out in *Le Fantôme de Staline:* the difficulty of shaking off the economic backwardness of post-revolutionary Russia, the conflicts between town and country, the problems of making a revolution in one country in terms of a philosophy that had always seen itself as an essentially international force. But on the unconscious or semi-conscious level at which even writers as self-conscious as Sartre inevitably work when creating works of the imagination, the answer was less easy. Only by elaborating a philosophy that presented all forms of political action as vitiated from the start by the inevitability of scarcity and conflict—as well as by the impossibility of escaping from the practico-inert—could Sartre make emotional sense of what had happened in Hungary in October and November 1956.

There does now seem, especially in retrospect, to have been a fundamental change in the pattern of Sartre's work round about 1960. Naturally, he still continued to write books that concern themselves with the nature of literature. But both *Les Mots* and the important interview which he gave to *Le Monde* a few months before refusing the Nobel Prize for literature express great skepticism about the ability of the writer to make either a political or an ethical contribution to the problems of his time, and the optimistic vision of the writer's calling which informed *Qu'est-ce que la littérature?* has completely disappeared. He also continued to be very active in politics, and the 1960s constituted a high-water mark in his campaign against Western policy in all its forms. But *Les Séquestrés d'Altona* is not only his last original play; it is the last of his own works that can be read as committed literature—as an allegory of French policy in Algeria. His attacks on American involvement in Vietnam take the form either of newspaper articles and interviews or of participation in international pressure groups. There seems to be no conceivable link between, on the one hand, his support for the student rebels of 1968 or his defense of *La Cause du Peuple,* and, on the other, his apparently all-consuming ambition to be the first author to write over a million and a half words on Flaubert. He also seemed to give up the idea of writing formal philosophy of any kind, and he never wrote the volume on ethics promised in the closing page of *L'Etre et le Néant.* His implied support for John Gerassi and the Weathermen,[10] like

his appeal to Kosygin to risk nuclear war rather than let the Americans have their way over Vietnam, also strikes a rather hysterical note when set against the criticism of intensely emotional attitudes which informed the *Esquisse d'un théorie des émotions,* and the concept of moral action seems quite remarkably absent from his whole approach to the problems of neocolonialism.[11] The question "Is there a concept of moral action in Sartre's work?" certainly highlights the recurrence of certain themes in the books he has written and the policies to which he has lent his support, and brings out a marked tendency toward a positive concept of moral action to coincide with periods when he believed in the possibility of a decided left-ward shift in French and even world politics. Similarly, it reveals a tendency to write pessimistic works at a time when political hopes seemed low. It does not lead to any resolution of the contradiction between the case for committed writing in *Qu'est-ce que la littérature?* and the nihilism of *L'Etre et le Néant.* But it does emphasize the coincidence between the dismissal, in *Les Séquestrés d'Altona,* of any hope in man's ability to help himself, and the pessimism of *La Critique de la raison dialectique.* Perhaps more depressingly, it reveals the Sartre of the 1960s and 1970s as a man going in two directions, neither of which involves any concept of action justifiable in the traditional terms of moral philosophy. On the one hand, there is an extreme and perhaps excessive preoccupation with Flaubert's attempt to make sense of his experience through literature and literature alone; and, on the other, there is a cult of violence without any clear or practicable notion of what kind of society, and what kind of value system, could replace what Sartre denounced in 1966 as "cet enfer de sang et de haine qu'on appelle le monde libre."[12]

PHILIP THODY

FRENCH DEPARTMENT
UNIVERSITY OF LEEDS, ENGLAND

NOTES

1. At a meeting of the Philosophical Society of The Queen's University of Belfast, in 1959, by the Very Reverend Father Davy, Lecturer in Scholastic Philosophy.
2. *Saint Genet, comédien et martyr* (Paris: Gallimard, 1952), pp. 512–13.
3. There is clearly a political element in this judgment, as there is in Sartre's own regret for the extreme individualism implicit in Orestes' action. For a view which Sartre himself would now accept, see Francis Jeanson, *Sartre par lui-même* (Paris: Editions du Seuil, 1955; rev. 1969), pp. 21–23.
4. *Baudelaire* (Paris: Gallimard, 1947), p. 79.
5. *L'Etre et le Néant* (Paris: Gallimard, 1943), p. 721. "Thus it amounts to the same thing whether one gets drunk alone or is a leader of peoples."

6. *Les Temps Modernes,* January 1957, p. 656. Reprinted in *Situations,* VII (Paris: Gallimard, 1965), p. 252.

7. *Situations,* III (Paris: Gallimard, 1947), p. 172.

8. *L'Age de raison* (Paris: Gallimard, 1945; Editions de Poche, 1962), p. 64.

9. See *Les Séquestrés d'Altona* (Paris: Gallimard, 1961), p. 222; and *Critique de la raison dialectique* (Gallimard, 1960), p. 208.

10. Thus in May 1970, *Les Temps Modernes* published the manifesto of the "Weathermen," and it was later rumored in Paris that Gerassi had been entrusted with the task of writing the "authorized biography" of Sartre.

Sartre's appeal to Kosygin appeared in *Les Temps Modernes,* August 1966, in an editorial article signed "T.M."

11. Thus he wrote in his preface to Frantz Fanon's *Les Damnés de la terre,* in 1961, that "to shoot a European is to kill two birds with one stone, abolishing at one and the same time an oppressor and a victim of oppression. What is left behind is a dead man and a free man; the survivor, for the first time in his life, feels a truly national soul beneath his feet." (See *Situations,* V [Gallimard, 1964], p. 182.) Whether the European happens to be a doctor, a missionary, a soldier, a landowner, a U.N. agricultural expert does not seem to matter.

12. See *Le Nouvel Observateur,* November 10, 1968.

Marie-Denise Boros Azzi
REPRESENTATION OF CHARACTER IN SARTRE'S DRAMA, FICTION, AND BIOGRAPHY

PASSING in review the different characters that inhabit Sartre's world—his novels, theatre, and biographies—one cannot help being struck by certain structural affinities. Indeed, once Sartre has posited the essential structure of human reality, he deduces from it a number of fundamental attitudes which are embodied in his fictional characters and in his biographical studies as well. There is, then, no point in making generic distinctions of a literary kind. It may be useful instead to describe the fundamental behavioral patterns of the Sartrean character and to trace them back to the original project that motivates them. Ultimately, as I shall try to indicate, we may be able to speak of a certain evolution in Sartre's conception of his protagonists as he slowly and progressively nudges them into the conditioning of History.

I

Sartre's characters are by no means simply mouthpieces for or concrete embodiments of his ideology. In a recent interview, he warned us: "'The Wall' is not a philosophical work. On the contrary, it is a spontaneous and emotional reaction to the Spanish Civil War."[1] Likewise, the images and metaphors of *Nausea* are not merely illustrative vehicles for a philosophical system. Michel Rybalka actually sets the traditional theory on its head when he suggests that "Sartre invents a philosophy in order to unify these images and account for his own obsessions."[2] Nor is *No Exit* a dramatization of certain passages of *Being and Nothingness:*

Editor's Note: The author has expressed her deepest thanks to Professor Elsa Vineberg for help in translating this study into English.

My story about the damned was not a symbol. I was not trying to retell *Being and Nothingness;* why should I? I merely invented stories based on imagination, sensibility, and thought that the conception and the writing of *Being and Nothingness* finally unified, integrated and structured in a certain way. My long philosophical book was, if you like, a kind of retelling of unphilosophical stories.[3]

The Sartrean character, then, turns out to be something quite different from a mere fleshing out of Sartrean ontology. He is a freedom in search of itself, finding or not finding itself, depending on the particular case. There is no universal human nature, no a priori essence, since "existence precedes essence," but Sartre does recognize a structural identity or sameness in human reality, and his characters represent the different manifestations of it. According to Sartrean ontology, man partakes of the two modalities of being; through his facticity, his situation in the world, he is "in-itself," that is to say, pure *contingence,* always *de trop,* "in excess," that which "is what it is"[4] without any connection with what it is not; but as consciousness, he is also "for-itself," constant "decompression of being," that which *is* not but "has to be what it is."[5] Therefore, at every moment of his life, man must simultaneously assume his "in-itself," which simply is, without necessity or justification, as well as his "for-itself," which is incessant transcendence. This is the only authentic conduct possible; however, it is extremely difficult to achieve.

As soon as we penetrate Sartre's fictional world, we notice that his characters exhibit a very obvious disgust for their flesh as such. Roquentin's reaction at the beginning of *Nausea,* in the scene in which he stands in front of the mirror, provides an excellent illustration of this phenomenon.[6] Overwhelmed by the image he sees reflected there, he is invaded by a nauseous awareness of insipid flesh. In order to free himself of an insidious paralysis which he feels taking hold of him, in order to repudiate the horror and shame he sees looming up from his innermost depth, he grimaces at himself and thereby further increases the hideousness of the spectacle the mirror offers to his gaze. Useless alibi. Waves of nausea continue to surge within his benumbed being.[7] Only when he loses his balance does he waken from this curious daze.

In *The Age of Reason,* Ivitch and Mathieu plunge a knife into their flesh in order to rid themselves of a similar nauseous feeling. They lose some blood, but nothing changes: the sick, sweetish sensation remains. Their totally negative and magic gesture discloses a daring challenge to their corporality, a latent revolt against flesh. In order to subjugate their nature, to make it submit to their fantasies, to disavow it, Boris and Ivitch are given to drinking precisely what they find distasteful; says Mathieu, "Well, you are a pair, you two. You're always drinking stuff you don't

like."[8] In the second volume of the trilogy, Mathieu observes that Ivitch "hates anything physiological, both in herself and others. . . . She fasts for days at a time, because it disgusts her to eat. When she feels sleepy at night, she drinks coffee to wake herself up."[9] As soon as Ivitch hears of Marcelle's pregnancy, she leaves Mathieu in complete disgust and once and for all renounces this rotten married man's money. And later, convinced that a deadly cataclysm is to befall the world, she abandons herself to Paul although she thoroughly despises him; for her, this act constitutes the ultimate sacrifice she can inflict on her body, a manifestation of total freedom on the eve of catastrophe, and precisely because of it. Hence her rage when she hears about the signing of the Munich agreements. She is left with another little piece of life to live, and she must live it with the atrocious memory of that night when she allowed her body to be trampled upon. Boris shares his sister's repugnance for the flesh but nevertheless gives in to an oppressive affair with Lola to prove to himself that he has entirely succeeded in dominating his "nature."

As for Daniel, he submits to his homosexuality as if it were a blemish that defines him once and for all. Thus he lets himself be imprisoned in his flesh, convinced that he has been deprived of all possibility of transcendence. When he tries to break away from this pseudo sequestration by suppressing his own instincts (through his attempts to drown his beloved cats, his threatened self-castration), he fails miserably because he always recoils at the last moment and falls back into the immanence of his facticity. These manifestations of auto-sadism are aimed at proving to himself that he remains entirely in control of his emotions, but all his efforts are in vain: after two failures, he abhors himself even more than before. At the end of *The Age of Reason* he proposes to marry Marcelle, but we can detect another masochistic impulse in this intention.

Lulu[10] exhibits a similar "antinaturalism." She finds sex repugnant and feels deeply humiliated at having been the object of her lover's pleasure. She fiercely proclaims that she never let herself be dominated by him and denies that she ever had any desire for him. Like most Sartrean characters, she abhors desire because it is a total adherence to the flesh and thus represents an essential compromise of our "for-itself."

This all-pervading antinaturalism that is so characteristic of Sartre's characters can be traced back to their consciousness of the danger constituted by the flesh as pure facticity, which threatens at all times to engulf the for-itself in its inertia. Pierre Boisdeffre accuses Sartre of always "showing us man plunged in the hell of immanence."[11] It is true that the Sartrean hero partakes of the fundamental immanence of beings. Does this mean he is unalterably condemned to confinement within the prison of the "in-itself" which he is and which at the same time he is not? By no means.

Daniel *is not* the homosexual he execrates on the level of being. He has attributed a certain way of experiencing his body to a physiological determinism for which he is solely responsible. The Sartrean character *is not* imprisoned in his body unless he so imprisons himself. His body, the contingent shape generated by his facticity, appears as the necessary and permanent condition of his transcendent project, namely, his freedom. Therefore, it constitutes not a prison but the constant threat of a trap that can ensnare his for-itself if he does not use it as a springboard to project himself toward the field of his possibilities.

However, while participating in the immanence of the in-itself, we are condemned to be free. This ontological freedom imposes formidable consequences, burdening each of our choices with tremendous weight. Consequently, many refuse to take it upon themselves. They prefer to escape from it, from the anguish it brings. It is precisely this simultaneous realization of freedom and flight from it, in the unity of the same consciousness, which Sartre calls "bad faith." In fact, many critics seem not to understand that most Sartrean characters are guilty of bad faith. Even those characters who seem to be spokesmen for the author (but actually are not), those who appear to have assumed their freedom and to be groping for the path they will invent (or take back upon themselves) in solitude and anguish—even they are not exempt from bad faith. Indeed, they will never achieve good faith, in part because it constitutes an ideal, "an ideal of being-in-itself."[12] One can never completely believe what one believes in, the same way that one can never totally be what one is; there is always a gap owing to consciousness. But mostly Sartre's characters are in bad faith out of a cowardice deeply rooted at the core of their being.

Thus in *No Exit,* Garcin steadfastly refuses to confront his fundamental cowardice. Whereas he claims to face his situation, he constantly deludes himself. He has always considered himself a hero, and this perception has allowed him to overlook his weaknesses. At the moment of real danger, his pseudo courage vanishes miraculously and he simply flees. However, as soon as he arrives in Hell he declares: "Anyhow, I can assure you I'm not frightened. Not that I take my position lightly: I realize its gravity only too well. But I'm not afraid."[13] As for Jacques Delarue,[14] Mathieu's brother, he is determined to hide his fear of the war from himself and from others; thus, he devotes himself to accumulating rational evidence to prove the absurdity and injustice of the war he dreads so much. When war nevertheless breaks out and the German occupation appears imminent, he resolves to justify his flight. He hopes to convince Odette, as well as himself, that if he is resigned to leave, it is partly because he is certain there is no danger but, more important, he does not want to let Odette leave alone because *she* is afraid. Here is flagrant bad faith pushed to an extreme.

Rather than assuming the necessity of choice and decision resulting
from their condition of being free, some Sartrean characters elect to create
a static image of themselves based on conventions, attitudes, and habits by
which they hope to define themselves once and for all. Thus, they deliber-
ately fix themselves in the permanency of a set existence. Lucien Fleurier
offers a striking example of this behavioral pattern. When only a small boy,
unable to cope with the contingency of his existence, he decided to ossify
himself in his cousin's consciousness by pretending he was a sleepwalker. In
that way, he had a definition; he *was* something. For the same reason, later
on, he chooses to become an anti-Semite. He thus creates for himself an
immutable nature which will determine from then on his whole way of
thinking, acting, and reacting in any circumstance whatsoever. He commits
himself to abide by that disquieting image of himself sent back by others:
Lucien Fleurier the anti-Semite, before whom one must never speak of
Jews. No more choices will be needed. Everything will necessarily derive
from his essence as an anti-Semite. Solidly installed in existence, his behav-
ior determined and foreseeable, he proclaims: "I exist . . . because I have
a right to exist."[15] Like the famous dignitaries from Bouville, Fleurier has
found a refuge against the unbearable gratuity of existence in the certainty
of the world of Rights. He too has Rights. "Something like triangles and
circles . . . rights were beyond existence, like mathematical objects and re-
ligious dogma."[16] In that remarkable scene in the Bouville museum, Sarte
denounces with biting irony the revolting bad faith of the *salauds* who has-
tened to fill up the nothingness surrounding them with a "bouquet" of
purely arbitrary rights and duties intended to fully reassure them of the
past, present, and future meaning of their lives.

We can also find many other Sartrean characters who have chosen
once and for all the being they want to present to the scrutiny of others and
to their own consciousness. Thus, although Ines of *No Exit* is less inauthen-
tic than her two companions in Hell, she has nonetheless an arbitrary image
of herself which she has adopted as her permanent essence. She *is* evil; that
is, she has chosen to be evil in the absolute. "When I say I'm cruel, I mean I
can't get on without making people suffer. Like a live coal. A live coal in
the other's heart."[17] Having been accused of being evil by others, she then
made evil the project of her existence. In fact, Ines belongs to a whole
group of characters who take back upon themselves the image they receive
from others and who deliberately push these images to their extreme con-
sequences. That is how Sartre has interpreted Baudelaire's case.[18] He sees
in Baudelaire's excessive exhibitionism an attempt to take possession of the
scandalous being he is for others. Says Sartre: "He saw himself, he read his
own character in the eyes of others, and he enjoyed this imaginary portrait
in a mood of unreality."[19] He will accept this shocking portrait of himself
which he perceives in the Other's eyes, and he will strive to act it out to the

extreme, in the belief that he can thereby possess those who thought they possessed him. However, all his efforts fail, because it is not his real being he is capturing, but an artificial image fashioned wholly by him from the material he finds in the Other's eyes.

"No doubt he did want to create himself, but he wanted to create himself in the image which other people had of him."[20] We discover this plight in a number of characters illustrating the typically Sartrean figure of the bastard.[21] For example, Kean, after being excluded from the community of the "right-thinking" people, chooses a theatrical career, thereby banishing himself voluntarily from society. Actually, he merely embodies the image that others send back of his being. "When I survey myself today," he says, "I see only a fashion plate. Thanks to the condescension of your Royal Highness, I have become a spectacle down to the last detail of my private life."[22] Fully conscious of his condition as an actor, he strongly affirms its unreality, boasting at being an illusionist, an impostor. Victim of a similar ostracism is the bastard Valéra-Nekrassov, who assumes his banishment by choosing to be a swindler and an impostor in a purely gratuitous challenge against those who seek to destroy him. Also, at the beginning of the play, he justifies his imminent suicide: "I shall myself have brought about both my death and my birth. A self-made man, I destroy my own creator."[23] And Goetz, the most fabulous bastard of Sartre's imaginary world, decides to deliberately lay claim to his parasitic condition by choosing to reject the world which does not want him, by opting to embody absolute Evil: " . . . I am a self-made man. I was a bastard by birth, but the fair title of fratricide I owe to no one but myself."[24] So he invents for himself an arbitrary essence from which he will take all his actions, derive all his thoughts. Then, when Heinrich convinces him of the banality of his choice, he simply eliminates it and decides to become the solitary champion of Good: "You tell me Good is impossible—therefore I wager I will live righteously. It is still the best way to be alone."[25] Since his early childhood, Goetz has been excluded from the human community, condemned to remain outside the world which rejects him. He will now concentrate his efforts on breaking open the well-closed circle which refuses to admit him. As a bastard, he is deprived of all possibility of authentic behavior. Society has granted him his right to existence out of sheer generosity. Now, he no longer wants to accept anything. "For twenty years, everything has been given to me most graciously, down to the very air I breathe; a bastard has to kiss the hand that feeds him. Oh! How I am going to give back in my turn!"[26] He exhibits a new essence, but here again, like all his brothers in bastardy, he fails—for he has cheated.[27]

But there are other means of fleeing the abyss of nothingness generated by freedom. Some Sartrean characters strive to elude the contingency of the present and the indefiniteness of the future by shutting themselves in

an immutable, determining, and determined past. Roquentin, for one, has devoted himself to reconstructing the life of a certain Marquis de Rollebon, and this attempt to resurrect a past frozen into inexistence has become his whole reason for being. It has provided him with a practical alibi that protects him from the sensation of an abrupt fall into an inconsistent present that is constantly slipping away under him. But one day he declares: "I have a feeling of doing a work of pure imagination."[28] He then becomes aware that the past does not exist, that all that exists is the present, and all which is not present does not exist. He must now face the anguish surging from the nothingness which emanates from his for-itself and which will multiply his attacks of nausea. As for the "good doctor Rogé," his unshakable smugness originates from a treasure of wisdom accumulated in his past. He utilizes his past to interpret the present. He explains the new by the old; he catalogs beings according to the categories of the past. Sartre finds the same cult of the past in Baudelaire: "In a sense what Baudelaire fled from into the Past was enterprises, plans, and perpetual instability."[29] He therefore takes refuge in the past to justify his incapacity to act in the present. Only in the past is he able to apprehend his "nature"; furthermore, in choosing consciously to *be* this past, he runs away from his freedom.

By this recourse to the past, the Sartrean character avoids facing the indetermination of his for-itself and ossifies himself intentionally within limits which prove to be as insurmountable as they are arbitrary. Thus, he acts in bad faith. Furthermore, as Roquentin discovers, it is impossible to resurrect the past in the present through memories: "I build memories with my present self. I am cast out, forsaken in the present: I vainly try to rejoin the past: I cannot escape."[30] He is unable even to think of Annie in the past, to recapture the taste of their past love: "As long as we loved each other, we never allowed the meanest of our instants, the smallest grief, to be detached and forgotten, left behind."[31] In the same way, when in *Reprieve* Mathieu goes back to his apartment after a prolonged absence, he no longer recognizes anything. He finds a clutter of fossilized projects hung everywhere in the room; they have become things. He feels he is an outsider. " . . . Ivitch's explosions of anger, Brunet's remonstrances—Mathieu remembered them already as an event, like the death of Louis XVI, and in the same dispassionate way. They belonged to the world's past, not his: he no longer had a past."[32] Hence his impression of total alienation from his past.

However, as we shall presently see, we cannot not be our past; we have to assume it as a fatality *à rebours*. Having become in-itself, the past transforms us into a thing-within-the-world. But as Sartre demonstrates in his later works, the relationship between present and past is dialectical.

As was the case with the past and with human "nature," religion too offers a comforting escape from the evanescence of human reality. First, we must note that, far from being an impenitent and gratuitous provocation of right-thinking people, Sartre's apparently militant atheism represents the touchstone of his entire system. In Sartre's first play, *The Flies*, God is portrayed as the main obstacle to human freedom. Jupiter appears, indeed, as a grotesque puppet, very jealous of his own authority. With the help of his accomplice Egisthe, he is prepared to go to all lengths to maintain his despotic power over men. In the name of absolute Good, he subjects the people of Argos to the most abject slavery. His power rests on their blindness, which he cultivates with great care and which he maintains through sessions of black magic, exorcisms of the Dead, public confessions and, finally, the swarms of flies which besiege Argos and symbolize the remorse to which Jupiter condemns the people. In return for their complete submission to his dictates, this hollow wooden puppet allows the people to unburden themselves of their crushing responsibilities and to take refuge in the soothing determinism of sacred beliefs. "I am forgetfulness, I am peace,"[33] Jupiter proclaims. This beguiling illusion draws Electre back to Jupiter when she can no longer bear the weight of the freedom which fell upon her at the moment of Oreste's crime. Enclosed in a fictitious world, radically alienated from reality, she will thenceforth be delivered from the anguish and the constant danger generated by her freedom.

Daniel, too, will resort to God in order to stop the incessant hemorrhage of his for-itself, to abolish his anguish by having himself released from his contingency. Says Daniel:

> God sees me, Mathieu, I feel it and I know it. . . . I know at last that I am. . . . I am seen, therefore I am. I need no longer bear the responsibility of my turbid and disintegrating self; he who sees me causes me to be; I am as he sees me. . . . I'm infinite and infinitely guilty. But I am, Mathieu, I am.[34]

Daniel has found in God's eye the solidity, the appeasing security of being. He does not have to establish himself in Being; God has taken care of this for him and is responsible for maintaining him there for all eternity.

Goetz will equally attempt to use God for his own objectives. He needs God if only to fight Him, for He is the only audience he considers worthy of himself. He seeks to prove to God that he has succeeded in emancipating himself from divine tutelage by turning against his creator the weapon the latter had granted him, that is, his freedom. Consequently, he decides to invent Evil for evil's sake, absolute Evil: "I am the man who makes the Almighty uneasy."[35] When Heinrich demonstrates to him that, far from having created something original, he is only following beaten paths, Goetz exclaims: "I turn my coat and wager I can be a saint."[36] But here again he

refuses to assume the responsibility of his choice, shifting it to God. He leaves his decision up to a throw of the dice. If he wins, he will continue the reign of Evil; if he loses, he will inaugurate the reign of Good. He loses. "I submit to the will of God,"[37] he proclaims. God is thus the one who leads the game; Goetz is nothing but his humble instrument. Yet Goetz has cheated. His entire metamorphosis is but an absurd act, for it was he who sent the orders which he pretends to have received. Whether he chooses Good or Evil, he always ends up doing the contrary of what he wants. Determined to cultivate disorder, he contributes to the maintenance of the established order. Intending to fight for the good of the peasants, he in fact helps the nobles and increases their power at the expense of the peasantry, which he leads to self-destruction. At every instance he makes the wrong move. Again, Heinrich will force him to see what he has kept so carefully hidden from himself from the beginning. God does not care at all about the bastard's masquerades. God is silence. Then, struck by a sudden revelation, Goetz concludes triumphantly that God does not exist: "If God exists, man is nothing; if man exists . . ."[38] Indeed, if God existed, it would be impossible to distinguish Good from Evil. In the third act, Goetz discovers the impossibility of all ethics so long as God exists. This discovery will lead him directly to concrete commitment among men.

It is for the same reason that Oreste decidedly refuses Jupiter's authority: "Once freedom lights its beacon in a man's heart, the Gods are powerless against him. It's a matter between man and man."[39] And Oreste intends to share this realization with the people of Argos. As we have seen, by resorting to religion Sartre's characters choose one of the fundamental patterns of behavior destined to hide from themselves their lack of stability and to confer upon themselves—in the imaginary, of course—an unshakable in-itself, sanctioned by the absolute Look of the Infinite Being. Therefore, far from being a gratuitous attack against God, Sartre's atheism tends to destroy the imaginary refuge constructed by man to justify in the absolute the order he establishes in the arbitrary, to provide himself with a compensation in the life beyond for the sequestration imposed here below by the limitations of his pseudo faith. This would-be refuge offers a practical and inauthentic evasion.

Some characters in Sartre's fiction prefer to follow the path of the imaginary, thereby avoiding the immediate demands of reality. By choosing the imaginative conscience, which is a degraded consciousness, they can negate the present situation, pretend it does not exist, and substitute an imaginary world in which they are justified, safe, and free from risks. For instance, it is in the imaginary that, for fifteen years, Electre has gratified her desire for vengeance against her mother and against Egisthe's tyranny through gestures and sacred dances, which she performs with relish as a

challenge to the dead. Comfortably settled in passive revolt, she has lived in a dream so as not to face the demands of reality. Meanwhile, she has based her whole reason for living on the expectation that her brother, or rather the image of her brother which she has constructed for herself, will "act." But when Oreste appears to her in real life, when he discloses his true identity and confronts her dream with an irreducible reality, she at first refuses to recognize him, for his mere presence destroys the justification she has given to her inactivity. "I felt less lonely when I didn't know you," she tells him. "I was waiting for the Oreste of my dream."[40] Now she no longer has excuses or alibis; she has her back to the wall. Jupiter casts a pitiless light on these years of lies: "I know you nursed bloodthirsty dreams—but there was a sort of innocence about them. They made you forget your servitude, they healed your wounded pride. But you never really thought of making them come true. . . . You toyed with dreams of murder because that's a game to play alone."[41] She could have transcended her inauthenticity and chosen to be free by taking upon herself the responsibility of the crime in real life. Yet, incapable of leaving her imaginary shelter, she preferred to abandon herself to Jupiter's protective cloak and to take refuge in slavery rather than going "on the far side of despair"[42] where human life begins.

But we all live more or less in an imaginary world; we are all actors, fake to the very marrow, to the extent that we adopt the magic attitude of a man possessed by a role while blinding ourselves by taking seriously the character we have decided to play, as if that character had been determined in the absolute. We have already examined the extravagant act Goetz puts on in order to hide God's silence from himself. Kean, a professional actor, lives only in the imaginary. Not even when he steps out of the theatre can he rid himself of this mask of tricks and artifices which he has permanently absorbed into his being. Lucien Fleurier, a performer since early childhood, also spends his life acting out fictitious patterns of behavior, unable to experience his own feelings as real. His play in the imaginary allows him to "better insert himself in the world of reality [which] he wishes to manipulate and in which he still feels unadapted."[43] He makes use of the imaginary in order to reach the real and his own reality. Thus when he wants to convince God and himself that he loves his mother, he begins by saying very quickly: "'Oh! How I love my mama,' pronouncing it carefully and you saw mama's face and felt all tender, . . . you were all creamy with tenderness and then there were words dancing in your ears: mama, MAMA, MAMA."[44] By pronouncing these words as if they were a magic formula, the little boy achieves a kind of incantation that evokes the image of what he is thinking in the midst of the affective atmosphere he is attempting to conjure up. In this way, he quickly realizes the tremendous power he has

over the words through his imagination. He discovers in his imaginative faculty an incomparable means of defense against the persistent onslaught of contingency. Similarly Roquentin, in *Nausea,* finds in Annie's "perfect moments" a momentary shelter from the gratuitous flow of existence. Thanks to her fantastic but unshakable decorum,[45] her myths in which everything has a precise, symbolic, absolute meaning, even if unknown to the outsider, Annie succeeds in putting between parentheses, if only temporarily, the radical contingency of Roquentin and the world. Roquentin himself will resort to the imaginary at the end of the novel in order to "wash himself of the sin of existing."[46]

As Sartre so brilliantly contends in *L'Imaginaire,* there is always "intentionality" of the image; there is always a choice of the imaginary life which deliberately renders its object unreal, taking it away from its condition of being-in-the-world. To opt for the imaginary is to choose a specific way of coping with things; the result is therefore a deliberate sequestration in unreality. This is precisely what the artist achieves. The work of art amounts to a systematic negation of the different manifestations of reality. It constitutes a daring challenge to contingency by creating a world where everything is endowed with necessity and permanence.

Having once been struck by the inescapable necessity of the portraits in the Bouville museum, Roquentin later finds the same solidity, the same inescapability, as he listens to a recording of "Some of These Days." He has become hard, as hard as the music that unfolds in another time and has nothing in excess since it *is.* Yet this record offers him but a momentary respite from his attacks of nausea. In fact, he cannot *be* in the manner of a work of art; he must create one, as he will understand at the end of the novel. Then, after having listened to the song again, he envies the composer and the singer: "So two of them are saved: the Jew and the Negress ... they have washed themselves of the sin of existing."[47] They have reached the stability of the in-itself because they are living in the thought of others with the same firmness, the same necessity as the heroes of a novel. At that moment Roquentin decides that he, too, will attempt to justify his existence by writing a novel, something that will not exist, something that will transcend, that will negate existence. In this way he may one day be recognized in the thought of others and thus justify his past, for he will always experience his present as gratuitous and unnecessary.

It seems that Sartre is here proposing an aesthetic and egotistical solution to the scandal of existence. As he recognizes in *The Words,* this was indeed his position at the beginning of his career, when literature amounted for him to a kind of religion which was to deliver his life from chance, to redeem him from the sin of existence, and to assure him of eternal life. Next to daily life, with its unforeseeable and superfluous

events, there stood that other world which arose from aesthetic creation and gave a value of necessity to each act of creation. "Literature was first for me the search for a justification in the future, a transposition of eternal life; to accept a contingent and vague existence in the present in order to be recognized by society after one's death."[48] Thus, Sartre admits he once chose literature to protect himself against death; however, as we shall see, he was soon to transcend and disavow this position.

Sartre discerns the same "original project" at the source of Baudelaire's poetic endeavor. The famous dandy's vocation betrays a fundamental rejection, a deep contempt for usefulness and action. "His poems . . . reveal the gratuitousness of conscience; they are completely useless. . . . At the same time, they remain in the sphere of the imaginary."[49] However, Baudelaire has created something "which did not exist before, which nothing can efface and which was in no way prepared by the rigorous economy of the world"[50]; yet he does not completely delude himself into believing he has thus redeemed his being from the gratuity of existence.

Indeed, does art actually offer the perfect road to salvation from the "sin of existence"? Since the work of art belongs to the sphere of the unreal, the imaginary world is a closed world, without direct relationship to the real world except for one of negation. Therefore, the artist actually sequesters himself. Sartre was convinced of that from early childhood, when he envied the famous prisoners who had enlightened the world from the darkness of their cells and wished he might emulate them. He secretly hoped that fate would allow his modest ambitions to come true. "While waiting, I locked myself up in advance."[51] And later, he admits he has always been fascinated by the sequestered life, especially by the myth of the writer who, isolated in his Ivory Tower and enslaved by the tumultuous torrents of his inspiration, writes because he cannot do otherwise—not because he has something to say, but because it is his nature to write. This concern is reflected in *The Condemned of Altona,* in which Frantz locks himself up in his room and proceeds to pour out the irrepressible stream of words he feels compelled to deliver to posterity. But the message Frantz intends for the generations of the future—in this case the Crabs—is not written but recorded on tapes. Will the Crabs of the thirtieth century understand the meaning of his testimony? How could they, since Frantz himself does not recognize his voice or his message when it is played back on the tape. "I didn't mean to say that!" he shouts in exasperation: "But who's speaking? Not a word of truth. I can't stand that voice any more. It's dead."[52] His words have become objects, radically altered in form and content from what they were supposed to express. An embodiment of the "damned" writer, Frantz is condemned to go about in circles in the hermetically sealed universe of his imagination. Having fallen victim of his own

trick, he will now push his sequestration to its extreme consequence, namely, madness—the ultimate escape into the imaginary. We must bear in mind that Frantz's alienation represents an attempt to escape the sense of guilt which has crushed him since he indulged in torture. He tries to rid himself of this guilt by testifying for the defense of a disintegrating century before a high tribunal which he has completely invented. The destruction of Germany stands at the core of the drama he is producing and acting out; it is an essential dénouement. The war had to be won at all costs in order to avoid this horrible outcome. That is why all means were good and justified, and justified, too, were the actions of those who used them. Although he claims he has sequestered himself in his room in order not to witness the awesome spectacle of his country dying in slow agony, what he actually refuses to face is Germany's prodigious recovery, its flourishing economy. For this prospect will bring about the immediate collapse of his fortress of excuses, and his act of torture will remain naked, unjustified in all its gratuitousness, in all its horror. He needs the orphans of Düsseldorf; he needs Germany in ruins in order to tolerate himself. In the last scene, having decided to break out of his sequestration and face his act, he confesses that his madness was but an illusion that could be traced back to his fundamental bad faith:

> The ruins gave me my justification; I loved our looted houses and our mutilated children. I pretended that I was locking myself up so that I shouldn't witness Germany's agony. It's a lie. I wanted my country to die; and I shut myself up so that I wouldn't be a witness to its resurrection.[53]

One must add, however, that Frantz has been maintained in his alienation by the complicity of pseudo-normal people. Johanna charges Frantz's father with responsibility for his son's sequestration by encouraging his illusions with lies.[54] "There are many ways of holding a man prisoner," she declares. "The best is to get him to imprison himself."[55] Nevertheless, as soon as she meets Frantz, Johanna herself yields to the same temptation. Increasingly fascinated by the fantastic world of Frantz's madness, she undergoes a strange transformation. She begins to find the downstairs world ridiculous and bizarre. She confesses that she, too, lies to Frantz, and that those orphans from Düsseldorf, starving in a concentration camp, have come to life in her imagination and now follow her everywhere, even in the real world. That is why she accepts Frantz's invitation to remain with him in his room. She will attempt to penetrate his madness completely, to make it her own. "Your madness is my cage," she tells him. "I turn around and around there."[56] But her attempt proves impossible; one cannot assume another's madness. Thus, instead of losing herself in the hell of his sequestration, she will help him get out. As soon as he does, however, he follows

his father in the Porsche which will carry him to his death. Thus the Imaginary is a hermetically sealed universe into which the Sartrean character escapes in order to avoid the immediate decisions, the concrete tasks constantly required by the real world. There, radically cut off from other beings, he is sequestered; however, even in madness, his isolation is his own choice.

If Johanna could not keep on believing Frantz's lies, it is because Leni's piercing stare destroyed the fortress of illusions which was to protect them from the dangers of reality. Ines will play a similar role in *No Exit.* Indeed, the Other's Look possesses formidable power. This is the reason why most Sartrean characters cannot stand to be looked at. For instance, in "The Wall," the Belgian doctor's look inflicts an unbearable wound upon those men condemned to death, for it sends back to them the image of decaying beings reduced to the last unconscious reflexes of the flesh, from which they feel completely alienated. In the same way, M. Darbédat's look, in the short story entitled "The Room," transforms Pierre into a pure object, a madman-in-itself. Darbédat's stare causes Eve to exclaim: "I hate him when he looks at him [Pierre], when I think he *sees* him."[57] Similarly, Pierre's alienated look transforms Eve into an inert object; he even changes her name. Eve becomes Agathe. Significantly, he endows her with the name of a stone. Hence her sense of shame and diffuse guilt. Likewise, Lucien Fleurier feels he is being changed into an object by the stare of the others, who have decided once and for all that he is tall: ". . . big beanpole. . . . It was as if someone had cast a spell over him: until then it had seemed natural to see his friends from above. But now it seemed he had been suddenly condemned to be big for the rest of his life."[58] Nor can Frantz bear his sister's look. "You are looking at me. I can feel my neck burning. I forbid you to look at me."[59]

Most of the characters in *The Age of Reason* feel constantly infringed upon by the stare of the Other. Haunted by fears of being transformed by this stare into massive objects, judged without being able to defend themselves, they always take the defensive. Having learned that Marcelle is pregnant, Mathieu finds he can no longer escape her condemning look no matter what physical distance divides them. On the evening he spends at the Sumatra with Boris, Ivitch, and Lola, he keeps recalling Marcelle's heavy, crushing world. He would like to forget, if only for that evening, but "Marcelle doesn't forget, she is in the room, outstretched on the bed, she remembers everything, she *sees* me."[60] But Ivitch's look, too, seems to transform him into an object. He abhors what he sees in this young girl's eyes. Assailed by shame and a vague guilt, he does not know what to do with his body; he does not know what to say to keep her from pronouncing an irrevocable verdict. Later on, Irene's look, equally accusing, classifies

him as a bourgeois-in-itself: "She sees me, as she sees the table and the ukulele. And for her, I *am*; a particle suspended in a look, a bourgeois. It is *true* that I am a bourgeois."[61] As for Ivitch, she hates compliments because "they made her feel as though a rather blatantly alluring image of herself were being hacked out with a hatchet, and she was afraid of being deluded by it."[62] She cannot abide the image the others make of her, for she considers it a blow to her freedom. Rejected by right-thinking people because of his homosexuality, Daniel experiences the Other's look as an even more painful gash, for it reduces him to the essence of a homosexual and nothing more. His case is closed, his life evaluated before it has been lived. He remains without defense. He pictures hell as a "vision that penetrated everything and saw to the very end of the world the depths of a man's self."[63]

These remarks lead us directly to *No Exit*. Sartre had originally entitled this play *The Others*. Indeed, its subject is a circle of human relationships strained to their limits. The characters' "dead" situation is symbolic. We shall discuss this point in greater detail later on. For now, suffice it to note that the three characters in the play are apparently deprived of their historical dimensions, which would allow them to transcend their present situation, dispossessed of all resources on the level of action, and seemingly condemned to lead a fixed existence whose sole concern is the image of the self which capriciously floats beyond control in the others' eyes. No mirrors. Each is entirely dependent on the others. Afraid to look in Ines' bewitched eyes, Estelle sighs: "I'm going to smile, and my smile will sink down into your pupils, and heaven knows what it will become."[64] And Ines triumphantly proclaims that she "possesses" Estelle, just as she "possesses" Garcin, by the slimy trap of her gaze. "You're a coward, Garcin, because I wish it. . . . So you've no choice, you must convince me, and you're at my mercy."[65] Garcin believes her, and this is one of the reasons why, far from attempting to escape when the door opens, he goes to close it himself, unwilling to leave Ines behind with her thoughts of his cowardice.[66] He must at any cost change that monstrous image which floats in the infernal lesbian's eyes. Possessed one by the other, these three damned characters are above all the prey of the living. Completely powerless, they cannot help being what the others have decided to make of them. In Garcin's perception, "They're thinking: Garcin's a coward. . . . That chap Garcin was a coward. That's what they've decided, those dear friends of mine. In six month's time they'll be saying: Cowardly as that skunk Garcin."[67] Ines voices the impression that everything has been decided beforehand. They are together forever, the coward, the lesbian, and the infanticide, because they represent one and the same thing in each others' eyes: they are Evil. They have no recourse but to wait and go on. But the situation is unbearable because they cannot know what will happen to them. Although

"dead," they are always "before." In fact, the infernal world of *No Exit* is an extreme representation of the existence of those who, having become bogged down by habits, easily let themselves be imprisoned in the Other's irrevocable judgment, which will insidiously become theirs, without any recourse whatsoever to change. The inability to transcend this arbitrary image leads directly to a kind of living death.

Actually, according to Sartre, we can always change the meaning of our actions by other actions, through use of our freedom. "Whatever the circle of Hell in which we are living, I think we are always free to break away from it."[68] This is precisely what Garcin, Ines, and Estelle fail to do when they let slip the opportunity to get out of their infernal sitting room. As a matter of fact, the heat becomes much more intolerable while the door is open. Therefore, Sartre continues, ". . . if people don't break away from it, they remain in it voluntarily. So that they place themselves in hell by their own free choice."[69] This mythical Hell is but the experience of human relationships pushed to the extreme. No need of a professional executioner, no need of instruments of torture. Ines discovers: ". . . each of us will act as torturer for the two others."[70] And Garcin concludes with the famous statement: "Hell is other people."[71] This statement has frequently been interpreted as a highly pessimistic observation about the impossibility of authentic relationships with others. But Sartre did not intend that at all: "I mean that if our relationship with the Other is distorted, vitiated, then the Other can only be Hell. . . . Actually, the Others are what is most important in ourselves, for our own self-knowledge."[72] But one can also interpret this statement on an ontological level. Since it freezes us in an arbitrary attitude, thereby annihilating our freedom, the Other's Look constitutes the threat of an ontological death if we refuse to assume our power of transcendence.

If most Sartrean characters experience the Other's Look as an intolerable infringement it is because, entirely responsible for a being they have not really created, they endure with anguish the indetermination and the unexpectedness of this being which they are for others, a being over which they have no control and which, far from constituting one of their potentialities, represents the limit of their freedom. The paralyzing power of the Other's Look ensnares the for-itself's free project and transforms it into a massive and inert in-itself: ". . . in order for me to be what I am, it suffices merely that the Other looks at me."[73]

Although the Other's Look infringes painfully on the for-itself of the Sartrean character, he cannot do without it. Goetz, a fraud of extraordinary stature, cannot live without an audience. However, since he accepts nothing less than the absolute, he chooses the absolute spectator, namely, God. He will force God to look at him. He wants to be seized by an infinite gaze

in order to become infinite too. Actually, most Sartrean characters play at being what they are. In "The Room," Mme. Darbédat plays at being a hypersensitive invalid while M. Darbédat, her husband, plays at being normal, virile, and young. As for Pierre, he plays at being mad. Indeed, after the incident of the bewitched fork in the presence of M. Darbédat, he admits bluffing for the purpose of frightening his father-in-law. Hugo and Jessica, the young couple in *Dirty Hands*, spend all their time together playing a multitude of characters they are not. Convinced that his mother has been acting, young Lucien Fleurier, too, will play, pretending he is an orphan. Moreover, he quickly notices that everybody has been acting. "Papa and Mama were playing papa and mama; mama was playing worried because her little darling wasn't eating, papa was playing at reading the paper. . . . And Lucien was playing too, but finally he didn't know at what."[74] Maybe at loving his mama. Everybody is acting.

But the game is not without danger. The player runs the risk of being caught in his own trap. This happens in *The Flies* to Egisthe, who uses and abuses the magic power emanating from his own image, which he projects in his subjects' consciousnesses. Wanting to cast a spell upon them, he so convincingly assumes the appearance of a vengeful god that he completely empties himself of all substance. "For fifteen years I have been dressing a part, playing the scaremonger, and the black of my robes has seeped through to my soul."[75] And later he discovers: "I have been trapped in my own net, I have come to see myself only as they see me. I peer into the dark pit of their souls, and then, deep down, I see the image that I have built up. I shudder, but I cannot take my eyes off it."[76] He has become pure absence.

Perhaps we cannot help but act, for we can never actually be what we are. The coincidence of our for-itself and our in-itself is an inaccessible ideal. We are forced to make of ourselves what we are. In other words, we act out our condition in order to "realize" it; that is, we never *are* it. As an example, let us recall the famous waiter in *Being and Nothingness* who "is playing at *being* a waiter in a café."[77] I can only play at being what I have to be. In the frequently criticized conclusion of *The Flies*, Oreste's sacrifice ends in a mythical performance. Metamorphosed into a legendary flute-player, Oreste steps down from his pedestal and slowly walks away from the temple, followed by the Erynnies—a very theatrical exit indeed. Thus all of us, players in spite of ourselves, compelled to act out what we are, urgently need others as an audience.

What is more, the Other's Look is indispensable to maintain us in being. In excess, without cause or justification, floating on the surface of things and beings without ever leaving traces, the Sartrean character must continuously confront the contingency of his being with regard to the world and of the world with regard to himself. Hence his pressing urge to belong

to someone or something. Oreste sighs bitterly: "Nobody is waiting for me anywhere; I wander from city to city, a stranger to all others and to myself, and the cities close again behind me like the waters of a pool."[78] He leaves no traces of his passage because he is too light.[79] Only a concrete commitment to a human endeavor will allow him to transcend this contingency and assume an authentic weight in the scales of existence. Hugo's protest can be traced back to the same phenomenon: "I'm in the way, I haven't found the right place for myself and I get on everyone's nerves. Nobody loves me, nobody trusts me."[80]

But it is in *Nausea* that Sartre presents in the most striking way the experience of the contingency of our being, of things, of the situation in which our being-there is thrown in the world. During that quasi-mystical experience in the Public Garde, existence suddenly reveals itself to Roquentin: "[O]ne cannot define existence as necessity. To exist is simply to be there; . . . contingency . . . is the absolute . . . the perfect free gift."[81] The varnish which once coated every being with a semblance of necessity has melted away. Beings appear to him in their monstrous nudity. They have not the slightest reason for being here rather than somewhere else, for being what they are rather than something else. He now understands the reason for his attacks of nausea. Unjustifiable amidst an unjustifiable world, he feels superfluous, gratuitous. We should not forget, however, that Roquentin's awareness of his radical contingency signals his liberation. For if he is contingent it means that he owes his being only to himself, he is but what he wants to be; therefore, he is free. But since he is free only within a given situation, he must take his freedom upon himself by an act of free will. Yet his project does not rest upon a solid foundation, nor does it emanate from any predetermined value; hence, it remains absolutely unjustified. This sudden realization gives rise to a persistent anguish. And it is precisely this diffuse anguish which arouses a pressing sense of exigency.

Sartrean characters need to exist in somebody's thought; they need to be judged by somebody. Estelle, in *No Exit,* clings desperately to her image in her former lover's memory: "Peter, dear, think of me, fix your thoughts on me, and save me. All the time you're thinking 'my glancing stream, my crystal girl,' I'm only half here, I'm half wicked."[82] In the same manner, in *The Victors,* Lucie holds onto existence with all her strength by imagining that Jean is thinking of her. She is no longer alone because Jean "sees" her. Meanwhile Henri protests quite bitterly against the absurdity of his imminent death, which will be in vain. His life has left no trace; his death will leave no void: "I'm not missed anywhere, I haven't left any vacancy. . . . I've slipped out of the world, and it has remained full. Like an egg. So it must be that I was not indispensable. I should have liked to be indispensable. To something or to someone."[83] But he regains his courage upon

Jean's arrival, which transforms their situation and gives meaning to their life as well as to their death: they will now have something to hide from their torturers. In *Dirty Hands,* Hugo, who has never been taken seriously even by his wife, whose actions have been taken as mere gestures of a spoiled child playing at being a revolutionary—Hugo begs Louis to entrust him with a dangerous mission. He wants to exist in his comrades' thoughts, he wants them to talk about him, to anxiously await the completion of his assignment. "Before the end of the week, you will be here, both of you, on a night such as this and you will be waiting to hear from me, you'll be uneasy and you'll speak of me. I'll mean something to you then."[84] He is willing to give up his task when it seems he has found in Hoederer a man who is disposed to trust him. But when he catches Jessica in Hoederer's arms, he shoots in frantic rage, convinced that he has once again been the victim of a sordid plot, that Hoederer has pretended to be his friend only to possess his wife.

Garcin is certain he will be saved only if he can convince Estelle that he is brave. Yet, when he understands he cannot expect that ultimate proof of trust from Estelle for the simple reason that she is not the least bit interested in all his complicated stories, he himself shuts the door since he cannot possibly leave her there with her thoughts of his cowardice. Likewise in *The Condemned of Altona,* Frantz begs for Johanna's trust in order to be delivered from his hell. Sartre pushes this situation to its limit when he embodies it in outcasts whose right to exist depends on the good will and condescension of respectable people. In *The Respectful Prostitute,* the doubly alienated Lizzie secretly longs to be indispensable in order to avoid the feeling of being nothing at all. For this reason, she is easily seduced by the specious reasoning of the Senator, who claims he wants to help her reach an authentic level of existence. If she agrees to his plan, she will win her place in the consciousness of an American mother, of all the mothers of the city. Caught in the trap, she cannot resist the offer: she is willing to do whatever is asked of her. But when she receives money from the happy mother for whom she has let herself be corrupted, she realizes she has been tricked. She had hoped for "a porcelain vase or some nylons, something she took the trouble to pick out for me herself,"[85] something which would have established a personal contact between the miserable prostitute and the honorable mother. Instead, she gains only bitterness and hopeless rage. Goetz, in *The Devil and the Good Lord,* is another character acutely conscious of his second-degree contingency. He says to Heinrich: "Since the day of my birth, I have only seen the world through the keyhole; it's a fine little egg, neatly packed, where everyone fits the place God has assigned to him. But I give you my word we are not inside that world. We are outcasts."[86] The egg metaphor expresses remarkably well Goetz's per-

ception that they are gliding on a smooth surface without ever making any indentation. However, their situation represents the ultimate limit of the human condition.

Not only do we long to be needed by someone, but we feel the need to be judged. The Other's judgment is presumed to endow our project with the objective solidity it so totally lacks. Whether positive or negative, this judgment proves indispensable in transforming our gestures into acts, our myths into enterprises. Thus, instead of fleeing from the peasants' hate after his last failure, Goetz decides to remain in spite of the danger: "I need to be put on trial. Every day, every hour, I condemn myself, but I can never convince myself because I know myself too well to trust myself. I cannot see my soul any longer, because it is under my nose; I need someone to lend me his eyes."[87] Similarly, Baudelaire continues to solicit the judgment of others. "He wanted judges—beings whom he could deliberately place beyond the fundamental law of contingence, beings . . . whose decree conferred on him in his turn a stable and sacred 'nature.'"[88] He forces others to judge him, to condemn him. Through his inauthentic exhibitionism, he increases the sequestration imposed by the Other's gaze and thus manages to lessen his sense of guilt by making himself the victim of his judges' inequity. And Frantz de Gerlach of *The Condemned of Altona* shuts himself in his room to plead for himself and his times before the formidable tribunal of Crabs. As a witness for the defense, he seeks to justify his entire country in the eyes of History. He needs this tribunal without appeal: "What is to become of me without a trial? . . . If a life is not sanctioned, the earth consumes it."[89] But although he needs to be judged, he cannot bear man's final verdict: "Well, I said no, men won't judge my time."[90] However indispensable the judgment of men may seem in confirming his existence, it inflicts unbearable torture on him because it is always arbitrary and unjustifiable: "You won't be my judge. . . . Two criminals. One condemns the other in the name of principles they have both violated. What do you call that farce?"[91] What right has one man to judge another? Equally guilty, equally unjustifiable, we are all confined within a vicious circle from which it seems impossible to escape.

Finally, the Sartrean character needs others in order to know himself. The Other's Look, through its implicit judgment, provides him with the possibility of looking at himself from a distance, hence with some objectivity. Goetz needs to be judged because he claims to know himself too well. Too well, or not well enough. Daniel writes Mathieu a letter to tell him of the extraordinary experience he has just undergone because his adventure does not seem quite real to him until it exists for others too. Unable to reach himself, he needs the Other as mediator between him and himself. "My vices, my virtues, are under my nose," he says, "but I can't see them,

nor stand far enough back to view myself as a whole."[92] On the June evening when he confessed himself to Mathieu, he saw himself solid and predictable in the latter's eyes: "For one instant you were the heaven-sent mediator between me and myself, you perceived that solid entity which I was and wanted to be, in just as simple and ordinary way as I perceived you. . . . I then understood that one could not reach oneself except through another's judgment, another's hatred."[93] Therefore, the Sartrean character cannot really know himself without this steady mirror which stops the incessant wavering of his for-itself. He cannot be anything unless others acknowledge him as such, yet they always find him to be different from the one he intends to be. Victimized by the Other's Look, we cannot do without it. Precisely because they constitute our hell, others are indispensable to our salvation—a paradoxical situation which we find present at every level of human relationships.

As a result, the Sartrean character generally strives to reduce and maintain the Other to the rank of object for fear that he may be objectified by the Other's transcending gaze. To do this, he employs various tricks. Through lies, he attempts to keep the Other at a distance, to seduce his consciousness, to make him fall into the trap of the "unreal." Garcin and Estelle both exploit this method, each pouring out a stream of lies aimed at subjugating the consciousness of the two others. But since they are in Hell, they are deprived of all possibility of lying. If they are three, it is not by chance. The obliging lie which could unite two accomplices is necessarily destroyed by the presence of the third, a role that each prisoner assumes respectively for the two others. Likewise, in *The Condemned of Altona,* Leni by her mere presence prevents Frantz from convincing Johanna of his innocence. Similarly, as soon as Oreste arrives in Argos he poses a terrible threat to the inauthentic relationship between Clytemnestre and Electre, a relationship which is built on an implicit lie. Says Clytemnestre: "Electre hates me—that, of course, I always knew. But for fifteen years we have kept peace; only our eyes betrayed our feelings. And now you have come, you have spoken and here we are showing our teeth and snapping at each other like two curs in the street."[94]

An attempt to subdue the Other, the lie is also an artificial escape from the terror of the human condition. Johanna admits she prefers to lie to herself rather than face "the horror of living." Yet the lie can offer but a temporary refuge, for it cannot last for long. Nonetheless, it represents a certain type of human relationship based on the antithesis of domination-submission. Thus, most Sartrean *salauds* long for absolute power, for the domination and possession of the Other's consciousness out of fear of being dominated and possessed themselves. The objectification of the Other will become their main project. If Valera in *Nekrassov* chooses to be

a swindler, it is to escape from the subjection imposed on him by his condition as a bastard. Through the newspaper and his fantastic secrets, he will exploit the magic power of the word to manipulate the consciousness of thousands of individuals: "I hold war and peace in my hands, I am writing History."[95] But it is only an illusion; he quickly finds out that, once again, the others have used him.

This type of behavior reaches its extreme, however, in the practice of torture, which constitutes the absolute crime in existentialist ethics. Sartre has often protested vehemently against this ignominious assault upon the Other's freedom. The most despicable example of it is to be found in *The Victors,* in which a band of collaborators who were mediocre and completely insignificant before the war suddenly find themselves endowed with an unexpected power which they will exploit to the very end. They torture the resistants not so much to obtain useful information from them as to force them to surrender, to crush in them all trace of human dignity. "I don't give a goddam about their leader," says one of the torturers. "I want them to talk."[96] What is important to them is their triumph over men's freedom. We find the same intoxication with power in the executioner who interrogates the prisoners in "The Wall." Sartre again raises the same question in *The Condemned of Altona,* which he situates in post-Nazi Germany, but which actually is intended to denounce the use of torture during the Algerian war. Frantz desires to go to the limit of power because he once experienced total impotence and abject humiliation:

> I have supreme power. . . . No! I shall never again fall into abject powerlessness. I swear it. . . . Horror has not yet been let loose . . . I'll grab them quickly. If anyone lets it loose, it will be me. I'll assume the evil. I'll display my power by the singularity of an unforgettable act; change living men into vermin.[97]

Similarly, sadism, as embodied by Paul Hilbert in "Erostrate," is essentially an attempt to reduce man to the level of a beast. In the vile scene between Hilbert and the prostitute, we realize that sadistic behavior consists in confining the Other in his flesh and forcing him to identify completely with it while the sadist remains pure spirit. But sadistic behavior also is doomed, because as soon as his victim looks at him, the sadist feels absolute alienation from his being-for-others, the petrification of his sadistic endeavor, with all the determinism it implies.

Is it impossible to go beyond the antagonism latent in all human relationships? Could not authentic love break this "damned" circle? One must admit that love plays a very minor role in Sartre's fiction. A project of implicit or explicit domination, it is generally doomed to failure. Intoxicated with the absolute, Frantz and Johanna will never be able to love each other except in the unreal, and this love in bad faith will soon become an

instrument of torture. Impossible too is Mathieu's love for Ivitch. For them, "Love was not something to be felt, not a particular emotion nor yet a particular shade of feeling, it was much more like a lowering curse on the horizon, a precursor of disaster."[98] Roquentin and Annie do not succeed either in loving each other authentically; and from the moment she is tortured, Lucie is forever separated from Jean. Love demands complete reciprocity between two free consciousnesses involved in a common venture, aiming at the same objectives. Sartre's concept of love has often been the object of bitter criticism. For instance, Iris Murdoch sees Sartrean lovers as constantly engaged in abstract speculation about each other's attitudes. According to her, Sartrean love is simply a struggle between disembodied lovers, "a battle between two hypnotists in a closed room."[99] Indeed for Sartre, love is always a conflict, an attempt by two freedoms to possess each other, a project to recover one's being by subjecting the Other's freedom to one's own, a desire to "possess a freedom as freedom."[100]

It is easy to see that this conception of love is but a logical consequence of Sartre's penetrating analysis of being-for-others. Yet it seems that he is not actually dealing with love, but with the desire to be loved, which is quite a different phenomenon. Most Sartrean lovers' feelings do not come from a spontaneous impulse, nor are the lovers intent upon achieving a deep and authentic communion with another free consciousness considered as such. Instead, they wish to be loved to escape from their loneliness, to possess someone else's consciousness, or to create their being through their lover's freedom. It is always a selfish project that can only lead to failure. The sole authentic love one can find in Sartre's imaginary world is Hilda's love for Goetz. Capable of suffering from somebody else's suffering, Hilda loves Goetz even in Evil and is willing to be "damned" out of love for him.

> Each day, you grow a little more like the corpse you will become, and I still love you. If you die, I will lie down beside you and stay there to the very end, without eating or drinking: you will rot away in my embrace, and I will love your carrion flesh, for you do not love at all if you do not love everything.[101]

But in this case, absolute love results in complete and deliberate annihilation of the for-itself. Hilda becomes nothing but love for Goetz.

Is authentic and reciprocal love impossible? Is it an unreachable ideal? We must confess our failure to find any examples of such a love in Sartre's world. Perhaps he deems it merely unrealizable in the socio-historical conditions that surround us now. But this position would subject love to a socio-historical determinism that would limit it considerably. We must keep in mind that at the time he was writing *Being and Nothingness,* Sartre felt that by my mere appearance in the world I establish myself as a limita-

tion to the Other's freedom; likewise, by his mere presence, the Other becomes a limitation to my freedom. Hence the constant instability of our relationship and the diffuse feeling of guilt. Is the situation hopeless? In *Critique de la raison dialectique* Sartre states that the perpetual fluctuation between my subjectivity and its objective reality owing to my existence among men, is the basis of human relationships; that is, it is praxis itself. It is through the dialectical movement of praxis that Sartre resolves the circular conflict of my relations with others. If the circle remains, it is nonetheless animated by a dynamism which propels it toward the realm of authenticity. But all this is theoretical, for Sartre has never dramatized this dialectical process in his characters, except perhaps in the end of *The Devil and the Good Lord,* where Goetz is determined to commit himself to a concrete undertaking aimed at the liberation of men. But even here we witness a somewhat miraculous last-minute metamorphosis whose scope and authenticity may be questioned. In *The Condemned of Altona,* we fall back into a "damned" circle from which none of the characters can break loose unless it is to rush toward death. Does this mean, as we have suggested in the discussion about love, that Sartre considers authentic relationships between human beings impossible so long as socio-historico-economical conditions remain as they are, so long as the domination of scarcity has not been abolished?

If all possibility of authentic relationships between men seems to be relegated to the sphere of the ideal, it is because the Other's consciousness appears to me as an insurmountable wall. This incommunicability between consciousnesses is particularly striking in the stories of *The Wall,* the title of which is extremely significant. In "The Room," the lack of communication is pushed to its extreme consequences, and from the depths of madness Pierre expresses a profound truth: "There is a wall between you and me. I see you, I speak to you, but you're on the other side. What keeps us from loving?"[102] He feels condemned to radical loneliness, but actually his isolation appears to be neither greater nor less than that of most other Sartrean characters. Johanna does not succeed any better in penetrating Frantz's madness; Roquentin is unable to integrate himself into the magic world of Annie's perfect moments. As for the characters in *The Age of Reason,* they too are victims of a painful loneliness. Confined in her room, Marcelle's isolation is increased because she carries the baby Mathieu is determined to eliminate. But Mathieu is just as alone as his mistress. In his desperate search for money to finance Marcelle's abortion, he constantly runs up against a wall of obtuseness. Daniel, Jacques, even Sarah—who is all too anxious to pour her overflowing kindness and generosity upon him—all end up by taking refuge behind an insurmountable barrier. Mathieu fails to

reach them in the same way that he fails to reach Ivitch, who represents an enigma he feels incapable of solving, but whose mere presence generates a guilt deep within him. Boris, as he contemplates Lola's distressed expression, has an intuition of her tragic solitude. He realizes that "she was now alone, even more so perhaps since she had fallen in love with him."[103] Hugo remains alone except for the instant when he perceives the possibility of establishing an authentic relationship with the only man who has ever been willing to trust him. In fact, the scene in which Hoederer offers Hugo his unselfish help represents one of the rare moments in Sartre's work where we can see "the outline of an authentic relationship between consciousnesses."[104] But Hugo will miss his chance for salvation because of an absurd crime whose motives he will never be able to elucidate. In sum, the absolute loneliness which characterizes most of Sartre's characters derives from their common perception of the impossibility of penetrating someone else's consciousness. Hence their total alienation.

It would seem that this realization constitutes a logical point of departure from which an attempt should be made to transcend this situation through the dialectical reciprocity of two freedoms. Yet, far from striving to go beyond this initial solitude, the Sartrean character most often deliberately confines himself within his subjectivity. Roquentin refuses to belong to any collectivity; he abhors all immediate contact. Finding the Self-taught Man's supplicating stare repugnant, he exclaims: "I don't want any communion of souls, I haven't fallen so low. I draw back."[105] He categorically denies any manifestation of complicity with others through his deliberate choice of solitude. He has established an insuperable distance between him and himself, between himself and the world. For the same reason, his description of Sunday in Bouville remains purely objective. It is a spectacle which he contemplates from a distance: "[I]t was their Sunday, not mine."[106] We must not forget that this step away from his situation marks the first sign of Roquentin's liberation. But subsequently, instead of concretely assuming his condition as a free man, he paralyzes his freedom, transforming it into an object, inert, useless, endowed with the opacity of the in-itself. This is the very danger which threatens all the Sartrean intellectuals. Oreste arrives in Argos light as a feather, "free from prejudice and superstition."[107] There he experiences solitude and exile, and a kind of nausea invades his being, nausea caused by an encroaching awareness of the emptiness, the unreality, the nothingness of his past life. Freedom has suddenly struck him. Reared in the rarefied atmosphere of radical intellectualism, he now longs for the sensuous promiscuity of things, for an immediate contact with real life. However, if Oreste's crime does not succeed in integrating him into the community of men, it is not, as M.

Boisdeffre contends,[108] because this outcome was determined a priori. It is because Oreste has committed his crime above all to save himself from contingency, to break away from the unreality of his empty freedom, and not to participate in the collective struggle of men for the achievement of a concrete liberation.

But it is Mathieu who seems most strikingly to embody the phenomenon of freedom as an end in itself. Since he was sixteen, he has set himself to be free: "I must be free. I must be self-impelled, and able to say: 'I am because I will: I am my own beginning' "[109] Having decided to be free in the absolute, Mathieu considers freedom a static possession that one acquires once and for all. He never commits himself nor does he become involved, because he never finds sufficient reason to do so, because he always fears being made a dupe. He feels as if an invisible force stays his every intent: "I can go where I please, I meet with no resistance, but that's worse; I am in an unbarred cage, I am cut off from Spain by—by nothing, and yet I cannot pass."[110] He can never completely identify with what he does or says. It is as if a band of nothingness stretches forever between him and his thoughts, between him and his actions, destroying any possibility of immediacy, keeping him at a distance from any concrete action. His precious lucidity furnishes him with a multitude of practical alibis, of good reasons not to act. He ends up by confining himself completely within the shell of his subjectivity. Prisoner and jailer at the same time, he will never truly attempt to break away. He has glided on the surface of things without leaving any traces. And at the end of the novel, Mathieu envies Daniel who is about to accomplish a decisive action that will upset his entire life.[111] Overcome by a painful feeling of nothingness, he sighs: "All I do, I do for *nothing*. It might be said that I am robbed of the consequences of my acts; everything happens as though I could always play my strokes again. I don't know what I would give to do something irrevocable."[112] Why can he not accomplish an irremediable act? Because he is guilty, not so much of wanting Marcelle's abortion, but of never having faced his responsibilities toward her, of always having eluded the concrete situation. While he claims constantly that he views everything with piercing lucidity, he never ceases lying to himself.

Like all the other Sartrean intellectuals, Mathieu has made himself a prisoner in the infernal circle of his own ideas, and this circle generates an impassable gap between himself and the world. Incapable of naivete, of spontaneity, the Sartrean intellectual can comprehend himself only while he is playing a role, for as soon as he is conscious of being something, he is no longer that something. But does not all action-for-itself become "gesture" as soon as it appears to someone else, since the Other judges it from

the outside, without participating in its goals? Are we not compelled to "perform" all our actions as soon as they are perceived by someone else's stare because of the very nature of the relationship between the being-for-itself and the being-for-others? In any case, the Sartrean intellectual suffers bitterly from his alienation and dreams of accomplishing a heroic action, as violent an action as possible, one which will allow him to break the carapace of abstractions that paralyzes him at the outset of any attempt at commitment. Oreste chooses to invent his path by murdering Egisthe and Clytemnestre. Hugo begs Louis to let him kill Hoederer with his own hands although he is not gifted in the role of murderer. Goetz also decides to inaugurate the reign of man with a crime. Likewise, Mathieu resolves to wreak vengeance on his old scruples and to plunge himself into concrete and violent action. Yet in almost every case the expiatory crime that is supposed to give its perpetrator the right to belong to the community of men, proves to be gratuitous and useless[113] because it proceeds from an attitude of failure. Indeed, it is to find personal salvation that these characters are determined to kill; they do not commit their crime out of solidarity with their oppressed fellow men. Their action is without foundation, unrealized by this abstract objective. Therefore, others refuse to take Hugo seriously even when he tries "direct action." He will never be accepted by his fellow workers. "Useless, there's nothing to be done about it," he cries. "Nothing! I am a rich kid, an intellectual, a fellow who doesn't work with his hands."[114] We again find this inferiority complex, which is typical of the bourgeois intellectual in Sartre's fiction, expressed by Brunet, who in *Reprieve* joins the Communist Party but will never be completely accepted by Maurice, Zézette, and the others. "Intellectual. Bourgeois. Separated forever. No use, we shall never have the same backgrounds."[115] Here Sartre might well be indulging in a kind of self-criticism, denouncing a tendency within himself (which he never ceased to fight) toward the inferiority complex of the bourgeois intellectual who is ashamed of his origins, of his education, of the bourgeois manners that will always remain a part of him. However, Sartre seems in some measure to have broken away from the circle of his subjectivity. That is, although he does not succeed in eliminating the circle permanently, he transcends it by an ever renewed contestation of himself, by a perpetual tension of his consciousness toward concrete objectives—transformations to realize, a world to create.

Most of the characters who inhabit Sartre's literary world follow the opposite path. Obsessed by a fundamental concern for his being, Roquentin reveals "the need to give a foundation to his own existence, to make it necessary, and in a way to statufy it."[116] Hence his fascination with Annie's "perfect moments." Likewise, Daniel's behavior emanates from his at-

tempt to coincide with himself, to be what he is in the way that things are what they are, "to be homosexual just as the oak is oak."[117] This may be the true meaning of Daniel's masochism—a secret longing to fuse the executioner and the victim in a single being whose for-itself would finally succeed in being-itself. In his study on Baudelaire, Sartre strives to show us that the source of this poet's original project lies in the same impulse. Having established an insurmountable distance between him and himself, between himself and the world, feeling himself constantly watched over by a spy who is none other than himself, he loses all naturalness. Baudelaire's famous lucidity is but an effort to recuperate the self by the self; his dandyism is a manifestation of the same effort. But of course the effort is bound to fail, for he will always be lacking a certain being which he is not, a being toward which he yet aims in a constantly renewed effort.

By confining themselves in the prison of their subjectivity, the Sartrean intellectuals do not understand that they condemn themselves to radical unreality, that there is no love except in acts of love, that the only genius is that which expresses itself in concrete masterpieces, that man is defined only through concrete enterprises in a concrete world which he must assume. Sartre dramatizes this point in his biting attack of the Self-taught Man's abstract humanism in *Nausea*. Prisoner of his abstract ideologies, the intellectual is guilty of bad faith by completely abdicating an aspect of his being, namely, his being-in-the-world, and confining himself in the circularity of the "self." He makes of his alienated condition the starting point of a total, inauthentic, and deliberate alienation instead of taking it as the source of an ever-renewed transcendence. The freedom to which we are all condemned will appear as but another form of determinism if we do not make it *our* freedom, if we do not always strive to *make ourselves free.*

This examination of various features of Sartrean characters leads us to a fundamental discovery: the nature of human reality manifests itself as essentially ambiguous. However, man most often refuses to assume the ambiguity of his condition and takes refuge instead in bad faith. Because of the very structure of the being of man, bad faith constitutes "an immediate, permanent threat to every project of the human being; it is because consciousness conceals in its being a permanent risk of bad faith."[118] And it is precisely this phenomenon which Sartre brings to light in his fictional world, or so it seems to us. In spite of what many of Sartre's critics claim, far from typifying ideal representations of the existential hero, most Sartrean characters embody various manifestations of bad faith. Even in the creation of his "intellectuals," Sartre has depicted the failure of a certain "intelligentsia" to fulfill its duties as men in the world because of a misunderstanding of the meaning of freedom. There is a contradiction to be

found in the very core of freedom, which reveals itself as a projection toward being and a refusal of being, an aspiration of the subject to coincide with itself and, at the same time, to maintain a distance, through reflection.

II

Now that we have examined the patterns of behavior distinctive to the Sartrean character, we shall consider its evolution through Sartre's work, which we shall divide into three fundamental stages. If we look at the characters from the works published before the end of World War II, we immediately distinguish a common feature: having become conscious of the contingency of their existence, they attempt to flee from it through egotistical means, thus acting in bad faith.[119] Roquentin suffers for some time from a vague and incomprehensible uneasiness in the presence of things; then, all of a sudden, the formidable revelation of the contingency of existence imposes itself upon his tormented consciousness. He will then seek a way to eliminate the nausea, to transcend the contingency, the gratuitousness of existence. The relief he experiences when he listens to his favorite record, "Some of These Days," will offer him the solution. He will have to create a work of art, following the examples of the composer and the singer. He determines to write a novel, but he will write it mainly to save himself from the void of contingency. Subsequently, Sartre confessed that Roquentin was a reflection of himself, a reflection which he ascribes to a literary neurosis that had paralyzed him for forty years. Indeed, in *The Words,* Sartre claims that he came to literature as one enters religion, to liberate his life from chance, in the hope that he would find assurance of an eternal life. "I infused my preference for writing with my wish for survival. This idea of literary survival, which I have since abandoned, was, to be sure, the starting point of my investments. . . . I was only concerned with my salvation."[120] And that is precisely how we should interpret the last pages of *Nausea.* We must notice that Roquentin, thanks to his lucidity, proves to be much less inauthentic than the other *salauds* portrayed in *Nausea* and other works of the period. In his final decision, however, Roquentin acts in bad faith.

Sartre subsequently became rather critical of the character of Roquentin and of his relationship with him. He has admitted that, while writing *Nausea,* he lacked a sense of reality: "I have changed since. I have slowly learned the difficult lessons of reality. I have seen children starve to death. In front of a starving child, *Nausea* has no weight."[121] In an interview conducted at about the time *Nausea* was published,[122] Sartre spoke of a new novel he was composing, *Roads to Freedom,* in which the hero's name was to be Antoine. He envisioned this hero as a possible follow-up to Roquen-

tin. He thought about embodying in Mathieu the change to positive ethics. Yet *The Age of Reason* and *Reprieve* do not reveal any expression of authentic freedom.

> It is only in "The Last Chance" that the conditions of true freedom will be defined. . . . Mathieu embodies the total receptivity which Hegel calls terrorist freedom and which is, in fact, anti-freedom. Like Oreste at the beginning of *The Flies*, he is without weight, without bonds, without ties with the world. He is not free because he was unable to commit himself. . . . Mathieu typifies freedom from commitment, abstract freedom, freedom in vain. Mathieu is not free; he is nothing, because he is always outside.[123]

Indeed, in Sartre's view, true freedom is freedom "in situation," freedom which generates a free act designed to eliminate any condition leading to the negation of someone's freedom. In this respect, the conclusion of *The Flies* proves quite ambiguous. After having murdered Clytemnestre and Egisthe, who were subjecting all Argos to remorse and infamy, Oreste gathers the people and, in a grand finale, tells them the fable of the flute player. He then exits, followed by the Erynnies, with the line: "I wish to be a king without kingdom, without subjects."[124] He thus transforms himself into a legendary hero. Instead of accepting the throne of Argos (as Goetz will accept the leadership of the army at the end of *The Devil and the Good Lord*), instead of opting to fight with his subjects and participate in their collective endeavor for liberation, he abandons them to the anarchy of a kingdom without a king, to the horror of a crime they did not commit and which they do not know how to handle, to the anguish of a radical emptiness they cannot fill. We are dealing here with an act of solitary heroism aimed at personal salvation and not at the liberation of all. Oreste's attitude corresponds to Sartre's in that period, when he considered commitment a question of individual ethics. This play epitomizes Sartre's state of mind during the war years, during the Resistance, when everything seemed to come down to a question of courage. He then thought that man could always choose. One was either for the Germans or against them, and one had to accept the risks of one's position, whether one was a hero or a traitor. But by the end of the war Sartre realized he had been elaborating a "writer's ethic."

Dirty Hands marks a transition between the first and second stages of Sartre's thought. It is not a political play, but a play about politics in which Sartre pretends he does not take sides. For this reason, there is no conclusion.

> I side with everybody: with the old, realistic leader of the proletarian party who, because he temporarily comes to terms with the reactionary powers, is accused of being a "socialist-traitor" purely out of opportunism. And also with his young disciple, wild with idealism, whom the "tough" have charged with the murder of the man he had idolized.[125]

By his effective politics, by his direct pragmatism, Hoederer recalls the spirit of the Front Populaire. Sartre projects himself in this character, ideally speaking. As for Hugo, a young bourgeois struggling with the contradictions inherent in his social class, contradictions he will be able to solve only through death, he embodies the danger Sartre must ceaselessly overcome in order to penetrate the world of praxis. Sartre does not choose between the man he no longer wants to be and the one he would like to be but cannot, because any choice at the time would be inauthentic.

A few years later, he frankly judges his previous position of individual heroism to be completely false:

> [It was] so wrong that later on I decided to refute myself by creating, in *The Devil and the Good Lord,* the character of Heinrich, who cannot choose. He would like to do so, of course, but he can neither choose the Church, which abandoned the poor, nor the poor, who abandoned the Church. He is totally conditioned by his situation. However, it was only much later that I understood all that.[126]

At this point, then, choice has become impossible. Henceforth, Sartre will plunge his characters into History, subjecting them to radical historical and social conditioning while granting them the possibility of reassuming this conditioning, and of becoming somewhat responsible for it, through concrete commitment to the collective fight.

> I have never ceased to develop the idea that, in the final analysis, one is always responsible for what has been made of one, even if he can do no more than assume this responsibility. I believe a man can always do something with what has been made of him. This is the definition of freedom I would give today; this little word which makes of a totally conditioned social being a person who does not restore the totality of what he has received from his conditioning.[127]

Like *Dirty Hands, The Devil and the Good Lord* deals with the opposition between the futility of abstract ethics and the effectiveness of praxis, but it carries the idea much farther. As Simone de Beauvoir points out:

> The contrast between Oreste's departure at the end of *The Flies* and Goetz's final stance illustrates the distance Sartre had covered between his original anarchistic attitude and his present commitment. . . . In 1944, Sartre thought that any situation could be transcended by subjective effort; in 1951, he knows that circumstances can sometimes steal our transcendence from us; in that case, no individual salvation is possible, only a collective struggle.[128]

At the end of the play, Goetz typifies the man of action as Sartre saw him then. He indeed succeeds in overcoming a contradiction which had distressed Sartre since the failure of the Rassemblement Démocratique Révolutionnaire[129] and, especially, since the Korean War. "I made Goetz do what I was unable to do,"[130] Sartre declared. Goetz's evolution reveals how the dilemma of idealism-opportunism can be resolved. Having discovered

that access to authentic existence requires that he devote himself to a concrete commitment in which he accepts the Evil necessary to the Good he wishes to do, he breaks away from the fascination of that absolute witness who blocked his way and prevented him from achieving any communication with men. He proclaims the non-existence of God and finds himself responsible only to men. Accordingly, his final murder is not a return to Evil, but a first step in the world of praxis, a "conversion to man." Meanwhile Heinrich, "the nocturnal aspect" of human reality, already foreshadows the characters belonging to the third stage.

But it is in his extraordinary study on Jean Genet that Sartre best explains the conception of freedom he sought to embody in *The Devil and the Good Lord*. In *Saint Genet, Actor and Martyr,* Sartre strives to show the process through which a man who had been conditioned to be a thief became a great poet. At the very moment when Genet declared "I *am* the thief," a schism was created which made him aware of his freedom and "simply opened up for him certain paths which had not been offered to him at the onset."[131] In this study Sartre draws upon existential psychoanalysis and the Marxist method to show that

> . . . freedom alone can account for a person in his totality; to show this freedom at grips with destiny, crushed at first by its mischances, then turning upon them and digesting them, little by little; to prove that genius is not a gift, but the way out that one invents in desperate cases; to learn the choice that a writer makes of himself, of his life and of the meaning of the universe, including even the formal characteristics of his style and composition, even the structure of his images and of the particularity of his tastes, to review in detail the history of his liberation.[132]

A very definite evolution appears between his study on Baudelaire and his phenomenological psychoanalysis of Genet. In *Baudelaire,* his analysis consists essentially in going back to the original and free choice Baudelaire made of himself, and in demonstrating how, through all its consequences—exhibitionism, dandyism, provocation—that choice inevitably led him to failure. The study on Genet proves to be much more complex. It is in fact during his work on Genet that Sartre gradually becomes aware of the present impossibility of setting up an ethic. He has heretofore elaborated only a "writer's ethic," completely separated from concrete reality. Now he realizes that, in order to be valid, an ethic can do no more than achieve

> . . . a synthesis of Good and Evil. . . . The fact remains that, in the historical situation, this synthesis cannot be achieved. Thus, any Ethic which does not explicitly profess that it is *impossible today* contributes to the bamboozling and alienation of men. The ethical "problem" arises from the fact that Ethic is *for us* inevitable and at the same time impossible.[133]

Thus, when Goetz kills the soldier at the end of *The Devil and the Good Lord,* he initiates the practical moralization of a world dominated by violence and struggle between classes. Goetz and Genet are both conditioned by their socio-historical environment; however, taking back their conditioning upon themselves, they rescue themselves "from the toils of being" by bringing about "the sudden back movement that transforms the fall into a dive."[134]

But when we reach the third stage in the development of Sartre's thought, the Sartrean character seems to be irrevocably condemned to failure and solitude while yet responsible for his impotence. The characters from *The Condemned of Altona* are powerless, but at the same time consenting, victims of a process of sequestration which they cannot transcend but for which they are entirely responsible. All the Gerlachs are sequestered by History; Luther has driven them mad with pride. What is more, they find themselves cornered by Nazism. Hence, unable to go beyond their situation, they will play a role in perpetuating it while fully cognizant of the fact that they are condemning themselves to complete failure. Sartre has said of this somber play with its dead-end situation:

> I didn't intend simply to put personalities on stage, but rather to suggest that objective circumstances condition the formation and the behavior of such and such an individual at a given moment. . . . Until then, I had written plays with heroes and conclusions which, in one way or another, had suppressed all contradictions. Such is the case in *The Devil and the Good Lord.* But in the bourgeois society in which we live, it is very difficult for an author like me to deal with anything but critical realism. If a hero reconciles himself with himself at the end of a play, the audience that watches him in the play risks reconciling itself with its own queries, with unsolved questions.[135]

Sartre thus once again has thrown his characters into History, but this time the "hero" cannot break away from his "sequestration" except by casting himself into the most unthinkable sequestration of all, namely, death.

Sartre's last work, his enormous study on Flaubert, emanates from the same ideological stream as *The Condemned of Altona* and the *Critique de la raison dialectique.* His goal is to return to Flaubert's origins in order to attempt to understand how this man became the author of *Madame Bovary.* He introduces the subject of this study in the following question: "What can be known of a man today?"[136] In order to answer this inquiry, he will begin with a problem, a "deeply ever-hidden wound," whose source he will discover in Flaubert's early childhood. This is the method he followed with Genet. But, while his analysis of Genet did not include a study of historical conditioning, his investigation of Flaubert derives from a certain dialectic in which History plays an essential part. He will depict Flaubert as an individual, but also as a being totally representative of his

time. Once he has discovered that Flaubert suffered from a kind of "ankylosis" when in contact with words, Sartre will attempt to interpret the deep meaning of this affliction. It has to do, he says, with "a bad immersion of the child in the linguistic world, which means in the social world, in his family."[137] As a consequence, Flaubert from early childhood was forbidden access to the realm of human praxis but was not allowed to abandon himself to the unconsciousness of inanimate things; he was thus restricted to the field of "pathos," that is, "affectivity, inasmuch as it is pure violence which is sustained, not assumed."[138]

Once again, Sartre emphasizes in the Flaubert study the importance of the original determination of early childhood. Like Frantz, Leni, and Werner, Flaubert has been so completely conditioned by History and by family regulations that he is left with no possibility of true action: "[E]verything is past, even the future, everything is immutable beforehand."[139] Flaubert is thus forced to take refuge in the world of the Imaginary.

According to Sartre, the study of Flaubert actually represents a sequel to one of his first books, *L'Imaginaire* (1940). While Genet freely assumed the condition imposed upon him from early childhood and succeeded in penetrating the field of praxis, Flaubert was condemned to the domain of passivity, from the beginning and forever.

What has become of freedom? It seems to have disappeared completely from the Sartrean perspective. Is man no longer condemned to be free? He is, to be sure; but presumably his socio-historical conditioning has now become so oppressive that it has suppressed all possibility of transcendence. Has Sartre reached a dead end? Is this the reason he stopped writing novels? Quite obligingly, Sartre provides us with his own explanation:

> I no longer felt the need for it. A writer is always a man who has more or less chosen the imaginary; he needs a certain dose of fiction. As for me, I find it in my work on Flaubert, which can be considered a novel. . . . In this book I attempt to reach a certain level of comprehension of Flaubert through various hypotheses.[140]

In other words, no novelistic technique would allow him to give an account of a fictional character at the level he could achieve by applying Marxist, psychoanalytic, and sociological interpretations to the case of a person who has actually lived. If Sartre came increasingly to devote himself to the biographical genre, he did so because he was interested in another level of human comprehension.

The characters who inhabit his imaginary world, in novel or theatre, have never been mere illustrations of his ideology. Far from being mouthpieces for existentialist "gospel," most of them represent various possibilities or actualizations of inauthentic behavior. They reveal a certain

danger; they state a problem without imposing a solution. Sartre has thus set up a gallery of remarkable characters engaged in concrete crucial situations requiring immediate reactions which disclose their true being. If they seem to emphasize the inevitable conflict between human consciousnesses, the impossibility of authentic communication, it is because in one way or another they all refuse to assume their own being and that of others as *totalisation en cours*. Trapped by freedom, they must abide their condition as free beings in a more or less acceptable situation. Even if they choose not to choose, that is a choice. The evolution of their reactions is essentially a reflection of the author's changing perspective concerning freedom. From freedom *en situation* (where the situation is merely the point of departure for choice), we gradually move to freedom as necessity in a world of scarcity that alienates freedom and puts it in parentheses until the conditions responsible for scarcity and oppression have disappeared.

RUTGERS—THE STATE UNIVERSITY MARIE-DENISE BOROS AZZI
OF NEW JERSEY

NOTES

1. Jean-Paul Sartre, press conference on the film *The Wall* (Venice Festival, September 5, 1967), published in *Jeune Cinéma*, no. 25 (October 1967):24–28 (my translation).

2. Michel Contat and Michel Rybalka, *Les Escrits de Sartre; Bibliographie commentée* (Paris: Gallimard, 1970), p. 63 (my translation).

3. Madeleine Chapsal, "Les Ecrivains en personne," in *Situations,* IX (Paris: Gallimard, 1971), p. 10 (my translation).

4. Sartre, *Being and Nothingness,* trans. by Hazel E. Barnes (New York: Washington Square Press, 1966), p. lxxviii.

5. Ibid.

6. Sartre, *Nausea,* trans. by Lloyd Alexander (New York: New Directions, 1964), p. 16.

7. Having had a similar experience, Sartre says in *The Words* (1964) that the mirror taught him he was "horribly natural." He never recovered from that discovery.

8. Sartre, *The Age of Reason,* trans. by Eric Sutton (New York: Alfred A. Knopf, 1966), p. 217.

9. Sartre, *The Reprieve,* trans. by Eric Sutton (New York: Alfred A. Knopf, 1966), p. 25.

10. Sartre, "Intimacy," in *The Wall and Other Stories,* trans. by Lloyd Alexander (New York: New Directions, 1969), passim.

11. Pierre de Boisdeffre, *Métamorphose de la littérature,* II (Paris: Alsatia, 1951), p. 201 (my translation).

12. Sartre, *Being and Nothingness,* p. 85.

13. Sartre, *No Exit and Three Other Plays,* trans. by Stuart Gilbert (New York: Vintage Books, 1947), p. 9.

14. *The Reprieve,* passim.

15. Sartre, "The Childhood of a Leader," in *The Wall and Other Stories,* p. 143.

16. Ibid.

17. *No Exit,* p. 27.

18. It is clear that what Sartre is examining in his study on Baudelaire is neither the aesthetic value nor the profound meaning of the latter's poetry, but the Baudelaire "case."

What he is interested in is the scandal the poet so passionately nurtured all his life. Moreover, Sartre discovers in Genet the same deliberate intention of taking back upon himself the damned character society imposed on him as a punishment for his first misdemeanor. In Genet's case, too, he goes back to the original motivation in order to "learn the choice that a writer makes of himself, of his life and of the meaning of the universe, including the formal characteristics of his style and composition, even the structure of his images" (*Saint Genet, Actor and Martyr,* trans. by Bernard Frechtman [New York: George Braziller, 1963], p. 584). Likewise, it is the Flaubert "case," much more than Flaubert's art, which he attempts to analyze in *L'Idiot de la famille.*

19. Sartre, *Baudelaire,* trans. by Martin Turnell (New York: New Directions, 1967), p. 152.

20. Ibid., p. 69.

21. Half-bourgeois, half-revolutionary, Hugo belongs to this group, as does Oreste, who is from Argos and at the same a foreigner.

22. Sartre, *Kean,* II, in *The Devil and the Good Lord and Two Other Plays,* trans. by Kitty Black (New York: Alfred A. Knopf, 1960), p. 182.

23. Sartre, *Nekrassov: A Farce in Eight Scenes,* I,2, trans. by Sylvia and George Leeson (London: Hamish Hamilton, 1956), p. 15.

24. Sartre, *The Devil and the Good Lord,* I,2, trans. by Kitty Black, p. 34.

25. Ibid., I,3, p. 64.

26. Ibid., p. 40.

27. But as Francis Jeanson shows throughout his well-known study *Sartre par lui-même,* bastardy constitutes a privileged situation which makes it easier to become aware of the human condition.

28. *Nausea,* p. 13.

29. Baudelaire, p. 169.

30. *Nausea,* p. 33.

31. Ibid., p. 63.

32. *Reprieve,* p. 342.

33. Sartre, *The Flies,* III, in *No Exit and Three Other Plays,* p. 122.

34. *Reprieve,* p. 407.

35. *The Devil and the Good Lord,* I,3, p. 61.

36. Ibid., p. 64.

37. Ibid., p. 65.

38. Ibid., III,10, p. 141.

39. *The Flies,* II,2, p. 104.

40. Ibid., II,1, p. 88.

41. Ibid., III,1, pp. 117–18.

42. Ibid., p. 123.

43. Francis Jeanson, *Le Problème moral et la pensée de Sartre* (Paris: Ed. du Myrte, 1947), p. 94 (my translation).

44. "The Childhood of a Leader," pp. 91–92.

45. There is a certain analogy between this magical, hermetically sealed universe and Pierre's darkly curtained room in "The Room," a pure product of Pierre's paranoia wherein the passage of frightening statues occurs at almost the same time every day.

46. *Nausea,* p. 177.

47. Ibid.

48. Francis Jeanson, *Sartre par lui-même* (Paris: Ed. du Seuil, 1955), p. 173 (my translation).

49. *Baudelaire,* p. 70.

50. Ibid., p. 73.

51. Sartre, *The Words,* p. 184.

52. Sartre, *The Condemned of Altona,* II, trans. by Sylvia and George Leeson (New York: Vintage Books, 1963), p. 59.

53. Ibid., V, p. 165.

54. Sartre had already portrayed a somewhat similar situation in "The Room," which

he wrote twenty years before *The Condemned.* In fact, Eve is the accomplice of her husband's alienation. In her willingness to appear to him as Agathe, who she *is* not, Eve leads Pierre to become that madman who he *is* not. By perpetuating his illusion, she contributes to his failure to realize his freedom. Having concealed from him her subjectivity and his being-for-others, she induces him—indirectly, to be sure—to remain alone in his room, forever deprived of the consciousness of his being-for-others. Like Johanna, Eve desperately strives to penetrate Pierre's madness. She would like to think like him, to have the same visions, to be possessed by the same hallucinations. For a while she believes she is succeeding, but she soon realizes it was only a game: she has always remained outside. But she no longer feels comfortable in the world of the "normal people." See Sartre, "The Room," in *The Wall and Other Stories.*

55. *The Condemned of Altona,* I, p. 20.
56. Ibid., IV, p. 131.
57. "The Room," p. 30.
58. "The Childhood of a Leader," p. 94.
59. *The Condemned of Altona,* II, p. 68.
60. *The Age of Reason,* p. 299.
61. *Reprieve,* p. 379.
62. Ibid., p. 71.
63. Ibid., p. 111.
64. *No Exit,* p. 21.
65. Ibid., p. 45.
66. But Garcin acts in bad faith. Indeed, by going to close the door himself, he refuses his freedom. He acts against freedom.
67. *No Exit,* p. 39.
68. Sartre, "Préface" (spoken) preceding the recording of *Huis clos* (Deutsche Grammophon Gesellschaft); see Contat and Rybalka, *Les Ecrits de Sartre,* p. 101.
69. Ibid.
70. *No Exit,* p. 18.
71. Ibid., p. 47.
72. "Préface" preceding the recording of *Huis clos.*
73. *Being and Nothingness,* p. 321.
74. "The Childhood of a Leader," p. 87.
75. *The Flies,* II, p. 98.
76. Ibid., III, p. 103.
77. *Being and Nothingness,* p. 72.
78. *The Flies,* II, p. 90.
79. In Sartrean imagery, lightness always suggests contingency, freedom; weight conveys commitment to concrete reality.
80. Sartre, *Dirty Hands,* VI, in *No Exit and Three Other Plays,* p. 233.
81. *Nausea,* p. 131.
82. *No Exit,* p. 33.
83. Sartre, *The Victors,* I, in *Three Plays,* trans. by Lionel Abel (New York: Alfred A. Knopf, 1949), p. 215.
84. *Dirty Hands,* II, pp. 151–52.
85. Sartre, *The Respectful Prostitute,* 2, in *No Exit and Three Other Plays,* p. 273.
86. *The Devil and the Good Lord,* I,2, p. 33.
87. Ibid., III,10, pp. 133–36.
88. *Baudelaire,* p. 56.
89. *The Condemned of Altona,* IV, p. 134.
90. Ibid., p. 132.
91. Ibid., V, p. 160.
92. *Reprieve,* p. 405.
93. Ibid.
94. *The Flies,* I, p. 72.

95. *Nekrassov*, 5, p. 91.

96. *The Victors*, IV, p. 262.

97. *The Condemned of Altona*, V,1, p. 164.

98. *The Age of Reason*, p. 330.

99. Iris Murdoch, *Sartre: Romantic Rationalist* (New Haven: Yale University Press, 1952), p. 65.

100. *Being and Nothingness*, p. 448.

101. *The Devil and the Good Lord*, III,10, p. 133.

102. "The Room," p. 35.

103. *The Age of Reason*, p. 30.

104. Jeanson, *Sartre par lui-même*, p. 44 (my translation).

105. *Nausea*, p. 105.

106. Ibid., p. 53.

107. *The Flies*, I, p. 63.

108. Boisdeffre, Métamorphose de la littérature, p. 217.

109. *The Age of Reason*, p. 63.

110. Ibid., p. 146.

111. But we should not mistake Daniel's sudden and spectacular gesture (or Oreste's when he kills his mother and his father-in-law, or Goetz's when he gives all his possessions to the poor) for an act of authentic commitment. It is rather an exhibitionistic outburst aimed at proving his freedom by a kind of unforeseeable and gratuitous act.

112. *The Age of Reason*, p. 395.

113. The only exception is the case of Goetz who, free from any selfish concern, chooses to devote himself entirely to the common struggle.

114. *Dirty Hands*, III, p. 73.

115. *Reprieve*, p. 20.

116. Jeanson, *Le Problème moral*, p. 233 (my translation).

117. *Reprieve*, p. 133.

118. *Being and Nothingness*, p. 86.

119. Let us keep in mind that Roquentin illustrates a stage in Sartre's thought which he had already transcended at the time of the publication of *Nausea*.

120. Chapsal, "Les Ecrivains en personne," p. 32.

121. Jacqueline Piatier, interview, *Le Monde*, April 18, 1964 (my translation). Here Sartre raises the question of the function of literature in a world where hunger exists.

122. Claudine Chonez, "A qui les lauriers des Goncourt, Fémina, Renaudot, Interallié?" article-interview, *Marianne*, December 7, 1938 (my translation).

123. Christian Grisoli, interview, *Paru* (Monaco), no. 13 (December 1945) (my translation).

124. *The Flies*, III, p. 127.

125. Guy Dornand, "Drame politique puis crime passionnel: Jean-Paul Sartre nous parle de sa prochaine pièce," *Franc-Tireur*, March 25, 1948 (my translation).

126. Sartre, "Sartre par Sartre," in *Situations*, IX, p. 100 (my translation).

127. Ibid.

128. Simone de Beauvoir, *Force of Circumstance*, trans. by Richard Howard (New York: G. P. Putnam's Sons, 1964), p. 242.

129. The R.D.R. was a political movement to which Sartre adhered in January 1948. However, nine months later, on October 15, 1948, deeply disillusioned, he decided to resign.

130. S. de Beauvoir, *Force of Circumstance*, from Sartre's unpublished notes, p. 243.

131. "Sartre par Sartre," p. 102.

132. *Saint Genet, Actor and Martyr*, p. 584.

133. Ibid., p. 186.

134. Ibid., p. 168.

135. Charles Haroche, "Entretien avec Jean-Paul Sartre," *France Nouvelle*, September 17, 1959 (my translation).

136. Sartre, *L'Idiot de la famille* (Paris: Gallimard, 1971), Preface, p. 7 (my translation).

137. Ibid., p. 21.

138. Ibid., p. 48.

139. Ibid., p. 144.

140. "Sartre par Sartre," p. 114.

Bernd Jager

SARTRE'S ANTHROPOLOGY: A PHILOSOPHICAL REFLECTION ON *LA NAUSEE*

I N the following pages I shall attempt to situate Sartre's early anthropology within the context of a general understanding of a philosophic journey. Sartrean man is a radical wanderer, an eternal *homo viator,* permanently beyond rest and settlement, forever ready to leave behind the comfort of familiar surroundings, of acquired habits and possessions, forever willing to travel to the very end of the world to pursue the limits of an idea or a practice.

This theme of a restless pursuit, of radical leavetaking, of breaking out of a comfortable mold is inherent in the history of Western thought. We find it at the very roots of our civilization, in the Epic of Gilgamesh, in the Book of Genesis, in the adventures of Odysseus. The very first *theorists* of the age of Theognis were travelers, delegates from one city to another, living links between their native city and a distant shrine. Their theoretic task required of them that they leave behind the comforts and self-evidences of their city to risk themselves on unfamiliar roads and unpredictable seas. They were to venture out in order to witness a religious celebration at a distant site, to participate as delegates of their city and then to return to give a truthful and detailed account of all they had seen.[1] From the beginning the theoretic effort was a journey, a sacrifice of what is nearby, comfortable and self-evident followed by a thrust into the unknown. And this effort would be crowned by a triumphal return to the native city, by a telling and re-telling, by a verbal linking of the distance and the past with the proximate and the present.

Plato's philosophy retained this fundamental theme of a theoretic departure from familiar surroundings followed by a return to the place of origin. Socrates was surrounded by young men in transition from the self-evident realities of the parental home to the new horizons of adult life.

Under his influence, theoretic activity became philosophy and assumed the form of a maieutic discipline drawing the aspiring theorist from the confines of a womb into a larger life. In the parable of the cave Plato gave us the image of philosophy as a painful upward journey of transition from the womb, the parental home, the taken-for-granted life of the child, from the dark bottom of comfortable ignorance to the bright vision of a distant shrine. Philosophy became above all departure from the illuminated realm with its play of light and shadow, on the way to the realm of pure illumination.

We could extend this understanding to Descartes, who proposed a disciplined exodus from all our habitual certitudes on the wings of doubt. And we may understand Husserl's work in a similar manner: as an attempt to reveal the world we share on the basis of a radical departure from it. Husserl remained till the end of his life preoccupied with the problems of effecting and describing a philosophically fruitful distance from an habitual environment. The *epochē* was to effect a subtle and clarifying distance between man and his normal daily environment so that all that which usually would count as self-evident, as obvious and real, would no longer unquestioningly be taken up as such. Under the influence of the *epochē,* the familiar and the self-evident was again to become a source of wonderment.

Husserl's strategy of reduction thus bears a family resemblance to the Cartesian strategy of doubt, while both show the traces of their common ancestry in the Socratic manner of questioning, in the exodus from the cave, and in the fundamental theme of a theoretic journey.

Husserl's thought must be counted among the most important influences on the beginning thought of Sartre. The objections to Husserl which Sartre raises in his earliest publications never are directed to phenomenology as a whole. On the contrary, Sartre's objections to Husserl's conception of the transcendental ego as he understood this from the *Ideas*, must be seen as an attempt to further radicalize the phenomenological journey, to deprive it of any possible harbor of interiority, to push it beyond any possible Archimedian point. Sartre seeks to empty consciousness of all weight, all opacity, all self-sufficiency, to take from it all possibility of absolute rest, to make it movement through and through.

In an essay written at about the time of *The Transcendence of the Ego* Sartre describes consciousness as pure movement permanently beyond any harbor of self, as "absolute flight," as "a great wind blowing," as a perpetual "glissement hors de soi"[2] The prize or advantage of this breaking loose of consciousness beyond any cocoon of self and ego is the radical new philosophical access which it makes possible. Sartre speaks enthusiastically of Husserl's phenomenology as a philosophical return to the many aspects of our daily life that are closed off by idealist and materialist thought.

"Husserl has given back to us the world of artists and prophets, has opened up to us a world which is frightening, hostile, dangerous, with harbors of grace and love."³ And Husserl accomplished this, according to Sartre, by destroying the old privileged retreats of interiority and exteriority. Consciousness cannot be understood once it has become substantified or allowed to hide absolutely within the inner recesses of man's soul or within the organizing power of an ego. Consciousness is there where it is active, where it surpasses what it touches in an unceasing transcendent movement. The truth of man therefore cannot be found within some particular domain of interiority (nor derived from some privileged exteriority), but instead must be discovered "on the way, in the village, in the midst of the crowd."⁴ Sartre's conception of consciousness becomes one of radical ceaseless upsurge toward the world; it becomes a departure which will forever refuse to solidify into an absolute beginning or an ultimate destiny to become ceaseless spontaneous movement. The dependable constant world revealed in the natural attitude now appears as a kind of mask or subterfuge. It is now viewed as the outcome of an effort made by consciousness to hide from itself the reality of its absolute freedom. The Husserlian *epoché* which released us from one mode of experiencing to open us up to another becomes transformed. With the early Sartre, the *epoché* becomes a dissolvant of our origins and the obliteration of all destinies, leaving us with an understanding of consciousness as pure spontaneity. The theoretic journey, the philosophic quest becomes first and foremost the suffering of a radical expatriation, the loss of anchorage in known purposes and destinies, the expulsion from all comfortable certitudes. The *epoché* no longer is lived as the beginning step on a journey of theoretic discovery, but rather becomes an ever-present threat of instability which comes to inhabit whatever we prize as true, as necessary or inevitable. In Sartre's own words, the *epoché* "becomes imposed on us as an anxiety, it becomes an ever present, ever possible accident of our life."⁵

From this point of view it becomes clear that consciousness as pure spontaneity can no longer issue from a "substantial" ego nor harbor itself within a substantial world. The "substantial" ego is a sham invented by a pure spontaneity, which in turn remains anguished before its own lack of determination. Spontaneity no longer is contained, no longer obeys laws or limits, no longer remains of necessity within the proprieties of form. Laws, form, character, syntax are all creations of spontaneity and serve as its hiding places. The self-evidences of the world within the natural attitude are the creations of a self-forgetful spontaneity that seeks to hide its restless origins from itself. Just below the surface of what is only "natural," of "what always has been this way," of "what unquestionably will always remain this way," there lurks the dangerous spontaneity *of what could be*.

Below the surface of a predictable, well-functioning, integrated person
gapes the abyss of a transcendental impersonal freedom.[6] "The way things
are" is constantly and secretly undermined by a furtive indeterminacy, by a
vertigo of possibility.[7]

The early Sartrean problematics of movement and substantiality, of
consciousness and flesh, of journeying and dwelling are most fully elabo-
rated in the early novel *Nausea*. Although it is true that Sartre has under-
gone numerous and interesting changes throughout his career as a writer,
certain basic characteristics of Sartrean anthropology have remained unal-
tered since the publication of that novel.

Jeanson argues with some merit that the later work of Sartre moves in
the direction of societal concerns, with an emphasis on action and ethics,
and in so doing departs from the sphere of the more static, esthetic, on-
tological concerns of *Nausea*.[8] This argument is somewhat weakened, how-
ever, when, upon closer inspection, we discover that *Nausea* contains a
heroic dimension, and that its main character hides qualities of decisiveness
and forthrightness under an appearance of passivity. Roquentin is both a
victim tossed about by a mysterious fate and a hero on a journey of funda-
mental discovery. Historically, he is a relative latecomer in a long line of
protagonists whose task is to transform a perilous drift into a heroic jour-
ney. In this respect Roquentin also foreshadows the great subjects of Sar-
trean biography—Baudelaire, Genet, Flaubert. It is precisely this trans-
formation of drift into journey which characterizes the Sartrean man of
Being and Nothingness who, like Roquentin, must take upon himself the
impossibility and absurdity of his condition. *Nausea* is not merely an early
interesting effort, as some critics have maintained, nor is it a work that has
been surpassed or invalidated by its author's subsequent work. There is
virtually no major theme opened up in Sartre's later works which is not
foreshadowed in some way in this seminal work. The incisiveness of its
phenomenological analysis is only rarely even equaled elsewhere. It pre-
sents in its passionate and astonishingly accurate descriptions the very soil
and climate out of which the rest of Sartre's work grows. Above all, it has
the virtue of brevity, the virtue of sudden youthful passion, of seeing the
world entire in one brief, blinding flash. It remains a masterpiece and un-
doubtedly will endure the test of time.

From the foregoing it becomes clear that theoretical effort needs to be
understood within the context of journeying. All journeying requires an
askese, a divestment of riches, a surrender of the securities inherent in
being known in a familiar place, confronted by habitual tasks, speaking a
known language. Traditionally the one who seeks after truth or salvation
must accept this radical divestment, this loss, poverty, and celibacy which is

the lot of the stranger. Husserl speaks of the philosophic journey leading him to the brink of a precipice.[9] According to him, this journey must begin "in absolute poverty, with an absolute divestment of all knowledge."[10] He speaks of the phenomenological reduction as "an abstention."[11]

Sartre clearly has such an abstention and divestment of knowledge in mind when, in his biography on Genet, he writes: "Apart from the very particular case of philosophical intention one is rarely able to perceive creatures against the background of the universe because we are involved in the world and are equally a part of it." Sartre goes on to say that if someone under ordinary circumstances wanted to view the world in perspective "he would have to cut himself off from his function, his family, would have to break the bonds of his social relationships, and from his self-enclosed solitude, consider men as if they were painted objects."[12] It appears that Genet himself saw a similar "existential reduction" operating in his life. Sartre quotes him as saying: "The world of the living is never too remote for me. I remove it as far as I can with all the means at my disposal. The world withdraws until it is only a golden point in a somber sky."[13]

Roquentin stands clearly within the tradition of those investigators and thinkers willing to undergo the hardships of alienation. He is willing to surrender whatever comforts ordinary settled life has to offer in order to gain the freedom and mobility required to reach the distant shores of insight and grace. When the hero of the novel *Nausea* makes his first appearance, he already seems divested of all those functions, habits, possessions, and convictions which under ordinary circumstances sustain life and identity. We find him in a little apartment near the train station in a state of extreme isolation. He has the semblance of a slightly forlorn traveler as he eyes crowds of people leaving the station and attempts to make sense of a bewildering variety of new experiences that have assailed him. He is totally alone. He rents his meager quarters and lives on a small capital. He has no family, no real friends, no pet. He has no boss, nor has he any particular tasks to fulfill or hours to keep. He has the freedom of a solitary wanderer. From this stark beginning Roquentin's life proceeds toward an ever deeper alienation and an ever increasing penetration of a hostile nether world beyond the frontiers of human settlement. His entire life appears obsessed with divestiture, with preparation for and subjection to ever more rigorous journeys. The visceral image for this divestiture is nausea.

Roquentin attempts to cast off what he is about to lose. He continually tries to overtake and own his fate, yet he never quite succeeds. Whenever he incurs a further loss and feels his alienation intensified he experiences an attack of nausea. Sartre describes nausea as "a pure apprehension of the self as factual existence," as a "pure non-positional apprehension of contingency."[14] He also speaks of a "dull and inescapable nausea" as "per-

petually revealing the body to consciousness.''[15] This disquieting feeling is
normally dulled by an active transcendence, but it remains nevertheless
ever present as an inescapable concomitant of physical existence. Tran-
scendence hides it as the look hides the flesh, as the ordinary activities of
every day hide the ultimate groundlessness of human existence. From this
perspective we might understand Roquentin's attacks of nausea as the up-
surgings of his own contingency in situations where he is paralyzed by loss,
where loss impedes his transcendence and locks him in.

Nausea, as Sartre has maintained, constitutes a mode of living our
body; it also must be understood as a manner of living our world in its
aspect of *ground*. This ground must be recognized in both its aspects as *soil*
and as *basis*. The soil is the source of upsurge for all our necessities; it
ultimately nourishes us all. Nausea as interrupted digestion announces our
alienation from the soil and the retraction of a gentle bond of exchange.
Digestion is a gently whispered conversation with what supports and sur-
rounds us. Nausea is a rude awakening, a sudden recollection from a gentle
diffusion; it is the breaking of a comfortable tie. Poisoning and starvation
are extreme examples of such an alienation and retraction.

Nausea attacks come about most readily when we lose our sure
footing—in elevators, on trains, at sea—and when we are temporarily
alienated from our ground as *basis*. Generally, any extensive change that
threatens our security is apt to provoke some form of indigestion. Some
element of resistance always accompanies this anticipated or actually ex-
perienced change. Nausea bespeaks a reluctant radical break within our
environment, a loss of what has been taken for granted, a sudden departure
from known and trusted ways, an alienation from our ground as *soil* and as
basis. Nausea indicates loss of ground and reluctant departure.

As we have seen, Roquentin feels the upsurge of nausea whenever he
feels his alienation intensified, whenever he incurs some further loss of
ground. Thus he experiences nausea after giving up the one meaningful
activity around which much of his life has been organized, namely, his his-
torical research on M. de Rollebon. Similarly, he becomes nauseous when
he violently tears himself away from the company of the Self-Taught man
at the Maison Bottanet, and when he fears M. Fasquelle may have died,
and when he learns that Françoise of the Rendez-vous des Cheminots will
not be in. At times Roquentin is able to suppress his disgust by means of
anger, which allows him to gain ascendancy over a fate that he might
otherwise have to suffer passively. When images of death and mourning
seem to crowd in around him as he enters the portrait gallery of the vener-
able citizens of Bouville, he overcomes his apprehension and manages to
stifle his longing for the benevolent father-figures of his childhood with
carefully controlled outbursts of anger. He finally makes a grand exit and
hopes to divest himself of still another deep attachment. During this visit he

also refines his skill in the battle of looks which so dominates Sartre's early anthropology. Roquentin first practices this skill on a rather forbidding portrait of Philip II in the library of the Escurial and learns that he can reduce the searing flame of that look to harmless ashes, to the inert flesh of a conquered face. Yet these victories only mark losses. Roquentin steadily loses ground. Whatever touches his life is bound to be left behind. His relationship with Anny equally and constantly refers to loss and separation. The entire substance of their relationship appears to be encompassed by the elaborate farewells they manage to create. Following their final farewell, Roquentin suffers an overwhelming attack of nausea and appears at the brink of losing his sanity altogether.

The progressive loss of ground made palpable in nausea is also visible in Roquentin's deteriorating initiative. He begins to read a book on whatever page happens to present itself rather than first turning the pages and choosing where to start.[16] When he feels like lighting his pipe in the Café Mably he decides against it because it might attract the attention of others.[17] When he sees an exhibitionist approaching a little girl playing in the park, Roquentin finds himself unable to interfere. He cannot insert himself into the stream of events, and thus he remains captive within his role as a passive observer.[18] At times he becomes so absorbed or fascinated or frightened that his body appears to act wholly on its own: "My body slowly turns eastward, oscillates a little and begins to walk."[19] Strangely congruous with this progressive passivity of the diarist is the unconvincing manner in which he describes action. The occasional references to the faraway places he has visited sound hackneyed and fail to give us concrete, believable images. Roquentin is believable as an observer of life, but not as an active participant within it. He realizes this himself when he tells the Self-Taught man: "I never had adventures. Things happen to me."[20]

Yet we also gather that this statement can be no more than a half-truth. Roquentin, after all, is the diarist who tells this story, who makes these detailed and passionate observations and who constantly affects us. His language is anything but passive, shot through as it is with bile and venom. He may be in the grip of a catastrophic paralyzing force, he may feel himself moving toward chaos and obliteration, but even at the center of the storm his bearing is that of a fascinated and occasionally bemused observer. Roquentin never quite dissolves in his passivity. It is ultimately his spunk, his quality of being *trop volontaire*, which keeps him from going mad, from committing suicide or growing fat and white like the plants of Bouville. In this fundamental respect Roquentin resembles the Sartrean heroes Genet and Flaubert.

The themes of nausea, passivity, and alienation all in turn evoke the theme of *loss of ground*. This loss of ground can be lived as a fate to be

endured, as violence or madness, as the result of being conquered. But this same loss also can make its appearance in a different context as *abstinence*, as disciplined divestiture, as first requirement for a journey of discovery. We have made brief mention of the Husserlian *epochē* as a disciplined and provoked loss of ground which enabled the theorist to find access to the transcendental plane. In the diary of Roquentin there is a close and constant interrelationship between a loss of ground as provoked and a loss of ground as fate to be suffered and endured. The account is most moving when Roquentin attempts to transform one into the other, when he seeks to metamorphose the experience of rejection and the sense of loss into a heroic gesture of departure for high adventure. It is by means of these transformations that Roquentin's passivity is to be distinguished from the corrupt passivity of the Self-Taught man who listens so eagerly to other men's stories, who visits strange places only through other men's eyes, who docilely follows the established order of the alphabet, who lives his masculinity vicariously and shapes his life to conform to dreadful clichés. In contrast to this docile and self-ignorant passivity, Roquentin's renunciations at times glow with a mysterious initiative that appears to transform them into the opposite. He becomes capable of a kind of renunciation that gives access. His passivity is rescued from ultimate sterility by being owned and willfully lived through. Thus a fall is transformed into a jump, which in turn might be metamorphosed into a graceful flight. Such at least appears to be his fervent hope and covert project.

Seen from this perspective, the diary is a meditation on passivity, on its pitfalls and its possibilities. It is a record of a passivity both heroically endured and creatively lived.

Thus from a certain perspective everything happens as if Roquentin had hoped, by divesting himself of all attachments to everyday life and reducing his very being to a simple clear light of consciousness, to come into the presence of a totally available, absolutely self-evident and transparent world. It appears as if he had aimed to remove from his life whatever would be irrelevant to this absolute spectatorship, as if he had dreamed of reducing his entire life to the light in one unblinking cyclopean eye before which the world would slowly emerge in its entirety. If so, this calm and majestic moment never comes. Instead, a sudden reversal of initiatives overpowers Roquentin, removes from his hands the reins that guide his withdrawal. He is cast adrift in a frightful turmoil from which there appears no escape and he moves to the brink of insanity. His loss of ground is almost absolute, and suddenly he has nowhere to stand, nothing to get a grip on. Ordinary objects are transformed into amorphous bulging masses, words have lost their meaning. The order of initiatives that operates in the world of everyday living and determines relationships between the viewer

and his spectacle, suddenly reverses itself. The viewer suddenly feels himself stared down by the spectacle, an object in the foreground refuses to detach itself from its background, a tool takes hold of a hand, a bench rises up and rejects the imperial designations of its would-be users. Things discard their names and begin to throb outside the limits imposed by usage. A root swells till it breaks the shackles of language and moves beyond the confines of understanding and availability. An unsuspected hidden life emerges which overrules the most fundamental order of the visual and the tactile, which refuses the quiet demand of vision that the world spread out before it in visibility, which stares down the eye attempting to see, which lays hold of the hand trying to reach and to touch. Objects stir to a new and ghastly life of mindless, boundless abundance, shaking off their previous availability. Things no longer acquiesce in being things-used, things-seen, things-felt, things-named, things-owned, and things-understood. A strange kind of refusal comes to pervade Roquentin's world, rendering everything strange and ominous, paralyzing consciousness and freezing the body in the fixedness of fear and utter impotence. Cut off from the visible, vision shrivels; cut off from meaningful action the body becomes disorganized; cut off from a comprehensible, stable, available world, man becomes estranged from himself, becomes odd, useless, "schizophrenic," impossible, becomes *de trop*.

Roquentin has reached the limit to where surrender can lead him. He has given up whatever appeared to be detachable from his existence. Somewhat after the manner of a balloonist, he has made gains through progressive sacrifices. Now, suddenly, there appears no way to go. He has reached the very brink and the limit of his world. And when he tries to look over the edge he "sees" chaos. But chaos cannot be directly contemplated, since chaos is precisely that which refuses to arrange itself into a spectacle. Chaos signals the end of the reign of man, of the skill of his hands, of the power and the light of his eyes; it is a refusal of the human order; it will not submit to the primordial separation of path and landscape, of foreground and background, of first and last, of this and that. Chaos is not a spectacle; it is instead the loss of ground on the basis of which any spectacle whatsoever may appear.

Roquentin's attempt at transforming an aimless drift into a purposive journey can be understood as a search for ground. The difference between drift and journey refers us to an origin and a destiny. To be well-grounded is precisely to have contact with one's origin and destiny. Roquentin, and with him Sartrean man, never reaches the ground for which he searches. Therefore his drift is never entirely transformed into a journey. After traversing the length and width of his universe, after supporting his own alienation with the full force of his diminishing strength, after suffering

stoically the indignities of his nausea, he is faced with his ultimate groundlessness in chaos. The cruelty of this fate casts a kind of black light over nearly every aspect of the novel.

The fate of Roquentin is foreshadowed many times in *Nausea* in descriptions involving violated children. Not entirely guiltless, partly responsible and often fascinated at the beginning of their downfall, these raped and murdered children haunt the pages of the diary and underline a recurring theme of violated innocence. Roquentin meanwhile assents to his constant losses, to his progressive powerlessness, in the hope of the ultimate benevolence of the world and of others. Some deeply hidden aspect of him keeps believing that if he surrenders all, he will eventually acquire a solid footing, an absolute ground and foundation. He never attains this sure and final mooring. In this respect the theme of *Nausea* echoes the theme of *The Transcendence of the Ego*. Roquentin ultimately reacts with acceptance of the groundlessness of his existence. He conquers chaos in the same way he has conquered the nausea. "The nausea has not left me," he writes, ". . . but I no longer suffer it, it is no longer an illness or a passing fit, it is me."[21] He overtakes the nausea as he overtakes the initial drift, that is, by owning it fully. In accepting his groundlessness he paradoxically finds somewhere to stand. The chaos, like the nausea, will not disappear; it will become part of his world. Roquentin discovers its presence everywhere. Just beneath the world's thin veneer of pliability and apparent accommodation to human needs he now finds a vast subterranean realm of pure indifference. He discovers a kind of counter-reality which interpenetrates and underlies everything and surrounds it with a sinister aspect. He becomes aware of a strange mass of horrid vegetation proliferating outside the perimeter of the city.[22] Beneath the placid surface of the ocean Roquentin sees a cold, black, immense body crawling with animals.[23] Behind the patrician, authoritative look of the administrator he perceives a mass of loathsome, inert flesh. Beyond the fragrant garden with its lush abundance of trees dwells a secret malevolent intention.[24] Eventually the appearances and the surfaces of things can no longer be trusted to conceal their dreadful contents. A man may suddenly undergo a metamorphosis and start running backward like a crab. During a pleasant evening walk a respectable citizen may at any moment be surprised by a grimy piece of red meat crawling across the street, squirting blood as it passes. Or a man may be inspecting his mouth in front of a mirror and find a live centipede where his tongue had been before. These expressionist tendencies and surrealistic images must not be regarded as mere devices Sartre borrows from his surrounding culture. These images truly indicate Roquentin's new estimate of the measure of man, the circumference of his laws and the depth of his securities. A man who has experienced the groundlessness of chaos can no longer reassure himself

with the fact that lead melts at 335 degrees Celsius or that the city park closes at 6 P.M. The melting, the lead, and the temperature all are held together by a fragile human fabric, as are the timetable and the park. The entire empire of words, of numbers, of laws and the dependable regularities of custom and of the sciences is but a flimsy and already threadbare covering over an immense dominion of indifference. Whatever is steady, predictable, absolutely sure, whatever is *comme il faut* is also a sham, a lullaby for the faint-hearted. At times even the very diversity of things, their individuality, is only an appearance, a veneer. "This veneer can melt, exposing soft monstrous masses, all in disorder, naked in a frightful and obscene nakedness."[25]

What appears to be stable ground cannot be trusted, because of its ultimate indifference. What sprouts up out of the soil is equally suspect. The ultimate indifference of the ground contaminates all that grows out of it. Plants appear either as "castrated, domesticated and fat," or as "fearsome masses of hair lying in wait outside the city."[26] There are half-breed bastard trees held up with crutches, half-rotted oak trees "with voracious claws tearing at the earth, devouring its food."[27] Roquentin appears to be particularly fascinated by trees, and he almost never fails to describe their roots variously as "claws," as "wrinkled paws," or as "beastly knotty masses."[28] His perception doubtless is guided by his own struggle for secure ground, for roots, for an assured place. His famous revelation about "existence" comes about as he sits near a great chestnut tree and looks at its "massive roots sunk down into the earth."[29] At times he envisions consciousness as a tree, populated with fugitive presences hovering about it like birds.[30] But soon the imagery grows malevolent: the tree is abandoned and grows bored, the tree is assaulted by a flock of angry birds which make it bleed.[31] Roquentin looks upon vegetation with a mixture of disgust and envy that reflects his ambivalent feelings about the self-evident ties that connect a plant to its ground. A tree is at one with its ground, but man is his *own* ground in the manner of not being it.

The journey toward the absolute self-evident ground of existence has ended in failure. No amount of sacrifice expended in even the most strenuous journey can bring man within reach of an absolute self-evident ground beyond all contradictions. Man cannot *be* the total self-coincidence of a rock, nor can he achieve the absolutely self-evident relationship of a tree to the ground in which it is rooted. It is man's constant obligation to exist as a being that perpetually effects within itself a break in being. Man must exist forever "in the form of an elsewhere in relation to itself."[32] But maybe man can achieve an absolute self-justification and ground by means of a work of art. Maybe the embarrassing clutter and proliferation of ordinary life can

for a moment, if only in retrospect, achieve some justification as the substratum of something that is both undeniable and enduring. Maybe life can be the broad pedestal for a work of art.

Roquentin has survived his severe crisis in the city park. He is about to board the train for Paris and leave Bouville for good. An impulse makes him visit his old hangout near the station to say goodbye to Mme. Jeanne, the patroness, and to hear for the last time his favorite tune, "Some of These Days. . . ." When he enters the cafe he notices without much apparent emotion that the patroness is already involved in another affair: Roquentin's place has been taken by someone else. Life is going on in this little cafe and it is already passing him by. He abruptly finds himself in the awkward position of being a flesh-and-blood memory, an obtrusive relic of bygone days. Thus he relives again his groundlessness, his being *de trop*, his utterly shameful superfluousness. He asks the waitress to play his favorite record. The jazz saxophone solo puts him into a profound reverie. He reflects on the directness and grace of four clear rhythmic tones on the saxophone, neatly separated and yet effortlessly connected. His thought moves from the sparse, unencumbered musical sounds to the entanglements and clutter of his own life and he feels ashamed. He feels ashamed before the useless profusion of dirty beer glasses on the counter, before the heavy undisciplined sadness that engulfs him. He would like to soar with those clear bright bursts of sound, cleaving through space and time, unencumbered by existence. Now Roquentin feels the nausea, "timid as dawn," impinging on his awareness. It lies there, waiting, like the stale warm beer remaining in the bottom of his glass. He would like to "drive existence out of himself," he wants to "rid the passing moments of their fat, to twist them, dry them, purify himself, harden himself" in order to be able "to give back at last the sharp, precise tone of a saxophone note."[33] Roquentin dreams of further sacrifices, of reducing his life to the point where it would no longer occupy space. He dreams of transforming his life into a pure effectiveness without encumbrance and therefore without ambiguity. He would like to be a pure melodious breath, encompassing all, reaching everywhere without subjection to humiliating and ambiguous alliances with flesh, with matter, with the ground. We recall here Sartre's early description of consciousness "as purified, as fresh as a strong wind blowing," and as a "perpetual gliding beyond itself."[34]

Roquentin tries to imagine how the song came to be written. From where arose this "white acidulated sound" of the saxophone? His imagination carries him to a cluttered apartment in a New York skyscraper. The situation in New York, as he comes to imagine it, is not dissimilar to his own. The composer is suffocating with heat, he is worried about bills to be

paid, his ashtrays fill up, his apartment is in disarray. But out of this clutter there emerges a fierce and undeniable sound. In a similar manner, it might just be possible that out of the shambles of his own disorganized life there will emerge some day a story "as beautiful and as hard as steel," which in its turn "will make people ashamed of their existence."[35]

It is in a similar manner that Alcibiades speaks in the *Symposium* about the powerful effect of Socrates' words. He too has first noted the clear sound of a flute as played by Marsyas, a famous composer and virtuoso. "Now the only difference, Socrates, between you and Marsyas is that you get the same effect without any instrument at all." Alcibiades then confesses that Socrates' words move him to a point where he feels ashamed of his life.[36] The similarities between the two accounts are striking. Yet there is also a fateful difference. Alcibiades is recalled from his wayward ways by the words of Socrates. These words call him to a common ground from which he has strayed and to which he has lost access. Roquentin is not called to a common ground by the sound of the jazz saxophone. Rather, he is reminded of how a man, if he really tries, can himself work to secure the ground on which to stand. Existence can secrete its own essence, its own incorruptible foundation. The sweaty American composer has succeeded. His past stands triumphantly on those four hard, incorruptible tones from a silver saxophone. Roquentin might in retrospect stand equally justified on the sure foundation of his own words. Each man can stand secure on a platform of his own making. Each man can be saved by the work of his own hands and, like Noah, float in safety above the terrifying Chaos.

Alcibiades can recover his ground through Socrates after going astray. Roquentin, however, must live with the knowledge of the ultimate groundlessness of his existence. He may stir the depths of feeling in those who read his story. But he will not be able to stir that vast indifferent ground above which he floats, to persuade it to grant him a place, to nourish him in generosity, to receive him in hospitality when he dies.

Roquentin's brief, passionate hope for a rooted existence is crushed once and for all during his painful crisis in the city park. Sartre's first novel can be understood as an effort at exorcism, as a manner of overcoming a primordial longing which must be laid to rest if life is to move on in new directions. Yet this longing remains everywhere present in this novel as well as in all his subsequent philosophical and literary works. Part of this longing for absolute justification and support, which is also the longing for paradise, is transformed into labor. The contemplative, passive attitude is transformed into an opposite, activist, stance of involvement and responsibility. This transformation never quite succeeds, however. A countervailing

deeper passivity often appears to be working secretly to undermine what is forthright in Sartrean characters. Their decisiveness is frequently robbed of its truth and almost always of its joy.

This longing for the solid and self-evident union of the tree and its ground is elsewhere expressed in Sartre's work in the form of a heightened sensitivity for what is separate and apart. In particular, it appears that the longing for the self-evident unity of self and its ground is transformed into a zeal for discovering dichotomies. The title of Sartre's first great philosophical work reflects a fundamental dichotomy, and its contents similarly reflect an almost exclusive concern for what is separate and cannot be joined together. The zeal for discovering what is irreconcilable and opposite also makes its appearance in Sartre's purely descriptive and literary work. The description in *Nausea* of a nice young couple at lunch quickly turns to an examination of the insincerities and falsifications that are at work underneath the harmonious appearance. Similarly, a pleasant view of a calm Atlantic on a Sunday afternoon quickly gives rise to thoughts about the horrors that might lie hidden beneath the surface of the waters. Everywhere in Sartre we find this acute awareness of contrasts, this continual discovery of a lack of continuity and support below what is placid and reassuring.

This same trend makes its appearance in a slightly different form as an ever present awareness of the possibility of rupture. The *epochē* which Husserl presented as a difficult and gradual procedure becomes for Sartre a constant threat of sudden rupture.[37] Similarly, the calm and reassuring aspect of our surroundings is in constant threat of being disturbed by the look of the Other.[38] The hand that touches a doorknob can be frozen in its intention by being touched in turn.[39] Man forever runs the risk of being stopped in his tracks by an alien initiative. Man is constantly threatened by a sudden rupture, by a reversal which tears away the surface appearances and reveals his ultimate groundlessness.

We have noted how the hidden longing for ultimate stability and ultimate justification makes its appearance through sensitivity for what is separate, contrasting, irremediably isolated, and through a constant awareness of possible ruptures in daily life. This longing also makes its appearance as a horror of stagnation. In this horror the very longing for a standing or lying on solid ground is transformed into its opposite. A longing for stable ground triggers a fear of being pinned down or held back. We should briefly remind ourselves here that to sit down or to lie down usually indicates a bond of trust. Standing, sitting, lying down constitute ways of enjoying a secure foundation. It is on water or on thin ice or on a snowy slope that we must keep moving and cannot afford to stand still or rest. On the other hand, it is possible to sustain an upright position on water or on soft

snow as long as we maintain uninterrupted movement. Sartre is particularly fascinated by the water-skier who through his use of speed stays above the water and appears to defy an unstable foundation. The sliding stance of the skier becomes for Sartre the very image of consciousness. He maintains in *Being and Nothingness* that "to slide is the opposite of taking root. . . ."[40]

Elsewhere he writes: "Water is the symbol of consciousness; its movement, its fluidity, its deceptive appearance of being solid, its perpetual flight, everything in it recalls the for-itself."[41] The horror of consciousness in its most virile form is to be stopped and to stagnate, to be overcome by semi-solidification. The tremendous tour de force of phenomenological description at the close of *Being and Nothingness* concerns precisely the quality of the viscous, of what is sticky and slimy, of what opposes free flow. "Slime is the death struggle of water. . . ."[42] This consciousness-as-water has no connection with the earth except to be stirred into mobility by its dangerous downward pull. This water no longer *belongs* to the earth. Its foundation is not that of cleansing or irrigating. It is not the water that stirs the earth out of its crusty dreams into new life. Rather, this water's sole delight would be its own silvery mobility, its own unpredictable cascading dance of freedom. The great horror of this water is to be stopped, to be subjected to mixture with dust and earth, to be absorbed and used. The great task of this water is to keep running.

This early thought of Sartre can be seen to enlarge upon and radicalize a theme that has been slowly emerging from its various contexts in Western societies over the last two centuries, and that only in recent years has begun to reveal its true dimensions. This theme concerns the apparently unceasing preoccupation of Western humanity with mobility and speed, with the growing distrust of solid ground and the constant search for what is new and changing. It concerns the flight from the sphere of contemplation, the decreasing affinity for cultivation, the distrust of and the impatience with natural processes. This theme can also be read as the disequilibration of an ancient relationship between two mutually interdependent spheres of life, namely, the sphere of dwelling, of cultivation, of relationship to a stable ground, and the sphere of journeying, of the pursuit of the distance. These two realms traditionally served each as a basis for the other. It was the age-old task of the one who dwells to be at the service of the one who journeys. The great authority of the ancient laws concerning hospitality can be seen in this light. It was the task of the one who travels to situate the place of dwelling within a larger universe. The one who dwells remains of necessity tied to what is nearby; to dwell means to allow oneself to become absorbed in a smaller world. The one who dwells must be willing to forgo the distance, the great truths at the horizon, the temptations of the straight path, in order to be available to respond to the demands of his daily rounds.

He must allow himself to be moved along in narrow circles of recurrent tasks, within the ebb and flow of days and seasons.

Such a world of dwelling, of preoccupation with what lies near at hand, expresses itself through cultivation and craftsmanship, through slow enhancement of whatever is met in daily rounds. The one who lives in the sphere of dwelling is easily moved to embroider, to polish, to tend what is given, to proceed carefully within circles. The one who travels exposes himself to what is radically new. He accepts being uprooted, he gives in to the call of the distance, divests himself of what would hold him back, submits to the discipline of the straight path. The path urges him on and limits his participation in the surrounding world to observation and to only intermittent periods of restoration. His great task is to keep moving, to overcome the longing for his home and to master the impulse to get sidetracked and forget about the road. But the one who dwells must move in a different manner, so that whatever needs his care can call out to him and engage his skills. It is precisely this giving in to what requires care, this curbing in responsiveness that creates the space of dwelling. It is this making of the rounds, this tireless circling about a narrow center which creates a space for children, for crops, for needful things and beings.

Dwelling creates a place of cultivation and increase. Its vitality is that of fertility; it works toward and celebrates abundance. The vitality of journeying is its endurance and its courage. It is the overcoming of involvement, the negation of temptations, the resolute drive toward the distance and the future.

The modern world, with its radical emphasis on progress and mobility, has long ceased to accord an honored place to dwelling. The Sartrean world reflects this modernity, draws it from its hiding places into a heightened visibility.

In Sartre's *Nausea,* dwelling is described either as a form of bourgeois degeneracy or as peasant animality. Plant life becomes incomprehensible, threatening, and vaguely disgusting. Soil becomes a mineral, fertility a form of stupidity and degeneracy. The beauties of nature become insincere inventions of bored vacationers fleeing their city in the summer.

Within this modern context, dwelling ceases to be the basis, the beginning and the end of journeying. Dwelling becomes the death struggle of journeying. And journeying, liberated from its origins and destinies and therefore freed of all itineraries, becomes pure free movement, unfettered spontaneity.

But in this radical separation both dwelling and journeying are destroyed. The realm of dwelling, deprived of the connecting, intertwining role of journeying, cut off from the saving contact with the distance, disintegrates under its own weight. And journeying, cut off from its base and

harbor, becomes an obsessive departure, an empty frenzy without content. Within this context the theoretic journey no longer can be accomplished, and thought is indeed condemned to become a useless passion. It is clear that the philosophical and societal problems which came to light in *Nausea* and *Being and Nothingness* require a new manner of framing the question of praxis and thought, that they impose the demand for a new dialectic between the polis and the theoretic journey, between ground and horizon. These works show the impasse in our understanding of society, of work, of thought and nature. All the later works of Sartre circle around the problems raised in these early writings. And these problems remain active in our life: they are embedded in our society and continue to demand our labor and our thought.

BERND JAGER

DEPARTMENT OF PSYCHOLOGY
SONOMA STATE UNIVERSITY

NOTES

1. Jager, B. "Theorizing, Journeying, Dwelling," *Review of Existential Psychology and Psychiatry*, 13, no. 3 (1974).
2. Sartre, J.-P. *Situations*, I (Paris: Gallimard, 1947), p. 33.
3. Ibid., p. 35.
4. Ibid.
5. Sartre, J.-P. *The Transcendence of the Ego*, tr. by Forrest Williams and Robert Kirkpatrick (New York: Farrar, Straus and Giroux, 1971), p. 103.
6. Ibid., p. 98.
7. Ibid., p. 100.
8. Jeanson, F. J., *Sartre par lui-même* (Paris: Editions du Seuil, 1955), p. 169.
9. Husserl, E. *Cartesian Meditations*, tr. by Dorian Cairns (The Hague: Martinus Nijhoff, 1960), p. 23.
10. Ibid., p. 2.
11. Ibid., p. 19.
12. Sartre, J.-P. *Saint Genet*, tr. by Bernard Frechtman (New York: George Braziller, 1963), p. 478.
13. Ibid.
14. Sartre, J.-P. *Being and Nothingness*, tr. by Hazel E. Barnes (New York: Philosophical Library, 1956), pp. 342, 338.
15. Ibid., p. 338.
16. Sartre, J.-P. *Nausea*, tr. by Lloyd Alexander (Norfolk, Conn.: James Laughlin, 1959), p. 67.
17. Ibid., p. 99.
18. Ibid., p. 109.
19. Ibid., p. 214.
20. Ibid., p. 53.
21. Ibid., p. 170.
22. Ibid., p. 208.
23. Ibid., p. 167.
24. Ibid., p. 181.

25. Ibid., p. 172.
26. Ibid., p. 209.
27. Ibid., p. 179.
28. Ibid., p. 171, 174.
29. Ibid., p. 170.
30. Ibid., p. 227.
31. Ibid., p. 213.
32. *Being and Nothingness*, p. 78.
33. *Nausea*, p. 234.
34. *Situations*, p. 33.
35. *Nausea*, p. 237.
36. Plato, *The Collected Dialogues of Plato*, ed. by Edith Hamilton and Huntington Cairns (New York: Bollinger Foundation, 1969), *Symposium* 216b.
37. *The Transcendence of the Ego*, p. 103.
38. *Being and Nothingness*, p. 255.
39. *Nausea*, p. 19.
40. *Being and Nothingness*, p. 584.
41. Ibid., p. 610.
42. Ibid.

22

Oreste F. Pucciani
SARTRE AND FLAUBERT AS DIALECTIC

S ARTRE has said that from early adolescence he experienced both attraction and repulsion upon reading the works of Flaubert. He has even spoken of a "score" to be settled with Flaubert. "How was such a man possible?" he asks. He further states that he began writing about Flaubert out of antipathy, that his antipathy gradually turned to empathy and finally to a kind of sympathy. If one reflects that Sartre's "score" with Flaubert lasted for more than fifty years and was settled only after the nearly three thousand pages of the "Flaubert" were written, one is obliged to conclude that something more than ordinary sympathy and empathy were involved. Indeed, it would seem that Flaubert's life and work hold one of the keys to Sartre's philosophy. It will be our purpose here to seek out this key and to inquire what "score" needed settling and how it was finally resolved.

Sartre tells us in *The Words* that he taught himself to read at the age of four by deciphering a copy of *Sans Famille* by Hector Malot, and that he read *Madame Bovary* for the first time in 1912–13.

> I reread the last pages of *Madame Bovary* twenty times. I finally knew whole paragraphs by heart. Still the poor widower's conduct became none the clearer to me. He found letters. Was this a reason for letting his beard grow? He cast a somber glance in the direction of Rodolph. He consequently bore him a grudge. Why exactly? And why did he say to him: "I don't resent you"? Why did Rodolph find him "funny and a little base"? Then Charles Bovary died. Of grief? Of sickness? And why did the doctor open him up since everything was finished?[1]

In short, Sartre read *Madame Bovary* at age seven or eight and did not understand it. This is not surprising, inasmuch as *Madame Bovary* was not written for children. What Sartre did not understand, of course, was the central theme of the book: adultery in the French provinces in the mid nineteenth century. But there were other things about the book which Sartre did understand, even as a child:

Editor's Note: All translations of passages quoted in the text are by the author.

I loved the tough resistance I could never master. Mystified, exhausted, I took delight in the ambiguous, sensuous pleasure of understanding without understanding. Here was the consistency of the world. The human heart, which my grandfather was so fond of talking about at home, seemed insipid and hollow to me everywhere except in books. . . . I said "Charbovary" and I saw nowhere a tall man with a beard, dressed in rags, walking inside a walled-in yard. I couldn't bear it.[2]

"Nowhere": this is Sartre the philosopher speaking in 1963. But "I couldn't bear it": this is certainly the residue of an authentic childhood memory. What Sartre was "understanding without understanding" was his own mind as it encountered the world of the imagination. His early reading experiences had a nightmare quality which fostered what he describes as "two contradictory fears" that often assailed him:

> . . . two contradictory fears . . . I was afraid that I would fall headlong into a fabulous universe and wander there forever in the company of Horace, of Charbovary, without any hope of finding again the Rue Le Goff, Karlémami, or my mother. . . . I was introducing into my head, through my eyes, poisonous words infinitely richer than I knew. An unknown force inside myself was reshaping, by means of speech, stories about mad people that didn't concern me. . . . Would I not become infected? Die of word-poisoning? Absorbing the Word, absorbed by the image, I was saved, finally, only by the incompatibility of these two simultaneous perils.[3]

It is not clear how Sartre concluded he was saved by this situation, since words and images may be perfectly compatible. But what does seem clear is that even as a child Sartre was experiencing the nature of the imaginary as against the real. He seems to have lived these two dimensions of human reality in some sort of fundamental anguish. They created stress within his mind. He says:

> At the end of the day, lost in a jungle of words, startled by the slightest sound, . . . I seemed to be discovering language in a state of nature where there were no human beings. With what cowardly relief, with what disappointment I would find myself back in the banality of my family when my mother would come in and exclaim: "But my poor dear, you will ruin your eyes!" Wild and drawn looking, I would jump to my feet, shout, run around, play the fool. But even in my reconquered childhood I would fret. What do books talk *about*? Who writes them? Why?[4]

Meanwhile, the word-poisoning had occurred and something of Flaubert had passed into Sartre: words as ends in themselves rather than as means. The grievance was beginning to take shape. It was soon to be compounded from an unexpected source: "I spoke to my grandfather about my anxieties. He thought for a moment, then decided to set me straight. He was so successful that he left his mark on me."[5] The mark was this:

> Stained glass windows, flying buttresses, carved church portals, chorales, crucifixion scenes cut in wood or stone, meditations in verse and poetic harmonies,

these were "Humanities" that led straight back to the Divine. All the more so as they included the beauties of nature. A single breath shaped the works of God and the great works of men. The same rainbow gleamed in the froth of waterfalls, glistened between the lines of Flaubert, glimmered in the chiaroscuro of Rembrandt: it was the Spirit.[6]

Karl Schweitzer, Sartre's grandfather, was a cultural product of the nineteenth century. An Alsatian, a teacher of German in France, his academic culture worked on the young Sartre like an epitome of History: Romantic fervor, Art for Art's Sake, Parnassian hard work. Though he had never read Flaubert, he used his powerful example to instruct the boy:

> Ah! said my grandfather, it is not enough to have eyes. You must learn to use them. Do you know what Flaubert did when Maupassant was a child? He sat him down in front of a tree and gave him two hours to describe it.[7]

And Sartre adds: "So I learned to see. . . . I observed."[8] It is interesting that Sartre's most famous literary description should be that of a tree!

Karl Schweitzer never intended that his grandson should be a writer; he hoped instead that he would enter the Ecole Normale Supérieure and pursue an academic career. To foster this purpose, he employed an intellectual sleight-of-hand that worked an insidious cultural reversal in the boy's mind. He urged the need for a second *métier* that would provide the young writer with the material security which the calling of letters required. It was a subtle form of brainwashing, and ultimately it resulted in a measure of success, for Sartre eventually did attend the Ecole Normale and establish an academic career. Tactfully and by means of a fundamental confusion, Schweitzer persuaded his grandson that an aristocracy of Pedagogy was grounded in an aristocracy of Art. It was Flaubert all over again, although neither "Poulou" nor his grandfather knew it. It worked:

> I identified the author with the pupil, the pupil with the future teacher. It was one and the same thing to write and to teach grammar. My socialized pen fell from my hand and it was months before I took it up again.[9]

Fortunately, it also operated in reverse. "Pure Art" had been a praxis by means of which creative individuals inserted themselves by contestation into the nascent industrial society. When Sartre made his acquaintance with this same society two or three generations later, he rediscovered their praxis by dint of its inherent contestation. Nudged in the direction of what he would one day call "Neurosis Art" by his grandfather—who had hoped to kill art with art, spirit with spirit, and culture with culture—Sartre began laying the groundwork for what he would one day call his own "neurosis" and at the same time derived an extraordinary energy from his efforts. He worked at it:

> . . . the wild beasts of the world . . . had every leisure to slaughter each other or to live out their truthless, dazed existence as best they could, since writers and

artists meditated for them on Beauty and on the Good. . . . I dug up this fero-
cious old religion and made it mine in order to adorn my dull calling. I drank in
rancor and bitterness that had nothing to do with me or with my grandfather.
The old jaundiced rages of Flaubert, the Goncourts, Gautier poisoned me.
Their abstract hatred of mankind, which I swallowed in the guise of love, in-
fected me with new pretensions . . . a viper's tangle that would take me thirty
years to undo. . . . [I]t never occurred to me that one could write in order to be
read.[10]

In short, Sartre had re-invented the doctrine of the artist's mandate.
He had turned himself into a child mandarin so that he could one day
destroy the mandarinate. But all of this might have amounted to nothing
more than an elaborate alibi had it not been accompanied by a fundamen-
tal choice of the real, a choice which Sartre had made by the age of twelve
and which relentlessly infected the example of Flaubert with negativity.

One morning in 1917, in La Rochelle, I was waiting for some school friends
who were to accompany me to the *lycée*. They were late. After a while I found
myself at a loss as to how to amuse myself. I decided to think about the Al-
mighty. He instantly toppled out of the sky and disappeared without leaving
any word of explanation. "He doesn't exist," I said to myself with polite sur-
prise, and I thought the matter settled. In a way it was, because I have never
since been tempted to revive him. But the Other remained, the Invisible One,
the Holy Spirit, who was guarantor of my mandate and who ruled over my life
by means of great, anonymous, sacred forces. . . . I was churched.[11]

What is striking about this recollection is the apparently complete lack
of anguish with which Sartre perceived that God did not exist. One is in-
evitably reminded of his definition of the atheist as a person who decides,
once and for all, that God does not exist. "I *decided* to think about the
Almighty. He *instantly* toppled out of the sky. . . . He doesn't exist . . .
polite surprise. . . ." Here is a kind of natural atheism quite astonishing in a
boy of twelve living in France in 1917. It suggests that on that morning in
La Rochelle Sartre *decided* God did not exist; if he was able to do this, he
already possessed a very firm grasp of reality.

The score with Flaubert had deepened. Henceforth, the "poison"
which had been injected into Sartre's veins by Flaubert's words and images
would have to contend with a fundamental position of Sartre's own mak-
ing. "No, I do not think there is any merit in saying I am discovering myself
in Flaubert," Sartre has said. But he said at the same time:

The child whose portrait I am painting in implicit opposition to the child Gus-
tave, the little boy who is so sure of himself, who possesses deep certainties
because in his first years he had all the love a child needs in order to make
himself into an individual and to build an ego that dared to affirm—that little
boy is myself.[12]

Sartre entered the Ecole Normale Supérieure in 1924 and remained
there until 1929. During these years he prepared himself for the academic

career for which his grandfather had hoped. On another level, however, he was vigorously pursuing a personal literary career and simultaneously investigating the realm of philosophy. Significantly, the main focus of his philosophical studies was the imagination, which was the subject of the thesis he presented for his *diplôme d'études supérieures* in 1926. His thesis was directed by the noted aesthetician Henri Delacroix, a professor at the Sorbonne. It was also during these years that Sartre "reread closely" the works of Flaubert.[13] What was his frame of mind?

Concerning Sartre at this period of his life, Simone de Beauvoir tells us that at the Ecole Normale Supérieure he adopted as a slogan: "Science is nothing; morality is asinine."[14] She further tells us that he refused to separate philosophy and literature: "He liked Stendhal as much as he liked Spinoza."[15] And speaking of Sartre and his friends: "All of them had drawn out the consequences of the non-existence of God much more radically than I, and had brought philosophy down from heaven onto the earth."[16] Nonetheless, the Holy Spirit remained: "Sartre had an unconditional faith in Beauty which he did not separate from Art."[17] Of this confusion, which Sartre would call his "neurosis" and which was also a strength, Simone de Beauvoir writes: "The originality of Sartre was to grant full weight to reality while at the same time granting to consciousness a glorious independence."[18] As to their social views, she says: "Together we tore the bourgeoisie apart. In Sartre and in me this hostility remained individualistic, hence bourgeois. It differed very little from that of Flaubert towards his 'grocers' and that of Barrès towards his 'barbarians.'"[19]

Sartre has described his own frame of mind while at the Ecole Normale and at the Sorbonne as a curious mixture of acceptance and revolt:

> When I was a student, a very small "élite" went to the University. If one had the added "luck" to get into the Ecole Normale, one enjoyed every material advantage. In a sense it was the university *system* that formed me much more than my teachers, because in my time, with one or two exceptions, the teachers were very mediocre. But I accepted the system, and even more the Ecole Normale, as absolutely natural. As the son and grandson of *petit-bourgeois* intellectuals, it never occurred to me to doubt it.[20]

But there was revolt as well. In an interview in 1960 Sartre said to Madeleine Chapsal:

> When I entered the Ecole Normale, no one . . . would have dared to say that one should refuse violence. Our concern was principally to channel it, to limit it. A well behaved violence, and profitable. We were for the most part very mild, and yet we had become creatures of violence because one of our problems was to know whether a given action was an act of revolutionary violence or whether it went beyond justifiable revolutionary violence. This problem has remained with us. We shall never solve it.[21]

If Sartre was indeed rereading Flaubert closely in this general context, he must already have seen that Flaubert presented many irreducible con-

tradictions. Certainly such an awareness lies behind his question to himself: "How was such a man possible?" To a young philosopher already in possession of many of the basic instruments of his future philosophy, this question must also have been a way of asking: "How is such a man as Sartre to become possible?" In other words, Sartre was already beginning to live what he would later explain by means of Flaubert: "the hiatus between the work and the life."[22] It is reasonable to imagine that at this point in his life Sartre normally would have expected this "hiatus" to be explained by the reigning ideologies at the Ecole Normale and the Sorbonne, the two most elitist intellectual institutions not only in France but in the entire world. These institutions in fact proffered only the two options of aesthetic idealism and literary Positivism by way of explanation.

Aesthetic idealism was a noble but confused philosophy that granted to consciousness the "glorious independence" which Sartre retained in his own philosophy. Essentially all it did, however, was to translate into aesthetic theory the implicit Platonism of the idea of "Pure Art" as it was developed in the nineteenth century. In order to explain the "man" and the "work," it required a theory of emanation, which in turn required a theory of immanentism. Henri Delacroix wrote in his *Psychologie de l'art*: "The work is a necessary emanation, co-eternal with the artist. The artist is the work itself."[23] Thus artists serve a kind of natural spiritual function because their works permit others to accede to consciousness of self. It is not surprising that Delacroix cited Flaubert to substantiate this view: "Great geniuses," Flaubert had written, "bring new characters to the consciousness of the human species. Do we not believe in the existence of Don Quixote as we believe in the existence of Julius Caesar?"[24] Sartre could not agree with such a statement.

Literary Positivism was rather more *terre à terre:* it saw the literary work in terms of causality. The work did not emanate from the man; the author authored the work. However, the author was himself authored by universal determinism. After 1880 literary Positivism, or "Literary History," as it was called, became the official ideology of French literary pedagogy. Its most powerful spokesman was Gustave Lanson, director of the Ecole Normale Supérieure from 1920 to 1927. Lanson's *History of French Literature*, first published in 1894, became for a time a veritable bible for academic culture even beyond France. Under its influence, the study of literature was supplanted by the study of the history of literature: literary works were to be read as the "perpetual illustration" of literary history and at the same time as leading to its "final goal."[25] But what was this final goal? On this point Literary History was extremely vague. It was ultimately the inert unintelligibility of the union of "man" and "work." It was "Spirit" and "Genius" in disguise: ". . . it is precisely this indetermi-

nate, unexplained residue that is the personal contribution of Corneille or of Hugo," wrote Lanson. "It constitutes their literary individuality."[26] (It is amusing to recall that in 1925, while a student at the Ecole Normale, Sartre played the role of Lanson in a play entitled *Le Désastre de Langson*.)

Clearly, literary idealism and literary Positivism both contained the same principle: whether one says that the work emanates from or is caused by the writer, we are left to suppose that some mysterious privilege of genius is at work in the creative process. Paul Nizan, who was Sartre's roommate at the Ecole and by far the more radical of the two, spoke of their teachers as "patient accomplices of the poets."[27] In *The Words*, Sartre says: "The word 'genius' had always appeared suspect to me. Ultimately I came to hold it totally in disgust. What of anguish, of proving oneself, of temptation overcome, of merit, if I had the gift?"[28] And in *Saint Genet* Sartre declared: "Genius is not a gift, but the solution one invents in desperate cases." At a time when Sartre was beginning to invent his own solutions, when in philosophy he was beginning to discover the radical difference between perception and imagination, he must have found these pseudo explanations trying and, worse, terroristic. Here was a bourgeois cultural institution supporting itself by an unspoken alliance with the arts and finding its justification in confusions which it could not disentangle because it lacked the intellectual instruments to do so. I would speculate that it was at this point that Sartre discovered and began to practice a fundamental principle of his emerging methodology: to distinguish without separating in order the better to relate. Clearly it would become necessary to distinguish the "writer" and the "work," since they had been so irrationally conjoined. It would be a long time before Sartre would be able to join them, but already he was living the dialectic of their difference in his own person, by admiring and detesting Flaubert.

Simone de Beauvoir writes of a great change that came over Sartre as a result of his war experiences: "His optimism had not been destroyed by the events. This did not surprise me. . . . What did unsettle me was the rigidity of his moralism."[29] She adds later: ". . . he surprised me in still another way. If he had come back to Paris, it was not to enjoy the comforts of his freedom, but to do something. . . . [W]e had to break out of our isolation, unite, organize the resistance."[30] This was, in fact, what Sartre did. He resumed teaching, wrote voluminously, and plunged into political activity. In 1943 he decided to create a politico-literary review after the war. The first issue of the new *Les Temps Modernes* appeared in October 1945. The vogue of Existentialism began. It was a period of dynamism and great intellectual certainty for Sartre. From a cluster of his works that appeared between 1943 and 1947—*Being and Nothingness* (1943), the introduction

to the *Ecrits intimes* of Baudelaire (1946), *What Is Literature?* (1947)—it became clear not only that Sartre was engaged in creating an abstract theory of human nature, but also that he had encountered a rigorous problem of art. "Engaged literature" was his militant response; it reflected his decision to inject social questions into the problem of the arts and to declare that ethical questions could not be avoided in any human enterprise. His challenge struck at the autonomy of the arts and at the corollary of that autonomy, gratuity: the *bibelot d'inanité sonore* of Mallarmé. "Universal Art" was no more a reality and of no more use than "Universal Principles," "Eternal Values," or "Universal Human Nature." As one might expect, Flaubert figured in these discoveries:

> The moment when I really confronted Flaubert came during the Occupation, when I read the four volumes of the *Correspondence* published by Charpentier. I found at the time that I disliked the man, but I found elements in the correspondence that clarified the novels for me. After some reflection I told myself in 1943 that one day I would certainly write a book about Flaubert.[31]

In reading the Flaubert correspondence Sartre came upon such statements as these: "Neo-Catholicism and Socialism have stupefied France. Everything goes on between the Immaculate Conception and the workers' lunch boxes"; "the first remedy would be to do away with universal suffrage, the shame of the human spirit"; "I have no hatred for *communeux* for the simple reason that I don't hate mad dogs"; "the common people are eternal minors; they will always be on the bottom because they are number, the mass, the limitless"; "Do you believe that if France, instead of being governed by the masses, were in the power of the Mandarins, we should be in such a predicament?"[32]

In the climate of the Occupation such statements were intolerable; it became obvious that when the schools said "genius" they should have said *salauds* and *lâches*! Just what did Lanson mean when he called Flaubert an "excellent man"? It is not surprising that Sartre wrote in the "Presentation" of *Les Temps Modernes* in 1945:

> All writers of bourgeois origin have known the temptation of irresponsibility. For a century it has been a tradition in the career of letters. . . . The theoreticians of Art for Art's Sake and of Realism have fixed [the writer] in this opinion. Has it been noticed that they have the same purpose and the same origin? . . . The Realist is a glad consumer. As for producing, that is another matter. Someone told him that Science was not concerned with the useful and so his ambition is the sterile impartiality of the scientist. . . . Thus the disinterestedness of pure science amounts to the same thing as Art for Art's Sake. It is not a matter of pure chance that Flaubert is at the same time a pure stylist, a pure lover of form, and the father of Naturalism.[33]

And more specifically:

Flaubert, who so railed against the bourgeoisie and who thought that he had stepped aside from the social machine, was for us nothing more than a man with a private income and talent. Doesn't his minute art presuppose the comfort of Croisset, the solicitude of his mother or his niece, an orderly government, and coupons to clip regularly?[34]

In the aftermath of world fusion in war and occupation, Sartre could write: "We recognized history and ourselves in history. We were a long way from Flaubert and Mauriac."[35] And so, finally, the confrontation became public and official. Sartre threw down the glove and challenged Flaubert in a statement that many found shocking and even scandalous at the time: "I hold Flaubert and Goncourt responsible for the repression which followed the Commune because they did not write one single line to prevent it."[36]

Sartre had built his new concept of "engagement" into the theoretical structure of *Being and Nothingness*. The purpose of *Being and Nothingness* was to create a total theory of universal individual man grasped by means of an ontology that made freedom a *sine qua non* condition of human consciousness itself. This was the "glorious independence" of which Simone de Beauvoir has spoken. It was also, to use another phrase coined by her, Sartre's way of "saving the reality of the world,"[37] of "understanding the real in its synthetic truth."[38] "Engagement" was thus woven into the theory as the truth of an ontological phenomenon: facticity. In the "ontological proof" contained in the Introduction to *Being and Nothingness*, Sartre stated: "Consciousness is born disposed toward a being that is not itself."[39] This being was, of course, the *en-soi*, things, the world; consciousness could not escape it. Because consciousness is engaged, there is "possibility" as there is "value": "And this possibility which haunts pure presence as its sense beyond reach and as what it lacks to be *en-soi*, is first of all a kind of projection of present negativity as engagement."[40] Finally, freedom itself required engagement: "There can be no free *pour-soi* except as engaged in a resistant world."[41]

From this position it became clear that Sartre had given himself an ideological base from which to issue a call for engagement in the arts as an ethical imperative. In the total synthesis of consciousness where everything begins except being itself, it became possible to distinguish without separation the ethical, the aesthetic, perception and imagination, value, possibility, instrumentality, quality, determination; in other words, there was distinction within fundamental unity; the old confusions and mystifications were beginning to give way. Sartre was thus free to formulate an ethico-aesthetic principle: ". . . although literature is one thing and ethics something quite different, we can discern the ethical imperative behind the aesthetic imperative."[42] And this:

What makes, I believe, the originality of our position is that the war and the occupation, by hurtling us into a world in fusion, forced us to rediscover the absolute inside of relativity itself. For our predecessors the rule of the game was to save everybody because grief redeems, because no one is bad voluntarily, because one cannot plumb the depths of the human heart, because divine grace is equally shared. This meant that literature . . . tended to establish a kind of moral relativism.[43]

On this ground Sartre could establish his own claim to a new type of literature, an "engaged" literature "which will reconcile the metaphysical absolute and the relativity of historical fact. I shall call it, for lack of a better term, the literature of extreme circumstances."[44] On this ground he could also "condemn" Flaubert: if the writer can be distinguished from the work but not separated from it, if all people are ontologically engaged by their innate nature, if we are born into the world and History, then it was Flaubert's engagement to be disengaged. He was an oppressor, whatever one might think of the "beauty" of *Madame Bovary*.

These questions, of course, were not discussed in *Being and Nothingness;* they did not belong there. They were reserved for the *Temps Modernes* and *What Is Literature?* Sartre was making a distinction without separation in his own general enterprise. Nonetheless, Flaubert was not altogether absent from *Being and Nothingness*. He began there to play the role which he would play increasingly in Sartre's philosophy, the role of formal exemplar. Sartre used Flaubert to illustrate the inadequacy of literary Positivism and to expose the emptiness of its methodology. Referring to an analysis of Flaubert by Paul Bourget in his *Essais de psychologie contemporaine*, written at a time when Bourget was a disciple of Taine, Sartre stated:

For example, a critic attempting to construct a "psychology" of Flaubert writes that he "seems to have known, as a normal state, in his first youth, a constant exaltation composed of a double feeling of grandiose ambition and invincible strength . . . therefore the effervescence of his young blood turned into a literary passion as happens around the eighteenth year to precocious souls who discover in the energy of style or the intensities of fiction the means for expressing their need for action or the excessive feeling which torments them."[45]

Sartre points out that this pseudo-scientific explanation begs the question, which is precisely to explain "the literary inclinations of the young Flaubert."[46] Instead of this, Sartre contends, the critic reduces Flaubert to a kind of psychic chemistry: "There is in this passage an effort to reduce the complex personality of an adolescent to a few primary desires, as the chemist reduces compound bodies to nothing more than a combination of simple bodies."[47] What is lost is the concrete individuality of the person, the specificity of Flaubert, which must be sought in the "pro-ject under consideration."[48] "Finally, the correspondence of Flaubert proves that long

before his 'crisis of adolescence,' from early childhood, Flaubert had been tormented by the need to write."[49] By a series of questions Sartre now demonstrates that Bourget's explanations point chiefly to questions that have not been asked.

> Why in Flaubert do ambition and the feeling of strength produce *exaltation* rather than calm expectation or somber impatience? Why does this exaltation become specific as a need to act or to feel excessively? Or rather, whence comes all of a sudden, as if by spontaneous generation, this need . . .? And precisely why, instead of seeking satisfaction in acts of violence, in escapades, amorous adventures or debauchery, does [Flaubert] seek satisfaction symbolically? And why does Flaubert find this satisfaction . . . in writing rather than in painting and music? Flaubert says somewhere: "I could have been a great actor." Why didn't he try to be one? In a word, we have understood nothing.[50]

In 1943 Sartre was not yet prepared to answer the questions he had raised, but he was prepared to stipulate the conditions of a response. Existential Psychoanalysis was a call for a method: a method that would explain "the individual and concrete content of psychoses"[51] instead of the abstract, archetypal psychoses described by Freud, and that would be grounded in a theory of consciousness which would make intelligible what Freud had somewhat hastily designated as the "unconscious." We can translate Sartre's call for a method as an assertion that, while science had successfully called forth external things by making the universal "thing" rise before the mind, it had failed to call forth a universal human object which, under its analysis, crumbled into dust. An ontology was required to ground this human object; but once grounded, it would deliver to philosophical inspection a phenomenon of human subjectivity. It was the purpose of *Being and Nothingness* to do this:

> With us this requirement does not come from the unending pursuit of causes, from the infinite regress which has often been described as constitutive of rational research and which, consequently, far from being a specific of psychological inquiry, is to be found in all disciplines and in all problems. . . . Our requirement is a requirement founded on a pre-ontological understanding of human reality and on the related refusal to consider man analyzable and reducible to primary *data*, to desires or to specific "tendencies" supported by a subject as properties are supported by an object.[52]

Sartre was at this point prepared to indicate what he would require by way of "explanation" of Flaubert: evidence of a "radical decision," a "true psychic irreducible."[53]

> But what we all require in our every effort to understand the other . . . is that . . . the being under consideration should not crumble into dust and that we should be able to discover in it that unity . . . which must be a unity of responsibility, a unity to be loved or hated, blameworthy or praiseworthy, in short, *personal*. This unity which is the being of the man under consideration is *free unification*. And unification cannot come *after* the diversity which it unifies. But

to be, for Flaubert as for any "biographical" subject, is to unify oneself in the world. The irreducible unification which we must find, which *is* Flaubert and which we ask biographers to reveal to us is, therefore, the unification of an *original project*, a unification which must reveal itself to us as a *non-substantial absolute*.[54]

When Sartre announced at the end of *Being and Nothingness* his intention to undertake a study on both Flaubert and Dostoevski in order to demonstrate the methods of Existential Psychoanalysis, it was possible for him to assume that he could proceed from his ontology to an ethic and thence, perhaps, to an aesthetic which would permit him to explain, as he had indicated in *What Is Literature?*, the ethical imperative which lay behind the aesthetic imperative. We know that after completing *Being and Nothingness* he in fact worked on an ethic until about 1950, when he abandoned it. It is not difficult to imagine how he would have analyzed aesthetic formalism during this period. He would have seen it as a kind of ethical disengagement, and "Pure Art" would have emerged as an attempt, however impossible, to flee from reality and to escape into the imaginary, with the creation of luxury objects serving as alibi for the artist's renunciation of social engagement. This was the sense of his condemnation of Baudelaire in 1946 and of Flaubert in 1947. In short, the distinction of the "man" and the "work" had yielded a positive result: divested of privilege, genius and art now rose before philosophical inspection as an "artist-man," a personal psychic object defined by a fundamental enterprise. However, if Sartre's philosophy did in fact yield a *hominem fabrum* at this point, his ontology was not yet able to account for the "work." Sartre's readers were vaguely aware of this difficulty at the time: What of *Les Fleurs du Mal*? What of *Madame Bovary*? But no one was able to put the question to Sartre theoretically. Merleau-Ponty tried in 1945: "The question is to know if one can do justice to freedom [by] granting it something without granting it everything. . . . *Being and Nothingness* in this respect seems to call for a continuation . . . we await from its author a theory of passivity."[55] Sartre doubtless could have responded that if one does not begin by granting everything to human freedom, one ends up granting it nothing at all. The Marxists were quick to claim that Sartre's philosophy was bourgeois crypto-idealism. Sartre responded in 1947 that "the consciousness of each of us is not reducible to matter."[56] But is not the work of art precisely a work of *matter*? A statue of Venus is a *thing*; so is *Madame Bovary*. Sartre had acknowledged they were material things in 1940, and had called them *analoga*. Is not a work of art a perfect example of consciousness reduced to matter? One could almost believe at that point that Flaubert was taking some sort of ironical posthumous revenge as the most material of manifestations of a radical decision "crumbled into dust." Sartre's response would

issue in the second phase of his philosophy, when Flaubert would become a dialectical thesis.

The "second Sartre," far from being a refutation of the "first Sartre," is a testing in total risk of all of Sartre's previous philosophy as it comes to grips with the postwar world and enters into a sometimes bitter dialogue with Marxism. By 1949 Sartre's attempts at political action through the *Rassemblement Démocratique Révolutionnaire* had failed; by 1950 he had given up writing his ethical treatise and was devoting himself to the study of history, economics, and Marxism; Simone de Beauvoir tells us that politically he was "swimming in uncertainty"; in 1952 he began writing *Les Communistes et la paix* and drew closer to the Communist Party; in 1954, in a fit of depression, he said to Simone de Beauvoir: "La littérature, c'est de la merde!"[57] Sartre has said that it was in 1953 that he discovered the "neurosis" which characterized all his previous work, and in that year he began writing his autobiography. "Converted to dialectics," writes Simone de Beauvoir, "he was attempting to give it a foundation from the standpoint of Existentialism."[58] Out of this evolution of thought and life came the works of the "second Sartre": *Question of Method*, first published in *Les Temps Modernes* in the fall of 1957 and later incorporated into the *Critique of Dialectical Reason* (1960) as an introduction; and finally the "Flaubert," that is, the three volumes entitled *L'Idiot de la famille* (1971– 1972).

This chronology is actually somewhat misleading: it suggests a sequence of thought, whereas in point of fact only a sequence of composition is involved. As far as Sartre's thought was concerned, there was but a single problem: a confrontation of Marxism by Existentialism. In this confrontation Flaubert came first:

> Around 1954, at a time when I was close to the Communist Party, Roger Garaudy proposed that we select some figure and try to explain it, he with Marxist methods, I with Existentialist methods. He thought I would approach the question subjectively while he would approach it objectively. Thus the initiative came from him; but I was the one to choose Flaubert, thinking of *Madame Bovary*. . . . In three months I filled a dozen notebooks. It was fast and superficial but already I was making use of psychoanalysis and Marxist methods. I showed these notebooks to Pontalis, who had just finished a study on Flaubert's illness, and he said to me: "Why don't you make a book out of them?" So I started, and I wrote about a thousand pages, which I abandoned around 1955. Some time later I said to myself that I couldn't go on abandoning my work in midstream forever . . . that for once I would have to finish something. This resolution to go to the end of things has never left me since. The "Flaubert" has occupied me for ten years, and I can say that since *The Condemned of Altona* I have done nothing else. . . . Thus my "Flaubert" has gone through three or four versions prior to the one which is now appearing and which was completely rewritten from 1968 to 1970.[59]

After abandoning the "Flaubert" in 1955, Sartre wrote an article entitled "Existentialism and Marxism" for a Polish journal. In this article, which appeared in 1957 and was recast as *Question of Method* for publication the same year in *Les Temps Modernes*, Sartre made extensive use of Flaubert. It was also in 1957 that Sartre began writing the *Critique*. Of the latter work Sartre said to Madeleine Chapsal in 1960:

> Upon rereading [*Question of Method*] I saw that it lacked a base: it was necessary to establish the range and validity of the Dialectic. I consequently wrote the thick volume that is about to appear [the *Critique*]. I had the ideas for it, but I didn't dare. Formerly when I published a book I had innocence on my side; I no longer do. . . . But the Polish request provided the kick that makes the apprentice parachutist jump into the void.[60]

He added: "There is an osmosis between the book on Flaubert and the *Critique of Dialectical Reason*. But what will never pass from the first book into the second is the effort to understand the individual Flaubert. . . . One will never make philosophy out of *Madame Bovary* because as a book it is unique—more unique than its author, as all books are. But one can study it with a *method*."[61]

Thus it becomes clear that the "second Sartre" is a single project contained in a number of volumes; it is also clear that the "second Sartre" is a continuation and a clarification of the "first Sartre": "As for Flaubert, he permits me to show that literature considered as pure art and deriving its rules only from its essence conceals a position taken up fiercely on all levels, including the social and the political, and an engagement on the part of its author."[62] "Pure literature is a dream."[63]

If the work of art seemed to crumble into dust during the first phase of Sartre's thought, it was only that "retrospective illusion" necessarily conditions our interpretation of history. It is almost impossible not to think of past events as given a priori. We know that Flaubert is the author of *Madame Bovary*. It is impossible to think of him otherwise. But this, of course, Flaubert could not know. He could only know it prospectively—and this, on the other hand, is what we cannot know. "Retrospective illusion" confuses the future and the past and fetishizes history. The work of art did not crumble into dust in Sartre's early philosophy, for the simple reason that it was not there. It was there, to be sure, according to the reason of common sense; but the reason of common sense is not philosophical reason. Consequently it was necessary, if Sartre was to respond to his own demands in *Being and Nothingness*, for him to create a theory of the "work" and, within the conditions of his philosophy, to determine the ontological conditions of such a "work." But this problem involved others.

If the work was to be explained, it must first be stated. Such a statement, however, could not be derived directly from *Being and Nothingness*. The work of art is neither an *en-soi* nor a *pour-soi* nor a *pour-autrui*, and there were no other modes of being in *Being and Nothingness*. There were, to be sure, the *en-soi* of facticity and the *en-soi manqué*, but neither of these could be applied directly to a work of art. Nonetheless, Sartre had stated in *L'Imaginaire* what a work of art was: it was an *analogon*, that is, a physical object which was not the sum total of the work of art. It was the support for an act of imagination. Could one then say that the work of art existed? The unreal existed as an unreal; the analogon existed as a real physical object. Sartre had left the matter at this stage in *L'Imaginaire*.

If this question was not advanced in *Being and Nothingness*, it was because other priorities intervened. An aesthetic theory which had not been grounded in a theory of the nature of human consciousness would necessarily run afoul of the "illusion of immanence" which would confuse objects of consciousness and objects of the world. It had been the purpose of *Being and Nothingness* to state the very different natures of these realities. Sartre had, however, established in *Being and Nothingness* the priority of matter over mind. This would be essential to all his subsequent philosophy. Meanwhile, in *What Is Literature?* Sartre advanced his reasoning concerning the aesthetic object: properly speaking, it is the perceiver of the aesthetic object who creates the aesthetic phenomenon. To the perceiver is given the object as object; this object is denied to the creator. It is in this sense and in this sense alone, as Sartre was to say later in *Saint Genet*, that one can say *esse est percipi*. In this light it becomes clear, I think, that when critics reproached Sartre after 1947 for neglecting *Madame Bovary* or *Les Fleurs du mal* in order to speak of Flaubert or Baudelaire, they were in fact reproaching him for not having completed a philosophy which was in full progress of creation. In short, Sartre knew what he was saying when he said to his Marxist critics in 1947, as he said again in 1960 in the *Critique*, that consciousness does not reduce to matter.

After 1950, when Sartre began his direct dialogue with the Marxists, there were still urgent priorities to be addressed in his philosophy before he could allow himself to discuss *Madame Bovary*. In view of what he had already stated in the *L'Imaginaire, Being and Nothingness, What Is Literature?* and what he had formulated in *Saint Genet* ("The truth is that 'human reality' 'is-in-society' as it 'is-in-the-world'; that it is neither nature nor a state but that it makes itself'[64]), it would have been philosophical catastrophe to proceed directly to the aesthetic object. Clearly a philosophical theory which places the aesthetic phenomenon, properly speaking, in the perceiver, requires a theory of society in order to speak about the aesthetic

object. Had not the error of previous aesthetic theories consisted in their failure to make this essential distinction? Clearly *Madame Bovary* was one thing for Flaubert, something else for the courts that tried him on charges of offending public morality and religion, something else again for readers in the twentieth century. Certainly all of these questions were present in Sartre's mind by 1957, when Flaubert began his role in Sartre's thought as historical and philosophical exemplar. But to solve the problem was another matter. Meanwhile, Sartre's "conversion to the Dialectic" meant that he had decided the philosophy of Marx was a necessary foundation for any twentieth-century philosophy that laid claim to universality. He had also decided that his "neurosis" was the last vestige of the mind structure which he had inherited from his childhood. In philosophy, this meant philosophical "idealism": he would now try it against Marxian "materialism" in order to find out if Existentialism could stand the test.

One difficulty which is encountered in discussing Sartre's *Question of Method* needs to be stated at the outset. Prior to the appearance of the *Method* any sympathetic reader who had followed Sartre's work over the years was likely to consider Existentialism a self-contained and autonomous philosophy with some strong Marxist overtones; indeed, it was considered by many to be the only modern-day philosophy capable of answering Marxist materialism without falling into the excesses of an anachronistic idealism. To be sure, it was philosophically an idealism but, as Sartre had said after the appearance of *Being and Nothingness*, it was an idealism that contested idealism. It consequently came as a surprise to most of his admirers to read in the *Method*: "I consider Marxism to be the unsurpassable philosophy of our time . . . and the ideology of existence with its 'comprehensive' method to be an enclave within Marxism itself which engenders it and refuses it at the same time."[65] This statement seemed very curious. Certainly Marxism had not engendered the various philosophies of existence which derived from Kierkegaard who, like Marx, derived from Hegel. Further, very early in his career Sartre had stated his opposition to dialectical materialism, a far more difficult Marxist doctrine to accept than that of class struggle. He had written in 1936: "It has always seemed to me that a working hypothesis as fruitful as historical materialism in no way required as a foundation the absurdity of metaphysical materialism."[66] This remained his position in the *Critique*, and he expressed it again in a response to Roger Garaudy in 1959: "I understand by Marxism historical materialism . . . and not dialectical materialism, if by this term is meant that metaphysical daydream which thinks there is such a thing as a dialectic of nature."[67] The distinction of philosophies and ideologies also seemed strange when applied to Sartre's own philosophy: "Since I must speak of

Existentialism, you will understand that I consider it to be an *ideology*. It is a parasitical system that lives on the margin of Knowledge, that first opposed it and today seeks to become integrated into it."[68] Sartre certainly did not intend these statements to be taken casually, but how are they to be understood?

The clarification lies, I think, in Sartre's changing concept of the philosophical enterprise itself and in his frequent assertions after the appearance of the *Critique* that philosophy had become "dramatic." It lies also in a fact of our age: the Russian Revolution created for the first time in history a state that is officially atheistic and that derives its justification from a philosopher rather than from an ethico-religious system. This changes our perception of the very nature of philosophy. Philosophy, if it is to live at all, must be considered as historical praxis and must in fact come to terms with reality; it can no longer consist in the construction of self-contained abstract systems which reflect societies rather than molding them. That philosophies can mold societies the long history of religion has amply proved. Philosophy so viewed does indeed become a dramatic affair. Truth acquires a survival value, and our material existence may well depend ultimately on right or wrong ideas. It was in this sense that Sartre could decide that Marxism was the "unsurpassable" philosophy of our time and that as historical fact it had engendered even his own philosophy without his knowing it:

> It was real men with their work and their difficulties that interested us. We were calling for a philosophy that would give an account of everything without noticing that it already existed and that it was this philosophy, precisely, which created in us this demand.[69]

Thus Sartre knew *about* Marxism, but he did not "understand" it. Hegel had said that the philosopher must risk his life in order to create philosophy; the sense of this extreme statement is expressed by Sartre when he says: "To understand is to change oneself, to go beyond oneself; the reading [of Marx's *Capital*] did not change me."[70] He is speaking of his student years and of the general absence of Marxism in the philosophies and pedagogy of his time.

> . . . when I was twenty, in 1925, there was no chair of Marxism at the University, and Communist students were careful not to have recourse to Marxism or even to mention it in their dissertations. They would have failed all their examinations. The horror of the dialectic was such that even Hegel was unknown to us. To be sure, we were allowed to read Marx . . . one had to know him in order to be able to "refute" him. But without any Hegelian tradition and without Marxist teachers, without any course of study or instruments of thought, our generation, like previous ones and the one to follow, was totally ignorant of historical materialism.[71]

We know today that the "change" came to Sartre after 1950. It was after 1950 that Sartre finally "understood" Marx. He abandoned his attempt to derive an ethical system from *Being and Nothingness*; and he wrote in a footnote to *Saint Genet:* ". . . ethics is either nonsense or it is the synthesis of Good and Evil. . . . It remains that this synthesis cannot be achieved in the present historical situation. Consequently, any ethic which does not explicitly represent itself as impossible today contributes to the mystification and the alienation of man."[72] In *Force of Circumstances* Simone de Beauvoir transcribes from an unpublished note of Sartre's from this period: " . . . the ethical attitude appears when technical conditions make positive conduct impossible."[73] It was in this context that Sartre began to think about Flaubert once more. The anchorite of Croisset began to pose new and troubling questions when viewed in the light of Marxism. He was nonetheless a *salaud* for the questions he asked, and it remained a fact that he had said: "The Commune reinstates murderers."[74] But it also remained a fact that he was a great writer and a great artist. And it remained a fact that Sartre had written in *What Is Literature?*: "I ask you to show me one single good novel whose express purpose was ever to serve oppression."[75] Here was either the unintelligibility of History or the simplistic requirement that Flaubert should be banished from the Republic of Letters.

It is with this problem that the *Method* begins. "I ask one question," writes Sartre, "a single question: do we possess today the means for creating a structural and historical anthropology?"[76]

Sartre found himself in a difficult position: he both agreed and disagreed with Marxism. He agreed with the doctrine of historical materialism but disagreed with dialectical materialism; he also rejected scientific materialism and determinism whether it was to be found in Marx, Taine, or Freud. Materialism, to be sure, freed man from theological determinism, but at the same time it enslaved human subjectivity—and *Being and Nothingness* had been written to prove that subjectivity was a fact of human existence in the world. When Lukacs accused Sartre in 1948 of being "theologico-mystical"[77] and contended that Sartre's atheism, like Heidegger's, was "just as religious as that of Nietzsche,"[78] he spoke a partial truth but a truth of which he had no understanding. If religion meant a belief in God, then Lukacs' statement was a non sequitur; but if it meant cultural and historical Judeo-Christianity in the Western world, then everyone was a Christian, including Lukacs, and atheism either was a philosophical position or it was dogma. Marxism, a philosophy for the liberation of man, had become dogmatic because it had become the justification of a political regime; traditional materialism, liberating in the eighteenth and nineteenth

centuries, had become oppressive in the twentieth; the mechanism of this oppression was a "society." Flaubert, viewed in this light, became a paradigm of such oppression and of cryptic revolt against it. History had never been written correctly for lack of intellectual instruments. Was it possible to forge such instruments? Was there a philosophical materialism which could answer scientific materialism on both sides of the Iron Curtain? The historical materialism of Marx was, in fact, such a materialism. If it was insufficiently stated, this was because it had been ahead of its time. If there is a truth of Marx against Hegel, there is a truth of Hegel against Marx. That truth is human subjectivity. Without *Being and Nothingness* Sartre would not have possessed the instruments for locating this problem; he would have been *forced* to fall into "Skinnerism": "Our requirement is a requirement founded on a pre-ontological understanding of human reality. . . ."[79] It has always been a great strength and a great originality of Sartre's philosophy to have been able to understand its own priorities.

Taken together, the *Method*, the *Critique*, and the "Flaubert" constitute a single philosophical enterprise: to call forth as an object of knowledge historical and social man. For this Sartre proposes: (1) a new way of thinking—"dialectical reason," which alone is capable of grasping subjectivity as interiority in the external world; (2) a regressive-progressive, analytico-synthetic method; and (3) a fundamental assumption:

> Since Kierkegaard a certain number of ideologues, in their effort to distinguish being and knowing, have been led to describe better what we might call the "ontological region" of existences. Without pre-judging the findings of animal psychology and of psychobiology, it goes without saying that the *presence-in-the-world* described by these ideologues characterizes one sector—or perhaps the whole—of the animal world. But in this living universe, man occupies *for us* a privileged place.[80]

Henceforth Flaubert will become Sartre's privileged laboratory animal.

When consciousness takes itself as external in an enterprise of knowledge, it produces analytical reason. It grasps being as *en-soi* and must project itself as *en-soi* in order to do so. The discovery of this position as possible became the foundation of the scientific method. Francis Bacon produced a classic statement of knowledge as this position in *The Great Instauration:*

> . . . if I have made any progress, the way has been opened to me by no other means than the true and legitimate humiliation of the human spirit . . . dwelling purely and constantly among the facts of nature, [I] withdraw my intellect from them no further than may suffice to let the images and rays of natural objects meet in a point, as they do in the sense of vision; whence it follows that the strength and excellency of the wit has but little to do in the matter. . . . I lead

[men] to things themselves and the concordance of things. . . . I have established forever a true and lawful marriage between the empirical and the rational faculty.[81]

To analytical Reason Sartre opposes dialectical Reason, not, as many think, out of scorn for analytical Reason, but because analytical Reason is inadequate to the task of grasping human reality in its intelligibility. Analytical Reason is adequate to the task of grasping things, and the ultimate intelligibility of things is their unintelligibility: things are as they are. When their being has been discovered, there is nothing more to be said about them by philosophy. But if this is a kind of intelligibility after all, and if science has been so effective as knowledge of things, this is because analytical Reason is a moment of dialectical Reason, that is, of reason as aware of its own creativity:

> . . . analytical Reason is a synthetic transformation with which thought affects itself intentionally ("humiliation of the human spirit" . . . "I withdraw my intellect" . . . "I lead men" . . . "I have established"). This thought must make itself a thing and govern itself as externity in order to become the *natural* milieu in which the object under consideration is defined *en soi* as conditioned by the external ("to let the images and rays of natural objects meet in a point as they do in the sense of vision" . . . "wit has but little to do in the matter" . . . "things themselves"). But while thought is making itself the object of this metamorphosis, it directs it and effects it in conjunction with the inert system which it seeks to study. It becomes the law of bodies in movement . . . or the rule of chemical combinations . . . ("the concordance of things" . . . "a true and lawful marriage between the empirical and rational faculty"). Thus analytical Reason as universal and pure schema of natural laws is only the result of a synthetic transformation or, if one prefers, only a certain practical moment of dialectical Reason.[82]

Analytical Reason can be a moment of dialectical Reason because human reality is "totalization"—an act, a unification in process which effects the synthetic unity of diversity: ". . . through multiplicities, [totalization] pursues its synthetic work, making each part a manifestation of the whole and relating the whole to itself by the mediation of the parts."[83] The intelligibility of dialectical Reason becomes apparent: "[I]t is nothing more than the movement itself of totalization."[84] In other words, man himself is a being that lives himself in-the-world as totalization. But at what point can we say that this fundamental "ontological totalization" becomes dialectical Reason and hence knowledge? This point is reached when ontological totalization seizes itself in-the-world as a position of itself and the world as totalization, that is, by a reflexive retotalization "as an indispensable structure and as a totalizing process within the process of the whole."[85] In other words, ontology arrests the infinite regress; since there are regions of being in the world and since only man can grasp himself as that being which by his

life totalizes himself in-the-world, there is ultimately presence of consciousness to an object. This act of man, when taken into consciousness, yields man in his history as a new object of philosophical inspection; subjectivity is assumed objectively in a totalization of consciousness-in-the-world; consequently, if dialectical Reason contains ontologically its own intelligibility and if there is a dialectic of the historical process, "the law of its appearance and of its becoming must be, from the point of view of knowledge, the pure foundation of this intelligibility."[86]

"The epistemological point of departure of dialectical Reason remains consciousness as apodictic certitude (of) self and as consciousness *of* this or that object."[87] This object is, however, none other than the knower himself in his life as "incomplete individual," calling himself forth as an agent-object of History as he totalizes himself in order to know. What he knows, because he lives them internally, are "alienation, the practico-inert, series, groups, classes, the components of History, work, individual and common praxis."[88] In short, there is no thinking *of* History without someone's thinking himself or herself as History. For the historical object to exist a living person must exist and call it forth. Flaubert is such a historical object *for Sartre*, and without Flaubert (or some other *appropriate* object) there would be no knowledge of History *for* and *by* Sartre. Sartre chose Flaubert (and not George Sand or Stendhal) because of his grandfather, because of the Ecole Normale Supérieure, and because of his own choice to be a writer; in other words, he had "lived" Flaubert and, in the course of his own totalization, he had come to discover by means of Flaubert that his own choice of the literary art was historically a rejection of the enterprise of "Art" as invented by Flaubert and as inserted into French culture as objective fact which Sartre began to live after 1905. After 1971, Sartre's own synthesis of this objective experience would become for the world of French culture (wherever it exists in the world) a "totality," the fruit of a "totalization" without which, in our own turn, it would be meaningless to attempt a totalization of "Sartre." Meanwhile it had become necessary that Sartre should one day write about *Flaubert*; this he knew positively by 1943. For this all of the *Critique* would be required, as he knew by 1957, and all of Marx as well as Freud. And for this a "method" must be invented.

In *Question of Method* Sartre defines his method as follows:

We shall define the Existentialist method of approach as a regressive-progressive, analytico-synthetic method: it is at once an enriching shuttling between its object (which contains all of the historical period as hierarchized meanings) and the historical period (which contains the object in its totalization). To be sure, when the object is *rediscovered* in its depth and in its singularity, instead of remaining external to [its] totalization (as it had up to that

point, which the Marxists took for its integration into history), it enters immediately into conflict with its totalization. In a word, the simple inert juxtaposition of the historical period and the object suddenly yields to a living conflict.[89]

Flaubert is the example:

If one has lazily defined Flaubert as a Realist and if one has decided that Realism is what the public of the Second Empire needed (which will permit one to create a brilliant and completely false theory of the evolution of Realism from 1857 to 1957), one will never be able to understand the strange monster which is *Madame Bovary* nor its author nor its public. In short, once more it will be a game of shadows.[90]

We have observed in our discussion of *Being and Nothingness* the distinction which Sartre made between the life and the work; we observe now that the essential relationship is beginning to be established. It will require all of the "Flaubert" to establish it finally, but in *Question of Method* and the *Critique* the terms of the relationship will be specified. Sartre writes: ". . . there is a hiatus between the work and the life."[91] The reason for this is: ". . . objectification in art is not reducible to objectification in the conduct of daily life."[92] Now, however, Sartre is able to state a relationship in terms very different from those used by idealism or Positivism: Flaubert is "the pure synthetic activity which engenders *Madame Bovary*."[93] The author *is* indeed the work, as Henri Delacroix had claimed; emanationism, however, could not deal with the "hiatus." It remains; it requires explanation and, if interrogated, will deliver a meaning. "The work asks questions of the life" and becomes "a hypothesis and method of research by which to illuminate the biography."[94] "The work *never* reveals the secrets of the biography"; it does, however, "contain a truth of the biography which even correspondence . . . does not contain."[95] As an adolescent, Sartre had asked how such a man as Flaubert was possible; what did Flaubert mean when he said, "Madame Bovary, c'est moi"? Sartre will now frame the question more precisely: "*Who must* Gustave Flaubert *be* for him to have possessed, within his field of possibilities, the possibility of painting himself as a woman?"[96] Returning to the biography, Sartre discovers that, late in life, Flaubert's doctors called him "a nervous old woman and he felt vaguely flattered."[97] Flaubert's work reveals his femininity, but this in turn raises questions. It obliges us to guess at "social structures and at a unique drama of childhood." What was Flaubert's mother, not as some Freudian archetype, a mythical Jocasta, but as a real woman in the small provincial nobility of the early nineteenth century and as wife of the celebrated Dr. Flaubert, once removed from the peasant stock of his veterinarian father and now the founder of a "semi-domestic" family? A woman whose greatest freedom was to live *en pouvoir de mari*!

At this level, by studying the early childhood as a way of obscurely living general conditions, we cause to appear, as the sense of the *vécu*, the intellectual *petite-bourgeoisie* which took shape under the Empire as well as its manner of living the evolution of French society. Here we pass into the purely objective, that is, into historical totalization: it is History itself, the concentrated rising of family capitalism, the return of ground landlords, the contradictions of the regime, the poverty of a still underdeveloped proletariat which we must interrogate. But these questions are *constituant* in the sense that Kantian concepts are said to be "constitutive." They permit concrete syntheses to be effected whereas, thus far, we have possessed only abstract and general conditions. Beginning with a childhood lived in obscurity, we are able to reconstitute the true characteristics of the families of the *petite-bourgeoisie*. . . . In this sense the study of the child Flaubert as universality lived within particularity enriches the general study of the *petite-bourgeoisie* in 1830.[98]

Thus a new Flaubert is beginning to emerge, one we have never before read about or even imagined, a Sartre–Flaubert which might even be the "true Flaubert," if Sartre has been correct in his philosophy. He will call his "Flaubert" a "true novel"; one now begins to see what he means by that claim. Flaubert is a paradigm for the understanding of man as History. The *Method* gives, in fact, the paradigm of his life:

. . . a life unwinds in spirals. It always comes back to the same points, but at different levels of integration and complexity. Flaubert as a child feels deprived of paternal affection because of his elder brother . . . to please his father he should imitate Achille. The child refuses, in sulkiness and resentment. At school Gustave finds the situation unchanged. . . . He must receive the same grades as his brother for the same work. He refuses . . . he will become a *fair* pupil: dishonor in the Flauberts' eyes. The third moment is an enrichment and an intensification of the initial conditions. Flaubert will agree to study law in order to be certain to be *different* from Achille. He will decide to be inferior to him. He will detest his future career as proof of this inferiority. He will hurl himself into idealistic over-compensation. Finally, reduced to becoming a lawyer, he will extricate himself by "hysteriform" attacks. Each phase, taken in isolation, seems to be a repetition, but the movement which goes from childhood to the nervous crises is a perpetual surpassing of these givens. Its final conclusion is the literary engagement of Gustave Flaubert.[99]

It is here in 1957, I think, that the "score" with Flaubert is finally settled. Through empathy, synthesis, the dialectic and a method, antipathy has yielded to sympathy and something has been understood. Sartre has said he does not agree with Dostoevski that "to understand is to forgive"; this of course is because Sartre makes distinctions which Dostoevski did not make. "We shall leave the full responsibility of [Flaubert's] ideas to Flaubert," Sartre says somewhere. But to understand those ideas was to begin to understand History and to liquidate an aesthetic. "Neurosis Art" would become Sartre's answer to Art for Art's Sake. It would have required more than half a century of philosophical work in order to pose the

problem. But to pose one problem correctly is to pose all problems potentially. The "Flaubert" is history *and* philosophy as they had never before been written: history written in the light of philosophy and made intelligible by ideas which dispel the opacity of history. "[T]he philosopher brings about the unification of all forms of knowledge by taking direction from certain regulating schemas which convey the attitudes and techniques of the rising class before its period and before the world."[100] Philosophy is a method of "investigation and explanation," and "method" is a "political and social weapon."[101] Marxism is fundamental because it dispels the opacity of history by the regulating schemas of class struggle, economic priorities, and historical materialism; Existentialism is fundamental because of its regulating schemas of human freedom, human subjectivity, a new method, and a new dialectic which permit the problems of the opacity of history to be stated afresh. These views fuse in the "second Sartre" to create a new philosophy which we may here call Marxism-Existentialism, a philosophy whose profound purpose is to explain the rising proletarian class to itself. This new philosophy is a third option between dogmatic Marxism and reactionary Existentialism; it is a philosophy of all third worlds. It will disappear with the appearance of historical freedom:

> As soon as a margin of *real* freedom shall exist *for everyone* beyond the production of life, Marxism will come to an end. A philosophy of freedom will take its place. But we have no means, no intellectual instrument, no concrete experience which will permit us to conceive of this freedom or of this philosophy.[102]

The "Flaubert" will show the great, impersonal forces of History creating a man as this man, Gustave Flaubert, creates himself. The entire historical process is implicit in this unique case: "[there is] a fundamental identity between an individual life and human history."[103] The individual life relates to society, society to History; as individual, man totalizes himself; social groups similarly totalize themselves: here is human subjectivity as historical agent. This would remain, however, a statement of pure idealism if it were not immediately and simultaneously qualified by another statement: the individual agent, like the collective social agent, the "practical multiplicity,"[104] is de-totalized in its totalization by external forces internalized by the subjective agent and then re-externalized as alienated subjectivity. Flaubert is conditioned by his family from the beginning as alienated self; the natural primacy of the real is pre-empted by his father and his brother; this fundamental alienation will be externalized by Flaubert as a necessary choice of the imaginary against the real, but his valuating act will leave intact the primacy of the real as the property of his father and his brother; as he creates his Ego in this first period of his life, he will produce

it as Alter Ego. But already a social problem is present: the "Family" of Flaubert as social "collective," as well as the source of energy of this "Family"—which is "pathogenic" by nature—act upon the child Gustave. An Existentialist "determinism" is required in order to explain this energy. Sartre had created this "regulating schema" in the *Critique*; it was Existentialist materialism as opposed to Marxist materialism. Sartre had written:

> The essential discovery of the dialectical experience . . . is that man is "mediated" by things to the exact extent that things are "mediated" by man. . . . We must keep this whole truth in our minds in order to develop all of its consequences: this is what we call dialectical *circularity*. . . . [I]f we were not already dialectical beings we could not even understand it.[105]

It was from this "prospective" position that Sartre had been able in the *Critique* to pose the question of materialism in an Existentialist context:

> If materiality is to be found everywhere and if it is indissolubly tied to the meanings which praxis inscribes on it, if a given group of men can act as a quasi-mechanical system and if a thing can produce its own idea, then where is *matter,* i.e., Being totally pure of meaning? The answer is simple: it presents itself *nowhere* in human experience. . . . Matter could be matter only for God or for pure matter, which would be absurd.[106]

It is apparent from these statements in the *Critique* that it would be impossible for Sartre, when he came to write of Flaubert, to place the child Flaubert within his family and then to assume, as conventional historical determinism does, that there would be an "influence" of the family on the child. To make such assumptions, one must first be able to say what a child is, what a family is, and what human "matter" is as that form of "matter" which is capable of praxis and which, as praxis, can call "matter" the apodictic certitude of its own nature as experienced within fundamental negativity over and against inert Being. Like all children, the child Gustave erupts within his family as a dialectic of human nature against nature (*natura naturans–natura naturata*) and as a dialectic of the child and family within a social collective. In other words, one cannot proceed immediately from the individual to the social group and one must understand the nature of the *practico-inert*. Since human reality is dialectical, since man is mediated by things as things are mediated by man, alienation becomes intelligible. Sartre had also forged this regulating schema in the *Critique*:

> We have to choose: man is first himself or first Other than himself. If one chooses the second doctrine, one is simply a victim and an accomplice of real alienation. But alienation exists only *if* man is *first of all action*. It is freedom that grounds servitude, the direct bond of interiority as the original type of human relationships which is the foundation of the human relationship of exteriority. Man lives in a universe where the future is a thing, where idea is an object, where the violence of matter is the "midwife of History." But it is man who has put his own praxis into the thing, his own future, his own knowledge.

If he could encounter matter in a wild state in his own experience, he would be a god or a stone.[107]

It is in this infernal world of tension and violence that we encounter our own freedom as necessity and necessity as freedom and fundamental human action as the modification of passivity. "[T]he materiality of things or of institutions is the radical negation of invention or of creation."[108] "*Invention* even before it occurs may be, under certain circumstances of production, an exigency of *practico-inert Being* which we have just defined."[109] "Subjectivity appears then, abstractly, as the condemnation which forces us to carry out, of our own free will and by ourselves, the sentence which a society 'in process' has passed on us and which defines us a priori in our being."[110]

The practico-inert is the field of social being, organized by social structures as the exploitative use of fundamental human materiality. Flaubert's family was such a structure within the specificity of French history that extended from the French Revolution to the fall of the Second Empire. It becomes clear why Sartre says that one cannot proceed directly from the individual to the group. A social group is not given like a fact of nature; it is made. It is a totality, a kind of analogon, unstable in its nature, on which a fiction may be lived as real. Built by human praxis, espousing matter, the group has the resistance of things and all the instability and weakness of human contingency. It can fall apart; it can be destroyed. But while it exists, it fashions its members while they fashion themselves. Flaubert's "pathogenic" family, as an instrument of French historical society, determined his being as *pathos* by leaving no other options open to the child. But whence derives the cohesion of the social group? It would have been impossible to write the "Flaubert" without explicating this. If Flaubert is born into a certain family, if this family is "pathogenic," if as a social institution it derives its strength from an espousal of matter in the field of the practico-inert, how does it administer this strength in order to enforce its authority upon Flaubert? The answer is violence, with its attendant social emotion of fear. "[E]verything occurs *in violence* and not *by violence*,"[111] writes Sartre. Ultimately it was social violence, internalized by Flaubert and re-externalized as hysteria, which produced his famous "epileptic" attack of 1844. But to clarify this situation, two other regulating schemas would be required: that of "collective" and that of "group," both operating in the field of the practico-inert.

> . . . [T]he group is defined by its enterprise and by a constant movement of integration which intends it as pure praxis by attempting to eliminate within itself all forms of inertia; the collective is defined *by its being*, i.e., to the extent that all praxis is constituted as *exis* by it. It is a material and inorganic object of the field of the practico-inert to the extent that a discrete multiplicity of acting

individuals produces itself under the sign of the Other as *real unity in Being*, i.e., as passive synthesis to the extent that the constituted object poses itself as essential and that its inertia penetrates *each individual praxis* as its fundamental determination through passive unity, i.e., by the previous and *given* interpenetration of all as Others.[112]

This very useful distinction permits a far more sophisticated analysis of the social field than one usually finds in the work of historians and sociologists, who tend to grant all social assemblages group status. Moreover, Sartre has by this distinction introduced a dialectical position into the question of "establishment groups" versus "activist groups" as they exist in contemporary society, thus eliminating the "conspiracy theory" which one often encounters today both on the Right and on the Left. As to the priority, however, of collectives over groups or vice versa, Sartre is categorical: "Who could affirm that the collective precedes the group? No hypothesis can be advanced on this subject."[113] Sartre states his own position in the terms he had used in *Being and Nothingness* to state the *logical* relationship of the *en-soi* and the *pour-soi*:

We pose the logical anteriority of the collective for the simple reason that groups constitute themselves—to the extent that History informs us—as its determinations and negations. In other words, they surpass it and preserve it. . . . Finally, whatever *pre-history* may be, what is of importance in a *history* conditioned by class struggle is to show the passage of oppressed classes from the state of collective to the revolutionary praxis of groups.[114]

Finally, these distinctions will permit Sartre to state the nature of a "social thing," a "totality," and to demonstrate the investment of these "things" in the social field of the practico-inert as the "interest" of their creators.

A totality is defined as a being which, radically distinct from the sum of its parts, is again to be found, wholly—in one form or another—in each of these [parts] and which enters into relationship with itself whether by its relationship with one or several of its parts, or by its relationship to the relationships which all or several of its parts have among them. But this reality being hypothetically *a created reality* (a painting, a symphony . . .), it can exist only in the imaginary, i.e., as the correlative of an act of the imagination. The ontological status which it requires is by definition that of the *en-soi* or, if you will, of the inert. The synthetic unity which produces its appearance of a totality cannot be an act but only the vestige of a past action. The inertia of the *en-soi* eats away at this appearance of unity by its being-in-exteriority. The passive totality is in fact eaten at by an infinite divisibility. Thus it is, as the power in act of retaining parts, merely the correlative of an act of the imagination: *the* symphony or *the* painting, as I have shown elsewhere, is an imaginary intended via the dried colors or the succession of sounds as a whole which serves as *analogon*. And when it is a question of practical objects (machines, utensils, objects of pure consumption, etc.), it is our present action which gives them the appearance of totalities by reawakening, in whatever manner, the praxis which attempted to

totalize their inertia. We shall see later that these inert totalities are of prime importance, and that they create among men that type of relationship which we shall call the practico-inert. These *human* objects deserve study in the human world. It is here that they receive their practico-inert status, i.e., they weigh on our destinies by the contradiction that opposes in them praxis (the work that made them and the work that uses them) and inertia. . . . [T]hey are products, and their *totality* . . . is only a regulatory principle of totalization (and reduces simultaneously to the inert whole of its temporary creations).[115]

Here, then, are the physical objects of our social worlds, human products that can be understood only in a human world: *Madame Bovary* and the quill pens with which Flaubert wrote his book. Their semblance of totality is but the counterpart of a permanent act of human totalization. It is here that the writer finds himself in permanent danger in the social world by his investment in his work:

. . . [O]ne can speak of ideological interests. By this term one must not understand the whole of a written work to the extent that it provides a certain income for its author . . . but this same work as a whole of inert meanings supported by verbal matter to the extent that the author has constituted in it his being-outside-of-himself in material meanings . . . whose pseudo-organic whole has been constituted as the inorganic reality of his practical organism and through which he is perpetually *in danger* in the world through the Other. . . . [The author] finds himself hurled into dependency on all of current History by the object in which he had taken refuge against History.[116]

Thus was "Art" dethroned and utterly demystified by all of Sartre's philosophy from the beginning, so that a human enterprise of creativity might take the place of the alienated product in a philosophical search for History. Meanwhile, it had at last become possible for Sartre to begin the long analysis of the historical artistic enterprise which would become the "Flaubert." The concept of "genius" is reassuring: it is an idea invented by society in an effort to assimilate one of its former enemies that has survived. But now Sartre will demonstrate how genius works: it is not a gift but "a way out invented in desperate cases." And if there is a "gift" after all—Sartre had called Baudelaire a "born creator"—it is the least interesting of all of the components of an enterprise of totalization that takes place under the crushing pressures of the "social machine"[117] and as a process of History. If "mute inglorious Miltons" exist in the world, they cannot be known because they have been destroyed. They may well signify symbolically some truth of anonymous human reality, but their muteness is their most interesting characteristic and it is unavailable. Like Flaubert's "stupidity," their muteness merely reflects a fact of human oppression. The engagement of the creator is a total engagement of being, but the "Artist" is not necessarily the creator. He is himself a creation of certain creators and non-creators who, in Flaubert's case, inserted themselves by counter-

violence into the real violence of French society after 1850, a society that placed a condition of social neurosis on its members, forcing them to "carry out of their own free will the sentence that had been passed on them." In 1871 Rimbaud wrote to Paul Demeny:

> *Je est un autre.* . . . The Poet makes himself a Seer by a long, immense and reasoned *dérangement* of *all his senses*. All forms of love, suffering, madness. . . . Ineffable torture in which he requires all of his faith, all of superhuman strength, in which he becomes the greatest sick man of all, the greatest criminal, the greatest of the cursed—and the supreme Knower![118]

In these words Rimbaud was stating a principle of what Sartre a century later would call "Neurosis Art." In coining this term Sartre was doubtless reflecting on what he had called his own "neurosis," and he would eventually explain what this "reasoned" derangement of the senses was: the inevitable rationality of any human enterprise, even that of "art," and its intelligibility when grasped by dialectical reason as the alienation of a fundamental human intentionality. "Pure Art" was the sick response of a sick society to the command of M. Guizot: "Get rich and save your money."

The illness that afflicted Flaubert is well documented in literary history: in January 1844, probably between the 20th and the 25th, at Pont-l'Evêque in Normandy, Flaubert collapsed in the carriage he was driving as he and his brother Achille were returning from Deauville. His father and his brother, both physicians, diagnosed this first attack as "cerebral congestion." With the onset of further attacks, however, they changed their diagnosis to a "nervous disorder," possibly "epilepsy." Flaubert, who attempted to study his own illness in his father's medical books, pronounced his ailment "une maladie des nerfs." His attacks continued with some frequency and violence through June 1844. They then began to taper off until finally, through 1847, they were occurring at a rate of about one every three months. After 1846 Flaubert considered himself essentially cured. He wrote to his mistress, Louise Colet, on August 9, 1856:

> Before knowing you I was calm. I had become so. I was entering into a virile period of mental health. The nervous illness which I had endured for two years was its conclusion, its end and logical result. Something rather tragic must have occurred previously in my brain case for me to have had happen what happened. But everything had returned to normal. I had come to understand what things were about and, what is more unusual, what I was about. I walked with the rectitude of a private system made for a special case.[119]

Sartre points out that, significantly, "the rectitude of a private system made for a special case" is the perfect definition of neurosis. It would consequently become the thesis of the "Flaubert" that this neurosis was in fact an "unconscious" positive and negative "strategy" which would permit Flaubert to accomplish his literary work. Further, it was a "social neurosis"

to which Flaubert was "programmed" by this time through the mediation of his "pathogenic family." By its prescriptions and interdictions it set up in Flaubert, from earliest childhood, the terms of a fundamental contradiction which, when transformed by the dialectic of Flaubert's own praxis, would convert him into the *grand malade* he had to be if he was to become the author of *Madame Bovary*. This aesthetico-hysterical engagement, a socio-individual phenomenon, was a response of freedom creating for its field the "monstrous and masterful ranges" which would come to be characterized as the method of "Realism" and which would result in the first true work of modern fiction. Here at last was to be found the ultimate relationship of the "man," the "work," and "society"—and beyond them, "History." But first it would be necessary for an "imaginary child" to turn himself into a writer. There would be three stages in this evolution: the "Actor," the "Poet," the "Artist." Finally, from 1840 to 1844, there would be a period of increasing "urgency," at the end of which lay Pont-l'Evêque. After Pont-l'Evêque, so Sartre will be able to say: "Finished. In January '44 at Pont-l'Evêque, Romanticism died and the post-romantic generation came of age."[120]

By the age of seven it was "Je est un Autre" for Flaubert. A "horrible alterity . . . assigned to him by [his father]"[121] had come to be his "nature." He had made a fundamental "choice of the unreal."[122] All his life he was to dream of perpetuating himself in the "rough materiality of a work"[123] because, as a child, he had been forced to substitute Non-Being for real Being. By the age of ten, in response to this fundamental alienation, Gustave would turn himself into an "actor": de-realized by his family, required by his fundamental choice to assert the absolute value of Non-Being over the absolute value of Being, Gustave would find no instrument for his infantile praxis other than his own body. The time for role-playing had come, writes Sartre. Gustave could not live indefinitely without some sort of support for the drama of Being and Non-Being which he had set up in himself. In the billiard room at the Hôtel-Dieu, Flaubert began playing theatre games with his sister and some other friends. Here, temporarily, the child made a wonderful discovery:

> . . . [A]s soon as he slips into a prefabricated role, he experiences a giddy happiness, an incredible revelation: against the fragility of his improvised *persona*, he seems to have discovered the most secure protection. Between this [improvised role] and a character in a play that has been written down there is very little difference.[124]

The actor is a strange person who takes himself as the analogon of a Non-Being in order to make this Non-Being exist in the world as the Non-Being that it is. As Gustave makes this discovery, "he passes from *Je est un Autre* . . . to *l'Autre est moi*. This means that he has at his disposal two synthetic

unities of his *vécu*, the most recent of which, imaginary, is set up to save him from the other."[125] In other words, he was alienated; he is now a bit de-alienated by the creation of a fiction which can be perceived by others and he begins to experience the instituting of being that communication can be. Unfortunately, his exhilaration did not last long. By the age of thirteen Flaubert had "given up the theater." His father never attended any of the little theatricals in which he took part, and although by the nineteenth century actors could be buried in hallowed ground, they could not be invited to dinner. Gustave was operating without a mandate.[126] But was anything more involved in the Hôtel-Dieu experience than a mere childhood game? Sartre thinks so, and he reproaches the Marxists for not understanding children; when children play, they are at work. Years later, Flaubert wrote to Louise Colet that he might have been a great actor if only he had been born poor! Meanwhile, he had made another important discovery and had begun to invent a way out. Nonetheless, when he finally came to literature it would be by a second choice.

A radical conversion of juvenile praxis would be required for Flaubert to come to the point of view of poetry and finally to the point of view of artistic prose.

Flaubert was never a poet in the sense of writing verse. For Flaubert, poetry was first of all "the fabulous opera that goes on in his head and which he often thinks he could never write down without degrading it."[127] It was, in other words, a point of view toward the world. When by a radical conversion it became a point of view toward language itself, it would contain the essence of his future "style."

In *What Is Literature?* Sartre had made a fundamental distinction between the attitude of prose and the attitude of poetry in language. In the attitude of poetry one uses language not as "sign," in order to signify, but as an end in itself and as if language were a thing of the world. In Sartre's system, which requires a primacy of the real, the natural attitude toward language is that of prose. The poet consequently hypostasizes language and inverts it. This is what Flaubert did. Inserted into language badly at the age of seven when his father undertook to teach him to read, Flaubert in his reversal of the natural order of the real and the unreal perceived language itself as bearing the mark of the "Other." Language is of the practico-inert; consequently, it can be taken as a thing or as signifying things. Flaubert was to use it as an analogon of reality, containing the "signified" in the "signifier" and to the extent that the "signifier" is also a "non-signifier."[128] This was to "imaginarize" language: "[T]o apprehend [language] as sign is an activity close to and complementary of perception. To grasp it in its material singularity is to imagine it."[129] It would thus become possible for Flaubert, by using language as an analogon, to exploit the ambiguities and

the material autonomy of language. A sumptuousness of language resulted from this initial choice of language as *en-soi*, and although language can never be this exclusively, its inversion does necessarily bring into being a "world of the Word" as against the "world of Things."[130] Thus language so used would yield its fictional object as an ambiguous unreal-real, a quasi-real by means of words made to float between sign and image.[131] A sensuous pleasure of language would become possible. A quasi-Ego was emerging:

> For [Flaubert] "Je" is present but unreal. "Il" is real but intended neutrally as absent . . . when he projects himself into written language in order to read *himself*, he offers himself as *other* to a witness who is *none other* than himself . . . he incorporates himself into the materiality of the grapheme and, for lack of reality, he will give himself material weight by making himself an *object as other* in his own eyes. The subjective "Je" will remain where it is, but in the word he writes there is a turning around of the "Je" into an "Il," a kind of free transformation not for the purpose of knowing himself, but simply for the purpose of existing.[132]

By April 1, 1836, this conversion will have been completed. "[Flaubert] will 'enter' definitively 'into literature' when he will consider literature to be his absolute end. On April 1, 1836, in the postface to *Un Parfum à sentir* he exclaims: 'To write! Oh, to write is to take possession of the world. . . .' We can then consider that the conversion has been completed."[133]

School, a "structured collective" where from 1831 or 1832 until 1839 Flaubert was obliged to confront the real in a more virulent form, would see the conversion of the "Poet" into the "Artist." In this further conversion Flaubert's friend Alfred Le Poittevin played an important role. He would also be a decisive factor in the great "radicalization" at Pont-l'Evêque in 1844.

The Le Poittevin family was a very different family from that of the Flauberts. The beautiful Madame Le Poittevin and her irresistible son were luxury creations of a rising bourgeoisie to which Flaubert, as Zola perceived, would one day lend ideological support and which he would help to destroy without ever fully understanding his role. In the Le Poittevin family the young Flaubert encountered that dangerous and powerful aesthetic object, the real as analogon of itself.

> I have written elsewhere: "What is 'beautiful' . . . is a being which cannot be given to perception and which is by its very nature isolated from the universe. . . . It happens, however, that we may take the attitude of aesthetic contemplation before events or objects that are real. In such a case anyone can observe in himself a kind of taking of distance with respect to the contemplated object, which itself glides into nothingness. . . . It functions as an analogon of itself, i.e., an unreal image of what it "is" is manifested to us through its actual presence. . . . The extreme beauty of a woman kills in us the desire we feel for her.[134]

Alfred Le Poittevin thought he was an artist. He was in fact a work of art, an aesthete made into an analogon of himself by the contemplation within aesthetic distance of his beautiful mother. At least so Sartre conjectures. At all events, it was under the influence of Alfred that Flaubert began talking of "Art" for the first time. It was one of those "deflections" in a life of which Sartre speaks in the *Critique*. Alfred was eighteen, Flaubert thirteen when they met, and their friendship lasted until Alfred's death in 1848. It was an *amitié amoureuse*. For a boy whose law of being was passivity, Alfred acted as a powerful catalyst. Flaubert internalized the anorexia of his beloved and took it for ataraxia; he adopted the notion of the perfect gratuity of the object of art; he became Alfred's slave; he would have liked to imitate him in everything. This was, however, impossible. Built into Flaubert's nature as superego, Achille-Cléophas came to the rescue of his son. The gap between Alfred and Gustave was social and economic in the final analysis: Alfred was a man of "superfluity," Gustave a man of "necessity"; they could be friends, but Gustave could not *be* Alfred. The bourgeois work ethic was too strong. However, grafted onto the quasi-aristocratic consumer ethic of Alfred, this bourgeois ethic produced a strange fruit, the "worker of art" that would lift Gustave to the level of Alfred. "[T]o the dialectical bond of having and being, [Flaubert] will substitute that of being and doing."[135] The result: "the gratuity of art as categorical imperative"[136]; " . . . what Flaubert is beginning to understand is that the only motive for the artist must be the determination a priori of his pathos, i.e., the despairing love which impossible Beauty causes in him from afar."[137] And so Alfred's anorexia enters into a nascent ethico-aesthetic system and once more there is a conversion. The Ego of the "Artist" is engaged as the pole of his emotions as he encloses them in his ethico-aesthetic *epochē*.[138] Literature will become "an *artisanat,* writing will be assimilated to physical effort. One will chip away at the marble of language. And what will be the result? An object which is its own end, as Alfred claims to be his own. Thus not only does the patient negation of the slave penetrate and transform the ethic of the master, but more profoundly the slave *produces* the master."[139] Does all this seem excessively conjectural? Sartre will reply:

> As is apparent, this conjecture merely brings together the whole of the descriptions that we have made and of the motivations that we have attempted to discover. It respects, as it must, the primacy of infrastructural and conjunctural conditionings since it presupposes the mode of production, social classes, the institution of the family outside of which an attempt at identification would not even be conceivable. It remains that it is not demonstrable and I give it for what it is worth.[140]

In the "structured collective" of the lycée, where Flaubert is by definition inferior to his brother, bourgeois society will descend upon him as

isolation and inhumanity by means of the competitive system which is an "introduction into bourgeois life."[141] Flaubert's fundamental alienation is now reinforced by one of the most impersonal institutions of his society: the post-Napoleonic lycée, "an abstractly fabricated universe of pure alterity."[142] Flaubert will be invited by this institution to use his freedom against himself in an act of perfect passivity, conformity, and to insert himself into his society by internalizing "social terror" as it is administered by the "school." After all, this is why children are sent here. But Flaubert is a "genius," that is, a child of no gifts but who "invents." The school will provide him with a negative stimulus and an audience: he will invent laughter against himself, and in the scandal of his creation he will produce a personal fiction soon to become a "collective fiction": *le Garçon*, "an imaginary solution to the antinomy of the century."[143] The *Garçon* will embody the Universal Science of Dr. Flaubert, a myth, to which Flaubert will add, under the aegis of Alfred Le Poittevin, the myth of his own election as "Artist," which is actually a work in progress, and will now create with the help of his comrades a *personnage combattant*. In his own person as the *Garçon* the "family idiot" will abolish himself in order to abolish the world and so execute his father's command that he should abolish himself. In this process the boy will discover by implication a "Je" of fiction in the "Il" that he was for himself as he creates of himself an analogon of an act of irrealization and in the *Garçon* a "center" of public irrealization. In other words, to a small degree but an important one for his future work, Flaubert will have achieved a minor "work of art," as yet unstable, but the process will have revealed to him without his knowing it that the work of art finds its termination and existence in social human reality.

"The thing is cooked up at the level of reflexion in the first instance—the only reflexion that is real *from the beginning* but which Gustave does not hesitate to fake in order to make it the analogon of the other."[144] Living his own ego as Alter Ego, Flaubert makes of his own Ego an analogon, the *Garçon*, who when he says "Je" is not speaking *as* Flaubert but *about* Flaubert while Flaubert reflects on himself through others. The real Ego of Flaubert remains implicit. What is explicit is not his own "Je," but a "Moi" that has been constituted as the "Other" of his "Je." The Rabelaisian *Garçon* reflects inside of Flaubert on the insignificant Flaubert; an illusion occurs which is the result of Flaubert's own strategy of fiction: a giant inside himself tells him he is a dwarf. But since both giant and dwarf are Flaubert, we can see the "pretense," and the fiction yields its content: if a super-being is thus reflecting inside of Flaubert on his real non-being, this super-being must be Dr. Flaubert, called here to crush his son and to disqualify him in the imaginary. But the imaginary is an infernal place, and by definition and in spite of Flaubert it is second to the real: the real is that Flaubert

is doing all of this. He invents in reality (in the first degree) what his imaginary *moi* (in the second degree) is supposed to see of his own immediate and reflected consciousness. This is a game: he takes his fictions for illuminations from on high as if they were intentions of his Alter Ego looking down on him. In fact he is looking at himself in the imagination through the wrong end of a telescope, in which he sees his real Ego transformed into an unreal Ego. Meanwhile, Gustave actually remains. A residual subject which is actually Flaubert is producing this act of fiction. Thus he gives himself a feeling of horror of himself in the imaginary, while in reality, like the actor once more, he converts himself into the analogon of this imaginary reality.[145]

This will remain Flaubert's position until Pont-l'Evêque. At bottom is an unhappy child breaking the bonds of his unhappiness and laughing in the imaginary. The *Garçon* is the "passion of Flaubert," writes Sartre; "fundamental laughter in his eyes is the point of view of nothingness with respect to Being."[146] When Flaubert has decided that he does in fact possess a "Je," that the imagination is not merely flight into the unreal but that one may use it to destroy the real, and that "Art" is the point of view of death toward life, he will have completed his conversion to "Art." But first he must pass through the crucible of Pont-l'Evêque.

> [T]he imaginary adolescent takes for his goal the establishing of a normative ontology where Non-Being will take precedence over Being, Appearance over Reality, the Impossible over the Possible . . . he will succeed not rationally and logically . . . but by the leap into madness which will hurl him at his brother's feet one night in January 1844, and by the child of this "Idumaean night," *Madame Bovary*.[147]

In order for the crucible of Pont-l'Evêque to occur, Flaubert's history must first acquire the dimension of absolute urgency. This "urgency" is in fact provided by the very nature of bourgeois life, which requires that a male adolescent, at the termination of his secondary education, shall enter a profession. In the case of Flaubert it had been determined by his family, that is, by Dr. Flaubert, that Gustave's profession should be the law. This was an intolerable decision to Flaubert who, by the time he had finished the lycée in 1840, had already turned himself into a writer and an "Artist." The law was condemnation to mediocrity, to the life-style of the bourgeoisie against which Flaubert would rail all his life. He nonetheless submitted to his father's decision in the constituted passivity of his being which resulted both from his own work and from his family's work on him. This conflict had been operant within him since at least 1835: his dissatisfaction with his early attempts at writing lent added urgency to the question of his choice of career. "The theme of literary failure and of selecting a profession are inseparably joined," writes Sartre, ". . . in the broad move-

ment that carries Flaubert toward the crisis of January 1844."[148] In other words, from the beginning and now with increasing pressure (the sense of which was violence), all of Flaubert's society through the agency of his family was driving him toward a final commitment which would provide another true "Flaubert" in the social hierarchy, that is, another *bon bourgeois*. It was time to go up to Paris and pass the necessary examinations. Sartre says that from 1840 to 1844 Flaubert was *afraid*.

It is Sartre's thesis that Flaubert responded with a strategy that found its culmination at Pont-l'Evêque: from 1840 to July 1842 Flaubert would attempt to gain time; ostensibly he would work at home; in July 1842 he would finally take up residence in Paris, but in August he would either fail his examinations or decline to take them. He did, however, take them in December, and he passed them. He took his second examinations in August 1843 and failed. He then spent the months of September and October with his family in Rouen. In the late Fall he again left for Paris, intending to retake his examinations in January or February 1844. He was, however, once more back in Rouen in January where he remained until around the twelfth. He then returned to Paris. Again he was back in Rouen by the twentieth and it was then, sometime between January 20th and January 25th, that the attack occurred. Sartre writes of Flaubert's frame of mind during this final return to Rouen before his attack:

> When he leaves for Rouen . . . he knows that he *can no longer* withstand this trial a fourth time and he also knows that he *will withstand* it, that he will leave with docility around the twelfth in order to go back to work. He had wanted to flee the future. Now the future has caught up with him, atrociously predictable in all of its details, *already lived through and to be lived through* once more. He tears himself away from it as he rides toward the Hôtel-Dieu while each turn of the wheel brings it closer. As soon as he arrives, he tries to cling to every moment but they fall apart. The truth of this voyage is that it is *a return*. He understands this from the first moment. He understands that he can no longer obey and that he cannot revolt. Two rigorously contradictory impossibilities. And yet the urgency is there. There is nothing to decide and yet he *must* decide. That was the moment when "something rather tragic happened in [his] brain case."[149]

Between January 20th and January 25th, 1844, at Pont-l'Evêque, a pathogenic society, a pathogenic and a now pathological individual coincide in a kind of reverse puberty rite "fatefully" predetermined by the dialectic and counter-dialectic of individual freedom and social practico-inert. Assuming himself in a moment of private and personal totalization, in bad faith and good conscience, Flaubert by an act of "radical somatization" moves from the position of "individual" to "universal singular" and decrees in submission that his father shall die in his person so that a true son may be born of an inversion of the real and the imaginary. This totalization

is "pathogenic" to the extent that "[Flaubert] cannot live it without its presenting to him the contradictory unity of all of his intentions, of the impossible and the necessary, of praxis and inertia. The abyss is there . . . but its almost pleasant attraction . . . has changed to vertigo."[150] When the carter, a "command object," passes on his right, the "passive agent" that is Flaubert decides that it has been decided elsewhere that he must die. The "real" that has been threatening for years erupts in the substance of the night where being and non-being are indiscernible and where the "solar reality" of his brother, Achille, is a ridiculous illumination. The "ancient paternal curse" is a sentence to be executed without further delay. "This time the totalization is made under constraint: [Flaubert] blots himself out *on command.*"[151] Here is no stimulus-response, but a response that is stimulus and a stimulus that is response in the unity of a consciousness that is by definition consciousness-in-the-world under the interdiction of a fundamental option of passivity. De-realizing the world and himself as the carter passes, Flaubert achieves a "false death" by totalizing in a single instant and event an original project that goes back to his childhood and that will permit him to be the writer he has decided to be: a fundamental choice of passivity that is a choice of being-in-itself, an impossible refusal of freedom and an attempt to substitute for being-in-the-world, which is by definition transcendency, being-in-the-midst-of-the-world, which is the being of things.

When the mind tries this impossible reversal of a natural order, it obtains an aberrant result: transcendency—which permits freedom to exploit the inertia of thingness and so, by inventing instrumentality, to act—inverts itself, making of the inert an end instead of the means that it is. As Flaubert falls to his brother's feet, he radicalizes his aberrant choice: he disengages the imaginary from its natural anchorage in the real and by his hysterical engagement guarantees an aesthetic engagement. There is now an irreversible commitment to a Flaubertian "truth": the being of non-being, Croisset as the property of a universal class standing in as surrogate for "human nature," ultimately the distance of nothingness introduced into being itself so as to yield being as non-being, the distance necessary for a "Flaubertian eye" to contemplate the world. Flaubert would call this his "aesthetic attitude." It was the irrevocable choice of his own determinacy. Now the bailbondsman of a fundamental and finally impossible reversal of the order of nature, by radical somatization, Flaubert was free to turn facticity into an end, being into non-being, non-being into being, perception into imagination, sensation into representation, the present into the past, and language, human communication by nature, into the essential substance and material of art. Of these "unnatural" conversions and pathology "Neurosis Art" would be born.[152] The bourgeois is a "realist"; his culture lives history

as a fiction while he destroys himself and the world in a hopeless attempt to consume the world. What is "pure Art"?

> We know now what this "idea of art, of pure art" means: it is the imperialism of the imagination. Instead of fleeing before the real, [the imagination] turns against it, attacks it and causes it to be devoured by an integrated totality that does not exist, a totality that one can call the world, Hell, or Beauty and which, by a clever trick, can be passed off as the *sense,* the profound truth of the engulfed real. . . . Art must be a prodigy of balance. Indeed, de-realization must preserve the real in all its freshness. Better still, it must discover fresh aspects of it. But at the same time the imaginary presentification of the Macrocosm must never become the object of an explicit intention. If the transmutation were completely lucid, it wouldn't "jell." The imaginary and the real would remain irreconcilable and separate. In fact nothing must be done deliberately except to marvel and to seek out the sense of what is seen. Then technique will do its work and the sense will appear—imaginary, since the event has already been transformed into an image, and infinitely obscure, since it will be the world itself mediated by the opacity of the sensory. What skill this balance will require! A little lucidity, a bit of unconsciousness, some self-persuasion that perception is being "treated" out of love for reality but without ever forgetting that the operation derives from a somber passion for nothingness. A manifest but discrete presence of the macrocosm as if it would take flight at the slightest gesture, a "sense" in chiaroscuro, suggested but never explicit, which must appear without there being any indication that it is sought, as if it occurred incidentally, while one is lost in contemplating the contexture of the event. A supple care that nothing should be forced, that the de-realizing invention should be guided along the nervures of the real.[153]

It is in this sense that Sartre can say that in January 1844, at Pont-l'Evêque, Romanticism died and the post-romantic generation came of age. Meanwhile, in the course of his investigation Sartre will have acquired the means for saying what *Madame Bovary* is when it is taken as *praxis* and not as *exis*:

> Venus is not there but the statue exists. We know it, know its value. It is worth just so much. Someone or some organization owns it. If it is to be sent abroad for an exhibition of the works of its author, one knows its weight, its fragility. Precautions will be taken. I call this strange object for the first time by a name which we shall often meet subsequently: *a real, permanent center of irrealization.* As a matter of fact, if it possesses an individual being, if it has not remained a stone in the mountains of Carrara, this is because it has been given the function of representing a certain non-being. But in reverse, the moment this non-being as such is recognized as a determination of the social imaginary, the complete object is instituted in its being: this society recognizes in it an ontological truth to the extent that the being of this object is considered a permanent incitement to de-realize oneself by irrealizing this piece of marble as a Venus. The object acts as support to the irrealization, but the irrealization gives it its necessity because it is necessary that it should be if the irrealization is to take place. Here the imaginary, far from being an escape, vague or shapeless, has the force, the impenetrability and the limits of a piece of marble. The

compact, inert being of the stone is there to be de-realized publicly while it de-realizes those who contemplate it. But forthwith something of its immutable consistency, of its radiant inertia passes into the Venus or the Pietà. This stone woman is an ideal of being, the representation of a *pour-soi* which could be taken for a dream of an *en-soi*. Thus the sculptured stone, a mineral indispensable to a social irrealization, possesses certainly the *maximum of being* if we reflect that in social intersubjectivity *being* is the *être-pour-autrui* when it is instituted.[154]

It will be apparent that with this statement, perhaps one of the most significant to have been made in this century about the artistic enterprise, that Sartre is completing the work begun in *L'Imaginaire*, in *Being and Nothingness*, and in the *Critique*. Here is not only what *Madame Bovary is*, but what it *does*, what Flaubert *intended* and what occurs when it *is read*. *Madame Bovary* is first de-realization then irrealization in the mind of Flaubert as a fundamental project. The writing of it is the fashioning of an analogon. Inserted by scandal, as we know, into the social imaginary of the Second Empire, this non-being is instituted in its being. It is taken from its author and made into a permanent center of irrealization. This is the "strange top" which Sartre had described in *What Is Literature?* and which exists only in movement. Here it is a "totality" and an "interest" of Flaubert. Inserted into Objective Culture by the totalization of History, it comes down to us in the twentieth century as a "classic," that is, as an inert being of culture until its praxis is revived by our own. But "totalization has the same status as the totality: it pursues through multiplicities its work of synthesis which makes of each part a manifestation of the whole and relates the whole to itself by the mediation of the parts."[155] Meanwhile, "the totality, contrary to what one might think, is only a regulating principle of totalization (and reduces itself simultaneously to the inert whole of its temporary creations)."[156] It would be impossible to say more eloquently that the most material aspects of human creations are their most insignificant aspects.

There is a unique Sartrean *Weltanschauung* which is the product of all of his philosophy and which goes back to his youthful "theory of contingency" described by Simone de Beauvoir in her *Memoirs* and of which she writes: "[I]n [it] were to be found in embryonic form his ideas on being, existence, necessity, freedom. It was clear to me that he would one day write an important philosophical work."[157] There are only two distinct realities, indissolubly joined, in all of Sartre's philosophy: the world and human reality. The rest is pure human artifact. When not perceived or used, these artifacts fall away into seeming nothingness. This notion might well appear to be a survival of idealism in Sartre's philosophy, and it is doubtless in this light that orthodox Marxists see it. But there is an important philosophical difference: these artifacts do not fall away; they *endure*

in meaninglessness. Here is the anchorage in the real. And here also is their permeability to thought. If the real is to be understood by the human mind, it must be thought in terms of a materiality that will include the mind itself; in other words, there is a meaning of matter. Nor can History be read until it is disengaged from the *en-soi* in which materialistic philosophies engage it. History is not the past but a dimension of the present which Human Reality must be as it projects itself toward future possibilities which Human Reality must also be. What we call History is but a social imaginary taken as real; when we understand its true irreality, we acquire the means for changing it. The unreal is a powerful component of Human Reality when it is anchored in the real. Here lies the proper *use* of the imagination and the necessary demystification of "Pure Art." The "score" to be settled with Flaubert was the necessity to assert in philosophy and to demonstrate in History against Flaubert that, if the imagination can never destroy the real, it can destroy the unreal. The power of the mind over things requires an understanding of its own nature: here is philosophy as "drama," art as revolution, and revolution as intelligible. The proper use of the imagination is to call up the real in which it has its foundation and its nothingness, and to engage the real as it engages itself in the construction of the quasi-reality of Human Reality. In this all human artifacts share the common status of work and there can be no privilege even for the work of genius.

Sartre writes in the "Flaubert" of the "inevitable malediction of the artist [who] can neither refuse nor accept contingency." But there is a solution: "to take original contingency as the final goal of constructive rigor. Few creators ever attempt it."[158] And he adds in a note: "Flaubert is one of these. . . . This is the greatness of his work."[159]

Sartre did not take original contingency as the final goal of his own work but as a point of departure. His path consequently crossed that of all creators, including Flaubert. But Flaubert was a special case: he was the temptation "to create Beauty." He was the ultimate and radical choice of the imaginary. But Sartre had chosen the real and had written in *L'Imaginaire* in 1940: "the real is never beautiful."[160] Of this dilemma a unique literary philosophical career was born within a fundamental enterprise: to grasp the real by thought in order to destroy the idols of the imagination which alienate men's minds. The "imperialism of the imagination" was the truth of a myth of "Neurosis Art." All imperialisms fall with its destruction. If Sartre has called the "Flaubert" a "true novel," surely this is because in this massive work the imagination has found a proper use within Sartre's own philosophy: to call up the real in a single movement of dialectical synthesis which produces as a whole a "man," a "work," a "period," finally a phenomenon of History and "Sartre" himself in a contestation of

History. This unique object had never before been available in the world of thought.

ORESTE F. PUCCIANI

DEPARTMENT OF FRENCH LANGUAGE AND LITERATURE
UNIVERSITY OF CALIFORNIA, LOS ANGELES

NOTES

1. Jean-Paul Sartre, *Les Mots* (Paris: Gallimard, Folio 24, 1964), pp. 49–50.
2. Ibid., p. 50.
3. Ibid.
4. Ibid., p. 51.
5. Ibid.
6. Ibid., p. 52.
7. Ibid., p. 135.
8. Ibid., p. 136.
9. Ibid., p. 141.
10. Ibid., pp. 151–52.
11. Ibid., p. 210.
12. Michel Contat and Michel Rybalka, "Un Entretien avec J.-P. Sartre," *Le Monde*, May 14, 1971, p. 20.
13. Ibid., p. 1.
14. Simone de Beauvoir, *La Force de l'age* (Paris: Gallimard, 1960), p. 47.
15. Simone de Beauvoir, *Mémoires d'une jeune fille rangée* (Paris: Gallimard, 1958), p. 342.
16. Ibid., p. 343.
17. Beauvoir, *La Force de l'age*, p. 30.
18. Ibid., p. 35.
19. Ibid., p. 37.
20. [Perry Anderson, Ronald Fraser, Quintin Hoare], "Sartre par Sartre," *Le Nouvel Observateur*, January 26, 1970, p. 49.
21. Madeleine Chapsal, *Les Ecrivains en personne* (Paris: René Julliard, 1960), p. 223.
22. J.-P. Sartre, *Critique de la raison dialectique* (précédé de *Question de méthode*), vol. I: *Théorie des ensembles* (Paris: Gallimard, 1960), p. 91.
23. Henri Delacroix, *Psychologie de l'art: Essai sur l'activité artistique* (Paris: Félix Alcan, 1927), p. 481.
24. Ibid., p. 132.
25. Gustave Lanson, *Histoire de la littérature française* (Paris: Librairie Hachette, 1922), p. vii.
26. Ibid., p. vii, n. 1.
27. Paul Nizan, *Aden Arabie* (Paris: François Maspero, 1960), p. 80.
28. Sartre, *Les Mots*, p. 157.
29. Beauvoir, *La Force de l'age*, p. 493.
30. Ibid., pp. 493–94.
31. Contat and Rybalka, "Entretien," p. 1.
32. J.-P. Sartre, *Qu'est-ce que la littérature?* (Paris: Gallimard, 1948), pp. 198–99.
33. Ibid., pp. 9–10.
34. Ibid., p. 12.
35. Ibid., p. 255.
36. Ibid., p. 13.

37. Beauvoir, *La Force de l'age*, p. 46.
38. Ibid., p. 501.
39. J.-P. Sartre, *L'Etre et le Néant*; *Essai d'ontologie ontologique* (Paris: Gallimard, 1943), p. 28.
40. Ibid., p. 242.
41. Ibid., p. 563.
42. Sartre, *Qu'est-ce que la littérature?*, p. 111.
43. Ibid., p. 245.
44. Ibid., p. 251.
45. Sartre, *L'Etre et le Néant*, p. 644.
46. Ibid.
47. Ibid.
48. Ibid.
49. Ibid., p. 645.
50. Ibid.
51. Ibid., p. 646.
52. Ibid., p. 647.
53. Ibid.
54. Ibid., pp. 647–48.
55. Maurice Merleau-Ponty, *Sens et non-sens* (Paris: Editions Nagel, 1965), p. 133.
56. Michel Contat and Michel Rybalka, *Les Ecrits de Sartre* (Paris: Gallimard, 1970), p. 678.
57. Simone de Beauvoir, *La Force des choses* (Paris: Gallimard, 1963), p. 333.
58. Ibid., p. 369.
59. Contat and Rybalka, "Entretien," pp. 1, 20.
60. Chapsal, *Ecrivains*, p. 207.
61. Ibid., p. 209.
62. Ibid., pp. 209–10.
63. Ibid., p. 211.
64. J.-P. Sartre, *Saint Genet, comédien et martyr* (Paris: Gallimard, 1952), p. 541.
65. Sartre, *Critique*, pp. 9–10.
66. J.-P. Sartre, *La Transcendance de l'ego*, ed. by Sylvie Le Bon (Paris: Librairie Philosophique J. Vrin, 1966), p. 86.
67. Roger Garaudy, *Perspectives de l'homme: Existentialisme, pensée catholique, structuralisme, marxisme* (Paris: Presses Universitaires de France, 1969), p. 112.
68. Sartre, *Critique*, pp. 17–18.
69. Ibid., p. 23.
70. Ibid.
71. Ibid., p. 22.
72. Sartre, *Saint Genet*, p. 177.
73. Beauvoir, *La Force des choses*, p. 218.
74. Sartre, *Qu'est-ce que la littérature?*, p. 198.
75. Ibid., p. 115.
76. Sartre, *Critique*, p. 9.
77. Georges Lukacs, *Existentialisme ou marxisme?*, trans. by E. Kelemen (Paris: Editions Nagel, 1948), p. 14.
78. Ibid., p. 21.
79. Sartre, *L'Etre et le Néant*, p. 647.
80. Sartre, *Critique*, p. 103.
81. Edwin A. Burtt, ed., *The English Philosophers from Bacon to Mill* (New York: Random House, Modern Library, 1939), pp. 11–12.
82. Sartre, *Critique*, p. 148.
83. Ibid., p. 138.
84. Ibid., p. 139.
85. Ibid.

86. Ibid., p. 137.
87. Ibid., p. 142.
88. Ibid.
89. Ibid., p. 94.
90. Ibid.
91. Ibid., p. 91.
92. Ibid.
93. Ibid., p. 90.
94. Ibid.
95. Ibid.
96. Ibid., p. 90.
97. Ibid., pp. 89–90.
98. Ibid., pp. 91–92.
99. Ibid., pp. 71–72.
100. Ibid., p. 15.
101. Ibid., p. 16.
102. Ibid., p. 32.
103. Ibid., p. 156.
104. Ibid.
105. Ibid., p. 165.
106. Ibid., p. 247.
107. Ibid., p. 248.
108. Ibid., p. 249.
109. Ibid., p. 256.
110. Ibid., pp. 157–58.
111. Ibid., p. 225.
112. Ibid., pp. 307–8.
113. Ibid., p. 384.
114. Ibid.
115. Ibid., p. 138.
116. Ibid., p. 266.
117. Ibid., pp. 268–73.
118. Arthur Rimbaud, *Oeuvres complètes*, ed. by Rolland de Renéville and Jules Mouquet (Paris: Gallimard, Bibliothèque de la Pléiade, 1946), p. 255.
119. J.-P. Sartre, *L'Idiot de la famille: Gustave Flaubert de 1821 à 1857*, 3 vols. (Paris: Gallimard, Bibliothèque de la Philosophie, 1971–1972), vol. II, p. 1798.
120. Ibid., p. 1926.
121. Ibid., vol. I, p. 330.
122. Ibid., p. 448.
123. Ibid., p. 627.
124. Ibid., p. 776.
125. Ibid., p. 771.
126. Ibid., p. 787.
127. Ibid., p. 916.
128. Ibid., p. 931.
129. Ibid., p. 929.
130. Ibid., p. 934.
131. Ibid., pp. 934–35.
132. Ibid., p. 949.
133. Ibid., p. 905 and 958.
134. Ibid., p. 1025. (Cf. J.-P. Sartre, *L'Imaginaire: Psychologie phénoménologique de l'imagination* (Paris: Gallimard, Bibliothèque des Idées, 1948), pp. 245–46.
135. Ibid., p. 1086.
136. Ibid. and p. 1087.
137. Ibid.

138. Ibid., p. 1088.
139. Ibid., p. 1089.
140. Ibid., p. 1027.
141. Ibid., vol. II, p. 1121.
142. Ibid.
143. Ibid., p. 1258.
144. Ibid., p. 1297.
145. Ibid., pp. 1293–98.
146. Ibid., p. 1298.
147. Ibid., vol. I, p. 837.
148. Ibid., vol. II, p. 1631.
149. Ibid., p. 1766.
150. Ibid., p. 1823.
151. Ibid., p. 1839.
152. Ibid., pp. 1854–82.
153. Ibid., pp. 1970–71.
154. Ibid., vol. I, pp. 785–86.
155. Sartre, *Critique*, p. 138.
156. Ibid.
157. Beauvoir, *Mémoires d'une jeune fille rangée* (Paris: Gallimard, 1958), p. 342.
158. Sartre, *L'Idiot*, vol. I, p. 60.
159. Ibid.
160. Sartre, *L'Imaginaire*, p. 245.

Lee Brown and Alan Hausman
MECHANISM, INTENTIONALITY, AND THE UNCONSCIOUS:
A COMPARISON OF SARTRE AND FREUD

I T has become a cliché to characterize Sartre's critique of Freudian theory in terms of his rejection of the unconscious. In a recent retrospective characterization of his views, Sartre emphasized another theme, namely Freud's seeming oscillation between terms which "express one moment a sort of finalism and the next moment a sort of mechanism."[1] The first issue is easily misunderstood, and Sartre's best insights on the matter might have been stated more perspicuously. There are important connections between the two issues, but they are not obvious. The central notion that links the two is psychic strategy. This insight, together with the most important supporting considerations, is obscured by having been located in rather misleading contexts, sometimes involving specious argumentation. We wish to disengage the main insight, and to elaborate its actual implications as clearly as possible. The result will clarify the problem of the unconscious, and the relation of this issue to the question about causal connections. Finally, we will show that Sartre's famous argument against Freud in *L'Etre et le Néant* is misdirected. The puzzle about self-deception can be thrust upon Freud's theory only in the light of an effective critique based upon an examination of symptom formation.

In the first section we shall discuss the general program of psychoanalysis as seen by both Freud and Sartre. On a great number of points apparent differences turn out to be superficial or nonexistent; our concern is to separate the real issues from the trivial. The second, third, and fourth sections provide a detailed discussion of the real issues: compartmentalization, symbolism, and causal explanation. In the fifth section we shall briefly discuss Sartre's treatment of Freud and the problem of self-deception. We shall demonstrate that Sartre has mislocated Freud's theory of repression

within a discussion of the notion of self-deception. In spite of structural similarities, these two concepts are not equivalent.

I

Sartre's polemic against Freud should not, of course, obscure the degree to which his own theory is Freudian. His program of psychoanalysis was based, like Freud's, on the significance of the "insignificant." Freud introduced his audiences to this kind of approach in his famous theory of slips of the tongue. As Sartre puts it in generalized terms, in referring to his own theory, a "gesture refers to a Weltanschauung." The sense of an act is elicited by reference to profounder mechanisms, which analysis can disengage. For Sartre, these analyses have a lapidary structure, any given act referring to a deeper layer of significance which in turn takes its meaning from a yet more profound level, which can itself be disengaged, until in the end we come to the signification which "implies" no other signification and which "refers" only to itself.[2]

Sartre's analytic program, however, is not a theory of the development of neuroses and their treatment. For Sartre, a person's actions, when properly understood, can be seen to constitute a pattern that is unified by a basic project of existence. Ultimately, all such projects are aimed at a synthesis of *pour-soi* and *en-soi*. This basic aim cannot be achieved; hence it is a futile aim. Nevertheless, there is freedom in the individual instantiation of this project. Sartre does not provide a technique for cure, however, but rather an ontological analysis of personality. His psychoanalytic approach is amplified by a theory of symbolism which holds that concrete actions symbolically satisfy original projects, just as conscious behaviors in Freud's theory exist in relationship to complexes and the libido.[3]

As is well known, Sartre argues that all consciousness is (nonpositionally) aware of itself. We question this line of argument, but will not discuss it here. The rhetoric of admitting to consciousness only that which pertains to consciousness and that which is thoroughly transparent to itself may have its appeal, but to oppose Freud in this way is facile. Freud struggled to make clear various senses in which thoughts could be said to be unconscious, and his position on this question underwent a good deal of modification over the course of his life. But out of this welter of shifting notions of the unconscious, a simple point can be elicited: it is no good pushing and pulling on the question of whether unconscious thoughts are possible, as if that could be answered by thinking hard about some essence or about words. If there are theoretical reasons for affirming the existence of material which on the one hand exhibits intentionality and on the other hand can be introspected only after the considerable application of a tech-

nique of analysis, we have found very good reasons for exercising the privilege of a convention that calls this material "unconscious thoughts." And if this designation goes against prior conventions, then that only shows what can happen to linguistic conventions. If one complains that talk of unconscious thoughts can only be a *façon de parler*, Freud can reply that this objection presupposes what is questionable, namely, that the issue is a matter of the essential nature of thought. Scientific theorizing has the habit of ignoring alleged natural kinds.

Every reader knows there are snarls in Freud's discussion of the modes of the unconscious (which Strachey tries to straighten out in his note to *The Ego and the Id*[4]). We need only introduce a couple of points from the discussion. Freud sometimes speaks of unconscious material as that which can be introspected only with effort, indeed perhaps only by a technique of therapy. But of course we could not define the unconscious as that which is difficult to bring to consciousness without incurring a serious threat of circularity. For what is it that is difficult to bring to consciousness? Precisely the unconscious material, so that one might claim there is a hidden appeal to an unanalyzed notion of the unconscious in the definiens. At this point we must note Freud's own distinction between the descriptive and the dynamically unconscious. What is descriptively unconscious lacks the property of being conscious. Thus, what is difficult to bring to consciousness is that descriptively unconscious material which is repressed—that is, the dynamically unconscious material. What may be somewhat confusing in Freud's theory is that his original argument in the *Introductory Lectures* from slips of the tongue is an argument for the existence of mental intentions that are unconscious in both senses: descriptively, in that the patient is not aware of the intention, and dynamically, in that it takes effort to make him aware of it. To be sure, Freud sometimes appears to invoke the descriptively unconscious only to solve a philosophical problem, namely that of mental continuity. But it is clear that there are also psychoanalytic reasons for his commitment to the descriptive unconscious; certainly this is part of the point of his argument from slips of the tongue. But it clearly is not the only point. His argument about slips of the tongue is at least intended to show not only that there are mental processes which lack the quality of being conscious, but that some of these have behavioral effects and resist attempts at bringing them to consciousness.

In what sense does Sartre reject the unconscious that Freud affirms? Is it in the sense of something unknowable in principle, as Sartre sometimes suggests?[5] Is it in the sense of material that can never be "relived" (in the early theory of cure Freud said it *could* be relived)? Let us see.

Sartre insists that the mind is translucent to itself; yet it becomes clear that for him, no less than for Freud, this is not quite the case. And again for

Sartre, no less than for Freud, the mind can within limits come to know itself. In the earlier psychoanalytic statements, unconscious material was clearly conceptualized as available to consciousness in the cathartic stages of therapy. Of course it turns out that in more sophisticated formulations, substantial changes qualify such material as it becomes conscious. But it seems clear that Sartre must grant some analogue of this change in his own positive doctrine. First, let us address the issue as Freud sees it.

We know that Freud himself spoke of a distinction between kinds of knowing. The obsessive patient may understand the connections between his present behavior and his early experience, and yet this may not be sufficient for the kind of self-awareness that would liberate him from his obsession. There is a difference between the doctor's knowledge and knowledge which the doctor wants to impart. The patient too can appropriate the doctor's third-person knowledge, even when the object of that knowledge is himself. But it is not the knowledge he needs for deliverance from his neurosis. That knowledge is not merely knowing the cause as the doctor knows it. Nor is it mere dispassionate recollection. During the Breuer period the goal of therapy was a cathartic experience, in which the ideational causes underlying the patient's conscious desires and feelings are themselves relived. Even after this model was modified, Freud was concerned about the distinction between effective knowing and ineffective knowing. The distinction is present in the *Introductory Lectures*, which not only marked it but sketched a theory about its dynamics.[6] Hence, we can in more than one way gain knowledge of ourselves. It is not the case, then, that for Freud the fundamental hypothesis is about a psychic mechanism that escapes knowledge in principle. Certainly what comes into the light of consciousness in therapy arises from the unconscious, but it is not unknowable in principle. Quite the contrary: if therapy is successful, the subject comes to know what he did not know before.[7]

Of course, had Sartre studied the metaphysiological papers—and it is not clear that he did—he might have asserted against Freud that on the latter's systematic conception of the unconscious, the unconscious material cannot be translated into conscious mentation without some loss of its intrinsic characteristics (exemption from contradiction, timelessness, and the like). Rather than a simple translation of a state from one region to another, there is a re-coding of material into the terms of the pre-conscious and the conscious. Freud sometimes suggested that this functional shift involved the recasting of material into a verbal format. But it is highly doubtful that Sartre has considered these refinements. If he had, he might have wondered about apparent analogues which can be turned up in his own theory. In his psychoanalytic program there is a parallel notion of behavior which has goals unknown to the patient. (Obviously something has to be

outside the patient's intelligence at the outset, else psychoanalysis would be pointless.) On the one hand, Sartrean psychoanalytic reflection brings out the significance of our actions, that is, their explicit connection with one's basic project. On the other, there are, as Sartre puts it, mysteries existing in broad daylight before analysis. Yet he somehow supposes that he escapes the unconscious altogether. The sense of one's actions is supposedly grasped even before analysis, all at once but without shading, without relief. Everything was always there, but nothing stood out.[8] Sartre says:

> ... if the fundamental project is fully experienced by the subject and hence wholly conscious, that certainly does not mean that it must by the same token be known to him.[9]

> [Ordinary reflection does not command] the instruments and techniques necessary to isolate the choice symbolized, to fix it by concepts, and to bring it into the full light of day.[10]

Thus Sartre sees a crucial distinction between consciousness and knowledge: one may be conscious of what one does not have knowledge of, in the sense that we do not fix all of what we are conscious of by concepts (words?), nor do we connect that which we conceptualize with that which we do not. What we do not conceptualize, in this pre-analytic consciousness, is the basic project and its relation to that of which we are conceptually aware. To put this point another way, in more traditional philosophic terms, Sartre is claiming that we have thoughts—for example, the thought "I guess I will go to the bank now"—whose object or intention is much more than the immediate one (the fact of going to the bank). Each intention somehow contains our basic project (and thus, by implication, the thought, too, somehow symbolizes or contains this project). Thus, where Freud says a descriptively unconscious thought lacks the quality of consciousness, Sartre speaks of part of the content of an intention of which one is conscious but which one does not know. Sartre's idea seems to be something like this: one may be said to be conscious of (but not to know) things implicated in the intentional object of consciousness. A Gestaltist like Kurt Koffka might say that one in some sense cognizes further expanses of a rug when the visual perceptual field is limited to a segment. In the same way, one may be conscious of the explicit goal of behavior and also the project which it symbolizes, but nevertheless may not see the limited goal *as* symbolizing the ultimate project.

If we consider the issue from Freud's side, we find strikingly Sartrean observations on the point. He often writes as if the goals of behavior are in a sense "there" to be seen as the psychoanalytic interpretation requires: "If I say to you: 'Look up at the sky! There's a balloon there!' you will discover it much more easily than if I simply tell you to look up and see if you can

see anything."[11] In other words, the patient has the benefit of the intelligence of the therapist in order to educate his perceptions.

It seems clear, then, that Sartre and Freud both agree that (1) there exists something which is unknown to the patient. Furthermore, they agree that (2) this may become known under certain conditions. And surely they would both agree that (3) after therapy, the patient might come to know that these hitherto unknown thoughts belonged to him all along. Some may wonder if this point would be accepted by Sartre, in the light of his emphasis on the element of "futurity" (which he says Freud's theory lacks).[12] In other words, it may seem that there is no sense in which the project did belong to the subject, even though the subject comes to know "his" project, because all there is to this project, pre-reflexively, is the goal to be realized *in the future*. For these rather curious reasons, Sartre might deny the third point above. But he surely could not do so reasonably. If the goal is mine, even though it is a future goal, then I seek it *now*, although I may not know it. Whether or not one interprets this present seeking as some desire in the psyche which is unknown to the psyche—which may be all that Freud means by the descriptive unconscious—or in some other way, as Sartre would have to, is of little importance. For Sartre's attack on Freud comes at another point.

The real issue is: What must the psyche be like, given that there is such an unknown? As we see it, this is not an issue over the descriptive unconscious; that is, it is not an issue over whether or not certain entities may be in the mind yet lack a property of consciousness. Freud's view on this matter, that there is such a property whose lack marks the unknown, is not merely naive, not merely puzzling; it does not even do justice to his own views about the psyche. What is important, is why the fact that we have a desire or a project is not known to us before analysis. Freud provides a mechanism to explain this fact: the desire is dynamically repressed into a region or a structure—we shall call it a compartment—of the mind. It is this notion which Sartre wants to demolish. In the next section we explore Sartre's attempt at demolition. We must add that Sartre's notion of self-deception—which he claims Freud must also embrace if he is to be consistent—is intimately tied to his own solution to the problem of how one can come to know one's basic project, know it as one's own, and know it was one's own even when one was merely conscious of it. This is explored in section V below.

The last preliminary point concerns the way in which the original motivations operate in Freud's theory. One can see two alternatives: either the unknown material is still active in producing the symptoms it yields; or it is no longer an active factor in the patient's psyche, but is still a necessary condition for any explanation for his present behavior. Captain Queeg's

well-known habit of juggling steel balls may express, by way of a desire to masturbate, a living primitive wish; or his behavior may be the result of his present personality, certain cues in his environment, and a past primitive wish to masturbate. That is, Jones and Johnson may experience the same present cues and even have the same personality, but only one exhibits the symptom—namely, the one who had certain desires and other experiences in the past. So viewed, the principle which explains the symptom is a historical law. In the one view, the unconscious primitive wish is taken seriously, as it were, denoting a factor now operative in the patient's behavior. In the other view, the unconscious is de-mythologized. The original wish which by accident associated itself with certain forms of behavior is quite dead. To speak of the operations of the unconscious is simply to speak elliptically of the causal links between a forgotten past desire and a present behavior.

One complaint against psychoanalytic theory is that its laws are merely historical laws in that, given the present status of the science, it is not theoretically possible to predict future behavior from a single temporal cross-section of the subject, and that this is a defect when compared with the laws of the physical sciences, i.e., process laws. One may well question the theoretical possibility of such a prediction even in the physical sciences, of course, but pending the payment of the promissory note in a physiological reduction of Freudian laws, the merely historical character of these laws is a source of annoyance to some philosophers. It has been shown that this defect, if it be one, infects psychology in general, where a little reflection on simple learning theory shows *all* psychological predictions to be based, at best, on historical laws.[13]

One of the curiosities about historical laws is that in predicting the future behavior of a person, account has to be taken of variables whose values are events in the distant past. The symptom displayed today is determined in part by the trauma of twenty years ago. Thus, there appears to be a magical action across a temporal distance. Sartre suggests such a concern in some passages:

> By rejecting the conscious unity of the psyche, Freud is obliged to imply everywhere a magic unity linking distant phenomena across obstacles, just as sympathetic magic unites the spellbound person and the wax image fashioned in his likeness.[14]

Sartre may thus be rejecting the plausibility of historical laws altogether; such deterministic relationships are impossible. So conceived, his point might therefore be incorporated into a dilemma: either the causal determination operates across temporal distances, or it does not (that is, it is operative contemporaneously with the behavior in which it issues and in which it expresses itself). In the former case, the determinist connection is impossi-

ble. In the latter case, the connection cannot be causal at all, for reasons we shall discuss in section IV. (The claim examined there will be that such motivation would have to express itself in the sense of contributing meaning to the symptom, and therefore could not also be the cause of it.) The result is that, contrary to Freud, the unknown complexes cannot causally determine behavior.

Now, such a dilemma is plainly interesting in its own right, and the second horn of the dilemma is clearly reflected in important passages of Sartre's criticism. But in spite of the suggestiveness of the reference to magic in the cited passage, it is not clear that Sartre thinks Freud is in danger of falling on the first horn of the dilemma. Rather, it seems that although Sartre is suspicious of historical laws, he interprets Freud as avoiding them altogether. This is suggested in his discussion of "horizontal" and "vertical" determinism in Freud.[15] In essence, this discussion asserts that because Freud requires the complex to be in part determined by various prior experiences, "the future does not exist" for Freudian psychoanalysis.[16] The charge is highly questionable; indeed, certain passages seem to give Freud some credit for *avoiding* historical laws:

> Like us, he refuses to interpret the action by the antecedent moment—i.e., to conceive of a horizontal determinism . . . a particular symbolic act expresses an underlying, contemporaneous desire just as this desire manifests a more profound complex and all this within the unity of a single psychic process.[17]

Clearly, Sartre views Freud's original affectivity as having survived through time although picking up concrete determination along the way.

The more likely point behind the reference to magic is this: unless mental compartments are abandoned, merely causal, and therefore *contingent*, connections obtain between the compartments. In that case, the analogies which indicate a symbolic relationship between symptoms and complexes (which Freud seems to take for granted) cannot be explained. Only a strategic plan could explain them.

II

Sartre's crucial arguments can be gleaned from certain key passages:

1. ". . . the description of the process of [Freudian] disguise implies a veiled appeal to finality."[18]

2. ". . . there is [for Freud] always an internal analogy between the conscious fact and the desire it expresses. . . ."[19]

3. ". . . how are we to account for the pleasure or the anguish which accompanies the symbolic and conscious satisfaction of the drive if

consciousness does not include—beyond the censor—an obscure comprehension of the end to be attained as simultaneously desired and forbidden?"[20]

4. "Thus the resistance of the patient implies on the level of the censor an awareness of the thing repressed as such, a comprehension of the end toward which the questions of the psychoanalyst are leading. . . ."[21]

5. "If the complex is really unconscious—that is, if there is a barrier separating the sign from the thing signified—how could the subject recognize it?"[22]

6. "The profound contradiction in all psychoanalysis is that it presents *at the same time* a bond of causality and a bond of understanding between the phenomena that it studies."[23]

Though suggestive, it is rather obvious that these passages do not constitute a set of complete arguments. We believe that they contain a few important insights mixed with questionable argumentation. In what follows, we attribute to Sartre a set of views based on our own disentanglement and interpretation.

The Freudian theory that Sartre is attacking posits compartments in the mind, that is, regions which have cognitive barriers between them. The Freudian censor is such a barrier. Sartre points out that in certain crucial instances there must be two-way communication across these supposed barriers and, furthermore, that important functions of certain compartments must be duplicated by certain other compartments. With such communication and duplication unavoidable, why not drop the notion of compartments altogether and speak of a unified psyche?[24] The alternative, as we shall see later, is a view of the mind as compartmentalized and with only accidental connections between each compartment. Such a view, Sartre believes, would not account for the phenomena Freud is trying to explain.

Let us now consider the implied charges against Freud in the foregoing description. Clearly, the theory involves compartments of the mind—the conscious and the unconscious, for instance—with the censor standing in a sort of doorway between. That is the topographical theory. Later Freud was to modify the construct to structural or functional divisions, that is, into id, ego, and superego; and indeed, he finally distinguished between the conscious and the unconscious ego. But whether we speak in terms of regions or functions, Freud did not introduce these distinctions because they constitute observable discriminable units. He introduced them because the notion of compartmentalization has explanatory value; it explains human behavior. The explanation concerns important relationships between

compartments—for example, one can explain behavior by showing how one compartment does something to another. Sartre holds that it is clear that, on Freud's own terms, such explanations can only be teleological. For example, the censor somehow knows the existence and character of certain libidinous wishes and effects a certain compromise behavior, which is—in a sense to be explored below—symbolic of the underlying motives.

Thus even in early Freudian theory the barriers between compartments are not absolute. The theory posits the existence of a censor between the conscious and the unconscious, and this censor in some way apprehends the contents of the unconscious. Indeed there is a kind of barrier between the conscious and the unconscious; one does not know what is in one's unconscious. But the censor both causes behavior (of the nature of this cause, more later) and *intends* that behavior. Similar comments apply for later Freudian theory. Thus the barriers between compartments are crossed in certain directions. The censor is cognizant of both the unconscious and the conscious.

But this is not enough for Sartre. He wants to demolish the compartments altogether. As we shall see, he argues that some of the compartments, supposedly barriered in certain directions from certain other compartments, can be demonstrated to have intentional connections in those directions. Put this way, we see that the question of the unconscious comes in not in an absolute sense (that is, as that which lacks a certain intrinsic quality), but in a relational sense. Of course, once such relations are shown to exist, since the barriers collapse, so too do the compartments. Some of Sartre's points seem to capitalize on the necessity of cognitive connections between supposed compartments to prove that there *are* no compartments.[25]

The arguments considered in this section are as follows: (1) One seeks to prove that Freud's notion of symptom formation involves the strategic, and hence teleological, effecting of compromise solutions to situations of inner conflict. This is a relatively uncontroversial point, except that Sartre thinks Freud does not always keep it in mind. (2) Two arguments are aimed at proving that desires, which Freud supposes to be unknown to the conscious ego, must really be known to it. (3) Two arguments contend not only that the conscious ego must know the unconscious libidinous drives (thereby breaking down one of the supposed cognitive barriers), but also that it must effect the actual strategy which the censor supposedly accomplishes. The result is the superfluity of the censor and the conscious unity of the psyche. One may as well say that the conscious ego shares in all the functions of Freudian divisions of the psyche. We shall now consider these points in order.

Passage 1 in the excerpts cited above refers to what Sartre calls "finality." One readily sees what Sartre has in mind if one reads Freud's *Introductory Lectures* and takes the discussion of slips of the tongue as a model. Here one finds that symptoms are intentional—they result from a conflict-resolving *strategy*. However, in his complex discussions of the etiology of symptomatic behavior, Freud often seems to forget to connect that etiology with the teleological model. One way to see the arguments that Sartre presents, then, is as an important reminder—if not as a genuine insight—that a symptom must be intentional. Freud's tendency to forget this aspect of his own theory manifests itself in subtle ways, and in Sartre's view the most important lapse occurs when he compartmentalizes the mind.

Let us look more closely at the issue of how symptoms are teleological in Freud's view. Just as in a slip of the tongue, where two competing intentions result in a sort of compromise, a symptom also represents the resolution of a conflict. Consider the case of a person who neurotically hates his mother. This hatred would express itself in conscious behavior were it not for the censor. Such hatred may then result in a neurotic symptom, such as cruelty toward women in general. It is obvious that this symptomatic behavior is somehow appropriate; it seems to be the result of a strategy of compromise. We interpret Sartre's claims about *finality* in Freud as essentially involving this notion of strategic ends. Freud, of course, would agree, even though he lapses into "mechanical" explanations of symptom formation.[26]

Sartre's intriguing concept of internal analogy, as stated in passage 2, allows us to construct an argument. Consider again the case of the person who hates his mother, and assume that he is also a ship's captain. Assume that his analyst hypothesizes that his being a ship's captain is the symptomatic expression of the hatred. Lacking further information and unless some further connections are drawn, we must question this hypothesis, for such behavior does not seem appropriate to the compromise expression of hatred for one's mother. We do not see immediately how such behavior could serve the goal of a compromise which allows a socially acceptable form of expression of this hatred. We cannot imagine that this compromise behavior could be just *any* behavior. The moral is that there must be a similarity between the unconscious aims and the symptom.

Certainly Sartre is correct here: Freud, in his early theory at least, continually resorts to examples of symptoms which exhibit such similarity. Take, for example, his famous case of the disappointed bride. There is an obvious sense in which her symptoms, the enacting of a scene using a table and a stained tablecloth, conceptually relate to the scene she wished had taken place on her wedding night, when her husband failed to make love to

her. In this case and many others, Freud obviously looks for analogies between symptoms and unconscious complex. The table symbolizes the bed in a partially iconic way. The fact that Freud looks for similarity shows that there is an appropriateness of symptom to complex; and, conversely, strategy must result in such similarities. In the present context the Sartrean argument seeks to remind Freud that, since he invokes internal analogies, his model of symptom formation is teleological. The appeal to similarity simply underscores the point that not just any behavior will constitute an acceptable substitute. In order to be acceptable to the psyche, it must in some way resemble what one would do if censorship had not intervened. A fuller discussion of the similarity criterion of appropriateness and, in particular, of the question of whether strategy *must* involve similarities, will be presented later.

So far, the Freudian might be convinced. Indeed, Sartre has only underscored what the Freudian theory of analysis really accepts. However, the Freudian will still insist on the necessity of cognitive barriers for the explanation of significant parts of human behavior. Although the censor is not in the dark about the motives among which it must adjudicate or the conscious behavior it knowingly effects, the conscious ego is not privy to these underground machinations. Of course the conscious ego may come to know about them as the result of therapy, but prior to therapy it will probably remain in the dark. Now Sartre's points may be used against this hypothesis, by assuming certain clinical facts and principles with which Freud would agree. Among these are the notions of strategy, the appropriateness of symptom to underlying drive, and the situation of conflict. One of Sartre's conclusions is that the construct of separate psychic mechanisms is superfluous. We shall now look at three of Sartre's most suggestive observations as a basis for patterns of argument.[27]

The Argument from Resistance

Passage 4 may be utilized in an argument against compartmentalization. This passage concerning the censor does not state the conclusion that the conscious ego must, contrary to Freud, know the truth. Nevertheless, we shall tentatively draw that conclusion. We are using the fact of resistance in an argument that is certainly in the spirit of Sartre's overall polemic against Freud—that the conscious ego must know what Freud claims it does not know. We shall return to the narrower intent of the passage later.[28]

The present argument builds upon the fact that at a certain point during analysis, the patient typically refuses to go forward in therapy. For this refusal there is a motive, which must be fear of the truth that might emerge.

And if we grant that fear is intentional, then this fear might seem to be fear of the truth, and hence an awareness of it. Presumably, mere consciousness is not sufficient to motivate this behavior; therefore, the conscious ego must know the feared object. At any rate, the compartments break down. If it is suggested that this fear be indeterminate, or objectless—but strong enough in affect to motivate behavior—the reply might be that there *must* be a determinate awareness of the fearful object: the fear itself must have a motive, this motive must be to avoid the terrible truth, and this truth must in some sense be known in order to motivate the behavior. Therefore the fearful truth is *itself* already known.

Suppose the patient simply fears talking to the doctor. The argument from resistance may push further here and insist that there have to be motives for such fear, and they are in the patient's cognizance. The man who says he fears talking to the doctor has feelings that stand in need of explanation, especially since he exhibited no such resistance earlier in the treatment. While it is in a sense normal to fear some things (the dark, for instance), it is not normal to fear talking to a doctor. But again, we might well balk at this point and maintain that the patient has an indeterminate fear with no known motive *or* object.

What really gives bite to the argument from resistance, however, is the factor of *increasing* resistance as time passes. The closer the patient is drawn to the solution, the more he holds back; and this seems evidence that he is increasingly aware of what he detects through the doorway. It becomes more and more distinct. He is not merely suspicious of something indeterminate. If it be indeterminate, he might as well have joyful feelings of anticipation. He is aware of something determinate that becomes clearer and more distinct, and the increasing resistance is a gauge of this progress. The answer to this, however, is that although it is of course true that the barriers are, in a sense, crumbling and the patient is indeed closer to the solution than he was earlier, still he does not *know,* at the level of the conscious ego, this diminishing distance. Rather, the unconscious is the source of resistance, for *it* sees the chain of associations leading ever closer to the truth which will, barring resistance, eventually become known to the conscious ego. Indeed, the patient resists admitting that he resists![29] He discounts not only his most recent answers as insignificant, but also the therapist's questions as irrelevant; and his own denial of resistance *itself* is now viewed as significant only of the seeming pointlessness of the therapy. The motivation, in other words, is repressed.

As to the character of his fear, it may be indeterminate, with no known motivation. But it need not be. Perhaps it is fear of a specific object of the form "what I might learn about myself." This need not betray that he knows the hidden material already, simply that he has an unhappy suspi-

cion. He may advance no reason for his suspicion, or he may even rationalize it: for example, "all people have undesirable characteristics that it is unpleasant for them to face." Whether he offers a rationale or not, we do not have to conclude that he is aware of some underlying ground in the form of a truth apprehended in advance.

So, the resistance behavior may simply be accompanied by ever-increasing negative affect.[30] It may have quite determinate, known motives. But in neither case does it establish that the patient already knows what he will allegedly find out only at the end of therapy. The argument from resistance, therefore, appears to fail.

The Recognition Argument

Passage 5 raises a kind of *Meno* problem as regards the patient's situation at the end of therapy. The conclusion of successful therapy, Sartre supposes, involves recognition in the sense of seeing again, but this time seeing clearly, what one supposedly knew before. Sartre's analogy is of a man recognizing an image of himself in a mirror.[31] The analogy is hardly transparent. A likely interpretation returns us to the cathartic view of cure, discussed earlier. The patient is led by a thread of ideas to the complex he has repressed, and he is invited to reanimate this idea, to live it out, as it were, or at least to remember that he has after all, for example, despised his mother all along. Here, presumably, the interpretation depends upon the kind of interchange naturally supposed to take place at the conclusion of therapy. Whatever form the patient's knowledge takes, it is more than a mere hypothesis. We shall call this the recognition argument. It is an argument against cognitive barriers. It says that the patient finally sees that he has known something all along. The supposed barrier between his underlying desires and his conscious ego did not really exist after all. It should be noted that for Sartre's argument to have any bite, he must be saying more than that the patient comes to remember some *time* during which he hated his mother (which does happen in many typical Freudian cases). For this allows that the memory was effectively repressed in the interim, and the compartmentalization would not be refuted.

Before considering criticisms, we must draw a distinction. Consider these statements:

1. I see that I hated my mother all along.
2. All along I saw that I hated my mother.

Item 1 is a plausible candidate for a patient's statement at the end of therapy. A question arises as to whether statement 1 implies statement 2. For the Sartrean argument to work, we must arrive at 2 as a statement of the truth of the situation.

Is there any way to interpret statement 1 so that it might plausibly imply statement 2? One possibility is the following. Statement 1 is interpreted as meaning that, in the Sartrean sense, one was conscious of one's hatred all along. This, however, would not establish anything to which Freud could not agree, given that we cannot conclude that in the Sartrean sense one also *knew* this hatred. But why should one think that one knew this? It appears that the only good reasons would be based on some *other* argument. In that case, the recognition argument presupposes the other argument pattern. That is, if we could prove that no cognitive barriers existed at any point *prior* to the end of therapy, then the insight gained at this end point could only be a kind of recognition, since the patient was never really in the dark. But then everything turns on the other proof, whatever that be. The statements reflecting the patient's state of mind at the end of therapy cannot themselves be used to prove the point. Even if statement 1 did imply 2, or even if the patient gave voice to statement 2, the clinical data still leave room for interpretation. Freud could consistently interpret the verbal behavior as only reflecting a seeing (for the first time) of one's behavior as mother-hating. At the same time, in Sartre's sense of "consciousness," the patient might have been conscious of the meaning of his behavior all along. Recognition in Freud's sense comes to this: the patient for the first time *connects* his behavior with its true motivation in the sense of seeing the former as partially fulfilling the latter.

The foregoing arguments attempt simply to use Freudian data to cross the cognitive barriers in certain ways not officially allowed by Freudian theory. A different pattern of argument seems to be suggested by certain passages in Sartre's critique which go beyond the other two and try to draw a stronger conclusion—namely, that a single mental center must do all the work which Freud divided among different compartments. Now, there are two forms which this argument can take, and we shall consider each. Both originate in a consideration of the partial gratification which symptom formation provides. One version of the argument invites a fairly easy but instructive Freudian reply. A stronger version brings out the questionable, but somewhat elusive, element of the theory. It should be observed that Sartre does not put the point in the terms developed here. Still, putting it this way does, we believe, capture Sartre's best insights.

The Argument from Affect

Freud claims that every symptom that stems from a libidinous drive must give some pleasure, since libidinous drives give pleasure in discharge. Some symptoms, of course, may also be accompanied by anguish. Now consider the question posed in passage 3. This question can be construed as an

implicit argument which capitalizes on the existence in symptom formation of affective components, to prove that there must be complicity between the conscious ego and the unconscious. More strongly, the conscious ego must itself *duplicate* the strategic maneuvers. Thus, not merely do crucial barriers fall, but the unconscious strategy is superfluous.

Sartre's comment suggests that one must somehow comprehend the end to be obtained in the symptomatic satisfaction, however skewed, of a repressed libidinous drive. The activity must be conceptually connected with the supposedly hidden motivation. On a hypothetical analysis, for example, Captain Queeg of *The Caine Mutiny* must connect his rolling of steel balls with the desire to masturbate; otherwise he would not take the limited pleasure in the action he does take. So he is, qua conscious ego, an accomplice in the satisfaction of that desire, and must, at that level, share in that desire. So, seemingly, the barrier between the unconscious and the conscious ego is broken down.

Sticking to the case of positive affect, one might reply that although the behavior gives pleasure to Captain Queeg, he needn't really know why. The assumption that he must know this is simply a piece of a prioristic question-begging in the face of the theory for which Freud believes he has marshaled evidence. Part of that theory is that affective components may split off from their original intentional objects. If the claim is that one must know the underlying causes of one's satisfactions, the obvious answer is that one often does not, quite apart from whether or not such causes be Freudian ones. Finally, there is one obvious sense in which Captain Queeg has supplied a perfectly satisfactory "why" simply in stating the intentional (or telic) aim of his activity as he comprehends it, that is, simply to juggle the balls. If one pointed out to Captain Queeg that his behavior followed an idiosyncratic pattern, that it was highly unusual, he might be perplexed about the answer.

Of course, Sartre appears to refer to the symptomatic phenomenon as a mixed one involving pleasure and pain, which does indeed accord with typical Freudian examples. Perhaps we should focus on the feature of pain to find Sartre's point. If Captain Queeg feels anguish from the continual rolling of steel balls, his reason might be that he simply enjoys pain. But there is something unsatisfactory about this answer, not just from the point of view of the psychoanalyst but from the point of view of common sense. We are not inclined to accept out of hand the claim that people like pain. It seems reasonable to ask why Captain Queeg likes to do painful things. The answer would seem to involve an underlying strategy or purpose which is not readily apparent. But surely, the argument goes, since Captain Queeg is in touch with his own pain, he must be in touch with this strategy. And this must be true of neurotic patients in general. Thus, if the patient's rea-

son for his action is that he likes pain, one may feel that he must know some reason *why* he likes it; for example, it may be a form of self-punishment. Against this, the Freudian can simply answer that there is no reason why the patient must know this underlying reason, even though there be one. Of course, common sense might be appeased by the Freudian claim of underlying motivation; but if it is not, we could describe the masochistic behavior in slightly different terms. We might say that in such cases the patient feels a compulsion to do things that produce negative affect. However, one could now reply that this feeling of compulsion only indicates that the patient has some obscure comprehension of the goals served by the behavior in question. How can he feel compelled unless he knows what he is compelled by?

Just as in the case of positive affect, the burden of proof is on the critic to show that the patient is incorrect when he claims he does not know what compels him, why he has this feeling of compulsion. The patient is bewildered by his wants and needs. Granting that there are underlying motives, it does not follow from the patient's awareness of his own behavior that he knows those motives. He might, for example, be convinced that his needs stem from some physiological ailment. There is, of course, a strong temptation to argue that if the patient does not like his behavior and is anguished by it, he could stop himself from performing it. But this is a peculiar argument. The patient may wonder about it himself precisely because it is compulsive. Even in cases where the patient acts normally, out of need, he might not be aware of why he has the need to do as he does.

The Argument from Symbolism

A reformulation of the argument just considered still capitalizes on affect—or at least on the satisfaction of the drives of the unconscious—but couples this with a delicate aspect of Freudian theory that has not yet been emphasized: namely, signification or symbolism. This argument is somewhat problematic in that it draws us into some of the more trackless areas of Freudian theory. In particular, we confront very tough questions about the character of the unconscious. Freud sometimes suggests (and important passages in Sartre seem to underscore the suggestion) that a symptom is a symbol. Captain Queeg's behavior not only partially satisfies the underlying drive, it also "means" that underlying drive. The analyst can interpret the behavior as a *sign* and, in the long run, the patient can too. Now, consider Captain Queeg and his obsession once again. In juggling the steel balls, he does not literally masturbate. But this, by hypothesis, is what the unconscious seeks to do. So we can ask a question similar to the one we raised in the argument from affect, but this time with more hope of success:

From the standpoint of the unconscious, why should this behavior suffice in the slightest degree? Why should it be acceptable? One condition for the behavior's "working" for the unconscious must surely be that the unconscious can correctly interpret the behavior, that is, correctly read the symbolism of the symptom. The limitations of an otherwise useful scenario illustrate the point. Think of the Freudian tripartite arrangement as follows: the *censor* persuades the *conscious ego* to do something that benefits a *third party*. The identity of the third party and the way in which that party will benefit are matters not disclosed to the conscious ego. The conscious ego accepts the assignment because the action it performs yields some pleasure to itself. It is as if one person were to persuade a second person to put money in a bank, thereby benefiting an unidentified third person who is a stockholder in the bank. The second person can be so persuaded simply because the proposed action will be beneficial to him. The third person's involvement is kept secret because it would be a source of annoyance to the depositor were it known. Now, thinking of the relationship in these terms, one might say that there is simply no reason why the stockholder and the agent who persuades the depositor should be two persons at all. The answer, of course, might be that in this case the stockholder is an incompetent fool who has no ability to engage in the manipulative actions we have suggested. He simply enjoys the profits with no conception of their source. At this point the scenario does not capture the essential part of Freudianism on which Sartre can capitalize, namely, that the sense in which symptom formation "works" requires that the unconscious recipient of benefits interpret the behavior done on his behalf. In other words, even if the censor and the unconscious remain distinct, both must possess some sort of interpretive capacities. We shall return to the depositor-stockholder analogy presently, although its limitations are already emerging.

For the time being, let us accept the account of the unconscious upon which the foregoing is predicated. In effect, the argument maintains that (1) interpretive powers must be given to the unconscious, (2) the unconscious might as well take over the duties of the censor, and (3) certain reasons finally dictate breaking down the distinction in kind between the unconscious and conscious ego.

As to the first point, the argument is that even though we may allow that the conscious ego does not understand the symbolism involved in symptoms, the unconscious cannot be in that position if it is to obtain any satisfaction. There must be a conscious connection between the drive and the behavior which allows the unconscious a modicum of satisfaction. Such a connection could not be a Leibnizian one, which merely exists in the eyes of a third party, such as the censor (which presumably *does* understand the symbolism it has evolved). The unconscious itself must understand the be-

havior in the example under consideration as masturbational. It must effect a translation.

As to the second point, one might wonder if there be any good reasons for identifying the unconscious with the censor. But the question would be, rather, if there be any good reasons for *not* doing so. Given that the unconscious has the relevant capacities, then what is the point any longer of distinguishing them? To the question as to why the unconscious would on the one hand seek certain goals and on the other hand effect certain substitutions for itself, the answer is that at the same time the conscious ego, whose complicity is required, must be kept in the dark about its unwitting cooperation. But its being so kept is not a function of the sameness or difference of unconscious and censor.

As it stands we have undercut one distinction and eroded some of Freud's compartmentalization, but the crucial barrier is still up. The unconscious machinations still go on behind the back of the conscious ego, and we seem to have no implements to break down that last wall. If we could, the result, presumably, would be that one center of mental activity desires, feels the inappropriateness of these desires, effects and deciphers symbolic substitutions, takes pleasure, and is satisfied, although not completely. This takes us to the third point.

Let us amplify the earlier scenario. Let us grant that the agent and the stockholder are one and the same being, although this fact is not known to the depositor. The analogy must accommodate a further condition. The stockholder's benefit is a state of affairs separate from the depositor's action. The two are related only by causality. Yet the depositor's action must result in dividends for the stockholder in order for the latter to be satisfied.

These mechanics are clear to anyone who understands investment. How do we carry the analogy over to the unconscious? In particular, why should the unconscious be satisfied by an action that is performed by its unwitting proxy, the conscious ego? Something further is required to explain how the benefits are conferred upon the unconscious by these proxy actions. The depositor-stockholder analogy is clearly no longer sustainable. The structure of the psyche at this point is more like the case of a person who is made to read pornography aloud in words which he does not understand, but which are of great interest to an auditor who *can* understand. Meaning seems to lie at the heart of the matter. If we agree with that important side of Freud which interprets symptoms as symbols, and therefore as involving meaning, then we can see the problem Sartre is posing. He posits a semantic relationship obtaining between symptoms (S_1) and symptomized (S_2); thus we may say that S_1 means S_2. But, of course, this meaning must be elliptic for "S_1 means S_2 for C," where C is a subject for whom this meaning obtains. Now the question is what C might be. Who

understands and profits thereby? If it is not the unconscious, then it is either the conscious ego itself or the censor. Surely it is not the censor, which, although it may effect and understand the symbolic substitution, does not do so for its own satisfaction. Presumably the benefactor is not the doctor. And although "entirely colored by its symbolic meaning," the conscious ego "cannot apprehend this meaning by itself."[32] This forces us, finally, to turn to the unconscious.

The main problem seems to be that for Freud, the unconscious both is and is not the sort of intelligence that could accomplish these sophisticated tasks. Sartre is forcing us to confront what is required by the theory of the unconscious. It must decipher symbolism, interpret texts, and even invent both symbols and texts. In contemporary cognitive psychology, one posits hierarchies of executive control, taking care that such capacities are rank ordered. The question is whether the rank here assigned to the mental activity of the unconscious is acceptably low and also acceptably high. In a broad but provocative study, Richard Wollheim seems to imply that there is no such problem.[33] The general question is the tenability of equating the unconscious with the repressed. In this context Wollheim makes certain claims which seem to bear on the present line of reasoning. Specifically, the assertion is made that it is a mistake to conceive the unconscious simply as material expelled from consciousness. That is, there are *systematic* or intrinsic features of the unconscious, as cited earlier in the present paper: the unconscious is subject to primary process, exempt from mutual contradiction, timeless, and prone to replace external reality by internal reality. And to this we might well add, as does Freud in the 1915 essay on the topic, that the unconscious consists of "thing" presentations devoid of connections to corresponding verbal presentations.[34] Now the difficulty is that this list of characteristics does not contain clear clues as to how the unconscious can manage to do what the theory—as we have supposed Sartre might see it—requires it to do, without simply requiring too much of it. Indeed, a survey of some of the aspects which Freud cites suggests that they might even *conflict* with the ascription to it of its required abilities. It has no truck with logic, no conception of external reality as such, and no language encoding capacities. But it is required to devise and interpret symbolisms! If one is tempted to fall back on some purely mechanical or energic model for what the unconscious does, as is at least limned in the manuscript of *The Project for a Scientific Psychology*, that would not be surprising.[35] But of course it is a Freud of strategies and intentionalities which Sartre is dealing with, as we have insisted.

Amplifying, but not clarifying, the point are some further observations made by Wollheim. We are told that the ascription of key characteristics to the unconscious (distorted, condensed, etc.) is to a certain extent a matter

of point of view. It depends upon whether we are considering the unconscious as it irrupts into consciousness or whether we are considering it in its own right. From the former angle we will impute such distortions to an external agency—presumably the censor. From the latter, we will not. Now this certainly seems to qualify seriously the main point Wollheim has made in insisting upon a systematic (intrinsic) conception of the unconscious. But, further, it is not clear what this perspectivalism comes to. We probably do *in general* conceive the unconscious in terms of its contrast with conscious mentation, or at least in terms of an ingrained model of such mentation. The list of supposedly intrinsic properties has the flavor of the *via negativa*. But this leaves us in the dark about how the unconscious can have the abilities which the view seems to require of it. Certainly we do not wish to ascribe to it, redundantly, the capacities of a person. This invites the spectre of a bizarre regress.

Nor does it help to add, as Wollheim does (perhaps in order to give more bite to the perspectivalism), that Freud sometimes harmlessly conflates characteristics intrinsic to the unconscious with the fact that the unconscious material is capable of evading repression even if distorted, thereby terming the whole complex set of factors "distortion."[36] This verbal point does not in itself contribute further insight into the intrinsic nature of the unconscious. Nor does it help to add, as Wollheim does, that such distortion also denotes, in part, material drawn into the orbit of the unconscious, as when residues from the day are subjected at night to dream work. These refinements have the effect of rewriting the perspectivalism in terms of a simple verbal affair. But neither of them contributes further insight into the intrinsic nature of the unconscious, and so they do not explain how the unconscious has just the right capacities which it apparently needs without having too many of them.

The conclusion, in effect, is that we do not know how to coherently characterize the unconscious. It must be both clever and stupid. Sartre, in effect, insists on its cleverness, and hence sees no reason to avoid collapsing the hidden intelligence and the manifest intelligence: there is one conscious subject which cannot but know what it is up to. Behind that move, we claim, is the recognition that Freud has created serious problems for himself with respect to the characterization of the unconscious. Sartre is in touch with our present argument pattern when he observes that the libido—which admittedly is not exactly coextensive with the unconscious—is a "blind conatus."[37] Perhaps the muted moral of Wollheim's discussion is that it is incorrect to treat the unconscious as a substantive entity. Rather, "the unconscious" is a name for a varied set of functions in terms of which ideational and conative input is processed or encoded. It names primary processing, non-verbal encoding, and censoring, for instance, and not any

independent *subject* of thinking. This is undoubtedly the way we shall want
to structure Freud's view, if guidelines from contemporary cognitive psy-
chology are to be trusted. But the problem remains that Freud has not
explained what the hierarchy of information processing actually looks
like, and what the needed separate levels actually do such that the "lower"
ones are not assigned capacities which alone can be assigned to the over-
all system. That a Freudian theory might be stated in coherent, contem-
porary terms is quite possible. That Sartre's approach to Freud might be
seen, finally, as an over-intellectualized one would be natural. Freud's
own picture of the situation, however, lends itself to such over-
simplification. The *reductio* which we think Sartre implicitly achieves will
force a broad recasting of the whole theory. Thus, simply pointing out the
non-substantive character of the unconscious, as Wollheim might be doing,
does not go nearly far enough. We need a more detailed model of a type of
processing which has capacities of a certain degree of sophistication, with-
out it being entailed that they have the capacities of the whole person, e.g.,
interpretation of the meaning of certain symbolic behaviors. Some writers
will wish to fasten on a fairly sharp distinction between analog and digital
functions of the mind to help clarify the roles of different levels of infor-
mation processing. Perhaps there is help to be had from that quarter; but as
matters stand now, we have been given a promissory note for a rather large
sum of cash to be delivered.

Clearly, Sartre has an overall way of drawing a conclusion about these
matters that is somewhat idiosyncratic. He believes he can foist off on
Freudian theory a sameness of mental functioning in all parts of the system,
and hence that we might as well collapse supposedly separate parts. He
opts, in effect, for the "smarter" horn of the dilemma which we have
applied to the unconscious. (This is, of course, in line with the unfortu-
nately Cartesian picture of mental life which he carries into his own
hypothesis on the topic.) Whether we speak of compartments or hierarchi-
cally arranged functions, if it can be shown that the separate dimensions
must have common capacities, then what's the point of the separateness?
But he is moved, we claim, by the questions we have raised.

Having successfully isolated the motivation behind Sartre's rather spe-
cial way of forming the general conclusion, let us now consider what conse-
quences he would undoubtedly see as following from that conclusion. The
problem is that it also seems to make unintelligible any conception of psy-
choanalytic theory, including that which Sartre, rather inconsistently, at-
tempts to outline. Among these consequences are the conclusions which
the arguments from resistance and recognition tried to establish.

It would follow trivially that there exists a motive for resistance,
namely knowledge of what lies behind the symbolism. And the end of

therapy would, after all, be mere recognition, since the subject did know everything all along. The compartmentalizations of Freudian theory would be demolished and there still would exist strategic projects of behavioral disguise. But this result would be achieved at heavy cost.

Since there is no longer a compartmentalized conscious ego to fool, the situation becomes unacceptably paradoxical. Our Freudianism now says that a single unified psyche is engaged in concocting a symbolism which it thereby understands. But for what purpose? The motive is to conceal the objectionable goals from *itself*. The paradox of self-deception surfaces, since the project seems to be a self-stultifying one. What Sartre has intended as an argument to force a modification of Freud's scheme into the form of his own view amounts to a complete *reductio* of psychoanalytic theory.[38] The problem is exemplified by considering resistance. If the motive for resistance is indeed prior knowledge of the conclusion of the trend of the questions, what is the point any longer of carrying on the charade? Indeed, how could it be carried on? The left hand must keep the right hand in the dark in a situation in which there is really only one hand! To generalize, what would be the point of psychoanalysis itself, if there be nothing unknown to bring to light? Or, what would bringing it to light mean any longer?

Grasping at straws, one might invoke the Sartrean distinction, unclear though it be, between consciousness and knowledge. The problem is that if consciousness is all that is required for a deciphering of the symptom, then Freud might well agree. If the claim is that knowledge is required for such interpretation, then we return to the paradox that some aspect of the psyche both knows and does not know without recourse to the very barriers that might have alleviated the paradox. It may be that Sartre does not quite decide which of these unhappy paths to take. His words "obscure comprehension" suggest a hesitation between consciousness and knowledge. The problem is that he needs both concepts, but as it stands they function as barely more than labels. Sartre has even more cash to deliver than Freud. The former concept does not really make any headway against Freud at all. The latter does, but at a heavy price.

If we are correct, then, Sartre is saying that symbolism is the weak spot in Freudian theory. Could all the difficulties be avoided, then, by simply rejecting the interpretation of symptoms as symbols? Indeed, are symptoms symbols?

III

Symptoms are not merely bearers of information, of course. They are pieces of partially satisfying behavior. But the point of the argument just

reviewed is that symptoms function like symbols in that their meaning must be understood as a necessary condition of satisfaction. Beyond this, we have spoken as if symbols are bearers of meaning, just as language is. A behavior can be interpreted by the censor just as an Arabic text can be interpreted by one who understands Arabic. The other side of the coin is that the meaning of the behavior, or of the Arabic text, is not available to one who lacks the key. Clearly the Arabic text is still symbolic material whether any given individual can read it or not. But, now, just why should we view symptoms in this manner? Presumably, the basic idea is that the censor can, by interpreting and manipulating symbols, effect some behavior that has a meaning which is understood by the unconscious while remaining unintelligible to consciousness. (In this respect, the analogy with the foreign language is inept, since the conscious ego will often have no knowledge that the behavior even *has* an interpretation.) The behavior is a mask for some real need. The point can be made by appealing to Freud's distinction between sublimation and repression. In sublimation, the drives are presumably redirected to new goals. But in repression, the behavior refers to a desire which still seeks a more "direct" outlet. One of the functions of the symbolic component is to capture this fact. The original drive is there, disguised but in principle capable of being grasped, just as the meaning of the foreign words can be grasped.[39]

As we have seen, the claim that symptoms are symbols is intimately tied in Sartre's interpretation to the notion that symptoms are *analogous* to underlying complexes. Iconic symbols are so analogous, but of course it does not follow that all analogies are indicative of symbolism. And symbolism, we have seen, gets Freud into serious trouble. Perhaps, though, not all symptoms are analogous to underlying complexes. If they were not, this would at least throw into doubt the notion of *iconic* symbolism. Or it may be the case that there are analogies but they need not be interpreted symbolically. Let us see if either of these alternatives helps Freud.

In our earlier discussion of Freud's apparent presupposition of the existence of analogies, we brushed by the fact that not *all* of Freud's cases obviously involve analogy. Now, the kinds of cases Sartre has in mind very likely include Freud's well-known dream symbols, in which an iconic element is obvious. We offered the case of the disappointed bride, in which the bed–table analogy seems to play an obvious role. In some other cases, such as that of the wolfman, similarities are not so obvious but might still be discerned, recalling always that they are, as with Rorschach ink-blots, similarities which the *patient* discerns.

If we consider the evolution of Freudian theory, however, the assumption of the universality of such analogies is not at all obvious. In Freud's later work it seems that analogies do not play such an important role in

symptom formation. The ego's defenses, for instance, include such phenomena as reversals, anxiety attacks, and reaction formation, which imply no obvious similarity between symptom and underlying complex. A patient might conceal his hatred of his mother by acts of kindness, for instance. To be sure, if we examine the pattern of behavior as a whole we might see a plan of "killing" the mother with kindness, and the analogy would emerge. But whether such examinations would in every case produce such a result is a moot point. A consideration of such cases does not seem decisive. In effect, though, we already have in our possession a reason why such similarities should obtain—namely, the fact that, viewed *as* a compromise, the symptom must be something like what the patient would do if censorship *had not* intervened.[40]

This rationale for the existence of similarity relationships between symptoms and the goals of underlying motives suggests a possible alternative to the interpretation of symptoms as symbols. Given that the partial success of symptom formation is to be understood in terms of a *type* of satisfaction which the symptom and the "real" goal share, then one is inclined to think of the relation between the two in terms of means and ends, rather than in terms of sign and signified.[41] But this explanation does not really suffice as an *alternative* to symbolism since it makes no allowance for the element of disguised meaning, which is one of the main factors that suggest symbolism. The problem, then, is that the explanation of the behavior presupposes the notion that it both disguises and expresses *specific* aims of underlying desires. Similarity, though, is understood in terms of some type of satisfaction which is not disguised at all. Presumably the end—the type of satisfaction sought and partially realized—is not itself disguised. But this means that if anything be disguised it would be the so-called means—say, the different sorts of hand motions in our example of Captain Queeg. But why would such means be disguised, unless they were *themselves* desired?[42] In that case, the subject would desire masturbational activity, not just some *type* of satisfaction which masturbation happens to bring about.

Perhaps a contextual model would offer a viable alternative to symbolism. A symptom could be described as follows. What the neurotic really desires to do is disguised by a shift in context. In Captain Queeg's action there is an obvious similarity to what is really desired, but one need not say that the behavior *denotes* that repressed desire. There is a behavioral and satisfactional similarity between the two. But the context or background disguises them in this sense: the patient simply does not see the relationship between the features of the experience he has and the features of the thing really desired, namely, masturbation. He does not see his experience as an approximation to something else, but solely as an experience in its own

right. This is enough for partial satisfaction, but it still leaves room for disguise of the real desire. What is disguised is what the pleasure *approximates*, but the behavior does not *denote* this. In itself, such a theory might well work as an alternative to a symbolic relationship, for even if the secret satisfaction taken in the behavior is in the light of this norm, still that does not imply a semantic relationship.

The problem seems to be, though, that any alternative model for the strategic situation which does dispense with symbolism nevertheless falls prey to the general form of Sartre's argument. Sartre makes his comments in terms of intellectual interpretation, or some such generic notion. In the last alternative sketched above, for instance, some part of the psyche must still make the right mental connection between the behavior and the goal of the desire. The unconscious, for instance, would have to see the behavior in the other, forbidden, context—in short, to see the behavior as approximating the forbidden goal. And barring this alternative, the conscious ego must do it. The result is the same pattern of argument, with the same paradoxical implications. The psyche must both interpret the behavior correctly and fool itself—be taken in by the context, for example. So we have, once again, both the crumbling of the compartment walls and the consequent paradox of a unified psyche fooling itself. If we have reconstructed Sartre's argument correctly, his intuitions were basically correct. The "bond of understanding" in passage 6 may, but need not, refer to the deciphering of a semantic connection. The argument is still telling.

IV

Sartre's term signification can now be seen to cover two elements: (1) finality, that is, purpose, and (2) meaning in the semantic sense.[43] Early in section II we discussed a pattern of reasoning from the apparently non-accidental character of symptoms to the conclusion that symptom formation is purposeful, that is, strategic. Later we saw that Sartre takes Freud to be holding that symptoms signify elements in relevant complexes. Hence there are both teleological relationships and semantic relationships involved in symptom formation, and this alone might give grounds for holding that causation alone is not sufficient as characterizing the relationship between underlying motivation and symptom. But Sartre appears to over-step himself in passage 6 of the items cited at the beginning of section II. He asserts that it is a "contradiction" to assert *both* a relationship of causality and a relationship of "signification" (as reflected by these analogies). Although there may be grounds for holding that there is more than a causal connection, why should we conclude that there be no causation whatsoever? That is the main question to which we address ourselves in this

section. Evidently Sartre thinks there is some reason why either the appropriateness or the symbolic character of symptoms rules out a causal explanation of their production.

Perhaps we can get some help in interpreting Sartre's point by turning to a retrospective account of his disagreements with Freudianism. The gist of that discussion involves not symbolism as such and its presumed incompatibility with causation, but *mechanism* and its contrast to teleology and mentalism. Let us see if that discussion sheds any light on the supposed contradiction in Freudian theory.

In the interview article cited earlier, Sartre says that he now accepts a form of Marxian determinism.[44] The part of his critique of Freud which remains in his mind as most important involves an objection to the "biological" and physiological language with which Freud "underpinned thoughts which were not translatable into [sic] without mediation."[45] One of the main points behind Sartre's complaint about biological and physiological language is an apparent oscillation in Freud between concepts which one moment express "a sort of finalism and the next moment a sort of mechanism."[46]

What is the difficulty in such mixed descriptions? Can one usefully describe the teleological aspects of symptom formation by means of quasi-mechanical concepts? Freud certainly uses such language freely, speaking, for example, of libidinous drives in terms of flows of energy. In addition, one finds the analogy with charging and discharging, as in electrical theory. One might hold that such models are heuristic devices which provide the best way of understanding Freud's theory. In other words, they might explain in quasi-physicalistic terms what we unclearly think of in terms of various personages interacting within a single psyche. Let us call this kind of explanatory model "ghostly mechanism," to distinguish it from the mechanism which would result from a translation of descriptions of the mind in (at least partially) mental terms into descriptions in purely physicalistic terms. The sort of mechanism involved at present, in other words, prima facie has nothing to do with the ontological question of reductionism, which refers to the analysis of mental items into purely physical entities.

Given this distinction between ghostly and reductionistic mechanism, it seems pretty obvious that Freud engages in the former. It is not obvious, though, that Sartre is willing to draw this distinction. He does not mention or challenge *specific* mechanical models. Certainly plenty of these are available which intuitively respond to aspects of Freud's theory. For instance, in light of the discussion of the slips of the tongue, one might think of symptoms in vectorial fashion, after the laws of mechanics. We might think of competing interests as being like clashing forces.

A biological variant on the notion of vectors comes from the theory of communicable diseases. One can understand why, as a physician, Freud might be liable to think in such terms. A physiological symptom is the (partial) resultant of a "hidden" cause, for example, a virus. We do not think it at all implausible to speculate that this causal view of symptoms dominates part of Freud's thinking. The counterpart of the virus is undoubtedly the unconscious drive, and there are many obvious analogies between them, including the rather important one that although one will be quite conscious of the pain of a sore throat, one will not be conscious of the virus that is its partial cause.

Obviously a number of other, possibly instructive analogies could be put forth. One might describe symptom formation as operating something like an electronic sound-mixer. That Sartre does not treat Freud's analogies separately on their own merits seems indicative of his attitude toward the whole issue. If Sartre's complaint against Freud about mechanism and teleology has any bearing on his cryptic criticism concerning a contradiction between causation and signification, we can conclude that Sartre assumes that (1) causal explanations are all mechanical. This is certainly a questionable assumption, and would considerably weaken his position. Theories involving non-mechanical, but deterministic, theories of the mind would thereby be rejected out of hand. Sartre apparently further assumes that (2) heuristic models which involve a mixture of teleology and mechanism are worthless. But that has not been shown.[47] Most important, Sartre's disinterest in specific models, whether mechanically pure (although possibly involving a mixture of mechanical models) or impure (and hence combining mechanical and teleological elements), indicates that (3) he rejects such models *simpliciter*. Otherwise, why would he show no interest in the attempts of those who, like Rapaport,[48] try to find one consistent mechanistic model that will capture the essentials of Freud's theory? Indeed, in the interview article, Sartre expanded his remarks by pointing out Freud's tendency to speak in mechanical terms reminiscent of earlier philosophical psychology of mind—for example, in terms of images as "condensing." In other words, in Sartre's view the mental, and presumably the teleological, cannot be described mechanistically at all.

What would be the grounds for such a sweeping claim? Presumably they would be ontological or phenomenological. Either he is saying that minds and bodies are just different kinds of things, and hence descriptions of the one in terms of the other will not be heuristic, since they will *mis*inform; or he is saying that thoughts are, phenomenologically, different from physical things. But the latter point, if given any force, raises the ontological issue. Unless one insists upon an ontological dualism, why should we rule out the possibility that, in the light of a demonstration of their identity,

our descriptions of mental items could be re-educated, as some American philosophers have recently suggested?

In other words, Sartre's criticism of Freud's use of a mechanistic vocabulary is weak, since he has not shown why such a vocabulary might not be useful, unless we construe him simply to *assume* a Cartesian dualism. Then, once we add the seeming error of equating mechanical causality with causality in general, the supposed "contradiction" boils down to the pronouncement that minds are not bodies.

Of course it may be that what Sartre has in the back of his mind is not precisely a concern about the identity of minds and bodies, but rather a problem which is *preliminary* to the question of metaphysical reduction. We know that Freud himself spoke as if a reductionist physiological theory, or at least a parallelist one, would eventually be produced. In that case, one might suppose that the quasi-mechanistic elements in his theory are part of the groundwork for such an eventuality. The difficulty is that this would be to put the cart before the horse. We would be saying that the Freudian theory will *become* clear when a reduction of its concepts and theories to neurophysiology has been effected. The absurdity of such a suggestion is patent. We are being asked to forgive Freud for the quasi-mechanistic parts of his theory—the "ghostly," i.e., *mental,* mechanism of plumbings, condensings, and chargings—because the final theory will be cast in such terms. But surely the theory must be stated clearly *before* a reductionist program can be undertaken. A related point might be made concerning psycho-physical parallelism, which is the ideal sometimes suggested by Freud. One might assume, with dualistic piety, that there would turn up in the last analysis physiological counterparts to the processes Freud describes. That would surely mean that they would be counterparts to elements which *are* mental. In that case, the problem is patent. The processes for which physiological counterparts are to be found are *already* a mélange of mechanistic and mentalistic items, or at least items which Freud does not seem to be able to explain in purely mentalistic terms.

If this is Sartre's worry, he is on somewhat stronger ground than if he is simply making pronouncements about the relationship between mind and body. But not even these subtler concerns explain what he means by the contradiction in Freudian theory. And his discussion is still seriously weakened by the apparent identification of the notions of cause and mechanical cause. One might have some sympathy with his views as regards the latter in Freudian theory, and yet not feel constrained to go the limit and conclude that the underlying desire could not be the cause of the symptom in any sense of the word. Given a Humean view of causality, for instance, why should one balk at mental states causing either mental states or bodily movements? Indeed, Sartre's point sounds rather like a flat asser-

tion that a causal theory of human action is indefensible. Presumably he does (or did) hold such a theory, but it would be incredible to criticize Freud for his failure to follow Sartre's libertarian metaphysics! One can see a way in which choice might lie at the back of Sartre's argument if we turn now to the other aspect of signification, namely, meaning. Unfortunately, the generalities of the interview cited earlier do not help us to understand his argument, and we must return to the sketchy remarks of the earlier texts.

What is it about the meaning relationship which interferes with causal explanations of such behavior? In *Sketch for a Theory of Emotions,* the amplification of the point amounts to the complaint that in Freudian theory the symbolic relationships are too rigid; for example, a pincushion always symbolizes a breast. The practitioner, Sartre urges, obtains success only "by flexible research into the intra-conscious relation between symbolization and symbol."[49] Again, this could be simply a veiled assertion of freedom against Freudian determinism, which amounts to nothing as an argument. More reasonably, the point might be that in symbolism the patient's interpretation must be included as a factor. There is no rigid correlation between Freudian symbols and their meanings. But if we are not to fall afoul of the freedom-determinism issue, this can only mean that a multitude of factors (for example, the patient's past and present experience) must be considered when deciphering some behavior. This in itself does not yet prove that there is no determining *cause* of the symptom. It only means that there are a multitude of factors to consider in order to determine such a causal relationship. But let us not draw a conclusion too quickly. Let us see how choice and individual interpretation function in connection with symbolic meaning.

The symptom, we say, is caused. How about the meaning of the symptom? Surely that cannot be some sort of extraordinary by-product of the hypothetical causal relationship. Sartre, we recall, closely connected the notions of analogy and meaning. If symptoms are caused merely by complexes, it seems a wonderful accident that they happen to signify them iconically as well. Sartre might be asking how a meaning relationship could be caused to exist at all, as if it were some transcendent or subsistent entity. But that would not be the real question to ask. The question, rather, is how this meaning relationship could come into existence as a sort of by-product of the causation of the symptom as a pure piece of behavior. If we are to take the notion of strategy seriously, the behavior is presumably selected as signifying the hidden wish. Hence the meaning relationship must *pre-exist* the causation of the behavior. The behavior embodies the choice of it as signifying the repressed drive. In other words, denotation must be *presupposed* in the production of given symptoms. In such a view of Freudian

theory, a number of themes come together, then: strategy, symbolism, and, finally, choice.

In the final analysis, then, the problem comes to whether choices either can be causes or are themselves caused. And as we have pointed out, it would indeed be odd to criticize Freud for failing to adopt a libertarian metaphysical stance before attempting a causal explanation. Let us take the two alternatives in order to see if Sartre *does* adopt such an unfortunate stance.

The question of whether choices can be causes is, of course, one that has dominated certain recent theories of human action. How far Sartre would agree with action theorists is questionable. Certainly he would not wish, in the last analysis, to deny that there are choices. He might well deny, however, that choices, given their existence, can be causes. One possible ground for such a denial is Sartre's seeming insistence on a Humean theory of causation.[50] There *is* something peculiar about choice on a Humean view. For, all things being equal, one can, knowing what choices are, "deduce" the result of carrying out the intention. Whether, ultimately, this is a defensible point does not interest us here; obviously the catch phrase is "knowing what choices are," for one might argue that, knowing what rocks are, one can also "deduce" their behavior in the same way, that spelling out what choices *are* might be said to involve their effects. Leaving this aside and adopting the view that there is a difference between choices and other sorts of causal conditions, one might then speculate that choices do not fulfill the conditions that Hume claimed causes must fulfill.

If this is what Sartre has in mind, it seems a mere verbal quibble. No Freudian would disagree with the claim that some sort of choice determines behavior; indeed, the therapist is interested in helping the patient discover the choices that he, the patient, has unconsciously made. Whether this connection should be called a causal one or not is irrelevant.

A more likely view of Sartre's point involves us finally in the claim that choices cannot be caused. Consider, once more, the case of the disappointed bride, who presumably chooses to reenact the scene of her wedding night with a table, a cloth, and a stain, these all being symbols. Why does she choose these symbols rather than others? A Freudian might indeed grant that symbol choice is, or can be, highly idiosyncratic without denying that such choices are determined. True, she must see the table as a bed, etc.; but why cannot this *seeing as* be explained in terms of her training, etc.? Perhaps Sartre would ask what form the answer to this question will take. No completely genetic account will do; environmental conditions as interpreted by the bride must be cited. The same sort of difficulties arise at an earlier stage in the bride's development. Somewhere, Sartre could say, there must be an undetermined choice by the bride of how she sees the

world. Thus the point is that choice of symbol ultimately involves us in an undetermined interpretation of the world.

Sartre might be saying, in effect, that if we do not, finally, simply accept an unaccountably free choice of the symptomatic behavior, then we remain within the pale of the prediction of human behavior in accordance with laws, where such laws would be hopelessly vague. If the laws governing the production of symptoms are framed in terms which predict that, given certain traumatic original experiences, some analogous kind of symbolic behavior will emerge in later years, this simply does not predict the precise symptom which *does* emerge. The concept of analogy or similarity is hopelessly vague. Indeed, some similarity might exist for a given person between any two things at all! If one were to reply that all these specific differences could be predicted by taking into account all intervening experiences, then at the very best we would have incredibly specific laws— laws which may in effect predict the symptoms only of a given individual. And one might even challenge the term "predict," since it seems likely that such symptoms could be precisely related to the complex only by ad hoc amendments to some less precise law.

Again, the crucial points, that all seeing is in effect seeing as, and that the patient must freely interpret his environment, are metaphysical issues and highly controversial ones. Of course it must be granted that the notion of choices which are so highly idiosyncratic that they cannot be subsumed under laws is questionable. The fact that a tremendous number of variables might be involved in determining such choices does not show that they are not subject to law.

V

Everyone knows that one person can deceive another, by lying, for example. In common speech we sometimes speak of a person deceiving himself, although what we mean is not clear. Indeed, it is not clear that we mean any *one* thing. If we try to explain such examples in terms of the model of *lying to another*, we immediately have problems. It does not seem possible to lie to oneself, since this seems to involve believing some proposition in the face of believing something contrary. And yet many philosophers, and this includes Sartre, take self-deception, so construed, as something that occurs and merely needs analysis.[51]

Self-deception as involving a lie to oneself is presumed to be different from ambivalence, inconsistency, or wishful thinking. Ambivalence is either an oscillation between approval and disapproval, or an experience of both at the same time. The latter may seem to be contradictory (ruling out obviously easy cases, such as liking and disliking something in different

respects), but whether it is or not depends on the analysis of certain intentional notions. The idea of inconsistency may also be puzzling, but is still different from self-deception so construed. The hypothetically definitive element in self-deception does not exist in these other phenomena, namely, believing one thing in the face of some contrary belief. Self-deception may imply inconsistency, but the converse does not seem to hold, given the model of lying to oneself. Wishful thinking also seems to lack the crucial element, for it denotes a kind of believing which may exist in the absence of any contrary belief. One may, for instance, simply invoke a strategy of refusing to look at the evidence which bears on a contrary belief.

Sartre describes what he thinks are two aspects of the puzzle about self-deception. The first seems reasonably close to the above: "I must know in my capacity as deceiver the truth which is hidden from me in my capacity as the one deceived."[52] To this, he adds another, which seems to have to do with the fact that inasmuch as a project of self-deception is, for him, conscious of itself, then just from this fact, "the whole psychic system is annihilated."[53] One could put the point in a slightly weaker way: If one reflectively attempted self-deception—that is, in full awareness of what one was attempting—it must fail. (The paradox is similar to that involved in the instruction "Constantly think to yourself: 'I must no longer think of Churchill.'" The undertaking seems self-stultifying.) Then, says Sartre, "The lie falls back and collapses beneath my look."[54] Whether these be *two* problems or not is moot. From one point of view, it is difficult to view the first situation as anything except an implicit involvement in self-consciousness or reflection. After all, one is attempting to maintain a belief, in the face of another *of which* one is presumably conscious. Perhaps the point is that if one initially characterized what one was about to do in its full terms, that is, *as* a paradoxical undertaking to deceive oneself, then one could not even begin. For the time being, such distinctions do not bear on our discussion.

Let us assume for the sake of argument that there is indeed such a puzzle, and that it is worth our while to look for a philosophical solution to it. This is the purpose for which Sartre introduces Freudian theory in his famous discussion of self-deception. As he puts it, to escape from the puzzle, "people gladly have recourse to the unconscious."[55] Is this a reasonable application of Freudian theory?

There are, of course, superficial similarities between the problems Freud deals with and the problems one would face trying to solve the problem Sartre addresses. Each describes a situation of conflict or discord. Each has the mind doing what in some sense it also opposes or rejects. Each posits at least an attempt at concealment. Freudian defense mechanisms, for instance, conceal one's true feelings and are prompted by the anxiety those feelings engender. And the patient does not consciously understand

the meaning of his conduct. The metaphor of concealment can be taken too far, of course, for in self-deception the puzzle itself arises out of a failure to banish the rejected belief successfully, for it is still believed and gives the opposing belief its impetus. The theory of repression (and the corollary theories of defense mechanisms) has some similarity to the situation as posed by the problem of self-deception in that Sartre might think that each of these structures applies to the same examples; hence they are extensionally equivalent. The story of seduction with which Sartre exemplifies the problem[56] is prima facie a case of self-deception. (Something warrants our calling it that, at any rate, and the explanation is simple: in the post-Freudian world we sometimes do call a situation interpreted in Freudian terms a "situation of self-deception.") There is patently a split in the woman's behavior. Partly she assents to the seduction situation as such, partly she gives it a "transcendent" interpretation. This case begs for description in Freudian terms; we may call the situation self-deception solely in the light of its Freudian elements.

But, despite these superficial similarities, the concerns of Freudian theory and Sartre's puzzle do not mesh. Freud is developing a scientific theory. He would not be interested in the putative phenomenon of self-deception as a logical-metaphysical conundrum. To the extent that such phenomena assimilate themselves to parapraxes, symptom-formation, and the like, as exhibiting elements of apparent conflict, then to be sure he might seek their underlying causes. Certainly, whatever his initial interest, it would be decreased by Sartre's peculiar description of the data. For there is no doubt that Sartre views self-deception as something *essentially* paradoxical. The conclusion one ought perhaps to draw is that there is no such thing as Sartre describes. Why Sartre shrinks from drawing this conclusion raises very broad questions about his philosophical approach. But it is important to see the sense in which Sartre does incorporate the paradox into the very essence of the phenomenon to be explained.

According to him, self-deception names "a double activity at the heart of unity tending on the one hand to maintain and locate the thing to be concealed and on the other hand to repress and disguise it."[57] Disregarding for a moment the Freudian terms in which he puts the point, this is presumably tantamount to defining self-deception as a process in which one belief just *is* maintained in the face of a belief in the contrary. If these are indeed the facts which are definitive of the phenomenon, it is, of course, impossible for any analysis to escape them, as Sartre contends Freud's analysis is trying to do. So viewed, Freud's theories would be inadequate. Indeed, they would be pathetically inadequate. Consider how they would proceed.

We first try to dodge the puzzle of self-deception by distinguishing between consciousness and the unconscious. But that seems to lose the

element of self-deception altogether, for nothing is believed in the face of a belief to the contrary. We might now try to repair this poor attempt by positing a whole strategy aiming at believing P in the face of its contrary and locating this strategy in a compartment separate from consciousness, the *conscious effect* of which would be a single unencumbered belief in P. The paradox is removed from consciousness and relocated in the unconscious. Why is it any less paradoxical in the unconscious? It is still a seemingly self-stultifying project of thought.[58]

Let us, therefore, return to the first attempt and try to repair it by appealing to a mediator which connects the unconscious and consciousness, and which, as it were, unifies diversity by locating and explaining the strategy which makes self-deception possible. The solution consists in locating one belief in the unconscious, and giving the censor the function of sending a contrary belief into consciousness; or the censor hides from consciousness a belief which would enter consciousness were it not for the censor. (This alone is good reason for doubting that the function of the censor is to make room anywhere for two contrary beliefs about the same subject matter. The conscious ego does not typically believe, for example, that "It is *not* the case that I hate my mother.") But we see clearly by this time that it would be hopeless for a Freudian to invoke these mechanisms to solve the puzzle, for the solution has completely lost touch with the essence of the matter, as Sartre sees it; namely, the "double activity at the heart of unity." In other words, there is nothing left in this "solution" of believing P in the face of believing its contrary.

What we are up against is this: we are debarred in principle from solving the problem as Sartre states it. If we begin with the supposition that self-deception is a fact that must be accounted for, we have two alternatives. If the account does not logically yield the fact, we may say it has failed. If the account does logically yield the fact, then it merely repeats the problem to be solved. If the analysis succeeds in dissolving the puzzle, it has failed in analyzing the fact. If it succeeds in analyzing the fact, it has failed to solve the puzzle. The moral: Freud's own theory is not to be viewed as a magical solution to an insoluble problem. One can imagine Freud asking why we suppose he sets himself such hopeless tasks. Freud neither begins with such a problem nor ends with it. He nowhere assumes self-deception (modeled after lying) as a piece of behavior to be explained, nor does he unwittingly invoke it as part of an explanatory theory. And yet it is clear that Sartre places such burdens upon Freud. In discussing Freud's tripartite division of the psyche into ego, id, and superego, he says that this reduces to a trinity what is actually a unity, and therefore fails as a way out of the self-deception puzzle.[59] It fails precisely because the essence of the puzzle is missing! That is, the thought that P is true must be held *together* with the

thought that some contrary is true. If the analysis does not preserve the paradox, it is no good as an analysis.[60]

Let us turn, finally, to Sartre's famous argument in *L'Etre et le Néant*. His strategy is to pose a question about the source of resistance in therapy, review alternative answers, and gradually to focus on the censor as the only likely source.[61] The resistance cannot come from the unconscious, which simply drives for expression and hence would try to get around the censor. It cannot be the conscious ego, which is deprived of any knowledge of the dawning truth. The censor is the culprit.[62] It must be in a state of duplicity vis-à-vis the drives suppressed, and therefore in a case of unanalyzable self-deception. But why is *the censor* in self-deception? Because the censor is conscious of the drive to be repressed "in order" not to be conscious of it.[63] That is, it must hide the drive but fail to hide it, a problem somewhat like the task of believing P in the face of believing the contrary. And, why must it play this game of concealing and revealing? The only explanation must be that Sartre views the censor as in a situation of ambivalence. It is in sympathy with the hidden wishes, but also antipathetic. At least this is what Sartre suggests when he says that the Freudian theory simply localizes a "double activity of repulsion and attraction on the level of the censor."[64] From this he concludes that the theory simply localizes the self-deception, and hence fails to explain it.

The objections to this reasoning are as follows: (1) The censor need not be ambivalent at all, but only seeking to maximize pleasure and minimize pain in a situation of competing interests. (2) Even if one granted the ambivalence, this would not entail that the censor is conscious of some P in order not to be conscious of it (where this in turn is allowed to entail that the censor believes some P in the face of some conflicting belief). The charge against the censor is not proven.

Of course, what constrains one's intuitions to believe that Sartre must be right is that he mixes with this argument some insights which *are* effective against psychic compartmentalization. We have discussed these arguments. If they are effective, then of course the results for the psyche would be very similar to the situation of self-deception in the paradoxical sense. The psyche would be engaged in elaborating disguises for itself which it perforce sees through from the beginning. It would be seeking, in effect, to deceive itself, and we should well wonder how that is possible. The confusion in Sartre's argument is at bottom a confusion of arguments against the compartmental theory of the mind, with arguments which grant the compartmentalization but search within the compartments for a single center of consciousness which deceives itself. What gives the latter enterprise an initial plausibility is the reinforcement from the former argument pattern which, if effective, *would* result in self-deception for the unified psyche that

remains after the compartment walls have been broken down, but which still accommodates projects of disguise.

It is beyond the scope of this paper to examine the manifold issues regarding the possibility of *mauvaise foi* as a purposeful human project. We shall confine ourselves to a consideration of one of Sartre's many exquisitely described cases to get an idea of the factors that must be considered in explaining how self-deception works. While not offering a thorough evaluation of Sartre's theory of *mauvaise foi,* we will then make four critical observations.

Sartre's general approach is to account for self-deception by describing the metaphysical facts about human existence which motivate it. In the long run, these have to do with taking refuge in freedom at the expense of being, and the converse—in other words, trying to have one's cake while eating it. Sartre concludes his discussion of the metaphysical conditions of self-deception with his well-known formula to the effect that human consciousness "must be what it is not and not be what it is."[65] The different emphases intended by the conjuncts are not readily apparent, but each in effect points in part to the fact that one can evade being—a coward, for example, can evade it by the fact that no behavioral pattern amounts to the constitution of one's essence as cowardice. At the same time, it indicates that one's behavior does leave a wake or pattern. Cowardice is *some* kind of determination of the agent: the bad-faith coward does not negate his essentiality in the abstract, but he negates it concretely. He does not "negate" his being a saint or a sea-captain, but rather his behavior as *coward*.

We content ourselves with four observations. (1) Sartre's account gives the appearance of building the paradox right into the structure of human existence. It appears to be reified in the saying "I must not be what I am." Now if that were the essence of the matter, it is hardly an explanation, for the explanatory structure is as mysterious as the self-deception it supposedly explains. (2) A second point emerges which moves our criticism to a new standpoint. The talk about "being cowardly and not being cowardly" which supposedly explains self-deception[66] could be taken as a dramatization of something entirely non-paradoxical. We need not have the subject affirming and denying his cowardice in the very same sense! This comes out quite clearly in Sartre's portrait of the self-deceived homosexual,[67] but once we see the way out of a straightforward logical paradox, then Sartre's example seems to suffer from losing contact with self-deception as he views it. Let us see.

In the case cited, the subject admits to each and every particular misdeed while refusing to consider himself to be a pederast. The results are sadly comical, for what is it to be a pederast except to do such things as he does? Now one might conclude that it is right to ask of the homosexual that

he at least be sincere about his homosexuality. But this demand itself obscures an element of truth to which the homosexual in all his self-deception clings. He obscurely comprehends that he is not *essentially* a homosexual. Homosexuality is not his destiny, nor does it flow in a predetermined way from his essence, as various attributes are exfoliated from the essence of a Leibnizian monad. In short, he is free. There are, therefore, two senses in which he might be said to be a homosexual. He is a homosexual₁ insofar as he adopts a conduct which is collectively labeled "homosexual." But he is a homosexual₂ insofar as his actions are determined by an essence or nature which he instances.

The homosexual's self-exculpating excuses contain an element of truth in that he is obscurely aware of the falsity of any attribution to him of homosexuality₂. But the homosexual only benefits from his insight by confusing homosexuality₂ with homosexuality₁. He imagines that inasmuch as homosexuality is not his essence, then he is not a homosexual in *any* sense. (Additionally, he believes this ought to affect the judgment society makes of him, that is, he ought not to be *called* a homosexual even though he cannot escape the plain fact that this is the right label for conduct such as his.) He implicitly holds that the characteristic should apply only to beings who have the appropriate essence. At the same time, in other cases—indeed, in his own description of other persons—he is willing to allow the use of purely behavioral criteria. The metaphysical theme emerges from Sartre's characterization of the subject's motivation as a desire to avoid being considered as a "thing."⁶⁸ He clings to his obscurely grasped freedom even while conforming behaviorally to the standard definition of "homosexual." (3) Oddly enough, though, it seems that in the end he does view himself as a thing with a given nature, for he seems to pass through the following steps in his implicit reasoning: he moves from "I possess no defining nature" to "the label does not apply to me," and from this to "I am not a homosexual" (in the sense in which this chair is not a table). The punch line, of course, comes with the latter contrast as involving contrary essences. In other words, he implicitly concludes that he has some *other* essence; for example, he is a sex explorer. Of course, Sartre can reply that this progress of reasoning simply illustrates the perpetual oscillation between being and freedom to which man is condemned, and with his view of human nature we do not here quarrel, except we question the use of it to idealize what seems to be a much less "philosophical" plight which this man finds himself in. The point is that the subject does not call attention to his freedom by denying that he is, for example, a sea-captain. The idealization of the situation has the effect of missing the obvious element in it, namely, that the man worries about being called a pederast, rather than being called a lawyer, a sea-captain (or whatever else might, in the light of

behavior, be appropriate). Obviously, being a homosexual is felt by him to be something bad, or at least he thinks it is so regarded by those who nevertheless exhort him to be sincere about his inclinations. And this seems to be the case whether he is (or believes himself to be) a homosexual by free choice or in virtue of some determining essence. (4) Given these difficulties with the explanans, we are forced to re-examine the explanandum. Sartre has spoken as if self-deception (a) has apparently paradoxical elements, (b) nevertheless exists, and hence (c) requires philosophical analysis. How does it exist? As an *accomplished* fact? Or as an undertaking, but one bound to fail? Sartre characterizes the phenomena of self-deception as "evanescent" and "metastable," as if to suggest they are always in flux and dissolution.[69] Such structures may disintegrate while being effected. But in Sartre's description of the case of the homosexual we certainly seem to be asked to consider self-deception as an accomplished fact. So what is supposed to engender and explain it? Our point is that Sartre's explanation is deficient. What is explained is not self-deception, as Sartre defines it, because the explanation appeals to the simple fact of logical error. Suppose, on the other hand, Sartre replied that the homosexual's self-deception is *not* an accomplished fact. His conjectures about the homosexual's thought processes are meant to show how he cannot even attempt to deceive himself as he seems to do, except in the sense of committing some species of intellectual error. Sartre's analysis, as we have seen, suggests nothing beyond a type of error. So what is all the fuss about? Errors are correctable.

The point is that if a person is merely making a mistake (or even a series of them, as we suggested), why should we describe him as in self-deception? In particular, the subject in our example exploits the denial of homosexuality$_2$ in order to undermine the charge of homosexuality$_1$. Of course, we can ask if he really does *see* the logical independence of these (his freedom is compatible with his being properly labeled "homosexual"). Shall we say that he is in self-deception at a second remove, in that he both believes and disbelieves that the two kinds of attributions are logically independent? The problem is that if he is thoroughly taken in by his own reasoning, then he is simply making a *mistake*.

Or shall we view the situation in reverse order? We are to consider certain facts about the metaphysical condition of man (insistence on freedom, while in pursuit of being) as explaining the phenomenon of self-deception. In the case before us the metaphysical facts explain why the homosexual reasons as he does, but the result seems to bite the hand that feeds it. For if we say that our human plight explains our susceptibility to certain patterns of reasoning, then if we yield to those patterns, what happens to the "duplicity at the heart of unity"? We are simply biased in our

reflections and tend to think of ourselves mistakenly. Or perhaps the metaphysical situation simply provides an *impetus* to accept reasoning which at the same time we see to be mistaken. But citing this impetus itself does not explain the possibility of the situation under consideration, namely, how one can accept a mistaken reasoning in the face of knowledge of its errors. Wherever there be self-deception, there is presumably a motive for it, a desire to see things in a different light. Citing such motives does not explain how the self-deception structure can *be*. Nor does describing the metaphysical motivation in pseudo-paradoxical terms do so.

Does self-deception with all its Sartrean paradoxical elements actually exist? It seems extremely doubtful. It might of course be otherwise with a range of phenomena associated with Freudian theory. Perhaps Sartre has simply "deduced" that there must be his sort of self-deception from his general metaphysical claim that man is the being "who can take negative attitudes with respect to himself."[70] If he is wrong, and if there be no such thing as he describes, then of course the problem vanishes. But his mistakes are quite independent of the really important things he has to say about Freudian theory and, as we have shown, Freudian theory is independent of what he has to say.

<div align="right">

LEE BROWN
ALAN HAUSMAN

</div>

THE OHIO STATE UNIVERSITY

NOTES

1. Perry Anderson, Ronald Fraser, and Quintin Hoare, "Itinerary of a Thought," *New Left Review*, no. 58 (November–December 1969): 46–57. Hereinafter cited as *NLR* Interview.

2. Jean-Paul Sartre, *Being and Nothingness*, tr. by Hazel Barnes (New York: Philosophical Library, 1956), p. 457; see also Jean-Paul Sartre, *L'Etre et le Néant* (Paris: Gallimard, 1955), p. 535. Hereinafter cited as *B and N;* pages in French edition indicated in parentheses.

3. *B and N*, p. 565 (652).

4. Sigmund Freud, "The Ego and the Id" in *The Standard Edition of the Complete Psychological Works of Sigmund Freud*, tr. by James Strachey (London: The Hogarth Press, 1963), vol. XIX, pp. 60–92. Hereinafter cited as *SE*.

5. *B and N*, pp. 570–71 (658).

6. *SE*, vol. XVI, pp. 279–81, 438.

7. Thus it seems the only plausible reading of Sartre's remark is that what is unconscious at a given moment is in principle not knowable to consciousness at that moment; this seems rather trivial unless one takes Sartre to be here railing against the very notion of an unconscious thought.

8. Contrary to what one might expect, Sartre does not contend that this prior knowledge was a knowledge of one's self as *such*. Rather such knowledge, being unreflective, is according to Sartre's theory of pre-reflexive consciousness, a naive, egoless consciousness of the world. We are not conscious, for example, of our need to punch this man in the nose, but

rather, as it were, of this man's face "needing" a punch in the nose. See Jean-Paul Sartre, "La Transcendance de l'ego: Esquisse d'une description phénoménologique," *Recherches Philosophiques*, VI (1936–37): 85–123.

9. *B and N*, p. 570 (658).

10. *B and N*, p. 570 (658).

11. *SE*, vol. XVI, p. 437.

12. *B and N*, p. 458 (535).

13. See Gustav Bergmann, "Psychoanalysis and Experimental Psychology," *Mind* (1943), pp. 122–40.

14. *B and N*, pp. 53–54 (92).

15. *B and N*, p. 458 (535).

16. *B and N*, p. 458 (536).

17. *B and N*, p. 458 (535). The reference to contemporaneity, of course, would seem to rule out process laws as well as historical laws. However, predictive power is unaffected. Sartre's point here reflects his concern that the symptom must be a symbol for a present drive or complex. If the drive has slipped into the past, the patient cannot be said to be acting symbolically.

18. *B and N*, p. 53 (92).

19. Jean-Paul Sartre, *Sketch for a Theory of Emotions*, tr. by Philip Mairet (London: Methuen, 1962), p. 53. See also Jean-Paul Sartre, *Esquisse d'une théorie des émotions* (Paris: Hermann, 1939), p. 27. Hereinafter cited as *Sketch;* pages in French edition indicated in parentheses.

20. *B and N*, p. 53 (92).

21. *B and N*, p. 53 (91).

22. *B and N*, p. 573 (661).

23. *Sketch*, p. 54 (28).

24. A repeated theme in Sartre's discussion is the unity of consciousness. See, for instance, *B and N*, pp. 53–54 (92).

25. We will use the terms "unconscious," "conscious," "unconscious ego," etc. The important issue is what kinds of things these labels denote and what their dynamic interaction is. Whether in the end we should say that the contents of the conscious ego are distinguished by having a property of consciousness, is a problem we simply do not consider.

26. The contrast between the issue of reduction and Freud's quasi-mechanical descriptions of mental phenomena will be discussed in section IV.

27. The first two of these come from a context in which Sartre attempts to prove a point rather different from the one under consideration here, namely, that Freud's theory does not avoid self-deception. We turn to this context in section V.

28. The context of the point about resistance is one in which Sartre is trying to prove that the *censor* in some way both knows and rejects the truth about the unconscious, and is in self-deception. The result includes the point in the present argument. The conscious ego knows the truth it fears.

29. *B and N*, p. 52 (90).

30. This fits, given that the anxiety be thought of as a signal of repressed material breaking through. Whatever difficulties this theory of the function of anxiety has, they seem not to be the issues preoccupying Sartre. One can imagine Sartrean arguments beginning with the phenomenon of anxiety, however.

31. *B and N*, p. 573 (661).

32. *B and N*, p. 54 (92).

33. Richard Wollheim, *Freud* (London: Fontana, 1971), chapter 6.

34. *SE*, vol. XIV.

35. *SE*, vol. I.

36. Wollheim, *Freud*, p. 165.

37. *B and N*, p. 53 (92).

38. One might say that the disguise is entirely for the sake of the Other, that is, the public. But given Freud's view of the developed superego with its capacity for guilt, this seems unacceptable. The desires are objectionable to the conscious ego.

39. The differences between symptoms and language do not really concern us here. Apparently, there are no conventions to appeal to in Freudian symbolism, although in some of his discussions Freud suggests that there are fixed bonds that are not learned, but rather, innate. Some have tried to make out a "logic" of psychoanalytic symbolism and to exhibit its differences from the logic of language. In some recent remarks Sartre shows his impatience with a treatment of Freudian symbolism as on the one hand fluid and unstructured, and on the other hand, just because of this, determinately indicative of "opposite" meanings. See Anderson, et al., *NLR* Interview, p. 47.

40. One might speculate on other reasons for the similarity—for example, perhaps only through some such "natural" connections could the symbols be understood. Of course, mere similarity would not by itself pick out that which is, *ex hypothesi*, symbolized. And if it were a language entirely of one's own devising, what would be the need for analogies?

41. However, we need not say that any behavior would gratify any desire whatsoever, as Freud is sometimes interpreted as saying. What is definitive of a species of satisfaction, how this is known, and how a relevant strategy is effected, are very difficult questions. Perhaps some behaviors are arbitrarily elected in the light of similarities idiosyncratically fastened upon.

42. Freud could object that the means are disguised only because of their associative hook-up with the desired. Sartre might well ask how chains of association can do double duty in the theory: they are used both as chains of discovery and as obfuscating screens.

43. In the present discussion we set aside the question raised in section III about the necessity of symbolism in symptom formation. In the end, it does not matter, for the point to be elucidated in this section seems just as easily expounded by means of the concept of interpretation or "seeing as."

44. Anderson, et al., *NLR* Interview, p. 46.

45. *NLR* Interview, p. 46.

46. *NLR* Interview, p. 47.

47. In section III, we saw one such mixed model which does seem to offer difficulties.

48. David Rapaport, "The Structure of Psychoanalytic Theory," *Psychological Issues,* II, no. 2 (1960).

49. Sartre, *Sketch,* p. 54 (28).

50. *Sketch,* p. 52 (26).

51. Attempts at analysis sometimes result in defining something which is not really self-deception at all, but rather some sort of wishful thinking. See, for instance, J. V. Canfield and D. F. Gustavson, "Self-Deception," *Analysis,* 23 (1962).

52. *B and N,* p. 49 (87).

53. *B and N,* p. 49 (88).

54. *B and N,* p. 49 (88).

55. *B and N,* p. 50 (88).

56. *B and N,* pp. 55–57 (94–96).

57. *B and N,* p. 53 (92).

58. Such a move is suggested and rejected by David Pears, "Freud, Sartre, and Self-Deception" in *Freud: A Collection of Critical Essays,* ed. by Richard Wollheim (New York: Anchor Press/Doubleday, 1974), p. 98.

59. *B and N,* p. 53 (92).

60. Recalling G. E. Moore, one might here speak of a paradox of psychoanalysis.

61. *B and N,* pp. 51–53 (90–92).

62. During a later phase of Freud's theory, it was held that it is the unconscious part of the ego which offers resistance. Indeed it was the very fact of unconscious resistance which, Freud claimed, led to the view that there is an unconscious aspect of the ego. Perhaps Sartre does not clearly separate earlier from later theory, but it does not matter for the present discussion.

63. *B and N,* p. 53 (92).

64. *B and N,* p. 53 (92).

65. *B and N*, p. 67 (108).
66. *B and N*, p. 66 (107).
67. *B and N*, pp. 63–65 (103–4).
68. *B and N*, p. 64 (104).
69. *B and N*, p. 50 (88).
70. *B and N*, p. 47 (85).

Ivan Soll
SARTRE'S REJECTION
OF THE FREUDIAN UNCONSCIOUS

ONE of the salient features of Sartre's philosophy is his total rejection of the idea of unconscious mental processes or of an unconscious region of the mind. This rejection involves an explicit criticism of Sigmund Freud's psychoanalytic theories, but Sartre's arguments against the existence of unconscious mental processes do not constitute a rejection of just psychoanalytic theory.[1] As Freud liked to point out, the belief that there are unconscious mental processes was widely held long before he started to work out his theories, and indeed that belief is held today by many who are ignorant of Freud's theories or who knowingly reject Freudianism because of significant disagreements with other of its aspects. Thus in rejecting unconscious mental processes Sartre is not only setting himself against psychoanalytic theory but also, and more radically, against a very widely accepted view concerning the workings of the human mind.

Sartre's case against the existence of unconscious mental processes or of an unconscious region of the mind is developed most clearly in the course of his discussion in *Being and Nothingness* of *mauvaise foi,* which is commonly translated literally, as "bad faith," but by which Sartre seems to mean *self-deception.*[2] Sartre's criticism of the unconscious depends, however, upon his general theory of human consciousness as presented in the "Introduction" to *Being and Nothingness* and in *The Transcendence of the Ego,*[3] in particular upon his theory of the "pre-reflective cogito."

Sartre convincingly argues that "bad faith," the fact that people deceive themselves, creates a perplexing theoretical problem. In accord with what he takes to be a common way of viewing self-deception, Sartre considers it to be the act of lying to oneself; however, he emphasizes that the notion of lying to oneself presents metaphysical and conceptual difficulties that ordinary lying (that is, lying to other people) does not. Sartre presents ordinary lying as a straightforward and unproblematic notion:

The essence of the lie implies in fact that the liar actually is in complete posses-
sion of the truth, which he is hiding. A man does not lie about what he is
ignorant of; he does not lie when he spreads an error of which he himself is the
dupe; he does not lie when he is mistaken. The ideal description of the liar
would be a cynical consciousness, affirming truth within himself, denying it in
his words, and denying that negation as such.[4]

There is nothing incoherent or incomprehensible about interpersonal lying
as Sartre presents it, and his analysis seems clear and correct. Typically,
Sartre expresses the conceptually unproblematic nature of interpersonal
lying in metaphysical terms: "The lie then does not require a special on-
tological foundation."[5]

Lying to oneself as opposed to lying to others, self-deception as op-
posed to deceiving others is, however, a paradoxical notion, because: "It
follows first that the one to whom the lie is told and the one who lies are
one and the same person, which means I must know in my capacity as
deceiver the truth which is hidden from me in my capacity as the one de-
ceived."[6] To put the paradox as baldly as possible, the person who deceives
himself must at the same time both know and not know the same thing.
Sartre's analysis makes clear that it is the "duality of deceiver and de-
ceived" that renders interpersonal lying conceptually unproblematic, and it
is the absence of this duality that renders self-deception paradoxical.

He views the positing of an unconscious region of the mind as an at-
tempt to resolve the paradox of self-deception: "To escape from these
difficulties people gladly have recourse to the unconscious. In the psy-
choanalytical interpretation, for example, they use the hypothesis of a cen-
sor, conceived as a line of demarcation with customs, passport division,
currency control, etc., to re-establish the duality of the deceiver and the de-
ceived."[7] As Sartre sees it, psychoanalytic theory attempts to resolve the
paradox of self-deception by constructing a model which represents the in-
dividual psyche as containing within itself divisions analogous to the divi-
sions among different people, enabling us to view self-deception as merely
a kind of intrapsychic interpersonal lying, possessing that duality between
deceiver and deceived which renders the operation conceptually coherent
and thus philosophically unproblematic. As Sartre puts it, psychoanalysis
"introduces into my subjectivity the deepest intersubjective structure of
the *mit-sein*."[8] Sartre's position emerges more clearly when freed from its
formulation as an ontological thesis and from its reference to a Heidegger-
ian category. Sartre is asserting that psychoanalysis represents the individ-
ual human mind as being somewhat like a community or society composed
of different parts or agencies, and these parts are themselves viewed as
being like persons. Although Sartre does not himself make this compari-

son, on his view psychoanalytic theory appears as a converse of Plato's *Republic:* whereas Plato develops his image of an ideal society as a projection of the structure of the human mind, psychoanalysis, Sartre implies, develops its account of the mind on the model of an interpersonal, social group. Sartre sees as the motivation for this socialization of the mind, the desire on the part of psychoanalytic theorists to reduce the paradoxical notion of self-deception to the philosophically unproblematical notion of ordinary interpersonal lying.

In order for such a paradox-resolving reduction to be effected, the mind must be divided to produce the "duality of the deceiver and the deceived." Moreover, the part of the mind that is deceived cannot have epistemological access to the part that does the deceiving. This is why, in Sartre's view, one of the parts is designated as unconscious, that is, epistemologically inaccessible to the other part, which is conscious. In short, psychoanalysis tries to account for the apparently paradoxical phenomenon of self-deception by redescribing it as a deception of the conscious ego by the unconscious (that is, epistemologically inaccessible) id.

But, Sartre maintains, this attempt to resolve the paradox with the theoretical constructs does not stand up under close scrutiny. On the psychoanalytic account, self-deception is effected by the mechanism of repression, the mechanism whereby certain psychic material, such as wishes, ideas, feelings, etc., are kept from becoming conscious. When in the course of psychoanalytic treatment the therapist tries to bring repressed material to consciousness by undoing the repression and its attendant self-deception, the psychic agency responsible for the repression "defends" its work by initiating "resistance." As Sartre points out, "Freud in fact reports resistance when at the end of the first period the doctor is approaching the truth. This resistance is objective behavior apprehended from without: the patient shows defiance, refuses to speak, gives fantastic accounts of his dreams, sometimes even removes himself completely from the psychoanalytic treatment."[9] Sartre asks, "It is a fair question to ask what part of himself can thus resist?"[10] An interim answer, which serves at least to suggest a reformulation of Sartre's question that bears more directly and fully upon the crucial issue, is that the part that is responsible for the resistance behavior is the same part that is responsible for the repression. Since the resistance behavior is merely an extension and outward manifestation of the repression itself, to ask what part of the self or psyche is responsible for resistance behavior is also to ask what part is responsible for the repression it defends.

Sartre denies that "the 'ego,' envisaged as the psychic totality of the facts of consciousness," could initiate resistance behavior, because, being unaware of the content of the repressed material, it could not possibly

know when therapy is approaching dangerously close to the revelation of this material. More basically, the ego, identified, as Sartre does, with the conscious part of the mind, cannot effect self-deception through repression, because for self-deception to succeed one cannot be conscious of the contents or process of repression.

Sartre also denies that resistance can be understood as "emanating from the complex which the psychoanalyst wishes to bring to light."[11] Although the drives and complexes that constitute the id are characterized by the unconsciousness (that is, by epistemological inaccessibility) required for successful repression or self-deception, they are described in psychoanalytic theory as continually and implacably seeking to "express themselves in clear consciousness." The same consideration shows that the id is not the source of repression.

We are forced to conclude, says Sartre, that on the psychoanalytic view the "censor" is the sole possible source of resistance and repression:

> The only level on which we can locate the refusal of the subject is that of the censor. It alone can comprehend the questions or revelations of the psychoanalyst as approaching more or less near the real drives which it strives to repress—it alone, because it alone *knows* what it is repressing.[12]

Sartre argues that the censor's activity of repression is conscious and deliberative. The censor must be able to discern which drives are to be allowed to become conscious and which must be repressed, and this discernment entails being conscious of the drives to be discerned. Moreover, "it is not sufficient that it discern the condemned drives; it must also apprehend them *as to be repressed,* which implies in it at the very least an awareness of its activity."[13]

It seems to Sartre that the censor must be "conscious of the drive to be repressed [if it is to be able to repress selectively] but precisely *in order* [for this is the aim of repression] *not to be conscious of it."*[14] He concludes:

> What does this mean if not that the censor is in bad faith? Psychoanalysis has not gained anything for us since in order to overcome bad faith, it has established between the unconscious and conscious an autonomous consciousness in bad faith. . . . By separating consciousness from unconsciousness by means of the censor, psychoanalysis has not succeeded in disassociating the two phases of the act, since the libido is a blind conatus toward conscious expression and since the conscious phenomenon is a passive, faked result. Psychoanalysis has merely localized this double activity of repulsion and attraction on the level of the censor.[15]

If Sartre's argument is sound, it shows that Freud's postulation of an unconscious region of the mind does not resolve the paradox of "bad faith" or self-deception. What Sartre neglects to make clear is that this argument alone, even if sound, supplies meager grounds for rejecting the notion of an

unconscious region of the mind or of unconscious mental processes. Even if the postulation of the unconscious does not resolve the paradox of self-deception, it is quite clear that it was not postulated solely to resolve that paradox. Freud justified the postulation of the unconscious by claiming that it helped to explain several sorts of otherwise incomprehensible human behavioral phenomena, such as parapraxes, dreams, memory, and various sorts of neurotic symptom formation. Any attempted rejection of the unconscious that does not consider the broad range of explanatory functions Freud claimed for it will necessarily remain inconclusive.

Let us now, however, consider the soundness of Sartre's argument. One disturbing and objectionable feature of his presentation of Freud's theories is his seeming insensitivity to the considerable development and change these theories underwent over the course of Freud's long career. Sartre tends to equate Freud's relatively early topographical distinction between the conscious and unconscious regions of the mind with his later distinction between the ego and the id. In defining the Freudian notion of the ego as "the psychic totality of the facts of consciousness," Sartre explicitly identifies the ego with the conscious part of the mind, and, by implication, the id with the unconscious part. But the true account of the relationships among the Freudian concepts of the ego, the id, the unconscious, and consciousness is not so simple.

In the course of his early work on hysteria, dreams, parapraxes, and jokes, Freud became convinced that by hypothesizing the existence of unconscious mental processes—that is, mental processes of which the conscious mind is not aware—one could achieve a theoretical "gain in meaning and connection" in the understanding of these phenomena: "We call a psychical process unconscious whose existence we are obliged to assume—for some such reason that we infer its effects—but of which we know nothing."[16] But Freud soon found that this general "descriptive" notion of an unconscious psychical process referred to two significantly different kinds of processes: "one which is easily, under frequently occurring circumstances, transformed into something conscious, and another with which this transformation is difficult and takes place only subject to a considerable expenditure of effort or possibly never at all."[17] This distinction, between what is unconscious simply in the sense that we are not at the moment thinking about it, paying attention to it, or recollecting it and what is unconscious because it is "dynamically" repressed, called for an elaboration of terminology:

> In order to escape the ambiguity as to whether we mean the one or the other unconscious, whether we are using the word in the descriptive or dynamic sense, we make use of a permissible and simple way out. We call the unconscious which is only latent, and thus easily becomes conscious, the "precon-

scious" and reserve the term "unconscious" for the other. We now have three terms, "conscious," "preconscious," and "unconscious," with which we can get along in our description of mental phenomena.[18]

In addition to the general or "descriptive" sense of the unconscious and the more specific "dynamic" sense, Freud speaks of "yet another, third, sense" of the unconscious:

Under the new and powerful impression of there being an extensive and important field of mental life which is normally withdrawn from the ego's knowledge so that the processes occurring in it have to be regarded as unconscious in the truly dynamic sense, we have come to understand the term "unconscious" in a topographical or systematic sense as well . . . and have used the word more and more to denote a mental province rather than a quality of what is mental.[19]

This systematic or topographical sense of the unconscious is part of a general topographical model of the mind and of the mechanism of repression that Freud developed in the years leading up to his publication in 1917 of *General Introduction to Psychoanalysis,* where the model finds its clearest expression:

The crudest conception of these systems is the one we shall find most convenient, a spatial one. The unconscious may therefore be compared to a large ante-room, in which the various mental excitations are crowding upon one another, like individual beings. Adjoining this is a second smaller apartment, a sort of reception-room, in which consciousness resides. But on the threshold between the two stands a personage with the office of doorkeeper, who examines the various mental excitations, censors them, and denies them admittance to the reception room when he disapproves of them. . . . But even those excitations which are allowed over the threshold do not necessarily become conscious; they can only become so if they succeed in attracting the eye of consciousness. This second chamber may be suitably called the preconscious system.[20]

Freud clearly viewed this account as metaphorical, acknowledged that it was "crude" and in some ways even "incorrect," but maintained that it "must indicate an extensive approximation to the actual reality."[21] One should note that this model is not only topographical (that is, spatial), as Freud himself points out, but also social or interpersonal in that the rooms or spaces representing the unconscious and preconscious systems are inhabited by personifications of the unconscious drives, the censor, and consciousness itself.

It is this particular model of the mind and the corresponding state in the development of Freud's theories which Sartre seems to be considering when he criticizes Freud's account of self-deception. Sartre's talk of a "censor, conceived as a line of demarcation with customs, passport division, currency control, etc." closely fits the language of this model, and in presenting this model Freud, like Sartre, explicitly attributes resistance as well

as repression to the censor.[22] Moreover, Sartre's contention that the entire paradox of self-deception is relocated at the level of the censor draws on and points up the fact that on this particular model the censor is pictured as being like a person within a person. Since self-deception is a phenomenon that afflicts persons, it can afflict a part of the psyche only in so far as this part is like a person.

But does this theory or model actually entail that the censor deceive itself in order to fulfill its functions of repression and resistance? Let us agree with Sartre that the model strongly suggests or even entails that the censor must be conscious of the contents of the systematic unconscious, since it must discriminate between those drives which are to be repressed and those which are to be allowed to pass. Must the censor, however, as Sartre claims, be "conscious of the drive to be repressed but precisely *in order not to be conscious of it"*? If so, the process of repression would essentially be a case of the censor deceiving itself and would entail the paradox of the censor both being conscious and not being conscious of the same repressed material.

But it is not the case that the censor must in any way be unconscious of the drives it represses or of its activity of repression. According to this model it is not the censor who is the dupe of repression, but rather that person-ification of consciousness who is represented as a separate person dwelling in the room representing the preconscious system. Sartre's contention that the paradox of self-deception reappears at the level of the censor is based on a faulty interpretation of the requirement that for material to be repressed it must be withheld from consciousness. He understands this re-quirement to entail this material be withheld from any consciousness the censor might possess. But, in the context of this particular model of the psyche, this general requirement comes to mean only that the material must be withheld from the personification of consciousness who resides in the room representing the preconscious system. Contrary to Sartre's criti-cism, Freud has in fact resolved the paradox of self-deception in contriving a model that socializes the psyche by personifying several of its parts. In this way Freud has indeed restored "the duality of the deceiver and the deceived" that allows him to represent self-deception non-paradoxically as the deception of one personified part of the psyche (consciousness) by another (the censor), as ordinary interpersonal lying on an intra-psychic level.

To defend this particular Freudian model of the psyche against the Sartrean criticism that its theoretical constructs do nothing to resolve the paradox of self-deception is of course not to claim that the model is in all respects adequate. It may even be the case that those very features of the model which are responsible for the resolution of the paradox of self-deception are problematic for other reasons, that the problem of self-

deception is here resolved, but only at an exorbitant theoretical price. Indeed, any account of a person as being composed of parts that are themselves to be viewed as persons strikes me as being somewhat circular and as possibly involving an objectionable infinite regress. Because Sartre mistakenly believes this psychoanalytic model has not removed the paradox of self-deception, he does not see that the real difficulty the paradoxical phenomenon of self-deception poses for psychoanalytic theory does not simply concern its ability to remove the paradox, but its ability to remove it without creating further theoretical problems. Nevertheless, although Sartre's refutation fails on its own terms, it does furnish stimulus for further investigation of the problems created by the notion of self-deception for psychoanalytic theory.

Whatever the theoretical difficulties of this model, one should be warier than Sartre seems to be of basing a general critical evaluation of Freud's theories of the unconscious and repression upon what Freud clearly offers only as a "crude" but heuristically useful metaphor of his views. Moreover, one should not fail, as Sartre does, to note that Freud eventually came to reject this particular topographical model and with it the notion of the systematic or topographical unconscious.

During the 1920s Freud, for a rather complex set of reasons, developed a different structural or topographical model of the mind. In place of the earlier picture of the mind as composed of a systematic unconscious and a systematic preconscious-conscious, symbolized as *Ucs.* and *Cs. (Pcs.)* (to clearly indicate their systematic, as opposed to their merely descriptive, uses), Freud substituted the structural notions of an *ego, super-ego,* and *id.* Roughly speaking, the ego is the synthesizing agency of the psyche that has the task of integrating the demands of the blind drives constituting the id with the exigencies of external reality. The super-ego is posited as a splitting off of part of the ego that achieves some measure of independence from the rest of the ego in becoming the agency of several related self-reflexive activities: self-observation, self-evaluation by comparing the self to an "ego ideal," and self-criticism or punishment in its role as conscience.

Freud repeatedly insists that the psychic regions mapped by these structural and topographical categories of his later theories definitely do not correspond to those mapped by his earlier notions of the systems *Ucs.* and *Cs. (Pcs.).* Freud was led to this position by a consideration of exactly the question that initiated Sartre's criticism: "From what part of the mind does an unconscious resistance arise?"[23] Sartre and Freud fully agree, and for the same reason, that the resistance cannot be the work of the repressed drives. Freud writes:

> The beginner in psychoanalysis will be ready at once with the answer: it is of course the resistance of the unconscious. An ambiguous and unserviceable answer! If it means that the resistance arises from the repressed, we must re-

join: certainly not. We must rather attribute to the repressed a strong upward drive, an impulsion to break through into consciousness.[24]

At this point Freud and Sartre part company, for Freud insists that "the resistance can only be a manifestation of the ego, which originally put the repression into force and now wishes to maintain it."[25] More specifically, Freud says: "Since we have come to assume a special agency in the ego, the super-ego, which represents demands of a restrictive and rejecting character, we may say that repression is the work of this super-ego and that it is carried out either by itself or by the ego in obedience to its orders."[26] From this Freud draws profound consequences for his theory:

> If then we are met by the case of the resistance in analysis not being conscious to the patient, this means either that in quite important situations the super-ego and the ego can operate unconsciously, or—and this would be still more important—that portions of both of them, the ego and the super-ego themselves, are unconscious. In both cases we have to reckon with the disagreeable discovery that on the one hand (super-) ego and conscious and on the other hand repressed and unconscious are far from coinciding.[27]

When Sartre asserts that in the psychoanalytic view resistance and repression could not be attributed to "the 'ego,' envisaged as the psychic totality of the facts of consciousness," he is dead wrong about where psychoanalytic theory locates the activities of repression and resistance. Moreover, his mistake seems to rest on a serious misunderstanding of the Freudian conception of the ego, and this misunderstanding in turn seems rooted in the erroneous belief that the topographical notions of the systematic *conscious* and *unconscious* are synonymous with those of the *ego* and *id*. It is true, as Sartre claims, that resistance could not be the work of "the 'ego,' envisaged as the psychic totality of the facts of consciousness," but this simply is not the way Freud envisaged the ego.

Sartre's general neglect of the changes that Freud's theories undergo in the course of their development is further evidenced in Sartre's failure to mention that this "disagreeable" and "inconvenient" discovery led Freud to reject completely any structural or topographical sense of "unconscious": "We perceive that we have no right to name the mental region that is foreign to the ego 'the system Ucs.,' since the characteristic of being unconscious is not restricted to it. Very well; we will no longer use the term unconscious in the systematic sense."[28] Freud thereupon resolved to use the term "unconscious" only in "the oldest and best meaning of the word . . . the descriptive one,"[29] that is, as a quality characteristic of certain mental processes at certain times. There is a considerable difference between the claim that there is an unconscious region of the mind and the claim that there are unconscious mental processes. To most people, I believe, the structural claim seems a lot more problematic. Freud himself, as we have

seen, eventually rejected it while never wavering in his belief that there are unconscious psychic processes.

Sartre clearly rejects the notion of an unconscious psychic system or region; but what is his position with respect to the more modest claim that there are unconscious psychic processes? Sartre does not supply a direct and definitive answer; but this is not so surprising, since he does not seem to distinguish clearly between the two claims. There are, however, several indications that he is also in opposition to the idea of unconscious mental processes.

For one thing, Sartre argues that the agency of repression and the repressed material, both described by Freud as unconscious, are conceived by Freud himself in a way that actually entails—though Freud does not see or admit it—that they be conscious. With respect to the agency of repression, Sartre asserts: "If we reject the language and the materialistic mythology of psychoanalysis, we perceive that the censor in order to apply its activity with discernment must know what it is repressing."[30] And the same censor must be the initiator of resistance because: "It alone can comprehend the questions or the revelations of the psychoanalyst as approaching more or less near to the real drives which it strives to repress—it alone, because it alone *knows* what it is repressing."[31]

Sartre argues that a consideration of the selectivity of repression and of resistance reveals the censor's knowledge—and thus consciousness—of what it represses. Similarly, he argues that a consideration of the way in which the repressed drives are described by Freud, as disguising themselves to get by the censor, reveals the consciousness they possess: "How can the repressed drive 'disguise itself' if it does not include (1) the consciousness of being repressed, (2) the consciousness of having been pushed back because of what it is, (3) a project of disguise."[32] Since Sartre seems somewhat confusedly to view the psychoanalytic model of the mind as consisting of a conscious ego, a censor, and an id composed of repressed drives, his claim that both the activities of censor and the drives of the id must be considered conscious, is tantamount to claiming that the entire psyche and its processes are conscious.

Sartre's attribution of consciousness to the repressing agency and to the repressed material is linked to his general rejection of any mechanistic model or causal explanation of these matters. Sartre is aware of Freud's tendency to offer mechanical and causal accounts wherever possible, and of Freud's tenacious belief that all psychic phenomena are ultimately amenable to such explanation. Sartre asks us to reject "the materialistic mythology of psychoanalysis" and "all the metaphors representing the repression as the impact of blind forces."[33] The fundamental reason why these psychic processes cannot be accounted for in causal or mechanistic terms, accord-

ing to Sartre, is that they are teleological. This view emerges clearly in his argument that the drives of the id must possess consciousness: "No mechanistic theory of condensation or transference can explain these modifications by which the drive itself is affected, for the description of the process of disguise implies a veiled appeal to finality."[34] Here Sartre's criticism of the notion of unconscious psychic processes touches upon what is probably a more basic disagreement with Freud. Sartre sees Freud's theories of the unconscious as one expression of a fundamental commitment to the thesis that psychic, and hence human, reality can ultimately be accounted for in physical, mechanical, and causal—in Freud's case, neurophysiological—terms. Sartre himself clearly believes that such an account of psychic and human reality is inherently inadequate. In particular, he seems to believe that the impossibility of causally explaining intentional, goal-directed behavior is so obvious as to require no demonstration. And he seems to consider the description of certain psychic processes as unconscious to be part of an unjustified and unsuccessful attempt to transform them into ordinary physical processes amenable to the same sort of explanation as those physical processes which are in no way mental or psychic. In criticizing the notion of unconscious psychic processes, then, Sartre is more fundamentally attacking Freud's program of explaining the psychic realm in terms that are not peculiar to it. Sartre's most profound dispute with Freud is that of a Cartesian dualist, defending the ultimate metaphysical irreducibility of the distinction between the mental and the physical (in Sartre's terminology, between "being-for-itself" and "being-in-itself") against a program of materialistic reduction of the mental to the physical.

How might a Freudian respond to Sartre's contention that the censor, in order to repress selectively, and the repressed drives of the id, in order to disguise themselves, must act consciously and purposively? The most probable line of defense would consist in denying that these activities necessarily entail consciousness. It might be pointed out that many inanimate, and thus unconscious, machines, such as cream separators, mechanical graders that sort fruit, coal, etc., by size, and winnowers that separate grain from chaff, could be anthropomorphically described as making "selections" and exercising "discernment." What is to prevent the Freudian from conceiving the selectivity of the censor as a more complex but no less mechanical and unconscious mechanism? And what is to prevent him from conceiving of the "attempts" of the repressed drives to find conscious expression to be like water flowing along every successive segment of a containing boundary until it "finds" a break that "allows" it to "escape"? Why must the Freudian envisage the adoption of a disguise by the repressed drive as arrived at by something analogous to the conscious deliberation of strategy rather

than the blind working through of a sequence of permutations whose form and order is fixed?

In addition to claiming that the censor must be conscious of what it is repressing in order to repress selectively, Sartre maintains that the censor must be conscious of its own cognitive activity: "In a word, how could the censor discern the impulses needing to be repressed without being conscious of discerning them? How can we conceive of a knowledge which is ignorant of itself?"[35] In making this point about the consciousness of the censor, Sartre is clearly applying his doctrine of "the pre-reflective cogito," the full argument for which is to be found only in the "Introduction" to *Being and Nothingness*.[36] This is a doctrine that demands consideration as an important element of Sartre's rejection of the unconscious, and not only in its application to the Freudian notion of a censor.

Sartre holds that "All consciousness, as Husserl has shown, is consciousness *of* something. This means that there is no consciousness which is not a *positing* of a transcendent object, or if you prefer, that consciousness has no content."[37] The object of consciousness is "transcendent" in that it cannot be conceived as existing in consciousness. Since the object is conceived as the potential source of an infinite number of experiences of it, it can never be exhausted by, nor contained in, the finite consciousness one has of it. It remains "opaque" to consciousness—that is, it is never completely and exhaustively known by a consciousness: "A table is not *in* consciousness—not even in the capacity of a representation. A table is *in* space, beside the window, etc. The existence of the table is in fact a center of opacity for consciousness; it would require an infinite process to inventory the contents of a thing."[38]

Sartre then argues that consciousness of a transcendent object must be self-conscious:

> However the necessary and sufficient condition for a knowing consciousness to be knowledge *of* its object, is that it be consciousness of itself as being that knowledge. This is a necessary condition, for if my consciousness were not consciousness of being consciousness of the table, it would then be consciousness of that table without consciousness of being so. In other words, it would be a consciousness ignorant of itself, an unconscious consciousness—which is absurd.[39]

This self-consciousness of the "positional" or "thetic" consciousness *of* a transcendent object, says Sartre, should not itself be conceived to be a positional consciousness having as its transcendent object the original positional consciousness. Sartre has two reasons for ruling this out. First: "This would be a complete consciousness directed toward something which is not; that is, toward consciousness as an object of reflection."[40] This would

be to confuse that self-consciousness which is the inevitable concomitant of *all* consciousness of an object with the kind of self-consciousness that arises *only occasionally,* that is, only when we reflect upon ourselves. Second: if the self-consciousness that accompanies all consciousness of an object is itself consciousness of an object, then by the same argument that leads to positing this self-consciousness a second self-consciousness must be posited to accompany it, and an objectionable infinite regress is generated. To preserve the distinction between ordinary, non-reflective consciousness of an external object and reflection upon such a consciousness, and to avoid an infinite regress, Sartre refers to the self-consciousness that always accompanies consciousness of an object as "the pre-reflective cogito" and asserts that it, unlike positional consciousness, has no object.

The pre-reflective cogito is not characterized by "the subject-object dualism which is typical of knowledge" and other types of positional consciousness: "This immediate consciousness which I have of perceiving . . . does not *know* my perception, does not posit it. . . . This spontaneous consciousness of my perception is constitutive of my perceptive consciousness. In other words, every positional consciousness of an object is at the same time a non-positional consciousness of itself."[41] Since the "of self" in the phrase "non-positional consciousness of self" still "evokes the idea of knowledge," that is, of a positional consciousness, Sartre resolves, "Henceforth, we shall put the 'of' inside parentheses to show that it merely satisfies a grammatical requirement."[42]

There seems to be an inconsistency between Sartre's claims that *all* consciousness is consciousness *of* something and that there is a non-positional self-consciousness which is not a consciousness *of* something. This apparent inconsistency is removed by Sartre's assertion that "This self-consciousness *[conscience (de) soi]* we ought to consider not as a new consciousness, but as *the only mode of existence which is possible for a consciousness of something.*"[43]

To ascertain the implications of Sartre's doctrine of the pre-reflective cogito for the question about the existence of unconscious psychic processes, we have to determine the scope of the doctrine. As we have seen, the main argument for the pre-reflective cogito is introduced as an analysis of a knowing consciousness *(une conscience connaissant)*. This is a bit misleading, for the argument, if it is sound, shows not merely that a knowing consciousness must be self-conscious, but that *any* consciousness *of* an object must be self-conscious. What is argued to be impossible or absurd is a consciousness of an object that is not conscious of being so and thus "an unconscious consciousness." The notion of a knowing consciousness actually functions in the argument only as an example of a positional consciousness *of* a transcendent object. Sartre probably uses this example so

that he can contrast his own doctrine, that to know (since it is to be conscious of an object) is to be conscious (of) knowing, with Alain's "to know is to know that one knows," a doctrine that generates an infinite regress.

Even as a doctrine pertaining to every consciousness of an object, the assertion of a pre-reflective cogito may not seem relevant to the question of the existence of unconscious psychic processes. The doctrine seems to rule out only the possibility that a consciousness of an object can be unconscious of itself; it seems in no way to argue against unconscious processes. But this is misleading.

Sartre seems implicitly to equate consciousness and psychic reality. Apart from his explicit attack on the psychoanalytic notion of the unconscious in the section "Bad Faith" in his *Being and Nothingness,* there is little reference to the unconscious in his work, and then always by way of cursorily rejecting it. Moreover, Sartre simply presents his philosophy of mind as a theory of consciousness. Offering an analysis of consciousness where an analysis of mind is called for could be viewed as begging the question of whether there are unconscious psychic processes. To some extent it is, but I think that the doctrine of the pre-reflective cogito is developed in part to address this issue.

For Sartre, as for others in the phenomenological tradition, the defining characteristic of the psychic or mental is *intentionality.* It might be helpful to paraphrase Sartre's thesis, that all consciousness is conscious *of* something that transcends it, in a more neutral, less question-begging manner. We could say that Sartre holds all psychic processes to be intentional or positional in that they posit, point at, or transcend themselves toward an object. This more neutral and comprehensive formulation is consonant with Sartre's own conception of consciousness as the generic category for various psychic processes. In one passage he explicitly includes in the category of consciousness all acts of judging and the psychic basis of practical activity (which would seem to include desires and intentions): "All that there is of *intention* in my actual consciousness is directed toward the outside, toward the table; all my judgments or practical activities, all my present inclinations transcend themselves."[44] And in his book *The Emotions: Outline of a Theory,* Sartre argues that the emotions also are intentional, in that they are not to be understood as a particular class of mental contents or sense-data but as "a certain way of apprehending the world."[45]

If by "consciousness" Sartre is referring, as it seems, to all psychic processes that are intentional—and these include knowledge, perceptions, desires, intentions, and emotions—then in arguing that all consciousness *of* an object is self-conscious, Sartre is arguing that no such psychic process can be unconscious. Thus, if the doctrine of the pre-reflective cogito is correct, there can be no unconscious desires, intentions, emotions, etc.

Having shown that Sartre's doctrine of the pre-reflective cogito is rele-
vant to the question of whether there are unconscious psychic processes, let
us return to his arguments for this doctrine and examine them critically.

The main argument for the doctrine of the pre-reflective cogito is, as
we have seen, a *reductio ad absurdum:* "If my consciousness were not con-
sciousness of being consciousness of that table, it would then be conscious-
ness of that table without consciousness of being so. In other words it
would be a consciousness ignorant of itself, an unconscious conscious-
ness—which is absurd."[46] It does seem that an "unconscious conscious-
ness" is a self-contradictory or absurd notion; but we must examine this
more closely. What is really self-contradictory is that someone be at the
same time both conscious and unconscious *of the same thing,* or that a
consciousness of some object is unconscious of *that same object.* If the re-
quirement that the object be the same is not explicitly stated or implicitly
understood, the notion of an unconscious consciousness is not necessarily
self-contradictory. To use Sartre's example of perceiving a table, I am con-
scious of the table which I am looking at, but at the same time unconscious
of many other objects outside my field of vision. My consciousness of the
table can be unconscious, that is, unconscious of other things. What is self-
contradictory is that my consciousness of the table be unconscious of that
same table, that I can at the same time be conscious and unconscious of the
same table.

In what sense, then, would a consciousness of something that is not
self-conscious be an unconscious consciousness? Would it be conscious and
unconscious of the same thing, and thus self-contradictory? No, it would be
a consciousness of something that was unconscious, not of that same thing,
but only of the process of being conscious of that thing. Since the table (of
which one is conscious) and the process of being conscious of that table are
different, the notion of a consciousness of the table that was not self-
conscious would not be self-contradictory or absurd. It would be an "un-
conscious consciousness" only in the unobjectionable sense that it is a con-
sciousness of one thing (of the table) that was unconscious of something
else (of being conscious of the table). Since the notion of a consciousness of
something that is not self-conscious is not self-contradictory, there is no
need to postulate an immediate, non-positional self-awareness that accom-
panies all positional consciousness. To put this in our more neutral and less
question-begging idiom: with the failure of Sartre's argument there is no
need to assume that all intentional psychic processes must be self-
conscious. Thus, the notion of intentional psychic processes that are not
self-conscious and in this sense unconscious is not absurd. For example, the
notion of one's wanting, intending, or hating something without being

conscious that one is wanting, intending, or hating that thing is not self-contradictory.

Sartre has, however, another argument for his doctrine of the pre-reflective cogito:

> If I count the cigarettes which are in that case, I have the impression of disclosing an objective property of this collection of cigarettes: *they are a dozen.* . . . It is possible that I have no positional consciousness of counting them. Then I do not know myself as counting . . . yet at the moment when these cigarettes are revealed to me as a dozen, I have a non-thetic [non-positional, pre-reflective] consciousness of my adding activity. If anyone questioned me, indeed if anyone should ask, "What are you doing there?" I should reply at once, "I am counting." This reply aims not only at the instantaneous consciousness which I can achieve by reflection but at those fleeting consciousnesses which have passed without being reflected-on, those which are forever not-reflected-on in my immediate past.[47]

The intent of this argument is clear enough. Sartre presents us with a possible sequence of events which he claims cannot be understood or accounted for without the postulation of a pre-reflective self-awareness. Having just finished counting twelve cigarettes in a case without reflecting upon what I have been doing, someone asks me what I am doing, and I am able to reply without hesitation that I am counting. Sartre asks how it is that I am able to make this reply and answers that it can only be because of my pre-reflective self-awareness of counting.

Even if this sort of case could not be accounted for without the postulation of a pre-reflective self-consciousness, it would not support the Sartrean thesis that all positional consciousness *of* an object is also a non-positional self-consciousness, the thesis that supports his rejection of unconscious mental processes. At most it would show that sometimes a non-positional self-awareness accompanies an unreflective positional consciousness *of* an object. To support the general Sartrean thesis, it would have to be shown that in all cases of unreflective positional consciousness one could give such an unhesitating and correct reply. Sartre does not even attempt to demonstrate that this is universally the case. Nor does it seem possible to show this, for it is a fact that sometimes people cannot, for whatever reason, successfully reply to the question, "What have you been doing?"

Admittedly, I have just changed the tense of this question from the present (as it appears in the Sartrean text) to the immediate past. I do this to stress that the reply in the example is presented as depending upon some sort of recollection, and that there is some slight inconsistency in the tenses used in the example. The question ("What are you doing?") and the reply ("I am counting.") are put in the present tense, but the fact that the count-

ing has just been completed and that the answer draws on "consciousnesses which *have passed*" and are "in the *immediate past*" suggests that it would be more exact to formulate both question and answer in the past. To put both question and reply in the present would be more appropriate where the activity begun in the past is still uncompleted in the present.

Does a reply concerning one's own activity in the immediate past necessarily rely upon a direct intuition in memory of a "consciousness which has passed"? Sartre assumes that it must, but I would like to suggest as an alternative possibility that at least sometimes such replies are based not upon direct memories, but upon inferences. In Sartre's example, "these cigarettes are revealed to me as a dozen" without my having "a positional consciousness of counting them." Upon being asked what I am or have been doing I might answer without hesitation that I am or have been counting, having inferred without deliberation or hesitation that I must be or have been counting them in order to be presently conscious of their total number. Verbal reports I make about what I am or have been doing need not be based on any direct self-consciousness of my activities, past or present, reflective or unreflective. The fact that I make such reports is not conclusive evidence for the existence of any direct self-consciousness of the reported activities.

Let us now consider how little remains at stake if my arguments are sound. First, Sartre has given us no reason to believe that for all psychic processes that have taken place without reflection an unhesitating and accurate report can be produced by the person whose processes they are. Second, Sartre has given us no reasons why at least some of those unhesitating and accurate reports that are produced cannot be based on very quick and obvious inferences. But suppose we admit that there are *at least some* cases in which I report what I have been doing unreflectively and base my report on memory. Does it follow that the memories on which my report is based must be memories of a pre-reflective self-consciousness, of a non-positional awareness of my own activity?

To understand better how to answer this question, let us briefly review some of the features of the theory of memory which Sartre develops in *The Transcendence of the Ego*. In this book reflective consciousness is defined, as it is in *Being and Nothingness,* as a positional consciousness having as its object another consciousness. I reflect upon my perception of a table by taking this perception of a table as the object of my reflective consciousness. In *The Transcendence of the Ego,* however, an additional criterion of reflective consciousness is found in the fact that the object of reflective consciousness contains the *I.* The object of my unreflective consciousness of the table is the table; the object of my reflection upon this consciousness is of *me* being conscious of the table or that *I* am conscious of the table.

Sartre holds that any memory of an originally unreflective consciousness can be performed unreflectively by simply re-experiencing it, or reflectively by remembering that *I* experienced it: "If, for example, I want to remember a certain landscape perceived yesterday from the train, it is possible for me to bring back the memory of the landscape as such. But I can also recollect that *I* was seeing that landscape."[48] Sartre clearly believes this "possibility of reflecting in memory," as Husserl called it, to be universal: "I can perform any recollection whatsoever in the personal mode and the *I* appears."[49] Sartre identifies this universal "possibility of reflecting in memory" with the "factual guarantee" of Kant's claim that "the I think *must be able* to accompany all our representations." But Sartre is quick to point out that Kant does not claim that the *I think* "in fact inhabits all our states of consciousness," but only that it "must be able to accompany"[50] them.

What explains this universal "possibility of reflecting in memory" if it is not based upon the remembered consciousness being originally reflective? More specifically, in the case of having unreflectively counted cigarettes, what explains my ability to remember reflectively that *I* have been counting? Sartre claims that the only explanation consists in the fact that all positional consciousness of an object is also non-positional consciousness (of) itself. More radically, he even suggests that all memory, reflective and unreflective, depends upon the fact that "every unreflected consciousness, being non-thetic consciousness of itself, leaves a non-thetic memory that one can consult."[51]

But why should we follow Sartre in believing that, if neither reflective nor unreflective memory is based on a previous reflective consciousness of self, it must be based on a pre-reflective self-consciousness? Why must memory depend upon any sort of previous self-consciousness?

When Sartre says that "every unreflected consciousness, being non-thetic consciousness of itself, leaves a non-thetic memory that one can consult," he is suggesting that only because unreflected consciousness is a non-thetic consciousness (of) itself can it leave a non-thetic memory trace. But why should it be impossible for an unreflected consciousness, which was *not* also non-thetic consciousness (of) itself, to leave a memory that one can consult? Sartre offers no analysis of the mechanism of leaving a memory trace, and lacking any such analysis it would seem no more mysterious for a consciousness of an object to leave a record for future recollection than for a self-consciousness to do so.

Perhaps Sartre believes that only a "non-thetic consciousness of itself" could be the source of "a non-thetic memory that one can consult," but this would be a confusion. By "non-thetic memory" Sartre simply means a memory of what was previously experienced, without any explicit concomitant memory that *I* experienced it. On Sartre's own theory, a posi-

tional consciousness *of* a table, which is unreflective, does not include the *I* that is conscious of the table. We should expect, then, that the memory trace left by this consciousness should likewise contain no *I*. Thus, according to Sartre's own theory, the memory trace left by an unreflective "thetic" or "positional" consciousness should be "non-thetic" or "non-positional." One does not need to postulate a "non-thetic" self-consciousness" to account for "non-thetic memory." Despite the specious paradox that seems to have confused Sartre, a non-thetic memory of some object can be simply explained as the recollection of a previous, unreflective, thetic consciousness *of* the same object.

If it is not necessary to postulate an unreflective self-awareness to explain unreflective memory, is it still necessary for the explanation of reflection in remembering where the consciousness remembered was not originally reflective?

It is difficult to see how the postulation of an unreflective self-consciousness is either necessary or sufficient to account for this phenomenon. Whether or not the original consciousness is provided with an unreflective self-consciousness, that *I* that is attached to the memory is not present in the original consciousness. Thus, the postulation of an unreflective self-consciousness accompanying the original unreflective consciousness cannot explain how the *I* enters the memory. Even if Sartre is right about the universal "possibility to reflect in remembering"—and I believe he is—his doctrine of the pre-reflective cogito does not remove the mystery of its mechanism.

Finally, how is the postulation of an unreflective self-consciousness necessary to explain my ability to reply "I have been counting," when I have been counting without reflecting and have, in fact, based my answer upon some sort of memory? As an instance of remembering an unreflective consciousness in the reflective mode, the postulation of an unreflective self-conscious will not, as just argued, account for the introduction of the *I* in remembering. However, this case presents a special problem that might seem to require the postulation of an unreflective self-consciousness. My reply seems based not upon a memory of a previous positional consciousness of an object, but upon an unreflective consciousness (of) my own activity.

Since it has not been demonstrated that one can always successfully report what it is that one has been doing, what we are now considering is at most whether one need postulate an unreflective self-consciousness accompanying those unreflective activities which we can later remember and report. I think not, for psychoanalytic theory supplies an alternative account, which is in some respects preferable.

Sartre's rejection of unconscious mental processes is focused on those processes that are unconscious because they are repressed or, in Freudian terms, "dynamically unconscious." There are also, according to Freud, many mental processes that are unconscious though not repressed, processes that can with no great effort or resistance be brought to consciousness. He calls these processes "pre-conscious" or "latent." They are unconscious in the simple descriptive sense that at the times they are pre-conscious or latent we are not thinking of them, focusing upon them or paying attention to them. For Freud, cases such as Sartre's example of unreflectively counting and then easily remembering what one was doing are cases of bringing pre-conscious or latent material to consciousness. The same account applies to cases of easily becoming aware of what we are presently doing by starting to pay attention to them.

The difference between the Freudian and Sartrean accounts of such cases is that Sartre's account entails that we are conscious of everything that we can remember even before we remember it, while Freud views remembering as the making conscious of latent or pre-conscious—that is, unconscious—material.

To some extent this difference may seem only terminological, but Freud's terminology seems more natural. In the case of material that is remembered, but only after a considerable period of trying to remember, does it not seem odd and misleading to say that, while I was unsuccessfully trying to remember it, I was conscious of it? Sartre fails to address the important problem of the status of psychic material in those periods after its original acquisition by the psyche when it is not being recollected, which is, after all, its status most of the time. The status of psychic material in these periods of latency presents a serious problem to a proponent of the view that what is psychic is conscious. Perhaps that is why Sartre fails to say anything about what happens when any kind of consciousness leaves a record for future recollection, "a memory that one can consult."

On the psychoanalytic view the psyche can, and regularly does, acquire material without becoming conscious of it; psychic acquisition can be acquisition by the pre-conscious of latent material, only some of which ever becomes conscious. According to this view it follows that one can first become conscious of something in memory. If this is true, one cannot infer, as Sartre tries to do, from the presence of some mental content in memory any previous consciousness of this content. Thus, Sartre's argument for the postulation of unreflective self-consciousness, to explain a memory of an activity performed unreflectively, is radically undermined.

I have tried to show that Sartre's rejection of the notions of an unconscious region of the psyche and of unconscious psychic processes is uncon-

vincing. Both his allegation that the psychoanalytic model of repression is incoherent and his doctrine that all intentional psychic processes are self-conscious appear vulnerable to criticism. In attacking his doctrine of "the conscious unity of the psyche," I have pointed out that behind his rejection of the psychic unconscious lies the rejection by a Cartesian dualist of any view, such as Freud's, that seems to have as a goal the reduction of the psychic realm to the physical. Still deeper than either Sartre's rejection of the unconscious or his dualism, and furnishing the fundamental motivation for both, is Sartre's thesis of the radical freedom and responsibility of each individual human being. Sartre views the Freudian postulation of an un-conscious, or id, as the creation of a segregated section of the self into which we can place those processes of our psyche for which we would rather not be responsible: "By the distinction between the 'id' and the 'ego,' Freud has cut the psychic whole into two. I *am* the *ego* but I *am not* the *id*."[52] Sartre also associates the postulation of a psychic unconscious with the introduction into the psychic realm of causal relationships and the freedom-threatening thesis of causal determinism so dear to Freud and so repugnant to him.[53] Whether the psychoanalytic postulation of an uncon-scious in any way entails that man is not responsible for the contents of his unconscious or reduces man's responsibility for his actions in general, is far from clear. But this is a question that needs to be carefully treated so that we can better understand and evaluate Sartre's rejection of unconscious mental processes.

IVAN SOLL

DEPARTMENT OF PHILOSOPHY
UNIVERSITY OF WISCONSIN, MADISON

NOTES

1. In this essay I shall, for convenience, follow Sartre's own rough equation of "psy-choanalytic theory" with Freudian theory. Because of the differences between Freudian and other psychoanalytic theories, the equation is obviously unsound. But Sartre in no way ap-pears to trade on this careless equation in developing his arguments, nor have I done so in my evaluation of Sartre.

2. Jean-Paul Sartre, *Being and Nothingness*, tr. by Hazel Barnes (New York: Washington Square Press, 1966); hereafter cited as *BN*. The relevant section is part I, ch. 2: "Bad Faith." Although Sartre's discussion of *"mauvaise foi"* is for the most part a discussion of self-deception, I think it is best to translate it "bad faith," as Hazel Barnes does, because this translation corresponds more closely with the term's general meaning in French and makes clear that Sartre in using the term in a somewhat idiosyncratic manner.

3. *The Transcendence of the Ego*, tr. by Forrest Williams and Robert Kirkpatrick (New York: Noonday Press, 1957); hereinafter cited as *TE*.

4. *BN*, p. 87.

5. *BN,* p. 88.

6. *BN,* p. 89.

7. *BN,* p. 90.

8. *BN,* p. 92. *Mit-sein* is a Heideggerian notion referring to one's *being with* other people. *Sein* means "to be" or "being"; *mit* means "with."

9. *BN,* p. 92.

10. *BN,* p. 92.

11. *BN,* p. 92.

12. *BN,* p. 93.

13. *BN,* p. 93.

14. *BN,* p. 94.

15. *BN,* p. 94.

16. Sigmund Freud, *New Introductory Lectures,* tr. and ed. by James Strachey (New York: W. W. Norton, 1965), p. 70; hereafter cited as *NIL.* All quotations from this book used in this essay are taken from Lecture XXI: "Dissection of the Personality."

17. *NIL,* p. 70.

18. *NIL,* p. 70.

19. *NIL,* p. 70.

20. Sigmund Freud, *General Introduction to Psychoanalysis,* tr. by Joan Riviere (New York: Pocket Books, 1963), Lecture 19, pp. 305–6.

21. Ibid., p. 306.

22. *NIL,* p. 68.

23. *NIL,* p. 68.

24. *NIL,* p. 68.

25. *NIL,* p. 68.

26. *NIL,* p. 69.

27. *NIL,* p. 69.

28. *NIL,* p. 72.

29. *NIL,* p. 70.

30. *BN,* p. 93.

31. *BN,* p. 93.

32. *BN,* p. 94.

33. *BN,* p. 93.

34. *BN,* p. 94.

35. *BN,* p. 93.

36. *BN,* "Introduction," sec. III: "The Pre-Reflective *Cogito* and the Being of the *Percipere.*"

37. *BN,* p. 11.

38. *BN,* p. 11.

39. *BN,* p. 11. Hazel Barnes's translation loses the full force of the paradox Sartre wants to generate, by the mistaken omission of one word, changing "an unconscious consciousness—which is absurd" to "an unconscious—which is absurd."

40. *BN,* p. 12.

41. *BN,* pp. 12–13.

42. *BN,* p. 14. Hazel Barnes notes at this point: "Since English syntax does not require the 'of,' I shall henceforth freely translate *conscience (de) soi* as 'self-consciousness.'" In the remainder of this essay I shall generally refer to the pre-reflective cogito as "self-consciousness" except where the more explicit "consciousness (of) itself" is called for.

43. *BN,* p. 14.

44. *BN,* p. 11.

45. Jean-Paul Sartre, *The Emotions: Outline of a Theory,* tr. by B. Frechtman (New York: Philosophical Library, 1948), p. 52.

46. *BN,* p. 14.

47. *BN,* p. 13.

48. *TE,* p. 43.

49. *TE*, pp. 43–44.
50. *TE*, p. 32.
51. *TE*, p. 46.
52. *BN*, p. 91.
53. For Sartre's rejection of the thesis of psychological causal determinism, see *BN*, pp. 78–81.

William Leon McBride
SARTRE AND MARXISM

S ARTRE begins his *Search for a Method* (1957) by outlining a theory
about philosophies in general; Marxism plays a central role in this
theory. Briefly put, Sartre's formulation tells us that every major historical
epoch is characterized by one or two particular philosophies, or world views
(*visions du monde*), which capture and epitomize the dominant social and
historical realities of that time. "Between the seventeenth century and the
twentieth," he says, "I see three such periods, which I would designate by
[famous names]: there is the 'moment' of Descartes and Locke, that of
Kant and Hegel, finally that of Marx." In the present day, then, either one
goes along with Marxism in some sense, or else one takes an anti-Marxist
stance, which is in effect a pre-Marxist stance. Moreover,

> As for "revisionism," this is either a truism or an absurdity. There is no need to
> readapt a living philosophy to the course of the world; it adapts itself by means
> of thousands of new efforts, thousands of particular pursuits, for the philos-
> ophy is one with the movement of society.[1]

In accord with this assertion, the existentialists, among whom Sartre then
numbered himself, had not succeeded in going beyond Marxism to some
new world view, since that would have been impossible; at best, they had
made a contribution to the dominant, Marxist, "Knowledge" or "Wisdom"
(*Savoir*) of the age by dealing with certain problems (roughly, with prob-
lems concerning the meaning and the role of the *individual* human being in
society) which mainstream Marxists were, for various historical reasons,
neglecting. Existentialism, thus understood, is what Sartre chooses to call
an "ideology": "a parasitic system living on the margin of Knowledge,
which at first it opposed but into which today it seeks to be integrated."[2]

My first quarrel with Sartre's "revision" of Marxism (in the sense in
which "revision" expresses a truism) may seem a picky one; it has to do
with his employment of the word "ideology." Although Marx himself
never actually provided a final concise definition of this term (since *The
German Ideology* was an unfinished work), he used it in a sense that is

clearly different from Sartre's usage. For Marx, all ideologies (including all systems of religion and metaphysics) are indeed "parasitic" in the sense that they depend for their vitality upon existing socioeconomic realities; but at the same time they are essentially *illusory,* since they pretend to be independent. However, Sartre, who is usually at his most brilliant when exposing illusions, seems to want to claim for the existentialist "ideology" at least a large fragment of important and otherwise neglected truth. Moreover, in Marx's usage ideologies are parasitic upon material facts rather than upon higher-level thought systems; indeed, Marx's conception of "ideologies" *includes* those higher-level systems which Sartre calls "philosophies." (Marx, of course, excepted his own theory from this general conception. Based as it was on the unveiling and critiquing of ideology, he did not consider it to be just one more ideology—or just one more philosophy, for that matter—on a par with all the others in the parade of history.)

It is the philosopher's prerogative to redefine technical terms within certain tacitly understood limits. Nevertheless, I consider it regrettable that Sartre redefined a term so central to the tradition with which he had aligned himself without even indicating in the passage in question that he was aware of doing so.[3]

But is it merely a rather pedantic matter of terminology that is at issue here? I am not so sure. In a frequently cited passage at the end of the first section of *Search for a Method,* Sartre looks ahead to a time when everyone will enjoy a certain modicum of freedom in his or her life and no individual will be required to devote every waking hour to working to provide the means of subsistence; at such a time, he says, "Marxism will have lived out its span [*le marxisme aura vécu*] [and] a philosophy of freedom will take its place."[4] He concludes, rightly, by stressing the impossibility of our now forming a precise idea of what that freedom would mean or what that philosophy would look like. (In this paraphrasing of Sartre's text the word "precise" is all-important: surely we can form some general ideas of this future time, as the Sartrean labels "*real* freedom beyond the production of life" and "a philosophy of freedom" imply. Sartre's own word for what we cannot do concerning the future condition and philosophy of freedom is *concevoir,* "conceive"; I assume that this word here connotes, among other things, the same quality of preciseness that it connotes in the language of Descartes.) But to speak in this way of a new epochal philosophy that will some day replace Marxism is to reinforce the previously implied model of Marxism as but one in the series of great world views—each, to be sure, corresponding to a determinate socioeconomic form—that have marched and will continue to march across the stage of history. I have no doubt that Marx, on the other hand, saw his theory as a radical break with

this series, indeed as a revelation that would bring this series to an end in some important, though perhaps ultimately elusive, sense.

From a mere difference in terminology have we now moved to a mere difference in perspective? Perhaps that is all; we shall see. And even if difference in perspective could be shown to lead to a more substantial difference in underlying world views between Marx and Sartre, that in itself would not give us reason to assume that Sartre's world view is less adequate and truthful than Marx's, although it would certainly call into question Sartre's claim of parasitism on Marx.

Let us return to our opening assertions. I have some doubts about Sartre's classification of pre-Marxian philosophical epochs—for example, I disagree with his lumping together of Kant and Hegel—but he provides no basis for argument about it since he reveals almost nothing about his criteria, and in any case it is of little importance with respect to his view of Marxism. Perhaps surprisingly, however, I do accept his point concerning the predominant importance, for our epoch, of ideas, language, and methods that are most concisely associated with the "famous name" of Marx. I anticipate that this agreement will occasion surprise because relatively few American philosophers can claim more than a superficial acquaintance with Marxist thought, and in many other academic spheres familiarity with Marxism is, if anything, even more rare. In Sartre's France and even in West Germany, it is true, Marxism has become so much a part of current culture that those thinkers who adhere to a different world view (Aron, the Americanophile, is a good example) are forced to define their positions in opposition to that of Marx and his followers. But here in the United States, the importance of Marxist insights for comprehending our historical situation remains veiled to most of our intellectual leadership and, to an even greater degree, to most of our general population.

Of course there is nothing logically incompatible between the two claims that Marxism is of predominant importance and that most members of our society remain unaware of this. The prevalence of false or mystified consciousness on a mass scale is, in my opinion as in Sartre's, not just a theoretical possibility but a frequently encountered reality. Wherever this is the case, it is incumbent upon intellectuals who are faithful to the main lines of Marx's thought to try to explain how mystification takes place and how it is sustained; for Marx himself provided precious little by way of such explanation. It is in carrying out this task, it seems to me, that Sartre has made his greatest contribution to twentieth-century Marxism. First of all, against the stultifying "orthodoxy" of rigidly disciplined Communist Party intellectuals of the post-World War II period, Sartre made a case for introducing a psychological dimension into any Marxist social explanation that pretends to adequacy. If in retrospect it seems shocking that such a case

ever needed to be made, it is even more shocking that it still needs to be made in certain circles. But it remains in large measure true, as Sartre maintained in 1957 in *Search for a Method,* that "today's Marxists are concerned only with adults; reading them, one would believe that they were born at the age when we earn our first wages. They have forgotten their own childhoods."[5] Those to whom this description applies can never take the first step toward accounting for the social attitudes and practices of an Eisenhower–Nixon America or of a Gaullist France. Unable to account for such phenomena, individuals are unlikely to be of much use in changing them.

Second, having made his case, Sartre proceeded to attempt to exemplify the requisite "anthropological" method in a number of detailed, concrete studies, combining Marxist categories with categories derived from Freud and other psychological theorists. Sketches of many such studies appear in *Search for a Method* and in the *Critique of Dialectical Reason.* In addition, Sartre's autobiographical work must be considered such a study; and his massive recent work on Flaubert, *L'Idiot de la famille,* is of course the most ambitious of all. I must admit that I find this last work uneven and not as successful as I would have hoped in fulfilling its assigned role of serving as the sequel to *Search for a Method*[6] (that is, I take it, of instantiating the method outlined therein). In particular, I am impressed by the fact that it presents a certain disproportion, even if it is primarily a quantitative one, between the psychological information and psychoanalytic interpretation concerning Flaubert that dominate (though not exclusively) the first two volumes, and the categorial framework of Marxist social explanation that comes to the fore only in the third volume. Of course ultimately the two types of explanation, individual and "universal," are not supposed to be seen as radically divergent; that is the point. But I am not entirely satisfied with the way Sartre integrates them. In any case, it is more important that Sartre undertook in this Flaubert enterprise the concrete, detailed work called for in *Search for a Method,* than that every sympathetic reader should find the result entirely satisfactory. *L'Idiot* can serve as a model, albeit an imperfect one, for future works of social explanation of a new type, a type that is far removed from the old-fashioned, superficial narratives that used to pass for history, biography, and even social science, and yet avoids the emaciating, distortive reductionisms associated with classical Freudian, behavioral, structural, and so-called orthodox Marxist methodological techniques.

So much for encomiums and my general view of the important place I think Sartre deserves in the history of that most important of twentieth-century world-views, Marxism. It is about the exact conceptual character of Sartre's Marxism, rather than, except incidentally, his interpretative em-

ployment of it in specific literary or current political matters, that I wish to raise some questions in the remainder of this essay. For among the legion of his detractors are many who contend that they themselves are Marxist and Sartre never was. Many of their objections are ridiculous, many pedantic, many simply politically inspired and dishonest, many honest but misguided. Having dismissed what I take to be all such criticisms, I find that some hard questions still remain. Just as Sartre was much more a Marxist than not, at least during the 1950s and 1960s, so I am much more a defender of his than not; yet on both counts there are certain points of deviance.

Let me begin with Sartre's own initial area of preoccupation in his more strictly Marxist philosophical works (a rubric by which I intend to *exclude*, in particular, *Being and Nothingness* and the important transitional essay "Materialism and Revolution")—namely, methodological questions. Although one chapter of *Search for a Method* is entitled "The Progressive-Regressive Method," I must confess to sharing in the puzzlement voiced by most students with whom I have discussed the book as to just what this method consists in. It is easy to form some general idea of what Sartre has in mind, needless to say; but to the extent to which his method may serve as a solution to the inadequacies of both contemporary "orthodox" Marxist and American social scientific approaches to the explanation of social man, it deserves the fullest possible clarification.

Sartre's point of departure in elaborating on this method, as far as I can determine, is a long footnote in the previous chapter. In that note he refers to an article by the Marxist sociologist Henri Lefebvre, in which a three-stage method of social explanation is proposed. (The ironies of the reference to Lefebvre—for whose work, though it is marked by very different theoretical influences from Sartre's, I also have great admiration—abound. Immediately after World War II Lefebvre had written a vitriolic and unworthy polemic against existentialist philosophers, including Sartre;[7] he later apologized for it, in the course of writing one of the more interesting early criticisms of Sartre's Marxism.[8] Another article by Lefebvre, this one critical of the then-current state of Marxism in France, appeared in the same issue of *Tworczosc* that contained the original version of *Search for a Method,* and this article was to play a major role in Lefebvre's subsequent expulsion from the Communist Party.) Sartre summarizes the method as follows:

a) *Descriptive.*—Observation but with a scrutiny guided by experience and by a general theory. . . .
b) *Analytico-regressive.*—Analysis of reality. Attempt to *date* it precisely. . . .
c) *Historical-genetic.*—Attempt to rediscover the present, but elucidated, understood, explained.

And he comments:

> We have nothing to add to this passage, so clear and so rich, except that we believe that this method, with its phase of phenomenological description and its double movement of regression followed by progress, is valid—with the modifications that its objects may impose upon it—*in all the domains of anthropology.* . . . [It] alone can be heuristic.[9]

This has always struck me as a good start toward explicating the sought-after Marxist method. Sartre proposes to use both regressive and progressive approaches together; this is what he actually does, as he informs us both in the index and at several points in the text, in *L'Idiot.*[10] By contrast, the method of "orthodox" contemporary Marxists, which Sartre rather confusingly (to the extent to which he wishes to identify himself as a Marxist) calls "the Marxist method,"

> . . . is progressive because it is the result—in the work of Marx himself—of long analyses. Today synthetic progression is dangerous. Lazy Marxists make use of it to constitute the real, a priori; [politicians] use it to prove that what has happened had to happen just as it did. They can discover nothing by this method of pure *exposition.*[11]

But a number of important questions remain.

In the first place, one would like to know more about the role of Lefebvre's first phase of explanation, the "descriptive" phase, which Sartre identifies as "phenomenological" in his comment. This phase is left by the wayside not only in the remainder of *Search for a Method* but throughout the entire *Critique of Dialectical Reason.* Although the latter contains a number of descriptions (such as the unforgettable account of the government-operated radio network's emission of propaganda into the homes of millions of isolated, impotent, "serialized" citizens[12]) that stylistically resemble descriptive passages in Sartre's subtitled "Preface to Phenomenological Ontology," *Being and Nothingness,* the phenomenological movement receives no explicit mention in the *Critique.* In *L'Idiot,* it is true that he is somewhat less sparing in his references to various relevant intellectual traditions, including the phenomenological.[13] But, as one who was strongly and obviously shaped in his early intellectual evolution by the highly technical phenomenology of Husserl, and who both identified himself and has been identified by historians with the phenomenological movement, Sartre owed it to us to provide a clearer account than any now in print of his present estimation of phenomenology. (He has been quite definite, after all, about his present view of existentialism.)

If, in accord with the important footnote I have cited from *Search for a Method,* phenomenological description really does constitute a necessary first step in the total method of social explanation that Sartre is proposing, then why is so little said about it in his later writings? Can it be that the

adjective "phenomenological" that characterizes this description is now being used in merely a general, non-technical sense? Or will such description at its best involve techniques and presuppositions for which we might still be indebted to Husserl and his close disciples? If so, what are some of those techniques and/or presuppositions? And finally, does the "moment" of phenomenological description which Sartre, following Lefebvre, names as the first step in an adequate method have anything in common (as I think it has, or should have) with the prior "method of inquiry," never systematically presented to his readers, that Marx distinguishes from his "method of presentation" in a famous passage in the Afterword to the second German edition of *Capital*?[14] If this connection is admitted, then I think we shall have made progress in understanding at once the reason for certain lacunae in Marx's own published work (for example, his failure to analyze in detail the machinery whereby ideological mystification gains the upper hand in the consciousnesses of individuals) that have led to the disastrous blindness and "laziness" of some of his "orthodox" followers, the potential value of phenomenology for twentieth-century Marxism, and the relation between the Sartrean "progressive-regressive" method and that of Marx.

Of the two poles in this pair, "progressive-regressive," the former is said to be the final, synthetic step in social explanation (hence "regressive-progressive" might be a more felicitous label than "progressive-regressive"), and it is this step which Marx, particularly in the historical writings to which Sartre rightly pays great tribute, carried out with élan. Later Marxists have imitated Marx's example in this aspect of his work, but often without undertaking the requisite prior analyses. Very well; there is no problem here. Unfortunately, it is precisely the full-fledged progressive "moment," which Lefebvre characterized as "historical-genetic," that is lacking in Sartre's unfinished Marxist magnum opus, *Critique of Dialectical Reason*. As the concluding paragraph of the single published volume of that work makes clear, it is the *regressive* part of his critical investigation that has been Sartre's principal concern throughout that tome; the "progressive" reconstruction of history on the basis of this achievement was to be the subject matter of the projected but never completed second volume.[15] Nevertheless, we should be able to form some idea of what the progressive movement of historical explanation would have looked like in Sartre's hands, and I shall return to this problem presently.

Meanwhile, on the subject of Sartrean *regressive* analysis I find many difficulties—and this despite the fact that so much of the published volume of the *Critique* (and of *L'Idiot* and *Words* as well) consists of illustrations of this aspect of Sartrean method. One could expound almost endlessly on the brilliance of the insights contained in some of these passages; but at present I am concerned about another matter, namely, their overall significance

with reference to the dominant theoretical structure of Marxism within which, as I agree with Sartre, they ought to be located. Sartre identifies the "regressive" movement with "analysis." "Analysis" makes sense for him, of course, only as long as it is seen to be one part of the fuller, more complete method that we have been considering—as long as it is not divorced from the broad conception of dialectical reason, of which analysis is at most a "moment." However, ambiguities arise with his use of this term, and the reason, I think, is twofold. First, in certain passages Sartre places greater emphasis than he should, for consistency's sake, on the *opposition* between analytic and dialectical reason, thus deterring his readers (and perhaps himself) from recognizing their real, if asymmetrical, complementarity.[16] And second, quite simply, "analysis" is now commonly used as a shorthand for Freudian theory. I believe these ambiguities ultimately can be resolved, although that would be too tedious and lengthy a task to undertake here.

But just what is supposed to be the *aim,* the goal, of a regressive analysis? Presumably, its aim is to reach the component parts of the existing structure that is under investigation—by a process that may well involve proceeding in a direction inverse to the historical one.[17] In an important respect, this methodological conception is similar to that advocated by Marx in the *Grundrisse*—"Human anatomy contains the key to the anatomy of the ape"[18]—and actually employed by him in *Capital,* particularly in parts of volume I. (I assume that Sartre would acknowledge these methodological similarities and thus Marx's right to be considered at least an occasional practitioner of the "progressive-regressive method," even though the expression itself is not Marx's.) At first blush, however, the theoretical results of the two regressive analyses, Marx's and Sartre's, seem quite disparate: in Marx's case, the result is the systematic exploitation of that peculiar surplus value–producing commodity, human labor–power, in the "sphere of production" in order to generate a process of endless accumulation known as capital; in Sartre's case, it is the dialectical action of free praxis on inert matter in a milieu of scarcity whereby the former takes on the characteristics of the latter in the "practico-inert field" and human collectivities assume the passive form of "seriality." Moreover, Sartre's application of regressive analyses to individuals, such as Flaubert, leads to the discovery of certain fundamental projects formed early in the individual consciousness.

Exactly what is the connection between these regressive analyses that employ the same method and arrive at such disparate (though not necessarily, from what has been said thus far, incompatible) results? In the original footnote in *Search for a Method* in which the progressive-regressive method was introduced, Sartre spoke of the possibility of applying this

method, with modifications appropriate to subject matter, "in all the domains of anthropology." Presumably, then, Sartre would be working in the domain of psychology (or psychoanalysis—the word is not important) in his regressive analysis of Flaubert, and in another domain (which for the moment we shall leave unnamed) in the *Critique of Dialectical Reason.* Marx, on the other hand, devoted most of his later years to the domain of economics, to critiquing bourgeois political economy.

This resolution, however, is too neat to be satisfactory. For the boundaries of the domains of the "sciences of man" (that is, of anthropology, in Continental philosophy's broad sense of the word) are established in accordance with the needs of their practitioners at given times, and are constantly shifting. Marx understood this phenomenon with particular clarity, and that is why none of the conventional professional labels, such as "economist" or "philosopher," can neatly be applied to him. Sartre, too, has always recognized the contingent nature of disciplinary boundaries, and that is why it is difficult to assign any such label to the *Critique,* in particular. ("Sociology" comes closest to fitting it, but professional sociologists would have many reservations about this.) In the *Critique,* in fact, there are more than a few hints that it is to be regarded as a sort of master theory, itself fixing the boundaries for all the particular "anthropological" domains; it is to be, in Sartre's oft-cited phrase, a "prolegomenon to any future anthropology."[19]

What does this conception say about Sartre's regressive analysis vis-à-vis that of Marx? Does it mean that in the *Critique* (though not in *L'Idiot*) Sartre has regressed farther, penetrated more deeply? This would seem to be the most reasonable conclusion to be drawn from Sartre's claims, and it is strongly supported by the fact that Marx's great work *Capital* is by definition intended to be a systematic analysis of an historically transitory form of society. Sartre, then, inspired by some suggestions made by Marx in many of his writings, would have proceeded through his regressive analysis to attempt to discover the component parts of all of human history and society up to now, whereas Marx would have confined most of his efforts to a certain period.

Understood in this way, Sartre's method, in the writings of his identifiably Marxist period, leads back to ontological claims of very much the same sort as those he made in *Being and Nothingness.* Indeed, in a footnote in the *Critique,* Sartre himself asserts the linkage:

For persons who have read *Being and Nothingness,* I shall say that the basis of the necessity [for the practical agent to discover himself in the organized inorganic, as a material being] is practical: it is the for-itself, as agent, first discovering itself as inert or, at best, practico-inert in the milieu of the in-itself.[20]

In *Being and Nothingness* Sartre appeared as an ontologist in the grand tradition, even though in important respects the ontological ultimates of his system turned out to be inversions of the dominant conceptions of that tradition (a non-existent God, non-substantival selves, and the attribution of massive, full Being to those aspects of reality outside of thought or consciousness which had formerly been regarded as closest to non-being). On the basis of the above citation and my previous reflections on the aims or goals of Sartre's regressive analysis, it would seem that the *Critique,* too, must be seen as somehow heir to that same grand tradition. But this conception of the *Critique* conflicts with another conception both of the method and of the substance of what Sartre is doing in his later writings and, indeed, of what Marx himself was doing. Repeatedly, in *Search for a Method,* Sartre insists that the "living Marxism" of which he is in favor, as opposed to the dead-handed "orthodox" approach, is *heuristic;* that is, it eschews a priori categories. Both in that work and near the beginning of the *Critique* proper, he severely criticizes Friedrich Engels for generating the sort of Marxist metaphysics that he does (as I agree) in his *Dialectics of Nature.* As for Marx himself, one of his letters, commenting on a Procrustean application of his work (to the then-current situation in Russia) with which he was in profound disagreement, contains a passage that I find particularly significant:

> My critic feels he absolutely must metamorphose my historical sketch of the genesis of capitalism in Western Europe into a historico-philosophic theory of the general path every people is fated to tread, whatever the historical circumstances in which it finds itself. . . . But I beg his pardon. . . .
> In several parts of *Capital* I allude to the fate which overtook the plebeians of ancient Rome. They were originally free peasants. . . . What happened? The Roman proletariat became not wage laborers but a *mob* of donothings more abject than the former "poor whites" in the South of the United States, and alongside of them there developed a mode of production which was not capitalist but based on slavery. Thus events strikingly analogous but taking place in different historical surroundings led to totally different results. By studying each of these forms of evolution separately and then comparing them one can easily find the clue to this phenomenon, but one will never arrive there by using as one's master key a general historico-philosophical theory, the supreme virtue of which consists in being super-historical.[21]

There is, then, in my opinion, a basic ambiguity in Sartre's conception of what he, as a social theorist in an historical era dominated by the philosophy of Marx, has come to discover through his lengthy regressive analyses. Is the outcome a pair (praxis–inert matter), or perhaps a larger set, of ontological ultimates that is valid for all times and places within the world of human beings as it has existed up to now (though perhaps not valid for a future "reign of freedom" or for a possible other world not

characterized by scarcity[22]), and can this pair or set serve as a more generalized underpinning for the set of component parts found by Marx to constitute the basic social structure of the specific historical form known as capitalism? Or is the outcome rather another contribution, perhaps of great heuristic value, to the new type of comprehensive explanation of society that is called for in *Search for a Method,* offered without pretensions to exclusive validity as fundamental Marxist ontology? The answer to these questions may shed some light on the apparent anomaly of Sartre's at once accepting Marx's radical critique of ideology, which involves a conception of philosophy's somehow coming to an end with Marxism, and yet advocating a more traditional view of the history of philosophy, according to which Marxism would be seen as one more transitory, if epochal, philosophy, destined to be superseded by another philosophy.

The ambiguity concerning the intended significance of Sartre's social theory can be pinpointed by concentrating for a moment on one of his putative ontological ultimates, praxis. In the *Critique* Sartre first presents praxis in its most nearly pure state: as individual praxis operating on inert matter. He is thoroughly aware of Marx's own fundamental objections to the "Robinsonades," the example of Robinson Crusoe on his desert island which the bourgeois political economists were so fond of using as a point of departure for their lessons about the supposedly constant features of *homo oeconomicus:* in most cases these lessons surreptitiously introduce characteristics peculiar to the system of capitalism and thus forfeit their scientific credibility.[23] Sartre's own most compelling defense against the charge of resurrecting "Robinsonism" is, as I take it, that he has deliberately chosen to begin his analysis at the farthest limits of *abstraction* appropriate to his subject matter, human society; the entire published volume of the *Critique* is intended to be a movement from abstract to concrete levels of analysis. (Thus, the theoretical context within which he speaks, completely impersonally, of his isolated actor is entirely different from that within which the economists were writing.) "Individual praxis operating on inert matter" is meant to name an abstract situation, not an actual or possible historical one. But then, one may ask, what is more ultimate or more like a limiting case about "praxis" than about, let us say, "practice" or "labor" or, alternatively, "being-for-itself"? It is simply a matter of names, will be the reply; "praxis" has past and present historical connotations, including connotations derived from the history of thought, that make it a preferable word to use for Sartre's purposes in the *Critique.* The connotations are very important; for instance, to shift from describing the career of being-for-itself to describing that of praxis is to signal a change of emphasis in one's predominant conception of human reality, a change from the orientation toward consciousness or intellect that characterizes the contemplative tradi-

tion of earlier mainstream Western philosophy, to the orientation toward activity that characterizes Marxism and some other modern movements. Nevertheless, the two terms "being-for-itself" and "praxis" presumably do not denote two denumerably different entities or kinds of entities.

If this is the case, as I assume it to be, then "praxis" is a very general term indeed, and the variety of its potential specific contents appears to be nearly endless. "Praxis" has, it may be conceded, proved useful to Sartre as an omnipresent, unifying category in the *Critique,* but one is forced to question whether it will prove similarly useful to any other Marxist theorist (although it appears in the work of Marx himself, of course, its employment there is *extremely* limited). In any case, I can see no way of demonstrating the *necessity* of its being similarly useful to all future Marxisms. As far as I can determine, *L'Idiot de la famille* would not have been greatly altered in content if its author had refused to allow himself to use either "praxis" or any synonym of equal generality and technicality in the places where it now appears. These considerations put in doubt any claims that might be made or implied concerning the status of the results of Sartre's regressive analysis in the *Critique* as Marxism's definitive ontology. (Indeed, although this is not the place to discuss the issue in detail, I doubt that Marxism needs any such thing, in the sense in which the word "ontology" is being used here.) The same considerations may also be taken to provide a theoretical explanation, supplementing those reasons that have been given by Sartre himself, for his decision to abandon the work of massive general system-building that would have been entailed in completing the second volume of the *Critique,* in favor of the equally demanding and even more massive labor of infinite detail that is *L'Idiot.*

Thus far, in discussing Sartre's use of the category of praxis, I have concentrated primarily on only one critical issue, namely, that of its alleged ultimacy as a Marxist ontological building-block. To many critics of Sartre, this is by no means the most important issue surrounding his use of the term. Of far greater concern to them is the question of whether his theoretical conception of praxis prevents his adherence to materialism. It is rather generally agreed, for seemingly obvious (but in fact often very superficial) reasons, that one cannot reasonably be considered a Marxist if one rejects materialism.

In both *Search for a Method* and the *Critique,* Sartre proclaims his adherence to various conceptions of materialism, while keeping his distance from the familiar set of "orthodox" dogmas, derived more from Engels than from Marx, that often goes under the name of "dialectical materialism"—"diamat." For example, he says:

> We support unreservedly that formulation in *Capital* by which Marx means to define his "materialism": "The mode of production of material life generally dominates the development of social, political, and intellectual life."[24]

Sartre is cautious; philosophically trained, he makes careful distinctions. He will not subscribe to a collection of vague slogans simply because it is fashionable. Although this attitude may dismay a certain type of political activist, it is not in question here. But although in the *Critique* Sartre goes so far as to accept "the monism of materiality" as the only viable contemporary philosophical world-view,[25] he has not resolved the fundamental doubts. In "Materialism and Revolution" he labeled materialism a "myth," albeit one that has been historically useful to oppressed classes (since it leads them to see their oppressors on their own level, their own "degree of reality," rather than on some intrinsically higher value plane). I have been assuming, and I continue to assume, that he has by now abandoned the first part of that position. But has this abandonment really been total?

In defining the source of this doubt, it is useless to focus on particular Sartrean texts. Its basis is all-pervasive; what is at issue is the elementary structure of Sartre's thought. Sartre has waged a career-long struggle against Descartes' dualism; both abetted and retarded by the influence of Husserl (whose own ambivalence about Cartesianism was as familiar to himself as it is to his interpreters), Sartre's struggle was launched in *Imagination,* is in a certain sense the principal theme of *The Transcendence of the Ego,* and is discussed with great explicitness in the introductory chapter of *Being and Nothingness.* And yet Wilfrid Desan, so far from being idiosyncratic, is merely representing a very widespread sentiment when he entitles the final chapter of his study of the *Critique* "The Last of the Cartesians."[26] Marx himself seldom uses the word "matter," and even "materialism" occurs with no great frequency in his writings. Granted, Engels introduced unnecessary difficulties into the question of Marxist materialism, and Lenin made a botch of a wide range of related issues in *Materialism and Empirio-Criticism,* in which the role played by "matter" in our universe was assigned heroic dimensions. But in Sartre, in the *Critique* as elsewhere in his writings, matter is omnipresent, and its role is primarily negative: it is the anti-dialectical element—a needed element, to be sure, much as "nature" is needed for Hegel's spirit to evolve—in dialectical development. Even though Sartre acknowledges human reality to be inescapably material, he also writes constantly about praxis as if it were an agent or force in its own right, rather than simply a way of characterizing the structure of human reality. In the Sartrean account of the opposition between praxis and matter, it sometimes appears as if two qualitatively different types of basic entities were involved. This manner of writing and thinking is clearly at cross-purposes with a commitment to monistic materialism and gives new strength to the vestiges of dualistic ontologies in readers' thought-sets.

Marx foresaw, it seems to me, that the issues of materialism–dualism–idealism would cease to be important in a future "society of associated producers," since the basis for such disputes would then have been elimi-

nated; in this respect, I think, Sartre and Marx are in agreement. (Husserl, too, though for reasons quite different from Marx's, looked forward to a time when controversies of this kind might be obviated.) Lenin, on the other hand, was more thoroughly oriented toward immediate concerns, and thus one of his primary reasons for raising high the banner of materialism was its great polemical value, as he saw it, in current controversies. In "Materialism and Revolution" Sartre clearly recognized this value, while distinguishing it sharply from the question of materialism's truth. There, he said:

> In so far as it permits of coherent action, in so far as it expresses a concrete situation, in so far as millions of men find in it hope and the image of their condition, materialism certainly must contain some truth. But that in no way means that it is wholly true as doctrine. . . . Materialism is indisputably the *only* *myth* that suits revolutionary requirements. . . . It is the philosopher's business to make the truths contained in materialism hang together and to build, little by little, a philosophy which suits the needs of the revolution as exactly as the myth does.[27]

Which of the following statements more clearly reflects Sartre's own perception of his intellectual evolution since 1946: (1) that he at least partially accomplished the task he set for himself in the above citation, that of building a philosophy to replace the "myth" of materialism; or (2) that he attained to a more nuanced, profound, and, most important, *positive* evaluation of materialism within the context of the dominant world views of the present era? My own perception of Sartre's evolution makes me favor statement 2, but I know that many critics, adherents of the political Right, Left, and Center alike, would disagree with this perception, contending that Sartre always continued to reject materialism in its most widely accepted usages. I must concede that there are passages throughout Sartre's later writings that can be singled out to justify such disagreement; indeed, if I am not completely mistaken, this latter opinion is a common one. And if that is the case, we are left with one question concerning Sartre's Marxism and the issue of materialism: is this not, perhaps, one crucial issue on which he failed to join theory with practice—an issue on which his theoretical constructions have either disserved, or at least failed to serve as well as they should have, his practical commitment to the side of the oppressed in the class struggle of the present time?

One of Sartre's greatest concerns throughout his career, obviously, has been to defend both the reality and (especially in his later writings) the future possibility of human freedom. It is this concern more than any other that explains his antipathy to the "orthodox" Marxist interpretation of materialism, which has traditionally been linked with a doctrine of flat and fairly rigid determinism. Sartre admitted, both in the *Critique*[28] and in vari-

ous interviews, that over the years he became much more aware of the limitations on human freedom. Well and good; meanwhile, it is to be hoped, his subtle analyses of the internally generated, active, "intentional" aspects of human behavior have caused some "orthodox" Marxist thinkers to abandon a few of their more extreme and totally untenable formulations of the thesis of universal causal determinism. Marx himself never developed a systematic, comprehensive theory of causality, and I have no intention of attempting to invent one for him in the present essay. But it can at least be said with confidence that Marx had no qualms about admitting that non-conscious entities can and do exert a direct influence over the activities of human consciousness. Sartre, on the other hand, with his Cartesian and Husserlian biases, has always resisted analyzing free human activity, or "internality," in "external," causal terms. Naturally, he asserts that human "projects" are inconceivable except against a background of external "coefficients of adversity," permanent menaces[29] of all sorts, both human and non-human. But he has consistently (and persuasively) argued that to admit even a small amount of direct action by *things* on consciousness or praxis is to undermine the claim that radical freedom is a fundamental structural characteristic of consciousness.[30]

In *Being and Nothingness,* the problem of causality arises in a particularly acute form because of Sartre's total refusal to attribute any qualities, much less activities, to being-in-itself; all meaning comes from human reality. I see the culmination of the difficulties posed by this stance as occurring in a relatively obscure passage in his discussion of temporality:

> So far our description of universal temporality has been attempted under the hypothesis that nothing may come from being save its non-temporal immutability. But *something* does come from being: what, for lack of a better term, we shall call *abolitions* and *apparitions*. These apparitions and abolitions ought to be the object of a purely metaphysical elucidation, not an ontological one, for we can conceive of their necessity neither from the standpoint of the structures of being of the for-itself nor those of the in-itself. Their existence is that of a contingent and metaphysical fact. . . . [31]

Two pages later, he connects these claims with a brief account of the meaning of the "principle of causality" (he himself places the phrase in quotation marks). "Causality," he says, "is simply the first apprehension of the temporality of the 'appeared' as an ecstatic mode of being."[32] A full explication of these remarks would have to be lengthy, since they presuppose a great deal of conceptual apparatus from other parts of Sartre's work (such as his strong distinction between ontology, which he thinks of himself as doing, and metaphysics, which deals with the genesis or origins of phenomena). But it should at least be clear that Sartre is here giving evidence that he feels some concern about his philosophy's ability to explain

what others might call causal sequences of events that originate in the non-human, in "being," rather than through the actions of a for-itself. And the response that he makes to this concern strikes me as singularly unsatisfactory, by reason both of its relative brevity and of its elusiveness and suggestion of unsolved mystery.

I submit that classical Marxism (and not just the "orthodox" version derived from certain writings of Engels and Lenin) takes for granted a less subjective and less mystery-shrouded conception of causality than the Sartrean one that is implied in the above citation from *Being and Nothingness*. Marx, of course, unlike Engels, was concerned almost exclusively with the human social world, so that he had little to say about *purely* non-human events. But in his accounts of human events—for instance, in his brief speculative anthropological reconstruction of the origins of human society in *The German Ideology* (which, it is true, he and Engels wrote jointly)— he deliberately stresses the evolution of consciousness out of what he sees as non-conscious factors, beginning with *need*. For Sartre, the primitive's active efforts to satisfy his needs are a sign that he is already characterized by consciousness. The difference is partly terminological, but it is by no means exclusively so; two different world views, one much more monistic than the other with respect to the relationship between the human and the non-human, are at stake.[33] My question is whether, regardless of the merits of the respective conceptions of causality, a philosophy that ultimately denies that there is such a thing as *la force des choses*—if one takes that idiomatic phrase to mean non-human entities actively exerting causal efficacy over human praxis—is compatible with the world view of Marx. For is it not the case that Sartre's philosophy, even in its later forms, entails just such a denial? Or is the later Sartre willing to accept a broader and less subjective conception of causality than that to be found in his treatises on imagination and in *Being and Nothingness*?

However these questions should be answered, it is certainly true that Sartre has come to give far greater *importance* in his later work to aspects of human experience in which reflective consciousness has little role to play. In place of, though not in opposition to, the analysis of human reality as fundamentally *lack* in *Being and Nothingness,* in later works the portrait of "the man of *need,*" repeatedly appears. This is certainly, as we have seen, a move in a Marxist direction, although it would also be compatible, theoretically speaking, with a move in the direction of bourgeois political economy. The peculiar qualities of human need, as it is analyzed in the *Critique,* derive from a state of affairs that Sartre discerns as looming large in our world (though not necessarily in every possible world of active beings or even in our world under all possible circumstances)—namely, *scarcity*. While it might seem linguistically odd to call "scarcity" a causal agent,

even if Sartre were willing to admit the possibility of non-human causality, nevertheless it would be difficult for readers of the *Critique* to exaggerate the prominence of its role in Sartre's account. This fact gives rise to some additional questions.

Scarcity, for Sartre, is the milieu in which we live; as such, it is one of the major explanatory factors in the theory of the *Critique*. Its role in the writings of Marx is not nearly so prominent. This fact in itself may not be very significant, particularly if we consider that Marx concentrated the bulk of his attention on the capitalist system, whereas Sartre explicitly regards scarcity as having characterized all of human history up to the present time. If Marx and Engels, in *The Communist Manifesto,* can proclaim that all of human history up to the present time has been a history of class struggle, then Sartre's emphasis on scarcity can be seen as an attempt to answer, in a very general way, the question as to *why* this has been the case.

When Sartre's *Critique* was first published, in 1960, this emphasis of his may well have appeared somewhat passé to many readers in advanced capitalist countries, in light of their then-current atmosphere of self-congratulation about the rise of "the affluent society." Since then a great reversal has taken place, and the fact of scarcity now looms large in the consciousness of the same readers. Paradoxically, however, in my opinion, this recent historical development actually serves to increase skepticism about the validity of Sartre's employment of "scarcity" as a means of explaining social man. For the term is inherently quite vague and, in order to begin to make some sense of it, we must be able to form some conception of what a state of non-scarcity (that is, of "abundance") would be like; it seems to me that recent events have cast doubt on our ability to do so. To illustrate this difficulty, here is a superficial question, but an important one: Was the condition of the majority of the population of the United States in the early 1960s truly one of comparative abundance?[34] Or was the widespread belief that this was the case simply an illusion? (Of course no one disputes that at that time there existed numerous instances of what were arrogantly called "pockets of poverty," and that the United States, together with its nearest capitalist competitors, was at best an oasis of comparative abundance in a desert of world poverty.)

One might reply that in general the United States in that period did enjoy a temporary, isolated condition of comparative abundance, although it was a condition doomed to extinction for global reasons that could have been foreseen and in fact were foreseen by a few individuals at the time. The question then arises as to why strong class differences (as illustrated by income distribution statistics and by the continuation of great inequalities in social and political power), were generally maintained during that period of abundance; scarcity, in that case, cannot be very useful in explaining

these familiar social structures of dominance and subordination, since they seem to have survived the elimination of scarcity. If it is replied instead that "the affluent society" was only an illusion that was fostered and reinforced by our ideologists and our advertising industry (and I think that this is the sounder answer of the two), then we must confront the problem of *defining* scarcity. For the fact of conspicuous consumption in the early 1960s was *not* simply an illusion: in the society in question, at least, there was enough, and more than enough, matter of many kinds—food, clothing, and building materials, to begin with, and such other items as energy sources besides. Moreover, wastage was vast (there exist many impressive statistics on this subject). I am not recalling anything new, but merely raising a significant difficulty for Sartre's Marxism in light of very simple, well-known facts.

"Scarcity" is a relative term, as is "need." Marx insisted on this in many passages of *Capital*,[35] and it was the widespread failure to take this point seriously that led, probably more than any other factor, to the Bernsteinean "revision" of Marx (on the grounds that Marx's alleged predictions of increasing impoverishment of the working class had been falsified) in the late nineteenth century. Unlike such items as necessary labor time or the rate of surplus value, scarcity does not lend itself to precise quantitative measure; to require such a measure in the case of scarcity is to demand the impossible. Simply because it cannot be totally quantified, the concept of "scarcity" is not therefore to be considered meaningless, of course; far from it. But with respect to Sartre's Marxism, these facts raise the issue of whether it was advisable for him to lay so much of the weight of explanation on the concept of scarcity and on the alternative possibility of a scarcity-free social world of the future.

It seems to me that in his classical works, particularly in *Capital* and the later writings, Marx never allows any single concept to play as decisive a role in distinguishing between the structures of pre-socialist societies and that of a projected future socialist society as Sartre allots to "scarcity" in the *Critique*. "Class division" comes closest to playing such a role, perhaps, but unfortunately *Capital* breaks off just at the point at which Marx is beginning to analyze the concept of "class." It may be contended that in contrast with a capitalist system, Marx's socialist society would be one in which the exploitation of workers by means of forcing them to produce surplus value would have ceased, and *this* is a decisive difference; that is true, but Marx himself often stressed that surplus labor, that is, labor beyond the amount needed to reproduce the workers' means of subsistence (itself now redefined so as to allow everyone to maintain a *relatively* abundant living standard), would still exist under socialism in order to make possible rational planning and reinvestment toward the future. For Marx, a large network of interrelated concepts, some of them quite complex and

dependent for their meanings on concrete details of present-day society, must be brought to bear to draw the contrast between pre-socialist and socialist structures. Too often in Sartre's *Critique,* on the other hand, "scarcity" and its elimination seem to have been given a unique importance in establishing this contrast.

It is no doubt partly for this reason that Sartre encounters such great difficulties in speaking about the future. He says very little about it. He is convinced, as I pointed out near the beginning of this essay, that we do not have the intellectual tools to talk about Marxism's future "reign of freedom" in which Marxism itself will become dispensable. Marx likewise generally eschewed idle speculation about ideal societies of the future. But Marx was generally optimistic about the prospects for a full, undeformed version of socialism; Sartre, living in a time when a number of nations call themselves socialist while still suffering many obvious deformations, is not so optimistic. In a 1972 interview he admitted as much, even while explicitly denying it:

> What I would say is that I know what I have to tear myself away from, but I do not know entirely with a view to what. Or again, what is the least founded in me is optimism: the reality of the future. I have that optimism, but I would not know how to found it.[36]

Does this difference in outlook stem from temperamental differences between Sartre and Marx? In part, certainly. Sartre has lived through most of the twentieth century; one could hardly have done that with intelligence and lucidity and still remain unreservedly optimistic about the future. But more than just this is involved, I think. The additional factor is Sartre's identification of a genuinely socialist society with one in which scarcity has once and for all, without qualification, been abolished. If I have been correct in my brief analysis of scarcity, then it can *never* be abolished without qualification. In this case, there is no alternative to pessimism.

A number of commentators have been so impressed by Sartre's tone of pessimism, particularly in the *Critique,* as to exaggerate its predominance. Such is the case, I believe, with Desan, who at one point reports as a Sartrean conclusion about "all of history" what Sartre in fact raises as a question, and then only in a somewhat context-bound manner, namely: "Is there not a perpetual double movement of regrouping and petrification?"[37] Such is also the case with Chiodi, who hammers away with great effectiveness at the theme that Sartre departs from Marx, in the direction of a partial return to Hegel, on the subject of whether alienation can ever be eliminated.[38] But in Chiodi's prize textual piece of evidence from the *Critique,* a passage in which Sartre himself asks whether his analysis constitutes a return to Hegel, "who makes of alienation a constant characteristic of objec-

tification of whatever sort [*quelle qu' elle soit*] and replies "yes and no," Sartre is in fact distinguishing two different senses of the word "alienation," and apparently is not dissenting from the Marxian view that alienation in the narrower sense, "exploitation," conceivably could be abolished.[39] Sartre does, after all, raise the possibility of there coming to be a non-alienated society at some time in the future, and he does it in the form of an open question:

> The real problem—which we do not have to study here—concerns less the past, where recurrence and alienation are found in every time, than the future: to what extent will a socialist society abolish atomism *in all its forms?* . . . Must the disappearance of capitalist forms of alienation be identified with the suppression of *all* forms of alienation?[40]

Granted, these questions are raised in a long footnote, but this simply points to a quirk that Sartre shares with Marx: often the most revealing passages are those that occur in footnotes.

It seems to me certain that Sartre would have "had to study" the question of a possible, non-alienated historical future if he had set about the task of completing the second volume of the *Critique*. The reason he gave Jeanson for not having fulfilled that project, namely, that it required a more comprehensive knowledge of history than he had, particularly for non-Western nations,[41] is quite understandable. But the suspicion remains that an equally important deterrent was his recognition that it would be difficult, within the framework of his social analysis, to give credence to the possibility of a non-alienated future society.

It is my contention that if Sartre has experienced great difficulty in maintaining some "faith" (a useful word which he rejected in his interview with Verstraeten) in the future, it is largely because, in contrast to Marx, his conception of what a radically different future society would be like is just a bit *too* radical. It may be true that Marx in his later years scaled down his expectations too much; certainly some of his followers have seized upon his insistence that communism emerges from the womb of capitalist society bearing the birthmarks of the old society[42] to justify retention of those bureaucratic excesses and capitalist "vestiges" in supposedly socialist countries which Sartre so effectively assails in the *Critique*. But Sartre, on the other hand, in vaunting the capacity of dialectical reason to comprehend "the absolute intelligibility of an irreducible novelty,"[43] sometimes writes as if social revolution could bring about something like absolute change. Is such a thing indeed possible? Is the concept itself meaningful? I doubt it. Let me illustrate this final point of my criticism by referring to Sartre's famous analysis of the "group in fusion" in the *Critique*.

It should be recalled that Sartre's technical terminology for the two principal types of social collective in the *Critique*, the one, roughly speak-

ing, passive and other-determined, the other active and self-determined, is "series" (or "seriality") and "group." Apropos the formation of the group in fusion, which he illustrates by reference to the residents of the Quartier Saint Antoine in Paris who captured the Bastille in what is now thought of as the beginning of the French Revolution, he says:

> From this moment on, something is given which is neither the group nor the series but what Malraux, in *L'Espoir,* called the Apocalypse, that is, the dissolution of the series in the group in fusion. And this group, still not structured, that is to say, entirely *amorphous,* is characterized as the direct [*immédiat*] contrary of otherness: in the serial relationship, in effect, unity, as the Reason of the series, is always *elsewhere;* in the Apocalypse, although seriality remains at least as a process on the path to liquidation—and although it may always reappear—the synthetic unity is always *here*.[44]

This high-water mark of incipient, perfervid revolutionary activity, group praxis at its limit (but so unique as to be irreducible, strictly speaking, to the status of a *group*) is, in Sartre's own words, "not structured, . . . *amorphous*." Phenomena of this sort may occur from time to time in any society; from this point of view, Sartre's account is simply an attempt to give a generalized description of such apparently structureless phenomena and to make them as intelligible as they can ever be made. But is it not in fact a mistake to say that any actual group in fusion, that is, any collective movement that breaks with old rules and restraints in an attempt to achieve novel social goals, is totally without structure in its initial phase of enthusiastic formation? After all, the members will always have their individual histories, which they will carry with them, and their nascent common project, whatever it may be, will itself dictate certain simple, general lines of conduct along which the group must act in order to retain any hope of success. Moreover, whereas the apocalypse of religious myth transcends time, no social group in fusion can ever operate totally outside temporal limits.[45]

If this is so, then Sartre's account of the group in fusion at its height can only be taken as an ideal model, not as a generalized description that is *exactly* applicable to any particular historical event, past, present, or future. This has important implications for his Marxism, particularly for that aspect of it which has to do with revolutionary change in the direction of a socialist society. Any such change, if it should occur (and I am inclined in my less cynical moments to concede that it already has occurred here and there in truncated form), would have to be radical and fundamental in order to be genuine, but it could not be apocalyptic.

One other aspect of Sartre's account of the group in fusion has caused considerable concern among some of his readers, and that is its normative force. Sartre does not, to be sure, explicitly present his group in fusion as a

social norm to be striven for; he himself depicts such phenomena as extremely ephemeral, and it is his clear intention throughout the *Critique* to avoid all moralizing and simply to describe various "social *ensembles*" in a certain conceptual order. He is, in fact, considerably more successful than either Hegel or Marx himself at maintaining this peculiar combination of strong, implicit, barely suppressed ethical commitment, together with a methodological ethical neutrality, which is characteristic of the Hegelian tradition. But if, as Sartre says, "the worker will only be delivered from his destiny if the entire human multiplicity is changed forever into group praxis,"[46] and if the group in fusion is the limiting case of group praxis, it seems to follow that the group in fusion must play some sort of ideal role in a normative, as well as in a conceptual, sense. This is dangerous, from a Marxist point of view, because Sartre's group in fusion is by definition a praxis without theory.[47] To treat it as being in any sense a normative model for social activity is to undermine Marxism's theoretical basis and to encourage the false charges, often made by political reactionaries, that revolutionary activity is inherently mindless and that Marxism is basically anti-intellectual.

It is paradoxical that a person of such intense intellectuality as Sartre should leave any opening within his theoretical framework for such inferences to be drawn. His detailed account of the Bastille episode and its prelude is, on the whole, not only powerful but extremely useful in facilitating our understanding of numerous relatively unanalyzed political protest incidents that have occurred throughout the world since the publication of the *Critique*. However, at certain points of Sartrean *interpretation* of the Bastille episode difficulties such as the one that I have just discussed arise. There has always been a streak of ultra-romanticism in Sartre's thought; perhaps it is just this streak which gives his works of philosophy and literature their peculiar flair, even much of their brilliance. But without doubt this same streak also accounts for the divergence—a relatively slight one, I think, not a large one—that I detect between Sartre's later philosophy and that of Marx on the related issues of revolutionary change and the possible socialist society of the future.

This concludes my survey of important possible deviations between Sartre's thought and Marxism, which I initiated in the domain of methodology and have developed through ontological questions about praxis, materialism, and causality and the categorial problem of Sartre's allegedly excessive stress on "scarcity" into the final issue of his normative orientation toward that portion of human history which remains to be acted out.

The Marx whom Sartre often appears to find most attractive is Marx the historian, the writer of *The Eighteenth Brumaire, The Class Struggles in*

France, and so on. This is a good choice on Sartre's part. Toward the end of his third Flaubert volume he reminds us that Marx maintained, very profoundly, that history progresses by its worst sides.[48] Having recognized this, Marx still remained in some way hopeful about the future. Despite all surface appearances to the contrary, Sartre's Marxist-based social theory also provides us with real, material (as opposed to ideal) grounds for hope, as well as furnishing us with abundant intellectual tools for understanding the social movements of our own time—tools not to be found in the writings of Marx or of his so-called orthodox followers.

Among the frequently repeated criticisms of Sartre's Marxism that do not impress me is the charge that his account of social structures has not been sufficiently holistic to remain within the Marxist tradition. The critics who make this contention, many of them from the group of Marxists labeled "orthodox," are in danger of reducing Marxist theory to one more organicist theory that accords to social wholes some higher sort of existence than the individuals who compose them; to do this is to fall back into the kind of mystified view of the nature of society which Marx struggled assiduously to overcome. Another unimpressive criticism, along somewhat similar lines, holds that Sartre has shown up the deficiencies in his theory by his refusal to join "the party of the proletariat." This criticism, which greatly disturbed Sartre himself in the years of his disagreements with Merleau-Ponty at the height of the Cold War, has since been allayed in large measure by events. In May 1968, in particular, the foot-dragging tactics of the French Communist Party in the face of nationwide student-worker demonstrations raised profound questions in almost everyone's mind concerning the relationship between that party and the Marxist theory it claimed to espouse. These were precisely the questions over which Sartre himself had been agonizing for years. In fact, in order to view the Communist Party as the sole depository of revolutionary truth, one must hold some form of organicist conception of both the party and society. To his credit, and at times against very great pressures, Sartre has always seen this and resisted any such retreat to a neo-Hegelian idealism.

There have been pressures in an opposite direction as well, pressures in favor of treating Marxism as just another variety of humanism. This word, of course, has been given a thousand different meanings over time, and Sartre himself—unfortunately, in retrospect—once identified his existentialism with "humanism." But he has far more frequently resisted the humanist tendency to idealize present-day human beings and their societies in terms of whatever future possibilities they may be said to possess. What is actual is by no stretch of the imagination ideal, either in the capitalist bloc, in those countries now thought by some to be on the road to socialism, or anywhere else. In constantly and brilliantly insisting upon this

one stark truth, Sartre's philosophy exemplifies what is best and most important in Marxism itself, both now and for an indefinitely long time to come: its role of radical social *criticism*.

WILLIAM LEON McBRIDE

DEPARTMENT OF PHILOSOPHY
PURDUE UNIVERSITY

NOTES

1. See J.-P. Sartre, *Search for a Method* (New York: Alfred A. Knopf, 1963), p. 7; hereinafter *SM*. For *des noms célèbres*, "famous names," Barnes' translation reads, "the names of the men who dominated them." See also Sartre, *Critique de la raison dialectique* (Paris: Gallimard, 1960), p. 17; hereinafter *CRD*.

2. *SM*, p. 8.

3. Sartre indicates that he is aware of the divergence of his usage from the Marxist one in a footnote to a recent passage in which he does employ the term "ideology" in Marx's sense. See Sartre, *L'Idiot de la famille*, III (Paris: Gallimard, 1972), p. 212; hereinafter *IF*. Unfortunately, many readers of *Search for a Method* and of the *Critique* will never read this later footnote.

4. *SM*, p. 34; *CRD*, p. 32.

5. *SM*, p. 62.

6. "*The Family Idiot* is the sequel to *Search for a Method*." *IF*, I (Paris: Gallimard, 1971), p. 7 (first sentence of the preface). This and all subsequent translations from original, untranslated French texts are mine.

7. See H. Lefebvre, *L'Existentialisme* (Paris: Editions du Sagittaire, 1946).

8. In *Métaphilosophie* (Paris: Editions de Minuit, 1965), esp. pp. 77–88.

9. *SM*, p. 52.

10. See, for example, *IF*, I, p. 181.

11. *SM*, p. 133. Barnes's translation says "political theorists" instead of "politicians," which I favor, for *les politiques*. See *CRD*, p. 86.

12. *CRD*, pp. 319–25.

13. In *IF*, I, p. 26, for example, he alludes to the phenomenological expression *sinngebend*, "productive of meaning," to help explain a typical human characteristic that was singularly lacking in Flaubert at the age of six.

14. For English translation, see *Capital*, I (Moscow: Foreign Languages Publishing House, 1961), p. 19.

15. See his statement in an interview reported by Francis Jeanson, in *Sartre dans sa vie* (Paris: Editions du Seuil, 1974), p. 298. Sartre did in fact, however, write several hundred pages toward this second volume, and they probably will be published some day. A short excerpt from them has already appeared, under the title, "Socialism in One Country," in *New Left Review*, 100 (November 1976):143–63.

16. This point is made very well by Claude Lévi-Strauss at the beginning of his critical essay on Sartre, "History and Dialectic," in *La Pensée sauvage* (Paris: Plon, 1962), pp. 324–25. To commend Lévi-Strauss for exposing this ambiguity is not, of course, to express agreement with the main points of his essay.

17. See *IF*, I, p. 181.

18. *Grundrisse* (New York: Vintage Books, 1973), p. 105 (first German edition 1939).

19. *CRD*, p. 153.

20. *CRD*, pp. 285–86.

21. Marx and Engels, *Basic Writings on Politics and Philosophy*, ed. by L. Feuer (Garden City: Anchor Books, 1959), p. 441. Marx wrote the letter to the editorial board of

Otechestvenniye Zapiski in November 1877. Sartre cites some of this text approvingly in *CRD*, pp. 214–15.

22. Sartre alludes to the hypothesis of such a world, different from our own, in two important passages in *CRD*, to wit, on pp. 201 and 352.

23. *Capital*, I, pp. 76–77.

24. *SM*, pp. 33–34.

25. *CRD*, p. 248.

26. *The Marxism of Jean-Paul Sartre* (Garden City: Doubleday, 1965), pp. 279–309.

27. "Materialism and Revolution" in Sartre, *Literary and Philosophical Essays* (New York: Collier Books, 1962), p. 223.

28. Most notably, in a footnote in *CRD*, p. 491: "I used to think that total indeterminacy was the genuine basis of choice. But from the point of view of the group . . . it is the contrary that is true."

29. Both terms, the first more reminiscent of *Being and Nothingness,* the second more characteristic of the *Critique,* appear together as synonyms in *IF,* I, p. 666.

30. One should also consider the following early statement, concerning the connection between consciousnesses; this insistence is particularly striking: "Between two consciousnesses there is no cause and effect relationship." See Sartre, *The Psychology of Imagination* (London: Rider, 1950), p. 34.

31. *Being and Nothingness* (New York: Washington Square Press, 1966), p. 282; hereinafter *BN.*

32. *BN,* p. 284.

33. One avenue by which this relationship can profitably be explored further is, of course, animal consciousness. I used to have the impression that Sartre's view of animals was uncomfortably close to Descartes' relegation of them to the status of machines. It is interesting, therefore, to read his brief digression on household pets in *IF,* I, pp. 144–47. His point there is that human culture has made pets eternally bored, ruining them as purely natural beings and preserving them in an atmosphere in which they can only be perpetually frustrated. To the extent to which Sartre now acknowledges the existence (regrettable though it may be) of a quasi-consciousness or of some praxis in animals (an acknowledgement that is made even more explicitly in *IF,* II, p. 1875, fn. 2), then the organic-inorganic dichotomy which appears so frequently in the *Critique of Dialectical Reason* has achieved greater importance than before by comparison with the simpler humans-things dichotomy.

34. This, after all, was being said by the Marcuses of the time (*One-Dimensional Man* was published in 1964), as well as by the Galbraiths.

35. For instance, Marx explicitly classifies tobacco as a consumer necessity, as distinguished from a luxury item, on the ground that it is habitually considered as such even if it is not a physiological necessity. See *Capital,* II (Moscow: Foreign Languages Publishing House, 1957), p. 403.

36. Interview with Pierre Verstraeten, cited in Jeanson, *Sartre dans sa vie,* p. 277.

37. *The Marxism of Jean-Paul Sartre,* p. 215; *CRD,* p. 643.

38. *Sartre and Marxism,* tr. by Kate Soper (Atlantic Highlands, N.J.: Humanities Press, 1976).

39. *CRD,* p. 285.

40. *CRD,* p. 349.

41. *Sartre dans sa vie,* p. 298.

42. "Critique of the Gotha Program," in Marx and Engels, *Basic Writings on Politics and Philosophy,* p. 117.

43. *CRD,* p. 147.

44. *CRD,* p. 391.

45. For a more extensive development of these themes, see the chapter entitled "Totalization," in W. L. McBride, *Fundamental Change in Law and Society: Hart and Sartre on Revolution* (The Hague: Mouton, 1970), pp. 176–86.

46. *CRD,* p. 351.

47. This criticism constitutes an updating of sorts, from the point of view of the *Critique,* of certain charges made earlier by Maurice Merleau-Ponty in his famous chapter on "Sartre

and Ultrabolshevism," in *Adventures of the Dialectic* (Evanston, Ill.: Northwestern University Press, 1973), pp. 95–201. However, I reject more of Merleau-Ponty's claims than I accept, even with respect to the journalistic Sartre of the pre-*Critique* period.

 48. *IF,* III, p. 613.

Klaus Hartmann
SARTRE'S THEORY OF *ENSEMBLES*

S ARTRE presents many facets of his mind to the reading public. He is, variously, playwright, publicist and political activist, essay writer and, of course, philosopher. With respect to the last, it is strikingly apparent that his contribution to philosophy is still seen largely in terms of existentialism. Sartre is thought of as the author of *L'Etre et le Néant* rather than of *Critique de la raison dialectique*.[1] We need not probe into the possible reasons for this association—the vicissitudes of publishing which so long delayed the appearance of an English-language edition of the *Critique*, the verbosity of that work, or its considerable difficulty compared to *L'Etre et le Néant*. It is enough for us here to register the fact and to try to solicit an appreciation for what so far has been largely neglected, namely, that in the *Critique* Sartre has provided a social theory, a theory of *ensembles pratiques* or social formations.

In retrospect, looking at *L'Etre et le Néant* from the vantage point of the *Critique*, it seems odd that advocates of existentialism did not criticize the earlier work for its limited subject matter. But then, they would say, isn't it so that man is eternally in search of self-identification without ever achieving it, and isn't he eternally opposed to his fellow man in relationships of outstripping him or of being outstripped by him? Aren't these the crucial predicaments of man? Existentialism almost succeeded in convincing us that there is little else that matters.

The restriction of subject matter in existentialism goes along with an attractive method. What particularly appeals to the reader of philosophic bent is its dialectical scheme by which man is grasped in terms of being and negation: negation keeps him from coincidence with his being, prevents conjunction with anybody else or anything else. The scheme detectable in *L'Etre et le Néant* is that of a "logic of being," as in Hegel's *Science of Logic*, urged with regard to entities and agents otherwise claimed to be of a higher order. It is a scheme of subjectivity of spirit.[2] The reduction of this sphere to that of a simple "logic of being" seems to provide philosophical

backing for the substantive appeal of existentialism: we now know in terms of dialectical logic that we cannot fully "be," that union with something other or with others is impossible. The attractive simplicity of the scheme accords well with the alleged evidence, just as the evidence is now sufficiently pruned down to support the scheme. Nothing seems to be missing.

On reflection, of course, we wonder what happened to the social domain. At first glance, *L'Etre et le Néant* seems to have an answer. Its theory has room for an opposition of transcending subject and any number of transcended subjects conjoined under the gaze of the transcending subject; they form a *nous-objet*.[3] Granting the attractive dialectical scheme of a "logic of being" governing man, are not all social formations really thus alienated? And isn't this theory, precisely because of its categorical simplicity, a welcome tool in the hands of critics of society? It appears we are well served, then—particularly when we consider that in addition to his ontology in *L'Etre et le Néant* Sartre has, in *L'Existentialisme est un humanisme*, adumbrated a Kantian ethics to make up for the grimness of the picture.

But we are brought up short when we realize that explicit social formations, especially affirmative ones, cannot be formulated within the theory. And as we suddenly remind ourselves, there certainly is, after all, evidence to the effect that there are free communities, and that even where they fail to make their appearance they can at least be the object of aspiration. What are these communities, and what can be said about explicit social formations in general, about affirmative ones as well as alienated ones? Clearly, philosophy has to tell us what they are and how they can be accounted for.

THE OBJECTIVE OF THE "CRITIQUE"

It would be too easy to conclude that an existentialist position could simply be expanded to include a theory of social formations or *ensembles*, that Sartre was led on to his theory of *ensembles* by the sheer inadequacy of his existentialism or by an urge to fill a blank on the philosophical map. Many other considerations enter into the making of the *Critique,* one of them being that after *L'Etre et le Néant* Sartre became increasingly convinced that Marxism constituted the only true analysis of society and history, providing as it does a theory of alienation in terms of classes which is at the same time a theory of a suitable remedy. It must have appeared to Sartre that philosophy somehow had to meet the Marxist plane of theory without sacrificing its moorings in existential analysis.[4] Conversely, Marxism, particularly in its post-Marxian forms, had failed to "ground" its theory in man by accepting a class drama as the ultimate level of analysis.

Thus anthropology (and in "Question de méthode," written in 1957 prefatory to the *Critique* of 1960, Sartre also speaks of "existentialism") had the task of "grounding" or "founding" Marxism.[5] Along with this task went the task of providing a theory of social formations or *ensembles*: concrete formations like classes had to be related to man and, if considerations of intelligibility were to be met, mediating links not only between man and class but also between class and free emancipatory formations had to be proposed in an intelligible order.[6] Hence we see that Marxist considerations, although important as a *terminus ad quem*, are not enough to justify Sartre's project of a theory of *ensembles pratiques*: we have to add the problem of making all manner of social formations intelligible by relating them to man who, in turn, must be analyzed with a view to affording such intelligibility. This "transcendental" feature of the theory is a novel element in Sartre, who in *L'Etre et le Néant* restricted transcendental intelligibility to borrowings from Hegel's "logic of being" as propounded in the latter's *Science of Logic*. Sartre's *Critique* may then be considered a "critique" in the positive sense of a transcendental theory establishing valid conceptions in its field of reference and rejecting invalid ones, as well as in the negative sense of a criticism of Marxism where this is transcendentally deficient.[7]

REQUIREMENTS OF INTELLIGIBILITY

Let us now note some of Sartre's basic ontological and methodological premises. If his theory stands committed to intelligibility, this must be construed as intelligibility for the individual human being, who is taken as the only real instance and source of intelligibility. Unities going beyond the individual to include others are not true higher subjects; they can either be totalities, alienated or "inert" entities, or else they have to be regarded as plural unities of individuals. Their supervening character as qualitatively different from a mere assemblage of individuals—as *totalization*[8]—must be rationalizable in terms of the practical concerns of any one individual subject or member; the sociological approach, which tends to treat such units as objective aggregates available to the theorizing spectator, is disavowed. Intelligibility is required, but it is always rooted in the particular subject. When we add that the rationalization of an individual relating to others in a social unit is "dialectical" in that the Other must be assimilated as "non-Other," as identical with the individual subject approaching him from his own center, we reach what Sartre calls *dialectical nominalism*.[9] This methodological and ontological premise is not only opposed to the position of Hegel and others that supra-individual social entities are equally or even more real than the individual; it is also opposed to positions such as sociol-

ogy, positivism, science, and a certain brand of materialism, which, in
Sartre's parlance, are committed to "analytic reason."[10]

Another of Sartre's ontological and methodological points concerns
the analysis of man in his function of making social formations intelligible:
he is interpreted as *praxis*.[11] Social formations are "made," just as an indi-
vidual "makes" himself by his purposive relationships to the world and in
the world. Here we see a reworking of Sartre's earlier notion of the *pour-
soi*, which in turn is a reductionist formulation of Hegel's and Heidegger's
notions of the subject. Now, however, the idea is formulated less in terms
of a "logic of being" than in terms of anthropology. Incidentally, Sartre's
choice of praxis as a key notion ties in well with Marxian tenets concerning
"practical materialism."[12] Sartre wants to provide an *anthropologie struc-
turelle*,[13] that is, an anthropology dealing with a variety of social formations
or *ensembles*, which are specified as *ensembles pratiques*, as social forma-
tions due to praxis. Praxis, in order to accommodate the requirements of
intelligibility, puts up its own "lights," provides an intelligibility of its
own.[14]

It would be a mistake to surmise that Sartre means to depict the mak-
ing of social formations in any empirical and historical sense, although his
structural anthropology, to be complete, is intended to be an *anthropologie
structurelle et historique*.[15] Rather, he seeks to rationalize those *intelligible*
practical relationships between individuals which can be adduced to ex-
plain social formations. What we have is a systematic theory of various
ensembles with no implication that what comes early in the theory also
comes early in history or vice versa. The theory thus exhibits a linear ar-
rangement of systematic import[16]: it devises a sequence of *explanantia* and
explananda which serves the aim of intelligibility of the various *expla-
nanda*.[17] In this, but for its commitment to nominalism, the theory shows
great similarity to Hegel's *Philosophy of Right*, which also proposes an
explanatory reconstruction of social formations in a sequence starting from
the will, or practical spirit, as their proximate principle.[18] Sartre's commit-
ment to dialectical nominalism, of course, poses a major problem. For him,
intelligibility remains tied to the individual. Can such intelligibility be
raised to the level of universality and of reason? The problem clearly is how
to relate intelligibility for a given individual, or individual comprehension,
to the rational subject of the theory—that is, to *dialectical* reason establish-
ing social rationality.

THE PRINCIPIAL DOMAIN OF ALIENATION

Having started with individual praxis as principle, Sartre goes on to
discuss certain enlargements or developments of praxis. First, we find *reci-*

procity of two individuals (or two pre-numerical social formations). Whereas in *L'Etre et le Néant* such a couple was polarized into ruling subject and overruled subject in object position, Sartre here sees a very different configuration, the subjective couple. He tells us that the coordination of two subjects in a couple is mediated by a Third acting in an ancillary function. The Third, in facing the couple, gives it an object unity; the configuration corresponds to the case of the *nous-objet,* which is homogeneous in view of shared objecthood. And yet by accepting the unifying imperative of the Third, the couple achieves an affirmative coordination of subjects who, precisely in their exposure to the mediating or catalytic Third, close themselves off against him. Sartre relativizes the conflicting aspects by arguing that the Third may vary, that his function may "rotate": reciprocals will amalgamate the subject that otherwise stood over against them—the couple is free—but a new Third will emerge to occasion another bond of object unity between them. Sartre also considers the reciprocal configuration under the eyes of a Third in relation to a common *matter* confronting the couple. The couple is seen as engaged in work on the same material object; it appears as a team or *équipe* (the term in *L'Etre et le Néant* denoting a *nous-sujet*[19]) but for the fact that it remains subject to the glance, or possible glance, of a Third.

Reciprocity is of an ambivalent status because it has to combine the principles of praxis and otherness. It stands for a first notion of plural praxis in that both an affirmative conjunction of two *praxes* and their mutual alienation under the eyes of a Third are ingredients of the notion. By itself it is a principial *ensemble* determining further enlargements or developments of *praxis;* nevertheless it is also a rich configuration, involving duality or pre-numerical plurality, confrontation of couple and matter, union of couple in matter, alienation of couple in matter, and alienation of couple vis-à-vis a Third and vis-à-vis matter, the latter since the Third may exact certain work from the couple. Thus the structure of reciprocity and the *ensembles* of couple and triple afford an instructive example of Sartre's method: he gives us a rich and picturable account of a typical situation—we can visualize such a configuration—and yet the theoretical function of this *Gestalt* is to enlarge and diversify the original praxis so as to result in still richer, and successively alienated, *ensembles*.

But the ambivalent concept of reciprocity with its attendant possibility of alienation is not enough: Sartre next introduces another principle, *scarcity*, to account for alienated *ensembles*, which he thinks must be developed before affirmative *ensembles* can make their appearance. He thus follows a Marxian inspiration which in the historical scheme of *The German Ideology*, as well as in the systematic works such as *Capital,* posits a development toward increasing alienation with emancipation as the only way out.[20]

The implication is that in an industrial society such as ours we find ourselves in the midst of a development toward, and immersion in, alienation.

The scarcity of products to satisfy man's needs accounts for *rivalry* in the attempt to gain access to those products. More explicitly, scarcity means that each individual considers every Other as a threat and is himself so considered by every Other. Each sees everyone else under the auspices of otherness; each internalizes the meaning of being an "excess person" (*excédentaire*). People thus come to view themselves and each other as mere Others, without the possibility of affirmative union or communion.

The configuration now reached is Sartre's way of accounting for alienation in general, economic alienation in particular, and the primacy of economic alienation among other forms of alienation. As is evident, the guiding thought in Sartre's work is more abstract than that of Marx who, in *The German Ideology*, derives economic alienation from the division of labor or, in the *Economic and Philosophic Manuscripts* and in *Capital*, simply grants it as a fact and reconstructs it from economic ultimates such as quantitative labor or the commodity.[21]

Obviously, Sartre's principle of scarcity merits only dubious theoretical status. To be sure, scarcity is a contingency of our historical epoch and it seems to be with us without a necessary reason, as an external, circumstantial phenomenon not derived from praxis. But then again, in view of the infinity of human needs and desires,[22] a world with limited resources cannot but feature scarcity: no finite world can ever escape scarcity in some respects. Thus the assertion of scarcity is trivial if not empirically specified. Empirical evidence is always available, but is it meaningful to ascribe such evidence to scarcity as a principle? Is this principle not too facile a way to account for specific types of alienation, and should it be cited as a factor that conditions alienated structures to stifle collective efforts toward providing what is needed? Must we (and the theory) go through the very depths of rivalry and internalized otherness in order to emerge triumphant in revolution? But the theory goes farther, now that alienation is doubly established by otherness and scarcity.[23]

Alienation is backed up, in quasi-multiple principiation, by *matter*, by otherness *confronting us* as distinct from otherness in and between us. Matter serves as an inert principle opposed to praxis, which is man. Man cannot avoid inscribing himself in inert matter, which in turn conditions him and conjoins him with others similarly inscribed. Matter coerces man by exigencies—as a tool coerces an individual worker or a team—and, under the rule of scarcity and the supervision of the Third, alienates him along with his fellows. Now otherness, extended to cover person-to-person and person-to-matter relationships as well as the Third controlling both, is "internalized" by man as what is called the *practico-inert*.[24]

Let us summarize the extent to which Sartre has abstracted Marx's concept of alienation. For Sartre it is not the economic entity of a commodity, or quantitative labor, which accounts for alienation, but rather matter in conjunction with scarcity and the internalized otherness of Others and Thirds—in a nexus of principles, as it were. In a sense this nexus of negative principles resumes itself in matter *tout court* as a counter-principle with a counter-finality, opposed to the finality or teleology of praxis. The abstract character of ontological analysis shows in Sartre's view that contingencies of nature—floods, for example—are just as much testimony to the counter-finality of matter as are societal conditions. Whereas Marx cites specific economic predicaments to account for alienation—for example, commodity fetishism, or exploitation through accumulation of surplus value—Sartre lays such predicaments at the door of the principle of counter-final matter which summarizes his nexus of alienating principles. Thus the economic specificity of alienation is submerged in Sartre; however, we should not underrate his intent to take this primary alienation into account when invoking highly abstract principles.

Concrete Alienated Ensembles

We are now ready to consider the role of *property* which, in Sartre's abstract construct of alienation, comes under the heading of *interest*. In Sartre's view, the proprietor has a vested interest in matter and thus affords an example of man conditioned by matter. The difficulty is, of course, how to distinguish this case of enjoying matter—as an outpost of the self, as a sphere of freedom of the kind Hegel proposed in the *Philosophy of Right*[25]—from the case of the worker alienated by matter or by someone else's property. The proprietor may be alienated in a different way; but this difference cannot be shown on the level of abstraction Sartre pursues. Although he does offer considerations to the effect that the worker has no interest in the machine while the proprietor has, and the latter will survive even if he goes bankrupt, these distinctions certainly cannot be derived from the crass opposition of man and matter.

Nor can we ignore the fact that Sartre's analysis offers no more than an abstract diagnosis of cases of alienation on the part of either workers or proprietors. Furthermore, the more complex configuration whereby proprietors own precisely that matter which occasions the workers' alienation, that is, where the means of production are privately owned, is not accounted for at all unless we conclude that on this level the idea of the Third affords a sufficient link between property and alienated workers. Again, Sartre's account, however theoretically ambitious, is inferior to that of Marx; for although Marx is less inspired in an issue such as non-productive

private property, he can comprehend tie-ups between capital and labor by viewing both in terms of the notion of *essence*, under which capital needs a counterpart, an inessential—the workers—in order to qualify as essence.[26]

It goes without saying that under the above nexus of principles Sartre can order a number of alienated human predicaments called *collectives*. The ultimate collective, the case of utter captivity in the *nous-objet*, is the *class*; other cases range from the queue at a bus stop to the buyer and seller on the market or the radio audience. Of particular interest here is Sartre's notion of *sérialité*, which he defines as *identité comme altérité*.[27] Conditioned by a material object—for example, a bus which several persons wish to board—each person is the Other to Others (as is generally the case under the rule of scarcity), but now Sartre has in mind more specifically those referential structures wherein one depends on an Other and that Other on yet another and, ultimately, all rely on a rule, the most telling one being "first come, first served." Understandably, the most important form of seriality is *recurrence*, a dependence of someone on Others who flee into other-directedness because, for them in turn, there are Others whom they have to consider in their alienated fear. The booms and depressions wrought by business speculation illustrate the kind of predicament that fosters this phenomenon.

The class for Sartre is the ultimate case of alienation because it conditions all less total predicaments: a worker who leaves an intolerable job cannot find work elsewhere; one who owns means of production cannot escape competition. With classes, we reach the nadir from which emancipation or subjecthood can emerge. It must emerge not only because the theory has yet to account for affirmative *ensembles* (provided we grant they are possible), but also because Sartre's aim is to rationalize in more basic terms, under the auspices of nominalistic intelligibility, the de-alienation demanded by Marx. Accordingly, the realization of central notions of social subjectivity, of affirmative social formations—or, sociologically speaking, of "systems"—occurs at the end of a cycle of alienated *ensembles*. Whereas classical social theory may see at this stage the formation of a political society to secure protection of property and its enjoyment, Sartre envisions something quite different, namely, the establishment of social freedom after extreme oppression by private property. Thus the suggestion is that social freedom emerges only by way of *revolution*, by forceful emancipation. Marx's historical drama is accepted and at the same time raised to the level of a systematic insight in social theory.

AFFIRMATIVE ENSEMBLES

The argument of Book II of the *Critique,* which seeks to account for free social formations, hinges, as we have noted, on man's emancipation

from the ultimate predicament of class-locked alienation. The very impossibility of survival in a class—Sartre now has in mind only the working class—triggers off free action. Such action cannot be expected of the whole class; a minority takes action and pulls the class after it.[28] But given conditions of utter alienation, how can a collective assume subjectivity and achieve self-assertion? Sartre has an interesting theory here. What is required is a common menace and a "regulating Third" (*tiers régulateur*) over against any two or more Others. Since this Third is himself threatened like all the others, he is also *homogeneous* with them. (We note that the role of the Third here is different from that of the external Third who makes his appearance in the case of reciprocity.) Sartre conceives of a scheme of relations between the regulating Third, who desires to solicit action, and all Others who could equally be Thirds vis-à-vis all the rest: each individual is identified with the Third as subject and yet, as long as the Third is an Other, all are subject to him and his direction. Now the Third, formerly an alienating figure or a catalyst for any two making up a couple, acts as a unifying factor, since his interest is conjoined with that of all. In the face of a sufficient, indeed total, threat, what will emerge is an *ensemble* of novel character, a group in the state of nascence, a *groupe en fusion*. It is a synthesis of praxes under leadership, a state of affairs which is non-antagonistic in view of the above considerations: any member of the group could replace the acting Third, who would then submit to another Third in order to achieve freedom. The *groupe en fusion* exhibits plural freedom with a "rotating" (or at least potentially rotating) structure.[29]

Although Sartre specifically analyzes the storming of the Bastille in developing his concept, the *groupe en fusion* clearly has a systematic role to play: it is a general principle of intelligibility of plural freedom. The affirmative character of any affirmative *ensemble* is grounded in the *groupe en fusion*. But, alas, no *ensemble* can remain a *groupe en fusion* for long. The occasion of its spontaneous constitution passes; the victorious rebels survey the spoils of their foray on a Sunday afternoon and are in danger of relapsing into an amorphous or serial entity. Thus, according to the Sartrean teleology, measures must be taken to assure the group's survival. To provide for its durable existence, the group has to give itself structures to prevent defection and dissolution.

The prototypical institution designed to prevent defection and dissolution is the *oath*. It instills terror in group members to deter disruptive behavior and threatens them with countermeasures in the event of noncompliance. We note that what in classical theories is attributed to the common will, a *consensus* leading to a social contract, is in this theory essentially bound up with blackmail and violence.[30] Although some may deem it too harsh to argue that in Sartre's concept social freedom is on principle based on violence,[31] and while some may prefer instead to stress

its parallels with Max Weber's views on status contracts,[32] there is no deny-
ing that from this stage on in Sartre's construct freedom is seen in the
restraining action applied to group members by group members, in the
curbing of particulars by particulars—indeed in an unwelcome if consistent
alternative to the universal agent that serves all and is therefore recognized
by all, as proposed in classical theories.

The present juncture of Sartre's theory would not be terribly
upsetting—in fact we might welcome this sworn group as an early stage—if
he were to posit a universal agent to come later. But for Sartre the sworn
group constitutes the institutional prototype for all other levels of social
freedom. Once conceived, it serves as the proximate principle for further
developments: in order to maintain itself on a larger scale, the group will
need a diversification of functions, and therefore a measure of internal con-
trol unthinkable without sanctions against disloyalty. Under such control,
group members are inevitably treated as objects or, in Sartre's parlance, as
practico-inert, by a group core which, being merely part of the group, can-
not but be particular. Any developed or articulate group will feature inter-
nal antagonisms controlled by minority power. There is a similarity here
with systems-theory sociology, which claims that a subsystem is established
whenever a system cannot adequately cope with its problems.[33] Sartre con-
ceives the group core to be such a subsystem; in fact, it is a governing
system within the system.

There is no need for us to analyze the major differentiations of groups
discussed by Sartre. Suffice it to say that they run from *organization* or *team*
(*équipe*), featuring diversification of functions among group members,
through *institution,* exhibiting sovereign leadership and authority, to *class,*
which assumes object-status vis-à-vis an opposing class and features praxis
as an objective process (*praxis-processus*). It appears that Sartre devises a
sequence of increasing structuredness in answer to an ever expanding scale
or comprehensiveness of groups; although we wonder whether the state,
one of the institutions he analyzes, is not more highly structured than the
class, which occupies the ultimate position on Sartre's continuum.[34] There
clearly are conflicting motives in the theory.

Sartre's view of the state merits further comment. Not surprisingly (in
view of its high degree of centralization and specification), the state turns
out to be a universally coercive group lording it over its group objects or
nationals. What matters theoretically is that, in view of its emergence in a
lineage starting from the *groupe en fusion*, the state is itself a group, a
particular comprising an opposite ruled by it. This notion of the state is
clearly adjusted to, even modeled on, Marx's idea of the state as an organ
of the ruling class. Such a notion, in Marx as in Sartre, excludes universality
of state agency, universality of the law as well as representation of all on

the political level; what we have instead is a political center organizing its objects of domination. Clearly, we cannot ask whether the state is legitimate. The theory is committed to class particularity and alleged class comprehensiveness, whereas the state is nothing but a ruling party with claims to universality. The state is however the wrong party, to be succeeded, in the theory, by the other class and its party, which are seen as the ultimate social subject. (Incidentally, with that class the theory has regained the level on which Book I ends, except that at the end of Book II, class means class of group status. The theory has come full cycle.)

Another point deserves note. As we have seen, Sartre's development of groups leads to a re-emergence of inertness or structuring; the most concrete groups will exhibit features of extreme alienation. Sartre thus rejects any such Marxian naiveté as the dictatorship of the proletariat.[35] In spite of his sympathy with Marxian vistas of the future and his advocacy of all sorts of good things like de-bureaucratization, de-centralization, and democratization,[36]—in short, de-alienation—he is more sober, indeed pessimistic: to have institutions means to put up with the practico-inert or, concretely, with particularized leadership, coercion, and the rest. In this appraisal Sartre is a forerunner of the latter-day Frankfurt school, whose major speaker, J. Habermas, has posited a similar antagonism between freedom and institutions.[37]

Sartre concludes with the assertion that the task remaining is to overcome the opposition of classes and ruling groups by envisioning a future solution in a theory of history or an historical anthropology. This theory he has promised to give us, but so far he has not done so.

THE DIALECTICAL INTELLIGIBILITY OF ENSEMBLES

However much Sartre stresses the idea that the function of his theory in the *Critique* is to brace up Marxism, to give it a foundation in terms of intelligibility, the fact remains that it can command interest as a systematic theory in its own right. Perhaps its main achievement is that it proposes a rationalization of *ensembles* which keeps a balance between supra-individual unities and mere assemblages of individuals, and that it provides a novel *dialectical nominalism*, and its conceptual vehicle of *totalization*, in respect to the social sphere. Further, in spite of its commitment to descriptive portrayal, it seems to succeed in offering an explanatory, intelligible sequence of structured *ensembles* running the whole gamut of social formations from couple and triple, through collectives, to groups and institutions of various types, including state, party (at least by implication), and class. If we compare this theory with an earlier critique of supra-individual unities of the Hegelian type, that given by Feuerbach and Marx, we find that those

thinkers opted for what now appears to be a crude "reversal" of Hegel's philosophy: social differentiation in the name of spirit had to give way to non-differentiation in the name of being, in other words to the notion of *species-life* or unstructured communism.[38] Conversely, structured social formations were to be viewed as alienated entities to be sublated in the process of history. Compared to this sweeping approach, albeit refined by Marx for certain alienated entities like the working class under capitalism, Sartre manages to accommodate social differentiations, including affirmative ones, in a foundational theory that encompasses their entirety. In view of its theoretical scope and level of reflection, Sartre's *Critique* constitutes a major proposal that ranks with Hegel's *Philosophy of Right* and surpasses Feuerbach and even Marx in its insistence on foundational rigor. This is no small matter if we consider the stature of Hegel's work as an account of social structures that achieves in a uniform theory the intelligibility of each structure as well as the intelligible concatenation of all. Of course certain important work in sociology also comes to mind in this context: we need mention only G. Simmel's sociology where couple and Third as well as a number of typical configurations occur,[39] and the recent systems-theory sociology of T. Parsons and N. Luhmann who set up reasoned accounts of systems and subsystems, with social evolution serving to connect stages of differentiation. However, it cannot be the objective of the present essay to place Sartre's *Critique* in this wider context of philosophical vs. sociological social theory; nor does Sartre seem to be positively influenced by systems-theory sociology.[40] To try to relate the *Critique* thereto would mean no more than to offer an intriguing comparison (a comparison which admittedly could throw light on the distinction of analytic and dialectical reason[41]); hence, except for a few remarks to be made later, our task here will be restricted to evaluating Sartre's work in the context of its own theoretical affiliation, which is dialectical rather than sociological.

In attempting to evaluate Sartre's theory in the *Critique*, our main concern must be with nominalistic social unities and their intelligibility, on the one hand, and their dialectical concatenation, on the other. In fact, these two areas of concern may be seen as one, that of the intelligibility of the theory, both on the level of a given *ensemble* and on that of the system comprising all *ensembles*.

Turning to *ensembles* first, we note that two considerations obtain, to wit: praxis is the "substance" of social formations; and the intelligibility of *ensembles* has to be based on a plurality of comprehending practical "centers," each comprehending all others when comprehending an *ensemble*. The former tenet, to treat social formations as practical unities, is of course a time-honored categorial insight in keeping with Aristotle's view as stated in the *Politics*[42] or with Hegel's view in the *Philosophy of Right*.[43] In these

classical theories, man *qua* practical gives rise to various types of community oriented toward the good life and culminating in an autonomous and self-sufficient state. The latter tenet, concerning the ontological status of social unities, however, has major implications for the problem of intelligibility. In line with its nominalistic bent, and at variance with the classical theories mentioned, there must "be" no supra-individual unities or totalities but only pluralities of individuals or *ensembles*. But then again, however made up of individuals, these are novel unities. Such unities, Sartre contends, permit of nominalistic intelligibility precisely because they are practical formations. To stress the practical character of *ensembles* is a way of saying that they are *totalisations en cours*[44] which have no "being" except insofar as inert components detract from their freedom.[45] The *groupe en fusion* is the pure example of the "non-being" of an *ensemble*. It is at the same time the prototypical case where nominalism can condone a merger of individuals in a higher unity: on nominalist terms, such a merger for the sake of a higher unity than the component individuals must not be allowed; but for Sartre the excuse in this case, and *pro tanto* for other cases, is that the *groupe en fusion* is fluid and so does not constitute a unity "in being," whereas structured groups have "being" to the extent that they are solidified, inert, non-fluid. Thus it is the exception from nominalism within nominalism, the *groupe en fusion*, which constitutes the centerpiece of Sartre's doctrine. In it, the nominalistic tenet is integrated with the practical one.

Rephrasing these ontological tenets in epistemological terms, we may say that the *groupe en fusion* is intelligible. Individual praxis can comprehend its merger with other praxes under conditions of threat, occasioning an identity of status or project, each praxis accepting a regulating Third who may rotate among the constituent praxes in view of their unison in a *groupe en fusion*.[46] Sartre's account of it is indeed the utmost of intelligibility that can be provided within nominalism where any dialectical unity must be describable and picturable at the level of individuals.[47]

As for the intelligibility of other *ensembles*, let us grant that praxis can comprehend other praxes in reciprocity with it, as well as alienated *ensembles* contingent upon an external Third and upon matter as the ultimate enslaving opposite. Praxis may be said to comprehend all these at least as coercions of itself, rejected and yet endured at the hands of the Third and/or of matter.

But what about groups other than the *groupe en fusion*—that is, structured groups exhibiting a particular will coercing group members in the interest of a particular totalization? Here, clearly, the unison, or practical identity, of members of a *groupe en fusion* no longer holds. Under the inspiration of nominalism—to the effect that there are no real universals

and that what the individual can comprehend must be on a par with him—
the group project *qua* different from that of all in a *groupe en fusion* must
either escape the individual or else be comprehended as a rejected coer-
cion.[48] Institutional "reason," precisely in view of its particularity, will be
unintelligible to all praxes except the ruling one—although the philosopher
may argue that repressive institutions are inevitable prior to an eventual
emancipation through successful class struggle.

Thus we are led to a further consideration: praxis-orientation and
nominalism combined can be seen to affect the very notion of intelligibility.
The fact that, under the theory, any individual praxis is an agent of com-
prehension prompts the question whether praxes are essentially
homogeneous and whether what one praxis regards as intelligible is univer-
sally intelligible; the realization that, in structured groups, there are un-
comprehending or alienated group objects subject to leading individuals,
highlights the difficulty. In addition to being universal, however, in-
telligibility must be tantamount to rationality if the theory, however in-
debted to individual praxis, is to have explanatory, transcendental, or jus-
tificatory status. Such a status is clearly aspired to by Sartre.

It would be unjust to impute to Sartre a failure to see the conflict
between a dialectical nominalism of praxes and rationality. One of his ways
of meeting the challenge is to speak of the "lights" praxis provides for
itself, or of "dialectical universals" which ensure that individual praxis will
in its comprehension concur with all others and, what is more, practice
rational comprehension, although, *qua* individual praxis, it will "sin-
gularize" these universals in its practical pursuits.[49]

This suggestion is, of course, no more than an attempt to solve the
problem by fiat, by flatly denying a significant difference between com-
prehension and reason or between individual intelligibility, universal in-
telligibility, and rationality.[50]

That Sartre means to cope with the gap between comprehension (at its
most extreme, the comprehension by individuals of individuals, as in
"Question de méthode") and rationality can be seen from his use of the
dialectic as a methodical articulation of intelligibility, undercutting the
idiom of comprehension or totalization. Although a concept of totalization
might also be assumed by Gestalt psychologists and hermeneuticists, a
strict dialectic offers a "logic" of totalizations by way of negation and dou-
ble negation. Engaging such a "logic" in support of his largely descriptive
or picturable account of *ensembles*, Sartre interprets praxis, whose defining
character is totalization, in terms of negation and double negation.[51] An
organism negates its environment and negates the otherness of its envi-
ronment, thus positing its identity with itself in a sphere of action. The
question is, of course, whether this dialectical articulation is a genuine ex-

pression of the (self-) intelligibility of individual praxis. The answer must be No, since the practical project of a particular praxis cannot be expected to conform to the notions proposed by dialectical (speculative) reason, designed as this is to reconstruct praxis and its intelligible social constructs rationally. Sartre's claim to a rational dialectic is in jeopardy: such a claim would involve dialectical universals that are more than intersubjectively shared meanings (although even these are not accounted for by Sartre); in other words, what is needed is a vantage point of reason from which to judge the comparative rationality of all manner of *ensembles*, articulated in steps of negation and double negation. However, no foundation in reason is provided to legitimate the "logic" of such dialectical articulation.

Accordingly, the negational apparatus, where it is used explicitly as in Sartre's analysis of praxis as an organism, is unaccounted for within the theory, indeed is reminiscent of Engels' superimposed dialectic which Sartre otherwise rejects, while in many later stages a negational articulation of the alleged dialectical intelligibility of *ensembles* is largely dispensed with. Quite often we fail to see a "dialectical" intelligibility of *ensembles*, left as we are with opposites which, rather than being reconstructable as negatives to be negated so as to result in novel content, are said to be "internalized" by the subject and "re-exteriorized" again. The intelligibility of *ensembles* has to be stated in the idiom of "picturing," in line with nominalism, whereas a strict dialectical articulation would have required a rational theory that can account for novel and successively more rational (that is, affirmative) content by way of dialectical synthesis.[52]

Such a theory cannot simply be a theory of praxis, either, because it has to purport a "logic" capable of reconstructing rational social content. Sartre's commitment to praxis as the vehicle of comprehension cannot stand in the absence of a foundational theory formulated in terms of theoretical reason. Thus in summary, our methodological queries, which are also criticisms, are these. Can intelligibility at the hands of praxis be related to reason? Can a strict dialectical articulation be provided? To the extent that less articulate or picturable relationships of praxis and *ensembles* can be considered "dialectical," is their character in keeping with a rational dialectic? Lastly, Can a rational dialectic be proposed by practical reason—is not theoretical reason required for foundational purposes?

The above criticisms can be given a substantive turn: Sartre's procedure of allowing for dialectical intelligibility and yet denying it a rational formulation means that, with the exception of the *groupe en fusion*, by itself an exception from nominalism, he cannot accept rational social formations, that is, formations in which the individual realizes fulfillment. If dialectical nominalism holds and if *ensembles* are conceived of as unities of particulars only, then affirmative structures cannot be theorized. Structures

exhibiting successful recognition on the part of their individual constituents are ruled out, a circumstance which shows the impact of the theoretical premises on the solution. A solution in terms of dialectical reason, rather than resting its case on the particularity of leadership or government, would provide for a recognition of the "office" of government as universal and *non*-alienating. Sartre's solution, identifying reason and particularity, can offer no normative account of universal institutions, such as the state, serving everybody; it can deal with them only in terms of particularity and, therefore, alienation.[53]

A descriptive approach, be it sociological or transcendental, will always tend to stress observable particulars; however, when turned into theory, such an approach pre-judges the issue of rational universality, in fact is bound to deny it. But universal *ensembles* need not be utopian or fallacious, as the institution of the state as an agent of universality shows. A demonstration that a state is no more than the arrogated universality of a particular group cannot be convincing if it proceeds from a theory whose very terms of reference defy an affirmative solution. Hence we conclude that on this crucial issue Sartre's theory certainly fails. Its failure can be attributed to its attachment to Marxism where, again, dialectical nominalism, although of a different vintage and with different application, holds sway and where accordingly the state as an agent of universality has no place.[54] But Marxism is an external conditioning factor, a *terminus ad quem*, incapable of proving the theory right. It is the internal defect of dialectical nominalism which is decisive and thus merits further analysis.

THE DIALECTICAL INTELLIGIBILITY OF THE THEORY

Having examined Sartre's rationalization of a given *ensemble* in terms of individual freedom and plurality, or otherness, let us now focus on the *systemic* features of the theory, that is, on those features which turn Sartre's mass of descriptions, however joined to a dialectical appraisal in the given case, into a coherent explanatory theory.[55] We have already suggested the theoretical function of *ensembles* as "stages" in an overall scheme. The various *ensembles* are ranged and interconnected by reference to certain dialectical considerations of intelligibility. In Book I of the *Critique,* praxis, the starting point and prime agent of intelligibility, becomes successively implicated in antagonistic counter-agents: another, freedom in reciprocity, scarcity as a global condition confronting, and occasioning alienation to, ever so many praxes to the point where they are seen to be subservient to a counter-finality. Intertwined with this build-up of alienation is the function of an antagonistic Third, in whose service such dependence on, and internalization of, matter occurs.

However suggestive all this may be,[56] what we must now address is the

theoretical problem of a linear progression, in Book I and again in Book II, from abstract praxis to successively more explicit, concrete, structured *ensembles*. This progression can be seen as an analogue to the Hegelian dialectic in the *Philosophy of Right* whereby the will gets implicated in opposites which serve to determine it, each opposition leading to a further stage of determinateness.[57] Hegel's progression is quite involved, but it obeys a strict pattern, repeating mediations between the subject as will and categorially alien and successively congenial opposites (matter first, persons next) until structures emerge that can count as affirmative determinations, or enrichments, of freedom.

In Book I (also in Book II, which we however lay aside for the time being), the drift of Sartre's progression is toward alienation of man, starting with person-to-person alienation which may, but need not, attend reciprocity, proceeding to rivalry under the auspices of scarcity, and leading to utter alienation of man by matter in its function as a counter-principle to praxis. Raised to a counter-principle, matter stands for person-to-person alienation, person-to-matter alienation, and the richer structure of an alienated complex vis-à-vis a Third instancing the propertied class. Sartre gradually works up to a domination of man by matter in classhood, with illustrative detail borrowed from the history of the European working class.[58] We have to ask, though, whether Sartre's drift to utter alienation, leaving emancipation as the only way out, is justified. Can we account for subjectivity or freedom in the social domain only by way of emancipation from utter misery?[59] Or is this progression a concession to a Marxian progression from bad to worse, designed as it is to make revolution appear as a necessity?

Whatever Sartre's sympathies with respect to Marx's ideas, the theory of the *Critique* has to be examined on its own terms. In a systematic theory such as this, there must be reasons other than sympathies for Marxism to explain why the drift is that of a paradoxical teleology, namely, that the affirmative can only emerge as a reversal of the worst, must be prompted by the worst. Why should we not rather expect *ensembles* expressing a mediation between praxis and matter (as hard to work, as owned by an Other, as scarce), and this in compact with Others or with catalytic Thirds so as to result in *ensembles* of agreement? Why are there no positive comments on such Hegelian configurations as Lordship and Bondage, contract, or society?

Is it enough to say that Sartre wanted to set freedom in relief by making all social freedom the result of freedom positing itself absolutely, without compromise with existing conditions, as pure self-assertion? Hegel, too, had the idea that man creates for himself a world made up of various social strata in which the recognition of man by man is constitutive of objective content. Hegel used this concept to formulate a categorical thesis to the effect that certain configurations exhibit a perfection in that they con-

front man only with what is congenial to him, in fact with himself as making up a world. To assert this, one need not contemplate a rescue operation from utter alienation, but rather a series of steps toward perfection ordered in such a way that each successive stage is more nearly perfect than the last and progressively less concerned with man's more alien, matter-like, opposites (property, objects of "formation" or work, others as particulars, etc.).[60] Sartre follows Hegel in his general architectonic. He gives us a dialectic with these stages: subject or praxis; object or matter, coincident with the inertness of man; reinstated subject on the plane of objectivity. But Sartre's "message" is very different from Hegel's; it focuses on alienation as a predominant predicament, then on emancipation, and finally, in the latter part of Book II, on the re-emergence of alienation. True social freedom is available only in the *groupe en fusion*, where everything is fluid, non-oppressive, and yet plural. The consolidation of that group, however, opens a new series of conflicts between group core and group objects. The final vista is class struggle, from which the victory over alienation must emerge.

Clearly, Sartre's theory argues for an historical (future) solution of the ultimate antagonism, thereby establishing existential import while obliging a Marxian vision. But equally clearly, whatever could emerge from this struggle historically would be subject to Sartre's systematic insights concerning the impossibility of a free and yet structured *ensemble*: there is no escaping the verdict of alienation at the hands of a particular group encompassing a totality of group objects. Even a social formation beyond all classes would be faced with considerations of survival and would therefore involve the governance of a leading group or group core. The theory is self-defeating if it seeks a way out which stands condemned by its systematic findings,[61] and it is self-defeating as a systematic theory if it needs such a way out in order for intelligibility to survive as a commitment to affirmativity. So we are left with an examination of the theory *qua* systematic.

For an explanation of its "drift," let us recall dialectical nominalism. Under its aegis, there can exist only alienated totalities and structured groups made up of particular leadership and group members in object position (due exception being made for praxis, affirmative reciprocity, and the *groupe en fusion* together with its immediate successors). Embodied or concrete universality, Hegel's conceptual vehicle for affirmative social formations, is ruled out and in its place Sartre envisions coercion on the part of a universally oppressive particular. The theory of the *Critique* deprives itself of acceptable social solutions by dint of its very theoretical foundations; its lack of ultimate affirmativity is a function of these foundations.

To forestall the charge that this is too sweeping a statement, let us investigate Sartre's dialectical nominalism more fully. His structural anthropology is concrete in the description of its various topics or stages:

praxis is meant as a concrete item of description; so is everything else from alienated *ensembles* to groups and their renewed alienation. This is a consequence of Sartre's methodological claims of structural anthropology, which is a modification of his earlier phenomenology. For purposes of the theoretical progression, however, there is a sequence running from abstraction to concreteness, the abstract stage leading to successively more concrete ones. Thus there are abstractions that are concrete for purposes of anthropological description and abstract for purposes of the explanatory scheme.[62] The question is how these two inspirations go together in dialectical nominalism.

To be truly concrete, a social formation or *ensemble* has to be taken in context, as related to other *ensembles* and as different for the fact that it is so related. Such concreteness, however, is precisely ruled out by claiming a stage as principle, as an explanation of another stage which is more concrete than its predecessor. In order to avoid a circle, such explanation must stand without reference to what has to be explained. And yet this more concrete stage, or *explanandum*, conditions the earlier stage, or the *explanans*, in concreteness.

Sartre is aware of this problem when he calls his method a *regressive* one,[63] that is, a method which retraces its steps from a select starting point to the full concreteness already impinging on that starting point to give rise to an explanation of concreteness. Such regressive progression[64] stands in contrast to the method of a *progressive* theory of history which would project future social *ensembles*,[65] a theory Sartre failed to supply.

What must concern us here is the progression Sartre invokes to move from praxis to a complete set of *ensembles* ordered and reconstructed by that progression. Praxis, an affirmative principle, finds itself confronted with otherness, with negation in view of its own particularity vis-à-vis a plurality of other praxes, and with matter as categorially other than itself. Should we not, as was hinted before, expect that practical reason will achieve a mediation in either case? To foreclose such mediation, Sartre introduces a more poignant negative, one which, for our historical epoch, cannot be lifted: scarcity. Scarcity is supposed to account for the predominance of otherness and for the impossibility of overcoming it in affirmative structures (such as contract, cooperation, economy, political institutions). In this context, we recall that the principle of scarcity is theoretically of dubious character: it is not derived dialectically from praxis or from otherness but appears as a circumstantial, empirical factor affecting our age, while, on the other hand, it expresses no more than the fact that there is a difference between the infinity of human desires and the finitude of nature.

But however that may be, this principle cannot relieve Sartre, or us, of the task of *construing* the progression from praxis to fully fledged *ensembles* dialectically. Can the progression Sartre provides be defended as the

right way of reconstructing the concrete by regressing to it from the abstract? Is the Sartrean progression intelligible? Is there a "logic" to dialectical nominalism?

Sartre's aim in his dialectical progression in Book I, and again in Book II, must be to avoid affirmative syntheses. A bad predicament must always take a turn for the worse, each time however with the prospect of an exceptional deliverance by way of emancipation (*groupe en fusion,* successful class struggle). How are affirmative syntheses avoided? On a theoretical plane, the answer is, Through the interplay of nominalistic and dialectical features. An abstract concreteness, a particular existent or a configuration of several of them, principles its successor. Reciprocity leads to collective, collective to class. The relationship is meant to be visualized or pictured as an event in reality. There is, it is true, no constant substratum underlying the progression as a whole—the same crowd of people, or consecutive generations of them, going through the various predicaments—but on any level, and between any two consecutive levels, relations can be pictured as influences plausibly imping on identical persons. Without nominalistic picturing, the dialectic would of course bid us move to dialectical redress: the oppressive opposite would call for mediation in contract, settling dissension among men with respect to matter or, on a higher plane of organization, in bargaining agreements between a trade union and employers. But according to Sartre's dialectical nominalism, this must not be: dialectical syntheses have to be avoided, particulars have to remain confronted with otherness, their own particularity vis-à-vis Others and Thirds included.

The rationale of Sartre's negative drift, then, is this. Under a combination of nominalism and dialectic, praxis as principle or abstract existent will principle its likeness, as in real life men will act in accord with what they are and want to maintain. A worker will want to continue earning a living even if this means giving in to pressures, a group leader will tighten controls when his leadership is threatened; neither can be credited with a dialectical step affording an affirmative mediation. And yet we have a dialectical semblance: on any given level of alienation, a new opposite will be claimed which occasions a further increase of alienation. So once the negative has been introduced (through otherness and scarcity), further developments, or *principiata*, will echo their negative antecedents. Nominalistically, what is negative about an antecedent is a "substantive" deficiency, an alienation perpetuating itself in further stages; dialectically, what is negative about an antecedent is its abstract nature, which invites redress by the inclusion of what it needs to become concrete and affirmative. These two ideas combined result in Sartre's progression: what in a pure dialectic is a methodical and categorial abstraction designed to principle the concrete (the way the

subject does), or to co-principle it (the way its opposite, matter or plurality, does), is in Sartre's dialectical nominalism a substantive abstraction or alienation designed to lead to ever worse ones. These more concrete stages are thus a *function of the abstraction* of antecedent stages. The theory commits a fallacy of explanation, a transcendental fallacy, namely, that of mistaking abstractions of dialectical principiation for existent determinants.[66]

Sticking to nominalism uncompromised by dialectical requirements of explanation, we cannot maintain conclusions such as Sartre reaches. An insistence on concreteness demands consideration of all manner of coexistents in the social world; abstraction from any one of them means no more than an incompleteness of the picture and cannot result in materially negative abstractions principling further negative stages. There will simply be no dimension of principle and *principiatum*. Description of the concrete takes precedence over explanation.

Sticking to the dialectic, on the other hand, we find that affirmative syntheses are here the obvious consequence. Its transitions must not be pictured as plausible actions of existent particulars; rather must they be rationalizable in a "logic"of negations and (affirmative) double negations, establishing novel categorial concepts.[67]

One might argue that even though Sartre's stages of alienation are a little drawn out, he does latch on to the affirmative eventually, so his group theory is immune to our charges. But if we look more closely, the group theory merits the same verdict. After a start with the *groupe en fusion*, consequents follow a steady drift to the negative; there must be no dialectical redress of negative stances, but a worsening continuation to the point of classhood and class struggle. We find the same theoretical situation as in Book I. The obvious solution would have been affirmatively dialectical: a movement to novel levels where alienation is overcome, first in societal arrangements and finally in a political system. Admittedly, such a solution, with its endorsement of various social levels encompassed by the state as the ultimate corrective, runs counter to Sartre's insistence on individuals as the unsurpassable categorial level.

In what has been said, we may seem to be relapsing into earlier positions without sufficient appreciation for Sartre's new proposal. Could not dialectical nominalism be that new vehicle of theory which will rid us of the dualism of dialectic and nominalism? Tempting though this suggestion may be, there seems to be no way to defend Sartre's methodological construct theoretically. It is true that Sartre wants to recreate in a foundational and systematic theory what Marx had cast in a systematic theory: the historical drama of alienation in the capitalist society. To achieve this, Sartre had to come up with theoretical means that would permit such foundational re-

creation and reconstruction. His ingenuity is to be admired; for a dialectic of particularity, located at a sufficiently foundational level, precisely affords such reconstruction. But that does not make it legitimate.

In fact, the defect of Sartre's theory, a transcendental fallacy, has its forerunner in Marx himself. In his surplus value theory, to choose a telling example, Marx can proclaim exploitation as an inescapable feature of capitalism simply by omitting the concrete condition of production—constant capital—in the computation of the surplus value rate. In abstraction, discounting constant capital, workers appear exploited since the rate of surplus value, that is, the ratio between wages and the increment accruing to the capitalist, easily reaches 100 per cent or more. From here, from exploitation as a principle of production, Marx goes on to explain constant capital as a negative consequent, that is, as a *principiatum* of exploitation, although it is a fundamental factor in production and only its nonconsideration makes surplus value negative in the first place.[68] With capital being the essence of the theory and immune to dialectical syntheses of an affirmative character, there is small wonder that its influence appears increasingly negative as it becomes more concrete in the progress of the theory. Redress by a higher stage of universality, such as the state, cannot be contemplated: the miscarriage of the economy can only lead to the notion of a state dependent on a ruling capitalist class. However, an economy under the impact of the state as an agent of universality need not exhibit the dysteleologies Marx foresaw as inevitable. Other Marxian contexts raise similar problems.

We have in Marx a transcendental fallacy not unlike that in Sartre. Consideration of what in concreteness is simultaneous with alleged antecedents—of constant capital with production, of societal and political organization with all manner of countervailing constraints—would have resulted in a very different position: dialectically, opposites to man, or praxis, would have afforded syntheses of affirmative novelty; nominalistically, such factors would simply have added to the concreteness of the picture without legitimating a "loaded" progression from better to worse. There is no excuse, in Sartre or in Marx, for ignoring societal organizations of redress, e.g., organized welfare, trade unions as countervailing forces of capital, and, ultimately, the state as a universal agent capable of adjusting the evil effects of *ensembles* which, left alone on their categorial level of particularity, may prove to be increasingly determined by adverse constraints. In both theories the compound of dialectical nominalism makes affirmative solutions impossible, but the negative view of reality and the insistence on revolution are a function of the type of theory adopted. In both theories the avoidance of affirmativity is the result of a transcendental fallacy.[69]

The subtle point of Sartre's *Critique* is, of course, that it is precisely his fallacious transcendental theory which enables him to back up Marxism. However, if Marxism is itself in doubt in view of *its* transcendental fallacy, Sartre's reconstruction of the false also falls to the ground in view of its ulterior inspiration.

SYSTEMATIC AND HISTORICAL DIALECTICS

A last point deserves mention. If nominalism in its dialectical version proposes a series of exemplary transitions in reality though not of historical continuity, it clearly suggests that explanation of systematic import can *prefigure* historical progression from oppression to emancipation of the kind envisioned by Marx. It is true that Sartre's theory in the *Critique* is systematic, that it is designed to account for the intelligibility of social formations or *ensembles*; but Sartre sees fit to fashion the explanatory sequence in such a way as to parallel a Marxian historical sequence from class-locked existence to emancipation (in the transition from inert structures to the *groupe en fusion*). Thus one might say that what Sartre tries to give is a systematic justification for revolution: social freedom rests on revolution although revolution accounts for further structures (such as institutions of all kinds) which do not historically hinge on revolution. But such further structures might derive from revolution in the future. So, in a sense, the *Critique* not only prefigures history but determines the "formal conditions of history,"[70] or "principles" it. As in a systematic sequence inertia can be overcome only by revolution, so in history inertia in class reciprocity calls for revolution. What Sartre envisages for history is the formation of a working class on an international scale and the emancipation of such a global working class, once it has achieved its unity, from the global capitalist class with respect to which it stands in antagonistic reciprocity. The move from class vis-à-vis a Third to group delineates in terms of principle the move from class vis-à-vis class to emancipation.[71]

We must not be confused by the fact that the theory of the *Critique* itself contains this confrontation of classes (as distinguished from that of class and Third) in its systematic context. As a solution to this confrontation, Sartre envisages a repetition of the drama leading from class to *groupe en fusion*, but in more concrete terms, as a drama of group-structured classes facing each other on an historical scale. The fact that his theory in Book II drifts into alienation again (the price for concreteness!) tempts him to provide for an historical upheaval to settle alienation: an Armageddon as the coping stone of the theory *qua* systematic, yet only to be envisaged in future history. The systematic theory "triggers off" its continuation and completion in history. This state of affairs affords yet another link between

the *Critique* and history—the theory entails a certain history, and the other links are suggestive prefiguration and abstract principiation of history.

However, the said transition to history can be seen to be a mistake; it is an illegitimate redress for the deficit of the theory *qua* systematic. In view of what we have noted about its self-defeating and fallacious character, the *Critique* cannot be a legitimate foundation leading over into, or "triggering off," a theory of history if not history itself. Nor can it as a whole "principle" history, since it is its very incapacity to outline affirmative structures or *ensembles* which serves as a reason for claiming a transition to history as the domain of future affirmative *ensembles*. Notions of principiation and notions of redress jar with one another.[72] Conversely, to the extent that we take the *Critique* seriously as a systematic theory that does not mean to be wrong in order to trigger its correction in history or in a theory of history, or to the extent that any future history is principled by the *Critique* as a whole, the negative message—that groups revert to inertia—governs history as well. As we have noted, the class emerging victorious from class struggle, the classless class, is subject to the systematic insights of the *Critique*: it cannot avoid developing particularity and repression. Thus even the definitive end of alienation in history is called into question again: a final historical solution militates against a cyclical movement.[73] The two inspirations—the *Critique* carrying over into history, the *Critique* principling history—are in conflict with each other and involve a paradoxical outlook.

CONCLUSION

It remains to say that Sartre's *Critique* is a major theoretical effort, an attempt to maintain explanatory or transcendental theory together with existentialist, phenomenological or nominalist concreteness. Precisely owing to this methodological compound, Sartre comes in for immanent criticism, as does Marx, albeit on somewhat different grounds. If Sartre's attempt is not acceptable, it is nonetheless highly instructive, particularly as a new variant of the dialectic and its foundational claims. It is one of the great theories of our time, and without it we might have less understanding concerning what we want to hold in matters of social theory.

KLAUS HARTMANN
PHILOSOPHISCHE FAKULTÄT
UNIVERSITÄT TÜBINGEN
GERMANY

NOTES

1. One of many possible examples is R. Bernstein's *Praxis and Action* (Philadelphia: University of Pennsylvania Press, 1971), a work which, in spite of its subject, largely ignores the *Critique de la raison dialectique I* (Paris: Gallimard, 1960, hereinafter cited as *CRD*). Raymond Aron, who will be our chief interlocutor in what follows, says that until his book was published in 1973, no serious French language study had been devoted to *CRD*. (See Aron, *Histoire et dialectique de la violence* [Paris: Gallimard, 1973], p. 186.) We may note, however, English language contributions by M. Cranston, W. Desan, G. Kline, R. D. Laing and D. G. Cooper, G. Lichtheim, W. Odajnyk, J. F. Sheridan, P. Thody, M. Warnock, and others, contributions which, to be sure, have a fair number of counterparts in German and other languages. For an extensive bibliography, see "Jean-Paul Sartre's Marxism—A Bibliographical Essay" by F. H. Lapointe and C. Lapointe, *Journal of the British Society for Phenomenology*, 5, no. 2 (May 1974): 184–92.

2. This is essentially the thesis of the author's *Sartre's Ontology* (Evanston, Ill.: Northwestern University Press, 1966; German ed., Berlin: de Gruyter, 1963). It differs from the Cartesian interpretation of most commentators. An interpretation crediting *L'Etre et le Néant* with a dialectical, and yet much more complex, scheme is available in G. Seel's *Sartres Dialektik* (Bonn: Bouvier Verlag H. Grundmann, 1971).

3. *L'Etre et le Néant* (Paris: Gallimard, 1943), pp. 486–95; English ed., *Being and Nothingness* (London: Methuen, 1957), pp. 415–23. R. Aron goes further in crediting *L'Etre et le Néant* with "non-antagonistic reciprocity" in action, though not ontologically. See Aron, *Histoire et dialectique...*, p. 191.

4. R. Aron stresses a continuity extending from *L'Etre et le Néant* to *CRD* in his *Histoire et dialectique...*, pp. 188 ff., 220 ff., 257, 263 ff.

5. *CRD*, pp. 107–11; cf. ibid., pp. 24, 59, 68 ff. Sartre considers existentialism to be part of Marxism, and once it is adopted as the foundation for Marxism the latter will fall away as an inquiry of its own. Ibid., p. 111.

6. *CRD*, pp. 33–59, esp. p. 44: "Pour saisir le processus qui produit la personne et son produit à l'intérieur d'une classe et d'une société donnée à un moment historique donné, il manque au marxisme une hierarchie de médiations." With respect to this quote from "Question de méthode," prefacing *CRD*, we have to bear in mind that here Sartre is concerned chiefly with the singularity of the person as an object of hermeneutic comprehension, while in the main body of the work his interest lies with theory and, accordingly, with generalities about singularities. For appraisals of this issue, cf. K. Hartmann, *Sartres Sozialphilosophie* (Berlin: de Gruyter, 1966), pp. 54–56, and Aron, *Histoire et dialectique...*, pp. 15 ff., 145, 151, 194 ff.

7. Sartre himself mistakes transcendental philosophy as a position imposing its alleged laws from outside. Thus he criticizes the Marxism of Engels as a "matérialisme dialectique du *dehors* ou transcendental." *CRD*, p. 124. The thesis concerning Sartre's transcendentalism in *CRD*, first voiced by the author in 1966, has lately been revived by R. Aron; see *Histoire et dialectique...*, pp. 33, 109, 111, 136. Cf., however, note 55 below.

8. *CRD*, p. 138.

9. *CRD*, p. 132. R. Aron notes a proximity of Sartre's tenet to K. R. Popper's idea of "methodological individualism," which in his view Sartre means to found ontologically. *Histoire et dialectique...*, pp. 227 ff. Popper himself speaks explicitly of "methodological nominalism" (*The Open Society and Its Enemies*, vol. I, 5th ed. [London: Routledge and Kegan Paul, 1966], p. 32), but we may wonder whether his individualism, however bound up with nominalism, is purely methodological (cf. ibid., pp. 99 ff.); it may simply be oblivious of its ontological premise.

10. The notion of "analytic reason" (*CRD*, p. 148), as well as its contrasting notion of "dialectical reason" (*CRD*, pp. 136 ff.), may be clear enough without a comment. See, however, note 41 below.

11. *CRD*, pp. 139, 149, 165 ff. The term was given modern currency by Marx. Cf. his

"Theses on Feuerbach" in *Writings of the Young Marx on Philosophy and Society*, ed. and tr. by Lloyd D. Easton and Kurt H. Guddat (New York: Doubleday, 1967; hereinafter Easton and Guddat), p. 400.

12. Marx speaks of the "practical materialist." See extracts from *The German Ideology*, in Easton and Guddat, p. 416.

13. *CRD*, p. 156.

14. *CRD*, pp. 150, 176.

15. *CRD*, pp. 105, 156.

16. Cf. *CRD*, p. 153: "Mais puisque nous partons de la *praxis* individuelle, il faudra suivre avec soin tous les fils d'Ariane qui, de cette *praxis*, nous conduiront aux diverses formes d'ensembles humains; . . . En chaque cas, il faudra montrer l'intelligibilité dialectique de ces transformations [génération des ensembles par les individus ou les uns par les autres, comment les individus sont produits par les ensembles qu'ils composent]."

17. We see no reason to avoid the term "explanation" and related terminology in the context of transcendental or speculative philosophy, although we are aware that a distinction has been made between comprehension and explanation on the grounds that "explanation" is reserved for causal factors accounting for events (cf. the pertinent studies by W. Dilthey, E. Rothacker, A. Pap, K. R. Popper and G. H. von Wright). In our sense, a genealogy of principles and *principiata* does serve purposes of explanation, that is, to tell by what vehicle we determine whether something meets the requirement of the theory—namely, in this case, the requirement to be rationally real (not, of course, to be an empirical fact). Traditionally, though not in Sartre's case, the vehicle for this demonstration is categories. For Sartre, we could speak of *quasi-categorial* accounts, in the sense that unities stand for categories and yet are tied to the exclusive reality of individuals. For a statement of the author's views, see "On Taking the Transcendental Turn," *Review of Metaphysics*, 20, no. 2 (1966): 223–49; and *Hegel: A Collection of Critical Essays*, ed. by A. MacIntyre (New York: Doubleday, 1972), pp. 101–24.

18. Sartre himself uses "principle" in contexts concerning intelligibility. Cf. *CRD*, p. 137: "Or, ces difficultés [of a dialectic of the Hegelian type, difficulties discussed by J. Hyppolite and O. Hamelin] viennent de ce qu'on envisage les 'principes' dialectiques comme de simples données ou comme des règles induites. . . . En fait, chacune de ces prétendues lois dialectiques retrouve une intelligibilité parfaite si l'on se place du point de vue de la totalisation." Better still, cf. *CRD*, p. 141: "Ainsi les universaux de la dialectique—principes et lois d'intelligibilité—sont des universaux singularisés: tout effort d'abstraction et d'universalisation n'aboutirait qu'à proposer des schèmes contamment valables pour *cette aventure*." Never mind Sartre's exaggeration of "thisness," the concrete instance, *praxis* or *totalisation*, is to serve as a universal, an existent principle of dialectical reason. Viewed nominalistically or descriptively, Sartre's account of praxis can nevertheless be likened to a portrayal of man's natural state. Cf. Aron, *Histoire et dialectique. . .*, pp. 85, 121, 241.

19. *L'Etre et le Néant*, pp. 495–503; *Being and Nothingness*, pp. 423–30.

20. The idea of scarcity itself is not specifically Marxian. Sartre points out a connection with Dühring (*CRD*, p. 221).

21. Marx' *Capital* (and, less clearly, the *Economic and Philosophic Manuscripts*) is regressive in the (non-Sartrean) sense of going back to economic principles explaining a concrete (present) economic fact (cf. the opening of *Capital*, tr. by S. Moore and E. Aveling, rev. by E. Untermann [New York: Modern Library, n.d.] p. 41; and Easton and Guddat, p. 289), without asking how alienated economic conditions came to pass in the first place, a question which Marx did ask historically in the *German Ideology*, and which Sartre poses once more in a systematic spirit. Cf. K. Hartmann, *Die Marxsche Theorie* (Berlin: de Gruyter, 1970), pp. 177 ff., 186 ff., 227, 551.

22. Cf. G. W. F. Hegel, *Philosophy of Right*, tr. with notes by T. M. Knox, corrected ed. (Oxford: Oxford, Clarendon, 1962), paragraphs 190 and 191 and additions thereto. Cf. also Aron's comments, *Histoire et dialectique. . .*, p. 250.

23. Cf. Aron, *Histoire et dialectique. . .*, pp. 48 ff.

24. *CRD*, p. 138 and passim.

25. Hegel, *Philosophy of Right*, paragraphs 41 ff.
26. Cf. K. Hartmann, *Die Marxsche Theorie*, pp. 154–59, 164–68, 454–64. The thesis is that Hegel's notion of essence is exemplary for Marx's treatment of capital. For Hegel's notion of essence, cf. his *Science of Logic*, Book II. While statements in *Capital* concerning capital as essence are elusive, Marx made his point quite clear in the *Economic and Philosophic Manuscripts*. See Karl Marx, *Early Writings*, tr. and ed. by T. B. Bottomore (New York: McGraw-Hill, 1964), pp. 147–51; and Easton and Guddat, p. 302 (on wealth as the "objective essence" of man).
27. *CRD*, p. 311. Cf. G. Gurvitch, *Dialectique et sociologie* (Paris: Flammarion, 1962), p. 165 f., and Hartmann, *Sartres Sozialphilosophie*, p. 127.
28. *CRD*, p. 357: "Une classe *tout entière active*—c'est-à-dire dont tous les membres seraient intégrés à une seule *praxis* et dont les appareils au lieu de s'opposes s'organiseraient dans l'unité—cela ne c'est réalisé qu'en certains moments très rares (et tous révolutionnaires) de l'histoire ouvrière." Cf. Hartmann, *Sartres Sozialphilosophie*, p. 128 f. Strictly speaking, the question of minority action vs. total upheaval which Sartre relativizes in the foregoing quote hinges on the degree of seriality of the collective due for emancipation. It is significant that Sartre can handle the problem with greater openness for questions of degree than can Marx, in whose dialectic the alternative cannot be resolved. For a discussion of the minority-vs.-totality problem in Marx, see Stanley Moore, *The Background of Marx: Three Tactics* (New York/London: Monthly Review Press, 1963).
29. Aristotle discusses rotation of offices from the angle that citizens should learn to govern and to be governed, clearly with a view to achieving a homogeneous social formation. Cf. *Politics*, 1277b 7–16, 1298a 14 ff., 1299a 37 ff., 1317b 1–4. In the writings of later theorists of democracy, the idea of rotation seems to give way to that of a renewal of "trust."
30. Consensus or contract would, for Sartre, be testimony to a predicament of seriality, not of joint spontaneity.
31. Aron, *Histoire et dialectique*. . . , pp. 214 ff., 222, 240 ff. and passim, comes close to this thesis.
32. Max Weber, *Wirtschaft und Gesellschaft*, vol. I (Cologne: Studienausgabe, 1964), pp. 513 ff. ("urwüchsige Statuskontrakte").
33. N. Luhmann's sociology seems to be best suited for a comparison since it advocates a pure functionalism whereas T. Parsons still accepts values and value commitments. In Luhmann, systems and subsystems are defined by their function of "reducing" complexity (see N. Luhmann, in J. Habermas and N. Luhmann, *Theorie der Gesellschaft oder Sozialtechnologie?* [Frankfurt: Suhrkamp, 1971], p. 16 and passim), a definition quite close to Sartre's view of the function of praxis vis-à-vis the practico-inert in matter as well as man. The difference is, of course, that Sartre develops groups on an ever greater scale (admittedly without a proper argument for such "evolution"), while Luhmann starts with society as the largest system and differentiates it by way of subsystems as problems arise. Cf. the author's "Systemtheoretische Soziologie und kategoriale Sozialphilosophie," in *Perspektiven*, vol. V (Frankfurt: Klostermann, 1973), pp. 130–61.
34. We may mention another difference with respect to systems-theory sociology: while this view sees several subsystems on a par (for example, political, scientific, cultural, economic), Sartre, in view of his unilinear lineage of *ensembles*, thinks of a central authority, political in character, which steps up its control as the theory proceeds.
35. *CRD*, p. 630: "Et la raison qui fait que la dictature du prolétariat n'est à aucun moment apparent . . . c'est que l'idée même en est absurde, comme compromis bâtard entre le groupe actif et souverain et la sérialité passive." The proletariat, in order to exert a dictatorship, would have to be a hyperorganism. The stronger reason to reject Marx's notion would have been its unstructuredness, for Sartre's developed groups, too, are "bastards" of grouphood and seriality.
36. *CRD*, p. 629.
37. See J. Habermas, in Habermas and Luhmann, *Theorie der Gesellschaft*. . . , pp. 101–41; and J. Habermas, *Theorie und Praxis* (Neuwied: 1963), pp. 231–57. Cf. B. Willms, *Kritik und Politik* (Frankfurt, 1973), pp. 138–50. In Habermas's cases, the polar-

ization of freedom and coercion is modeled on an antagonism between freedom or communication and technology.

38. Easton and Guddat, pp. 293–96, 301–14, esp. 303, 304, 306 f. (the translators use both "species-life" [p. 295] and "generic life" [p. 306] for Marx's term *Gattungsleben*). Cf. Hartmann, *Die Marxsche Theorie*, pp. 146–49, 170–76.

39. G. Simmel, *Soziologie* (Berlin: Dunker & Humblot, 1968), pp. 93–126.

40. Sartre does take notice of a sociologist like Kardiner and, whatever their proper classification, of Marc Bloch, Lévi-Strauss, Lewin, and Mauss. Cf. *CRD*, p. 50 f., 52 f., and passim.

41. R. Aron is of the opinion that analytic reason can cope with whatever dialectical reason considers its domain. Even Marx's *Capital* does not, except for the introduction of key concepts, owe anything to dialectical reason (Aron, *Histoire et dialectique...*, pp. 154–59, 173). However unclear the relationship between economic or sociological and dialectical theory may be in Marx, it is evident that we cannot argue for an equivalence of the two approaches to a common subject matter, or for the replaceability of dialectical theory by analytic theory; their results are as distinct as Popper is from Marx, or Lévi-Strauss or Parsons from Sartre. What connects Marx and Sartre with Popper, Lévi-Strauss, and Parsons is nominalism; but still the dialectic in Marx and Sartre makes a significant difference.

42. In Book I of Aristotle's *Politics*, social formations (family, village, city) are analyzed as to the good they afford, and Aristotle holds that it is because of what seems good that people do what they do. A social formation is thus "made" for the sake of attaining a good; in other words, it is a practical entity. This idea also emerges from statements in the *Nicomachean Ethics:* the science dealing with this field is itself practical, political, science, a study of "what is the highest of all goods that action can achieve." *Nicomachean Ethics*, tr. by H. Rackham (London: Loeb Classical Library, 1934), 1095a 15–16.

43. Hegel, *Philosophy of Right*, paragraph 4 and addition thereto.

44. *CRD*, pp. 137, 139.

45. *CRD*, p. 138.

46. In this context, we may note Sartre's term denoting the pooling of praxes in a group: he speaks of a *dialectique constituée (CRD,* p. 154), thereby indicating that individual praxes, who are credited with a constitutive or positing dialectic, a *dialectique constituante (CRD,* p. 154), reach a stage where such individual "dialectics" constitute a common one which is thus a "constituted" one. This latter dialectic applies only in the case of groups.

47. When we call something "picturable" or when we speak of "picturing," we have in mind Hegel's sense of *Vorstellung*. Cf. G. W. F. Hegel, *Enzyklopädie* 1830, secs. 3, 20, 29, 451 ff.; *The Logic of Hegel*, tr. by W. Wallace (Oxford: Oxford, Clarendon, 1892), secs. 3, 20, 29; *Hegel's Philosophy of Mind* (Oxford: Oxford, Clarendon, 1971), secs. 451 ff.

48. Modern sociology has put its finger on the problem of whether institutions are to be considered "understood" by each affected individual, or whether they transcend his comprehension. Cf., e.g., N. Luhmann, in Habermas and Luhmann, *Theorie der Gesellschaft...,* p. 83. Sartre, in view of his commitment to intelligibility, would have to opt for the former, a position not only unrealistic empirically but hard to defend theoretically if practical reason remains a particular praxis.

49. Cf. above, note 18.

50. Cf. Hartmann, *Sartres Sozialphilosophie*, pp. 62–65; Aron, *Histoire et dialectique...,* pp. 156 f., 161.

51. *CRD*, pp. 170 ff., 229–31. Cf. R. Aron, p. 155.

52. R. Aron has suggested (*Histoire et dialectique...*, pp. 198 ff.) that Sartre's dialectic is faulty since in its oppositions it features contrariety rather than contradiction. We see no need to revive the battle over the logical character of dialectical opposition, which we believe should be taken as a reconstruction of otherness (and thus contrariety) in terms of negation (and thus contradiction). (For a fuller statement, see K. Hartmann, "Hegel: A Non-Metaphysical View," in *Hegel: A Collection of Critical Essays*, ed. by A. MacIntyre, pp. 101–24, or "Zur neuesten Dialektik-Kritik," *Archiv für Geschichte der Philosophie*, 55, no. 2 [1973]: 220–42.) Whether Sartre offends on this score, that is, in the issue of dialectical

opposition, depends on whether we grant that there is a dialectical rationale behind his descriptive oppositions. Then we may, for example, rationalize an opposition of praxis and matter in much the same way as Hegel does for subjectivity and objectivity. Aron, however, contends that an opposition of series and group is not truly dialectical. But if series are recognized as *principiata* of otherness, the case could be made. What really matters is whether a nominalistic understanding of oppositions makes them merely appear as irreducible contraries, or whether it vitiates the dialectic. In the last resort, the problem is whether Sartre's dialectic in the *Critique*, in view of its nominalistic cast, has to avoid affirmative syntheses and therefore comes under Aron's criticism that its oppositions are not dialectical ones at all. We shall return to the question.

53. Once again, we recall modern systems-theory sociology. From its perspective, systems will generate subsystems in order to cope with increasing complexity. The system will delegate certain functions to the subsystem—it will prefer to be relieved of its strenuous competencies—and yet the subsystem is in fact a remote agent whose recognition by the parent system is not essential to it. Sartre's dialectical nominalism and the nominalism of sociology share a common result as to the repressive nature of "higher" systems or *ensembles*, albeit that Sartre thinks of an antagonism of subjectivity vs. inertness (plurality, matter etc.) while sociology, at least in its most recent form, prefers the idiom of system and subsystem vs. complexity. By now it will have become clear that the author favors a dialectical but non-nominalist rationalization of institutions, since this alone seems capable of accounting for non-alienating structures. Cf. *Perspektiven*, vol. V, pp. 130–61.

54. Cf. Easton and Guddat, p. 470 (from the *German Ideology*).

55. R. Aron seems to underrate the systemic aspect when he divides his account of Sartre's *ensembles pratiques* into a "descriptive typology" (*Histoire et dialectique.*.., pp. 113, 136) and a "transcendental analysis" (ibid., pp. 112, 136), although he also speaks of a "transcendental deduction of sociological concepts" (ibid., p. 112).

56. Aron speaks of a "pathetic description." Ibid., pp. 120 ff.

57. The Hegelian progression in the *Philosophy of Right* takes this form: mediation between man and matter—property; mediation of man and man vis-à-vis property—contract; redress of contraventions—punishment and re-integration of deviant man in the common subjectivity of social plurality. In the following section, on morality, the subject is shown as self-communing and thus disregarding social objectivity. This configuration is transcended in favor of types of recognition of Others—family, society, state, of which each exhibits a different degree of affirmativity. The final stage, the state, is characterized by an objectivity which, by affording each member fulfillment in a universal beyond the natural bonds of the family and the antagonistic relationships of society, is fully affirmative.

58. *CRD*, p. 153.

59. Aron speaks of a "dialectique descendante inexorable." *Histoire et dialectique.*.., p. 134.

60. It is essential that we recognize that Hegel's architectonic, his disposition of dialectical stages, can be defended in the ultimate idiom of being, negation and double negation. Its prototype, to be further developed from a "logic of being" via a "logic of essence" to a "logic of concept," is the move from being to being-for-itself in Book I of the *Science of Logic*. Cf. Hartmann, in *Hegel: A Collection of Critical Essays*, ed. by A. MacIntyre, pp. 101–24.

61. Cf. Hartmann, *Sartres Sozialphilosophie*, p. 177; and Aron, *Histoire et dialectique.*.., pp. 161, 235. We shall return to this question.

62. This theoretical situation is reflected already in Marx's methodological section of his (posthumous) Introduction (of 1857) to *Zur Kritik der politischen Ökonomie* (1859); see *Marx Engels Werke*, vol. 13 (Berlin: Dietz, 1969), pp. 631–39. For English version, see *A Contribution to the Critique of Political Economy*, tr. by N. I. Stone (Chicago: C. H. Kerr, 1904), pp. 292–305.

63. *CRD*, p. 134. Sartre's account of the regressive method in "Question de méthode" (*CRD*, pp. 60–103, esp. p. 97) differs from that of the main body of the work in that "Question de méthode" is concerned with a regression to the conditioning factors of an individual item of comprehension, while *CRD* aims at disclosing social formations on the basis of praxis.

In the former case, the point of interest is the individual phenomenon; in the latter it is social reality itself. Accordingly, but also in view of the point made in note 6 above, "Question de méthode" is not a suitable methodological prelude to *CRD*, as some authors, including G. Lichtheim, have believed. Cf. Hartmann, *Sartres Sozialphilosophie*, pp. 52–56. R. Aron thinks, mistakenly as we believe, that "Question de méthode" offers more or less the methodology of which *CRD* constitutes the foundations. See *Histoire et Dialectique*..., pp. 15 ff.

64. *CRD*, p. 156: "Et naturellement, la progression n'aura à traiter d'autres structures que celles mises au jour par l'expérience régressive."

65. *CRD*, p. 134.

66. For a fuller treatment of this fallacy, see Hartmann, *Sartres Sozialphilosophie*, pp. 187–92.

67. It may be contended that a speculative position of the Hegelian type remains objectionable because of its commitment to a linear progression of explanation, and thus to an arbitrary abstraction from concreteness to explain concreteness. Admittedly, the impact of consequents on antecedents in a concrete setting must be ignored, as in Sartre's dialectic, but in Hegel's case further stages will be corrections, affirmative or more true *principiata*, rather than corroborations of the untrue. Thus the advantage of an explanatory linear scheme is not invalidated by a fallacy, although problems arise concerning the relevance of such a theory where the very coexistence of stages—for example, the relations between society and state— is at issue. Incidentally, Hegel was aware of the problem that in the *Philosophy of Right* consequents of antecedents are co-eval with their antecedents. He justifies his procedure in *Philosophy of Right*, addition to paragraph 32, p. 233. For comments, see Hartmann, *Die Marxsche Theorie*, pp. 416, 450–52, and *Sartres Sozialphilosophie*, pp. 187–89.

68. Cf. K. Marx, *Capital*, tr. by S. Moore and E. Aveling, pp. 221–55, esp. pp. 237 ff. For a fuller treatment of this issue, see Hartmann, *Die Marxsche Theorie*, pp. 415 ff., 424 ff. Cf. also K. Hartmann, "Praxis: A Ground for Social Theory?" *Journal of the British Society for Phenomenology*, 1, no. 2 (May 1970): 57.

69. We could give our criticism another turn and say that the fallacy in Marx is to stick to capital as the *essence* immune to compromise with its opposite, labor. In such a perspective, focusing on the categorial rather than the systemic aspect of the theory, the fallacy is due to the unwarranted fixation of the category of "essence" as governing capital—unwarranted because the dialectic would have to move on to a negation of essence in favor of an affirmative universal stance.

70. *CRD*, p. 743. Cf. ibid., pp. 152–56.

71. Aron calls this historical dialectic a "cumulative" one while the systematic dialectic of *CRD* (i.e., of volume I) is called "static." *Histoire et dialectique*..., pp. 161, 235.

72. Sartre might rush to his own defense and argue that his systematic theory is historical, a systematic theory for our age which features unsuccessful *ensembles* only (with the exception of the *groupe en fusion*), in much the way as Marx would argue in order to defend his departure from a "present economic fact." The difficulty is that on this score the theory, by dialectically reconstructing such an alleged state of affairs (whose existence or non-existence is subject to empirical falsification and categorial counter-representations), prejudges not only the systematic possibility of affirmative *ensembles*, but also the possibility of *ensembles* to be brought about by a future revolution (for which it constitutes the domain of principles).

73. The fact that *CRD* suggests a final historical solution as well as an up and down of emancipation and repression leads R. Aron to distinguish a Marxist-Leninist and a "gauchiste" reading of the work. *Histoire et dialectique*..., p. 138.

27

Hazel E. Barnes
SARTRE AS MATERIALIST

I N the "Conclusion" of *Being and Nothingness* Sartre indicates briefly both the metaphysical implications and the ethical implications of the long discussion of ontology which has preceded. Critics have made much of Sartre's failure to write the promised volume on ethics, and he has explicitly stated his reasons for not doing so. Nobody, including the author himself, has followed up on his suggestions for an approach to a "metaphysics of nature." Sartre has not yet formulated a metaphysical position as such; certainly he has never raised the question in the direct, naive style of the Greek Hylozoists: What is everything made of *really?* Yet the initial problem he set for anyone wishing to attempt a metaphysics of nature is one which he answers explicitly in the *Critique of Dialectical Reason.* In *Being and Nothingness** Sartre said that the metaphysician must decide whether to retain the ancient dualism of consciousness and being or to consider the existent phenomenon as provided with two dimensions of being:

> For ontology it makes no difference whether we consider the for-itself articulated in the in-itself as a well-marked *duality* or as a disintegrated being. It is up to metaphysics to decide which will be more profitable for knowledge (p. 794).

In the *Critique*** Sartre made his decision in favor of a materialistic monism.

> The only monism which *starts with the human world* and which *situates* men in Nature is the monism of materiality. It alone is a realism (p. 248).

Setting aside the question of materialism itself, there are two things here which would be surprising to one acquainted only with the early Sartre. We

* Jean-Paul Sartre, *Being and Nothingness,* tr. by Hazel E. Barnes (New York: Washington Square Press, 1972). Page numbers hereinafter cited for *Being and Nothingness* refer to this edition.

** Jean-Paul Sartre, *Critique de la raison dialectique (précédé de Question de méthode)* (Paris: Gallimard, 1960). Page numbers hereinafter cited for the *Critique* refer to this edition. Unless otherwise indicated, all translations in this article are my own.

recall Orestes' anguished, defiant proclamation that his discovery of human freedom has made him an exile from Nature. Of course, Sartre might remind us here that one's sense of exile still presupposes that one has known one's natural origin. We remember, too, Sartre's painstaking effort in his "Introduction" to *Being and Nothingness* to demonstrate that his proposed ontology avoids idealism and realism, both of which he deems to be inevitably in error; later, in the *Critique,* he seems to take it for granted that an acceptable philosophy must, in some way, be "a realism." Obviously the later attitude does not mean that Sartre has left some middle path in order to retreat to a position which he earlier denounced. His view in the *Critique* has little in common with traditional realism (naive or otherwise); rather, he uses the word to emphasize by contrast his abhorrence of all idealist mystification. The term he prefers for his own theory of reality is "realistic materialism"; this he contrasts with the dialectical materialism of established Marxism, which he labels a disguised idealism.

> There is a materialistic idealism which is actually only a discourse on the idea of matter; its true opposite is realistic materialism, the thought of a human being *situated* in the world and acted upon by all the cosmic forces, one which speaks of the material universe as something which is revealed gradually through a *praxis in "situation"* (p. 126).

Most of his critics, including Communists as well as professional philosophers, have stressed the idealist aspects of Sartre's thought.[1] His view of consciousness as free, translucent process of negation has seemed to set man apart from the world of nature, if not in outright opposition to it. Human reality cannot be made the proper object of purely scientific study. His insistence that man's self-consciousness demands that we assign to him a special region of being, being-for-itself, appears to preclude any claim that Sartre's existentialism is simply a naturalism or that man and his achievements may be "reduced" to the manifestation of natural causation in the manner of old-fashioned materialism. To all of this I agree. Sartre's philosophy is not a restatement of any outmoded form of thought. Yet I propose the following for serious consideration:

1. Sartre's ontology, as developed in *Being and Nothingness* and anticipated as early as *The Transcendence of the Ego,* must properly be viewed as a new and unique brand of materialism.

2. It is because of the materialist nature of his ontology that Sartre was able so easily to blend his "existentialism" with his "neo-Marxism."

3. To those who might object that it is unprofitable to worry about finding an appropriate rubric for Sartre's philosophy, particularly if it means modifying the significance of the traditional term almost beyond recognition, I reply that the question involves more than academic labeling. If it is indeed correct to say that this complex analysis of the individual and of society and of the individual in society rests upon the foundation of a

materialism, then there are two important consequences. On the positive side, I think we must grant that Sartre has tried to provide for the social theory of Marxism the kind of philosophical foundation which he, at least, has believed to be lacking in the writing of Marx and his followers. But there also arise certain problems. In the *Critique* Sartre is interested primarily in the social conflicts arising among groups in the milieu of scarcity; consequently, he does not address himself directly to the implications of materialism assumed as a metaphysical position. Still, if one adopts a materialist position, there are definite questions about matter and man's relation to it which cry out for an answer. Personally, I believe that Sartre could respond to these without revealing serious inconsistencies and inadequacies in his philosophy. But unless he does reply, some persons might well say that his own reproach of the Marxists might be turned back against him: that he assumes a materialism without providing a metaphysical position to support it.

Let us now address ourselves to these three considerations.

Sartre's Ontology as a Neo-Materialism

We must admit at the outset that many passages in *Being and Nothingness* have an idealist tinge. It is consciousness which differentiates and gives significance to an otherwise meaningless being-in-itself. Such phenomena as emergence and destruction exist solely for a consciousness. That glittering entity in the sky is a quarter moon only if a consciousness establishes that something of the entity is lacking. Obstacles are the ingredients out of which a freedom makes itself. Values are created, not discovered. The phenomenal world is revealed solely to particular consciousnesses. And so on indefinitely. But this is, of course, to look at only half the data. "Consciousness is born *supported by* a being which is not itself" (p. 23). Consciousness does not create its material objects; it cannot exist apart from the outside world of matter. Simone de Beauvoir perceived and stated the essential point very clearly: "Sartre's originality lies in the fact that, while allotting a glorious independence to consciousness, he bestowed upon reality its full weight; reality gave itself to knowledge in a perfect translucency but also in the irreducible density of its being."[2] Consciousness is inseparable from matter. Or better, consciousness stands in a dialectical relation with matter.

As early as 1937, in *The Transcendence of the Ego*,* Sartre had rejected the idealist tendencies of the later Husserl and insisted on viewing the human person firmly situated in the world. The "Conclusion" of that

* Jean-Paul Sartre, *The Transcendence of the Ego,* tr. by Forrest Williams and Robert Kirkpatrick (New York: Noonday Press, 1957). Page numbers hereinafter cited for *The Transcendence of the Ego* refer to this edition.

essay contains an especially significant statement: "It has always seemed to me that a working hypothesis as fruitful as historical materialism never needed for a foundation the absurdity which is metaphysical materialism. In fact, it is not necessary that the object precede the subject for spiritual pseudo-values to vanish and for ethics to find its bases in reality" (p. 105).[3]

What is required, according to Sartre, is that the Ego and the world should be "contemporaneous." Instead of positing a personal I-subject confronting a world external to it, Sartre rejects the subject-object duality as "purely logical" and puts both on the side of being-in-itself.

> The World has not created the me; the me has not created the World. These are two objects for absolute impersonal consciousness, and it is by virtue of this consciousness that they are connected (pp. 105-6).

It would be easy for anyone to accept the idea that the biographical, contemplated self is an object inextricably associated with the world of its experiences. Sartre, of course, goes much farther than this. The I is only "an infinite contraction of the material me" (p. 54). It is not part of the structure of consciousness. The Ego, including both the I and the me, is "the ideal and indirect (noematic) unity of the infinite series of our reflected consciousnesses" (p. 60). The personal Self is the ordered unity of our remembered past experiences and the projected ideal unity of those to come. It belongs to the realm of the psychic, the mental material of our conscious life, resulting from, not determining, the activity of consciousness. Years earlier, when he was still a student, Sartre had evolved a notion of consciousness as an "emptiness in being."[4] In the 1937 essay he indicates clearly that the being of consciousness is dependent on its objects. Consciousness is outside in the world. A fuller development of his view of the inextricability of consciousness and matter is found primarily in *Being and Nothingness,* but two other relevant and significant passages appear in *The Transcendence of the Ego.*

First, Sartre says that if we were to seek an analogue for non-reflective consciousness, an analogue which would correspond to what the ego is for reflective consciousness,

> it would be necessary to think of the *World,* conceived as the synthetic totality of all things. Sometimes we do, in fact, apprehend the World beyond our immediate surroundings as a vast concrete existence. In this case, the things which surround us appear only as the extreme point of this World which surpasses them and envelops them. The ego is to psychical objects what the world is to things (pp. 74-75).

Consciousness exists only as a process of intending objects. Here Sartre seems to say that the ideal unity of consciousness is the material world itself, the same world which is ordered by consciousness, which exists as "a World" (rather than as non-signifying being-in-itself) only when revealed

to consciousness. The *being* of consciousness is derived—even borrowed—from its objects; that is, from the in-itself.

The second passage occurs when Sartre speaks of the empty "I-concept" which appears as we attempt to refer to non-reflective activities. Sartre uses the example of a person gathering wood for a fire. "These actions are qualities of the world and not unities of consciousness." The body represents an "illusory fulfillment" of the I-concept. "I say: 'I' break the wood and I see and feel the object, 'body' engaged in breaking the wood" (p. 90). Sartre places the body (unlike the ego) on the non-reflective level and "in the domain of the psycho-physical."

Turning now to *Being and Nothingness,* I should like to consider first the relation of consciousness and the body, since this question is absolutely crucial to any discussion of materialism. At the outset Sartre rejects any suspicion of duality. We are not to think of a spiritual being-for-itself residing in or even combined with a physical in-itself. "Being-for-itself must be wholly body and it must be wholly consciousness; it cannot be *united* with a body" (p. 404). This statement introduces the section called "The Body as Being-for-Itself: Facticity." It would be accurate to say that the body *is* the facticity of the for-itself. Sartre writes, "To be conscious is always to be conscious of the world, and the world and body are always present to my consciousness, although in different ways" (pp. 439–40). And again, "To say that I have entered into the world, 'come to the world,' or that there is a world, or that I have a body is one and the same thing" (p. 419). Moreover, it is the body which individualizes, for it is the body which allows me to be situated in the world, which makes possible the distinction between dream and reality.

Of course, nobody would deny that consciousness is embodied. Is this the same as to say that consciousness *is* body? In an arresting statement Sartre declares: "The body is what this consciousness *is;* it is not even anything except body. The rest is nothingness and silence" (p. 434). These two sentences, to my mind, simultaneously proclaim Sartre's materialism and remove it from all psycho-physical reductionism. Let us look at them one at a time.

Just how can Sartre say that consciousness *is* body? First of all, we may describe consciousness as an activity of a body. As a process of intending objects, consciousness is neither its objects nor the sense organs, any more than digestion is to be identified with the digestive organs or with food. Yet it is nothing without the organs and the objects. Second, the body is the focus of reference which locates or situates consciousness in the world:

> My body is coextensive with the world, spread across all things, and at the same time it is condensed into this single point which all things indicate and which I am, without being able to know it (p. 420).

Embodied consciousness is the point of view on which consciousness cannot take a point of view. The body is the master instrument for all other instruments. Yet "we do not use this instrument, for we *are* it" (p. 427). On this ontological level, the body is lived, not known. The body is a permanent structure of my being, the necessity of my contingency. It is, in short, my facticity, my being-in-the-world.

In these and other comparable assertions, Sartre underscores the impossibility of even a logical separation of consciousness and the material body. The for-itself *is* embodied consciousness; it *is* conscious body. I "exist my body." And since consciousness can exist its body only as consciousness, Sartre can even say, "My body is a conscious structure of my consciousness" (p. 434).

At the same time, the body is being-in-itself and not only when it is viewed as an object by a consciousness (another's consciousness or my own as when, for example, I examine a cut finger). The truth is that I both am and am not my body. "I *am* my body to the extent that I *am;* I *am not* my body to the extent that I am not what I am" (p. 430). Here we are at the roots of Sartre's ontology. The for-itself exists as the nihilation of the in-itself: "To have a body is to be the foundation of one's own nothingness and not to be the foundation of one's being" (p. 430). To be a for-itself and to have a body are defined in identical terms. We know that the in-itself has ontological priority over the for-itself. In another definition of the for-itself, Sartre says,

> The for-itself is the in-itself losing itself as in-itself in order to found itself as consciousness. Thus consciousness holds within itself its own being-as-consciousness, and since it is its own nihilation, it can refer only to itself; but *that which* is nihilated in consciousness—though we cannot call it the foundation of consciousness—is the contingent in-itself (p. 130).

Elsewhere Sartre reminds us that only Being can nihilate itself, "In order to nihilate itself, it must be" (p. 57). By virtue of the body the for-itself *is*. Just as we cannot say that the for-itself *has* a body, so we cannot say that the body is an in-itself which is *in* the for-itself. Sartre says that "we could define the body as *the contingent form which is assumed by the necessity of my contingency*" (p. 408). The body is the particular contingency of a particular for-itself.

Sartre says that the body is that which is surpassed or passed over: it is "the neglected," in the sense in which we may say that a painted sign is passed over or neglected in favor of its meaning. The body is also "the past," and Sartre tells us that the past is the same as facticity. I think it is here that we can best understand Sartre's view of the inextricability of consciousness and the material. The for-itself, we are told, is never without a past. To be for-itself is to be already born. That is, as soon as there is

consciousness, there is awareness of not-being the in-itself. Simultaneously with that mysterious event by which the in-itself is lost as in-itself and the for-itself has appeared as the nihilation of the in-itself, we confront the absolutely new and the sense of the past.

> The for-itself, which can in no case be reduced to this being, represents an absolute newness in relation to it, but the for-itself feels a profound solidarity of being with it and indicates this by the word *before*. The in-itself is what the for-itself was *before* (p. 198).

The *being* of the for-itself is indeed the being of the conscious body. That is why the being (of) my body is included as part of the structure of any intentional act. Thus body awareness is always present in pre-reflective consciousness even when the body is not the focused object of intention.

Is the body identical with that self (*le soi*) which Sartre claims exists in all non-positional self-consciousness (*la conscience [de] soi*), which is always present when there is consciousness? The question is not easy to answer, and I should like to have Sartre's response. It seems to me that the body is not quite an integral part of the *soi,* but rather its inevitable companion. Just as Sartre says of the past that I am it in the mode of not-being it, that I drag my past behind me—like the mermaid with her tail (p. 208)—so with the body. As the implied reference point of all intention, it is transcended by consciousness—like all being-in-itself. The body comes close to being the ground of all intentional focusing. When consciousness is aware of not being its posited object, there is a psychic separation or nothingness between the object and it. This "it" is not the body *per se,* nor is it some entity called consciousness but rather the very activity of being aware. We can now see why Sartre says that consciousness *is* body and that the rest is "nothingness and silence." The body is the in-itself of which a consciousness is the nihilation, thus rendering it no longer in-itself. The body stands as the ever possible reapprehension of the for-itself by the in-itself. When this is accomplished, we call it death.

At the same time, we see how far removed Sartre's materialism is from naturalistic psycho-physical reductionism. Since consciousness is *not* body (by virtue of the nihilation), it cannot be explained and determined by biological laws, nor is it subject to any reductionist psychologism. The free upsurge of the for-itself gives rise to a new being, which is its own law.

In the light of these remarks, let us look again at two of the most important and all-pervasive ideas in *Being and Nothingness*. First, we recall that freedom is always in situation. In fact, freedom and the situation are but two sides of the same coin. Neither can exist without the other. This is because freedom *is* the internalization of the circumstances in which the embodied consciousness finds itself. Freedom is the choice to live objective opportunities in one way rather than in an infinity of other possible ways.

To say this is almost identical with saying that consciousness is a free process of intending objects in the world. Consciousness establishes itself as a point of view on these objects, posits them in relation to one another, always on the ground of their relation to the conscious body as point of reference. Second, there is Sartre's insistence that the experimenter is always within the experimental system. Often this is given an idealist interpretation, as though the experimenter cannot get out of the experimental system because consciousness cannot get outside itself. It is true that the experimental system depends on a consciousness which has made it what it is. But if consciousness were in no way linked to a body and to the experiences associated with this body, there would be no reason why it could not survey from above in total detachment. Just as the experimental system depends on a particular consciousness, so the organizing consciousness is *in* the system which it has organized. The world emerges as the result of the upsurge of consciousness in being, but consciousness arises simultaneously with the world. Consciousness is *in-the-world.*

By the end of *Being and Nothingness* it is clear that human reality cannot be adequately understood by analytic, scientific reason. Sartre's very definitions of man—as the being who is not what he is (the past) and is what he is not (the future)—and of consciousness—as both being and not being its body—point to the need for some other method of understanding. Already we sense that a dialectic is required. To put it another way, Sartre's description of man-in-the-world is already dialectical. First, there are the obvious contradictions to be surmounted. Consciousness is not its objects, but it does not exist except as it intends objects. The being of consciousness is body; but the body is also in-itself, and consciousness puts its being into question. Possibilities and potentialities are objective qualities, out there in the world, but they exist only for a consciousness. Being-in-itself is prior ontologically to the for-itself, but the for-itself reveals being and bestows all form and meaning on the in-itself. Second, the only way to surmount these contradictions is by a totalizing synthesis. Third, the consciousness which synthesizes is itself situated. Fourth, the only way to understand human consciousness is in terms of its projects. To comprehend the being of man is to look at him in terms of his constant movement toward the future. Sartre argues that my present actions are determined by the particular future which I project. This pull of the future represents a finality which is literally "causality reversed—that is, the efficacy of the future state" (pp. 181–182). We are not speaking the language of idealism. Consciousness must be understood as the process of a continued nihilation of being-in-itself which simultaneously entails all three temporal dimensions.

Contradictions, synthesis, situated totalization, comprehension based upon finality. What is dialectical reason if it is not a form of understanding which seeks to surmount existing contradictions in a totalizing synthesis, where the totalizer is himself situated, a comprehension which involves both purposiveness and the drawing power of the future? Could we say, then, that the only method appropriate for understanding human reality is a dialectical materialism? We might be tempted to do so if the term had never been used before. But did not Sartre explicitly attack and reject dialectical materialism—and perhaps even all materialism—in a two-part article which appeared in 1946?

SARTRE AND DIALECTICAL MATERIALISM

Sartre's 1946 two-part article, "Materialism and Revolution,"* has often been taken to be a total rejection of all materialism and a great source of embarrassment to the later neo-Marxist Sartre. Actually, it is neither. It is an attack on the philosophical inadequacy of dialectical materialism specifically, and it is Sartre's first attempt to demonstrate that his own view of human freedom is not only commensurate with Marx's dream of permanent revolution but also its necessary accompaniment. For my present purpose, we may note two major points of interest in the article.

First, the specific arguments which Sartre then opposed to Marxist materialism have never been retracted; indeed, Sartre repeats and elaborates on the most essential of them in the *Critique*.[5] He claimed in 1946 that the Marxists implicitly offer a metaphysics when they reduce mind to matter and make of man, the world, and all its contents a system of objects linked by universal relationships. Yet they deny that their theory rests upon metaphysical principles and reject all metaphysics as idealist mystification. Instead, they lay claim to a truth based on the observation of nature as it really is. Sartre quoted Marx: "The materialist conception of the world means simply the conception of nature as it is, with no extraneous addition" (p. 141).[6] Sartre stressed once again that we must remember that the experimenter is always a part of the experimental system. The materialist first denies all subjectivity by establishing the human individual as merely an object in nature on the same level as any other object that constitutes the subject matter of science. But then "he makes of himself an *objective observation* and claims to contemplate nature as it is absolutely." This logi-

* The page numbers hereinafter cited for this work refer to Jean-Paul Sartre, "Matérialisme et révolution," *Situations,* III (Paris: Gallimard, 1949). This article was first published in *Les Temps Modernes,* 1, nos. 9 and 10 (June–July 1946).

cal inconsistency turns materialism into an irrationalism. Sartre went on to claim that the validity of Lenin's view of the relation between consciousness and being must ultimately rest on idealist criteria. Lenin said of consciousness, "It is only the reflection of being, under the best of circumstances an approximately exact reflection" (p. 143). Once again, if Lenin or anyone else is to determine that it is materialism which provides "the best of circumstances," he will have to be simultaneously outside and inside. Or, since this is not possible, the sole criteria he can apply in order to test "the reflection's validity" are subjective: "its conformity with other reflections, its clarity, its distinctness, its permanence." Sartre himself has at least avoided this mistake. He insisted that in the establishing of the dialectic, the process is itself dialectical. The totalizer is part of the totalizing process; he effects the totalization from a particular position and becomes immediately thereafter a detotalized totality. There is no vantage point from which any thinker may constitute a totality otherwise.

Sartre's most serious objection to dialectical materialism is summed up still more effectively in the *Critique*. There, he says of Engels:

> He killed dialectic twice in order to be sure of its death, the first time by claiming to discover it in Nature, the second time by suppressing it in society. The result is the same for these two attempts: it amounts to the same thing to declare that dialectic is discovered in physico-chemical sequences or to proclaim oneself a dialectician by reducing human relations to the functional relation of quantitative variables (p. 670).

In the first section of the *Critique* Sartre declares, "The dialectic of Nature is Nature without men" (pp. 123–24). Latter-day Marxists have evolved a dialectic without men. But matter does not oppress; it is man who is pitiless, not things (p. 699). In "Materialism and Revolution" Sartre argued that no objective state of the world can by itself evoke a revolution. It is men who must question it and decide to act. Unlike natural processes, human actions are future-oriented, motivated by the drawing power of an envisioned state which does not yet exist.

Despite his rejection of materialism, Sartre, in the early essay, dwelt almost wistfully on the appeal of materialism as a myth. He criticized the Marxists for at times treating materialism as a faith, almost as a "life style." He accused them of surreptitiously adopting a pragmatic criterion of truth, of accepting materialism because it is "the best instrument of action," because it has worked. The myth satisfies certain psychological needs. Sartre noted that historically, since the time of Epicurus, materialism has always been the doctrine of those who want to liberate man on this earth. Materialism is indisputably the *only myth* that satisfies revolutionary requirements" (p. 175). If we look closely at Sartre's analysis of this "myth,"

I think we will see that its essentially positive aspects are picked up by his own philosophy as developed in the *Critique*. What is false in the myth is the fact that in its attempt to account for our ability to transcend the present toward a future state, it ascribes "freedom to things, not to man—which is absurd." But Sartre says that it is natural that in the mind of the slave or worker the idea of liberation should be linked with determinism. "It is the determinism of matter which offers to him the first image of his freedom" (p. 199). This is because the worker through his action upon matter gains a certain sovereignty over objects and at the same time a sense of autonomous expertise over which his master has no control. The slave feels that his master has made him into his property, a thing. But if master and slave are equally determined, then they are equally a part of nature. The master no longer possesses any sacred rights over the slave. Neither the one nor the other is the end or the means for purposes beyond this purely human order of things. It is through action amidst the material things of the world that the slave or worker realizes his power and his freedom. "In fact there is no opposition," Sartre claims, "between these two necessities of action, namely that the agent be free and that the world in which he acts be determined" (p. 208). Where materialism goes wrong is in reducing man to the status of the very objects he has learned to master. Materialism "gives the revolutionary more than he asks. For the revolutionary does not demand to be a thing, but to control things" (p. 203).

In the *Critique* Sartre continues to reject any view that sees man as a puppet for either a god or a natural process. "Every philosophy which subordinates the human to Other than man, whether it be an existentialist idealism or a Marxist idealism, has for its foundation and for its consequence the hatred of man" (p. 248). He himself is careful neither to submerge man in a world in which he is indistinguishable from other existents nor to make him a wholly non-material being of whom we can no longer truly say that he is *in the world*. Sartre holds that his own philosophy, unlike either Hegelianism or Marxism, gives due weight both to consciousness and to matter. In working out the intimate relation between the two, the *Critique* makes explicit much which hitherto had been only implied. His position is summed up in the passage from which I have already quoted:

> The only monism which *starts with the human world* and which *situates* men in Nature is the monism of materiality. It alone is a realism; it alone resists the *purely theological* temptation to contemplate Nature "with no extraneous addition"; it alone makes of man neither a molecular dispersion nor a being apart; it alone defines him *first of all* by his *praxis* in the general environment of animal life; it alone is able to encompass those two equally true and contradictory assertions: in the universe, every existence is material, in the world of man everything is human (p. 248).

One is reminded of Sartre's statement, in "Materialism and Revolution," that we may easily conceive of the world of nature as completely determined and of the human individual as radically free. In 1946 Sartre was content to let the paradox stand. Fifteen years later, in the *Critique*, he shows how the contradictions are synthesized. It should not surprise us to find that Sartre now finds at the heart of all experience a "dialectical circularity" based on the mutual mediation of man and matter (p. 165). He argues that we could not understand this aspect of reality if the human individual were not already a dialectical being. The dialectical movement is the result of contradictions in the status of two kinds of material beings. Sartre makes it very clear that the dialectic is not inscribed in things a priori.

Pure matter, he observes, exists for us solely as an abstraction (p. 247). A god or a pebble might be imagined to encounter pure matter. But God does not exist, and strictly speaking, the pebble does not "encounter" anything. On the subject of whether there may be a dialectic in Nature, Sartre is surprisingly uncertain. He is emphatic in denying that the dialectic which we observe in social history is to be in any way related to the possible existence of a dialectical process in Nature; this is his great quarrel with Engels. Nature, as being-in-itself, is incapable of what we call dialectical operations. "Of course matter passes from one state to another. This means that there is change. But a material change is neither affirmation nor negation" (p. 169). It is humans who effect transformations of energy into negations by indicating the direction of the process. At the same time Sartre allows that there might possibly be something like dialectical connections in Nature existing independently of our knowledge of them. We simply do not at present have enough information to judge, and the Dialectical Reason which he proposes for interpreting human reality cannot afford to replace what we know to be a truth of human relations by a science fiction concerning what is external to us and unknown. Our dialectic is a human achievement. Dialectical Reason establishes the history and principles of human actions and social relations. Nevertheless, the human individual must not be thought of as wholly separated from matter, not even ontologically. Admitting that there is nothing to preclude the possibility of our some day discovering a dialectical process in Nature which we should then include in a further development of historical dialectic, Sartre makes a firm assertion: "We shall accept the idea that man is one material being among others and that as such he does not enjoy any privileged status" (p. 129).

It is in his discussion of *need* that Sartre best explains how man is "neither a molecular dispersion nor a being apart." *Need* is defined as "the

first totalizing relation between that material being, a man, and the material group to which he belongs." Through the need of nourishment and of air, of something from outside to preserve its existence, the human organism experiences itself as a lack.

> The primitive negation is, in fact, a first contradiction between the organic and the inorganic in this twofold sense—that the lack is defined *for a totality*, but that a *lacuna, a negativity,* has as such a mechanical type of existence and that, in the final analysis, *what is lacking* can be reduced to unorganized or less organized elements, or, quite simply, to dead flesh, etc. (p. 166).

The organism finds itself in danger of death within the environing material universe. "Matter revealed as a passive totality by an organic being which tries there to find its being—this is Nature in its first form" (p. 167). Sartre points out the basic contradiction which provides the dialectical genesis: the very being of the organism depends on unorganized being and the inorganic (for oxygen and for food, etc.), and through this dependence it "imposes a biological status upon the inorganic." Sartre adds that in fact we are dealing with the imposition of different status on *the same materiality*. For

> everything leads us to believe[7] that living bodies and inanimate objects are composed of the same molecules. But their status is mutually contradictory, since the first supposes an interior bond between the whole as a unity and the molecular connections, whereas the second is a status of pure exteriority (pp. 166–67).

Sartre goes on to describe for the first time an interaction which in a later passage he calls a "transubstantiation." Within the body a biological status is superimposed upon the physico-chemical. Consequently Nature itself, by virtue of the needs of the organism, takes on the appearance of a "false organism." But if we may say that to some degree the inorganic has taken on the dimension of the organic, there has been also a movement in the reverse direction. When this absorption of external matter by the living body is looked at—as it rightly may be—from the exterior point of view, the entire process may be seen to satisfy "external laws." "In this sense one could say that matter outside of [the organism] reduces it to the inorganic status to the exact degree that the organism transforms matter into a totality" (p. 167). In order to modify the material environment, the organism must itself in some way be or become matter. For it is only as a mechanical system that such interaction can take place.

At this primitive level, we are speaking only of animal existence. Sartre claims that this same pattern of "transubstantiation" is perpetually repeated at increasing levels of complexity.

> Nothing happens to men and to objects except in their material being and by

means of the materiality of Being. But man is precisely that material reality by which matter receives its human functions (p. 249).

In each one of his actions man carves out his being in the world. Machines and tools are thought written in matter. In labor man makes himself into inorganic materiality in order that, by acting upon matter, he may change his material life. "By transubstantiation, the project, which, by means of our body, is inscribed in the thing, takes on the substantial characteristics of that thing without entirely losing its own original qualities" (p. 246). And since every human project is a self-projection into the future, we may even say, "The future comes to man through things to the degree that it has come to things through man" (p. 246).

In *Being and Nothingness* Sartre claimed that it is consciousness which introduces meaning into being. He does not take this back in the *Critique*, but he adds a new dimension. He writes: "It is not understanding which fixes meanings; it is Being" (p. 249). "Matter alone sets meanings. It retains them in itself like inscriptions and gives to them their true efficacy" (p. 245). I think that by these statements Sartre means at least two things. First, meanings arise amidst things in the same way that (as he pointed out in *Being and Nothingness*) potentialities are *in* external objects even though revealed only to and by consciousness. Second, it is solely through material expressions that meanings are conveyed from one person to another. "They become Being" (p. 246). In this way Sartre maintains that we can simultaneously assert the truth of the opposing claims of Durkheim and Weber. Durkheim directed, "Treat social facts as things"; to which Weber responded, "Social facts are not things." But "social facts are things to the degree that *all things*, directly or indirectly, are social facts." Materialized human praxis, by being made into a thing, is infinitely richer and more complex than the intention of the original agent. As such it both unites men and separates them. The social object achieves its being by an interchange. "Man and his product exchange, in the very act of production, their qualities and their status" (p. 252). Material objects become humanized exactly insofar as persons become dehumanized, which common parlance recognizes when referring to "the factory." Matter that has been subjected to human praxis, worked-on matter, as Sartre calls it (*matière ouvrée* or *travaillée*), carries these contradictions within itself and as such "becomes *for* and *through* men the fundamental moving force (*moteur*) of History."

> It is simultaneously the social memory of a collectivity, its transcendent, yet internal unity, the made totality of all dispersed activities, the fixed threat of the future, the synthetic relation of otherness which unites all living persons (p. 250).

Even without the intervention of any other human praxis, a person may find his project deviated, may encounter a "counter-finality." One of Sartre's examples is the activity of peasants who clear a mountainside of trees with the intention of creating more cultivable land, and thereby cause floods and soil erosion which lessen the arable territory. At times Sartre seems almost to evoke the ancient dualism, to pit consciousness against matter. For the very reason that it does fix and conserve meanings, he says, "the materiality of the thing or of the institution is the radical negation of invention or of creation" (p. 249). Of course, this negation has come about through the action of the human being, who "denies himself by means of matter." Sartre sums up the contradictory nature of our relation with matter in an overpowering sentence: "At every moment we experience material reality as a threat against our life, as resistance to our work, as a limit to our knowledge, and as an already revealed or possible instrumentality" (p. 247).

At this point I think it is pertinent to recall from *Being and Nothingness* Sartre's discussion of the nausea, the taste of my facticity which reveals to me the inextricability of my consciousness and finite bodily existence in the world. Consciousness *is* a relation to the world and to its body. But as a relation, while it is nothing without or in addition to the in-itself, it *is not* the in-itself. The very existence of consciousness involves a contradiction, one which is revealed in the experience, simultaneously, of my freedom and my anguish.

The contradictory and dialectical relation of praxis and matter is abundantly demonstrated in Sartre's analysis of the formation and disintegration of the group-in-fusion. "A man is a practical organism living with a plurality of his counterparts in a field of scarcity" (p. 688). From the beginning the individual is both united and separated from others because he must find physical sustenance in the same territory, and because within this area there is not enough for everybody. Thus each one realizes that he is expendable and discovers within himself the dimension of the inhuman— he, like every other person, is a threat of death to the other. The *Critique* provides, one might say, a sociological basis for the view that the origin of human relations is conflict, just as *Being and Nothingness* described the ontological and psychological dimensions. Over and over Sartre reminds us that it is not matter which is pitiless, but man. If our society has become the product of its product, this is because men and women have chosen to enslave and dominate over other human beings *by means of worked-on matter,* in a field of scarcity which at first was simply there but which has from the beginning of history been organized and to some extent deliberately perpetuated. It is because man as a material being is dependent upon

matter that he is both the subject and the object of human exploitation. He could not be reified, forced into the status of a thing if he were not in some way a material object at the start. In seriality, in collectives, we find molecular relations which are supported by worked-on matter, which are themselves material. Most significantly, the emergence of the group-in-fusion comes about when individual praxis becomes one with the group project. The "We" is not a hyperorganism; there is no group-consciousness. The group is unified by common action in the external material world. Its unity comes from the outside. In a footnote on the ethical consequences of his analysis, Sartre comments on praxis in its free development as being the only ethical relation of man with man insofar as they together overcome matter (p. 302). If in one sense the group-in-fusion represents man's liberation from matter, it is equally true that only in and through matter is the liberation effected in the present and (at least in men's hopes) ensured for the future.

The root of failure for the group is the simple fact that it is not, and cannot be, an organism. Hence the oath and all the other imposed structure designed to provide the kind of permanence which belongs to material beings which—to employ the terminology of *Being and Nothingness*—are what they are and cannot be thrown into question. Sartre describes the disintegration of the group as coming about not as the result of willed and deliberate action, but as the slow encroachment of matter, which transforms and reifies the structures inscribed by a free praxis. The abundance of detail becomes overwhelming. There is the sheer inert weight of time and space. The order given, the order received, the order executed are not the same, both because of the hands through which they have passed and because of the altered state of the world. There is a world of difference between a structure created and a structure into which one has been born. Differentiation of function in organized programs is significantly distinct from the varied activities taken up by the collection of Thirds in the heat of battle. Most of the particularizing characteristics of the individuals who effect the group-in-fusion are put out of play at the time of the first common praxis; these characteristics will bring all their weight to bear as the group continues in time. The newly formed group shows traces of the series which preceded it; it is branded as if with a birthmark (pp. 643 ff.). The institution into which the group will degenerate will continue to display some of the structures of its earlier free praxis—like a scar (p. 748).

Throughout the *Critique* Sartre is always careful to distinguish between objectification and reification. Objectification is not *per se* alienation. Only insofar as my acts effect a modification in the world around me can I come to know myself. The world in which I "inscribe my being" returns to me my

own image. In my relations with the Other, it is true that he knows me as an object and that I can never fully grasp my self-for-the-Other. But even this is not alienation unless, with my own connivance, the Other so completely identifies me with my objectness that my status is not different from that of a *thing*. Instead of my acting as a freedom in-a-situation, my situation is reified. Total reification occurs when human praxis has so structured the physical and cultural milieu that now exploiters and exploited alike can find no scope for free praxis but can only live their being in accord with the demands of the system.

The great metaphor with which the *Critique* comes to a close—the chess game—brilliantly illustrates Sartre's distinction between objectification and reification as well as the relation between consciousness and matter. At any stage in the game, the chessmen positioned on the board represent materialized praxis. The past is inscribed in the arrangement of the pieces. But this is not all. Each player sees in the arrangement a patterned future in which every anticipated move of his will elicit a predicted, more or less inevitable move by his opponent, and so it will go until the game is ended. If the skill of the players is roughly equal, anyone watching will witness the game as an antagonistic reciprocity in a structured field. But if one player is much less skilled than the other, the observer may well view the action as one which is structured and determined by a single player. With this example in mind, Sartre pleads the need for dialectical comprehension in order that true reciprocity (not necessarily hostile) may replace the exploitation of reified subhuman groups and the dehumanization of mankind.

Sartre and the Metaphysics of Nature

I should like to examine four striking summary statements by Sartre—each of them half metaphorical, yet obviously intended to convey a literal meaning as well.

1. "Man *loses himself as man* in order that God may be born" (*Being and Nothingness*, p. 784).

2. "[Man] *loses himself* in order that *the human thing* may exist" (*Critique*, p. 238).

3. "The for-itself is the in-itself losing itself as in-itself in order to found itself as consciousness" (*Being and Nothingness*, p. 130).

4. "All this happens as if the for-itself had a passion *to lose itself* in order that the affirmation 'world' might come to the in-itself" (*Being and Nothingness*, p. 296).

The first two of these sentences concerning the loss or denial of self are ontological. They seem to me to present no difficulty so far as our understanding of them is concerned. They reflect a change of focus between *Being and Nothingness* and the *Critique,* but they are not inconsistent. The first speaks of an illegitimate and abortive self-sacrifice. Sartre points out that human consciousness vainly tries to achieve the solidity and absoluteness of non-conscious reality while at the same time remaining a free nihilating upsurge. As a lack of being and as a nihilation of being, the human individual is also a perpetual project of being. If he could become the foundation of his being as well as of his nothingness, he would be the being-in-itself-for-itself, or Self-cause, which for centuries has been hypostatized as God. Since man cannot become God, and since the self-contradictory Self-cause does not exist, we must accept the full responsibility of a freedom which, without external guarantees or support, must work without respite at the never-to-be-completed task of making itself what it is. This statement by Sartre stresses the ineradicable distinction between self-conscious being and the rest of being to the point of seeming almost to set up a dichotomy between them.

The second declaration shows the human and the material interacting, even if we cannot properly speak of reciprocity. "Man loses himself as man in order that the human thing may exist." Insofar as man *is,* he is a material being. That is why he both can and must interact with the natural world. In all interaction, he is called upon to acknowledge simultaneously his own materiality and the fact that whatever non-human reality he meets is transformed by his encounter with it. The "human thing" is not in-itself-for-itself, but it is certainly the result of the coming together of these two regions of being. Sartre places such "human things" on the side of the *practico-inert;* more than ever, man's being is outside consciousness, in the world.

The third and fourth statements are presented as ontological, but obviously they have metaphysical implications. Although they appear in widely separated passages, they belong together as descriptions of the original emergence of for-itself from in-itself and the existential relation between the two. Sartre has denied that there is any reciprocity between the two kinds of being. This is because the for-itself needs the in-itself for its very existence; whereas the in-itself does not need the for-itself in order to be. The in-itself could not be revealed without the for-itself, but it contains no lack. It *is.* It does not *need* to be revealed. All the same, the two quoted sentences suggest that there is activity on both sides, or at least an interaction in which more than the for-itself is affected. Sartre goes so far as to call the emergence of for-itself "the only possible adventure of the in-itself."

We shall even be able to consider this articulation of the for-itself in relation to the in-itself as the perpetually moving outline of a quasi-totality which we can call *Being*. From the point of view of this totality, the upsurge of the for-itself is not only the absolute event for the for-itself; it is also *something which happens to the in-itself*, the only possible adventure of the in-itself (p. 295).

When Sartre says that the "for-itself is the in-itself losing itself as in-itself in order to found itself as consciousness," he is careful not to instill any purposiveness into being-in-itself. The idea of foundation emerges only with the for-itself. "The in-itself cannot provide the foundation for anything; if it founds itself, it does so by giving itself the modification of for-itself" (p. 130). We may admit that what has been transformed is no longer in-itself; nevertheless, it does seem as if the in-itself has done something. Or if we cannot go that far, we can say that the emergence of for-itself from in-itself results from an activity which, if not originally purposive, results in the introduction of purpose. At the very least, we have Sartre's own words to establish that something significant has *happened to* Being-in-itself. It has been "affirmed" by the for-itself.

The affirmation is like a passive ekstasis of the in-itself which leaves the in-itself unchanged yet is achieved in the in-itself and from the standpoint of the in-itself (pp. 295–96).

Meanwhile, the for-itself acts as if it had a Passion to deny itself in the interest of constituting the in-itself as the situated totality of "the world."

All of this has a very different flavor from Sartre's introductory description of the two kinds of Being. It is perhaps just barely consistent with his contention that neither the in-itself nor the for-itself can touch the other in its being, but it gives rise to certain questions. I find it significant that in a discussion which precedes the last of the sentences quoted, Sartre considers a quality of being that leads him to postulate the relation of ontology to metaphysics. This is his discussion of motion.

In the section called "Transcendence" Sartre states that "motion cannot be derived ontologically from the nature of the for-itself, nor from its fundamental relation to the in-itself, nor from what we can discover originally in the phenomenon of Being" (pp. 285–86). This assertion is quite unlike the claims he makes concerning a multitude of other categories of being which either depend entirely on the for-itself—like time—or are in the world but revealed by a for-itself—for example, potentiality, quality, abolition, or destruction. Motion appears to be almost a hybrid phenomenon. It demands that we attribute to being-in-itself characteristics which strongly resemble those normally associated exclusively with the for-itself. Sartre makes the startling statement that we must give up the assumption that when a being is in motion, it preserves its being-in-itself. Instead, we

should recognize that in passing from A to B, a mobile being changes into nothing. "A category of 'thises' is encountered in the world which have the peculiar property of never being without thereby becoming nothingnesses" (p. 290). A moving object brings space into being and then abolishes it in the trajectory.

> The trajectory is the line which is described—that is, an abrupt appearance of synthetic unity in space, a counterfeit which collapses immediately into the infinite multiplicity of exteriority. When the *this is at rest,* space *is:* when it is in motion space *is engendered* or *becomes.* . . . The line vanishes at the same time as motion, and this phantom of the temporal unity of space is founded continually in non-temporal space (pp. 290–91).

To be sure, it is to the for-itself that these relations are revealed. The for-itself apprehends motion and the spatializing trajectory because it is itself temporal and identifies the moving object with itself. Yet Sartre points out that motion reveals in being-in-itself an exteriority-to-self, and he calls this "a pure disorder [*maladie*] of being."

In the "Conclusion" Sartre picks up the concept of motion once again and suggests still more strongly that here we may find the first anticipations of the upsurge of the for-itself from the in-itself. It is meaningless, he says, to ask what there was *before* the appearance of the for-itself. Ontology must "limit itself to declaring that *everything takes place as if* the in-itself in a project to found itself gave itself the modification of the for-itself." Nevertheless, metaphysics should attempt to establish the nature and meaning of the articulation of Being-in-itself and the absolute event of the upsurge of the for-itself.

> In particular it is the task of the metaphysician to decide whether motion is or is not a first "attempt" on the part of the in-itself to found itself, and to determine what are the relations of motion as "a disorder of being" with the for-itself as a more profound disorder pushed to nihilation (p. 790).[8]

Sartre seems to suggest that motion may be our clue as we try to understand how being-in-itself tries "to found itself." Is motion indeed a "first attempt" on the part of being-in-itself, an anticipation of the upsurge of the for-itself, a necessary transitional phase? We are not told, not even by way of conjecture or hypothesis.

CONCLUSION

Sartre has never been under any obligation to provide a metaphysics as well as an ontology in *Being and Nothingness* or in any other work. Insofar as metaphysics asks the question "Why?" he insists that we can answer only by hypotheses whose validity cannot possibly be proved or disproved,

or else by reference to a direct intuition of a contingency, to a "That's it." Yet we note that in his discussion of being-for-others, he recognized that at least it was necessary to prove that the metaphysical phenomenon considered was indeed "an irreducible contingency" (p. 395). In my view, Sartre's work has raised several such metaphysical questions, especially concerning the nature of the in-itself, or matter. One does not expect him to indulge in idle speculations as to the "why" of origins or to provide answers that belong strictly to the provinces of physico-chemistry and biology. It would be possible, I suppose, to argue that whatever may be the nature of the in-itself, the human being must deal with it as an opaque passivity and take it to his own account, impose his own terms upon it. But this does not seem to me to go far enough. Sartre has demonstrated brilliantly—to my mind, absolutely convincingly—that the activity of consciousness is neither determined nor explained by reference to natural laws and discernible physico-chemical reactions. I should like to propose in Sartrean terms a corollary question: What must be the being of matter if it is capable of giving rise to a being which nihilates it, which is free of it while continuing to be nothing but it?

Of course Sartre told us long ago that we cannot discuss the nature of being-in-itself. "Being is. Being is in itself. Being is what it is" (*Being and Nothingness*, p. 29). And that is all that we can say about it. Either Sartre was speaking then only about the abstract concept of Being (which I do not believe), or he himself has forgotten his own limitations. For he has made numerous statements about the in-itself which assume something more than the imposition of form by consciousness. Even in his discussion of *destruction*, which he claims does not exist before or without a consciousness, Sartre still speaks of the non-signifying rearrangement of masses of being (*Being and Nothingness*, p. 39). He emphasizes on several occasions the "coefficient of resistance" in being-in-itself. Where does this resistance come from if the in-itself is passive and inert? Possibly I am wrong in assuming that being-in-itself is to be identified with matter, Nature, and reified psychic material, though I can see no alternative. Even so, Sartre has not adequately discussed the nature or being of the objects on which consciousness depends for its being. It is all very well for him to hold that consciousness is free, whereas the universe is determined. But how does he account for this determinism? What is its ontological status? We may admit that human beings have imposed a rational order upon the world, have picked out inherent pattern by ignoring the non-signifying confusion of the ground. We may grant that the universe offers no meaning or purpose. But natural process remains. It is hardly possible to argue that Nature in itself is inert passivity, even if we cannot say that there is motivated action in Nature. Sartre himself allows that, unknown to us, there *might be* a kind of

dialectic in Nature. How can he say this of the being-in-itself, which he described as simple plenitude?

In "Materialism and Revolution" Sartre said that no materialism had ever been able to account for the fact that man is free to rise above his situation so as to get a perspective on it. In the *Critique* his own "realistic materialism" shows man as material being, but one capable of making a dialectic by which he may free himself from the domination of worked-on matter, so that he may become his own product instead of being the product of his product. I am not greatly concerned about the question of consistency. If Sartre could be shown to have moved from idealism to materialism, I should be glad to accept the fact of development. But I have attempted to demonstrate that throughout his work he has placed consciousness in a dialectical relation with matter. One of the results of this peculiar tension has been a certain ambivalence as to whether Sartre's position finally is monistic or dualistic. Consciousness posits all that is material as its object. There is certainly a dichotomy between the two regions of being insofar as we recognize a qualitative difference between them. But if consciousness is only the nihilating process of a material being, we cannot call it a subject (not even an impersonal subject) existing separately from its objects. To me it would not make much sense to speak of consciousness as non-material. What possible meaning could the term have in a materialist monism? But the question could be clarified, and I wish that Sartre had turned his attention to it. I do not find it difficult to think of part of being (that is, conscious being) as wrenching itself away from the rest of being so as to interiorize its own situation. It may be offensive to ecologists, but I have no problem myself in looking at human achievement as constituting in some sense an "antiphysis." I can accept as valid Sartre's ethical ideal, expressed on at least three occasions, of a community of free human persons joined in the harmonious exploitation of the physical world.[9] But if the human being is not wholly apart from Nature, we need to be told more about those roots which still hold him there.

Sartre often seems to presuppose and to accept the established theory of natural evolution and the entire framework of the physiological environment of consciousness. He has never made explicit the connections in either case. What, for example, are we to say of the consciousness of non-human animals? It appears to be to some degree intentional; probably it is not a self-consciousness. Do all but human animals belong with the in-itself? Since Sartre is careful to spell out the primitive interaction of the organic and the inorganic, it seems reasonable to ask him to indicate the relations between human being and other animal life. Furthermore, if the body is a permanent structure of my consciousness, we want to know more about the region of the psychosomatic. Sartre made certain tantalizing re-

marks in this connection long ago in *The Psychology of the Imagination*. It would be important if he could discuss more fully the relations of consciousness to the brain and to the rest of our organic body, especially now, when we have been confronted with so many exaggerated claims of physiological determinism on the part of geneticists and researchers in biochemistry.

I myself believe that Sartre's view of human reality implies a new concept of a matter which can give rise to a consciousness both dependent on it and yet free.[10] Whether or not Sartre is willing to accept the term "materialism" for his philosophy, I think it is important that he should provide some further explanation for what I have called its materialistic aspects. In other words, I hope that Sartre will consent to outline, or at least to specify a few general possibilities and limitations for, a metaphysics of nature. The need is urgent, for the problem is this:

If Sartre confines himself entirely to a description of consciousness in a human world set over against the unintelligible being-in-itself or matter, then it is difficult to see how his position can be defended for long against either of two quite different sorts of criticisms. First, the empiricist might argue that Sartre's philosophy is basically not different from earlier forms of naturalism which postulate consciousness as an epiphenomenon. To be sure, Sartrean consciousness is a nihilating process and not an entity. But its connection with that body which it both is and is not remains abstract and obscure. Second, the idealist may find in Sartre's refusal to say anything about the nature and status of process in the material world a confession of failure to account for obvious data in our experience. He will see in this "failure" an invitation to propose appealing myths where Sartre has sought for truth.

Personally, I am persuaded that Sartre has provided for the Marxist interpretation of history a philosophy of man-in-the-world which in truth merits the name of a dialectical materialism. One cannot say that this philosophy is without a metaphysical foundation, but the structure deserves to be filled in and strengthened.[11]

Hazel E. Barnes

Center for Interdisciplinary Studies
University of Colorado, Boulder

NOTES

1. I do not mean to say that absolutely nobody before me has commented on the materialistic aspect of Sartre's philosophy. McBride, for example, has concluded that Sartre is "a materialist in terms of the traditional philosophical controversy among idealists, dualists,

and materialists." McBride, however, was not interested in exploring the consequences of his assertion. He wrote, "Sartrean man . . . is material, and as a thing, as a substance, nothing else can be said about him, but this is just what it is not important to say about him." My point is that, while man is material, he is *not* a thing. Sartre's materialism is all-pervasive; but the terms in which it is presented are not traditional. Cf. William Leon McBride, "Man, Freedom, and Praxis," *Existential Philosophies: Kierkegaard to Merleau-Ponty,* ed. by George Alfred Schrader, Jr. (New York: McGraw-Hill Book Company, 1967), especially pp. 276–77.

2. Simone de Beauvoir, *La Force de l'Age* (Paris: Gallimard, 1960), p. 35.

3. Cf. Sartre's remark in the *Critique* (p. 34), "I repeat that the only valid interpretation of human History was historical materialism."

4. See Michel Contat and Michel Rybalka, *Les Ecrits de Sartre. Chronologie, bibliographie commentée* (Paris: Gallimard, 1970), p. 23. This work is now also available in English translation.

5. Especially in "Introduction," sec. A, "Dialectique dogmatique et dialectique critique."

6. Cf. *Critique,* p. 124.

7. Here Sartre adds a footnote: "Although no *definitive* experience has proved it."

8. In this passage I have corrected a slight infelicity of language and possible unclarity in my translation as published.

9. See "Materialism and Revolution," p. 201; *Being and Nothingness,* p. 550; *Critique,* p. 302.

10. To me it appears that Sartre's concept of matter might be closer to that of the Greek Hylozoists than to that of Plato and Aristotle, though obviously without theological implications. At least with the Hylozoists there had not yet appeared the fatal dualism which separated a non-material mind from the world. The latter was differentiated as a specific and specialized function of the former.

11. Several months after I had written this article, I found two significant remarks in an interview which Sartre had just held on the occasion of his seventieth birthday. "For me there is no difference in nature between body and consciousness." And "Ideas are modifications of matter." See "Autoportrait à dix-ans," interview with Michel Contat, *Situations,* X (Paris: Gallimard, 1976), p. 142.

28

Ronald Aronson
SARTRE'S TURNING POINT: THE ABANDONED *CRITIQUE DE LA RAISON DIALECTIQUE*, VOLUME TWO

THE unpublished second volume of the *Critique de la raison dialectique* is certainly the most intriguing, if not downright puzzling, of all of Sartre's works. For twenty years it has had a phantom existence among Sartre's many incomplete works as one of the few he chose not to make available. It has been understood as embodying Sartre's turn toward concrete history after he had laid out the abstract categories of Volume One ("Theory of Practical Ensembles"). In 1970 Contat and Rybalka, Sartre's bibliographers, indicated that it contained two parts, one about boxing and the other on the Soviet Union.[1] The brief section which has now reached print[2] is a characteristically rich and penetrating analysis of how "socialism in one country" became the Soviet project. Why, then, did Sartre choose neither to complete the 200,000-word manuscript (781 pages in the original) nor to publish what he had already written?

The question deepens as we recall the decisive place occupied by this period of writing in Sartre's itinerary.[3] After November 1956, in what he wrongly called a "break" with the Soviet Union, Sartre urged the Soviet rulers, whom he addressed as comrades, to relax their grip now that industrialization, modernization, and military parity with the West had been achieved and made repression no longer necessary.[4] At the same time he announced and initiated his own project of revitalizing Marxism and giving it a philosophical basis: *Question de méthode* and the *Critique*. The Soviet invasion of Hungary notwithstanding, these years of the middle 1950s were the time of Sartre's greatest optimism as a Marxist, culminating in the years

Editor's Note: The Editor heard Professor Aronson's address on this subject at the sessions of the Western Division of the American Philosophical Association in Detroit in late April 1980 and on the strength of that invited Professor Aronson to contribute his important analysis to our Sartre volume.

he spent "working furiously" on the *Critique* project from 1957 to 1960. Politically, he hoped for the appearance of a humane socialism, and his attack on the Soviet intervention in Hungary was intended as a contribution to the process. Intellectually, he took upon himself the role of Marxism's Immanuel Kant, seeking to forge the tools to understand no less than human history itself. His two relatively light-hearted plays, *Kean,* first performed in late 1953, and *Nekrassov,* opening in June 1955, convey Sartre's expectancy and optimism of this period.

However, by fall 1959, near the end of the *Critique* project, another and far more significant play announced a drastic shift in Sartre's outlook. In *Les Sequestres d'Altona* the France that was obstinately and brutally refusing to loosen its grip on Algeria was symbolized by Frantz, who, both impotent and all-powerful, saw himself as "Hitler's bride" and became a torturer on the Eastern front. The play expressed the sense that some historical acts and their perpetrators are, very simply, beyond redemption. Interrupting the writing of the *Critique* and completed in a period of illness and great tension, this historicized version of *Huis clos* evokes a mood that connects with Sartre's growing discouragement with both East and West, with both the socialist world and the chances for change in the capitalist world. This mood found explicit voice only after Volume One of the *Critique* was published, in the bitter and disillusioned tone of Sartre's essays on Nizan (1960) and Merleau-Ponty (1961), as well as in his virtually anti-Marxist and certainly anti-intellectual writings on the Cuban Revolution (1960) and his powerful but self-lacerating preface to Fanon's *Les Damnés de la Terre* (1961).

In short, Sartre's interruption of the *Critique* project to write *Les Sequestres d'Altona,* followed by his abandonment of Volume Two, signals a turning point in his political and intellectual life. In a remarkably short space of time the fellow traveler became embittered toward the French Communist Party and discovered the Third World; the man who would unravel the riddle of history itself turned instead to an attempt to understand first himself (in *Les Mots,* 1963) and then Gustave Flaubert; and the revolutionary playwright of *Le Diable et le bon Dieu* (1950) translated Euripides' *The Trojan Women* (1965) as a generalized condemnation of European civilization.

Volume Two of the *Critique* is the key to this change. As we shall see, a drastic shift takes place within the manuscript itself. Having studied the manuscript, I am further prepared to argue that it shows Sartre reaching fundamental intellectual and political limits which deeply affect his subsequent attitudes and projects. Thus our study will help to illuminate the reasons *why* Sartre changed and so will reveal the abandoned portion of the *Critique* as Sartre's philosophical and political turning point.

Introducing Volume Two

In the terminology of *Question de méthode,* the first volume of the *Critique* is a *regressive* analysis: it deconstructs history into its elements. By the end we have studied the series, the practico-inert, the group in fusion, the sworn group, the institution, the sovereign and class—studied them not as static entities or forces but as products of individual human *praxis* under conditions of scarcity. It is now time for the *progressive* moment of the study: "These structures must be left to live freely, to oppose and to co-operate with one another: and reflective investigation of this still formal project will be the object of the next volume."[5] Sartre's more substantive goal is to throw light on the "real problem of history": can two or more praxes in conflict be comprehensible as a *single* struggle, as a *single* history?

Thus, the second volume of the *Critique* poses what is in one sense the unresolved problem of the first and in another sense the unresolved problem of Marxism itself.[6] "Is there a unity of the different classes which supports and produces their irreducible conflicts?"[7] Marxism depends for its truth on an affirmative answer; otherwise, "human history decomposes into a plurality of particular histories."[8] And yet this plurality had been Sartre's unshakable starting point in posing anew the classical question of social theory: How can we understand both concrete individuals *and* the social world to which they belong? In Sartre's eyes this question became: How do separate individuals combine to produce a constituted social world? For Sartre never doubted that the multiplicity of individual praxes produced this world, and he repeatedly warned against the "hyperorganicism" which would tear society away from its individual foundations and make it an autonomous force obeying its *own* laws and acting upon *us.* Against this, he proposed from the beginning of Volume One to explain social groupings by first deconstructing the larger wholes into the multitude of acts which compose them. This meant postponing until now the decisive question of how the separate acts join to become a larger whole.

Boxers and Subgroups

Sartre's first analysis understands the boxers in terms of their place in "the world of boxing," an organized hierarchy present in the evening's program; in terms of the art of boxing incarnated by the participants; and in terms of their common acceptance of the rules to be observed. "Boxing *as a whole* is present at each moment of battle, as sport and as technique with all the human qualities and all the material conditioning (training, conditions of health, etc.) that it demands."[9] He goes on to relate the boxing match to the whole of social life, as the "public incarnation of *all* conflict."[10] More specifically, he discusses the way in which capitalism

domesticates the interiorized violence of scarcity into a regulated and profitable unleashing of violence by the oppressed against each other.

Without fully answering his original question, Sartre now turns to subgroups of a larger group which are in struggle with each other. His point here is that competing subgroups are not merely destructive forces; rather they express the dialectic of the group itself. Why is an organized group with a common praxis split by two subgroups opposed to each other in the name of the whole? Because in its praxis a group creates a practico-inert field which in turn imposes "the practical realization of an impossible coexistence" between alternative praxes and thus between the subgroups advocating them. In short, struggle between two subgroups appears only insofar as it is based on the actual unfolding of the common praxis.

Sartre is of course talking about a moment in the life of a collectivity which, having begun as a group in fusion, has solidified itself into an organization but is still unified by a common praxis. Insofar as the survival of the group is at stake, such a post-revolutionary moment can lead to violent splits, liquidation of the vanquished subgroup, and denunciation of its members as traitors. The split, by breaking the unity of the group, threatens its very life. But Sartre's point is that the factional struggle of each subgroup is both generated by and itself generates the larger whole, even as its very existence is threatened and its course is in question.

SOCIALISM IN ONE COUNTRY

If he has been discussing the Soviet Union, only now does Sartre become explicit as he selects "a single, contemporary example: the emergence in the U.S.S.R. of the ideological monstrosity of socialism in one country."[11] With this example, he approaches the heart of the second volume: 400 pages on the Soviet Union, from the conflict within the leadership in the 1920s to Stalin's revival of anti-Semitism in the early 1950s. The single point made in the first part of this discussion builds on the analyses of boxers and subgroups: the Stalin-Trotsky conflict "was a totalization, through the protagonists, of a contradiction in the common praxis of the Party."[12] The contradiction was that, on the one hand, the realization of socialism in the backward and ravaged Soviet Union depended on revolution elsewhere in Europe, while, on the other, the Bolshevik Revolution split the workers' movement everywhere and drove local bourgeoisie into the arms of fascism.

In the resulting conflict the revolutionary Soviet government recognized the impossibility of building a genuinely socialist society without the help of more advanced socialist allies. But to act to encourage the creation of those allies under conditions of encirclement, underdevelopment, and

devastation and the revolutionary ebb in Europe was to risk the Bolshevik Revolution itself. And yet not to act was to abandon the hope of any but the most brutal socialism. Victorious, the Bolshevik leadership now faced the torn halves of what had once been a unified revolutionary project: to preserve or to radicalize socialism in Russia. This choice manifested itself in Stalin's Russian particularism and Trotsky's Western universalism, in Stalin's project of turning inward and Trotsky's espousal of European revolution, in Stalin's caution and Trotsky's ardor, in Stalin's pedantic gearing of Marxist culture to Russian backwardness and Trotsky's brilliance as a Marxist theoretician, in the very reasons why Stalin and Trotsky at different moments advocated similar policies. It was as if the more cultivated, democratic, and advanced socialism symbolized by Trotsky was expelled bodily from the Soviet Union and attacked as treason precisely in order that Stalin might adapt the universal concepts of Marxism to the concrete tasks of building *this* socialism. "Socialism in one country," Stalin's provocative and distorted answer to Trotsky, "became the simple signification of the way in which this still-traditionalist country, with its illiterate population, absorbed and assimilated at once the overthrow of its ancient traditions; a traditional withdrawal into itself; and the acquisition of new traditions, through the gradual absorption of an internationalist, universalist ideology which helped the peasants sucked into industry to comprehend the transition from rural to factory labor."[13] In other words, this unintelligible monstrosity became a praxis and, as such, the deformed truth of the Revolution. It succeeded because it united "theory and practice; the universal and the particular; the traditionalist depths of a still alienated history and the movement of cultural liberation; the negative movement of withdrawal and the positive movement of hope."[14]

Sartre's primary goal was to demonstrate internal conflict in an already integrated group as "an incarnation and a historialization" of the group's "global totalization."[15] In other words, the actual historical unfolding of the group's practical project generated irreconcilable choices and conflicts. But the significance of the example is limited, inasmuch as the Bolshevik leadership was an *already integrated group*. What happens when we pass to the plane of history and its shifting multitude of collectivities? Do we find a single internally connected history or "*several* totalizations related only by coexistence or some other external relation"?[16] Sartre now turns for an answer to the development of the Soviet working class during the 1930s in relation to Bolshevik praxis.

Sartre reveals the tragic and brutal features of Soviet development as an intelligible praxis-process: "in the historical circumstances of Russian industrialization," the revolutionary praxis of the leadership entailed "destroying the workers as free practical organisms and as common individ-

uals, to be able to create man from their destruction."[17] Sartre's discussion proceeds in three stages: first, a study of how revolutionary Bolshevik praxis led to the creation of elites within the working class and the bureaucracy; second, an analysis of how the demographic upheaval induced by Bolshevik praxis created a new working class whose control and integration called for yet greater oppression; and third, an examination of how the Bolshevik struggle against backwardness under threat led to forced collectivization and terror, which in turn reduced the Soviet peasantry to a state of impotence and permanent passive resistance.

How—to dwell briefly on the first analysis—did a revolution committed to equality create a society "of dignitaries where merit is pompously rewarded"?[18] "The goal of the proletarian revolution," Sartre begins, "is to permit the construction of a society where the worker will have permanent and integral control over the process of production."[19] In conditions of scarcity and external threat, the revolutionary leadership is forced to vanquish as quickly as possible "the resistance of things": the first priority *must be* to develop heavy industry. In such a situation no responsible leadership can leave different economic sectors to themselves to determine their own capacities and needs. In calling forth new functions of control and thus giving rise to a practico-inert organizational structure, Soviet industrialization engenders a bureaucratic "skeleton indispensable to all transcendence but which by itself rigorously limits the possibilities of inventing responses to each situation."[20] This necessary, and necessarily inertial, organizational structure in turn redefines the goals and limits of the process, inducing the "petrifying repercussion of praxis on itself."[21] We see this most clearly in the establishment of a salary range contradicting Bolshevik egalitarianism. Bolshevik principles could not be conserved *and* the Revolution saved at the same time: "it is necessary to choose between the shattering of the Revolution and its deviation."[22]

But how, then, could the masses be interested in production? Since no "interest in production" could be built in as an *objective* condition of labor performed in such circumstances and could never be generated by simple coercion, the leadership developed Stakhanovism. Lacking the objective conditions for either democratic control or a general rise in living standards, the most productive workers were rewarded by incorporation into a labor elite on the model of the Party and State leadership. The Plan engendered the "man of the Plan": a synthesis of "individualism (ambition, personal interest, pride) and of total devotion to the common cause, meaning socialism."[23] The leadership was in turn modified by its own creation, needing now to justify its right to distribute such honors by awarding *itself* the highest honorific distinctions. It was unthinkable, Sartre pungently observes, that the agents of such a society could any longer be "a group of

poor revolutionaries without privileges, refusing all titles—as was Le-
nin."[24] And so the circle is completed: under conditions of scarcity, the
practico-inert field engendered by revolutionary praxis reaches back and
imposes a contrary praxis, shaping its people as it does so. Now, in his next
discussion, Sartre goes on to show how Soviet praxis was carried out by the
very individual that such a praxis demanded.

STALIN

Was there an alternative to Stalin and to the bloody policies he pur-
sued? Many non-Stalinist Marxists accept the notion that industrialization
and collectivization required coercion. "Simply they ask themselves if it
was not possible to avoid the propaganda lies, purges, police oppression in
workers' centers, and the terrible repression of the peasant revolts."[25] In-
asmuch as the purges and the Moscow trials do not seem called for by the
mere project of industrial growth in an underdeveloped country, they are
often ascribed to the individual personality of Stalin. It might be said, for
example, that the same results could have been attained with more flexibil-
ity, foresight, and respect for human life, and further that Stalin, because of
his personal idiosyncrasies, exaggerated to appalling excess the necessity to
subordinate human need to the construction of machines. To the degree
that Stalin bears responsibility for the purges and the trials, they are ex-
plained by chance or by personal factors extrinsic to the revolutionary
project.

Sartre sharply rejects this line of thought as intolerably abstract with-
out, on the other hand, rooting all the specific features of Stalinism in the
revolutionary process as such. The circumstances of the Soviet praxis-
process entailed that its organs of sovereignty could subsist and act only by
placing power in the hands of *one* individual.

> But since the regime completely demands a personal sovereign in the name of
> *maximum integration* and that he be, at the summit of the pyramid, the living
> suppression of all multiplicity, when the constructive effort of the U.S.S.R.
> implies that this society find its unity in the biological indissolubility of one
> individual, it is not even conceivable that this individual could be in himself and
> in his praxis eliminated as idiosyncrasy on behalf of an abstract objectivity.[26]

In short, the conditions of Soviet development *called for* the "cult of
personality" as a way of unifying people from whom the greatest effort was
needed as they were kept politically passive and separated. But why was
singularized sovereignty vested in *this* particular individual, Stalin, and not
in someone else capable of unifying the construction of a Russian socialism
amid the urgencies of the 1930s—some other dogmatic opportunist
sufficiently able to adapt Marxism to the unique Russian situation, some

other "militant known by militants," "inflexible, without nerves, and without imagination," able both to retain the loyalty of the Party and to impose surplus labor on workers and peasants? As we pursue the question, it begins to answer itself. But need the Soviet leader have been precisely "this former Georgian seminarian"?[27] Stalin's upbringing interiorized the very qualities demanded by the situation. But if "the situation in 1929 demanded the inflexibility of the sovereign, this demand leaves indeterminate the question of the individual origins of this inflexibility."[28] If there were no others available who happened to unite these qualities in themselves, it is because scarcity, reaching into all sectors of social life, becomes at a time of urgency a *"scarcity of men."* Stalin, then, becoming the man of the specific situation, "will adapt himself progressively to praxis to the degree that praxis adapts itself to his prefabricated idiosyncrasy; from compromise to compromise, equilibrium will realize itself finally by a transformation of the man and a deviation of the enterprise."[29]

Stalin is *necessarily* disadapted to his role because his personal traits, however apt, emerge not from the situation but from elsewhere. Thus his inflexibility "will present itself also and necessarily as *not being exactly the required inflexibility*."[30] Arising from his childhood, however deeply that childhood may have interiorized fundamental aspects of Russian life, Stalin's inflexibility does not have the building of a new social order as its preordained objective. He can only adapt himself to his tasks *more or less* completely.

There is, then, a necessary disjuncture between the individual and his historical tasks. In claiming that the function creates the man who exercises it, Plekhanov ignored the profound fact that history individualizes itself in its man, who then changes history according to his idiosyncrasy as he carries out its work. The Soviet situation demanded an individual sovereign who incarnated its vital need to draw exclusively on Russian resources, unflinchingly to drain surplus labor from its own citizens, to present Marxism as a crude dogma to semiliterate peasants who had a need to believe. It was Stalin himself who pressed on to the Great Purges and the Moscow trials, forms of oppression which, if instigated by *his* eccentricities, soon became absorbed as definitive dimensions of Soviet life. The difference in standard of living was so great between Soviet and Western workers as to *propose* the Iron Curtain, "but it did not *demand* endless lies about the condition of the European worker."[31] Stalin, not the objective situation, required the "absurd cultural isolation" into which he led the Soviet Union. We may imagine a sovereign individual who would have done only and precisely what was necessary rather than, as Stalin did, both more and less—but we can only *imagine*.

DRAWING CONCLUSIONS:
THE TOTALIZATION OF ENVELOPMENT

Broadly speaking, the purpose of this discussion has been to show how praxis becomes deviated as the men carrying it out "become other men occupied in attaining other objectives by other means: and they do not even know it."[32] While historians who could blame the Bolsheviks for Soviet brutality falsely dream of "action as a pure force," the real truth is that the acting agent, even where successful, loses himself in the *totalization of envelopment*. This, the major concept of Volume Two, demands clarification. The totalization of envelopment differs from the practico-inert because it is the unfolding totality of praxis as *deviated* by its products: "it is *autonomous praxis* and affirming itself as such, insofar as it produces, undergoes, repeats and hides its own subjection as the passive and re-actualized unity of its own byproducts."[33] In this concept—which in one sense is synonymous with history itself—Sartre tries to convey *both* human praxis and its absorption into, and domination by, a practico-inert world which it has created but which is out of its control. The totalization of envelopment is, in short, "the dialectical link of the intended result (with its foreseen consequences) and unforeseen consequences of the result insofar as its incarnation in the totalization of the practical field should condition at a distance every element of the field including the agents themselves."[34]

Our interaction with the practical/historical/social field can be thus explained neither by the "activist illusion" of the Stalinist—who "makes history but history does not make him"[35]—nor by sociology—which sees the world filled with abstract structures and objects neither rooted in nor supported by human beings. The totalization of envelopment rather points to the movement of circularity which:

> . . . in some fashion realizes practically the objectives of agents (leaders and others) and in some fashion . . . transforms them into other men discovering other results but believing that they have attained their objectives since they are transformed at the same time as them. In short, men realize themselves in objectifying themselves and this objectification *alters* them.[36]

Before turning to meditate further on the totalization of envelopment, Sartre, following his reference to sociology, cautions us again to beware of hyperorganicism: his Soviet example reveals "no super-human synthesis." A multiplicity of free practical organisms were at the root of every development he described. How, then, were they united? First, by a *labor* of integration performed by the leadership, the Party, and the apparatus of coercion; second, by a kind of internal link of immanence in which the praxis of one conditions the praxes of all others; and third, by a process of

incarnation in which individuals absorb, singularize, and re-exteriorize the imperatives of the sovereign which have been imposed indifferently on all. After exploring an example of how forms of sexual conduct incarnated the process of accelerated urbanization of peasants, Sartre concludes that "all individual conduct represents the reproduction of *the* social totalization of envelopment under the form of *an* enveloped totalization."[37]

This discussion of the concept of incarnation becomes a key for understanding how the whole, the totalization of envelopment, becomes individualized: "it is incarnated by every singularity and each singularity is defined at the same time as incarnation and enveloped totalization."[38] In the case of Stalin, this singularization inevitably included, as we have seen, an objective lag (*décalage*) between the imperatives of the situation and the idiosyncrasies of the course taken. Sartre now explores Stalin's postwar anti-Semitism, asking how far it was the idiosyncrasy of a leadership formed and rooted in terror and fundamental isolation from the West and how far it had deeper roots in Soviet society and the Russian people. The strictly political anti-Semitism which saw Soviet Jews as connected with the Jews of the West and thus with the Western powers appealed to a deeper, older layer of racist anti-Semitism, which, "by an inflexible dialectic,"[39] reconditioned and enveloped it. Stalin's "action finds itself constrained to invent its only contemporary possibility, and to invent it freely: in fact it transcends *theoretical* resistance in order to choose racism as the only possible means to render this politics popular."[40]

With this example, Sartre says, "we have looped the loop (*bouclé la boucle*) because we have seen the sovereign as enveloped totalization of his sovereignty."[41] Sartre goes on to summarize as follows "the *meaning* of the totality of envelopment as praxis-process"[42]:

1. It is always a *human* process, meaning that it is produced in the characteristic way in which humans act: by posing objectives, to achieve which they negate the past and go toward the future. That is, it unfolds in time, "and its agent is a man, and that man, be he a slave, is sovereign in his work."[43]

2. Its deviation produces men inasmuch as the world produced thereby creates *its* people, who have a false consciousness of themselves. This is an anti-human, not an *inhuman* dimension of the process. A totalization of envelopment is conceivable which would not be deviated by its product, in a culture in which masses and leaders might be more homogeneous. Circularity would remain a formal structure, but in a more advanced economy the "feedback" which currently falsifies praxis might be comprehended, submitted to, and controlled; that is, perhaps the circularity might become *directed*.

3. Although the concept of the totalization of envelopment points to "a return of the inert upon the agent to recondition him,"[44] this does not render the agent incapable of grasping this process of involution. While positivistic reason cannot comprehend this reconditioning, dialectical thought can, in the end, grasp this "anti-dialectical reconditioning of the dialectic."[45]

4. The deviation of praxis by its product is not uniquely linked to *common* actions. Circularity is a structure of all constituting praxis, on the individual level. An example of individual praxis being deviated is *fatigue.* The cost of the action, even in its success, is the modification of the agent performing it. This shows that "the indissoluble unity of the human and anti-human is manifested at each instant of daily life and in every individual we meet."[46] Another example of this unity can be seen in someone who dresses according to what is "in style."

The *meaning* of this or any praxis-process comes not from grasping its formal structures but from viewing it—like Stalinism—as a project unfolding in time. Does this mean that there are several meanings or a single meaning to the totalization? Certainly there are different meanings according to the different levels and sectors of totalization, but each one produces and is based on the unity of a total meaning which mediates between all partial meanings. That each reconstruction is *situated* does not hopelessly relativize the project of understanding.

> What is revealed, in fact, through the situated reconstruction is this part of being which the chosen perspective allows to be discovered: and this part of being is totally and fully real; only the limit is relative which separates the known from the unknown and which reflects other limits: that of present-day historians.[47]

Changes in the situation of historians will change the meaning of the past, as when in the nineteenth century industrialism and imperialism had created *one world* and given a new meaning to the prior distance between societies and cultures. Historians are able to *comprehend* it anew only because human action has changed their very *being*.

5. The question now becomes: What is "*the real-being* of this totalization"?[48] Sartre first disavows any intention to study the ontological structures of this dialectical unity of the human and the anti-human: this goal would be appropriate for an ontology of history, not a critique of dialectical reason. His question is rather how to *comprehend* the totalization of envelopment: "through a positivistic nominalism or in the perspective of a radicalizing realism"?[49] He argues for a *situated* comprehension, meaning that "historians cannot place themselves *at the point of the inhuman* to know and understand historical reality."[50] Objectivity is not some *absolute*

reality independent of human action but is rather a human product. Indeed, neither the object nor the researcher is independent: Marxist, idealistic, and positivist distortions fall on one side or the other.

BEING-IN-ITSELF

Sartre's discussion now takes a new turn with the statement that "since, in fact, we recognize the existence of a totality of envelopment, considered as the temporalization of praxis-process, we discover that our *situated analysis* was incomplete and can stop being indeterminate only by placing in question the ontological reality of the enveloping totalization."[51] This initiates the ontological speculations of the final one-fifth of the manuscript, which begins by inquiring anew into the existence of *being-in-itself* (*être-en-soi*). "The simple possibility that a cooling of the sun would stop history"[52] throws into sharp relief the fact that our human project is limited and conditioned by forces which are *on principle* beyond our comprehension or control. Our "praxis-process grasps itself, in interiority, as making itself through its products: but its transcendent qualification constitutes it as a reality which is not the foundation of its own possibility."[53] Thus "we discover, in our dialectical experience, the being-in-itself of praxis-process as that which could be called its inassimilable and irrecoverable reality: and this being-in-itself as exterior limit of totalization is realized as interior limit of transcendent exteriority."[54] Being-in-itself is *self-sufficient* in relation to being-for-itself (the practical agent). "Not only does it have no need to-be-known in order to be, but it escapes knowledge *on principle*."[55] Thus the enveloping totalization which humans produce and which produces them has, so to speak, an *outside* which is beyond our reach: being-in-itself.

While *death* is a pre-eminently human and social fact and therefore "each violent death is the incarnation of the internal limit of the enveloping totalization,"[56] death itself is an example of an utter and transcendent limit to each praxis-process. Each individual must die before, or indeed after, achieving his goals, meaning that every praxis is conditioned from beyond itself by "the necessity of being deserted along the way by its man."[57]

Death thus reveals its conditioning in exteriority, by incomprehensible forces, of the entire human adventure.

The terms "interiority" and "exteriority" have now become decisive for characterizing praxis and its (intended and unintended) results on the one hand and on the other those forces which, while they may penetrate and condition us, remain resolutely beyond our knowledge or praxis. The in-itself is a kind of absolute limit of the for-itself: its condition, its absolute exteriority, its threat. Science fiction is a popular way of seeking to become conscious of this "in-itself of our history."[58] Martians would hypothetically

know those things which we cannot, would be able to grasp us from outside the circle of interiority, the practical field in which we must dwell. Only the achievement of this perspective—which is impossible for us—would permit "an exterior testimony on the human species."[59]

The Passive Humanity of the Tool

The *exteriority* of the in-itself refers not only to the cosmic beyond of our practical field; this exteriority is a precondition of each praxis as the infinite dispersion to be negated by human action and as "condition, menace, instrument or worked product."[60] We are, then, dealing with the very in-itself of *L'Etre et le Néant:* at first radically exterior, then negated and interiorized by praxis, yet returning to exteriority and perpetually reconditioning praxis. Note, however, that praxis is reconditioned by independent, inert objects which can only be called *passive syntheses.* Until humanity can artificially create life itself, it will reproduce itself through producing such inert objects as tools and machines and will be able to act on life only by creating inorganic substances or by inducing modifications in the forms of life which it takes as prerequisites.

Were we able to synthesize life, human history itself would be transformed, inasmuch as we would no longer need the vast practico-inert field of instruments and machines to produce our means and we could thus dissolve and eliminate its *feedback* (circularity) of survival. But in *our* life, in *our* history, in order to create tools to aid in rendering organic materials assimilable by us, a certain materialization of praxis is called for, thus a transformation of the organic—ourselves—into the inorganic.

> It is a matter here both of a projection of organic life at the foundation of synthesis as continuous creation of a permanence, and of an impregnation of worked matter by the act (labor) which is there changed into a passive structure to the very degree that it cedes to it its transcendence.[61]

Praxis creates the *"passive humanity of the tool"* and the *"human efficacy of the inert."*[62] In working the matter up into tools "the organic becomes practical . . . and the practical organic,"[63] creating a kind of ontological unity of the inert material and the organic life whose action shapes it and which it serves.

The origin of all alienation lies in precisely this feature of worked matter. For example, as machinery of this or that sector of production, this inertia bearing a human stamp unites the labor of separated men. But in the process, the powers of unity and control have been removed from those who work at this or that task and lodged in the passive synthesis which is the machinery. The activity of the organism, parceled out and regulated by machines, becomes no more than a form of "directed inertia"—"he al-

ready behaves as a machine directed by its conductor."[64] "The paradox of
our action is that all can be and most are in fact reducible to a succession of
inert processes."[65] This is "the scandal of the nineteenth century, accen-
tuated in the twentieth—the discovery of the permanent possibility of de-
composing any praxis whatever into elementary conducts of which any one
can be effected indifferently by a practical organism or by an inorganic
system."[66]

This negative determination of praxis is complemented by the fact that
its source is human invention: "the intrusion of life as demand of integra-
tion in the world of exterior dispersion."[67] Sartre now explores knowing
and perception as types of invention which likewise involve unifying the
inert into a practical field according to human ends and are likewise tied to
human action. *Essences,* as forms of comprehension, can now be explained
in the terms Sartre has been developing as passive or inert syntheses "of
abstract determinations, insofar as the coming together of qualities should
be produced by a practical and *self-sufficient* operation."[68] The essence of
an individual, for example, is simply "the passive rendering of his existence
and its projection in the being in exteriority simultaneous with the unifica-
tion of the diverse by the unifying praxis of the knowing organism."[69]

A Reaffirmation of Dialectical Reason

Now Sartre further explores both the nature of discrete units of labor
in a division of labor and their dialectical comprehension: governed by
exteriority, rendering itself inert, the agent's act can only be understood in
relation to every other agent's act and across a temporal field in which the
desired object is sequentially produced. Analytical reason, "our first
machine," comprehends the process only from the outside, as a "passive
series of inert successions."[70] It is indeed

> only *exteriority itself,* as practical rule of the operations: it realizes the negation
> of the organism by itself but at the level of the inert; as such, it has no instru-
> ments to become conscious of the totalizing temporalization which governs and
> supports it, although it lives this unity as the very basis of its reasons; it is
> produced as *time of succession of exteriority* in dialectical temporalization, that
> is at the heart of a reason which knows, which utilizes it and which it does not
> know.[71]

Analytical reason is, in short, a tool for the rationalization of action whose
origin and purposes are decided elsewhere. Improvements in a given fac-
tory and the "thought of things" which is homogeneous with and produces
them can be understood in their full signification only by a thought which
sees the whole process in its unity and full historical complexity. Positivistic

reason, the logic of machines, regards man as just another machine, a factor of production. Dialectical reason, on the contrary, views each action as part of a creative and totalizing praxis. For it, "human action is irreducible to any other process insofar as it defines itself as practical organization of inert multiplicities by an inertia-passion and through an irreversible project of integration of all elements of the practical field—as transcendence, temporalization, unification, totalization."[72] Ideally, under the guidance of dialectical reason, each improvement would permit "the agent to govern it better and more profoundly."[73]

Now, as the manuscript draws to a close, Sartre for the first time discusses the *purpose* of "the immense circuit of machines" which he has been examining, namely, to meet the biological needs of the human organism. Sartre reasserts the circularity that springs from this process: the organism becomes inertia to modify things and is thereby conditioned by the inertia which it has worked. This takes place as the organism "tries to make his *material environment* a combination of inert elements which are favorable to his life."[74] Actions which in themselves are evanescent produce passive syntheses which retain nothing of the act. This "inertia placed at the service of life" itself becomes an exigency which commands future action. The relationship to the original end is retained through the passive demands of the apparatus, which must be satisfied or a mortal risk is run. This practico-inert field becomes an *order* of passive demands. In the process that unfolds, the original organism in need must transform himself into an *agent* capable of operating the inert apparatus. Under the division of labor he even gets remunerated for an action which seems to lose its contact with the original goal and at times even poses itself as a "free act"—such as sports, art, and games. Sartre now attacks as false the notion of activities as ends in themselves and so re-emphasizes *biological need* as the source of the entire practical field.

The manuscript ends by affirming man over his creation, but barely. The factory worker determined *as agent* by his fulfillment of so many specific tasks an hour,

> . . . and *in his organism* by the means that it gives to him to satisfy his needs, is alienated and reified; he is an inert synthesis. But *precisely,* praxis refuses in him and in all other cases to let itself be limited to *that. Action* struggles against its own alienation by matter (and by men, it goes without saying) insofar as it is posed dialectically as the unifying temporalization which transcends and conserves in itself every form of *unity.* Thus the dialectic appears as what is truly irreducible in action: between the inert synthesis and functional integration, it affirms its ontological status of temporalizing synthesis which becomes unified in unifying and in order to unify itself, and which never leaves itself to be defined by the result—whatever it is—that it attains.[75]

The Turning Point:
From Achievement to Failure

I have purposely let the manuscript speak for itself insofar as possible, avoiding evaluative comments in order to leave the reader maximum freedom to experience it. By now, hopefully, the reader has a taste of the manuscript, an idea of its strengths and weaknesses, and perhaps even some sense of why it was abandoned. Its most remarkable feature is the divide separating the section on the Soviet Union from the subsequent ontological reflections: most of the first part is a concrete study of a specific history, whereas the second part consists of general reflections on being as such. The first part moves vigorously and is filled with fresh insight; the second part moves exceedingly slowly and never approaches the penetration of the earlier section. In other words the break in substance is also a break in quality: the section on the Soviet Union is among the most brilliant work of Sartre's career, and the final part of the manuscript is among his muddiest and most inconclusive writings. Even the moods differ drastically: the studies of boxers, subgroups, and Soviet praxis are bold, innovative, and typically confident, whereas the ontological reflections are hesitant and redundant and evoke a sense of being overwhelmed.

At the outset I indicated some external considerations why this manuscript may be claimed to span a political and philosophical turning point for Sartre. And, as we have now seen, Volume Two itself is marked by a deep internal shift. No doubt we may look outside of the *Critique* project to explain this. Was the first three-fifths of Volume Two, through the discussion of Stalin, written before the dispiriting referendum confirming De Gaulle's accession to power in the autumn of 1958, when Sartre became ill? And was work on the remainder of the manuscript resumed between the completion and premiere of *Les Sequestres d'Altona* a year later and Sartre's exhilarating trip to Cuba in early 1960? In other words, was the play's grim tone, reflecting in part Sartre's relation to the war in Algeria, the Left's prostration, and De Gaulle's return to power, paralleled by a drastic internal shift *within* the *Critique?*

Although only a carefully dated biography can answer these questions in terms of Sartre's life, a close reading of Volume Two will answer them in terms of Sartre's thought. It reveals, in fact, the philosophical and political logic of the shift. Its internal causes are two: first, Sartre's analysis discloses the inevitable deviation of Bolshevism which gave rise to the Soviet and Stalinist monster; and second, his individualist ontology reaches the limits of its explanatory power well before attaining the goals of the project. The first leads him to write off the Soviet Union and, consequently, the French

Communist Party, and to turn elsewhere for political sustenance; the second marks the end of Sartre's efforts as a social philosopher.

To see the dramatic reversal of penetration and power, let us look back for a moment to the manuscript's high point. In his discussion of the formation of the Soviet elite and in his ensuing analyses of the Soviet demographic changes and of collectivization, Sartre has achieved a main goal of the *Critique:* the intelligibility, rooted in praxis, of the material structures which dominate human action. He sees more deeply and clearly here than anywhere else in the two volumes. He shows convincingly how human action can turn back on itself to create results opposite to those it intends, how a "given" such as the Soviet hierarchy was created to save a revolution committed to abolishing all hierarchy, and how forced collectivization and its accompanying terror have made it impossible to integrate the Soviet peasantry into society down into the present. And in his next discussion Sartre goes on to show how Soviet praxis was carried out by Stalin, the very individual whom such a praxis demanded.

Certainly his examples have a disturbingly necessitarian tone. As if aware of this problem, Sartre argues in several places that nothing justifies the assertion that Stalin's policies were the only ones possible. And in the climactic passage of the manuscript, he emphasizes the way in which "accident"—Stalin's idiosyncracies, his excesses—was *necessary* to Soviet history:

> . . . doubtless, if the process of planned growth could be directed by an angel, praxis would have the maximum unity joined to the maximum objectivity. The angel would never be blind, nor spiteful, nor brutal: it would be in each case whatever it is necessary to be. But precisely for this reason, angels are not individuals; they are abstract models of virtue and wisdom. In a situation the real individual, ignorant, worried, fallible, flustered by the brusque urgency of perils, will react (according to his history) at first too softly, then, at the point of being overwhelmed, too brutally. These jerks, these accelerations, these brakings, these hairpin turns, these violences which characterize Stalinism, were not all required by the objectives and the demands of socialization. However, they were inevitable in so far as this socialization demanded, in its first phase, to be directed by one individual.[76]

And what follows is certainly not without interest or importance. Sartre undertakes, after all, the Herculean task of accounting for the domination of human activity by the practical field originally created by that activity. But neither sharp nor clear, his argument wanders along at a devilishly slow pace, characterized not by accustomed Sartrean flashes of insight but by redundancy and a paucity of examples. Much of the argument has been made before in his discussion of the practico-inert in Volume One. The crucial concept of *need,* which remains left out for most of

the 600,000 words of the two volumes, is brought in only at the end as an apparent afterthought; yet *need* had to be the theoretical underpinning of the entire project. Sartre's final argument on behalf of human praxis seems a gallant but rather tired restatement of the basic Sartrean position. And the manuscript contains flagrant errors, most notably in the characterization of Stalin's anti-Semitism as *racist*. Moreover, Sartre's exaggerated sense of the extent of deviation of the Communist project would be belied by the continued return of Eastern bloc intellectuals and workers to the *original* vision of socialism. But no doubt the difficulty of Sartre's undertaking itself could be held liable for many of its problems. Indeed, wouldn't an ever more ponderous vocabulary and the manuscript's drifts and fluctuations of direction be accounted for—and perhaps excused—by Sartre's heroic venture?

Many of its shortcomings would certainly be excusable if the manuscript had not strayed decisively off the path, taking up radically out of place the question of the totalization of envelopment and without having first forged the appropriate tools. To consider the way in which the final two-fifths of the manuscript aborts the whole project, we must recall the stated purpose of the *Critique,* especially of Volume Two. Within the broad goals of ascertaining the intelligibility of human history, of providing a foundation for historical materialism and setting out the limits of the dialectic, Sartre has in Volume Two specifically hoped to render class struggle intelligible. We may recall that he asked at the outset how, given an infinite multiplicity of individual systems and praxes, there could "be dialectical intelligibility of the process in course."[77] That is, How can opposed individuals and collectivities, struggling against each other, produce *a single* history?

If we keep this formal goal in mind, it is strikingly clear that the manuscript never even begins to approach the question of class struggle. The boxers, subgroups, and Party factions show us conflicting praxes, but within an already integrated group. In fact, instead of studying history as a plurality of praxes cohering somehow —the *how* to be the actual objective of study—he chose to study the history of a totalitarian state, from the perspective of its domination by a single praxis. What the project *was to be* about might have led him, within this study, to show a plurality of divergent projects coexisting under Stalin, united not by external intention or terror but by their own internal relations. This at least would have led toward answering the question of how separate, opposing groups can make *a* single history. On the contrary, what the project *became,* so strikingly different, was the study of a single praxis becoming dominated and deviated by *its own* products. Even so, the Soviet example may still have found its place in Sartre's original purpose by providing keys—for example, *deviation, circu-*

larity, incarnation, the totalization of envelopment—to be used to chart the cohering of disparate and antagonistic praxes.

In other words, through his study of Stalin we still cannot say that Sartre has decisively strayed, and certainly the strengths of that study would in any case lead us to seek a place for it. But once Sartre has formulated his general conclusions about *deviation* in the pages that follow, there is no question that the second volume must *now* turn to redeem its pledge. Instead Sartre raises the already general reflections to an ontological level as if he had already completed the project which alone could justify such meditations—the study of class struggle. If we survey world history, its accruing *totalization of envelopment* only rarely and fleetingly results from a single dominant praxis. The dialectic of history—and perforce of historical materialism—is rather one unfolding through the colliding and overlapping intentionalities of millions. Its story, as Sartre himself said at the conclusion of Volume One, is that of "a totalization without a totalizer." Its comprehension therefore demands precisely the kind of study announced by Sartre.

The Turning Point

But why did Sartre avoid this project, returning instead to more timeless reflections in the vein of *L'Etre et le Néant*? Possible answers to this question emerge from studying the manuscript yet more closely in terms of its original purposes. First, what was the outcome of Sartre's political project in writing the *Critique*? And, second, how adequate were Sartre's tools for achieving his formal project?

Regarding the first question, I have claimed a certain goal for the *Critique,* namely, to explain the hell of successful socialist revolution with an eye to its humanization. No single statement, but rather Sartre's entire political evolution, requires this formulation. Sartre's every political step after 1948 is a search for zones of hope, for a socialism which would be both rooted in the real world and fit for human beings. Hungary only intensified this search and made theoretical study of the "monster" more urgent. What now is the result of this study? Immediately after his discussion of Stalin, Sartre concludes that "Stalinism saved socialization in deviating socialism"; it remains for his successors, who have received the means from him, to correct this deviation.[78] But why should they want to correct it? Even the most casual reader of this summary of the manuscript must know that its *main conclusion* is that praxis deviates its *agents* without their even knowing it—meaning that a new society has indeed been created but that it is one whose rulers *believe in* their privileges. The original goals of socialism have been partially accomplished and partially abandoned—but

above all they have been transformed—by Soviet praxis. They are *no longer* the goal of the Soviet Union in 1959.

We might indeed quarrel with the necessitarianism of much of Sartre's analysis. He is unquestionably saying that the Revolution had to pursue its *very* course to survive, from "socialism in one country" to Stalin's postwar anti-Semitism. Sartre has, however, adumbrated a logic of deviation in which we see how the greatest of human visions became barbaric in order to fulfill its promise. To the extent that Sartre is convincing, we should be under no illusion that the Soviet leaders of 1959 shared his vision of a humane socialism or indeed would have felt anything but threatened by it. This means that the *Critique* project, politically at least, was doomed to end in discouragement. It is one thing to show the revolution institutionalizing itself in a sovereign to save itself, and still another to show that sovereign required to use terror and rely on privilege to build a modern society *against* its citizens; but no room for change remains if his successors receive the technical means for liberation through a decisively deviated outlook and social structure which are bent on continuing domination. In *Le Fantôme de Staline* Sartre showed the Soviet monstrosity as having been required by past conditions and called upon Stalin's heirs to jettison his baggage in the new situation. The *Critique,* Volume Two, scotches as naive such visions of free action and humane intentions in the present and future: these men are every bit as determined and blinded by Stalin and his accomplishments as he was by the urgencies he faced.

But if the manuscript points toward political disillusionment, why did Sartre also lose heart philosophically and not pursue his intended explanation of class struggle? To answer this question, we need only speculate on how that analysis would have had to look. What, for example, would be its key terms? And how, for example, would it unfold? Be the contenders gardener and road mender or two boxers—or, indeed, in a possible study of class struggle a trade union on strike against a capitalist—Sartre would be required early in his analysis to show their *internal* connections. In other words, no explanation of their struggle is possible without reference to their prior or coeval cooperation, and this cooperation raises the specter of that "hyperorganism," society. Cooperation within struggle remains unintelligible without appealing to a commonly shared social layer at the heart of these radically separated individuals or groups.[79] But in saying this let us also be clear that Sartre's question itself *stems from* his vision of their fundamental separation and Sartre's rejection of any hyperorganism—*society*—to explain their interaction. "Society" is in fact the missing term of the entire project, whether it is regarded as standing outside the individuals/classes or at their core. Rejecting it from the outset, Sartre must mystify social processes and yet be driven again and again to pose the question of how these separate individuals produce larger unities.

In other words, Sartre cannot explain class struggle after his discussion of the Soviet Union, or at any other time, without revising the fundamental premise of the *Critique*—as the act of separated individuals. The manuscript was in this sense doomed in advance to avoid its motivating question, and so, when time came to answer it, Sartre could only avoid it once more, by ascending to the ontological conclusions whose clarity presupposed his answering the very question he avoided.

This may perhaps explain my earlier remark about Sartre's discussion of the totalization of envelopment, namely, that it appears *out of place*. As the practical field created by us which yet deviates our purposes it can only be understood as the entire historical-social field. Yet Sartre does not develop the keys to let us understand the totalization of envelopment—or indeed to let us understand praxis, except as individual or as dominated by an individual. As complex as Sartre's discussion is, it remains one-dimensional without first considering how this enveloping totalization is a *collective* product, created under both conflict and cooperation. Vital determinations of my praxis are missing from Sartre's vision of praxis deviated by *its* product: its shaping by those with whom I cooperate and by those with whom I struggle.

This rapid sketch of its internal problems should help explain some of the troubling features of Sartre's unfinished manuscript. For example, one of its key concepts, *incarnation,* is never made sufficiently clear. Why? Because it appeals to, but cannot articulate, the social layer Sartre has expelled from his analysis from the start. As a result, we again and again are asked to see how, for example, the boxers *incarnate* violent struggle in this society or how Stalin's praxis *incarnated* socialism by deviating it. But because the concept makes implicit appeal to a generalized social layer which it cannot name as such in Sartre's radicalized individualist framework, incarnation must remain murky and unilluminating.

Similarly, these comments should help explain the punchless, redundant quality of the final two-fifths of a manuscript that moved so slowly because it had nowhere to go. Furthermore, we can see why until the very end its analyses are mostly cloaked in negativity. Even more than Volume One, Volume Two explores the logic of alienation, an alienation endemic to praxis regardless of its social framework. Sartre emphasizes the deviation, emphasizes praxis being overwhelmed by its results, and only briefly speculates about some day controlling this circularity. But if part of the logic of negativity—the social part—is suppressed, so will be the routes to its reversal. Such a totalization of envelopment, deviated in its very ontological structure, must indeed appear as an immovable force to the isolated individual who, in Sartre's analysis, is doomed to confront it alone.

In the end, however, the fundamental feature of the manuscript is that, in spite of its richness, Sartre abandoned it and refused to publish it during

his lifetime. This external fact is indeed an internal one: an unfinished manuscript is not a book and imposes on us the *why* of its suppression. Can we say that we now understand why it did not see the light of day? I believe so. Technically speaking a failed project, the *Critique* was therefore a turning point of Sartre's energies. Insofar as it succeeded, Volume Two seemed to show that the Soviet Union was hopelessly deviated. Insofar as it failed, it did so because Sartre *could not* complete it, would indeed have had to be a different thinker with different premises in order to do so.

The consequences were enormous. For ten years his political hopes would be transferred to the Third World and in any case would never return to the universe of communism. As a philosopher he would cease writing, abandoning forever the goal of understanding human history. Still, Sartre embarked on the equally ambitious project of understanding a single man, Gustave Flaubert. This project too yielded great riches. But it likewise remained unfinished, adrift on the question of Flaubert the social individual, author of *Madame Bovary*.[80]

In this essay and elsewhere I have argued that collectivity is the missing dimension of Sartre's itinerary; his last interviews confirmed that he had become aware of this.[81] The problem was that he saw dependence and society as fundamentally negative and oppressive dimensions of life and fought against them theoretically even while proclaiming them politically. I have argued, against Sartre, for the fundamentally positive nature of collectivity, that it is indeed constitutive of us in our deepest individuality.

Accordingly, I am acutely aware that this essay about an unpublished manuscript seen by not even a handful of people has been just a single reading, by just one individual. I look forward to the publication of Volume Two, not merely to confirm or deny this study, but to create that collectivity of reading which alone can give it its meaning and integrate it into the history of Sartre's thought.

<div align="right">RONALD ARONSON</div>

UNIVERSITY STUDIES
WAYNE STATE UNIVERSITY

NOTES

1. Michel Contat and Michel Rybalka, *Les Ecrits de Sartre: Chronologie, bibliographie commentée* (Paris, 1970); tr. by Richard C. Cleary, *The Writings of Jean-Paul Sartre* (Evanston, Ill., 1974), 60/332.

2. As "Socialism in One Country," *New Left Review,* 100 (November 1976–January 1977); hereinafter *NLR.* NLB plans the first publication of the entire manuscript. The author wishes to thank NLB for making the manuscript available to him.

3. See the extended discussion in my *Jean-Paul Sartre: Philosophy in the World* (London, 1980), part III, chapters 1–3.

4. *Le Fantôme de Staline*, in *Situations*, VII (Paris, 1965); tr. by Irene Clephane, *The Spectre of Stalin* (London, 1969), pp. 71–90.

5. *Critique de la raison dialectique*. vol. I: *Théorie des ensembles pratiques* (Paris, 1960), p. 755; tr. by Alan Sheridan-Smith, *Critique of Dialectical Reason*. I: *Theory of Practical Ensembles* (London, 1976), p. 818.

6. For the following, through the discussion of Stalin, see Aronson, *Jean-Paul Sartre*, part III, chapter 4.

7. *Critique de la raison dialectique*, vol. II (unpublished manuscript), p. 20; hereinafter *CRD*.

8. *CRD*, p. 20.

9. *CRD*, pp. 25–26.

10. *CRD*, p. 30.

11. *CRD*, p. 148; this section appeared in English in *NLR*, 100, p. 143.

12. *CRD*, p. 212; *NLR*, p. 149.

13. *CRD*, p. 226; *NLR*, p. 155.

14. *CRD*, p. 228; *NLR*, p. 156.

15. *CRD*, p. 240; *NLR*, p. 161.

16. *CRD*, p. 246; *NLR*, p. 163.

17. *CRD*, p. 317.

18. *CRD*, p. 290.

19. *CRD*, p. 265.

20. *CRD*, p. 286.

21. *CRD*, p. 281.

22. *CRD*, p. 281.

23. *CRD*, p. 289.

24. *CRD*, p. 291.

25. *CRD*, p. 426.

26. *CRD*, p. 426.

27. *CRD*, p. 445.

28. *CRD*, p. 451.

29. *CRD*, p. 452.

30. *CRD*, p. 452.

31. *CRD*, p. 460.

32. *CRD*, p. 490.

33. *CRD*, p. 500.

34. *CRD*, p. 500.

35. *CRD*, p. 503.

36. *CRD*, p. 505.

37. *CRD*, p. 526.

38. *CRD*, p. 539.

39. *CRD*, p. 554.

40. *CRD*, p. 553.

41. *CRD*, p. 555.

42. *CRD*, p. 573.

43. *CRD*, p. 573.

44. *CRD*, p. 579.

45. *CRD*, p. 580.

46. *CRD*, p. 594.

47. *CRD*, p. 609.

48. *CRD*, p. 614.

49. *CRD*, p. 615.

50. *CRD*, p. 616.

51. *CRD*, p. 618.

52. *CRD*, p. 623.

53. *CRD*, p. 629.

54. *CRD*, p. 631.

55. *CRD*, p. 632.
56. *CRD*, p. 634.
57. *CRD*, p. 635.
58. *CRD*, p. 649.
59. *CRD*, p. 655.
60. *CRD*, p. 676.
61. *CRD*, p. 699.
62. *CRD*, p. 702.
63. *CRD*, p. 703.
64. *CRD*, p. 709.
65. *CRD*, p. 713.
66. *CRD*, p. 713.
67. *CRD*, p. 715.
68. *CRD*, p. 735.
69. *CRD*, p. 736.
70. *CRD*, p. 749.
71. *CRD*, p. 749.
72. *CRD*, p. 758.
73. *CRD*, p. 760.
74. *CRD*, p. 765.
75. *CRD*, pp. 780–81.
76. *CRD*, p. 435.
77. *CRD*, p. 3.
78. *CRD*, p. 472.
79. For this argument, see Aronson, *Jean-Paul Sartre,* part III, chapter 4.
80. See Aronson, *Jean-Paul Sartre,* part IV, chapter 3.
81. See Benny Lévy, "The Last Words of Jean-Paul Sartre," interview, *Dissent* (Fall 1980).

PART THREE

JEAN-PAUL SARTRE: A SELECTED GENERAL BIBLIOGRAPHY

Compiled by Michel Rybalka

I. WORKS BY SARTRE

Listed below, chronologically arranged, are Sartre's main works, with their English translations. For more detailed information, please consult: Contat, Michel, and Rybalka, Michel. *Les Ecrits de Sartre*. Gallimard, 1970. Revised edition, translated by Richard C. McCleary: *The Writings of Jean-Paul Sartre*, 2 vols. Evanston, Ill.: Northwestern University Press, 1974.

This work has been updated in *Magazine Littéraire*, no. 55–56 (September 1971): 36–47, and no. 103–104 (September 1975): 9–49; and in *Obliques*, no. 18–19 (1979): 331–47. The same issue of *Obliques* contains a bibliography of works on Sartre by Robert Wilcocks (pp. 348–57) and a "Bibliographie espagnole et latino-américaine" by Paul Aubert (pp. 358–60).

Les Ecrits de Sartre can also be consulted for a number of unpublished texts by Sartre, especially *Bariona*, the Christmas play he wrote in 1940.

The following pages give dates of original publication only. When place of publication is not mentioned, it is Paris.

L'Imagination. Librairie Félix Alcan, 1936; P.U.F., 1949.

> *Imagination: A Psychological Critique*. Tr. by Forrest Williams. Ann Arbor: University of Michigan Press, 1962.

La Transcendance de l'ego. First appeared in *Recherches Philosophiques*, vol. VI, 1936–1937, then in a volume edited by Sylvie Le Bon: Vrin, 1965.

> *The Transcendence of the Ego*. Tr. by Forrest Williams and Robert Kirkpatrick. New York: Noonday Press, 1957.

La Nausée. Gallimard, 1938.

> *Nausea*. Tr. by Lloyd Alexander. New York: New Directions, 1949.

> *The Diary of Antoine Roquentin*. Tr. by Lloyd Alexander. London: John Lehmann, 1949.

> *Nausea*. Tr. by Robert Baldick. Penguin Books, 1965.

Le Mur. Gallimard, 1939.

> *The Wall and Other Stories*. Tr. by Lloyd Alexander. New York: New Directions, 1948.

Intimacy and Other Stories. Tr. by Lloyd Alexander. London: Peter Neville, 1949.

Esquisse d'une théorie des émotions. Hermann, 1939.

The Emotions: Outline of a Theory. Tr. by Bernard Frechtman. New York: Philosophical Library, 1948.

Sketch for a Theory of Emotions. Tr. by Philip Mairet. London: Methuen, 1962.

L'Imaginaire: Psychologie phénoménologique de l'imagination. Gallimard, 1940.

Psychology of the Imagination. Tr. by Bernard Frechtman. New York: Philosophical Library, 1948.

Les Mouches. Gallimard, 1943.

The Flies. Tr. by Stuart Gilbert. In volume with *No Exit,* New York: Knopf, 1947.

L'Etre et le Néant: Essai d'ontologie phénoménologique. Gallimard, 1943.

Being and Nothingness. Tr. by Hazel Barnes. New York: Philosophical Library, 1956.

Huis clos. First published in *L'Arbalète,* 1944, then in volume: Gallimard, 1945.

No Exit. Tr. by Stuart Gilbert. In volume with *The Flies,* New York: Knopf, 1947. English edition (London: Hamish Hamilton, 1946) entitled *In Camera.*

No Exit. Tr. by Lionel Abel. In *No Exit and Three Other Plays.* New York: Vintage Books, 1955.

L'Age de raison. Gallimard, 1945.

The Age of Reason. Tr. by Eric Sutton. New York: Knopf, 1947. Revised tr., Penguin Books, 1961.

Le Sursis. Gallimard, 1945.

The Reprieve. Tr. by Eric Sutton. New York: Knopf, 1947. Revised tr., Penguin Books, 1963.

L'Existentialisme est un humanisme. Nagel, 1946.

Existentialism. Tr. by Bernard Frechtman. New York: Philosophical Library, 1947.

Existentialism and Humanism. Tr. by Philip Mairet. London: Methuen, 1948.

Morts sans sépulture. Lausanne: Marguerat, 1946. Modified text in *Théâtre,* I. Gallimard, 1947.

The Victors. Tr. by Lionel Abel. In *Three Plays,* New York: Knopf, 1949.

Men Without Shadows. Tr. by Kitty Black. In *Three Plays,* London: Hamish Hamilton, 1949.

La Putain respectueuse. Nagel, 1946. In *Théâtre,* I. Gallimard, 1947.

The Respectful Prostitute. Tr. by Lionel Abel. In *Three Plays,* New York: Knopf, 1949.

The Respectful Prostitute. Tr. by Kitty Black. In *Three Plays,* London: Hamish Hamilton, 1949.

Réflexions sur la question juive. Morihien, 1946; Gallimard, 1954.

Anti-Semite and Jew. Tr. by George J. Becker. New York: Schocken, 1948.

Portrait of the Anti-Semite. Tr. by Eric de Mauny. London: Secker and Warburg, 1948.

Baudelaire. Point du Jour, 1946; Gallimard, 1947.

Baudelaire. Tr. by Martin Turnell. London: Horizon Press, 1949; New York: New Directions, 1950.

Situations, I. Gallimard, 1947.

Partly tr. as *Literary and Philosophical Essays* by Annette Michelson. New York: Criterion Books, 1955.

Les Jeux sont faits. Nagel, 1947.

The Chips Are Down, tr. by Louise Varese. New York: Lear, 1948.

Les Mains sales. Gallimard, 1948.

Dirty Hands. Tr. by Lionel Abel. In *Three Plays,* New York: Knopf, 1949.

Crime passionnel. Tr. by Kitty Black. In *Three Plays,* London: Hamish Hamilton, 1949.

L'Engrenage. Nagel, 1948.

In the Mesh. Tr. by Mervyn Savill. London: Andrew Dakers, 1954.

Situations, II. Gallimard, 1948.

Major part tr. as *What Is Literature?* by B. Frechtman. New York: Philosophical Library, 1949.

Orphée noir. First published in *Anthologie de la nouvelle poésie nègre et malgache,* Leopold Sedar Senghor, ed., 1948, then in *Situations,* III, 1949.

Black Orpheus. Tr. by S. W. Allen. Présence Africaine, 1963.

Black Orpheus. Tr. by Arthur Gilette. New York: University Place Book Shop, 1963.

Situations, III. Gallimard, 1949.

Partly tr. by Annette Michelson in *Literary and Philosophical Essays,* 1955. Other essays tr. by Wade Baskin et al.

La Mort dans l'âme. Gallimard, 1949.

> *Iron in the Soul.* Tr. by Gerard Hopkins. London: Hamish Hamilton, 1950.
>
> *Troubled Sleep.* Tr. by Gerard Hopkins. New York: Knopf, 1951.

Entretiens sur la politique, with David Rousset and Gérard Rosenthal. Gallimard, 1949.

> No translation.

Le Diable et le bon Dieu. Gallimard, 1951.

> *Lucifer and the Good Lord.* Tr. by Kitty Black. London: Hamish Hamilton, 1953.
>
> *The Devil and the Good Lord.* Tr. by S. and G. Leeson. New York: Knopf, 1960.

Saint Genet, comédien et martyr. Gallimard, 1952.

> *Saint Genet, Actor and Martyr.* Tr. by B. Frechtman. New York: G. Braziller, 1963.

Kean. Gallimard, 1954.

> *Kean.* Tr. by Kitty Black. London: Hamish Hamilton, 1954.

Nekrassov. Gallimard, 1956.

> *Nekrassov.* Tr. by S. and G. Leeson. London: Hamish Hamilton, 1956.

Les Séquestrés d'Altona. Gallimard, 1960.

> *Loser Wins.* Tr. by Sylvia and George Leeson. London: Hamish Hamilton, 1960.
>
> *The Condemned of Altona.* Tr. by Sylvia and George Leeson. New York: Knopf, 1961.

Critique de la raison dialectique. Gallimard, 1960.

> Large excerpts tr. by Starr and James B. Atkinson in *The Philosophy of Jean-Paul Sartre,* ed. by Robert D. Cumming. New York: Random House, 1965.
>
> *Critique of Dialectical Reason.* Tr. by Alan Sheridan-Smith. London: NLB [New Left Books], 1976.

Question de méthode. First published in Polish periodical *Twórczość,* 1957, then in *Critique de la raison dialectique.* Separate volume: Gallimard, 1967.

> *Search for a Method.* Tr. by Hazel E. Barnes. New York: Knopf, 1963.
>
> *Problem of Method.* Tr. by Hazel E. Barnes. London: Methuen, 1964.

"Ouragan sur le sucre," first published in *France-Soir,* 1960.

> *Sartre on Cuba.* New York: Ballantine Books, 1961.

Les Mots. Gallimard, 1964.

Words. Tr. by Irene Clephane. London: Hamish Hamilton, 1964.

The Words. Tr. by B. Frechtman. New York: G. Braziller, 1964.

Situations, IV. Gallimard, 1964.

Situations. Tr. in part by Benita Eisler and in part by Maria Jolas. New York: G. Braziller, 1965.

Situations, V. Gallimard, 1964.

Mostly untranslated.

Situations, VI. Gallimard, 1964.

Part of volume tr. as *The Communists and Peace* by Martha E. Fletcher. New York: G. Braziller, 1968. Other tr. of same by Irene Clephane, London: Hamish Hamilton, 1969.

Les Troyennes. Gallimard, 1966.

The Trojan Women. Tr. by Ronald Duncan. New York: Knopf, 1967.

Situations, VII. Gallimard, 1965.

"A Reply to Claude Lefort" tr. by Philip Berk in *The Communists and Peace.* New York: G. Braziller, 1968.

The Ghost of Stalin. Tr. by Martha E. Fletcher. New York: G. Braziller, 1968.

L'Idiot de la famille, I and II. Gallimard, 1971.

English tr. by University of Chicago Press. German tr. by Traugott König. Reinbeck bei Hamburg: Rowohlt.

L'Idiot de la famille, III. Gallimard, 1972.

No translation.

Situations, VIII and IX. Gallimard, 1972.

Parts of both volumes tr. by John Matthews as *Between Existentialism and Marxism.* London: NLB, 1974.

Un Théâtre de situations, ed. by M. Contat and M. Rybalka. Gallimard, 1973.

Sartre on Theater. Tr. by Frank Jellinek. New York: Pantheon Books, 1975.

On a raison de se révolter, with Philippe Gavi and Pierre Victor. Gallimard, 1974.

No translation.

Situations, X. Gallimard, 1976.

Life/Situations. Tr. by Paul Auster and Lydia Davis. New York: Pantheon Books, 1977.

Sartre, texte du film réalisé par Alexandre Astruc et Michel Contat. Gallimard, 1977.

Sartre by Himself. Tr. by Richard Seaver. New York: Urizen Books, 1978.

Iconography

Sartre: Images d'une vie. Compiled by Liliane Sendyk-Siegel, with commentary by Simone de Beauvoir. Gallimard, 1978.

II. STUDIES ON SARTRE

The following list includes most of the books published on Sartre and a few select articles which have appeared in periodicals. For a more thorough listing, please consult:

> Wilcocks, Robert. *Jean-Paul Sartre: A Bibliography of International Criticism.* Edmonton: University of Alberta Press, 1975.

> Lapointe, François and Claire. *Jean-Paul Sartre and His Critics: An International Bibliography (1938–1975).* Bowling Green, Ken.: Philosophy Documentation Center, 1975. This volume contains a number of errors, but is nevertheless useful. Revised edition scheduled for 1981.

> Belkind, Allen J. *Jean-Paul Sartre and Existentialism in English: A Bibliographical Guide.* Kent, Ohio: Kent State University Press, 1970. Now obsolete.

For bibliographies with critical comments, please see:

> Douglas, Kenneth. *A Critical Bibliography of Existentialism.* New Haven: Yale French Studies, 1950. Kraus reprint, 1966.

> Alden, Douglas, and Brooks, Richard A. *A Critical Bibliography of French Literature,* vol. VI, pt. 3, pp. 1524–72. Syracuse, N.Y.: Syracuse University Press, 1980.

Adereth, Maxwell. *Commitment in Modern French Literature: Politics and Society in Péguy, Aragon, and Sartre.* London: Gollancz, 1967; New York: Schocken Books, 1968. On Sartre, pp. 127–91.

Albérès, René Marill. *Jean-Paul Sartre.* Editions Universitaires, Classiques du XXe Siècle, 1953. 7th ed., rev., 1972.

> Tr. as *Jean-Paul Sartre: Philosopher Without Faith* by Wade Baskin. New York: Philosophical Library, 1961.

> Several other translations in Spanish, Dutch, etc.

Anderson, Thomas C. *The Foundation and Structure of Sartrean Ethics.* Lawrence: Regents Press of Kansas, 1979.

Arnold, Albert James, and Piriou, Jean-Pierre. *Genèse et critique d'une autobiographie:* Les Mots *de Jean-Paul Sartre.* Minard, Archives des Lettres Modernes, 1973.

Arntz, Joseph. *De Liefde in de ontologie van J.-P. Sartre.* Nijmegen: Drukk. Gebr. Janssen, 1960.

Aron, Raymond. *Histoire et dialectique de la violence.* Gallimard, 1973.

Tr. as *History and the Dialectic of Violence* by Barry Cooper. Oxford: Blackwell, 1975.

See also Aron's *L'Opium des intellectuels* (Calmann-Lévy, 1955; English tr., 1957) and *D'une Sainte Famille à l'autre: Essais sur les marxismes imaginaires* (Gallimard, 1969; English tr., 1969).

Audry, Colette, ed. *Pour ou contre l'existentialisme.* Ed. Atlas, 1948.

———. *Sartre et la réalité humaine.* Seghers, Philosophes de Tous les Temps, 1966.

Barnes, Hazel E. *Humanistic Existentialism: The Literature of Possibility.* Lincoln: University of Nebraska Press, 1959.

———. *Sartre,* New York: Lippincott, 1973.

Barrett, William. *Irrational Man: A Study in Existential Philosophy.* Garden City, N.Y.: Doubleday, 1962.

Bataille, Georges. *La Littérature et le mal.* Gallimard, 1957. On Sartre's *Baudelaire,* see pp. 35–67.

Bauer, George H. *Sartre and the Artist.* Chicago: University of Chicago Press, 1969.

Bausola, Adriano. *Il Problema della libertà: Introduzione a Sartre.* Milano: Celuc, 1971.

Bauters, Paul. *Jean-Paul Sartre.* Brugge: Desclee de Brouwer, 1964. In Flemish.

Beigbeder, Marc. *L'Homme Sartre: Essai de dévoilement pré-existentiel.* Bordas, 1947.

Biemel, Walter. *Jean-Paul Sartre in Selbstzeugnissen und Bilddokumenten.* Reinbeck bei Hamburg: Rowohlt, 1964.

Bishop, Thomas. *Huis clos de Jean-Paul Sartre.* Hachette, 1975.

Bolle, Louis. *Les Lettres et l'absolu: Valéry, Sartre, Proust.* Genève: Perret-Gentil, 1959.

Borello, Oreste. *Studi su Sartre.* Bologna: Capelli, 1964.

Boros, Marie-Denise. *Un séquestré: L'Homme sartrien.* Nizet, 1968.

Boutang, Pierre, and Pingaud, Bernard. *Sartre est-il un possédé?* Ed. de la Table Ronde, 1946.

Brée, Germaine. *Camus and Sartre.* New York: Delta Books, 1972.

Briosi, Sandro. *Il Pensiero di Sartre.* Ravenna: Longo, 1978.

Brufau-Prats, Jaime. *Moral, vida social y derecho en Jean-Paul Sartre.* Salamanca: Universidad de Salamanca, 1967.

———. *Líneas fundamentales de la ontología y antropología de Sartre en* L'Etre et le Néant. Salamanca: Universidad de Salamanca, 1971.

Burnier, Michel-Antoine. *Les Existentialistes et la politique.* Gallimard, 1966. English tr. by B. Murchland, 1968.

Cabús, José D. *Sartre, Castro y el azúcar.* Mexico: Ed. Mexicanos Unidos, 1965.

Campbell, Robert. *Jean-Paul Sartre ou une littérature philosophique.* Pierre Ardent, 1945. Rev. ed., 1947 and 1965.

Carson, Ronald A. *Jean-Paul Sartre.* Valley Forge, Pa.: Judson Press, 1974.

Catalano, Joseph. *A Commentary on Sartre's* Being and Nothingness. New York: Harper, 1974. Chicago: University of Chicago Press, 1980.

Cavaciuti, S. *L'Ontologia di Jean-Paul Sartre.* Milano: Marzorati, 1969.

Caws, Peter. *Sartre.* London/Boston: Routledge and Kegan Paul, Arguments of the Philosophers, 1979.

Cera, Giovanni. *Sartre tra ideologia e storia.* Bari: Ed. Laterza, 1972.

Ceroni, Angelo. *L'Alterità in Sartre.* Milano: Marzorati, 1974.

Champigny, Robert. *Stages on Sartre's Way, 1938–1952.* Bloomington, Ind.: Indiana University Press, 1959.

———. *Pour une esthétique de l'essai: Breton, Sartre, Robbe-Grillet.* Minard, 1967. On Sartre, pp. 29–57.

———. *Humanisme et racisme humain.* Ed. Saint-Germain-des-Prés, 1972. English tr., The Hague: Mouton, 1972.

Chieppa, Vincenzo. *Pirandello e Sartre.* Firenze: Kursaal, 1967.

Chiodi, Pietro. *Sartre e il marxismo.* Milano: Feltrinelli, 1965. English tr. by Kate Soper. Atlantic Highlands, N.J.: Humanities Press, 1976.

Coffy, Robert. *Le Dieu des athées: Marx, Sartre, Camus.* Lyon: Chronique Sociale de France, 1965.

Collins, Douglas. *Sartre as Biographer.* Cambridge: Harvard University Press, 1980.

Contat, Michel. *Explication des* Séquestrés d'Altona. Minard, 1968.

Cormeau, Nelly. *La Littérature existentialiste: Le Roman et le théâtre de Jean-Paul Sartre.* Liège: G. Thone, 1950.

Cotroneo, Girolamo. *Sartre, rareté e storia.* Napoli: Guida, 1976.

Craib, Ian. *Existentialism and Sociology: A Study of Jean-Paul Sartre.* Cambridge: Cambridge University Press, 1976.

Cranston, Maurice W. *Jean-Paul Sartre.* New York: Grove Press, 1962.

————. *The Quintessence of Sartrism*. Montreal: Harvest House, 1970. French tr. published at the same time.

Cumming, Robert D. *Starting Point: An Introduction to the Dialectic of Existence.* Chicago: University of Chicago Press, 1979.

Cunillera, Antonio. *Sartre y el existencialismo*. Barcelona: Lib. Cervantes, 1968.

Dalma, Juan. *Jean-Paul Sartre*. Buenos Aires: Centro Editor de America Latina, 1968.

Danto, Arthur C. *Jean-Paul Sartre*. New York: Viking Press, 1975. German tr., 1977.

Dempsey, Peter. *The Psychology of Sartre*. Eire: Cork University Press, 1950.

Desan, Wilfrid. *The Tragic Finale: An Essay on the Philosophy of Jean-Paul Sartre.* Cambridge: Harvard University Press, 1954; Harper, 1960.

————. *The Marxism of Jean-Paul Sartre*. Garden City, N.Y.: Doubleday, 1965. Spanish tr., Buenos Aires, 1971.

Diaz, Raymond. *Les Cadres sociaux de l'ontologie sartrienne*. Diffusion H. Champion, 1975. Doctoral thesis.

Dutton, K. R. *Thesis and Theatre: Sartre's* Les Mains sales. North Ryde, N.S.W.: Macquarie University, 1977.

Falconi, Carlo. *Jean-Paul Sartre*. Modena: U. Guanda, 1948.

Falk, Eugene H. *Types of Thematic Structure. The Nature and Function of Motifs in Gide, Camus, and Sartre.* Chicago: University of Chicago Press, 1967.

Fatone, Vicente. *El Existencialismo y la libertad creadora: Una crítica al existencialismo de Jean-Paul Sartre.* Buenos Aires: Argos, 1948.

Faucitano, Filiberto. L'Essere e il Nulla *di Jean-Paul Sartre*. Napoli: S. Iodice, 1959.

Fe, Franco. *Sartre e il communismo*. Firenze: La Nuova Italia, 1970.

Fell, Joseph P. *Heidegger and Sartre: An Essay on Being and Place.* New York: Columbia University Press, 1979.

————. *Emotion in the Thought of Sartre*. New York: Columbia University Press, 1965.

Fitch, Brian T. *Le Sentiment d'étrangeté chez Malraux, Sartre, Camus, Simone de Beauvoir.* Minard, 1964. On Sartre, pp. 95–139.

Flam, Leopold. *De Walg van Jean-Paul Sartre*. Vilvoorde, Belg.: Dethier, 1960.

Fritsch, Renate. *Motive, Bilder und Schlüsselwörter in Jean-Paul Sartres literarischen Werken.* Bern: Herbert Lang; Frankfurt: Peter Lang, 1976.

Gabriel, Leo. *Existenzphilosophie von Kierkegaard bis Sartre*. Vienna: Verlag Herold, 1951. On Sartre, pp. 223–72.

Gagnebin, Laurent. *Connaître Sartre.* Ed. Resma, 1972; Ed. Marabout, 1977.

Galler, Dieter. *Kretschmers Typologie in den dramatischen Charakteren Sartres.* München: Huebner, 1967.

Gallo, Blas Raúl. *Jean-Paul Sartre y el marxismo.* Buenos Aires: Ed. Quetzal, 1966.

Garaudy, Roger. *Une Littérature de fossoyeurs: Un Faux prophète, Jean-Paul Sartre.* Editions Sociales, 1948. English tr., New York, 1948.

——. *Questions à Jean-Paul Sartre.* Revue Clarté, 1960.

George, François. *Deux études sur Sartre.* Christian Bourgois, 1976.

Goldstein, Walter B. *Jean-Paul Sartre und Martin Buber.* Jerusalem: R. Mass, 1965.

Gore, Keith O. *Sartre;* La Nausée *and* Les Mouches. London: Edward Arnold, 1970.

Gorz, André. *Le Socialisme difficile.* Le Seuil, 1967. On Sartre, pp. 215–44.

Greene, Norman N. *Jean-Paul Sartre: The Existentialist Ethic.* Ann Arbor: University of Michigan Press, 1960.

Grene, Marjorie. *Dreadful Freedom: A Critique of Existentialism.* Chicago: University of Chicago Press, 1948.

——. *Sartre.* New York: New Viewpoints, 1973.

Guindey, Guillaume. *Le Drame de la pensée dialectique: Hegel, Marx, Sartre.* Vrin, 1974.

Gutwirth, Rudolf. *La Phénoménologie de Jean-Paul Sartre.* Privat, 1974.

Halpern, Joseph. *Critical Fictions: The Literary Criticism of Jean-Paul Sartre.* New York/London: Yale University Press, 1976.

Hana, Ghanem-George. *Freiheit und Person: Eine Auseinandersetzung mit der Darstellung J.-P. Sartres.* München: Beck, 1965.

Hartmann, Klaus. *Grundzüge der Ontologie Sartres in ihrem Verhältnis zu Hegels Logik: Eine Untersuchung zu* L'Etre et le Néant. Berlin: de Gruyter, 1963. English tr., Northwestern University Press, 1966.

——. *Sartres Sozialphilosophie: Eine Untersuchung zu* Critique de la raison dialectique *I.* Berlin: de Gruyter, 1966.

Hasenhüttl, Gotthold. *Gott ohne Gott: Ein Dialog mit Jean-Paul Sartre, mit d. Weinachtspiel* Bariona. Graz/Cologne: Verlag Styria, 1972.

Haug, Wolfgang F. *Jean-Paul Sartre und die Konstruction des Absurden.* Frankfurt-am-Main: Suhrkampf, 1966.

Helbo, André. *L'Enjeu du discours: Lecture de Sartre.* Bruxelles: Ed. Complexe; Paris: Presses Universitaires de France, 1978.

Herra, Rafael Angel. *Sartre y los prolegómenos a la antropología.* San Jose: Publ. de la Universidad de Costa Rica, 1968.

Hervé, Pierre. *Lettre à Sartre et à quelques autres par la même occasion.* La Table Ronde, 1956.

Hodard, Philippe. *Sartre entre Marx et Freud.* Jean-Pierre Delarge, 1980.

Holz, Hans Heinz. *Jean-Paul Sartre: Darstellung und Kritik seiner Philosophie.* Meisenheim-am-Glan: Westkultur Verlag, 1951.

Horodinca, Georgeta. *Jean-Paul Sartre.* Bucaresti, 1964.

Houbart, Jacques. *Un Père dénaturé: Essai critique sur la philosophie de Jean-Paul Sartre.* Julliard, 1964.

Idt, Geneviève. La Nausée: *Analyse critique.* Hatier, 1971.

———. Le Mur: *Techniques et contexte d'une provocation.* Larousse, 1972.

Invitto, Giovanni, ed. *Colloqui con Sartre.* Lecce: Milella, 1974.

Jameson, Fredric R. *Sartre: The Origins of a Style.* New Haven: Yale University Press, 1961.

Jaroszewski, Tadeusz M. *Der 'verlassene' Mensch Jean-Paul Sartres.* Berlin: Akademie-Verlag, 1950; Franfurt-am-Main: Verlag Marxistische Blätter, 1975.

Jeanson, Francis. *Le Problème moral et la pensée de Sartre.* Le Seuil, 1947. 2d ed. with new chapter, 1965.

———. *Sartre par lui-même.* Le Seuil, 1955. Rev. later.

———. *Sartre.* Desclée de Brouwer, Les Ecrivains devant Dieu, 1966. Italian tr., 1971.

———. *Sartre dans sa vie.* Le Seuil, 1974.

Jolivet, Régis. *Les Doctrines existentialistes de Kierkegaard à Jean-Paul Sartre.* Abbaye de St-Wandrille: Ed. de Fontenelle, 1948. Spanish tr., Madrid, 1969.

———. *Le Problème de la mort chez M. Heidegger et J.-P. Sartre.* Abbaye de St-Wandrille: Ed. de Fontanelle, 1950.

———. *Sartre ou la théologie de l'absurde.* Arthème Fayard, 1965. English tr., 1967.

Joubert, Ingrid. *Aliénation et liberté dans* Les Chemins de la liberté *de Jean-Paul Sartre.* Didier, 1973.

Juin, Hubert. *Jean-Paul Sartre ou la condition humaine.* Paris/Bruxelles: Ed. de la Boétie, 1946.

Kaelin, Eugene F. *An Existentialist Aesthetic: The Theories of Sartre and Merleau-Ponty.* Madison: University of Wisconsin Press, 1962.

Kampits, Peter. *Sartre und die Frage nach dem Anderen.* Wien/München: R. Oldenbourg Verlag, 1975.

Kanapa, Jean. *L'Existentialisme n'est pas un humanisme.* Editions Sociales, 1947.

Kaufmann, Walter A. *Existentialism from Dostoevsky to Sartre.* New York: Meridian Books, 1956.

Kellogg, Jean D. *Dark Prophets of Hope: Dostoievsky, Sartre, Camus, Faulkner.* Chicago: Loyola University Press, 1975.

Kemp, Peter. *Det Ulykkelige Begaer: Grundtanken i Jean-Paul Sartres filosofi.* Copenhagen: Gyldendal, 1966.

Kern, Edith. *Existential Thought and Fictional Technique: Kierkegaard, Sartre, Beckett.* New Haven: Yale University Press, 1970.

———, ed. *Sartre: A Collection of Critical Essays.* Englewood Cliffs, N.J.: Prentice-Hall, 1962.

King, Thomas M. *Sartre and the Sacred.* Chicago: University of Chicago Press, 1974.

Kirsner, Douglas. *The Schizoid World of Jean-Paul Sartre and R. D. Laing.* St. Lucia, Queensland: University of Queensland Press, 1976. On Sartre, pp. 9–115.

Knecht, Ingbert. *Theorie der Entfremdung bei Sartre und Marx.* Bonn: 1972; Meisenheim: Hain, 1975.

Koefoed, Oleg. "L'Oeuvre littéraire de Sartre," *Orbis Litterarum,* 6, no. 3–4 (1948): 209–72; 7, no. 1–2 (1949): 61–138.

Kohut, Karl. *Was ist Literatur? Die Theorie der 'littérature engagée' bei Jean-Paul Sartre.* Marburg, 1965.

König, Traugott, ed. *Sartres Flaubert Lesen: Essays über* Der Idiot Familie. Reinbeck bei Hamburg: Rowohlt, 1980.

Krauss, Henning. *Die Praxis der 'littérature engagée' im Werk Sartres 1938–1948.* Heidelberg, 1970.

Krosigk, F. von. *Philosophie und politische Aktion bei Jean-Paul Sartre.* München: Beck, 1969.

Kuznetsov, V. N. *Jean-Paul Sartre i ekzistentializm.* Moskva: Izd MGU, 1969. In Russian.

LaCapra, Dominick. *A Preface to Sartre.* Ithaca, N.Y.: Cornell University Press, 1978.

Lafarge, René. *La Philosophie de Jean-Paul Sartre.* Toulouse: Privat, 1967. Tr. as *Jean-Paul Sartre: His Philosophy.* Dublin: Gill and Macmillan, 1970.

Laing, R. D., and Cooper, D. G. *Reason and Violence: A Decade of Sartre's Philosophy, 1950–1960.* With Foreword by Sartre. London: Tavistock, 1964; New York: Pantheon Books, 1971. French tr.: Payot, 1972.

Laraque, Franck. *La Révolte dans le théâtre de Sartre.* Jean-Pierre Delarge–Ed. Universitaires, 1976.

Las Vergnas, Raymond. *L'Affaire Sartre.* Haumont, 1946.

Lawler, James. *The Existentialist Marxism of Jean-Paul Sartre.* Amsterdam: Grüner, 1976.

Launay, Claude. Le Diable et le bon Dieu: *Analyse critique*. Hatier, 1970.

Laurent, Jacques. *Paul et Jean-Paul*. Grasset, 1951. On Paul Bourget and Sartre.

Lausberg, Heinrich. *Interpretationen dramatischer Dichtungen. I.* Les Séquestrés d'Altona. *II.* Huis clos *und* La Putain respectueuse. München: Max Hueber, 1964.

Lecarme, Jacques, ed. *Les Critiques de notre temps et Sartre*. Garnier, 1973.

Lecherbonnier, Bernard. Huis clos: *Analyse critique*. Hatier, 1972.

Lee, Edward N., and Mandelbaum, Maurice, eds. *Phenomenology and Existentialism*. Baltimore: Johns Hopkins Press, 1967. On Sartre, pp. 139–78.

Lefebvre, Henri. *L'Existentialisme*. Le Sagittaire, 1946.

Lefevre, Luc J. *L'Existentialiste est-il un philosophe?* Ed. Alsatia, 1946.

Lejeune, Philippe. *Le Pacte autobiographique*. Le Seuil, 1975.

Lévi-Strauss, Claude. *La Pensée sauvage*. Plon, 1962.

Lilar, Suzanne. *A propos de Sartre et de l'amour*. Grasset, 1967.

Lorris, Robert. *Sartre dramaturge*. Nizet, 1975.

Lukacs, Georg. *Existentialisme ou marxisme?* Nagel, 1948.

Lutz-Muller, Marcos. *Sartres Theorie der Negation*. Frankfurt: Peter Lang; Bern: Herbert Lang, 1976.

Maciel, Luis Carlos. *Sartre, vida y obra*. Rio de Janeiro: José Alavaro, 1967.

Madsen, Axel. *Hearts and Minds: The Common Journey of Simone de Beauvoir and Jean-Paul Sartre*. New York: William Morrow, 1977.

Magny, Claude-Edmonde. *Les Sandales d'Empédocle*. Neuchâtel: La Baconnière, 1945. See pp. 105–73.

Maier, Willi. *Des Problem der Lieblichkeit bei Jean-Paul Sartre und Maurice Merleau-Ponty*. Tübingen: Max Niemeyer, 1964.

Mancarella, Angelo. *L'Intellettuale e il potere: Saggio su Sartre*. Manduria: Lacaita, 1977.

Manser, Anthony R. *Sartre: A Philosophic Study*. London: Athlone Press, 1966. Rev. ed., 1967.

Marcel, Gabriel. *Les Grands Appels de l'homme contemporain*. Ed. du Temps Présent, 1946. See pp. 111–76. Also by Marcel, see esp. *Homo viator* (Aubier, 1945).

Marcuse, Herbert. "Existentialism: Remarks on Jean-Paul Sartre's *L'Etre et le Néant*," *Philosophy and Phenomenological Research*, 8, no. 3 (March 1948): 309–36. Reprinted in the volume *Kultur und Gesellschaft 2* (Frankfurt: Suhrkamp, 1965).

Marín Ibáñez, Ricardo. *Libertad y compromiso en Sartre*. Valencia, 1959.

Martin-Deslias, Noël. *Jean-Paul Sartre ou la conscience ambiguë*. Nagel, 1972.

Masters, Brian. *A Student's Guide to Sartre*. London: Heinemann, 1970.

Masullo, Aldo. *La Communità come fondamente: Fichte, Husserl, Sartre*. Napoli: Libreria Scientifica, 1965.

Mauro, Walter. *Invito alla lettura di Jean-Paul Sartre*. Milano: Mursia, 1976.

McBride, William L. *Fundamental Change in Law and Society: Hart and Sartre on Revolution*. The Hague: Mouton, 1970.

McCall, Dorothy. *The Theatre of Jean-Paul Sartre*. New York: Columbia University Press, 1969.

McMahon, Joseph J. *Humans Being: The World of Jean-Paul Sartre*. Chicago: University of Chicago Press, 1971.

Menchon, Saturnino. *Sartre: Diálogo con un hombre que ne encuentra a Dios*. Madrid: Ed. Zero, 1969.

Merks-Leinen, Gabriele. *Literaturbegriff und Bewusstseinstheorie zur Bestimmung der Literatur bei Jean-Paul Sartre*. Bonn: Bouvier Verlag H. Grundmann, 1976.

Merleau-Ponty, Maurice. *Les Aventures de la dialectique*. Gallimard, 1955.

————. *Le Visible et l'invisible*. Gallimard, 1964.

Meszaros, Istvan. *Work of Sartre: Search for Freedom*, vol. I. Humanities Press, 1979.

Moeller, Charles. *Littérature du XXe siècle*, vol. II. Tournai: Casterman, 1963. See pp. 35–164.

Möller, Joseph. *Absurdes Sein? Eine Auseinandersetzung mit der Ontologie Jean-Paul Sartres*. Stuttgart: Kohlhammer, 1959.

Molnar, Thomas. *Sartre, Ideologue of Our Time*. New York: Funk and Wagnalls, 1968. Tr. as *Sartre, philosophe de la contestation* (Le Prieuré, 1969).

Moravia, Sergio. *Introduzione a Sartre*. Roma/Bari: Laterza, 1973.

Morot-Sir, Edouard. *Les Mots de Jean-Paul Sartre*. Hachette, 1975.

Morris, Phyllis S. *Sartre's Concept of a Person: An Analytic Approach*. Amherst: University of Massachusetts Press, 1976.

Mougin, Henri. *La Sainte Famille existentialiste*. Editions Sociales, 1947.

Mounier, Emmanuel. *L'Espoir des désespérés: Malraux, Camus, Sartre, Bernanos*. Le Seuil, 1953.

Müller-Lissner, Adelheid. *Sartre als Biograph Flauberts*. Bonn: Bouvier Verlag, 1977.

Murdoch, Iris. *Sartre, Romantic Rationalist*. New Haven: Yale University Press, 1953. Paperback, 1959.

Naess, Arne. *Four Modern Philosophers: Carnap, Wittgenstein, Heidegger, Sartre*. Chicago: University of Chicago Press, 1968. See pp. 265–359.

Natanson, Maurice. *A Critique of Jean-Paul Sartre's Ontology*. Lincoln: University of Nebraska Press, 1951; The Hague: Nijhoff, 1973.

Nauta, Lolle W. *Jean-Paul Sartre.* Baarn: Het Wereldvenster, 1966.

Naville, Pierre. *L'Intellectuel communiste (à propos de Jean-Paul Sartre).* Rivière, 1956.

Neudeck, Rupert. *Die politische Ethik bei Jean-Paul Sartre und Albert Camus.* Bonn: Bouvier Verlag H. Grundmann, 1975.

Niel, André. *Jean-Paul Sartre, héros et victime de la 'conscience malheureuse.'* Courrier du Livre, 1966.

Niftrik, Gerrit C. van. *De Boodschap van Sartre.* Nijkerk: Gellenbach, 1967.

Odajnyk, Walter. *Marxism and Existentialism.* New York: Anchor Books, 1965.

Otto, Maria. *Reue und Freiheit. Versuch über ihre Beziehung im Ausgang von Sartres Drama.* München/Freiburg: Karl Alber, 1961.

Pagano, Giacoma M. *Sartre e la dialettica.* Napoli: Giannini, 1970.

Paissac, Henry. *Le Dieu de Sartre.* Arthaud, 1950.

Papone, Annagrazia. *Esistenza e corporeità in Sartre.* Firenze: F. Le Monnier, 1969.

Patte, Daniel. *L'Athéisme d'un chrétien, ou un chrétien à l'écoute de Sartre.* Nouvelles Editions latines, 1965.

Pellegrino, Giuseppe. *Gli operai della nostra storia: Nietzsche, Freud, Sartre.* Fossano: 1971.

Pesch, Edgar. *L'Existentialisme: Essai critique.* Ed. Dynamo, 1946.

Peyre, Henri. *Jean-Paul Sartre.* New York: Columbia University Press, 1968.

Piazzolla, Marino. *J.-P. Sartre, intellettuale massificato.* Roma: Ed. dell'Ippogrifo, 1973.

Pintos, Juan Luis. *El ateísmo del último Sartre.* Madrid: Razón y Fe, 1968.

Pollman, Leo. *Sartre und Camus.* Stuttgart: Kohlhammer, 1967. English tr., New York: Frederick Ungar, 1970.

Poster, Mark. *Existential Marxism in Postwar France: From Sartre to Althusser.* Princeton, N.J.: Princeton University Press, 1975.

Presseault, Jacques. *L'Etre-pour-autrui dans la philosophie de Jean-Paul Sartre.* Montreal: Bellarmin; Paris: Desclée de Brouwer, 1970.

Prince, Gerald J. *Métaphysique et technique dans l'oeuvre romanesque de Sartre.* Genève: Droz, 1968.

Pruche, Benoît. *L'Homme de Sartre.* Arthaud, 1949.

Pucciani, Oreste F. "Jean-Paul Sartre," in Yvon Belaval, ed. *Encyclopédie de la Pléiade, Histoire de la philosophie,* vol. 3. Gallimard, 1974. Pp. 641–91.

Quiles, Ismael. *Sartre y su existencialismo.* 3d ed. Madrid: Espasa-Calpe, 1967.

Rahv, Betty T. *From Sartre to the New Novel.* Port Washington, N.Y.: Kennikat Press, 1974.

Raillard, Georges. La Nausée *de Jean-Paul Sartre.* Hachette, 1972.

Richter, Liselotte. *Jean-Paul Sartre.* Berlin: Colloquium Verlag, 1961. English tr., New York: Frederick Ungar, 1970.

Riu, Federico. *Ensayos sobre Sartre.* Caracas: Monte Avila, 1968.

Rovatti, Pier Aldo. *Che cosa ha veramente detto Sartre.* Roma: Ubaldini, 1969.

Royle, Peter. *Sartre, l'Enfer et la liberté: Étude de* Huis clos *et des* Mouches. Québec: Presses de l'Université Laval, 1973.

Sábato, Ernesto. *Tres aproximaciones a la literature de nuestro tiempo: Robbe-Grillet, Borges, Sartre.* Santiago, Chile: Ed. Universitaria, 1968.

Sabin, Walter. *Jean-Paul Sartre: Die schmützigen Hände.* Berlin/München: Diesterweg, 1976.

Salvan, Jacques L. *To Be or Not to Be: An Analysis of Jean-Paul Sartre's Ontology.* Detroit, Mich.: Wayne State University Press, 1962.

———. *The Scandalous Ghost: Sartre's Existentialism as Related to Vitalism, Humanism, Mysticism, and Marxism.* Detroit, Mich.: Wayne State University Press, 1967.

Savage, Catherine. *Malraux, Sartre, and Aragon as Political Novelists.* Gainesville: University of Florida Press, 1965.

Schaff, Adam. *Marx oder Sartre? Versuch einer Philosophie des Menschen.* Berlin: Deutscher Verlag der Wissenschaften, 1965. Tr. from Polish.

Schaldebrand, Mary A. *Phenomenology of Freedom: An Essay on the Philosophies of Sartre and G. Marcel.* Washington, D.C.: Catholic University of America, 1960.

Schmidt-Schweda, Dietlinde. *Werden und Wirken des Kunstwerks: Untersuchungen zur Kunsttheorie von Jean-Paul Sartre.* Meisenheim-am-Glan: Hain, 1975.

Schwarz, Theodor. *Jean-Paul Sartres Kritik der dialektische Vernunft.* Berlin: Deutscher Verlag der Wissenschaften, 1967. Tr. as *Jean-Paul Sartre et le marxisme.* Lausanne: L'Age d'Homme, 1976.

Seel, Gerhard. *Sartres Dialektik.* Bonn: Bouvier Verlag H. Grundmann, 1971.

Sheridan, James F. *Sartre: The Radical Conversion.* Athens: Ohio University Press, 1973.

Sicard, Michel. *La Critique littéraire de Jean-Paul Sartre, I. Object et thèmes.* Minard, 1976.

Sotelo, Ignacio. *Sartre y la razón dialéctica.* Madrid: Tecnos, 1967.

Spiegelberg, Herbert. *The Phenomenological Movement.* The Hague: M. Nijhoff, 1960. 2d ed., 1965. See pp. 445–515.

Stack, George J. *Sartre's Philosophy of Social Existence.* St. Louis: Warren H. Green, 1978.

Stefani, Mario. *La Libertà esistenziale in J.-P. Sartre*. Milano: Soc. Ed., 1949.

Stenstroem, Thure. *Existentialismen*. Stockholm: Natur och Kultur, 1966. See pp. 190–260.

Stern, Alfred. *Sartre: His Philosophy and Existential Psychoanalysis*. New York: Liberal Arts Press, 1953. Rev. ed., Dell, 1967. Spanish tr.: Buenos Aires, 1962.

Streller-Justus, J. *Zur Freiheit verurteilt: Ein Grundriss der Philosophie Jean-Paul Sartres*. Hamburg: Meiner, 1952. Tr. by Wade Baskin as *Jean-Paul Sartre: To Freedom Condemned*, New York: Philosophical Library, 1960.

Struyker Boudier, C. E. M. *Jean-Paul Sartre*. The Hague: Lannoo, 1967.

Suhl, Benjamin. *Jean-Paul Sartre: The Philosopher as Literary Critic*. New York: Columbia University Press, 1970. French tr., Editions Universitaires, 1971.

Sulzer, Elisabeth. *L'Engagement et la personne chez Sartre*. Winterthur: H. Schellenberg, 1972.

Theau, Jean. *La Philosophie de Sartre*. Eds. de l'Université d'Ottawa, 1978.

Thody, Philip. *Jean-Paul Sartre: A Literary and Political Study*. London: Hamilton, 1960. Paperback, 1964.

———. *Sartre: A Biographical Introduction*. London: Studio Vista, 1971; New York: Scribner's, 1972.

Troisfontaines, Roger. *Le Choix de Jean-Paul Sartre: Exposé et critique de* L'Etre et le Néant. Aubier, 1945. Rev. ed., 1946. Spanish tr., 1949.

Truc, Gonzague. *De Jean-Paul Sartre à Louis Lavelle, ou désagrégation et réintégration*. P. Tissot, 1946.

Ussher, Arland. *Journey Through Dread: A Study of Kierkegaard, Heidegger, and Sartre*. New York: Devin-Adair, 1955. New ed., New York: Biblo and Tannen, 1968.

Varet, Gilbert. *L'Ontologie de Sartre*. Presses Universitaires de France, 1948.

Verhoeff, Johan P. *Sartre als toneelschrijver*. Amsterdam: Groninguen, 1962.

Verstraeten, Pierre. *Violence et éthique: Esquisse d'une critique de la moral dialectique à partir du théâtre politique de Sartre*. Gallimard, 1972.

Wacquez, Mauricio. *Conocer Sartre y su obra*. Barcelona: Dopesa, 1977.

Wahl, Jean. *Esquisse pour une histoire de l'existentialisme*. Ed. de l'Arche, 1949.

Warnock, Mary. *The Philosophy of Jean-Paul Sartre*. London: Hutchinson, 1965; New York: Barnes and Noble, 1967.

———, ed. *Sartre: A Collection of Critical Essays*. Garden City, N.Y.: Doubleday, 1971.

Werner, Eric. *De la violence au totalitarisme: Essai sur la pensée de Camus et de Sartre.* Calmann-Lévy, 1972. See pp. 123–227.

Zehm. Günter A. *Historische Vernunft und directe Aktion zur Politik und Philosophie Jean-Paul Sartres.* Stuttgart: E. Klett, 1964.

————. *Jean-Paul Sartre.* Velber bei Hanover: Friedrich Verlag, 1965.

Zuidema, Syste U. *Jean-Paul Sartre.* Philadelphia: Presbyterian and Reformed Pub., 1960. Original Dutch version published in 1948.

Forthcoming

Aronson, Ronald. *Jean-Paul Sartre.* New York: Schocken.

Barnes, Hazel E. *Sartre and Flaubert.* University of Chicago Press.

Briosi, Sandro. *Sartre critico.* Bologna: Zanichelli.

Colombel, Jeannette. Study on Sartre.

Doubrovsky, Serge. La Nausée *ou le sexe de l'écriture.*

Feher, Ferenc. *Sartre.*

Issacharoff, Michael, ed. *Sartre et la mise en signe.* Colloque de London, Ontario. Klincksieck.

Proceedings of the June 1979 Sartre colloquium at Cerisy. Paris.

Silverman, H. J., and Elliston, F. A., eds. *The Philosophy of Sartre: Contemporary Approaches.* Pittsburgh: Duquesne University Press.

Special Numbers of Periodicals

Adam International Review, no. 343–45 (1970).

L'Arc, no. 30 (1966).

Aut Aut, "Sartre dopo la 'Critique,'" no. 136–37 (July–October 1973).

Biblio/Livres de France, 17, no. 1 (January 1966).

Essais, [Bordeaux], no. 2–3 (Spring 1968).

Journal of the British Society for Phenomenology, 1, no. 2 (May 1970).

Magazine Littéraire, no. 55–56 (September 1971); no. 103–4 (September 1975).

Nouvelle Critique, "Sartre est-il marxiste?," no. 173–74 (1966).

Obliques, no. 18–19 (1979). Has original texts by Sartre on Mallarmé, 'la Morale,' etc., and a number of articles.

Philosophy Today, 24, no. 3–4 (Fall 1980).

Tulane Drama Review, 5, no. 3 (1961).

Yale French Studies, no. 1 (1948); no. 30 (1966).

Forthcoming

Special number of *Critique* (Paris).

Second number of *Obliques*.

Several special numbers planned to mark Sartre's death: *Journal of the British Society for Phenomenology, Les Temps Modernes, Telos,* etc.

INDEX

(by Pappu S. S. Rama Rao)

Abel, Lionel, 474n, 713
Abel, Stuart, 712
absence, 168; and presence, 171; image of, 171; pure, 454; role of, 173
Absolute, 288
abundance, 492, 621
action(s), 89, 183f, 193, 219, 543; and choice, 384; free, 383f; meaningful, 224; paradox of, 698; right, 423f, 431f; theory of, 568f
activity, 233; practical, 232
Adereth, Maxwell, 716
aesthetics, 15f, 41, 112ff, 135, 509; and creative process, 113; and freedom, 41; and ontology, 113; and Platonism, 500; and situation, 119; elements of, 42; imperative, 503; processes of, 112; traditional, 42, 114, 131
affect, 555
"affective logic," 69ff
affective meaning, 75
affectivity, 72, 546
Albérès, René Marill, 716
Alden, Douglas, 716
Alexander, Lloyd, 472n, 493n, 711f
Algeria, 399, 416f, 419, 435, 686, 700
alienation, 268f, 309, 363ff, 450, 464, 481, 518f, 623, 632, 634ff, 651, 653; and class, 638, 648; and exploitation, 405; and incarnation, 318; concept of, 637; economic, 636; logic of, 705; meaning of, 624; origin of, 697
Allen, S. W., 713
aloneness, 289
alterity, 363; free, 352f
ambiguity, philosophy of, 238
ambivalence, 574

analogon, 14f, 42, 146ff, 509, 521; and imagination, 147ff; phenomenological description of, 161; physical, 147, 150ff; psychical, 147ff, 161; relation to analogate, 150; role of, 147
analogue, 172; and consciousness, 180; hyletic, 175
analysis, 113, 137, 543f; aesthetic, 112; goal of regressive, 612; intentional, 75; linguistic, 167f, 174; method of, 72; philosophical, 163; regressive, 611ff, 687
anarchism, 21
anatomy, human, 612
Anderson, Perry, 535n, 578n, 580n
Anderson, Thomas C., 716
anguish, 253, 441, 445, 455, 496, 546, 553; and fear, 252
animality, 97
animals, consciousness of, 28f, 682
animus, 115
Anscombe, G. E. M., 165n
Anselm, Saint, 339
anthropology, 102, 261, 477, 610, 613, 633f; historical, 512; structural, 648f
anthropomania, 28, 101
anxiety, 257, 479
appearance(s), 234; and reality, 67
Aristotle, 112f, 143, 658n, 684n
Arnold, Albert James, 717
Arntz, Joseph, 717
Aron, Raymond, 10, 393, 655nff, 717
Aronson, Ronald, 322n, 685ff, 728
arrachement, 98ff
art, 112ff, 288, 448f, 466, 522, 527; and being, 130; and bracketing, 123f; and nature, 42, 114, 121; as imagined object, 124; as praxis, 497; as project, 121; autonomy of,

502; closed, 123; eternal, 45; experience of, 113; for art's sake, 497, 502, 517; freedom of, 41, 126f, 415; intention of, 125; literary, 136, 515; naturalistic, 123; neurosis, 45, 497, 517, 523, 531, 534; non-representative, 127; objectification in, 516; object of, 113, 117; official, 114f, 118, 130; open, 42, 118; pure, 497, 500, 506, 523, 532; realistic, 114; representative, 114, 126; revolutionary, 41; romantic, 114; traditional, 118; two schemes of, 118; unifying, 113; Venetian, 116; work of, 152f, 506, 508f, 528
atheism, 82n, 445f, 512
Atkinson, James B., 714
Atkinson, Starr, 714
atomic bomb, 102f
atomism, 359
attitude, aesthetic, 264; negative, 247
Aubert, Paul, 711
Audri, Colette, 404, 717
Aufhebung, 65, 68, 103, 362
Auflösung, 68
Auster, Paul, 715
authenticity, 96, 198, 204, 207, 253f, 257, 281, 426; explained, 201f; freedom in, 206; meaning of, 289; possibility of, 252
Aveling, E., 656n, 660n
awareness, 208f, 278, 280, 290; and knowledge, 286; and understanding, 291
axiology, 113
Azzi, Marie-Denise Boros, 26, 438ff, 717

Bacon, Francis, 513
bad faith *(mauvaise foi),* 34, 36, 86, 100, 216, 246ff, 285, 299n, 338, 399f, 427, 441, 444, 450, 459, 465f, 582, 595; and art, 114; and emotions, 253; and self-deception, 575f; as pretending, 252; as self-hypocrisy, 90; as self-imposed, 248; as sincerity, 247; conditioning of, 248; eidetic of, 75; examples of, 248ff; internalization of, 251; origin of, 249, 253, 255; paradox of, 582ff
Baldick, Robert, 711
Barnes, Hazel E., 39f, 166n, 196n, 212n, 243, 244n, 255nf, 323n, 343n, 366n, 390n, 472n, 493n, 578n, 602nf, 628n, 661ff, 712, 714, 717, 728

Barrett, William, 717
Baskin, Wade, 164n, 713, 716
Bataille, Georges, 717
Baudelaire, Charles, 140, 165n
Bauer, George H., 717
Bausola, Adriano, 717
Bauters, Paul, 717
beauty, 42, 127f, 130, 498, 526f, 534; and non-being, 90; and ugliness, 129f, 134f
Beauvoir, Simone de, 5, 15, 17, 43, 60, 81n, 182, 184, 227n, 255n, 276n, 300f, 307ff, 372, 419, 430, 433, 475n, 499, 501, 503, 507, 533, 535f, 663, 684n, 716
Becker, George J., 255n, 713
Beethoven, Ludwig van, 153
Befindlichkeit, 71f
behavior, 191, 542f, 545, 547f, 550, 563; and choice, 569; and complexes, 546; and consciousness, 180, 553; and emotions, 221ff; and unconscious, 556, 564; cause of, 568; explanation of, 568; intentional, 619; magical, 222; meaning of, 562; prediction of, 570; resistance, 551f; unreflective, 217
behaviorism, 174, 192f, 215; and man, 192; philosophical, 215
"behaviorology," 180
Beigbeder, Marc, 717
being, 14, 103, 113, 121, 124, 126f, 257ff, 330f, 503, 531, 533, 666; and art, 130; and class, 261; and *cogito,* 231; and human beings, 262; and knowledge, 45; and language, 284; and meaning, 339, 341, 674; and non-being, 340, 524; and nothingness, 127f; and scientific thought, 14; and value, 94, 374; and world, 266; as disclosing, 290; as *en-soi,* 513; as faith, 266; as manifestation, 279; break in, 331; concept of, 681; contingency of, 455; development of, 269; dimensions of, 661; event of, 268; fullness of, 130; immanence of, 338; immediacy of, 296; instauration, 332; kinds of, 678; law of, 331; logic of, 631ff; malady of, 39; material, 268; nihilation of, 678; nothingness of, 90, 145; openness of, 296f; plenitude of, 340; practico-inert, 520; releasement of, 296; self-awareness of, 282; temporal, 262; theory of, 133; three kinds of, 271; totality of, 128; understanding of, 277f; unity in, 521

being-for-itself, 615f, 665
being-in-itself, 267, 296, 663ff, 679ff, 696
being-in-the-world, 214, 277, 282
belief, 330
Belkind, Allen J., 716
Bell, Daniel, 420
Bergmann, Gustav, 579
Bergson, Henri, 6ff, 18, 94, 113, 169
Berk, Philip, 715
Berkeley, George, 258
Bernstein, R., 655n
Biemel, Walter, 717
Bien, Joseph, 323n
Binswanger, Ludwig, 299n
biography, concept of, 90
birth, and zero moment, 98
Bishop, Thomas, 717
Black, Kitty, 473n, 712ff
Bloch, Marc, 658n
"block universe," 120
body, 229, 305; and consciousness, 234,
 665ff; and emotions, 221; and for-itself,
 311; and mind, 566f; and Other, 313; and
 self, 667; and subjectivity, 304; and world,
 243; as a point of view, 235f; as passivity,
 243; as past, 666f; experience of, 235;
 lived, 222; Other's, 316; psychic, 194; the-
 ory of, 234ff
Boisdeffre, Pierre de, 472n, 475n
Bolle, Louis, 717
Bolsheviks, 693
Bolshevism, ultra-, 303, 414
Borello, Oreste, 717
Boss, Medard, 297, 299n
Bottomore, T. B., 657n
bourgeoisie, 137, 413f, 433, 452, 464, 499;
 contempt for, 302; petite, 252, 517
Bourget, Paul, 504f
Boutang, Pierre, 717
boxing, 687, 705
bracketing, 42, 122f, 130; and art, 123f
Brée, Germaine, 408, 410, 413, 416, 418ff,
 717
Brentano, Franz, 64, 68, 216
Briosi, Sandro, 717, 728
Brombert, Victor, 414, 421n
Brooks, Richard A., 716
Brown, Lee, 36, 539ff
Brufau-Prats, Jaime, 718

Burnier, Michel-Antoine, 323n, 418, 718
Burtt, Edwin A., 536n

Cabus, Jose D., 718
Caesar, Julius, 500
Cairns, Dorion, 344n, 493n
Cairns, Huntington, 494n
Calder, Alexander, 117, 130f, 135, 288
Calder, John, 423
Campbell, Robert, 718
Camus, Albert, 61, 218, 307, 408ff
Canfield, J. V., 580n
capitalism, 21, 409, 614f, 621, 642; mystifies
 biology, 29
Carson, Ronald A., 718
Cartesianism, 214
Casey, Edward S., 139ff, 165n
Catalano, Joseph, 718
categorical imperative, 237f
categories, 608, 614, 616
category mistake, 248, 271
catharsis, 211
cathaxis, 211
Catholicism, 104; neo-, 502
causality, 91, 547, 557, 567; and destiny, 98;
 Humean, 567; inert, 101; principle of, 619f
causation, 566, 568f; Humean, 569; mechani-
 cal, 567
Caute, David, 323n
Cavacivti, S., 718
Caws, Peter, 718
censor, 33, 216, 548f, 562, 574, 585, 587f,
 592f; and conscious ego, 556; and uncon-
 scious, 557f
Cera, Giovanni, 718
Ceroni, Angelo, 718
Champigny, Robert, 18, 28, 86ff, 718
chance, 390
change, diachronic, 101
chaos, 485f, 489
Chapsal, Madeleine, 472n, 499, 535n
character, representation of, 438ff
Chiaromonte, Nicola, 410ff, 420nf
Chieppa, Vincenzo, 718
Chiodi, Pietro, 718
choice, 237, 373, 375, 379f, 397ff, 442, 468f;
 and action, 384; and cause, 569; and com-
 mitment, 242; and freedom, 380f, 384ff; au-
 tonomy of, 386, 389; idea of, 402; impos-

sibility of, 468; meaning of, 392; original, 101; possibility of, 406; universality of, 388

Chonez, Claudine, 475n

Christianity, 103f

circularity, 694; and praxis, 695

class(es), 14, 360, 470, 632, 640f, 654; and alienation, 638; and nature, 29; as collective, 638; concept of, 622; dialectic of social, 18; interests, 428; problems of, 14; relation to species, 29; social, 434, 468; struggle, 30, 618, 621, 648, 703ff; working, 20, 30

classicism, 114, 123

Cleary, Richard C., 706n

Clephane, Irene, 707n, 715

"coefficient of adversity," 397, 402f

Coffy, Robert, 718

cogito, 204, 216, 279ff; and being, 231; as intentionality, 340; as "process self," 203; as pure consciousness, 203; nature of, 280; pre-reflexive, 34f, 220, 330ff, 340ff, 593ff

cognition, pure, 160

Cohn, Robert Greer, 412, 417, 421n

Cold War, 413, 417, 420, 627; cultural, 408ff

Colet, Louise, 523, 525

collective(s), 405, 639, 676, 702; and groups, 349, 520f; as class, 638; as "seriality," 612

collective responsibility, 364

collectivism, 133

collectivity, 674, 688, 706

collectivization, 690f, 701

Collins, Douglas, 718

Colombel, Jeannette, 728

colonialism, 412; neo-, 436

commitments, 374, 387, 416

communism, 301, 409f, 412ff, 706; emergence of, 624

communist(s), 20, 301ff, 430, 434; party, 307, 412f, 431ff, 464, 507, 607, 609; French, 26, 425, 429f, 627, 686, 700f

compartmentalization, 539, 547f, 557, 560f; argument against, 550f; psychic, 574

complexes, 540, 546; and symbols, 568; and symptoms, 562; and unconscious, 547

compulsion, 555

conatus, 559, 585

concepts, 11, 543; Kantian, 517

conflict, 308f; and consciousness, 347

conformism, 62

consciousness, 7, 10, 22, 39, 67, 69f, 83n, 85n, 122f, 128, 148ff, 169, 171, 180ff, 229ff, 247ff, 278ff, 327ff, 393ff, 454, 472, 478, 499, 503, 505, 509, 513, 531, 540, 661ff; act of, 15, 222; and behavior, 180, 553; and body, 44, 234ff, 655ff; and brain, 40, 683; and conflict, 347; and ego, 11, 36, 310f, 329f, 479; and emotions, 214f, 219, 222; and facticity, 313; and flesh, 316; and image, 143, 159, 170; and imagination, 142, 144f, 156, 173, 188; and knowledge, 183f, 197f, 543, 561, 593; and language, 28; and life, 29; and man, 439; and matter, 40, 663; and memory, 206f; and need, 242; and nothingness, 199, 259f; and object, 172, 200, 231; and psychic reality, 33, 181, 595; and psychology, 180; and self, 34, 184; and science, 190; and subject, 309; and things, 84n, 162, 278, 619; and unconscious, 35, 540, 558f, 572f, 585, 596; and world, 260, 279, 306, 336, 396ff, 668; animal, 28f; as ekstatic, 199; as epiphenomenon, 683; as free, 242, 662; as manifestation, 278; as non-material, 682; as projective, 121f; as pure spontaneity, 479; as reality, 34; as self-generating, 260; as sui generis, 279f; being of, 665; class, 350; collective, 19, 357f; data of, 7; defining, 40; degraded, 225, 446; detotalized unity, 200; dimensions of, 74; discarding, 259; distinctness of, 279; distinguished from psychical, 182; distraction of, 75; ego-less, 250ff; evolution of, 620; false, 607; flow of, 491; idealism of, 233; identified with emptiness, 95; identity of, 231; immediacy of, 182, 207, 282; impersonal, 199ff; incarnate, 313, 315, 317f, 321; individual(izing), 77, 247, 317; intentional, 170, 199, 208f, 328, 339, 341; intentionality of, 182, 185, 310; levels of, 187; meaning of, 34; mentation as, 162; negativity of, 251; non-cognitive, 198; non-conceptual, 209; non-positional, 201, 204, 209, 594; non-reflective, 11, 664; non-thetic, 83n, 171, 184, 198, 205, 214, 340; not a generic category, 34; not a unity, 279; not egological, 278; objectified, 184; opacity, 23, 75; Other's, 280, 461; personal, 200, 204; philosophy of, 75; plant, 29; positional, 206, 209, 593f, 597ff; pre-

analytic, 543; pre-reflective, 34, 199, 204, 330, 338; produces itself, 207; purified, 204, 488; reflected, 11, 36; reflective, 170f, 182ff, 202, 331, 620, 664; reflexive dimension of, 11, 35, 72; role of, 209; spectator, 305; spontaneity of, 173ff; states of, 183, 220; stream of, 188f; structures of, 34f, 253; subjectivity of, 11; symbolism of, 234; synthetic, 19, 142; temporalizing of, 199, 203; theory of, 23; thetic, 214; transcendence of, 329, 340; translucidity of, 23; unity of, 200, 202ff, 250, 664f; unreflective, 182ff, 205

"constitution," Husserlian, 222

Contat, Michel, 4, 8, 80n, 165n, 227n, 276n, 472n, 535n, 684nf, 711, 715, 718

contingency, theory of, 533f

conversion, 379

Cooper, Barry, 717

Cooper, D. G., 655n, 722

Cormeau, Nelly, 718

cosmologies, mythopoetic, 264

Cotroneo, Girolamo, 718

cowardice, 575

Craib, Ian, 718

Cranston, Maurice W., 655n, 718

creation, 401

criticism, art, 136

Crowley, R. A., 165n

culture, 46; saves nobody, 105

Cumming, Robert D., 5, 12, 18f, 55ff, 714, 719

Cunillera, Antonio, 719

Dalma, Juan, 719

Danto, Arthur C., 81n, 719

Dasein, 78, 85n, 260, 263, 283, 292, 296; as being-in-the-world, 282; as clearing, 267; as disclosiveness, 282f; as transcendental subjectivity, 281; does not create, 266; inauthentic, 265; not human reality, 262; openness of, 284; structures of, 281

Davis, Lydia, 715

Davis, Robert Gorham, 409

daydreams, 157

death, 91, 99, 455f, 667, 675, 696

deception, 295

decision, free, 378; psychological, 378

defense mechanism, 571

De Gaulle, Charles, 700

Delacroix, Henri, 8, 164n, 499f, 516, 535n

Deleuze, Gilles, 228n

Demeny, Paul, 523

democracy, direct, 364f

democratization, 641

Dempsey, Peter, 719

de-realization, 532f

Desan, Wilfrid, 617, 623, 655n, 719

Descartes, René, 8f, 142, 158, 163, 169, 187, 197, 200, 248, 259f, 268, 299n, 388, 401, 478, 605f

description, phenomenological, 610

desire, 34, 281, 313f, 316ff, 546; and ontology, 293; communion of, 315; sexual, 314

despair, 423f

destiny, 91f, 260, 295; and causality, 98; and freedom, 469; choice and, 101; class, 261; justification of, 100; rational, 261

determinism, 319f, 427, 445, 459, 512, 545, 568, 602, 618, 671, 681; and freedom, 465; and negation, 279; causal, 216; existential, 519; horizontal, 546; Marxian, 565; psychological, 181; universal, 619; vertical, 546

detotalization, 87

development, 56ff; laws of, 70

dialectic, 9f, 14, 39, 60ff, 90, 303, 308, 362, 367n, 511, 651ff, 670, 695; and philosophy, 269; and synthesis, 19; anti-, 306; as scientific, 76; bilateral, 66, 77, 84n; existential, 61ff, 77, 83n; Hegelian, 65f; Marxist, 61, 63ff, 326; nascent, 18f; not fundamental, 272; phenomenological, 68ff; pure, 650; reflexive, 67

Diaz, Raymond, 719

Dilthey, W., 656n

d'Istria, Colonna, 6, 9

Dornand, Guy, 475n

Dostoevski, F. M., 517

Doubrovsky, Serge, 728

Douglas, Kenneth, 716

drama, 117; a myth, 107

dreams, 223

Dreyfus, Hubert L., 229ff, 243n, 323

Dreyfus, Patricia, 323n

dualism, 221, 230, 234, 239, 305, 310, 317, 675; Cartesian, 149, 308, 567, 592, 602, 617; ontological, 566

Dufrenne, Mikel, 157, 160, 165nf

Duncan, Ronald, 715
Durand, Gilbert, 165n
duration, 6f; psychic, 194
Durkheim, E., 674
Dutton, K. R., 719
dwelling, and abundance, 492; and journeying, 492; sphere of, 491

Easton, Lloyd D., 656nff
eclecticism, 73
Ecole Normale Supérieure, 5ff, 46, 497ff, 515
Ecole Polytechnique, 7
ecology, 29f, 682; and scarcity, 30
Edie, J., 196n
Edman, Irwin, 409, 420n
egalitarianism, Bolshevik, 690
ego, 10, 33, 183f, 193, 209, 247, 251, 308f, 518, 528f, 547, 573, 584ff, 602; alter, 326, 333, 335ff, 519, 528f; and consciousness, 36, 310f, 329f, 479; and Other, 312; and self-consciousness, 197ff; and world, 182, 664; as fact, 11; as object, 11, 199, 201; as transcendent, 182; conscious, 95, 547f, 550, 554, 556ff, 573f, 584; defenses of, 563; false, 201, 207; objectified, 98; primacy of, 281; problem of, 10f; production of, 201; psychological, 200f; resistance of, 590; role of, 201; substantial, 200, 204; transcendental, 44, 78, 199f, 328f, 332, 478; unconscious, 547
eidetics, 173
Eisenhower, Dwight, 608
Eisler, Benita, 256n, 322n, 715
ekstasis, 63, 262, 679
élan vital, 94
Elliston, F. A., 728
emanationism, 516
emotion(s), 34, 38, 75, 84n, 190, 211ff; a mode of consciousness, 219; and bad faith, 253; and behavior, 221ff; and consciousness, 95, 214f, 222f; and expression, 215, 221f, 225f; and ideology, 224ff; and magic, 218ff; and meaning, 217f; and psychology, 211, 213; as conscious acts, 212; as epiphenomena, 215; as intentional, 595; as isolated, 224; as meaningful, 224; as prereflective, 220f; as transcendental, 213; demeaning, 223; dialectical, 66; functional theory of, 215; hydraulics model of, 211, 215, 226; intentional model of, 216; knowl-

edge of, 213; mechanical model of, 216; not a disruption, 218f; origin of, 223; phenomenology of, 213; physiology of, 220; poisonous, 219; psychological theories of, 214ff; significance of, 217f; transform the world, 218, 222f; two forms of, 219f; unconscious, 216; world of, 217
empiricism, 163f, 273
ends, 319
engagement, 503; and freedom, 503
Engels, Friedrich, 77, 353, 367n, 614, 617, 620f, 628n, 645, 655n, 670
ensembles, affirmative, 638f; alienated, 637f; and praxis, 634, 642f, 645f; and reciprocity, 635; intelligibility of, 641ff; non-being of, 643; rationalization of, 641; social, 626; structured, 648; theory of, 631ff; universal, 646
en soi, 10, 158, 307
envelopment, totalization of, 693f, 696, 705
Epicurus, 670
epistemology, 10; and ontology, 337
epochē, 214, 336f, 478f, 490; ethico-aesthetic, 527
essence(s), 127, 182, 187, 189f, 213, 257, 443, 698; and existence, 273, 439; intuiting, 144; metaphysical, 266
eternal, 263
ethical imperative, 503, 506
ethics, 38, 371ff, 469, 480, 512, 664; and intentions, 378; and ontology, 96, 373; and praxis, 364; and society, 38; bourgeois, 527; Christian, 376f; function of, 371; indifference, 38; Kantian, 377; theological, 96; traditional, 433; universal, 371
etiology, 549
evil, 96, 109n, 140, 442, 446, 460, 469, 512; absolute, 445
evolutionism, 13, 64
exhibitionism, 442, 457, 469
exis, literature of, 126
existence, 80n, 85n, 118, 127, 155, 161, 232, 257, 291; and essence, 273; and meaning, 208; and self-consciousness, 197; and situation, 119; anguish of, 115; animal, 673; as actualitas, 78; as anti-value, 129; as material, 671; authentic, 456, 469; bracketing of, 198; brute, 208; conditions of, 372; consciousness of, 72; contingency of, 442, 466; experience of, 71f; fixed, 452; gratuity of,

449; ground of, 486ff; human, 283ff, 482; justifying, 100; ontological, 513; precedes essence, 99, 198, 439; project of, 540; secretes essence, 489; sin of, 448f; structure of, 575; theory of, 121; types of, 169

existentialism, 22, 25, 57, 61, 68, 258, 287, 425, 518, 631ff, 662; and Marxism, 20, 507, 510f; as humanism, 627; as ideology, 605f

experience, aesthetic, 152f, 157; articulation of, 73; cathartic, 542; imaginative, 162f; immediate, 76f; phenomenological, 74, 76; reflexive, 70, 72

explanation, 362f; causal, 566, 568f; social, 609, 611; types of, 608

exploitation, 624, 652, 676

expression, 227; and emotion, 221f, 225f

ex-sistential, 64ff

ex-stases, 98

exteriority, 698; and praxis, 696ff

fable, and truth, 92f

facticity, 232, 235, 307, 313, 440f, 665, 675; as past, 666; explained, 231; mineness of, 235; pure, 239; thickness of, 318

facts, 186, 377; psychic, 194; social, 674

Falconi, Carlo, 719

Falk, Eugene H., 719

family, 520, 524

Fanon, Frantz, 417, 419, 437n

fascism, 409

fate, 486

Fatone, Vicente, 719

Faucitano, Filiberto, 719

Faulkner, William, 131, 135, 423

Fe, Franco, 719

fear, 551; indeterminate, 551

Feher, Ferenc, 728

Fell, Joseph P., 257ff, 343n, 719

Feuer, L., 628n

Feuerbach, L. A., 641f

fiction, 167, 171; and picture, 168; creates new idea, 177; spontaneity of, 173

Fiedler, Leslie, 414

film, 139

finalism, 216, 539, 565

finality, 549

Finch, Henry A., 368n

Fink, Eugen, 141, 165n

Fitch, Briant, 719

Flam, Leopold, 719

Flaubert, Gustave, 55f, 75ff, 86ff, 109n, 121, 131, 136f, 212, 238, 360f, 470f, 480, 495ff, 608, 613, 686, 706

flesh, 313, 315, 320, 322, 439f, 451, 482; and consciousness, 316; and interworld, 317f; and Other, 317; and world, 315f, 322

Fletcher, Martha, 323n, 715

Flynn, Thomas R., 345ff

Føllesdal, Dagfinn, 392ff

forgetting, theory of, 23

for-itself, 13, 37, 39f, 43, 194, 310, 319, 661ff; and body, 311; and consciousness, 311; as sexual, 313

formalism, aesthetic, 506

Frankfurt school, 641

Fraser, J. G., 228n

Fraser, Ronald, 535n, 578n

Frechtman, Bernard, 138f, 143, 164n, 212n, 227n, 255nf, 473n, 493n, 603n, 712ff

freedom, 22, 38, 95, 110n, 123, 130, 134, 206, 236ff, 252, 254, 295, 297, 308, 318, 348, 352, 357, 365, 375, 392ff, 427, 432, 441, 443, 452, 455, 462, 469, 471, 531, 540, 602, 614, 618f, 638, 640, 646f, 669, 671f; absolute, 382f, 386, 479; abstract, 319, 467; and aesthetics, 126f; and choice, 385f; and creation, 401; and destiny, 469; and determinism, 465; and engagement, 503; and God, 445; and imagination, 145; and law, 381; and love, 460; and necessity, 100; and nothingness, 383; and obligation, 387; and ontology, 382f; and situation, 397, 467, 472, 667; and spontaneity, 230; and temporality, 98; and value, 381, 389; and viscosity, 129; as necessity, 520; bourgeois ideology, 230; constraint of, 388; creative, 384; impersonal, 480; limitations of, 385f, 397, 399; meaning of, 381ff; metaphysical, 404; not caprice, 319f; ontological, 41, 441; Other's, 312, 459, 461; philosophy of, 21; political, 404; potential, 385; proof of, 383; real, 406, 518, 606; reifying, 382; social, 639, 653; tragedy of, 399; unreality of, 463

Freud, Sigmund, 12, 33f, 36f, 81n, 90, 211, 214ff, 247, 249ff, 294, 296, 505, 512, 515, 539ff, 582ff, 608

frigidity, 249f

Fritsch, Renate, 719

Frondizi, Risieri, 38, 371ff

fulfillment, 295

"fundamental project," 224f, 238
future, 97f, 102, 623f, 668, 674, 677
futurity, 544

Gabriel, Leo, 719
Gadamer, H.-G., 291
Gagnebin, Laurent, 720
Galler, Dieter, 720
Gallo, Blas Raúl, 720
Garaudy, Roger, 507, 510, 536n, 720
Gavi, Philippe, 80n, 367n, 715
Genesis, Book of, 477
Genet, Jean, 55, 77f, 79, 86, 90, 106, 131,
 137, 157, 212, 424, 469, 480f
genius, 288, 500, 522; not a gift, 136, 469,
 501
George, François, 720
Gerassi, John, 435
Gerlach, Franz von, 434
Gestalt, 191, 193, 215, 218, 223, 248, 543,
 635
Giacometti, Alberto, 116, 130f, 288f
Gilbert, Stuart, 472n, 712
Gillette, Arthur, 713
Giorgi, Amedeo, 8, 37, 179ff
givenness, mode of, 169f, 186
God, 96, 102f, 108nf, 128, 158, 339, 374,
 380, 446f, 453, 456, 497, 512, 519, 614,
 672, 677f; and freedom, 445; and man, 39,
 260, 401f, 446; as ground of being, 129,
 293; as work of art, 128f; death of, 108; ex-
 istence of, 498f
Goldstein, Walter B., 720
good, 96, 109n, 140, 446, 469, 498, 512; ab-
 solute, 445; impossibility, 443
Gore, Keith O., 720
Gorz, André, 345, 358, 366n, 720
Greene, Norman N., 720
Grene, Marjorie, 720
Gris, Juan, 116
Grisoli, Christian, 475n
ground, loss of, 483f; stable, 487
group, 354, 356, 368n, 625, 639ff, 653, 676f,
 689; and collectives, 349, 520f; and individ-
 ual, 358f; existence of, 359; paradox of,
 359; sub-, 688
groupe en fusion, 639, 643ff, 676
Gruenheck, Susan, 4ff, 44
Guattari, Felix, 228n
Guddat, Kurt H., 656nff
Guillaume, P., 215

guilt, 450f, 461; bourgeois, 424
Guindey, Guillaume, 720
Guizot, M., 523
Gurvitch, Georges, 362, 369n, 657n
Gurwitsch, Aron, 329, 343n
Gustavson, D. F., 580n
Gutwirth, Rudolf, 720

Habermas, J., 363, 641, 657n
Halpern, Joseph, 164n, 720
Hamilton, Edith, 494n
Hana, Ghanem-George, 720
harmony, 272f
Haroche, Charles, 475n
Hartmann, Klaus, 378, 631ff, 655nff, 720
Hartshorne, C., 165n
Hasenhüttl, Gotthold, 720
Haug, Wolfgang, F., 720
Hausman, Alan, 36, 539ff
Hegel, G. W. F., 9, 15, 57, 64f, 80n, 82n,
 110n, 219, 224, 232, 234, 240, 258ff, 327,
 349, 363, 367n, 405, 416, 510f, 513, 605,
 607, 617, 623, 626, 633f, 637, 641f, 647f,
 656nff
Hegelianism, 220, 358, 671
Heidegger, Martin, 14, 25, 32, 43f, 57, 63f,
 71ff, 83, 85n, 103, 110n, 160f, 166n, 214,
 219, 257ff, 276n, 277, 280ff, 298nf, 327,
 342, 362, 373, 512, 583, 634; and Nazism,
 32f
Helbo, André, 720
hell, 441f, 456
Hemingway, Ernest, 131
Heraclitus, 272
hermeneutics, 334, 342, 361
Herra, Rafael Angel, 720
Hervé, Pierre, 721
historialization, 689
historicism, Marxist, 432
history, 86, 230, 239, 241, 252, 269, 318,
 334, 360, 438, 459, 468, 470, 503f, 512f,
 515ff, 623f, 648, 653, 683, 693, 697, 703;
 alienated, 689; anarchist view of, 21; and
 nature, 103; deconstructing, 687; end of,
 104; flux of, 411, 413; intelligibility of,
 702; literary, 500; Marxist social, 71; mean-
 ing of, 410; opacity of, 518; progress of,
 627; social, 67, 70; Soviet, 702; theory of,
 654; totalization of, 533
Hoare, Quintin, 535n, 578n
Hodard, Philippe, 721

Hoffman, Piotr, 229ff
Holy Ghost, 96
Holy Spirit, 499
Holz, Hans Heinz, 721
homo oeconomicus, 615
homosexuality, 440f, 452, 465; meaning of, 575ff
Hopkins, Gerard, 714
Horace, 92
Horodinca, Georgeta, 721
Houbart, Jacques, 721
Howard, Richard, 255n, 366n
Hughes, Stuart H., 414, 421n
humanism, 101f, 108, 627; and violence, 303; concept of, 363; existential, 260; Marxist, 102
humanities, 496
humanity, anguished, 115f; aspects of, 16; passive, 697f
humanization, 703
humanness, 317
Hume, David, 142, 169, 197, 384, 402
Husserl, Edmund, 10, 25, 37, 43f, 61, 64, 68, 70, 73, 75f, 78, 83n, 85n, 122, 141, 143f, 154, 160, 163ff, 168, 170, 174, 178n, 182, 186f, 193, 198, 200, 213f, 218, 222, 224, 229, 257, 259, 267, 327ff, 362, 373, 393ff, 478f, 490, 599, 610f, 617f, 663
Huston, John, 12
hylē, 267
hyperorganicism, 687
hypotheses, inventing, 27
Hyppolite, Jean, 83

iconicity, 150
iconic relationship, 147
id, 33, 220, 247, 251, 547, 573, 584ff, 602
idealism, 13, 46, 68, 112, 233, 267, 271, 287, 305, 308, 336, 339, 402, 510, 516, 518, 533, 617, 627, 662, 682; aesthetic, 500; crypto-, 506; literary, 500; Marxist, 671; materialistic, 662; philosophical, 68; Platonic, 94; transcendental, 329, 337
ideas, abstract, 31; character of, 69; Platonic, 378
identity, 279; law of, 262, 271; personal, 89, 95
ideology, 224ff, 408, 438, 465, 471, 511; and emotion, 224ff; and existentialism, 605f; and philosophy, 20, 268f; critique of, 615; totalitarian, 412

Idt, Geneviève, 721
illusion, intellectualist, 158; prospective, 59f; retrospective, 59, 91f, 508; romantic, 106
illusionism, 127
image(s), 8, 69, 117f, 448, 566; and act, 162; and analogon, 149; and art, 124; and consciousness, 143, 170; and contradiction, 70; and feelings, 125; and intention, 175; and knowing, 159; and nothingness, 173; and object, 169; and ontology, 162; and perceiving, 169, 186; as mental entity, 169; as mini-things, 142f; as relation, 146; as thing, 169; atomistic, 142; eidetics of, 144; essence of, 144; explained, 149, 173; external, 150; freedom of, 173; levels of, 188; liberating, 167; materiality of, 68; mental, 148ff; metaphysics of, 142f; paradox of, 175; picture, 167; poverty of, 171; structure of, 152; teaches nothing, 141, 159
image-family, 172, 188
image-form, 145
image-world, 141
imaginary, 14, 47, 79, 136, 446, 451, 471, 528f, 532; and nothingness, 154f; and perception, 154f; and real, 124, 139, 156f, 161; and sensuous, 157; as unreal, 154; entering into, 157; existence of, 155; life, 172; object, 128; realizing, 154; theory of, 47
imagination, 23, 75, 113, 124, 197, 365, 444, 448f, 496, 499, 501, 534; and analogon, 14, 147ff; and consciousness, 173; and knowledge, 158ff; and nothingness, 145ff; and perception, 158, 170ff; and thinking, 160; as modes of consciousness, 144f; as "presentifying,"141; certainty of, 145; created world, 140; nihilating character of, 145; objects of, 155; omnipotence of, 142; phenomenology of, 141f; productive, 167, 174; reproductive, 167, 174; specificity of, 167f; transcendental, 157
"imaginative variations," 168
imagined object, 124ff, 147, 150, 156; and signs, 125; as transcendence, 143; dimension of, 148; representative element in, 151; thetic character of, 161
imagining, act of, 191; and seeing, 174; as imaging, 163; as knowing, 163; as nihilating, 156; eidetic, 142; positional act of, 171; theories of, 142ff
imitation, 114
immanence, absolute, 330; fallacy of, 169;

hell of, 440; illusion of, 143, 148ff
immanentism, 500; idealist, 46
immediacy, 73, 75f, 82n, 231; non-objective, 283; uncritical, 287
inauthenticity, 447
incarnation, 314, 703, 705; and alienation, 318; concept of, 694; reciprocity of, 316
indifference, ethics of, 381, 386
individual, and group, 19, 358f; and *persona,* 88, 90, 93; and Third, 361; disappearance of, 358; essence, 698; incomplete, 515; primacy of, 357
individualism, 133, 690; bourgeois, 309
individuation, 87f, 109n; material, 88, 95, 102
induction, 402
industrialization, 690
Ingarden, Roman, 153, 165n
in-itself, 37, 39f, 43, 194, 661ff
In-Itself-for-Itself, 231ff
innocence, 447, 486
intellection, 158f, 162
intellectual, 462; bourgeois, 412f, 417, 464; Communist Party, 607; French, 418; liberal, 414; modern, 415; Sartrean, 462f, 465
intellectualism, 158, 163f
intelligence, 559
intelligibility, 270; limits of, 268; requirements of, 633f
intention(s), 22, 34, 287, 378, 402f, 595; and ethics, 378; and unconscious, 541
intentionality, 182, 185, 199, 205f, 209, 213f, 224, 259, 313, 329, 403, 448, 539, 595; and cogito, 340; and consciousness, 310, 329; pure, 217
interest, ideological, 522
interiority, 345; and praxis, 696
interiorization, 254
intersubjectivity, 43f, 238ff, 304, 306ff, 318f, 322, 533; as human, 86f
"interworld," 43, 304, 306ff, 319ff; and flesh, 317f
intuition, 37, 168; intellectual, 158
invention, 520
Invitto, Giovanni, 721
Iron Curtain, 692
isomorphism, methodological, 334
Issacharoff, Michael, 728

Jager, Bernd, 477ff
James, William, 120, 211, 215, 225, 227n

Jameson, Fredric, 420n, 721
Jaroszewski, Tadeusz, 721
Jastrow, J., 395
Jeanson, Francis, 109n, 196n, 256n, 381, 391n, 409ff, 473n, 475, 493, 624, 628n, 721
Jolas, Maria, 715
Jolivet, Régis, 721
Joubert, Ingrid, 721
Juin, Hubert, 721
Jung, C. G., 81n

Kaelin, Eugene F., 721
Kafka, Franz, 275
Kampits, Peter, 721
Kanapa, Jean, 721
Kant, Immanuel, 8, 25, 57, 112, 140, 167, 197, 213, 222, 224, 259, 281, 329, 350, 384, 388, 400, 404, 599, 605, 607, 686
Kaufmann, Walter A., 228n, 722
Kellogg, Jean D., 722
Kemp, Peter, 722
Kenevan, Phyllis Berdt, 197ff
Kern, Edith, 722
Khrushchev, Nikita, 435
Kierkegaard, Sören, 10, 12, 257, 266, 358, 510, 513
King, Thomas M., 722
Kirkpatrick, Robert, 165n, 196n, 227n, 255n, 323n, 343n, 493n, 602n, 663n, 711
Kirsner, Douglas, 722
Kline, G., 655n
Knecht, Ingbert, 722
knowing, as imagining, 163; "gut-level," 209; imagistic, 159; kinds of, 542; primacy of, 281; pure, 159
knowledge, 107, 152, 206, 329, 331, 542, 605; and awareness, 286; and consciousness, 36f, 183f, 197f, 543, 561, 593; and essences, 208; and imagination, 158ff; foundations of, 197, 208; non-thetic, 37; pure, 319
Knox, T. M., 656n
Koefoed, Oleg, 722
Koffka, Kurt, 543
Kohak, E., 228n
Kohut, Karl, 722
König, Traugott, 715, 722
Kosygin, Aleksei, 436, 437n
Krauss, Henning, 722

Krosigk, F. von, 722
Kuznetsov, V. N., 722

labor, 674; and production, 690; surplus, 622, 691
LaCapra, Dominick, 722
Lafarge, René, 722
Laing, R. D., 655n, 722
Lange, C. G., 211
Langer, Monika, 43f, 164, 300ff, 323n
language, 97, 290, 526; and awareness, 291; and humans, 496; and ontology, 285; and truth, 270; and world, 100; animal, 28f; as a tool, 274; as practico-inert, 525; cognitive-practical, 106f; concept of, 106; descriptive, 290; philosophy of, 17; structuralist, 81n
Lansner, Kermit, 409, 420n
Lanson, Gustave, 46, 500ff, 535n
Lapointe, Claire, 655n, 716
Lapointe, François H., 655n, 716
Laraque, Franck, 722
Lasch, Christopher, 408
Las Vergnas, Raymond, 722
Launay, Claude, 723
Laurent, Jacques, 723
Laurever, N., 196n
Lausberg, Heinrich, 723
law(s), 545, 570, 640; historical, 546
Lawler, James, 722
Lawrence, Nathaniel, 210n
Lazere, Donald, 408ff
Le Bon, Sylvie, 343n, 536n, 711
Lecarme, Jacques, 723
Lecherbonnier, Bernard, 723
Lee, Edward N., 723
Leeson, George, 473n, 714
Leeson, Sylvia, 473n, 714
Lefebvre, Henri, 609ff, 628n, 723
Lefevre, Luc J., 723
Leibniz, G. W. von, 142, 158, 163, 169, 228n, 556
Lejeune, Philippe, 723
Lemaître, H., 165n
Lenin, N., 414, 617f, 620, 670
Le Poittevin, Alfred, 526ff
le vécu, 74ff, 166n, 214
Lévi-Strauss, Claude, 628n, 658n, 723
Lévy, Benny, 708n

Liar, paradox of the, 93
liberation, 26, 136, 253, 381, 455, 461; artistic, 405; colonial, 411; human, 254; metaphysical, 405; political, 405; Third World, 417; working class, 433
libertarianism, 136
liberty, 426
libido, 109n, 540, 553, 585; as blind conatus, 559f
Lichtheim, George, 323n, 655n
lie, to oneself, 246, 249; transcendence of, 247
life, 243, 455f, 481, 488; absurdity of, 91; and consciousness, 29; as theatrical, 109n; eternal, 448; imaginary, 448; stylization of, 94
life-world, 334, 338, 342
Lilar, Suzanne, 723
Lingis, Alphonso, 325n
literation, 467
literature, 104ff, 132, 435, 449, 466; and philosophy, 17, 76ff; and value, 105; engaged, 502, 504; foundations of, 7; not everything, 106; professionalism in, 110n; pure, 125, 508
lived body, 230
Locke, John, 605
logic, 110n, 113, 187, 272; dialectical, 632
logical positivists, 375
loneliness, 460ff
Look, and consciousness, 306; and Other, 312, 335ff
Lorris, Robert, 723
love, 110n, 459ff; analysis of, 13; and freedom, 460; authentic, 459; relation to sadism, 13
Luhmann, N., 642, 657nf
Lukacs, Georg, 512, 536n, 723
Lutz-Muller, Marcos, 723
lying 570, 582f; interpersonal, 583f

Mach, Ernst, 113
machines, and human needs, 691
Maciel, Luis Carlos, 723
MacIntyre, A., 656n, 658nf
Macquarrie, J., 166n
Madame Bovary, 430, 470, 506, 508ff, 522, 524, 533
madness, 217, 223
Madsen, Axel, 723

magic, 218ff, 273, 546
Magny, Claude-Edmonde, 723
Maier, Willi, 723
Mairet, Philip, 196n, 390n, 579n, 712
Malebranche, Nicolas de, 299n
Mallarmé, S., 55, 106, 110n, 116, 502
Malot, Hector, 495
man, 78, 179, 193, 677ff; alienation of, 647;
 and behaviorism, 192; and commitment,
 374; and consciousness, 393, 439; and God,
 401f, 446; and language, 97; and madmen,
 89; and materialism, 671; and matter, 350,
 637, 647, 672; and psychoanalysis, 192; as
 anti-man, 103; as being-in-the-world, 185;
 as material being, 241, 675f, 682; as
 meaning-endowing, 78f; as need, 241; as
 praxis, 348; as value, 102; capacities of,
 232; condition of, 577; definition of, 238,
 668; ends of, 260; mundane, 333f; mystic,
 102; psychological, 180; sciences of, 76,
 613; self-taught, 462, 465, 482ff; theory of,
 373, 503; total, 121; transcendence of, 185;
 underground, 333; understanding, 55, 86ff
Mancarella, Angelo, 723
Mandelbaum, Maurice, 723
Manicheism, 90
Manser, Anthony R., 723
Maoists, 25
Marbach, E., 165n
Marcel, Gabriel, 257, 723
Marcuse, Herbert, 629n, 723
Marín Ibáñez, Ricardo, 723
Martin, Henri, 432
Martin-Deslias, Noël, 723
Marx, Karl, 9, 12, 20, 24f, 30, 56, 63ff, 82n,
 233, 268f, 301, 362f, 367n, 385, 405,
 410f, 416, 510ff, 605ff, 622ff, 640ff,
 656nff, 669ff
Marxism, 16, 20f, 24, 33, 56, 60ff, 79, 81n,
 300f, 369n, 406, 425, 434, 506f, 510f,
 518, 605ff, 632ff, 642ff, 662ff, 672ff, 691;
 and existentialism, 65, 507, 510f; and free-
 dom, 606; applied, 20; as humanism, 627;
 contemporary, 67; critique of, 304;
 difficulties of, 21; living, 614; Stalinist, 67;
 theoretical, 20
Marxist(s), 20, 22, 39, 63ff, 90, 133, 135f,
 265, 358, 361, 525, 533
masochism, 13, 465
Masters, Brian, 723
masturbation, 563

Masullo, Aldo, 724
materialism, 94f, 112, 661ff; and psycho-
 analysis, 359f; conceptions of, 616f; dialec-
 tical, 39, 510, 616, 669ff; existentialist,
 519; historical, 360, 510ff, 664, 702f;
 Marxist, 510, 617, 669; metaphysical, 664;
 myth of, 618, 670; practical, 634; realistic,
 662; Sartrean, 39
materiality, monism, of, 617
Matlaw, R., 228n
matter, 306, 509, 519, 534, 617, 636, 670;
 and consciousness, 40, 663; and man, 350,
 637, 647; and praxis, 267, 675f; as non-
 man, 364; ideality of, 349
Matthews, John, 228n, 256n, 715
Mauny, Eric de, 713
Mauro, Walter, 724
McBride, William Leon, 605ff, 629n, 683nf,
 724
McCall, Dorothy, 724
McCarran Act, 417
McCarthyism, era of, 409
McCleary, Richard C., 227n, 325n, 711
McMahon, Joseph J., 724
meaning(s), 11, 168, 186f, 223, 283, 290,
 305f, 568; and being, 341, 674; and sym-
 bol, 568; not imposed, 320; subjective, 333
meaninglessness, 534
mechanism, 216, 539, 565ff; ghostly, 565; re-
 ductionistic, 565
mediation, 348
meditation, 275
"melting pot," 62f, 65, 67, 73, 76f, 82n
memory, 598f, 601; and consciousness, 36,
 206f; non-thetic, 599f; paradox of, 36
Menchon, Saturnino, 724
mental acts, 141; and imagining, 141
mental image, and analogon, 14f
mentalism, 565
"mental labor," 232f, 236, 240
mentation, conscious, 559
Merks-Leinen, Gabriele, 724
Merleau-Ponty, Maurice, 4, 7, 25, 43f, 82nf,
 86, 154, 157, 160, 163, 166n, 193, 196n,
 217f, 222, 229f, 238f, 242, 244n, 256n,
 300ff, 323n, 325n, 413, 418, 506, 536,
 627, 629nf, 686, 724; relationship with Sar-
 tre, 300ff
Meszaros, Istvan, 724
metaphysics, 39, 117, 263, 680; overcoming,
 264

method, 508; analytico-regressive, 609; analytico-synthetic, 513; anthropological, 608; descriptive, 609f; dialectical, 18, 61f, 73; existentialist, 515; historical-genetic, 609; Marxist, 610; phenomenological, 189, 340; problem of, 37f; progressive-regressive, 189, 195, 609ff; regressive, 649; theory of, 163; transcendental, 287
Michelson, Annette, 713
Mill, J. S., 362
mind, 583; and body, 566f; and unconscious, 587; compartments in, 547f; functions of, 560; model of, 591; theory of, 566
Mitsein, 247f, 265f, 332, 583, 603n
Moeller, Charles, 724
Möller, Joseph, 724
Molnar, Thomas, 724
"moments of truth," 71f, 84n
monad, Leibnizian, 576
monism, 670; materialistic, 661, 682; perceptual, 157, 160
monkeys, 29
Moore, Harry T., 418
Moore, Stanley, 656n, 660n
moral action, 426f, 430; concept of, 422ff; positive, 436
moralism, 501
morality, 364, 499; traditional, 431; universal, 372
Moravia, Sergio, 724
Morot-Sir, Edouard, 724
Morris, Phyllis, S., 724
"motility," 218
motion, 117, 679f
motivation, 555
Mougin, Henri, 724
Mounier, Emmanuel, 724
Müller-Lissner, Adelheid, 724
mundanity, 333f
Murchland, Bernard, 418
Murdoch, Iris, 142, 165n, 369n, 460, 475n, 724
museums, 115
mystics, 274; Christian, 102
myth, 90, 107

Naess, Arne, 724
Napoleon, 77
Natanson, Maurice, 13f, 228n, 326ff, 724
naturalism, 502; anti-, 440

natural kinds, 541
nature, 29, 263, 519, 661f, 671, 681ff; and art, 42, 114, 121; and class struggle, 30; and history, 103; and man, 29, 32; dialectic of, 39, 510, 670, 672; human, 439, 502; metaphysics of, 39, 677ff; politicization of, 30; resources of, 29
nausea, 71f, 96, 208, 448, 462, 466, 481ff; 675; defined, 481; upsurge of, 482
Nauta, Lolle W., 725
Naville, Pierre, 725
Nazism, 32, 470; and Heidegger, 32f
necessitarianism, 704
necessity, practical, 613
need(s), 86, 100, 236f, 271, 620, 622, 672f, 691, 701f; and consciousness, 242; and scarcity, 31f; animal, 102; as transcendence, 230; biological, 699; natural, 32; not an oppression, 31f; organic, 237, 241, 243
negation, 233, 286, 298n, 348, 631, 644f; founded in being, 279; internalized, 247, 254; interpersonal, 247, 253; other-initiated, 247; primitive, 673; self, 247
negritude, 116
Neudeck, Rupert, 725
neurophysiology, 567
neurosis, 98, 105, 510, 523, 540; historical, 27; social, 523
Niel, André, 725
Nietzsche, F. W., 9, 12, 224, 262, 266, 272, 373, 512
Niftrik, Gerrit C. van, 725
nihilism, 273
Nizan, Paul, 7, 86, 109n, 501, 535n, 686
nominalism, 174, 270, 643; dialectical, 353, 355, 359, 633f, 641, 644, 646, 648, 650f; group, 352
non-being, 532; and beauty, 90; and being, 524; as unreality, 171
nothingness, 122ff, 176, 257, 259, 280, 311, 315, 330f, 443, 463, 531; and art, 124; and beauty, 127f; and consciousness, 199, 259f; and freedom, 383; and image, 173; and imaginary, 154f; and imagination, 145ff; in the world, 259
nous, 229, 367n

object, 75, 509; and consciousness, 172, 200, 231; and ego, 201; and ontology, 286; imaginary, 173; imagined, 189, 191; in-

tentional, 193; physical, 116, 155, 396; psychic, 183, 194; quasi-, 184; transcendent, 593

objectification, 242, 676f

objectivism, 70

objectivity, 184

obligation, and freedom, 387

O'Brien, Conor Cruise, 415f, 418f, 421n

Ockham's razor, 143

O'Connor, Daniel, 196n, 210n

Odajnyk, Walter, 655n, 725

Ofstad, Harald, 407n

Olson, K. R., 165n

ontological commitment, 359

ontological proof, 503

ontological separation, 280f, 285, 290, 295, 297, 317

ontology, 13f, 41, 43ff, 113, 133, 330ff, 358, 439, 505, 514, 614, 616, 619, 661ff, 679; and aesthetics, 113, 131; and deception, 294; and desire, 293; and epistemology, 337; and ethics, 96, 373; and freedom, 382f; and human well-being, 292ff; and images, 162; and sociology, 333ff; as moral edification, 45; as neo-materialism, 663ff; atomistic, 358; beyond, 285ff; concept of, 45; descriptive, 295; function of, 295; fundamental, 14; history of, 263f; limits of, 284f, 680; materialist, 662; new, 282; phenomenological, 212, 221, 257, 300, 308f; relation to sociology, 13f, task of, 279; uses of, 286, 292; validity of, 289f

Openness, 291f

oppression, 69f, 411, 472, 522

optimism, 99f, 390, 424, 428, 501

oratio obliqua, 175f

organism, 673, 699; dialectical, 368n

"original project," 449

Orwell, George, 255n

Other, 81n, 209, 239ff, 287, 305, 308, 314ff, 451, 637ff, 677; and alter ego, 335; and body, 313; and consciousness, 280; and ego, 312; and flesh, 317; and freedom, 312; and Look, 239f, 335ff, 452ff, 490; and me, 336; and non-Other, 633; and scarcity, 636; and self, 47f, 332; and Third, 346ff; as hell, 100, 453; as mediator, 457f; as praxis, 350f; as subject, 208; concrete, 336; knowledge of, 327; objectification of, 458f; ontology of, 341; problem of, 326ff

Otto, Maria, 725

pacifism, 303

Pagano, Giacoma M., 725

painting, 16, 115f, 124f, 127

Paissac, Henry, 725

Pap, A., 656n

Papone, Annagrazia, 725

parallelism, 567

Parker, Emmett, 410f, 418, 420n

Parmenides, 130

Parsons, T., 642, 657nf

particulars, and universals, 270, 272ff

passion, 87

passivity, 480, 483f, 506, 531; body as, 243; theory of, 242

past, 443ff

Patte, Daniel, 725

Pears, David, 580n

Peirce, C. S., 165n

Pellegrino, Giuseppe, 725

perceiving, 144, 160, 162, 164; and image, 169

perception, 47, 139, 153, 157, 162, 176, 197, 340, 394, 501; and image, 186; and imaginary, 154f; and imagination, 142ff, 158, 170ff; as a simple act, 160

performance(s), 176; and pretending, 177

Perry, Ralph B., 375, 390n

personality, 540; cult of, 691

perspectivalism, 559

Pesch, Edgar, 725

pessimism, 390, 423, 425, 430, 434, 436, 623

Peyre, Henri, 725

phenomenology, 10, 24f, 61, 68f, 76, 167f, 175f, 212f, 258, 331, 338, 341f, 392, 478, 610; and natural sciences, 70; and psychology, 57, 80n, 185ff; existential, 214; explained, 187f; pure, 188f, 195; transcendental, 213, 338

philosophy, 110n, 438f, 477f, 511, 518, 618, 632; and action, 12; and being, 14; and ideology, 20, 109n, 268f; and language, 17; and literature, 17, 76ff; and politics, 33, 263f; and psychology, 8, 180; and social sciences, 56; as dogmatic, 108n; as interpretation of experience, 6; as totalization, 56; as visions of whole, 260; clarity in, 11; concept of, 76ff; dialectical, 269; Marxist, 20, 77, 615; role of, 18; Sartre's conception of, 55ff; teaching of, 50f

photograph, 151f

Piatier, Jacqueline, 475n

Piazzolla, Marino, 725
Picasso, Pablo, 116
picture, and original, 175; as "paperless," 175; two kinds of, 172
Pingaud, Bernard, 717
Pintos, Juan Luis, 725
Piriou, Jean-Pierre, 717
Plato, 8f, 61, 81n, 113, 143, 160, 207, 265, 477f, 584, 684n
Platonic cave, 100
Platonism, 94
pleasure, 546, 553
plenitude, 129f
poetry, 16, 116, 125f, 525; African, 116; and prose, 125f; as *aesthesis*, 132; committed, 134; distinguished from prose, 16f; theory of, 106
politics, 436; and ontology, 263; and philosophy, 33, 263f; coalition, 65
Pollman, Leo, 725
Ponge, Francis, 116, 135
Pope, the, 59, 104
Popper, K. R., 655nf, 658n
positivism, 112, 516; literary, 46, 500, 504
possibility, pure, 162
Poster, Mark, 725
pour-soi, 158, 260, 307, 338, 341f, 346, 348, 354, 396; dialectic of, 10; not a subject, 259; status of, 332
poverty, 347
practico-inert, 21, 72, 76, 103, 118, 237f, 254, 348, 352f, 355, 363, 365, 405, 519, 636, 640, 693; and freedom, 349; as anti-dialectic, 349; as anti-praxis, 349
praxis, 103f, 108, 131, 137, 233, 237f, 242, 269, 271, 306, 353, 355, 366nf, 405, 468f, 471, 493, 497, 519ff, 636, 643, 650, 659ff, 693ff; analysis of, 254; and dialectic, 269; and *ensembles*, 634, 642f, 645f; and exteriority, 696ff; and matter, 267, 617, 685f; and Other, 351; and scarcity, 687, 691; and totalization, 350, 699; as organism, 644f; as unifying category, 616; autonomous, 693; Bolshevik, 689f; common, 354, 357; dialectical, 357; free, 676f; group, 352f, 358f, 363, 368n, 625f, 688; historical, 511; human, 620, 674f; individual, 348, 352, 358ff, 521, 525, 615, 643ff, 676; literature of, 126; makes distinctions, 270; material, 234, 674, 677; movement of, 461; negative, 698; social, 140; Soviet, 700, 704; tempo-

ralization of, 696
preconscious, 34, 36, 542, 587
prediction, 545, 570
presence, 280
"presence-to-itself," 231
presentification, 141
Presseault, Jacques, 725
pretending, 174f, 252; analysis of, 175f; and performance, 176f; logic of, 176f
Prince, Gerald J., 725
production, 361, 367n; and labor, 690
progress, and destiny, 101
project, as appearance, 241; open-ended, 121; philosophy of, 120ff
proletariat, 134, 302ff, 321, 419, 432; destiny of, 303; dictatorship of, 641
property, 637f
prose, 525; and praxis, 126; artistic, 16f; as craft, 125; as utilitarian, 107; committed, 134
Pruche, Benôit, 725
"pseudo-Sartrism," 43, 300f, 318
psyche, 180, 193, 550, 583f, 588, 601f; and consciousness, 181, 195; and for-itself, 194; characteristics of, 183f; concept of, 544; defined, 191; dilemma of, 37; division of, 573; hydraulic model of, 226; impure, 207; knowledge of, 184; meaning of, 182ff; structure of, 557; unconscious, 591; unified, 547, 561, 564; unity of, 545, 548
psychiatry, phenomenological, 362
psychic, as "being-in-tension," 37; as intentionality, 595; aspects of, 184f; events, 186; fact, 216; object, 191
psychical, analysis of, 190; as degraded, 194; distinguished from consciousness, 182
psychoanalysis, 16, 33, 72, 81n, 191, 193, 216, 361, 507, 539f, 545, 582f; and man, 192; and materialism, 359f; contradiction in, 547; existential, 38, 79, 86, 116, 131, 135, 179, 183, 195, 234, 336, 361, 469, 505f; mythology of, 591; phenomenological, 136, 469; *reductio* of, 561
psychologism, 329
psychology, 48, 142, 179ff, 504; and consciousness, 180; and emotions, 211, 213; and philosophy, 180; behaviorism in, 8; cognitive, 560; critique of traditional, 181ff; does not exist, 8, 38; eidetic, 186, 195; empirical, 37, 186, 188f, 195; Gestalt, 191; movements in, 191f; phenomenological, 37f,

143f, 179, 182ff, 195; scientific, 179, 190;
systematic, 37, 179f, 193; traditional, 8,
179, 190, 192ff; Würtzburg school of, 169
psychoses, 505
psychotherapy, 295
Pucciani, Oreste F., 3ff, 25, 33, 36, 45,
495ff, 725
Puritanism, 62

quality, 183f, 193
quasi-observation, 171, 174f
Quiles, Ismael, 725
Quine, W. V. O., 359, 368n

racism, 28, 694
Rackham, H., 658n
Rahv, Betty T., 726
Raillard, Georges, 726
Rapaport, David, 228n, 566, 580n
rationalism, 75f, 163; dramatic, 104
rationality, 160f, 164, 273, 644
reading, 78
real, and imaginary, 139, 156, 161; and
unreal, 139, 154, 156
realism, 10, 13, 402, 502, 662; artistic, 127;
Marxist, 364; method of, 524
reality, 372, 397, 400, 466, 499, 533;
common-sense, 334; degrees of, 617; hu-
man, 86, 95, 109, 190, 192, 195, 213f,
237, 241, 260, 398, 438, 465, 496, 509,
514, 519, 522, 534, 615, 617, 620, 662,
668f; social, 251
Realpolitik, 411
reason, 113, 668; analytical, 62, 513f, 612,
634, 698; dialectical, 62, 513ff, 612, 624,
634, 672, 695, 698f; institutional, 644; pos-
itivistic, 698f; practical, 649; universal, 514
reciprocity, 639, 646, 650, 678; abstract, 354;
and *ensembles,* 635; defined, 350; free,
351; mediated, 345ff, 356ff; unmediated,
351
Reck, Rima Drell, 418
recognition, and therapy, 552f
reduction, existential, 481; metaphysical, 567;
phenomenological, 73, 75, 141, 144, 327f,
334, 336ff, 481
reductionism, 112, 565, 567, 665, 667
reflection, 144, 201, 331f; and essences, 187;
and self-consciousness, 220; impure, 183,
191, 199f, 202, 207; pure, 184, 203, 207;

purified, 198, 201, 204ff
reification, 676f
relativism, moral, 504
relativization, 88f
religion, 445, 466, 498
Rembrandt, 497
Renéville, Rolland de, 537n
repentance, 379
repression, 211, 588ff; agency of, 591; and
bad faith, 252; and motive, 551; and self-
deception, 572, 584f; and sublimation, 562;
and superego, 590; and unconscious, 559,
589ff; interpersonal, 247, 252; model of,
602; social, 246
resentment, 222, 252
resistance, 250, 426f, 467, 560, 588ff; and
unconscious, 574; movement, 425; psychic,
550f, 584f; selectivity of, 591f; uncon-
scious, 551
responsibility, 86, 294, 373, 387, 392ff, 427;
meaning of, 398
revisionism, 605
revolution, 302ff, 638, 704; Bolshevik, 688;
colonial, 408; Cuban, 686; French, 625;
managerial, 409; Portuguese, 26; pro-
letarian, 690; Russian, 511; social, 624; so-
cialist, 703
Rhein, Phillip H., 418
Richardson, William J., 83n
Richter, Liselotte, 726
Ricoeur, Paul, 167ff, 228n, 297nf
rights, world of, 442
Rimbaud, Arthur, 312, 523, 537n
Riu, Federico, 726
Riviere, Joan, 603n
Robinson, C., 166n
Rolo, Charles, 412, 420n
Romains, Jules, 392
romanticism, 109n, 114, 123, 140, 524
Rosenthal, Gérard, 714
Rothacker, E., 656n
Rousseau, Jean Jacques, 357
Rousset, David, 714
Rovatti, Pier Aldo, 726
Royle, Peter, 726
Ryan, John K., 366n
Rybalka, Michel, 3ff, 80, 164nf, 227n, 276n,
438, 472n, 535nf, 684n, 685, 706n,
709ff
Ryle, Gilbert, 141, 165n, 173ff, 215

Sábato, Ernesto, 726
Sabin, Walter, 726
sadism, 13, 440, 459
saintliness, 294
salvation, 96, 287, 462, 464, 467, 480
sameness, 355f, 358
Sand, George, 515
Sartre, Jean-Paul, (a) *Philosophical Development:* at Ecole Normale, 6ff; continuity and break in thought, 11f; conversion to philosophy, 6; differences with Maurice Merleau-Ponty, 43f; discovery of sociality, 12f; discovery of the dialectic, 9; existentialism, 22; influence of Bergson, 6f; influence of Freud, 12; influence of Hegel, 9; influence of Husserl, 15, 25; influence of Kant, Plato, and Descartes, 8f; influence of Kierkegaard, 10; influence of Maoism, 25; influence of Marx and Marxism, 9, 20ff; influence of Nietzsche, 9; interest in scientific thought and epistemology, 10; phenomenology, 24; philosophy of Anti-Nature, 29ff; relation to Delacroix, 8; relation to Heidegger, 25, 32; relation to Paul Nizan, 7; relation to Simone de Beauvoir, 17; views on teaching philosophy, 50f

 (b) *Sartre's Replies to Critics:* Hazel E. Barnes, 39f; Lee Brown and Alan Hausman, 36f; Robert Champigny, 18, 28; R. D. Cumming, 12f, 18f; Risieri Frondizi, 38; Amedeo Giorgi, 8, 37f; Monika Langer, 43f; Maurice Natanson, 13f; Charles E. Scott, 44f; Ivan Soll, 33ff; Charles D. Tenney, 16f, 41ff

 (c) *Main References to Published Works:* The Age of Reason (L'Age de raison), 439, 440, 451, 461, 467; *Bariona,* 404, 422, 426, 432; *Baudelaire,* 422, 427, 469; *Being and Nothingness (L'Etre et le Néant),* 9f, 13f, 16, 19, 23, 25, 27f, 35f, 39ff, 57ff, 73f, 86, 90, 96ff, 121, 181, 198, 202, 212ff, 230ff, 246, 253f, 257, 261, 270, 278, 280, 287, 289, 308f, 321, 326, 329ff, 340ff, 371ff, 386, 393, 399f, 403, 405f, 422ff, 432f, 436, 438f, 454, 480, 491, 493, 501, 503ff, 521, 533, 539, 574, 582, 593, 595, 598, 609f, 613f, 617, 620, 631ff, 661ff, 697, 703; *Les Chemins de la liberté,* 27, 115, 121, 423, 428f, 432; *The Chips Are Down (Les Jeux sont faits),* 404; *The*

Communists and Peace (Les Communistes et la paix), 93, 99, 302, 304, 307, 321, 422, 431f; *The Condemned of Altona (Les Séquestrés d'Altona),* 100, 104, 399f, 422, 434ff, 449, 456f, 461, 507, 686, 700; *Critique of Dialectical Reason (Critique de la raison dialectique),* 11ff, 27, 29, 31, 39ff, 56ff, 76, 86, 89, 93, 99ff, 121, 230, 233, 236ff, 253, 308, 321, 326, 345ff, 371f, 386, 403ff, 419, 422ff, 461, 507ff, 608, 610ff, 626, 631ff, 653f, 661ff, 685ff, 701, 703f; *La Dernière chance,* 428f; *The Devil and the Good Lord (Le Diable et le bon Dieu),* 422, 431, 461, 467ff; *Dirty Hands (Les Mains sales),* 117, 132, 422f, 428, 467; *Drôle d'amitié,* 428; *Existentialism Is a Humanism (L'Existentialisme est un humanisme),* 89, 102, 257, 374, 422, 428, 632; *The Flies (Les Mouches),* 95f, 98, 399, 403ff, 422, 426, 428f, 434, 445, 454, 468; *The Ghost of Stalin (Le Fantôme de Staline),* 435, 704; *L'Idiot de la famille,* 17, 28, 45, 55, 68, 72, 74, 140, 168, 254, 350, 362, 423, 507, 608, 610f; *Imagination: A Psychological Critique (L'Imagination),* 7, 11, 140f, 162, 168, 170, 617; *Kean,* 422, 431f, 686; *Literary and Philosophical Essays,* 414; *Matérialisme et révolution,* 433; *Nausea (La Nausée),* 12f, 72, 78f, 86, 89, 94, 97f, 102, 115, 117, 132, 212, 405, 438f, 448, 455, 465f, 480f, 493; *Nekrassov,* 422, 431f, 686; *No Exit (Huis clos),* 100, 345, 438, 442, 450, 452f, 455; *Psychology of the Imagination (L'Imaginaire: Psychologie phénoménologique de l'imagination),* 8, 15, 60, 68, 79, 140, 143f, 153, 156f, 160, 162f, 168, 188, 193, 448, 471, 509, 533, 683; *The Question of Method (also Search for a Method, Question de méthode),* 20, 57, 79, 88, 254, 270, 406, 423, 432, 507f, 510, 513, 516f, 605f, 608ff, 685; *Reflections on the Jewish Question (Réflexions sur la question juive),* 96, 422, 427, 432, 434; *The Reprieve (Le Sursis),* 467; *The Respectful Prostitute (La Putain respectueuse),* 456; *Saint Genet, Actor and Martyr (Saint Genet, comédien et martyr),* 13, 15, 18, 38, 58, 87, 90, 96, 99, 136, 139, 153, 254, 422, 424, 432, 469, 501, 512; *Situations,* 100, 102ff, 137;

Sketch for a Theory of Emotions (L'Esquisse d'une théorie des émotions), 8, 189, 422; *The Transcendence of the Ego (La Transcendance de l'ego)*, 10, 35, 198, 202, 207, 212, 217, 221, 241f, 342, 478, 582, 598, 617, 662; *The Wall (Le Mur)*, 461; *What Is Literature? (Qu'est-ce-que la littérature?)*, 11, 16, 79, 97, 100, 104ff, 422, 426f, 430, 435f, 502, 504, 506, 509, 512, 525, 533; *The Words (Les Mots)*, 5, 13, 17, 46, 49, 56, 79, 86, 88f, 90, 92ff, 139, 261, 287, 422, 435, 466, 495, 501, 611
satisfaction, 546, 562, 564; symptomatic, 554
Savage, Catherine, 726
Savage, Dennis, 297n
Savill, Mervyn, 713
scarcity, 103, 240, 242, 349, 425, 461, 472, 612, 615, 623, 646, 649, 663, 675, 688, 690, 692; and existence, 31; and Other, 636; and praxis, 687, 691; and technology, 363; as causal agent, 620f; as social oppression, 31; defining, 622; end of, 32; Marxist conception of, 30; not social, 32; ontology of, 13, 31, 45; relation to ecology, 30; relation to need, 31; relativity of, 622; rule of, 638
Schaff, Adam, 726
Schaldebrand, Mary A., 726
Scheler, Max, 247, 378
Schelling, Friedrich von, 14, 140
Schmidt-Schweda, Dietlinde, 726
Schopenhauer, A., 109n
Schrader, George Alfred, 684n
Schutz, Alfred, 332f, 343n
Schwartz, Theodor, 726
Schweitzer, Karl, 497
science, 7, 84n, 113, 499, 502, 505; and consciousness, 190
Scott, Charles E., 44, 277ff
sculpture, 116f
Seaver, Richard, 716
seeing, 287; and imagining, 174; and picturing, 141, 175
Seel, Gerhard, 655n, 726
"seeming to see," 175f
Sein, 262f, 266
self, 197, 210, 232, 327, 330f, 336, 345ff, 465, 602, 664; and body, 667; and ground, 490; and world, 195; as evanescent, 208; as

process, 209; authentic, 209; circuit of, 34; concept of, 358; consciousness of, 34, 184, 217; false, 209; incompleteness of, 205; instantiated, 332; knowledge of, 204; loss of, 678; not a thing, 200; personal, 204; revelation of, 206; structure of, 200; temporalizing, 204; transcendental, 282; unity of, 197
self-as-subject, 197f
self-awareness, 597
self-consciousness, 593f; and ego, 197ff; and memory, 36; and reflection, 220; nonpositional, 35, 198f, 205f, 208, 309; positional, 35, 199; pre-reflective, 209, 597f; unreflective, 600
self-deception, 61, 172, 216, 250, 540, 544, 570, 582ff; and bad faith, 575; and concealment, 577; and repression, 572, 584f; existence of, 578; paradox of, 539, 561, 571, 573f, 583ff
self-for-the-other, 240
self-fulfillment, 280, 297
self-identity, 197, 262
self-in-temporal-process, 202f
self-knowledge, 197, 206, 453; and Others, 47f; impossibility of, 205; three kinds of, 48
self-understanding, 295
Sendyk-Siegel, Liliane, 716
sensory data, 144
sex, 63, 576
sexuality, 43, 50, 316; and human relationships, 313
Shakespeare, William, 91
shame, 96, 451
Sheridan, James F., 322n, 655n, 726
Sheridan-Smith, Alan, 255n, 707n, 714
Shils, Edward A., 368n
Sicard, Michel, 726
sign, and signatum, 148; indexical, 147
signification, 566, 568; concept of, 564
Silverman, H. J., 728
Simmel, G., 642, 658n
sin, 424
singular, universal, 530
situation, 360; and art, 119f; and freedom, 397, 467, 472; and project, 120; meaning of, 237; philosophy of, 119f
Skinnerism, 513
Smith, Colin, 322nf
social contract, 639

social contradictions, 77
social criticism, 136
socialism, 22, 32, 364, 428, 502, 622f, 685ff; goals of, 703f; humane, 686, 704; monstrosity of, 688f; Russian, 691; true, 365
socialist man, 365
sociality, 12f, 333ff; degrees of, 352
society, 12f, 493, 509, 513, 620, 627, 662; affluent, 621f; analysis of, 632; and ethics, 38; and individual, 518; as hyperorganism, 704; bourgeois, 45, 470; socialist, 22, 625
sociology, 613, 642, 693; and ontology, 13f, 333ff; criticism of dialectical, 362; domain of, 349; systems theory, 640, 659n
Socrates, 477, 489
Soleto, Ignacio, 726
solipsism, 279, 281, 283, 336, 347; epistemological, 341; problem of, 278; reef of, 327, 335, 337; refutation of, 337
solitude, 328, 441, 462, 470
Soll, Ivan, 33ff, 582ff
Solomon, Robert C., 211ff
Solzhenitsyn, A., 50
Sontag, Susan, 418, 421n
Soper, Kate, 629n, 718
sorcery, 75f
soul, 103, 207
space, 157, 680
species, 642
Sperber, Manes, 409
Spiegelberg, Herbert, 164n, 276n, 726
Spinoza, B., 142, 158, 166n, 499
spontaneity, 479; and freedom, 230
Sprott, W., 255n
stability, 490f
Stack, George J., 726
Stakhanovism, 690
Stalin, Joseph, 691f
state, 8, 183f; as legitimate, 641; idea of, 640f
status contract, 640
Stefani, Mario, 727
Stenstroem, Thure, 727
Stern, Alfred, 727
Stone, N. I., 659n
Stone, Robert V., 246ff
Strachey, James, 227n, 603n
Strasser, S., 343n
strategy, psychic, 539
Streller-Justus, J., 727

Struyker Boudier, C. E. M., 723
style, 11
subject, 75f; and consciousness, 309f; as "historical density," 319; embodied, 321; incarnate, 318; transcending, 632
subjectivity, 95, 98f, 202, 214, 255, 304, 374, 461f, 464f, 512f, 518, 520, 647, 669; and personality, 202; collective, 347; human, 505; incarnate, 305, 320; transcendental, 229, 281, 283, 305f, 328, 338f, 342
sublimation, 211; and repression, 562
substance, 184
substance, illusion of, 181
suffering, 133
Suhl, Benjamin, 727
suicide, 400, 443
Sulzer, Elisabeth, 727
superego, 95, 251, 547, 573; and resistance, 590
surrealist, 156
Sutton, Eric, 472n, 712
symbolism, 539, 558, 561; argument from, 555ff; theory of, 540
symbols, aesthetic, 128; and complexes, 568; and meaning, 568; and symptoms, 557, 561ff; dream, 562; iconic, 562
symptom, 544f, 553; and complexes, 562; and unconscious, 549f; as historical law, 545; as intentional, 549; as symbols, 556f, 561ff; as teleological, 549; cause of, 566, 568; formation of, 539, 548, 550, 554, 563f, 566, 572, 586; meaning of, 568
syncretism, 73, 82n
syndicalism, 417
synthesis, absolute, 19; historical, 19

Tao, 274
teleology, 243, 262, 565f, 647; dialectical, 360
temporality, 619
temporalization, 698f
Ten Commandments, 375
Tenney, Charles D., 16, 41, 112ff
Theau, Jean, 727
therapy, 544, 550, 552; and recognition, 552f; end of, 552
thesis, realizing, 47
things, 485; and consciousness, 278, 619; and thoughts, 271; and words, 270f, 526

thinking, 162; and awareness, 290f; and imagination, 160; and understanding, 284; Being, 286; non-representational, 292; reflexive, 289; wishful, 570f
Third, 635ff, 653, 676; alienating, 346f, 351, 353f; and Other, 346ff; concept of, 345ff; ethics of, 364; genius of, 358; mediating, 352f, 355, 359ff; praxis of, 360; regulating, 356f, 368n, 638; structure of, 353
"third term," 317
Third World, 413, 686, 706
Thody, Philip, 422ff, 655n, 727
thought, 159, 273; imaged, 68, 159; pure, 160; reflexive, 68; syntheses of, 271; unconscious, 540f
time, 157, 306; and transcendence, 98; privation of, 262
Tollenaere, M. de, Jr., 322n
torture, 399f, 450, 453, 459; defined, 100
totalitarianism, 275, 412
totality, 19; defined, 46f, 521
totalization, 57, 62, 65, 87, 89, 98, 104f, 110n, 120, 128, 350, 354, 362, 367n, 405, 515, 518, 522, 530f, 533, 633, 641, 643f, 670, 693ff; aesthetic, 125, 135, 137; as *Aufhebung,* 59; explained, 87; global, 689; historical, 517; ontological, 514; rational, 47; real-being of, 695f; self-, 88; social, 694
transcendence, 185, 233, 281, 337, 471; active, 482; possibility of, 440
transcendency, 531
transcendental fallacy, 651ff
transubstantiation, 673
Troisfontaines, Roger, 727
Trotsky, Leon, 688f
Trotskyites, 307
Truc, Gonzague, 727
truth, 57, 107, 292, 322, 386, 480, 550, 583, 670; and fable, 92f; and facticity, 320; and language, 270
Turnell, Martin, 473n, 713

ubiquity, 356
Unamuno, Miguel de, 109n
unconscious, 12, 33ff, 180, 216, 249, 251, 362, 505, 539ff; and behavior, 556, 564; and censor, 557f; and conscious, 36, 554ff; and consciousness, 541, 572, 585, 596; and emotions, 216; and repression, 558f, 589f;

and resistance, 551, 574; and symbolism, 558; and symptom, 549f; character of, 555f; concept of, 542, 559f; descriptive, 541, 543, 586f, 601; does not exist, 34; drives of, 555; dynamic, 541, 586f, 601; modes of, 541; rejection of, 541f, 582ff; topography of, 590
understanding, 22, 283, 298n, 496; without understanding, 22f
unity, 352, 505f; synthetic, 87
universal(s), and individual, 88, 99; and particulars, 270, 272ff; concrete, 273; dialectical, 645; singular, 77, 87
universalization, 388
unreal, 509; and imaginary, 156f; theory of, 171
Untermann, E., 656n
Ussher, Arland, 727

value(s), 94, 104, 237, 364, 374f, 379f, 394, 399, 402, 434; aesthetic, 113ff; and freedom, 381, 389; as interest, 375; being as, 128; inventing, 377; surplus, 20, 612, 622, 637, 652
Varese, Louise, 713
Varet, Gilbert, 727
vectors, 566
Verhoeff, Johan P., 727
Verstraeten, Pierre, 629n, 727
Vestre, Bernt, 407n
Victor, Pierre, 25, 80n, 367n, 715
Vienna Circle, 14
Vietnam, 417, 435f
Vineberg, Elsa, 438n
violence, 137, 303, 318, 411, 425, 431, 436, 520, 639; revolutionary, 499
viscosity, and freedom, 129; and petrifaction, 130
vision, nauseous, 72
volition, 292
von Wright, G. H., 165n, 656n

Wacquez, Mauricio, 727
Waelhens, A. de, 235, 244n
Wahl, Jean, 727
Wallace, W., 658n
war, 392, 398, 441, 450, 459; Algerian, 417f, 459; Korean, 301f, 304, 430, 468; prisoners of, 426; Spanish Civil, 438

Warnock, Mary, 322n, 655n, 727
Weber, Max, 333, 360, 363, 368n, 640,
 657n, 674
Weiss, P., 165n
Weltanschauung, 540
Werner, Eric, 728
We-subject, 347
Wilcocks, Robert, 711, 716
Willhoite, Fred H., 418
Williams, Forrest, 165n, 169n, 196n, 227n,
 255n, 323n, 343n, 493n, 602n, 663n, 711
Willms, B., 657n
wisdom, 605
wish, libidinal, 548; unconscious, 545
Wittgenstein, Ludwig, 109n, 141f, 165n, 166,
 215, 228n, 404
Wollheim, Richard, 558ff, 579nf
words, and things, 270f, 526; as ends, 496;
 concept of, 283
work, theory of, 508f

working class, 302f, 413, 622, 642; Soviet,
 689
world, 10, 39, 284, 329, 454, 481, 678, 681;
 and Being, 266; and body, 243; and con-
 sciousness, 234f, 260, 279, 306, 336,
 396ff, 668; and ego, 182, 664; and flesh,
 305, 322; and human beings, 44; and lan-
 guage, 100; and meaning, 305; as magical,
 221ff; constituting the, 399ff; fictional, 439;
 human, 522; imaginary, 447; inter-
 subjective, 328; social, 687
world-openness, 297
world-view, 606ff, 620
writer(s), and work, 501; bourgeois, 502; re-
 sponsibility of, 97
writing, 97, 132, 526; art of, 105; reasons for,
 104

Zehm, Günter, 728
Zuidema, Syste U., 728